Collins

Collins
World Atlas

Contents

Contents

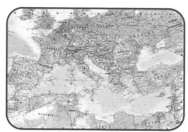
Southern Europe

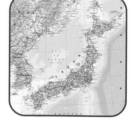
Japan

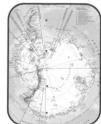
Antarctica

Settlements

Population	National capital	Administrative capital	Other city or town
over 10 million	BEIJING ✹	Karachi ◉	New York ◉
5 million to 10 million	JAKARTA ✶	Tianjin ◉	Nova Iguaçu ◉
1 million to 5 million	KĀBUL ✶	Sydney ◎	Kaohsiung ◉
500 000 to 1 million	BANGUI ✶	Trujillo ◎	Jeddah ◎
100 000 to 500 000	WELLINGTON ✶	Mansa ◎	Apucarana ◎
50 000 to 100 000	PORT OF SPAIN ✿	Potenza ◦	Arecibo ◦
10 000 to 50 000	MALABO ✿	Chinhoyi ◦	Ceres ◦
under 10 000	VALLETTA ✿	Ati ◦	Venta ◦

⬤ Built-up area

Boundaries

──────── International boundary

▬·▬·▬·▬ Disputed international boundary or alignment unconfirmed

──────── Administrative boundary

········ Ceasefire line

Miscellaneous

---------- National park

·············· Reserve or Regional park

✦ Site of specific interest

⬤⬤⬤⬤⬤ Wall

Land and sea features

Desert

⌄ Oasis

Lava field

1234 △ Volcano
height in metres

Marsh

Ice cap or Glacier

Escarpment

Coral reef

1234 ⌄ Pass
height in metres

Lakes and rivers

Lake

Impermanent lake

Salt lake or lagoon

Impermanent salt lake

Dry salt lake or salt pan

123 Lake height
surface height above
sea level, in metres

──── River

──── Impermanent river or watercourse

‖ Waterfall

── Dam

∣ Barrage

Relief

Contour intervals and layer colours

Height
metres
5000
3000
2000
1000
500
200
0
below sea level
0
200
2000
4000
6000

Depth

1234 ▲ Summit
height in metres

-123 Spot height
height in metres

123 Ocean deep
depth in metres

Transport

─➤═══ -----	Motorway (tunnel; under construction)
─➤── -----	Main road (tunnel; under construction)
─➤── -----	Secondary road (tunnel; under construction)
············	Track
─╫──╫─ ═══	Main railway (tunnel; under construction)
─╫──╫─ ───	Secondary railway (tunnel; under construction)
─➤── ───	Other railway (tunnel; under construction)
────	Canal
✈	Main airport
✈	Regional airport

Satellite imagery - The thematic pages in the atlas contain a wide variety of photographs and images. These are a mixture of terrestrial and aerial photographs and satellite imagery. All are used to illustrate specific themes and to give an indication of the variety of imagery available today. The main types of imagery used in the atlas are described in the table below. The sensor for each satellite image is detailed on the acknowledgements page.

Main satellites/sensors

Satellite/sensor name	Launch dates	Owner	Aims and applications	Internet links	Additional internet links
Landsat 1, 2, 3, 4, 5, 7	July 1972–April 1999	National Aeronautics and Space Administration (NASA), USA	The first satellite to be designed specifically for observing the Earth's surface. Originally set up to produce images of use for agriculture and geology. Today is of use for numerous environmental and scientific applications.	landsat.gsfc.nasa.gov	asterweb.jpl.nasa.gov
					earth.jsc.nasa.gov
					earthnet.esrin.esa.it
SPOT 1, 2, 3, 4, 5 (Satellite Pour l'Observation de la Terre)	February 1986–March 1998	Centre National d'Etudes Spatiales (CNES) and Spot Image, France	Particularly useful for monitoring land use, water resources research, coastal studies and cartography.	www.spotimage.fr	earthobservatory.nasa.gov
					eol.jsc.nasa.gov
					modis.gsfc.nasa.gov
Space Shuttle	Regular launches from 1981	NASA, USA	Each shuttle mission has separate aims. Astronauts take photographs with high specification hand held cameras. The Shuttle Radar Topography Mission (SRTM) in 2000 obtained the most complete near-global high-resolution database of the earth's topography.	science.ksc.nasa.gov/shuttle/countdown www.jpl.nasa.gov/srtm	seawifs.gsfc.nasa.gov
					topex-www.jpl.nasa.gov
					visibleearth.nasa.gov
IKONOS	September 1999	Space Imaging	First commercial high-resolution satellite. Useful for a variety of applications mainly Cartography, Defence, Urban Planning, Agriculture, Forestry and Insurance.	www.geoeye.com	www.rsi.ca
					www.usgs.gov

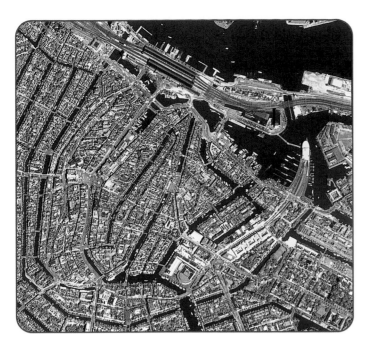

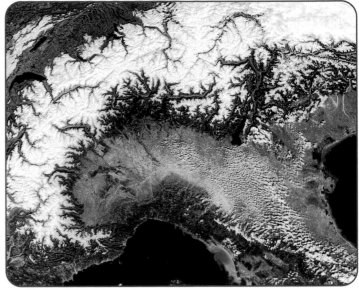

Above: **The Alps**
Left: **Amsterdam,** Netherlands

Europe		Area sq km	Area sq miles	Population	Capital	Languages	Religions	Currency
ALBANIA		28 748	11 100	3 130 000	Tirana	Albanian, Greek	Sunni Muslim, Albanian Orthodox, Roman Catholic	Lek
ANDORRA		465	180	67 000	Andorra la Vella	Spanish, Catalan, French	Roman Catholic	Euro
AUSTRIA		83 855	32 377	8 189 000	Vienna	German, Croatian, Turkish	Roman Catholic, Protestant	Euro
BELARUS		207 600	80 155	9 755 000	Minsk	Belorussian, Russian	Belorussian Orthodox, Roman Catholic	Belarus rouble
BELGIUM		30 520	11 784	10 419 000	Brussels	Dutch (Flemish), French (Walloon), German	Roman Catholic, Protestant	Euro
BOSNIA-HERZEGOVINA		51 130	19 741	3 907 000	Sarajevo	Bosnian, Serbian, Croatian	Sunni Muslim, Serbian Orthodox, Roman Catholic, Protestant	Marka
BULGARIA		110 994	42 855	7 726 000	Sofia	Bulgarian, Turkish, Romany, Macedonian	Bulgarian Orthodox, Sunni Muslim	Lev
CROATIA		56 538	21 829	4 551 000	Zagreb	Croatian, Serbian	Roman Catholic, Serbian Orthodox, Sunni Muslim	Kuna
CZECH REPUBLIC		78 864	30 450	10 220 000	Prague	Czech, Moravian, Slovak	Roman Catholic, Protestant	Czech koruna
DENMARK		43 075	16 631	5 431 000	Copenhagen	Danish	Protestant	Danish krone
ESTONIA		45 200	17 452	1 330 000	Tallinn	Estonian, Russian	Protestant, Estonian and Russian Orthodox	Kroon
FINLAND		338 145	130 559	5 249 000	Helsinki	Finnish, Swedish	Protestant, Greek Orthodox	Euro
FRANCE		543 965	210 026	60 496 000	Paris	French, Arabic	Roman Catholic, Protestant, Sunni Muslim	Euro
GERMANY		357 022	137 849	82 689 000	Berlin	German, Turkish	Protestant, Roman Catholic	Euro
GREECE		131 957	50 949	11 120 000	Athens	Greek	Greek Orthodox, Sunni Muslim	Euro
HUNGARY		93 030	35 919	10 098 000	Budapest	Hungarian	Roman Catholic, Protestant	Forint
ICELAND		102 820	39 699	295 000	Reykjavík	Icelandic	Protestant	Icelandic króna
IRELAND		70 282	27 136	4 148 000	Dublin	English, Irish	Roman Catholic, Protestant	Euro
ITALY		301 245	116 311	58 093 000	Rome	Italian	Roman Catholic	Euro
LATVIA		63 700	24 595	2 307 000	Rīga	Latvian, Russian	Protestant, Roman Catholic, Russian Orthodox	Lats
LIECHTENSTEIN		160	62	35 000	Vaduz	German	Roman Catholic, Protestant	Swiss franc
LITHUANIA		65 200	25 174	3 431 000	Vilnius	Lithuanian, Russian, Polish	Roman Catholic, Protestant, Russian Orthodox	Litas
LUXEMBOURG		2 586	998	465 000	Luxembourg	Letzeburgish, German, French	Roman Catholic	Euro
MACEDONIA (F.Y.R.O.M.)		25 713	9 928	2 034 000	Skopje	Macedonian, Albanian, Turkish	Macedonian Orthodox, Sunni Muslim	Macedonian denar
MALTA		316	122	402 000	Valletta	Maltese, English	Roman Catholic	Maltese lira
MOLDOVA		33 700	13 012	4 206 000	Chişinău	Romanian, Ukrainian, Gagauz, Russian	Romanian Orthodox, Russian Orthodox	Moldovan leu
MONACO		2	1	35 000	Monaco-Ville	French, Monegasque, Italian	Roman Catholic	Euro
MONTENEGRO		13 812	5 333	620 145	Podgorica	Serbian (Montenegrin), Albanian	Montenegrin Orthodox, Sunni Muslim	Euro
NETHERLANDS		41 526	16 033	16 299 000	Amsterdam/The Hague	Dutch, Frisian	Roman Catholic, Protestant, Sunni Muslim	Euro
NORWAY		323 878	125 050	4 620 000	Oslo	Norwegian	Protestant, Roman Catholic	Norwegian krone
POLAND		312 683	120 728	38 530 000	Warsaw	Polish, German	Roman Catholic, Polish Orthodox	Złoty
PORTUGAL		88 940	34 340	10 495 000	Lisbon	Portuguese	Roman Catholic, Protestant	Euro
ROMANIA		237 500	91 699	21 711 000	Bucharest	Romanian, Hungarian	Romanian Orthodox, Protestant, Roman Catholic	Romanian leu
RUSSIAN FEDERATION		17 075 400	6 592 849	143 202 000	Moscow	Russian, Tatar, Ukrainian, local languages	Russian Orthodox, Sunni Muslim, Protestant	Russian rouble
SAN MARINO		61	24	28 000	San Marino	Italian	Roman Catholic	Euro
SERBIA		88 361	34 116	9 379 000	Belgrade	Serbian, Albanian, Hungarian	Serbian Orthodox, Sunni Muslim	Serbian dinar, Euro
SLOVAKIA		49 035	18 933	5 401 000	Bratislava	Slovak, Hungarian, Czech	Roman Catholic, Protestant, Orthodox	Slovakian koruna
SLOVENIA		20 251	7 819	1 967 000	Ljubljana	Slovene, Croatian, Serbian	Roman Catholic, Protestant	Tólar
SPAIN		504 782	194 897	43 064 000	Madrid	Castilian, Catalan, Galician, Basque	Roman Catholic	Euro
SWEDEN		449 964	173 732	9 041 000	Stockholm	Swedish	Protestant, Roman Catholic	Swedish krona
SWITZERLAND		41 293	15 943	7 252 000	Bern	German, French, Italian, Romansch	Roman Catholic, Protestant	Swiss franc
UKRAINE		603 700	233 090	46 481 000	Kiev	Ukrainian, Russian	Ukrainian Orthodox, Ukrainian Catholic, Roman Catholic	Hryvnia
UNITED KINGDOM		243 609	94 058	59 668 000	London	English, Welsh, Gaelic	Protestant, Roman Catholic, Muslim	Pound sterling
VATICAN CITY		0.5	0.2	552	Vatican City	Italian	Roman Catholic	Euro

Dependent territories		Territorial status	Area sq km	Area sq miles	Population	Capital	Languages	Religions	Currency
Azores		Autonomous Region of Portugal	2 300	888	241 762	Ponta Delgada	Portuguese	Roman Catholic, Protestant	Euro
Faroe Islands		Self-governing Danish Territory	1 399	540	47 000	Tórshavn	Faroese, Danish	Protestant	Danish krone
Gibraltar		United Kingdom Overseas Territory	7	3	28 000	Gibraltar	Engllish, Spanish	Roman Catholic, Protestant, Sunni Muslim	Gibraltar pound
Guernsey		United Kingdom Crown Dependency	78	30	62 692	St Peter Port	English, French	Protestant, Roman Catholic	Pound sterling
Isle of Man		United Kingdom Crown Dependency	572	221	77 000	Douglas	English	Protestant, Roman Catholic	Pound sterling
Jersey		United Kingdom Crown Dependency	116	45	87 500	St Helier	English, French	Protestant, Roman Catholic	Pound sterling

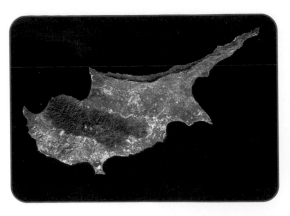

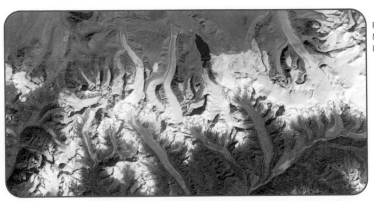

Far left: **Cyprus**, eastern Mediterranean
Left: **Bhutan**, Himalaya

Asia		Area sq km	Area sq miles	Population	Capital	Languages	Religions	Currency
AFGHANISTAN		652 225	251 825	29 863 000	Kābul	Dari, Pushtu, Uzbek, Turkmen	Sunni Muslim, Shi'a Muslim	Afghani
ARMENIA		29 800	11 506	3 016 000	Yerevan	Armenian, Azeri	Armenian Orthodox	Dram
AZERBAIJAN		86 600	33 436	8 411 000	Baku	Azeri, Armenian, Russian, Lezgian	Shi'a Muslim, Sunni Muslim, Russian and Armenian Orthodox	Azerbaijani manat
BAHRAIN		691	267	727 000	Manama	Arabic, English	Shi'a Muslim, Sunni Muslim, Christian	Bahrain dinar
BANGLADESH		143 998	55 598	141 822 000	Dhaka	Bengali, English	Sunni Muslim, Hindu	Taka
BHUTAN		46 620	18 000	2 163 000	Thimphu	Dzongkha, Nepali, Assamese	Buddhist, Hindu	Ngultrum, Indian rupee
BRUNEI		5 765	2 226	374 000	Bandar Seri Begawan	Malay, English, Chinese	Sunni Muslim, Buddhist, Christian	Brunei dollar
CAMBODIA		181 035	69 884	14 071 000	Phnom Penh	Khmer, Vietnamese	Buddhist, Roman Catholic, Sunni Muslim	Riel
CHINA		9 584 492	3 700 593	1 323 345 000	Beijing	Mandarin, Wu, Cantonese, Hsiang, regional languages	Confucian, Taoist, Buddhist, Christian, Sunni Muslim	Yuan, HK dollar*, Macau pataca
CYPRUS		9 251	3 572	835 000	Nicosia	Greek, Turkish, English	Greek Orthodox, Sunni Muslim	Cyprus pound
EAST TIMOR		14 874	5 743	947 000	Dili	Portuguese, Tetun, English	Roman Catholic	United States dollar
GEORGIA		69 700	26 911	4 474 000	T'bilisi	Georgian, Russian, Armenian, Azeri, Ossetian, Abkhaz	Georgian Orthodox, Russian Orthodox, Sunni Muslim	Lari
INDIA		3 064 898	1 183 364	1 103 371 000	New Delhi	Hindi, English, many regional languages	Hindu, Sunni Muslim, Shi'a Muslim, Sikh, Christian	Indian rupee
INDONESIA		1 919 445	741 102	222 781 000	Jakarta	Indonesian, local languages	Sunni Muslim, Protestant, Roman Catholic, Hindu, Buddhist	Rupiah
IRAN		1 648 000	636 296	69 515 000	Tehrān	Farsi, Azeri, Kurdish, regional languages	Shi'a Muslim, Sunni Muslim	Iranian rial
IRAQ		438 317	169 235	28 807 000	Baghdād	Arabic, Kurdish, Turkmen	Shi'a Muslim, Sunni Muslim, Christian	Iraqi dinar
ISRAEL		20 770	8 019	6 725 000	Jerusalem (Yerushalayim) (El Quds)**	Hebrew, Arabic	Jewish, Sunni Muslim, Christian, Druze	Shekel
JAPAN		377 727	145 841	128 085 000	Tōkyō	Japanese	Shintoist, Buddhist, Christian	Yen
JORDAN		89 206	34 443	5 703 000	'Ammān	Arabic	Sunni Muslim, Christian	Jordanian dinar
KAZAKHSTAN		2 717 300	1 049 155	14 825 000	Astana	Kazakh, Russian, Ukrainian, German, Uzbek, Tatar	Sunni Muslim, Russian Orthodox, Protestant	Tenge
KUWAIT		17 818	6 880	2 687 000	Kuwait	Arabic	Sunni Muslim, Shi'a Muslim, Christian, Hindu	Kuwaiti dinar
KYRGYZSTAN		198 500	76 641	5 264 000	Bishkek	Kyrgyz, Russian, Uzbek	Sunni Muslim, Russian Orthodox	Kyrgyz som
LAOS		236 800	91 429	5 924 000	Vientiane	Lao, local languages	Buddhist, traditional beliefs	Kip
LEBANON		10 452	4 036	3 577 000	Beirut	Arabic, Armenian, French	Shi'a Muslim, Sunni Muslim, Christian	Lebanese pound
MALAYSIA		332 965	128 559	25 347 000	Kuala Lumpur/Putrajaya	Malay, English, Chinese, Tamil, local languages	Sunni Muslim, Buddhist, Hindu, Christian, traditional beliefs	Ringgit
MALDIVES		298	115	329 000	Male	Divehi (Maldivian)	Sunni Muslim	Rufiyaa
MONGOLIA		1 565 000	604 250	2 646 000	Ulan Bator	Khalka (Mongolian), Kazakh, local languages	Buddhist, Sunni Muslim	Tugrik (tögrög)
MYANMAR		676 577	261 228	50 519 000	Rangoon	Burmese, Shan, Karen, local languages	Buddhist, Christian, Sunni Muslim	Kyat
NEPAL		147 181	56 827	27 133 000	Kathmandu	Nepali, Maithili, Bhojpuri, English, local languages	Hindu, Buddhist, Sunni Muslim	Nepalese rupee
NORTH KOREA		120 538	46 540	22 488 000	P'yŏngyang	Korean	Traditional beliefs, Chondoist, Buddhist	North Korean won
OMAN		309 500	119 499	2 567 000	Muscat	Arabic, Baluchi, Indian languages	Ibadhi Muslim, Sunni Muslim	Omani riyal
PAKISTAN		803 940	310 403	157 935 000	Islamabad	Urdu, Punjabi, Sindhi, Pushtu, English	Sunni Muslim, Shi'a Muslim, Christian, Hindu	Pakistani rupee
PALAU		497	192	20 000	Koror	Palauan, English	Roman Catholic, Protestant, traditional beliefs	United States dollar
PHILIPPINES		300 000	115 831	83 054 000	Manila	English, Pilipino, Cebuano, local languages	Roman Catholic, Protestant, Sunni Muslim, Aglipayan	Philippine peso
QATAR		11 437	4 416	813 000	Doha	Arabic	Sunni Muslim	Qatari riyal
RUSSIAN FEDERATION		17 075 400	6 592 849	143 202 000	Moscow	Russian, Tatar, Ukrainian, local languages	Russian Orthodox, Sunni Muslim, Protestant	Russian rouble
SAUDI ARABIA		2 200 000	849 425	24 573 000	Riyadh	Arabic	Sunni Muslim, Shi'a Muslim	Saudi Arabian riyal
SINGAPORE		639	247	4 326 000	Singapore	Chinese, English, Malay, Tamil	Buddhist, Taoist, Sunni Muslim, Christian, Hindu	Singapore dollar
SOUTH KOREA		99 274	38 330	47 817 000	Seoul	Korean	Buddhist, Protestant, Roman Catholic	South Korean won
SRI LANKA		65 610	25 332	20 743 000	Sri Jayewardenepura Kotte	Sinhalese, Tamil, English	Buddhist, Hindu, Sunni Muslim, Roman Catholic	Sri Lankan rupee
SYRIA		185 180	71 498	19 043 000	Damascus	Arabic, Kurdish, Armenian	Sunni Muslim, Shi'a Muslim, Christian	Syrian pound
TAIWAN		36 179	13 969	22 858 000	T'aipei	Mandarin, Min, Hakka, local languages	Buddhist, Taoist, Confucian, Christian	Taiwan dollar
TAJIKISTAN		143 100	55 251	6 507 000	Dushanbe	Tajik, Uzbek, Russian	Sunni Muslim	Somoni
THAILAND		513 115	198 115	64 233 000	Bangkok	Thai, Lao, Chinese, Malay, Mon-Khmer languages	Buddhist, Sunni Muslim	Baht
TURKEY		779 452	300 948	73 193 000	Ankara	Turkish, Kurdish	Sunni Muslim, Shi'a Muslim	Turkish lira
TURKMENISTAN		488 100	188 456	4 833 000	Aşgabat	Turkmen, Uzbek, Russian	Sunni Muslim, Russian Orthodox	Turkmen manat
UNITED ARAB EMIRATES		77 700	30 000	4 496 000	Abu Dhabi	Arabic, English	Sunni Muslim, Shi'a Muslim	United Arab Emirates dirham
UZBEKISTAN		447 400	172 742	26 593 000	Toshkent	Uzbek, Russian, Tajik, Kazakh	Sunni Muslim, Russian Orthodox	Uzbek som
VIETNAM		329 565	127 246	84 238 000	Ha Nôi	Vietnamese, Thai, Khmer, Chinese, local languages	Buddhist, Taoist, Roman Catholic, Cao Dai, Hoa Hao	Dong
YEMEN		527 968	203 850	20 975 000	Şan'ā'	Arabic	Sunni Muslim, Shi'a Muslim	Yemeni rial

Dependent and disputed territories		Territorial status	Area sq km	Area sq miles	Population	Capital	Languages	Religions	Currency
Christmas Island		Australian External Territory	135	52	1 508	The Settlement	English	Buddhist, Sunni Muslim, Protestant, Roman Catholic	Australian dollar
Cocos Islands		Australian External Territory	14	5	621	West Island	English	Sunni Muslim, Christian	Australian dollar
Gaza		Semi-autonomous region	363	140	1 406 423	Gaza	Arabic	Sunni Muslim, Shi'a Muslim	Israeli shekel
Jammu and Kashmir		Disputed territory (India/Pakistan)	222 236	85 806	13 000 000	Srinagar			
West Bank		Disputed territory	5 860	2 263	2 421 491		Arabic, Hebrew	Sunni Muslim, Jewish, Shi'a Muslim, Christian	Jordanian dinar, Israeli shekel

*Hong Kong dollar
**De facto capital. Disputed

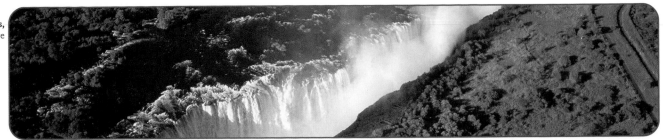

Victoria Falls,
Zambia/Zimbabwe

Africa		Area sq km	Area sq miles	Population	Capital	Languages	Religions	Currency
ALGERIA		2 381 741	919 595	32 854 000	Algiers	Arabic, French, Berber	Sunni Muslim	Algerian dinar
ANGOLA		1 246 700	481 354	15 941 000	Luanda	Portuguese, Bantu, local languages	Roman Catholic, Protestant, traditional beliefs	Kwanza
BENIN		112 620	43 483	8 439 000	Porto-Novo	French, Fon, Yoruba, Adja, local languages	Traditional beliefs, Roman Catholic, Sunni Muslim	CFA franc*
BOTSWANA		581 370	224 468	1 765 000	Gaborone	English, Setswana, Shona, local languages	Traditional beliefs, Protestant, Roman Catholic	Pula
BURKINA		274 200	105 869	13 228 000	Ouagadougou	French, Moore (Mossi), Fulani, local languages	Sunni Muslim, traditional beliefs, Roman Catholic	CFA franc*
BURUNDI		27 835	10 747	7 548 000	Bujumbura	Kirundi (Hutu, Tutsi), French	Roman Catholic, traditional beliefs, Protestant	Burundian franc
CAMEROON		475 442	183 569	16 322 000	Yaoundé	French, English, Fang, Bamileke, local languages	Roman Catholic, traditional beliefs, Sunni Muslim, Protestant	CFA franc*
CAPE VERDE		4 033	1 557	507 000	Praia	Portuguese, creole	Roman Catholic, Protestant	Cape Verde escudo
CENTRAL AFRICAN REPUBLIC		622 436	240 324	4 038 000	Bangui	French, Sango, Banda, Baya, local languages	Protestant, Roman Catholic, traditional beliefs, Sunni Muslim	CFA franc*
CHAD		1 284 000	495 755	9 749 000	Ndjamena	Arabic, French, Sara, local languages	Sunni Muslim, Roman Catholic, Protestant, traditional beliefs	CFA franc*
COMOROS		1 862	719	798 000	Moroni	Comorian, French, Arabic	Sunni Muslim, Roman Catholic	Comoros franc
CONGO		342 000	132 047	3 999 000	Brazzaville	French, Kongo, Monokutuba, local languages	Roman Catholic, Protestant, traditional beliefs, Sunni Muslim	CFA franc*
CONGO, DEM. REP. OF THE		2 345 410	905 568	57 549 000	Kinshasa	French, Lingala, Swahili, Kongo, local languages	Christian, Sunni Muslim	Congolese franc
CÔTE D'IVOIRE		322 463	124 504	18 154 000	Yamoussoukro	French, creole, Akan, local languages	Sunni Muslim, Roman Catholic, traditional beliefs, Protestant	CFA franc*
DJIBOUTI		23 200	8 958	793 000	Djibouti	Somali, Afar, French, Arabic	Sunni Muslim, Christian	Djibouti franc
EGYPT		1 000 250	386 199	74 033 000	Cairo	Arabic	Sunni Muslim, Coptic Christian	Egyptian pound
EQUATORIAL GUINEA		28 051	10 831	504 000	Malabo	Spanish, French, Fang	Roman Catholic, traditional beliefs	CFA franc*
ERITREA		117 400	45 328	4 401 000	Asmara	Tigrinya, Tigre	Sunni Muslim, Coptic Christian	Nakfa
ETHIOPIA		1 133 880	437 794	77 431 000	Addis Ababa	Oromo, Amharic, Tigrinya, local languages	Ethiopian Orthodox, Sunni Muslim, traditional beliefs	Birr
GABON		267 667	103 347	1 384 000	Libreville	French, Fang, local languages	Roman Catholic, Protestant, traditional beliefs	CFA franc*
THE GAMBIA		11 295	4 361	1 517 000	Banjul	English, Malinke, Fulani, Wolof	Sunni Muslim, Protestant	Dalasi
GHANA		238 537	92 100	22 113 000	Accra	English, Hausa, Akan, local languages	Christian, Sunni Muslim, traditional beliefs	Cedi
GUINEA		245 857	94 926	9 402 000	Conakry	French, Fulani, Malinke, local languages	Sunni Muslim, traditional beliefs, Christian	Guinea franc
GUINEA-BISSAU		36 125	13 948	1 586 000	Bissau	Portuguese, crioulo, local languages	Traditional beliefs, Sunni Muslim, Christian	CFA franc*
KENYA		582 646	224 961	34 256 000	Nairobi	Swahili, English, local languages	Christian, traditional beliefs	Kenyan shilling
LESOTHO		30 355	11 720	1 795 000	Maseru	Sesotho, English, Zulu	Christian, traditional beliefs	Loti, S. African rand
LIBERIA		111 369	43 000	3 283 000	Monrovia	English, creole, local languages	Traditional beliefs, Christian, Sunni Muslim	Liberian dollar
LIBYA		1 759 540	679 362	5 853 000	Tripoli	Arabic, Berber	Sunni Muslim	Libyan dinar
MADAGASCAR		587 041	226 658	18 606 000	Antananarivo	Malagasy, French	Traditional beliefs, Christian, Sunni Muslim	Malagasy ariary, Malagasy franc
MALAWI		118 484	45 747	12 884 000	Lilongwe	Chichewa, English, local languages	Christian, traditional beliefs, Sunni Muslim	Malawian kwacha
MALI		1 240 140	478 821	13 518 000	Bamako	French, Bambara, local languages	Sunni Muslim, traditional beliefs, Christian	CFA franc*
MAURITANIA		1 030 700	397 955	3 069 000	Nouakchott	Arabic, French, local languages	Sunni Muslim	Ouguiya
MAURITIUS		2 040	788	1 245 000	Port Louis	English, creole, Hindi, Bhojpurī, French	Hindu, Roman Catholic, Sunni Muslim	Mauritius rupee
MOROCCO		446 550	172 414	31 478 000	Rabat	Arabic, Berber, French	Sunni Muslim	Moroccan dirham
MOZAMBIQUE		799 380	308 642	19 792 000	Maputo	Portuguese, Makua, Tsonga, local languages	Traditional beliefs, Roman Catholic, Sunni Muslim	Metical
NAMIBIA		824 292	318 261	2 031 000	Windhoek	English, Afrikaans, German, Ovambo, local languages	Protestant, Roman Catholic	Namibian dollar
NIGER		1 267 000	489 191	13 957 000	Niamey	French, Hausa, Fulani, local languages	Sunni Muslim, traditional beliefs	CFA franc*
NIGERIA		923 768	356 669	131 530 000	Abuja	English, Hausa, Yoruba, Ibo, Fulani, local languages	Sunni Muslim, Christian, traditional beliefs	Naira
RWANDA		26 338	10 169	9 038 000	Kigali	Kinyarwanda, French, English	Roman Catholic, traditional beliefs, Protestant	Rwandan franc
SÃO TOMÉ AND PRÍNCIPE		964	372	157 000	São Tomé	Portuguese, creole	Roman Catholic, Protestant	Dobra
SENEGAL		196 720	75 954	11 658 000	Dakar	French, Wolof, Fulani, local languages	Sunni Muslim, Roman Catholic, traditional beliefs	CFA franc*
SEYCHELLES		455	176	81 000	Victoria	English, French, creole	Roman Catholic, Protestant	Seychelles rupee
SIERRA LEONE		71 740	27 699	5 525 000	Freetown	English, creole, Mende, Temne, local languages	Sunni Muslim, traditional beliefs	Leone
SOMALIA		637 657	246 201	8 228 000	Mogadishu	Somali, Arabic	Sunni Muslim	Somali shilling
SOUTH AFRICA, REPUBLIC OF		1 219 090	470 693	47 432 000	Pretoria/Cape Town	Afrikaans, English, nine official local languages	Protestant, Roman Catholic, Sunni Muslim, Hindu	Rand
SUDAN		2 505 813	967 500	36 233 000	Khartoum	Arabic, Dinka, Nubian, Beja, Nuer, local languages	Sunni Muslim, traditional beliefs, Christian	Sudanese dinar
SWAZILAND		17 364	6 704	1 032 000	Mbabane	Swazi, English	Christian, traditional beliefs	Emalangeni, South African rand
TANZANIA		945 087	364 900	38 329 000	Dodoma	Swahili, English, Nyamwezi, local languages	Shi'a Muslim, Sunni Muslim, traditional beliefs, Christian	Tanzanian shilling
TOGO		56 785	21 925	6 145 000	Lomé	French, Ewe, Kabre, local languages	Traditional beliefs, Christian, Sunni Muslim	CFA franc*
TUNISIA		164 150	63 379	10 102 000	Tunis	Arabic, French	Sunni Muslim	Tunisian dinar
UGANDA		241 038	93 065	28 816 000	Kampala	English, Swahili, Luganda, local languages	Roman Catholic, Protestant, Sunni Muslim, traditional beliefs	Ugandan shilling
ZAMBIA		752 614	290 586	11 668 000	Lusaka	English, Bemba, Nyanja, Tonga, local languages	Christian, traditional beliefs	Zambian kwacha
ZIMBABWE		390 759	150 873	13 010 000	Harare	English, Shona, Ndebele	Christian, traditional beliefs	Zimbabwean dollar

Dependent and disputed territories		Territorial status		Area sq km	Area sq miles	Population	Capital	Languages	Religions	Currency
Canary Islands		Autonomous Community of Spain		7 447	2 875	1 944 700	Santa Cruz de Tenerife/Las Palmas	Spanish	Roman Catholic	Euro
Madeira		Autonomous Region of Portugal		779	301	245 012	Funchal	Portuguese	Roman Catholic, Protestant	Euro
Mayotte		French Territorial Collectivity		373	144	186 026	Dzaoudzi	French, Mahorian	Sunni Muslim, Christian	Euro
Réunion		French Overseas Department		2 551	985	785 000	St-Denis	French, creole	Roman Catholic	Euro
St Helena and Dependencies		United Kingdom Overseas Territory		121	47	5 000	Jamestown	English	Protestant, Roman Catholic	St Helena pound
Western Sahara		Disputed territory (Morocco)		266 000	102 703	341 000	Laâyoune	Arabic	Sunni Muslim	Moroccan dirham

*Communauté Financière Africaine franc

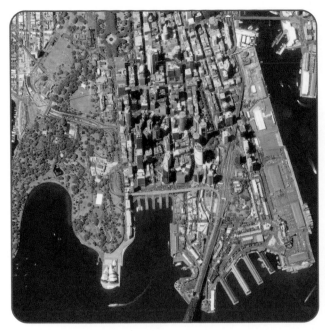

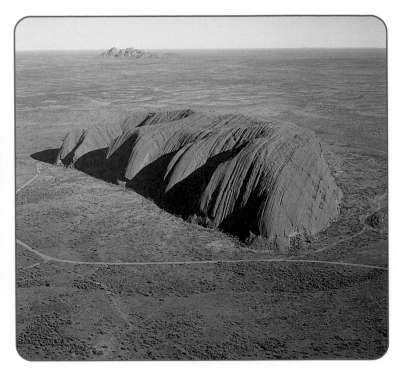

Above: **Sydney,** Australia
Right: **Uluru (Ayers Rock),** Australia

Oceania		Area sq km	Area sq miles	Population	Capital	Languages	Religions	Currency
AUSTRALIA		7 692 024	2 969 907	20 155 000	Canberra	English, Italian, Greek	Protestant, Roman Catholic, Orthodox	Australian dollar
FIJI		18 330	7 077	848 000	Suva	English, Fijian, Hindi	Christian, Hindu, Sunni Muslim	Fiji dollar
KIRIBATI		717	277	99 000	Bairiki	Gilbertese, English	Roman Catholic, Protestant	Australian dollar
MARSHALL ISLANDS		181	70	62 000	Delap-Uliga-Djarrit	English, Marshallese	Protestant, Roman Catholic	United States dollar
MICRONESIA, FEDERATED STATES OF		701	271	110 000	Palikir	English, Chuukese, Pohnpeian, local languages	Roman Catholic, Protestant	United States dollar
NAURU		21	8	14 000	Yaren	Nauruan, English	Protestant, Roman Catholic	Australian dollar
NEW ZEALAND		270 534	104 454	4 028 000	Wellington	English, Maori	Protestant, Roman Catholic	New Zealand dollar
PAPUA NEW GUINEA		462 840	178 704	5 887 000	Port Moresby	English, Tok Pisin (creole), local languages	Protestant, Roman Catholic, traditional beliefs	Kina
SAMOA		2 831	1 093	185 000	Apia	Samoan, English	Protestant, Roman Catholic	Tala
SOLOMON ISLANDS		28 370	10 954	478 000	Honiara	English, creole, local languages	Protestant, Roman Catholic	Solomon Islands dollar
TONGA		748	289	102 000	Nuku'alofa	Tongan, English	Protestant, Roman Catholic	Pa'anga
TUVALU		25	10	10 000	Vaiaku	Tuvaluan, English	Protestant	Australian dollar
VANUATU		12 190	4 707	211 000	Port Vila	English, Bislama (creole), French	Protestant, Roman Catholic, traditional beliefs	Vatu

Dependent territories		Territorial status	Area sq km	Area sq miles	Population	Capital	Languages	Religions	Currency
American Samoa		United States Unincorporated Territory	197	76	65 000	Fagatogo	Samoan, English	Protestant, Roman Catholic	United States dollar
Cook Islands		Self-governing New Zealand Territory	293	113	18 000	Avarua	English, Maori	Protestant, Roman Catholic	New Zealand dollar
French Polynesia		French Overseas Territory	3 265	1 261	257 000	Papeete	French, Tahitian, Polynesian languages	Protestant, Roman Catholic	CFP franc*
Guam		United States Unincorporated Territory	541	209	170 000	Hagåtña	Chamorro, English, Tapalog	Roman Catholic	United States dollar
New Caledonia		French Overseas Territory	19 058	7 358	237 000	Nouméa	French, local languages	Roman Catholic, Protestant, Sunni Muslim	CFP franc*
Niue		Self-governing New Zealand Territory	258	100	1 000	Alofi	English, Niuean	Christian	New Zealand dollar
Norfolk Island		Australian External Territory	35	14	2 601	Kingston	English	Protestant, Roman Catholic	Australian Dollar
Northern Mariana Islands		United States Commonwealth	477	184	81 000	Capitol Hill	English, Chamorro, local languages	Roman Catholic	United States dollar
Pitcairn Islands		United Kingdom Overseas Territory	45	17	47	Adamstown	English	Protestant	New Zealand dollar
Tokelau		New Zealand Overseas Territory	10	4	1 000		English, Tokelauan	Christian	New Zealand dollar
Wallis and Futuna Islands		French Overseas Territory	274	106	15 000	Matā'utu	French, Wallisian, Futunian	Roman Catholic	CFP franc*

*Franc des Comptoirs Français du Pacifique

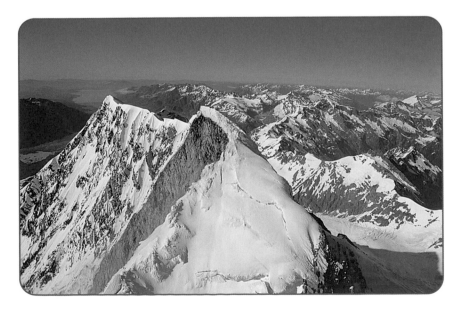

Left: **Aoraki (Mount Cook),** New Zealand

Next page
Top left: **The Pentagon,** Washington DC, USA
Top right: **Cuba,** Caribbean Sea

North America		Area sq km	Area sq miles	Population	Capital	Languages	Religions	Currency
ANTIGUA AND BARBUDA		442	171	81 000	St John's	English, creole	Protestant, Roman Catholic	East Caribbean dollar
THE BAHAMAS		13 939	5 382	323 000	Nassau	English, creole	Protestant, Roman Catholic	Bahamian dollar
BARBADOS		430	166	270 000	Bridgetown	English, creole	Protestant, Roman Catholic	Barbados dollar
BELIZE		22 965	8 867	270 000	Belmopan	English, Spanish, Mayan, creole	Roman Catholic, Protestant	Belize dollar
CANADA		9 984 670	3 855 103	32 268 000	Ottawa	English, French, local languages	Roman Catholic, Protestant, Eastern Orthodox, Jewish	Canadian dollar
COSTA RICA		51 100	19 730	4 327 000	San José	Spanish	Roman Catholic, Protestant	Costa Rican colón
CUBA		110 860	42 803	11 269 000	Havana	Spanish	Roman Catholic, Protestant	Cuban peso
DOMINICA		750	290	79 000	Roseau	English, creole	Roman Catholic, Protestant	East Caribbean dollar
DOMINICAN REPUBLIC		48 442	18 704	8 895 000	Santo Domingo	Spanish, creole	Roman Catholic, Protestant	Dominican peso
EL SALVADOR		21 041	8 124	6 881 000	San Salvador	Spanish	Roman Catholic, Protestant	El Salvador colón, United States dollar
GRENADA		378	146	103 000	St George's	English, creole	Roman Catholic, Protestant	East Caribbean dollar
GUATEMALA		108 890	42 043	12 599 000	Guatemala City	Spanish, Mayan languages	Roman Catholic, Protestant	Quetzal, United States dollar
HAITI		27 750	10 714	8 528 000	Port-au-Prince	French, creole	Roman Catholic, Protestant, Voodoo	Gourde
HONDURAS		112 088	43 277	7 205 000	Tegucigalpa	Spanish, Amerindian languages	Roman Catholic, Protestant	Lempira
JAMAICA		10 991	4 244	2 651 000	Kingston	English, creole	Protestant, Roman Catholic	Jamaican dollar
MEXICO		1 972 545	761 604	107 029 000	Mexico City	Spanish, Amerindian languages	Roman Catholic, Protestant	Mexican peso
NICARAGUA		130 000	50 193	5 487 000	Managua	Spanish, Amerindian languages	Roman Catholic, Protestant	Córdoba
PANAMA		77 082	29 762	3 232 000	Panama City	Spanish, English, Amerindian languages	Roman Catholic, Protestant, Sunni Muslim	Balboa
ST KITTS AND NEVIS		261	101	43 000	Basseterre	English, creole	Protestant, Roman Catholic	East Caribbean dollar
ST LUCIA		616	238	161 000	Castries	English, creole	Roman Catholic, Protestant	East Caribbean dollar
ST VINCENT AND THE GRENADINES		389	150	119 000	Kingstown	English, creole	Protestant, Roman Catholic	East Caribbean dollar
TRINIDAD AND TOBAGO		5 130	1 981	1 305 000	Port of Spain	English, creole, Hindi	Roman Catholic, Hindu, Protestant, Sunni Muslim	Trinidad and Tobago dollar
UNITED STATES OF AMERICA		9 826 635	3 794 085	298 213 000	Washington DC	English, Spanish	Protestant, Roman Catholic, Sunni Muslim, Jewish	United States dollar

Dependent territories		Territorial status	Area sq km	Area sq miles	Population	Capital	Languages	Religions	Currency
Anguilla		United Kingdom Overseas Territory	155	60	12 000	The Valley	English	Protestant, Roman Catholic	East Caribbean dollar
Aruba		Self-governing Netherlands Territory	193	75	99 000	Oranjestad	Papiamento, Dutch, English	Roman Catholic, Protestant	Arubian florin
Bermuda		United Kingdom Overseas Territory	54	21	64 000	Hamilton	English	Protestant, Roman Catholic	Bermuda dollar
Cayman Islands		United Kingdom Overseas Territory	259	100	45 000	George Town	English	Protestant, Roman Catholic	Cayman Islands dollar
Greenland		Self-governing Danish Territory	2 175 600	840 004	57 000	Nuuk	Greenlandic, Danish	Protestant	Danish krone
Guadeloupe		French Overseas Department	1 780	687	448 000	Basse-Terre	French, creole	Roman Catholic	Euro
Martinique		French Overseas Department	1 079	417	396 000	Fort-de-France	French, creole	Roman Catholic, traditional beliefs	Euro
Montserrat		United Kingdom Overseas Territory	100	39	4 000	Plymouth	English	Protestant, Roman Catholic	East Caribbean dollar
Netherlands Antilles		Self-governing Netherlands Territory	800	309	183 000	Willemstad	Dutch, Papiamento, English	Roman Catholic, Protestant	Neth. Antilles guilder
Puerto Rico		United States Commonwealth	9 104	3 515	3 955 000	San Juan	Spanish, English	Roman Catholic, Protestant	United States dollar
St Pierre and Miquelon		French Territorial Collectivity	242	93	6 000	St-Pierre	French	Roman Catholic	Euro
Turks and Caicos Islands		United Kingdom Overseas Territory	430	166	26 000	Grand Turk	English	Protestant	United States dollar
Virgin Islands (U.K.)		United Kingdom Overseas Territory	153	59	22 000	Road Town	English	Protestant, Roman Catholic	United States dollar
Virgin Islands (U.S.A.)		United States Unincorporated Territory	352	136	112 000	Charlotte Amalie	English, Spanish	Protestant, Roman Catholic	United States dollar

South America		Area sq km	Area sq miles	Population	Capital	Languages	Religions	Currency
ARGENTINA		2 766 889	1 068 302	38 747 000	Buenos Aires	Spanish, Italian, Amerindian languages	Roman Catholic, Protestant	Argentinian peso
BOLIVIA		1 098 581	424 164	9 182 000	La Paz/Sucre	Spanish, Quechua, Aymara	Roman Catholic, Protestant, Baha'i	Boliviano
BRAZIL		8 514 879	3 287 613	186 405 000	Brasília	Portuguese	Roman Catholic, Protestant	Real
CHILE		756 945	292 258	16 295 000	Santiago	Spanish, Amerindian languages	Roman Catholic, Protestant	Chilean peso
COLOMBIA		1 141 748	440 831	45 600 000	Bogotá	Spanish, Amerindian languages	Roman Catholic, Protestant	Colombian peso
ECUADOR		272 045	105 037	13 228 000	Quito	Spanish, Quechua, other Amerindian languages	Roman Catholic	US dollar
GUYANA		214 969	83 000	751 000	Georgetown	English, creole, Amerindian languages	Protestant, Hindu, Roman Catholic, Sunni Muslim	Guyana dollar
PARAGUAY		406 752	157 048	6 158 000	Asunción	Spanish, Guaraní	Roman Catholic, Protestant	Guaraní
PERU		1 285 216	496 225	27 968 000	Lima	Spanish, Quechua, Aymara	Roman Catholic, Protestant	Sol
SURINAME		163 820	63 251	449 000	Paramaribo	Dutch, Surinamese, English, Hindi	Hindu, Roman Catholic, Protestant, Sunni Muslim	Suriname guilder
URUGUAY		176 215	68 037	3 463 000	Montevideo	Spanish	Roman Catholic, Protestant, Jewish	Uruguayan peso
VENEZUELA		912 050	352 144	26 749 000	Caracas	Spanish, Amerindian languages	Roman Catholic, Protestant	Bolívar

Dependent territories		Territorial status	Area sq km	Area sq miles	Population	Capital	Languages	Religions	Currency
Falkland Islands		United Kingdom Overseas Territory	12 170	4 699	3 000	Stanley	English	Protestant, Roman Catholic	Falkland Islands pound
French Guiana		French Overseas Department	90 000	34 749	187 000	Cayenne	French, creole	Roman Catholic	Euro

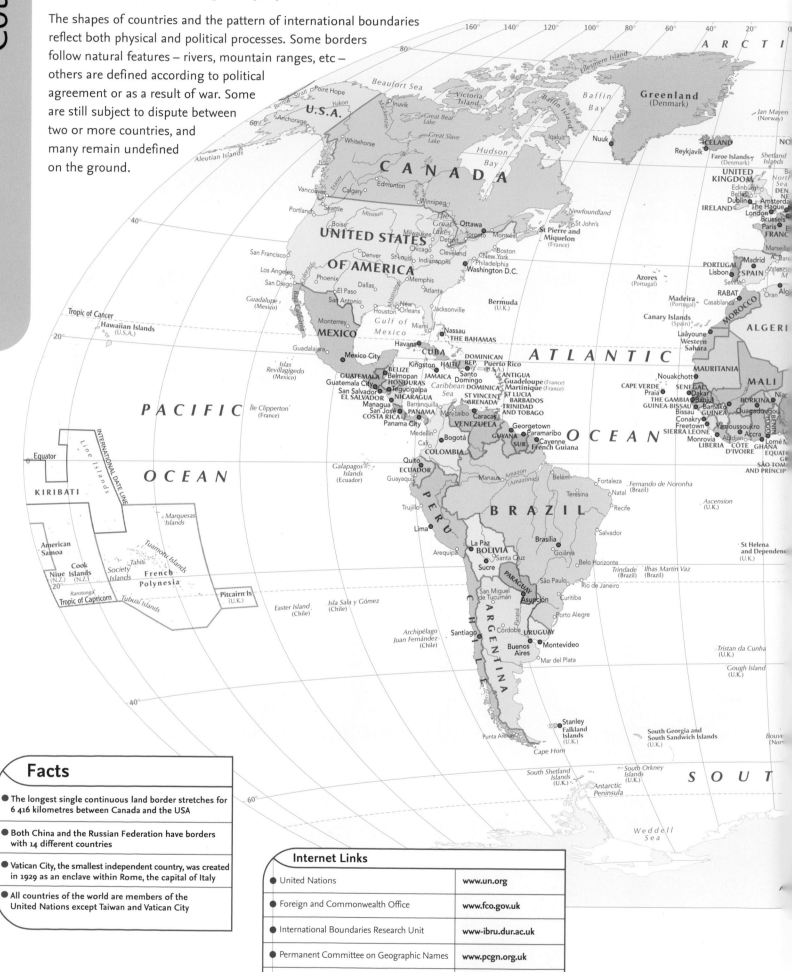

The current pattern of the world's countries and territories is a result of a long history of exploration, colonialism, conflict and politics. The fact that there are currently 194 independent countries in the world – the most recent, Montenegro, only being created in June 2006 – illustrates the significant political changes which have occurred since 1950 when there were only eighty two. There has been a steady progression away from colonial influences over the last fifty years, although many dependent overseas territories remain.

The shapes of countries and the pattern of international boundaries reflect both physical and political processes. Some borders follow natural features – rivers, mountain ranges, etc – others are defined according to political agreement or as a result of war. Some are still subject to dispute between two or more countries, and many remain undefined on the ground.

Facts

● The longest single continuous land border stretches for 6 416 kilometres between Canada and the USA

● Both China and the Russian Federation have borders with 14 different countries

● Vatican City, the smallest independent country, was created in 1929 as an enclave within Rome, the capital of Italy

● All countries of the world are members of the United Nations except Taiwan and Vatican City

Internet Links

● United Nations	**www.un.org**
● Foreign and Commonwealth Office	**www.fco.gov.uk**
● International Boundaries Research Unit	**www.ibru.dur.ac.uk**
● Permanent Committee on Geographic Names	**www.pcgn.org.uk**
● United States Board on Geographic Names	**geonames.usgs.gov**

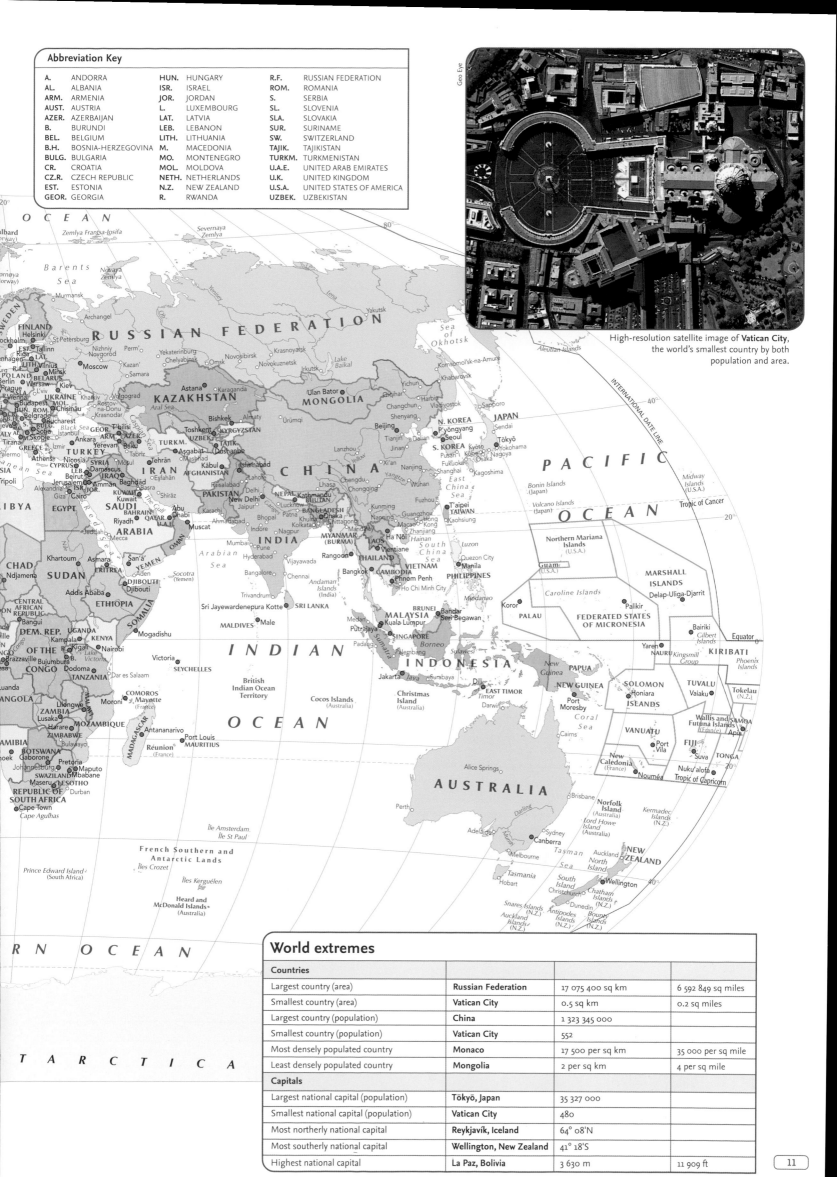

Abbreviation Key

A.	ANDORRA	HUN.	HUNGARY	R.F.	RUSSIAN FEDERATION
AL.	ALBANIA	ISR.	ISRAEL	ROM.	ROMANIA
ARM.	ARMENIA	JOR.	JORDAN	S.	SERBIA
AUST.	AUSTRIA	L.	LUXEMBOURG	SL.	SLOVENIA
AZER.	AZERBAIJAN	LAT.	LATVIA	SLA.	SLOVAKIA
B.	BURUNDI	LEB.	LEBANON	SUR.	SURINAME
BEL.	BELGIUM	LITH.	LITHUANIA	SW.	SWITZERLAND
B.H.	BOSNIA-HERZEGOVINA	M.	MACEDONIA	TAJIK.	TAJIKISTAN
BULG.	BULGARIA	MO.	MONTENEGRO	TURKM.	TURKMENISTAN
CR.	CROATIA	MOL.	MOLDOVA	U.A.E.	UNITED ARAB EMIRATES
CZ.R.	CZECH REPUBLIC	NETH.	NETHERLANDS	U.K.	UNITED KINGDOM
EST.	ESTONIA	N.Z.	NEW ZEALAND	U.S.A.	UNITED STATES OF AMERICA
GEOR.	GEORGIA	R.	RWANDA	UZBEK.	UZBEKISTAN

High-resolution satellite image of **Vatican City**, the world's smallest country by both population and area.

World extremes

Countries			
Largest country (area)	**Russian Federation**	17 075 400 sq km	6 592 849 sq miles
Smallest country (area)	**Vatican City**	0.5 sq km	0.2 sq miles
Largest country (population)	**China**	1 323 345 000	
Smallest country (population)	**Vatican City**	552	
Most densely populated country	**Monaco**	17 500 per sq km	35 000 per sq mile
Least densely populated country	**Mongolia**	2 per sq km	4 per sq mile
Capitals			
Largest national capital (population)	**Tōkyō, Japan**	35 327 000	
Smallest national capital (population)	**Vatican City**	480	
Most northerly national capital	**Reykjavík, Iceland**	64° 08'N	
Most southerly national capital	**Wellington, New Zealand**	41° 18'S	
Highest national capital	**La Paz, Bolivia**	3 630 m	11 909 ft

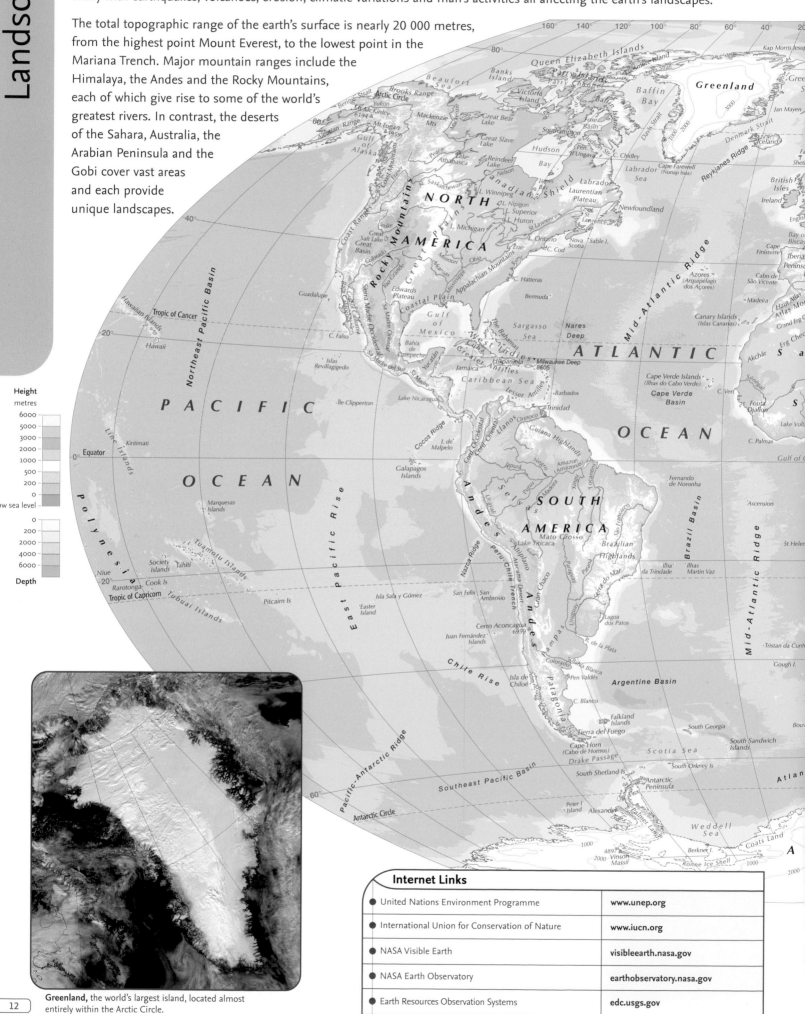

Landscapes

World

The earth's physical features, both on land and on the sea bed, closely reflect its geological structure. The current shapes of the continents and oceans have evolved over millions of years. Movements of the tectonic plates which make up the earth's crust have created some of the best-known and most spectacular features. The processes which have shaped the earth continue today with earthquakes, volcanoes, erosion, climatic variations and man's activities all affecting the earth's landscapes.

The total topographic range of the earth's surface is nearly 20 000 metres, from the highest point Mount Everest, to the lowest point in the Mariana Trench. Major mountain ranges include the Himalaya, the Andes and the Rocky Mountains, each of which give rise to some of the world's greatest rivers. In contrast, the deserts of the Sahara, Australia, the Arabian Peninsula and the Gobi cover vast areas and each provide unique landscapes.

Height
metres
6000
5000
3000
2000
1000
500
200
0
below sea level
0
200
2000
4000
6000
Depth

Greenland, the world's largest island, located almost entirely within the Arctic Circle.

12

Internet Links

United Nations Environment Programme	www.unep.org
International Union for Conservation of Nature	www.iucn.org
NASA Visible Earth	visibleearth.nasa.gov
NASA Earth Observatory	earthobservatory.nasa.gov
Earth Resources Observation Systems	edc.usgs.gov

Earth's dimensions

Mass	5.974 x 10²¹ tonnes
Total area	509 450 000 sq km / 196 699 746 sq miles
Land area	148 721 936 sq km / 57 421 861 sq miles
Water area	360 728 064 sq km / 139 277 885 sq miles
Volume	1 083 207 x 10⁶ cubic km / 259 911 x 10⁶ cubic miles
Equatorial diameter	12 756 km / 7 927 miles
Polar diameter	12 714 km / 7 901 miles
Equatorial circumference	40 075 km / 24 903 miles
Meridional circumference	40 008 km / 24 861 miles

Facts

- Approximately 10% of the earth's land surface is permanently covered by ice

- The Pacific Ocean is larger than all the continents' land areas combined

- The world's highest waterfall, 980 metres high, is Angel Falls, Venezuela

- 52% of the earth's land surface is below 500 metres

- The mean elevation of the earth's land surface is 840 metres

- Lake Baikal is the world's deepest lake with a maximum depth of 1 637 metres

World's physical features

Highest mountains			Largest islands		
Mt Everest, China/Nepal	8 848 m	29 028 ft	Greenland, North America	2 175 600 sq km	840 004 sq miles
K2, China/Jammu and Kashmir	8 611 m	28 251 ft	New Guinea, Oceania	808 510 sq km	312 167 sq miles
Kangchenjunga, India/Nepal	8 586 m	28 169 ft	Borneo, Asia	745 561 sq km	287 863 sq miles
Lhotse, China/Nepal	8 516 m	27 939 ft	Madagascar, Africa	587 040 sq km	226 657 sq miles
Makalu, China/Nepal	8 463 m	27 765 ft	Baffin Island, North America	507 451 sq km	195 928 sq miles
Longest rivers			**Largest lakes**		
Nile, Africa	6 695 km	4 160 miles	Caspian Sea, Asia/Europe	371 000 sq km	143 244 sq miles
Amazon, South America	6 516 km	4 049 miles	Lake Superior, North America	82 100 sq km	31 699 sq miles
Yangtze, Asia	6 380 km	3 965 miles	Lake Victoria, Africa	68 800 sq km	26 564 sq miles
Mississippi-Missouri, North America	5 969 km	3 709 miles	Lake Huron, North America	59 600 sq km	23 012 sq miles
Ob'-Irtysh, Asia	5 568 km	3 460 miles	Lake Michigan, North America	57 800 sq km	22 317 sq miles

Earthquakes and Volcanoes

Earthquakes and volcanoes hold a constant fascination because of their power, their beauty, and the fact that they cannot be controlled or accurately predicted. Our understanding of these phenomena relies mainly on the theory of plate tectonics. This defines the earth's surface as a series of 'plates' which are constantly moving relative to each other, at rates of a few centimetres per year. As plates move against each other enormous pressure builds up and when the rocks can no longer bear this pressure they fracture, and energy is released as an earthquake. The pressures involved can also melt the rock to form magma which then rises to the earth's surface to form a volcano. The distribution of earthquakes and volcanoes therefore relates closely to plate boundaries. In particular, most active volcanoes and much of the earth's seismic activity are centred on the 'Ring of Fire' around the Pacific Ocean.

Facts

- Over 900 earthquakes of magnitude 5.0 or greater occur every year

- An earthquake of magnitude 8.0 releases energy equivalent to 1 billion tons of TNT explosive

- Ground shaking during an earthquake in Alaska in 1964 lasted for 3 minutes

- Indonesia has more than 120 volcanoes and over 30% of the world's active volcanoes

- Volcanoes can produce very fertile soil and important industrial materials and chemicals

Earthquakes

Earthquakes are caused by movement along fractures or 'faults' in the earth's crust, particularly along plate boundaries. There are three types of plate boundary: constructive boundaries where plates are moving apart; destructive boundaries where two or more plates collide; conservative boundaries where plates slide past each other. Destructive and conservative boundaries are the main sources of earthquake activity.

The epicentre of an earthquake is the point on the earth's surface directly above its source. If this is near to large centres of population, and the earthquake is powerful, major devastation can result. The size, or magnitude, of an earthquake is generally measured on the Richter Scale.

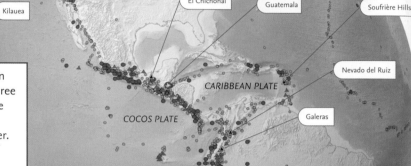

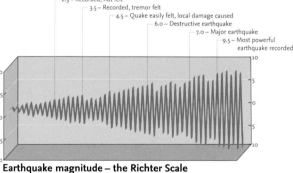

2.5 – Recorded, not felt
3.5 – Recorded, tremor felt
4.5 – Quake easily felt, local damage caused
6.0 – Destructive earthquake
7.0 – Major earthquake
9.5 – Most powerful earthquake recorded

Earthquake magnitude – the Richter Scale
The scale measures the energy released by an earthquake. It is a logarithmic scale: an earthquake measuring 5 is ten times more powerful than one measuring 4.

Plate boundaries

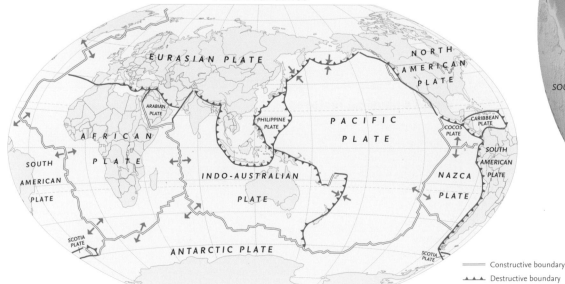

—— Constructive boundary
▲▲▲ Destructive boundary
—— Conservative boundary

Volcanoes

The majority of volcanoes occur along destructive plate boundaries in the 'subduction zone' where one plate passes under another. The friction and pressure causes the rock to melt and to form magma which is forced upwards to the earth's surface where it erupts as molten rock (lava) or as particles of ash or cinder. This process created the numerous volcanoes in the Andes, where the Nazca Plate is passing under the South American Plate. Volcanoes can be defined by the nature of the material they emit. 'Shield' volcanoes have extensive, gentle slopes formed from free-flowing lava, while steep-sided 'continental' volcanoes are created from thicker, slow-flowing lava and ash.

Deadliest earthquake

● Earthquake of magnitude 7.5 or greater

○ Earthquake of magnitude 5.5 – 7.4

▲ Major volcano

▲ Other volcano

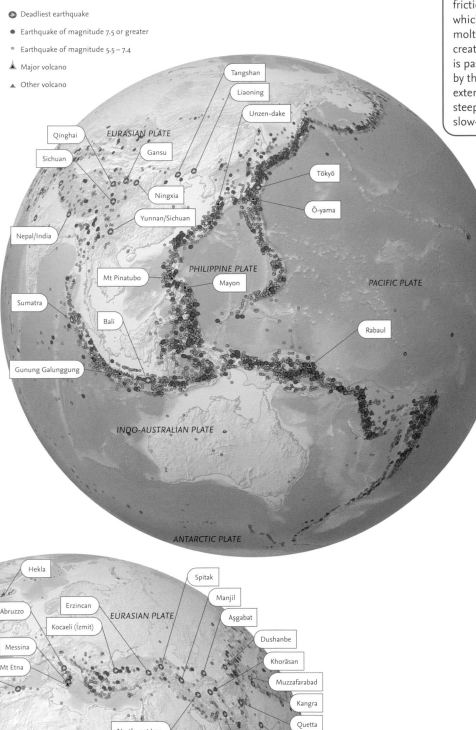

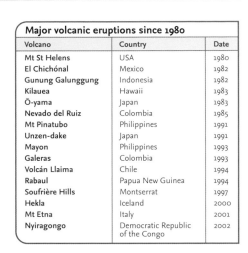

Major volcanic eruptions since 1980

Volcano	Country	Date
Mt St Helens	USA	1980
El Chichónal	Mexico	1982
Gunung Galunggung	Indonesia	1982
Kilauea	Hawaii	1983
Ō-yama	Japan	1983
Nevado del Ruiz	Colombia	1985
Mt Pinatubo	Philippines	1991
Unzen-dake	Japan	1991
Mayon	Philippines	1993
Galeras	Colombia	1993
Volcán Llaima	Chile	1994
Rabaul	Papua New Guinea	1994
Soufrière Hills	Montserrat	1997
Hekla	Iceland	2000
Mt Etna	Italy	2001
Nyiragongo	Democratic Republic of the Congo	2002

Deadliest earthquakes since 1900

Year	Location	Deaths
1905	**Kangra**, India	19 000
1907	west of **Dushanbe**, Tajikistan	12 000
1908	**Messina**, Italy	110 000
1915	**Abruzzo**, Italy	35 000
1917	**Bali**, Indonesia	15 000
1920	**Ningxia Province**, China	200 000
1923	**Tōkyō**, Japan	142 807
1927	**Qinghai Province**, China	200 000
1932	**Gansu Province**, China	70 000
1933	**Sichuan Province**, China	10 000
1934	**Nepal/India**	10 700
1935	**Quetta**, Pakistan	30 000
1939	**Chillán**, Chile	28 000
1939	**Erzincan**, Turkey	32 700
1948	**Aşgabat**, Turkmenistan	19 800
1962	**Northwest Iran**	12 225
1970	**Huánuco Province**, Peru	66 794
1974	**Yunnan** and **Sichuan Provinces**, China	20 000
1975	**Liaoning Province**, China	10 000
1976	central **Guatemala**	22 778
1976	**Tangshan**, Hebei Province, China	255 000
1978	**Khorāsan Province**, Iran	20 000
1980	**Ech Chélif**, Algeria	11 000
1988	**Spitak**, Armenia	25 000
1990	**Manjil**, Iran	50 000
1999	**Kocaeli (İzmit)**, Turkey	17 000
2001	**Gujarat**, India	20 000
2003	**Bam**, Iran	26 271
2004	off **Sumatra**, Indian Ocean	266 435
2005	around **Muzzafarabad**, Pakistan	73 338

Internet Links

● USGS National Earthquake Information Center	**neic.usgs.gov**
● USGS Volcano Information	**volcanoes.usgs.gov**
● British Geological Survey	**www.bgs.ac.uk**
● NASA Natural Hazards	**earthobservatory.nasa.gov/NaturalHazards**
● Volcano World	**volcano.und.nodak.edu**

Climate and Weather

The climate of a region is defined by its long-term prevailing weather conditions. Classifcation of Climate Types is based on the relationship between temperature and humidity and how these factors are affected by latitude, altitude, ocean currents and winds. Weather is the specifc short term condition which occurs locally and consists of events such as thunderstorms, hurricanes, blizzards and heat waves. Temperature and rainfall data recorded at weather stations can be plotted graphically and the graphs shown here, typical of each climate region, illustrate the various combinations of temperature and rainfall which exist worldwide for each month of the year. Data used for climate graphs are based on average monthly figures recorded over a minimum period of thirty years.

World Statistics: see pages **154–160**

Major climate regions, ocean currents and sea surface temperatures

Ice cap	Humid subtropical
Tundra	Mediterranean
Subarctic	Steppe
Continental cool summer	Desert
Continental warm summer	Savanna
Temperate	Rain forest

YUMA ★ Weather extreme location
Moscow • Weather station
→ Warm current
→ Cold current
→ Seasonal drift during northern winter

Sea surface temperature: 30°C / 20 / 0

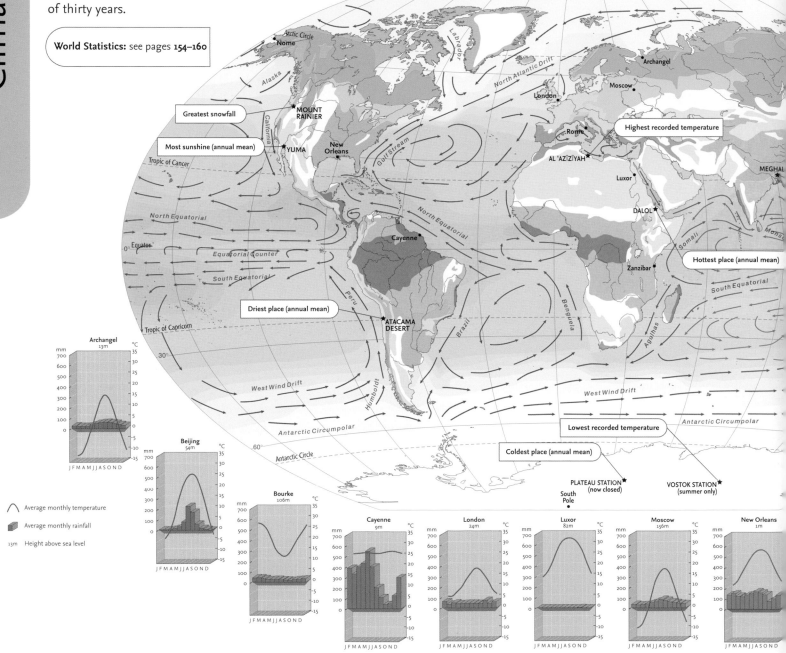

Average monthly temperature

Average monthly rainfall

13m Height above sea level

Climate change

In 2004 the global mean temperature was over 0.6°C higher than that at the end of the nineteenth century. Most of this warming is caused by human activities which result in a build-up of greenhouse gases, mainly carbon dioxide, allowing heat to be trapped within the atmosphere. Carbon dioxide emissions have increased since the beginning of the industrial revolution due to burning of fossil fuels, increased urbanization, population growth, deforestation and industrial pollution. Annual climate indicators such as number of frost-free days, length of growing season, heat wave frequency, number of wet days, length of dry spells and frequency of weather extremes are used to monitor climate change. The map opposite highlights some events of 2004 which indicate climate change. Until carbon dioxide emissions are reduced it is likely that this trend will continue.

Evidence of climate change in 2004

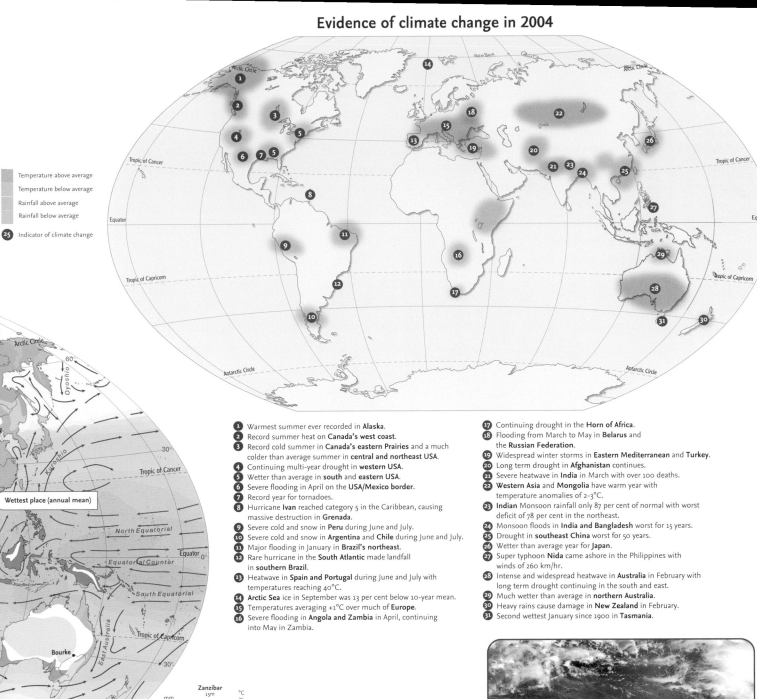

Temperature above average
Temperature below average
Rainfall above average
Rainfall below average

25 Indicator of climate change

Wettest place (annual mean)

Bourke •

Windiest place

COMMONWEALTH

Nome
11m

Rome
2m

Zanzibar
15m

1. Warmest summer ever recorded in **Alaska**.
2. Record summer heat on **Canada's west coast**.
3. Record cold summer in **Canada's eastern Prairies** and a much colder than average summer in **central and northeast USA**.
4. Continuing multi-year drought in **western USA**.
5. Wetter than average in **south and eastern USA**.
6. Severe flooding in April on the **USA/Mexico border**.
7. Record year for tornadoes.
8. Hurricane **Ivan** reached category 5 in the Caribbean, causing massive destruction in **Grenada**.
9. Severe cold and snow in **Peru** during June and July.
10. Severe cold and snow in **Argentina** and **Chile** during June and July.
11. Major flooding in January in **Brazil's northeast**.
12. Rare hurricane in the **South Atlantic** made landfall in **southern Brazil**.
13. Heatwave in **Spain and Portugal** during June and July with temperatures reaching 40°C.
14. **Arctic Sea** ice in September was 13 per cent below 10-year mean.
15. Temperatures averaging +1°C over much of **Europe**.
16. Severe flooding in **Angola and Zambia** in April, continuing into May in Zambia.

17. Continuing drought in the **Horn of Africa**.
18. Flooding from March to May in **Belarus** and the **Russian Federation**.
19. Widespread winter storms in **Eastern Mediterranean** and **Turkey**.
20. Long term drought in **Afghanistan** continues.
21. Severe heatwave in **India** in March with over 100 deaths.
22. **Western Asia** and **Mongolia** have warm year with temperature anomalies of 2-3°C.
23. **Indian** Monsoon rainfall only 87 per cent of normal with worst deficit of 78 per cent in the northeast.
24. Monsoon floods in **India and Bangladesh** worst for 15 years.
25. Drought in **southeast China** worst for 50 years.
26. Wetter than average year for **Japan**.
27. Super typhoon **Nida** came ashore in the Philippines with winds of 260 km/hr.
28. Intense and widespread heatwave in **Australia** in February with long term drought continuing in the south and east.
29. Much wetter than average in **northern Australia**.
30. Heavy rains cause damage in **New Zealand** in February.
31. Second wettest January since 1900 in **Tasmania**.

Facts

- Arctic Sea ice thickness has declined 40% in the last 40 years
- 2001 marked the end of the La Niña episode
- Sea levels are rising by one centimetre per decade
- Precipitation in the northern hemisphere is increasing
- Droughts have increased in frequency and intensity in parts of Asia and Africa

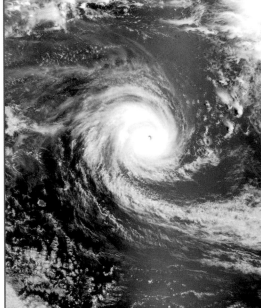

Tropical storm Dina, January 2002,

Weather extremes

Highest recorded temperature	**57.8°C/136°F** Al'Azīzīyah, Libya (September 1922)
Hottest place - annual mean	**34.4°C/93.6°F** Dalol, Ethiopia
Driest place - annual mean	**0.1mm/0.004 inches** Atacama Desert, Chile
Most sunshine - annual mean	**90%** Yuma, Arizona, USA (over 4000 hours)
Lowest recorded temperature	**-89.2°C/-128.6°F** Vostok Station, Antarctica (July 1983)
Coldest place - annual mean	**-56.6°C/-69.9°F** Plateau Station, Antarctica
Wettest place annual mean	**11 873 mm/467.4 inches** Meghalaya, India
Greatest snowfall	**31 102 mm/1 224.5 inches** Mount Rainier, Washington, USA (February 1971 – February 1972)
Windiest place	**322 km per hour/200 miles per hour** (in gales) Commonwealth Bay, Antarctica

Internet Links

● Met Office	**www.met-office.gov.uk**
● BBC Weather Centre	**www.bbc.co.uk/weather**
● National Oceanic and Atmospheric Administration	**www.noaa.gov**
● National Climate and Data Center	**www.ncdc.noaa.gov**
● United Nations World Meteorological Organization	**www.wmo.ch**

Land Cover

The oxygen- and water- rich environment of the earth has helped create a wide range of habitats. Forest and woodland ecosystems form the predominant natural land cover over most of the earth's surface. Tropical rainforests are part of an intricate land-atmosphere relationship that is disturbed by land cover changes. Forests in the tropics are believed to hold most of the world's bird, animal, and plant species. Grassland, shrubland and deserts collectively cover most of the unwooded land surface, with tundra on frozen subsoil at high northern latitudes. These areas tend to have lower species diversity than most forests, with the notable exception of Mediterranean shrublands, which support some of the most diverse floras on the earth. Humans have extensively altered most grassland and shrubland areas, usually through conversion to agriculture, burning and introduction of domestic livestock. They have had less immediate impact on tundra and true desert regions, although these remain vulnerable to global climate change.

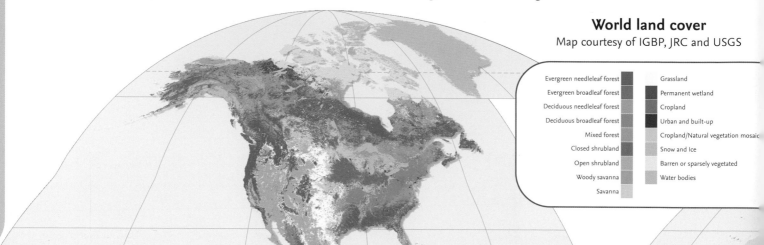

World land cover

Map courtesy of IGBP, JRC and USGS

Evergreen needleleaf forest	Grassland
Evergreen broadleaf forest	Permanent wetland
Deciduous needleleaf forest	Cropland
Deciduous broadleaf forest	Urban and built-up
Mixed forest	Cropland/Natural vegetation mosaic
Closed shrubland	Snow and Ice
Open shrubland	Barren or sparsely vegetated
Woody savanna	Water bodies
Savanna	

Land cover

The land cover map shown here was derived from data aquired by the Advanced Very High Resolution Radiometer sensor on board the polar orbiting satellites of the US National Oceanic and Atmospheric Administration. The high resolution (ground resolution of 1km) of the imagery used to compile the data set and map allows detailed interpretation of land cover patterns across the world. Important uses include managing forest resources, improving estimates of the earth's water and energy cycles, and modelling climate change.

Barren/Shrubland, Death Valley, California, United States of America.

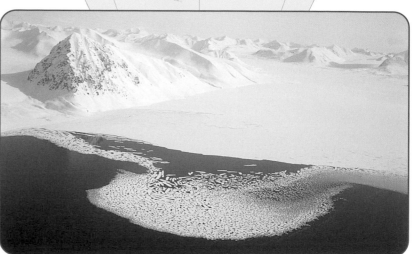

Snow and ice, Spitsbergen, Svalbard, inside the Arctic Circle.

Slash and burn deforestation in the **tropical rainforest** of Madagascar.

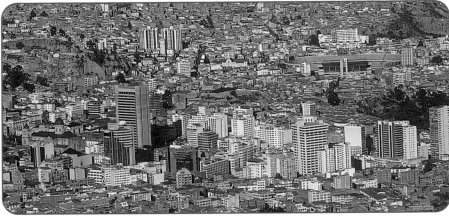
Urban, La Paz, Bolivia.

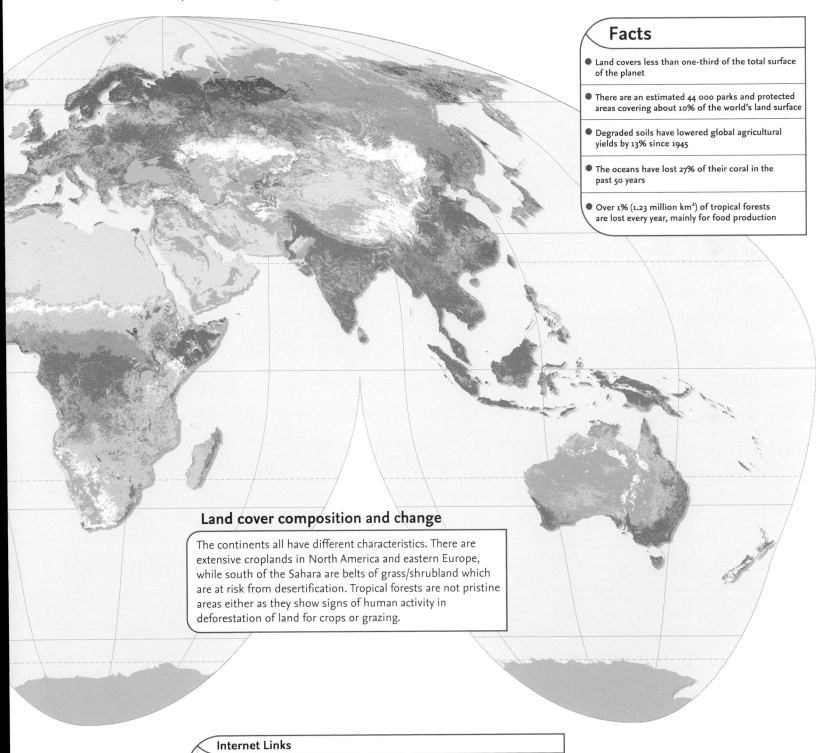

Land cover composition and change

The continents all have different characteristics. There are extensive croplands in North America and eastern Europe, while south of the Sahara are belts of grass/shrubland which are at risk from desertification. Tropical forests are not pristine areas either as they show signs of human activity in deforestation of land for crops or grazing.

Population

After increasing very slowly for most of human history, world population more than doubled in the last half century. Whereas world population did not pass the one billion mark until 1804 and took another 123 years to reach two billion in 1927, it then added the third billion in 33 years, the fourth in 14 years and the fifth in 13 years. Just twelve years later on October 12, 1999 the United Nations announced that the global population had reached the six billion mark. It is expected that another three billion people will have been added to the world's population by 2050.

Facts

- The world's population is growing at an annual rate of 76 million people per year

- Today's population is only 5.7% of the total number of people who ever lived on the earth

- It is expected that in 2050 there will be more people aged over 60 than children aged less than 14

- More than 90% of the 70 million inhabitants of Egypt are located around the River Nile

- India's population reached 1 billion in August 1999

World Statistics: see pages 154–160

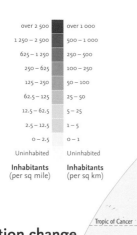

Inhabitants (per sq mile)	Inhabitants (per sq km)
over 2 500	over 1 000
1 250 – 2 500	500 – 1 000
625 – 1 250	250 – 500
250 – 625	100 – 250
125 – 250	50 – 100
62.5 – 125	25 – 50
12.5 – 62.5	5 – 25
2.5 – 12.5	1 – 5
0 – 2.5	0 – 1
Uninhabited	Uninhabited

World population distribution

Population density, continental populations (2002) and continental population change (2000–2005)

North America
Total population 332 156 000
Population change 1.0%

Latin America and the Caribbean
Total population 558 281 000
Population change 1.4%

Arctic Circle

Tropic of Cancer

World population change

Population growth since 1950 has been spread very unevenly between the continents. While overall numbers have been growing rapidly since 1950, a massive 89 per cent increase has taken place in the less developed regions, especially southern and eastern Asia. In contrast, Europe's population level has been almost stationary and is expected to decrease in the future. India and China alone are responsible for over one-third of current growth. Most of the highest rates of growth are to be found in Sub-Saharan Africa and until population growth is brought under tighter control, the developing world in particular will continue to face enormous problems of supporting a rising population.

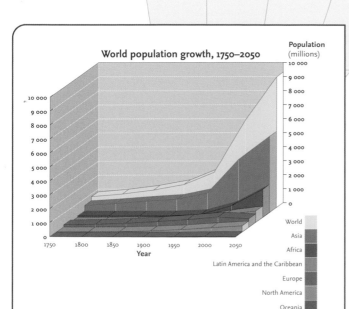

World population growth, 1750–2050

Population (millions)

Year

World
Asia
Africa
Latin America and the Caribbean
Europe
North America
Oceania

Top 10 countries by population, 2005

Rank	Country	Population
1	China	1 323 345 000
2	India	1 103 371 000
3	United States of America	298 213 000
4	Indonesia	222 781 000
5	Brazil	186 405 000
6	Pakistan	157 935 000
7	Russian Federation	143 202 000
8	Bangladesh	141 822 000
9	Nigeria	131 530 000
10	Japan	128 085 000

Masai village in sparsely populated southwest Kenya.

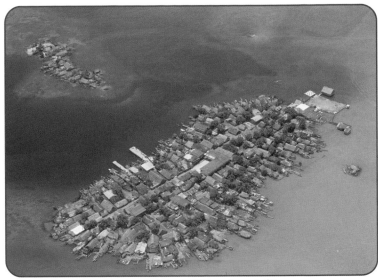

Kuna Indians inhabit this congested island off the north coast of Panama.

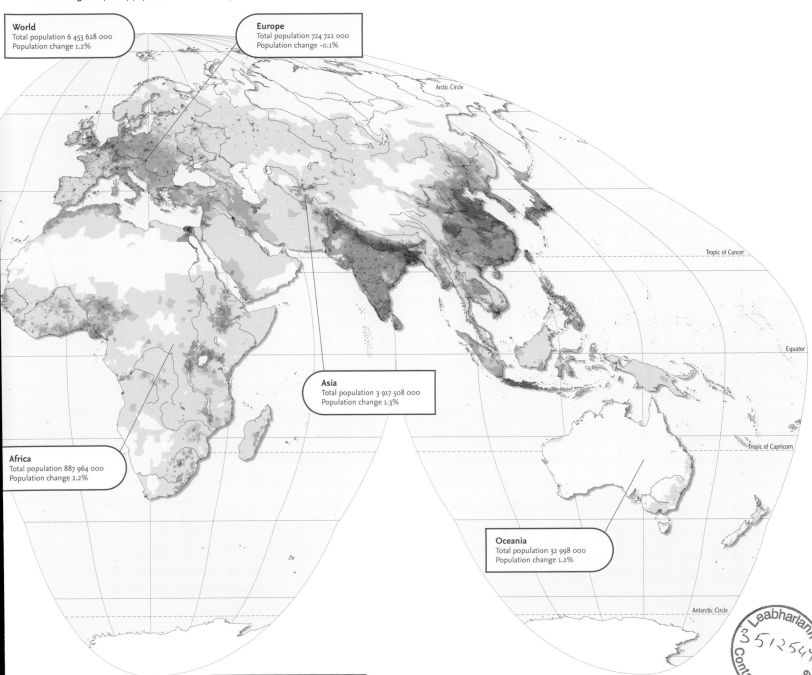

World
Total population 6 453 628 000
Population change 1.2%

Europe
Total population 724 722 000
Population change -0.1%

Asia
Total population 3 917 508 000
Population change 1.3%

Africa
Total population 887 964 000
Population change 2.2%

Oceania
Total population 32 998 000
Population change 1.2%

Arctic Circle

Tropic of Cancer

Equator

Tropic of Capricorn

Antarctic Circle

Top 10 countries by population density, 2005
(persons per square kilometre)

Rank	Country	Population density
1	Monaco	17 500
2	Singapore	6 770
3	Malta	1 272
4	Maldives	1 104
5	Vatican City	1 104
6	Bahrain	1 052
7	Bangladesh	985
8	Nauru	667
9	Taiwan	632
10	Barbados	628

Internet Links

United Nations Population Information Network	www.un.org/popin
US Census Bureau	www.census.gov
UK Census	www.statistics.gov.uk/census2001
Population Reference Bureau Popnet	www.prb.org
Socioeconomic Data and Applications Center	sedac.ciesin.columbia.edu

World

The world is becoming increasingly urban but the level of urbanization varies greatly between and within continents. At the beginning of the twentieth century only fourteen per cent of the world's population was urban and by 1950 this had increased to thirty per cent. In the more developed regions and in Latin America and the Caribbean seventy per cent of the population is urban while in Africa and Asia the figure is less than one third. In recent decades urban growth has increased rapidly to nearly fifty per cent and there are now 387 cities with over 1 000 000 inhabitants. It is in the developing regions that the most rapid increases are taking place and it is expected that by 2030 over half of urban dwellers worldwide will live in Asia. Migration from the countryside to the city in the search for better job opportunities is the main factor in urban growth.

World Statistics: see pages **154–160**

per cent urban
80 – 100
60 – 80
40 – 60
20 – 40
0 – 20

World percentage urbanization

City population (millions)
over 20
10 – 20
5 – 10
2.5 – 5

City population (millions)

Level of urbanization and the world's largest cities

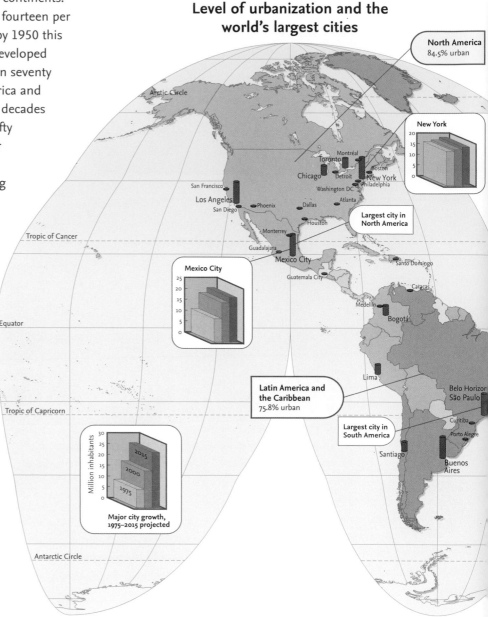

North America
84.5% urban

New York

Largest city in North America

Mexico City

Latin America and the Caribbean
75.8% urban

Largest city in South America

Major city growth, 1975–2015 projected

Facts

- Cities occupy less than 2% of the earth's land surface but house almost half of the human population

- Urban growth rates in Africa are the highest in the world

- Antarctica is uninhabited and most settlements in the Arctic regions have less than 5 000 inhabitants

- India has 32 cities with over one million inhabitants; by 2015 there will be 50

- London was the first city to reach a population of over 5 million

Megacities

There are currently forty-nine cities in the world with over 5 000 000 inhabitants. Twenty of these, often referred to as megacities, have over 10 000 000 inhabitants and one has over 30 000 000. Tōkyō, with 35 327 000 inhabitants, has remained the world's largest city since 1970 and is likely to remain so for the next decade. Other cities expected to grow to over 20 000 000 by 2015 are Mumbai, São Paulo, Delhi and Mexico City. Eleven of the world's twenty largest cities are in Asia, all of them have over 10 000 000 inhabitants.

Internet Links

United Nations Population Division	www.un.org/esa/population/unpop.htm
United Nations World Urbanization Prospects	www.un.org/esa/population/publications/publications.htm
United Nations Population Information Network	www.un.org/popin
The World Bank - Urban Development	www.worldbank.org/urban
City Populations	www.citypopulation.de

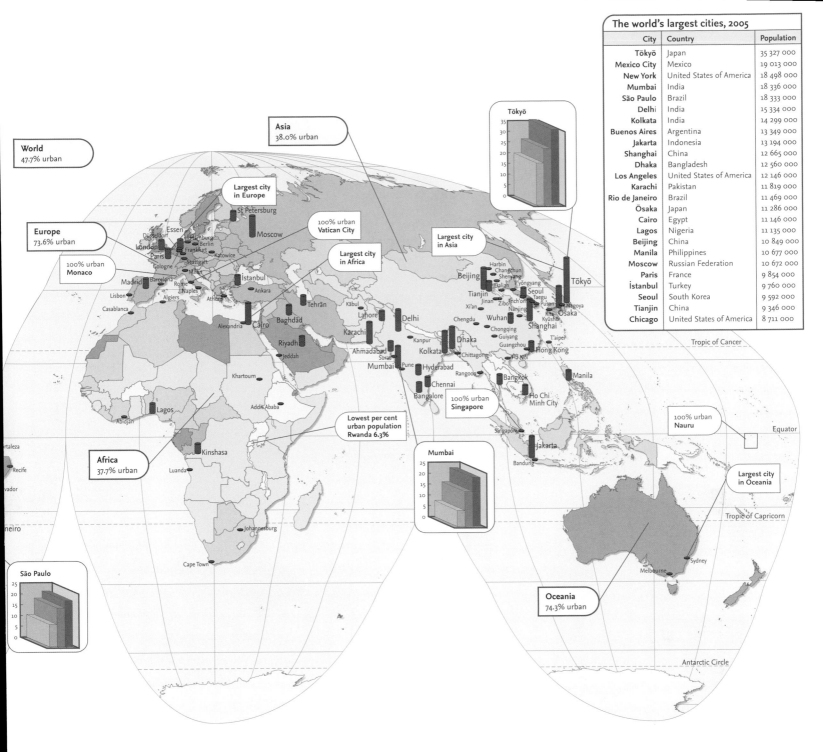

World
47.7% urban

Asia
38.0% urban

Europe
73.6% urban

Africa
37.7% urban

Oceania
74.3% urban

100% urban
Vatican City

100% urban
Monaco

100% urban
Singapore

100% urban
Nauru

Largest city in Europe

Largest city in Africa

Largest city in Asia

Largest city in Oceania

Lowest per cent urban population
Rwanda 6.3%

Tōkyō

Mumbai

São Paulo

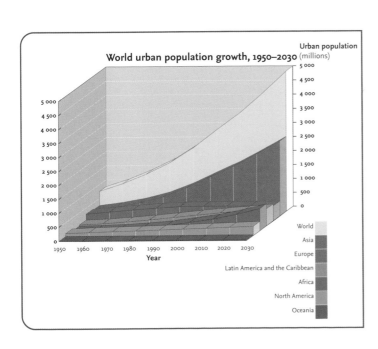

World urban population growth, 1950–2030
Urban population (millions)

Year

- World
- Asia
- Europe
- Latin America and the Caribbean
- Africa
- North America
- Oceania

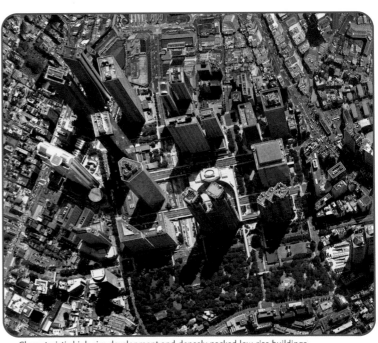

Characteristic high-rise development and densely packed low-rise buildings in **Tōkyō**, the world's largest city.

Communications

Increased availability and ownership of telecommunications equipment since the beginning of the 1970s has aided the globalization of the world economy. Over half of the world's fixed telephone lines have been installed since the mid-1980s and the majority of the world's internet hosts have come on line since 1997. There are now over one billion fixed telephone lines in the world. The number of mobile cellular subscribers has grown dramatically from sixteen million in 1991 to well over one billion today.

The internet is the fastest growing communications network of all time. It is relatively cheap and now links over 140 million host computers globally. Its growth has resulted in the emergence of hundreds of Internet Service Providers (ISPs) and internet traffic is now doubling every six months. In 1993 the number of internet users was estimated to be just under ten million, there are now over half a billion.

Facts

- Bermuda has the world's highest density of telephone lines per person
- Fibre-optic cables can now carry approximately 20 million simultaneous telephone calls
- The first transatlantic telegraph cable came into operation in 1858
- The internet is the fastest growing communications network of all time and now has over 267 million host computers
- Sputnik, the world's first artificial satellite, was launched in 1957

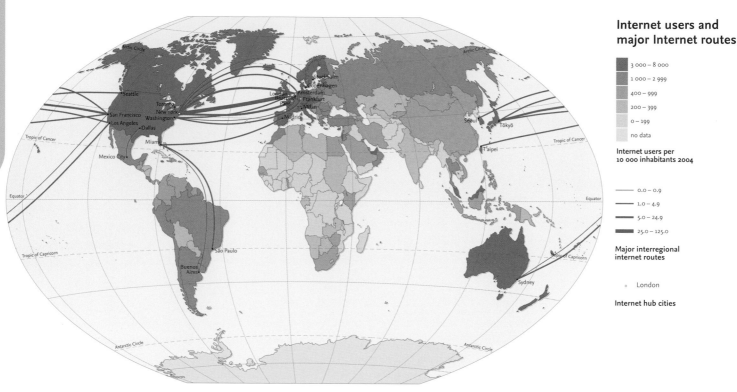

Internet users and major Internet routes

Internet users per 10 000 inhabitants 2004
- 3 000 – 8 000
- 1 000 – 2 999
- 400 – 999
- 200 – 399
- 0 – 199
- no data

Major interregional internet routes
- 0.0 – 0.9
- 1.0 – 4.9
- 5.0 – 24.9
- 25.0 – 125.0

○ London — Internet hub cities

The Internet

The Internet is a global network of millions of computers around the world, all capable of being connected to each other. Internet Service Providers (ISPs) provide access via 'host' computers, of which there are now over 267 million. It has become a vital means of communication and data transfer for businesses, governments and financial and academic institutions, with a steadily increasing proportion of business transactions being carried out on-line. Personal use of the Internet – particularly for access to the World Wide Web information network, and for e-mail communication – has increased enormously and there are now estimated to be over half a billion users worldwide.

Top 20 Internet Service Providers (ISPs)

Internet Service	Web Address	Subscribers (000s)
AOL (USA)	www.aol.com	20 500
T-Online (Germany)	www.t-online.de	4 151
Nifty-Serve (Japan)	www.nifty.com	3 500
EarthLink (USA)	www.earthlink.com	3 122
Biglobe (Japan)	www.biglobe.ne.jp	2 720
MSN (USA)	www.msn.com	2 700
Chollian (South Korea)	www.chollian.net	2 000
Tin.it (Italy)	www.tin.it	1 990
Freeserve (UK)	www.freeserve.com	1 575
AT&T WorldNet (USA)	www.att.net	1 500
Prodigy (USA)	www.prodigy.com	1 502
NetZero (USA)	www.netzero.com	1 450
Terra Networks (Spain)	www.terra.es	1 317
HiNet (Taiwan-China)	www.hinet.net	1 200
Wanadoo (France)	www.wanadoo.fr	1 124
AltaVista	www.microav.com	750
Freei (USA)	www.freei.com	750
SBC Internet Services	www.sbc.com	720
Telia Internet (Sweden)	www.telia.se	613
Netvigator (Hong Kong SAR)	www.netvigator.com	561

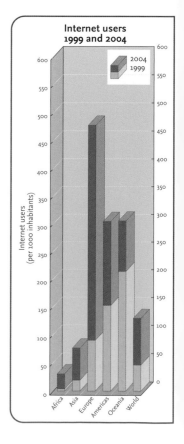

Internet users 1999 and 2004

Internet users (per 1000 inhabitants)

Africa, Asia, Europe, Americas, Oceania, World

2004 / 1999

Internet Links

OECD Information and Communication Technologies	**www.oecd.org**
Telegeography Inc.	**www.telegeography.com**
International Telecommunication Union	**www.itu.int**

Satellite communications

International telecommunications use either fibre-optic cables or satellites as transmission media. Although cables carry the vast majority of traffic around the world, communications satellites are important for person-to-person communication, including cellular telephones, and for broadcasting. The positions of communications satellites are critical to their use, and reflect the demand for such communications in each part of the world. Such satellites are placed in 'geostationary' orbit 36 000 km above the equator. This means that they move at the same speed as the earth and remain fixed above a single point on the earth's surface.

Mobile phone subscribers and communications satellites

over 100	⊙ In service
80 – 100	● Inclined orbit
60 – 79.9	○ Planned
40 – 59.9	
20 – 39.9	**Geostationary communications satellites**
0 – 19.9	
no data	

Cellular mobile subscribers per 100 inhabitants 2004

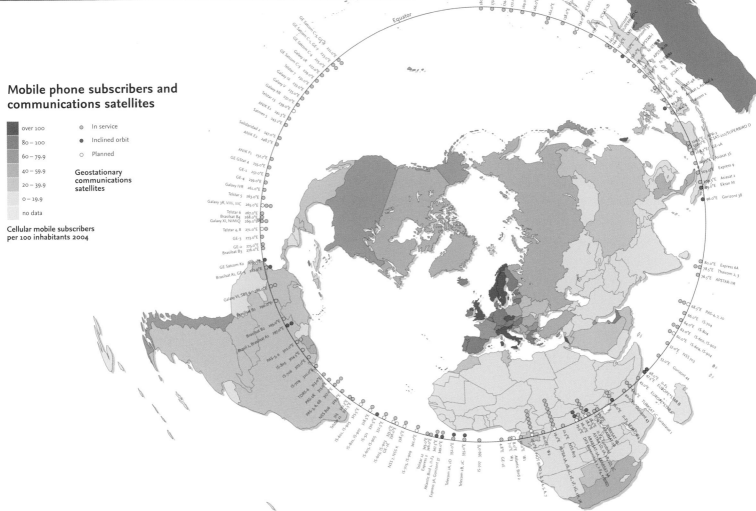

Telephone lines and telecommunications traffic

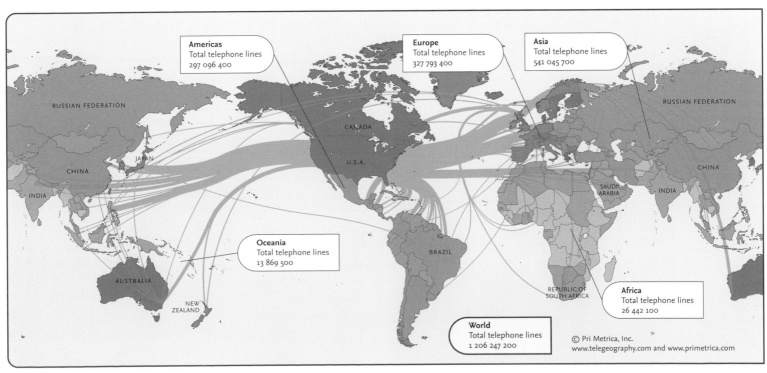

Americas
Total telephone lines
297 096 400

Europe
Total telephone lines
327 793 400

Asia
Total telephone lines
541 045 700

Oceania
Total telephone lines
13 869 500

Africa
Total telephone lines
26 442 100

World
Total telephone lines
1 206 247 200

© Pri Metrica, Inc.
www.telegeography.com and www.primetrica.com

over 50.0	5.0 – 9.9
35.0 – 50.0	1.0 – 4.9
15.0 – 34.9	0 – 0.9
10.0 – 14.9	no data

Telephone lines per 100 inhabitants

Traffic flows

5 000 2 500 1 000 100
Million minutes of telecommunications traffic (mMiTTs)

Social Indicators

World

Countries are often judged on their level of economic development, but national and personal wealth are not the only measures of a country's status. Numerous other indicators can give a better picture of the overall level of development and standard of living achieved by a country. The availability and standard of health services, levels of educational provision and attainment, levels of nutrition, water supply, life expectancy and mortality rates are just some of the factors which can be measured to assess and compare countries.

While nations strive to improve their economies, and hopefully also to improve the standard of living of their citizens, the measurement of such indicators often exposes great discrepancies between the countries of the 'developed' world and those of the 'less developed' world. They also show great variations within continents and regions and at the same time can hide great inequalities within countries.

World Statistics: see pages 154–160

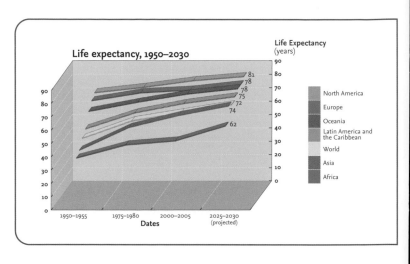

Life expectancy, 1950–2030

Life Expectancy (years)

- North America — 81
- Europe — 78
- Oceania — 78
- Latin America and the Caribbean — 75
- World — 72
- Asia — 74
- Africa — 62

Dates: 1950–1955, 1975–1980, 2000–2005, 2025–2030 (projected)

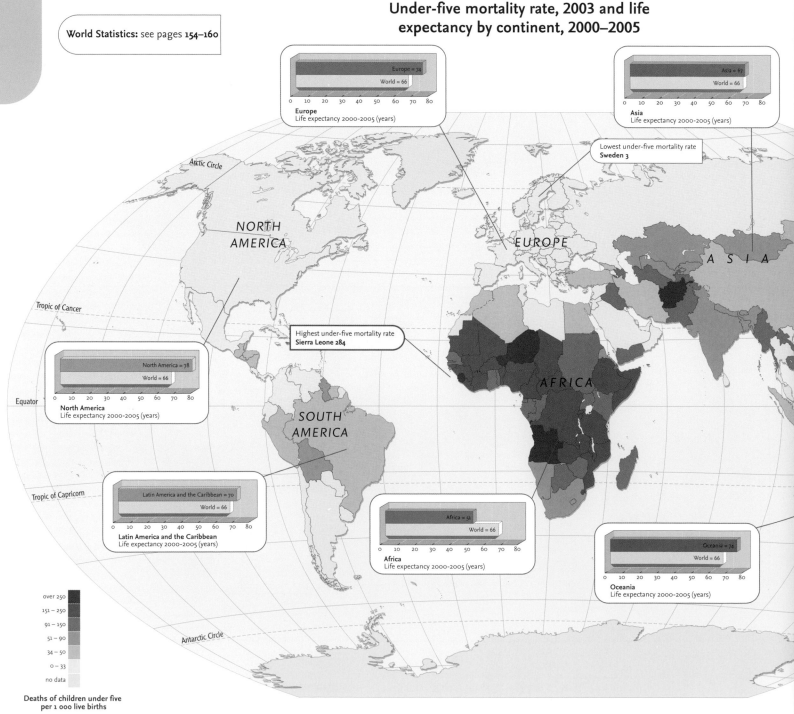

Under-five mortality rate, 2003 and life expectancy by continent, 2000–2005

Europe
Life expectancy 2000-2005 (years)
Europe = 74
World = 66

Asia
Life expectancy 2000-2005 (years)
Asia = 67
World = 66

Lowest under-five mortality rate
Sweden 3

North America
Life expectancy 2000-2005 (years)
North America = 78
World = 66

Highest under-five mortality rate
Sierra Leone 284

Latin America and the Caribbean
Life expectancy 2000-2005 (years)
Latin America and the Caribbean = 70
World = 66

Africa
Life expectancy 2000-2005 (years)
Africa = 51
World = 66

Oceania
Life expectancy 2000-2005 (years)
Oceania = 74
World = 66

NORTH AMERICA · EUROPE · ASIA · AFRICA · SOUTH AMERICA

Arctic Circle · Tropic of Cancer · Equator · Tropic of Capricorn · Antarctic Circle

- over 250
- 151 – 250
- 91 – 150
- 51 – 90
- 34 – 50
- 0 – 33
- no data

Deaths of children under five per 1 000 live births

Facts

- Of the 10 countries with under-5 mortality rates of more than 200, 9 are in Africa

- Many western countries believe they have achieved satisfactory levels of education and no longer closely monitor levels of literacy

- Children born in Nepal have only a 12% chance of their birth being attended by trained health personnel, for most European countries the figure is 100%

- The illiteracy rate among young women in the Middle East and north Africa is almost twice the rate for young men

Health and education

Perhaps the most important indicators used for measuring the level of national development are those relating to health and education. Both of these key areas are vital to the future development of a country, and if there are concerns in standards attained in either (or worse, in both) of these, then they may indicate fundamental problems within the country concerned. The ability to read and write (literacy) is seen as vital in educating people and encouraging development, while easy access to appropriate health services and specialists is an important requirement in maintaining satisfactory levels of basic health.

Literacy rate

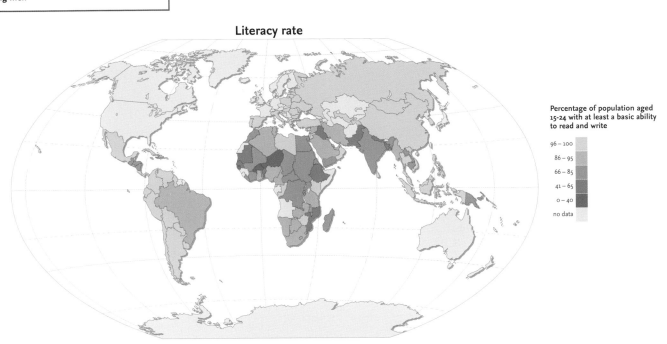

Percentage of population aged 15-24 with at least a basic ability to read and write

- 96 – 100
- 86 – 95
- 66 – 85
- 41 – 65
- 0 – 40
- no data

Lowest under-five mortality rate
Singapore 3

Tropic of Cancer

Equator

Tropic of Capricorn
OCEANIA

Doctors per 100 000 people

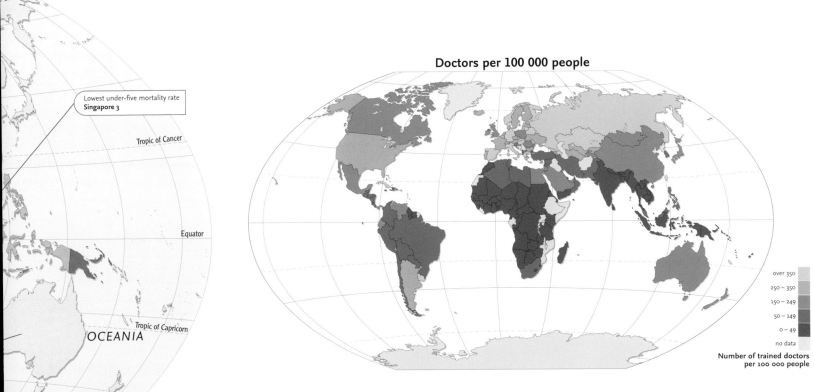

- over 350
- 250 – 350
- 150 – 249
- 50 – 149
- 0 – 49
- no data

Number of trained doctors per 100 000 people

UN Millennium Development Goals
From the Millennium Declaration, 2000

Goal 1	Eradicate extreme poverty and hunger
Goal 2	Achieve universal primary education
Goal 3	Promote gender equality and empower women
Goal 4	Reduce child mortality
Goal 5	Improve maternal health
Goal 6	Combat HIV/AIDS, malaria and other diseases
Goal 7	Ensure environmental sustainability
Goal 8	Develop a global partnership for development

Internet Links

United Nation Development Programme	**www.undp.org**
World Health Organization	**www.who.int**
United Nations Statistics Division	**unstats.un.org**
United Nations Millennium Development Goals	**www.un.org/millenniumgoals**

World

Economy and Wealth

The globalization of the economy is making the world appear a smaller place. However, this shrinkage is an uneven process. Countries are being included in and excluded from the global economy to differing degrees. The wealthy countries of the developed world, with their market-led economies, access to productive new technologies and international markets, dominate the world economic system. Great inequalities exist between and also within countries. There may also be discrepancies between social groups within countries due to gender and ethnic divisions. Differences between countries are evident by looking at overall wealth on a national and individual level.

Facts

- The City, one of 33 London boroughs, is the world's largest financial centre and contains Europe's biggest stock market

- Half the world's population earns only 5% of the world's wealth

- During the second half of the 20th century rich countries gave over US$1 trillion in aid

- For every £1 in grant aid to developing countries, more than £13 comes back in debt repayments

- On average, The World Bank distributes US$30 billion each year between 100 countries

World Statistics: see pages 154–160

Personal wealth

A poverty line set at $1 a day has been accepted as the working definition of extreme poverty in low-income countries. It is estimated that a total of 1.2 billion people live below that poverty line. This indicator has also been adopted by the United Nations in relation to their Millennium Development Goals. The United Nations goal is to halve the proportion of people living on less than $1 a day in 1990 to 14.5 per cent by 2015. Today, over 80 per cent of the total population of Ethiopia, Uganda and Nicaragua live on less than this amount.

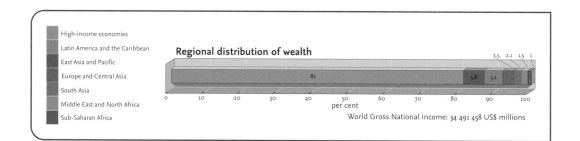

Regional distribution of wealth

High-income economies
Latin America and the Caribbean
East Asia and Pacific
Europe and Central Asia
South Asia
Middle East and North Africa
Sub-Saharan Africa

World Gross National Income: 34 491 458 US$ millions

Percentage of population living on less than $1 a day

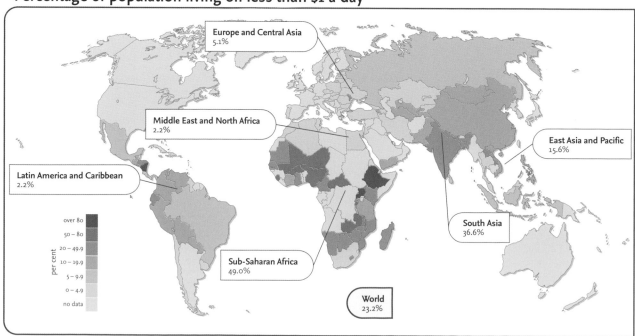

Europe and Central Asia 5.1%
Middle East and North Africa 2.2%
Latin America and Caribbean 2.2%
East Asia and Pacific 15.6%
South Asia 36.6%
Sub-Saharan Africa 49.0%
World 23.2%

per cent
over 80
50 – 80
20 – 49.9
10 – 19.9
5 – 9.9
0 – 4.9
no data

The world's biggest companies		
Rank	Name	Sales (US$ millions)
1	Wal-Mart Stores	256 330
2	BP	232 570
3	ExxonMobil	222 880
4	General Motors	185 520
5	Ford Motor	164 200
6	DaimlerChrysler	157 130
7	Toyota Motor	135 820
8	General Electric	134 190
9	Royal Dutch/Shell Group	133 500
10	Total	131 640

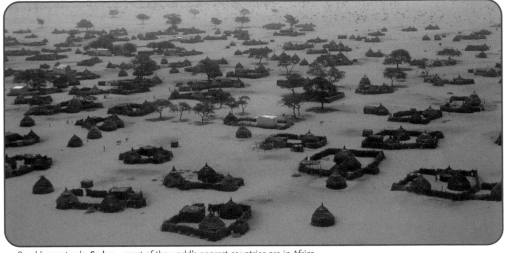

Rural homesteads, **Sudan** – most of the world's poorest countries are in Africa.

Gross National Income per capita

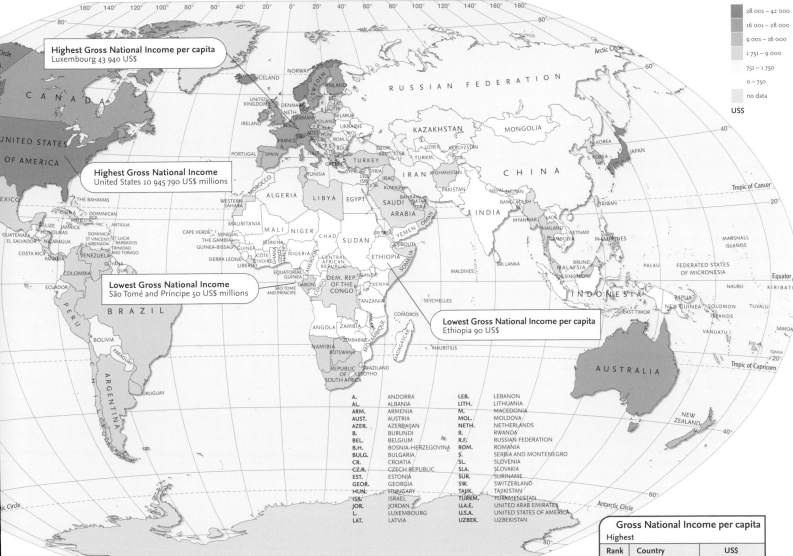

Highest Gross National Income per capita
Luxembourg 43 940 US$

Highest Gross National Income
United States 10 945 790 US$ millions

Lowest Gross National Income
São Tomé and Príncipe 50 US$ millions

Lowest Gross National Income per capita
Ethiopia 90 US$

28 001 – 42 000	
16 001 – 28 000	
9 001 – 16 000	
1 751 – 9 000	
751 – 1 750	
0 – 750	
no data	
US$	

A.	ANDORRA	LEB.	LEBANON
AL.	ALBANIA	LITH.	LITHUANIA
ARM.	ARMENIA	M.	MACEDONIA
AUST.	AUSTRIA	MOL.	MOLDOVA
AZER.	AZERBAIJAN	NETH.	NETHERLANDS
B.	BURUNDI	R.	RWANDA
BEL.	BELGIUM	R.F.	RUSSIAN FEDERATION
B.H.	BOSNIA-HERZEGOVINA	ROM.	ROMANIA
BULG.	BULGARIA	S.	SERBIA AND MONTENEGRO
CR.	CROATIA	SL.	SLOVENIA
CZ.R.	CZECH REPUBLIC	SLA.	SLOVAKIA
EST.	ESTONIA	SUR.	SURINAME
GEOR.	GEORGIA	SW.	SWITZERLAND
HUN.	HUNGARY	TAJIK.	TAJIKISTAN
ISR.	ISRAEL	TURKM.	TURKMENISTAN
JOR.	JORDAN	U.A.E.	UNITED ARAB EMIRATES
L.	LUXEMBOURG	U.S.A.	UNITED STATES OF AMERICA
LAT.	LATVIA	UZBEK.	UZBEKISTAN

Measuring wealth

One of the indicators used to determine a country's wealth is its Gross National Income (GNI). This gives a broad measure of an economy's performance. This is the value of the final output of goods and services produced by a country plus net income from non-resident sources. The total GNI is divided by the country's population to give an average figure of the GNI per capita. From this it is evident that the developed countries dominate the world economy with the United States having the highest GNI. China is a growing world economic player with the sixth highest GNI figure and a relatively high GNI per capita (US$1 100) in proportion to its huge population.

Internet Links	
● United Nations Statistics Division	**unstats.un.org**
● The World Bank	**www.worldbank.org**
● International Monetary Fund	**www.imf.org**
● Organisation for Economic Co-operation and Development	**www.oecd.org**

Gross National Income per capita		
Highest		
Rank	Country	US$
1	Luxembourg	43 940
2	Norway	43 350
3	Switzerland	39 880
4	United States	37 610
5	Japan	34 510
6	Denmark	33 750
7	Iceland	30 810
8	Sweden	28 840
9	United Kingdom	28 350
10	Finland	27 020
Lowest		
Rank	Country	US$
142	Niger	200
143=	Eritrea	190
143=	Tajikistan	190
144	Malawi	170
145	Sierra Leone	150
146	Guinea-Bissau	140
147	Liberia	130
148=	Burundi	100
148=	Dem. Rep. Congo	100
149	Ethiopia	90

Conflict

Geo-political issues shape the countries of the world and the current political situation in many parts of the world reflects a long history of armed conflict. Since the Second World War conflicts have been fairly localized, but there are numerous 'flash points' where factors such as territorial claims, ideology, religion, ethnicity and access to resources can cause friction between two or more countries. Such factors also lie behind the recent growth in global terrorism.

Military expenditure can take up a disproportionate amount of a country's wealth – Eritrea, with a Gross National Income (GNI) per capita of only US$190 spends nearly twenty per cent of its total GDP on military activity. There is an encouraging trend towards wider international cooperation, mainly through the United Nations (UN) and the North Atlantic Treaty Organization (NATO), to prevent escalation of conflicts and on peacekeeping missions.

Military spending, 2003 and conflicts, 1946–2003

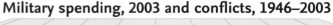

Location of international wars and wars of independence since 1946

AFGHANISTAN International war

Angola War of independence

Military expenditure as a percentage of Gross Domestic Product (GDP)

- 15.1 – 20.0
- 10.1 – 15.0
- 5.1 – 10.0
- 2.1 – 5.0
- 0 – 2.0
- no data

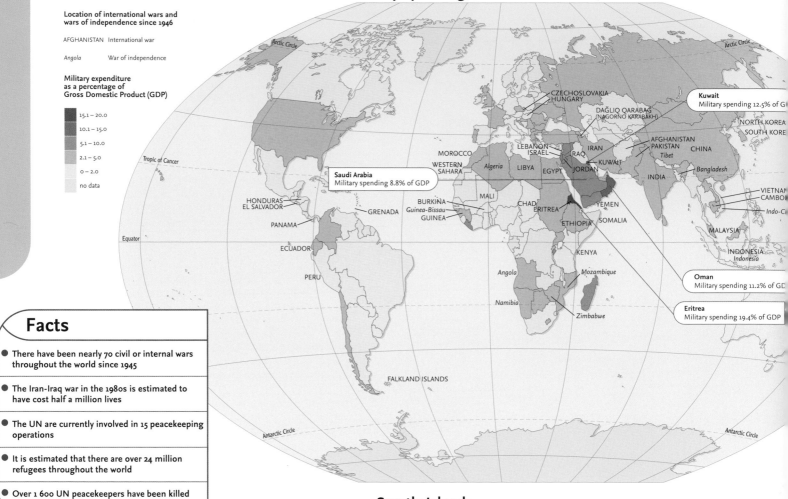

Kuwait
Military spending 12.5% of G

Saudi Arabia
Military spending 8.8% of GDP

Oman
Military spending 11.2% of GD

Eritrea
Military spending 19.4% of GDP

Facts

- There have been nearly 70 civil or internal wars throughout the world since 1945
- The Iran-Iraq war in the 1980s is estimated to have cost half a million lives
- The UN are currently involved in 15 peacekeeping operations
- It is estimated that there are over 24 million refugees throughout the world
- Over 1 600 UN peacekeepers have been killed since 1948

Spratly Islands

The Spratly Islands in the South China Sea are an excellent example of how apparently insignificant pieces of land can become the source of conflict. Six countries claim ownership of some or all of these remote, tiny islands and reefs, the largest of which covers less than half a square kilometre. The islands are strategically important – approximately a quarter of all the world's shipping trade passes through the area – and ownership of the group would mean access to 250 000 square kilometres of valuable fishing grounds and sea bed believed to be rich in oil and gas reserves. Five of the claimant countries have occupied individual islands to endorse their claims, although there appears little prospect of international agreement on ownership.

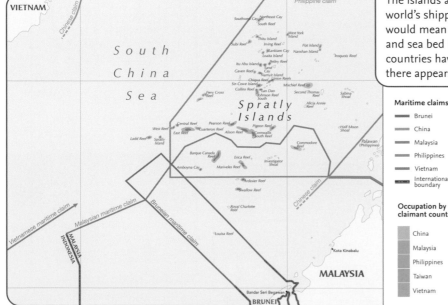

Maritime claims

- Brunei
- China
- Malaysia
- Philippines
- Vietnam
- International boundary

Occupation by claimant countries

- China
- Malaysia
- Philippines
- Taiwan
- Vietnam

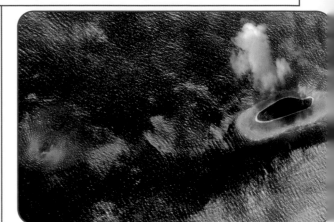

A small island and reef in the disputed **Spratly Islands** in the South China Sea.

Global terrorism

Terrorism is defined by the United Nations as "All criminal acts directed against a State and intended or calculated to create a state of terror in the minds of particular persons or a group of persons or the general public". The world has become increasingly concerned about terrorism and the possibility that terrorists could acquire and use nuclear, chemical and biological weapons. One common form of terrorist attack is suicide bombing. Pioneered by Tamil secessionists in Sri Lanka, it has been widely used by Palestinian groups fighting against Israeli occupation of the West Bank and Gaza. In recent years it has also been used by the Al Qaida network in its attacks on the western world.

Major terrorist incidents

Date	Location	Summary	Killed	Injured
December 1988	Lockerbie, Scotland	Airline bombing	270	5
March 1995	Tōkyō, Japan	Sarin gas attack on subway	12	5 700
April 1995	Oklahoma City, USA	Bomb in the Federal building	168	over 500
August 1998	Nairobi, Kenya and Dar es Salaam, Tanzania	US Embassy bombings	257	over 4 000
August 1998	Omagh, Northern Ireland	Town centre bombing	29	330
September 2001	New York and Washington D.C., USA	Airline hijacking and crashing	2 752	4 300
October 2002	Bali, Indonesia	Car bomb outside nightclub	202	300
October 2002	Moscow, Russian Federation	Theatre siege	170	over 600
March 2004	Baghdad and Karbalā', Iraq	Suicide bombing of pilgrims	181	over 400
March 2004	Madrid, Spain	Train bombings	191	1 800
September 2004	Beslan, Russian Federation	School siege	330	700
July 2005	London, UK	Underground and bus bombings	52	700
July 2005	Sharm ash Shaykh, Egypt	Bombs at tourist sites	88	200

Terrorist incidents

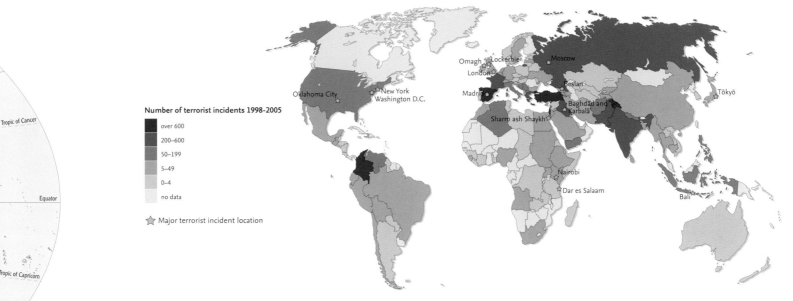

Number of terrorist incidents 1998-2005

- over 600
- 200–600
- 50–199
- 5–49
- 0–4
- no data

☆ Major terrorist incident location

Middle East politics
Changing boundaries in Israel/Palestine since 1922

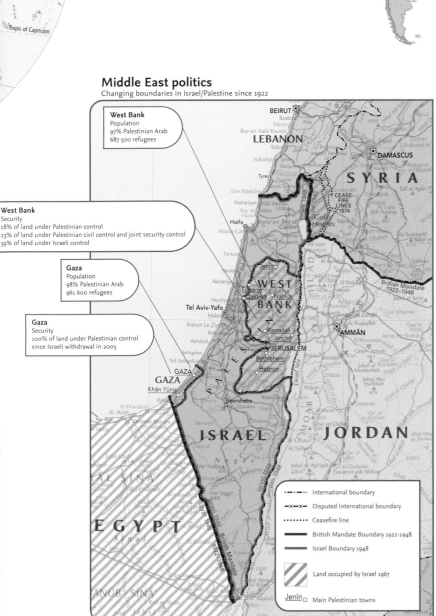

West Bank
Population
97% Palestinian Arab
687 500 refugees

West Bank
Security
18% of land under Palestinian control
23% of land under Palestinian civil control and joint security control
59% of land under Israeli control

Gaza
Population
98% Palestinian Arab
961 600 refugees

Gaza
Security
100% of land under Palestinian control
since Israeli withdrawal in 2005

·—·—· International boundary
—×—×— Disputed International boundary
········· Ceasefire line
——— British Mandate Boundary 1922-1948
——— Israel Boundary 1948
▨ Land occupied by Israel 1967
Jenin □ Main Palestinian towns

The Middle East

The on-going Israeli/Palestinian conflict reflects decades of unrest in the region of Palestine which, after the First World War, was placed under British control. In 1947 the United Nations (UN) proposed a partitioning into separate Jewish and Arab states – a plan which was rejected by the Palestinians and by the Arab states in the region. When Britain withdrew in 1948, Israel declared its independence. This led to an Arab-Israeli war which left Israel with more land than originally proposed under the UN plan. Hundreds of thousands of Palestinians were forced out of their homeland and became refugees, mainly in Jordan and Lebanon. The 6-Day War in 1967 resulted in Israel taking possession of Sinai and Gaza from Egypt, West Bank from Jordan, and the Golan Heights from Syria. These territories (except Sinai which was subsequently returned to Egypt) remain occupied by Israel – the main reason for the Palestinian uprising or 'Intifada' against Israel. The situation remains complex, with poor prospects for peace and for mutually acceptable independent states being established.

Internet Links

● United Nations Peace and Security	**www.un.org/peace**
● NATO	**www.nato.int**
● BBC News	**news.bbc.co.uk**
● International Boundaries Research Unit	**www-ibru.dur.ac.uk**
● International Peace Research Institute	**www.prio.no**

Global Issues

With the process of globalization has come an increased awareness of, and direct interest in, issues which have global implications. Social issues can now affect large parts of the world and can impact on large sections of society. Perhaps the current issues of greatest concern are those of national security, including the problem of international terrorism (see World Conflict pages 30–31), health, crime and natural resources. The three issues highlighted here reflect this and are of immediate concern.

The international drugs trade, and the crimes commonly associated with it, can impact on society and individuals in devastating ways; scarcity of water resources and lack of access to safe drinking water can have major economic implications and cause severe health problems; and the AIDS epidemic is having disastrous consequences in large parts of the world, particularly in sub-Saharan Africa.

The drugs trade

The international trade in illegal drugs is estimated to be worth over US$400 billion. While it may be a lucrative business for the criminals involved, the effects of the drugs on individual users and on society in general can be devastating. Patterns of drug production and abuse vary, but there are clear centres for the production of the most harmful drugs – the opiates (opium, morphine and heroin) and cocaine. The 'Golden Triangle' of Laos, Myanmar and Thailand, and western South America respectively are the main producing areas for these drugs. Significant efforts are expended to counter the drugs trade, and there have been signs recently of downward trends in the production of heroin and cocaine.

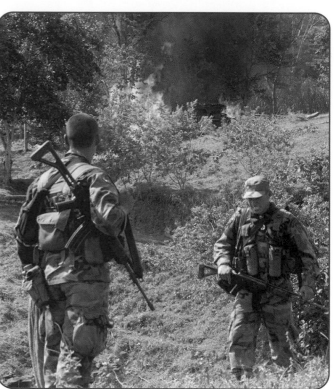

Soldiers in **Colombia**, a major producer of cocaine, destroy an illegal drug processing laboratory.

The international drugs trade

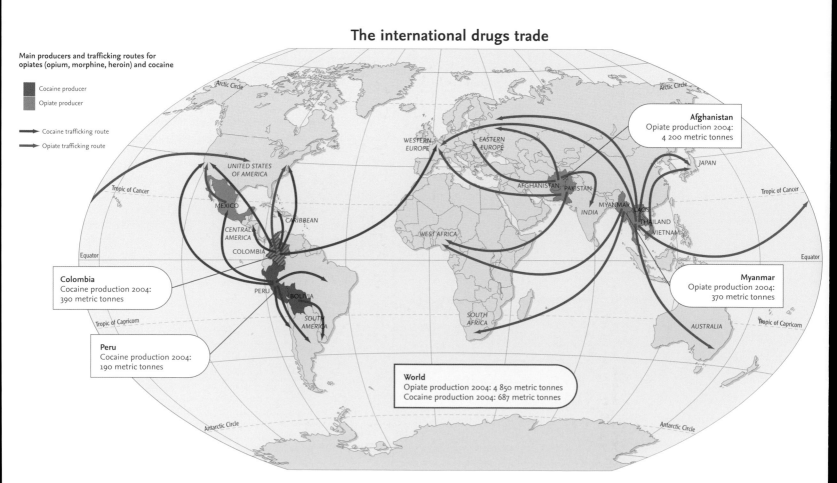

Main producers and trafficking routes for opiates (opium, morphine, heroin) and cocaine

- Cocaine producer
- Opiate producer

→ Cocaine trafficking route
→ Opiate trafficking route

Afghanistan
Opiate production 2004:
4 200 metric tonnes

Colombia
Cocaine production 2004:
390 metric tonnes

Peru
Cocaine production 2004:
190 metric tonnes

Myanmar
Opiate production 2004:
370 metric tonnes

World
Opiate production 2004: 4 850 metric tonnes
Cocaine production 2004: 687 metric tonnes

AIDS epidemic

With over 40 million people living with HIV/AIDS (Human Immunodeficiency Virus/Acquired Immune Deficiency Syndrome) and more than 20 million deaths from the disease, the AIDS epidemic poses one of the biggest threats to public health. The UNAIDS project estimated that 5 million people were newly infected in 2003 and that 3 million AIDS sufferers died. Estimates into the future look bleak, especially for poorer developing countries where an additional 45 million people are likely to become infected by 2010. The human cost is huge. As well as the death count itself, more than 11 million African children, half of whom are between the ages of 10 and 14, have been orphaned as a result of the disease.

Population living with HIV/AIDS, 2005

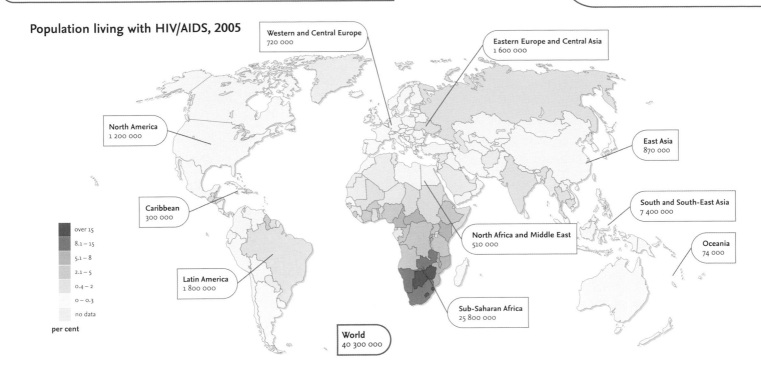

Western and Central Europe
720 000

Eastern Europe and Central Asia
1 600 000

North America
1 200 000

East Asia
870 000

Caribbean
300 000

South and South-East Asia
7 400 000

North Africa and Middle East
510 000

Oceania
74 000

Latin America
1 800 000

Sub-Saharan Africa
25 800 000

World
40 300 000

over 15
8.1 – 15
5.1 – 8
2.1 – 5
0.4 – 2
0 – 0.3
no data

per cent

Water resources

Water is one of the fundamental requirements of life, and yet in some countries it is becoming more scarce due to increasing population and climate change. Safe drinking water, basic hygiene, health education and sanitation facilities are often virtually nonexistent for impoverished people in developing countries throughout the world. WHO/UNICEF estimate that the combination of these conditions results in 6 000 deaths every day, most of these being children. Currently over 1.2 billion people drink unclean water and expose themselves to serious health risks, while political struggles over diminishing water resources are increasingly likely to be the cause of international conflict.

Domestic use of **untreated water** in Kathmandu, Nepal

Access to safe water, 2002
Percentage of population with access to improved drinking water

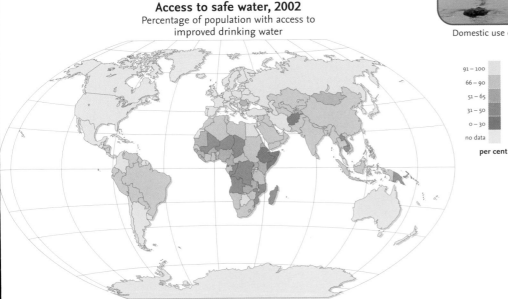

91 – 100
66 – 90
51 – 65
31 – 50
0 – 30
no data

per cent

Many parts of the world are undergoing significant changes which can have widespread and long-lasting effects. The principal causes of change are environmental – particularly climatic – factors and the influence of man. However, it is often difficult to separate these causes because man's activities can influence and exaggerate environmental change. Changes, whatever their cause, can have significant effects on the local population, on the wider region and even on a global scale. Major social, economic and environmental impacts can result from often irreversible changes – deforestation can affect a region's biodiversity, land reclamation can destroy fragile marine ecosystems, major dams and drainage schemes can affect whole drainage basins, and local communities can be changed beyond recognition through such projects.

Facts

- The Sundarbans stretching across the Ganges delta is the largest area of mangrove forest in the world, covering 10 000 square kilometres (3 861 square miles) forming an important ecological area, home to 260 species of birds, the Bengal tiger and other threatened species

- Over 90 000 square kilometres of precious tropical forest and wetland habitats are lost each year

- The surface level of the Dead Sea has fallen by 16 metres over the last 30 years

- Climate change and mis-management of land areas can lead to soils becoming degraded and semi-arid grasslands becoming deserts – a process known as desertification

Environmental change

Whenever natural resources are exploited by man, the environment is changed, and where these changes interfere with existing biological and environmental processes environmental degradation can occur. Approximately half the area of post-glacial forest has been cleared or degraded, and the amount of old-growth forest continues to decline. Desertification caused by climate change and the impact of man can turn semi-arid grasslands into arid desert. Regions bordering tropical deserts are most vulnerable to this process such as the Sahel region south of the Sahara and regions around the Thar Desert in India. Coral reefs are equally fragile environments, and many are under threat from coastal development, pollution and over-exploitation of marine resources.

Water resources in certain parts of the world are becoming increasingly scarce and competition for water is likely to become a common cause of conflict. The Aral Sea in central Asia was once the world's fourth largest lake but it now ranks only tenth after shrinking by almost 40 000 square kilometres. This shrinkage has been due to climatic change and to the diversion, for farming purposes, of the major rivers which feed the lake. The change has had a devastating effect on the local fishing industry and has caused health problems for the local population.

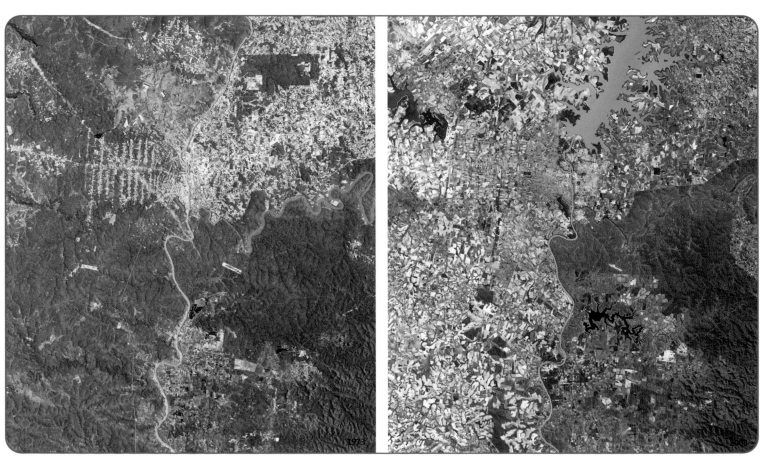

Deforestation and the creation of the **Itaipu Dam** on the Paraná river in Brazil have had a dramatic effect on the landscape and ecosystems of this part of South America.

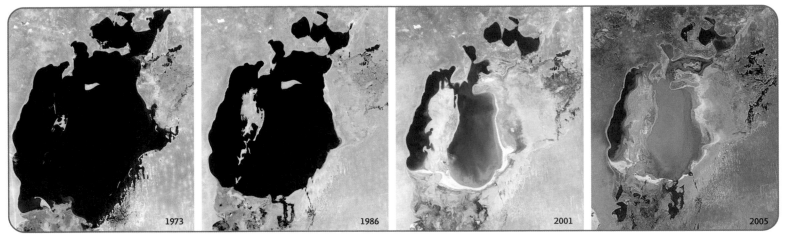

Aral Sea, Kazakhstan/ Uzbekistan 1973-2005 Climate change and the diversion of rivers have caused its dramatic shrinkage.

Environmental Impacts

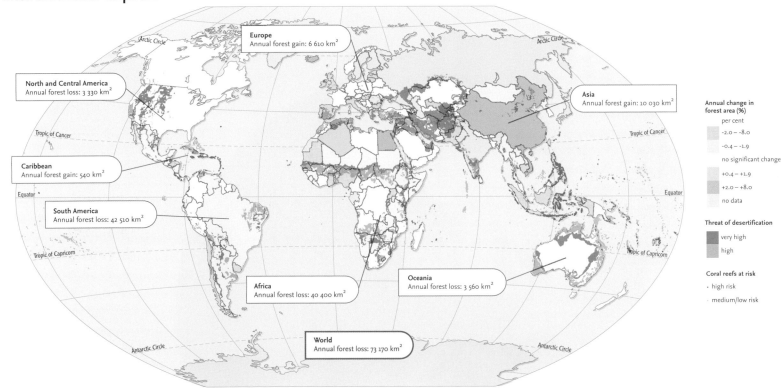

Europe
Annual forest gain: 6 610 km²

North and Central America
Annual forest loss: 3 330 km²

Asia
Annual forest gain: 10 030 km²

Caribbean
Annual forest gain: 540 km²

South America
Annual forest loss: 42 510 km²

Africa
Annual forest loss: 40 400 km²

Oceania
Annual forest loss: 3 560 km²

World
Annual forest loss: 73 170 km²

Annual change in
forest area (%)
per cent
-2.0 – -8.0
-0.4 – -1.9
no significant change
+0.4 – +1.9
+2.0 – +8.0
no data

Threat of desertification
very high
high

Coral reefs at risk
· high risk
· medium/low risk

Internet links

● NASA Visible Earth	**visibleearth.nasa.gov**
● NASA Earth Observatory	**earthobservatory.nasa.gov**
● USGS Earthshots	**earthshots.usgs.gov**

Environmental protection

Top 10 protected areas by size

Rank	Protected area	Country	Size (sq km)	Designation
1	Northeast Greenland	Greenland	972 000	National Park
2	Rub'al Khālī	Saudi Arabia	640 000	Wildlife Management Area
3	Great Barrier Reef	Australia	345 400	Marine Park
4	Northwestern Hawaiian Islands	United States	341 362	Coral Reef Ecosystem Reserve
5	Qiangtang	China	298 000	Nature Reserve
6	Macquarie Island	Australia	162 060	Marine Park
7	Sanjiangyuan	China	152 300	Nature Reserve
8	Northern Wildlife Management Zone	Saudi Arabia	100 875	Wildlife Management Area
9	Ngaanyatjarra Lands	Australia	98 129	Indigenous Protected Area
10	Alto Orinoco-Casiquiare	Venezuela	84 000	Biosphere Reserve

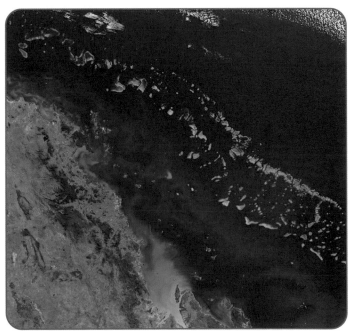

Great Barrier Reef, Australia, the world's third largest protected area.

Europe

Europe, the westward extension of the Asian continent and the second smallest of the world's continents, has a remarkable variety of physical features and landscapes. The continent is bounded by mountain ranges of varying character – the highlands of Scandinavia and northwest Britain, the Pyrenees, the Alps, the Carpathian Mountains, the Caucasus and the Ural Mountains. Two of these, the Caucasus and Ural Mountains define the eastern limits of Europe, with the Black Sea and the Bosporus defining its southeastern boundary with Asia.

Across the centre of the continent stretches the North European Plain, broken by some of Europe's greatest rivers, including the Volga and the Dnieper and containing some of its largest lakes. To the south, the Mediterranean Sea divides Europe from Africa. The Mediterranean region itself has a very distinct climate and landscape.

Facts

- The Danube flows through 7 countries and has 7 different name forms

- Lakes cover almost 10% of the total land area of Finland

- The Strait of Gibraltar, separating the Atlantic Ocean from the Mediterranean Sea and Europe from Africa, is only 13 kilometres wide at its narrowest point

- The highest mountain in the Alps is Mont Blanc, 4 808 metres, on the France/Italy border

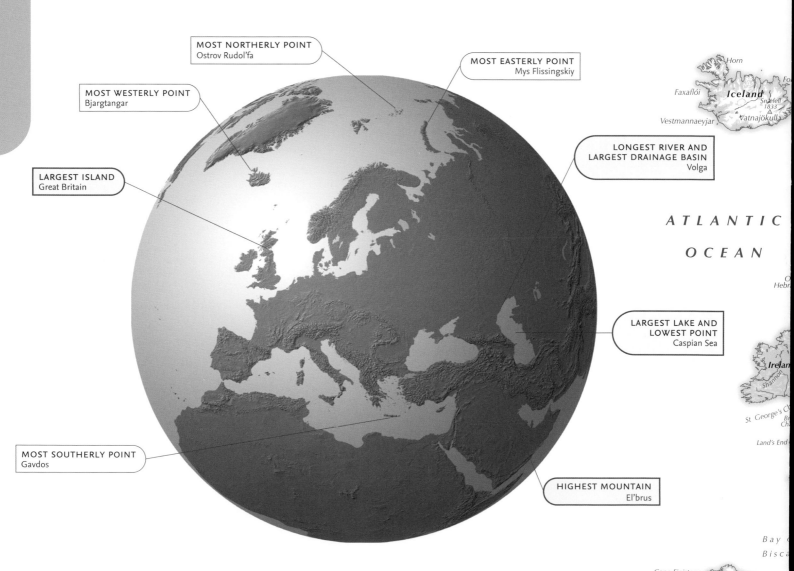

MOST NORTHERLY POINT
Ostrov Rudol'fa

MOST EASTERLY POINT
Mys Flissingskiy

MOST WESTERLY POINT
Bjargtangar

LONGEST RIVER AND
LARGEST DRAINAGE BASIN
Volga

LARGEST ISLAND
Great Britain

LARGEST LAKE AND
LOWEST POINT
Caspian Sea

MOST SOUTHERLY POINT
Gavdos

HIGHEST MOUNTAIN
El'brus

Europe's greatest physical features

Highest mountain	El'brus, Russian Federation	5 642 metres	18 510 feet
Longest river	Volga, Russian Federation	3 688 km	2 291 miles
Largest lake	Caspian Sea	371 000 sq km	143 243 sq miles
Largest island	Great Britain, United Kingdom	218 476 sq km	84 354 sq miles
Largest drainage basin	Volga, Russian Federation	1 380 000 sq km	532 818 sq miles

Europe's extent

Total Land Area	9 908 599 sq km / 3 825 710 sq miles
Most northerly point	Ostrov Rudol'fa, Russian Federation
Most southerly point	Gavdos, Crete, Greece
Most westerly point	Bjargtangar, Iceland
Most easterly point	Mys Flissingskiy, Russian Federation

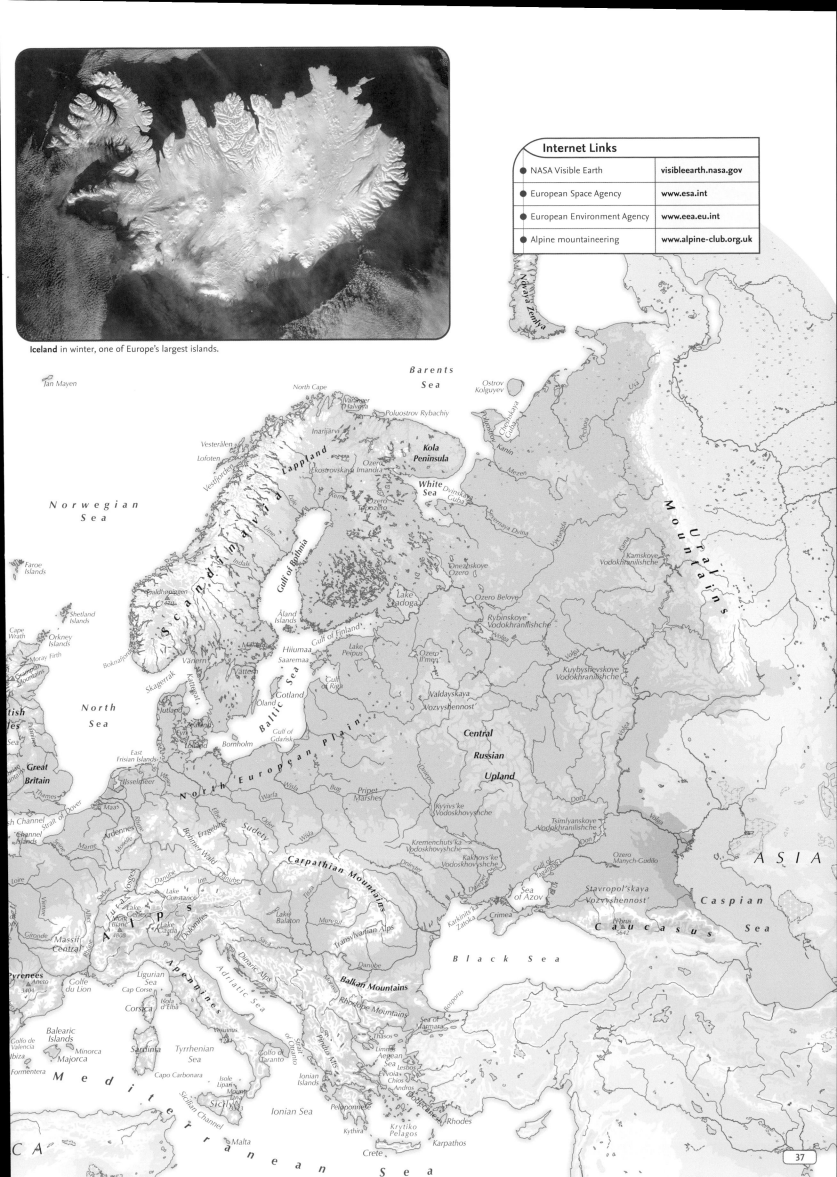

Iceland in winter, one of Europe's largest islands.

Internet Links

● NASA Visible Earth	**visibleearth.nasa.gov**
● European Space Agency	**www.esa.int**
● European Environment Agency	**www.eea.eu.int**
● Alpine mountaineering	**www.alpine-club.org.uk**

Jan Mayen

Barents Sea

North Cape

Varanger Halvøya

Poluostrov Rybachiy

Ostrov Kolguyev

Poluostrov Kanin

Cheshskaya Guba

Usa

Pechora

Inarijärvi

Vesterålen

Lofoten

Vestfjorden

Kola Peninsula

Ozero Ekostrovskaya Imandra

White Sea

Dvinskaya Guba

Mezen

S c a n d i n a v i a

L a p p l a n d

Lule

Kem

Ozero Topozero

Severnaya Dvina

Vychegda

Kama

Kamskoye Vodokhranilishche

U r a l M o u n t a i n s

Norwegian Sea

Ume

Gulf of Bothnia

Onezhskoye Ozero

Galdhøpiggen 2470

Indals

Faroe Islands

Shetland Islands

Cape Wrath

Orkney Islands

Moray Firth

Grampian Mountains

Boknafjord

Malaren

Vänern

Skagerrak

Kattegat

Vättern

Åland Islands

Gulf of Finland

Lake Peipus

Hiiumaa Saaremaa

Gulf of Riga

Ozero Il'men'

Lake Ladoga

Ozero Beloye

Rybinskoye Vodokhranilishche

Volga

Volga

Kuybyshevskoye Vodokhranilishche

Volga

North Sea

B a l t i c S e a

Gotland

Öland

Jutland

Zealand

Fyn

Lolland

Bornholm

Gulf of Gdańsk

Valdayskaya Vozvyshennost'

Central Russian Upland

tish les

Sea

Great Britain

Pennines

Thames

East Frisian Islands

IJsselmeer

N o r t h E u r o p e a n P l a i n

Weser

Elbe

Oder

Warta

Wisła

Bug

Pripet Marshes

Dnieper

Kyyivs'ke Vodoskhovyshche

Don

Tsimlyanskoye Vodokhranilishche

Volga

h Channel

Strait of Dover

Channel Islands

Maas

Rhine

Ardennes

Erzgebirge

Böhmer Wald

Sudety

Wisła

Tisza

Kremenchuts'ka Vodoskhovyshche

Dniester

Kakhovs'ke Vodoskhovyshche

Don

Ozero Manych-Gudilo

A S I A

Seine

Marne

Moselle

Danube

Inn

Danube

Carpathian Mountains

Dniester

Gulf of Taganrog

Loire

Vienne

Saône

Jura

Vosges

Lake Constance

Lake Geneva

Mont Blanc 4808

A l p s

Dolomites

Lake Garda

Lake Balaton

Muresul

Sava

Po

Transylvanian Alps

Sea of Azov

Karkinits'ka Zatoka

Crimea

Stavropol'skaya Vozvyshennost'

C a u c a s u s

Elbrus 5642

C a s p i a n S e a

Massif Central

Rhône

A p e n n i n e s

Dinaric Alps

Adriatic Sea

Morava

Danube

Drava

Balkan Mountains

B l a c k S e a

Bosporus

Pyrenees

Aneto 3404

Golfe du Lion

Ligurian Sea

Cap Corse

Isola d'Elba

Corsica

Vesuvius

Rhodope Mountains

Sea of Marmara

Golfo de Valencia

Balearic Islands

Minorca

Majorca

Ibiza

Formentera

Sardinia

Tyrrhenian Sea

Golfo di Taranto

Isole Lipari

Mount Etna 3323

Sicily

Thasos

Limnos

Lesbos

Aegean Sea

Evvoia

Chios

Andros

Pindus Mts

Dodecanese

Rhodes

Karpathos

Capo Carbonara

Sicilian Channel

Strait of Otranto

Ionian Islands

Ionian Sea

Peloponnese

Kythira

Krytiko Pelagos

Karpathos

Malta

Crete

C A

M e d i t e r r a n e a n S e a

Novaya Zemlya

Europe

The predominantly temperate climate of Europe has led to it becoming the most densely populated of the continents. It is highly industrialized, and has exploited its great wealth of natural resources and agricultural land to become one of the most powerful economic regions in the world.

The current pattern of countries within Europe is a result of numerous and complicated changes throughout its history. Ethnic, religious and linguistic differences have often been the cause of conflict, particularly in the Balkan region which has a very complex ethnic pattern. Current boundaries reflect, to some extent, these divisions which continue to be a source of tension. The historic distinction between 'Eastern' and 'Western' Europe is no longer made, following the collapse of Communism and the break up of the Soviet Union in 1991.

Facts

- The European Union was founded by six countries: Belgium, France, Germany, Italy, Luxembourg, and the Netherlands. It now has 25 members

- The newest members of the European Union joined in 2004: Cyprus, Czech Republic, Estonia, Hungary, Latvia, Lithuania, Malta, Poland, Slovakia, and Slovenia

- Europe has the 2 smallest independent countries in the world – Vatican City and Monaco

- Vatican City is an independent country entirely within the city of Rome, and is the centre of the Roman Catholic Church

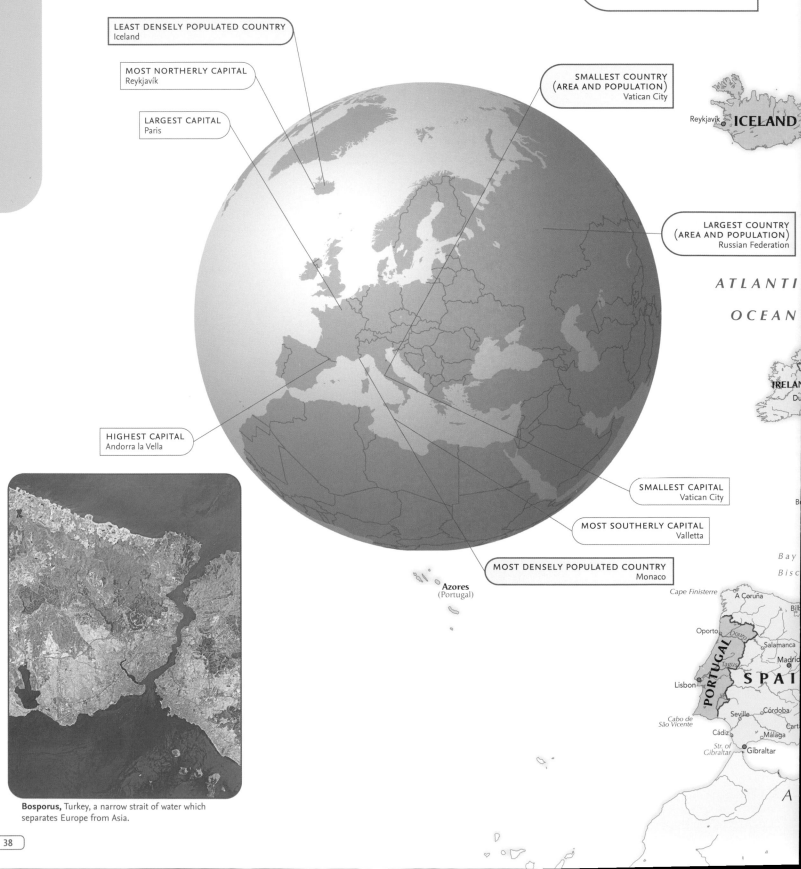

LEAST DENSELY POPULATED COUNTRY
Iceland

MOST NORTHERLY CAPITAL
Reykjavík

LARGEST CAPITAL
Paris

SMALLEST COUNTRY
(AREA AND POPULATION)
Vatican City

Reykjavík ICELAND

LARGEST COUNTRY
(AREA AND POPULATION)
Russian Federation

ATLANTI

OCEAN

IRELAN
Du

HIGHEST CAPITAL
Andorra la Vella

SMALLEST CAPITAL
Vatican City

MOST SOUTHERLY CAPITAL
Valletta

MOST DENSELY POPULATED COUNTRY
Monaco

Bay
Bisc

Azores
(Portugal)

Cape Finisterre A Coruña

Bil

Oporto Douro Salamanca

PORTUGAL Tagus Madri

SPAI

Lisbon

Cabo de Seville Córdoba
São Vicente
Cádiz Car

Str. of Gibraltar Málaga
Gibraltar

A

Bosporus, Turkey, a narrow strait of water which separates Europe from Asia.

Europe's capitals

Largest capital (population)	Paris, France	9 854 000
Smallest capital (population)	Vatican City	921
Most northerly capital	Reykjavík, Iceland	64° 39'N
Most southerly capital	Valletta, Malta	35° 54'N
Highest capital	Andorra la Vella, Andorra	1 029 metres 3 376 feet

Europe's countries

Largest country (area)	Russian Federation	17 075 400 sq km	6 592 849 sq miles
Smallest country (area)	Vatican City	0.5 sq km	0.2 sq miles
Largest country (population)	Russian Federation	143 202 000	
Smallest country (population)	Vatican City	921	
Most densely populated country	Monaco	17 000 per sq km	34 000 per sq mile
Least densely populated country	Iceland	3 per sq km	7 per sq mile

Jan Mayen
(Norway)

Barents Sea

North Cape

Ostrov Kolguyev

Vorkuta

Kola Peninsula

Murmansk

Lappland

White Sea

Archangel

Mezen

SWEDEN

Severnaya Dvina

RUSSIAN

Syktyvkar

Norwegian Sea

FINLAND

Onezhskoye Ozero

Petrozavodsk

FEDERATION

Perm'

Kirov

Izhevsk

Lake Ladoga

Vologda

Volga

Naberezhnyye Chelny

Ufa

Faroe Islands
(Denmark)

Trondheim

Indals

Ume

Gulf of Bothnia

Åland Islands

Turku

Helsinki

St Petersburg

Yaroslavl'

Kazan'

Gulf of Finland

Nizhniy Novgorod

Ul'yanovsk

Orenburg

Shetland Islands

Skagerrak

Bergen

NORWAY

Oslo

Vänern

Lake Peipus

Moscow

Samara

Orkney Islands

Aalborg

Vättern

ESTONIA

Tallinn

Tula

Penza

Saratov

Edinburgh

Stockholm

Gotland

Gulf of Riga

Riga

LATVIA

Vitsyebsk

Smolensk

Astrakhan'

North Sea

DENMARK

Malmö

Öland

Baltic Sea

LITHUANIA

Minsk

Mahilyow

Voronezh

Volgograd

UNITED

Leeds

Manchester

Copenhagen

Bornholm

Vilnius

RUS. FED.
Kaliningrad

Hrodna

Homyel'

KINGDOM

Gdańsk

Białystok

BELARUS

Chernihiv

Beldorod

Rostov-na-Donu

NETHERLANDS

Hamburg

Bydgoszcz

Brest

Kiev

Kharkiv

Donets'k

GERMANY

The Hague
Rotterdam

Amsterdam

Bremen

Berlin

Poznań

Wisła

Warsaw

UKRAINE

London

Essen

Leipzig

Wrocław

Łódź

Rivne

Kirovohrad

Dnipropetrovs'k

English Channel

Brussels

BELGIUM

LUXEMBOURG

POLAND

Katowice

Kraków

L'viv

Chernivtsi

Mykolaiyv

Guernsey
Jersey

Frankfurt am Main

CZECH
REPUBLIC

Prague

Brno

SLOVAKIA

Košice

Chișinău

Odesa

Stavropol'

Rennes

Paris

Stuttgart

Munich

Vienna

Bratislava

Iași

MOLDOVA

Sea of Azov

Krasnodar

Caspian Sea

FRANCE

Dijon

Strasbourg

Danube

LIECHTEN-STEIN

Salzburg

Budapest

AUSTRIA

HUNGARY

Szeged

ROMANIA

Crimea

Novorossiysk

Caucasus

Grozny

Orléans

Nantes

Loire

SWITZERLAND

Bern

Vaduz

SLOVENIA

Zagreb

Timișoara

Brașov

Simferopol'

Elbrus 5642

Loire

Lyon

Geneva

Milan

Ljubljana

CROATIA

Belgrade

Bucharest

Black Sea

Bordeaux

Rhône

Turin

Po

Venice

Trieste

BOSNIA
HERZEGOVINA

Sarajevo

SERBIA

Craiova

Constanța

Toulouse

Genoa

Bologna

Florence

ITALY

Split

Adriatic Sea

MONTENEGRO

Niš

BULGARIA

Danube

Pleven

Varna

Marseille

MONACO

SAN MARINO

Podgorica

Sofia

Burgas

Andorra la Vella

ANDORRA

Rome

Vatican City

Skopje

Tirana

MACEDONIA

Plovdiv

Edirne

TURKEY

Zaragoza

Barcelona

Corsica

Bari

ALBANIA

Istanbul

Balearic Islands

Naples

Sardinia

Thessaloniki

Aegean Sea

Valencia

Palma
de Mallorca

Minorca

Ibiza

Majorca

Cosenza

Larisa

Mediterranean Sea

Palermo

Sicily

Messina

Syracuse

Ionian Sea

GREECE

Athens

Rhodes

Dodecanese

MALTA
Valletta

Crete

ASIA

Internet Links

European Union	europa.eu.int
UK Foreign and Commonwealth Office	www.fco.gov.uk
CIA World Factbook	www.odci.gov/cia/publications/factbook

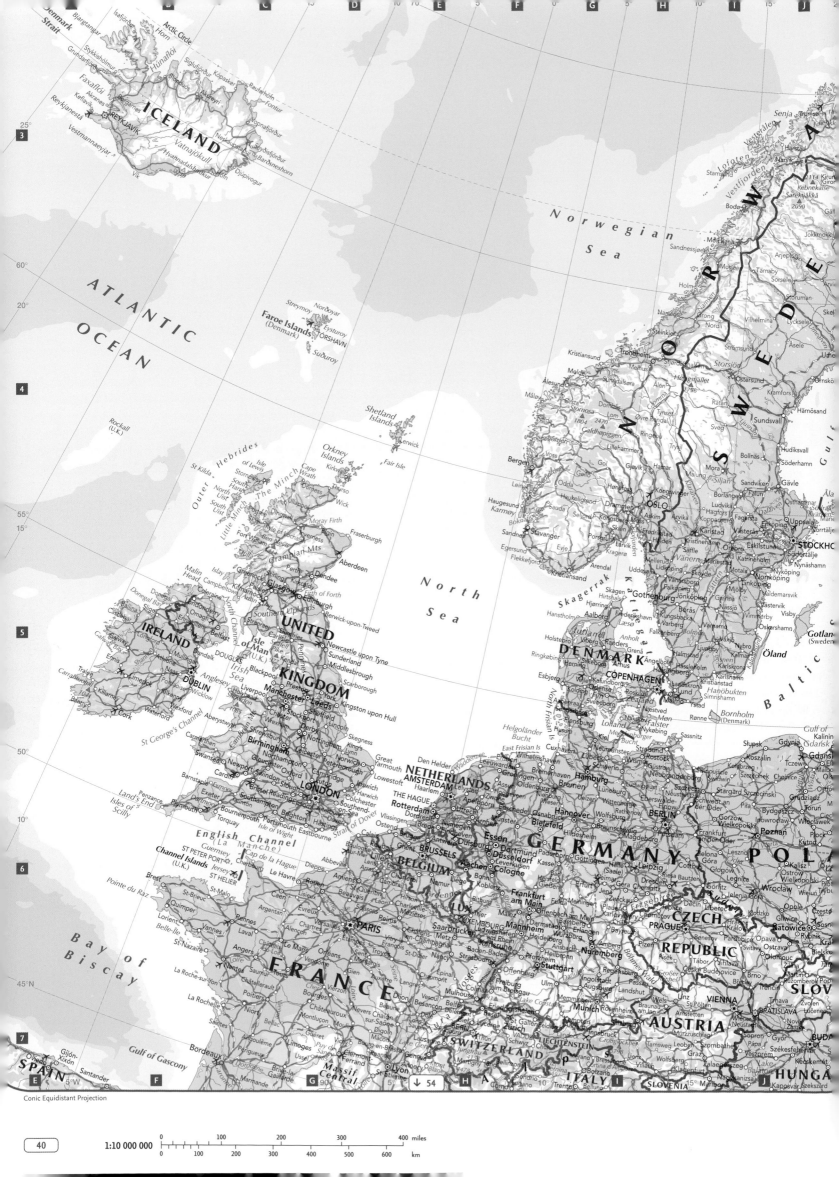

Conic Equidistant Projection

1:10 000 000

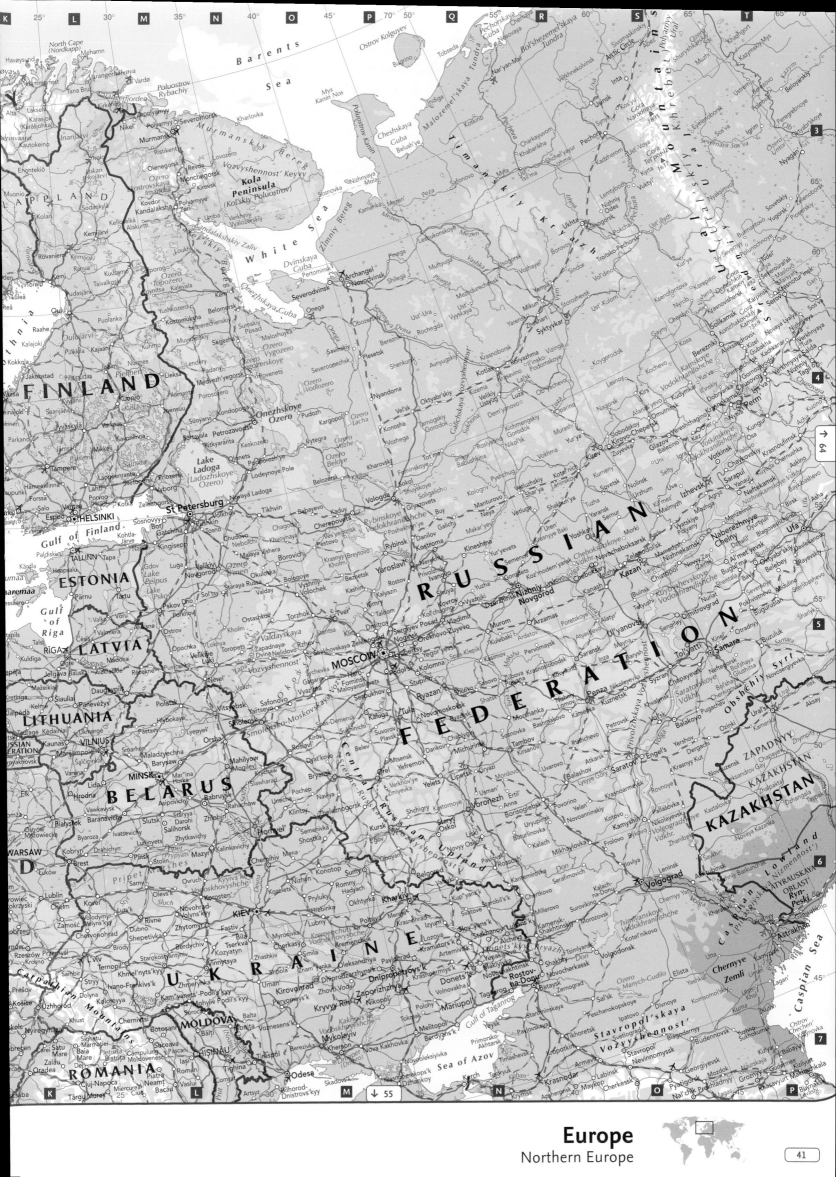

Europe
Northern Europe

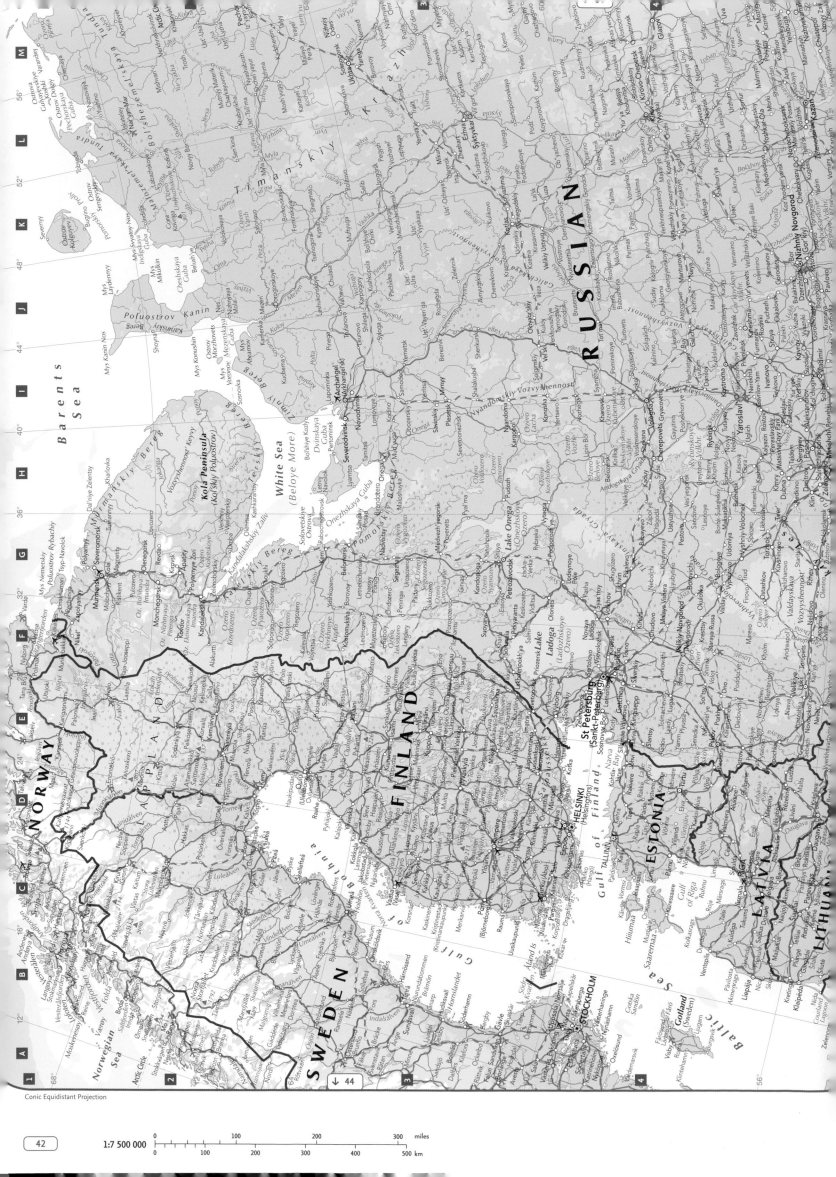

Conic Equidistant Projection

1:7 500 000

miles
0 100 200 300

km
0 100 200 300 400 500

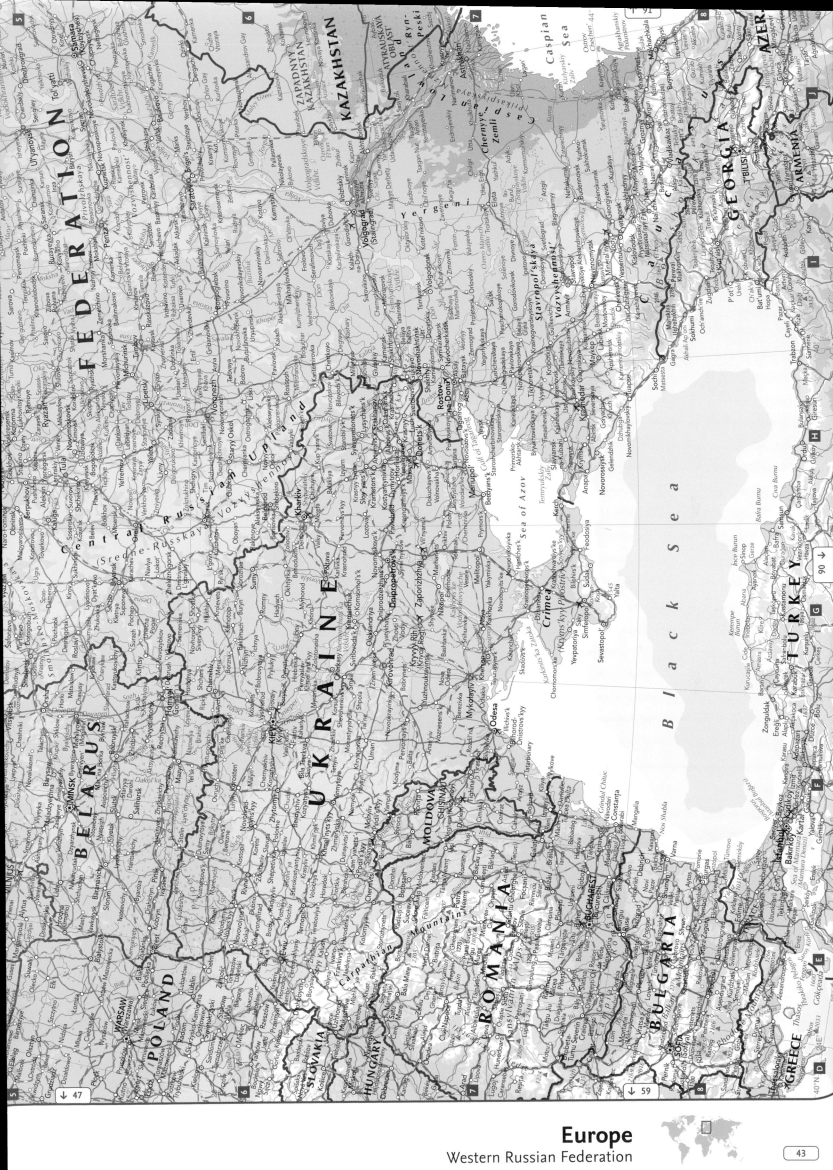

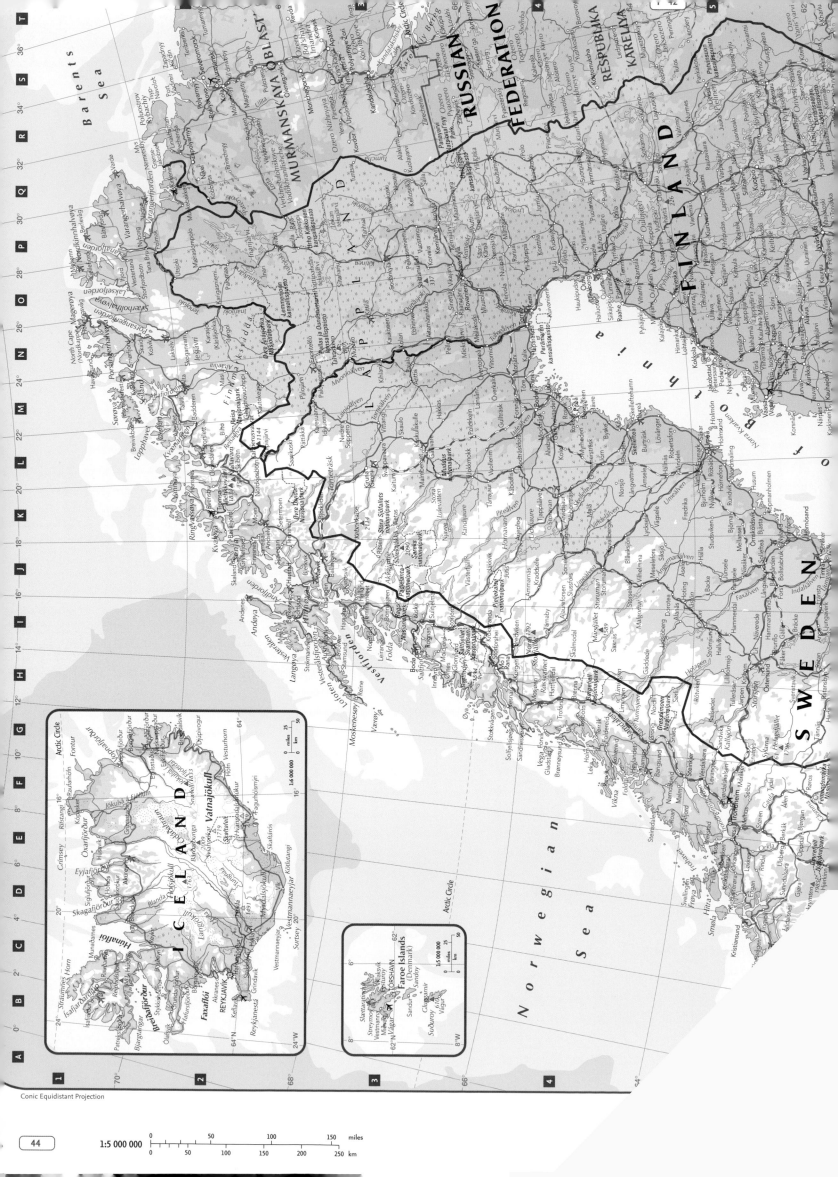

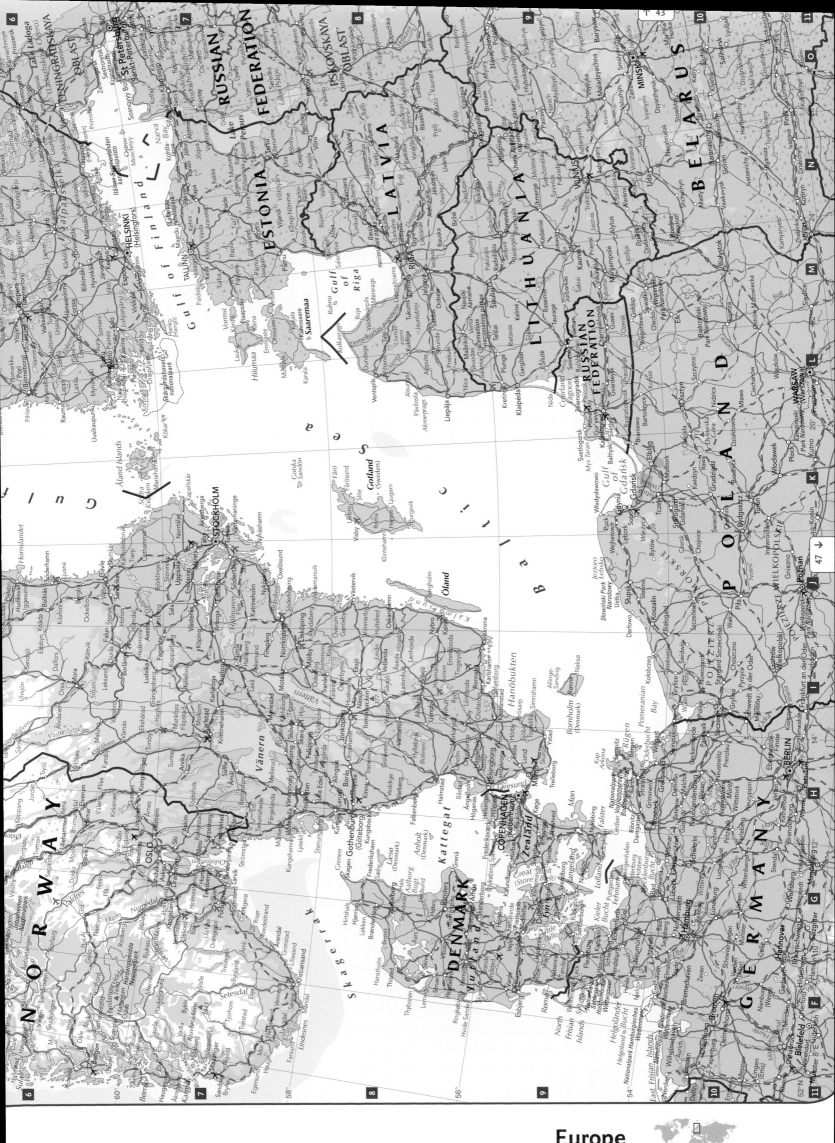

Europe

Scandinavia and the Baltic States

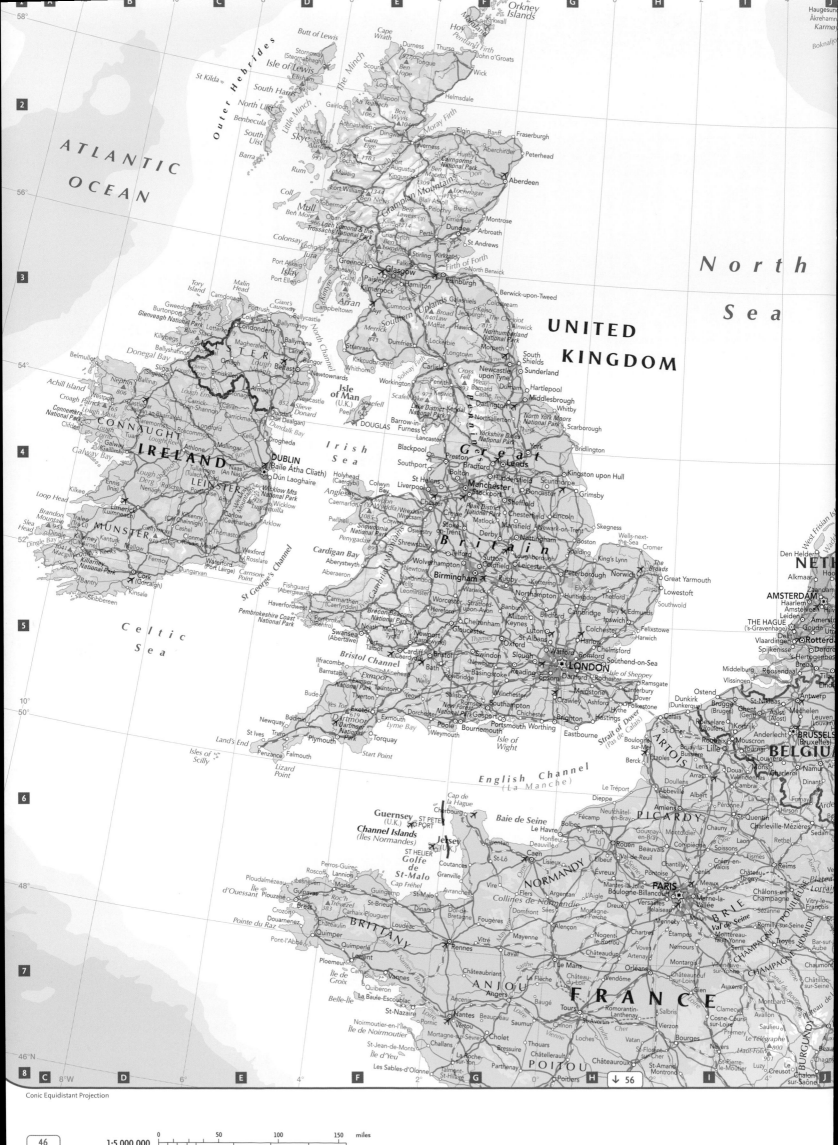

Conic Equidistant Projection

1:5 000 000

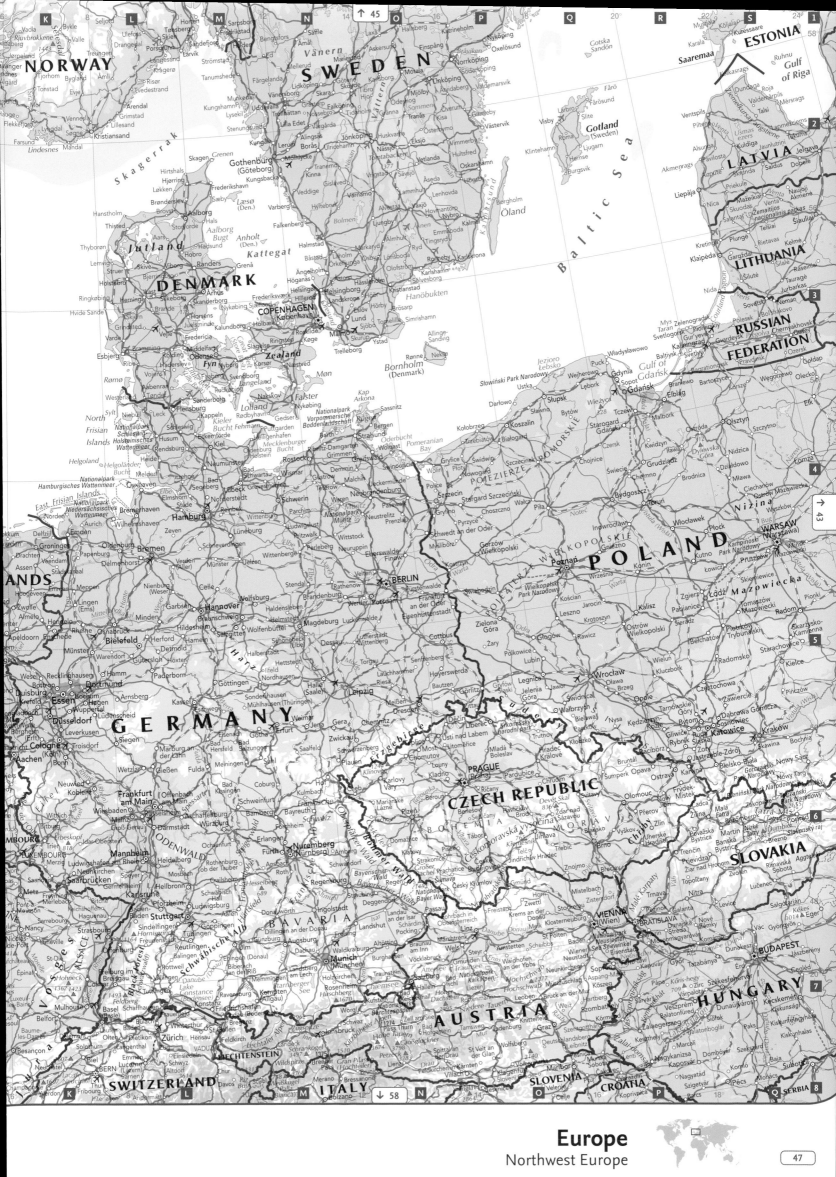

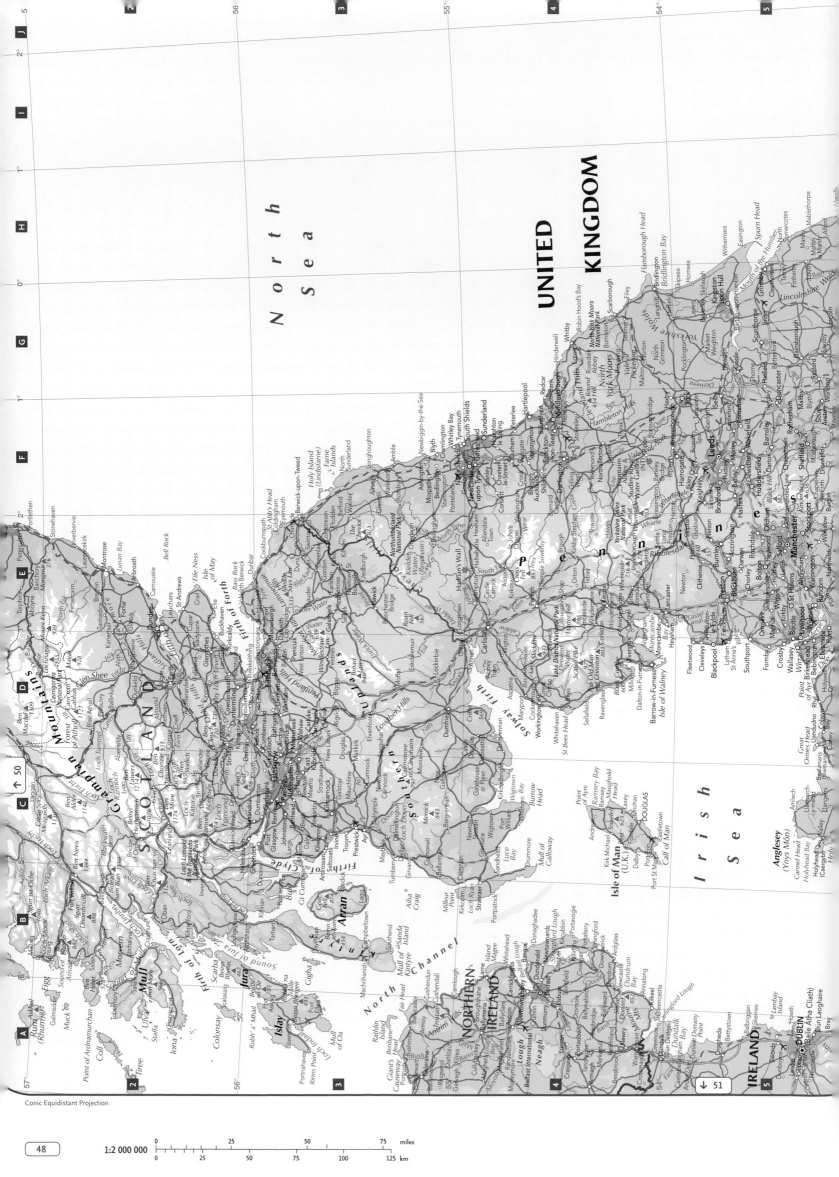

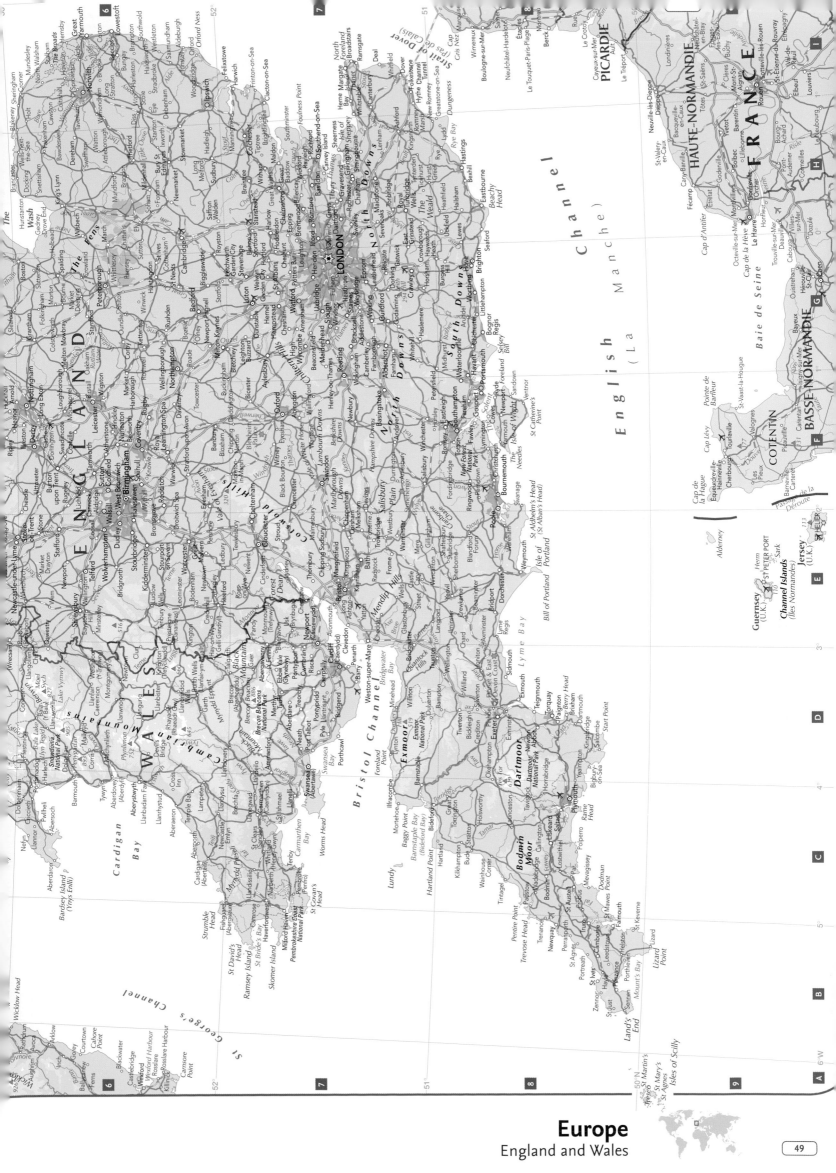

Europe
England and Wales

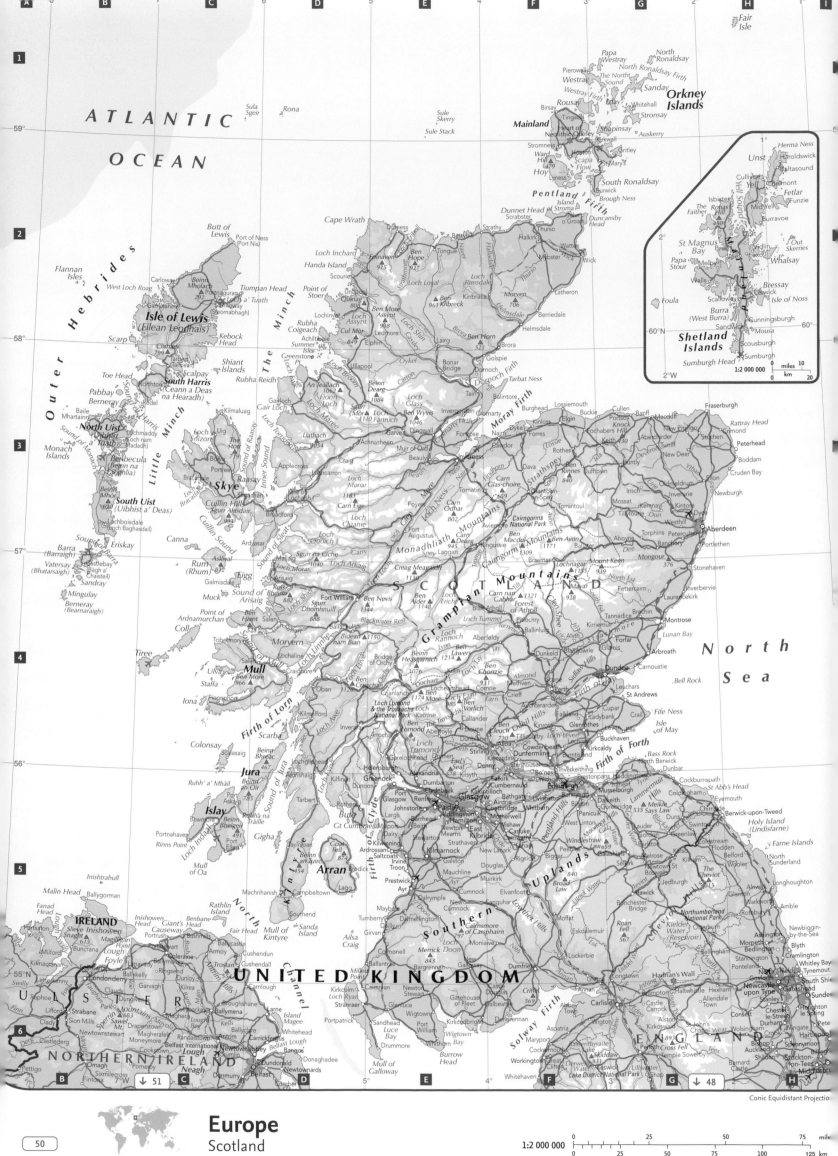

Europe
Scotland

1 : 2 000 000

Conic Equidistant Projection

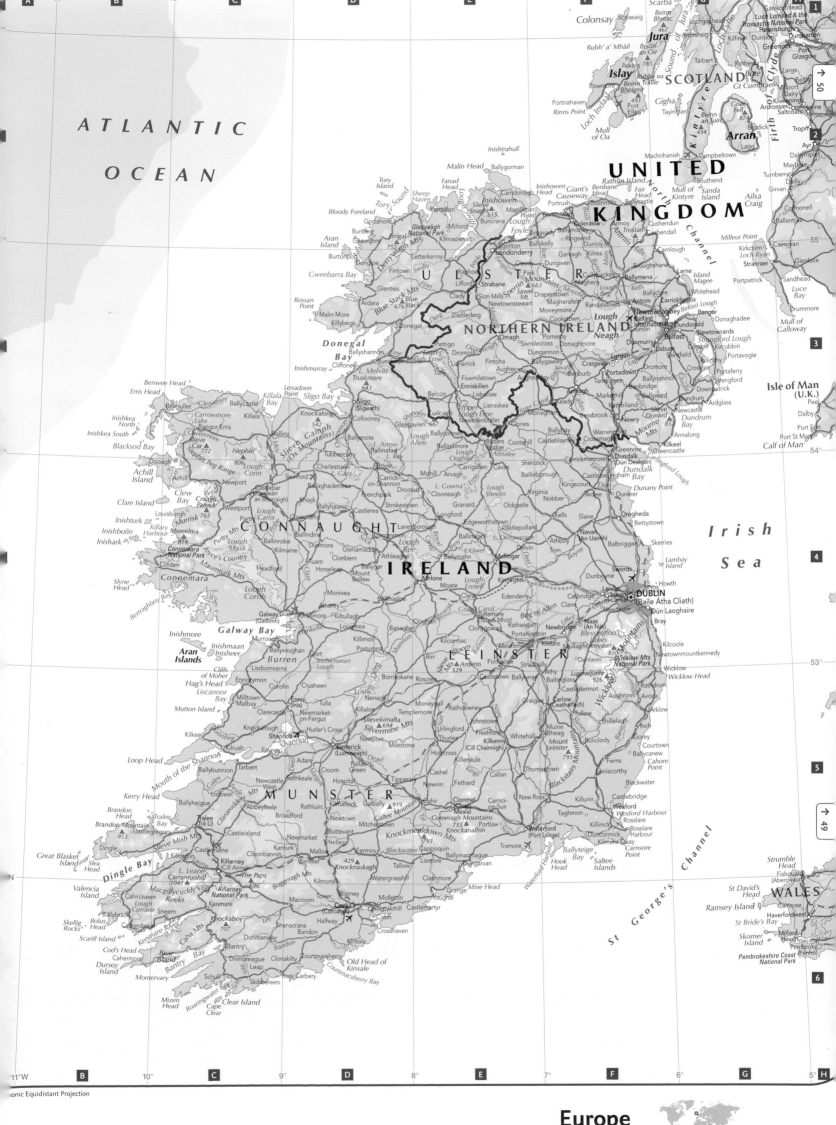

ATLANTIC

OCEAN

1:2 000 000

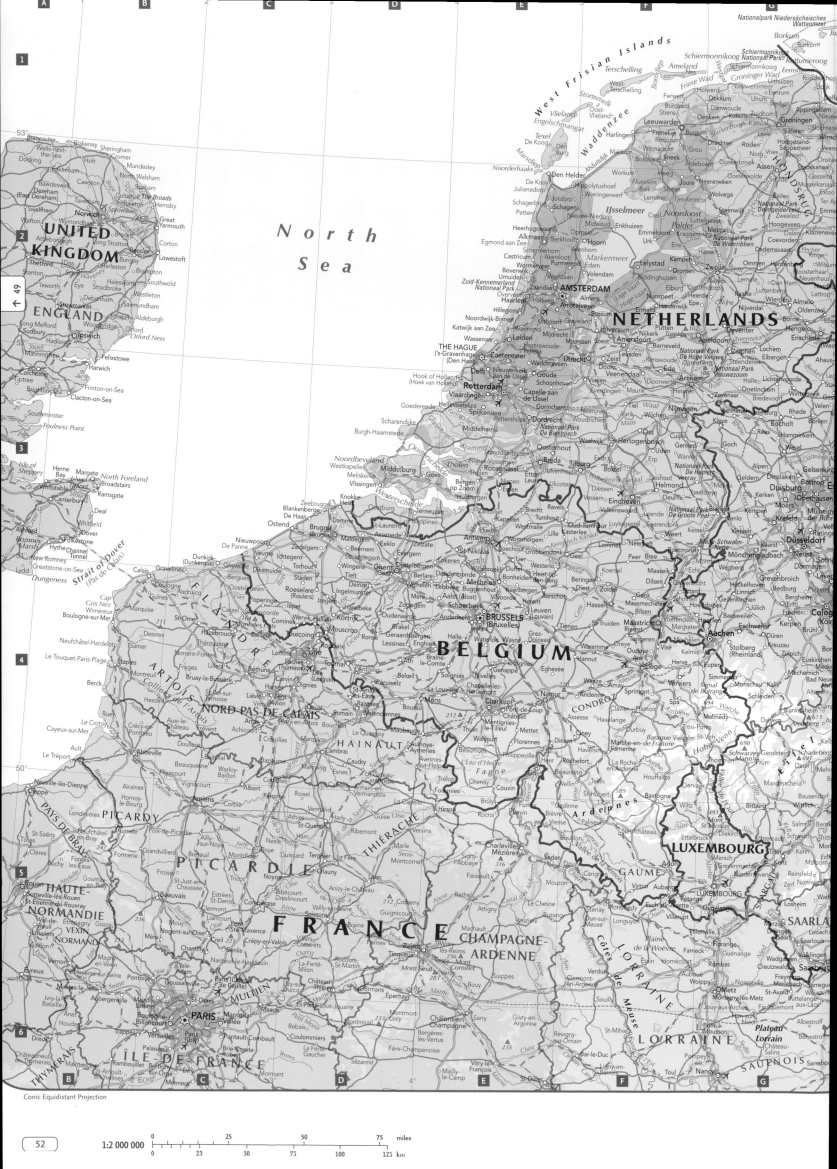

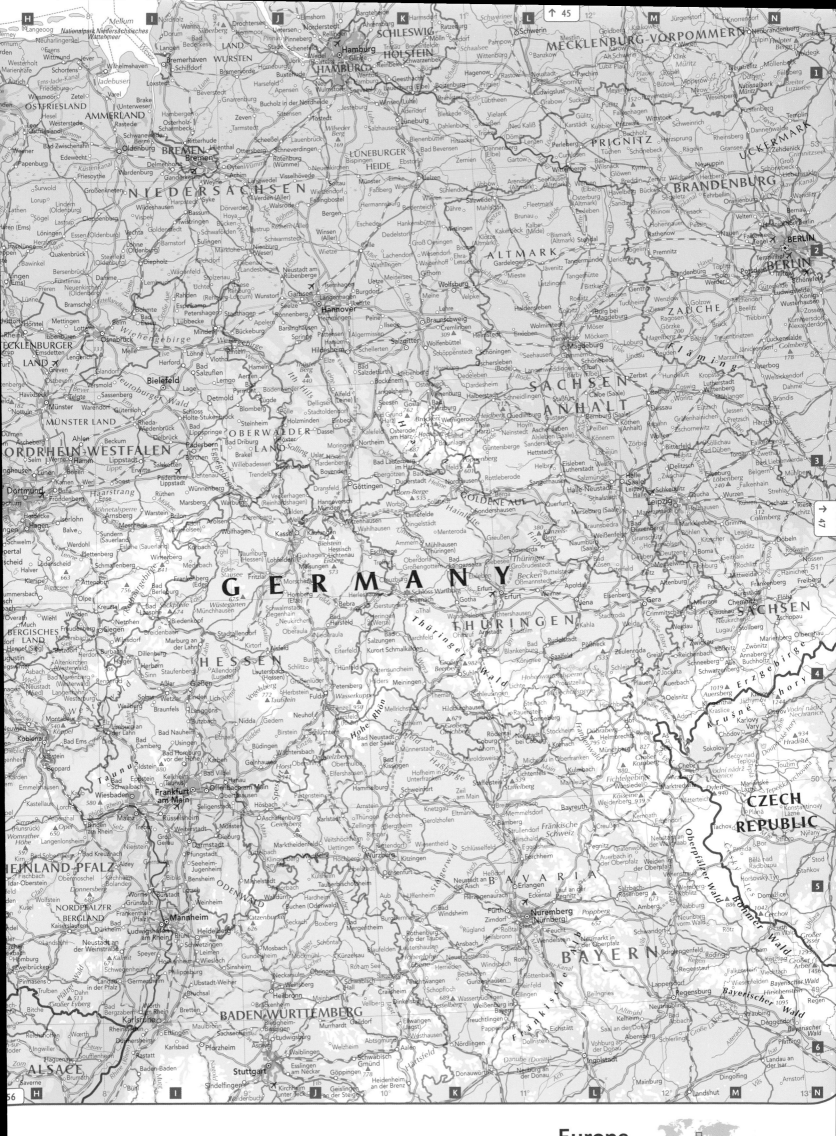

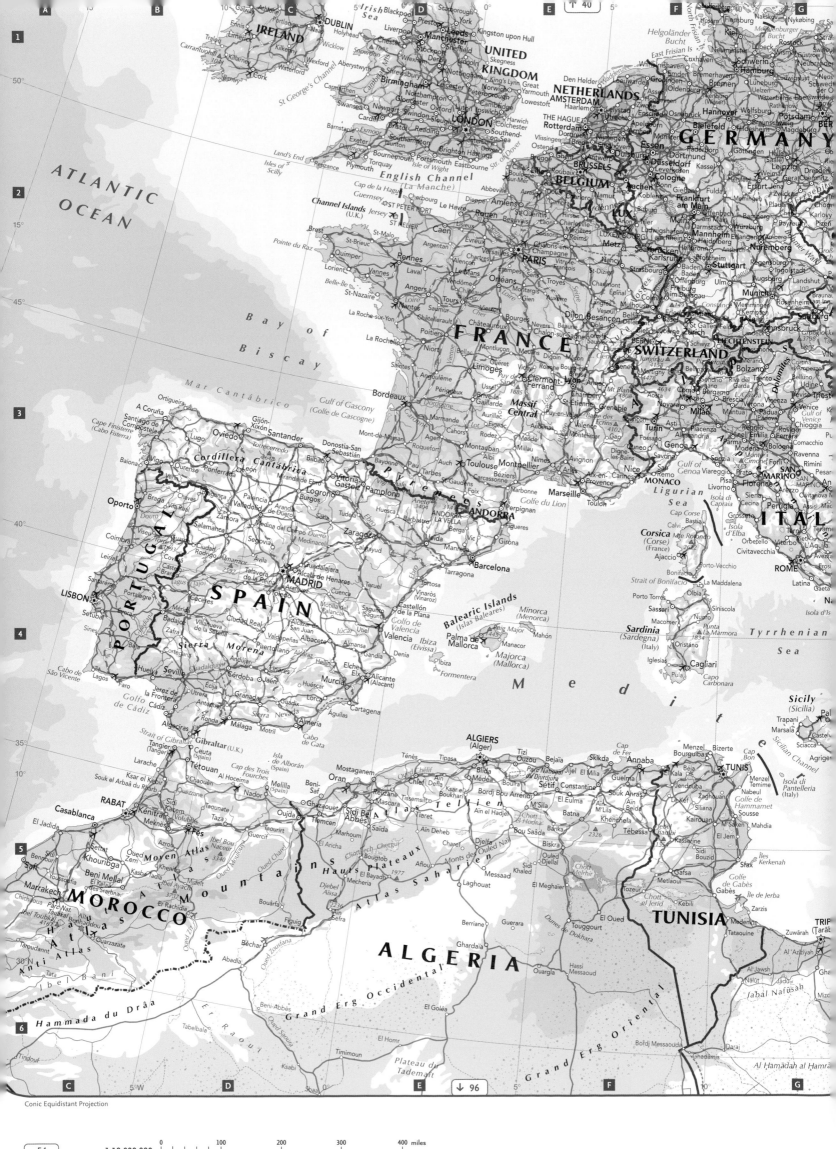

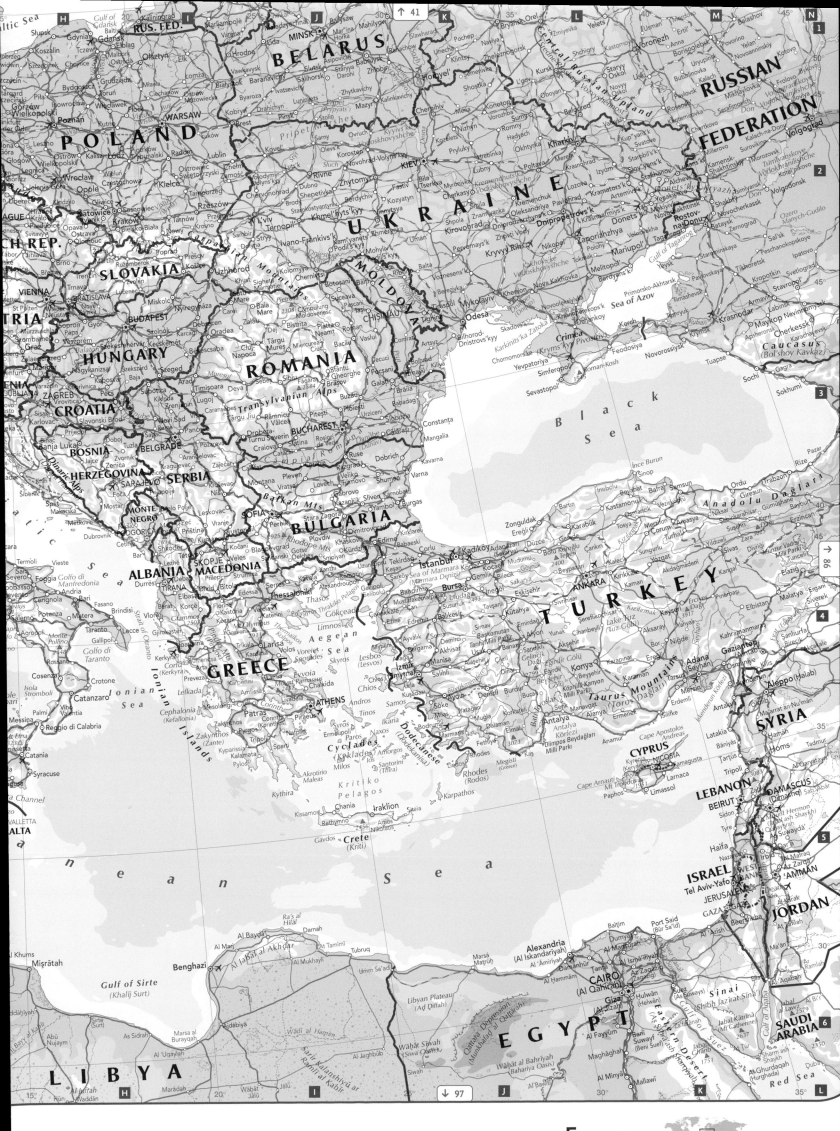

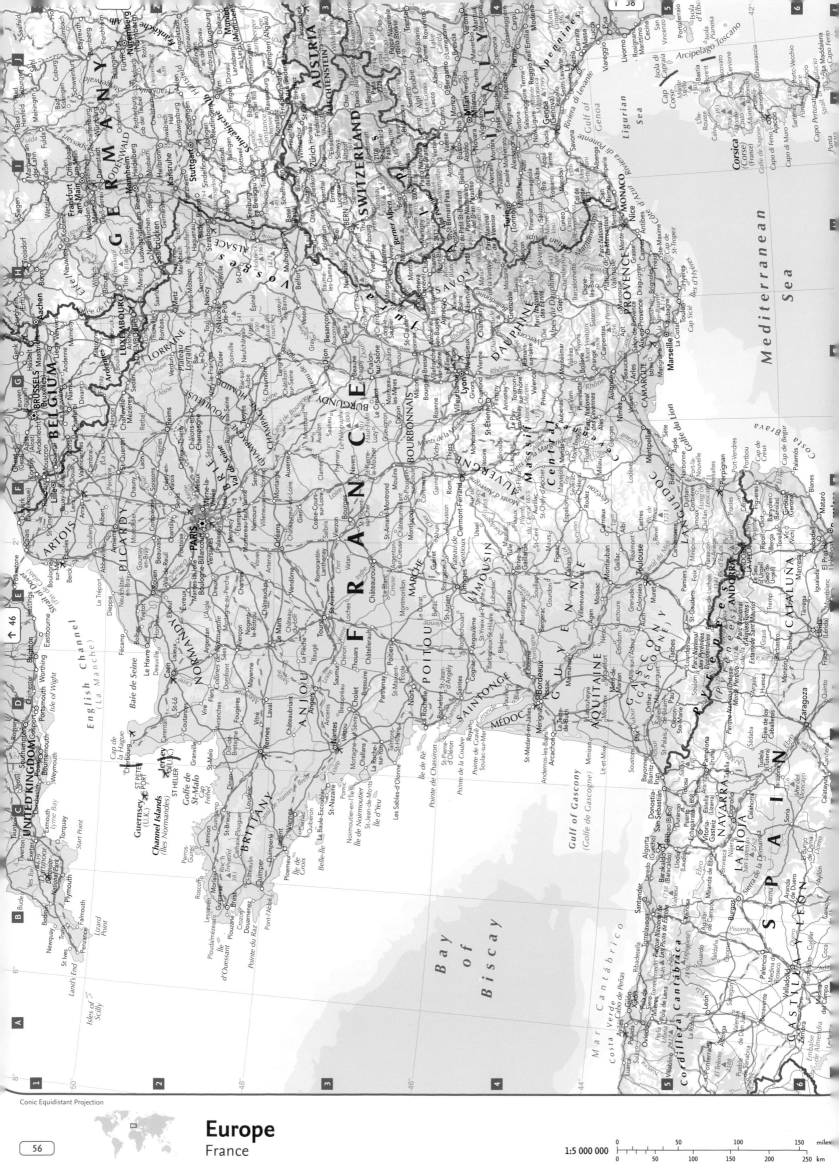

Conic Equidistant Projection

Europe
France

1:5 000 000

0	50		100		150	miles
0	50	100	150	200	250 km	

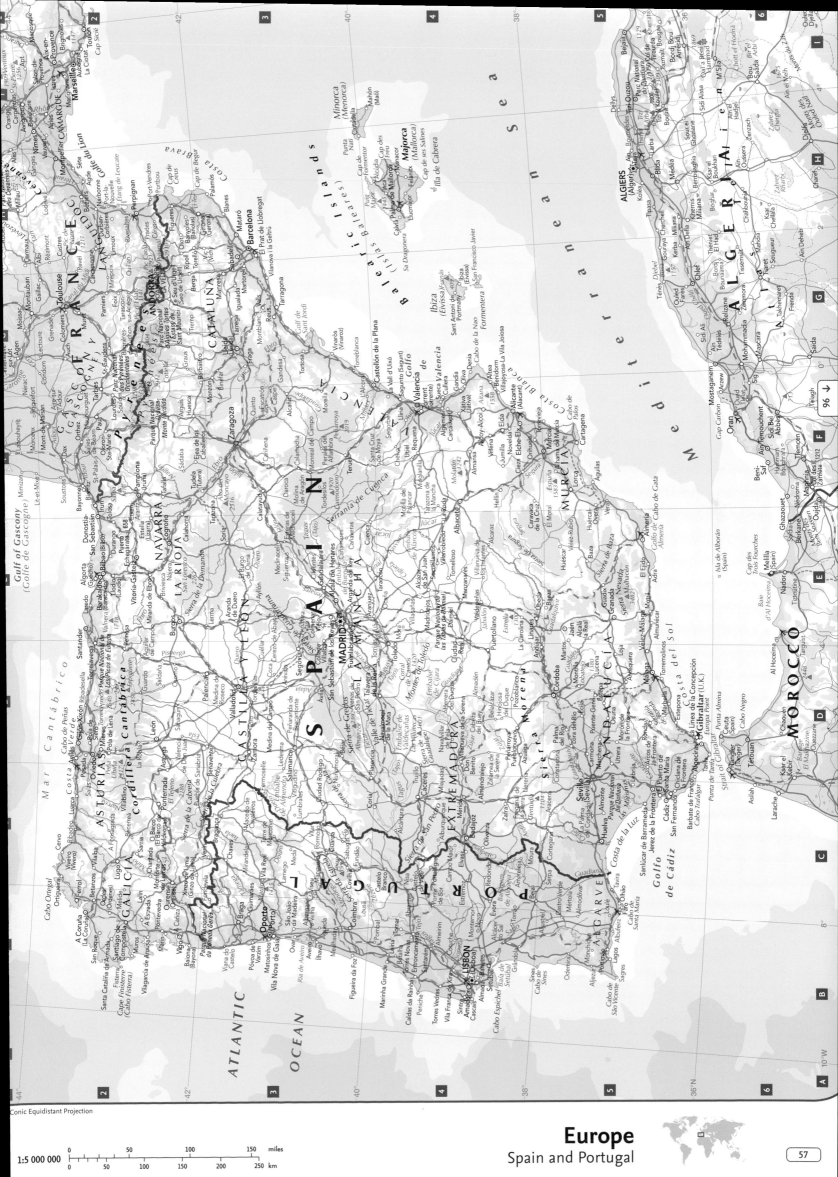

Europe

Spain and Portugal

1:5 000 000

Conic Equidistant Projection

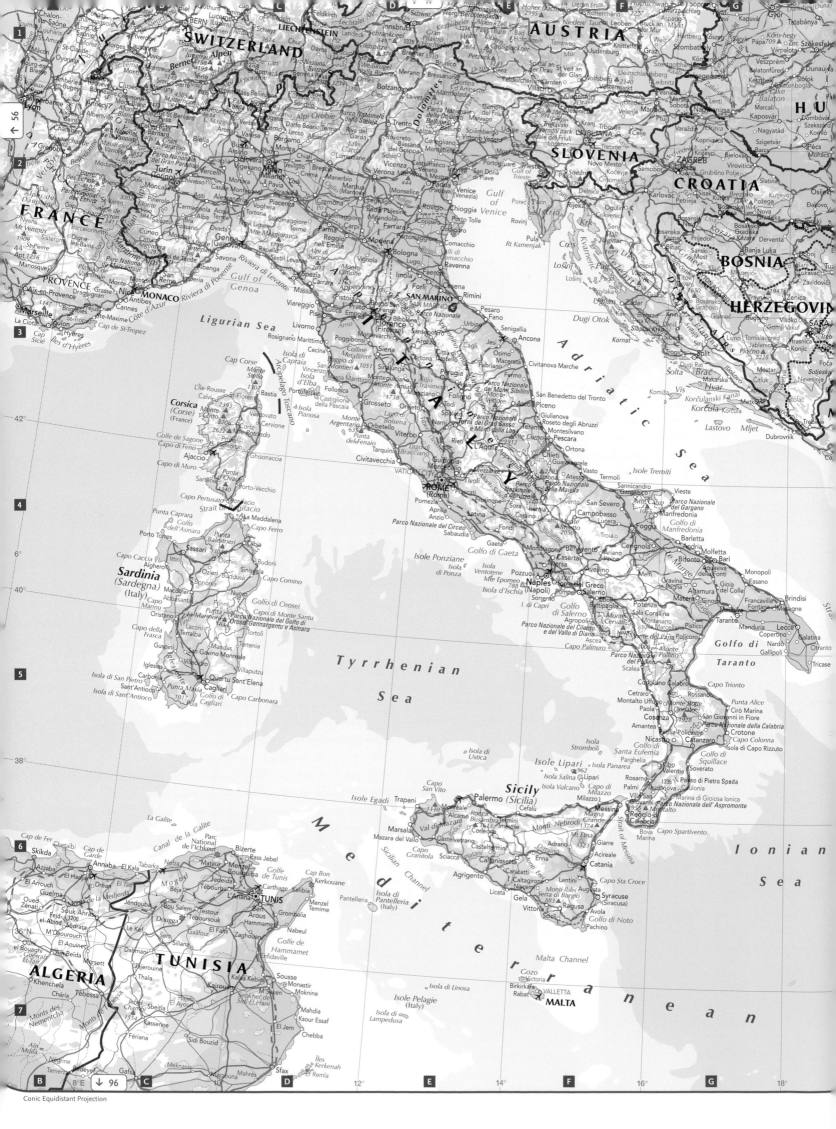

Conic Equidistant Projection

1:5 000 000

0 50 100 150 miles

0 50 100 150 200 250 km

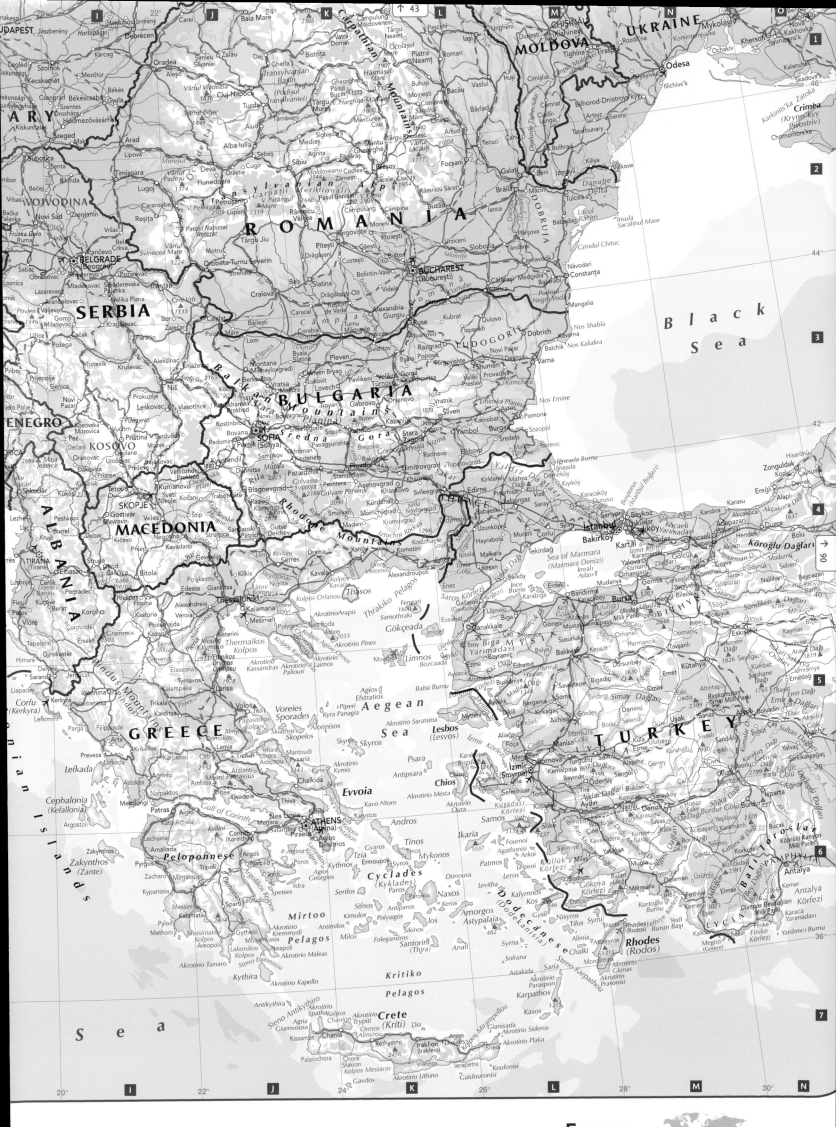

Asia

Asia is the world's largest continent and occupies almost one-third of the world's total land area. Stretching across approximately 165° of longitude from the Mediterranean Sea to the easternmost point of the Russian Federation on the Bering Strait, it contains the world's highest and lowest points and some of the world's greatest physical features. Its mountain ranges include the Himalaya, Hindu Kush, Karakoram and the Ural Mountains and its major rivers – including the Yangtze, Tigris-Euphrates, Indus, Ganges and Mekong – are equally well-known and evocative.

Asia's deserts include the Gobi, the Taklimakan, and those on the Arabian Peninsula, and significant areas of volcanic and tectonic activity are present on the Kamchatka Peninsula, in Japan, and on Indonesia's numerous islands. The continent's landscapes are greatly influenced by climatic variations, with great contrasts between the islands of the Arctic Ocean and the vast Siberian plains in the north, and the tropical islands of Indonesia.

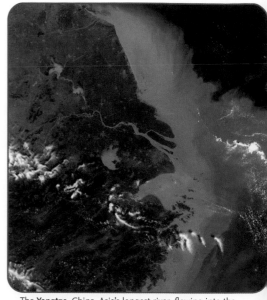

The **Yangtze**, China, Asia's longest river, flowing into the East China Sea near Shanghai.

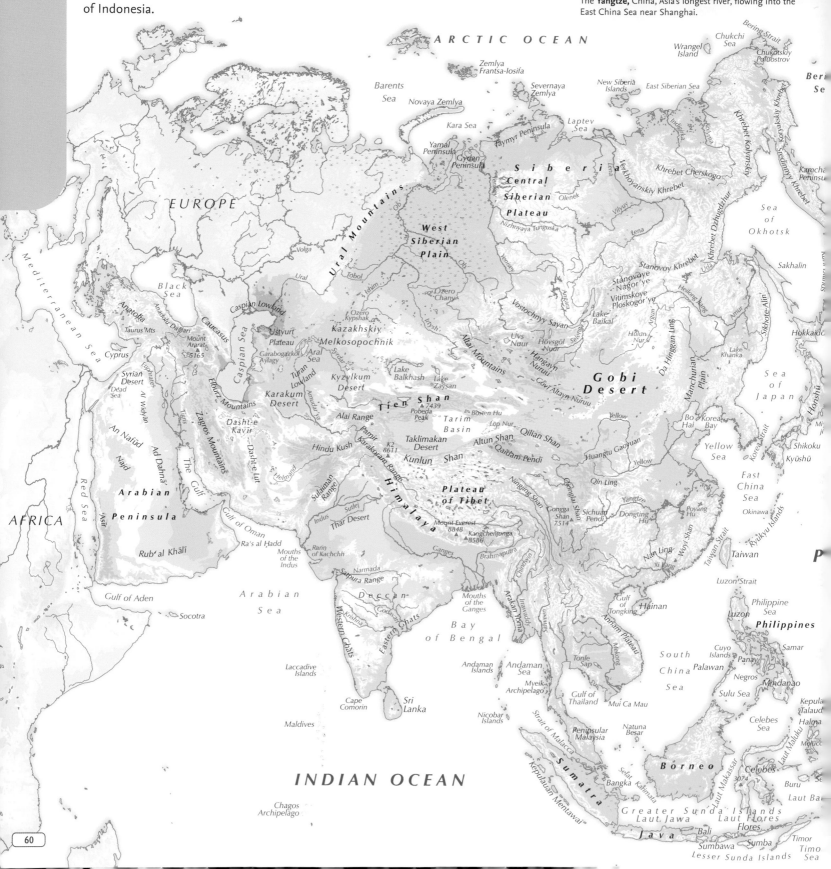

Asia's physical features

Highest mountain	Mt Everest, China/Nepal	8 848 metres	29 028 feet
Longest river	Yangtze, China	6 380 km	3 965 miles
Largest lake	Caspian Sea	371 000 sq km	143 243 sq miles
Largest island	Borneo	745 561 sq km	287 861 sq miles
Largest drainage basin	Ob'-Irtysh, Kazakhstan/Russian Federation	2 990 000 sq km	1 154 439 sq miles
Lowest point	Dead Sea	-411 metres	-1 348 feet

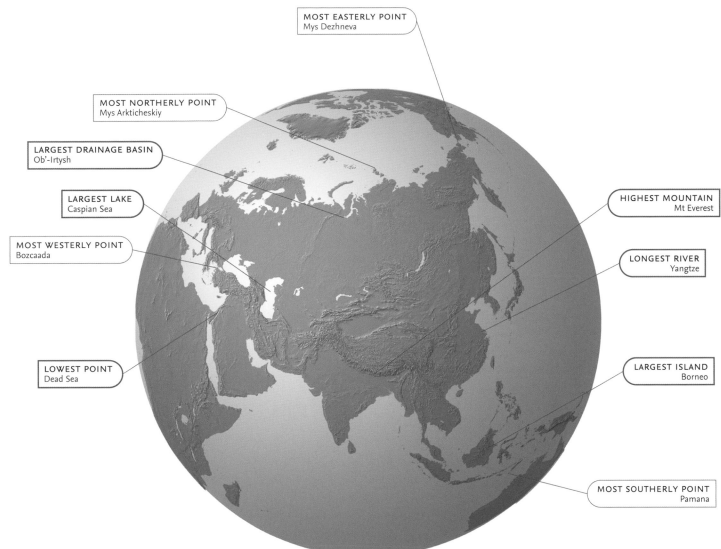

MOST EASTERLY POINT
Mys Dezhneva

MOST NORTHERLY POINT
Mys Arkticheskiy

LARGEST DRAINAGE BASIN
Ob'-Irtysh

LARGEST LAKE
Caspian Sea

MOST WESTERLY POINT
Bozcaada

LOWEST POINT
Dead Sea

HIGHEST MOUNTAIN
Mt Everest

LONGEST RIVER
Yangtze

LARGEST ISLAND
Borneo

MOST SOUTHERLY POINT
Pamana

Asia's extent

TOTAL LAND AREA	45 036 492 sq km / 17 388 686 sq miles
Most northerly point	Mys Arkticheskiy, Russian Federation
Most southerly point	Pamana, Indonesia
Most westerly point	Bozcaada, Turkey
Most easterly point	Mys Dezhneva, Russian Federation

Facts

● 90 of the world's 100 highest mountains are in Asia

● The Indonesian archipelago is made up of over 13 500 islands

● The height of the land in Nepal ranges from 60 metres to 8 848 metres

● The deepest lake in the world is Lake Baikal, Russian Federation, which is over 1 600 metres deep

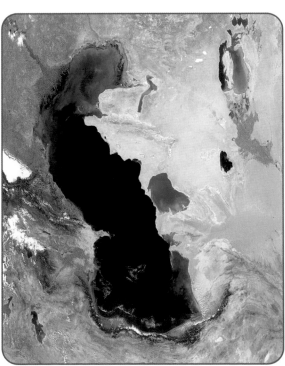

Caspian Sea, Europe/Asia, the world's largest expanse of inland water.

*Hahajima-
retto*

IFIC
EAN

*Puncak
Jaya
5030*

New Guinea

*Kepulauan
Aru*

Asia

With approximately sixty per cent of the world's population, Asia is home to numerous cultures, people groups and lifestyles. Several of the world's earliest civilizations were established in Asia, including those of Sumeria, Babylonia and Assyria. Cultural and historical differences have led to a complex political pattern, and the continent has been, and continues to be, subject to numerous territorial and political conflicts – including the current disputes in the Middle East and in Jammu and Kashmir.

Separate regions within Asia can be defined by the cultural, economic and political systems they support. The major regions are: the arid, oil-rich, mainly Islamic southwest; southern Asia with its distinct cultures, isolated from the rest of Asia by major mountain ranges; the Indian- and Chinese-influenced monsoon region of southeast Asia; the mainly Chinese-influenced industrialized areas of eastern Asia; and Soviet Asia, made up of most of the former Soviet Union.

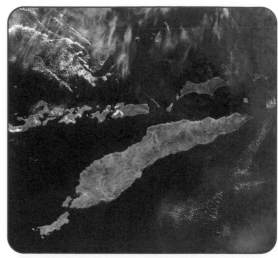

Timor island in southeast Asia, on which East Timor, the world's newest independent state, is located.

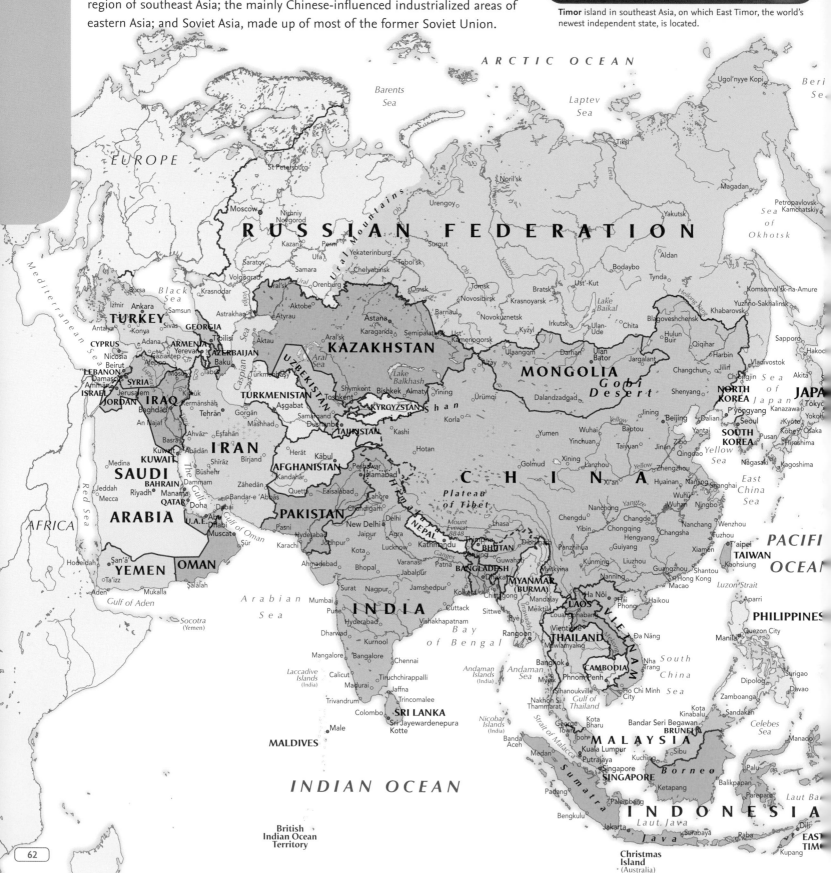

Internet Links

● UK Foreign and Commonwealth Office	**www.fco.gov.uk**
● CIA World Factbook	**www.odci.gov/cia/publications/factbook**
● Asian Development Bank	**www.adb.org**
● Association of Southeast Asian Nations (ASEAN)	**www.aseansec.org**
● Asia-Pacific Economic Cooperation	**www.apecsec.org.sg**

Asia's countries

Largest country (area)	Russian Federation	17 075 400 sq km	6 592 849 sq miles
Smallest country (area)	Maldives	298 sq km	115 sq miles
Largest country (population)	China	1 323 345 000	
Smallest country (population)	Palau	20 000	
Most densely populated country	Singapore	6 656 per sq km	17 219 per sq mile
Least densely populated country	Mongolia	2 per sq km	4 per sq mile

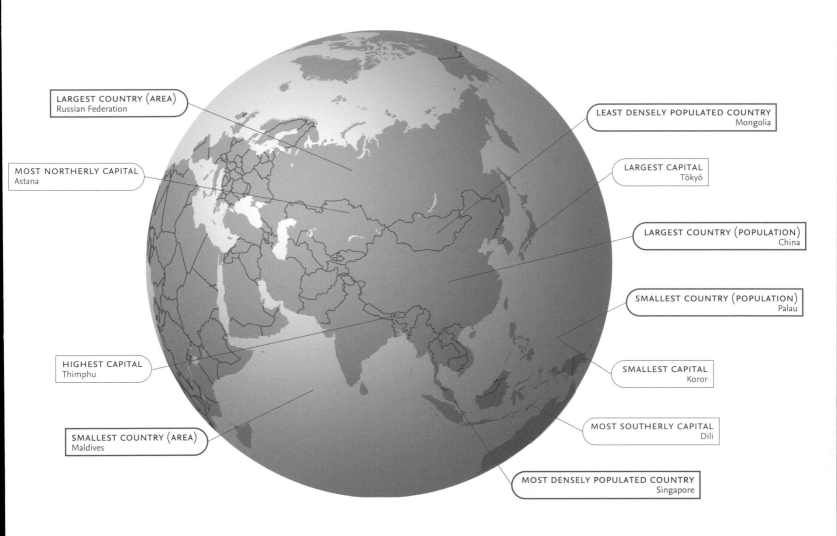

LARGEST COUNTRY (AREA)
Russian Federation

MOST NORTHERLY CAPITAL
Astana

HIGHEST CAPITAL
Thimphu

SMALLEST COUNTRY (AREA)
Maldives

LEAST DENSELY POPULATED COUNTRY
Mongolia

LARGEST CAPITAL
Tōkyō

LARGEST COUNTRY (POPULATION)
China

SMALLEST COUNTRY (POPULATION)
Palau

SMALLEST CAPITAL
Koror

MOST SOUTHERLY CAPITAL
Dili

MOST DENSELY POPULATED COUNTRY
Singapore

Asia's capitals

Largest capital (population)	Tōkyō, Japan	35 327 000
Smallest capital (population)	Koror, Palau	11 200
Most northerly capital	Astana, Kazakhstan	51° 10'N
Most southerly capital	Dili, East Timor	8° 35'S
Highest capital	Thimphu, Bhutan	2 423 metres 7 949 feet

Koror
PALAU

Jayapura

New Guinea

Facts

- ● Over 60% of the world's population live in Asia

- ● Asia has 11 of the world's 20 largest cities

- ● The Korean peninsula was divided into North Korea and South Korea in 1948 approximately along the 38th parallel

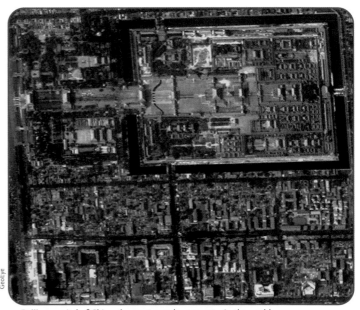

Beijing, capital of China, the most populous country in the world.

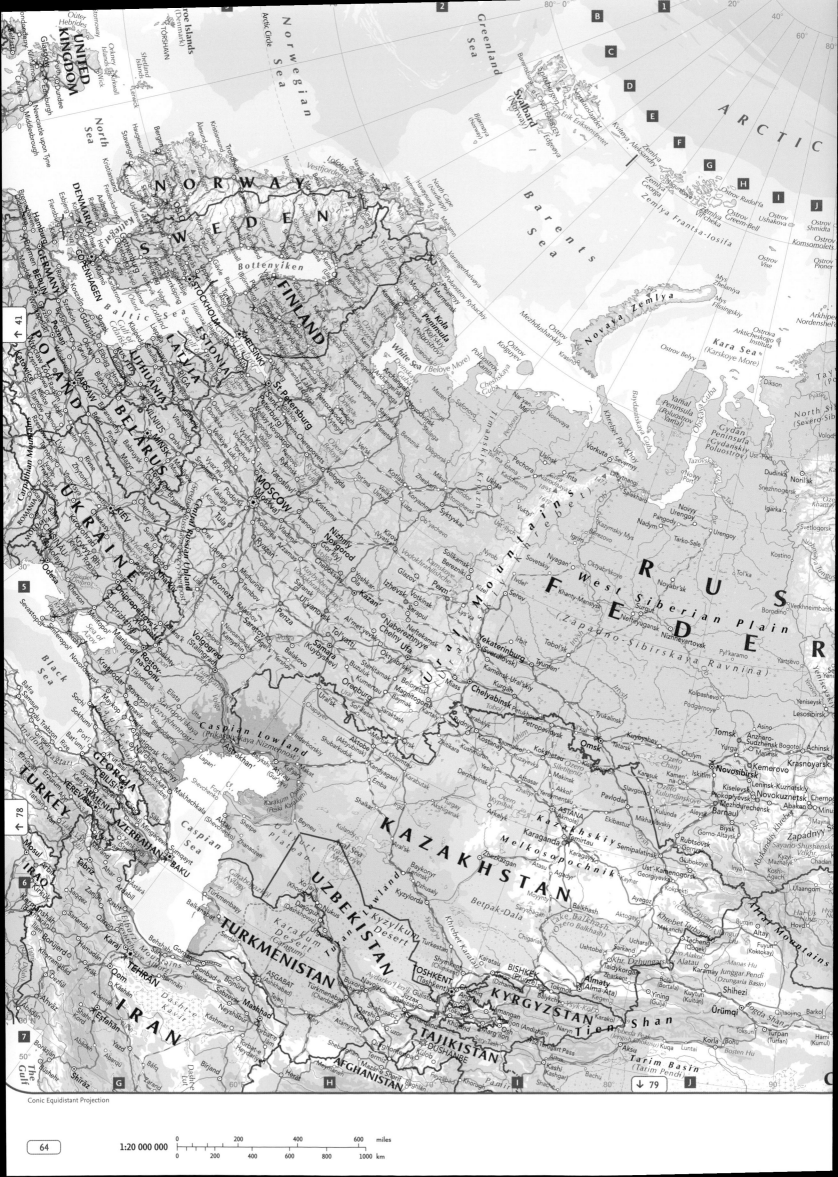

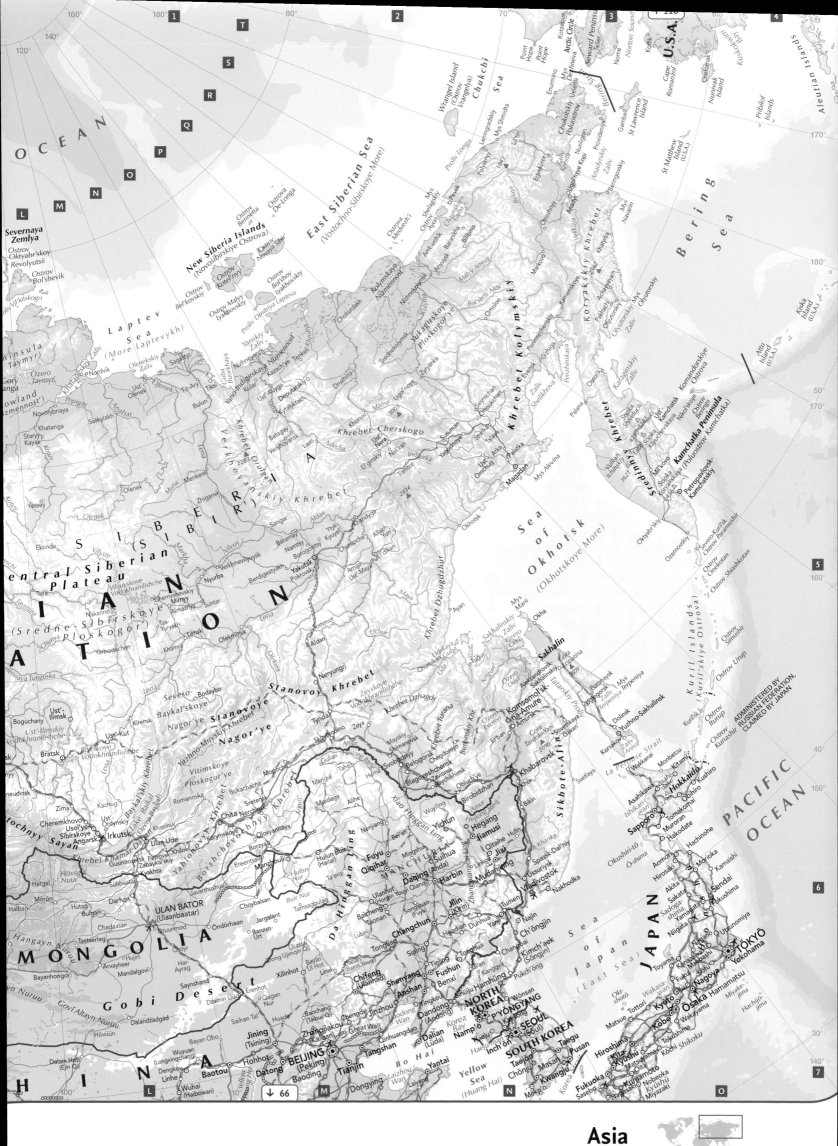

Asia
Northern Asia

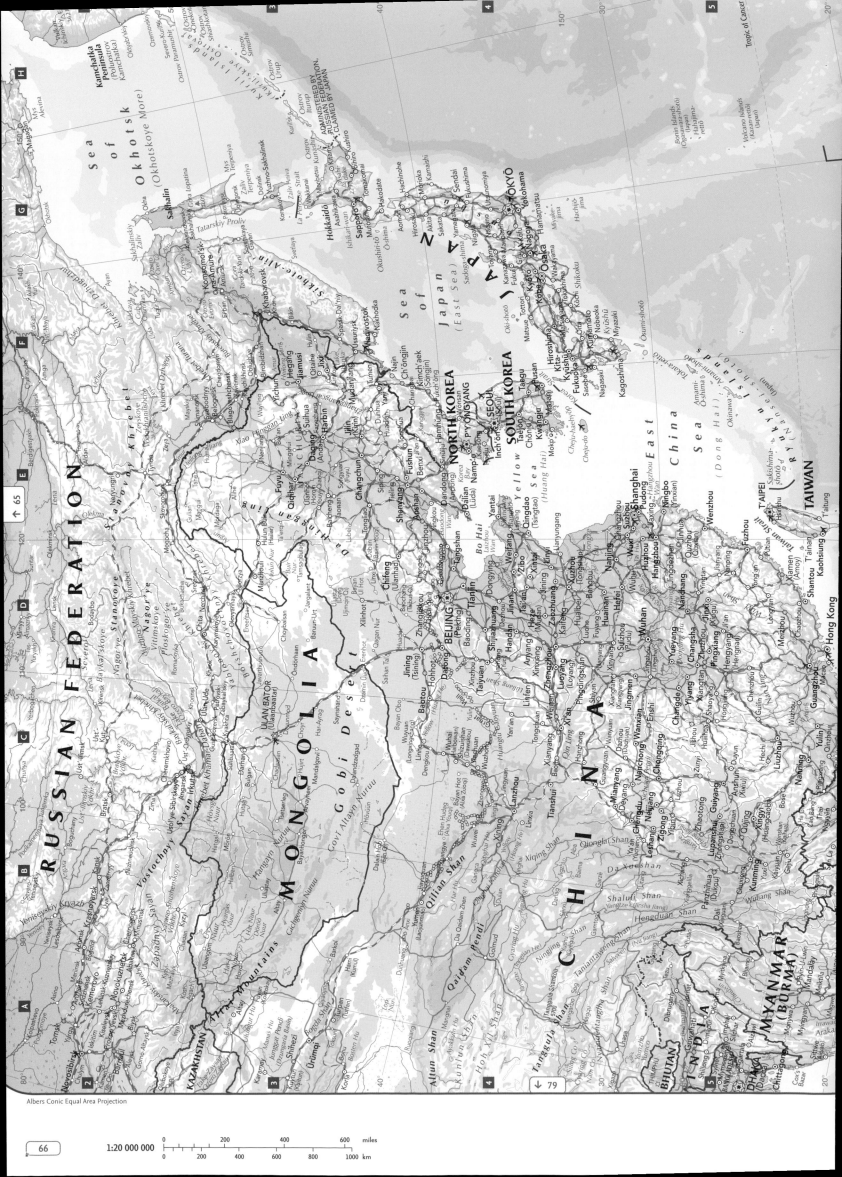

Kamchatka
Peninsula
(Poluostrov
Kamchatka)

S e a
o f
O k h o t s k
(Okhotskoye More)

ADMINISTERED BY
RUSSIAN FEDERATION.
CLAIMED BY JAPAN

Sakhalin

Tatarskiy Proliv

Sea of
Japan
(East Sea)

Hokkaidō

J A P A N

TŌKYŌ
Yokohama

Volcano Islands
(Ogasawara-shotō)
(Japan)

Tropic of Cancer

← 65

R U S S I A N F E D E R A T I O N

MANCHURIA

Vladivostok

NORTH KOREA
PYONGYANG

SEOUL
SOUTH KOREA

Yellow
Sea
(Huang Hai)

E a s t

C h i n a

S e a

(Dong Hai)

Shanghai

TAIWAN

T'AIPEI

M O N G O L I A

ULAN BATOR
(Ulaanbaatar)

Gobi Desert

BEIJING
(Peking)

Tianjin

C H I N A

Hong Kong

K A Z A K H S T A N

Altai Mountains

Qilian Shan

Qin Ling

Da Xueshan

Hengduan Shan

MYANMAR
(BURMA)

Altun Shan

Kunlun Shan

Hoh Xil Shan

Tanggula Shan

BHUTAN

INDIA

DHAKA
(Dacca)

Chittagong

Tropic of Cancer

↓ 79

Albers Conic Equal Area Projection

1:20 000 000

| 0 | | 200 | | 400 | | 600 | miles |
| 0 | 200 | 400 | 600 | 800 | 1000 km | |

Internet Links

UK Foreign and Commonwealth Office	**www.fco.gov.uk**
CIA World Factbook	**www.odci.gov/cia/publications/factbook**
Asian Development Bank	**www.adb.org**
Association of Southeast Asian Nations (ASEAN)	**www.aseansec.org**
Asia-Pacific Economic Cooperation	**www.apecsec.org.sg**

Asia's countries

Largest country (area)	Russian Federation	17 075 400 sq km	6 592 849 sq miles
Smallest country (area)	Maldives	298 sq km	115 sq miles
Largest country (population)	China	1 323 345 000	
Smallest country (population)	Palau	20 000	
Most densely populated country	Singapore	6 656 per sq km	17 219 per sq mile
Least densely populated country	Mongolia	2 per sq km	4 per sq mile

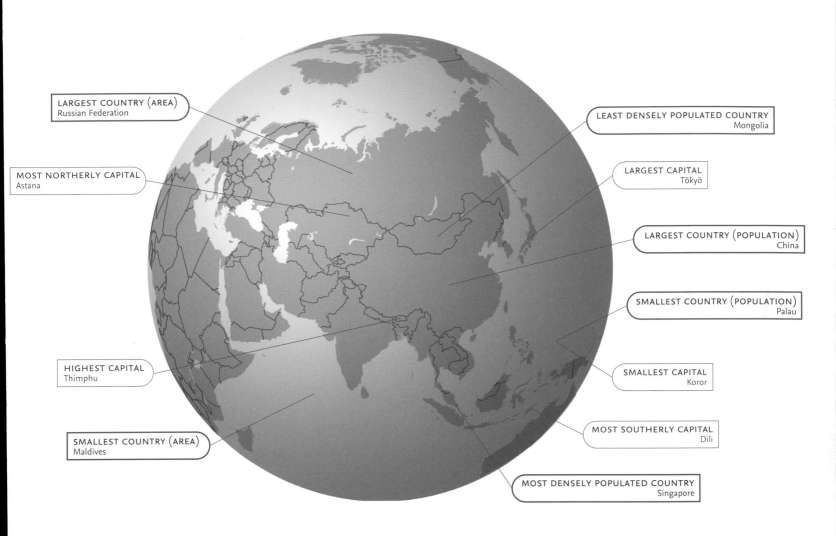

LARGEST COUNTRY (AREA)
Russian Federation

MOST NORTHERLY CAPITAL
Astana

HIGHEST CAPITAL
Thimphu

SMALLEST COUNTRY (AREA)
Maldives

LEAST DENSELY POPULATED COUNTRY
Mongolia

LARGEST CAPITAL
Tōkyō

LARGEST COUNTRY (POPULATION)
China

SMALLEST COUNTRY (POPULATION)
Palau

SMALLEST CAPITAL
Koror

MOST SOUTHERLY CAPITAL
Dili

MOST DENSELY POPULATED COUNTRY
Singapore

Koror
PALAU

Jayapura

New Guinea

Asia's capitals

Largest capital (population)	Tōkyō, Japan	35 327 000	
Smallest capital (population)	Koror, Palau	11 200	
Most northerly capital	Astana, Kazakhstan	51° 10'N	
Most southerly capital	Dili, East Timor	8° 35'S	
Highest capital	Thimphu, Bhutan	2 423 metres	7 949 feet

Facts

- Over 60% of the world's population live in Asia

- Asia has 11 of the world's 20 largest cities

- The Korean peninsula was divided into North Korea and South Korea in 1948 approximately along the 38th parallel

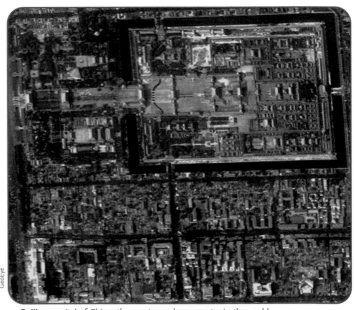

Beijing, capital of China, the most populous country in the world.

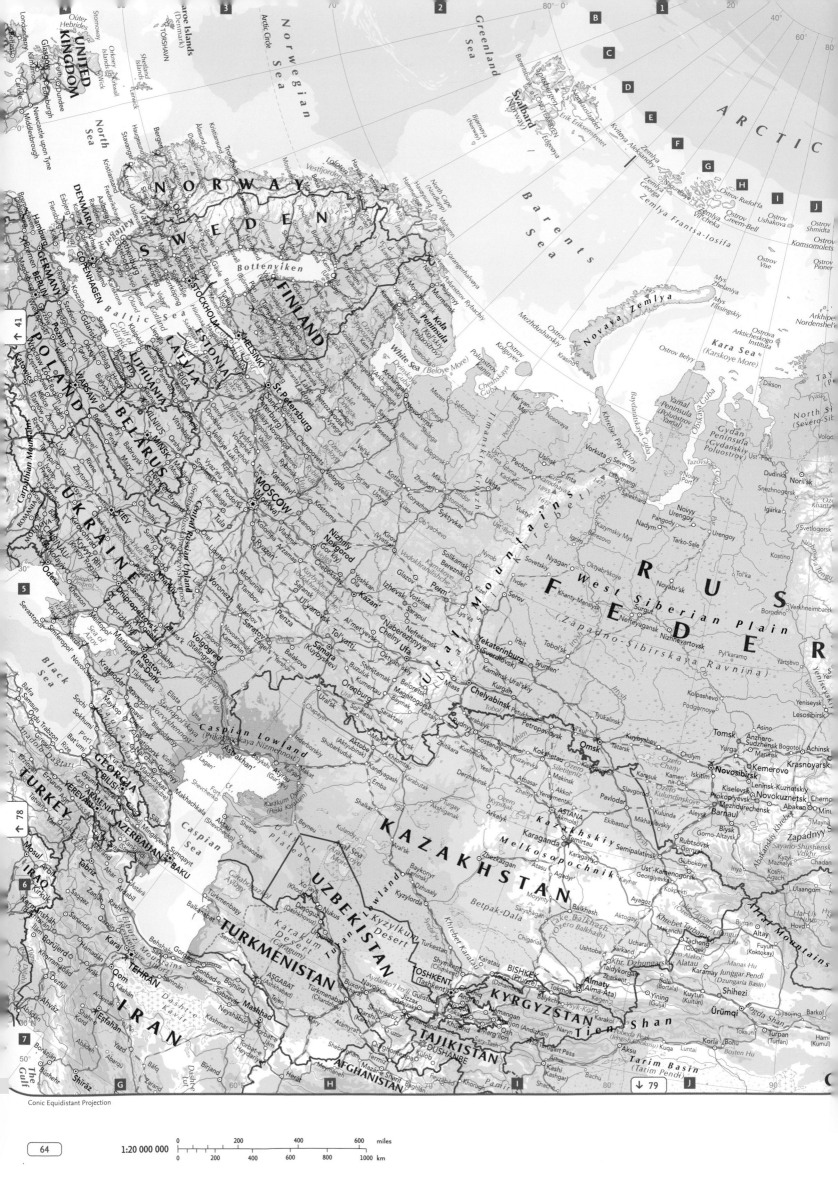

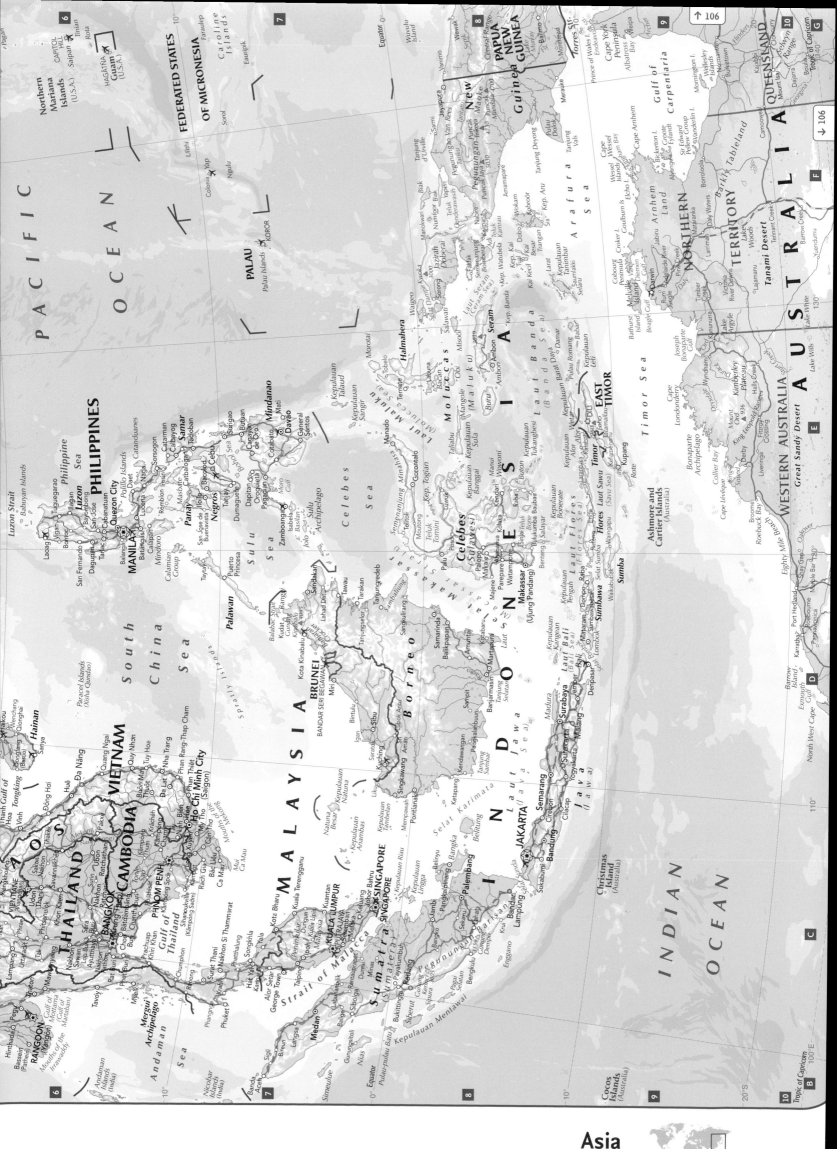

Asia

Eastern and Southeast Asia

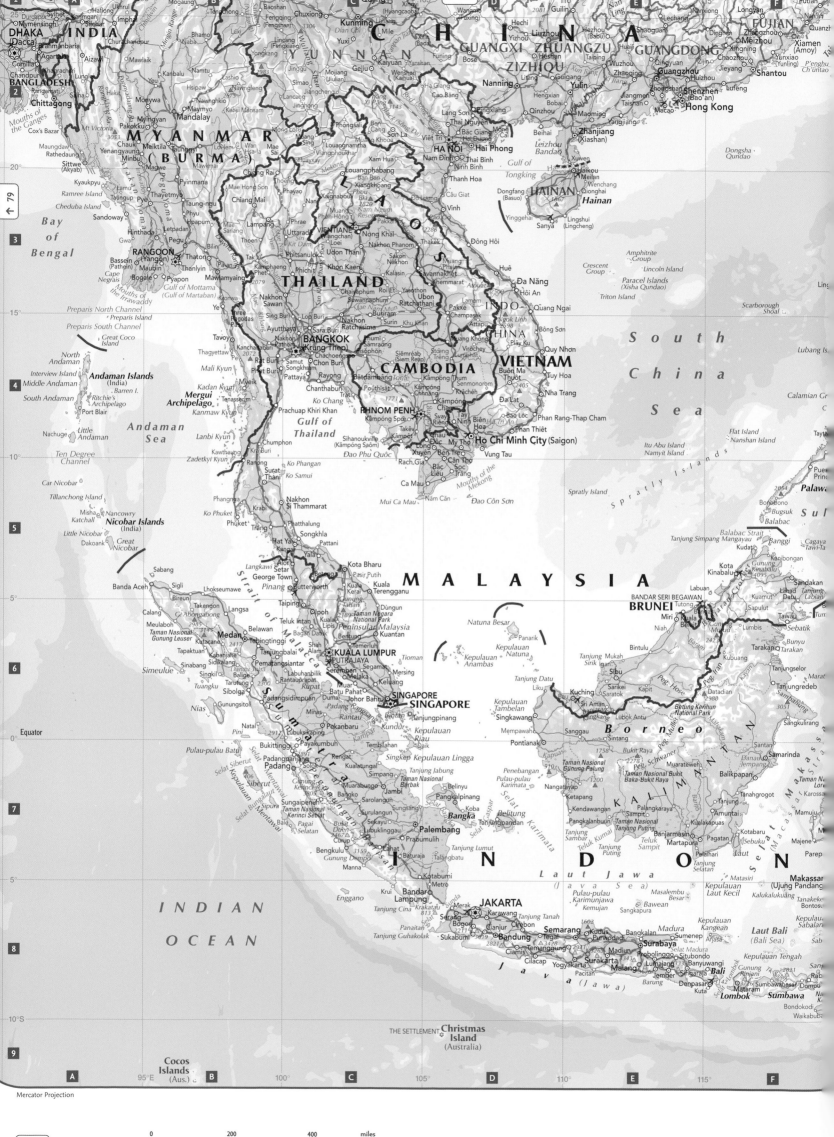

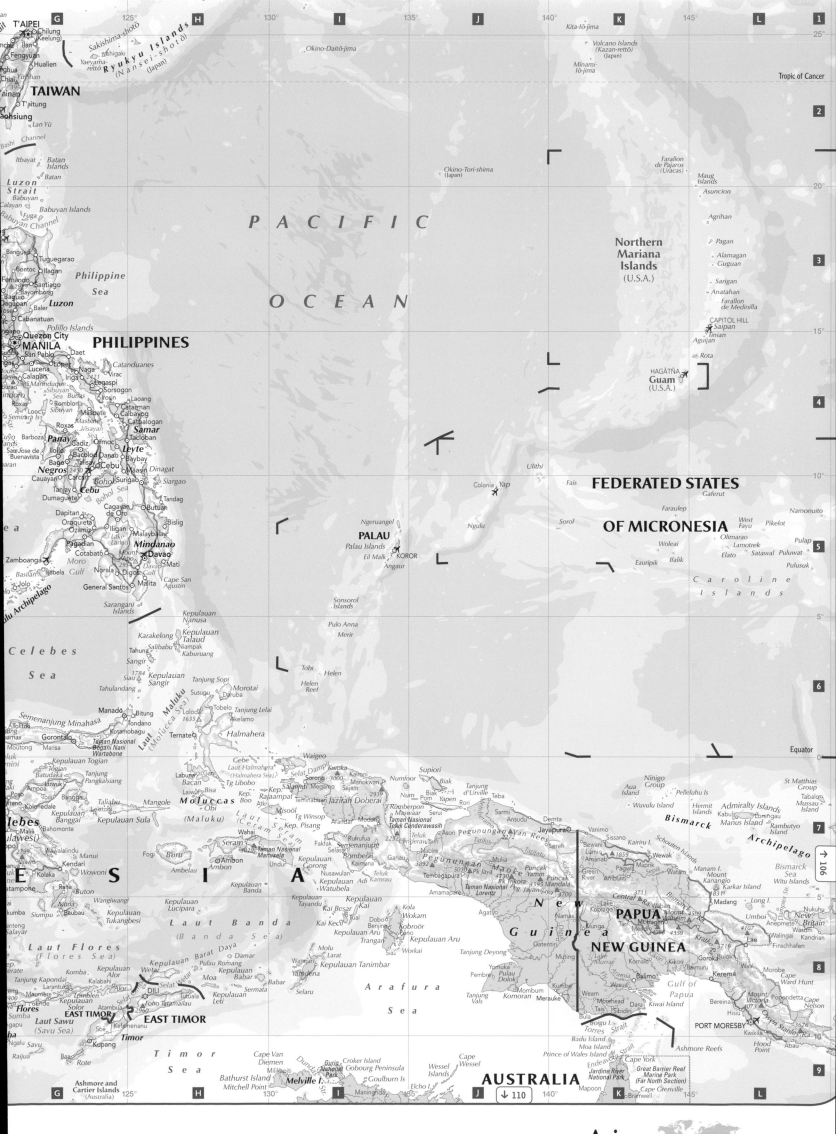

Asia
Southeast Asia

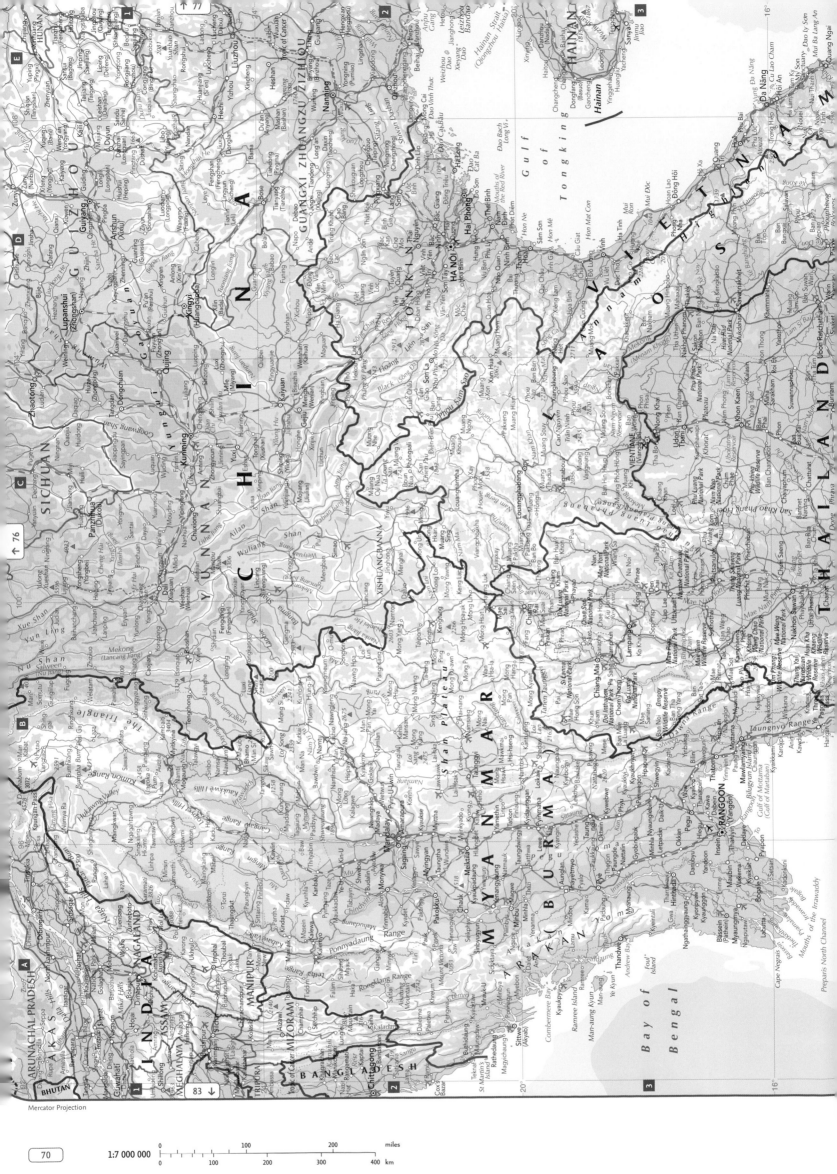

Mercator Projection

1:7 000 000

miles

km

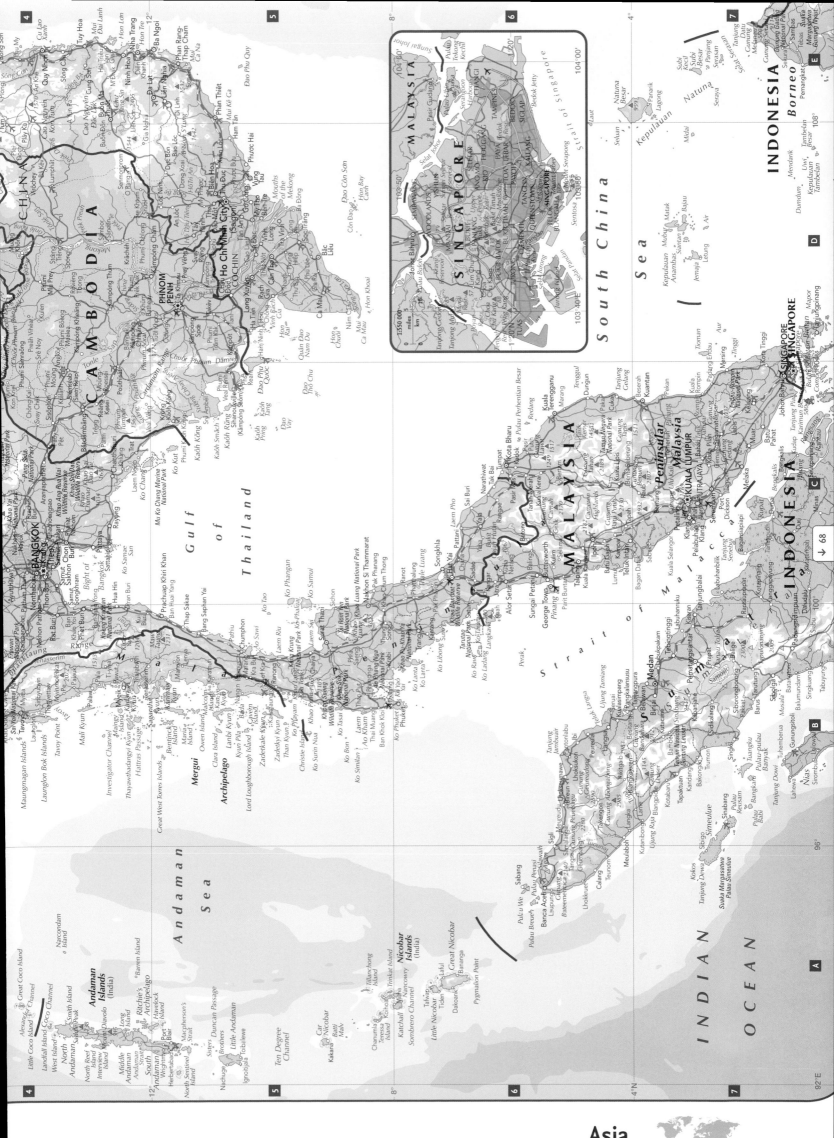

Asia

Myanmar, Thailand, Peninsular Malaysia and Indo-China

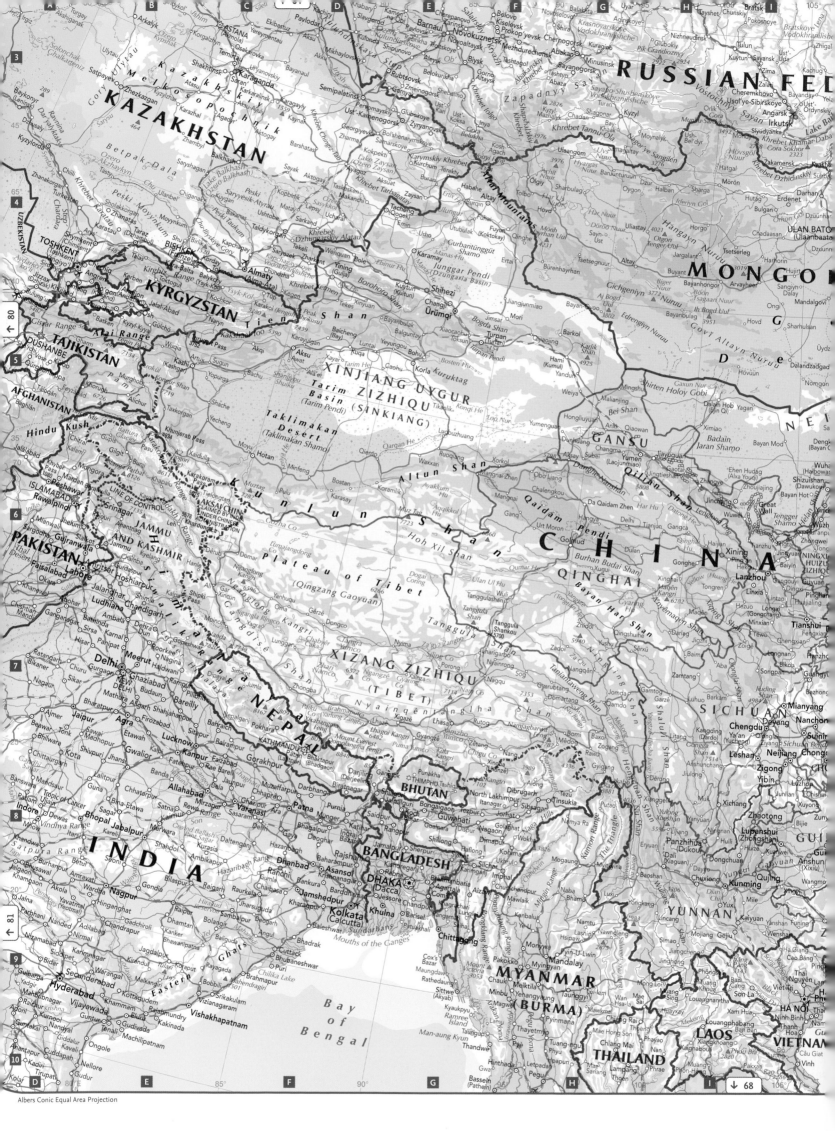

Albers Conic Equal Area Projection

1:15 000 000

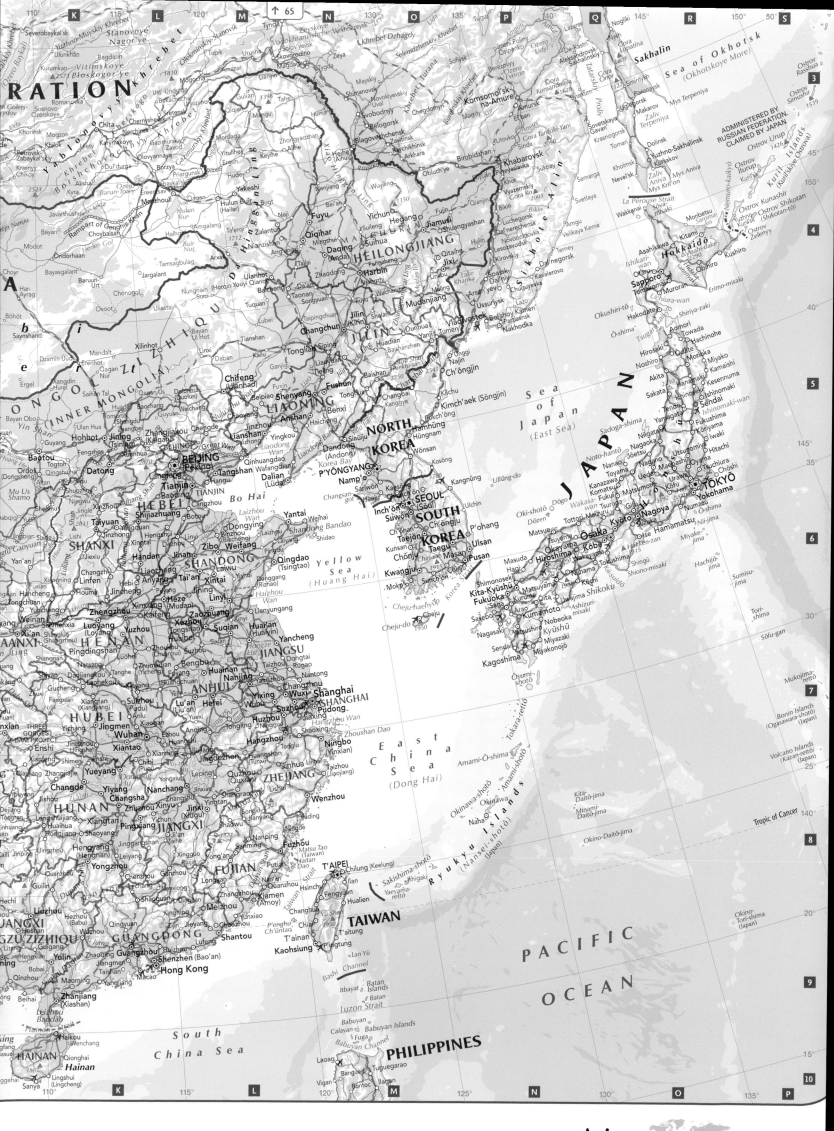

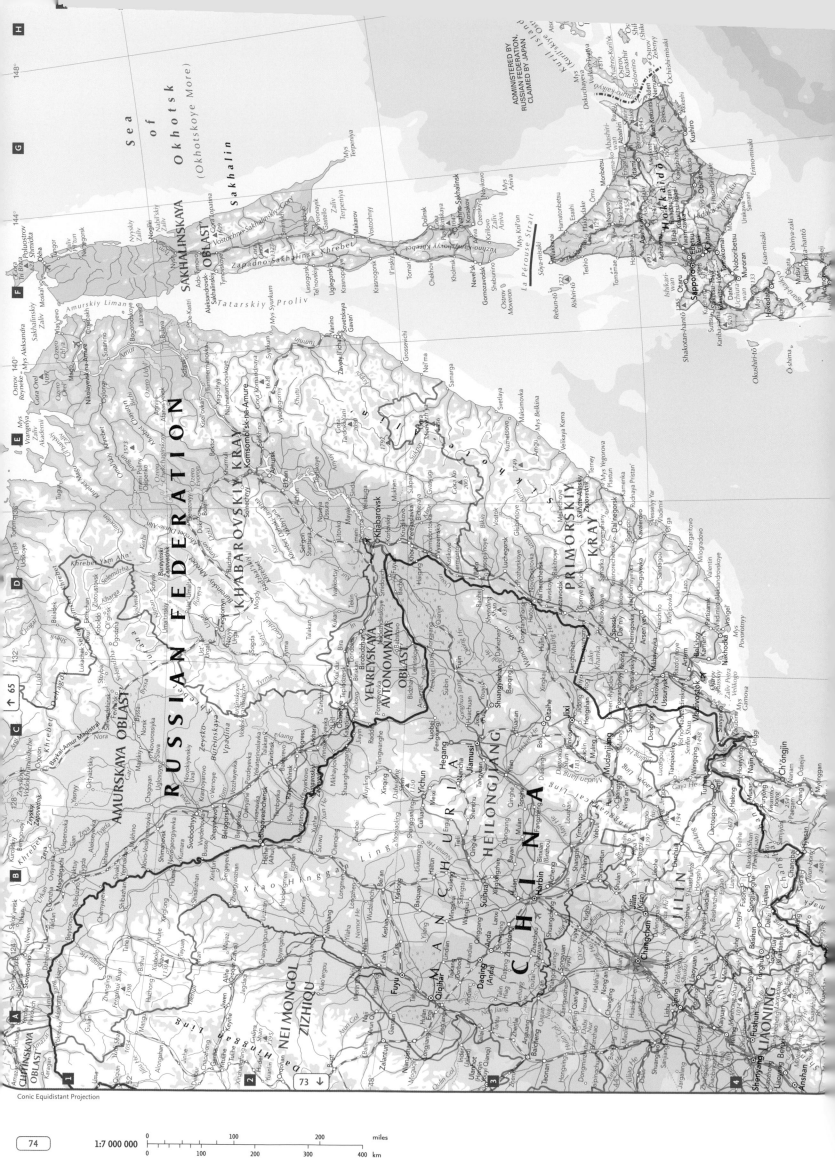

Conic Equidistant Projection

1:7 000 000

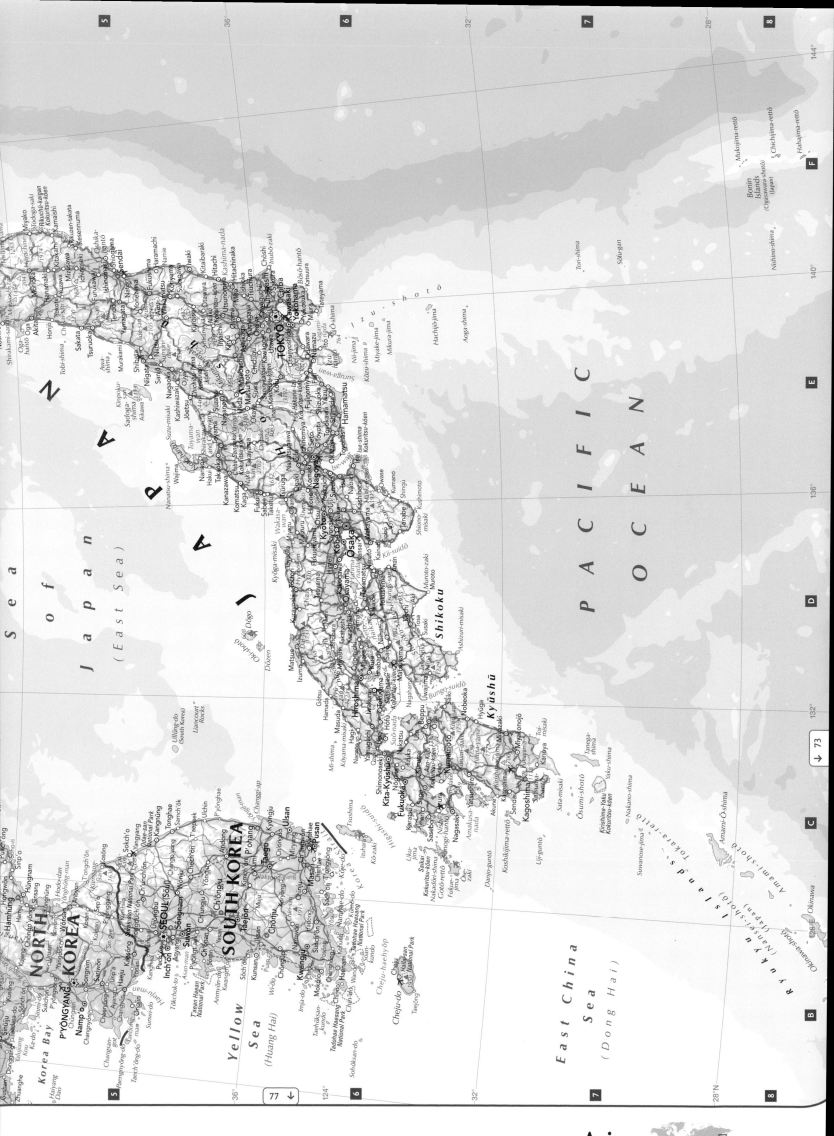

Asia

Japan, North Korea and South Korea

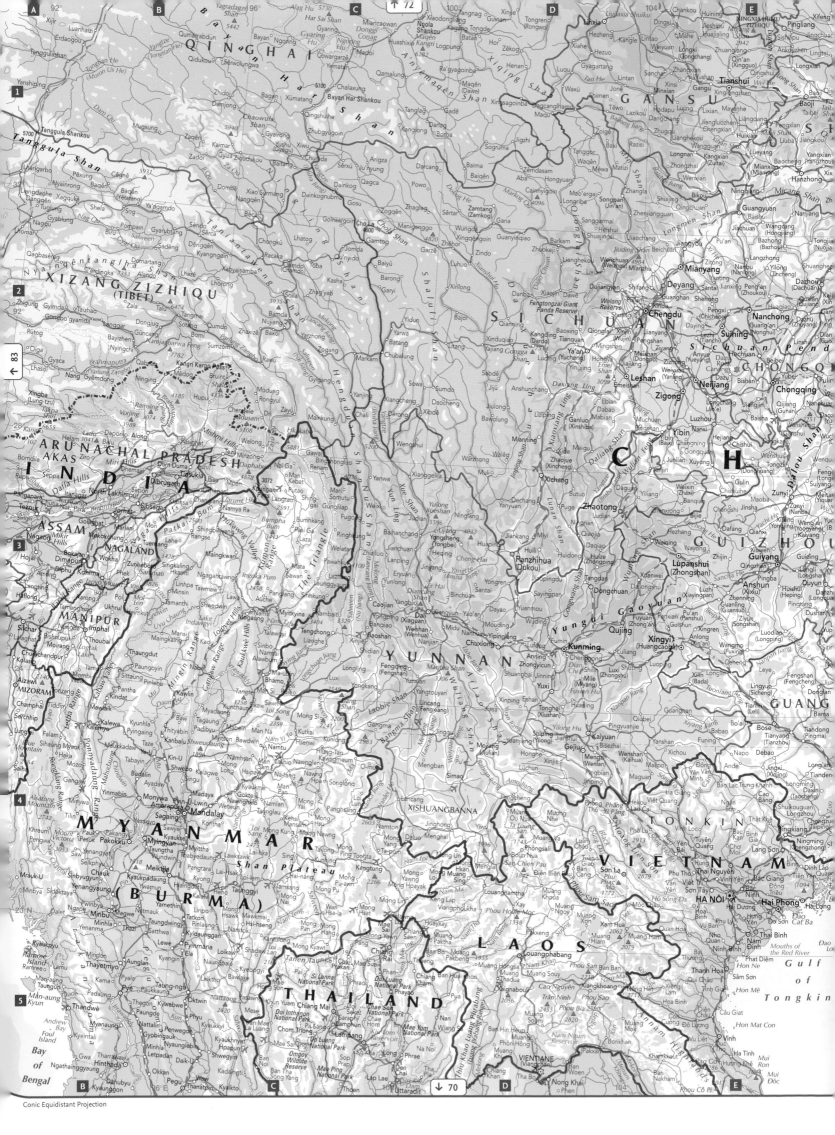

Conic Equidistant Projection

1:7 000 000

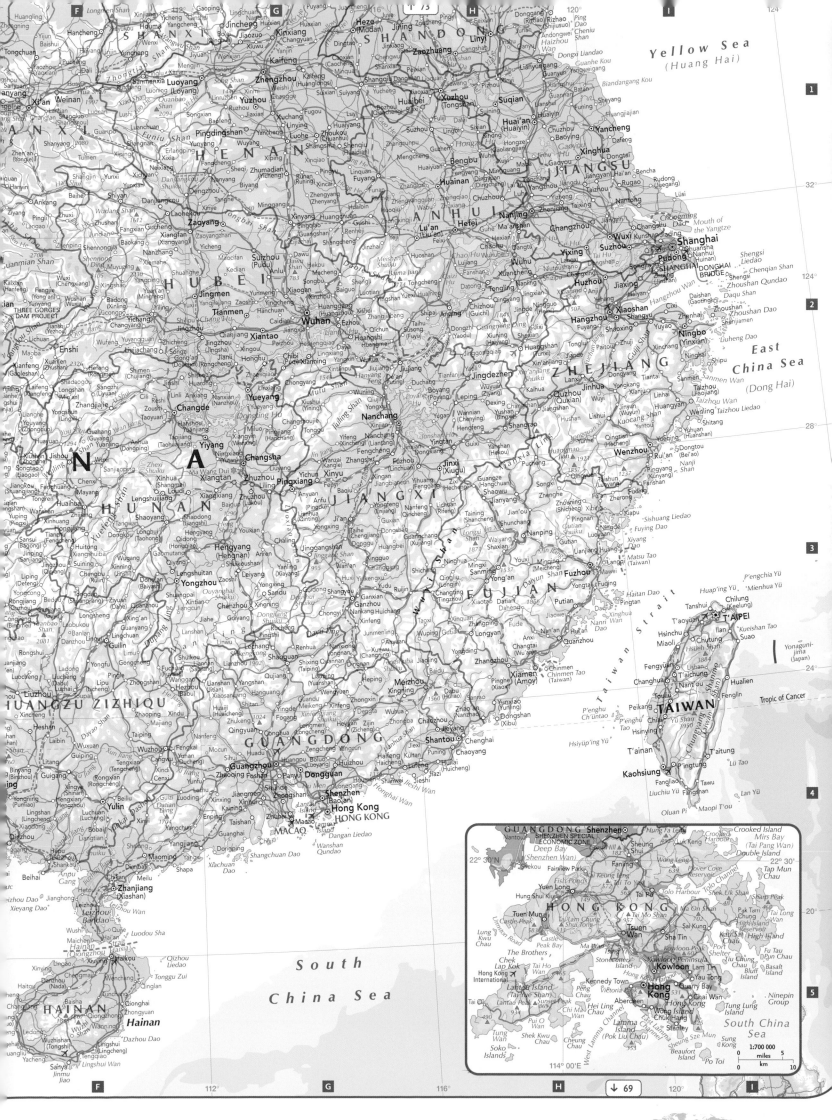

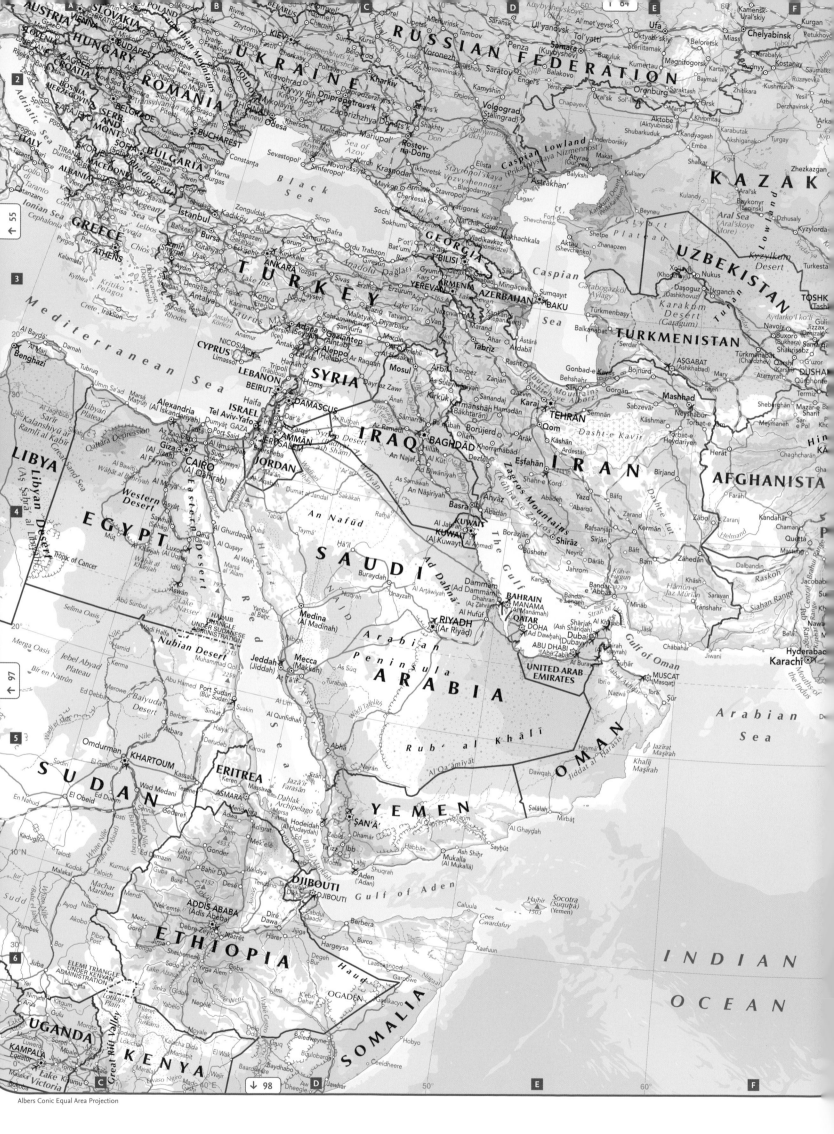

Albers Conic Equal Area Projection

1:20 000 000

0	200	400	600	miles	
0	200	400	600	800	1000 km

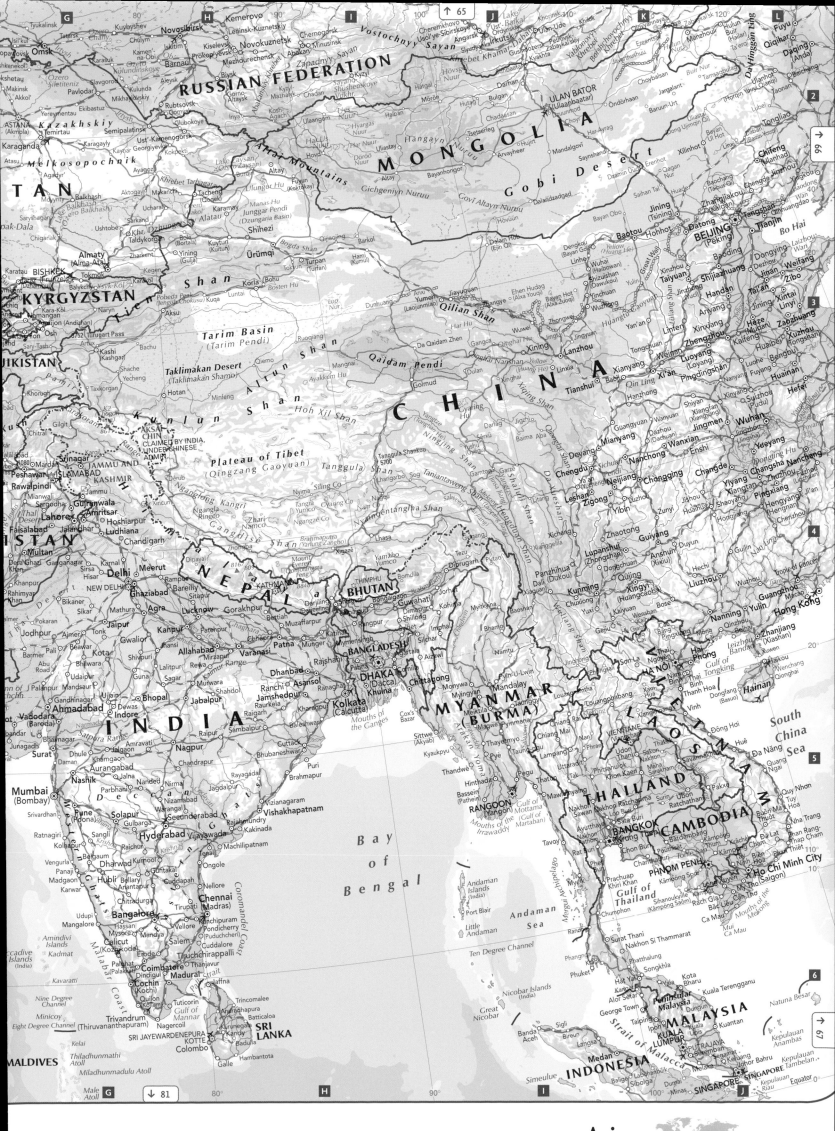

Asia

Central and Southern Asia

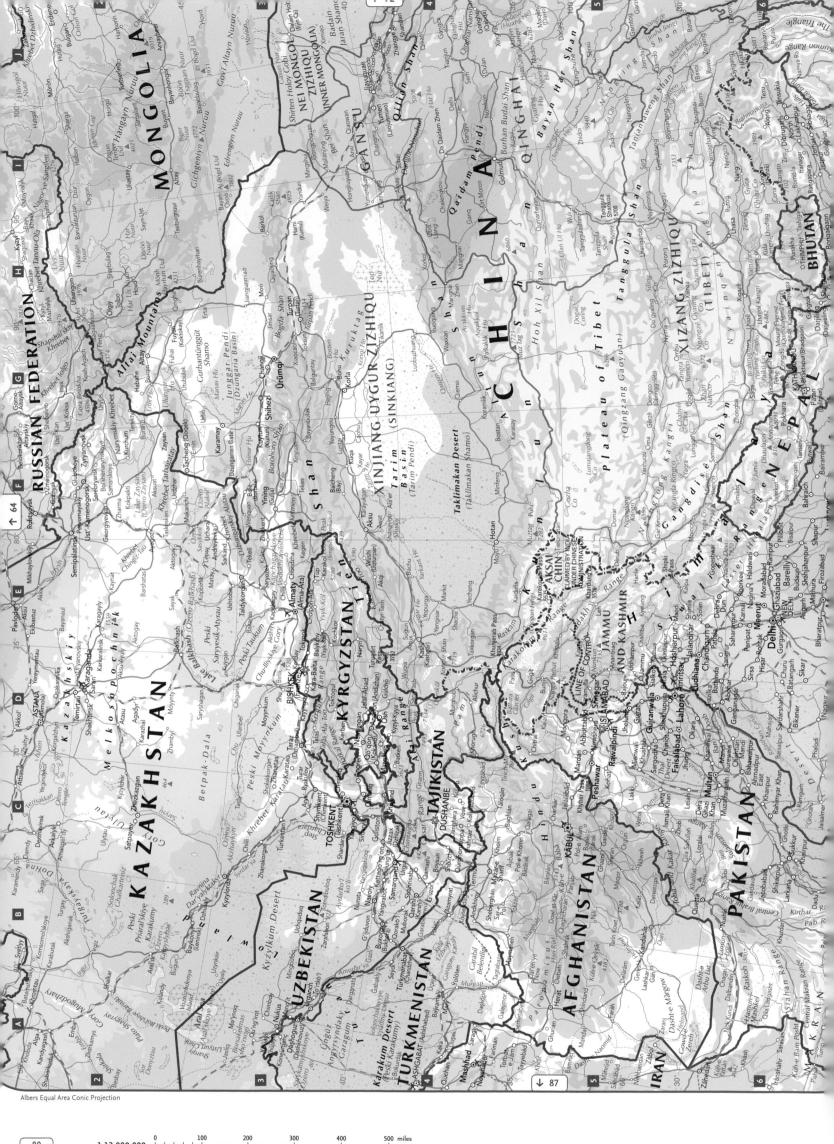

Albers Equal Area Conic Projection

1:13 000 000

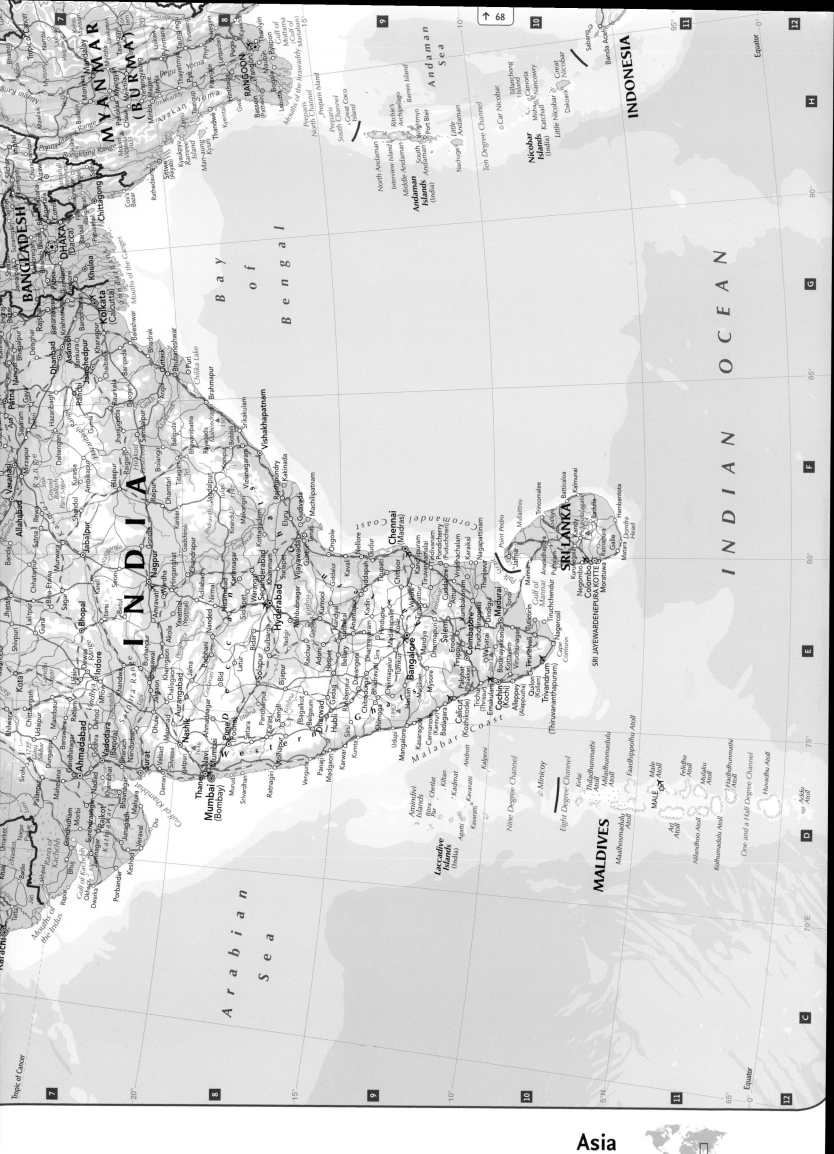

Asia
Southern Asia

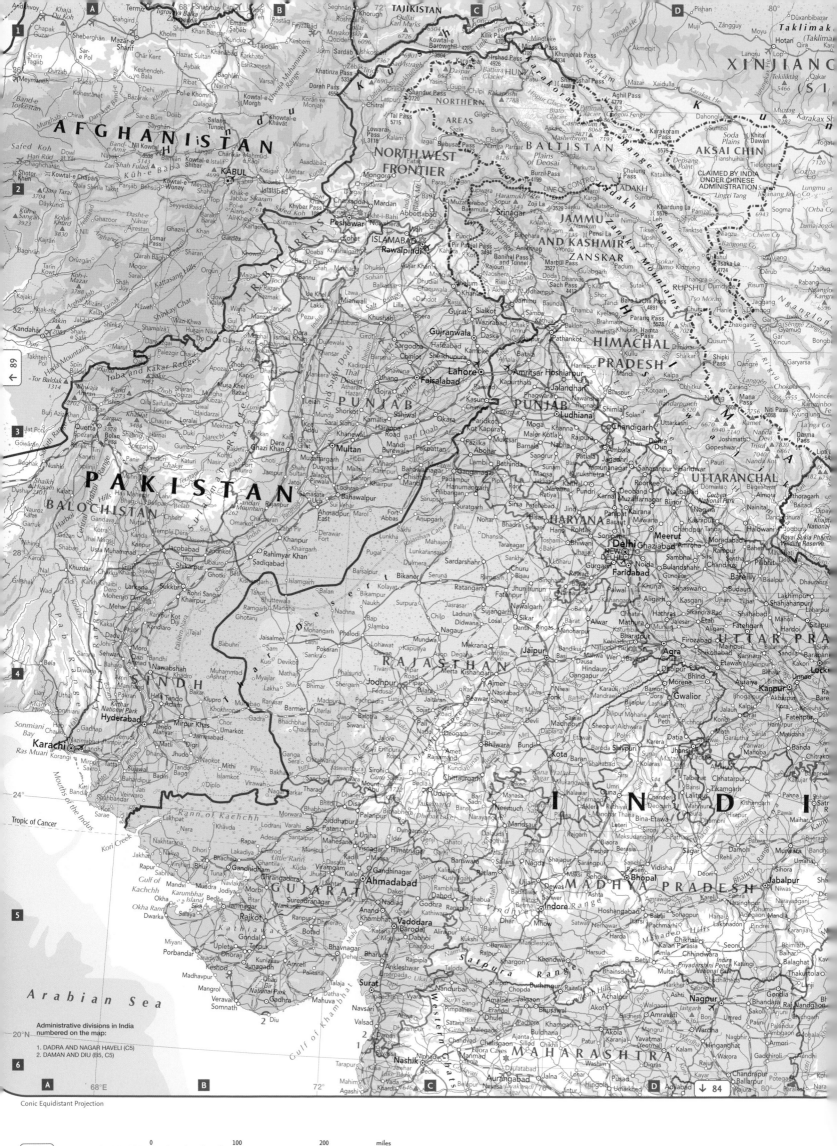

Conic Equidistant Projection

1:7 000 000

Administrative divisions in India
numbered on the map:

1. DADRA AND NAGAR HAVELI (C5)
2. DAMAN AND DIU (B5, C5)

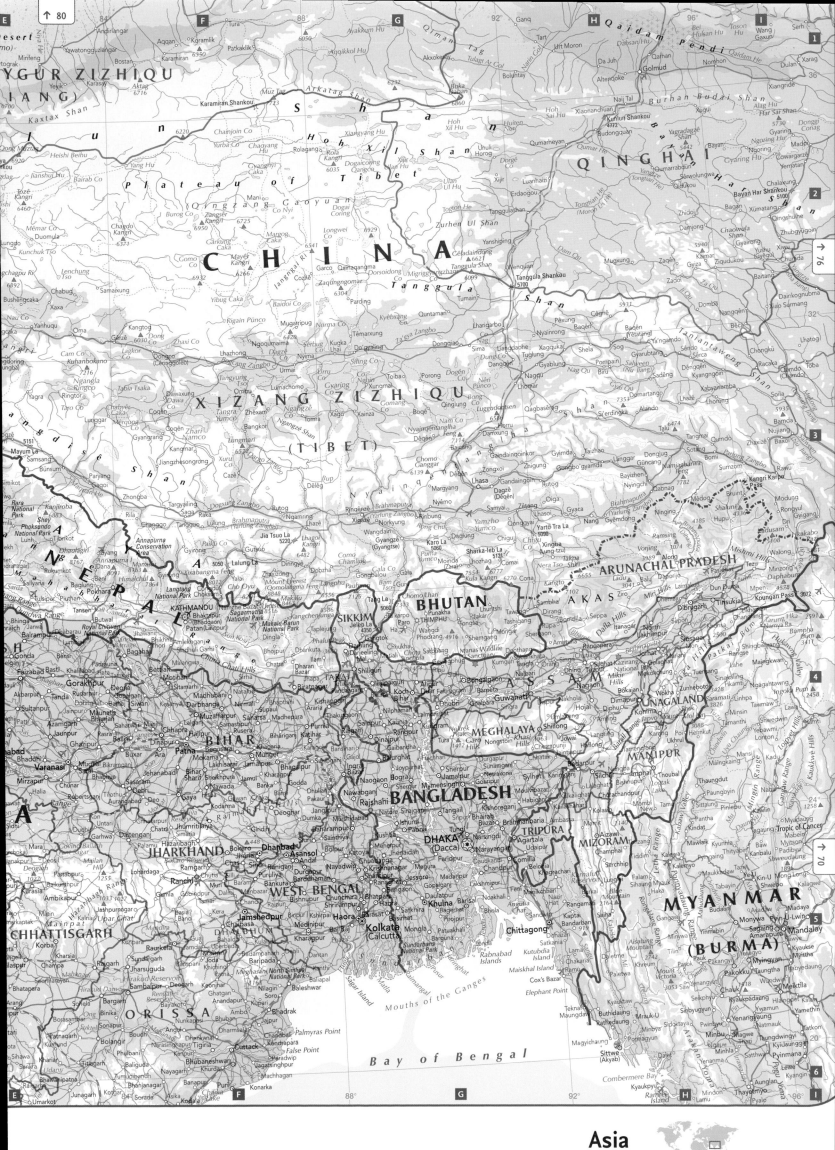

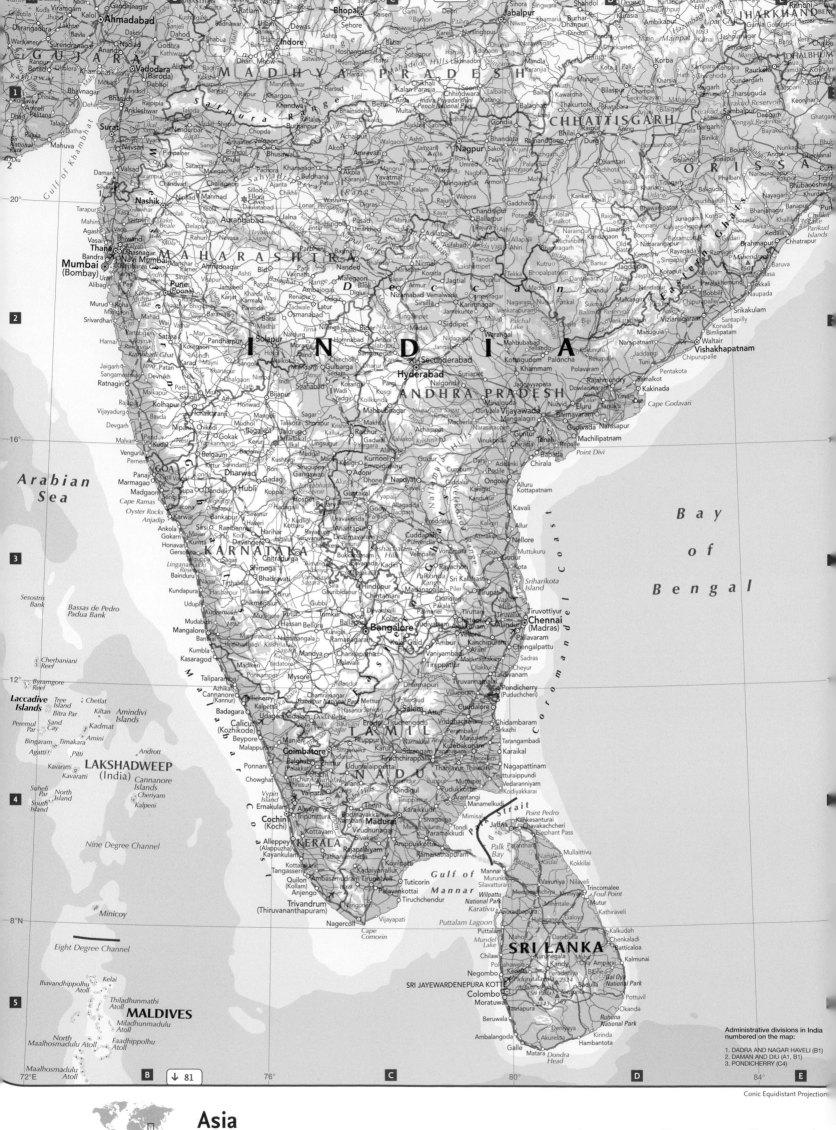

Asia
Southern India and Sri Lanka

Conic Equidistant Projection

1:7 000 000

Administrative divisions in India
numbered on the map:

1. DADRA AND NAGAR HAVELI (B1)
2. DAMAN AND DIU (A1, B1)
3. PONDICHERRY (C4)

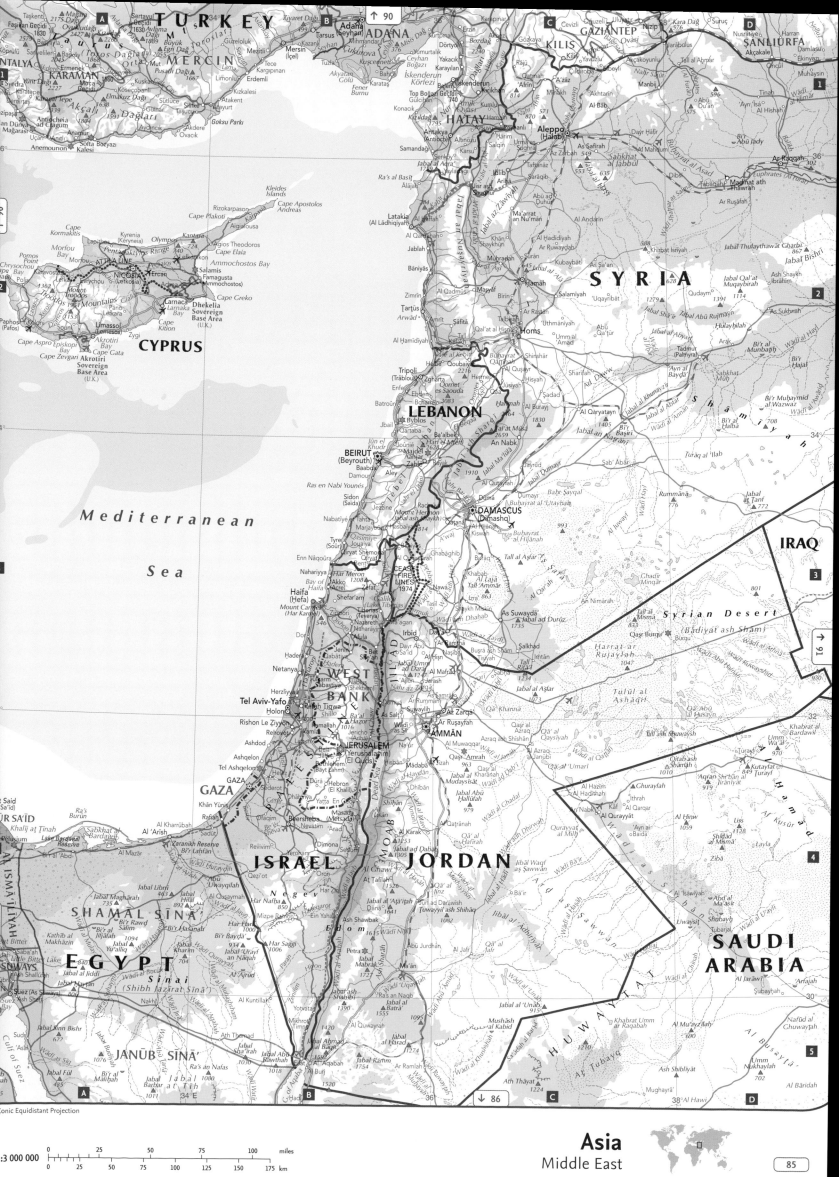

Asia

Middle East

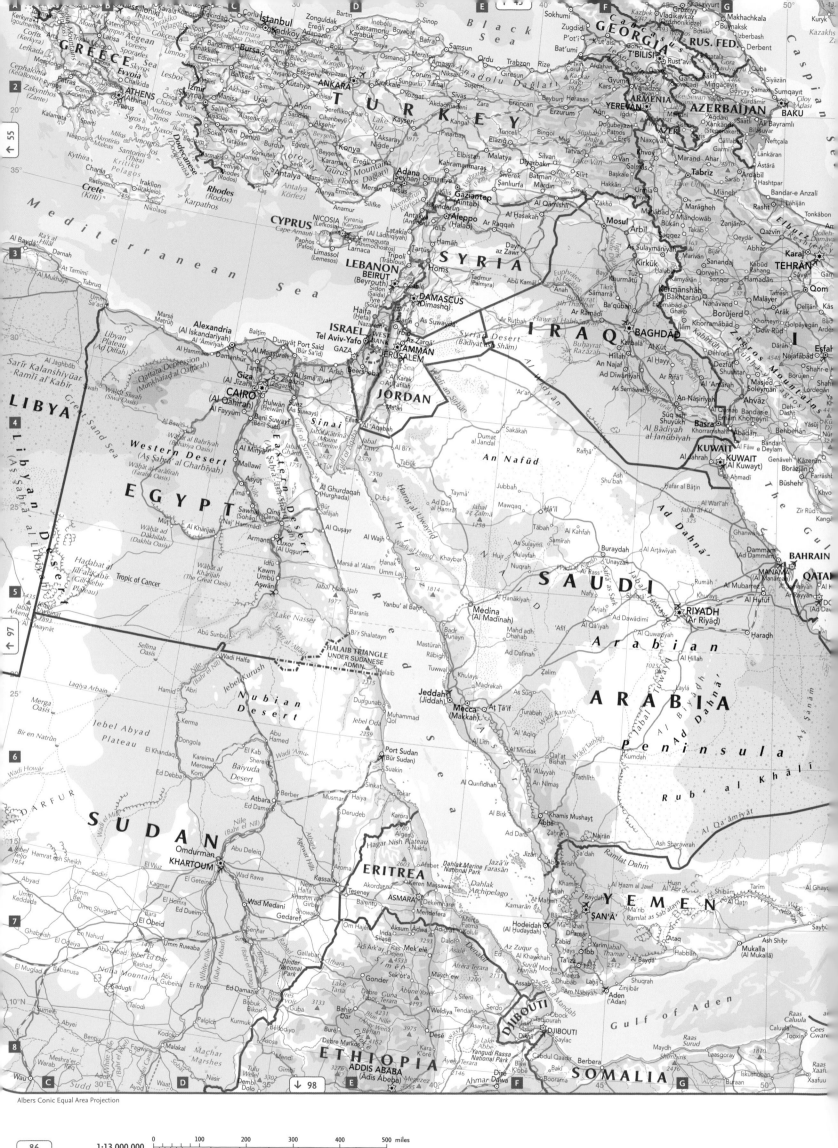

Albers Conic Equal Area Projection

1:13 000 000

| 0 | 100 | 200 | 300 | 400 | 500 miles |
| 0 | 100 | 200 | 300 | 400 | 500 | 600 | 700 | 800 km |

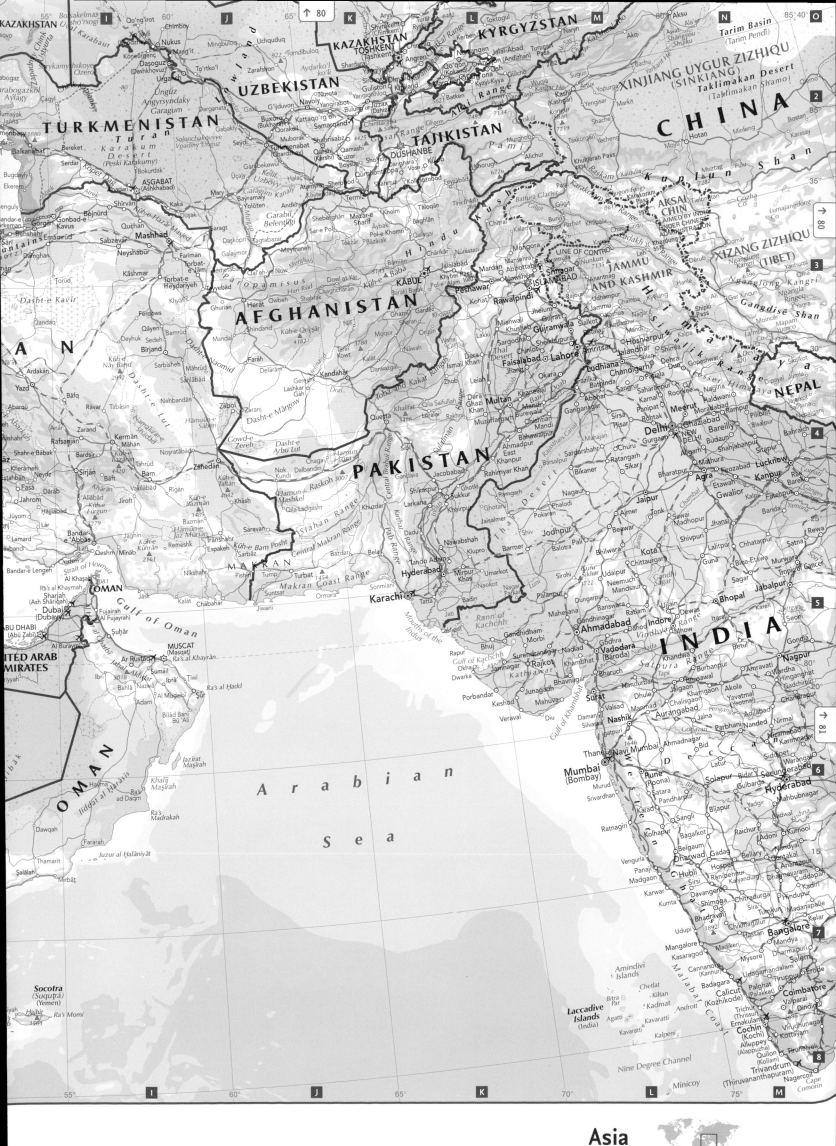

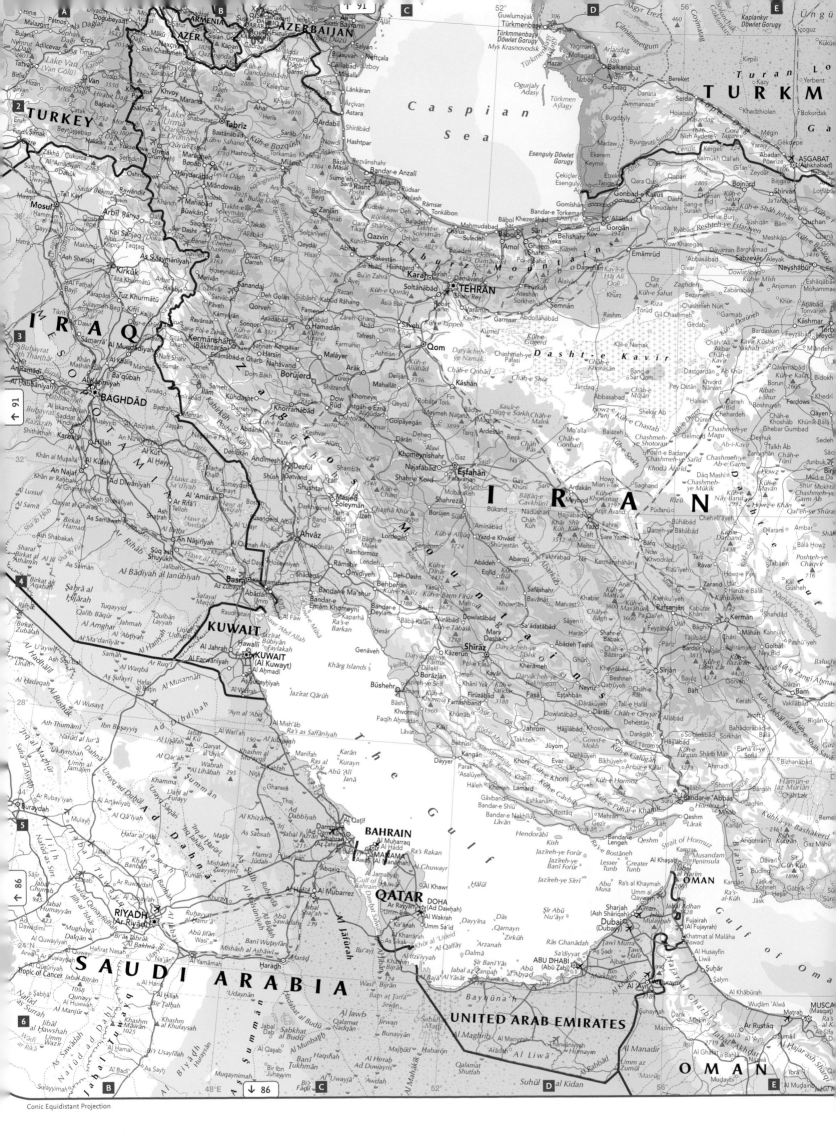

Conic Equidistant Projection

1:7 000 000

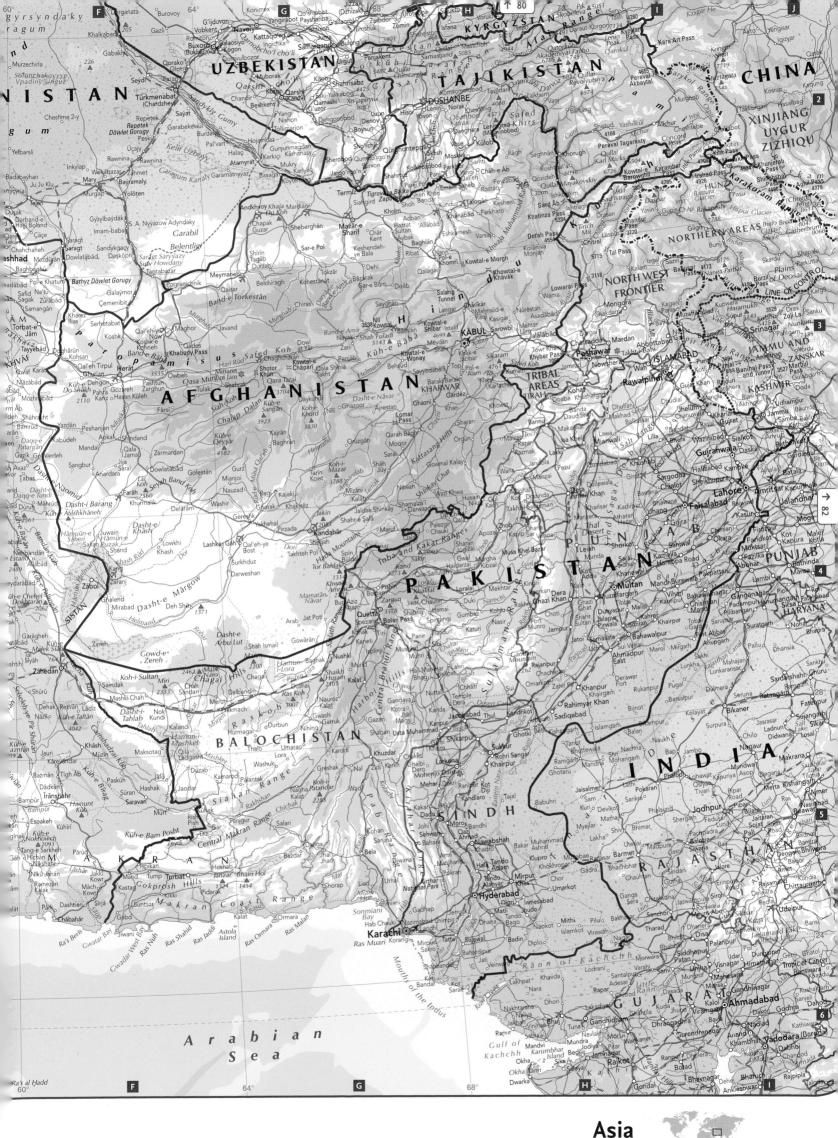

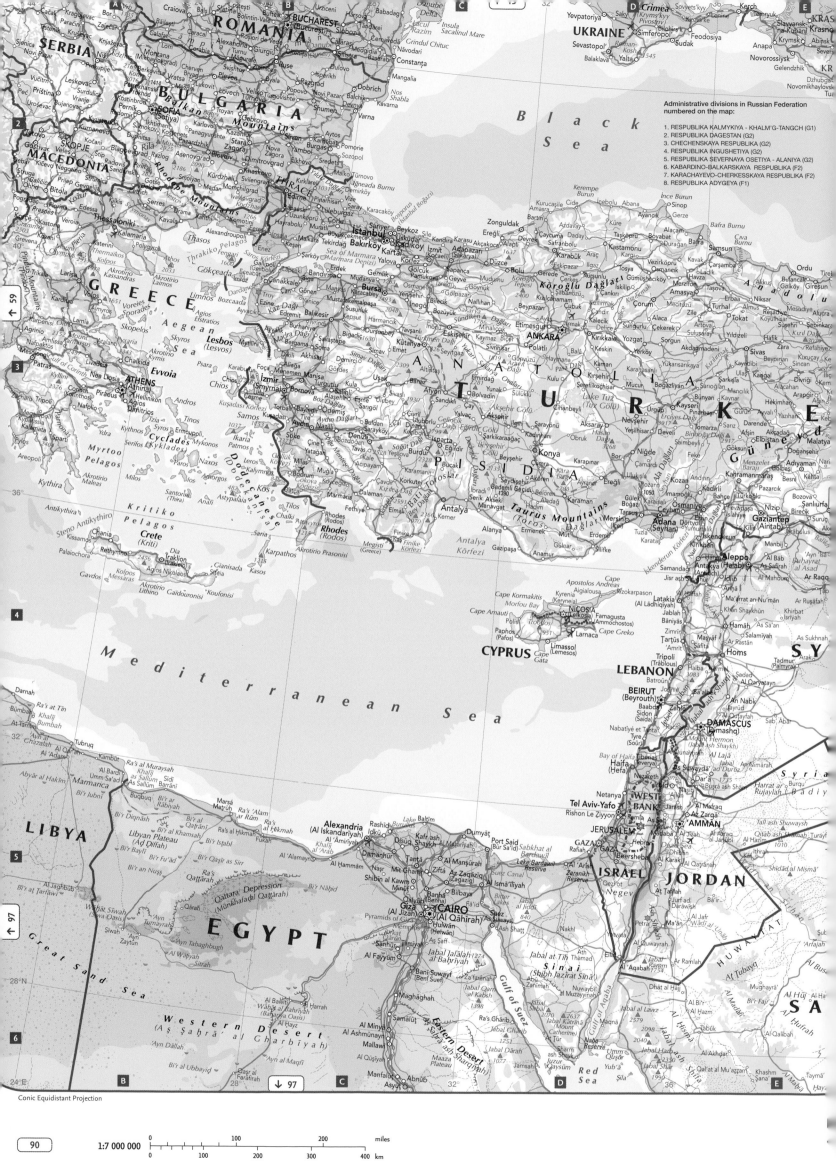

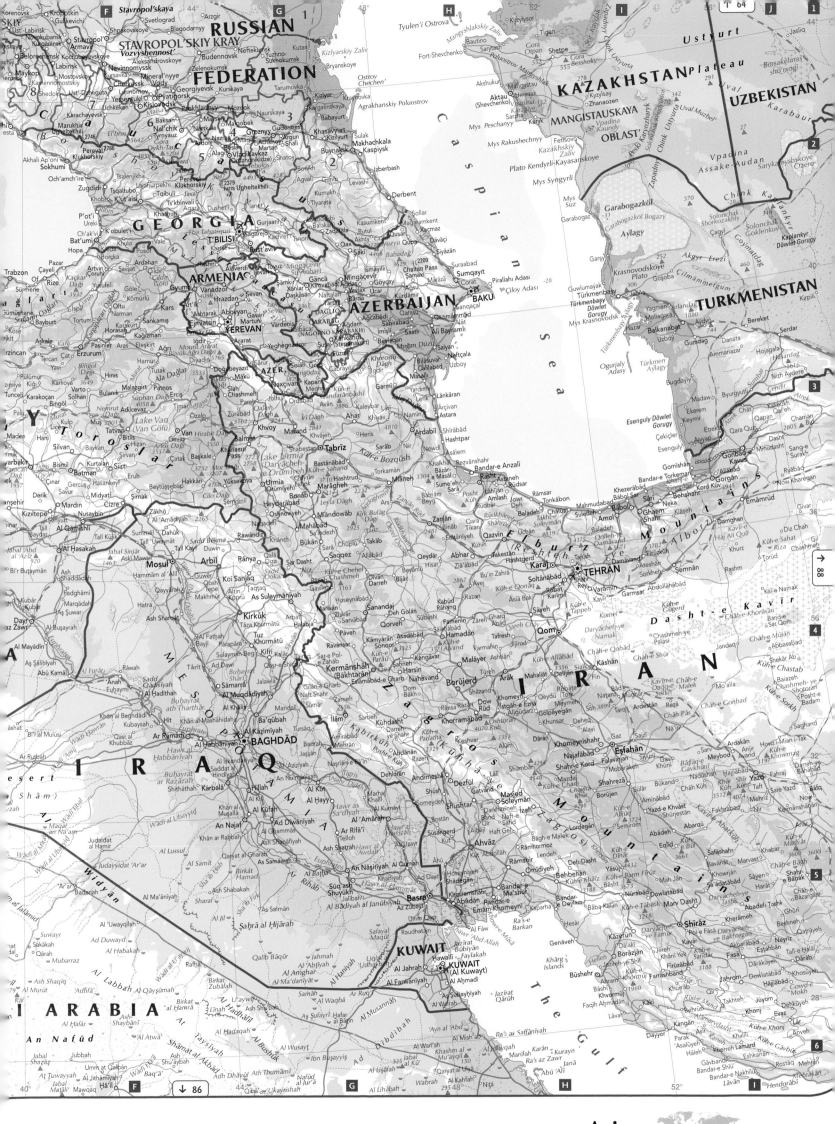

Asia

Eastern Mediterranean, the Caucasus and Iraq

Africa

Some of the world's greatest physical features are in Africa, the world's second largest continent. Variations in climate and elevation give rise to the continent's great variety of landscapes. The Sahara, the world's largest desert, extends across the whole continent from west to east, and covers an area of over nine million square kilometres. Other significant African deserts are the Kalahari and the Namib. In contrast, some of the world's greatest rivers flow in Africa, including the Nile, the world's longest, and the Congo.

The Great Rift Valley is perhaps Africa's most notable geological feature. It stretches for nearly 3 000 kilometres from Jordan, through the Red Sea and south to Mozambique, and contains many of Africa's largest lakes. Significant mountain ranges on the continent are the Atlas Mountains and the Ethiopian Highlands in the north, the Ruwenzori in east central Africa, and the Drakensberg in the far southeast.

The confluence of the Ubangi and Africa's second longest river, the **Congo**.

Africa's extent

TOTAL LAND AREA	30 343 578 sq km / 11 715 655 sq miles
Most northerly point	La Galite, Tunisia
Most southerly point	Cape Agulhas, South Africa
Most westerly point	Santo Antão, Cape Verde
Most easterly point	Raas Xaafuun, Somalia

Internet Links

NASA Visible Earth	visibleearth.nasa.gov
NASA Astronaut Photography	eol.jsc.nasa.gov
Peace Parks Foundation	www.peaceparks.org

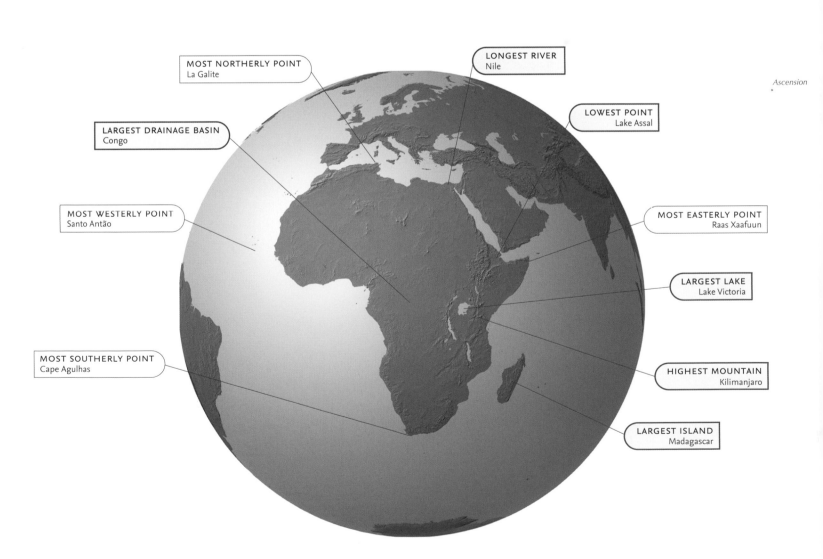

MOST NORTHERLY POINT
La Galite

LONGEST RIVER
Nile

LARGEST DRAINAGE BASIN
Congo

LOWEST POINT
Lake Assal

MOST WESTERLY POINT
Santo Antão

MOST EASTERLY POINT
Raas Xaafuun

LARGEST LAKE
Lake Victoria

MOST SOUTHERLY POINT
Cape Agulhas

HIGHEST MOUNTAIN
Kilimanjaro

LARGEST ISLAND
Madagascar

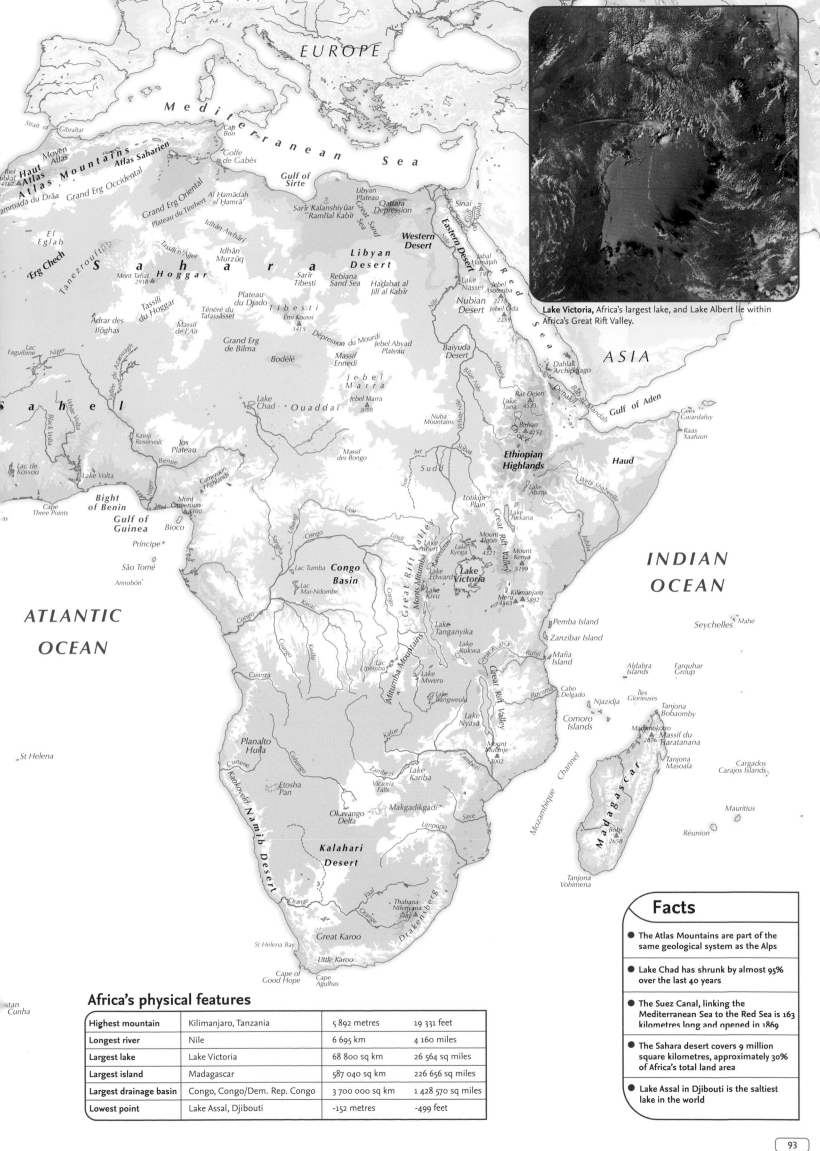

EUROPE

Mediterranean Sea

Strait of Gibraltar
Cape Bon
Golfe de Gabès
Gulf of Sirte

Moyen Atlas
Haut Atlas
Jbel Toubkal 4167
A t l a s M o u n t a i n s
Atlas Saharien
hammada du Drâa
Grand Erg Occidental
Plateau du Tinrhert
Grand Erg Oriental
Al Hamādah al Ḥamrā'
Sarīr Kalanshiyūar Ramlīal Kabīr
Qattara Depression
Great Sand Sea

El Eglab
'Erg Chech
Tanezrouft
S a h a r a
Tassili n'Ajjer
Idhān Awbārī
Libyan Plateau
Sinai
Gulf of Aqaba

Western Desert
Idhān Murzūq
Libyan Desert
Sarīr Tibesti
Rebiana Sand Sea
Haḍabat al Jilf al Kabīr

Mont Tahat 2918
H o g g a r
Plateau du Djado
T i b e s t i
Emi Koussi 3415

Adrar des Ifôghas
Tassili du Hoggar
Ténéré du Tafassâsset
Massif de l'Aïr
Grand Erg de Bilma
Dépression du Mourdi
Jebel Abyad Plateau

Lac Faguibine
Niger
Vallée de Azaouagh
Bodélé
Massif Ennedi

Eastern Desert
Nile
Jabal Hamāṭah 1977
Lake Nasser
Jebel Asoteriba 2215
Jebel Oda 2259

Nubian Desert
Baiyuda Desert

Dahlak Archipelago
Ras Dejen 4533
Lake Tana
Denakil
Bāb al Mandab
Gulf of Aden
Gees Gwardafuy
Raas Xaafuun

ASIA

Red Sea

S a h e l
White Volta
Black Volta
Niger
Kainji Reservoir
Jos Plateau
Benue

Lac de Kossou
Lake Volta

Bight of Benin
Cape Three Points
Gulf of Guinea
Cameroon Highlands
Mont Cameroun 4100
Bioco
Príncipe
São Tomé
Annobón

J e b e l M a r r a
Jebel Marra 3088
Lake Chad
O u a d d a ï
Massif des Bongo
Jur
S u d d
Sue

Nuba Mountains
Blue Nile
White Nile
Sobat

Birhan 4752

Ethiopian Highlands
Lake Abaya
Webi Shabeelle
Lake Turkana
Haud

ATLANTIC OCEAN

Congo
Lac Tumba
Congo Basin
Lac Mai-Ndombe
Ubangi
Sangha
Kasai

Uele
Lotikipi Plain
Lindi
G r e a t R i f t V a l l e y
Lake Albert
Lake Kyoga
Mount Elgon 4321
Mount Kenya 5199
Lake Edward
Lake Victoria
Lake Kivu
Kilimanjaro 5892
Meru 4565

INDIAN OCEAN

Congo
Kwilu
Cuango
Cuanza
Kwango

Lac Upemba
Mtumba Mountains
Monts Mitumba
Lake Tanganyika
Lake Rukwa
Great Ruaha
Rufiji

Pemba Island
Zanzibar Island
Mafia Island
Seychelles Mahé

Lake Mweru
Lake Bangweulu
Ruvuma
Cabo Delgado
Njazidja
Comoro Islands

Aldabra Islands
Farquhar Group
Îles Glorieuses
Tanjona Bobaomby
Maromokotro 2876
Massif du Tsaratanana

Planalto Huíla
Cunene
Cubango
Kafue
Zambezi
Lake Nyasa
Mount Mulanje 3002

Great Rift Valley
Save

Mozambique Channel

M a d a g a s c a r
Tanjona Masoala

Cargados Carajos Islands

St Helena

Kaokoveld
N a m i b D e s e r t
Etosha Pan
Okavango Delta
Makgadikgadi
Limpopo
Zambezi
Lake Kariba
Victoria Falls

Boby 2658
Tanjona Vohimena

Mauritius
Réunion

Kalahari Desert
Vaal
Orange
Thabana-Ntlenyana 3482
Drakensberg

Great Karoo
St Helena Bay
Little Karoo
Cape of Good Hope
Cape Agulhas

...stan Cunha

Lake Victoria, Africa's largest lake, and Lake Albert lie within Africa's Great Rift Valley.

Africa's physical features

Highest mountain	Kilimanjaro, Tanzania	5 892 metres	19 331 feet
Longest river	Nile	6 695 km	4 160 miles
Largest lake	Lake Victoria	68 800 sq km	26 564 sq miles
Largest island	Madagascar	587 040 sq km	226 656 sq miles
Largest drainage basin	Congo, Congo/Dem. Rep. Congo	3 700 000 sq km	1 428 570 sq miles
Lowest point	Lake Assal, Djibouti	-152 metres	-499 feet

Facts

- The Atlas Mountains are part of the same geological system as the Alps

- Lake Chad has shrunk by almost 95% over the last 40 years

- The Suez Canal, linking the Mediterranean Sea to the Red Sea is 163 kilometres long and opened in 1869

- The Sahara desert covers 9 million square kilometres, approximately 30% of Africa's total land area

- Lake Assal in Djibouti is the saltiest lake in the world

Africa

Africa is a complex continent, with over fifty independent countries and a long history of political change. It supports a great variety of ethnic groups, with the Sahara creating the major divide between Arab and Berber groups in the north and a diverse range of groups, including the Yoruba and Masai, in the south.

The current pattern of countries in Africa is a product of a long and complex history, including the colonial period, which saw European control of the vast majority of the continent from the fifteenth century until widespread moves to independence began in the 1950s. Despite its great wealth of natural resources, Africa is by far the world's poorest continent. Many of its countries are heavily dependent upon foreign aid and many are also subject to serious political instability.

Facts

- Africa has over 1 000 linguistic and cultural groups

- Only Liberia and Ethiopia have remained free from colonial rule throughout their history

- Over 30% of the world's minerals, and over 50% of the world's diamonds, come from Africa

- 9 of the 10 poorest countries in the world are in Africa

Madeira (Portugal)

Canary Islands (Spain)

Laâyoune

WESTERN SAHARA

Nouâdhibou

MAURITANIA
Nouakchott

St-Louis

Dakar SENEGAL
Kaolack

Banjul THE GAMBIA
Bissau

GUINEA-BISSAU GUINEA

Conakry

Freetown
SIERRA LEONE
Monrovia LIBERIA

CAPE VERDE
Praia

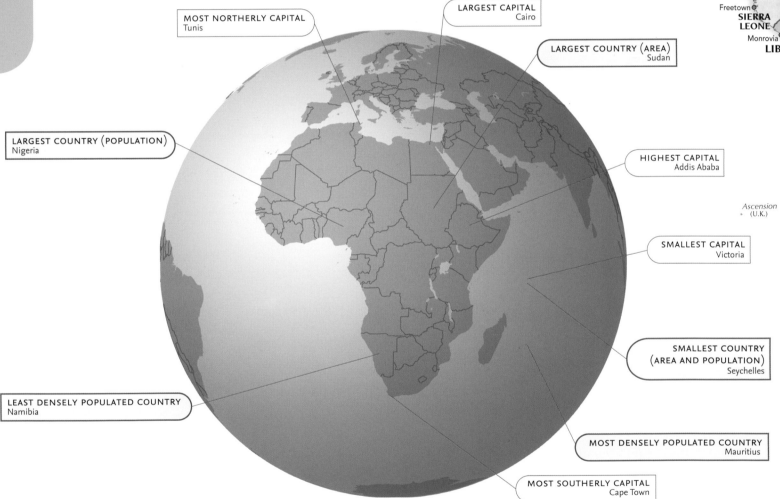

MOST NORTHERLY CAPITAL
Tunis

LARGEST CAPITAL
Cairo

LARGEST COUNTRY (AREA)
Sudan

LARGEST COUNTRY (POPULATION)
Nigeria

HIGHEST CAPITAL
Addis Ababa

Ascension (U.K.)

SMALLEST CAPITAL
Victoria

SMALLEST COUNTRY (AREA AND POPULATION)
Seychelles

LEAST DENSELY POPULATED COUNTRY
Namibia

MOST DENSELY POPULATED COUNTRY
Mauritius

MOST SOUTHERLY CAPITAL
Cape Town

Internet Links

UK Foreign and Commonwealth Office	www.fco.gov.uk
CIA World Factbook	www.odci.gov/cia/publications/factbook
Southern African Development Community	www.sadc.int
Satellite imagery	www.spaceimaging.com

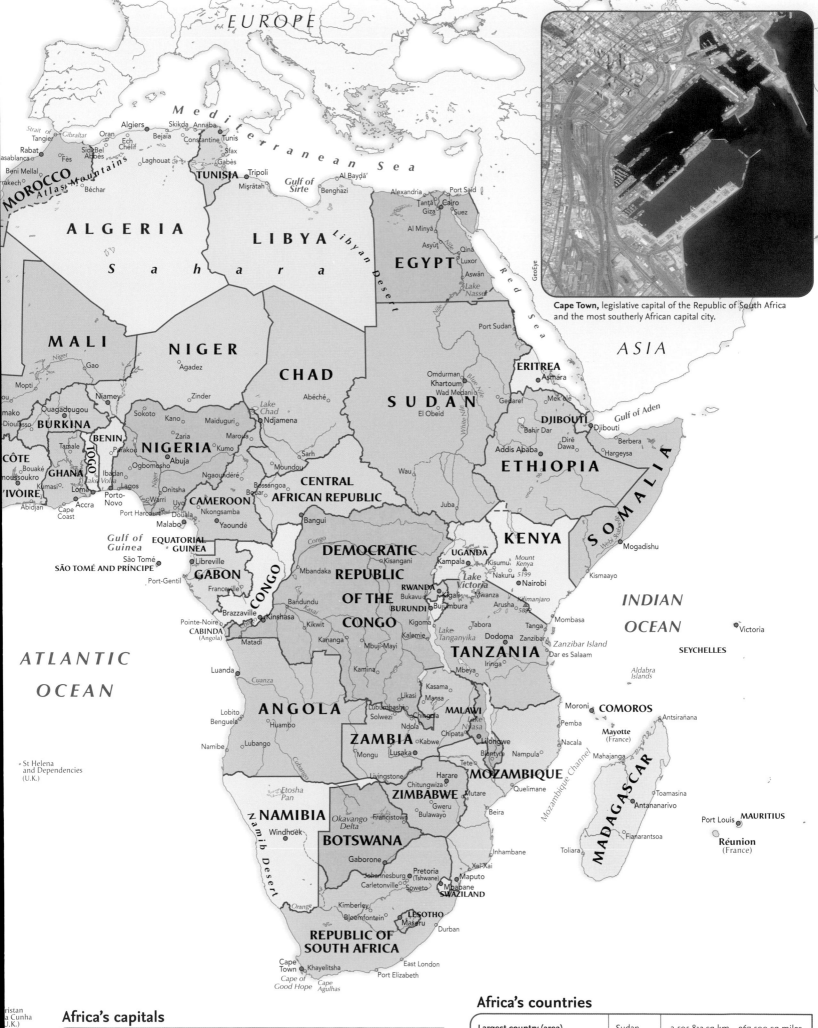

Cape Town, legislative capital of the Republic of South Africa and the most southerly African capital city.

Africa's capitals

Largest capital (population)	Cairo, Egypt	11 146 000
Smallest capital (population)	Victoria, Seychelles	25 500
Most northerly capital	Tunis, Tunisia	36° 46'N
Most southerly capital	Cape Town, Republic of South Africa	33° 57'S
Highest capital	Addis Ababa, Ethiopia	2 408 metres 7 900 feet

Africa's countries

Largest country (area)	Sudan	2 505 813 sq km	967 500 sq miles
Smallest country (area)	Seychelles	455 sq km	176 sq miles
Largest country (population)	Nigeria	131 530 000	
Smallest country (population)	Seychelles	81 000	
Most densely populated country	Mauritius	599 per sq km	1 549 per sq mile
Least densely populated country	Namibia	2 per sq km	6 per sq mile

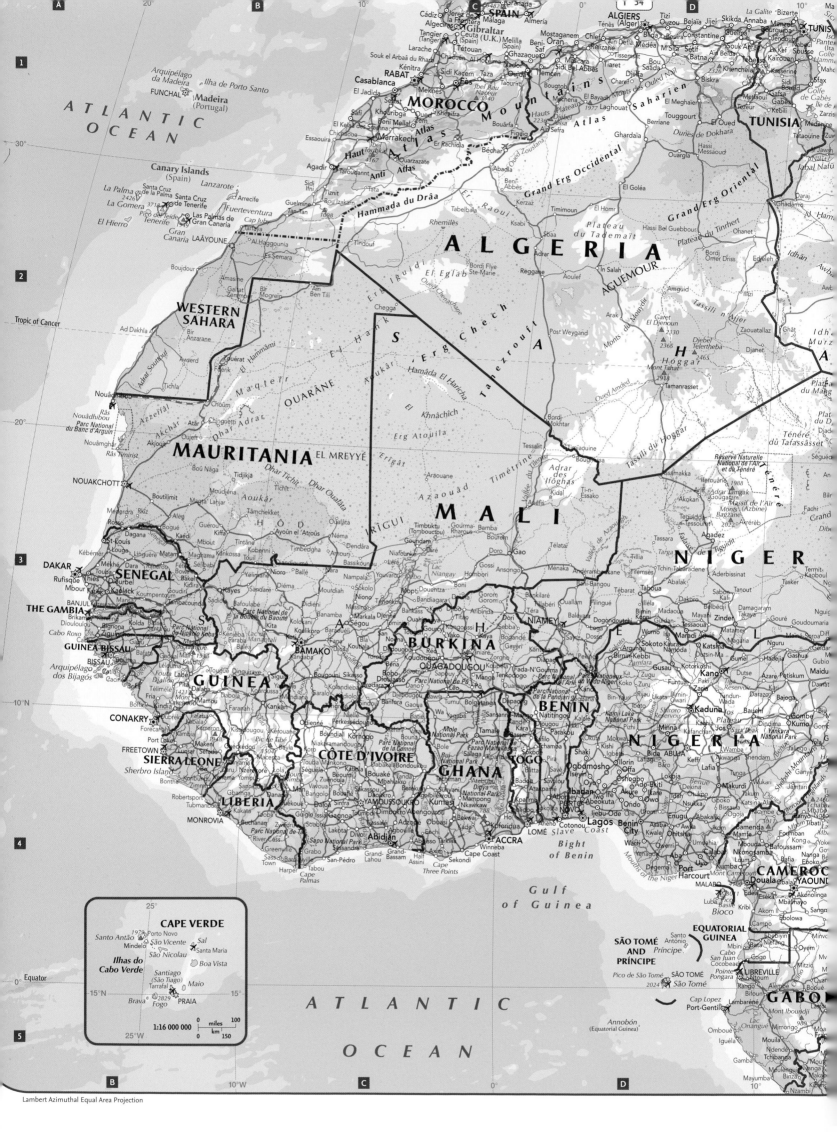

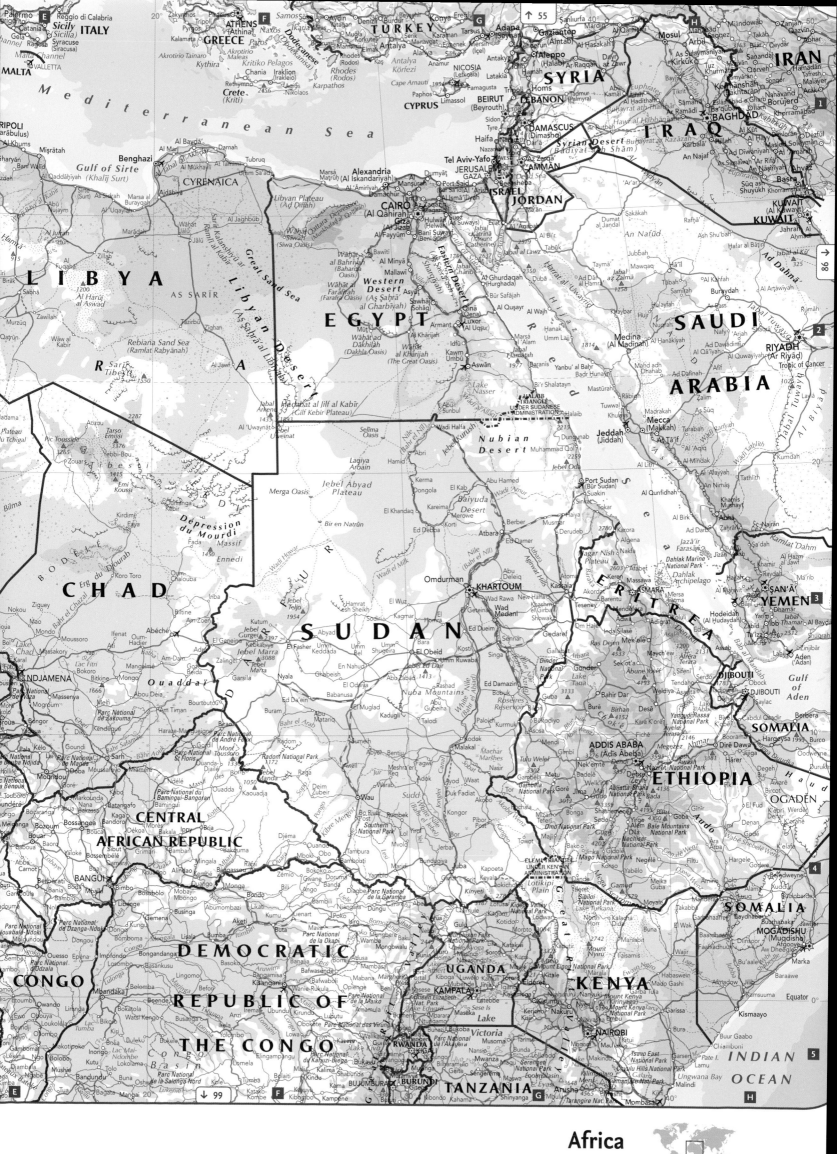

Africa
Northern Africa

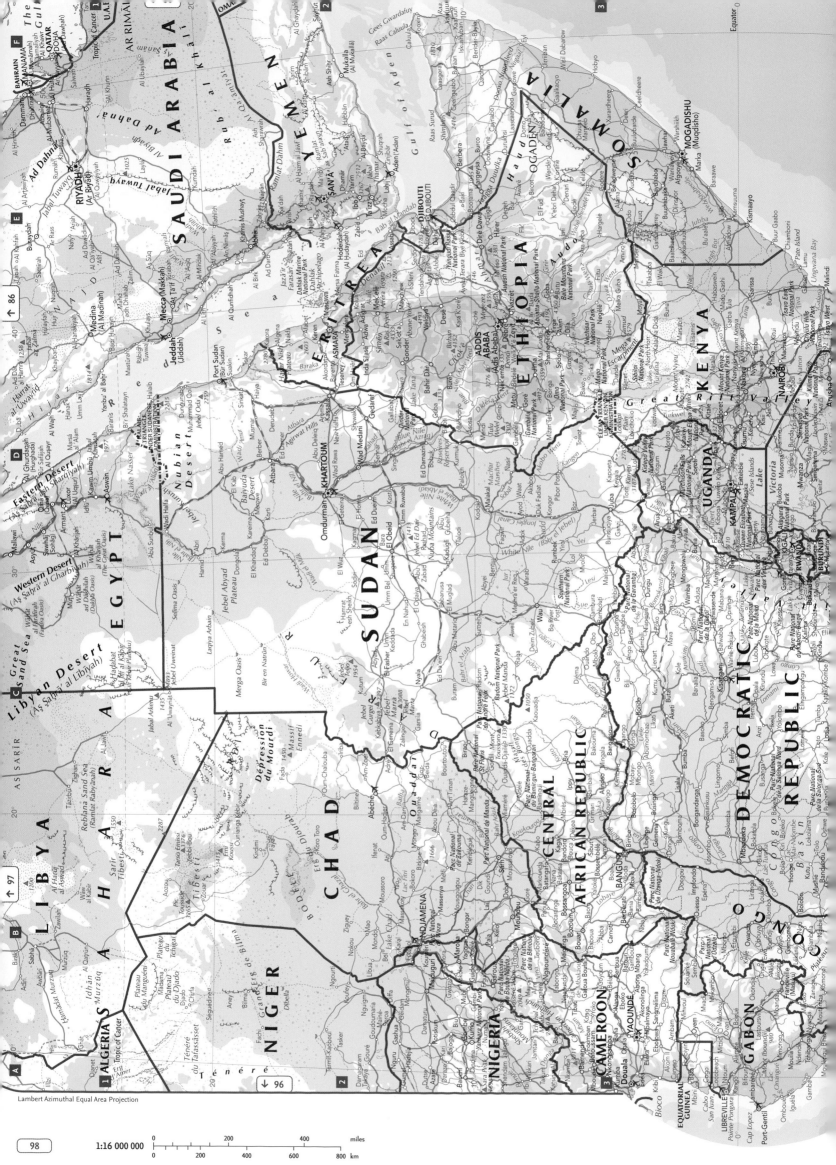

Lambert Azimuthal Equal Area Projection

1:16 000 000

	200		400	
0				miles

| 0 | 200 | 400 | 600 | 800 km |

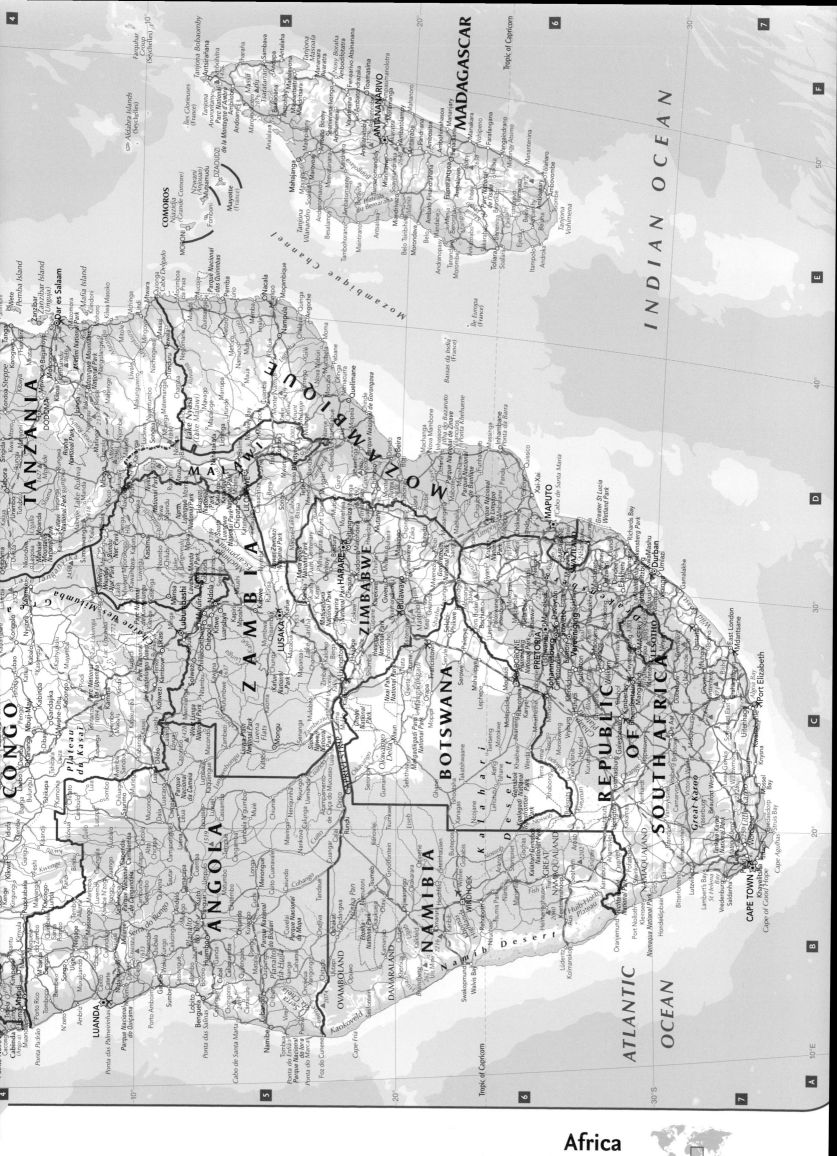

Africa

Central and Southern Africa

99

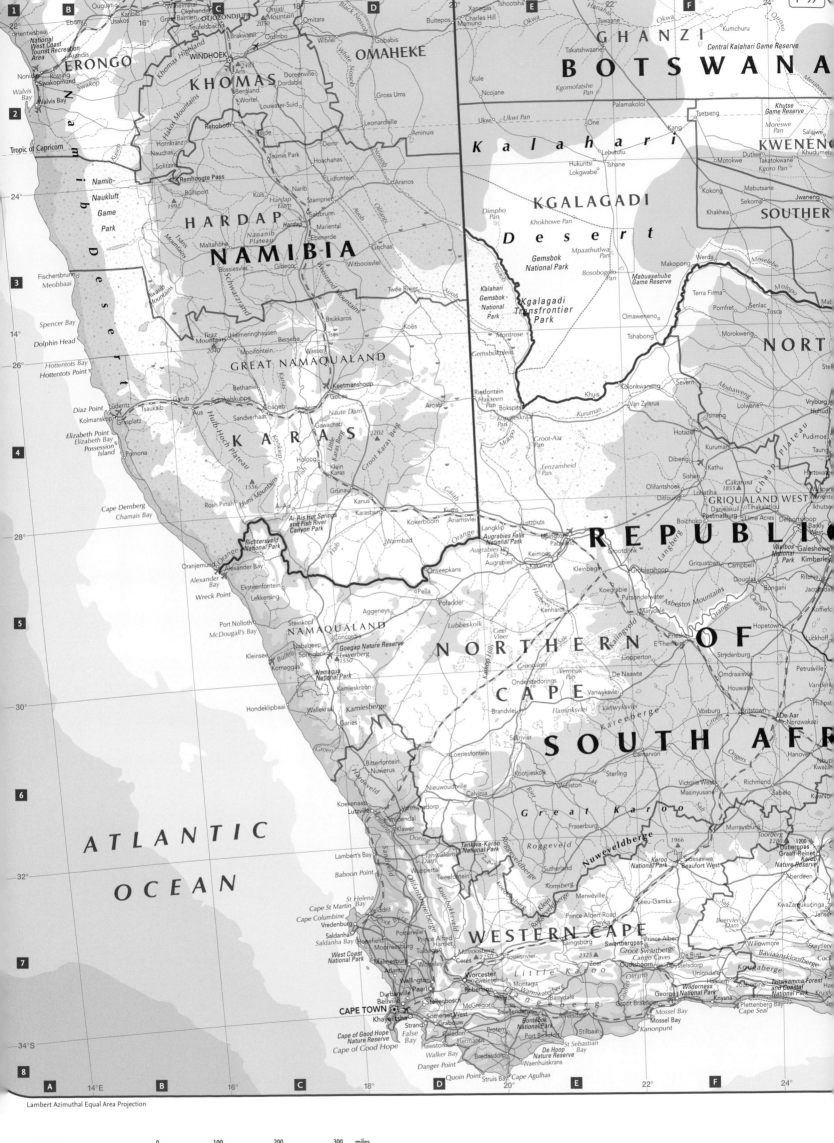

A · B · C · D · E · F

1
Ougatjie Wilhelmstal Xanagas Shootsa GHANZI
Ebony Okahandja Omitara Buitepos Charles Hill Mamuno Okwa Kumchuru
Karibib Gross Barmen Teufelsbach OTJOZONDJUPA Tswane Central Kalahari Game Reserve
Hentiesbaai Okahandja Onjati Mountain 2050 Omitara Kule Kgomofatshe Pan Takatshwaane
Rossing Okombahe OMAHEKE Ncojane Kgomofatshe Pan Mabutsane Jwaneng

ERONGO Swakop WINDHOEK Witvlei Gobabis Ukwi Okwa Palamakoloi Tsetseng Kang Moreswe Pan Salajwe
Walvis Bay Khomas Highland Dordabis White Nossob Kalahari KWENENG
KHOMAS Bergland Black Nossob Ukwi Pan One Dutlwe Motokwe Takatokwane
Wortel Louwater-Suid Aminuis KGALAGADI Hukuntsi Tshane Kgoro Pan Khudumelapye

2
Walvis Bay Hornkranz Rehoboth Nossob Lokgwabe SOUTHER
Tropic of Capricorn Nauchas Heide Leonardville Dimpho Pan Khokhowe Pan Kokong Mabutsane Sekoma
Solitaire Remhoogte Pass Derm **Desert** Gemsbok National Park Khakhea

24° Namib-Naukluft Game Park Büllsport Kuis Hardap Dam Stampriet Mpaathutlwa Pan Makopong Werda Moselebe
1992 Maltahöhe **HARDAP** Mariental Bosobogolo Pan Tshabong Sekoma
NAMIBIA Nananib Plateau Ebenerde Kalahari Gemsbok National Park Terra Firma
Tsaris Mountains Hardap Kgalagadi Transfrontier Park Omaweneno Senlac Pomfret

3 Fischersbrunn Schwarzrand Witbooisvlei Gochas Rietfontein Morokweng
Meobbaai Bossiesvlei Gibeon Twee Rivier Auob Hakseen Pan Kuruman **NORT**
Namib Tiras Mountains Helmeringhausen Koës Montrose Bokspits Van Zylsrus Moshaweng

14° Spencer Bay 2040 Berseba Gemsbokplein Kolonkwaneng Severn Tsineng
Dolphin Head Mooifontein Wasser Ises Khuis Lolwane Vryburg
26° Hottentots Bay GREAT NAMAQUALAND Koppieskraal Hotazel Kuruman
Hottentots Point Bethanie Keetmanshoop 2202 Groot-Aar Pan Olifantshoek Kathu Dibeng Huhudi

4 Diaz Point Lüderitz Tsaukaib Goageb Gobas **KARAS** Eenzamheid Pan Ditloung Lohatla Cakarosa 1855 GRIQUALAND WEST
Kolmanskop Grasplatz Seeheim Naute Dam Little Karas Berg Koppieskraal Pan Sishen Danielskuil Tlhakalatlu Ikhutse
Elizabeth Point Aus Hub-Hoch Plateau Gawachab Croot Karas Berg Kuruman Postmasburg Lime Acres Delportshoop
Elizabeth Bay Sandverhaar Holoog Klein Karas Upington Groot-Aar Pan Boichoko Barkly West
Possession Island Konkiep 1556 Grünau Kums Keimoes Kakamas Griquatown Campbell Ritchie
Pomona Huns Mountains Kanus Calub Langklip Augrabies Falls National Park Grootdrink Douglas Bongani Jacobsdal

28° Cape Dernberg Rosh Pinah Ai-Ais Hot Springs and Fish River Canyon Park Karasburg Kokerboom Ariamsvlei Augrabies Falls Keimoes Kleinbegin Goblershoop **REPUBLIC**
Chamais Bay Ai-Ais Warmbad Orange Augrabies Koegrabie Griquatown Vaalbos National Park Galeshewe
Richtersveld National Park Onseepkans Putsonderwater Asbestos Mountains Kimberley
Oranjemund Orange Alexander Bay Pella Kenhardt Marydale Hopetown

5 Alexander Bay Eksteenfontein Pofadder Geel Vloer **NORTHERN** Koegabie Phieska Luckhoff
Wreck Point Lekkersing Aggeneys Lubbeskolk Koegrabie Copperton Strydenburg Petrusville
Port Nolloth Steinkopf Concordia De Naawte Omdraaisvlei Vanderkloof
McDougall's Bay **NAMAQUALAND** Goegap Nature Reserve Verneuk Pan Vosburg Britstown De Aar Philipstown

6 Kleinsee Nababeep Springbok Leeuberg **CAPE** Vanwyksvlei Carnarvon Victoria West Richmond Hanover
Komaggas Buffels 1550 Brandvlei Flaminksvlei Vanwyksvlei Great Karoo Murraysburg KwaZama
Namaqua National Park Kamieskroon Onderstedorings Groot Vloer Sterling Wolston Masinyusane Sabelo KwaZamu
Hondeklipbaai Wallekraal Kamiesberge Nieuwoudtville Calvinia Sak River Fraserburg Toorberg 2280 Graaff-Reinet

30° Garies Loeriesfontein Kootjieskolk Roggeveld Nuweveldberge 1966 1200 Toorberg
ATLANTIC Bitterfontein Calvinia Sutherland Karoo National Park Qubergpas Graaff-Reinet Karoo Nature Reserve
Nuwerus Hardeveld Kareeberge Nuweveldberge Beaufort West Aberdeen
OCEAN Koekenaap Vanrhynsdorp Komsberg Merweville Leeu-Gamka Beervlei Dam Steytler

7 Lutzville Vredendal Doring Tankwa-Karoo National Park Great Karoo Oudtshoorn Cango Caves Willowmore
Klawer Clanwilliam Dam Roggeveldberge Prince Albert Road Swartbergpas Groot Swartberge Koueberge Baviaanskloofberge
Lambert's Bay Sandveld Wuppertal Tweefontein 2325 Prince Albert De Rust Uniondale Tsitsikamma Forest
Baboon Point Olifantsrivierberge Kouebokkeveld Komsberg Laingsburg Klein Karoo Oudtshoorn Haarlem and Coastal National Park

32° St Helena Bay Velddrif Koue Bokkeveld Merweville Little Karoo George National Park Knysna Kruis
Cape St Martin Saldanha Hopefield Moorreesburg Ceres 2250 Touwsrivier Robertson Montagu Oudtshoorn Wilderness National Park Plettenberg Bay
Cape Columbine Saldanha Bay Prince Alfred Hamlet Matroosberg Swartbergpas Barrydale George Cape Seal
Vredenburg West Coast National Park Malmesbury Tulbagh Worcester **WESTERN CAPE** Riversdale Groot Brakrivier Mossel Bay

8 Atlantis Wellington Paarl Robertson McGregor Swellendam Stilbaai Kanonpunt
Durbanville Bellville Stellenbosch Bonnievale Bontebok National Park Port Beaufort De Hoop Nature Reserve
CAPE TOWN Khayelitsha Somerset West Grabouw Caledon Stilbaai St Sebastian Bay
Cape of Good Hope Nature Reserve Strand False Bay Hermanus Bredasdorp Mossel Bay
Cape of Good Hope Hawston Walker Bay Danger Point De Hoop Nature Reserve Waenhuiskrans
Quoin Point Struis Bay Cape Agulhas

A · B · C · D · E · F

14°E 16° 18° 20° 22° 24°

Lambert Azimuthal Equal Area Projection

1:5 000 000

0 100 200 300 miles
0 100 200 300 400 500 km

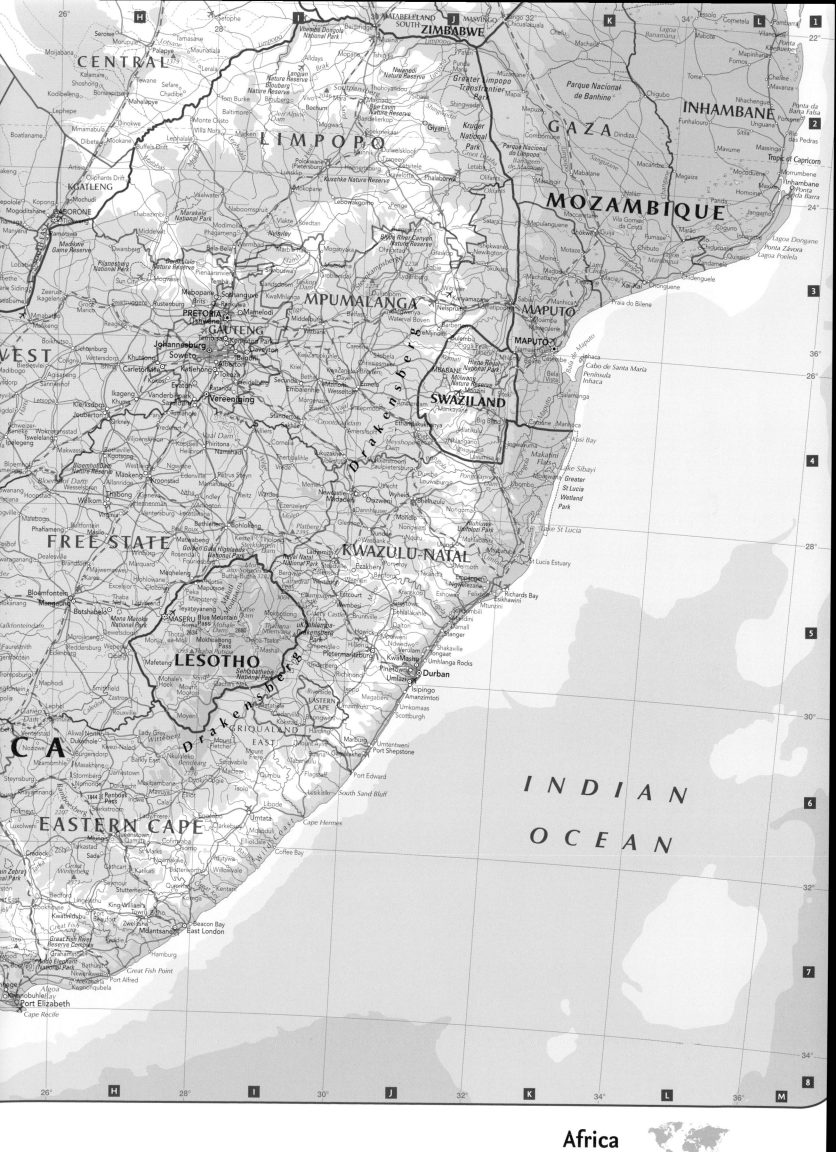

Africa
Republic of South Africa

101

Oceania

Oceania comprises Australia, New Zealand, New Guinea and the islands of the Pacific Ocean. It is the smallest of the world's continents by land area. Its dominating feature is Australia, which is mainly flat and very dry. Australia's western half consists of a low plateau, broken in places by higher mountain ranges, which has very few permanent rivers or lakes. The narrow, fertile coastal plain of the east coast is separated from the interior by the Great Dividing Range, which includes the highest mountain in Australia.

The numerous Pacific islands of Oceania are generally either volcanic in origin or consist of coral. They can be divided into three main regions of Micronesia, north of the equator between Palau and the Gilbert islands; Melanesia, stretching from mountainous New Guinea to Fiji; and Polynesia, covering a vast area of the eastern and central Pacific Ocean.

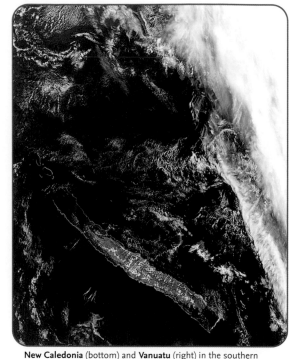

New Caledonia (bottom) and **Vanuatu** (right) in the southern Pacific Ocean.

Facts

- Australia's Great Barrier Reef is the world's largest coral reef and stretches for over 2 000 kilometres

- The highest point of Tuvalu is only 5 metres above sea level

- New Zealand lies directly on the boundary between the Pacific and Indo-Australian tectonic plates

- The Mariana Trench in the Pacific Ocean contains the earth's deepest point – Challenger Deep, 10 920 metres below sea level

Oceania's physical features

Highest mountain	Puncak Jaya, Indonesia	5 030 metres	16 502 feet
Longest river	Murray-Darling, Australia	3 750 km	2 330 miles
Largest lake	Lake Eyre, Australia	0–8 900 sq km	0–3 436 sq miles
Largest island	New Guinea, Indonesia/Papua New Guinea	808 510 sq km	312 166 sq miles
Largest drainage basin	Murray-Darling, Australia	1 058 000 sq km	408 494 sq miles
Lowest point	Lake Eyre, Australia	-16 metres	-53 feet

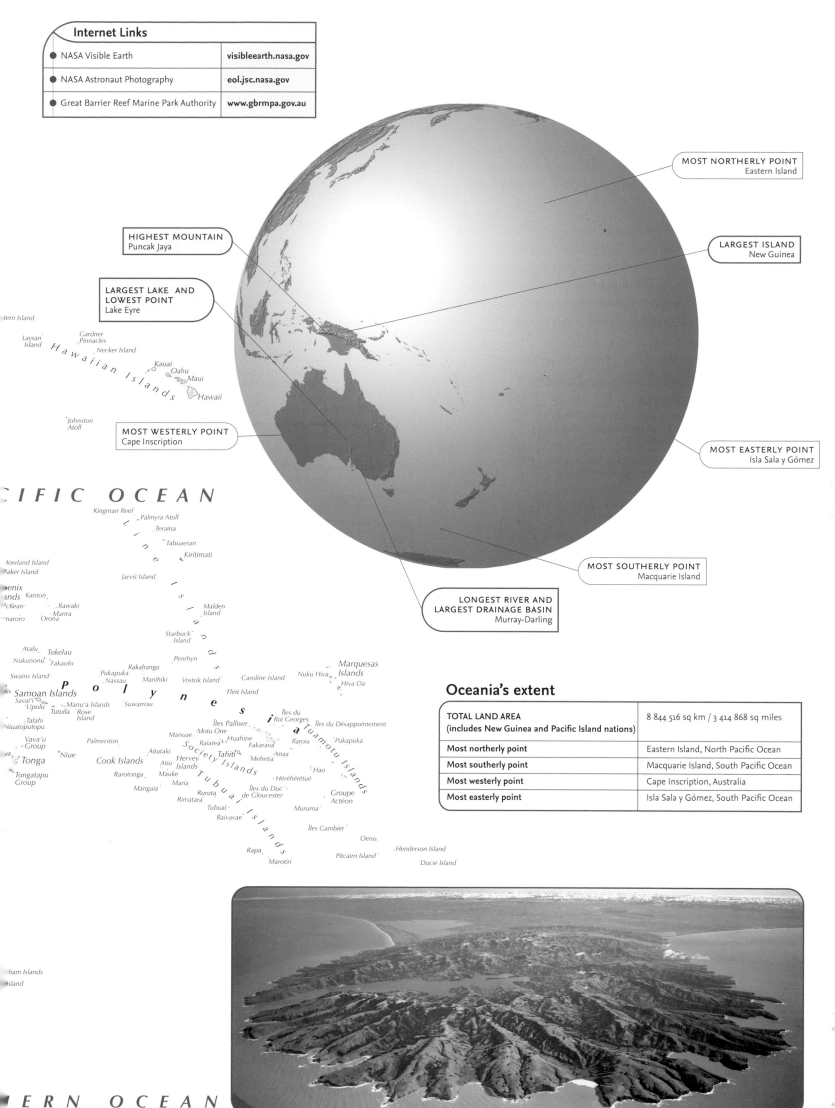

MOST NORTHERLY POINT
Eastern Island

HIGHEST MOUNTAIN
Puncak Jaya

LARGEST ISLAND
New Guinea

LARGEST LAKE AND LOWEST POINT
Lake Eyre

MOST WESTERLY POINT
Cape Inscription

MOST EASTERLY POINT
Isla Sala y Gómez

MOST SOUTHERLY POINT
Macquarie Island

LONGEST RIVER AND LARGEST DRAINAGE BASIN
Murray-Darling

ern Island

Laysan Island

Gardner Pinnacles

Necker Island

Kauai
Oahu
Maui
Hawaii

Hawaiian Islands

Johnston Atoll

CIFIC OCEAN

Kingman Reef *Palmyra Atoll*
Teraina
Tabuaeran
Kiritimati

Howland Island
aker Island
Jarvis Island

Line Islands

enix
nds *Kanton*
cKean *Rawaki*
Manra
naroro *Orona*

Malden Island

Starbuck Island

Atafu
Nukunonu *Tokelau*
Fakaofo
Swains Island

Rakahanga
Pukapuka *Manihiki*
Nassau

Penrhyn

Vostok Island *Caroline Island*

Marquesas Islands
Nuku Hiva
Hiva Oa

is *Samoan Islands*
Savai'i *Manu'a Islands*
Upolu *Tutuila* *Rose Island*
Tafahi
Niuatoputopu

Flint Island

P o l y n e s i a

Suwarrow

Îles du Roi Georges
Îles du Désappointement

Îles Palliser
Motu One
Manuae *Huahine* *Pukapuka*
Raiatea *Fakarava* *Raroia*

Vava'u Group
Niue *Palmerston*
Tonga
Tongatapu Group

Cook Islands
Aitutaki
Atiu
Hervey Islands *Mauke*
Rarotonga
Mangaia *Maria*

Society Islands
Tahiti
Mehetia *Anaa*
Hao
Héréhérétué

Tuamotu Islands

Tubuai Islands

Îles du Duc de Gloucester
Ruritu *Maria*
Rimatara
Tubuai
Raivavae
Rapa
Marotiri

Mururoa

Groupe Actéon

Îles Gambier

Oeno
Henderson Island
Pitcairn Island *Ducie Island*

Oceania's extent

TOTAL LAND AREA (includes New Guinea and Pacific Island nations)	8 844 516 sq km / 3 414 868 sq miles
Most northerly point	Eastern Island, North Pacific Ocean
Most southerly point	Macquarie Island, South Pacific Ocean
Most westerly point	Cape Inscription, Australia
Most easterly point	Isla Sala y Gómez, South Pacific Ocean

ham Islands
Island

ERN OCEAN

The spectacular **Banks Peninsula**, South Island, New Zealand, formed by two overlapping volcanic centres.

Oceania

Stretching across almost the whole width of the Pacific Ocean, Oceania has a great variety of cultures and an enormously diverse range of countries and territories. Australia, by far the largest and most industrialized country in the continent, contrasts with the numerous tiny Pacific island nations which have smaller, and more fragile economies based largely on agriculture, fishing and the exploitation of natural resources.

The division of the Pacific island groups into the main regions of Micronesia, Melanesia and Polynesia – often referred to as the South Sea islands – broadly reflects the ethnological differences across the continent. There is a long history of colonial influence in the region, which still contains dependent territories belonging to Australia, France, New Zealand, the UK and the USA.

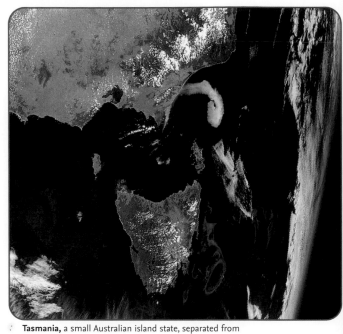

Tasmania, a small Australian island state, separated from the mainland by the Bass Strait.

Facts

- Over 91% of Australia's population live in urban areas

- The Maori name for New Zealand is Aotearoa, meaning 'land of the long white cloud'

- Auckland, New Zealand, has the largest Polynesian population of any city in Oceania

- Over 800 different languages are spoken in Papua New Guinea

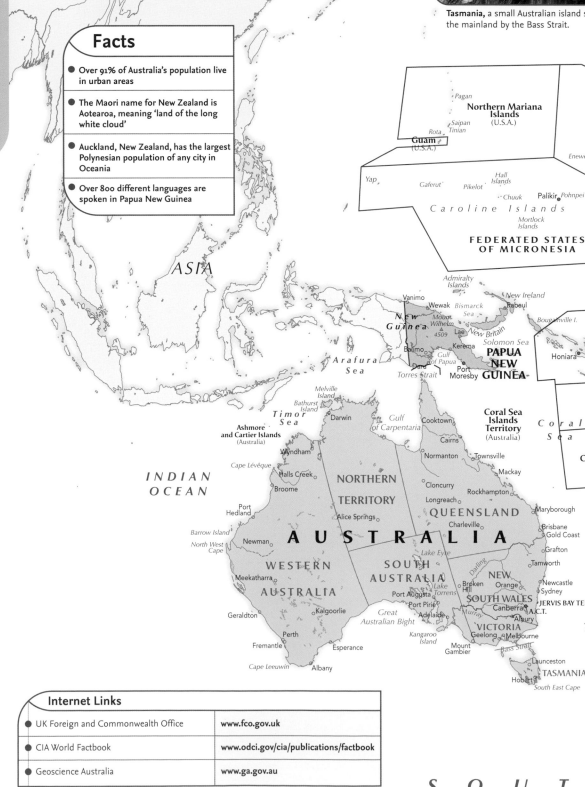

Internet Links

UK Foreign and Commonwealth Office	www.fco.gov.uk
CIA World Factbook	www.odci.gov/cia/publications/factbook
Geoscience Australia	www.ga.gov.au

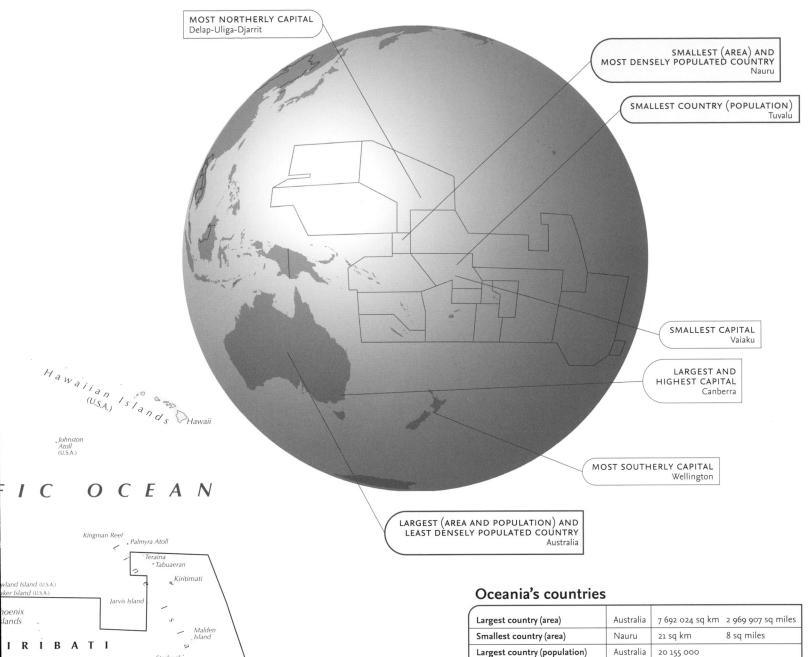

MOST NORTHERLY CAPITAL
Delap-Uliga-Djarrit

SMALLEST (AREA) AND
MOST DENSELY POPULATED COUNTRY
Nauru

SMALLEST COUNTRY (POPULATION)
Tuvalu

SMALLEST CAPITAL
Vaiaku

LARGEST AND
HIGHEST CAPITAL
Canberra

MOST SOUTHERLY CAPITAL
Wellington

LARGEST (AREA AND POPULATION) AND
LEAST DENSELY POPULATED COUNTRY
Australia

Hawaiian Islands
(U.S.A.)
Hawaii

Johnston
Atoll
(U.S.A.)

FIC OCEAN

Kingman Reef
Palmyra Atoll

Teraina
Tabuaeran

Kiritimati

wland Island (U.S.A.)
ker Island (U.S.A.)

Jarvis Island

hoenix
slands

Malden
Island

KIRIBATI

Starbuck
Island

Tokelau
(N.Z.)

Penrhyn

Samoan Islands

Nuku Hiva
Hiva Oa
Marquesas
Islands

SAMOA
Savai'i
'Upolu
Apia
Manu'a
Islands

Îles du
Roi Georges

American
Samoa
(U.S.A.)

Îles Palliser

Tuamotu Islands

Vava'u
Group

Cook
Islands
(N.Z.)

Aitutaki

Society Islands
Tahiti
Moorea
Hervey
Islands

Alofi
Niue
(N.Z.)

French

TONGA
Nuku'alofa

Rarotonga

Îles du Duc
de Gloucester

Groupe
Actéon

Tongatapu
Group

Tubuai Islands

Tubuai

Mururoa

Polynesia

Îles Gambier

Pitcairn Is
(U.K.) Henderson Island

Rapa

Pitcairn Island

Oceania's countries

Largest country (area)	Australia	7 692 024 sq km	2 969 907 sq miles
Smallest country (area)	Nauru	21 sq km	8 sq miles
Largest country (population)	Australia	20 155 000	
Smallest country (population)	Tuvalu	10 000	
Most densely populated country	Nauru	619 per sq km	1 625 per sq mile
Least densely populated country	Australia	3 per sq km	7 per sq mile

Oceania's capitals

Largest capital (population)	Canberra, Australia	381 000
Smallest capital (population)	Vaiaku, Tuvalu	516
Most northerly capital	Delap-Uliga-Djarrit, Marshall Islands	7° 7'N
Most southerly capital	Wellington, New Zealand	41° 18'S
Highest capital	Canberra, Australia	581 metres 1 906 feet

ham Islands

OCEAN

Tahiti and Moorea, islands in the Society Islands group which form
part of the dependent territory of French Polynesia.

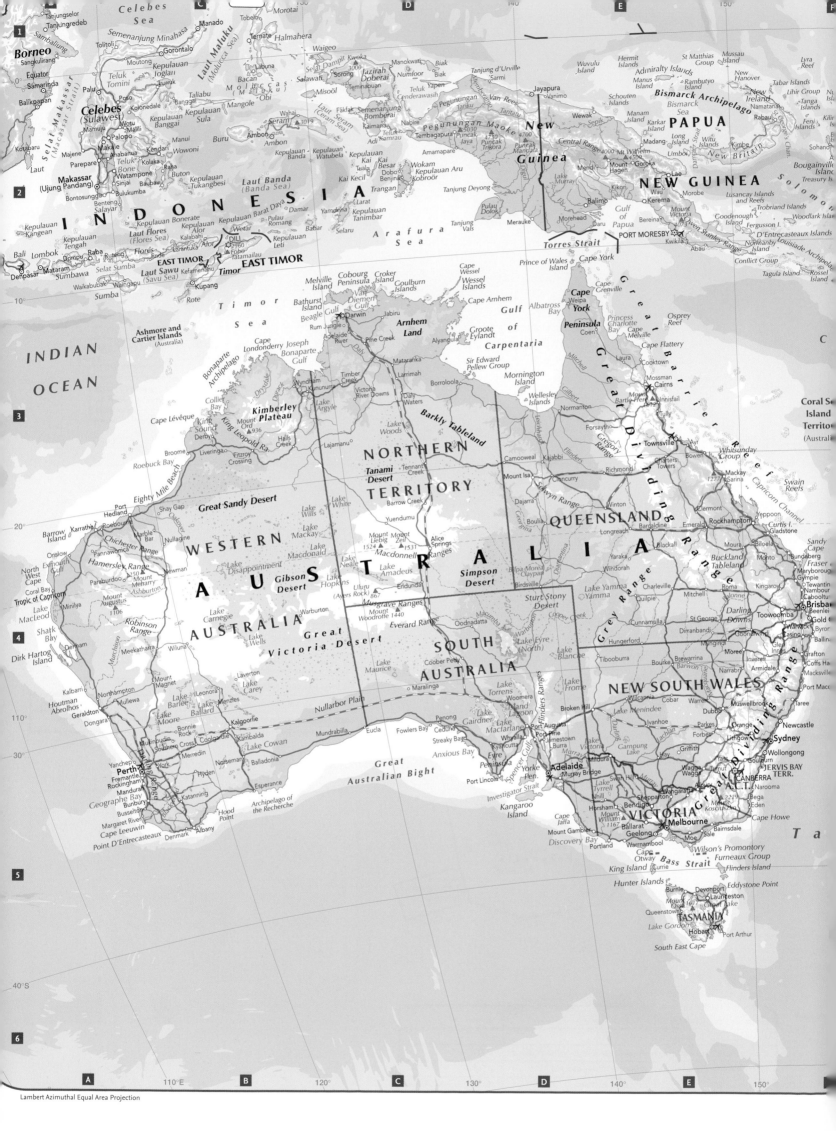

Lambert Azimuthal Equal Area Projection

1:20 000 000

| | 0 | 200 | 400 | 600 miles |
| | 0 | 200 | 400 | 600 | 800 | 1000 km |

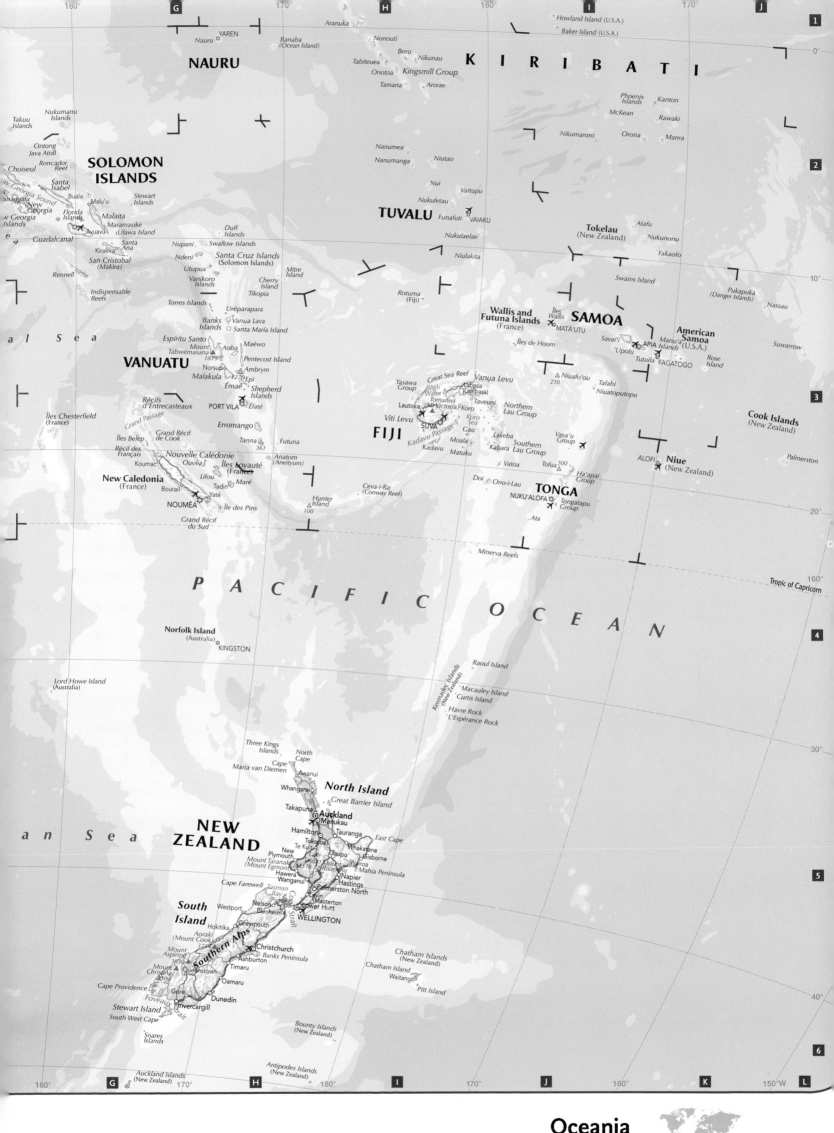

Howland Island (U.S.A.)

Aranuka

Baker Island (U.S.A.)

Nonouti

K I R I B A T I

Nauru

YAREN

Banaba
(Ocean Island)

Beru

Nikunau

Tabiteuea

Onotoa

NAURU

Kingsmill Group

Tamana

Arorae

Phoenix
Islands

Kanton

McKean

Rawaki

Takuu
Islands

Nukumanu
Islands

Orona

Manra

Ontong
Java Atoll

Nanumea

Nikumaroro

Roncador
Reef

Choiseul

**SOLOMON
ISLANDS**

Nanumanga

Niutao

Santa
Isabel

W. Georgia Sound

Nui

Vaitupu

New
Georgia

Buala

Stewart
Islands

Nukufetau

W. Georgia
Islands

Malu'u

Malaita

Duff
Islands

TUVALU

Funafuti

VAIAKU

Tokelau
(New Zealand)

Atafu

Florida
Islands

Maramasike

Ulawa Island

Nukunonu

Guadalcanal

Aywu

Ulawa Island

Nupani

Swallow Islands

Nukulaelae

Fakaofo

Kirakira

Santa
Ana

Ndeni

Santa Cruz Islands
(Solomon Islands)

Niulakita

Swains Island

San Cristobal
(Makira)

Utupua

Mitre
Island

Rennell

Vanikoro
Islands

Rotuma
(Fiji)

Pukapuka
(Danger Islands)

Nassau

Indispensable
Reefs

Torres Islands

Tikopia

Wallis and
Futuna Islands
(France)

Îles
Wallis

SAMOA

Suwarrow

al Sea

Uréparapara

MATÀ'UTU

Banks
Islands

Vanua Lava

Îles de Hoorn

Savai'i

Manu'a
Islands

American
Samoa
(U.S.A.)

Espíritu Santo

Santa María Island

APIA

Mount
Tabwémasana

Aoba

Maéwo

'Upolu

Tutuila

Rose
Island

1879

Great Sea Reef

Vanua Levu

FAGATOGO

VANUATU

Pentecost Island

Yasawa
Group

Labasa
(Lambasa)

Niuafo'ou

Tafahi

Norsup

Ambrym

Bligh
Water

210

Niuatoputapu

Malakula

Épi

Tomanivi

Taveuni

Northern
Lau Group

Émaé

Shepherd
Islands

Victoria

Koro

Cook Islands
(New Zealand)

Récifs
d'Entrecasteaux

PORT VILA

Éfaté

Viti Levu

Lautoka

Koro
Sea

Îles Chesterfield
(France)

Erromango

FIJI

SUVA

Gau

Lakeba

Southern
Lau Group

Grand Récif
de Cook

Tanna

Futuna

Kadavu Passage

Moala

Vava'u
Group

Îles Belep

361

Anatom
(Aneityum)

Kadavu

Matuku

Kabara

Niue
(New Zealand)

Récif des
Français

Nouvelle Calédonie

Îles Loyauté
(France)

Ceva-i-Ra
(Conway Reef)

Vatoa

Tofua

500

Ha'apai
Group

ALOFI

Koumac

Ouvéa

Doi

Ono-i-Lau

ALOFI

New Caledonia
(France)

Lifou

Hunter
Island

Palmerston

Bourail

Tadin

Maré

Ono-i-Lau

TONGA

NOUMÉA

Yaté

Île des Pins

NUKU'ALOFA

Tongatapu
Group

Grand Récif
du Sud

100

Ata

Minerva Reefs

Tropic of Capricorn

P A C I F I C

Norfolk Island
(Australia)

KINGSTON

O C E A N

Lord Howe Island
(Australia)

an Sea

Raoul Island

Kermadec Islands
(New Zealand)

Macauley Island

Curtis Island

Havre Rock

L'Espérance Rock

Three Kings
Islands

Cape
North
Cape

Maria van Diemen

Awanui

Whangarei

North Island

Takapuna

Great Barrier Island

Auckland

Manukau

Hamilton

Tauranga

East Cape

**NEW
ZEALAND**

Te Kuiti

Tokoroa

Whakatane

Taupo

Gisborne

New
Plymouth

Mount Taranaki
(Mount Egmont)

Ruapehu

Rotorua

Mahia Peninsula

Hawera

Napier

Cape Farewell

Wanganui

Hastings

Tasman
Bay

Palmerston North

Nelson

Levin

Masterton

**South
Island**

Westport

Blenheim

Lower Hutt

WELLINGTON

Hokitika

Greymouth

Cook Strait

Chatham Islands
(New Zealand)

Aoraki
(Mount Cook)

Southern Alps

Christchurch

Banks Peninsula

Mount
Aspiring

Ashburton

Chatham Island

3030

Timaru

Waitangi

Pitt Island

Mount
Christina

Queenstown

2502

Oamaru

Cape Providence

Gore

Dunedin

Foveaux Strait

Invercargill

Stewart Island

Bounty Islands
(New Zealand)

South West Cape

Snares
Islands

Antipodes Islands
(New Zealand)

Auckland Islands
(New Zealand)

Oceania

Australia, New Zealand and Southwest Pacific

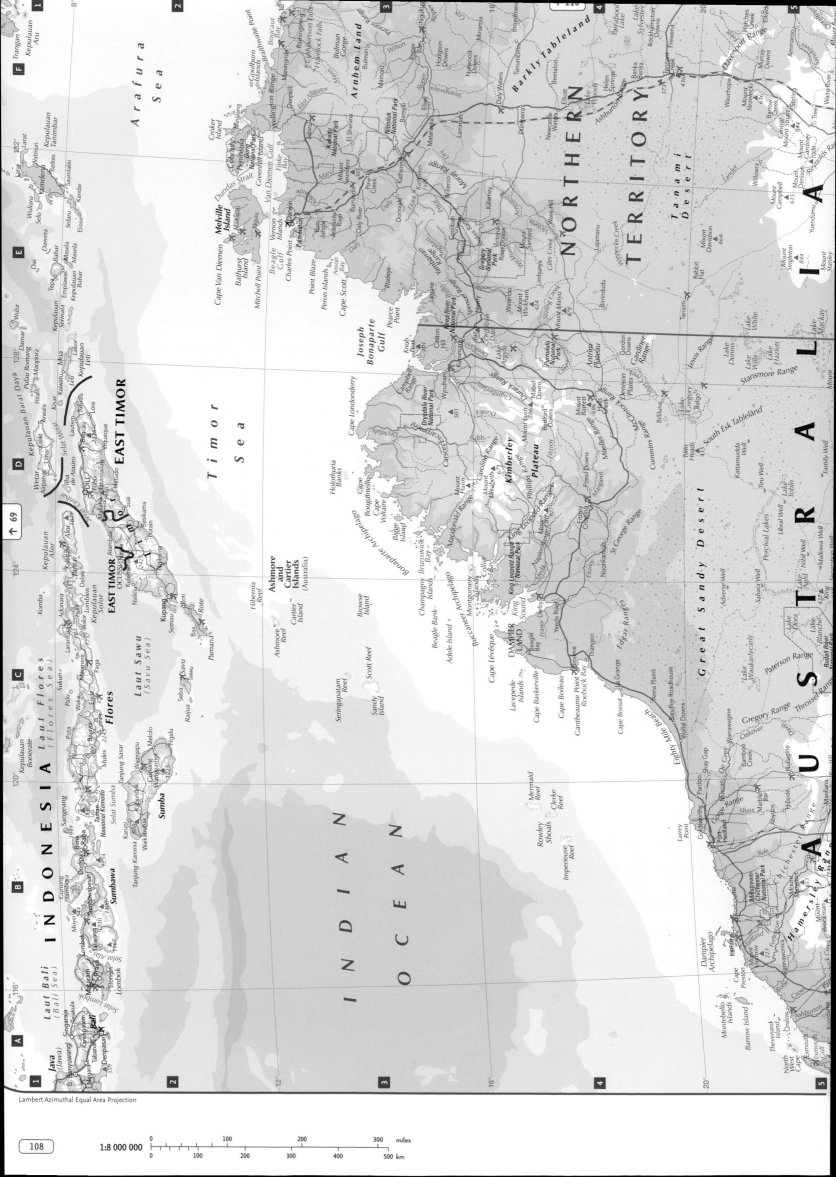

Lambert Azimuthal Equal Area Projection

1:8 000 000

0 100 200 300 miles

0 100 200 300 400 500 km

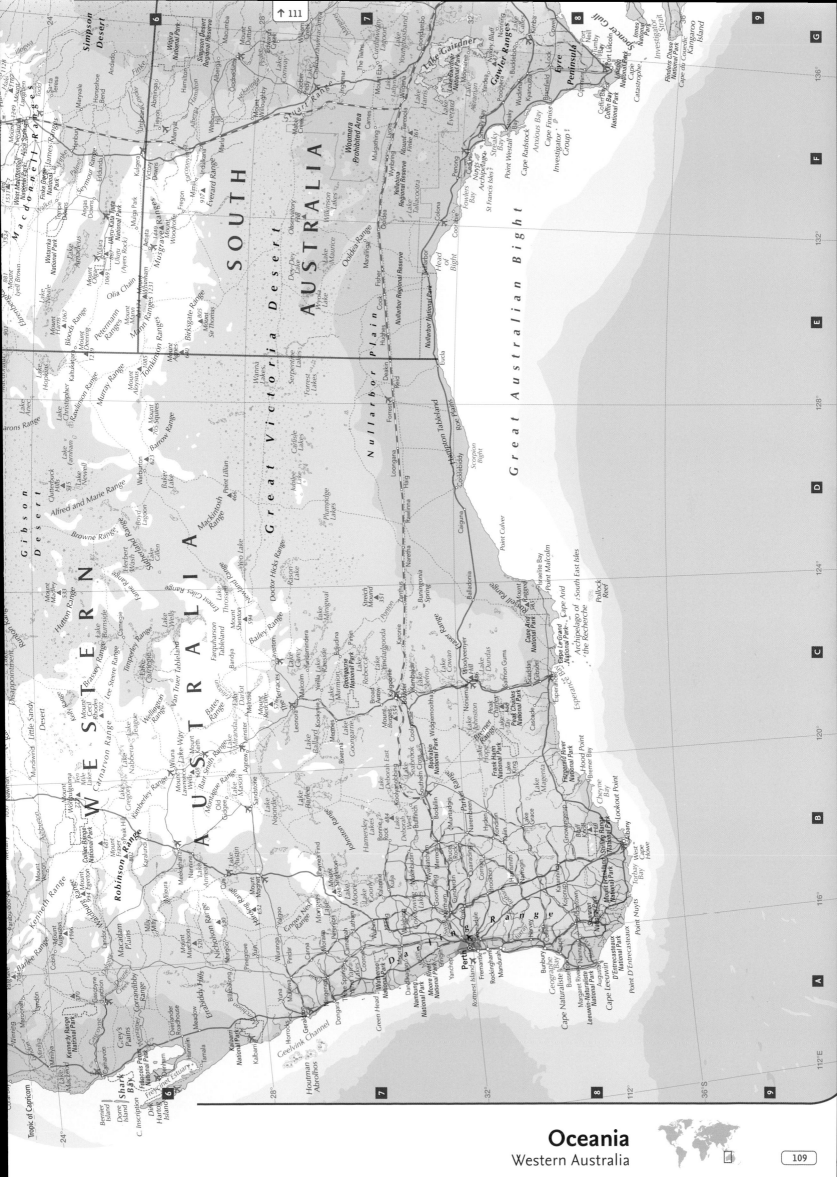

Oceania
Western Australia

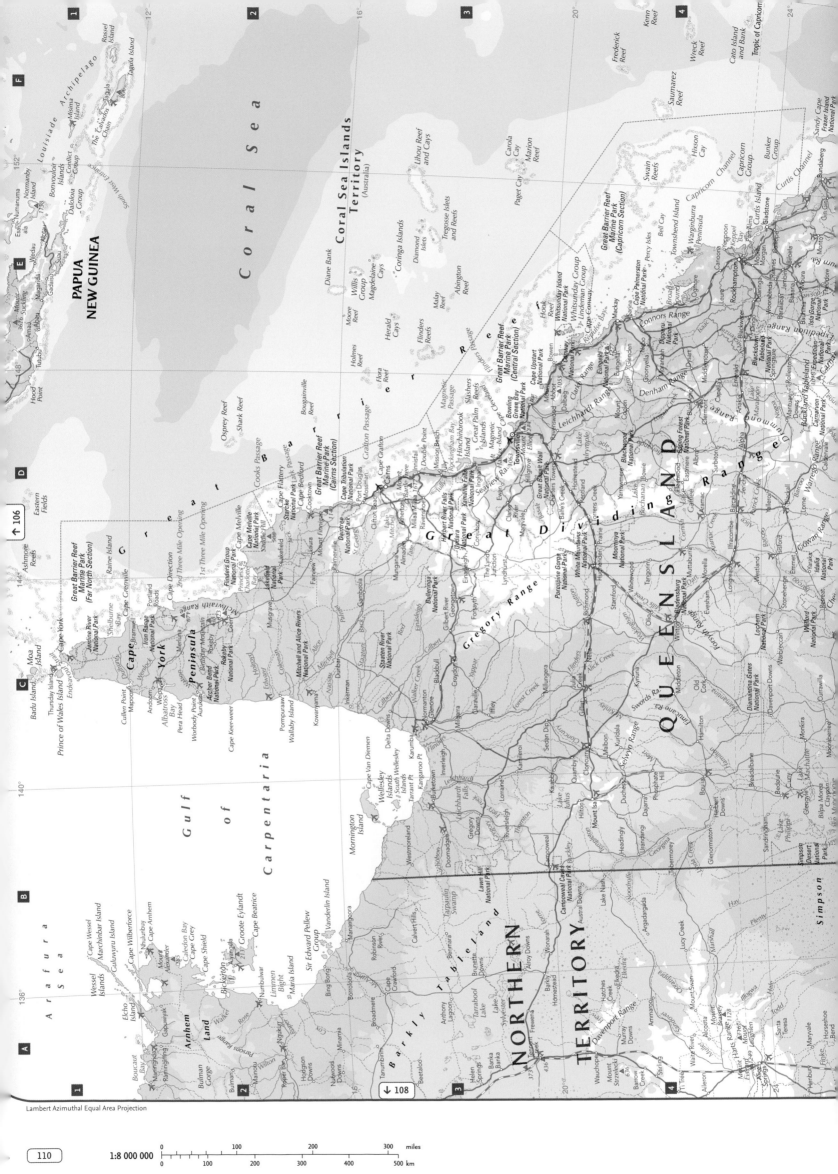

Lambert Azimuthal Equal Area Projection

1:8 000 000

| 0 | 100 | 200 | 300 | miles |
| 0 | 100 | 200 | 300 | 400 | 500 km |

PAPUA
NEW GUINEA

Coral Sea Islands
Territory
(Australia)

Coral Sea

Arafura Sea

Gulf

of

Carpentaria

Cape York
Peninsula

NORTHERN
TERRITORY

QUEENSLAND

Great Dividing Range

Barkly Tableland

Arnhem Land

Simpson
Desert

Great Barrier Reef

← 106

↓ 108

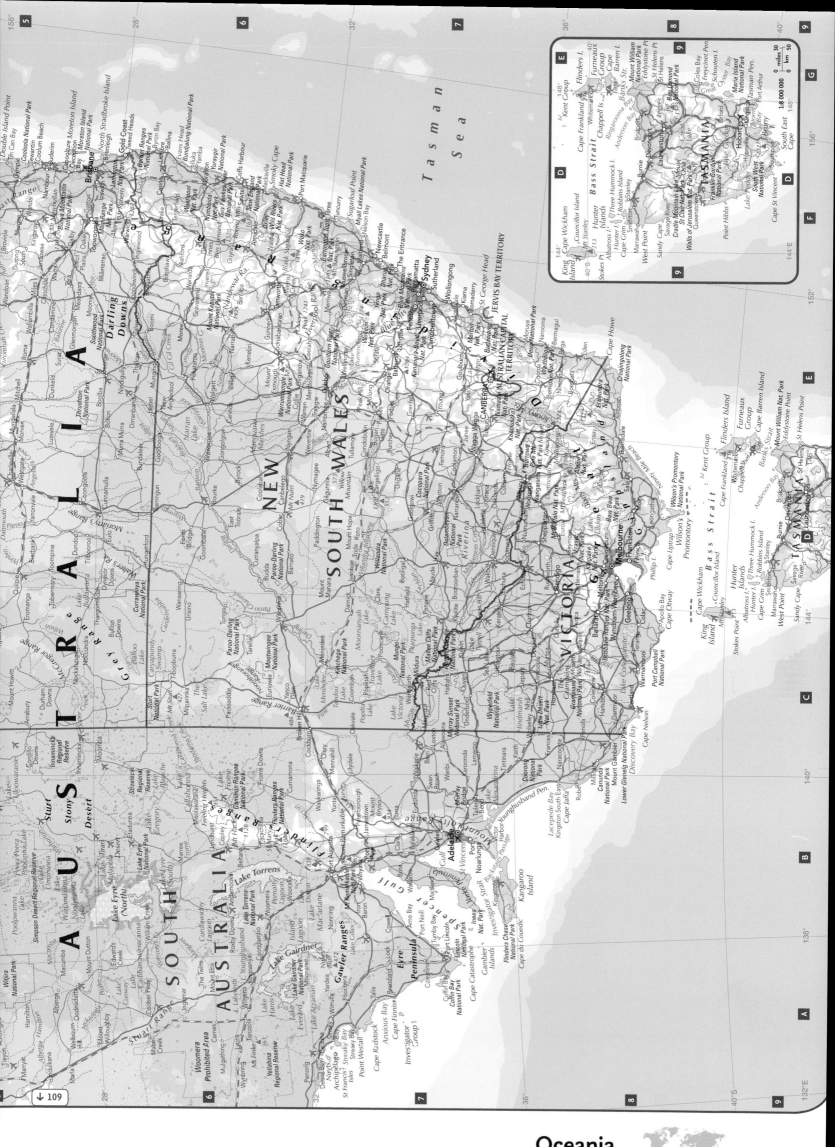

Oceania
Eastern Australia

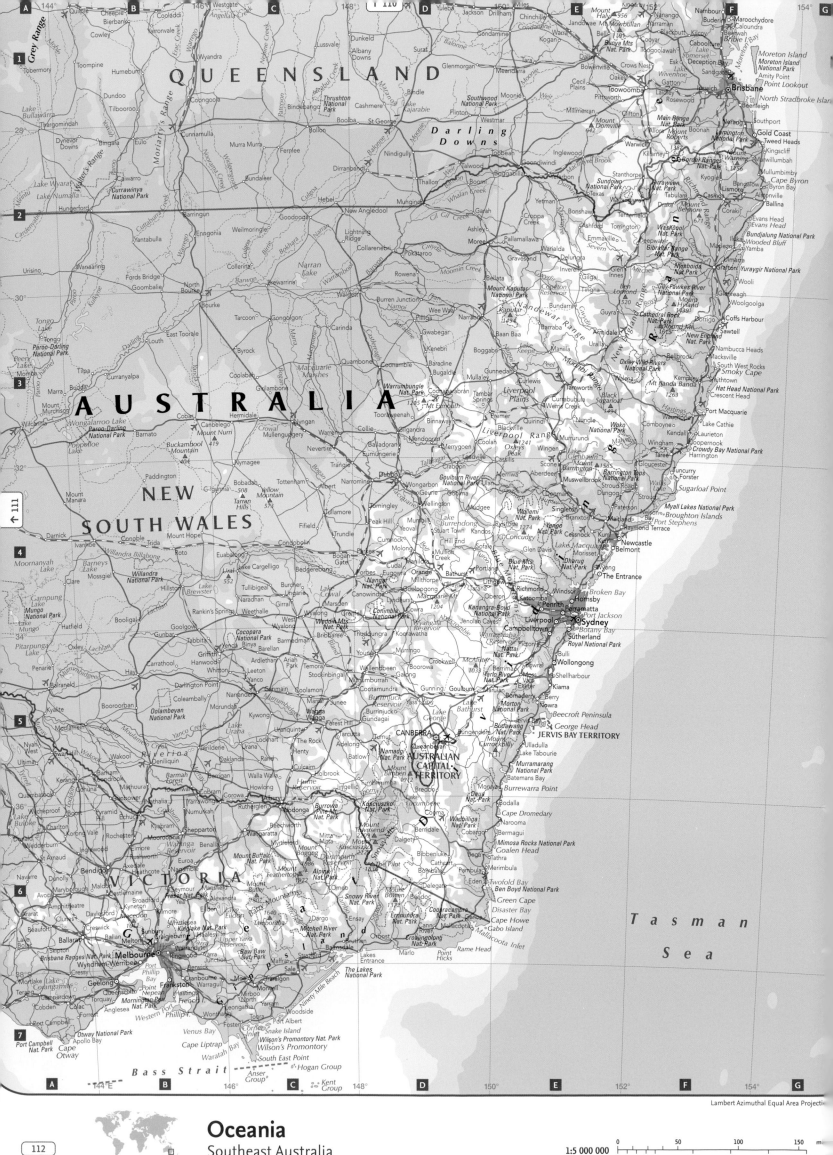

Oceania
Southeast Australia

1:5 000 000

Lambert Azimuthal Equal Area Projection

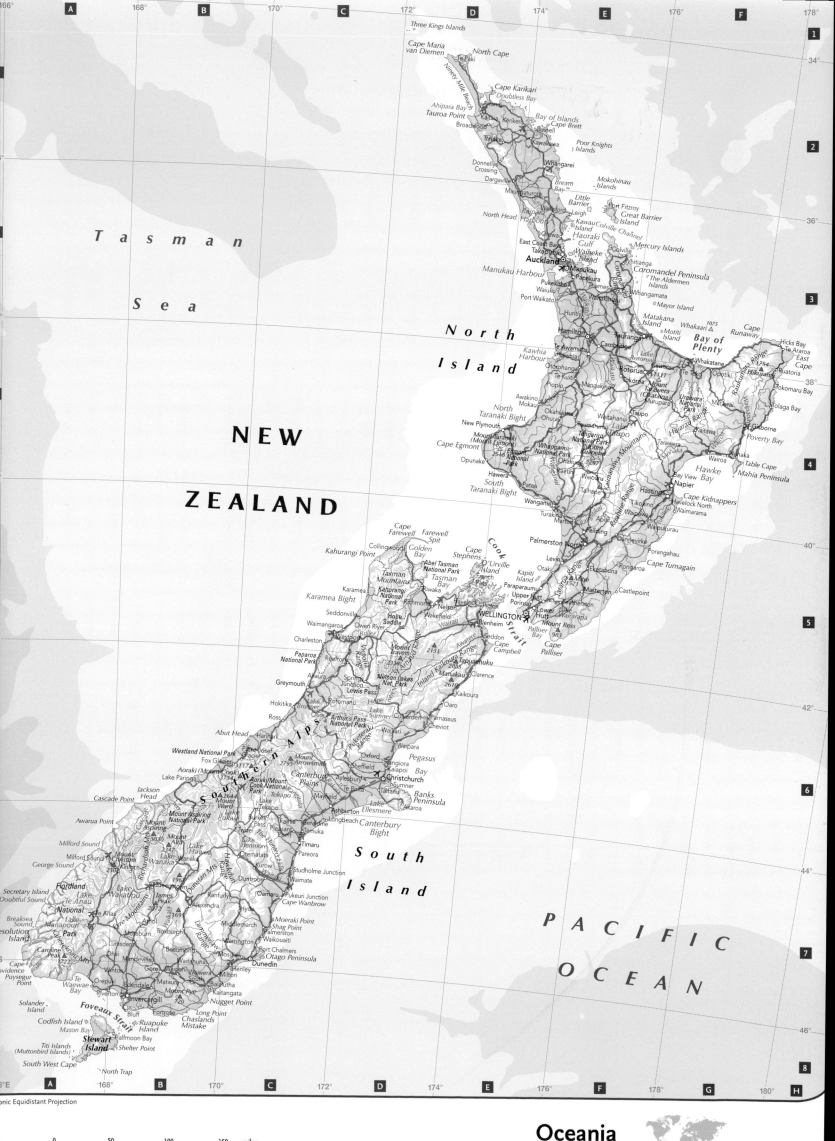

NEW ZEALAND

Oceania
New Zealand

North America

North America, the world's third largest continent, supports a wide range of landscapes from the Arctic north to sub-tropical Central America. The main physiographic regions of the continent are the mountains of the west coast, stretching from Alaska in the north to Mexico and Central America in the south; the vast, relatively flat Canadian Shield; the Great Plains which make up the majority of the interior; the Appalachian Mountains in the east; and the Atlantic coastal plain.

These regions contain some significant physical features, including the Rocky Mountains, the Great Lakes – three of which are amongst the five largest lakes in the world – and the Mississippi-Missouri river system which is the world's fourth longest river. The Caribbean Sea contains a complex pattern of islands, many volcanic in origin, and the continent is joined to South America by the narrow Isthmus of Panama.

Internet Links	
● NASA Visible Earth	**visibleearth.nasa.gov**
● U.S. Geological Survey	**www.usgs.gov**
● Natural Resources Canada	**www.nrcan-rncan.gc.ca**
● SPOT Image satellite imagery	**www.spotimage.fr**

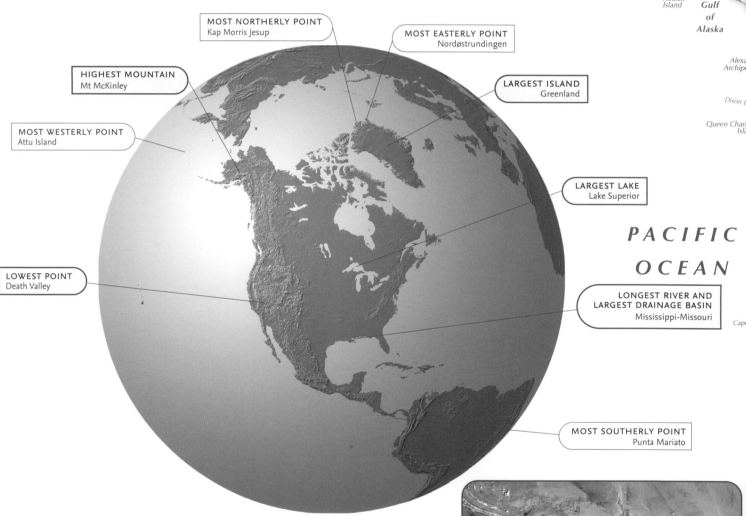

MOST NORTHERLY POINT
Kap Morris Jesup

MOST EASTERLY POINT
Nordøstrundingen

HIGHEST MOUNTAIN
Mt McKinley

LARGEST ISLAND
Greenland

MOST WESTERLY POINT
Attu Island

LARGEST LAKE
Lake Superior

LOWEST POINT
Death Valley

LONGEST RIVER AND LARGEST DRAINAGE BASIN
Mississippi-Missouri

MOST SOUTHERLY POINT
Punta Mariato

North America's physical features

Highest mountain	Mt McKinley, USA	6 194 metres	20 321 feet
Longest river	Mississippi-Missouri, USA	5 969 km	3 709 miles
Largest lake	Lake Superior, Canada/USA	82 100 sq km	31 699 sq miles
Largest island	Greenland	2 175 600 sq km	839 999 sq miles
Largest drainage basin	Mississippi-Missouri, USA	3 250 000 sq km	1 254 825 sq miles
Lowest point	Death Valley, USA	-86 metres	-282 feet

North America's longest river system, the **Mississippi-Missouri**, flows into the Gulf of Mexico through the Mississippi Delta.

North America's extent

TOTAL LAND AREA (including Hawaiian Islands)	24 680 331 sq km / 9 529 076 sq miles
Most northerly point	Kap Morris Jesup, Greenland
Most southerly point	Punta Mariato, Panama
Most westerly point	Attu Island, USA
Most easterly point	Nordostrundingen, Greenland

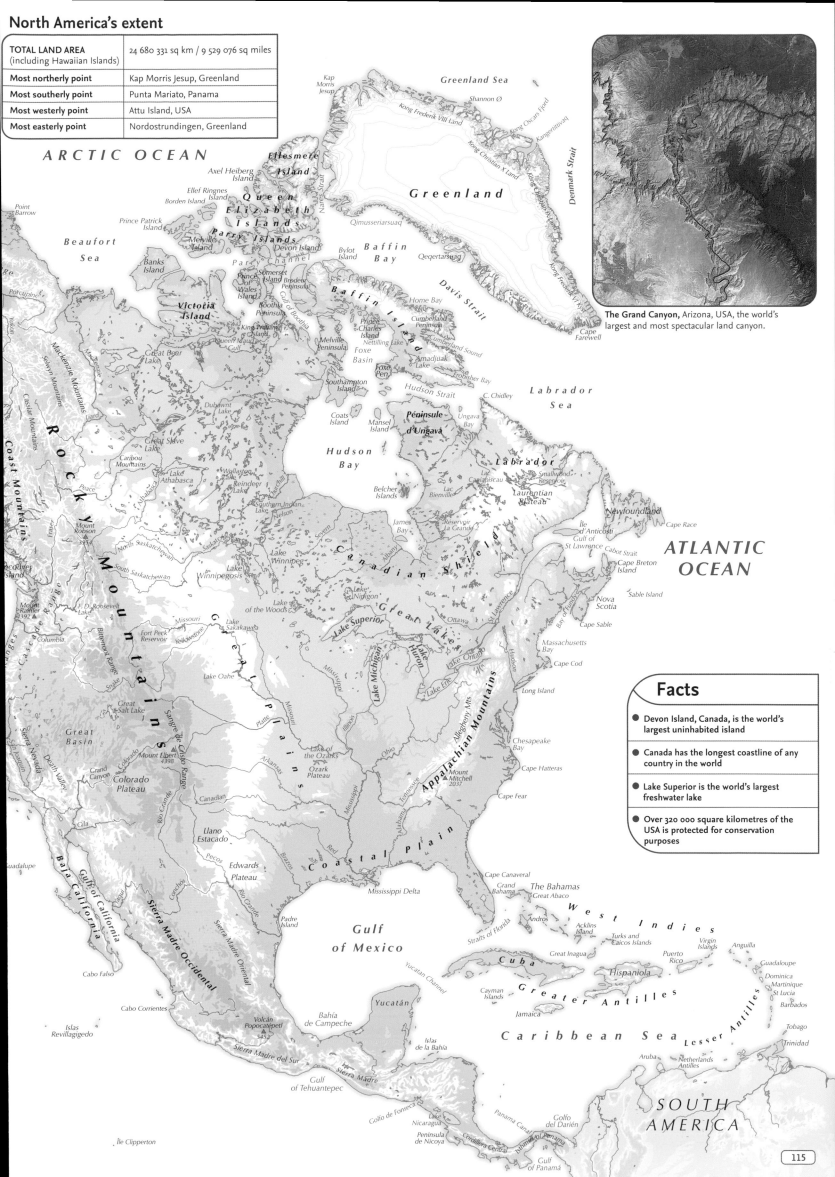

The Grand Canyon, Arizona, USA, the world's largest and most spectacular land canyon.

ARCTIC OCEAN

Point Barrow

Kap Morris Jesup

Greenland Sea

Shannon Ø

Kong Frederik VIII Land

Kong Oscars Fjord

Kangertittivaq

Denmark Strait

Ellesmere Island

Axel Heiberg Island

Ellef Ringnes Island

Borden Island

Prince Patrick Island

Queen Elizabeth Islands

Parry Islands

Melville Island

Devon Island

Greenland

Kong Christian X Land

Kong Christian IX Land

Qimusseriarsuaq

Kong Frederik VI Kyst

Beaufort Sea

Banks Island

Victoria Island

Somerset Island

Prince of Wales Island

King William Island

Boothia Peninsula

Gulf of Boothia

Brodeur Peninsula

Parry Channel

Bylot Island

Baffin Bay

Devon Island

Baffin Island

Home Bay

Davis Strait

Cape Farewell

Mackenzie Mountains

Selwyn Mountains

Cassiar Mountains

Liard

Mackenzie

Great Bear Lake

Melville Peninsula

Prince Charles Island

Nettilling Lake

Foxe Basin

Foxe Pen.

Cumberland Peninsula

Cumberland Sound

Amadjuak Lake

Frobisher Bay

Labrador Sea

Peace

Great Slave Lake

Caribou Mountains

Lake Athabasca

Wollaston Lake

Reindeer Lake

Southampton Island

Coats Island

Mansel Island

Hudson Strait

Ungava Bay

C. Chidley

Péninsule d'Ungava

Coast Mountains

Fraser

Mount Robson 3954

North Saskatchewan

South Saskatchewan

Athabasca

Churchill

Southern Indian Lake

Nelson

Hudson Bay

Belcher Islands

Lac Bienville

James Bay

Réservoir La Grande 2

Albany

Lac Caniapiscau

Smallwood Reservoir

Labrador

Laurentian Plateau

ROCKY MOUNTAINS

Vancouver Island

F. D. Roosevelt Lake

Columbia

Mount Rainier 4392

Canadian Shield

Severn

Lake Winnipeg

Lake Winnipegosis

Lake of the Woods

Lake Nipigon

Great Lakes

Lake Superior

Newfoundland

Île d'Anticosti

Gulf of St Lawrence

Cabot Strait

Cape Breton Island

Cape Race

ATLANTIC OCEAN

Cascade Range

Snake

Fort Peck Reservoir

Yellowstone

Missouri

Lake Sakakawea

Lake Oahe

Great Plains

Lake Michigan

Lake Huron

Lake Erie

Lake Ontario

Ottawa

St Lawrence

Hudson

Massachusetts Bay

Cape Cod

Sable Island

Nova Scotia

Bay of Fundy

Cape Sable

Columbia

Platte

Missouri

Illinois

Ohio

Allegheny Mts

Appalachian Mountains

Long Island

Chesapeake Bay

Facts

● Devon Island, Canada, is the world's largest uninhabited island

● Canada has the longest coastline of any country in the world

● Lake Superior is the world's largest freshwater lake

● Over 320 000 square kilometres of the USA is protected for conservation purposes

Great Salt Lake

Sierra Nevada

San Joaquin

Great Basin

Sangre de Cristo Range

Mount Elbert 4398

Colorado

Grand Canyon

Colorado Plateau

Lake of the Ozarks

Ozark Plateau

Arkansas

Tennessee

Alabama

Mount Mitchell 2037

Cape Hatteras

Cape Fear

Death Valley

Guadalupe

Baja California

Gulf of California

Canadian

Llano Estacado

Pecos

Edwards Plateau

Brazos

Conchos

Rio Grande

Coastal Plain

Red

Mississippi

Mississippi Delta

Cape Canaveral

Grand Bahama

The Bahamas

Great Abaco

West Indies

Cabo Falso

Cabo Corrientes

Sierra Madre Occidental

Gila

Sierra Madre Oriental

Padre Island

Gulf of Mexico

Straits of Florida

Andros

Acklins Island

Turks and Caicos Islands

Virgin Islands

Puerto Rico

Anguilla

Cayman Islands

Cuba

Great Inagua

Guadaloupe

Dominica

Martinique

St Lucia

Barbados

Islas Revillagigedo

Yucatán

Bahía de Campeche

Volcán Popocatépetl 5452

Jamaica

Hispaniola

Greater Antilles

Caribbean Sea

Lesser Antilles

Tobago

Trinidad

Islas de la Bahía

Sierra Madre del Sur

Sierra Madre

Gulf of Tehuantepec

Golfo de Fonseca

Lake Nicaragua

Panama Canal

Golfo del Darién

SOUTH AMERICA

Île Clipperton

Peninsula de Nicoya

Cordillera Central

Isthmus of Panama

Gulf of Panamá

Aruba

Netherlands Antilles

North America

North America has been dominated economically and politically by the USA since the nineteenth century. Before that, the continent was subject to colonial influences, particularly of Spain in the south and of Britain and France in the east. The nineteenth century saw the steady development of the western half of the continent. The wealth of natural resources and the generally temperate climate were an excellent basis for settlement, agriculture and industrial development which has led to the USA being the richest nation in the world today.

Although there are twenty three independent countries and fourteen dependent territories in North America, Canada, Mexico and the USA have approximately eighty five per cent of the continent's population and eighty eight per cent of its land area. Large parts of the north remain sparsely populated, while the most densely populated areas are in the northeast USA, and the Caribbean.

North America's capitals

Largest capital (population)	Mexico City, Mexico	19 013 000	
Smallest capital (population)	Belmopan, Belize	13 500	
Most northerly capital	Ottawa, Canada	45° 25'N	
Most southerly capital	Panama City, Panama	8° 56'N	
Highest capital	Mexico City, Mexico	2 300 metres	7 546 feet

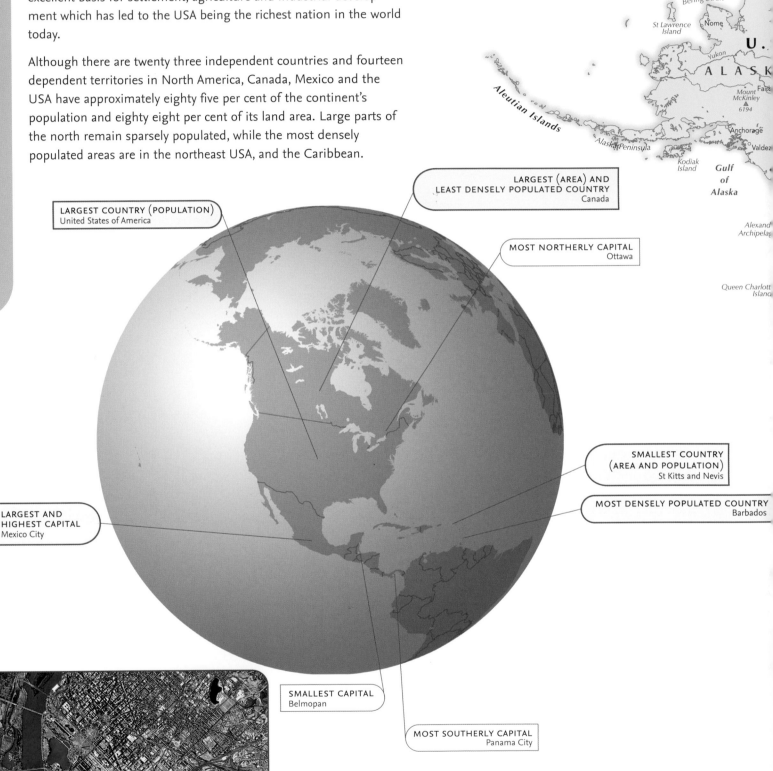

LARGEST COUNTRY (POPULATION)
United States of America

LARGEST (AREA) AND
LEAST DENSELY POPULATED COUNTRY
Canada

MOST NORTHERLY CAPITAL
Ottawa

SMALLEST COUNTRY
(AREA AND POPULATION)
St Kitts and Nevis

MOST DENSELY POPULATED COUNTRY
Barbados

LARGEST AND
HIGHEST CAPITAL
Mexico City

SMALLEST CAPITAL
Belmopan

MOST SOUTHERLY CAPITAL
Panama City

Washington DC, a leading international political centre and capital city of the United States.

North America's countries

Largest country (area)	Canada	9 984 670 sq km	3 855 103 sq miles
Smallest country (area)	St Kitts and Nevis	261 sq km	101 sq miles
Largest country (population)	United States of America	298 213 000	
Smallest country (population)	St Kitts and Nevis	43 000	
Most densely populated country	Barbados	628 per sq km	1 627 per sq mile
Least densely populated country	Canada	3 per sq km	8 per sq mile

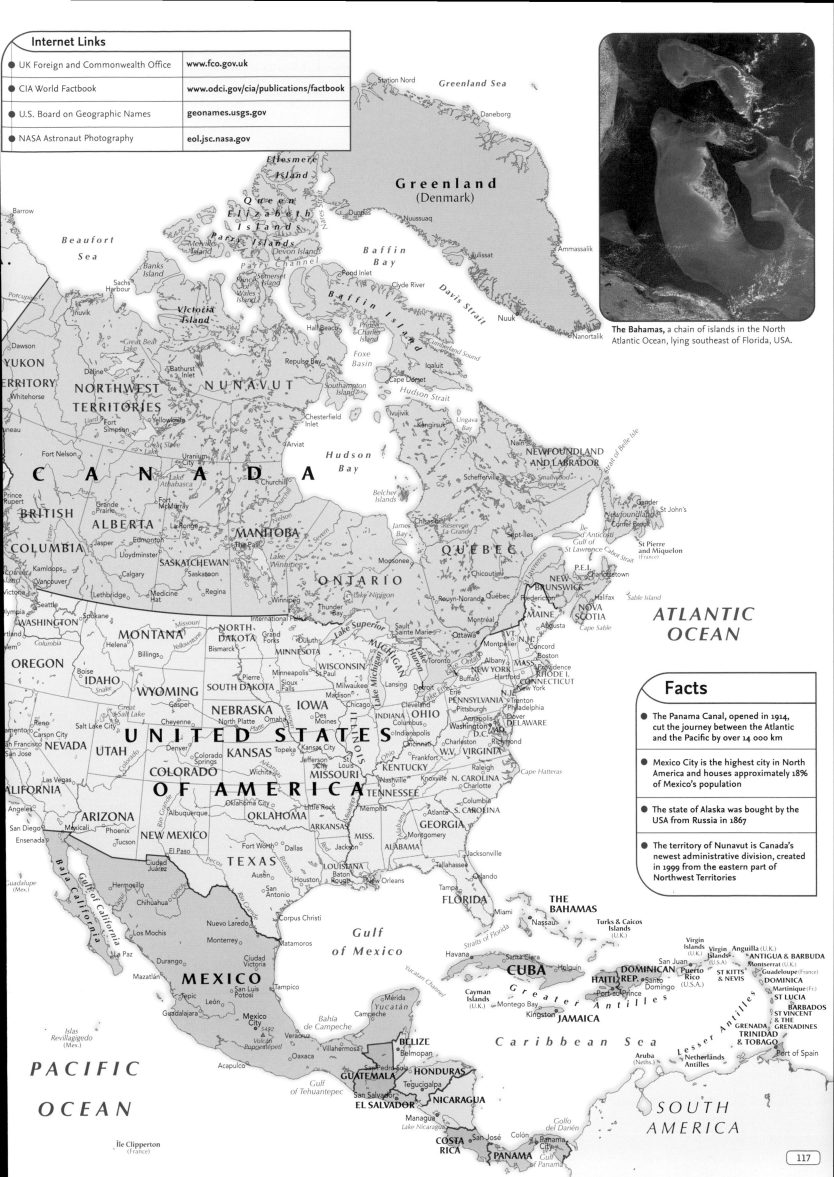

Internet Links

● UK Foreign and Commonwealth Office	www.fco.gov.uk
● CIA World Factbook	www.odci.gov/cia/publications/factbook
● U.S. Board on Geographic Names	geonames.usgs.gov
● NASA Astronaut Photography	eol.jsc.nasa.gov

The Bahamas, a chain of islands in the North Atlantic Ocean, lying southeast of Florida, USA.

Facts

- The Panama Canal, opened in 1914, cut the journey between the Atlantic and the Pacific by over 14 000 km

- Mexico City is the highest city in North America and houses approximately 18% of Mexico's population

- The state of Alaska was bought by the USA from Russia in 1867

- The territory of Nunavut is Canada's newest administrative division, created in 1999 from the eastern part of Northwest Territories

117

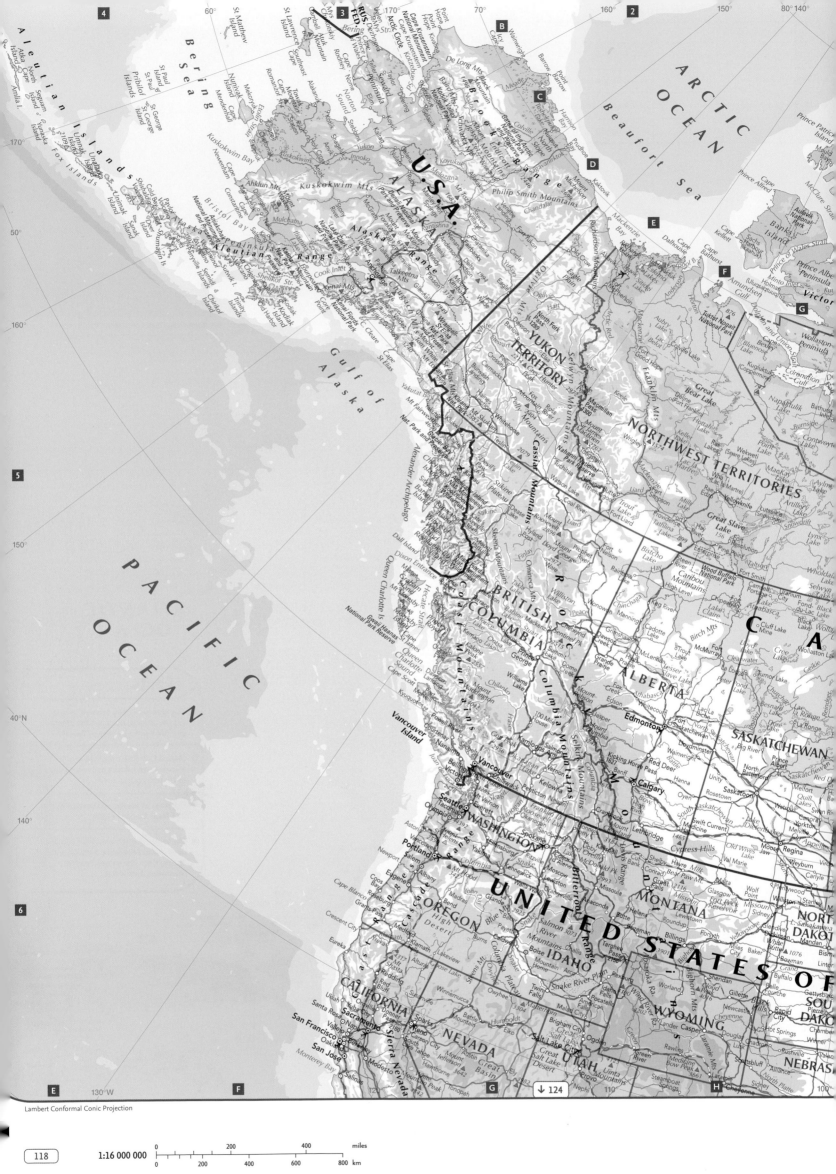

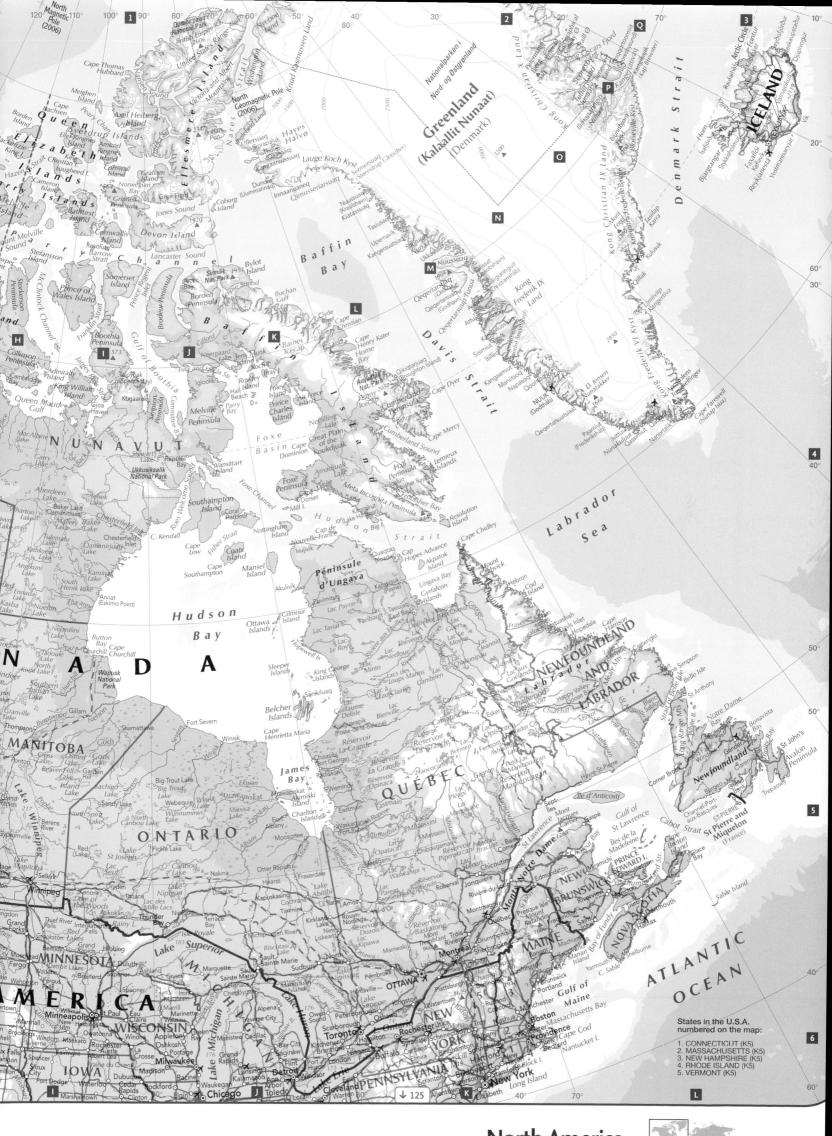

North America
Canada

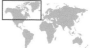

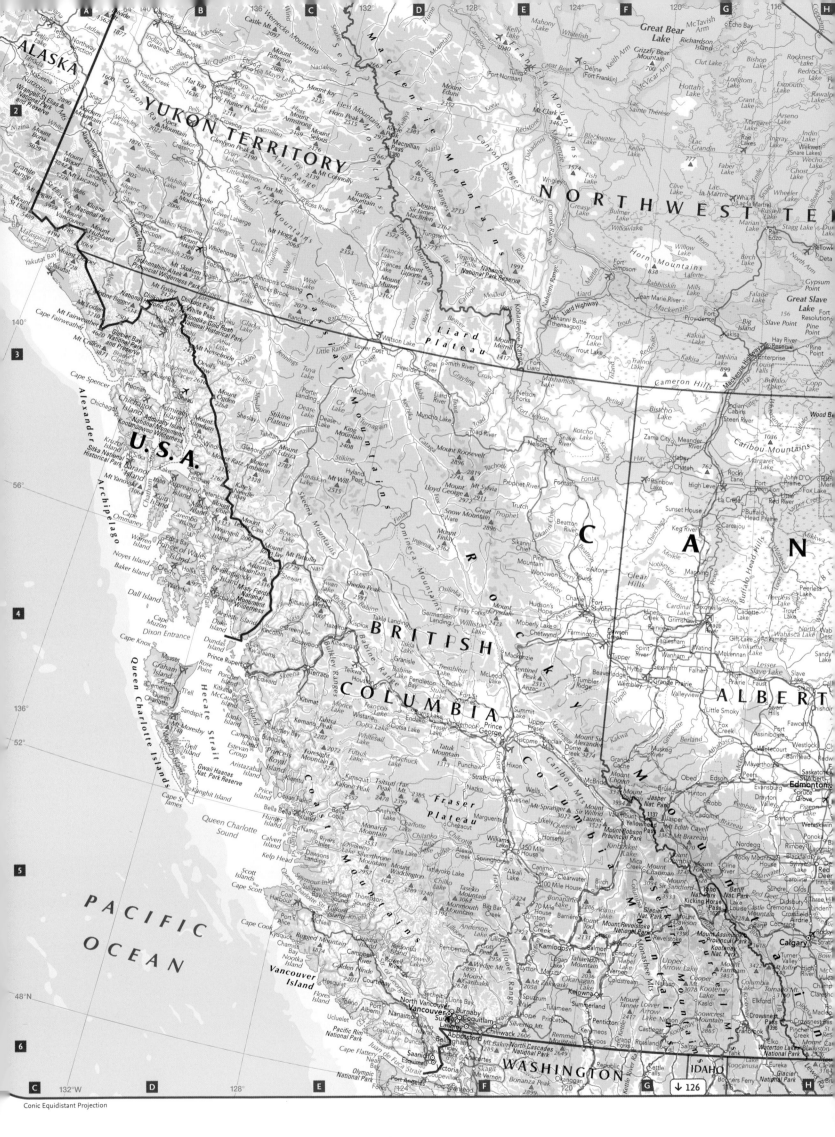

Conic Equidistant Projection

1:7 000 000

0 100 200 miles

0 100 200 300 400 km

↓ 126

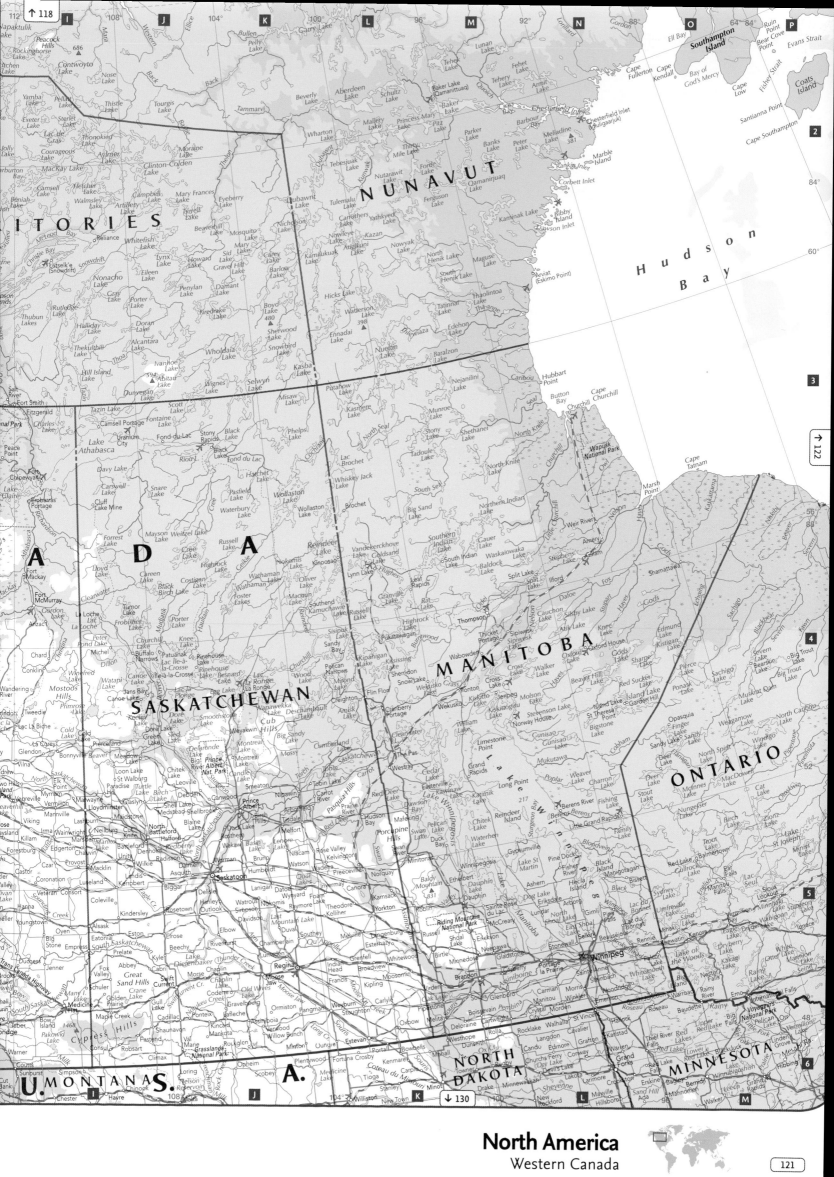

North America

Western Canada

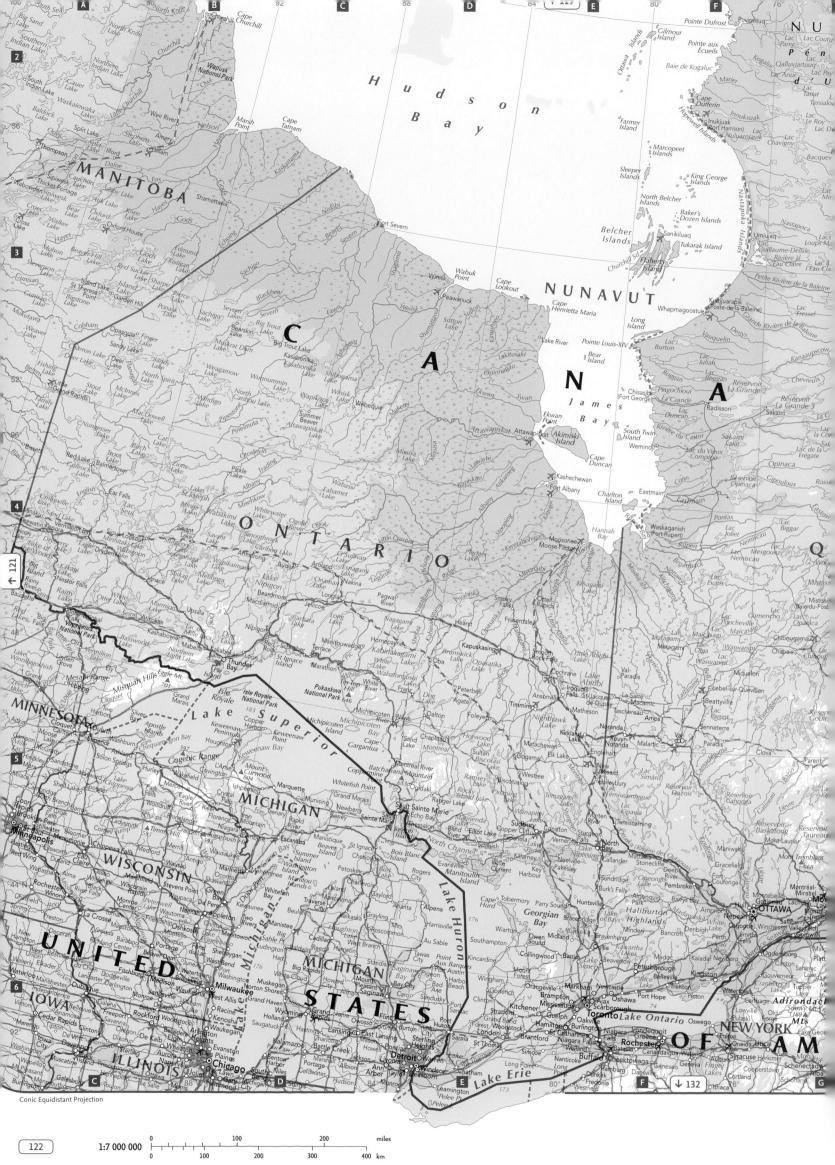

Conic Equidistant Projection

1:7 000 000

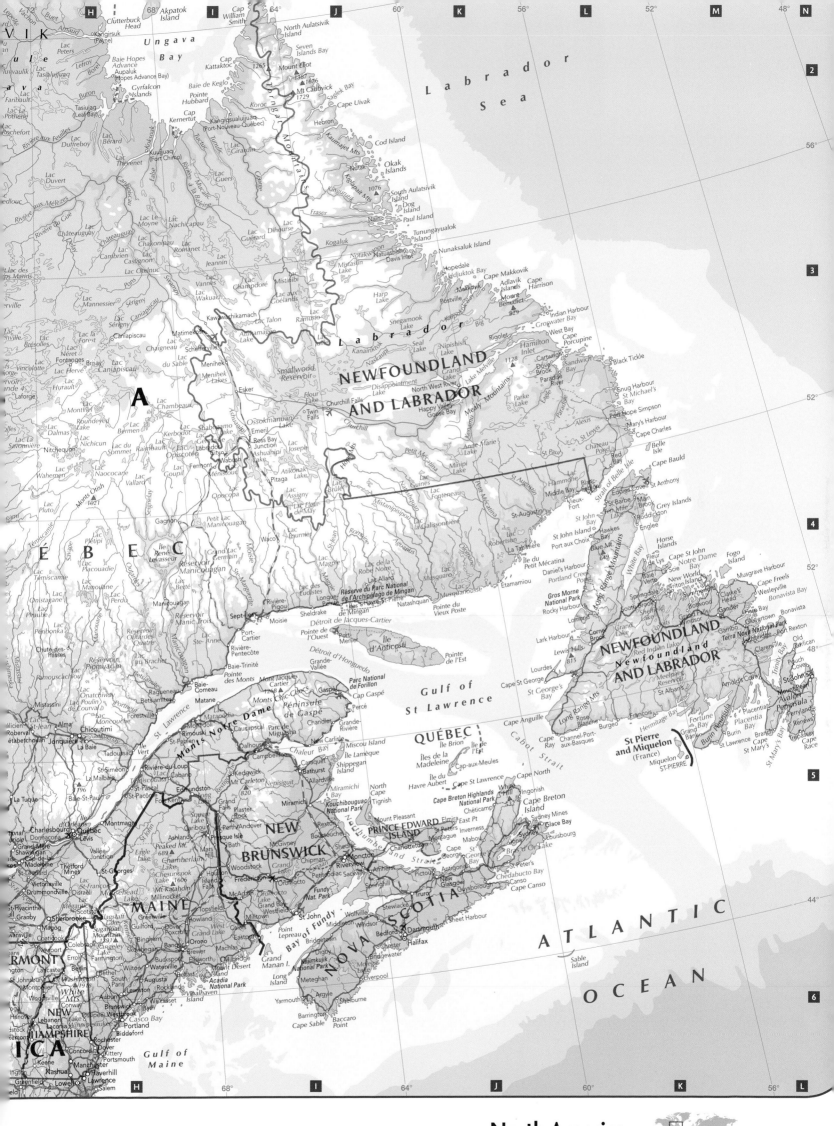

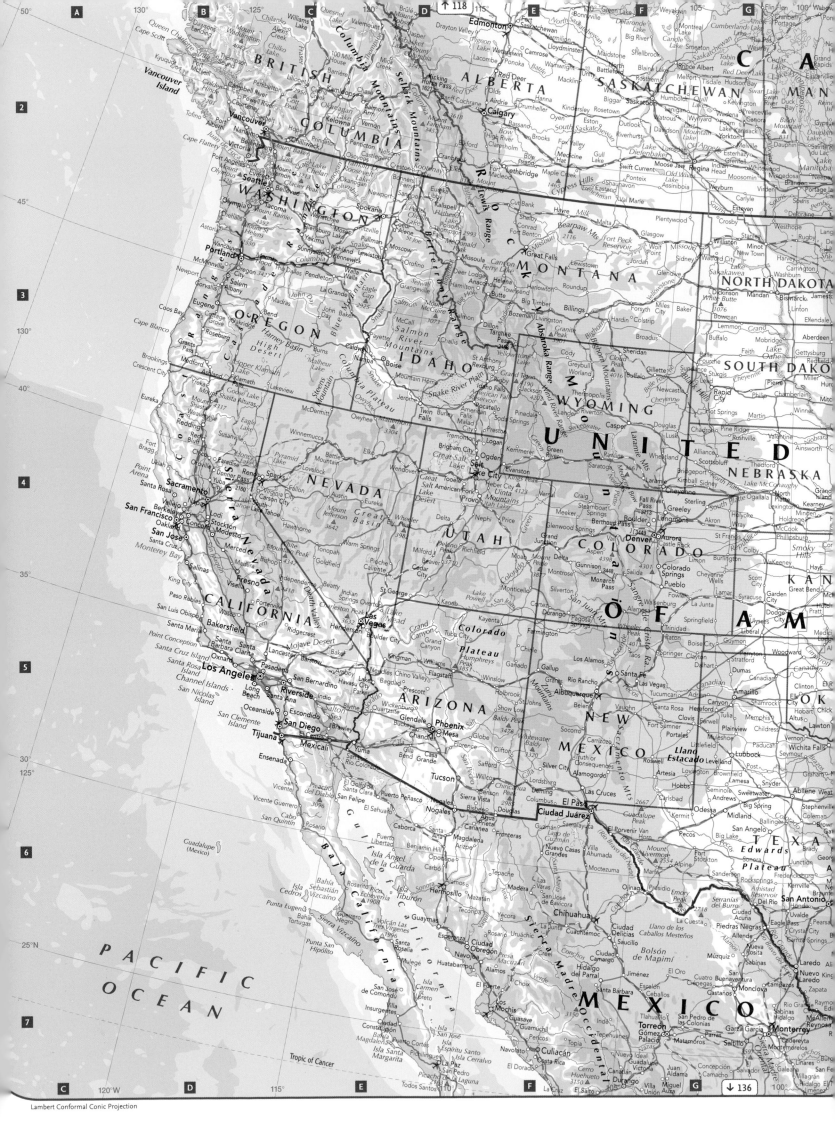

Lambert Conformal Conic Projection

1:12 000 000

0	100	200	300	400	miles		

0	100	200	300	400	500	600	700	km

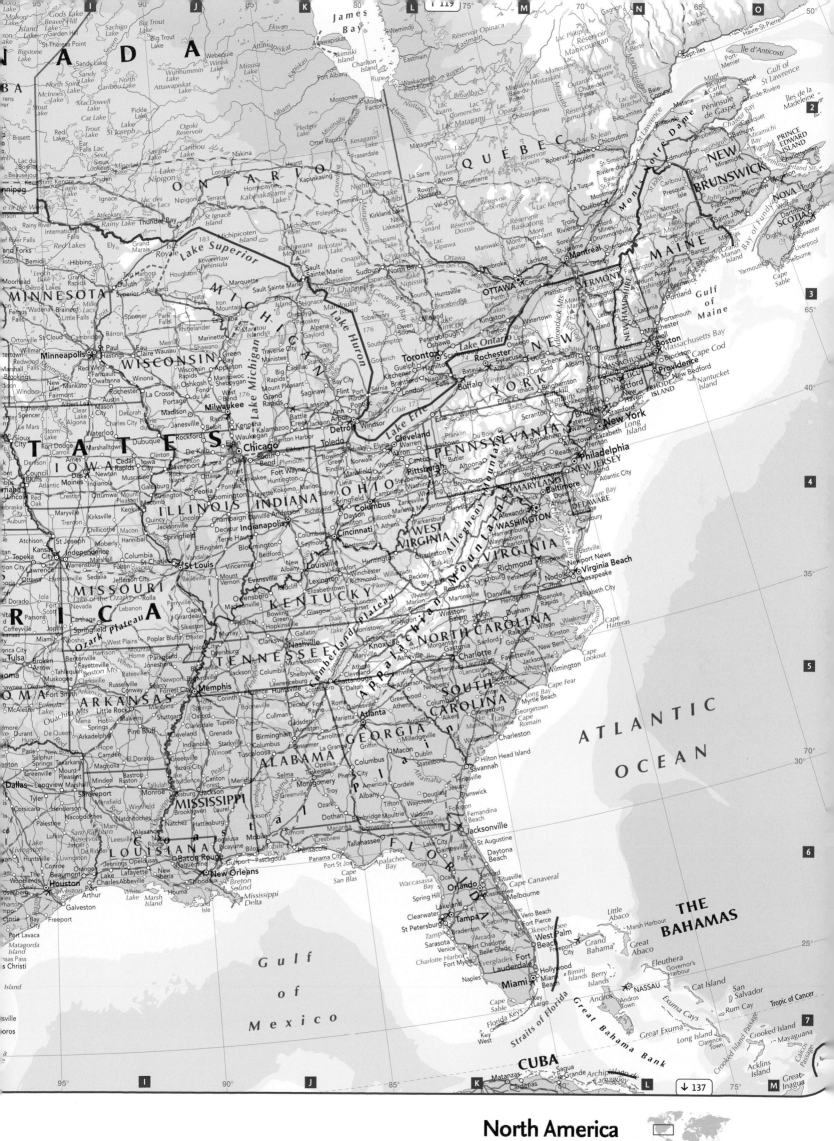

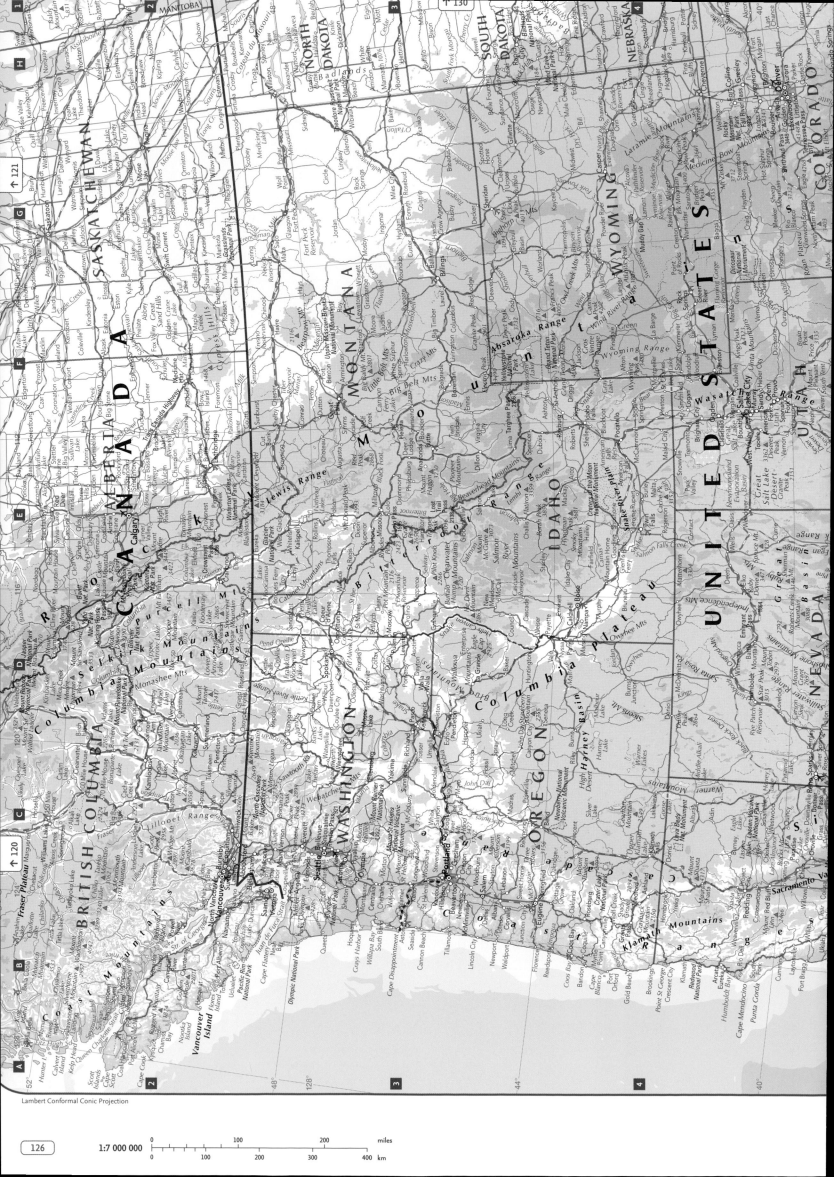

Lambert Conformal Conic Projection

1:7 000 000

| 0 | 100 | 200 | miles |
| 0 | 100 | 200 | 300 | 400 | km |

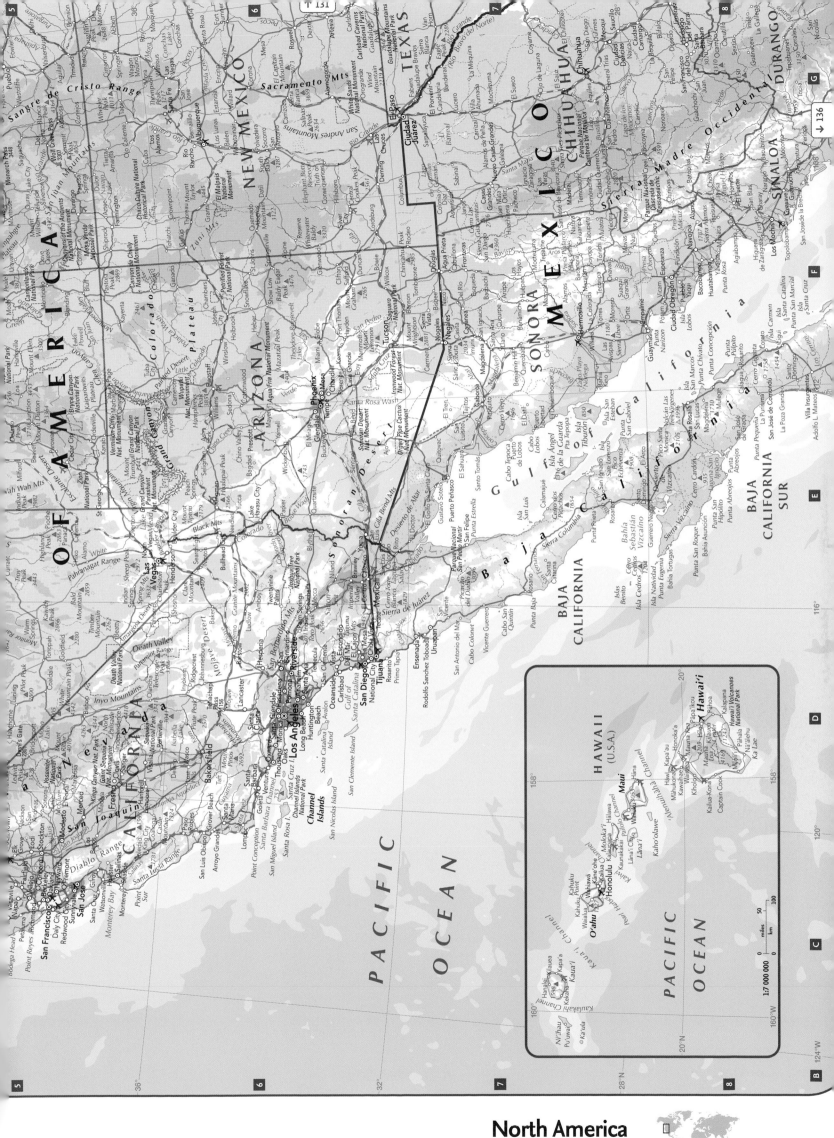

North America

Western United States

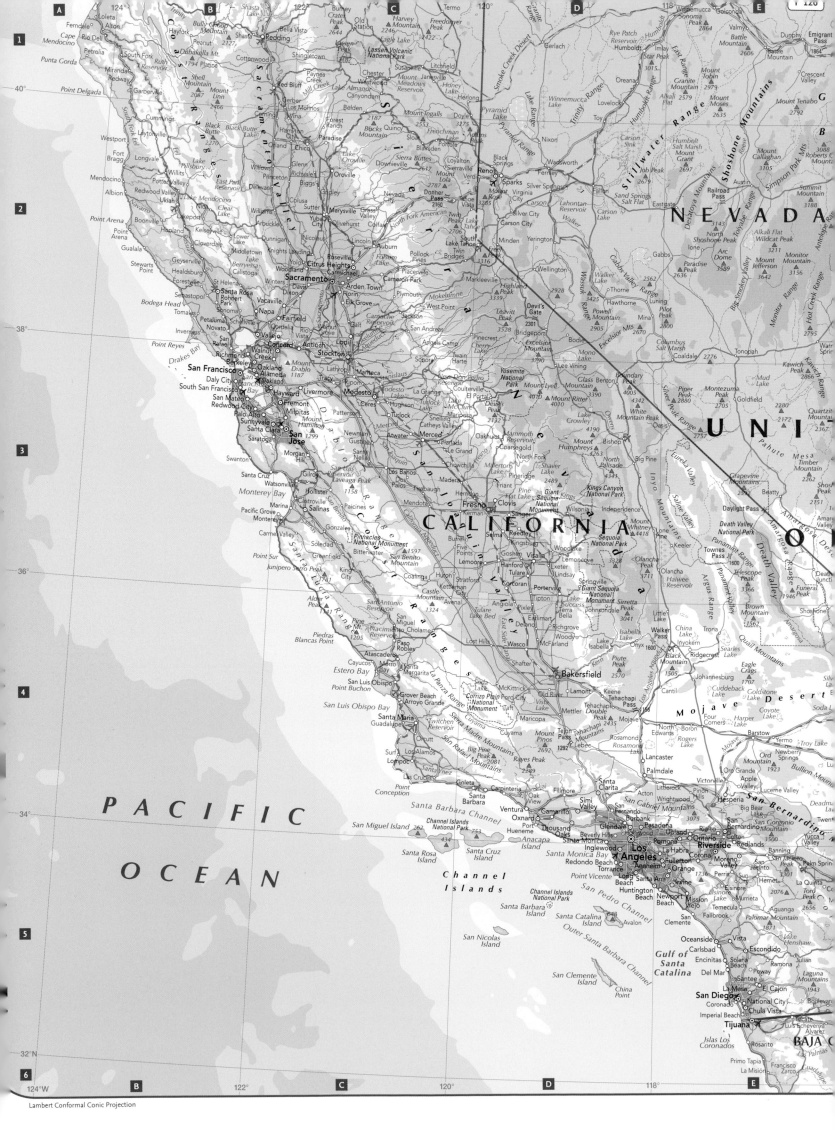

Lambert Conformal Conic Projection

1:3 500 000

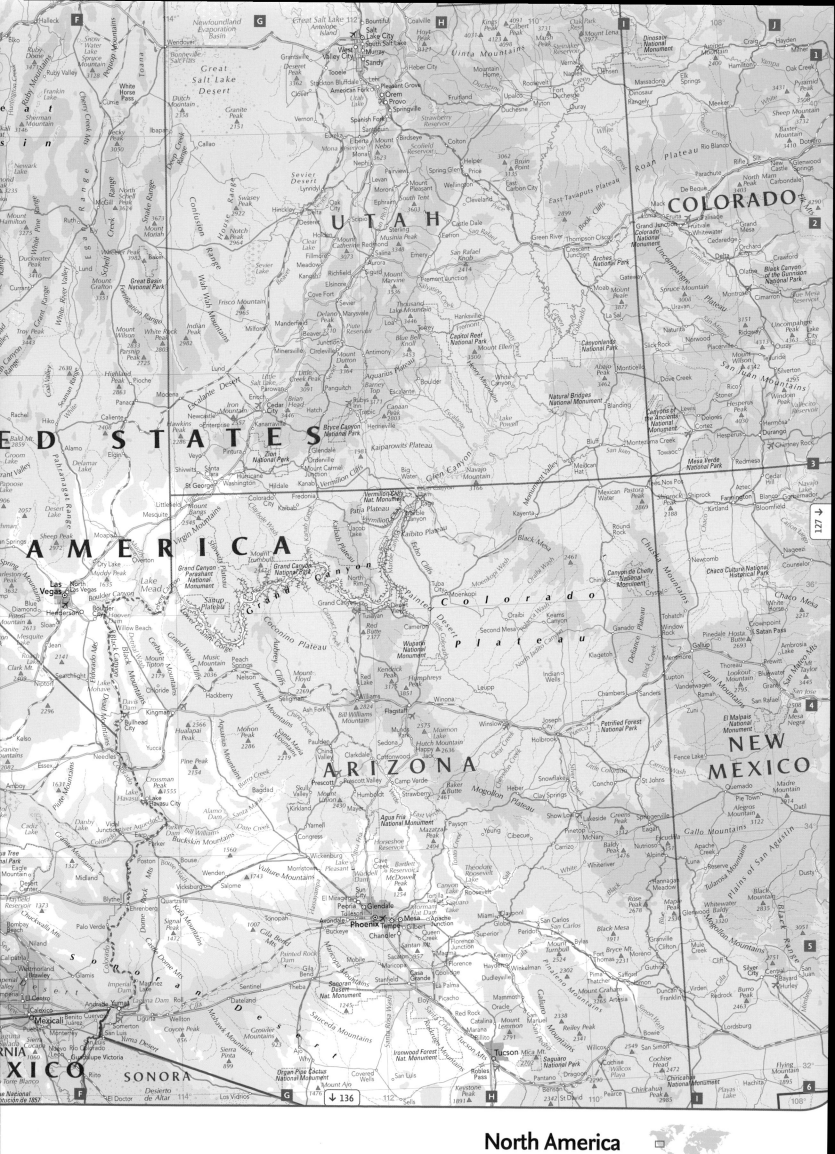

North America
Southwest United States

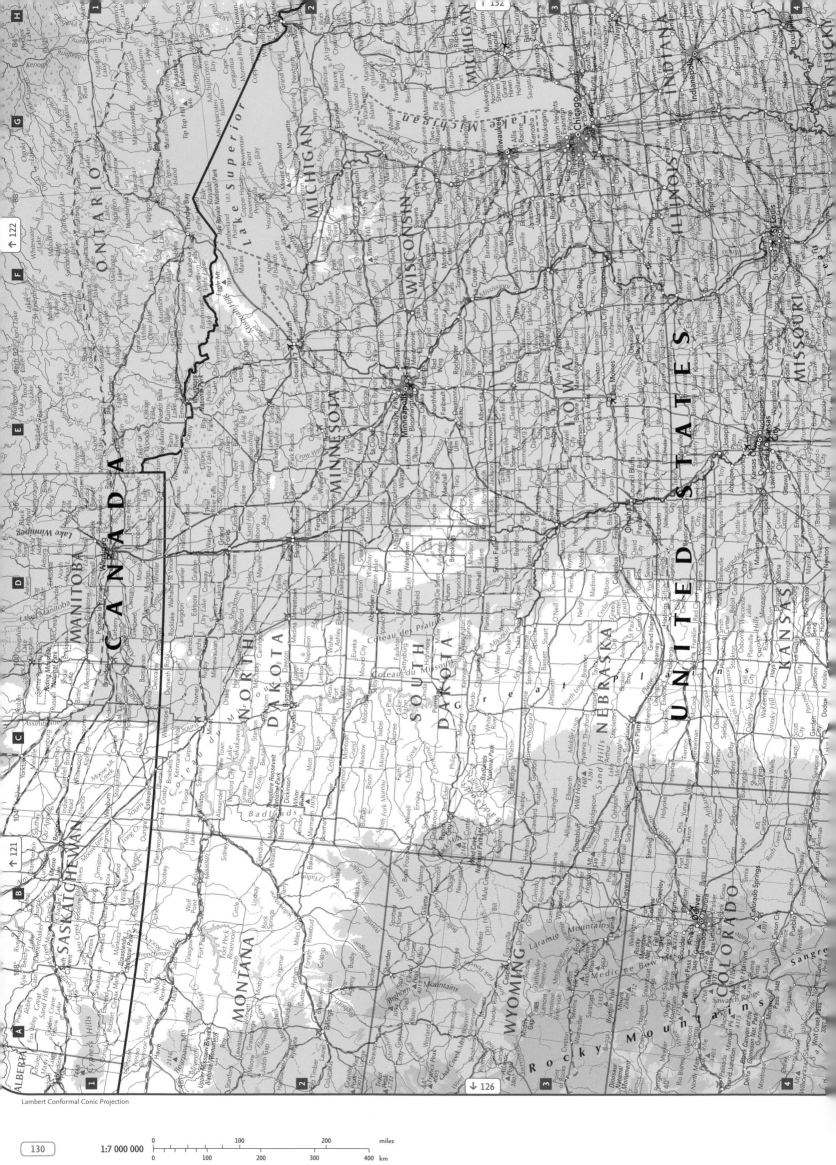

Lambert Conformal Conic Projection

1:7 000 000

0	100	200	miles

| 0 | 100 | 200 | 300 | 400 | km |

↑ 122

↑ 121

↓ 126

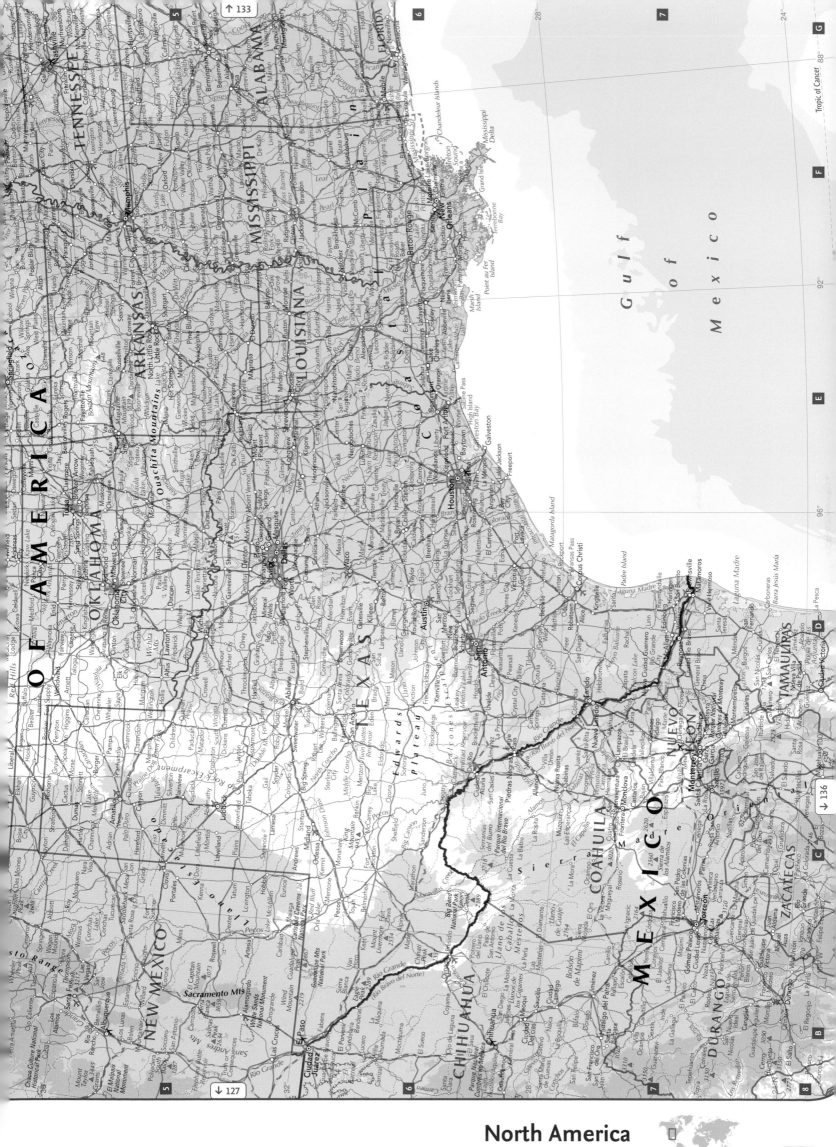

G

Tropic of Cancer

F

E

D

C

B

G u l f

o f

M e x i c o

TENNESSEE

ALABAMA

MISSISSIPPI

ARKANSAS

LOUISIANA

New Orleans

Baton Rouge

Mississippi Delta

Houston

Dallas

Fort Worth

Austin

San Antonio

Corpus Christi

Laredo

Matamoros

Reynosa

Monterrey

Saltillo

O F A M E R I C A

OKLAHOMA

Oklahoma City

Tulsa

T E X A S

NEW MEXICO

El Paso

Ciudad Juárez

CHIHUAHUA

COAHUILA

NUEVO LEÓN

TAMAULIPAS

ZACATECAS

DURANGO

M E X I C O

Albuquerque

Roswell

Amarillo

Lubbock

Midland

Odessa

Edwards Plateau

Big Bend National Park

Rio Grande (Rio Bravo del Norte)

Memphis

Little Rock

Shreveport

Torreón

Gómez Palacio

North America
Central United States

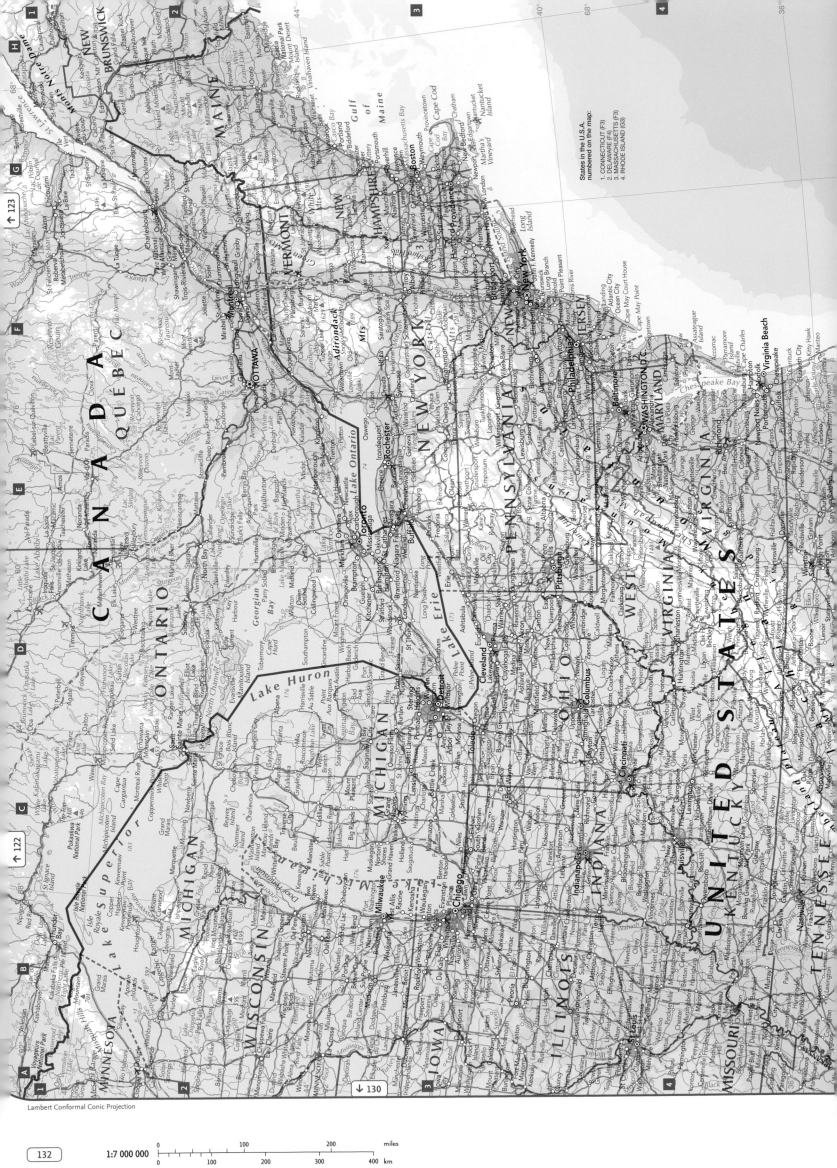

States in the U.S.A.
numbered on the map:

1. CONNECTICUT (F3)
2. DELAWARE (F4)
3. MASSACHUSETTS (F3)
4. RHODE ISLAND (G3)

CANADA

QUÉBEC

ONTARIO

NEW BRUNSWICK

MAINE

NEW HAMPSHIRE

VERMONT

NEW YORK

MASSACHUSETTS

PENNSYLVANIA

NEW JERSEY

MARYLAND

WASHINGTON D.C.

VIRGINIA

WEST VIRGINIA

OHIO

MICHIGAN

WISCONSIN

MINNESOTA

IOWA

ILLINOIS

INDIANA

KENTUCKY

TENNESSEE

MISSOURI

UNITED STATES

Lake Superior

Lake Michigan

Lake Huron

Lake Erie

Lake Ontario

Georgian Bay

Gulf of Maine

Cape Cod

Chesapeake Bay

Ottawa

Montréal

Québec

Toronto

Detroit

Cleveland

Columbus

Cincinnati

Pittsburgh

Chicago

Milwaukee

Indianapolis

Louisville

Washington D.C.

Baltimore

Philadelphia

New York

Boston

Buffalo

Rochester

Virginia Beach

St Louis

Lambert Conformal Conic Projection

1:7 000 000

0 100 200 miles

0 100 200 300 400 km

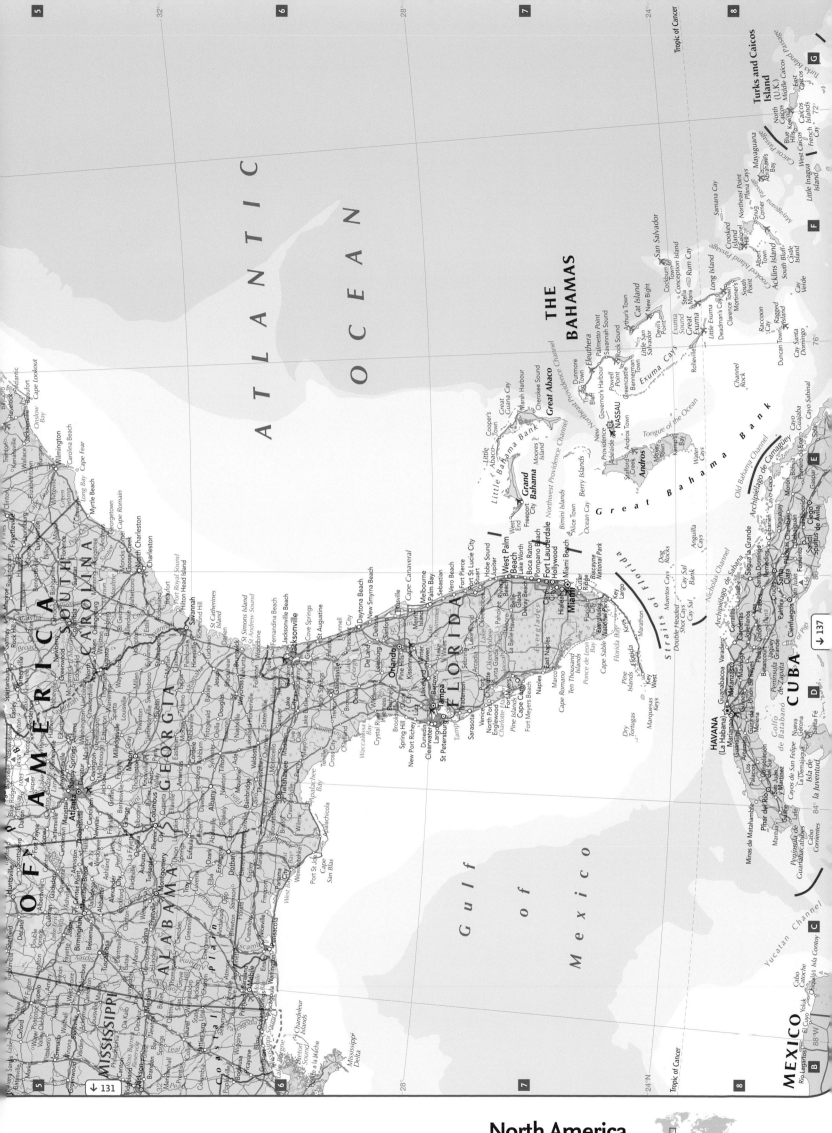

G

F

E

D

C

THE BAHAMAS

Turks and Caicos Island (U.K.)

A T L A N T I C

O C E A N

Cape Lookout

Cape Fear

Wilmington

SOUTH CAROLINA

NORTH CAROLINA

Charleston

Fayetteville

GEORGIA

Savannah

Jacksonville

FLORIDA

Orlando

Tampa

St Petersburg

Cape Canaveral

Daytona Beach

West Palm Beach

Fort Lauderdale

Miami

Miami Beach

Everglades National Park

Key West

ALABAMA

MISSISSIPPI

Montgomery

Mobile

Pensacola

Atlanta

Columbus

Coastal Plain

G u l f

o f

M e x i c o

Gulf of Mexico

Straits of Florida

Grand Bahama

Freeport City

West End

NASSAU

New Providence

Andros

Great Bahama Bank

Eleuthera

Cat Island

San Salvador

Exuma Cays

Long Island

Crooked Island

Acklins Island

Mayaguana

Great Inagua

Little Inagua Island

North America

MEXICO

HAVANA (La Habana)

CUBA

Archipiélago de Camagüey

Tropic of Cancer

Yucatan Channel

→ 137

North America
Eastern United States

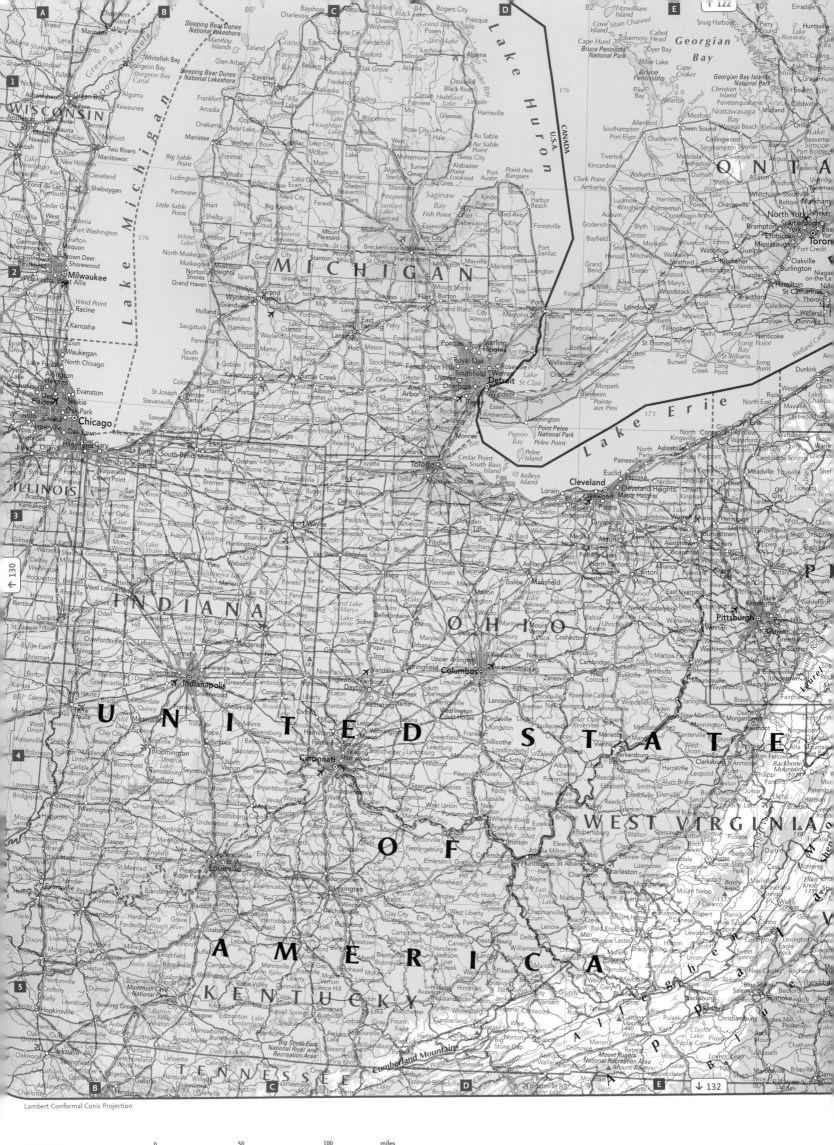

Lambert Conformal Conic Projection

1:3 500 000

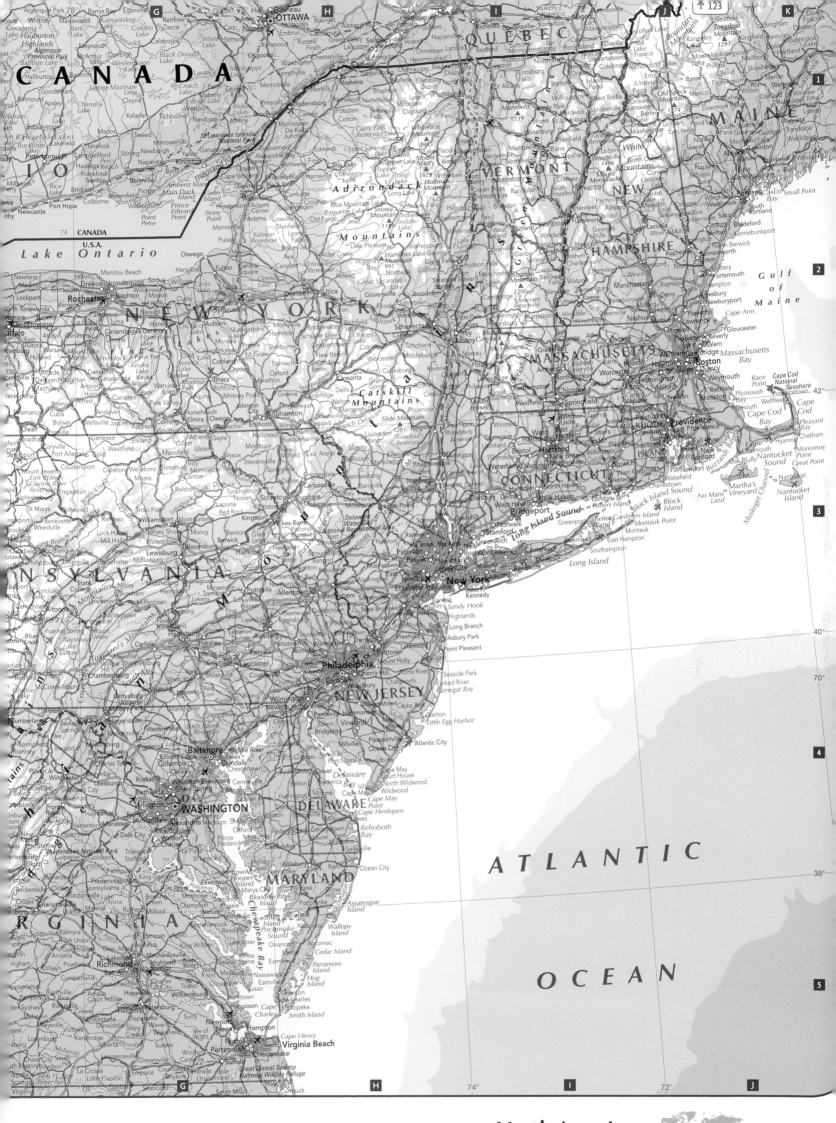

North America

Northeast United States

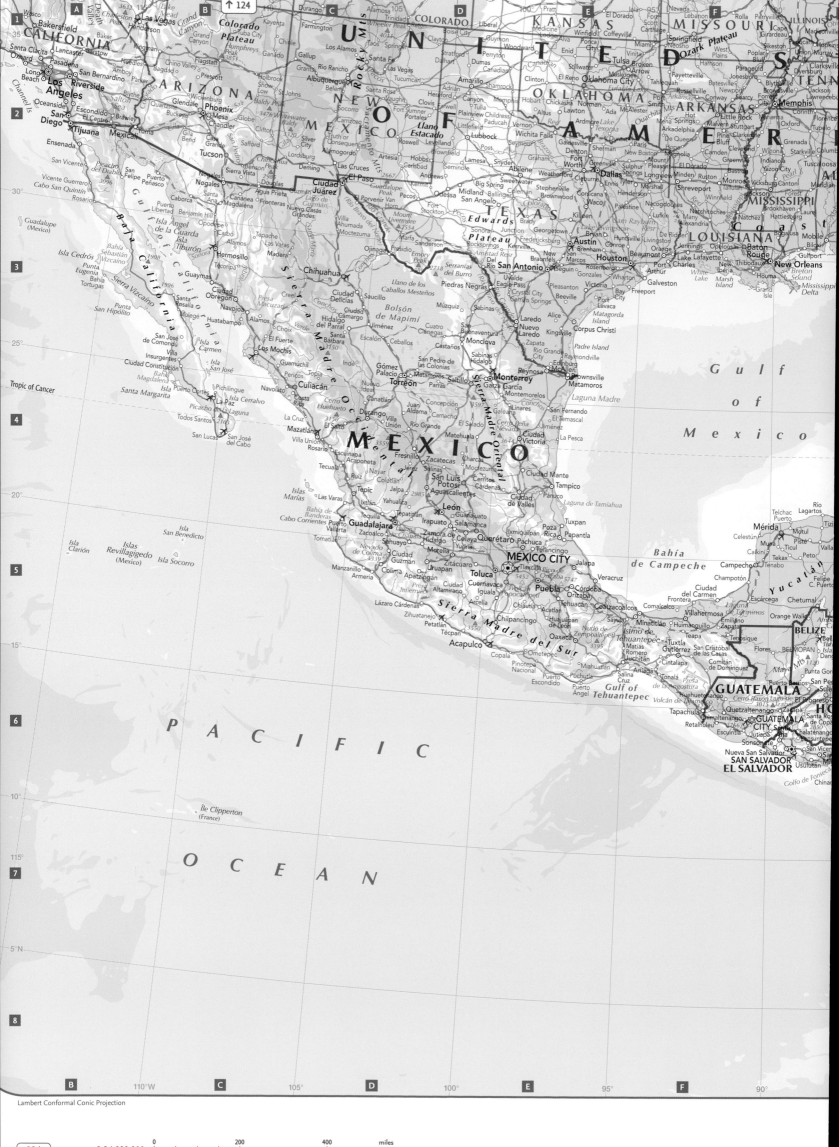

Lambert Conformal Conic Projection

1:14 000 000

| 0 | | 200 | | 400 | miles |
| 0 | 200 | 400 | 600 | 800 | km |

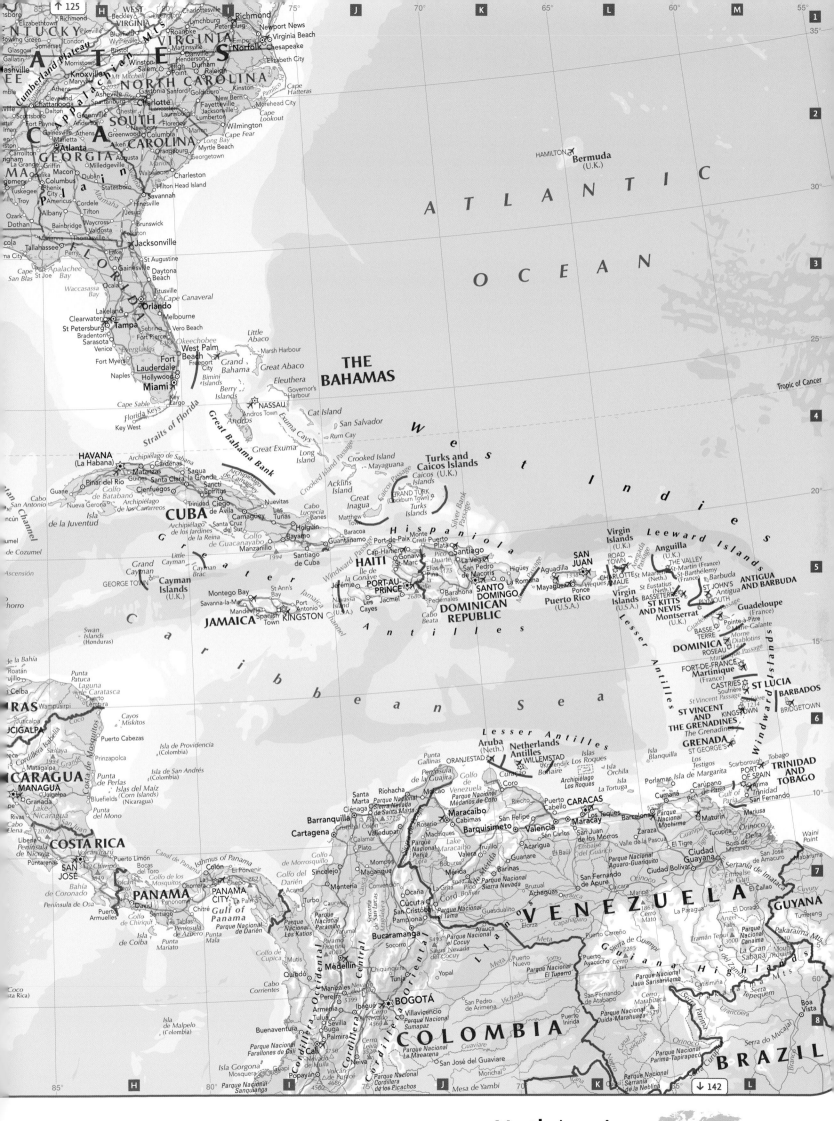

South America

South America is a continent of great contrasts, with landscapes varying from the tropical rainforests of the Amazon Basin, to the Atacama Desert, the driest place on earth, and the sub-Antarctic regions of southern Chile and Argentina. The dominant physical features are the Andes, stretching along the entire west coast of the continent and containing numerous mountains over 6 000 metres high, and the Amazon, which is the second longest river in the world and has the world's largest drainage basin.

The Altiplano is a high plateau lying between two of the Andes ranges. It contains Lake Titicaca, the world's highest navigable lake. By contrast, large lowland areas dominate the centre of the continent, lying between the Andes and the Guiana and Brazilian Highlands. These vast grasslands stretch from the Llanos of the north through the Selvas and the Gran Chaco to the Pampas of Argentina.

Confluence of the **Amazon** and **Negro** rivers at Manaus, northern Brazil.

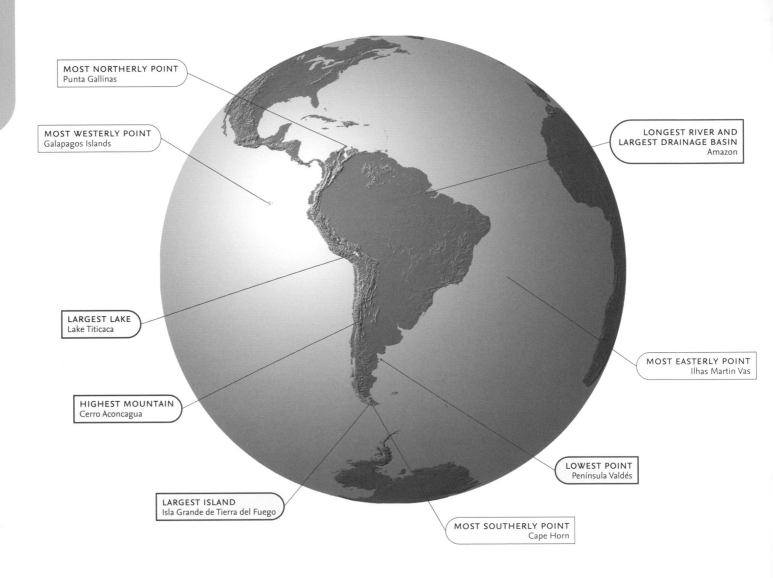

MOST NORTHERLY POINT
Punta Gallinas

MOST WESTERLY POINT
Galapagos Islands

LONGEST RIVER AND LARGEST DRAINAGE BASIN
Amazon

LARGEST LAKE
Lake Titicaca

MOST EASTERLY POINT
Ilhas Martin Vas

HIGHEST MOUNTAIN
Cerro Aconcagua

LOWEST POINT
Península Valdés

LARGEST ISLAND
Isla Grande de Tierra del Fuego

MOST SOUTHERLY POINT
Cape Horn

South America's physical features

Highest mountain	Cerro Aconcagua, Argentina	6 959 metres	22 831 feet
Longest river	Amazon	6 516 km	4 049 miles
Largest lake	Lake Titicaca, Bolivia/Peru	8 340 sq km	3 220 sq miles
Largest island	Isla Grande de Tierra del Fuego, Argentina/Chile	47 000 sq km	18 147 sq miles
Largest drainage basin	Amazon	7 050 000 sq km	2 722 005 sq miles
Lowest point	Península Valdés, Argentina	-40 metres	-131 feet

Internet Links

NASA Visible Earth	visibleearth.nasa.gov
NASA Astronaut Photography	eol.jsc.nasa.gov
World Rainforest Information Portal	www.rainforestweb.org
Peakware World Mountain Encyclopedia	www.peakware.com

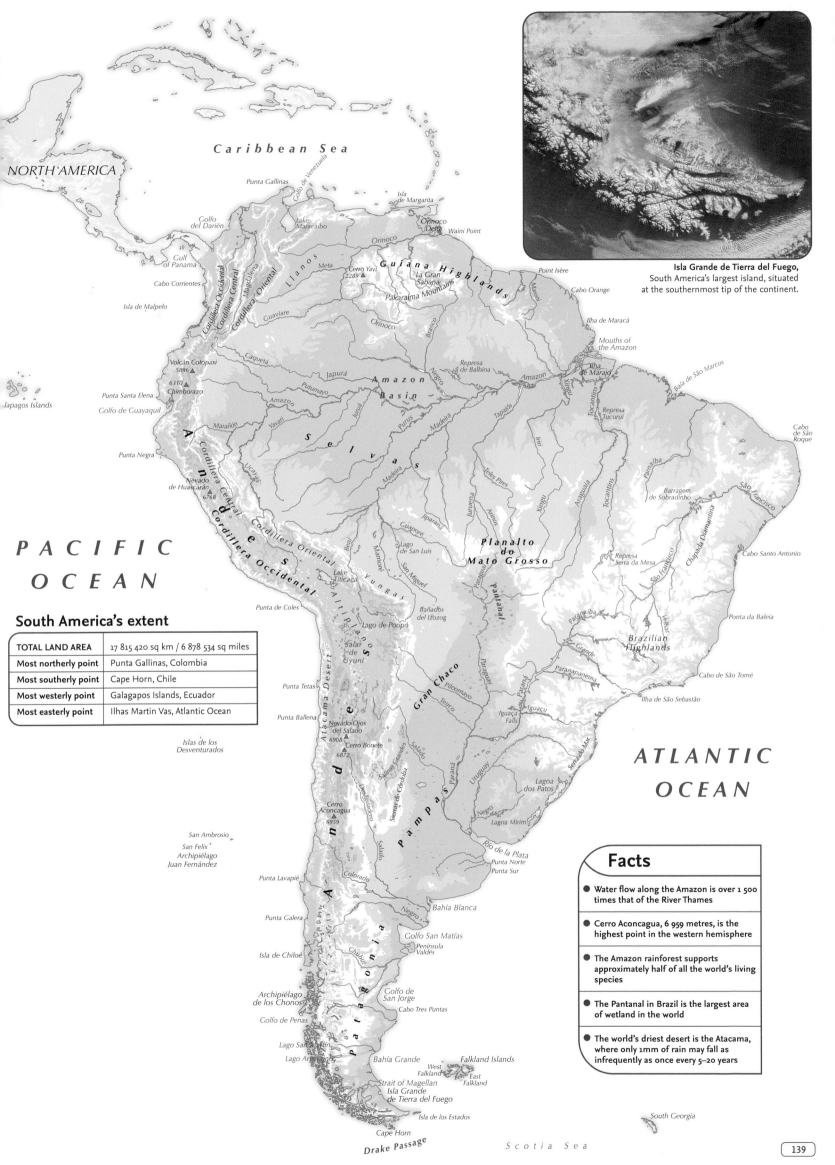

NORTH AMERICA

Caribbean Sea

Isla Grande de Tierra del Fuego,
South America's largest island, situated
at the southernmost tip of the continent.

Punta Gallinas
Golfo de Venezuela
Isla de Margarita
Orinoco Delta
Waini Point
Golfo del Darién
Lake Maracaibo
Point Isère
Gulf of Panama
Llanos
Meta
Cerro Yavi 2285
La Gran Sabana
Guiana Highlands
Cabo Corrientes
Cabo Orange
Pakaraima Mountains
Isla de Malpelo
Cordillera Occidental
Cordillera Central
Cordillera Oriental
Guaviare
Orinoco
Branco
Maroni
Ilha de Maracá
Volcán Cotopaxi 5896
Caquetá
Japurá
Amazon Basin
Negro
Represa de Balbina
Mouths of the Amazon
Ilha de Marajó
6310 Chimborazo
Putumayo
Amazon
Baía de São Marcos
Punta Santa Elena
Amazon
Iça
Purus
Amazon
Xingu
Golfo de Guayaquil
Marañón
Yavari
S e l v a s
Madeira
Tapajós
Tocantins
Represa Tucuruí
Galapagos Islands
Ucayali
Purus
Madeira
Iriri
Cabo de São Roque
Punta Negra
Nevado de Huascarán 6768
Juruá
Teles Pires
Arinos
Xingu
Araguaia
Parnaíba
Barragem de Sobradinho
São Francisco
Jiparaná
Guaporé
Juruena
Tocantins

PACIFIC OCEAN

A n d e s
Cordillera Central
Cordillera Oriental
Cordillera Occidental
Lago de San Luis
Planalto do Mato Grosso
Represa Serra da Mesa
São Francisco
Chapada Diamantina
Cabo Santo Antonio
Lake Titicaca
Yungas
Beni
Mamoré
San Miguel
Paraguai
Velhas
Punta de Coles
Altiplano
Lago de Poopó
Bañados del Izozog
Pantanal
Grande
Brazilian Highlands
Ponta da Baleia

South America's extent

TOTAL LAND AREA	17 815 420 sq km / 6 878 534 sq miles
Most northerly point	Punta Gallinas, Colombia
Most southerly point	Cape Horn, Chile
Most westerly point	Galapagos Islands, Ecuador
Most easterly point	Ilhas Martin Vas, Atlantic Ocean

Salar de Uyuni
Atacama Desert
Gran Chaco
Pilcomayo
Teuco
Paraná
Paranapanema
Cabo de São Tomé
Islas de los Desventurados
Punta Tetas
Nevado Ojos del Salado 6908
Cerro Bonete 6872
Salado
Iguaçu Falls
Iguaçu
Ilha de São Sebastião
Punta Ballena
Salinas Grandes
Uruguay
Paraná
Serra do Mar
San Ambrosio
San Felix
Archipiélago Juan Fernández
Cerro Aconcagua 6959
Sierras de Córdoba
Desaguadero
Salado
Pampas
Paraná

ATLANTIC OCEAN

Lago dos Patos
A n d e s
Río de la Plata
Punta Norte
Punta Sur
Negro
Lagoa Mirim
Punta Lavapié
Colorado
Salado
Bahía Blanca

Facts

- Water flow along the Amazon is over 1 500 times that of the River Thames
- Cerro Aconcagua, 6 959 metres, is the highest point in the western hemisphere
- The Amazon rainforest supports approximately half of all the world's living species
- The Pantanal in Brazil is the largest area of wetland in the world
- The world's driest desert is the Atacama, where only 1mm of rain may fall as infrequently as once every 5–20 years

Punta Galera
Isla de Chiloé
Negro
Golfo San Matías
Península Valdés
P a t a g o n i a
Chubut
Archipiélago de los Chonos
Golfo de San Jorge
Cabo Tres Puntas
Golfo de Penas
Lago San Martín
Lago Argentino
Bahía Grande
Falkland Islands
West Falkland
East Falkland
Strait of Magellan
Isla Grande de Tierra del Fuego
Isla de los Estados
Cape Horn
South Georgia

Drake Passage
Scotia Sea

South America

French Guiana, a French Department, is the only remaining territory under overseas control on a continent which has seen a long colonial history. Much of South America was colonized by Spain in the sixteenth century, with Britain, Portugal and the Netherlands each claiming territory in the northeast of the continent. This colonization led to the conquering of ancient civilizations, including the Incas in Peru. Most countries became independent from Spain and Portugal in the early nineteenth century.

The population of the continent reflects its history, being composed primarily of indigenous Indian peoples and mestizos – reflecting the long Hispanic influence. There has been a steady process of urbanization within the continent, with major movements of the population from rural to urban areas. The majority of the population now live in the major cities and within 300 kilometres of the coast.

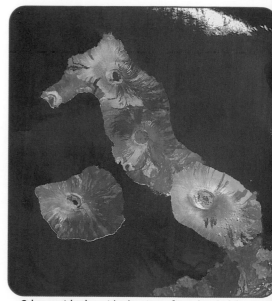

Galapagos Islands, an island territory of Ecuador which lies on the equator in the eastern Pacific Ocean over 900 kilometres west of the coast of Ecuador.

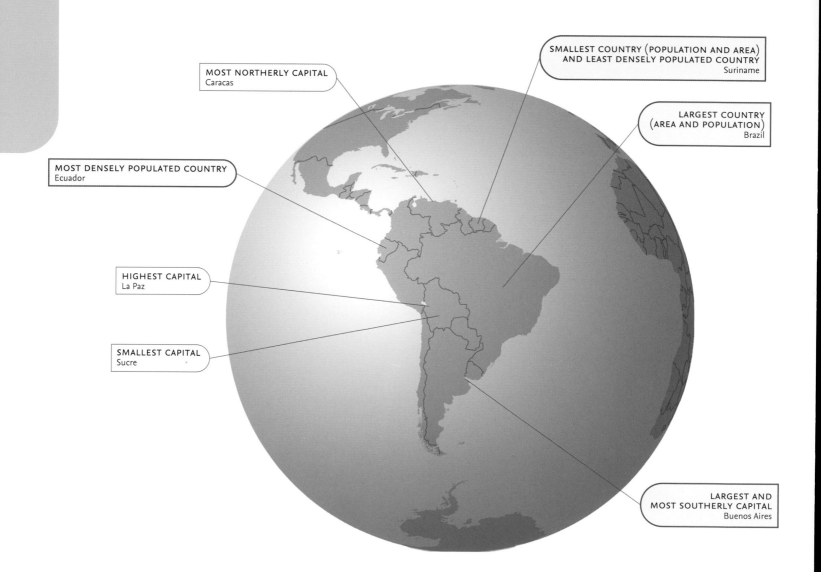

MOST NORTHERLY CAPITAL
Caracas

SMALLEST COUNTRY (POPULATION AND AREA) AND LEAST DENSELY POPULATED COUNTRY
Suriname

LARGEST COUNTRY (AREA AND POPULATION)
Brazil

MOST DENSELY POPULATED COUNTRY
Ecuador

HIGHEST CAPITAL
La Paz

SMALLEST CAPITAL
Sucre

LARGEST AND MOST SOUTHERLY CAPITAL
Buenos Aires

South America's countries

Largest country (area)	Brazil	8 514 879 sq km	3 287 613 sq miles
Smallest country (area)	Suriname	163 820 sq km	63 251 sq miles
Largest country (population)	Brazil	186 405 000	
Smallest country (population)	Suriname	449 000	
Most densely populated country	Ecuador	48 per sq km	124 per sq mile
Least densely populated country	Suriname	3 per sq km	7 per sq mile

Internet Links

UK Foreign and Commonwealth Office	www.fco.gov.uk
CIA World Factbook	www.odci.gov/cia/publications/factbook
Caribbean Community (Caricom)	www.caricom.org
Latin American Network Information Center	lanic.utexas.edu

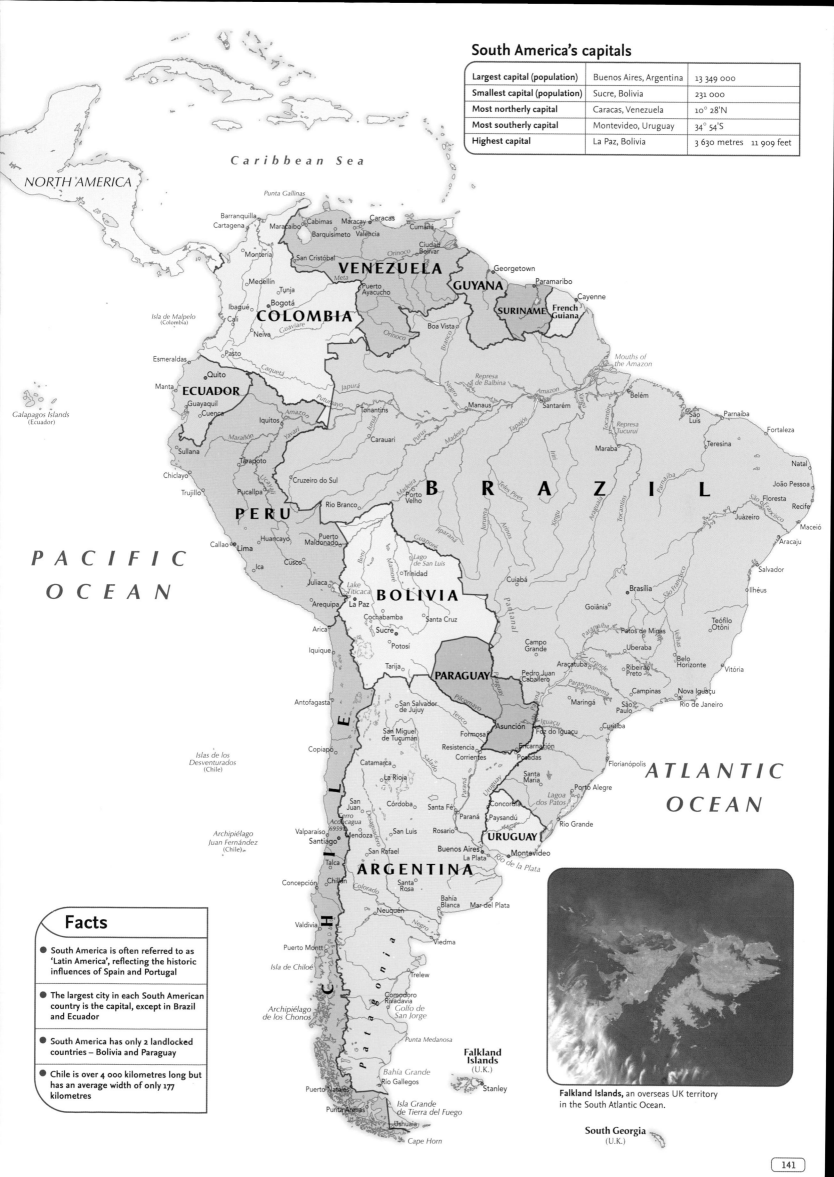

South America's capitals

Largest capital (population)	Buenos Aires, Argentina	13 349 000
Smallest capital (population)	Sucre, Bolivia	231 000
Most northerly capital	Caracas, Venezuela	10° 28'N
Most southerly capital	Montevideo, Uruguay	34° 54'S
Highest capital	La Paz, Bolivia	3 630 metres 11 909 feet

Caribbean Sea

NORTH AMERICA

Punta Gallinas

Barranquilla
Cartagena
Maracaibo Cabimas Maracay Caracas
Barquisimeto Valencia Cumaná
Monteria San Cristóbal *Orinoco* Ciudad Bolívar

VENEZUELA Georgetown

Medellín Tunja *Meta* Puerto Ayacucho **GUYANA** Paramaribo
Ibagué Bogotá Cayenne
COLOMBIA **SURINAME** French Guiana
Isla de Malpelo (Colombia) Cali *Guaviare* Boa Vista
Neiva *Orinoco*

Esmeraldas Pasto *Caquetá* *Branco* *Mouths of the Amazon*
Quito *Japurá* *Represa de Balbina* *Amazon* Belém
Manta **ECUADOR** *Putumayo* Manaus Santarém São Luís Parnaíba
Guayaquil *Marañón* Iquitos *Amazon* *Tapajós* Fortaleza
Cuenca *Yavari* Tonantins Teresina
Galapagos Islands (Ecuador) Sullana *Juruá* Carauari *Purus* *Madeira* Marabá Natal
Chiclayo Tarapoto *Teles Pires* João Pessoa
Trujillo Cruzeiro do Sul **B R A Z I L** Floresta Recife
Pucallpa *Madeira* Juàzeiro
PERU Rio Branco Porto Velho *Xingu* *Tocantins* Maceió
Callao Huancayo Puerto Maldonado *Iriri* *Araguaia* Aracaju
Lima *Guaporé* *Arinos* Salvador
Cusco *Beni* *Lago de San Luis* Cuiabá Brasília Ilhéus
Ica Juliaca Trinidad *Mamoré* Goiânia *São Francisco*
Lake Titicaca **BOLIVIA** *Pantanal* Teófilo Otôni
Arequipa La Paz Campo Grande Patos de Minas Uberaba Vitória
Arica Cochabamba Santa Cruz *Paraíba* Belo Horizonte
Sucre Araçatuba Ribeirão Preto
Potosí *Grande* Campinas Nova Iguaçu
Iquique Tarija **PARAGUAY** Pedro Juan Caballero *Paranapanema* Maringá São Paulo Rio de Janeiro
Antofagasta San Salvador de Jujuy Asunción Foz do Iguaçu Curitiba
Pilcomayo *Iguaçu*
San Miguel de Tucumán *Teuco* Formosa Encarnación Florianópolis
Copiapó Resistencia Posadas
Catamarca *Salado* Corrientes Santa Maria *Lagoa dos Patos* Porto Alegre
La Rioja Paraná Concordia Rio Grande
San Juan *Cerro Aconcagua 6959* Córdoba Santa Fé Paysandú
Valparaíso Mendoza San Luis Rosario **URUGUAY**
Santiago San Rafael Buenos Aires Montevideo
Talca La Plata *Río de la Plata*
Chillán **ARGENTINA** Santa Rosa
Concepción *Colorado* Bahía Blanca Mar del Plata
Neuquén
Valdivia *Negro*
Puerto Montt Viedma
Isla de Chiloé Trelew
Patagonia
Comodoro Rivadavia
Archipiélago de los Chonos *Golfo de San Jorge*
Punta Medanosa
Falkland Islands (U.K.)
Bahía Grande Río Gallegos
Puerto Natales Stanley
Punta Arenas
Isla Grande de Tierra del Fuego
Ushuaia
Cape Horn

South Georgia (U.K.)

PACIFIC OCEAN

Islas de los Desventurados (Chile)

Archipiélago Juan Fernández (Chile)

C H I L E

ATLANTIC OCEAN

Falkland Islands, an overseas UK territory in the South Atlantic Ocean.

Facts

- South America is often referred to as 'Latin America', reflecting the historic influences of Spain and Portugal

- The largest city in each South American country is the capital, except in Brazil and Ecuador

- South America has only 2 landlocked countries – Bolivia and Paraguay

- Chile is over 4 000 kilometres long but has an average width of only 177 kilometres

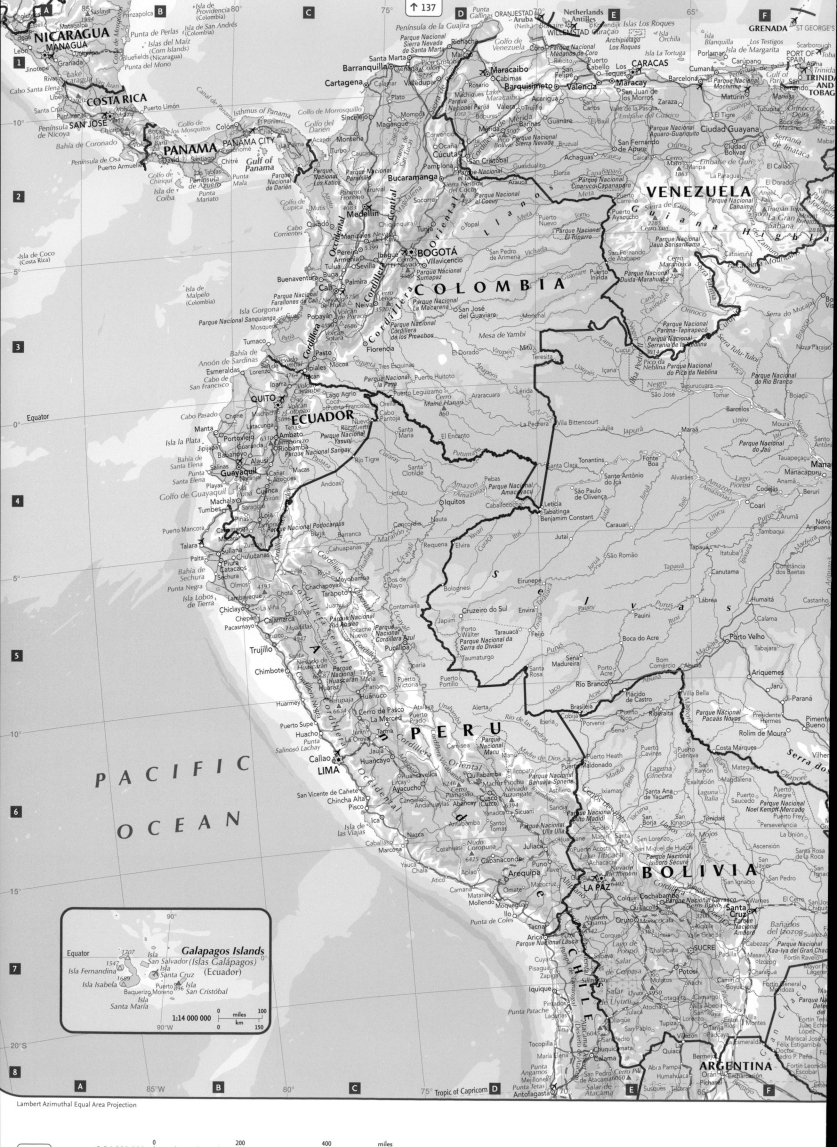

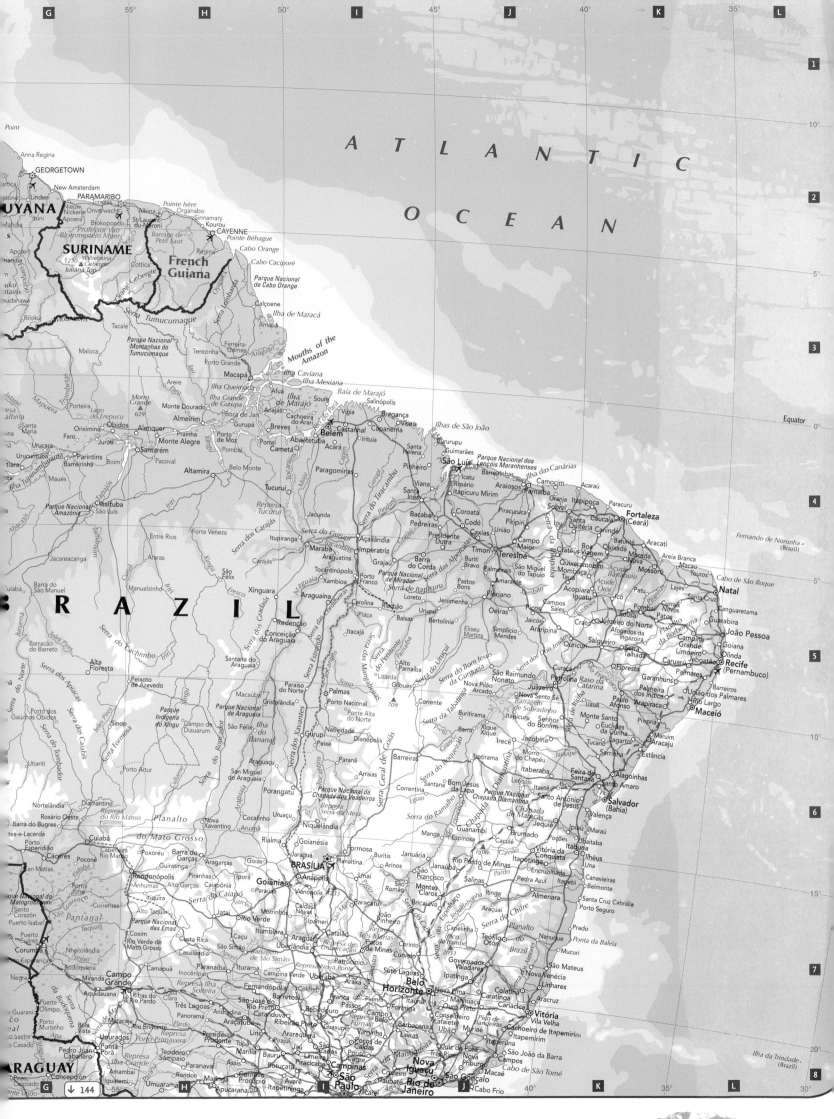

South America
Northern South America

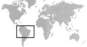

Map labels

BOLIVIA

PARAGUAY

BRAZIL

ASUNCIÓN

URUGUAY

ARGENTINA

SANTIAGO

BUENOS AIRES

MONTEVIDEO

ATLANTIC

OCEAN

Falkland Islands
(U.K.)

West Falkland

Weddell Island

STANLEY

East Falkland

Beauchene
Island

South Georgia
(U.K.)

South America
Southern South America

1:14 000 000

Lambert Azimuthal Equal Area Projection

	200	400	miles	
0	200	400	600	800 km

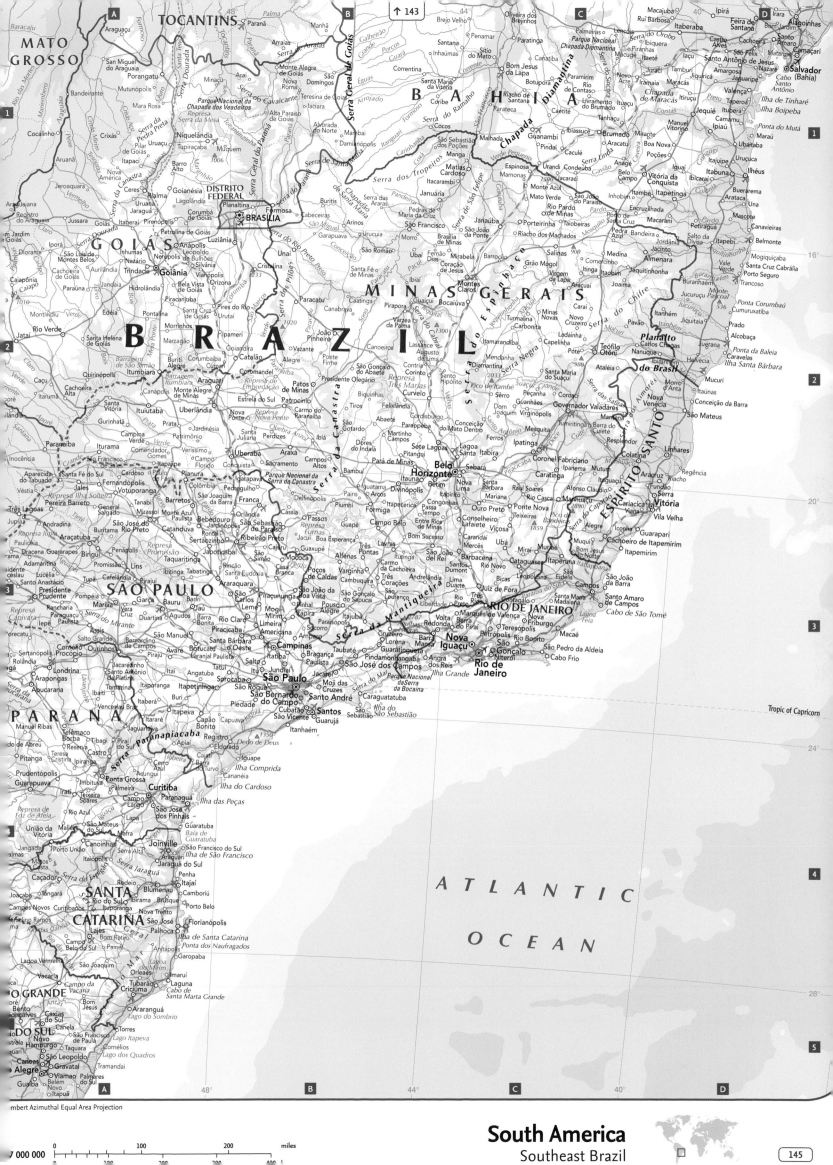

South America
Southeast Brazil

Oceans and Poles

Between them, the world's oceans and polar regions cover approximately seventy per cent of the earth's surface. The oceans contain ninety six per cent of the earth's water and a vast range of flora and fauna. They are a major influence on the world's climate, particularly through ocean currents. The Arctic and Antarctica are the coldest and most inhospitable places on the earth. They both have vast amounts of ice which, if global warming continues, could have a major influence on sea level across the globe.

Our understanding of the oceans and polar regions has increased enormously over the last twenty years through the development of new technologies, particularly that of satellite remote sensing, which can generate vast amounts of data relating to, for example, topography (both on land and the seafloor), land cover and sea surface temperature.

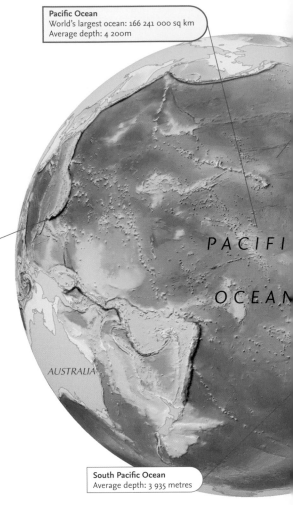

Pacific Ocean
World's largest ocean: 166 241 000 sq km
Average depth: 4 200m

Challenger Deep: 10 920 metres
Mariana Trench
Deepest point

PACIFIC

OCEAN

AUSTRALIA

South Pacific Ocean
Average depth: 3 935 metres

The oceans

The world's major oceans are the Pacific, the Atlantic and the Indian Oceans. The Arctic Ocean is generally considered as part of the Atlantic, and the Southern Ocean, which stretches around the whole of Antarctica is usually treated as an extension of each of the three major oceans.

One of the most important factors affecting the earth's climate is the circulation of water within and between the oceans. Differences in temperature and surface winds create ocean currents which move enormous quantities of water around the globe. These currents re-distribute heat which the oceans have absorbed from the sun, and so have a major effect on the world's climate system. El Niño is one climatic phenomenon directly influenced by these ocean processes.

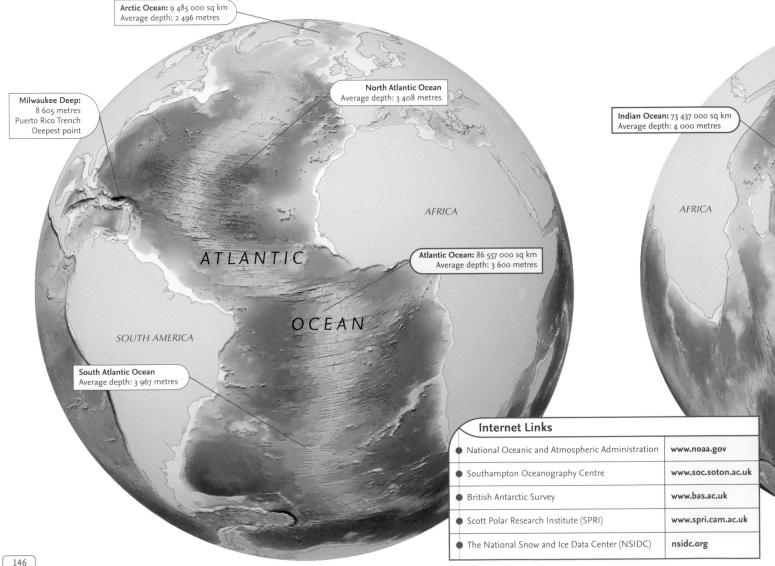

Arctic Ocean: 9 485 000 sq km
Average depth: 2 496 metres

Milwaukee Deep:
8 605 metres
Puerto Rico Trench
Deepest point

North Atlantic Ocean
Average depth: 3 408 metres

Indian Ocean: 73 437 000 sq km
Average depth: 4 000 metres

AFRICA

AFRICA

ATLANTIC

Atlantic Ocean: 86 557 000 sq km
Average depth: 3 600 metres

OCEAN

SOUTH AMERICA

South Atlantic Ocean
Average depth: 3 967 metres

Internet Links

● National Oceanic and Atmospheric Administration	**www.noaa.gov**
● Southampton Oceanography Centre	**www.soc.soton.ac.uk**
● British Antarctic Survey	**www.bas.ac.uk**
● Scott Polar Research Institute (SPRI)	**www.spri.cam.ac.uk**
● The National Snow and Ice Data Center (NSIDC)	**nsidc.org**

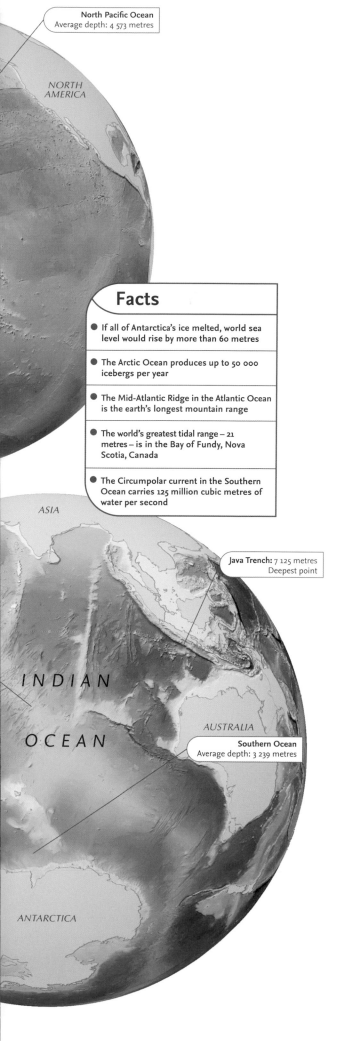

North Pacific Ocean
Average depth: 4 573 metres

NORTH
AMERICA

ASIA

Java Trench: 7 125 metres
Deepest point

INDIAN

OCEAN

AUSTRALIA

Southern Ocean
Average depth: 3 239 metres

ANTARCTICA

Facts

- If all of Antarctica's ice melted, world sea level would rise by more than 60 metres

- The Arctic Ocean produces up to 50 000 icebergs per year

- The Mid-Atlantic Ridge in the Atlantic Ocean is the earth's longest mountain range

- The world's greatest tidal range – 21 metres – is in the Bay of Fundy, Nova Scotia, Canada

- The Circumpolar current in the Southern Ocean carries 125 million cubic metres of water per second

Polar regions

Although a harsh climate is common to the two polar regions, there are major differences between the Arctic and Antarctica. The North Pole is surrounded by the Arctic Ocean, much of which is permanently covered by sea ice, while the South Pole lies on the huge land mass of Antarctica. This is covered by a permanent ice cap which reaches a maximum thickness of over four kilometres. Antarctica has no permanent population, but Europe, Asia and North America all stretch into the Arctic region which is populated by numerous ethnic groups. Antarctica is subject to the Antarctic Treaty of 1959 which does not recognize individual land claims and protects the continent in the interests of international scientific cooperation.

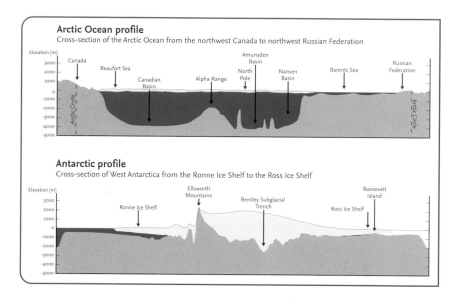

Arctic Ocean profile
Cross-section of the Arctic Ocean from the northwest Canada to northwest Russian Federation

Antarctic profile
Cross-section of West Antarctica from the Ronne Ice Shelf to the Ross Ice Shelf

Antarctica's physical features

Highest mountain: Vinson Massif	4 897 m	16 066 ft
Total land area (excluding ice shelves)	12 093 000 sq km	4 669 107 sq miles
Ice shelves	1 559 000 sq km	601 930 sq miles
Exposed rock	49 000 sq km	18 919 sq miles
Lowest bedrock elevation (Bentley Subglacial Trench)	2 496 m below sea level	8 189 ft below sea level
Maximum ice thickness (Astrolabe Subglacial Basin)	4 776 m	15 669 ft
Mean ice thickness (including ice shelves)	1 859 m	6 099 ft
Volume of ice sheet (including ice shelves)	25 400 000 cubic km	6 094 628 cubic miles

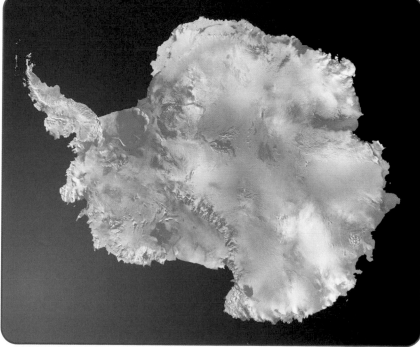

Antarctica, frozen continent lying around the South Pole.

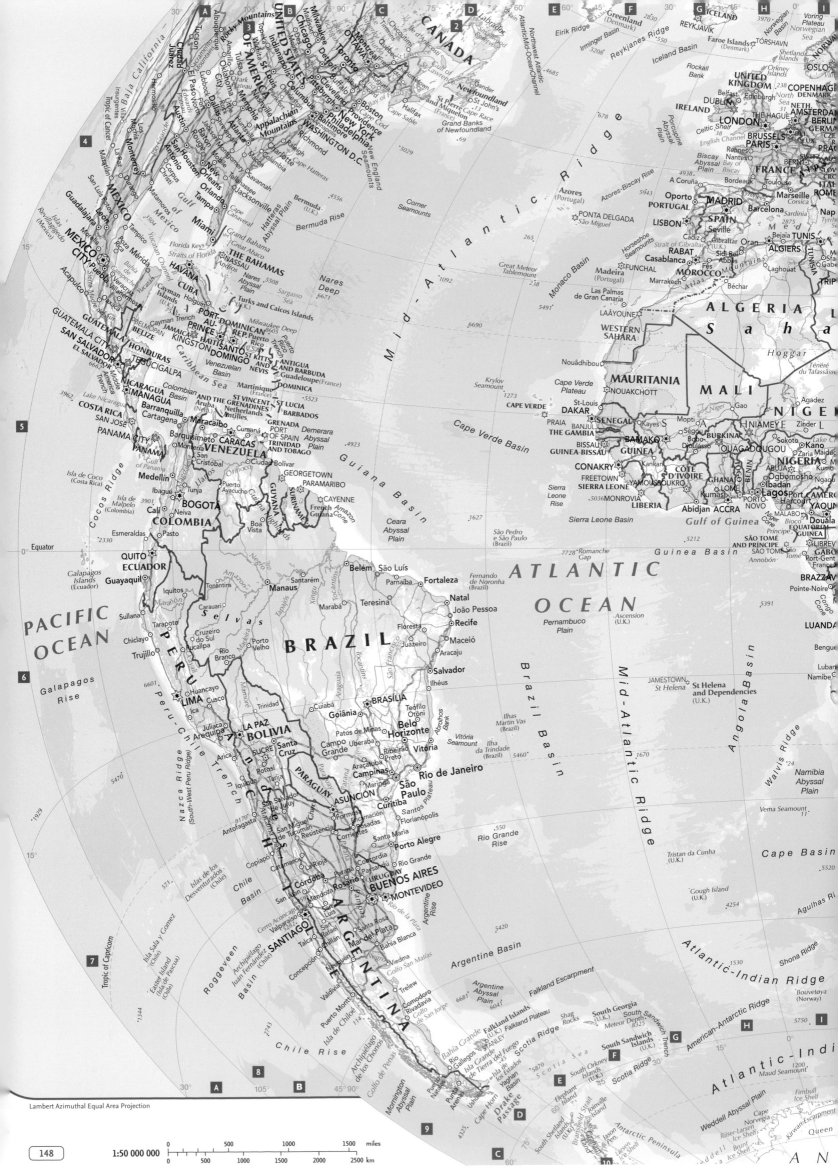

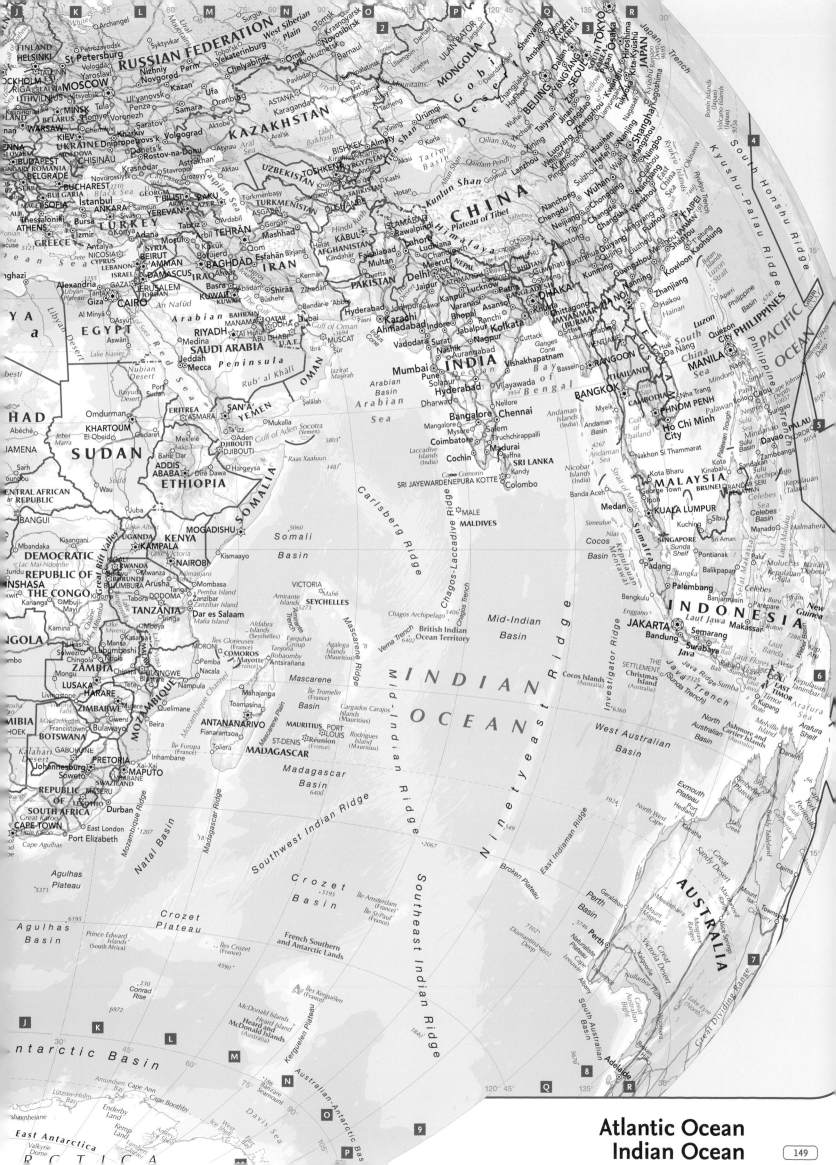

Atlantic Ocean
Indian Ocean

149

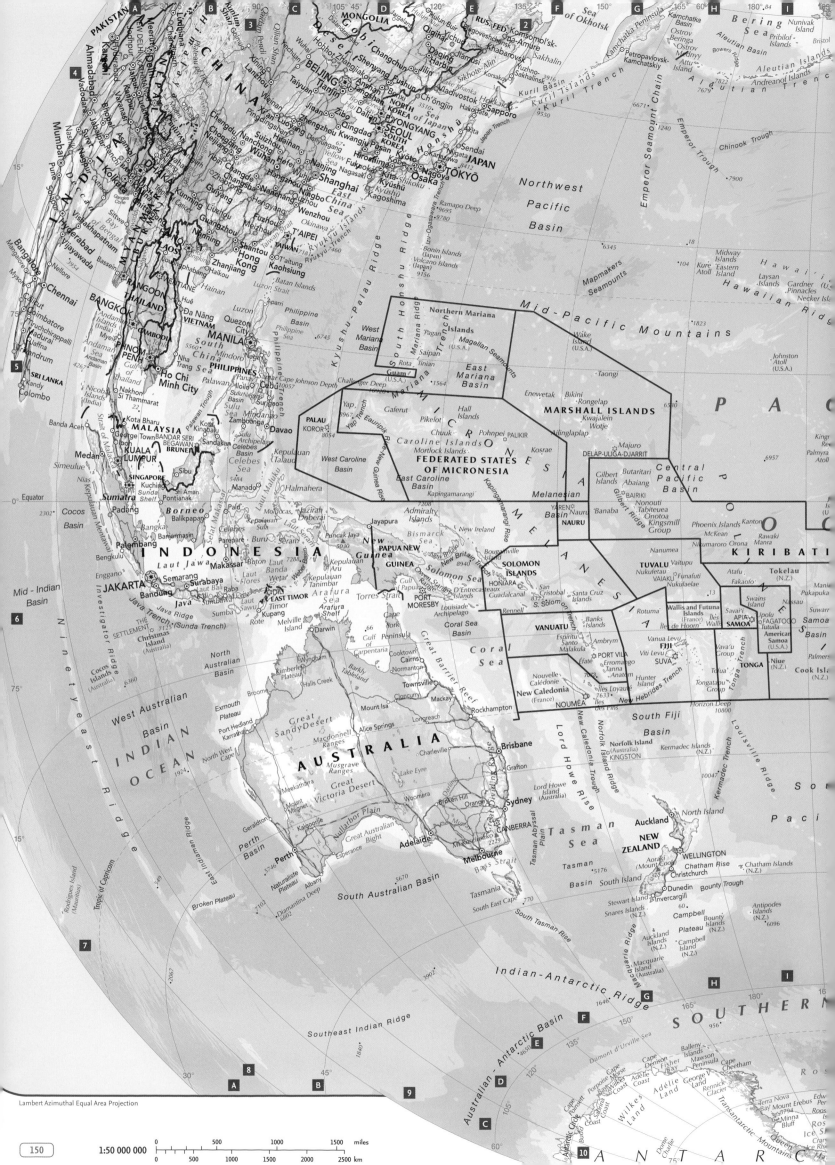

Lambert Azimuthal Equal Area Projection

1:50 000 000

0 500 1000 1500 miles

0 500 1000 1500 2000 2500 km

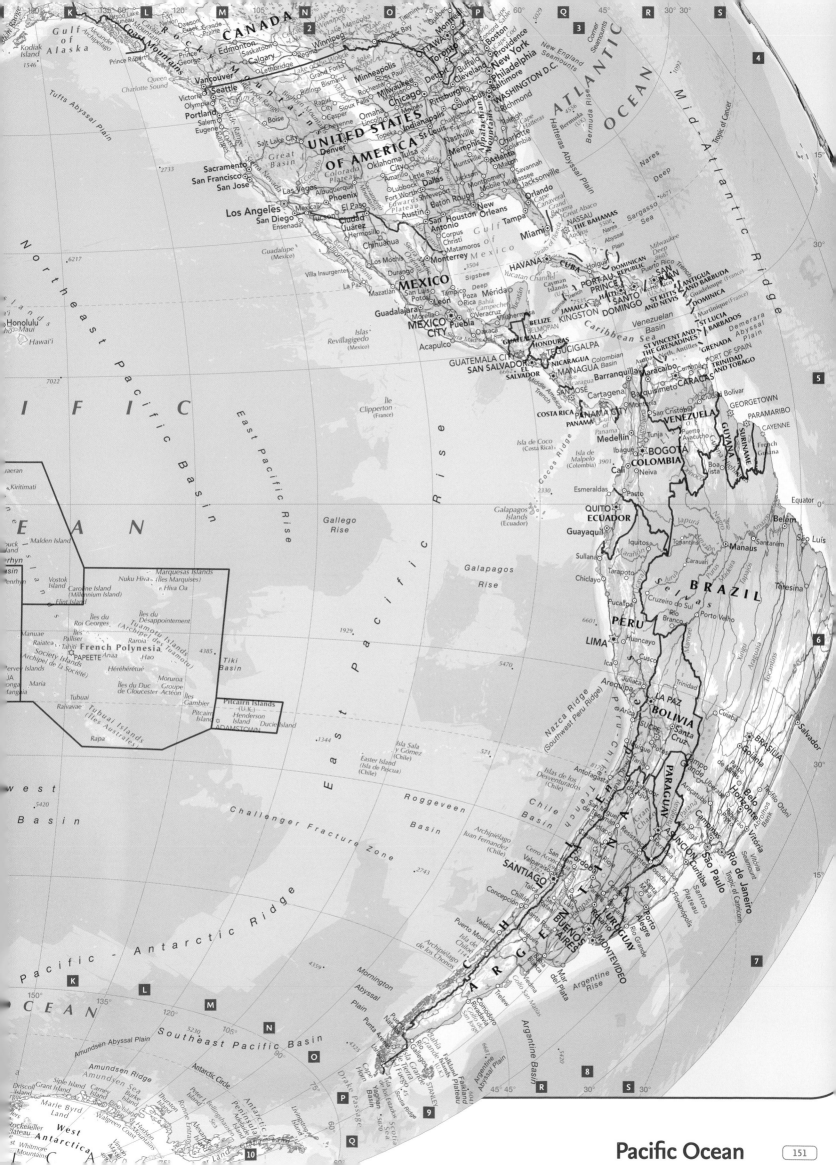

Pacific Ocean 151

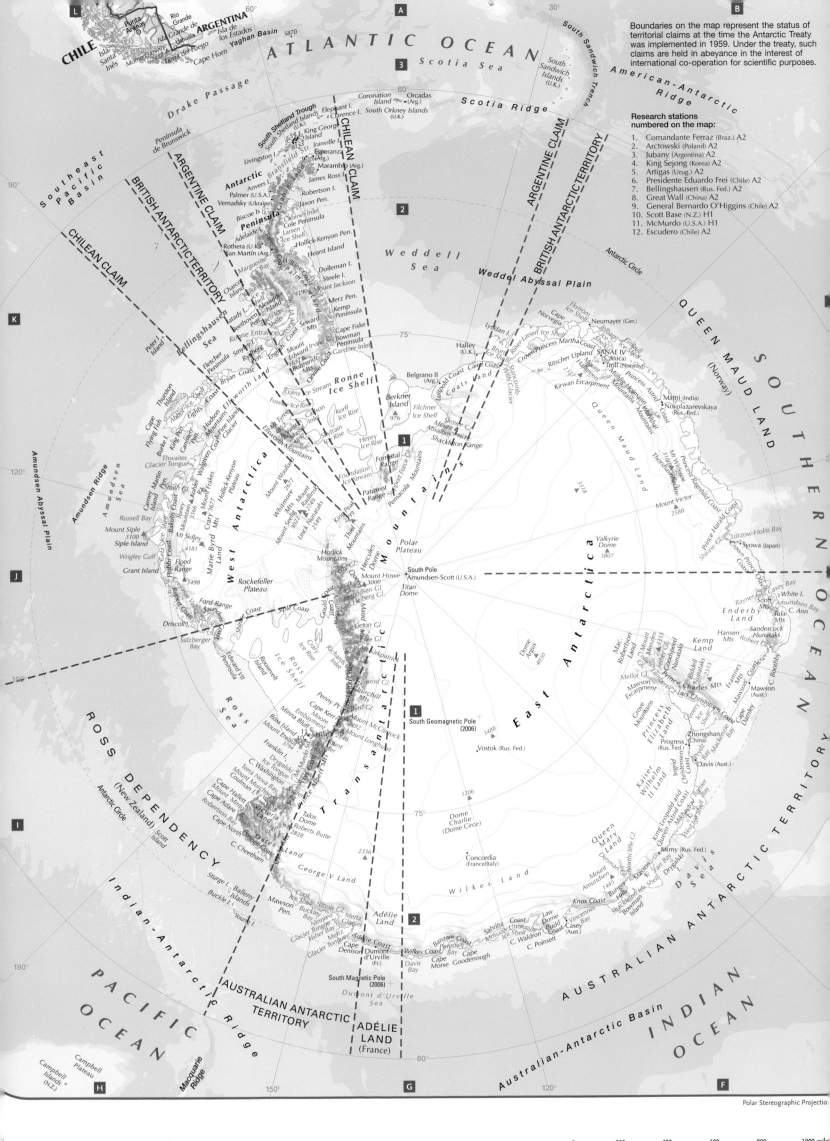

Boundaries on the map represent the status of territorial claims at the time the Antarctic Treaty was implemented in 1959. Under the treaty, such claims are held in abeyance in the interest of international co-operation for scientific purposes.

Research stations numbered on the map:

1. Comandante Ferraz (Braz.) A2
2. Arctowski (Poland) A2
3. Jubany (Argentina) A2
4. King Sejong (Korea) A2
5. Artigas (Urug.) A2
6. Presidente Eduardo Frei (Chile) A2
7. Bellingshausen (Rus. Fed.) A2
8. Great Wall (China) A2
9. General Bernardo O'Higgins (Chile) A2
10. Scott Base (N.Z.) H1
11. McMurdo (U.S.A.) H1
12. Escudero (Chile) A2

Polar Stereographic Projection

Antarctica

1:26 000 000

| 0 | 200 | 400 | 600 | 800 | 1000 miles |
| 0 | 200 | 400 | 600 | 800 | 1000 | 1200 | 1400 | 1600 km |

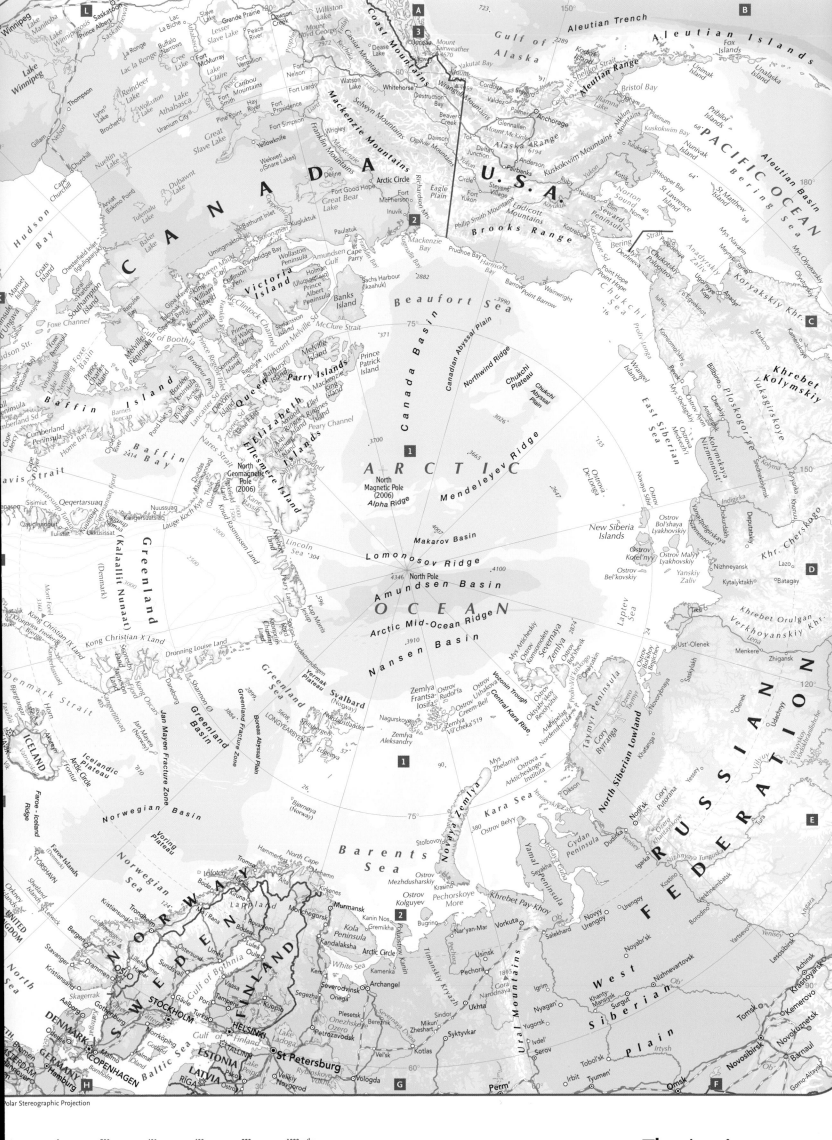

The Arctic 153

Polar Stereographic Projection

See page 160 for explanatory table and sources

	Population							Economy					
					Population by age (%)		2050 projected population	Total Gross National Income (GNI) (US$M)	GNI per capita (US$)	Debt service ratio (% GNI)	Total debt service (US$)	Aid receipts (% GNI)	Military spending (% GDP)
	Total population	Population change (%)	% urban	Total fertility	0–14	60 or over							
WORLD	6 464 750 000	1.2	48.6	2.7	28.2	10.4	9 075 903 000	34 491 458	6 280	2.6
AFGHANISTAN	29 863 000	4.6	...	7.5	46.5	4.4	97 324 000
ALBANIA	3 130 000	0.4	44.4	2.3	27.0	12.0	3 458 000	5 517	2 080	1.2	58 400 000	6.2	1.3
ALGERIA	32 854 000	1.5	59.4	2.5	29.6	6.5	49 500 000	60 221	2 280	7.8	4 166 400 000	0.6	3.2
ANDORRA	67 000	0.4	91.5	58 000
ANGOLA	15 941 000	2.8	36.5	6.8	46.5	3.9	43 501 000	10 004	1 030	9.3	862 800 000	4.5	4.7
ANTIGUA AND BARBUDA	81 000	1.3	38.1	112 000	719	10 000	2.0	...
ARGENTINA	38 747 000	1.0	90.3	2.4	26.4	13.9	51 382 000	140 114	3 720	6.1	5 825 699 840	0.1	1.1
ARMENIA	3 016 000	-0.4	64.3	1.3	20.8	14.5	2 506 000	2 910	1 120	3.0	74 200 000	12.0	2.7
AUSTRALIA	20 155 000	1.1	92.3	1.8	19.6	17.3	27 940 000	430 533	26 900	1.8
AUSTRIA	8 189 000	0.2	65.8	1.4	15.5	22.7	8 073 000	215 372	32 300	0.8
AZERBAIJAN	8 411 000	0.7	50.0	1.9	25.8	9.2	9 631 000	6 709	950	3.2	186 700 000	6.0	1.9
THE BAHAMAS	323 000	1.4	89.7	2.3	28.3	9.3	466 000	4 684	15 100
BAHRAIN	727 000	1.6	90.1	2.5	27.1	4.5	1 155 000	7 569	12 410	1.0	4.9
BANGLADESH	141 822 000	1.9	24.6	3.3	35.5	5.7	242 937 000	54 587	440	1.5	722 200 000	1.8	1.2
BARBADOS	270 000	0.3	52.3	1.5	18.9	13.2	255 000	2 512	9 270	0.1	...
BELARUS	9 755 000	-0.6	71.3	1.2	15.2	18.6	7 017 000	15 700	2 120	1.4	197 400 000	...	1.2
BELGIUM	10 419 000	0.2	97.2	1.7	16.8	22.4	10 302 000	267 227	31 030	1.3
BELIZE	270 000	2.2	48.5	3.2	36.8	5.9	442 000	807	3 940	22.7	188 000 000	2.7	...
BENIN	8 439 000	3.2	45.3	5.9	44.2	4.3	22 123 000	2 990	530	2.4	63 200 000	8.1	...
BHUTAN	2 163 000	2.2	8.8	4.4	38.4	7.0	4 393 000	578	760	1.2	6 400 000	13.7	...
BOLIVIA	9 182 000	2.0	63.9	4.0	38.1	6.7	14 908 000	7 985	960	6.3	476 000 000	9.0	1.7
BOSNIA-HERZEGOVINA	3 907 000	0.3	44.8	1.3	16.5	19.2	3 170 000	6 386	2 040	2.7	158 100 000	9.6	...
BOTSWANA	1 765 000	0.1	52.0	3.2	37.6	5.1	1 658 000	5 911	4 340	1.2	60 000 000	0.8	4.0
BRAZIL	186 405 000	1.4	83.6	2.4	27.9	8.8	253 105 000	478 922	3 090	11.7	51 631 599 616	0.1	1.4
BRUNEI	374 000	2.3	76.8	2.5	29.6	4.7	681 000
BULGARIA	7 726 000	-0.7	70.2	1.2	13.8	22.4	5 065 000	16 639	2 740	8.9	1 368 000 000	...	2.6
BURKINA	13 228 000	3.2	18.2	6.7	47.2	4.2	39 093 000	3 587	360	1.7	52 800 000	14.8	1.3
BURUNDI	7 548 000	3.0	10.3	6.8	45.0	4.2	25 812 000	702	90	3.3	23 300 000	24.2	6.2
CAMBODIA	14 071 000	2.0	19.2	4.1	37.1	5.6	25 972 000	4 105	320	0.5	21 000 000	12.7	2.4
CAMEROON	16 322 000	1.9	52.2	4.7	41.2	5.6	26 891 000	10 287	800	3.9	357 800 000	6.6	1.5
CANADA	32 268 000	1.0	80.8	1.5	17.6	17.9	42 844 000	756 770	28 390	1.2
CAPE VERDE	507 000	2.4	56.7	3.8	39.5	5.5	1 002 000	701	1 770	3.4	21 700 000	14.6	0.7
CENTRAL AFRICAN REPUBLIC	4 038 000	1.3	43.3	5.0	43.0	6.1	6 747 000	1 019	310	0.1	900 000	5.8	1.1
CHAD	9 749 000	3.4	25.4	6.7	47.3	4.7	31 497 000	2 104	260	1.5	29 100 000	11.6	1.5
CHILE	16 295 000	1.1	87.3	2.0	24.9	11.6	20 657 000	69 193	4 910	11.9	7 728 999 936	0.0	3.5
CHINA	1 323 345 000	0.7	39.6	1.7	21.4	10.9	1 402 062 000	1 417 301	1 290	2.4	30 615 799 808	0.1	2.3
COLOMBIA	45 600 000	1.6	76.9	2.6	31.0	7.5	65 679 000	80 488	2 000	8.9	6 920 699 904	0.6	3.9
COMOROS	798 000	2.7	35.7	4.9	42.0	4.3	1 781 000	269	530	1.9	4 800 000	13.1	...
CONGO	3 999 000	3.0	54.0	6.3	47.1	4.5	13 721 000	2 407	770	1.1	24 000 000	2.6	1.4
CONGO, DEM. REPUBLIC OF THE	57 549 000	2.8	32.3	6.7	47.3	4.3	177 271 000	5 369	120	16.8	926 700 032	21.3	...
COSTA RICA	4 327 000	1.9	61.2	2.3	28.4	8.3	6 426 000	17 157	4 670	4.1	670 000 000	0.0	...
CÔTE D'IVOIRE	18 154 000	1.6	45.4	5.1	41.9	5.3	33 959 000	11 159	770	7.5	831 500 032	9.6	...
CROATIA	4 551 000	0.2	59.4	1.4	15.5	22.1	3 686 000	23 839	6 590	13.6	3 018 400 000	0.6	...
CUBA	11 269 000	0.3	75.8	1.6	19.1	15.3	9 749 000	1.5
CYPRUS	835 000	1.2	69.3	1.6	19.9	16.8	1 174 000	9 373	17 580	1.5
CZECH REPUBLIC	10 220 000	-0.1	74.4	1.2	14.6	20.0	8 452 000	68 711	9 150	6.9	4 534 400 000	...	2.1
DENMARK	5 431 000	0.3	85.5	1.8	18.8	21.1	5 851 000	181 825	40 650	1.6
DJIBOUTI	793 000	2.1	84.1	5.1	41.5	4.7	1 547 000	643	1 030	2.0	12 100 000	12.9	...
DOMINICA	79 000	0.3	72.4	98 000	239	3 650	4.8	11 100 000	12.9	...
DOMINICAN REPUBLIC	8 895 000	1.5	59.7	2.7	32.7	6.2	12 668 000	18 078	2 080	3.3	670 600 000	0.7	...
EAST TIMOR	947 000	5.4	7.7	7.8	41.1	5.0	3 265 000	351	550	58.3	...
ECUADOR	13 228 000	1.5	62.3	2.8	32.4	8.3	19 214 000	23 347	2 180	9.7	2 192 900 096	1.0	2.4
EGYPT	74 033 000	1.9	42.2	3.3	33.6	7.1	125 916 000	93 850	1 310	2.3	2 065 799 936	1.4	2.8
EL SALVADOR	6 881 000	1.8	59.8	2.9	34.0	7.6	10 823 000	14 387	2 350	3.2	453 300 000	1.7	0.1
EQUATORIAL GUINEA	504 000	2.3	49.0	5.9	44.4	6.0	1 146 000	437	...	1.0	3 600 000
ERITREA	4 401 000	4.3	20.4	5.5	44.8	4.0	11 229 000	850	180	1.2	9 200 000	30.8	19.4
ESTONIA	1 330 000	-0.6	69.6	1.4	15.2	21.6	1 119 000	6 699	7 010	12.7	782 899 968	...	1.8
ETHIOPIA	77 431 000	2.4	15.9	5.9	44.5	4.7	170 190 000	6 325	110	1.8	108 100 000	21.7	4.5
FIJI	848 000	0.9	52.5	2.9	31.7	6.4	934 000	1 969	2 690	1.6	27 800 000	1.9	1.8
FINLAND	5 249 000	0.3	60.9	1.7	17.3	21.3	5 329 000	140 755	32 790	1.2
FRANCE	60 496 000	0.4	76.5	1.9	18.2	21.1	63 116 000	1 523 025	30 090	2.6
GABON	1 384 000	1.7	84.4	4.0	40.0	6.2	2 279 000	4 813	3 940	9.8	410 100 000	1.7	...
THE GAMBIA	1 517 000	2.9	26.1	4.8	40.1	6.0	3 106 000	442	290	4.8	19 200 000	15.3	0.6
GEORGIA	4 474 000	-1.1	51.7	1.5	18.9	17.9	2 985 000	3 780	1 040	3.9	128 800 000	9.4	1.1

	Social Indicators					Environment				Communications				
Child mortality rate	Life expectancy M	Life expectancy F	Literacy rate (%)	Access to safe water (%)	Doctors per 100 000 people	Forest area (%)	Annual change in forest area (%)	Protected land area (%)	CO_2 emissions (metric tonnes per capita)	Main telephone lines per 100 people	Cellular phone subscribers per 100 people	Internet users per 10 000 people	International dialling code	Time zone
80	63.3	67.6	87.3	83	152	29.6	0.2	11.4	4.0	19.0	27.6	1 362
257	43.0	43.3	...	13	19	2.1	-3.1	0.3	...	0.2	2.4	10	93	+4.5
21	70.9	76.7	98.2	97	139	36.2	0.6	2.6	1.3	8.3	39.5	235	355	+1
41	68.1	71.3	90.4	87	85	0.9	1.2	5.1	2.4	7.1	14.5	261	213	+1
7	100	259	...	0.0	6.4	...	52.3	93.4	1 642	376	+1
260	38.8	41.5	...	50	8	56.0	-0.2	10.0	0.5	0.7	6.7	122	244	+1
12	91	17	20.5	0.0	0.0	4.9	49.4	70.1	2 597	1 268	-4
20	70.6	77.7	98.6	94	301	12.7	-0.4	6.3	3.4	22.8	35.4	1 610	54	-3
33	69.0	75.6	99.8	92	353	12.4	-1.5	10.1	1.1	15.3	5.4	395	374	+4
6	76.4	82.0	...	100	249	20.1	-0.1	9.7	17.4	58.6	82.8	6 528	61	+8 to +11
5	75.4	81.5	...	100	324	47.0	0.1	28.0	9.2	46.2	97.4	4 752	43	+1
91	68.7	75.5	...	77	354	13.1	0.0	4.6	3.4	12.3	17.4	489	994	+4
14	63.9	70.3	97.4	97	106	84.1	0.0	1.7	5.9	44.1	58.7	2 934	1 242	-5
15	72.5	75.9	98.6	...	160	...	3.8	1.4	22.7	26.7	90.6	2 130	973	+3
69	61.0	61.8	52.1	75	23	10.2	-0.3	0.5	0.2	0.6	2.0	22	880	+6
13	74.5	79.5	...	100	121	4.7	0.0	0.0	4.4	50.1	73.9	5 535	1 246	-4
17	64.9	75.3	99.8	100	450	45.3	0.1	6.4	5.9	32.2	22.7	2 498	375	+2
5	75.7	81.9	418	22.2	0.0	3.4	11.6	46.4	88.3	4 062	32	+1
39	69.9	73.0	98.2	91	105	59.1	0.0	47.6	3.1	12.9	35.1	1 341	501	-6
154	48.4	53.0	55.5	68	6	24.0	-2.5	22.6	0.3	1.0	5.3	138	229	+1
85	62.0	64.5	...	62	5	64.2	0.3	30.2	0.5	3.9	2.5	256	975	+6
66	61.8	66.0	96.3	85	73	48.9	-0.5	19.4	1.0	7.0	20.1	390	591	-4
17	71.3	76.7	...	98	134	44.6	0.0	0.5	3.7	24.0	34.0	581	387	+1
112	38.9	40.5	89.1	95	29	21.9	-1.0	30.2	2.3	8.0	32.9	350	267	+2
35	64.0	72.6	93.0	89	206	64.3	-0.6	18.0	1.7	23.5	36.3	1 218	55	-2 to -5
6	74.2	78.9	99.5	...	101	83.9	-0.7	56.2	14.8	25.6	56.3	1 530	673	+8
15	67.4	74.6	99.7	100	338	33.4	1.4	10.1	6.0	35.1	60.9	1 590	359	+2
207	45.2	46.2	36.9	51	4	25.9	-0.3	15.4	0.0	0.6	3.0	40	226	GMT
190	40.4	41.4	66.1	79	5	3.7	-5.2	5.4	0.0	0.3	1.4	35	257	+2
140	55.2	59.5	80.1	34	16	52.9	-2.0	22.7	0.0	0.3	6.0	28	855	+7
166	45.1	47.4	94.4	63	7	51.3	-1.0	8.0	0.2	0.6	9.4	102	237	+1
6	76.7	81.9	...	100	209	26.5	0.0	6.3	17.5	64.3	46.7	6 236	1	-3.5 to -8
35	67.0	72.8	89.2	80	17	21.1	0.4	3.8	0.3	15.6	13.9	530	238	-1
180	38.5	40.6	69.9	75	4	36.8	-0.1	16.6	0.1	0.3	1.5	23	236	+1
200	43.7	45.7	69.9	34	3	10.1	-0.7	9.4	0.0	0.2	1.4	40	235	+1
9	73.0	79.0	99.0	95	109	20.7	0.4	3.6	3.4	21.5	62.1	2 790	56	-3
37	68.9	73.3	98.2	77	164	17.5	2.2	11.8	2.9	24.0	25.8	723	86	+8
21	69.2	75.3	97.2	92	135	47.8	-0.1	72.3	1.3	17.1	23.0	894	57	-5
73	59.4	62.2	59.0	94	7	4.3	-7.4	...	0.1	1.7	1.2	101	269	+3
108	46.6	49.7	97.8	46	25	64.6	-0.1	17.7	0.2	0.4	10.1	94	242	+1
205	40.8	42.8	83.7	46	7	59.6	-0.2	8.3	0.0	0.0	3.5	9	243	+1 to +2
10	75.8	80.6	98.4	97	172	38.5	0.1	23.5	1.3	31.6	21.7	2 354	506	-6
192	40.8	41.2	67.6	84	9	22.4	0.1	16.9	0.3	1.4	9.1	144	225	GMT
7	70.3	78.1	99.8	...	237	31.9	0.1	6.4	4.7	42.7	63.6	2 951	385	+1
8	74.8	78.7	99.8	91	591	21.4	2.2	1.3	2.2	6.8	0.7	132	53	-5
5	76.0	80.5	99.8	100	298	18.6	0.2	8.4	9.1	51.8	79.4	3 693	357	+2
4	72.1	78.7	343	34.1	0.1	18.3	11.5	33.6	105.6	4 997	420	+1
4	74.2	79.1	...	100	366	10.7	0.6	25.5	10.4	64.5	95.5	6 041	45	+1
138	44.7	46.8	85.7	80	13	0.3	0.0	0.5	0.6	1.6	5.1	132	253	+3
14	97	49	61.3	-0.6	25.6	1.4	29.4	58.7	2 875	1 767	-4
35	64.4	69.2	91.7	93	188	28.4	0.0	24.5	2.0	10.7	28.8	910	1 809	-4
124	48.7	50.4	...	52	...	34.3	-1.3	670	+9
27	68.3	73.5	97.5	86	148	38.1	-1.7	27.0	1.6	12.2	26.9	473	593	-5
39	66.7	71.0	71.3	98	212	0.1	2.6	5.7	1.8	13.5	10.9	557	20	+2
36	67.7	73.7	89.0	82	127	5.8	-1.7	2.0	0.9	13.4	27.7	888	503	-6
146	47.8	50.5	97.4	44	25	62.5	-0.9	16.8	0.4	1.8	11.0	99	240	+1
85	51.2	54.2	72.0	57	3	13.5	-0.3	4.1	0.2	0.9	0.5	118	291	+3
9	66.5	76.8	99.8	...	316	48.7	0.4	19.6	12.0	34.0	96.0	5 122	372	+2
169	44.6	46.3	57.2	22	3	4.2	-1.1	16.4	0.1	0.6	0.3	16	251	+3
20	68.1	71.5	99.2	93	34	44.6	0.0	15.9	0.9	12.4	16.8	720	679	+12
5	74.4	81.5	...	100	311	72.0	...	8.8	13.9	45.4	95.6	6 300	358	+2
5	75.2	82.8	329	27.9	0.3	3.0	6.3	56.0	73.7	4 137	33	+1
91	55.8	57.5	...	87	29	84.7	...	3.4	1.2	2.9	36.2	296	241	+1
123	52.7	55.5	60.0	82	4	48.1	0.4	3.2	0.2	2.9	12.0	335	220	GMT
45	69.5	77.6	...	76	391	43.7	...	4.3	0.6	13.5	16.6	346	995	+3

Statistics

See page 160 for explanatory table and sources

	Population							Economy					
	Total population	Population change (%)	% urban	Total fertility	Population by age (%) 0 – 14	Population by age (%) 60 or over	2050 projected population	Total Gross National Income (GNI) (US$M)	GNI per capita (US$)	Debt service ratio (% GNI)	Total debt service (US$)	Aid receipts (% GNI)	Military spending (% GDP)
GERMANY	82 689 000	0.1	88.3	1.3	14.3	25.1	78 765 000	2 084 631	30 120	1.5
GHANA	22 113 000	2.1	45.8	4.4	39.0	5.7	40 573 000	6 563	380	3.5	211 000 000	10.8	0.7
GREECE	11 120 000	0.3	61.1	1.3	14.3	23.0	10 742 000	146 563	16 610	4.1
GRENADA	103 000	0.3	41.5	157 000	396	3 760	6.8	25 600 000	2.6	...
GUATEMALA	12 599 000	2.4	46.8	4.6	43.2	6.1	25 612 000	23 486	2 130	1.8	412 000 000	1.1	0.5
GUINEA	9 402 000	2.2	35.7	5.9	43.7	5.6	22 987 000	3 372	460	4.3	135 800 000	7.9	2.9
GUINEA-BISSAU	1 586 000	3.0	34.8	7.1	47.5	4.7	5 312 000	202	160	7.6	14 800 000	30.5	3.1
GUYANA	751 000	0.2	38.0	2.3	29.3	7.4	488 000	689	990	11.6	77 500 000	9.7	...
HAITI	8 528 000	1.4	38.1	4.0	37.5	6.0	12 996 000	3 214	390	0.8	28 000 000	4.7	...
HONDURAS	7 205 000	2.3	46.0	3.7	39.2	5.6	12 776 000	6 760	1 030	6.2	396 800 000	6.8	0.8
HUNGARY	10 098 000	-0.3	65.5	1.3	15.7	20.8	8 262 000	64 028	8 270	24.3	14 869 900 288	...	1.8
ICELAND	295 000	0.9	92.9	2.0	22.0	15.8	370 000	8 813	38 620	0.0
INDIA	1 103 371 000	1.6	28.5	3.1	32.1	7.9	1 592 704 000	567 605	620	2.6	13 127 600 128	0.3	2.3
INDONESIA	222 781 000	1.3	46.7	2.4	28.3	8.4	284 640 000	172 733	1 140	10.3	16 971 100 160	0.8	1.0
IRAN	69 515 000	0.9	67.3	2.1	28.7	6.4	101 944 000	132 896	2 300	1.3	1 460 400 000	0.1	4.5
IRAQ	28 807 000	2.8	...	4.8	41.0	4.5	63 693 000	...	23 290
IRELAND	4 148 000	1.8	60.1	1.9	20.2	15.1	5 762 000	106 417	34 280	0.6
ISRAEL	6 725 000	2.0	91.7	2.9	27.8	13.3	10 403 000	105 160	17 380	8.7
ITALY	58 093 000	0.1	67.5	1.3	14.0	25.6	50 912 000	1 242 978	26 120	1.9
JAMAICA	2 651 000	0.5	52.2	2.4	31.2	10.2	2 586 000	7 285	2 900	11.6	842 099 968	0.3	...
JAPAN	128 085 000	0.2	65.6	1.3	14.0	26.3	112 198 000	4 389 791	37 180	1.0
JORDAN	5 703 000	2.7	79.2	3.5	37.2	5.1	10 225 000	9 800	2 140	6.3	584 899 968	5.6	8.5
KAZAKHSTAN	14 825 000	-0.3	55.9	2.0	23.1	11.3	13 086 000	26 535	2 260	17.4	4 115 300 096	0.8	0.9
KENYA	34 256 000	2.2	40.5	5.0	42.8	4.1	83 073 000	12 604	460	3.7	452 400 000	3.2	1.7
KIRIBATI	99 000	2.1	48.7	177 000	84	970	22.9	...
KUWAIT	2 687 000	3.7	96.3	2.4	24.3	3.1	5 279 000	38 037	17 970	12.5
KYRGYZSTAN	5 264 000	1.2	33.9	2.7	31.5	7.6	6 664 000	1 649	400	11.2	172 800 000	12.0	1.4
LAOS	5 924 000	2.3	21.2	4.8	40.9	5.3	11 586 000	1 821	390	2.6	44 600 000	16.2	2.1
LATVIA	2 307 000	-0.6	66.1	1.3	14.7	22.5	1 678 000	9 441	5 460	7.7	650 000 000	...	1.8
LEBANON	3 577 000	1.0	87.7	2.3	28.6	10.3	4 702 000	18 187	4 980	12.2	2 187 699 968	2.5	4.1
LESOTHO	1 795 000	0.1	18.1	3.7	38.6	7.5	1 601 000	1 049	740	7.7	67 200 000	8.7	2.8
LIBERIA	3 283 000	1.4	47.3	6.8	47.1	3.6	10 653 000	445	110	0.2	900 000	11.0	7.5
LIBYA	5 853 000	2.0	86.6	3.0	30.1	6.5	9 553 000	...	4 450	2.1
LIECHTENSTEIN	35 000	1.0	21.7	44 000
LITHUANIA	3 431 000	-0.4	66.7	1.3	16.7	20.7	2 565 000	15 509	5 740	9.2	1 281 400 064	...	1.9
LUXEMBOURG	465 000	1.3	92.1	1.7	18.9	18.3	721 000	19 683	56 230	0.9
MACEDONIA (F.Y.R.O.M.)	2 034 000	0.2	59.6	1.5	19.6	15.5	1 884 000	4 058	2 350	6.3	237 900 000	7.3	2.8
MADAGASCAR	18 606 000	2.8	26.8	5.4	44.0	4.8	43 508 000	4 848	300	1.7	72 900 000	8.6	7.2
MALAWI	12 884 000	2.3	16.7	6.1	47.3	4.7	29 452 000	1 832	170	1.9	36 200 000	20.2	0.8
MALAYSIA	25 347 000	2.0	64.4	2.9	32.4	7.0	38 924 000	93 683	4 650	9.1	8 081 999 872	0.1	2.3
MALDIVES	329 000	2.5	29.3	4.3	40.7	5.1	682 000	674	2 510	3.7	22 100 000	4.6	...
MALI	13 518 000	3.0	33.0	6.9	48.2	4.2	41 976 000	3 428	360	2.9	89 700 000	15.0	2.0
MALTA	402 000	0.5	91.9	1.5	17.6	18.8	428 000	3 678	12 250	0.3	0.8
MARSHALL ISLANDS	62 000	3.5	66.6	150 000	143	2 370	48.4	...
MAURITANIA	3 069 000	3.0	63.0	5.8	43.0	5.3	7 497 000	1 163	420	5.7	64 300 000	30.6	1.6
MAURITIUS	1 245 000	1.0	43.5	2.0	24.6	9.6	1 465 000	5 012	4 640	5.5	250 600 000	0.5	0.2
MEXICO	107 029 000	1.3	75.8	2.4	31.0	7.8	139 015 000	637 159	6 770	6.8	43 535 499 264	0.0	0.5
MICRONESIA, FED. STATES OF	110 000	0.6	29.7	4.4	39.0	4.9	99 000	261	1 990	45.6	...
MOLDOVA	4 206 000	-0.3	46.2	1.2	18.3	13.7	3 312 000	2 137	710	12.6	228 500 000	7.8	0.4
MONACO	35 000	1.1	100.0	55 000
MONGOLIA	2 646 000	1.2	56.9	2.5	30.5	5.7	3 625 000	1 188	590	4.7	52 400 000	18.6	2.1
MOROCCO	31 478 000	1.5	58.1	2.8	31.1	6.8	46 397 000	39 661	1 520	10.4	3 690 800 128	1.4	4.2
MOZAMBIQUE	19 792 000	2.0	36.8	5.5	44.0	5.2	37 604 000	3 897	250	2.2	75 600 000	60.3	2.4
MYANMAR	50 519 000	1.1	30.0	2.5	29.5	7.5	63 657 000	113 300 000
NAMIBIA	2 031 000	1.4	33.0	4.0	41.5	5.3	3 060 000	3 771	2 370	4.5	2.8
NAURU	14 000	2.2	18 000
NEPAL	27 133 000	2.1	15.4	3.7	39.0	5.8	51 172 000	5 824	260	1.8	98 000 000	6.7	1.5
NETHERLANDS	16 299 000	0.5	66.3	1.7	18.2	19.2	17 139 000	426 641	31 700	1.6
NEW ZEALAND	4 028 000	1.1	85.9	2.0	21.3	16.7	4 790 000	63 608	20 310	1.0
NICARAGUA	5 487 000	2.0	57.7	3.3	38.9	4.9	9 371 000	3 989	790	4.0	151 400 000	13.6	0.9
NIGER	13 957 000	3.4	22.7	7.9	49.0	3.3	50 156 000	2 361	230	1.3	27 900 000	13.8	0.9
NIGERIA	131 530 000	2.2	47.5	5.9	44.3	4.8	258 108 000	42 984	390	4.0	1 489 900 032	0.9	0.9
NORTH KOREA	22 488 000	0.6	61.4	2.0	25.0	11.2	24 192 000
NORWAY	4 620 000	0.5	79.5	1.8	19.6	20.0	5 435 000	197 658	52 030	2.0
OMAN	2 567 000	1.0	78.1	3.8	34.5	4.2	4 958 000	19 877	7 890	8.8	1 748 099 968	0.2	11.2

| Social Indicators | | | | | Environment | | | | Communications | | | | |
| Child mortality rate | Life expectancy | | Literacy rate (%) | Access to safe water (%) | Doctors per 100 000 people | Forest area (%) | Annual change in forest area (%) | Protected land area (%) | CO₂ emissions (metric tonnes per capita) | Main telephone lines per 100 people | Cellular phone subscribers per 100 people | Internet users per 10 000 people | International dialling code | Time zone |
	M	F												
5	75.2	81.2	...	100	362	30.7	0.0	31.3	10.4	66.2	86.4	4 267	49	+1
95	56.5	59.3	92.1	79	9	27.8	-2.0	15.4	0.3	1.5	7.9	172	233	GMT
5	75.7	80.9	99.8	...	440	27.9	0.8	3.2	8.6	57.8	84.8	1 781	30	+2
23	95	50	14.7	0.0	0.0	2.1	31.8	42.1	1 690	1 473	-4
47	63.0	68.9	80.3	95	90	26.3	-1.3	23.2	0.8	8.9	25.0	597	502	-6
160	48.8	49.5	...	51	9	28.2	-0.5	6.4	0.2	0.3	2.0	59	224	GMT
204	43.8	46.9	60.9	59	17	60.5	-0.5	0.0	0.2	0.8	3.2	199	245	GMT
69	60.1	66.3	99.8	83	48	78.5	0.0	2.3	2.1	13.4	13.6	1 890	592	-4
118	49.0	50.0	66.2	71	25	3.2	-0.7	0.3	0.2	1.7	4.9	609	509	-5
41	66.5	71.4	84.2	90	83	48.1	-3.1	20.8	0.8	5.6	10.1	318	504	-6
8	67.7	76.0	99.8	99	316	19.9	0.7	8.9	5.7	35.4	86.4	2 674	36	+1
4	77.6	81.9	...	100	347	0.3	3.9	4.7	7.6	65.0	99.0	7 700	354	GMT
87	63.2	64.6	74.1	86	51	21.6	...	5.1	1.0	4.1	4.4	324	91	+5.5
41	64.8	68.8	98.0	78	16	58.0	-2.0	13.6	1.5	4.5	13.5	652	62	+7 to +9
39	68.9	71.9	94.8	93	105	4.5	0.0	6.5	5.3	22.0	6.2	788	98	+3.5
125	59.2	62.3	45.3	81	54	1.8	0.1	0.0	2.8	4.0	2.2	14	964	+3
6	74.4	79.6	237	9.6	1.9	1.1	10.3	49.9	93.5	2 963	353	GMT
6	77.1	81.0	99.5	100	391	6.4	0.8	22.3	9.2	43.7	105.3	4 663	972	+2
4	75.5	81.9	99.8	...	606	34.0	1.1	10.8	7.8	44.8	108.2	4 978	39	+1
20	73.7	77.8	94.5	93	85	30.0	-0.1	15.9	3.9	14.6	82.2	3 987	1 876	-5
4	77.9	85.1	...	100	201	64.0	...	14.0	9.4	46.0	71.6	5 020	81	+9
28	69.7	72.5	99.5	91	205	1.0	0.0	10.9	2.8	11.0	28.4	1 069	962	+2
73	60.9	71.9	...	86	330	4.5	-0.2	2.9	10.2	16.2	17.9	260	7	+4 to +6
123	43.5	45.6	95.8	62	13	30.0	-0.3	12.3	0.3	0.9	7.9	463	254	+3
66	64	30	38.4	0.0	...	0.3	5.1	0.7	235	686	+12 to +14
9	74.9	79.0	93.1	...	153	0.3	2.7	0.0	24.4	19.5	78.3	2 350	965	+3
68	64.8	72.3	...	76	268	5.2	0.3	3.6	1.0	8.2	5.2	516	996	+5
91	53.3	55.8	73.3	43	59	54.4	-0.5	16.2	...	1.3	3.5	36	856	+7
12	65.6	76.2	99.8	...	291	47.1	0.4	15.1	3.1	28.5	67.2	3 543	371	+2
31	71.9	75.1	95.6	100	325	3.5	0.8	0.7	3.8	17.8	25.0	1 690	961	+2
84	32.3	37.7	91.1	76	5	0.5	2.7	0.2	...	2.1	8.8	239	266	+2
235	40.7	42.2	71.7	62	2	31.3	-1.8	15.8	0.1	0.2	2.7	...	231	GMT
16	70.8	75.4	97.0	72	129	0.2	0.0	0.1	7.8	13.6	4.2	362	218	+2
11	46.7	0.0	35.4	423	+1
11	67.5	77.6	99.8	...	403	31.9	0.8	9.2	3.5	23.8	99.3	2 809	370	+2
5	75.1	81.4	...	100	255	...	0.0	17.1	22.0	79.8	138.2	5 900	352	+1
11	71.4	75.8	219	35.6	0.0	7.9	4.0	25.2	47.7	770	389	+1
126	52.5	54.8	81.5	45	9	20.2	-0.3	3.1	0.1	0.3	1.9	50	261	+3
178	37.3	37.7	72.5	67	1	27.2	-0.9	16.3	0.1	0.8	1.8	37	265	+2
7	70.8	75.7	97.9	95	70	58.7	-0.7	30.5	5.0	17.4	57.1	3 862	60	+8
72	67.8	67.0	99.2	84	78	3.3	0.0	9.6	34.5	579	960	+5
220	48.0	49.1	69.9	48	4	10.8	-0.8	3.7	0.1	0.7	3.6	45	223	GMT
6	75.9	80.7	98.7	100	293	n.s.	0.0	13.5	6.3	51.6	76.5	7 525	356	+1
61	85	47	...	0.0	8.3	1.1	351	692	+12
183	50.9	54.1	49.6	56	14	43.9	-3.4	0.2	1.2	1.3	17.5	47	222	GMT
18	68.4	75.8	94.3	100	85	7.9	-0.5	29.8	2.4	28.7	41.4	1 460	230	+4
28	70.4	76.4	97.2	91	171	28.9	-0.4	5.0	3.6	17.2	36.6	1 338	52	-6 to -8
23	68.0	69.1	...	94	60	21.7	0.0	6.7	...	10.8	11.5	1 081	691	+10 to +11
32	65.5	72.2	99.8	92	269	9.9	0.2	1.4	1.7	20.3	18.5	952	373	+2
4	100	586	...	0.0	0.0	377	+1
68	61.9	65.9	99.6	62	267	6.8	-0.8	14.0	3.1	5.6	16.3	760	976	+8
39	66.8	70.5	69.6	80	48	6.8	0.2	1.2	1.1	4.4	31.2	1 171	212	GMT
158	36.6	39.6	62.8	42	2	39.0	-0.3	5.7	0.1	0.4	3.7	73	258	+2
107	54.6	60.2	91.4	80	30	52.3	-1.4	5.3	0.2	0.8	0.2	12	95	+6.5
65	42.9	45.6	92.3	80	30	9.8	-0.9	5.6	1.2	6.4	14.2	373	264	+2
30	82	0.0	674	+12
82	60.1	59.6	62.8	84	5	27.3	-1.4	18.1	0.1	1.7	0.5	48	977	+5.75
5	75.6	81.0	98.3	100	329	11.1	0.3	26.7	11.4	48.4	91.2	6 163	31	+1
6	75.8	80.7	...	97	223	29.7	0.2	24.3	8.1	46.1	77.5	5 263	64	+13
38	67.2	71.9	72.3	81	164	27.0	-1.3	21.9	0.7	3.8	13.0	220	505	-6
262	45.9	46.5	24.4	46	3	1.0	-1.0	8.2	0.3	0.2	1.2	19	227	+1
198	51.1	51.8	88.5	60	27	14.8	-3.3	6.0	0.4	0.8	7.2	139	234	+1
55	60.5	66.0	...	100	297	68.2	-1.9	2.6	3.0	4.1	850	+9
4	76.0	81.9	...	100	356	28.9	0.2	6.2	7.8	47.2	103.6	3 937	47	+1
12	71.0	74.4	98.5	79	126	0.0	0.0	0.1	9.7	10.1	33.3	1 014	968	+4

See page 160 for explanatory table and sources

	Population							Economy					
	Total population	Population change (%)	% urban	Total fertility	Population by age (%) 0 – 14	Population by age (%) 60 or over	2050 projected population	Total Gross National Income (GNI) (US$M)	GNI per capita (US$)	Debt service ratio (% GNI)	Total debt service (US$)	Aid receipts (% GNI)	Military spending (% GDP)
PAKISTAN	157 935 000	2.0	34.5	4.3	38.3	5.8	304 700 000	69 236	600	4.8	2 844 100 096	3.6	4.1
PALAU	20 000	0.7	68.4	21 000	150	6 870	21.2	...
PANAMA	3 232 000	1.8	57.5	2.7	30.4	8.8	5 093 000	12 681	4 450	13.9	1 677 200 000	0.2	...
PAPUA NEW GUINEA	5 887 000	2.1	13.2	4.1	40.3	3.9	10 619 000	2 823	580	10.4	277 500 000	7.6	...
PARAGUAY	6 158 000	2.4	57.9	3.9	37.6	5.6	12 095 000	6 213	1 170	5.8	327 000 000	1.0	0.7
PERU	27 968 000	1.5	74.2	2.9	32.2	7.8	42 552 000	58 458	2 360	6.1	3 356 499 968	0.9	1.5
PHILIPPINES	83 054 000	1.8	61.8	3.2	35.1	6.1	127 068 000	87 771	1 170	11.1	9 191 999 488	0.7	1.0
POLAND	38 530 000	-0.1	62.0	1.3	16.3	16.8	31 916 000	201 389	6 090	7.1	13 488 799 744	...	1.9
PORTUGAL	10 495 000	0.5	55.1	1.5	15.9	22.3	10 723 000	123 664	14 350	2.1
QATAR	813 000	5.9	92.2	3.0	21.7	2.6	1 330 000
ROMANIA	21 711 000	-0.4	54.7	1.3	15.4	19.3	16 757 000	51 194	2 920	6.8	3 088 199 936	...	2.4
RUSSIAN FEDERATION	143 202 000	-0.5	73.3	1.3	15.3	17.1	111 752 000	374 937	3 410	4.2	14 330 099 712	...	4.3
RWANDA	9 038 000	2.4	20.1	5.7	43.5	3.9	18 153 000	1 826	220	1.3	22 000 000	20.5	2.9
SAMOA	185 000	0.8	22.4	4.4	40.7	6.5	157 000	284	1 860	3.0	7 800 000	14.3	...
SAN MARINO	28 000	0.9	88.7	30 000
SÃO TOMÉ AND PRÍNCIPE	157 000	2.3	37.9	4.1	39.5	5.7	295 000	50	370	13.1	6 100 000	56.0	...
SAUDI ARABIA	24 573 000	2.7	88.0	4.1	37.3	4.6	49 464 000	186 776	10 430	0.0	8.8
SENEGAL	11 658 000	2.4	50.3	5.1	42.6	4.9	23 108 000	5 563	670	4.5	218 700 000	9.2	1.4
SERBIA AND MONTENEGRO*	10 503 000	-0.1	52.2	1.7	18.3	18.5	9 426 000	15 512	2 620	1.0	150 200 000	12.4	4.2
SEYCHELLES	81 000	0.9	50.1	99 000	626	8 090	2.3	14 600 000	1.3	1.7
SIERRA LEONE	5 525 000	4.1	39.5	6.5	42.8	5.5	13 786 000	808	200	3.1	23 000 000	47.0	1.7
SINGAPORE	4 326 000	1.5	100.0	1.4	19.5	12.2	5 213 000	90 229	24 220	5.1
SLOVAKIA	5 401 000	0.0	57.7	1.2	16.7	16.2	4 612 000	26 483	6 480	14.2	3 376 999 936	...	1.8
SLOVENIA	1 967 000	0.0	50.8	1.2	13.9	20.5	1 630 000	23 230	14 810	0.2	1.5
SOLOMON ISLANDS	478 000	2.6	16.8	4.3	40.6	4.2	921 000	273	550	2.4	5 700 000	10.9	...
SOMALIA	8 228 000	3.2	35.4	6.4	44.1	4.2	21 329 000	200 000
SOUTH AFRICA, REPUBLIC OF	47 432 000	0.8	57.4	2.8	32.6	6.8	48 660 000	125 971	3 630	4.5	4 691 500 032	0.5	1.6
SOUTH KOREA	47 817 000	0.4	80.5	1.2	18.6	13.7	44 629 000	576 426	13 980	2.4
SPAIN	43 064 000	1.1	76.6	1.3	14.3	21.4	42 541 000	698 208	21 210	1.2
SRI LANKA	20 743 000	0.9	21.0	2.0	24.1	10.7	23 554 000	17 846	1 010	4.4	715 900 032	2.1	2.5
ST KITTS AND NEVIS	43 000	1.1	32.0	59 000	321	7 600	12.4	38 200 000	9.2	...
ST LUCIA	161 000	0.8	30.9	2.2	28.8	9.7	188 000	650	4 310	4.1	26 200 000	5.3	...
ST VINCENT AND THE GRENADINES	119 000	0.5	59.3	2.3	29.2	8.9	105 000	361	3 650	3.8	13 200 000	1.4	...
SUDAN	36 233 000	1.9	39.8	4.5	39.2	5.6	66 705 000	15 372	530	0.2	23 400 000	2.5	2.2
SURINAME	449 000	0.7	76.6	2.6	30.1	9.0	429 000	841	2 250	1.3	...
SWAZILAND	1 032 000	0.2	23.7	4.0	41.0	5.4	1 026 000	1 492	1 660	1.6	20 200 000	1.8	1.7
SWEDEN	9 041 000	0.4	83.4	1.6	17.5	23.4	10 054 000	258 319	35 770	1.7
SWITZERLAND	7 252 000	0.2	67.5	1.4	16.5	21.8	7 252 000	292 892	48 230	1.0
SYRIA	19 043 000	2.5	50.2	3.5	36.9	4.7	35 935 000	20 211	1 190	1.4	258 200 000	0.4	6.9
TAIWAN	22 858 000	0.4	19.8	9.2*
TAJIKISTAN	6 507 000	1.1	24.5	3.8	39.0	5.1	10 423 000	1 221	280	7.0	79 200 000	14.8	1.3
TANZANIA	38 329 000	2.0	36.5	5.0	42.6	5.1	66 845 000	10 201	330	1.6	145 400 000	13.2	1.5
THAILAND	64 233 000	0.9	32.2	1.9	23.8	10.5	74 594 000	136 063	2 540	15.8	19 737 800 704	0.2	1.3
TOGO	6 145 000	2.7	35.8	5.4	43.5	4.9	13 544 000	1 492	380	1.0	13 100 000	3.8	1.6
TONGA	102 000	0.4	33.8	3.5	35.9	8.8	75 000	152	1 830	2.0	2 700 000	16.5	...
TRINIDAD AND TOBAGO	1 305 000	0.3	75.8	1.6	21.5	10.7	1 230 000	9 538	8 580	3.0	265 300 000	-0.1	...
TUNISIA	10 102 000	1.1	64.1	2.0	25.9	8.6	12 927 000	22 211	2 630	7.2	1 437 799 936	1.3	1.6
TURKEY	73 193 000	1.4	66.8	2.5	29.2	8.0	101 208 000	197 220	3 750	15.2	27 604 400 128	0.2	4.9
TURKMENISTAN	4 833 000	1.4	45.6	2.8	31.8	6.2	6 780 000	5 426	1 340	0.9	...
TUVALU	10 000	0.5	12 000
UGANDA	28 816 000	3.4	12.4	7.1	50.5	3.8	126 950 000	6 173	270	1.4	79 200 000	11.2	2.5
UKRAINE	46 481 000	-1.1	67.3	1.1	14.9	20.9	26 393 000	46 739	1 260	7.8	3 242 899 968	...	2.9
UNITED ARAB EMIRATES	4 496 000	6.5	85.3	2.5	22.0	1.6	9 056 000	...	20 080	3.6
UNITED KINGDOM	59 668 000	0.3	89.2	1.7	17.9	21.2	67 143 000	1 680 300	33 940	2.4
UNITED STATES OF AMERICA	298 213 000	1.0	80.4	2.0	20.8	16.7	394 976 000	10 945 790	41 400	4.1
URUGUAY	3 463 000	0.7	92.8	2.3	24.3	17.4	4 043 000	12 904	3 950	10.5	1 280 000 000	0.1	1.1
UZBEKISTAN	26 593 000	1.5	36.5	2.7	33.2	6.2	38 665 000	10 779	460	7.7	733 000 000	2.0	0.8
VANUATU	211 000	2.0	23.3	4.2	39.9	5.1	375 000	248	1 340	1.0	2 200 000	11.9	...
VATICAN CITY	552	-0.1	1 000
VENEZUELA	26 749 000	1.8	87.9	2.7	31.2	7.6	41 991 000	89 150	4 020	8.2	7 487 399 936	0.1	1.4
VIETNAM	84 238 000	1.4	26.2	2.3	29.5	7.5	116 654 000	38 786	550	3.4	1 180 999 936	3.6	...
YEMEN	20 975 000	3.1	26.0	6.2	46.4	3.6	59 454 000	9 894	570	1.9	171 200 000	6.3	7.0
ZAMBIA	11 668 000	1.7	36.2	5.7	45.8	4.6	22 781 000	3 945	450	8.7	308 500 000	18.1	...
ZIMBABWE	13 010 000	0.7	35.4	3.6	40.0	5.4	15 805 000	6 165	890	1.4	57 600 000	...	3.5

*figures are for period prior to independence of Montenegro in June 2006

*figure for 65 or over, 2003

	Social Indicators					Environment				Communications				
Child mortality rate	Life expectancy		Literacy rate (%)	Access to safe water (%)	Doctors per 100 000 people	Forest area (%)	Annual change in forest area (%)	Protected land area (%)	CO_2 emissions (metric tonnes per capita)	Main telephone lines per 100 people	Cellular phone subscribers per 100 people	Internet users per 10 000 people	International dialling code	Time zone
	M	F												
103	61.2	60.9	58.7	90	66	3.1	-2.1	8.3	0.7	3.0	3.3	131	92	+5
28	84	109	76.1	0.4	0.0	680	+9
24	72.3	77.4	97.0	91	168	38.6	-0.1	17.5	2.0	11.9	27.0	946	507	-5
93	56.8	58.7	76.9	39	5	67.6	-0.5	1.6	0.5	1.1	0.4	291	675	+10
29	68.6	73.1	97.3	83	117	58.8	-0.9	4.1	0.7	4.7	29.4	249	595	-3
34	67.3	72.4	97.1	81	117	50.9	-0.1	16.7	1.0	7.4	14.8	1 161	51	-5
36	68.0	72.0	98.8	85	116	19.4	-2.1	8.2	0.9	4.2	39.9	532	63	+8
7	69.8	78.0	99.8	...	220	29.7	0.3	22.7	7.7	31.9	59.9	2 335	48	+1
5	72.6	79.6	99.8	...	324	40.1	1.1	5.2	5.6	40.3	98.4	2 803	351	GMT
15	70.5	75.4	95.3	100	221	0.1	0.0	0.0	50.9	25.7	65.9	2 218	974	+3
20	67.0	74.2	99.7	57	189	28.0	...	2.5	4.4	20.3	47.1	2 076	40	+2
21	60.8	73.1	99.8	96	417	50.4	...	7.6	10.6	27.5	51.6	1 110	7	+2 to +12
203	38.8	39.7	84.9	73	2	12.4	6.9	7.7	0.1	0.3	1.6	45	250	+2
24	66.9	73.4	99.8	88	70	37.2	0.0	7.3	5.8	333	685	-11
5	251	...	0.0	378	+1
118	67.0	72.8	...	79	47	28.3	0.0	4.6	5.0	1 220	239	GMT
26	71.1	73.7	93.6	90	140	0.7	0.0	41.8	13.6	14.8	36.8	636	966	+3
137	50.8	55.1	52.9	72	8	32.2	-0.5	11.0	0.4	2.4	10.9	466	221	GMT
14	70.9	75.6	...	93	...	28.3	0.3	3.7	6.1	32.9	58.0	1 861	381	+1
15	87	132	66.7	0.0	12.3	...	26.2	60.8	2 469	248	+4
284	33.1	35.5	...	57	7	14.7	-0.7	4.5	0.1	0.5	2.3	19	232	GMT
3	75.9	80.3	99.8	100	140	3.3	0.0	5.2	9.0	43.2	89.5	5 612	65	+8
8	69.8	77.6	...	100	325	45.3	0.1	22.5	7.2	23.2	79.4	4 227	421	+1
4	72.6	79.8	99.8	100	219	55.0	0.4	14.4	7.6	40.7	100.5	4 796	386	+1
22	67.9	70.7	...	70	13	88.8	-1.7	0.1	...	1.3	0.2	61	677	+11
225	46.4	49.5	...	29	4	12.0	-1.0	0.3	...	1.7	4.2	13	252	+3
66	45.1	50.7	91.8	87	69	7.3	0.0	6.1	6.9	10.4	43.1	789	27	+2
5	71.8	79.3	99.8	92	181	63.3	-0.1	3.6	9.4	55.3	76.1	6 568	82	+9
4	75.9	82.8	99.8	...	320	28.8	1.7	9.1	7.7	41.5	89.5	3 318	34	+1
15	69.9	75.9	97.1	78	43	30.0	-1.5	26.5	0.6	5.1	11.4	144	94	+6
22	99	118	11.1	0.0	0.1	...	50.0	20.0	2 141	1 869	-4
18	70.8	74.1	...	98	518	14.8	0.0	13.8	...	32.0	62.0	3 667	1 758	-4
27	72.6	75.6	...	93	88	15.4	0.8	11.1	...	27.3	59.5	661	1 784	-4
93	54.1	57.1	79.1	69	16	25.9	-0.8	4.9	0.3	3.0	3.0	330	249	+3
39	68.5	73.7	...	92	45	90.5	0.0	12.7	5.0	18.6	48.5	683	597	-3
153	33.3	35.4	91.2	52	18	30.3	0.9	3.5	0.4	4.4	10.4	332	268	+2
3	77.6	82.6	...	100	305	65.9	...	10.1	6.0	71.5	108.5	7 546	46	+1
5	75.9	82.3	...	100	352	30.3	0.4	28.7	6.0	71.0	84.6	4 720	41	+1
18	70.6	73.1	88.3	79	140	2.5	1.3	1.4	2.6	14.6	12.9	439	963	+2
...	73.4	79.1	58.1	...	8.2	10.9	59.6	100.3	5 381	886	+8
118	66.2	71.4	99.8	58	218	2.8	0.0	18.3	0.8	3.8	2.1	8	992	+5
165	42.5	44.1	91.6	73	2	43.9	-1.1	39.6	0.1	0.4	4.4	88	255	+3
26	65.3	73.5	99.0	85	30	28.9	-0.4	15.6	3.0	11.0	44.2	1 125	66	+7
140	48.2	51.1	77.4	51	6	9.4	-4.5	11.3	0.4	1.2	9.4	441	228	GMT
19	68.0	69.1	...	100	34	5.5	0.0	23.7	...	11.3	16.4	301	676	+13
20	68.4	74.4	99.8	91	79	50.5	-0.2	4.8	16.1	24.6	49.8	1 224	1 868	-4
24	70.8	74.9	94.3	82	70	3.1	1.9	1.5	1.9	12.1	35.9	840	216	+1
39	68.0	73.2	96.9	93	124	13.3	0.2	2.6	2.9	26.5	48.0	1 413	90	+2
102	63.9	70.4	...	71	317	8.0	0.0	4.2	8.8	7.7	1.0	73	993	+5
51	93	0.0	688	+12
140	45.4	46.9	80.3	56	5	21.0	-2.2	26.4	0.1	0.3	4.4	75	256	+3
20	64.7	74.7	99.9	98	297	16.5	0.1	3.3	6.1	25.2	28.5	779	380	+2
8	73.3	77.4	91.5	...	202	3.8	0.1	0.2	23.8	27.3	84.7	3 185	971	+4
6	75.7	80.7	...	100	166	11.6	0.4	24.8	9.1	56.4	102.2	6 288	44	GMT
8	74.3	79.9	...	100	549	24.7	0.1	15.8	19.7	60.6	62.1	6 300	1	-5 to -10
14	71.6	78.9	99.3	98	365	7.4	1.3	0.4	1.2	30.9	18.5	2 098	598	-3
69	66.8	72.5	99.7	89	289	4.8	0.5	4.6	4.7	6.7	2.1	332	998	+5
38	67.5	70.5	...	60	11	36.7	0.0	1.4	...	3.2	4.9	352	678	+11
...	0.0	39	+1
21	70.9	76.7	98.2	83	194	56.1	-0.6	70.4	4.7	12.8	32.2	884	58	-4
23	66.9	71.6	97.3	73	53	30.2	2.0	4.2	0.8	12.3	6.0	712	84	+7
113	58.9	61.1	67.8	69	22	0.9	0.0	0.0	0.9	3.9	5.2	87	967	+3
182	32.7	32.1	89.1	55	7	42.0	-1.0	41.4	0.2	0.8	4.3	211	260	+2
126	33.7	32.6	97.6	83	6	49.2	-1.7	14.7	0.8	2.7	3.6	690	263	+2

Statistics

Definitions

Indicator	Definition
Population	
Total population	Interpolated mid-year population, 2005.
Population change	Percentage average annual rate of change, 2000–2005.
% urban	Urban population as a percentage of the total population, 2004.
Total fertility	Average number of children a women will have during her child-bearing years, 2000–2005.
Population by age	Percentage of population in age groups 0–14 and 60 or over, 2005.
2050 projected population	Projected total population for the year 2050.
Economy	
Total Gross National Income (GNI)	The sum of value added to the economy by all resident producers plus taxes, less subsidies, plus net receipts of primary income from abroad. Data are in U.S. dollars (millions), 2003, 2002, 2001. Formerly known as Gross National Product (GNP).
GNI per capita	Gross National Income per person in U.S. dollars using the World Bank Atlas method, 2004.
Debt service ratio	Debt service as a percentage of GNI, 2002.
Total debt service	Sum of principal repayments and interest paid on long-term debt, interest paid on short-term debt and repayments to the International Monetary Fund (IMF), 2002, *2001.
Aid receipts	Aid received as a percentage of GNI from the Development Assistance Committee (DAC) of the Organization for Economic Co-operation and Development (OECD), 2002.
Military spending	Military-related spending, including recruiting, training, construction and the purchase of military supplies and equipment, as a percentage of Gross National Income, 2003.
Social Indicators	
Child mortality rate	Number of deaths of children aged under 5 per 1 000 live births, 2003.
Life expectancy	Average life expectancy, at birth in years, male and female, 2000–2005.
Literacy rate	Percentage of population aged 15–24 with at least a basic ability to read and write, 2002.
Access to safe water	Percentage of population with sustainable access to sources of improved drinking water, latest available data.
Doctors	Number of trained doctors per 100 000 people, 2004.
Environment	
Forest area	Percentage of total land area covered by forest, 2000.
Change in forest area	Average annual percentage change in forest area, 2000-2005.
Protected land area	Percentage of total land area designated as protected land, 2004.
CO_2 emissions	Emissions of carbon dioxide from the burning of fossil fuels and the manufacture of cement, divided by the population, expressed in metric tons, 2003.
Communications	
Telephone lines	Main telephone lines per 100 inhabitants, 2004.
Cellular phone subscribers	Cellular mobile subscribers per 100 inhabitants, 2004.
Internet users	Internet users per 10 000 inhabitants, 2004.
International dialling code	The country code prefix to be used when dialling from another country.
Time zone	Time difference in hours between local standard time and Greenwich Mean Time.

Main Statistical Sources	Internet Links
United Nations Statistics Division	unstats.un.org/unsd
World Population Prospects: The 2004 Revision and World Urbanization Prospects: The 2003 Revision, United Nations Population Division	www.un.org/esa/population/unpop
United Nations Population Information Network	www.un.org/popin
United Nations Development Programme	www.undp.org
Organisation for Economic Cooperation and Development	www.oecd.org
Global Forest Resources Assessment 2005, Food and Agriculture Organization of the UN	www.fao.org
World Development Indicators online, World Bank	www.worldbank.org/data
Earthtrends Environmental Database online, World Resources Institute	www.wri.org
International Telecommunication Union	www.itu.int

Introduction to the index

The index includes all names shown on the reference maps in the atlas. Each entry includes the country or geographical area in which the feature is located, a page number and an alphanumeric reference. Additional entry details and aspects of the index are explained below.

Name forms

The names policy in this atlas is generally to use local name forms which are officially recognized by the governments of the countries concerned. Rules established by the Permanent Committee on Geographical Names for British Official Use (PCGN) are applied to the conversion of non-roman alphabet names, for example in the Russian Federation, into the roman alphabet used in English.

However, English conventional name forms are used for the most well-known places for which such a form is in common use. In these cases, the local form is included in brackets on the map and appears as a cross-reference in the index. Other alternative names, such as well-known historical names or those in other languages, may also be included in brackets on the map and as cross-references in the index. All country names and those for international physical features appear in their English forms. Names appear in full in the index, although they may appear in abbreviated form on the maps.

Referencing

Names are referenced by page number and by grid reference. The grid reference relates to the alphanumeric values which appear on the edges of each map. These reflect the graticule on the map – the letter relates to longitude divisions, the number to latitude divisions. Names are generally referenced to the largest scale map page on which they appear. For large geographical features, including countries, the reference is to the largest scale map on which the feature appears in its entirety, or on which the majority of it appears.

Rivers are referenced to their lowest downstream point – either their mouth or their confluence with another river. The river name will generally be positioned as close to this point as possible.

Alternative names

Alternative names appear as cross-references and refer the user to the index entry for the form of the name used on the map.

For rivers with multiple names - for example those which flow through several countries - all alternative name forms are included within the main index entries, with details of the countries in which each form applies.

Administrative qualifiers

Administrative divisions are included in entries to differentiate duplicate names - entries of exactly the same name and feature type within the one country - where these division names are shown on the maps. In such cases, duplicate names are alphabetized in the order of the administrative division names.

Additional qualifiers are included for names within selected geographical areas, to indicate more clearly their location.

Descriptors

Entries, other than those for towns and cities, include a descriptor indicating the type of geographical feature. Descriptors are not included where the type of feature is implicit in the name itself, unless there is a town or city of exactly the same name.

Insets

Where relevant, the index clearly indicates [inset] if a feature appears on an inset map.

Alphabetical order

The Icelandic characters Ð and þ are transliterated and alphabetized as 'Th' and 'th'. The German character ß is alphabetized as 'ss'. Names beginning with Mac or Mc are alphabetized exactly as they appear. The terms Saint, Sainte, etc, are abbreviated to St, Ste, etc, but alphabetized as if in the full form.

Numerical entries

Entries beginning with numerals appear at the beginning of the index, in numerical order. Elsewhere, numerals are alphabetized before 'a'.

Permuted terms

Names beginning with generic geographical terms are permuted - the descriptive term is placed after, and the index alphabetized by, the main part of the name. For example, Mount Everest is indexed as Everest, Mount; Lake Superior as Superior, Lake. This policy is applied to all languages. Permuting has not been applied to names of towns, cities or administrative divisions beginning with such geographical terms. These remain in their full form, for example, Lake Isabella, USA.

Gazetteer entries and connections

Selected entries have been extended to include gazetteer-style information. Important geographical facts which relate specifically to the entry are included within the entry in coloured type.

Entries for features which also appear on, or which have a topical link to, the thematic pages of the atlas include a reference to those pages.

Abbreviations

admin. dist.	administrative district	IL	Illinois	plat.	plateau
admin. div.	administrative division	imp. l.	impermanent lake	P.N.G.	Papua New Guinea
admin. reg.	administrative region	IN	Indiana	Port.	Portugal
Afgh.	Afghanistan	Indon.	Indonesia	pref.	prefecture
AK	Alaska	Kazakh.	Kazakhstan	prov.	province
AL	Alabama	KS	Kansas	pt	point
Alg.	Algeria	KY	Kentucky	Qld	Queensland
AR	Arkansas	Kyrg.	Kyrgyzstan	Que.	Québec
Arg.	Argentina	l.	lake	r.	river
aut. comm.	autonomous community	LA	Louisiana	reg.	region
aut. reg.	autonomous region	lag.	lagoon	res.	reserve
aut. rep.	autonomous republic	Lith.	Lithuania	resr	reservoir
AZ	Arizona	Lux.	Luxembourg	RI	Rhode Island
Azer.	Azerbaijan	MA	Massachusetts	Rus. Fed.	Russian Federation
b.	bay	Madag.	Madagascar	S.	South, Southern
Bangl.	Bangladesh	Man.	Manitoba	S.A.	South Australia
B.C.	British Columbia	MD	Maryland	salt l.	salt lake
Bol.	Bolivia	ME	Maine	Sask.	Saskatchewan
Bos.-Herz.	Bosnia-Herzegovina	Mex.	Mexico	SC	South Carolina
Bulg.	Bulgaria	MI	Michigan	SD	South Dakota
c.	cape	MN	Minnesota	sea chan.	sea channel
CA	California	MO	Missouri	Serb. and Mont.	Serbia and Montenegro*
Cent. Afr. Rep.	Central African Republic	Moz.	Mozambique	Sing.	Singapore
CO	Colorado	MS	Mississippi	Switz.	Switzerland
Col.	Colombia	MT	Montana	Tajik.	Tajikistan
CT	Connecticut	mt.	mountain	Tanz.	Tanzania
Czech Rep.	Czech Republic	mts	mountains	Tas.	Tasmania
DC	District of Columbia	N.	North, Northern	terr.	territory
DE	Delaware	nat. park	national park	Thai.	Thailand
Dem. Rep. Congo	Democratic Republic of the Congo	N.B.	New Brunswick	TN	Tennessee
depr.	depression	NC	North Carolina	Trin. and Tob.	Trinidad and Tobago
des.	desert	ND	North Dakota	Turkm.	Turkmenistan
Dom. Rep.	Dominican Republic	NE	Nebraska	TX	Texas
E.	East, Eastern	Neth.	Netherlands	U.A.E.	United Arab Emirates
Equat. Guinea	Equatorial Guinea	NH	New Hampshire	U.K.	United Kingdom
esc.	escarpment	NJ	New Jersey	Ukr.	Ukraine
est.	estuary	NM	New Mexico	U.S.A.	United States of America
Eth.	Ethiopia	N.S.	Nova Scotia	UT	Utah
Fin.	Finland	N.S.W.	New South Wales	Uzbek.	Uzbekistan
FL	Florida	N.T.	Northern Territory	VA	Virginia
for.	forest	NV	Nevada	Venez.	Venezuela
Fr. Guiana	French Guiana	N.W.T.	Northwest Territories	Vic.	Victoria
F.Y.R.O.M.	Former Yugoslav Republic of Macedonia	NY	New York	vol.	volcano
g.	gulf	N.Z.	New Zealand	vol. crater	volcanic crater
GA	Georgia	OH	Ohio	VT	Vermont
Guat.	Guatemala	OK	Oklahoma	W.	West, Western
HI	Hawaii	OR	Oregon	WA	Washington
H.K.	Hong Kong	PA	Pennsylvania	W.A.	Western Australia
Hond.	Honduras	Para.	Paraguay	WI	Wisconsin
i.	island	P.E.I.	Prince Edward Island	WV	West Virginia
IA	Iowa	pen.	peninsula	WY	Wyoming
ID	Idaho	Phil.	Philippines	Y.T.	Yukon Territory

*Places in both Serbia and Montenegro are indexed to the country as it was before the split in 2006.

3-y Severnyy Rus. Fed. 41 S3
5 de Outubro Angola see Xá-Muteba
9 de Julio Arg. 144 D5
25 de Mayo Buenos Aires Arg. 144 D5
25 de Mayo La Pampa Arg. 144 C5
70 Mile House Canada 120 F5
100 Mile House Canada 120 F5
150 Mile House Canada 120 F4

Aabenraa Denmark 45 F9
Aachen Germany 52 G4
Aalborg Denmark 45 F8
Aalborg Bugt b. Denmark 45 G8
Aalen Germany 53 K6
Aalesund Norway see Ålesund
Aaley Lebanon see Aley
Aanaar Fin. see Inari
Aarhus Denmark see Århus
Aarlen Belgium see Arlon
Aars Denmark 45 F8
Aarschot Belgium 52 E4
Aasiaat Greenland 119 M3
Aath Belgium see Ath
Aba China 76 D1
Aba Dem. Rep. Congo 98 D3
Aba Nigeria 96 D4
Abacaxis r. Brazil 143 G4
Ābādān Iran 88 C4
Abadan Turkm. 88 E2
Ābādeh Iran 88 D4
Ābādeh Ţashk Iran 88 D4
Abadla Alg. 54 D5
Abaeté Brazil 145 B2
Abaetetuba Brazil 143 I4
Abagnar Qi China see Xilinhot
Abaiang atoll Kiribati 150 H5
Abajo Peak U.S.A. 129 I3
Abakaliki Nigeria 96 D4
Abakan Rus. Fed. 72 G2
Abakanskiy Khrebet mts
Rus. Fed. 72 F2
Abalak Niger 96 D3
Abana Turkey 90 D2
Abancay Peru 142 D6
Abariringa atoll Kiribati see Kanton
Abarkūh, Kavīr-e des. Iran 88 D4
Abarqū Iran 88 D4
Abarshahr Iran see Neyshābūr
Abashiri Japan 74 G3
Abashiri-wan b. Japan 74 G3
Abasolo Mex. 131 D7
Abau P.N.G. 110 E1
Abaya, Lake Eth. 98 D3
Ābaya Hāyk' l. Eth. see Abaya, Lake
Ābay Wenz r. Eth. 98 D2 see Blue Nile
Abaza Rus. Fed. 72 G2
Abba Cent. Afr. Rep. 98 B3
Abbasabad Iran 88 D3
'Abbāsābad Iran 88 E2
Abbasanta Sardinia Italy 58 C4
Abbatis Villa France see Abbeville
Abbe, Lake Djibouti/Eth. 86 F7
Abbeville France 52 B4
Abbeville AL U.S.A. 133 C6
Abbeville GA U.S.A. 133 D6
Abbeville LA U.S.A. 131 E6
Abbeville SC U.S.A. 133 D5
Abbey Canada 121 I5
Abbeyfeale Ireland 51 C5
Abbey Town U.K. 48 D4
Abborrträsk Sweden 44 K4
Abbot, Mount Australia 110 D4
Abbot Ice Shelf Antarctica 152 K2
Abbotsford Canada 120 F5
Abbott NM U.S.A. 127 G5
Abbott VA U.S.A. 134 E5
Abbottabad Pak. 89 I3
'Abd al 'Azīz, Jabal hill Syria 91 F3
'Abd al Kūrī i. Yemen 86 H7
'Abd Allah, Khawr sea chan.
Iraq/Kuwait 88 C4
Abd al Ma'asīr well Saudi Arabia 85 D4
Ābdānān Iran 88 B3
Abdollāhābād Iran 88 D3
Abdulino Rus. Fed. 41 Q5
Abéché Chad 97 F3
Abellinum Italy see Avellino
Abel Tasman National Park N.Z. 113 D5
Abengourou Côte d'Ivoire 96 C4
Åbenrå Denmark see Aabenraa
Abensberg Germany 53 L6
Abeokuta Nigeria 96 D4
Aberaeron U.K. 49 C6
Aberchirder U.K. 50 G3
Abercorn Zambia see Mbala
Abercrombie r. Australia 112 D4
Aberdare U.K. 49 D7
Aberdaron U.K. 49 C6
Aberdaugleddau U.K. see Milford Haven
Aberdeen Australia 112 E4
Aberdeen H.K. China 77 [inset]
Aberdeen U.K. 50 G3
Aberdeen S. Africa 100 F7
Aberdeen U.S.A. 130 D2
Aberdeen Lake Canada 121 L1
Aberdovey U.K. 49 C6
Aberdyfi Wales U.K. see Aberdovey
Aberfeldy U.K. 50 F4
Aberford U.K. 48 F5
Aberfoyle U.K. 50 E4
Abergavenny U.K. 49 D7
Abergwaun U.K. see Fishguard
Aberhonddu U.K. see Brecon
Abermaw U.K. see Barmouth
Abernathy U.S.A. 131 C5
Aberporth U.K. 49 C6
Abersoch U.K. 49 C6
Abertawe U.K. see Swansea
Aberteifi U.K. see Cardigan
Aberystwyth U.K. 49 C6
Abeshr Chad see Abéché
Abez' Rus. Fed. 41 S2

Åb Gāh Iran 89 E5
Abhā Saudi Arabia 86 F6
Abhar Iran 88 C2
Abiad, Bahr el r. Sudan/Uganda 86 D6 see
White Nile

▶Abidjan Côte d'Ivoire 96 C4
Former capital of Côte d'Ivoire.

Abijatta-Shalla National Park Eth. 98 D3
Ab-i-Kavīr salt flat Iran 88 E3
Abilene KS U.S.A. 130 D4
Abilene TX U.S.A. 131 D5
Abingdon U.K. 49 F7
Abingdon U.S.A. 134 D5
Abington Reef Australia 110 E3
Abinsk Rus. Fed. 90 E1
Abitau Lake Canada 121 J2
Abitibi, Lake Canada 122 E4
Ab Khūr Iran 88 E3
Abminga Australia 109 F6
Abnūb Egypt 90 C6
Abohar India 82 C3
Aboisso Côte d'Ivoire 96 C4
Aboite U.S.A. 134 C3
Abomey Benin 96 D4
Abongabong, Gunung mt. Indon. 71 B6
Abong Mbang Cameroon 96 E4
Abou Déia Chad 97 E3
Abovyan Armenia 91 G2
Aboyne U.K. 50 G3
Abqaiq Saudi Arabia 88 C5
Abraham's Bay Bahamas 133 F8
Abramov, Mys pt Rus. Fed. 42 I2
Abrantes Port. 57 B4
Abra Pampa Arg. 144 C2
Abreojos, Punta pt Mex. 127 E8
'Abri Sudan 86 D5
Abrolhos Bank sea feature
S. Atlantic Ocean 148 F7
Abruzzo, Parco Nazionale d' nat. park
Italy 58 E4
Absalom, Mount Antarctica 152 B1
Absaroka Range mts U.S.A. 126 F3
Abtar, Jabal al hills Syria 85 C2
Abtsgmünd Germany 53 J6
Abū aḑ Ḑuhūr Syria 85 C2
Abū al Abyaḑ i. U.A.E. 88 D5
Abū al Ḩusayn, Qāʿ imp. l. Jordan 85 D3
Abū 'Alī i. Saudi Arabia 88 C5
Abū 'Āmūd, Wādī watercourse
Jordan 85 C4
Abū 'Arīsh Saudi Arabia 86 F6
Abu 'Aweigîla well Egypt see
Abū 'Uwayqilah
Abu Deleiq Sudan 86 D6

▶Abu Dhabi U.A.E. 88 D5
Capital of the United Arab Emirates.

Abū Du'ān Syria 85 D1
Abu Gubeiha Sudan 86 D7
Abū Ḩafnah, Wādī watercourse
Jordan 85 D3
Abu Haggag Egypt see Ra's al Ḩikmah
Abū Ḩallūfah, Jabal hill Jordan 85 C4
Abu Hamed Sudan 86 D6

▶Abuja Nigeria 96 D4
Capital of Nigeria.

Abū Jifān well Saudi Arabia 88 B5
Ābū Jurdhān Jordan 85 B4
Abū Kamāl Syria 91 F4
Abu Matariq Sudan 97 F3
Abumombazi Dem. Rep. Congo 98 C3
Abu Musa i. The Gulf 88 D5
Abū Mūsá, Jazīreh-ye i. The Gulf see
Abu Musa
Abunā r. Bol. 142 E5
Abunã Brazil 142 E5
Ābune Yosēf mt. Eth. 86 E7
Abū Nujaym Libya 97 E1
Abū Qa'ţūr Syria 85 C2
Abu Rawthah, Jabal mt. Egypt 85 B5
Aburo mt. Dem. Rep. Congo 98 D3
Abu Road India 79 G4
Abū Rujmayn, Jabal mts Syria 85 D2
Abū Rūtha, Gebel mt. Egypt see
Abū Rawthah, Jabal
Abū Sawādah well Saudi Arabia 88 C5
Abu Simbel Egypt see Abū Sunbul
Abū Sunbul Egypt 86 D5
Abū Ţarfā', Wādī watercourse Egypt 85 A5
Abū 'Uwayqilah well Egypt 85 B4
Abu Zabad Sudan 86 C7
Abū Ẕabī U.A.E. see Abu Dhabi
Abūzam Iran 88 C4
Abū Zanīmah Egypt 90 D5
Abu Zenîma Egypt see Abū Zanīmah
Abyad Sudan 86 C7
Abyaḑ, Jabal al mts Syria 85 C2
Abyār al Ḩakīm well Libya 90 A5
Abydos Australia 108 B5
Abyei Sudan 86 C8
Abyssinia country Africa see Ethiopia
Academician Vernadskiy research station
Antarctica see Vernadsky
Academy Bay Rus. Fed. see Akademii, Zaliv
Acadia prov. Canada see Nova Scotia
Acadia National Park U.S.A. 132 G2
Açailândia Brazil 143 I5
Acamarachi mt. Chile see Pili, Cerro
Acampamento de Caça do Mucusso
Angola 99 C5
Acandí Col. 142 C2
A Cañiza Spain 57 B2
Acaponeta Mex. 136 C4
Acapulco Mex. 136 E5
Acapulco de Juárez Mex. see Acapulco
Acará Brazil 143 I4
Acarai Mountains hills
Brazil/Guyana 143 G3
Acaraú Brazil 143 J4
Acaray, Represa de resr Para. 144 E3
Acarigua Venez. 142 E2
Acatlan Mex. 136 E5
Accho Israel see 'Akko
Accomac U.S.A. 135 H5
Accomack U.S.A. see Accomac

▶Accra Ghana 96 C4
Capital of Ghana.

Accrington U.K. 48 E5
Ach r. Germany 53 L6
Achacachi Bol. 142 E7
Achaguas Venez. 142 E2
Achalpur India 82 C1
Achampet India 84 C2
Achan Rus. Fed. 74 C2
Achayvayam Rus. Fed. 65 S3
Acheng China 74 B3
Achhota India 84 D1
Achicourt France 52 C4
Achillbeg Island Ireland 51 C4
Achill Ireland 51 C4
Achill Island Ireland 51 B4
Achiltibuie U.K. 50 D2
Achim Germany 53 J1
Achinsk Rus. Fed. 64 K4
Achit Nuur l. Mongolia 80 H2
Achkhoy-Martan Rus. Fed. 91 G2
Achna Cyprus 85 A2
Achnasheen U.K. 50 D3
Acıgöl l. Turkey 59 M6
Acıpayam Turkey 59 M6
Acireale Sicily Italy 58 F6
Ackerman U.S.A. 131 F5
Ackley U.S.A. 130 E3
Acklins Island Bahamas 133 F8
Acle U.K. 49 I6

▶Aconcagua, Cerro mt. Arg. 144 B4
Highest mountain in South America.
South America 138–139

Acopiara Brazil 143 K5
A Coruña Spain 57 B2
Acqui Terme Italy 58 C2
Acra U.S.A. 135 H2
Acragas Sicily Italy see Agrigento
Acraman, Lake salt flat Australia 111 A7
Acre r. Brazil 142 E6
Acre Israel see 'Akko
Acre, Bay of Israel see Haifa, Bay of
Acri Italy 58 G5
Ács Hungary 47 Q7
Actaeon Group is Fr. Polynesia see
Actéon, Groupe
Actéon, Groupe is Fr. Polynesia 151 K7
Acton Canada 134 E2
Acton U.S.A. 128 D4
Acungui Brazil 145 A4
Acunum Acusio France see Montélimar
Ada MN U.S.A. 130 D2
Ada OH U.S.A. 134 D3
Ada OK U.S.A. 131 D5
Ada WI U.S.A. 134 B2
Adabazar Sakarya Turkey see Adapazarı
Adaja r. Spain 57 D3
Adalia Turkey see Antalya
Adam Oman 87 I5
Adam, Mount hill Falkland Is 144 E8
Adamantina Brazil 145 A3
Adams IN U.S.A. 134 C4
Adams KY U.S.A. 134 D4
Adams MA U.S.A. 135 I2
Adams NY U.S.A. 135 G2
Adams, Mount U.S.A. 126 C3
Adams Center U.S.A. 135 G2
Adams Lake Canada 120 G5
Adams Mountain U.S.A. 120 D4
Adam's Peak Sri Lanka 84 D5
Adams Peak U.S.A. 128 C2

▶Adamstown Pitcairn Is 151 L7
Capital of the Pitcairn Islands.

'Adan Yemen see Aden
Adana Turkey 85 B1
Adana prov. Turkey 85 B1
Adana Yemen see Aden
Adapazarı Turkey 59 N4
Adare Ireland 51 D5
Adare, Cape Antarctica 152 H2
Adavale Australia 111 D5
Adban Afgh. 89 H2
Ad Dabbah Sudan see Ed Debba
Ad Ḑabbīyah well Saudi Arabia 88 C5
Ad Dafinah Saudi Arabia 86 F5
Ad Dahnā' des. Saudi Arabia 86 G5
Ad Dakhla W. Sahara 96 B2
Ad Damir Sudan see Ed Damer
Ad Dammām Saudi Arabia see Dammam
Addanki India 84 C3
Ad Dār al Ḩamrā' Saudi Arabia 86 E4
Ad Darb Saudi Arabia 86 F6
Ad Dawādimī Saudi Arabia 86 F5
Ad Dawḩah Qatar see Doha
Ad Dawr Iraq 91 F4
Ad Dawr plain Syria 85 D3
Ad Dayr Iraq 91 G5
Ad Dibdibah plain Saudi Arabia 88 B5
Aḑ Ḑiffah plat. Egypt see Libyan Plateau

▶Addis Ababa Eth. 98 D3
Capital of Ethiopia.

Addison U.S.A. 135 G2
Ad Dīwānīyah Iraq 91 G5
Addlestone U.K. 49 G7
Addo Elephant National Park
S. Africa 101 G7
Addoo Atoll Maldives see Addu Atoll
Addu Atoll Maldives 81 D12
Ad Duwayd well Saudi Arabia 91 F5
Ad Duwaym Sudan see Ed Dueim
Ad Duwayris well Saudi Arabia 88 C6
Adegaon India 82 D5
Adel GA U.S.A. 133 D6
Adel IA U.S.A. 130 E3

▶Adelaide Australia 111 B7
State capital of South Australia.

Adelaide r. Australia 108 E3
Adelaide S. Africa 101 H7
Adelaide Island Antarctica 152 L2
Adelaide River Australia 108 E3
Adele Island Australia 108 C3

Adélie Coast Antarctica 152 G2
Adélie Coast reg. Antarctica see
Adélie Land
Adélie Land reg. Antarctica 152 G2
Adelong Australia 112 D5
Aden Yemen 86 F7
Aden, Gulf of Somalia/Yemen 86 G7
Adena U.S.A. 134 E3
Adenau Germany 52 G4
Adendorf Germany 53 K1
Aderbissinat Niger 96 D3
Adesar India 82 B5
Adhan, Jabal mt. U.A.E. 88 E5
Adh Dhayūf well Saudi Arabia 91 G6
'Adhfā' well Saudi Arabia 91 F5
'Ādhiriyāt, Jibāl al mts Jordan 85 C4
Adi i. Indon. 69 I7
Ādī Ārk'ay Eth. 86 E7
Adige r. Italy 58 E2
Adigrat Eth. 98 D2
Adilabad India 84 C2
Adilcevaz Turkey 91 F3
Adin U.S.A. 126 C1
Adīrī Libya 97 E2
Adirondack Mountains U.S.A. 135 H1
Ādīs Ābeba Eth. see Addis Ababa
Adi Ugri Eritrea see Mendefera
Adiyaman Turkey 91 E3
Adjud Romania 59 L1
Adlavik Islands Canada 123 K3
Admiralty Island Canada 119 H3
Admiralty Island U.S.A. 120 C3
Admiralty Island National Monument-
Kootznoowoo Wilderness nat. park
U.S.A. 120 C3
Admiralty Islands P.N.G. 69 L7
Ado-Ekiti Nigeria 96 D4
Adok Sudan 86 D8
Adolfo L. Mateos Mex. 127 E8
Adolphus U.S.A. 134 B5
Adonara i. Indon. 108 C2
Adoni India 84 C3
Adorf Germany 53 M4
Adorf (Diemelsee) Germany 53 I3
Ado-Tymovo Rus. Fed. 74 F2
Adour r. France 56 D5
Adra Spain 57 E5
Adrano Sicily Italy 58 F6
Adrar Alg. 96 C2
Adrar hills Mali see Ifôghas, Adrar des
Adraskand r. Afgh. 89 F3
Adré Chad 97 F3
Adrian MI U.S.A. 134 C3
Adrian TX U.S.A. 131 C5
Adrianople Turkey see Edirne
Adrianopolis Turkey see Edirne
Adriatic Sea Europe 58 E2
Adua Eth. see Ādwa
Adunara i. Indon. see Adonara
Adusa Dem. Rep. Congo 98 C3
Aduwa Eth. see Ādwa
Ādwa Eth. 98 D2
Adycha r. Rus. Fed. 65 O3
Adyk Rus. Fed. 43 J7
Adzopé Côte d'Ivoire 96 C4
Aegean Sea Greece/Turkey 59 K5
Aegina i. Greece see Aigina
Aegviidu country Africa see Egypt
Aela Jordan see Al 'Aqabah
Aelana Jordan see Al 'Aqabah
Aelia Capitolina Israel/West Bank see
Jerusalem
Aenus Turkey see Enez
Aerzen Germany 53 J2
Aesernia Italy see Isernia
A Estrada Spain 57 B2
Afabet Eritrea 86 E6
Afanas'yevo Rus. Fed. 42 L4
Afghānestān country Asia see Afghanistan
▶Afghanistan country Asia 89 G3
Asia 6, 62–63
Afgooye Somalia 98 E3
'Afif Saudi Arabia 86 F5
Afiun Karahissar Turkey see Afyon
Âfjord Norway 44 G5
Aflou Alg. 54 E5
Afmadow Somalia 98 E3
Afogados da Ingazoira Brazil 143 K5
A Fonsagrada Spain 57 C2
Afonso Cláudio Brazil 145 C3
Afrēra Terara vol. Eth. 86 F7
Africa Nova country Africa see Tunisia
'Afrīn Syria 85 C1
'Afrīn, Nahr r. Syria/Turkey 85 C1
Afsin Turkey 90 E3
Afsluitdijk barrage Neth. 52 F2
Afton U.S.A. 126 F4
Afuá Brazil 143 H4
'Afula Israel 85 B3
Afyon Turkey 59 N5
Afyonkarahisar Turkey see Afyon
Aga Germany 53 M4
Agadès Niger see Agadez
Agadez Niger 96 D3
Agadir Morocco 96 C1
Agadyr' Kazakh. 80 D2
Agalega Islands Mauritius 149 L6
Agana Guam see Hagåtña
Agapa Georgia 91 F2
Agartala India 83 G5
Agashi India 84 B2
Agate Canada 122 F4
Agathe France see Agde
Agathonisi i. Greece 59 L6
Agats Indon. 69 J8
Agatti i. India 84 B4
Agawa r. Canada 122 D4
Agboville Côte d'Ivoire 96 C4
Ağcabädi Azer. 91 G2
Ağdam Azer. 91 G3
Ağdaş Azer. 91 G2
Agdash Azer. see Ağdaş
Agde France 56 F5
Agdzhabedi Azer. see Ağcabädi
Agedabia Libya see Ajdābiyā

Agen France 56 E4
Aggeneys S. Africa 100 D5
Aggteleki nat. park Hungary 47 R6
Aghil Pass China/Jammu and
Kashmir 82 D1
Ağın Turkey 90 E3
Aginum France see Agen
Aginskoye Rus. Fed. 72 G1
Agiabampo Mex. 127 F8
Agiguan i. N. Mariana Is see Aguijan
Agin Turkey 90 E3
Aginum France see Agen
Agios Dimitrios Greece 59 J6
Agios Efstratios i. Greece 59 K5
Agios Georgios i. Greece 59 J6
Agios Nikolaos Greece 59 K7
Agios Theodoros Cyprus 85 B2
Agirwat Hills Sudan 86 E6
Agisanang S. Africa 101 G4
Agnes, Mount hill Australia 109 E6
Agnew Australia 109 C6
Agnibilékrou Côte d'Ivoire 96 C4
Agnita Romania 59 K2
Agniye-Afanas'yevsk Rus. Fed. 74 E2
Agra India 82 D4
Agra r. Spain 57 C4
Agrakhanskiy Poluostrov pen.
Rus. Fed. 91 G2
Agram Croatia see Zagreb
Ağrı Turkey 91 F3
Agri r. Italy 58 G4
Agria Gramvousa i. Greece 59 J7
Agrigan i. N. Mariana Is see Agrihan
Agrigento Sicily Italy 58 E6
Agrigentum Sicily Italy see Agrigento
Agrihan i. N. Mariana Is 69 L3
Agrinio Greece 59 I5
Agropoli Italy 58 F4
Agryz Rus. Fed. 41 Q4
Agua, Volcán de vol. Guat. 136 F6
Água Clara Brazil 144 F2
Aguadilla Puerto Rico 137 K5
Agua Escondida Arg. 144 C5
Agua Fria r. U.S.A. 129 G4
Agua Fria National Monument nat. park
U.S.A. 129 G4
Aguanaval r. Mex. 131 C7
Aguanga U.S.A. 128 E5
Aguanus r. Canada 123 J4
Aguapeí r. Brazil 145 A3
Agua Prieta Mex. 127 F7
Aguaro-Guariquito, Parque Nacional
nat. park Venez. 142 E2
Aguascalientes Mex. 136 D4
Agudos Brazil 145 A3
Águeda Port. 57 B3
Águeda r. Spain 57 C3
Aguemour well Alg. 96 D2
Aguié Niger 96 D3
Aguijan i. N. Mariana Is 69 L4
Aguilar U.S.A. 127 G5
Aguilar de Campóo Spain 57 D2
Águilas Spain 57 F5

▶Agulhas, Cape S. Africa 100 E8
Most southerly point of Africa.

Agulhas Basin sea feature
Southern Ocean 149 J9
Agulhas Negras mt. Brazil 145 B3
Agulhas Plateau sea feature
Southern Ocean 149 J8
Agulhas Ridge sea feature
S. Atlantic Ocean 148 I8
Ağva Turkey 59 M4
Agvali Rus. Fed. 91 G2
Ahaggar plat. Alg. see Hoggar
Āhangarān Iran 89 F3
Ahar Iran 88 B2
Ahaura N.Z. 113 C6
Ahaus Germany 52 H2
Ahipara Bay N.Z. 113 D2
Ahiri India 84 D2
Ahklun Mountains U.S.A. 118 B4
Ahlen Germany 53 H3
Ahmadabad Iran 88 E3
Aḩmadābād Iran 89 F3
Aḩmad al Bāqir, Jabal mt. Jordan 85 B5
Ahmadī Iran 88 E5
Ahmadnagar India 84 B2
Ahmadpur East Pak. 89 H4
Ahmar Iran 88 E3
Ahmar Mountains Eth. see Ahmar
Ahmedabad India see Ahmadabad
Ahmednagar India see Ahmadnagar
Ahorn Germany 53 K4
Ahr r. Germany 52 H4
Ahram Iran 88 C4
Ahrensburg Germany 53 K1
Āhtāri Fin. 44 N5
Ahtme Estonia 45 O7
Ahu China 77 H1
Āhū Iran 88 C4
Ahun France 56 F3
Ahuzhen China see Ahu
Ahväz Iran 88 C4
Ahwa India 84 B1
Ahwāz Iran see Ahväz
Ai-Ais Namibia 100 C4
Ai-Ais Hot Springs and Fish River Canyon
Park nature res. Namibia 100 C4
Aichwara India 82 D4
Aid U.S.A. 134 D4
Aigialousa Cyprus 85 B2
Aigina i. Greece 59 J6
Aigio Greece 59 J5
Aigle de Chambeyron mt. France 56 H4
Aigües Tortes i Estany de Sant Maurici,
Parc Nacional d' nat. park Spain 57 G2
Ai He r. China 74 B4
Aihua China see Yunxian
Aihui China see Heihe
Aijal India see Aizawl
Aikawa Japan 75 E5
Aiken U.S.A. 133 D5
Ailao Shan mts China 76 D3
Aileron Australia 108 F5
Ailigandí Panama 137 I7
Ailinglabelab atoll Marshall Is see
Ailinglaplap
Ailinglaplap atoll Marshall Is 150 H5
Ailly-sur-Noye France 52 C5
Ailsa Craig Canada 134 E2
Ailsa Craig i. U.K. 50 D5
Aimangala India 84 C3
Aimorés, Serra dos hills Brazil 145 C2

Aïn Beïda Alg. 58 B7
'Aïn Ben Tili Mauritania 96 C2
'Aïn Dâlla spring Egypt see 'Ayn Dâllah
Aïn Defla Alg. 57 H5
Aïn Deheb Alg. 57 G6
Aïn el Hadjel Alg. 57 H6
'Aïn el Maqfi spring Egypt see 'Ayn al Maqfi
Aïn el Melh Alg. 57 I6
Aïn Mdila well Alg. 58 B7
Aïn-M'Lila Alg. 54 F4
Aïn Oussera Alg. 57 H6
Ain Salah Alg. see In Salah
Aïn Sefra Alg. 54 D5
Ainsworth U.S.A. 130 D3
Aintab Turkey see Gaziantep
Aïn Taya Alg. 57 H5
Aïn Tédélès Alg. 57 G5
Aïn Temouchent Alg. 57 F6
'Aïn Tibaghbagh spring Egypt see
'Ayn Tabaghbugh
'Aïn Timeira spring Egypt see 'Ayn Tumayrah
'Aïn Zeitûn Egypt see 'Ayn Zaytūn
Aiquile Bol. 142 E7
Air i. Indon. 71 D7
Airaines France 52 B5
Airdrie Canada 120 H5
Airdrie U.K. 50 F5
Aire r. France 52 E5
Aire, Canal d' France 52 C4
Aire-sur-l'Adour France 56 D5
Air Force Island Canada 119 K3
Airpanas Indon. 108 D1
Aisatung Mountain Myanmar 70 A2
Aisch r. Germany 53 K5
Aishihik Canada 120 B2
Aishihik Lake Canada 120 B2
Aisne r. France 52 D5
Aïssa, Djebel mt. Alg. 54 D5
Aitamännikkö Fin. 44 N3
Aitana mt. Spain 57 F4
Aït Benhaddou tourist site Morocco 54 C5
Aiterach r. Germany 53 M6
Aitkin U.S.A. 130 E2
Aiud Romania 59 J1
Aix France see Aix-en-Provence
Aix-en-Provence France 56 G5
Aix-la-Chapelle Germany see Aachen
Aix-les-Bains France 56 G4
Aíyina i. Greece see Aigina
Aíyion Greece see Aigio
Aizawl India 83 H5
Aizkraukle Latvia 45 N8
Aizpute Latvia 45 L8
Aizu-Wakamatsu Japan 75 E5
Ajaccio Corsica France 56 I6
Ajanta India 84 B1
Ajanta Range hills India see
Sahyadriparvat Range
Ajaureforsen Sweden 44 I4
Ajax Canada 134 F2
Ajayameru India see Ajmer
Ajban U.A.E. 88 D5
Aj Bogd Uul mt. Mongolia 80 I3
Ajdābiyā Libya 97 F1
a-Jiddēt des. Oman see Ḩarāsīs, Jiddat al
'Ajlūn Jordan 85 B3
'Ajman U.A.E. 88 D5
Ajmer India 82 C4
Ajmer-Merwara India see Ajmer
Ajnala India 82 C3
Ajo U.S.A. 129 G5
Ajo, Mount U.S.A. 129 G5
Ajrestan Afgh. 89 G3
Ajyyap Turkm. 88 D2
Akademii, Zaliv b. Rus. Fed. 74 E1
Akademii Nauk, Khrebet mt. Tajik. see
Akademiyai Fanho, Qatorkŭhi
Akademiyai Fanho, Qatorkŭhi mt.
Tajik. 89 H2
Akagera National Park Rwanda 98 C4
Akalkot India 84 C2
Akama, Akra c. Cyprus see Arnauti, Cape
Akamagaseki Japan see Shimonoseki
Akan Kokuritsu-kōen Japan 74 G4
Akaroa N.Z. 113 D6
Akas reg. India 76 B3
Akäshat Iraq 91 F4
Akbarābād Iran 91 I5
Akbarpur Uttar Prad. India 82 E4
Akbarpur Uttar Prad. India 83 E4
Akbaytal, Pereval pass Tajik. 89 I2
Akbaytal Pass Tajik. see Akbaytal, Pereval
Akbez Turkey 85 C1
Akçadağ Turkey 90 E3
Akçakale Turkey 85 D1
Akçakoca Turkey 59 N4
Akçakoyunlu Turkey 85 C1
Akçalı Dağları mts Turkey 85 A1
Akchâr reg. Mauritania 96 B3
Akchi Kazakh. see Akshiy
Akdağ mts Turkey 59 M6
Akdağmadeni Turkey 90 D3
Akdere Turkey 85 A1
Akelamo Indon. 69 H6
Åkersberga Sweden 45 K7
Akersloot Neth. 52 E2
Aketi Dem. Rep. Congo 98 C3
Akgyr Erezi hills Turkm. 88 D1
Akhali-Afoni Georgia see Akhali Ap'oni
Akhali Ap'oni Georgia 91 F2
Akhḑar, Al Jabal al mts Libya 97 F1
Akhḑar, Jabal mts Oman 88 E6
Akhisar Turkey 59 L5
Akhnoor Jammu and Kashmir 82 C2
Akhta Armenia see Hrazdan
Akhtarīn Syria 85 C1
Akhtubinsk Rus. Fed. 43 J6
Akhtyrka Ukr. see Okhtyrka
Aki Japan 75 D6
Akiéni Gabon 98 B4
Akimiski Island Canada 122 E3
Akishma r. Rus. Fed. 74 D1
Akita Japan 75 F5
Akjoujt Mauritania 96 B3
Akkajaure l. Sweden 44 J3
Akkerman Ukr. see Bilhorod-Dnistrovs'kyy
Akkeshi Japan 74 G4
'Akko Israel 85 B3
Akkol' Akmolinskaya Oblast' Kazakh. 80 D1

Akkol' Atyrauskaya Oblast' Kazakh. 43 K7
Akku Kazakh. 80 E1
Akkul' Kazakh. see Akkol'
Akkuş Turkey 90 E2
Akkyr, Gory hills Turkm. see Akgyr Erezi
Aklavik Canada 118 E3
Aklera India 82 D4
Ak-Mechet Kazakh. see Kyzylorda
Akmenrags pt Latvia 45 L8
Akmeqit China 82 D1
Akmola Kazakh. see Astana
Akmolinsk Kazakh. see Astana
Akobo Sudan 97 G4
Akobo Wenz r. Eth./Sudan 98 D3
Akokan Niger 96 D3
Akola India 84 C1
Akom II Cameroon 96 E4
Akonolinga Cameroon 96 E4
Akordat Eritrea 86 E6
Akören Turkey 90 D3
Akot India 82 D5
Akpatok Island Canada 123 I1
Akqi China 80 E3
Akra, Jabal mt. Syria/Turkey see
 Aqra', Jabal al
Akranes Iceland 44 [inset]
Åkrehamn Norway 45 D7
Akréréb Niger 96 D3
Akron CO U.S.A. 130 C3
Akron IN U.S.A. 134 B3
Akron OH U.S.A. 134 E3
Akrotiri Bay Cyprus 85 A2
Akrotirion Bay Cyprus see Akrotiri Bay
Akrotiriou, Kolpos b. Cyprus see
 Akrotiri Bay
Akrotiri Sovereign Base Area military base
 Cyprus 85 A2

▶Aksai Chin terr. Asia 82 D2
 Disputed territory (China/India).

Aksaray Turkey 90 D3
Aksay China 80 H4
Aksay Kazakh. 41 Q5
Ak-Say r. Kyrg. 87 M1
Aksay Rus. Fed. 43 H7
Akşehir Turkey 59 N5
Akşehir Gölü l. Turkey 59 N5
Akseki Turkey 90 C3
Aksha Rus. Fed. 73 K2
Akshiganak Kazakh. 80 B2
Akshiy Kazakh. 80 E3
Akshukur Kazakh. 91 H2
Aksu China 80 F3
Aksu Kazakh. 80 E1
Aksu r. Tajik. see Oqsu
Aksu r. Turkey 59 N6
Aksuat Kazakh. 80 F2
Aksu-Ayuly Kazakh. 80 D2
Aksubayevo Rus. Fed. 43 K5
Åksum Eth. 86 E7
Aktag mt. China 83 F1
Aktas Dağı mt. Turkey 91 G3
Aktau Kazakh. 78 E2
Akto China 89 J2
Aktobe Kazakh. 78 E1
Aktogay Karagandinskaya Oblast'
 Kazakh. 80 E2
Aktogay Vostochnyy Kazakhstan
 Kazakh. 80 E2
Aktsyabrski Belarus 43 F5
Aktyubinsk Kazakh. see Aktobe
Akulivik Canada 119 K3
Akune Japan 75 C6
Akure Nigeria 96 D4
Akuressa Sri Lanka 84 D5
Akureyri Iceland 44 [inset]
Akusha Rus. Fed. 43 J8
Akwanga Nigeria 96 D4
Akxokesay China 83 G1
Akyab Myanmar see Sittwe
Akyatan Gölü salt l. Turkey 85 B1
Akyazı Turkey 59 N4
Akzhaykyn, Ozero salt l. Kazakh. 80 C3
Ål Norway 45 F6
Alā, Jabal al hills Syria 85 C2
Alabama r. U.S.A. 133 C6
Alabama state U.S.A. 133 C5
Alabaster AL U.S.A. 133 C5
Alabaster MI U.S.A. 134 D1
Al 'Abţīyah well Iraq 91 G5
Alaca Turkey 90 D2
Alacahan Turkey 90 E3
Alaçam Turkey 90 D2
Alaçam Dağları mts Turkey 59 M5
Alacant Valencia Spain see Alicante
açatı Turkey 59 L5
adağ Turkey 90 D3
la Dağlar mts Turkey 91 F3
la Dağları mts Turkey 90 D3
'Adam Libya 90 A5
a'er China 80 F3
Aflaj reg. Saudi Arabia 88 B6
ag Hu l. China 76 C1
agir Rus. Fed. 91 G2
agoinhas Brazil 145 D1
ahärmä Fin. 44 M5
ai Range mts Asia 89 H2
aivän Iran 88 D3
ajah Syria 85 B2
ajärvi Fin. 44 M5
'Ajrūd well Egypt 85 B4
akanuk U.S.A. 118 B3
Akhdar Saudi Arabia 90 E5
akol', Ozero salt l. Kazakh. 80 F2
a Kul salt l. Kazakh. see Alakol', Ozero
akurtti Rus. Fed. 44 Q3
'Alamayn Egypt 90 C5
'Alayyah Saudi Arabia 86 F6
ama Somalia 98 E3
'Amādīyah Iraq 91 F3
amagan i. N. Mariana Is 69 L3
amaguan i. N. Mariana Is see Alamagan
'Amārah Iraq 91 G5
am ar Rūm, Ra's pt Egypt 90 B5
āmarvdasht watercourse Iran 88 D4
am el Rūm, Rās pt Egypt see
 am ar Rūm, Ra's
Amghar waterhole Iraq 91 G5
'Āmirīyah Egypt 90 C5

Alamo GA U.S.A. 133 D5
Alamo NV U.S.A. 129 F3
Alamo Dam U.S.A. 129 G4
Alamogordo U.S.A. 127 G6
Alamo Heights U.S.A. 131 D6
Alamos Sonora Mex. 127 F7
Alamos Sonora Mex. 127 F8
Alamos r. Mex. 131 C7
Alamos, Sierra mts Mex. 127 F8
Alamosa U.S.A. 127 G5
Alamos de Peña Mex. 127 G7
Alampur India 84 C3
Alan Myanmar see Aunglan
Alanäs Sweden 44 I4
Åland is Fin. see Åland Islands
Aland r. Germany 53 L1
Aland India 84 C2
Al Andarīn Syria 85 C2
Åland Islands Fin. 45 K6
Alando China 76 B2
Alandur India 84 D3
Alanson U.S.A. 134 C1
Alanya Turkey 90 D3
Alaplı Turkey 59 N4
Alappuzha India see Alleppey
Alapuzha India see Alleppey
Al 'Aqabah Jordan 85 B5
Al 'Aqīq Saudi Arabia 86 F5
Al 'Arabīyah as Sa'ūdīyah country Asia see
 Saudi Arabia
Alarcón, Embalse de resr Spain 57 E4
Al 'Arīsh Egypt 85 A4
Al Arţāwīyah Saudi Arabia 86 G4
Alas, Selat sea chan. Indon. 108 B2
Alaşehir Turkey 59 M5
Alashiya country Asia see Cyprus
Al Ashmūnayn Egypt 90 C6
Alaska state U.S.A. 118 D3
Alaska, Gulf of U.S.A. 118 D4
Alaska Highway Canada/U.S.A. 120 A2
Alaska Peninsula U.S.A. 118 B4
Alaska Range mts U.S.A. 118 D3
Älät Azer. 91 H3
Alat Uzbek. see Olot
Alataw Shankou pass China/Kazakh. see
 Dzungarian Gate
Al Atwā' well Saudi Arabia 91 F5
Alatyr' Rus. Fed. 43 J5
Alatyr' r. Rus. Fed. 43 J5
Alausí Ecuador 142 C4
Alaverdi Armenia 91 G2
'Alavī Iran 88 C3
Alavieska Fin. 44 N4
Alavus Fin. 44 M5
Alawbum Myanmar 70 B1
Alawoona Australia 111 C7
Alay Kyrka Toosu mts Asia see Alai Range
Al 'Ayn Oman 88 E6
Al 'Ayn U.A.E. 88 D5
Alayskiy Khrebet mts Asia see Alai Range
Al 'Azīzīyah Iraq 91 G4

▶Al 'Azīzīyah Libya 55 G5
 Highest recorded shade temperature in the
 world.

Al Azraq al Janūbī Jordan 85 C4
Alba Italy 58 C2
Alba U.S.A. 134 C1
Al Bāb Syria 85 C1
Albacete Spain 57 F4
Al Badi' Saudi Arabia 88 B6
Al Bādiyah al Janūbīyah hill Iraq 91 G5
Al Bahrayn country Asia see Bahrain
Alba Iulia Romania 59 J1
Al Bajā' well U.A.E. 88 C5
Albājī Iran 88 C4
Al Bakhrā well Saudi Arabia 88 B5
Albanel, Lac l. Canada 123 G4
▶Albania country Europe 59 H4
 Europe 5, 38–39
Albany Australia 109 B8
Albany r. Canada 122 E3
Albany GA U.S.A. 133 C6
Albany IN U.S.A. 134 C3
Albany KY U.S.A. 134 C5
Albany MO U.S.A. 130 E3

▶Albany NY U.S.A. 135 I2
 State capital of New York.

Albany OH U.S.A. 134 D4
Albany OR U.S.A. 126 C3
Albany TX U.S.A. 131 D5
Albany Downs Australia 112 D1
Albardão do João Maria coastal area
 Brazil 144 F4
Al Bardī Libya 90 B5
Al Bāridah hills Saudi Arabia 85 D5
Al Başrah Iraq see Basra
Al Baţha' marsh Iraq 91 G5
Al Baţinah reg. Oman 88 E5
Albatross Bay Australia 110 C2
Albatross Island Australia 111 [inset]
Al Bawītī Egypt 90 C5
Al Baydā' Libya 90 B3
Al Baydā' Yemen 86 G7
Albemarle U.S.A. 133 D5
Albemarle Island Galápagos Ecuador see
 Isabela, Isla
Albemarle Sound sea chan. U.S.A. 132 E5
Albenga Italy 58 C2
Alberche r. Spain 57 D4
Alberga watercourse Australia 111 A5
Albergaria-a-Velha Port. 57 B3
Albert Australia 112 C4
Albert France 52 C5
Albert, Lake Dem. Rep. Congo/Uganda
 98 D3
Albert, Parc National nat. park
 Dem. Rep. Congo see
 Virunga, Parc National des
Alberta prov. Canada 120 H4
Alberta U.S.A. 135 G5
Albert Kanaal canal Belgium 52 F4
Albert Lea U.S.A. 130 E3
Albert Nile r. Sudan/Uganda 97 G4
Alberto de Agostini, Parque Nacional
 nat. park Chile 144 B8
Alberton S. Africa 101 I4
Alberton U.S.A. 126 E3

Albert Town Bahamas 133 F8
Albertville Dem. Rep. Congo see Kalemie
Albertville France 56 H4
Albertville U.S.A. 133 C5
Albestroff France 52 G6
Albi France 56 F5
Albia U.S.A. 130 E3
Al Bīḍah des. Saudi Arabia 88 C5
Albina Suriname 143 H2
Albino Italy 58 C2
Albion CA U.S.A. 128 B2
Albion IL U.S.A. 130 F4
Albion IN U.S.A. 134 C3
Albion MI U.S.A. 134 C2
Albion NE U.S.A. 130 D3
Albion NY U.S.A. 135 F2
Albion PA U.S.A. 134 E3
Al Biqā' valley Lebanon see El Béqaa
Al Bi'r Saudi Arabia 90 E5
Al Birk Saudi Arabia 86 F6
Al Biyāḍh reg. Saudi Arabia 86 G5
Alborán, Isla de i. Spain 57 E6
Ålborg Denmark see Aalborg
Ålborg Bugt b. Denmark see Aalborg Bugt
Albro Australia 110 D4
Al Budayyi' Bahrain 88 C5
Albufeira Port. 57 B5
Al Buḩayrāt al Murrah lakes Egypt see
 Bitter Lakes
Albuquerque U.S.A. 127 G6
Al Burayj Syria 85 C2
Al Buraymī Oman 88 D5
Al Burj Jordan 85 B5
Alburquerque Spain 57 C4
Albury Australia 112 C6
Al Buşayrah Syria 91 F4
Al Busaytā' plain Saudi Arabia 85 D4
Al Bushūk well Saudi Arabia 88 B4
Alcácer do Sal Port. 57 B4
Alcalá de Henares Spain 57 E3
Alcalá la Real Spain 57 E5
Alcamo Sicily Italy 58 E6
Alcañiz Spain 57 F3
Alcántara Spain 57 C4
Alcantara Lake Canada 121 I2
Alcaraz Spain 57 E4
Alcázar de San Juan Spain 57 E4
Alcazarquivir Morocco see Ksar el Kebir
Alchevs'k Ukr. 43 H6
Alcobaça Brazil 145 D2
Alcoi Spain see Alcoy-Alcoi
Alcoota Australia 108 F5
Alcova U.S.A. 126 G4
Alcoy Spain see Alcoy-Alcoi
Alcoy-Alcoi Spain 57 F4
Alcúdia Spain 57 H4
Aldabra Islands Seychelles 99 E4
Aldan Rus. Fed. 65 N4
Aldan r. Rus. Fed. 65 N3
Alde r. U.K. 49 I6
Aldeboarn Neth. 52 F1
Aldeburgh U.K. 49 I6
Alder Creek U.S.A. 135 H2
Alderney i. Channel Is 49 E9
Alder Peak U.S.A. 128 C4
Aldershot U.K. 49 G7
Al Dhafrah reg. U.A.E. 88 D6
Aldingham U.K. 48 D4
Aldridge U.K. 49 F6
Aleg Mauritania 96 B3
Alegre Espírito Santo Brazil 145 C3
Alegre Minas Gerais Brazil 145 B2
Alegrete Brazil 144 E3
Alegros Mountain U.S.A. 129 I4
Aleksandra, Mys hd Rus. Fed. 74 E1
Aleksandriya Ukr. see Oleksandriya
Aleksandro-Nevskiy Rus. Fed. 43 I5
Aleksandropol Armenia see Gyumri
Aleksandrov Rus. Fed. 42 H4
Aleksandrov Gay Rus. Fed. 43 K6
Aleksandrovsk Rus. Fed. 41 R4
Aleksandrovsk Ukr. see Zaporizhzhya
Aleksandrovskiy Rus. Fed. see
 Aleksandrovsk
Aleksandrovskoye Rus. Fed. 91 F1
Aleksandrovsk-Sakhalinskiy Rus. Fed.
 74 F2
Aleksandry, Zemlya i. Rus. Fed. 64 F1
Alekseyevka Akmolinskaya Oblast'
 Kazakh. see Akkol'
Alekseyevka Vostochnyy Kazakhstan
 Kazakh. see Terekty
Alekseyevka Amurskaya Oblast' Rus. Fed.
 74 B1
Alekseyevka Belgorodskaya Oblast'
 Rus. Fed. 43 H6
Alekseyevka Belgorodskaya Oblast'
 Rus. Fed. 43 H6
Alekseyevskaya Rus. Fed. 43 I6
Alekseyevskoye Rus. Fed. 42 K5
Aleksin Rus. Fed. 43 H5
Aleksinac Serb. and Mont. 59 I3
Alèmbé Gabon 98 B4
Ålen Norway 44 G5
Alençon France 56 E2
Alenquer Brazil 143 H4
'Alenuihāhā Channel U.S.A. 127 [inset]
Alep Syria see Aleppo
Aleppo Syria 85 C1
Alert Canada 119 L1
Alerta Peru 142 D6
Alès France 56 G4
Aleşd Romania 59 J1
Aleshki Ukr. see Tsyurupyns'k
Aleşkirt Turkey see Eleşkirt
Alessandria Italy 58 C2
Alessio Albania see Lezhë
Ålesund Norway 44 E5
Aleutian Basin sea feature
 Bering Sea 150 H2
Aleutian Islands U.S.A. 118 A4
Aleutian Range mts U.S.A. 118 C4
Aleutian Trench sea feature
 N. Pacific Ocean 150 I2
Alevina, Mys c. Rus. Fed. 65 Q4
Alexander U.S.A. 130 C2
Alexander, Kap c. Greenland see Ullersuaq
Alexander, Mount hill Australia 110 B2
Alexander Archipelago is U.S.A. 120 B3
Alexander Bay b. Namibia/S. Africa 100 C5
Alexander Bay S. Africa 100 C5

Alexander City U.S.A. 133 C5
Alexander Island Antarctica 152 L2
Alexandra Australia 112 B6
Alexandra N.Z. 113 B7
Alexandra, Cape S. Georgia 144 I8
Alexandra Channel India 71 A4
Alexandra Land i. Rus. Fed. see
 Aleksandry, Zemlya
Alexandreia Greece 59 J4
Alexandretta Turkey see İskenderun
Alexandria Afgh. see Ghaznī
Alexandria Canada 135 H1

▶Alexandria Egypt 90 C5
 5th most populous city in Africa.

Alexandria Romania 59 K3
Alexandria S. Africa 101 H7
Alexandria Turkm. see Mary
Alexandria U.K. 50 E5
Alexandria IN U.S.A. 134 C3
Alexandria KY U.S.A. 134 C4
Alexandria LA U.S.A. 131 E6
Alexandria VA U.S.A. 135 G4
Alexandria Arachoton Afgh. see Kandahār
Alexandria Areion Afgh. see Herāt
Alexandria Bay U.S.A. 135 H1
Alexandria Prophthasia Afgh. see Farāh
Alexandrina, Lake Australia 111 B7
Alexandroupoli Greece 59 K4
Alexis r. Canada 123 K3
Alexis Creek Canada 120 F4
Aley Lebanon 85 B3
Aleyak Iran 88 E2
Alf Germany 52 H4
Al Farwānīyah Kuwait 88 B4
Al Fas Morocco see Fès
Al Fatḩah Iraq 91 F4
Al Fāw Iraq 91 H5
Al Fayyūm Egypt 90 C5
Alfeld (Leine) Germany 53 J3
Alfenas Brazil 145 B3
Alford U.K. 48 H5
Alfred ME U.S.A. 135 J2
Alfred NY U.S.A. 135 G2
Alfred and Marie Range hills
 Australia 109 D6
Al Fujayrah U.A.E. see Fujairah
Al Fuqahā' Libya 97 E2
Al Furāt r. Iraq/Syria 85 D2 see Euphrates
Alga Kazakh. 80 A2
Al Gaḩādīyah Iraq 91 G4
Ålgård Norway 45 D7
Algarrobo del Aguililla Arg. 144 C5
Algarve reg. Port. 57 B5
Algeciras Spain 57 D5
Algemesí Spain 57 F4
Algena Eritrea 86 E6
Alger Alg. see Algiers
Alger U.S.A. 134 C1

▶Algeria country Africa 96 C2
 2nd largest country in Africa.
 Africa 7, 94–95

Algérie country Africa see Algeria
Algermissen Germany 53 J2
Algha Kazakh. see Alga
Al Ghāfāt Oman 88 E6
Al Ghammās Iraq 91 G5
Al Ghardaqah Egypt see Al Ghurdaqah
Al Ghawr plain Jordan/West Bank 85 B4
Al Ghaydah Yemen 86 H6
Alghero Sardinia Italy 58 C4
Al Ghurdaqah Egypt 86 D4
Al Ghuwayr well Qatar 88 C5

▶Algiers Alg. 57 H5
 Capital of Algeria.

Algoa Bay S. Africa 101 G7
Algoma U.S.A. 134 B1
Algona U.S.A. 130 E3
Algonac U.S.A. 134 D2
Algonquin Park Canada 135 F1
Algonquin Provincial Park Canada 135 F1
Algorta Spain 57 E2
Algueirao Moz. see Hacufera
Al Habakah well Saudi Arabia 91 F5
Al Ḩabbānīyah Iraq 91 F4
Al Ḩadaqah well Saudi Arabia 88 B4
Al Hadd Bahrain 88 C5
Al Hadhālīl plat. Saudi Arabia 91 F5
Al Ḩadīdīyah Syria 85 C2
Al Ḩadīthah Iraq 91 F4
Al Hadīthah Saudi Arabia 85 C4
Al Ḩadr Iraq see Hatra
Al Ḩafār well Saudi Arabia 91 F5
Al Ḩaffah Syria 85 C2
Al Haggounia W. Sahara 96 B2
Al Ḩajar al Gharbī mts Oman 88 E6
Al Hajar ash Sharqī mts Oman 88 E6
Al Ḩamād plain Asia 91 F4
Al Ḩamādah al Ḩamrā' plat. Libya 96 E2
Alhama de Murcia Spain 57 F5
Al Ḩamar Saudi Arabia 86 G5
Al Ḩamīdīyah Syria 85 B2
Al Ḩammām Egypt 90 C5
Al Ḩanākīyah Saudi Arabia 86 F5
Al Haniyah esc. Iraq 91 G5
Al Hariq Saudi Arabia 88 B6
Al Ḩarrah Egypt 90 C5
Al Harūj al Aswad hills Libya 97 E2
Al Hasa reg. Saudi Arabia 88 C5
Al Ḩasakah Syria 91 F3
Al Hawi salt pan Saudi Arabia 85 D5
Al Ḩawjāʾ reg. Saudi Arabia 88 B6
Al Ḩayy Iraq 91 G4
Al Hazim Jordan 85 C4
Al Ḩazm Saudi Arabia 90 E5
Al Ḩazm al Jawf Yemen 86 F6
Al Ḩibāk des. Saudi Arabia 87 H6
Al Ḩijānah Syria 85 C3
Al Ḩillah Iraq see Hillah
Al Ḩillah Saudi Arabia 86 G5
Al Ḩinnah Saudi Arabia 88 E1
Al Ḩinw mt. Saudi Arabia 85 C5
Al Hirrah well Saudi Arabia 88 C6
Al Hīshah Syria 85 D1
Al Ḩismā plain Saudi Arabia 90 D5

Al Ḩişn Jordan 85 B3
Al Hoceima Morocco 57 E6
Al Ḩudaydah Yemen see Hodeidah
Al Ḩufrah reg. Saudi Arabia 90 E5
Al Hufūf Saudi Arabia 86 G4
Al Hūj hills Saudi Arabia 90 E5
Al Husayfin Oman 88 E5
Al Ḩuwwah Saudi Arabia 88 B6
Ali China 82 D2
'Alīābād Afgh. 89 H2
'Alīābād Golestān Iran 88 D2
'Alīābād Hormozgan Iran 88 D4
'Alīābād Khorāsān Iran 89 F4
'Alīābād Kordestān Iran 88 B2
Alīābād, Kūh-e mt. Iran 88 C3
Aliağa Turkey 59 L5
Aliakmonas r. Greece 59 J4
Alibag India 84 B2
Åli Bayramlı Azer. 91 H3
Alicante Spain 57 F4
Alice r. Australia 110 C2
Alice watercourse Australia 110 D5
Alice U.S.A. 131 D7
Alice, Punta pt Italy 58 G5
Alice Springs Australia 109 F5
Alice Town Bahamas 133 E7
Aliceville U.S.A. 131 F5
Alichur Tajik. 89 I2
Alichur r. Tajik. 89 I2
Alick Creek r. Australia 110 C4
Alifu Atoll Maldives see Ari Atoll
Al Ifzi'iyyah i. U.A.E. 88 C5
Aliganj India 82 D4
Aligarh Rajasthan India 82 D4
Aligarh Uttar Prad. India 82 D4
Aligüdarz Iran 88 C3
Alihe China 74 A2
Alījūq, Kūh-e mt. Iran 88 C4
'Alī Kheyl Afgh. 89 H3
Al Imārāt al 'Arabīyah at Muttaḩidah
 country Asia see United Arab Emirates
Alimia i. Greece 59 L6
Alindao Cent. Afr. Rep. 98 C3
Alingsås Sweden 45 H8
Aliova r. Turkey 59 M5
Alipura India 82 D4
Alipur Duar India 83 G4
Alirajpur India 82 C5
Al 'Irāq country Asia see Iraq
Al 'Īsāwīyah Saudi Arabia 85 C4
Al Iskandarīyah Egypt see Alexandria
Al Iskandarīyah Iraq 91 G4
Al Ismā'īlīyah Egypt 90 D5
Al Ismā'īlīyah governorate Egypt 85 A4
Aliveri Greece 59 K5
Aliwal North S. Africa 101 H6
Alix Canada 120 H4
Al Jafr Jordan 85 C4
Al Jāfūrah des. Saudi Arabia 88 C5
Al Jaghbūb Libya 90 B5
Al Jahrah Kuwait 88 B4
Al Jamalīyah Qatar 88 C5
Al Jarāwī well Saudi Arabia 85 D4
Al Jauf Saudi Arabia see Dumat al Jandal
Al Jawb reg. Saudi Arabia 88 C6
Al Jawf Libya 97 F2
Al Jawsh Libya 96 E1
Al Jazā'ir country Africa see Algeria
Al Jazā'ir Alg. see Algiers
Aljezur Port. 57 B5
Al Jīān reg. Saudi Arabia 88 C5
Al Jil well Iraq 91 F5
Al Jilh esc. Saudi Arabia 88 B5
Al Jithāmīyah Saudi Arabia 91 F5
Al Jīzah Egypt see Giza
Al Jīzah Jordan 85 B4
Al Jubayl Saudi Arabia 88 C5
Al Jubaylah Saudi Arabia 88 B5
Al Jufrah Libya 97 E2
Al Julayqah well Saudi Arabia 88 C5
Aljustrel Port. 57 B5
Al Juwayf depr. Syria 85 C3
Al Kahfah Al Qaşīm Saudi Arabia 86 F4
Al Kahfah Ash Sharqīyah Saudi Arabia 88 C5
Alkali Lake Canada 120 F5
Al Karak Jordan 85 B4
Al Kāzimīyah Iraq 91 G4
Al Khābūrah Oman 88 E6
Al Khalīl West Bank see Hebron
Al Khāliş Iraq 91 G4
Al Khārijah Egypt 86 D4
Al Kharj reg. Saudi Arabia 88 B5
Al Kharrārah Qatar 88 C5
Al Kharrūbah Egypt 85 A4
Al Khaşab Oman 88 E5
Al Khatam reg. U.A.E. 88 D5
Al Khawkhah Yemen 86 F7
Al Khawr Qatar 88 C5
Al Khizāmī well Saudi Arabia 88 C5
Al Khums Libya 97 E1
Al Khunfah sand area Saudi Arabia 90 E5
Al Khunn Saudi Arabia 98 E1
Al Kifl Iraq 91 G4
Al Kir'ānah Qatar 88 C5
Al Kiswah Syria 85 C3
Alkmaar Neth. 52 E2
Al Kūbrī Egypt 85 A4
Al Kūfah Iraq 91 G4
Al Kumayt Iraq 91 G4
Al Kuntillah Egypt 85 B4
Al Kusūr hills Saudi Arabia 85 C5
Al Kūt Iraq 91 G4
Al Kuwayt country Asia see Kuwait
Al Kuwayt Kuwait see Kuwait
Al Labbah plain Saudi Arabia 91 F5
Al Lādhiqīyah Syria see Latakia
Allagadda India 84 C3
Allahabad India 83 E4
Al Lajā lava field Syria 85 C3
Allakaket U.S.A. 118 C3
Allakh-Yun' Rus. Fed. 65 O3
Allanmyo Myanmar see Aunglan
Allanridge S. Africa 101 H4
Allapalli India 84 D2
'Allāqī, Wādī al watercourse Egypt 86 D5
'Allāqī, Wādī al watercourse Egypt see
 'Allāqī, Wādī al
Allardville Canada 123 I5
Alldays S. Africa 101 I2
Allegan U.S.A. 134 C2
Allegheny r. U.S.A. 134 F3
Allegheny Mountains U.S.A. 134 D5

Allegheny Reservoir U.S.A. 135 F3
Allen, Lough l. Ireland 51 D3
Allendale U.S.A. 133 D5
Allendale Town U.K. 48 E4
Allende Coahuila Mex. 131 C6
Allende Nuevo León Mex. 131 C7
Allendorf (Lumda) Germany 53 I4
Allenford Canada 134 E1
Allenstein Poland see Olsztyn
Allensville U.S.A. 134 B5
Allentown U.S.A. 135 H3
Alleppey India 84 C4
Aller r. Germany 53 J2
Alliance NE U.S.A. 130 C3
Alliance OH U.S.A. 134 E3
Al Lībīyah country Africa see Libya
Allier r. France 56 F3
Al Liḩābah well Saudi Arabia 88 B5
Allinge-Sandvig Denmark 45 I9
Al Lişāfah well Saudi Arabia 88 B5
Al Lisān pen. Jordan 85 B4
Alliston Canada 134 F1
Al Lith Saudi Arabia 86 F5
Al Liwā' oasis U.A.E. 88 D6
Alloa U.K. 50 F4
Allons U.S.A. 134 C5
Allora Australia 112 F2
Allur India 84 D3
Alluru Kottapatnam India 84 D3
Al Lussuf well Iraq 91 F5
Alma Canada 123 H4
Alma MI U.S.A. 134 C2
Alma NE U.S.A. 130 D3
Alma WI U.S.A. 130 F2
Al Ma'āniyah Iraq 91 F5
Alma-Ata Kazakh. see Almaty
Almada Port. 57 B4
Al Madāfi' plat. Saudi Arabia 90 E5
Al Ma'danīyāt well Iraq 91 G5
Almaden Australia 110 D3
Almadén Spain 57 D4
Al Madīnah Saudi Arabia see Medina
Al Mafraq Jordan 85 C3
Al Maghrib country Africa see Morocco
Al Maghrib reg. U.A.E. 88 D6
Al Mahākīk reg. Saudi Arabia 88 C6
Al Mahdum Syria 85 C1
Al Maḩiā depr. Saudi Arabia 90 E6
Al Maḩwīt Yemen 86 F6
Al Malsūnīyah reg. Saudi Arabia 88 C5
Almalyk Uzbek. see Olmaliq
Al Manādir reg. Oman 88 D6
Al Manāmah Bahrain see Manama
Al Manjūr well Saudi Arabia 88 B6
Almanor, Lake U.S.A. 128 C1
Almansa Spain 57 F4
Al Manşūrah Egypt 90 C5
Almanzor mt. Spain 57 D3
Al Mariyyah U.A.E. 88 D6
Al Marj Libya 97 F1
Almas, Rio das r. Brazil 145 A1
Al Maţariyyah Egypt 90 D5

▶Almaty Kazakh. 80 E3
 Former capital of Kazakhstan.

Al Mawşil Iraq see Mosul
Al Mayādīn Syria 91 F4
Al Mazār Egypt 85 A4
Almaznyy Rus. Fed. 65 M3
Almeirim Brazil 143 H4
Almeirim Port. 57 B4
Almelo Neth. 52 G2
Almenara Brazil 145 C2
Almendra, Embalse de resr Spain 57 C3
Almendralejo Spain 57 C4
Almere Neth. 52 F2
Almería Spain 57 E5
Almería, Golfo de b. Spain 57 E5
Almetievsk Rus. Fed. see Al'met'yevsk
Al'met'yevsk Rus. Fed. 41 Q5
Älmhult Sweden 45 I8
Almina, Punta pt Spain 57 D6
Al Mindak Saudi Arabia 86 F5
Al Minyā Egypt 90 C5
Almirós Greece see Almyros
Al Mish'āb Saudi Arabia 88 C4
Almodôvar Port. 57 B5
Almond r. U.K. 50 F4
Almont U.S.A. 134 D2
Almonte Spain 57 C5
Almora India 82 D3
Al Mu'ayzilah hill Saudi Arabia 85 D5
Al Mubarrez Saudi Arabia 86 G4
Al Muḏaibī Oman 87 I5
Al Muḏairib Oman 88 E6
Al Muḩarraq Bahrain 88 C5
Al Mukallā Yemen see Mukalla
Al Mukhā Yemen see Mocha
Al Mukhaylī Libya 86 B3
Al Munbaţiḩ des. Saudi Arabia 88 C6
Almuñécar Spain 57 E5
Al Muqdādīyah Iraq 91 G4
Al Mūrītānīyah country Africa see
 Mauritania
Al Murūt well Saudi Arabia 91 E5
Almus Turkey 90 E2
Al Musannāh ridge Saudi Arabia 88 B4
Al Musayyib Iraq 88 B3
Al Muwaqqar Jordan 85 C4
Almyrou, Ormos b. Greece 59 K7
Alnwick U.K. 48 F3

▶Alofi Niue 107 J3
 Capital of Niue.
 Oceania 8, 104–105

Aloja Latvia 45 N8
Alon Myanmar 70 A2
Along India 83 H3
Alongshan China 74 A2
Alonnisos i. Greece 59 J5
Alor i. Indon. 108 D2
Alor, Kepulauan is Indon. 108 D2
Alor Setar Malaysia 71 C6
Alor Star Malaysia see Alor Setar
Alost Belgium see Aalst
Aloysius, Mount Australia 109 E6
Alozero Rus. Fed. 44 Q4
Alpen Germany 52 G3
Alpena U.S.A. 134 D1

Alpercatas, Serra das *hills* Brazil 143 J5
Alpha Australia 110 D4
Alpha Ridge *sea feature*
 Arctic Ocean 153 A1
Alpine AZ U.S.A. 129 I5
Alpine NY U.S.A. 135 G2
Alpine TX U.S.A. 131 C6
Alpine WY U.S.A. 126 F4
Alpine National Park Australia 112 C6
Alps *mts* Europe 50 H4
Al Qaʻāmīyah *reg.* Saudi Arabia 86 G6
Al Qaddāḥīyah Libya 97 E1
Al Qadmūs Syria 85 C2
Al Qāhirah Egypt *see* Cairo
Al Qaffāy *i.* U.A.E. 88 D5
Al Qāḥirah *reg.* Saudi Arabia 86 F5
Al Qāʻīyah Saudi Arabia 86 F5
Al Qāʻīyah *well* Saudi Arabia 88 B5
Al Qāmishlī Syria 91 F3
Al Qarʻah Libya 97 F3
Al Qarʻah *well* Saudi Arabia 88 B5
Al Qarʻah *lava field* Syria 85 C3
Al Qardāḥah Syria 85 C2
Al Qarqar Saudi Arabia 85 C4
Al Qaṣab *Ar Riyāḍ* Saudi Arabia 88 B5
Al Qaṣab *Ash Sharqīyah* Saudi Arabia 88 C6
Al Qaṭīf Saudi Arabia 88 C5
Al Qaṭn Yemen 86 G6
Al Qaṭrānah Jordan 85 C4
Al Qaṭrūn Libya 97 E2
Al Qāysūmah *well* Saudi Arabia 91 F5
Alqueva, Barragem de 57 C4
Al Qumur *country* Africa *see* Comoros
Al Qunayṭirah Syria 85 B3
Al Qunfidhah Saudi Arabia 86 F6
Al Qurayyāt Saudi Arabia 85 C4
Al Qurnah Iraq 91 G5
Al Quṣaymah Egypt 85 B4
Al Quṣayr Egypt 86 D4
Al Quṣayr Syria 85 C2
Al Qūṣīyah Egypt 90 C6
Al Qūṣūrīyah Saudi Arabia 88 B6
Al Quṭayfah Syria 85 C3
Al Quwayʻ *i.* Saudi Arabia 88 B5
Al Quwayrah Jordan 85 B5
Al Quwayrah Jordan 85 B5
Al Rabbād *i.* U.A.E. 88 D6
Alroy Downs Australia 110 B3
Alsace *admin. reg.* France 53 H6
Alsace *reg.* France 56 H2
Alsager U.K. 49 E5
Al Samīt *well* Iraq 91 F5
Alsatia *reg.* France *see* Alsace
Alsek *r.* U.S.A. 120 B3
Alsfeld Germany 53 J4
Alsleben (Saale) Germany 53 L3
Alston U.K. 48 E4
Alstonville Australia 112 F2
Alsunga Latvia 45 L8
Alta Norway 44 M2
Alta, Mount N.Z. 113 B7
Altaelva *r.* Norway 44 M2
Alta Floresta Brazil 143 G5
Altamaha *r.* U.S.A. 133 D6
Altamira Brazil 143 H4
Altamura Italy 58 G4
Altan Shiret China 73 J5
Altan Xiret China *see* Altan Shiret
Alta Paraiso de Goiás Brazil 145 B1
Altar *r.* Mex. 127 F7
Altar, Desierto de *des.* Mex. 129 F6
Altavista U.S.A. 134 F5
Altay China 80 G1
Altay Mongolia 80 I2
Altayskiy Rus. Fed. 80 G1
Altayskiy Khrebet *mts* Asia *see*
 Altai Mountains
Altdorf Switz. 56 I3
Altea Spain 57 F4
Alteidet Norway 44 M1
Altenahr Germany 52 G4
Altenberge Germany 53 H2
Altenburg Germany 53 M4
Altenkirchen (Westerwald) Germany 53 H4
Altenqoke China 83 H1
Altin Köprü Iraq 91 G4
Altınoluk Turkey 59 L5
Altınözü Turkey 85 C1
Altıntaş Turkey 59 N5
Altiplano *plain* Bol. 142 E7
Altmark *reg.* Germany 53 L2
Altmühl *r.* Germany 53 L6
Alto, Monte *hill* Italy 58 D2
Alto Chicapa Angola 99 B5
Alto del Moncayo *mt.* Spain 57 F3
Alto de Pencoso *hills* Arg. 144 C4
Alto Garças Brazil 143 H7
Alto Madidi, Parque Nacional *nat. park*
 Bol. 142 E6
Alton CA U.S.A. 128 A1
Alton IL U.S.A. 130 F4
Alton MO U.S.A. 131 F4
Alton NH U.S.A. 135 J2
Altona Canada 120 F3
Altoona U.S.A. 135 F3
Alto Parnaíba Brazil 143 I5
Alto Taquari Mato Grosso Brazil 143 H7
Altötting Germany 47 N6
Altrincham U.K. 48 E5
Alt Schwerin Germany 53 M1
Altun Kübri Iraq *see* Altin Köprü
Altun Shan *mts* China 80 C4
Alturas U.S.A. 126 C4
Altus U.S.A. 131 D5
Al Ubaylah Saudi Arabia 98 F1
Alucra Turkey 90 E2
Alūksne Latvia 45 O8
Alūm Iran 88 C3
Alum Bridge U.S.A. 134 E4
Al ʻUqaylah Libya 97 E1
Al ʻUqaylah Saudi Arabia *see* An Nabk
Al Uqṣur Egypt *see* Luxor
Alur India 84 C3
Al Urayq *des.* Saudi Arabia 90 E5
Al ʻUrdun *country* Asia *see* Jordan
Alur Setar Malaysia *see* Alor Setar
ʻĀlūṭ Iran 88 B3
Aluva India *see* Alwaye

Al ʻUwayjāʼ *well* Saudi Arabia 88 C6
Al ʻUwaynāt Libya 86 B5
Al ʻUwayqīlah Saudi Arabia 91 F5
Al ʻUzayr Iraq 91 G5
Alva U.S.A. 131 D4
Alvand, Küh-e *mt.* Iran 88 C3
Alvarães Brazil 142 F4
Alvdal Norway 44 G5
Älvdalen Sweden 45 I6
Alvesta Sweden 45 I8
Ålvik Norway 45 E6
Alvik Sweden 44 J5
Alvin U.S.A. 131 E6
Alvorada do Norte Brazil 145 B1
Älvsbyn Sweden 44 L4
Al Wafrah Kuwait 88 B5
Al Wajh Saudi Arabia 86 E4
Al Waqbāʼ *well* Saudi Arabia 88 B4
Alwar India 82 D4
Al Warīʻah Saudi Arabia 86 G4
Al Wāṭiyah *well* Egypt 90 B5
Alwaye India 84 C4
Al Widyān *plat.* Iraq/Saudi Arabia 91 F4
Al Wusayṭ *well* Saudi Arabia 88 B4
Alxa Youqi China *see* Ehen Hudag
Alxa Zuoqi China *see* Bayan Hot
Al Yamāmah Saudi Arabia 88 B5
Al Yaman *country* Asia *see* Yemen
Alyangula Australia 110 B2
Al Yāsāt *i.* U.A.E. 88 C5
Alyth U.K. 50 F4
Alytus Lith. 45 N9
Alzey Germany 53 I5
Amacayacu, Parque Nacional *nat. park*
 Col. 142 D4
Amadeus, Lake *salt flat* Australia 109 E6
Amadi Sudan *see* Amadi
Amadjuak Lake Canada 119 K3
Amadora Port. 57 B4
Amakusa-nada *b.* Japan 75 C6
Åmål Sweden 45 H7
Amalfi Italy 58 F4
Amalia S. Africa 101 I4
Amaliada Greece 59 I6
Amalner India 82 C5
Amamapare Indon. 69 J7
Amambaí Brazil 144 E2
Amambaí, Serra de *hills* Brazil/Para. 144 E2
Amami-Ō-shima *i.* Japan 75 C7
Amami-shotō *is* Japan 75 C8
Amamula Dem. Rep. Congo 98 C4
Amanab P.N.G. 69 K7
Amangel'dy Kazakh. 80 C1
Amankeldi Kazakh. *see* Amangel'dy
Amantea Italy 58 G5
Amanzimtoti S. Africa 101 J6
Amapá Brazil 143 H3
Amarante Brazil 143 J5
Amarapura Myanmar 70 B2
Amareleja Port. 57 C4
Amargosa Brazil 145 D1
Amargosa *watercourse* U.S.A. 128 E3
Amargosa Desert U.S.A. 128 E3
Amargosa Range *mts* U.S.A. 128 E3
Amargosa Valley U.S.A. 128 E3
Amarillo U.S.A. 131 C5
Amarillo, Cerro *mt.* Arg. 144 C4
Amarkantak India 83 E5
Amasia Turkey *see* Amasya
Amasine W. Sahara 96 B2
Amasra Turkey 90 D2
Amasya Turkey 90 D2
Amata Australia 109 E6
Amatulla India 83 H4
Amau P.N.G. 110 E1
Amay Belgium 52 F4
Amazar Rus. Fed. 74 A1
Amazar *r.* Rus. Fed. 74 A1

▶Amazon *r.* S. America 142 F4
 *Longest river and largest drainage basin in
 South America and 2nd longest river in the
 world.
 Also known as Amazonas or Solimões.*
 South America 138–139

Amazon, Mouths of the Brazil 143 I3
Amazonas *r.* S. America 142 F4 *see* Amazon
Amazon Cone *sea feature*
 S. Atlantic Ocean 148 E5
Amazônia, Parque Nacional *nat. park*
 Brazil 143 G4
Ambajogai India 84 C2
Ambala India 82 D3
Ambalangoda Sri Lanka 84 D5
Ambalavao Madag. 99 E6
Ambam Cameroon 98 B3
Ambar Iran 88 E4
Ambarchik Rus. Fed. 65 R3
Ambarnyy Rus. Fed. 44 R4
Ambasa India *see* Ambassa
Ambasamudram India 84 C4
Ambassa India 83 H5
Ambathala Australia 111 D5
Ambato Ecuador 142 C4
Ambato Boeny Madag. 99 E5
Ambato Finandrahana Madag. 99 E6
Ambatolampy Madag. 99 E5
Ambatomainty Madag. 99 E5
Ambatondrazaka Madag. 99 E5
Ambejogai India *see* Ambajogai
Ambelau *i.* Indon. 69 H7
Amberg Germany 53 L5
Ambergris Cay *i.* Belize 136 G5
Ambérieu-en-Bugey France 56 G4
Amberley N.Z. *see* Amberley
Amberley Canada 134 E1
Ambgaon India 84 D1
Ambianum France *see* Amiens
Ambikapur India 83 E5
Ambilobe Madag. 99 E5
Ambition, Mount Canada 120 D3
Amble U.K. 48 F3
Ambler U.S.A. 118 C3
Ambleside U.K. 48 E4
Amblève *r.* Belgium 52 F4
Ambo India 83 F5
Amboasary Madag. 99 E6
Ambodifotatra Madag. 99 E5
Ambohimahasoa Madag. 99 E6
Ambohitra *mt.* Madag. 99 E5

Amboina Indon. *see* Ambon
Ambon Indon. 69 H7
Ambon Indon. 69 H7
Ambon *i.* Indon. 69 H7
Amboró, Parque Nacional *nat. park*
 Bol. 142 F7
Ambositra Madag. 99 E6
Ambovombe Madag. 99 E6
Amboy U.S.A. 129 F4
Ambre, Cap d' *c.* Madag. *see*
 Bobaomby, Tanjona
Ambrim *i.* Vanuatu *see* Ambrym
Ambriz Angola 99 B4
Ambrizete Angola *see* N'zeto
Ambrosia Lake U.S.A. 129 J4
Ambrym *i.* Vanuatu 107 G3
Ambunti P.N.G. 69 K7
Am-Dam Chad 97 F3
Amded, Oued *watercourse* Alg. 96 D2
Amdo China *see* Lharigarbo
Ameland *i.* Neth. 52 F1
Amelia Court House U.S.A. 135 G5
Amenia U.S.A. 135 I3
Amer, Erg d' *des.* Alg. 98 A1
Amereli India *see* Amreli
American, North Fork *r.* U.S.A. 128 C2
Americana Brazil 145 B3
American-Antarctic Ridge *sea feature*
 S. Atlantic Ocean 148 I9
American Falls U.S.A. 126 E4
American Falls Reservoir U.S.A. 126 E4
American Fork U.S.A. 129 H1

▶American Samoa *terr.* S. Pacific Ocean
 107 J3
 *United States Unincorporated Territory.
 Oceania 8, 104–105

Americus U.S.A. 133 C5
Amersfoort Neth. 52 F2
Amersfoort S. Africa 101 I4
Amersham U.K. 49 G7
Amery Canada 121 M3
Amery Ice Shelf Antarctica 152 E2
Ames U.S.A. 130 E3
Amesbury U.K. 49 F7
Amesbury U.S.A. 135 J2
Amet India 82 C4
Amethi India 83 E4
Amfissa Greece 59 J5
Amga Rus. Fed. 65 O3
Amgalang China 73 L3
Amgu Rus. Fed. 74 E3
Amguid Alg. 96 D2
Amgun' *r.* Rus. Fed. 74 D1
Amherst Canada 123 I5
Amherst Myanmar *see* Kyaikkami
Amherst MA U.S.A. 135 I2
Amherst OH U.S.A. 134 D3
Amherst VA U.S.A. 134 F5
Amherstburg Canada 134 D2
Amherst Island Canada 135 G1
Amiata, Monte *mt.* Italy 58 D3
Amida Turkey *see* Diyarbakır
Amidon U.S.A. 130 C2
Amiens France 52 C5
'Amij, Wādī *watercourse* Iraq 91 F4
Amik Ovası *marsh* Turkey 85 C1
'Amīnābād Iran 88 D4
Amindivi *atoll* India *see* Amini
Amindivi Islands India 84 B4
Amini *atoll* India 84 B4
Amino Eth. 98 E3
Amīrābād Iran 88 B3
Amirante Islands Seychelles 149 L6
Amirante Trench *sea feature* Indian Ocean
 149 L6
Amisk Lake Canada 121 K4
Amistad, Represa de *resr* Mex./U.S.A. *see*
 Amistad Reservoir
Amistad Reservoir Mex./U.S.A. 131 C6
Amisus Turkey *see* Samsun
Amite U.S.A. 131 F6
Amity Point Australia 112 F1
Amla India 82 D5
Amlapura Indon. *see* Karangasem
Amlash Iran 88 C2
Amlekhganj Nepal 83 F4
Åmli Norway 45 F7
Amlia Island U.S.A. 118 A4
Amlwch U.K. 48 C5

▶ʻAmmān Jordan 85 B4
 Capital of Jordan.

Ammanazar Turkm. 88 D2
Ammanford U.K. 49 D7
Ämmänsaari Fin. 44 P4
'Ammār, Tall *hill* Syria 85 C3
Ammarnäs Sweden 44 J4
Ammaroo Australia 110 A4
Ammassalik Greenland *see* Tasiilaq
Ammer *r.* Germany 47 M7
Ammerland *reg.* Germany 53 H1
Ammern Germany 53 K3
Ammochostos Cyprus *see* Famagusta
Ammochostos Bay Cyprus 85 B2
Am Nābīyah Yemen 86 F7
Amne Machin Range *mts* China *see*
 A'nyêmaqên Shan
Amnok-kang *r.* China/N. Korea *see*
 Yalu Jiang
Amo Jiang *r.* China 76 D4
Amol Iran 88 D2
Amorbach Germany 53 J5
Amorgos *i.* Greece 59 K6
Amory U.S.A. 131 F5
Amos Canada 122 F4
Amoura Alg. 96 C3
Amoy China *see* Xiamen
Ampani India 84 D2
Ampanihy Madag. 99 E6
Amparai Sri Lanka 84 D5
Amparo Brazil 145 B3
Ampasimanolotra Madag. 99 E5
Amper *r.* Germany 53 L6
Amposta Spain 57 G3
Ampthill U.K. 49 G6
Amqui Canada 123 I5
Amraoti India *see* Amravati
Amravati India 84 C1
Amrawad India 82 D5
Amreli India 82 B5

Amri Pak. 89 H5
Amring India 83 H4
'Amrīt Syria 85 B2
Amritsar India 82 C3
Amroha India 82 D3
Amsden U.S.A. 134 D3
Åmsele Sweden 44 K4
Amstelveen Neth. 52 E2

▶Amsterdam Neth. 52 E2
 Official capital of the Netherlands.

Amsterdam S. Africa 101 J4
Amsterdam U.S.A. 135 H2
Amsterdam, Île *i.* Indian Ocean 149 N8
Amstetten Austria 47 O6
Am Timan Chad 97 F3
Amudar'ya r. Asia 89 F2
Amudaryo *r.* Asia *see* Amudar'ya
Amund Ringnes Island Canada 119 I2
Amundsen, Mount Antarctica 152 F2
Amundsen Abyssal Plain *sea feature*
 Southern Ocean 152 J2
Amundsen Basin *sea feature*
 Arctic Ocean 153 H1
Amundsen Bay Antarctica 152 D2
Amundsen Coast Antarctica 152 J1
Amundsen Glacier Antarctica 152 I1
Amundsen Gulf Canada 118 F2
Amundsen Ridges *sea feature*
 Southern Ocean 152 K2
Amundsen-Scott *research station*
 Antarctica 152 D1
Amundsen Sea Antarctica 152 K2
Amuntai Indon. 68 F7
Amur *r.* China 74 D2
 also known as Heilong Jiang (China)
'Amur, Wadi *watercourse* Sudan 86 D6
Amur Oblast *admin. div.* Rus. Fed. *see*
 Amurskaya Oblast'
Amursk Rus. Fed. 74 E2
Amurskaya Oblast' *admin. div.*
 Rus. Fed. 74 C1
Amurskiy Liman *strait* Rus. Fed. 74 F1
Amurzet Rus. Fed. 74 C3
Amvrosiyivka Ukr. 43 H7
Amyderya *r.* Asia *see* Amudar'ya
Am-Zoer Chad 97 F3
An Myanmar 70 A3
Anaa *atoll* Fr. Polynesia 151 K7
Anabanua Indon. 69 G7
Anabar *r.* Rus. Fed. 65 M2
Anacapa Islands U.S.A. 128 D4
Anaco Venez. *see* Anaco
Anaconda U.S.A. 126 E3
Anacortes U.S.A. 126 C2
Anadarko U.S.A. 131 D5
Anadolu Dağları *mts* Turkey 90 E2
Anadyr' Rus. Fed. 65 S3
Anadyr, Gulf of Rus. Fed. *see*
 Anadyrskiy Zaliv
Anadyrskiy Zaliv *b.* Rus. Fed. 65 T3
Anafi *i.* Greece 59 K6
Anáfi Greece 59 K6
Anagé Brazil 145 C1
'Ānah Iraq 91 F4
Anaheim U.S.A. 128 E5
Anahim Lake Canada 120 E4
Anáhuac Mex. 131 C7
Anahuac U.S.A. 131 E6
Anaimalai Hills India 84 C4
Anaiteum *i.* Vanuatu *see* Anatom
Anajás Brazil 143 I4
Anakie Australia 110 D4
Analalava Madag. 99 E5
Anamã Brazil 142 F4
Anambas, Kepulauan *is* Indon. 71 D7
Anamosa U.S.A. 130 F3
Anamur Turkey 85 A1
Anan Japan 75 D6
Anand India 82 C5
Anandapur India 83 F5
Anantapur India 84 C3
Anantnag India 82 C2
Anant Peth India 82 D4
Anantpur India *see* Anantapur
Ananyev Ukr. *see* Anan'yiv
Anan'yiv Ukr. 43 F7
Anapa Rus. Fed. 90 E1
Anápolis Brazil 145 A2
Anār Fin. *see* Inari
Anār Iran 88 D4
Anardara Afgh. 89 F3
Anatahan *i.* N. Mariana Is 69 L3
Anatajan *i.* N. Mariana Is *see* Anatahan
Anatolia *reg.* Turkey 90 D3
Anatom *i.* Vanuatu 107 G4
Añatuya Arg. 144 D3
Anbu China *see* Gülnar
Anbūr-e Kālāri Iran 88 D5
Anbyon N. Korea 75 B5
Ancenis France 56 D3
Ancha Rus. Fed. 72 I2
Anchorage U.S.A. 118 D3
Anchorage Island *atoll* Cook Is *see*
 Suwarrow
Anchor Bay U.S.A. 134 D2
Anchuthengu India *see* Anjengo
Anci China *see* Langfang
An Cóbh Ireland *see* Cobh
Ancona Italy 58 E3
Ancud Chile 144 B6
Ancud, Golfo de *g.* Chile 144 B6
Ancyra Turkey *see* Ankara
Anda Heilong. China *see* Daqing
Anda Heilong. China 74 B3
Andacollo Chile 144 B4
Andado Australia 110 A5
Andahuaylas Peru 142 D6
Andal India 83 F5
Andalgalá Arg. 144 C3
Andalsnes Norway 44 E5
Andalucía *aut. comm.* Spain 57 D5
Andalusia *aut. comm.* Spain *see* Andalucía
Andalusia U.S.A. 133 C6
Andaman Basin *sea feature*
 Indian Ocean 149 O5
Andaman Islands India 71 A4
Andaman Sea Indian Ocean 71 A5
Andaman Strait India 71 A4
Andamooka Australia 111 B6
Andapa Madag. 99 E5
Andaráb *reg.* Afgh. 89 H3
Ande China 76 E4
Andegavum France *see* Angers

Andelle *r.* France 52 B5
Andenes Norway 44 J2
Andenne Belgium 52 E4
Anderlecht Belgium 52 E4
Andermatt Switz. 56 I3
Andernos-les-Bains France 56 D4
Anderson *r.* Canada 118 F3
Anderson AK U.S.A. 118 D3
Anderson IN U.S.A. 134 C3
Anderson SC U.S.A. 133 D5
Anderson TX U.S.A. 131 E6
Anderson Bay Australia 111 [inset]
Anderson Lake Canada 120 F5
Andes *mts* S. America 144 C4
Andes, Lake U.S.A. 130 D3
Andfjorden *sea chan.* Norway 44 J2
Andhíparos *i.* Greece *see* Antiparos
Andhra Lake India 84 B2
Andhra Pradesh *state* India 84 C2
Andijon Uzbek. 80 D3
Andikithira *i.* Greece *see* Antikythira
Andilamena Madag. 99 E5
Andilanatoby Madag. 99 E5
Andímeshk Iran 88 C3
Andimilos *i.* Greece *see* Antimilos
Andípsara *i.* Greece *see* Antipsara
Andırın Turkey 90 E3
Andirlangar China 83 E1
Andizhan Uzbek. *see* Andijon
Andkhvoy Afgh. 89 G2
Andoany Madag. 99 E5
Andoas Peru 142 C4
Andogskaya Gryada *hills* Rus. Fed. 42 H4
Andol India 84 C2
Andong China *see* Dandong
Andong S. Korea 75 C5
Andongwei China 77 H1
Andoom Australia 110 C2

▶Andorra *country* Europe 57 G2
 Europe 5, 38–39

▶Andorra la Vella Andorra 57 G2
 Capital of Andorra.

Andorra la Vieja Andorra *see*
 Andorra la Vella
Andover U.K. 49 F7
Andover NY U.S.A. 135 G2
Andover OH U.S.A. 134 E3
Andøya *i.* Norway 44 I2
Andrade U.S.A. 129 F5
Andradina Brazil 145 A3
Andranomavo Madag. 99 E5
Andranopasy Madag. 99 E6
Andreanof Islands U.S.A. 150 I2
Andreapol' Rus. Fed. 42 G4
Andreas Isle of Man 48 C4
André Félix, Parc National de *nat. park*
 Cent. Afr. Rep. 98 C3
Andrelândia Brazil 145 B3
Andrew Canada 121 H4
Andrews SC U.S.A. 133 E5
Andrews TX U.S.A. 131 C5
Andreyevka Kazakh. 80 D2
Andria Italy 58 G4
Androka Madag. 99 E6
Andropov Rus. Fed. *see* Rybinsk
Andros *i.* Bahamas 133 E7
Andros *i.* Greece 59 K6
Androscoggin *r.* U.S.A. 135 K2
Andros Town Bahamas 133 E7
Androth *i.* India 84 B4
Andselv Norway 44 K2
Andújar Spain 57 D4
Andulo Angola 99 B5
Anec, Lake *salt flat* Australia 109 E5
Åneby Sweden 45 I8
Anegada, Bahía *b.* Arg. 144 D6
Anegada Passage Virgin Is (U.K.) 137 L5
Aného Togo 96 D4
Aneityum *i.* Vanuatu *see* Anatom
Aneityum *i.* Vanuatu *see* Anatom
Anemourion *tourist site* Turkey 85 A1
Anepmete P.N.G. 69 L8
Anet France 52 B6
Anetchom, Île *i.* Vanuatu *see* Anatom
Aneto *mt.* Spain 57 G2
'Aneiza, Jabal *hill* Iraq *see* 'Unayzah, Jabal
Anewetak *atoll* Marshall Is *see* Enewetak
Aney Niger 96 E3
Aneytioum, Île *i.* Vanuatu *see* Anatom
Anfu China 77 G3
Angalarri *r.* Australia 108 E3
Angamos, Punta *pt* Chile 144 B2
Ang'angxi China 74 A3
Angara *r.* Rus. Fed. 72 G1
 *Part of the Yenisey-Angara-Selenga,
 3rd longest river in Asia.*

Angarsk Rus. Fed. 72 I2
Angas Downs Australia 109 F6
Angatuba Brazil 145 A3
Angaur *i.* Palau 69 I5
Ånge Sweden 44 I5
Angel, Salto *waterfall* Venez. *see* Angel Falls
Ángel de la Guarda, Isla *i.* Mex. 127 E7

▶Angel Falls *waterfall* Venez. 142 F2
 Highest waterfall in the world.

Ängelholm Sweden 45 H8
Angellala Creek *r.* Australia 112 C1
Angels Camp U.S.A. 128 C2
Ångermanälven *r.* Sweden 44 J5
Angers France 56 D3
Angikuni Lake Canada 121 L2
Angiola U.S.A. 128 D4
Angkor *tourist site* Cambodia 71 C4
Anglesea Australia 112 B7
Anglesey *i.* U.K. 48 C5
Angleton U.S.A. 131 E6
Anglo-Egyptian Sudan *country* Africa *see*
 Sudan
Angmagssalik Greenland *see* Ammassalik
Ang Mo Kio Sing. 71 [inset]
Ango Dem. Rep. Congo 98 C3
Angoche Moz. 99 E5
Angohrān Iran 88 E5
Angol Chile 144 B5

▶Angola *country* Africa 99 B5
 Africa 7, 94–95

Angola IN U.S.A. 134 C3
Angola NY U.S.A. 134 F2
Angola Basin *sea feature*
 S. Atlantic Ocean 148 H7
Angora Turkey *see* Ankara
Angostura Mex. 127 F8
Angoulême France 56 E4
Angra dos Reis Brazil 145 B3
Angren Uzbek. 80 D3
Ang Thong Thai. 71 C4
Anguang China 74 A3

▶Anguilla *terr.* West Indies 137 L5
 *United Kingdom Overseas Territory.
 North America 9, 116–117

Anguilla Cays *is* Bahamas 133 E8
Anguille, Cape Canada 123 K5
Angul India 84 E1
Angus Canada 134 F1
Angutia Char *i.* Bangl. 83 G5
Anholt *i.* Denmark 45 G8
Anhua China 77 F2
Anhui *prov.* China 77 H1
Anhumas Brazil 143 H7
Anhwei *prov.* China *see* Anhui
Aniak U.S.A. 118 C3
Aniakchak National Monument and
 Preserve *nat. park* U.S.A. 118 C4
Anin Myanmar 70 B4
Anitápolis Brazil 145 A4
Antlı Turkey 85 A1
Aniva Rus. Fed. 74 F3
Aniva, Mys *c.* Rus. Fed. 74 F3
Aniva, Zaliv *b.* Rus. Fed. 74 F3
Anizy-le-Château France 52 D5
Anjadip *i.* India 84 B3
Anjalankoski Fin. 45 O6
Anjangaon India 84 C1
Anjar India 82 B5
Anjengo India *see* Anjengo
Anji China 77 H2
Anjir Avand Iran 88 D3
Anjoman Iran 88 E3
Anjou *reg.* France 56 D3
Anjouan *i.* Comoros *see* Nzwani
Anjozorobe Madag. 99 E5
Anjuman *reg.* Afgh. 89 H3
Anjuthengu India *see* Anjengo
Ankang China 77 F1

▶Ankara Turkey 90 D3
 Capital of Turkey.

Ankaratra *mt.* Madag. 99 E5
Ankazoabo Madag. 99 E6
Ankeny U.S.A. 130 E3
An Khê Vietnam 71 E4
Ankleshwar India 82 C5
Ankola India 84 B3
Ankouzhen China 76 E1
An Lôc Vietnam 71 D5
Anlong China 76 E3
Anlu China 77 G2
Anmoore U.S.A. 134 E4
An Muileann gCearr Ireland *see* Mullingar
Anmyŏn-do *i.* S. Korea 75 B5
Ann, Cape Antarctica 152 D2
Ann, Cape U.S.A. 135 J2
Anna Rus. Fed. 43 I6
Anna, Lake U.S.A. 135 G4
Annaba Alg. 58 B6
Annaberg-Buchholtz Germany 53 N4
An Nabk Saudi Arabia 85 C4
An Nabk Syria 85 C2
An Nafūd *des.* Saudi Arabia 91 F5
An Najaf Iraq 91 G5
Annalee *r.* Ireland 51 E3
Annalong U.K. 51 G3
Annam *reg.* Vietnam 68 D3
Annam Highlands *mts* Laos/Vietnam
 70 D3
Annan *r.* U.K. 50 F6
Annan U.K. 50 F6
'Annān, Wādī al *watercourse* Syria 85 D2
Annandale Australia 110 C4
Anna Plains Australia 108 C4

▶Annapolis U.S.A. 135 G4
 State capital of Maryland.

Annapurna Conservation Area *nature res.*
 Nepal 83 F3
Annapurna I *mt.* Nepal 83 E3
Ann Arbor U.S.A. 134 D2
Anna Regina Guyana 143 G2
An Nás Ireland *see* Naas
An Nāşirīyah Iraq 91 G5
An Naşrānī, Jabal *mts* Syria 85 C3
Annean, Lake *salt flat* Australia 109 B6
Anne Arundel Town U.S.A. *see* Annapolis
Annecy France 56 H4
Anne Marie Lake Canada 123 J3
Annen Neth. 52 G1
Annette Island U.S.A. 120 D4
An Nimārah Syria 85 C3
An Nimāş Saudi Arabia 86 F6
Anning China 76 D3
Anniston U.S.A. 133 C5
Annobón *i.* Equat. Guinea 96 D5
Annonay France 56 G4
An Nu'mānīyah Iraq 91 G4
An Nuşayrīyah, Jabal *mts* Syria 85 C2
Anonima atoll Micronesia *see* Namonuito
Anónon de Sardinas, Bahía de *b.*
 Col. 142 C3
Anorontany, Tanjona *hd* Madag. 99 E5
Ano Viannos Kriti Greece *see* Viannos
Anpu Gang *b.* China 77 F4
Anqing China 77 H2
Anren China 77 G3
Ans Belgium 52 F4
Ansbach Germany 53 K5
Anser Group *is* Australia 112 C7
Anshan China 74 A4
Anshun China 76 E3
Anshunchang China 76 D2
An Sirhān, Wādī *watercourse*
 Saudi Arabia 90 E5
Ansley U.S.A. 130 D3
Anson U.S.A. 131 D5

Anson Bay Australia 108 E3
Ansongo Mali 96 D3
Ansonville Canada 122 E4
Ansted U.S.A. 134 E4
Ansudu Indon. 69 J7
Antabamba Peru 142 D6
Antakya Turkey 85 C1
Antalaha Madag. 99 F5
Antalya Turkey 59 N6
Antalya prov. Turkey 85 A1
Antalya Körfezi g. Turkey 59 N6

▶Antananarivo Madag. 99 E5
Capital of Madagascar.

An tAonach Ireland see Nenagh

▶Antarctica 152
Most southerly and coldest continent, and the continent with the highest average elevation.
Poles 146–147

Antarctic Peninsula Antarctica 152 L2
Antas r. Brazil 145 A5
An Teallach mt. U.K. 50 D3
Antelope Island U.S.A. 129 G4
Antelope Range mts U.S.A. 128 E2
Antequera Spain 57 D5
Anthony Lagoon Australia 110 A3
Anti Atlas mts Morocco 54 C6
Antibes France 56 H5
Anticosti, Île d' i. Canada 123 J4
Anticosti Island Canada see Anticosti, Île d'
Antifer, Cap d' c. France 49 H9
Antigo U.S.A. 130 F2
Antigonish Canada 123 J5
Antigua i. Antigua and Barbuda 137 L5
Antigua country West Indies see Antigua and Barbuda
▶Antigua and Barbuda country
West Indies 137 L5
North America 9, 116–117
Antikythira i. Greece 59 J7
Antikythiro, Steno sea chan. Greece 59 J7
Anti Lebanon mts Lebanon/Syria see Sharqī, Jabal ash
Antimilos i. Greece 59 K6
Antimony U.S.A. 129 H2
An tInbhear Mór Ireland see Arklow
Antioch Turkey see Antakya
Antioch U.S.A. 128 C2
Antiocheia ad Cragum tourist site Turkey 85 A1
Antiochia Turkey see Antakya
Antiparos i. Greece 59 K5
Antipodes Islands N.Z. 107 H6
Antipsara i. Greece 59 K5
Antium Italy see Anzio
Antlers U.S.A. 131 E5
Antofagasta Chile 144 B2
Antofagasta de la Sierra Arg. 144 C3
Antofalla, Volcán vol. Arg. 144 C3
Antoing Belgium 52 D4
António Enes Moz. see Angoche
Antri India 82 D4
Antrim U.K. 51 F3
Antrim Hills U.K. 51 F2
Antrim Plateau Australia 108 E4
Antropovo Rus. Fed. 42 I4
Antsalova Madag. 99 E5
Antseranana Madag. see Antsirañana
Antsirabe Madag. 99 E5
Antsirañana Madag. 99 E5
Antsla Estonia 45 O8
Antsohihy Madag. 99 E5
Anttis Sweden 44 M3
Anttola Fin. 45 O6
An Tuc Vietnam see An Khê
Antwerp Belgium 52 E3
Antwerp U.S.A. 135 H1
Antwerpen Belgium see Antwerp
An Uaimh Ireland see Navan
Anuc, Lac l. Canada 122 G2
Anuchino Rus. Fed. 74 D4
Anugul India see Angul
Anupgarh India 82 C3
Anuradhapura Sri Lanka 84 D4
Anvers Island Antarctica 152 L2
Anvik U.S.A. 118 B3
Anvil Range mts Canada 120 C2
Anxi Fujian China 77 H3
Anxi Gansu China 80 I3
Anxiang China 77 G2
Anxious Bay Australia 109 F8
Anyang Guangxi China see Du'an
Anyang Henan China 73 K5
Anyang S. Korea 75 B5
'nyêmaqên Shan mts China 76 C1
Anyuan Jiangxi China 77 G3
Anyuan Jiangxi China 77 G3
Anyue China 76 E2
Anyuy r. Rus. Fed. 74 E2
Anyuysk Rus. Fed. 65 R3
Anzac Alta Canada 121 I3
Anzac B.C. Canada 120 F4
Anzhero-Sudzhensk Rus. Fed. 64 J4
Anzi Dem. Rep. Congo 98 C4
Anzio Italy 58 E4
Aoba i. Vanuatu 107 G3
Aoga-shima i. Japan 75 E6
Aokal Afgh. 89 F3
Ao Kham, Laem pt Thai. 71 B5
Aomen China see Macao
Aomori Japan 74 F4
Ao Phang Nga National Park Thai. 71 B5

▶Aoraki mt. N.Z. 113 C6
Highest mountain in New Zealand.

Aoraki/Mount Cook National Park N.Z. 113 C6
Aôral, Phnum mt. Cambodia 71 D4
Aorangi mt. N.Z. see Aoraki
Aorangi mt. N.Z. see Aoraki
Aosta Italy 58 B2
Aotearoa country Oceania see New Zealand
Aouk, Bahr r. Cent. Afr. Rep./Chad 97 E4
Aoukâr reg. Mali/Mauritania 96 C2

Aoulef Alg. 96 D2
Aozou Chad 97 E2
Apa r. Brazil 144 E2
Apache Creek U.S.A. 129 I5
Apache Junction U.S.A. 129 H5
Apaiang atoll Kiribati see Abaiang
Apalachee Bay U.S.A. 133 C6
Apalachicola U.S.A. 133 C6
Apalachicola r. U.S.A. 133 C6
Apalachin U.S.A. 135 G2
Apamea Turkey see Dinar
Apaporis r. Col. 142 E4
Aparecida do Tabuado Brazil 145 A3
Aparima N.Z. see Riverton
Aparri Phil. 150 E4
Apatity Rus. Fed. 44 R3
Apatzingán Mex. 136 D5
Ape Latvia 45 O8
Apeldoorn Neth. 52 F2
Apelern Germany 53 J2
Apennines mts Italy 58 C2
Apensen Germany 53 J1
Apex Mountain Canada 120 B2
Api mt. Nepal 82 E3
Api i. Vanuatu see Épi
Apia atoll Kiribati see Abaiang

▶Apia Samoa 107 I3
Capital of Samoa.

Apiacas, Serra dos hills Brazil 143 G6
Apiaí Brazil 145 A4
Apishapa r. U.S.A. 130 C4
Apiti N.Z. 113 E4
Apizolaya Mex. 131 C7
Aplao Peru 142 D7
Apo, Mount vol. Phil. 69 H5
Apoera Suriname 143 G2
Apolda Germany 53 L3
Apollo Bay Australia 112 A7
Apollonia Bulg. see Sozopol
Apolo Bol. 142 E6
Aporé Brazil 145 A2
Aporé r. Brazil 145 A2
Apostle Islands U.S.A. 130 F2
Apostolens Tommelfinger mt. Greenland 119 N3
Apostolos Andreas, Cape Cyprus 85 B2
Apoteri Guyana 143 G3
Apozai Pak. 89 H4
Appalachian Mountains U.S.A. 134 D5
Appalla i. Fiji see Kabara
Appennino mts Italy see Apennines
Appennino Abruzzese mts Italy 58 E3
Appennino Tosco-Emiliano mts Italy 58 D3
Appennino Umbro-Marchigiano mts Italy 58 E3
Appingedam Neth. 52 G1
Applecross U.K. 50 D3
Appleton MN U.S.A. 130 D2
Appleton WI U.S.A. 134 A1
Apple Valley U.S.A. 128 E4
Appomattox U.S.A. 135 F5
Aprilia Italy 58 E4
Aprunyi India 76 B2
Apsheronsk Rus. Fed. 91 E1
Apsheronskaya Rus. Fed. see Apsheronsk
Apsley Canada 135 F1
Apt France 56 G5
Apucarana Brazil 145 A3
Apucarana, Serra da hills Brazil 145 A3
Apulum Romania see Alba Iulia
Aq"a Georgia see Sokhumi
'Aqaba Jordan see Al 'Aqabah
Aqaba, Gulf of Asia 90 D5
'Aqaba, Wādī el watercourse Egypt see 'Aqabah, Wādī al
'Aqabah, Birkat al well Iraq 88 A4
'Aqabah, Wādī al watercourse Egypt 85 A4
Aqadyr Kazakh. see Agadyr'
Aqdoghmish r. Iran 88 B2
Aqköl Akmolinskaya Oblast' Kazakh. see Akkol'
Aqköl Atyrauskaya Oblast' Kazakh. see Akkol'
Aqmola Kazakh. see Astana
Aqqan China 83 F1
Aqqikkol Hu salt l. China 83 G1
Aqra', Jabal an mt. Syria/Turkey 85 B2
'Aqran hill Saudi Arabia 85 D4
Aqsay Kazakh. see Aksay
Aqsayqin Hit terr. Asia see Aksai Chin
Aqshī Kazakh. see Akshiy
Aqshuqyr Kazakh. see Akshukur
Aqsū Kazakh. see Aksu
Aqsüat Kazakh. see Aksuat
Aqsū-Ayuly Kazakh. see Aksu-Ayuly
Aqtaū Kazakh. see Aktau
Aqtöbe Kazakh. see Aktobe
Aqtoghay Kazakh. see Aktogay
Aquae Grani Germany see Aachen
Aquae Gratianae France see Aix-les-Bains
Aquae Sextiae France see Aix-en-Provence
Aquae Statiellae Italy see Acqui Terme
Aquarius Mountains U.S.A. 129 G4
Aquarius Plateau U.S.A. 129 H3
Aquaviva delle Fonti Italy 58 G4
Aquidauana Brazil 144 E2
Aquiles Mex. 127 G7
Aquincum Hungary see Budapest
Aquiry r. Brazil see Acre
Aquisgranum Germany see Aachen
Aquitaine reg. France 56 D5
Aquitania reg. France see Aquitaine
Aqzhayqyn Köli salt l. Kazakh. see Akzhaykyn, Ozero
Ara India 83 F4
Āra Ārba Eth. 98 E3
Arab Afgh. 89 G4
Arab, Bahr el watercourse Sudan 97 F4
'Arab, Khalīj el b. Egypt see 'Arab, Khalīj al
'Arab, Khalīj al b. Egypt 90 C5
'Arabah, Wādī al watercourse Israel/Jordan 85 B5
Arabian Basin sea feature Indian Ocean 149 M5
Arabian Gulf Asia see The Gulf
Arabian Peninsula Asia 86 G5
Arabian Sea Indian Ocean 87 K6
Araç Turkey 90 D2
Araça r. Brazil 142 F4
Aracaju Brazil 143 K6

Aracati Brazil 143 K4
Aracatu Brazil 145 C1
Araçatuba Brazil 145 A3
Aracena Spain 57 C5
Aracruz Brazil 145 C2
Araçuaí Brazil 145 C2
Araçuaí r. Brazil 145 C2
'Arad Israel 85 B4
Arad Romania 59 I1
'Arādah U.A.E. 88 D6
Arafura Sea Australia/Indon. 106 D2
Arafura Shelf sea feature Australia/Indon. 150 E6
Aragarças Brazil 143 H7
Aragón r. Spain 57 F2
Araguaçu Brazil 145 A1
Araguaia r. Brazil 145 A1
Araguaia, Parque Nacional de nat. park Brazil 143 H6
Araguaiana Brazil 145 A1
Araguaína Brazil 143 I5
Araguari Brazil 145 A2
Araguari r. Brazil 143 I3
Araguatins Brazil 143 I5
Arai Brazil 145 B1
'Arāif el Naga, Gebel hill Egypt see 'Urayf an Nāqah, Jabal
Araiosos Brazil 143 J4
Arak Alg. 96 D2
Arāk Iran 88 C3
Arak Syria 85 D2
Arakan reg. Myanmar 70 A2
Arakan Yoma mts Myanmar 70 A2
Arakkonam India 84 C3
Araks r. Armenia see Araz
Araku India 84 D2
Aral Kazakh. see Aral'sk
Aral Tajik. see Vose

▶Aral Sea salt l. Kazakh./Uzbek. 80 B2
4th largest lake in Asia.

Aral'sk Kazakh. 80 B2
Aral'skoye More salt l. Kazakh./Uzbek. see Aral Sea
Aralsor, Ozero l. Kazakh. 43 K6
Aral Tengizi salt l. Kazakh./Uzbek. see Aral Sea
Aramac Australia 110 D4
Aramac Creek watercourse Australia 110 D4
Aramah plat. Saudi Arabia 88 B5
Aramberri Mex. 131 D7
Aramia r. P.N.G. 69 K8
Aran r. India 84 C2
Aranda de Duero Spain 57 E3
Arandai Indon. 69 I7
Arandelovac Serb. and Mont. 59 I2
Arandis Namibia 100 B2
Arang India 83 E5
Arani India 84 C3
Aran Island Ireland 51 D3
Aran Islands Ireland 51 C4
Aranjuez Spain 57 E3
Aranos Namibia 100 D3
Aransas Pass U.S.A. 131 D7
Arantangi India 84 C4
Aranuka atoll Kiribati 107 H1
Aranyaprathet Thai. 71 C4
Arao Japan 75 C6
Araouane Mali 96 C3
Arapaho U.S.A. 131 D5
Arapgir Turkey 90 E3
Arapiraca Brazil 143 K5
Arapis, Akra pt Greece see Arapis, Akrotirio
Arapis, Akrotirio pt Greece 59 K4
Arapkir Turkey see Arapgir
Arapongas Brazil 145 A3
Araquari Brazil 145 A4
'Ar'ar Saudi Arabia 91 F5
Araracuara Col. 142 D4
Araranguá Brazil 145 A5
Araraquara Brazil 145 A3
Araras Brazil 143 H5
Ararat Armenia 91 G3
Ararat Australia 112 A6
Ararat, Mount Turkey 91 G3
Araria India 83 F4
Araripina Brazil 143 J5
Aras Turkey 91 F3
Aras r. Turkey see Araz
Arataca Brazil 145 D1
Arauca Col. 142 D2
Arauca r. Venez. 142 E2
Aravalli Range mts India 82 C4
Aravete Estonia 45 N7
Arawa P.N.G. 106 F2
Araxá Brazil 145 B2
Araxes r. Asia see Araz
Arayıt Dağı mt. Turkey 59 N5
Araz r. Azer. 91 H2
also spelt Araks (Armenia), Aras (Turkey), formerly known as Araxes.
Arbailu Iraq see Arbīl
Arbat Iraq 91 G4
Arbela Iraq see Arbīl
Arberth U.K. see Narberth
Arbīl Iraq 91 G3
Arboga Sweden 45 I7
Arborfield Canada 121 K4
Arborg Canada 121 L5
Arbroath U.K. 50 G4
Arbuckle U.S.A. 128 B2
Arbu Lut, Dasht-e des. Afgh. 89 F4
Arcachon France 56 D4
Arcade U.S.A. 135 F2
Arcadia FL U.S.A. 133 D7
Arcadia LA U.S.A. 131 E5
Arcadia MI U.S.A. 134 B1
Arcanum U.S.A. 134 C4
Arcata U.S.A. 126 B4
Arc Dome mt. U.S.A. 128 E2
Arcelia Mex. 136 D5
Archangel Rus. Fed. 42 I2
Archer r. Australia 67 G9
Archer Bend National Park Australia 110 C2
Archer City U.S.A. 131 D5
Arches National Park U.S.A. 129 I2
Archipiélago Los Roques nat. park Venez. 142 E1
Árçivan Azer. 91 H3
Arckaringa watercourse Australia 111 A6

Arco U.S.A. 126 E4
Arcos Brazil 145 B3
Arcos de la Frontera Spain 57 D5
Arctic Bay Canada 119 J2
Arctic Institute Islands Rus. Fed. see Arkticheskogo Instituta, Ostrova
Arctic Mid-Ocean Ridge sea feature Arctic Ocean 153 H1
▶Arctic Ocean 153 B1
Poles 146–147
Arctic Red r. Canada 118 E3
Arctowski research station Antarctica 152 A2
Arda r. Bulg. 59 L4
also known as Ardas (Greece)
Ardabīl Iran 88 C2
Ardahan Turkey 91 F2
Ardakān Iran 88 D3
Årdalstangen Norway 45 E6
Ardara Ireland 51 D3
Ardas r. Bulg. see Arda
Ard aş Şawwān plain Jordan 85 C4
Ardatov Nizhegorodskaya Oblast' Rus. Fed. 43 I5
Ardatov Respublika Mordoviya Rus. Fed. 43 J5
Ardee Ireland 51 F4
Ardennes plat. Belgium 52 E5
Ardennes, Canal des France 52 E5
Arden Town U.S.A. 128 C2
Arderin hill Ireland 51 E4
Ardestān Iran 88 D3
Ardglass U.K. 51 G3
Ardila r. Port. 57 C4
Ardlethan Australia 112 C5
Ardmore U.S.A. 131 D5
Ardnamurchan, Point of U.K. 50 C4
Ardon Rus. Fed. 91 G2
Ardrishaig U.K. 50 D4
Ardrossan U.K. 50 E5
Ardvasar U.K. 50 D3
Areia Branca Brazil 143 K4
Arel Belgium see Arlon
Arelas France see Arles
Arelate France see Arles
Aremberg hill Germany 52 G4
Arena, Point U.S.A. 128 B2
Arenas de San Pedro Spain 57 D3
Arendal Norway 45 F7
Arendsee (Altmark) Germany 53 L2
Areopoli Greece 59 J6
Arequipa Peru 142 D7
Arere Brazil 143 H4
Arévalo Spain 57 D3
Arezzo Italy 58 D3
'Arfajah well Saudi Arabia 85 D4
Argadargada Australia 110 B4
Arganda del Rey Spain 57 E3
Argel Alg. see Algiers
Argentan France 56 D2
Argentario, Monte hill Italy 58 D3
Argentera, Cima dell' mt. Italy 58 B2
Argenthal Germany 53 H5
▶Argentina country S. America 144 C5
2nd largest country in South America. 3rd most populous country in South America.
South America 9, 140–141
Argentine Abyssal Plain sea feature S. Atlantic Ocean 148 E9
Argentine Basin sea feature S. Atlantic Ocean 148 E8
Argentine Republic country S. America see Argentina
Argentine Rise sea feature S. Atlantic Ocean 148 E8
Argentino, Lago l. Arg. 144 B8
Argenton-sur-Creuse France 56 E3
Argentoratum France see Strasbourg
Argeş r. Romania 59 L2
Arghandab r. Afgh. 89 G4
Argi r. Rus. Fed. 74 C1
Argolikos Kolpos b. Greece 59 J6
Argos Greece 59 J6
Argos U.S.A. 134 B3
Argostoli Greece 59 I5
Arguís Spain 57 F2
Argun' r. China/Rus. Fed. 73 M2
Argun r. Rus. Fed. 91 G2
Argungu Nigeria 96 D3
Argyle Canada 123 I6
Argyle, Lake Australia 108 E4
Argyrokastron Albania see Gjirokastër
Ar Horqin Qi China see Tianshan
Århus Denmark 45 G8
Ariah Park Australia 112 C5
Ariamsvlei Namibia 100 D5
Ariana Tunisia see L'Ariana
Ariano Irpino Italy 58 F4
Ari Atoll Maldives 81 D11
Aribinda Burkina 96 C3
Arica Chile 142 D7
Arid, Cape Australia 109 C8
Arigza China 76 C1
Ariḩā Syria 85 C2
Ariḩā West Bank see Jericho
Arikaree r. U.S.A. 130 C3
Arima Trin. and Tob. 137 L6
Ariminum Italy see Rimini
Arinos Brazil 145 B1
Aripuanã Brazil 143 G6
Aripuanã r. Brazil 142 F5
Ariquemes Brazil 142 F5
Aris Namibia 100 C2
Arisaig U.K. 50 D4
Arisaig, Sound of sea chan. U.K. 50 D4
'Arīsh, Wādī al watercourse Egypt 85 A4
Aristazabal Island Canada 120 D4
Arixang China see Wenquan
Ariyalur India 84 C4
Arizaro, Salar de salt flat Arg. 144 C2
Arizona Arg. 144 C5
Arizona state U.S.A. 127 F6
Arizpe Mex. 127 F7
'Arjah Saudi Arabia 86 F5
Arjasa Indon. 68 F8
Arjeplog Sweden 44 J3
Arjuni Chhattisgarh India 84 D1
Arjuni India 82 E5
Arkadak Rus. Fed. 43 I6
Arkadelphia U.S.A. 131 E5

Arkaig, Loch l. U.K. 50 D4
Arkalyk Kazakh. 80 C1
Arkansas r. U.S.A. 131 F5
Arkansas state U.S.A. 131 E5
Arkansas City AR U.S.A. 131 F5
Arkansas City KS U.S.A. 131 D4
Arkatag Shan mts China 83 G1
Arkell, Mount Canada 120 C2
Arkenu, Jabal mt. Libya 86 B5
Arkhangel'sk Rus. Fed. see Archangel
Arkhara Rus. Fed. 74 C2
Arkhipovka Rus. Fed. 74 D4
Árki i. Greece see Arkoi
Arklow Ireland 51 F5
Arkoi i. Greece 59 L6
Arkona Canada 134 E2
Arkona, Kap c. Germany 47 N3
Arkonam India see Arakkonam
Arkport U.S.A. 135 G2
Arkticheskogo Instituta, Ostrova is Rus. Fed. 64 J2
Arkul' Rus. Fed. 42 K4
Arlandag mt. Turkm. 88 D2
Arles France 56 G5
Arlington S. Africa 101 H5
Arlington NY U.S.A. 135 I3
Arlington OH U.S.A. 134 D3
Arlington SD U.S.A. 130 D2
Arlington VA U.S.A. 135 G4
Arlington Heights U.S.A. 134 A2
Arlit Niger 96 D3
Arlon Belgium 52 F5
Arm r. Canada 121 J5
Armadale Australia 109 A8
Armagh U.K. 51 F3
Armant Egypt 86 D4
Armavir Armenia 91 G2
Armavir Rus. Fed. 91 F1
▶Armenia country Asia 91 G2
Asia 6, 62–63
Armenia Col. 142 C3
Armenopolis Romania see Gherla
Armeria Mex. 136 D5
Armidale Australia 112 E3
Armington U.S.A. 126 F3
Armit Lake Canada 121 N1
Armori India 84 D1
Armour U.S.A. 130 D3
Armoy U.K. 51 F2
Armstrong r. Australia 108 E4
Armstrong Canada 122 C4
Armstrong, Mount Canada 120 C2
Armstrong Island Cook Is see Rarotonga
Armu r. Rus. Fed. 74 E3
Armur India 84 C2
Armutçu Dağı mts Turkey 59 L5
Armyanskaya S.S.R. country Asia see Armenia
Arnaoutis, Cape Cyprus see Arnauti, Cape
Arnaud r. Canada 123 H2
Arnauti, Cape Cyprus 85 A2
Årnes Norway 45 G6
Arnett U.S.A. 131 D4
Arnhem Neth. 52 F3
Arnhem, Cape Australia 110 B2
Arnhem Bay Australia 111 B7
Arnhem Land reg. Australia 108 F3
Arno r. Italy 58 D3
Arno Bay Australia 111 B7
Arnold U.K. 49 F5
Arnold's Cove Canada 123 L5
Arnon r. Jordan see Mawjib, Wādī al
Arnprior Canada 135 G1
Arnsberg Germany 53 I3
Arnstadt Germany 53 K4
Arnstein Germany 53 J5
Arnstorf Germany 53 M6
Aroab Namibia 100 D4
Aroland Canada 122 D4
Arolsen Germany 53 J3
Aroma Sudan 86 E6
Arona Italy 58 C2
Arorae i. Kiribati 107 H2
Arore i. Kiribati see Arorae
Aros r. Mex. 127 F7
Arossi i. Solomon Is see San Cristobal
Arqalyq Kazakh. see Arkalyk
Arquipélago da Madeira aut. reg. Port. 96 B1
Arrah India see Ara
Arraias Brazil 145 B1
Arraias, Serra de hills Brazil 145 B1
Ar Ramādī Iraq 91 F4
Ar Ramlah Jordan 85 B5
Ar Ramthā Jordan 85 C3
Arran i. U.K. 50 D5
Ar Raqqah Syria 85 D2
Arras France 52 C4
Ar Rass Saudi Arabia 86 F4
Ar Rastān Syria 85 C2
Ar Rayyān Qatar 88 C5
Arrecife Canary Is 96 B2
Arretium Italy see Arezzo
Arriagá Mex. 136 F5
Ar Rifā'ī Iraq 91 G5
Ar Rihāb salt flat Iraq 91 G5
Ar Rimāl reg. Saudi Arabia 98 F1
Ar Riyāḍ Saudi Arabia see Riyadh
Arrochar U.K. 50 E4
Arrojado r. Brazil 145 B1
Arrow, Lough l. Ireland 51 D3
Arrowsmith, Mount N.Z. 113 C6
Arroyo Grande U.S.A. 128 C4
Ar Rubay'iyah Saudi Arabia 88 B5
Ar Rummān Jordan 85 B3
Ar Ruq'ī well Saudi Arabia 88 B4
Ar Ruşāfah Syria 85 D2
Ar Ruşayfah Jordan 85 C3
Ar Rustāq Oman 88 E6
Ar Ruţbah Iraq 91 F4
Ar Ruwaydah Saudi Arabia 88 B5
Ar Ruwaydah Saudi Arabia 88 B6
Ar Ruwayḍah Syria 85 C2

Artemivs'k Ukr. 43 H6
Artemovsk Ukr. see Artemivs'k
Artenay France 56 E2
Artesia AZ U.S.A. 129 I5
Artesia NM U.S.A. 127 G6
Arthur Canada 134 E2
Arthur NE U.S.A. 130 C3
Arthur TN U.S.A. 134 D5
Arthur, Lake U.S.A. 134 E3
Arthur's Pass National Park N.Z. 113 C6
Arti Rus. Fed. 41 R4
Artigas research station Antarctica 152 A2
Artigas Uruguay 144 E4
Art'ik Armenia 91 F2
Artillery Lake Canada 121 I2
Artisia Botswana 101 H3
Artois reg. France 52 B4
Artois, Collines d' hills France 52 B4
Artos Dağı mt. Turkey 91 F3
Artova Turkey 90 E2
Artsakh aut. reg. Azer. see Dağlıq Qarabağ
Artsiz Ukr. see Artsyz
Artsyz Ukr. 59 M2
Artur de Paiva Angola see Kuvango
Artux China 80 E4
Artvin Turkey 91 F2
Artyk Turkm. 88 E2
Aru, Kepulauan is Indon. 108 F1
Arua Uganda 98 D3
Aruanã Brazil 145 A1

▶Aruba terr. West Indies 137 K6
Self-governing Netherlands Territory.
North America 9, 116–117

Arumã Brazil 142 F4
Arunachal Pradesh state India 83 H4
Arundel U.K. 49 G8
Arun Gol r. China 74 B3
Arun He r. China see Arun Gol
Arun Qi China see Naji
Aruppukkottai India 84 C4
Arusha Tanz. 98 D4
Aruwimi r. Dem. Rep. Congo 98 C3
Arvada U.S.A. 126 G5
Arvagh Ireland 51 E4
Arvayheer Mongolia 80 J2
Arviat Canada 121 M2
Arvidsjaur Sweden 44 K4
Arvika Sweden 45 H7
Arvonia U.S.A. 135 F5
Arwā' Saudi Arabia 88 B6
Arwād i. Syria 85 B2
Arwala Indon. 108 D1
Arxan China 73 L3
Aryanah Tunisia see L'Ariana
Arys' Kazakh. 80 C3
Arzamas Rus. Fed. 43 I5
Arzanah i. U.A.E. 88 D5
Arzberg Germany 53 M4
Arzew Alg. 57 F6
Arzgir Rus. Fed. 91 G1
Arzila Morocco see Asilah
Aš Czech Rep. 53 M4
Asaba Nigeria 96 D4
Asad, Buḩayrat al resr Syria 85 D1
Asadābād Afgh. 89 H3
Asadābād Iran 88 C3
Asahi-dake vol. Japan 74 F4
Asahikawa Japan 74 F4
'Asal Egypt 85 A5
Āsalē l. Eth. 98 E2
Asālem Iran 88 C2
'Asalūyeh Iran 88 D5
Asan-man b. S. Korea 75 B5
Asansol India 83 F5
Āsayita Eth. 98 E2
Asbach Germany 53 H4
Asbestos Canada 123 H4
Asbestos Mountains S. Africa 100 F5
Asbury Park U.S.A. 135 H3
Ascalon Israel see Ashqelon
Ascea Italy 58 F4
Ascensión Bol. 142 F7
Ascensión Mex. 127 G7
Ascension atoll Micronesia see Pohnpei

▶Ascension i. S. Atlantic Ocean 148 H6
Dependency of St Helena.

Aschaffenburg Germany 53 J5
Ascheberg Germany 53 H3
Aschersleben Germany 53 L3
Ascoli Piceno Italy 58 E3
Asculum Italy see Ascoli Piceno
Asculum Picenum Italy see Ascoli Piceno
Ascutney U.S.A. 135 I2
Āseb Eritrea see Assab
Āseda Sweden 45 I8
Åsele Sweden 44 J4
Asenovgrad Bulg. 59 K3
Aşfar, Jabal al mt. Jordan 85 C3
Aşfar, Tall al hill Syria 85 C3

▶Aşgabat Turkm. 88 D2
Capital of Turkmenistan.

Aşgabat Turkm. see Aşgabat
Asha Rus. Fed. 41 R5
Ashburn U.S.A. 133 D6
Ashburton watercourse Australia 108 A5
Ashburton N.Z. 113 C6
Ashburton Range hills Australia 108 F4
Ashdod Israel 85 B4
Ashdown U.S.A. 131 E5
Asheboro U.S.A. 132 E5
Asher U.S.A. 131 D5
Ashern Canada 121 L5
Asheville U.S.A. 132 D5
Asheweig r. Canada 122 D3
Ashford Australia 112 E2
Ashford U.K. 49 H7
Ash Fork U.S.A. 129 G4
Ashgabat Ahal Turkm. see Aşgabat
Ashibetsu Japan 74 F4
Ashikaga Japan 75 E5
Ashington U.K. 48 F3
Ashizuri-misaki pt Japan 75 D6
Ashkelon Israel see Ashqelon
Ashkhabad Ahal Turkm. see Aşgabat
Ashkhabad Turkm. see Aşgabat
Ashkum U.S.A. 134 B3

Ashkun reg. Afgh. 89 H3
Ashland AL U.S.A. 133 C5
Ashland ME U.S.A. 132 G2
Ashland OH U.S.A. 134 D3
Ashland NH U.S.A. 135 J2
Ashland OR U.S.A. 126 C4
Ashland VA U.S.A. 135 G5
Ashland WI U.S.A. 130 F2
Ashland City U.S.A. 134 B5
Ashley Australia 112 D2
Ashley MI U.S.A. 134 C2
Ashley ND U.S.A. 130 D2

▶Ashmore and Cartier Islands terr.
Australia 108 C3
Australian External Territory.

Ashmore Reef Australia 108 C3
Ashmore Reefs Australia 110 D1
Ashmyany Belarus 45 N9
Ashqelon Israel 85 B4
Ash Shabakah Iraq 91 F5
Ash Shaddādah Syria 91 F3
Ash Shallūfah Egypt 91 G5
Ash Sham Syria see Damascus
Ash Shanāfiyah Iraq 91 G5
Ash Shaqīq well Saudi Arabia 91 F5
Ash Sharāh mts Jordan 85 B4
Ash Sharawrah Saudi Arabia 86 G6
Ash Shāriqah U.A.E. see Sharjah
Ash Sharqāt Iraq 91 F4
Ash Shaṭṭ Egypt 85 A5
Ash Shaṭrah Iraq 91 G5
Ash Shawbak Jordan 85 B4
Ash Shaybānī well Saudi Arabia 91 F5
Ash Shaykh Ibrāhīm Syria 85 D2
Ash Shibliyah hill Saudi Arabia 85 C5
Ash Shiḥr Yemen 86 G7
Ash Shu'aybah Saudi Arabia 91 F6
Ash Shu'bah Saudi Arabia 86 F4
Ash Shurayf Saudi Arabia see Khaybar
Ashta India 82 D5
Ashtabula U.S.A. 134 E3
Ashtarak Armenia 91 G2
Ashti Mahar. India 82 D5
Ashti Mahar. India 84 B2
Ashti Mahar. India 84 C2
Ashtiān Iran 88 C3
Ashton S. Africa 100 E7
Ashton U.S.A. 126 F3
Ashton-under-Lyne U.K. 48 E5
Ashuanipi r. Canada 123 I3
Ashuanipi Lake Canada 123 I3
Ashur Iraq see Ash Sharqāt
Ashville U.S.A. 133 C5
Ashwaubenon U.S.A. 134 A1
Asi r. Asia 90 E3 see 'Āṣī, Nahr al
'Āṣī r. Lebanon/Syria see Orontes
'Āṣī, Nahr al r. Asia 90 E3
also known as Asi or Orontes
Āsīā Bak Iran 88 C3
Asifabad India 84 C2
Asika India 84 E2
Asilah Morocco 57 C6
Asino Rus. Fed. 64 J4
Asipovichy Belarus 43 F5
Asīr Iran 88 D5
'Asīr reg. Saudi Arabia 86 F5
Asisium Italy see Assisi
Askale Jammu and Kashmir 82 C2
Aşkale Turkey 91 F3
Asker Norway 45 G7
Askersund Sweden 45 I7
Askim Norway 45 G7
Askī Mawṣil Iraq 91 F3
Askino Rus. Fed. 41 R4
Askival hill U.K. 50 C4
Asl Egypt see 'Asal
Aslanköy r. Turkey 85 B1
Asmar reg. Afgh. 89 H3

▶Asmara Eritrea 86 E6
Capital of Eritrea.

Āsmera Eritrea see Asmara
Åsnen l. Sweden 45 I8
Aso-Kuju Kokuritsu-kōen Japan 75 C6
Asonli India 76 B2
Asop India 82 C4
Asori Indon. 69 J7
Āsosa Eth. 98 D2
Asotin U.S.A. 126 D3
Aspang-Markt Austria 47 P7
Aspatria U.K. 48 D4
Aspen U.S.A. 126 G5
Asperg Germany 53 J6
Aspiring, Mount N.Z. 113 B7
Aspro, Cape Cyprus 85 A2
Aspromonte, Parco Nazionale dell'
nat. park Italy 58 F5
Aspron, Cape Cyprus see Aspro, Cape
Aspur India 89 I6
Asquith Canada 121 J4
As Sa'an Syria 85 C2
Assab Eritrea 86 F7
As Sabsab well Saudi Arabia 88 C5
Assad, Lake resr Syria see Asad, Buḥayrat al
Aş Ṣadr U.A.E. 88 D5
Aş Ṣafā lava field Syria 85 C3
Aş Ṣafāqis Tunisia see Sfax
Aş Ṣaff Egypt 90 C5
As Safirah Syria 85 C1
Aş Ṣaḥrā' al Gharbīyah des. Egypt see
Western Desert
Aş Ṣaḥrā' ash Sharqīyah des. Egypt see
Eastern Desert
Aş Ṣaḥrā' ash Sharqīyah des. Egypt see
Eastern Desert
Assake-Audan, Vpadina depr.
Kazakh./Uzbek. 91 J2
'Assal, Lac l. Djibouti see Assal, Lake

▶Assal, Lake Djibouti 86 F7
Lowest point in Africa.
Africa 92–93

Aş Şālihīyah Syria 91 F4
As Sallūm Egypt 90 B5
As Salmān Iraq 91 G5
As Salṭ Jordan 85 B3

Assam state India 83 G4
Assamakka Niger 96 D3
As Samāwah Iraq 91 G5
As Samrā' Jordan 85 C3
Aş Şanām reg. Libya 97 F2
Assateague Island U.S.A. 135 H4
As Sawādah reg. Saudi Arabia 88 B6
Assayeta Eth. see Āsayita
As Sayḥ Saudi Arabia 88 B6
Assenede Belgium 52 D3
Assen Neth. 52 G1
Assesse Belgium 52 F4
As Sidrah Libya 97 E1
Aş Şīfah Oman 88 E6
Assigny, Lac l. Canada 123 I3
As Sikak Saudi Arabia 88 C5
Assiniboia Canada 121 J5
Assiniboine r. Canada 121 L5
Assiniboine, Mount Canada 118 G4
Assis Brazil 145 A3
Assisi Italy 58 E3
Aßlar Germany 53 I4
Aş Şubayḩiyah Kuwait 88 B4
As Sukhnah Syria 85 D2
As Sulaymānīyah Iraq 91 G4
As Sulaymī Saudi Arabia 86 F4
Aş Şulb reg. Saudi Arabia 88 C5
As Sūq Saudi Arabia 86 F5
Aş Şummān plat. Saudi Arabia 88 B5
Aş Şummān plat. Saudi Arabia 88 C6
As Sūriyah country Asia see Syria
Aş Şuwar Syria 85 D3
As Suwaydā' Syria 85 C3
As Suways Egypt see Suez
As Suways governorate Egypt 85 A4
Assynt, Loch l. U.K. 50 D2
Astacus Kocaeli Turkey see İzmit
Astakida i. Greece 59 K7
Astakos Greece 59 I5
Astalu Island Pak. see Astola Island
Astaneh Iran 88 C2
Astara Azer. 91 H3
Āstārā Iran 86 G2
Asterabad Iran see Gorgān
Asti Italy 58 C2
Astillero Peru 142 E6
Astin Tag mts China see Altun Shan
Astipálaia i. Greece see Astypalaia
Astola Island Pak. 89 F5
Astor r. Pak. 89 I3
Astorga Spain 57 C2
Astoria U.S.A. 126 C3
Åstorp Sweden 45 H8
Astrabad Iran see Gorgān
Astrakhan' Rus. Fed. 43 K7
Astrakhan' Bazar Azer. see Cälilabad
Astravyets Belarus 45 N9
Astrida Rwanda see Butare
Asturias aut. comm. Spain 57 C2
Asturias, Principado de aut. comm. Spain
see Asturias
Asturica Augusta Spain see Astorga
Astypalaia i. Greece 59 L6
Asuncion i. N. Mariana Is 69 L3

▶Asunción Para. 144 E3
Capital of Paraguay.

Aswad Oman 88 E5
Aswān Egypt 86 D5
Aswân Egypt see Aswān
Asyûṭ Egypt see Asyūṭ
Asyūṭ Egypt 90 C6
Ata i. Tonga 107 I4
Atacama, Desierto de des. Chile see
Atacama Desert
Atacama, Salar de salt flat Chile 144 C2

▶Atacama Desert Chile 144 C3
Driest place in the world.

Atafu atoll Tokelau 107 I2
Atafu i. Tokelau 150 I6
'Aṭā'iṭah, Jabal al mt. Jordan 85 B4
Atakent Turkey 85 B1
Atakpamé Togo 96 D4
Atalándi Greece see Atalanti
Atalanti Greece 59 J5
Atalaya Peru 142 D6
Ataléia Brazil 145 C2
Atambua Indon. 108 D2
Atamyrat Turkm. 89 G2
Ataniya Turkey see Adana
'Ataq Yemen 86 G7
Atâr Mauritania 96 B2
Atari Pak. 89 I4
Atascadero U.S.A. 128 C4
Atasu Kazakh. 80 D2
Ataúro, Ilha de i. East Timor 108 D2
Atáviros mt. Greece see Attavyros
Atayurt Turkey 85 A1
Atbara Sudan 86 D6
Atbara r. Sudan 86 D6
Atbasar Kazakh. 80 C1
Atchison U.S.A. 130 E4
Atebubu Ghana 96 C4
Ateransk Kazakh. see Atyrau
Āteshān Iran 88 D3
Āteshkhāneh, Kūh-e hill Afgh. 89 F3
Atessa Italy 58 F3
Ath Belgium 52 D4
Athabasca r. Canada 121 I3
Athabasca, Lake Canada 121 I3
Athalia U.S.A. 134 D4
'Athāmīn, Birkat al well Iraq 88 A4
Atharan Kalat Pak. 89 I4
Athboy Ireland 51 F4
Athenae Greece see Athens
Athenry Ireland 51 D4
Athens Canada 135 H1

▶Athens Greece 59 J6
Capital of Greece.

Athens AL U.S.A. 133 C5
Athens GA U.S.A. 133 D5

Athens MI U.S.A. 134 C2
Athens OH U.S.A. 134 D4
Athens PA U.S.A. 135 G3
Athens TN U.S.A. 132 C5
Athens TX U.S.A. 131 E5
Atherstone U.K. 49 F6
Atherton Australia 110 D3
Athies France 52 C5
Athina Greece see Athens
Athínai Greece see Athens
Athleague Ireland 51 D4
Athlone Ireland 51 E4
Athna', Wādī al watercourse Jordan 85 D3
Athni India 84 B2
Athol N.Z. 113 B7
Athol U.S.A. 135 I2
Atholl, Forest of reg. U.K. 50 E4
Athos mt. Greece 59 K4
Ath Thamad Egypt 85 B5
Ath Thāyat mt. Saudi Arabia 85 C5
Ath Thumāmī well Saudi Arabia 88 B5
Athy Ireland 51 F5
Ati Chad 97 E3
Aṭīābād Iran 88 E3
Atico Peru 142 D7
Atikameg Canada 120 H4
Atikameg r. Canada 122 E3
Atik Lake Canada 121 M4
Atikokan Canada 119 I5
Atikonak Lake Canada 123 I3
Atka Rus. Fed. 65 Q3
Atka Island U.S.A. 118 A4
Atkri Indon. 69 I7

▶Atlanta GA U.S.A. 133 C5
State capital of Georgia.

Atlanta IN U.S.A. 134 B3
Atlanta MI U.S.A. 134 C1
Atlantic IA U.S.A. 130 E3
Atlantic NC U.S.A. 133 E5
Atlantic City U.S.A. 135 H4
Atlantic-Indian-Antarctic Basin sea feature
S. Atlantic Ocean 148 H10
Atlantic-Indian Ridge sea feature
Southern Ocean 148 H9

▶Atlantic Ocean 148
2nd largest ocean in the world.

Atlantic Peak U.S.A. 126 F4
Atlantis S. Africa 100 D7
Atlas Méditerranéen mts Alg. see
Atlas Tellien
Atlas Mountains Africa 54 C5
Atlas Saharien mts Alg. 54 D5
Atlas Tellien mts Alg. 57 H6
Atlin Canada 120 C3
Atlin Lake Canada 120 C3
Atmakur India 84 C3
Atmore U.S.A. 133 C6
Atnur India 84 C2
Atocha Bol. 142 E8
Atoka U.S.A. 131 D5
Atouat mt. Laos 70 D3
Atouila, Erg des. Mali 96 C2
Atqan China see Aqqan
Atrak r. Iran/Turkm. see Atrek
Atrato r. Col. 142 C2
also known as Atrak, alt. Etrek
Atrek r. Iran/Turkm. 88 D2
Atrek r. Iran/Turkm. 88 D2
Atropatene country Asia see Azerbaijan
Atsonupuri vol. Rus. Fed. 74 G3
Aṭ Ṭafīlah Jordan 85 B4
Aṭ Ṭā'if Saudi Arabia 86 F5
Attalea Turkey see Antalya
Attalia Turkey see Antalya
At Tamīmī Libya 90 A4
Attapu Laos 70 D4
Attavyros mt. Greece 59 L6
Attawapiskat Canada 122 E3
Attawapiskat r. Canada 122 E3
Attawapiskat Lake Canada 122 D3
Aṭ Ṭawīl mts Saudi Arabia 91 F5
At Taysīyah plat. Saudi Arabia 91 F5
Attendorn Germany 53 H3
Attersee l. Austria 47 N7
Attica IN U.S.A. 134 B3
Attica NY U.S.A. 135 F2
Attica OH U.S.A. 134 D3
Attigny France 52 E5
Attikamagen Lake Canada 123 I3
Attila Line Cyprus 85 A2
Attleborough U.K. 49 I6
Attopeu Laos see Attapu
Attu Greenland 119 M3
Aṭ Ṭubayq reg. Saudi Arabia 85 C5

▶Attu Island U.S.A. 65 S4
Most westerly point of North America.

At Tūnisīyah country Africa see Tunisia
Aṭ Ṭūr Egypt 90 D5
Attur India 84 C4
Aṭ Ṭuwayyah well Saudi Arabia 91 F5
Atuk Mountain hill U.S.A. 118 A3
Åtvidaberg Sweden 45 I7
Atwater U.S.A. 128 C3
Atwood U.S.A. 130 C4
Atwood Lake U.S.A. 134 E3
Atyasheyo Rus. Fed. 43 J5
Atyrau Kazakh. 78 E2
Atyraū admin. div. Kazakh. see
Atyrauskaya Oblast'
Atyrau Oblast admin. div. Kazakh. see
Atyrauskaya Oblast'
Atyrauskaya Oblast' admin. div.
Kazakh. 41 Q6
Aua Island P.N.G. 69 K7
Aub Germany 53 K5
Aubagne France 56 G5
Aubange Belgium 52 F5
Aubenas France 56 F4
Aubergenville France 52 B6
Auboué France 52 F5
Aubrey Cliffs mts U.S.A. 129 G4
Aubry Lake Canada 118 F3
Auburn Canada 134 E2
Auburn r. Australia 111 E5
Auburn AL U.S.A. 133 C5
Auburn CA U.S.A. 128 C2

Auburn IN U.S.A. 134 C3
Auburn KY U.S.A. 134 B5
Auburn ME U.S.A. 135 J1
Auburn NE U.S.A. 130 E3
Auburn NY U.S.A. 135 G2
Auburn Range hills Australia 110 E5
Aubusson France 56 F4
Auch France 56 E5
Auche Myanmar 70 B1
Auchterarder U.K. 50 F4

▶Auckland N.Z. 113 E3
5th most populous city in Oceania.

Auckland Islands N.Z. 107 G7
Auden Canada 122 D4
Audenarde Belgium see Oudenaarde
Audo mts Eth. 98 E3
Audo Range mts Eth. see Audo
Audruicq France 52 C4
Audubon U.S.A. 130 E3
Aue Germany 53 M4
Auerbach Germany 53 M4
Auerbach in der Oberpfalz Germany 53 L5
Auersberg mt. Germany 53 M4
Augathella Australia 111 D5
Augher U.K. 51 E3
Aughnacloy U.K. 51 F3
Aughrim Ireland 51 F5
Augrabies S. Africa 100 E5
Augrabies Falls S. Africa 100 E5
Augrabies Falls National Park
S. Africa 100 E5
Au Gres U.S.A. 134 D1
Augsburg Germany 47 M6
Augusta Australia 109 A8
Augusta Sicily Italy 58 F6
Augusta AR U.S.A. 131 F5
Augusta GA U.S.A. 133 D5
Augusta KY U.S.A. 134 C4

▶Augusta ME U.S.A. 135 K1
State capital of Maine.

Augusta MT U.S.A. 126 E3
Augusta Auscorum France see Auch
Augusta Taurinorum Italy see Turin
Augusta Treverorum Germany see Trier
Augusta Vindelicorum Germany see
Augsburg
Augusto de Lima Brazil 145 B2
Augustus, Mount Australia 109 B6
Auke Bay U.S.A. 120 C3
Auld, Lake salt flat Australia 108 C5
Auliye Ata Kazakh. see Taraz
Aulnoye-Aymeries France 52 D4
Aulon Albania see Vlorë
Ault France 52 B4
Aumale Alg. see Sour el Ghozlane
Aumale France 52 B5
Aumont-Aubrac France see Aumont
Aunglan Myanmar 70 A3
Auob watercourse Namibia/S. Africa
100 E4
Aupaluk Canada 123 H2
Aur i. Malaysia 71 D7
Auraiya India 82 D4
Aurangabad Bihar India 83 F4
Aurangabad Mahar. India 84 B2
Aure r. France 49 F9
Aurich Germany 53 H1
Aurignac France 56 E5
Aurigny i. Channel Is see Alderney
Aurillac France 56 F4
Aurora CO U.S.A. 126 G5
Aurora IL U.S.A. 134 A3
Aurora MO U.S.A. 131 E4
Aurora NE U.S.A. 130 D3
Aurora UT U.S.A. 129 H2
Aurora Island Vanuatu see Maéwo
Aurukun Australia 110 C2
Aus Namibia 100 C4
Au Sable U.S.A. 134 D1
Au Sable r. U.S.A. 134 D1
Auskerry i. U.K. 50 G1
Austin IN U.S.A. 134 C4
Austin MN U.S.A. 130 E3
Austin NV U.S.A. 128 E2

▶Austin TX U.S.A. 131 D6
State capital of Texas.

Austin, Lake salt flat Australia 109 B6
Austintown U.S.A. 134 E3
Austral Downs Australia 110 B4
Australes, Îles is Fr. Polynesia see
Tubuai Islands

▶Australia country Oceania 106 C4
Largest country in Oceania.
Most populous country in Oceania.
Oceania 8, 104–105

Australian-Antarctic Basin sea feature
S. Atlantic Ocean 150 D9
Australian Antarctic Territory reg.
Antarctica 152 G2
Australian Capital Territory admin. div.
Australia 112 D5
Austria country Europe 47 N7
Europe 5, 38–39
Austvågøy i. Norway 44 I2
Autazes Brazil 143 G4
Autesiodorum France see Auxerre
Authie r. France 52 B4
Autti Fin. 44 O3
Auvergne reg. France 56 F4
Auvergne, Monts d' mts France 56 F4
Auxerre France 56 F3
Auxi-le-Château France 52 C4
Auxonne France 56 G3
Auyuittuq National Park Canada 119 L3
Auzangate, Nevado mt. Peru 142 D6
Ava MO U.S.A. 131 E4
Ava NY U.S.A. 135 H2
Avallon France 56 F3
Avalon U.S.A. 128 D5

Avalon Peninsula Canada 123 L5
Avān Iran 91 G3
Avarau atoll Cook Is see Palmerston
Avaré Brazil 145 A3
Avaricum France see Bourges

▶Avarua Cook Is 151 J7
Capital of the Cook Islands, on Rarotonga
island.

Avawam U.S.A. 134 D5
Avaz Iran 89 F3
Aveiro Port. 57 B3
Aveiro, Ria de est. Port. 57 B3
Āvej Iran 88 C3
Avellino Italy 58 F4
Avenal U.S.A. 128 C3
Avenhorn Neth. 52 E2
Avenio France see Avignon
Aversa Italy 58 F4
Avesnes-sur-Helpe France 52 D4
Avesta Sweden 45 J6
Aveyron r. France 56 E4
Avezzano Italy 58 E3
Aviemore U.K. 50 F3
Avignon France 56 G5
Ávila Spain 57 D3
Avilés Spain 57 D2
Avion France 52 C4
Avis U.S.A. 135 G3
Avlama Dağı mt. Turkey 85 A1
Avlama Dağı mt. Turkey 85 A1
Avlona Albania see Vlorë
Avnyugskiy Rus. Fed. 42 J3
Avoca Australia 112 A6
Avoca r. Australia 112 A5
Avoca Ireland 51 F5
Avoca IA U.S.A. 130 E3
Avoca NY U.S.A. 135 G2
Avola Sicily Italy 58 F6
Avon r. England U.K. 49 E6
Avon r. England U.K. 49 E7
Avon r. England U.K. 49 F8
Avon r. Scotland U.K. 50 F3
Avon U.S.A. 135 G2
Avondale U.S.A. 129 G5
Avonmore r. Ireland 51 F5
Avonmouth U.K. 49 E7
Avranches France 56 D2
Avre r. France 52 C5
Avsuyu Turkey 85 C1
Avu'avu Solomon Is 107 G2
Avveel Fin. see Ivalo
Avvil Fin. see Ivalo
A'waj r. Syria 85 B3
Awakino N.Z. 113 E4
'Awālī Bahrain 88 C5
Awanui N.Z. 113 D2
'Awārid, Wādī al watercourse Syria 85 D2
Awarua Point N.Z. 113 B7
Āwash Eth. 98 E3
Āwash r. Eth. 98 E2
Awa-shima i. Japan 75 E5
Āwash National Park Eth. 98 D3
Awasib Mountains Namibia 100 B3
Awat China 80 F3
Awatere r. N.Z. 113 E5
Awbārī Libya see Ubari
Awbeg r. Ireland 51 D5
'Awdah well Saudi Arabia 88 C6
'Awdah, Hawr al imp. l. Iraq 91 G5
Aw Dheegle Somalia 97 H4
Awe, Loch l. U.K. 50 D4
Aweil Sudan 97 F4
Awka Nigeria 96 D4
Awserd W. Sahara 96 B2
Axe r. England U.K. 49 D8
Axe r. England U.K. 49 E7
Axedale Australia 112 B6
Axel Heiberg Glacier Antarctica 152 I1
Axel Heiberg Island Canada 119 I2
Axim Ghana 96 C4
Axminster U.K. 49 D8
Axum Eth. see Āksum
Ay France 52 E5
Ayachi, Jbel mt. Morocco 54 C5
Ayacucho Arg. 144 E5
Ayacucho Peru 142 D6
Ayadaw Myanmar 70 A2
Ayagoz Kazakh. 80 F2
Ayaguz Kazakh. see Ayagoz
Ayakkum Hu salt l. China 83 G1
Ayaköz Kazakh. see Ayagoz
Ayan Rus. Fed. 65 O4
Ayancık Turkey 90 D2
Ayang N. Korea 75 B5
Ayaş Turkey 90 D2
Āybak Afgh. 89 H2
Aybas Kazakh. 43 K7
Aydar r. Ukr. 43 H6
Aydarko'li ko'li Uzbek. 80 C3
Aydın Turkey 59 L6
Aydıncık Turkey 85 A1
Aydın Dağları mts Turkey 59 L5
Aýdyñ Turkm. 88 D2
Āyelu Terara vol. Eth. 86 F7
Ayer U.S.A. 135 J2
Ayers Rock hill Australia see Uluru
Ayeyarwady r. Myanmar see Irrawaddy
Ayila Ri'gyü mts China 82 D2
Áyios Dhimítrios Greece see
Agios Dimitrios
Áyios Evstrátios i. Greece see
Agios Efstratios
Áyios Nikólaos Greece see Agios Nikolaos
Áyios Yeóryios i. Greece see Agios Georgios
Aylesbury N.Z. 113 D6
Aylesbury U.K. 49 G7
Aylett U.S.A. 135 G5
Ayllón Spain 57 E3
Aylmer Ont. Canada 134 E2
Aylmer Que. Canada 135 H1
Aylmer Lake Canada 121 I1
'Ayn 'Abd well Saudi Arabia 88 C6
'Ayn al Baidā' Saudi Arabia 85 C4
'Ayn al Baydā' well Syria 85 C2
'Ayn al Ghazalah well Libya 90 A4
'Ayn al Maqfi spring Egypt 90 C6
'Ayn Dāllah spring Egypt 90 B6
Aynī Tajik. 89 H2

'Ayn 'Īsá Syria 85 D1
'Ayn Tabaghbugh spring Egypt 90 B5
'Ayn Tumayrah spring Egypt 90 B5
Ayod Sudan 86 D8
Ayon, Ostrov i. Rus. Fed. 65 R3
'Ayoûn el 'Atroûs Mauritania 96 C3
Ayr Australia 110 D3
Ayr Canada 134 E2
Ayr U.K. 50 E5
Ayr r. U.K. 50 E5
Ayr, Point of U.K. 48 D5
Ayrancı Turkey 90 D3
Ayre, Point of Isle of Man 48 C4
Aytos Bulg. 59 L3
A Yun Pa Vietnam 71 E4
Ayuthia Thai. see Ayutthaya
Ayutthaya Thai. 71 C4
Ayvacık Turkey 59 L5
Ayvalı Turkey 90 E3
Ayvalık Turkey 59 L5
Azak Rus. Fed. see Azov
Azalia U.S.A. 134 D3
Azamgarh India 83 E4
Azaouâd reg. Mali 96 C3
Azaouagh, Vallée de watercourse
Mali/Niger 96 C3
Azaran Iran see Hashtrud
Azārbāyjān country Asia see Azerbaijan
Āzārbāyjān country Asia see Azerbaijan
Azare Nigeria 96 E3
A'zāz Syria 85 C1
Azbine reg. Niger see L'Aïr, Massif de
Azdavay Turkey 90 D2

▶Azerbaijan country Asia 91 G2
Asia 6, 62–63

Azerbaydzhanskaya S.S.R. country Asia see
Azerbaijan
Azhikal India 84 B4
Aziscohos Lake U.S.A. 135 J1
'Azīzābād Iran 88 E4
Aziziye Turkey see Pınarbaşı
Azogues Ecuador 142 C4

▶Azores terr. N. Atlantic Ocean 148 G3
Autonomous region of Portugal.
Europe 5, 38–39

Azores-Biscay Rise sea feature
N. Atlantic Ocean 148 G3
Azotus Israel see Ashdod
Azov Rus. Fed. 43 H7
Azov, Sea of Rus. Fed./Ukr. 43 H7
Azovs'ke More sea Rus. Fed./Ukr. see
Azov, Sea of
Azovskoye More sea Rus. Fed./Ukr. see
Azov, Sea of
Azraq, Bahr el r. Sudan 86 D6 see Blue Nile
Azraq ash Shīshān Jordan 85 C4
Azrou Morocco 54 C5
Aztec U.S.A. 129 I3
Azuaga Spain 57 D4
Azuero, Península de pen. Panama 137 H7
Azul, Cordillera mts Peru 142 C5
Azuma-san vol. Japan 75 F5
'Azza Gaza see Gaza
Azzaba Alg. 58 B6
Aẕ Ẕahrān Saudi Arabia see Dhahran
Az Zaqāzīq Egypt 90 C5
Az Zarbah Syria 85 C1
Az Zarqā' Jordan 85 C3
Az Zawr, Ra's pt Saudi Arabia 91 H6
Azzeffâl hills Mauritania/W. Sahara 96 B2
Az Zubayr Iraq 91 G5
Az Zuqur i. Yemen 86 F7

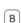

B

Ba, Sông r. Vietnam 71 E4
Baa Indon. 108 C2
Baabda Lebanon 85 B3
Ba'albek Lebanon 85 C2
Ba'al Ḥazor mt. West Bank 85 B4
Baan Baa Australia 112 D3
Baardheere Somalia 98 E3
Bab India 82 D4
Bābā, Kūh-e mts Afgh. 89 H3
Baba Burnu pt Turkey 59 L5
Babadağ mt. Azer. 91 H2
Babadag Romania 59 M2
Babadurmaz Turkm. 88 E2
Babaeski Turkey 59 L4
Babahoyo Ecuador 142 C4
Babai r. Nepal 83 E3
Bābā Kalān Iran 88 C4
Babai Jiang r. China 76 D4
Babao Qinghai China see Qilian
Babao Yunnan China 76 D4
Babar i. Indon. 108 E1
Babar, Kepulauan is Indon. 108 E1
Babati Tanz. 99 D4
Babayevo Rus. Fed. 42 G4
Babayurt Rus. Fed. 91 G2
B'abdā Lebanon see Baabda
Bab al Mandeb, Straits of Africa/Asia see
Bāb al Mandab
Babi, Pulau i. Indon. 71 B7
Babian Jiang r. China 76 D4
Babine r. Canada 120 E4
Babine Lake Canada 120 E4
Babine Range mts Canada 120 E4
Bābol Iran 88 D2
Bābol Sar Iran 88 D2
Babongo Cameroon 97 E4
Baboon Point S. Africa 100 D7
Baboua Cent. Afr. Rep. 98 B3
Babruysk Belarus 43 F5
Babstovo Rus. Fed. 74 D2
Babu China see Hezhou
Babuhri India 82 B4
Babusar Pass Pak. 89 I3
Babuyan i. Phil. 69 G3
Babuyan Channel Phil. 69 G3
Babuyan Islands Phil. 69 G3
Bacaadweyn Somalia 98 E3
Bacabal Brazil 143 J4
Bacan i. Indon. 69 H7

Bacanora Mex. 127 F7
Bacău Romania 59 L1
Baccaro Point Canada 123 I6
Bắc Giang Vietnam 70 D2
Bacha China 74 D2
Bach Ice Shelf Antarctica 152 L2
Bach Long Vi, Đao i. Vietnam 70 D2
Bachu China 80 E4
Bachuan China see Tongliang
Back r. Australia 110 C3
Back r. Canada 121 M1
Bačka Palanka Serb. and Mont. 59 H2
Backbone Mountain U.S.A. 134 F4
Backbone Ranges mts Canada 120 D2
Backe Sweden 44 J5
Backstairs Passage Australia 111 B7
Bắc Liêu Vietnam 71 D5
Bắc Ninh Vietnam 70 D2
Bacoachi Mex. 127 F7
Bacoachi watercourse Mex. 127 F7
Bacobampo Mex. 127 F8
Bacolod Phil. 69 G4
Bacqueville, Lac l. Canada 122 G2
Bacqueville-en-Caux France 49 H9
Bacubirito Mex. 127 G8
Bād Iran 88 D3
Bada China see Xilin
Bada mt. Eth. 98 D3
Bada i. Myanmar 71 B5
Badabayhan Turkm. 89 F2
Badagara India 84 B4
Badain Jaran Shamo des. China 80 J3
Badajoz Spain 57 C4
Badampahar India 83 F5
Badanah Saudi Arabia 91 F5
Badanjilin Shamo des. China see
 Badain Jaran Shamo
Badaojiang China see Baishan
Badarpur India 83 H4
Badaun India see Budaun
Bad Axe U.S.A. 134 D2
Bad Bederkesa Germany 53 I1
Bad Bergzabern Germany 53 H5
Bad Berleburg Germany 53 I3
Bad Bevensen Germany 53 K1
Bad Blankenburg Germany 53 L4
Bad Camberg Germany 53 I4
Badderen Norway 44 M2
Bad Driburg Germany 53 J3
Bad Düben Germany 53 M3
Bad Dürkheim Germany 53 I5
Bad Dürrenberg Germany 53 M3
Bademli Turkey see Aladağ
Bademli Geçidi pass Turkey 90 C3
Bad Ems Germany 53 H4
Baden Austria 47 P6
Baden Switz. 56 I3
Baden-Baden Germany 53 I6
Baden-Württemberg land Germany 53 I6
Bad Essen Germany 53 I2
Bad Grund (Harz) Germany 53 K3
Bad Harzburg Germany 53 K3
Bad Hersfeld Germany 53 J4
Bad Hofgastein Austria 47 N7
Bad Homburg vor der Höhe
 Germany 53 I4
Badia Polesine Italy 58 D2
Badin Pak. 89 H5
Bad Ischl Austria 47 N7
Bādiyat ash Shām des. Asia see
 Syrian Desert
Bad Kissingen Germany 53 K4
Bad Königsdorff Poland see
 Jastrzębie-Zdrój
Bad Kösen Germany 53 L3
Bad Kreuznach Germany 53 H5
Bad Laasphe Germany 53 I4
Badlands reg. ND U.S.A. 130 C2
Badlands reg. SD U.S.A. 130 C3
Badlands National Park U.S.A. 130 C3
Bad Langensalza Germany 53 K3
Bad Lauterberg im Harz Germany 53 K3
Bad Liebenwerda Germany 53 N3
Bad Lippspringe Germany 53 I3
Bad Marienberg (Westerwald)
 Germany 53 H4
Bad Mergentheim Germany 53 J5
Bad Nauheim Germany 53 I4
Badnera India 82 C5
Bad Neuenahr-Ahrweiler Germany 52 H4
Bad Neustadt an der Saale Germany 53 K4
Badnor India 82 C4
Badong China 77 F2
Ba Đông Vietnam 71 D5
Badou Togo 96 D4
Bad Pyrmont Germany 53 J3
Badrah Iraq 91 G4
Bad Reichenhall Germany 47 N7
Badr Ḥunayn Saudi Arabia 86 E5
Bad Sachsa Germany 53 K3
Bad Salzdetfurth Germany 53 K2
Bad Salzuflen Germany 53 I2
Bad Salzungen Germany 53 K4
Bad Schwalbach Germany 53 I4
Bad Schwartau Germany 47 M4
Bad Segeberg Germany 47 M4
Bad Sobernheim Germany 53 H5
Badu Island Australia 110 C1
Badulla Sri Lanka 84 D5
Bad Vilbel Germany 53 I4
Bad Wilsnack Germany 53 L2
Bad Windsheim Germany 53 K5
Badzhal Rus. Fed. 74 D2
Badzhal'skiy Khrebet mts Rus. Fed. 74 D2
Bad Zwischenahn Germany 53 I1
Bae Colwyn U.K. see Colwyn Bay
Baesweiler Germany 52 G4
Baeza Spain 57 E5
Bafatá Guinea-Bissau 96 B3
Baffa Pak. 89 I3
Baffin Bay sea Canada/Greenland 119 L2

▶Baffin Island Canada 119 L3
 2nd largest island in North America and
 5th in the world.
 World 12–13

Bafia Cameroon 96 E4
Bafilo Togo 96 D4

Bafing r. Africa 96 B3
Bafoulabé Mali 96 B3
Bafoussam Cameroon 96 E4
Bāfq Iran 88 D4
Bafra Turkey 90 D2
Bafra Burnu pt Turkey 90 D2
Bāft Iran 88 E4
Bafwaboli Dem. Rep. Congo 98 C3
Bafwasende Dem. Rep. Congo 98 C3
Bagaha India 83 F4
Bagalkot India 84 B2
Bagalkote India see Bagalkot
Bagamoyo Tanz. 99 D4
Bagan China 76 C1
Bagan Datoh Malaysia see Bagan Datuk
Bagan Datuk Malaysia 71 C7
Bagansiapiapi Indon. 71 C7
Bagata Dem. Rep. Congo 98 B4
Bagdad U.S.A. 129 G4
Bagdarin Rus. Fed. 73 K2
Bagé Brazil 144 F4
Bagerhat Bangl. 83 G5
Bageshwar India 82 D3
Baggs U.S.A. 126 G4
Baggy Point U.K. 49 C7
Bagh India 82 C5
Bāgh a' Chaisteil U.K. see Castlebay
Baghak Pak. 89 G4
Baghbaghū Iran 89 F2

▶Baghdād Iraq 91 G4
 Capital of Iraq.

Bāgh-e Malek Iran 88 C4
Bagherhat Bangl. see Bagerhat
Bāghīn Iran 88 E4
Baghlān Afgh. 89 H2
Baghrān Afgh. 89 G3
Bağırsak r. Turkey 85 C1
Bağırsak Deresi r. Syria/Turkey see
 Sājūr, Nahr
Bagley U.S.A. 130 E2
Baglung Nepal 83 E3
Bagnères-de-Luchon France 56 E5
Bago Myanmar see Pegu
Bago Phil. 69 G4
Bagong China see Sansui
Bagor India 89 I5
Bagrationovsk Rus. Fed. 45 L9
Bagrax China see Bohu
Bagrax Hu l. China see Bosten Hu
Baguio Phil. 69 G3
Bagur, Cabo c. Spain see Begur, Cap de
Bagzane, Monts mts Niger 96 D3
Bahādurābād-e Bālā Iran 88 E4
Bahalda India 83 F5
Bahāmābād Iran see Rafsanjān

▶Bahamas, The country West Indies 133 E7
 North America 9, 116–117

Bahara Pak. 89 G5
Baharampur India 83 G4
Bahardipur Pak. 89 H5
Bahariya Oasis oasis Egypt see
 Bahrīyah, Wāḥāt al
Bahau Malaysia 71 C7
Bahawalnagar Pak. 89 I4
Bahawalpur Pak. 89 H4
Bahçe Adana Turkey 85 B1
Bahçe Osmaniye Turkey 90 E3
Baher Dar Eth. see Bahir Dar
Baheri India 82 D3
Bahia Brazil see Salvador
Bahia state Brazil 145 C1
Bahía Asunción Mex. 127 E8
Bahía Blanca Arg. 144 D5
Bahía Kino Mex. 127 F7
Bahía Laura Arg. 144 C7
Bahía Negra Para. 144 E2
Bahía Tortugas Mex. 127 E8
Bahir Dar Eth. 98 D2
Bahl India 82 C3
Bahlā Oman 88 E6
Bahomonte Indon. 69 G7
Bahraich India 83 E4

▶Bahrain country Asia 88 C5
 Asia 6, 62–63

Bahrain, Gulf of Asia 88 C5
Bahrām Beyg Iran 88 C2
Bahrāmjerd Iran 88 E4
Bahrīyah, Wāḥāt al oasis Egypt 90 C6
Bahuaja-Sonene, Parque Nacional
 nat. park Peru 142 E6
Baia Mare Romania 59 J1
Baiazeh Iran 88 D3
Baicang China 83 G3
Baicheng Henan China see Xiping
Baicheng Jilin China 74 A3
Baicheng Xinjiang China 80 F3
Baidoa Somalia see Baydhabo
Baidoi Co l. China 83 F2
Baidu China 77 H3
Baie-aux-Feuilles Canada see Tasiujaq
Baie-Comeau Canada 123 H4
Baie-du-Poste Canada see Mistissini
Baie-St-Paul Canada 123 H5
Baie-Trinité Canada 123 I4
Baie Verte Canada 123 K4
Baiguan China see Shangyu
Baiguo Hubei China 77 G2
Baiguo Hunan China 77 G3
Baihanchang China 76 C3
Baihar India 82 E5
Baihe Jilin China 74 C4
Baihe Shaanxi China 77 F1
Baiji Iraq see Bayjī

▶Baikal, Lake Rus. Fed. 72 J2
 Deepest lake in the world and
 2nd largest in Asia.

Baikunthpur India 83 E5
Baile Átha Cliath Ireland see Dublin
Baile Átha Luain Ireland see Athlone
Baile Mhartain U.K. 50 B3
Bāilești Romania 59 J2
Bailey Range hills Australia 109 C7
Bailianhe Shuiku resr China 77 G2
Bailieborough Ireland 51 F4
Bailleul France 52 C4
Baillie r. Canada 121 J1
Bailong China see Hadapu
Bailong Jiang r. China 76 E1

Baima Qinghai China 76 D1
Baima Xizang China see Baxoi
Baima Jian mt. China 77 H2
Baimuru P.N.G. 69 K8
Bain r. U.K. 48 G5
Bainang China see Norkyung
Bainbridge GA U.S.A. 133 C6
Bainbridge IN U.S.A. 134 B4
Bainbridge NY U.S.A. 135 H2
Bainduru India 84 B3
Baingoin China see Porong
Baini China see Yuqing
Baiona Spain 57 B2
Baiqên China 76 D1
Baiquan China 74 B3
Bā'ir Jordan 85 C4
Bā'ir, Wādī watercourse
 Jordan/Saudi Arabia 85 C4
Bairab Co l. China 83 E2
Bairat India 82 D4
Baird U.S.A. 131 D5
Baird Mountains U.S.A. 118 C3

▶Bairiki Kiribati 150 H5
 Capital of Kiribati, on Tarawa atoll.

Bairin Youqi China see Daban
Bairnsdale Australia 112 C6
Baisha Chongqing China 76 D2
Baisha Hainan China 77 F5
Baisha Sichuan China 77 F2
Baishan Guangxi China see Mashan
Baishan Jilin China 74 B4
Baishan Jilin China see Baishanzhen
Baishanzhen China 74 B4
Baishui Shaanxi China 77 F1
Baishui Sichuan China 76 E1
Baishui Jiang r. China 76 E1
Baisogala Lith. 45 M9
Baitadi Nepal 82 E3
Baitang China 76 C1
Bai Thương Vietnam 70 D3
Baixi China see Yibin
Baiyashi China see Dong'an
Baiyin China 72 I5
Baiyü China 76 C2
Baiyuda Desert Sudan 86 D6
Baja Hungary 58 H1
Baja, Punta pt Mex. 127 E7
Baja California pen. Mex. 127 E7
Baja California state Mex. 127 E7
Baja California Norte state Mex. see
 Baja California
Baja California Sur state Mex. 127 E8
Bajan Mex. 131 C7
Bajau i. Indon. 71 D7
Bajaur reg. Pak. 89 H3
Bajawa Indon. 108 C2
Baj Baj India 83 G5
Bäjgīrān Iran 88 E2
Bājil Yemen 86 F7
Bajo Caracoles Arg. 144 B7
Bajoga Nigeria 96 E3
Bajoi China 76 D2
Bajrakot India 83 F5
Bakala Cent. Afr. Rep. 97 F4
Bakanas Kazakh. 80 E3
Bakar Pak. 89 H5
Bakel Senegal 96 B3
Baker CA U.S.A. 128 E4
Baker ID U.S.A. 126 E3
Baker LA U.S.A. 131 F6
Baker MT U.S.A. 126 G3
Baker NV U.S.A. 129 F2
Baker OR U.S.A. 126 D3
Baker WV U.S.A. 135 F4
Baker, Mount vol. U.S.A. 126 C2
Baker Butte mt. U.S.A. 129 H4

▶Baker Island terr. N. Pacific Ocean 107 I1
 United States Unincorporated Territory.

Baker Island U.S.A. 120 C4
Baker Lake salt flat Australia 109 D6
Baker Lake Canada 121 M1
Baker Lake l. Canada 121 M1
Baker's Dozen Islands Canada 122 F2
Bakersfield U.S.A. 128 D4
Bakersville U.S.A. 132 D4
Bā Kêv Cambodia 71 D4
Bakhardok Turkm. see Bokurdak
Bākharz mts Iran 89 F3
Bakhasar India 82 B4
Bakhirevo Rus. Fed. 74 C2
Bakhmach Ukr. 43 G6
Bakhma Dam Iraq see Bēkma, Sadd
Bakhmut Ukr. see Artemivs'k
Bākhtarān Iran see Kermānshāh
Bakhtegan, Daryācheh-ye l. Iran 88 D4
Bakhtiari Country reg. Iran 88 C3
Bakı Azer. see Baku
Baki 98 E2
Bakırköy Turkey 59 M4
Bakkejord Norway 44 K2
Bakloh India 82 C2
Bako Eth. 98 D3
Bakongan Indon. 71 B7
Bakouma Cent. Afr. Rep. 98 C3
Baksan Rus. Fed. 91 F2

▶Baku Azer. 91 H2
 Capital of Azerbaijan.

Baku Dem. Rep. Congo 98 D3
Bakutis Coast Antarctica 152 J2
Baky Azer. see Baku
Balā Turkey 90 D3
Bala U.K. 49 D6
Balabac i. Phil. 68 F5
Balabac Strait Malaysia/Phil. 68 F5
Baladeh Māzandarān Iran 88 C2
Baladeh Māzandarān Iran 88 C2
Baladek Rus. Fed. 74 D1
Balaghat India 82 E5
Balaghat Range hills India 84 B2
Balā Ḥowz Iran 88 E4
Balaka Malawi 99 D5
Balakān Azer. 91 G2
Balakhna Rus. Fed. 42 I4
Balakhta Rus. Fed. 72 G1
Balaklava Australia 111 B7

Balaklava Ukr. 90 D1
Balakleya Ukr. see Balakliya
Balakliya Ukr. 43 H6
Balakovo Rus. Fed. 43 J5
Bala Lake l. U.K. 49 D6
Balaman India 82 E4
Balan India 82 B4
Balanda Rus. Fed. see Kalininsk
Balanda r. Rus. Fed. 43 J6
Balan Dağı hill Turkey 59 M6
Balanga Phil. 69 G4
Balangir India see Bolangir
Balaōzen r. Kazakh./Rus. Fed. see
 Malyy Uzen'
Balarampur India see Balrampur
Balashov Rus. Fed. 43 I6
Balasore India see Baleshwar
Balaton, Lake Hungary 58 G1
Balatonboglár Hungary 58 G1
Balatonfüred Hungary 58 G1
Balbina Brazil 143 G4
Balbina, Represa de resr Brazil 143 G4
Balbriggan Ireland 51 F4
Balchik Bulg. 59 M3
Balclutha N.Z. 113 B8
Balcones Escarpment U.S.A. 131 C6
Bald Knob U.S.A. 134 E5
Bald Mountain U.S.A. 129 F3
Baldock Lake Canada 121 L3
Baldwin U.S.A. 134 E5
Baldwin FL U.S.A. 133 D6
Baldwin MI U.S.A. 134 C2
Baldwin PA U.S.A. 134 D4
Baldy Mount Canada 126 D2
Baldy Mountain hill Canada 121 K5
Baldy Peak U.S.A. 129 I5
Bale Phil. 69 G5
Bâle Switz. see Basel
Baléa Mali 96 B3
Baleares is Spain see Balearic Islands
Baleares, Islas is Spain see Balearic Islands
Baleares Insulae is Spain see
 Balearic Islands
Balearic Islands is Spain 57 G4
Balears is Spain see Balearic Islands
Balears, Illes is Spain see Balearic Islands
Baleia, Ponta da pt Brazil 145 D2
Bale Mountains National Park Eth. 98 D3
Baler Phil. 69 G3
Baleshwar India 83 F5
Balestrand Norway 45 E6
Baléyara Niger 96 D3
Balezino Rus. Fed. 41 Q4
Balfe's Creek Australia 110 D4
Balfour Downs Australia 108 C5
Balgo Australia 108 D5
Balguntay China 80 G3
Bali India 82 C4
Bali i. Indon. 108 A2
Bali, Laut sea Indon. 108 A1
Balia India see Ballia
Baliapal India 83 F5
Balige Indon. 71 B7
Baliguda India 84 D1
Balıkesir Turkey 59 L5
Balikh r. Syria/Turkey 85 D2
Balikpapan Indon. 68 F7
Balimila Reservoir India 84 D2
Bālimīn Afgh. 89 G3
Balimo P.N.G. 69 K8
Balin China 74 A2
Baling Malaysia 71 C6
Balingen Germany 47 L6
Balintore U.K. 50 F3
Bali Sea Indon. see Bali, Laut
Balk Neth. 52 F2
Balkanabat Turkm. 88 D2
Balkan Mountains Bulg./Serb. and Mont.
 59 J3
Balkassar Pak. 89 I3
Balkhash Kazakh. 80 D2

▶Balkhash, Lake Kazakh. 80 D2
 3rd largest lake in Asia.

Balkhash, Ozero l. Kazakh. see
 Balkhash, Lake
Balkuduk Kazakh. 43 J7
Ballachulish U.K. 50 D4
Balladonia Australia 109 D6
Balladoran Australia 112 D3
Ballaghaderreen Ireland 51 D4
Ballan Australia 112 B6
Ballangen Norway 44 J2
Ballantine U.S.A. 126 F3
Ballantrae U.K. 50 E5
Ballarat Australia 112 A6
Ballard, Lake salt flat Australia 109 C7
Ballarpur India 84 C2
Ballater U.K. 50 F3
Ballé Mali 96 C3
Ballena, Punta pt Chile 144 B3
Balleny Islands Antarctica 152 H2
Ballia India 83 F4
Ballina Australia 112 F2
Ballina Ireland 51 C3
Ballinafad Ireland 51 D3
Ballinalack Ireland 51 E4
Ballinamore Ireland 51 E3
Ballinasloe Ireland 51 D4
Ballindine Ireland 51 D4
Ballinger U.S.A. 131 D6
Ballinluig U.K. 50 F4
Ballinrobe Ireland 51 C4
Ballston Spa U.S.A. 135 I2
Ballybay Ireland 51 F3
Ballybrack Ireland 51 B6
Ballybunnion Ireland 51 C5
Ballycanew Ireland 51 F5
Ballycastle Ireland 51 C3
Ballycastle U.K. 51 F2
Ballyclare U.K. 51 G3
Ballyconnell Ireland 51 E3
Ballygar Ireland 51 D4
Ballygawley U.K. 51 E3
Ballygorman Ireland 51 E2
Ballyhaunis Ireland 51 D4
Ballyheige Ireland 51 C5
Ballykelly U.K. 51 E2
Ballylynan Ireland 51 E5
Ballymacmague Ireland 51 E5
Ballymahon Ireland 51 E4
Ballymena U.K. 51 F3

Ballymoney U.K. 51 F2
Ballymote Ireland 51 D3
Ballynahinch U.K. 51 G3
Ballyshannon Ireland 51 D3
Ballyteige Bay Ireland 51 F5
Ballyvaughan Ireland 51 C4
Ballyward U.K. 51 F3
Balmartin U.K. see Baile Mhartain
Balmer India see Barmer
Balmertown Canada 121 M5
Balmorhea U.S.A. 131 C6
Balochistan prov. Pak. 89 G4
Balombo Angola 99 B5
Balonne r. Australia 112 D2
Balotra India 82 C4
Balqash Kazakh. see Balkhash
Balqash Köli l. Kazakh. see Balkhash, Lake
Balrampur India 83 E4
Balranald Australia 112 A5
Balsam Lake Canada 135 F1
Balsas Brazil 143 I5
Balta Ukr. 43 F7
Baltasound U.K. 50 [inset]
Bălți Moldova 43 E7
Baltay Rus. Fed. 43 J5
Baltic U.S.A. 134 E3
Baltic Sea g. Europe 45 J9
Baltim Egypt 90 C5
Baltīm Egypt see Baltīm
Baltimore S. Africa 101 I2
Baltimore MD U.S.A. 135 G4
Baltimore PA U.S.A. 134 D4
Baltinglass Ireland 51 F5
Baltistan reg. Jammu and Kashmir 82 C2
Baltiysk Rus. Fed. 45 K9
Balu India 76 B3
Baluarte, Arroyo watercourse U.S.A. 131 D7
Baluch Ab well Iran 88 E4
Balumundam Indon. 71 B7
Balurghat India 83 G4
Balve Germany 53 H3
Balvi Latvia 45 O8
Balya Turkey 59 L5
Balykchy Kyrg. 80 E3
Balykshi Kazakh. 78 E2
Balyqshy Kazakh. see Balykshi
Bam Iran 88 E4
Bām Iran 88 E2
Bama China 76 E3
Bama Mali 96 C3
Bambari Cent. Afr. Rep. 98 C3
Bambel Indon. 71 B7
Bamberg Germany 53 K5
Bamberg U.S.A. 133 D5
Bambili Dem. Rep. Congo 98 C3
Bambio Cent. Afr. Rep. 98 B3
Bamboesberg mts S. Africa 101 H6
Bamboo Creek Australia 108 C5
Bambouti Cent. Afr. Rep. 98 C3
Bambuí Brazil 145 B3
Bamda China 76 C2
Bamenda Cameroon 96 E4
Bāmīān Afgh. 89 G3
Bamiantong China see Muling
Bamingui Cent. Afr. Rep. 98 B3
Bamingui-Bangoran, Parc National du
 nat. park Cent. Afr. Rep. 98 B3
Bāmnak Cambodia 71 D4
Bamnet Narong Thai. 70 C4
Bamor India 82 D4
Bamori India 84 C1
Bam Posht reg. Iran 89 F5
Bam Posht, Kūh-e mts Iran 89 F5
Bampton U.K. 49 D8
Bampūr Iran 89 F5
Bampūr watercourse Iran 89 F5
Bamrūd Iran 89 F3
Bam Tso l. China 83 G3
Bamyili Australia 108 F3
Banaba i. Kiribati 107 G2
Banabuiu, Açude resr Brazil 143 K5
Bañados del Izozog swamp Bol. 142 F7
Banagher Ireland 51 E4
Banalia Dem. Rep. Congo 98 C3
Banamana, Lagoa l. Moz. 101 K2
Banamba Mali 96 C3
Banámichi Mex. 127 F7
Banana Australia 110 E5
Bananal, Ilha do i. Brazil 143 H6
Bananga India 71 A6
Banapur India 84 E2
Banas r. India 82 D4
Banaz Turkey 59 M5
Ban Ban Laos 70 C3
Banbar China see Domartang
Ban Bo Laos 70 C3
Banbridge U.K. 51 F3
Ban Bua Chum Thai. 70 C4
Ban Bua Yai Thai. 70 C4
Ban Bungxai Laos 70 D4
Banbury U.K. 49 F6
Ban Cang Vietnam 70 C2
Banchory U.K. 50 G3
Bancroft Canada 135 G1
Bancroft Zambia see Chililabombwe
Banda Dem. Rep. Congo 98 C3
Banda India 82 E4
Banda, Kepulauan is Indon. 69 H7
Banda, Laut sea Indon. 69 H8
Banda Banda, Mount Australia 112 F3
Banda Daud Shah Pak. 89 H3
Bandahara, Gunung mt. Indon. 71 B7
Bandama r. Côte d'Ivoire 96 C4
Bandān Kūh mts Iran 89 F4
Bandanaira Indon. see Machilipatnam
Bandar Moz. 99 D5
Bandar Abbas Iran see Bandar-e 'Abbās
Bandarban Bangl. 83 H5
Bandar-e 'Abbās Iran 88 E5
Bandar-e Deylam Iran 88 C4
Bandar-e Emām Khomeynī Iran 88 C4
Bandar-e Lengeh Iran 88 D5

Bandar-e Ma'shur Iran 88 C4
Bandar-e Nakhīlū Iran 88 D5
Bandar-e Pahlavī Iran see Bandar-e Anzalī
Bandar-e Shāh Iran see
 Bandar-e Torkeman
Bandar-e Shāhpūr Iran see
 Bandar-e Emām Khomeynī
Bandar-e Shīū' Iran 88 D5
Bandar-e Torkeman Iran 88 D2
Bandar Labuan Malaysia see Labuan
Bandar Lampung Indon. 68 D8
Bandarpunch mt. India 82 D3

▶Bandar Seri Begawan Brunei 68 E6
 Capital of Brunei.

Banda Sea sea Indon. see Banda, Laut
Band-e Amīr I. Afgh. 89 G3
Band-e Amīr, Daryā-ye r. Afgh. 89 G2
Band-e Bābā mts Afgh. 89 F3
Bandeira Brazil 145 C1
Bandeirante Brazil 145 A1
Bandeiras, Pico de mt. Brazil 145 C3
Bandelierkop S. Africa 101 I2
Banderas Mex. 131 B6
Banderas, Bahía de b. Mex. 136 C4
Band-e Sar Qom Iran 88 D3
Band-e Torkestān mts Afgh. 89 F3
Bandhi Pak. 89 H5
Bandhogarh India 82 E5
Bandi r. India 82 C4
Bandiagara Mali 96 C3
Bandikui India 82 D4
Bandipur National Park India 84 C4
Bandırma Turkey 59 L4
Bandjarmasin Indon. see Banjarmasin
Bandon Ireland 51 D6
Bandon r. Ireland 51 D6
Ban Don Thai. see Surat Thani
Bandon U.S.A. 126 B4
Band Qīr Iran 88 C4
Bandra India 84 B2
Bandundu Dem. Rep. Congo 98 B4
Bandung Indon. 68 D8
Bandya Australia 109 C6
Bāneh Iran 88 B3
Banera India 82 C4
Banes Cuba 137 I4
Banff Canada 120 H5
Banff U.K. 50 G3
Banff National Park Canada 120 G5
Banfora Burkina 96 C3
Banga Dem. Rep. Congo 99 C4
Bangalore India 84 C3
Bangalow Australia 112 F2
Bangar Brunei 68 F6
Bangassou Cent. Afr. Rep. 98 C3
Bangdag Co salt l. China 83 E2
Banggai Indon. 69 G7
Banggai, Kepulauan is Indon. 69 G7
Banggi i. Malaysia 68 F5
Banghāzī Libya see Benghazi
Banghiang, Xé r. Laos 70 D3
Bangka i. Indon. 68 D7
Bangka, Selat sea chan. Indon. 68 D7
Bangkalan Indon. 68 E8
Bangkaru i. Indon. 71 B7
Bangko Indon. 68 C7

▶Bangkok Thai. 71 C4
 Capital of Thailand.

Bangkok, Bight of b. Thai. 71 C4
Bangkor China 83 F3
Bangla state India see West Bengal
▶Bangladesh country Asia 83 G4
 Asia 6, 62–63

Bangma Shan mts China 76 C4
Bang Mun Nak Thai. 70 C3
Ba Ngoi Vietnam 71 E5
Bangolo Côte d'Ivoire 96 C4
Bangong Co salt l.
 China/Jammu and Kashmir 82 D2
Bangor Northern Ireland U.K. 51 G3
Bangor Wales U.K. 48 C5
Bangor ME U.S.A. 132 G2
Bangor MI U.S.A. 134 B2
Bangor PA U.S.A. 135 H3
Bangor Erris Ireland 51 C3
Bangs, Mount U.S.A. 129 G3
Bang Saphan Yai Thai. 71 B5
Bangsund Norway 44 G4
Bangued Phil. 69 G3

▶Bangui Cent. Afr. Rep. 98 B3
 Capital of Central African Republic.

Bangweulu, Lake Zambia 99 C5
Banhā Egypt 90 C5
Banhine, Parque Nacional de nat. park
 Moz. 101 K2
Ban Hin Heup Laos 70 C3
Ban Houei Sai Laos see Huayxay
Ban Huai Khon Thai. 70 C3
Ban Huai Yang Thai. 71 B5
Bani, Jbel ridge Morocco 54 C5
Bania Cent. Afr. Rep. 98 B3
Bani-Bangou Niger 96 D3
Banifing r. Mali 96 C3
Banī Forūr, Jazīreh-ye i. Iran 88 D5
Banihal Pass and Tunnel
 Jammu and Kashmir 82 C2
Banister r. U.S.A. 134 F5
Banī Suwayf Egypt 90 C5
Banī Walīd Libya 97 E1
Banī Wuṭayfān well Saudi Arabia 88 C5
Bāniyās Al Qunayṭirah Syria 85 B3
Bāniyās Ṭarṭūs Syria 85 B2
Bani Yas U.A.E. 88 D6
Banja Luka Bos.-Herz. 58 G2
Banjarmasin Indon. 68 E7
Banjes, Liqeni i resr Albania 59 I4

▶Banjul Gambia 96 B3
 Capital of The Gambia.

Banka India 83 F4
Banka Banka Australia 108 F4
Bankapur India 84 B3
Bankass Mali 96 C3
Ban Kengkabao Laos 70 D3

Ban Khao Yoi Thai. 71 B4
Ban Khok Kloi Thai. 71 B5
Bankilaré Niger 96 D3
Banks Island *B.C.* Canada 120 D4
Banks Island *N.W.T.* Canada 118 F2
Banks Islands Vanuatu 107 G3
Banks Lake Canada 121 M2
Banks Lake U.S.A. 126 D3
Banks Peninsula N.Z. 113 D6
Banks Strait Australia 111 [inset]
Bankura India 83 F5
Ban Lamduan Thai. 71 C4
Banlai China 77 F3
Ban Mae La Luang Thai. 70 B3
Banmaw Myanmar *see* Bhamo
Banmo Myanmar *see* Bhamo
Bann *r.* Ireland 51 F5
Bann *r.* U.K. 51 F2
Ban Nakham Laos 70 D3
Banning U.S.A. 128 E5
Banningville Dem. Rep. Congo *see* Bandundu
Ban Noi Myanmar 70 B3
Ban Nong Kung Thai. 70 D3
Bannu Pak. 89 H3
Bano India 83 E5
Bañolas Spain *see* Banyoles
Ban Phai Thai. 70 C3
Ban Phôn Laos *see* Lamam
Banqiao *Yunnan* China 76 C3
Banqiao *Yunnan* China 76 E3
Bansi *Bihar* India 83 F4
Bansi *Rajasthan* India 82 C4
Bansi *Uttar Prad.* India 83 E4
Bansi *Uttar Prad.* India 83 E4
Bansihari India 83 G4
Banská Bystrica Slovakia 47 Q6
Banspani India 83 F5
Bansur India 82 D4
Ban Sut Ta Thai. 70 B3
Ban Suwan Wari Thai. 70 D4
Banswara India 82 C5
Banteer Ireland 51 D5
Ban Tha Song Yang Thai. 70 B3
Banthat *mts* Cambodia/Thai. *see* Cardamom Range
Ban Tha Tum Thai. 70 C4
Ban Tôp Laos 70 D3
Bantry Ireland 51 C6
Bantry Bay Ireland 51 C6
Bantval India 84 B3
Ban Wang Chao Thai. 70 B3
Ban Woen Laos 70 D3
Ban Xepian Laos 70 D4
Banyak, Pulau-pulau *is* Indon. 71 B7
Ban Yang Yong Thai. 71 B4
Banyo Cameroon 96 E4
Banyoles Spain 57 H2
Banyuwangi Indon. 108 A2
Banzare Coast Antarctica 152 G2
Banzare Seamount *sea feature* Indian Ocean 149 N9
Banzart Tunisia *see* Bizerte
Banzkow Germany 53 L1
Banzyville Dem. Rep. Congo *see* Mobayi-Mbongo
Bao'an China *see* Shenzhen
Baochang China 73 L4
Baocheng China 76 E1
Baoding China 73 L5
Baofeng China 77 G1
Baohe China *see* Weixi
Baoji *Shaanxi* China 76 E1
Baoji *Shaanxi* China 76 E1
Baokang *Hubei* China 77 F2
Baokang *Nei Mongol* China 74 A3
Bao Lac Vietnam 70 D2
Baolin China 74 C3
Bao Lôc Vietnam 71 D5
Baoqing China 74 D3
Baoro Cent. Afr. Rep. 98 B3
Baoshan China 76 C3
Baotou China 73 K4
Baotou Shan *mt.* China/N. Korea 74 C4
Baoulé *r.* Mali 96 C3
Baoxing China 76 D2
Baoying China 77 H1
Baoyou China *see* Ledong
Bap India 82 C4
Bapatla India 84 D3
Bapaume France 52 C4
Baptiste Lake Canada 135 F1
Bapu China *see* Meigu
Baq'a' *oasis* Saudi Arabia 91 F6
Baqbaq Egypt *see* Buqbuq
Baqên *Xizang* China 76 B1
Baqên *Xizang* China 76 B2
Baqiu China 77 G3
Ba'qūbah Iraq 91 G4
Bar Serb. and Mont. 59 H3
Bara Sudan 86 D7
Baraawe Somalia 98 E3
Bara Banki India *see* Barabanki
Barabanki India 82 E4
Baraboo U.S.A. 130 F3
Baracaju *r.* Brazil 145 A1
Baracaldo Spain *see* Barakaldo
Baracoa Cuba 137 J4
Baradá, Nahr *r.* Syria 85 C3
Baradine Australia 112 D3
Baragarh India *see* Bargarh
Barahona Dom. Rep. 137 J5
Barail Range *mts* India 83 H4
Barakaldo Spain 57 E2
Barakī Barak Afgh. 89 H3
Barakala Spain 57 E2
Bara Lacha Pass India 82 D2
Baralzon Lake Canada 121 L3
Baram India 83 F5
Baram *r.* Malaysia 68 E6
Baramati India 84 B2
Baramula India *see* Baramulla
Baramulla India 82 C2
Baran India 82 D4
Baran *r.* Pak. 89 H5
Bārān, Kūh-e *mts* Iran 89 F3
Baranavichy Belarus 45 O10
Barang, Dasht-i *des.* Afgh. 89 F3
Baranikha Rus. Fed. 65 R3

Baranīs Egypt 86 E5
Baranīs Egypt *see* Baranīs
Barannda India 82 E4
Baranof Island U.S.A. 120 C3
Baranovichi Belarus *see* Baranavichy
Baranowicze Belarus *see* Baranavichy
Baraouéli Mali 96 C3
Baraque de Fraiture *hill* Belgium 52 F4
Barasat India 83 G5
Barat Daya, Kepulauan *is* Indon. 108 D1
Baraut India 82 D3
Barbacena Brazil 145 C3
▶Barbados *country* West Indies 137 M6
North America 9, 116–117
Barbar, Gebel el *mt.* Egypt *see* Barbar, Jabal
Barbar, Jabal *mt.* Egypt 85 A5
Barbara Lake Canada 122 D4
Barbastro Spain 57 G2
Barbate de Franco Spain 57 D5
Barberton S. Africa 101 J3
Barberton U.S.A. 134 E3
Barbezieux-St-Hilaire France 56 D4
Barbour Bay Canada 121 M2
Barbourville U.S.A. 134 D5
Barboza Phil. 69 G4
Barbuda *i.* Antigua and Barbuda 137 L5
Barby (Elbe) Germany 53 L3
Barcaldine Australia 110 D4
Barce Libya *see* Al Marj
Barcelona Spain 57 H3
Barcelona Venez. 142 F1
Barcelonnette France 56 H4
Barcelos Brazil 142 F4
Barchfeld Germany 53 K4
Barcino Spain *see* Barcelona
Barclay de Tolly *atoll* Fr. Polynesia *see* Raroia
Barclayville Liberia 96 C4
Barcoo *watercourse* Australia 110 C5
Barcoo Creek *watercourse* Australia *see* Cooper Creek
Barcoo National Park Australia *see* Welford National Park
Barcs Hungary 58 G2
Bārda Azer. 91 G2
Bárðarbunga *mt.* Iceland 44 [inset]
Bardaskan Iran 88 E3
Bardawīl, Khabrat al *salt pan* Saudi Arabia 85 D4
Bardawīl, Sabkhat al *lag.* Egypt 85 A4
Barddhaman India 83 F5
Bardejov Slovakia 43 D6
Bardera Somalia *see* Baardheere
Bardhaman India *see* Barddhaman
Bardsey Island U.K. 49 C6
Bardsīr Iran 88 E4
Bardstown U.S.A. 134 C5
Barduli Italy *see* Barletta
Bardwell U.S.A. 131 F4
Bareilly India *see* Bareilly
Barellan Australia 112 C5
Barentin France 49 H9
Barentsburg Svalbard 64 C2
Barents Sea Arctic Ocean 42 I1
Barentu Eritrea 86 E6
Barfleur, Pointe de *pt* France 49 F9
Bārgāh Iran 88 D4
Bargarh India 83 E5
Barghamad Iran 88 E2
Bargrennan U.K. 50 E5
Bargteheide Germany 53 K1
Barguna Bangl. 83 G5
Barhaj India 83 E4
Barham Australia 112 B5
Bari Italy 58 G4
Bari Doab *lowland* Pak. 89 I4
Barika Alg. 54 F4
Barinas Venez. 142 D2
Baripada India 83 F5
Bariri Brazil 145 A3
Bari Sadri India 82 C4
Barisal Bangl. 83 G5
Barisan, Pegunungan *mts* Indon. 68 C7
Barito *r.* Indon. 68 E7
Barium Italy *see* Bari
Barkal Bangl. 83 H5
Barkam China 76 D2
Barkan, Ra's-e *pt* Iran 88 C4
Barkava Latvia 45 O8
Bark Lake Canada 135 G1
Barkly East S. Africa 101 H6
Barkly Homestead Australia 110 A3
Barkly-Oos S. Africa *see* Barkly East
Barkly Tableland *reg.* Australia 110 A3
Barkly-Wes S. Africa *see* Barkly West
Barkly West S. Africa 100 C5
Barkol China 80 H3
Barla Turkey 59 N5
Barlee, Lake *salt flat* Australia 109 B7
Barlee Range *hills* Australia 109 A5
Barletta Italy 58 G4
Barlow Canada 128 D2
Barlow Lake Canada 121 K2
Barmah Forest Australia 112 B5
Barmedman Australia 112 C5
Barmer India 82 B4
Barmen-Elberfeld Germany *see* Wuppertal
Barmer India 82 B4
Barm Fīrūz, Kūh-e *mt.* Iran 88 C4
Barmouth U.K. 49 C6
Barnala India 82 C3
Barnard Castle U.K. 48 F4
Barnato Australia 112 B3
Barnaul Rus. Fed. 72 J2
Barnegat Bay U.S.A. 135 H4
Barnes Icecap Canada 119 K2
Barnesville GA U.S.A. 133 D5
Barnesville MN U.S.A. 130 D2
Barneveld Neth. 52 F2
Barneville-Carteret France 49 F9
Barneys Lake *imp. l.* Australia 112 B4
Barney Top *mt.* U.S.A. 129 H3
Barnsley U.K. 48 F5
Barnstable U.S.A. 135 J3
Barnstaple U.K. 49 C7
Barnstaple Bay U.K. 49 C7
Barnstorf Germany 53 I2
Baro Nigeria 96 D4
Baroda *Gujarat* India *see* Vadodara
Baroda *Madh. Prad.* India 82 D4

Barong China 76 C2
Barons Range *hills* Australia 109 D6
Barowghil, Kowtal-e Afgh. 89 I2
Barpathar India 76 B3
Barpeta India 83 G4
Bar Pla Soi Thai. *see* Chon Buri
Barques, Point Aux U.S.A. 134 D1
Barquisimeto Venez. 142 E1
Barra Brazil 143 J6
Barra *i.* U.K. 50 B4
Barra, Ponta da *pt* Moz. 101 L2
Barra, Sound of *sea chan.* U.K. 50 B3
Barraba Australia 112 E3
Barra Bonita Brazil 145 A3
Barracão do Barreto Brazil 143 G5
Barra do Bugres Brazil 143 G7
Barra do Corda Brazil 143 I5
Barra do Cuieté Brazil 145 C2
Barra do Garças Brazil 143 H7
Barra do Piraí Brazil 145 C3
Barra do São Manuel Brazil 143 G5
Barra do Turvo Brazil 145 A4
Barra Falsa, Ponta da *pt* Moz. 101 L2
Barraigh *i.* U.K. *see* Barra
Barra Mansa Brazil 145 B3
Barranca Peru 142 C4
Barrancas Arg. 144 E3
Barranquilla Col. 142 D1
Barre MA U.S.A. 135 I2
Barre VT U.S.A. 135 I1
Barre des Ecrins *mt.* France 56 H4
Barreiras Brazil 143 J6
Barreirinha Brazil 143 G4
Barreirinhas Brazil 143 J4
Barreiro Port. 57 B4
Barreiros Brazil 143 K5
Barren Island India 71 A4
Barren Island Kiribati *see* Starbuck Island
Barren River Lake U.S.A. 134 B5
Barretos Brazil 145 A3
Barrett, Mount *hill* Australia 108 D4
Barrhead Canada 120 H4
Barrhead U.K. 50 E5
Barrie Canada 134 F1
Barrier Bay Antarctica 152 E2
Barrière Canada 120 F5
Barrier Range *hills* Australia 111 C6
Barrington Canada 123 I6
Barrington, Mount Australia 112 E4
Barrington Tops National Park Australia 112 E4
Barringun Australia 112 B2
Barro Alto Brazil 145 A1
Barron U.S.A. 130 F2
Bar-row U.S.A. 118 C2
Barrow *r.* Ireland 51 F5
Barrow, Point U.S.A. 118 C2
Barrow Creek Australia 108 F5
Barrow-in-Furness U.K. 48 D4
Barrow Island Australia 108 A5
Barrow Range *hills* Australia 109 D6
Barrow Strait Canada 119 I2
Barr Smith Range *hills* Australia 109 C6
Barry U.K. 49 D7
Barrydale S. Africa 100 E7
Barry Mountains Australia 112 C6
Barrys Bay Canada 135 G1
Barryville U.S.A. 135 H3
Barsalpur India 82 C3
Barshatas Kazakh. 80 E2
Barshi India *see* Barsi
Barsi India 84 B2
Barsur India 84 D2
Bar-sur-Aube France 56 G2
Barstow U.S.A. 128 E4
Barth Germany 47 N3
Bartica Guyana 143 G2
Bartın Turkey 90 D2
Bartle Frere, Mount Australia 110 D3
Bartlett U.S.A. 130 D3
Bartlett Reservoir U.S.A. 129 H5
Barton U.S.A. 135 I1
Barton-upon-Humber U.K. 48 G5
Bartoszyce Poland 47 R3
Bartow U.S.A. 133 D7
Barú, Volcán *vol.* Panama 137 H7
Barung *i.* Indon. 68 E8
Barunga Australia *see* Bamyili
Barun-Torey, Ozero *l.* Rus. Fed. 73 L2
Barus Indon. 71 B7
Baruunturuun Mongolia 80 H2
Baruun-Urt Mongolia 73 K3
Baruva India 82 C5
Barwani India 82 C5
Barwéli Mali *see* Baraouéli
Barwon *r.* Australia 112 C3
Barygaza India *see* Bharuch
Barysaw Belarus 45 P9
Barysh Rus. Fed. 43 J5
Basaga Turkm. 89 G2
Basak, Tônlé *r.* Cambodia 71 D5
Basalt *r.* Australia 110 D3
Basalt U.S.A. 128 E2
Basankusu Dem. Rep. Congo 98 B3
Basar India 84 C2
Basarabi Romania 59 M2
Basargechar Armenia *see* Vardenis
Bascuñán, Cabo *c.* Chile 144 B3
Basel Switz. 56 H3
Bashäkerd, Kühhä-ye *mts* Iran 88 E5
Bashanta Rus. Fed. *see* Gorodovikovsk
Bashaw Canada 121 H4
Bashee *r.* S. Africa 101 I7
Bāshī Iran 88 C4
Bashi Channel Phil./Taiwan 69 G2
Bashmakovo Rus. Fed. 43 I5
Bāshtī Iran 88 C4
Bashtanka Ukr. 43 G7
Basi *Punjab* India 82 D3
Basi *Rajasthan* India 82 C4
Basia India 83 F5
Basilan *i.* Phil. 69 G5
Basildon U.K. 49 H7
Basile, Pico *mt.* Equat. Guinea 96 D4
Basin U.S.A. 126 F3
Basingstoke U.K. 49 F7
Basin Lake Canada 121 J4
Basirhat India 83 G5

Basīṭ, Ra's al *pt* Syria 85 B2
Başkale Turkey 91 G3
Battura Glacier Jammu and Kashmir 82 C1
Baskatong, Réservoir *resr* Canada 122 G5
Baskerville, Cape Australia 108 C4
Başkomutan Tarihi Milli Parkı *nat. park* Turkey 59 N5
Başköy Turkey 85 A1
Baskunchak, Ozero *l.* Rus. Fed. 43 J6
Basle Switz. *see* Basel
Basmat India 84 C2
Basoko Dem. Rep. Congo 98 C3
Basra Iraq *see* Al Başrah
Bassano Canada 121 H5
Bassano del Grappa Italy 58 D2
Bassar Togo 96 D4
Bassas da India *reef* Indian Ocean 99 D6
Bassas de Pedro Padua Bank *sea feature* India 84 B3
Bassein Myanmar 70 A3
Bassein *r.* Myanmar 70 A3
Basse-Normandie *admin. reg.* France 49 F9
Bassenthwaite Lake U.K. 48 D4
Basse Santa Su Gambia 96 B3
▶Basse-Terre Guadeloupe 137 L5
Capital of Guadeloupe.

▶Basseterre St Kitts and Nevis 137 L5
Capital of St Kitts and Nevis.

Bassett *NE* U.S.A. 130 D3
Bassett *VA* U.S.A. 134 F5
Bassikounou Mauritania 96 C3
Bass Rock *i.* U.K. 50 G4
Bassum Germany 53 I2
Basswood Lake Canada 122 C4
Båstad Sweden 45 H8
Bastānābād Iran 88 B2
Bastheim Germany 53 K4
Basti India 83 E4
Bastia *Corsica* France 56 I5
Bastiões *r.* Brazil 143 K5
Bastogne Belgium 52 F4
Bastrop *LA* U.S.A. 131 F5
Bastrop *TX* U.S.A. 131 D6
Basul *r.* Pak. 89 G5
Basuo China *see* Dongfang
Basutoland *country* Africa *see* Lesotho
Başyayla Turkey 85 A1
Bata Equat. Guinea 96 D4
Batabanó, Golfo de *b.* Cuba 137 H4
Batagay Rus. Fed. 65 O3
Batala India 82 C3
Batalha Port. 57 B4
Batam *i.* Indon. 71 D7
Batamay Rus. Fed. 65 N3
Batamshinskiy Kazakh. 80 A1
Batamshy Kazakh. *see* Batamshinskiy
Batan *Jiangsu* China 77 I1
Batan *Qinghai* China 76 D1
Batan *i.* Phil. 69 G2
Batang China 76 C2
Batangafo Cent. Afr. Rep. 98 B3
Batangas Phil. 69 G4
Batangtoru Indon. 71 B7
Batan Islands Phil. 69 G2
Batavia Indon. *see* Jakarta
Batavia *NY* U.S.A. 135 F2
Batavia *OH* U.S.A. 134 C4
Batavsk Rus. Fed. 43 H7
Batchawana Mountain *hill* Canada 122 D5
Bätdâmbâng Cambodia 71 C4
Bateemeucica, Gunung *mt.* Indon. 71 A6
Batéké, Plateau Congo 98 B4
Batemans Bay Australia 112 E5
Bates Range *hills* Australia 109 C6
Batesville *AR* U.S.A. 131 F5
Batesville *IN* U.S.A. 134 C4
Batesville *MS* U.S.A. 131 F5
Batetskiy Rus. Fed. 42 F4
Bath *N.B.* Canada 123 I5
Bath *Ont.* Canada 135 G1
Bath U.K. 49 E7
Bath *ME* U.S.A. 135 K2
Bath *NY* U.S.A. 135 G2
Bath *PA* U.S.A. 135 H3
Batha *watercourse* Chad 97 E3
Bathgate U.K. 50 F5
Bathinda India 82 C3
Bathurst Australia 112 D4
Bathurst Canada 123 I5
Bathurst Gambia *see* Banjul
Bathurst S. Africa 101 H7
Bathurst, Cape Canada 118 F2
Bathurst, Lake Australia 112 D5
Bathurst Inlet Canada 118 H3
Bathurst Inlet *inlet* Canada 118 H3
Bathurst Island Australia 108 E2
Bathurst Island Canada 119 I2
Bathyz Döwlet Gorugy *nature res.* Turkm. 89 F3
Batié Burkina 96 C4
Batı Menteşe Dağları *mts* Turkey 59 L6
Batı Toroslar *mts* Turkey 59 N6
Batken Kyrg. 80 D4
Batkes Indon. 108 E1
Bāţlāq-e Gavkhūnī *marsh* Iran 88 D3
Batley U.K. 48 F5
Batlow Australia 112 D5
Batman Turkey 91 F3
Batna Alg. 54 F4
Batok, Bukit *hill* Sing. 71 [inset]

▶Baton Rouge U.S.A. 131 F6
State capital of Louisiana.

Batopilas Mex. 127 G8
Batouri Cameroon 97 E4
Batrā' *tourist site* Jordan *see* Petra
Batrā', Jabal al *mt.* Jordan 85 B5
Batroûn Lebanon 85 B2
Båtsfjord Norway 44 P1
Battambang Cambodia *see* Bätdâmbâng
Batticaloa Sri Lanka 84 D5
Batti Malv *i.* India 71 A5
Battipaglia Italy 58 F4
Battle *r.* Canada 121 I4
Battle Creek U.S.A. 134 C2
Battleford Canada 121 I4
Battle Mountain U.S.A. 128 E1

Battle Mountain *mt.* U.S.A. 128 E1
Batu, Eth. 98 D3
Batu, Pulau-pulau *is* Indon. 68 B7
Batu Gajah Malaysia 71 C7
Batu Putih, Gunung *mt.* Malaysia 71 C6
Baturaja Indon. 68 C7
Baturité Brazil 143 K4
Baturin Ukr. 43 G6
Batyrevo Rus. Fed. 43 J5
Batys Qazaqstan *admin. div.* Kazakh. *see* Zapadnyy Kazakhstan
Bau *Sarawak* Malaysia 68 E6
Baubau Indon. 69 G8
Baucau East Timor 108 D2
Bauchi Nigeria 96 D3
Bauda India *see* Boudh
Bauda U.S.A. 130 E1
Baudh India *see* Boudh
Baugé France 56 D3
Bauhinia Australia 110 E5
Baukau East Timor *see* Baucau
Bauld, Cape Canada 123 L4
Baume-les-Dames France 56 H3
Baunach *r.* Germany 53 K5
Baundal India 82 C2
Baura Bangl. 83 G4
Bauru Brazil 145 A3
Bausendorf Germany 52 G4
Bauska Latvia 45 N8
Bautino Kazakh. 91 H1
Bautzen Germany 47 O5
Bāvānāt Iran 88 D4
Bavaria *reg.* Germany *see* Bayern
Bavaria *reg.* Germany 53 L6
Bavda India 84 B2
Baviaanskloofberge *mts* S. Africa 100 F7
Bavispe *r.* Mex. 127 F7
Bavla India 82 C5
Bavly Rus. Fed. 41 Q5
Baw Myanmar 70 A2
Bawal India 82 D3
Baw Baw National Park Australia 112 C6
Bawdeswell U.K. 49 I6
Bawean *i.* Indon. 68 E8
Bawinkel Germany 53 H2
Bawlake Myanmar 70 B3
Bawolung China 76 D2
Baxi China 76 D1
Baxley U.S.A. 133 D6
Baxoi China 76 C2
Baxter Mountain U.S.A. 129 I3
Bay China *see* Baicheng
Bayamo Cuba 137 I4
Bayamón Puerto Rico 137 K5
Bayan *Heilong.* China 74 B3
Bayan *Qinghai* China 76 C1
Bayan Mongolia 73 K3
Bayana India 82 D4
Bayanaul Kazakh. 80 E1
Bayanbulak Mongolia 80 I2
Bayanbulak China 80 F3
Bayanday Rus. Fed. 72 J2
Bayan Gol China *see* Dengkou
Bayan Har Shan *mts* China 76 B1
Bayan Har Shankou *pass* China 76 C1
Bayanhongor Mongolia 80 J2
Bayan Hot China 72 J5
Bayan Mod China 72 I4
Bayan Obo China 73 J4
Bayan-Ovoo Mongolia 80 H3
Bayan Ul Hot China 73 L4
Bayard U.S.A. 129 I5
Bayasgalant Mongolia 73 K3
Bayat Turkey 59 N5
Bayāz Iran 88 E4
Baybay Phil. 69 G4
Bayboro U.S.A. 133 E5
Bayburt Turkey 91 F2
Bay Canh, Hon *i.* Vietnam 71 D5
Bay City *MI* U.S.A. 134 D2
Bay City *TX* U.S.A. 131 D6
Baydaratskaya Guba *b.* Rus. Fed. 64 H3
Baydhabo Somalia 98 E3
Bayerischer Wald *mts* Germany 53 M5
Bayerischer Wald *nat. park* Germany 53 M5
Bayern *reg.* Germany 53 L6
Bayer Wald, Nationalpark *nat. park* Germany 47 N6
Bayeux France 49 G9
Bayfield Canada 134 E2
Bayındır Turkey 59 L5
Bay Islands *is* Hond. *see* La Bahía, Islas de
Bayizhen China 76 B2
Bayjī Iraq 91 F4
Baykal, Ozero *l.* Rus. Fed. *see* Baikal, Lake
Baykal-Amur Magistral Rus. Fed. 74 C1
Baykal Range *mts* Rus. Fed. *see* Baykal'skiy Khrebet
Baykal'skiy Khrebet *mts* Rus. Fed. 73 J2
Baykan Turkey 91 F3
Bay-Khaak Rus. Fed. 80 H1
Baykibashevo Rus. Fed. 41 R4
Baykonur Kazakh. 80 B2
Baykonyr Kazakh. *see* Baykonur
Baymak Rus. Fed. 64 G4
Bay Minette U.S.A. 133 C6
Bayna'un'h Iran U.A.E. 88 D6
Bayona Spain *see* Baiona
Bayonne France 56 D5
Bayonne U.S.A. 135 H3
Bay Port U.S.A. 134 D2
Bayqongyr Kazakh. *see* Baykonyr
Bayram-Ali Turkm. *see* Bayramaly
Bayramaly Turkm. 89 F2
Bayramiç Turkey 59 L5
Bayreuth Germany 53 L5
Bayrūt Lebanon *see* Beirut
Bays, Lake of Canada 134 F1
Bayshore U.S.A. 134 C1
Bay Shore U.S.A. 135 I3
Bay Springs U.S.A. 131 F6
Bayston U.K. 49 E6
Baysun Uzbek. *see* Boysun
Baytown U.S.A. 131 E6
Bay View N.Z. 113 F4
Battle Mountain U.S.A. 128 E1

Bayy al Kabīr, Wādī *watercourse* Libya 97 E1
Baza Spain 57 E5
Baza, Sierra de *mts* Spain 57 E5
Bäzärak 89 G3
Bazardüzü Dağı *mt.* Azer./Rus. Fed. *see* Bazardyuzyu, Gora
Bazardyuzyu, Gora *mt.* Azer./Rus. Fed. 91 G2
Bāzār-e Māsāl Iran 88 C2
Bazarnyy Karabulak Rus. Fed. 43 J5
Bazaruto, Ilha do *i.* Moz. 99 D6
Bazdar Pak. 89 G5
Bazhong China 76 E2
Bazhou China *see* Bazhong
Bazin *r.* Canada 122 G5
Bazmān Iran 89 F5
Bazmān, Kūh-e *mt.* Iran 89 F4
Bcharré Lebanon 85 C2
Be, Sông *r.* Vietnam 71 D5
Beach U.S.A. 130 C2
Beachy Head *hd* U.K. 49 H8
Beacon U.S.A. 135 I3
Beacon Bay S. Africa 101 H7
Beaconsfield U.K. 49 G7
Beagle, Canal *sea chan.* Arg. 144 C8
Beagle Bank *reef* Australia 108 C3
Beagle Bay Australia 108 C4
Beagle Gulf Australia 108 E3
Bealanana Madag. 99 E5
Béal an Átha Ireland *see* Ballina
Béal Átha na Sluaighe Ireland *see* Ballinasloe
Beale, Cape India 84 B2
Beaminster U.K. 49 E8
Bear *r.* U.S.A. 126 E4
Bearalváhki Norway *see* Berlevåg
Bear Cove Point Canada 121 O2
Beardmore Canada 122 D4
Beardmore Glacier Antarctica 152 H1
Bear Island Arctic Ocean *see* Bjørnøya
Bear Island Canada 122 E4
Bear Island Ireland 51 C6
Bear Lake *l.* Canada 122 A3
Bear Lake U.S.A. 134 B1
Bear Lake *l.* U.S.A. 126 F4
Bearma *r.* India 82 D4
Bear Mountain U.S.A. 130 C3
Bearnaraigh *i.* U.K. *see* Berneray
Bear Paw Mountain U.S.A. 126 F2
Bearpaw Mountains U.S.A. 126 F2
Bearskin Lake Canada 121 N4
Beas Dam India 82 C3
Beata, Cabo *c.* Dom. Rep. 137 J5
Beatrice U.S.A. 130 D3
Beatrice, Cape Australia 110 B2
Beatton *r.* Canada 120 F3
Beatton River Canada 120 F3
Beatty U.S.A. 128 E3
Beattyville Canada 122 F4
Beattyville U.S.A. 134 D5
Beaucaire France 56 G5
Beauchene Island Falkland Is 144 E8
Beaufort Australia 112 A6
Beaufort *NC* U.S.A. 133 E5
Beaufort *SC* U.S.A. 133 D5
Beaufort Island *H.K.* China 77 [inset]
Beaufort Sea Canada/U.S.A. 118 D2
Beaufort West S. Africa 100 F7
Beaulieu *r.* Canada 121 I2
Beauly U.K. 50 E3
Beauly *r.* U.K. 50 E3
Beaumaris U.K. 48 C5
Beaumont Belgium 52 E4
Beaumont N.Z. 113 B7
Beaumont *MS* U.S.A. 131 F6
Beaumont *TX* U.S.A. 131 E6
Beaune France 56 G3
Beaupréau France 56 D3
Beauquesne France 52 C4
Beauraing Belgium 52 E4
Beauséjour Canada 121 L5
Beauvais France 52 C5
Beauval France 52 C4
Beaver *r. Alberta/Saskatchewan* Canada 121 I4
Beaver *r.* Ont. Canada 122 D3
Beaver *r.* Y.T. Canada 120 E3
Beaver *OK* U.S.A. 131 C4
Beaver *PA* U.S.A. 134 E3
Beaver *UT* U.S.A. 129 G2
Beaver *r.* U.S.A. 129 G2
Beaver Creek Canada 153 A2
Beavercreek U.S.A. 134 C4
Beaver Creek *r. MT* U.S.A. 130 B1
Beaver Creek *r. ND* U.S.A. 130 C2
Beaver Dam *KY* U.S.A. 134 B5
Beaver Dam *WI* U.S.A. 130 F3
Beaver Falls U.S.A. 134 E3
Beaverhead Mountains U.S.A. 126 E3
Beaverhill Lake *Alta* Canada 121 H4
Beaverhill Lake *l.* Canada 121 M4
Beaverhill Lake *N.W.T.* Canada 121 J2
Beaver Island U.S.A. 132 C2
Beaverlodge Canada 120 G4
Beaverton Canada 134 F1
Beaverton *MI* U.S.A. 134 C2
Beaverton *OR* U.S.A. 126 C3
Beawar India 82 C4
Beazley Arg. 144 C4
Bebedouro Brazil 145 A3
Bebington U.K. 48 D5
Bebra Germany 53 J4
Bêca China 76 C2
Bécard, Lac *l.* Canada 123 G1
Beccles U.K. 49 I6
Bečej Serb. and Mont. 59 I2
Becerreá Spain 57 C2
Béchar Alg. 54 D5
Bechhofen Germany 53 K5
Beckingen Germany 52 G5
Beckley U.S.A. 134 E5
Beckum Germany 53 I3
Becky Peak U.S.A. 129 F2
Bečov nad Teplou Czech Rep. 53 M4
Bedale U.K. 48 F4
Bedburg Germany 52 G4
Bedelê Eth. 98 D3
Bedford *N.S.* Canada 123 J5
Bedford *Que.* Canada 135 I1
Bedford *E. Cape* S. Africa 101 H7
Bedford *Kwazulu-Natal* S. Africa 101 J5
Bedford U.K. 49 G6

Bedford *IN* U.S.A. 134 B4
Bedford *KY* U.S.A. 134 C4
Bedford *PA* U.S.A. 135 F3
Bedford *VA* U.S.A. 134 F5
Bedford, Cape Australia 110 D2
Bedford Downs Australia 108 D4
Bedgerebong Australia 112 C4
Bedi India 82 B5
Bedla India 82 B4
Bedlington U.K. 48 F3
Bedok Sing. 71 [inset]
Bedok Jetty Sing. 71 [inset]
Bedok Reservoir Sing. 71 [inset]
Bedou China 77 F3
Bedourie Australia 110 B5
Bedum Neth. 52 G1
Bedworth U.K. 49 F6
Beechworth Australia 112 C6
Beecroft Peninsula Australia 112 E5
Beechy Canada 121 J5
Beed India *see* Bid
Beelitz Germany 53 M2
Beenleigh Australia 112 F1
Beernem Belgium 52 D3
Beersheba Israel 85 B4
Be'ér Sheva' Israel *see* Beersheba
Be'ér Sheva' *watercourse* Israel 85 B4
Beervlei Dam S. Africa 100 F7
Beerwah Australia 112 F1
Beetaloo Australia 108 F4
Beethoven Peninsula Antarctica 152 L2
Beeville U.S.A. 131 D6
Befori Dem. Rep. Congo 98 C3
Beg, Lough *l.* U.K. 51 F3
Bega Australia 112 D6
Begari *r.* Pak. 89 H4
Begicheva, Ostrov *i.* Rus. Fed. *see*
 Bol'shoy Begichev, Ostrov
Begur, Cap de *c.* Spain 57 H3
Begusarai India 83 F4
Béhague, Pointe *pt* Fr. Guiana 143 H3
Behbehän Iran 88 C4
Behrendt Mountains Antarctica 152 L2
Behrūsī Iran 88 D4
Behshahr Iran 88 D2
Behsūd Afgh. 89 G3
Bei'an China 74 B2
Bei'ao China *see* Dongtou
Beibei China 76 E2
Beichuan China 76 E2
Beida Libya *see* Al Baydā'
Beigang Taiwan *see* Peikang
Beiguan China *see* Anyang
Beihai China 77 F4
Bei Hulsan Hu *salt l.* China 83 H1

►Beijing China 73 L5
 Capital of China.

Beijing *municipality* China 73 L4
Beik Myanmar *see* Myeik
Beilen Neth. 52 G2
Beiliu China 77 F4
Beilngries Germany 53 L5
Beiluheyan China 76 B1
Beinn an Oir *hill* U.K. 50 D5
Beinn an Tuirc *hill* U.K. 50 D5
Beinn Bheigeir *hill* U.K. 50 C5
Beinn Bhreac *hill* U.K. 50 D4
Beinn Dearg *mt.* U.K. 50 E3
Beinn Heasgarnich *mt.* U.K. 50 E4
Beinn Mholach *hill* U.K. 50 C2
Beinn Mhòr *hill* U.K. 50 B3
Beinn na Faoghla *i.* U.K. *see* Benbecula
Beipan Jiang *r.* China 76 E3
Beipiao China 73 M4
Beira Moz. 99 D5

►Beirut Lebanon 85 B3
 Capital of Lebanon.

Bei Shan *mts* China 80 I3
Beitbridge Zimbabwe 99 C6
Beith U.K. 50 E5
Beit Jālā West Bank 85 B4
Beja Port. 57 C4
Béja Tunisia 58 C6
Bejaïa Alg. 57 I5
Béjar Spain 57 D3
Beji *r.* Pak. 89 H4
Bekaa *valley* Lebanon *see* El Béqaa
Békés Hungary 59 I1
Békéscsaba Hungary 59 I1
Bekily Madag. 99 E6
Bekkai Japan 74 G4
Bëkma, Sadd *dam* Iraq 91 G3
Bekovo Rus. Fed. 43 I5
Bekwai Ghana 96 C4
Belá India 83 E4
Bela Pak. 89 G5
Belab *r.* Pak. 89 H4
Bela-Bela S. Africa 101 I3
Bélabo Cameroon 96 E4
Bela Crkva Serb. and Mont. 59 I2
Bel Air U.S.A. 135 G4
Belalcázar Spain 57 D4
Bělá nad Radbuzou Czech Rep. 53 M5
Belapur India 84 B2
►Belarus *country* Europe 43 E5
 Europe 5, 38–39
Belau *country* N. Pacific Ocean *see* Palau
Bela Vista Brazil 144 E2
Bela Vista Moz. 101 K4
Bela Vista de Goiás Brazil 145 A2
Belawan Indon. 71 B7
 also known as Bila
Belaya *r.* Rus. Fed. 65 S3
Belaya Glina Rus. Fed. 43 I7
Belaya Kalitva Rus. Fed. 43 I6
Belaya Kholunitsa Rus. Fed. 42 K4
Belaya Tserkva Ukr. *see* Bila Tserkva
Belbédji Niger 96 D3
Bełchatów Poland 47 Q5
Belcher U.S.A. 134 D5
Belcher Islands Canada 122 F2
Belchiragh Afgh. 89 G3
Belcoo U.K. 51 E3
Belden U.S.A. 128 C1
Belding U.S.A. 134 C2
Beleapani *reef* India *see* Cherbaniani Reef
Belebey Rus. Fed. 41 Q5
Beledweyne Somalia 98 E3

Belém Brazil 143 I4
Belém Novo Brazil 145 A5
Belén Arg. 144 C3
Belen *Antalya* Turkey 85 A1
Belen *Hatay* Turkey 85 C1
Belen U.S.A. 127 G6
Belep, Îles *is* New Caledonia 107 G3
Belev Rus. Fed. 43 H5
Belfast S. Africa 101 J3

►Belfast U.K. 51 G3
 Capital of Northern Ireland.

Belfast U.S.A. 132 G2
Belfast Lough *inlet* U.K. 51 G3
Bélfodiyo Eth. 98 D2
Belford U.K. 48 F3
Belfort France 56 H3
Belgaum India 84 B3
Belgern Germany 53 N3
Belgian Congo *country* Africa *see*
 Congo, Democratic Republic of the
België *country* Europe *see* Belgium
Belgique *country* Europe *see* Belgium
►Belgium *country* Europe 52 E4
 Europe 5, 38–39
Belgorod Rus. Fed. 43 H6
Belgorod-Dnestrovskyy Ukr. *see*
 Bilhorod-Dnistrovs'kyy

►Belgrade Serbia 59 I2
 Capital of Serbia.

Belgrade *ME* U.S.A. 135 K1
Belgrade *MT* U.S.A. 126 F3
Belgrano II *research station*
 Antarctica 152 A1
Belice *r.* Sicily Italy 58 E6
Belinskiy Rus. Fed. 43 I5
Belinyu Indon. 68 D7
Belitung *i.* Indon. 68 D7
Belize Angola 99 B4

►Belize Belize 136 G5
 Former capital of Belize.

►Belize *country* Central America 136 G5
 North America 9, 116–117
Beljak Austria *see* Villach
Belkina, Mys *pt* Rus. Fed. 74 E3
Bel'kovskiy, Ostrov *i.* Rus. Fed. 65 O2
Bell Australia 112 E1
Bell *r.* Australia 112 D4
Bell *r.* Canada 122 F4
Bella Bella Canada 120 D4
Bellac France 56 E3
Bella Coola Canada 120 E4
Bella Union Uruguay 144 E4
Bella Vista U.S.A. 128 B1
Bellbrook Australia 112 F3
Bell Cay *reef* Australia 110 E4
Belledonne *mts* France 56 G4
Bellefontaine U.S.A. 134 D3
Bellefonte U.S.A. 135 G3
Belle Fourche U.S.A. 130 C2
Belle Fourche *r.* U.S.A. 130 C2
Belle Glade U.S.A. 133 D7
Belle-Île *i.* France 56 C3
Belle Isle *i.* Canada 123 L4
Belle Isle, Strait of Canada 123 K4
Belleville Canada 135 G1
Belleville *IL* U.S.A. 130 F4
Belleville *KS* U.S.A. 130 D4
Bellevue *IA* U.S.A. 130 F3
Bellevue *MI* U.S.A. 134 C2
Bellevue *OH* U.S.A. 134 D3
Bellevue *WA* U.S.A. 126 C3
Bellin Canada *see* Kangirsuk
Bellingham U.K. 48 E3
Bellingham U.S.A. 126 C2
Bellingshausen *research station*
 Antarctica 152 A2
Bellingshausen Sea Antarctica 152 L2
Bellinzona Switz. 56 I3
Bellows Falls U.S.A. 135 I2
Bellpat Pak. 89 H4
Belluno Italy 58 E1
Belluru India 84 C3
Bell Ville Arg. 144 D4
Bellville S. Africa 100 D7
Belm Germany 53 I2
Belmont Australia 112 E4
Belmont U.K. 50 [inset]
Belmont U.S.A. 135 F2
Belmonte Brazil 145 D1

►Belmopan Belize 136 G5
 Capital of Belize.

Belmore, Mount *hill* Australia 112 F2
Belmullet Ireland 51 C3
Belo Madag. 99 E6
Belo Campo Brazil 145 C1
Belœil Belgium 52 D4
Belogorsk Rus. Fed. 74 C2
Belogorsk Ukr. *see* Bilohirs'k
Beloha Madag. 99 E6
Belo Horizonte Brazil 145 C2
Beloit *KS* U.S.A. 130 D4
Beloit *WI* U.S.A. 130 F3
Belokurikha Rus. Fed. 80 F1
Belo Monte Brazil 143 H4
Belomorsk Rus. Fed. 42 G2
Belonia India 83 G5
Belorechensk Rus. Fed. 91 E1
Belorechenskaya Rus. Fed. *see*
 Belorechensk
Belören Turkey 90 D3
Beloretsk Rus. Fed. 64 G4
Belorussia *country* Europe *see* Belarus
Belorusskaya S.S.R. *country* Europe *see*
 Belarus
Belostok Poland *see* Białystok
Belot, Lac *l.* Canada 118 F3
Belo Tsiribihina Madag. 99 E5
Belovo Rus. Fed. 72 F2
Beloyarskiy Rus. Fed. 41 T3
Beloye, Ozero *l.* Rus. Fed. 42 H3
Beloye More *sea* Rus. Fed. *see* White Sea

Belozersk Rus. Fed. 42 H3
Belpre *r.* Nigeria 96 D4
Beltana Australia 111 B6
Belted Range *mts* U.S.A. 128 E3
Belton U.S.A. 131 D6
Bel'ts' Moldova *see* Bălţi
Bel'tsy Moldova *see* Bălţi
Belukha, Gora *mt.* Kazakh./Rus. Fed. 80 G2
Belush'ye Rus. Fed. 42 J2
Belvidere *IL* U.S.A. 130 F3
Belvidere *NJ* U.S.A. 135 H3
Belyando *r.* Australia 110 D4
Belyayevka Ukr. *see* Bilyayivka
Belyy Rus. Fed. 42 G5
Belyy, Ostrov *i.* Rus. Fed. 64 I2
Belzig Germany 53 M2
Belzoni U.S.A. 131 F5
Bemaraha, Plateau du Madag. 99 E5
Bembe Angola 99 B4
Bemidji U.S.A. 130 E2
Béna Burkina 96 C3
Bena Dibele Dem. Rep. Congo 98 C4
Ben Alder *mt.* U.K. 50 E4
Benalla Australia 112 B6
Benares India *see* Varanasi
Ben Arous Tunisia 58 D6
Benavente Spain 57 D2
Ben Avon *mt.* U.K. 50 F3
Benbane Head *hd* U.K. 51 F2
Benbecula *i.* U.K. 50 B3
Ben Boyd National Park Australia 112 E6
Benburb U.K. 51 F3
Bencha China 77 I1
Ben Chonzie *hill* U.K. 50 F4
Ben Cleuch *hill* U.K. 50 F4
Ben Cruachan *mt.* U.K. 50 D4
Bend U.S.A. 126 C3
Bendearg *mt.* S. Africa 101 H6
Bender Moldova *see* Tighina
Bender-Bayla Somalia 98 F3
Bendery Moldova *see* Tighina
Bendigo Australia 112 B6
Bendoc Australia 112 D6
Bene Moz. 99 D5
Benedict, Mount *hill* Canada 123 K3
Benešov Czech Rep. 47 O6
Bénestroff France 52 G6
Benevento Italy 58 F4
Beneventum Italy *see* Benevento
Benezette U.S.A. 135 F3
Beng, Nam *r.* Laos 70 C3
Bengal, Bay of *sea* Indian Ocean 81 G8
Bengamisa Dem. Rep. Congo 98 C3
Bengbu China 77 H1
Benghazi Libya 97 F1
Bengkalis Indon. 71 C7
Bengkalis *i.* Indon. 71 C7
Bengkulu Indon. 68 C7
Bengtsfors Sweden 45 H7
Benguela Angola 99 B5
Benha Egypt *see* Banhā
Ben Hiant *hill* U.K. 50 C4
Ben Hope *hill* U.K. 50 E2
Ben Horn *hill* U.K. 50 E2
Beni *r.* Bol. 142 E6
Beni Dem. Rep. Congo 98 C3
Beni Nepal 83 E3
Benî-Abbès Alg. 54 D5
Beniah Lake Canada 121 H2
Benidorm Spain 57 F4
Beni Mellal Morocco 54 C5
Ben Snassen, Monts des *mts*
 Morocco 57 E6
Beni Suef Egypt *see* Banî Suwayf
Benito, Islas *is* Mex. 127 E7
Benito Juárez Arg. 144 E5
Benito Juárez Mex. 129 F5
Benjamim Constant Brazil 142 E4
Benjamin U.S.A. 131 D5
Benjamín Hill Mex. 127 F7
Benjina Indon. 69 I8
Benkelman U.S.A. 130 C3
Benkovac Ukr. *see* Beryslav
Ben Klibreck *hill* U.K. 50 E2
Ben Lavin Nature Reserve S. Africa 101 I2
Ben Lawers *mt.* U.K. 50 E4
Ben Lomond *mt.* Australia 112 E3
Ben Lomond *hill* U.K. 50 E4
Ben Lomond National Park Australia
 111 [inset]
Ben Macdui *mt.* U.K. 50 F3
Benmara Australia 110 B3
Ben More *hill* U.K. 50 C4
Ben More *mt.* U.K. 50 E4
Benmore, Lake N.Z. 113 C7
Ben More Assynt *hill* U.K. 50 E2
Bennetta, Ostrov *i.* Rus. Fed. *see*
 Bennetta, Ostrov
Bennett Lake Canada 120 C3
Bennettsville U.S.A. 133 E5
Ben Nevis *mt.* U.K. 50 D4
Bennington *NH* U.S.A. 135 J2
Bennington *VT* U.S.A. 135 I2
Benoni S. Africa 101 I4
Bénoué, r. Cameroon *see* Benue
Bensheim Germany 53 I5
Benson AZ U.S.A. 129 H6
Benson MN U.S.A. 130 E2
Benta Seberang Malaysia 71 C6
Benteng Indon. 69 G8
Bentinck Island Myanmar 71 B5
Bentiu Sudan 97 G4
Bent Jbaïl Lebanon 85 B3
Bentley U.K. 48 F5
Bento Gonçalves Brazil 145 A5
Benton *AR* U.S.A. 131 E5
Benton *CA* U.S.A. 128 D3
Benton *IL* U.S.A. 130 F4
Benton *KY* U.S.A. 131 F4
Benton *LA* U.S.A. 131 E5
Benton *MO* U.S.A. 131 F4
Benton *PA* U.S.A. 135 G3
Bentong Malaysia *see* Bentung
Benton Harbor U.S.A. 134 B2
Bentonville U.S.A. 131 E4
Benton *r.* Rus. Fed. 74 E1
Beloye, Ozero *l.* Rus. Fed. 42 H3
Beloye More *sea* Rus. Fed. *see* White Sea

Bentung Malaysia 71 C7
Benue *r.* Nigeria 96 D4
Benum, Gunung *mt.* Malaysia 71 C7
Ben Vorlich *hill* U.K. 50 E4
Benwee Head *hd* Ireland 51 C3
Benwood U.S.A. 134 E3
Ben Wyvis *mt.* U.K. 50 E3
Benxi *Liaoning* China 74 A4
Benxi *Liaoning* China 74 B4
Beograd Serb. and Mont. *see* Belgrade
Béoumi Côte d'Ivoire 96 C4
Beppu Japan 75 C6
Béqaa *valley* Lebanon *see* El Béqaa
Berach *r.* India 82 C4
Beraketa Madag. 99 E6
Bérard, Lac *l.* Canada 123 H2
Berasia India 82 D5
Berat Albania 59 H4
Beravina Madag. 99 E5
Berbak, Taman Nasional Indon. 68 C7
Berber Sudan 86 D6
Berbera Somalia 98 E2
Berbérati Cent. Afr. Rep. 98 B3
Berchtesgaden, Nationalpark *nat. park*
 Germany 47 N7
Berck France 52 B4
Berdigestyakh Rus. Fed. 65 N3
Berdyans'k Ukr. 43 H7
Berdyaush Rus. Fed. 41 R4
Berdychiv Ukr. 43 F6
Berea *KY* U.S.A. 134 C5
Berea *OH* U.S.A. 134 E3
Beregovo Ukr. *see* Berehove
Beregovoy Rus. Fed. 74 B1
Berehove Ukr. 43 D6
Bereina P.N.G. 69 L8
Bereket Turkm. 88 D2
Berekum Ghana 96 C4
Berenice Egypt *see* Baranîs
Berenice Libya *see* Benghazi
Berens *r.* Canada 121 L4
Berens Island Canada 121 L4
Berens River Canada 121 L4
Beresford U.S.A. 130 D3
Bereza Belarus *see* Byaroza
Berezino Belarus *see* Byerazino
Berezivka Ukr. 43 F7
Berezne Ukr. 43 E6
Bereznik Rus. Fed. 42 I3
Berezniki Rus. Fed. 41 R4
Berezov Rus. Fed. *see* Berezovo
Berezovka Rus. Fed. 74 B2
Berezovka Ukr. *see* Berezivka
Berezovo Rus. Fed. 41 T3
Berezoyyy Rus. Fed. 74 D2
Berga Germany 53 L3
Berga Spain 57 G2
Bergama Turkey 59 L5
Bergamo Italy 58 C2
Bergen *Mecklenburg-Vorpommern*
 Germany 47 N3
Bergen *Niedersachsen* Germany 53 J2
Bergen Norway 45 D6
Bergen U.S.A. 135 G2
Bergen op Zoom Neth. 52 E3
Bergerac France 56 E4
Bergères-lès-Vertus France 52 E6
Bergisches Land *reg.* Germany 53 H4
Bergisch Gladbach Germany 52 H4
Bergland Namibia 100 C2
Bergomum Italy *see* Bergamo
Bergoo U.S.A. 134 E4
Bergsjö Sweden 45 J6
Bergsviken Sweden 44 L4
Bergtheim Germany 53 K5
Bergues France 52 C4
Bergum Neth. *see* Burgum
Bergville S. Africa 101 I5
Berhampur India *see* Baharampur
Beringa, Ostrov *i.* Rus. Fed. 65 R4
Beringen Belgium 52 F3
Beringovskiy Rus. Fed. 65 S3
Bering Sea N. Pacific Ocean 65 S4
Bering Strait Rus. Fed./U.S.A. 65 U3
Berīs, Ra's *pt* Iran 89 F5
Berislav Ukr. *see* Beryslav
Berkåk Norway 44 G5
Berkane Morocco 57 E6
Berkel *r.* Neth. 52 G2
Berkeley U.S.A. 128 B3
Berkeley Springs U.S.A. 135 F4
Berkhout Neth. 52 E2
Berkner Island Antarctica 152 A1
Berkovitsa Bulg. 59 J3
Berkshire *hills* U.K. 49 F7
Berkshire Downs *hills* U.K. 49 F7
Berland *r.* Canada 120 G4
Berlare Belgium 52 E3
Berlevåg Norway 44 P1

►Berlin Germany 53 N2
 Capital of Germany.

Berlin *land* Germany 53 N2
Berlin *MD* U.S.A. 135 H4
Berlin *NH* U.S.A. 135 J1
Berlin *PA* U.S.A. 135 F4
Berlin Lake U.S.A. 134 E3
Bermagui Australia 112 E6
Bermejo *r.* Arg./Bol. 144 E3
Bermejo Bol. 142 F8
Bermen, Lac *l.* Canada 123 H3

►Bermuda *terr.* N. Atlantic Ocean 137 L2
 United Kingdom Overseas Territory.
 North America 9, 116–117

Bermuda Rise *sea feature*
 N. Atlantic Ocean 148 D4

►Bern Switz. 56 H3
 Capital of Switzerland.

Bernalillo U.S.A. 127 G6
Bernardo de Campos Brazil 145 A3
Bernardo O'Higgins, Parque Nacional
 nat. park Chile 144 B7
Bernasconi Arg. 144 D5
Bernau Germany 53 N2
Bernburg (Saale) Germany 53 L3

Berne Germany 53 I1
Berne Switz. *see* Bern
Berne U.S.A. 134 C3
Berner Alpen *mts* Switz. 56 H3
Berneray *i.* Scotland U.K. 50 B3
Berneray *i.* Scotland U.K. 50 B4
Bernier Island Australia 109 A6
Bernina Pass Switz. 56 J3
Bernkastel-Kues Germany 52 H5
Beroea Greece *see* Veroia
Beroea Syria *see* Aleppo
Beroroha Madag. 99 E6
Beroun Czech Rep. 47 O6
Berounka *r.* Czech Rep. 47 O6
Berri Australia 111 C7
Berriane Alg. 54 E5
Berridale U.K. 50 F2
Berrigan Australia 112 B5
Berrima Australia 112 E5
Berrouaghia Alg. 57 H5
Berry Australia 112 E5
Berry U.S.A. 134 C4
Berryessa, Lake U.S.A. 128 B2
Berry Head *hd* U.K. 49 D8
Berry Islands Bahamas 133 E7
Berryville U.S.A. 135 G4
Berseba Namibia 100 C4
Bersenbrück Germany 53 H2
Bertá Malaysia 71 C6
Berté, Lac *l.* Canada 123 H4
Berthoud Pass U.S.A. 126 G5
Bertolínia Brazil 143 J5
Bertoua Cameroon 96 E4
Bertraghboy Bay Ireland 51 C4
Beru *atoll* Kiribati 107 H2
Beruri Brazil 142 F4
Beruwala Sri Lanka 84 C5
Berwick Australia 112 B7
Berwick U.S.A. 135 G3
Berwick-upon-Tweed U.K. 48 E3
Berwyn U.K. 49 D6
Beryslav Ukr. 59 O1
Berytus Lebanon *see* Beirut
Besalampy Madag. 99 E5
Besançon France 56 H3
Besar, Gunung *mt.* Malaysia 71 C7
Besbay Kazakh. 80 A2
Beserah Malaysia 71 C7
Beshkent Uzbek. 89 G2
Beshneh Iran 88 D4
Besikama Indon. 108 D2
Besitang Indon. 71 B6
Beskra Alg. *see* Biskra
Beslan Rus. Fed. 91 G2
Besnard Lake Canada 121 J4
Besni Turkey 90 E3
Besor *watercourse* Israel 85 B4
Beşparmak Dağları *mts* Cyprus *see*
 Pentadaktylos Range
Bessbrook U.K. 51 F3
Bessemer U.S.A. 133 C5
Besshoky, Gora *hill* Kazakh. 91 I1
Besskorbnaya Rus. Fed. 43 I7
Bessonovka Rus. Fed. 43 J5
Betanzos Spain 57 B2
Bethal S. Africa 101 I4
Bethanie Namibia 100 C4
Bethany U.S.A. 130 E3
Bethel U.S.A. 123 H5
Bethel Park U.S.A. 134 E3
Bethesda U.K. 48 C5
Bethesda *MD* U.S.A. 135 G4
Bethesda *OH* U.S.A. 134 E3
Bethlehem S. Africa 101 I5
Bethlehem *PA* U.S.A. 135 H3
Bethlehem West Bank 85 B4
Bethulie S. Africa 101 G6
Béthune France 52 C4
Betim Brazil 145 B2
Bet Lehem West Bank *see* Bethlehem
Betma India 82 C5
Betong Thai. 71 C6
Betoota Australia 110 C5
Betpak-Dala *plain* Kazakh. 80 D2
Betroka Madag. 99 E6
Bet She'an Israel 85 B3
Betsiamites Canada 123 H4
Betsiamites *r.* Canada 123 H4
Bettiah India 83 F4
Bettyhill U.K. 50 E2
Bettystown Ireland 51 F4
Betul India 82 D5
Betung Kerihun National Park
 Indon. 68 E6
Betwa *r.* India 82 D4
Betws-y-coed U.K. 49 D5
Betzdorf Germany 53 H4
Beuthen Poland *see* Bytom
Bever *r.* Germany 53 H2
Beverley U.K. 48 G5
Beverly *MA* U.S.A. 135 J2
Beverly *OH* U.S.A. 134 E4
Beverly Hills U.S.A. 128 C5
Beverly Lake Canada 121 K1
Beverstedt Germany 53 I1
Beverungen Germany 53 J3
Beverwijk Neth. 52 E2
Bewani P.N.G. 69 K7
Bexbach Germany 53 H5
Bexhill U.K. 49 H8
Bexley, Cape Canada 118 G3
Beyänlü Iran 88 B3
Beyce Turkey *see* Orhaneli
Bey Dağları *mts* Turkey 59 N6
Beykoz Turkey 59 M4
Beyla Guinea 96 C4
Beylagan Azer. *see* Beyläqan
Beyläqan Azer. 91 G3
Beyneu Kazakh. 78 E2
Beypazarı Turkey 59 N4
Beypınarı Turkey 90 E3
Beypore India 84 B4
Beyrouth Lebanon *see* Beirut
Beyşehir Turkey 90 C3
Beyşehir Gölü *l.* Turkey 90 C3

Beytonovo Rus. Fed. 74 B1
Beytüşşebap Turkey 91 F3
Bezameh Iran 88 E3
Bezbozhnik Rus. Fed. 42 K4
Bezhanitsy Rus. Fed. 42 F4
Bezhetsk Rus. Fed. 42 H4
Béziers France 56 F5
Bezmein Turkm. *see* Abadan
Bezwada India *see* Vijayawada
Bhabha India *see* Bhabhua
Bhabhar India 82 B4
Bhabhua India 83 E4
Bhabua India *see* Bhabhua
Bhachau India 82 B5
Bhachbhar India 82 B4
Bhadgaon Nepal *see* Bhaktapur
Bhadohi India 83 E4
Bhadra India 82 C3
Bhadrachalam Road Station India *see*
 Kottagudem
Bhadrak India 83 F5
Bhadrakh India *see* Bhadrak
Bhadravati India 84 B3
Bhag Pak. 89 G4
Bhagalpur India 83 F4
Bhainsa India 84 C2
Bhainsdehi India 82 D5
Bhairab Bazar Bangl. 83 G4
Bhairi Hol *mt.* Pak. 89 G5
Bhaktapur Nepal 83 F4
Bhalki India 84 C2
Bhamo Myanmar 70 B1
Bhamragarh India 84 D2
Bhandara India 82 D5
Bhanjanagar India 84 E2
Bhanrer Range *hills* India 82 D5
Bhaptiahi India 83 F4
Bharat *country* Asia *see* India
Bharatpur India 82 D4
Bhareli *r.* India 83 H4
Bharuch India 82 C5
Bhatapara India 83 E5
Bhatarsaigh *i.* U.K. *see* Vatersay
Bhatghar Lake India 84 B2
Bhatinda India *see* Bathinda
Bhatnair India *see* Hanumangarh
Bhatpara India 83 G5
Bhaunagar India *see* Bhavnagar
Bhavani *r.* India 84 C4
Bhavani Sagar *l.* India 84 C4
Bhavnagar India 82 C5
Bhawana Pak. 89 I4
Bhawanipatna India 84 D2
Bhearnaraigh, Eilean *i.* U.K. *see* Berneray
Bheemavaram India *see* Bhimavaram
Bhekuzulu S. Africa 101 J4
Bhera Pak. 89 I3
Bhigvan India 84 B2
Bhikhna Thori Nepal 83 F4
Bhilai India 82 E5
Bhildi India 82 C4
Bhilwara India 82 C4
Bhima *r.* India 84 C2
Bhimar India 82 B4
Bhimavaram India 84 D2
Bhimlath India 82 E5
Bhind India 82 D4
Bhinga India 83 E4
Bhiwandi India 84 B2
Bhiwani India 82 D3
Bhogaipur India 82 D4
Bhojpur Nepal 83 F4
Bhola Bangl. 83 G5
Bhongweni S. Africa 101 I6
Bhopal India 82 D5
Bhopalpatnam India 84 D2
Bhrigukaccha India *see* Bharuch
Bhuban India 84 E1
Bhubaneshwar India *see* Bhubaneshwar
Bhubaneswar India 84 E1
Bhuj India 82 B5
Bhumiphol Dam Thai. 70 B3
Bhusawal India 82 C5
►Bhutan *country* Asia 83 G4
 Asia 6, 62–63
Bhuttewala India 82 B4
Bia *r.* Ghana 96 C4
Bia, Phou *mt.* Laos 70 C3
Biabãn *mts* Iran 88 E5
Biafo Glacier Jammu and Kashmir 82 C2
Biafra, Bight of *g.* Africa *see* Benin, Bight of
Biak Indon. 69 J7
Biak *i.* Indon. 69 J7
Biała Podlaska Poland 43 D5
Białogard Poland 47 O4
Białystok Poland 43 D5
Bianco, Monte *mt.* France/Italy *see*
 Blanc, Mont
Biandangang Kou *r. mouth* China 77 I1
Bianzhao China 74 A3
Bianzhuang China *see* Cangshan
Biaora India 82 D5
Biarritz France 56 D5
Bi'ar Tabrāk *well* Saudi Arabia 88 B5
Bibai Japan 74 F4
Bibbenluke Australia 112 D6
Bibbiena Italy 58 D3
Bibby Island Canada 121 M2
Biberach an der Riß Germany 47 L6
Bibile Sri Lanka 84 D5
Biblis Germany 53 I5
Biblos Lebanon *see* Jbail
Bicas Brazil 145 C3
Biçer Turkey 59 N5
Bicester U.K. 49 F7
Bichabhera India 82 C4
Bicheng China *see* Bishan
Bichevaya Rus. Fed. 74 D3
Bichi *r.* Rus. Fed. 74 E1
Bickerton Island Australia 110 B2
Bickleigh U.K. 49 D8
Bicknell U.S.A. 134 B4
Bicuari, Parque Nacional do *nat. park*
 Angola 99 B5
Bid India 84 B2
Bidar India 84 C2
Biddeford U.S.A. 135 J2
Biddinghuizen Neth. 52 F2
Bidean nam Bian *mt.* U.K. 50 D4
Bideford U.K. 49 C7
Bideford Bay U.K. *see* Barnstaple Bay

169

Bidokht Iran 88 E3
Bidzhan Rus. Fed. 74 C3
Bié Angola see Kuito
Bié, Planalto do Angola 99 B5
Biebrzański Park Narodowy nat. park
Poland 45 M10
Biedenkopf Germany 53 I4
Biel Switz. 56 H3
Bielawa Poland 47 P5
Bielefeld Germany 53 I2
Bielitz Poland see Bielsko-Biała
Biella Italy 58 C2
Bielsko-Biała Poland 47 Q6
Bielstein hill Germany 53 J3
Biên Hoa Vietnam 71 D5
Bienne Switz. see Biel
Bienville, Lac l. Canada 123 G3
Bierbank Australia 112 B1
Biesiesvlei S. Africa 101 G4
Bietigheim-Bissingen Germany 53 J6
Bièvre Belgium 52 F5
Bifoun Gabon 98 B4
Big r. Canada 123 K3
Biga Turkey 59 L4
Bigadiç Turkey 59 M5
Biga Yarımadası pen. Turkey 59 L5
Big Baldy Mountain U.S.A. 126 F3
Big Bar Creek Canada 120 F5
Big Bear Lake U.S.A. 128 E4
Big Belt Mountains U.S.A. 126 F3
Big Bend Swaziland 101 J4
Big Bend National Park U.S.A. 131 J4
Bigbury-on-Sea U.K. 49 D8
Big Canyon watercourse U.S.A. 131 C6
Biger Nuur salt l. Mongolia 80 I2
Big Falls U.S.A. 130 E1
Big Fork r. U.S.A. 130 E1
Biggar Canada 121 J4
Biggar U.K. 50 F5
Biggar, Lac l. Canada 122 G4
Bigge Island Australia 108 D3
Biggenden Australia 111 F5
Bigger, Mount Canada 120 B3
Biggesee l. Germany 53 H3
Biggleswade U.K. 49 G6
Biggs CA U.S.A. 128 C2
Biggs OR U.S.A. 126 C3
Big Hole r. U.S.A. 126 E3
Bighorn r. U.S.A. 126 G3
Bighorn Mountains U.S.A. 126 G3
Big Island Nunavut Canada 119 K3
Big Island N.W.T. Canada 120 G2
Big Island Ont. Canada 121 M5
Big Kalzas Lake Canada 120 C2
Big Lake l. Canada 121 H1
Big Lake U.S.A. 131 C6
Bignona Senegal 96 B3
Big Pine U.S.A. 128 D3
Big Pine Peak U.S.A. 128 C4
Big Raccoon r. U.S.A. 134 B4
Big Rapids U.S.A. 134 C2
Big River Canada 121 J4
Big Sable Point U.S.A. 134 B1
Big Salmon r. Canada 120 C2
Big Sand Lake Canada 121 L3
Big Sandy r. U.S.A. 126 F4
Big Sandy Lake Canada 121 J4
Big Smokey Valley U.S.A. 128 E2
Big South Fork National River and
Recreation Area park U.S.A. 134 C5
Big Spring U.S.A. 131 C5
Big Stone Canada 121 I5
Big Stone Gap U.S.A. 134 D5
Bigstone Lake Canada 121 M4
Big Timber U.S.A. 126 F3
Big Trout Lake Canada 121 N4
Big Trout Lake l. Canada 121 N4
Big Valley Canada 121 H4
Big Water U.S.A. 129 H3
Bihać Bos.-Herz. 58 F2
Bihar state India 83 F4
Bihariganj India 83 F4
Bihar Sharif India 83 F4
Bihor, Vârful mt. Romania 59 J1
Bihoro Japan 74 G4
Bijагós, Arquipélago dos is
Guinea-Bissau 96 B3
Bijaipur India 82 D4
Bijapur India 84 B2
Bijār Iran 88 B3
Bijbehara Jammu and Kashmir 82 C2
Bijeljina Bos.-Herz. 59 H2
Bijelo Polje Serb. and Mont. 59 H3
Bijeraghogarh India 82 E5
Bijiang China see Zhiziluo
Bijie China 76 E3
Bijji India 84 D2
Bijnor India 82 D3
Bijnore India see Bijnor
Bijnot Pak. 89 H4
Bijrān well Saudi Arabia 88 C5
Bijrān, Khashm hill Saudi Arabia 88 C5
Bikampur India 82 C4
Bikaner India 82 C3
Bikhūyeh Iran 88 D5
Bikin Rus. Fed. 74 D3
Bikin r. Rus. Fed. 74 D3
Bikini atoll Marshall Is 150 H5
Bikori Sudan 86 D7
Bikoro Dem. Rep. Congo 98 B4
Bikou China 76 E1
Bikramganj India 83 F4
Bilād Banī 'Alī Oman 87 I5
Bilaigarh India 84 D1
Bilara India 82 C4
Bilaspur Chhattisgarh India 83 E5
Bilaspur Hima. Prad. India 82 D3
Biläsuvar Azer. 91 H3
Bila Tserkva Ukr. 43 F6
Bilauktaung Range mts Myanmar/Thai.
71 B4
Bilbao Spain 57 E2
Bilbays Egypt see Bilbays
Bilbeis Egypt see Bilbays
Bilbo Spain see Bilbao
Bilecik Turkey 59 M4
Bitgoraj Poland 43 D6
Bilharamulo Tanz. 98 D4
Bilhaur India 82 E4
Bilhorod-Dnistrovs'kyy Ukr. 59 N1
Bili Dem. Rep. Congo 98 C3

Bilibino Rus. Fed. 65 R3
Bilin Myanmar 70 B3
Bill U.S.A. 126 G4
Billabalong Australia 109 A6
Billabong Creek r. Australia see
Moulamein Creek
Billericay U.K. 49 H7
Billiluna Australia 108 D4
Billingham U.K. 48 F4
Billings U.S.A. 126 F3
Billiton i. Indon. see Belitung
Bill of Portland hd U.K. 49 E8
Bill Williams r. U.S.A. 129 F4
Bill Williams Mountain U.S.A. 129 G4
Bilma Niger 96 E3
Bilo r. Rus. Fed. see Belaya
Biloela Australia 110 E5
Bilohirs'k Ukr. 90 D1
Bilohir"ya Ukr. 43 E6
Biloku Guyana 143 G3
Biloli India 84 C2
Bilovods'k Ukr. 43 H6
Biloxi U.S.A. 131 F6
Bilpa Morea Claypan salt flat
Australia 110 B5
Bilston U.K. 50 F5
Biltine Chad 97 F3
Bilto Norway 44 L2
Bilugyun Island Myanmar 70 B3
Bilyayivka Ukr. 59 N1
Bilzen Belgium 52 F4
Bima Indon. 108 B2
Bimberi, Mount Australia 112 D5
Bimbo 97 E4
Bimini Islands Bahamas 133 E7
Bimlipatam India 84 D2
Bināb Iran 88 C2
Bina-Etawa India 82 D4
Binaija, Gunung mt. Indon. 67 E8
Bīnālūd, Kūh-e mts Iran 88 E2
Binboğa Daği mt. Turkey 90 E3
Bincheng China see Binzhou
Binchuan China 76 D3
Bindebango Australia 112 C1
Bindle Australia 112 D1
Bindu Dem. Rep. Congo 99 B4
Bindura Zimbabwe 99 D5
Binefar Spain 57 G3
Binga Zimbabwe 99 C5
Binga, Monte mt. Moz. 99 D5
Bingara Australia 112 B2
Bingaram i. India 84 B4
Bing Bong Australia 110 B2
Bingen am Rhein Germany 53 H5
Bingham U.S.A. 135 K1
Binghamton U.S.A. 135 H2
Bingmei China see Congjiang
Bingöl Turkey 91 F3
Bingol Daği mt. Turkey 91 F3
Bingxi China see Yushan
Bingzhongluo China 76 C2
Binh Gia Vietnam 70 D2
Binika India 83 E5
Binjai Indon. 71 B7
Binnaway Australia 112 D3
Binpur India 83 F5
Bintan i. Indon. 71 D7
Bint Jbeil Lebanon see Bent Jbaïl
Bintulu Sarawak Malaysia 68 E6
Binxian Heilong. China 74 B3
Binxian Shaanxi China 77 F1
Binya Australia 112 C5
Binyang China 77 F4
Bin-Yauri Nigeria 96 D3
Binzhou Guangxi China see Binyang
Binzhou Heilong. China see Binxian
Binzhou Shandong China 73 L5
Bioco i. Equat. Guinea see Bioko
Biograd na Moru Croatia 58 F3
Bioko i. Equat. Guinea 96 D4
Biokovo mts Croatia 58 G3
Biquinhas Brazil 145 B2
Bir India see Bid
Bira Rus. Fed. 74 D2
Bi'r Abū Jady oasis Syria 85 D2
Bīrag, Kūh-e mts Iran 89 F5
Birāk Libya 97 E2
Birakan Rus. Fed. 74 C2
Bi'r al 'Abd Egypt 85 A4
Bi'r al Halba well Syria 85 D2
Bi'r al Jidfāh well Egypt 85 A4
Bi'r al Khamsah well Egypt see
Bi'r al Khamsa
Bi'r al Mālihah well Egypt 85 A5
Bi'r al Mulūsi Iraq 91 F4
Bi'r al Munbaṭiḥ well Syria 85 D2
Bi'r al Qaṭrāni well Egypt 90 B5
Bi'r al Ubbayiḍ well Egypt 90 B6
Birandozero Rus. Fed. 42 H3
Bi'r an Nuṣf well Egypt see Bi'r an Nuṣṣ
Bi'r an Nuṣṣ well Egypt 90 B5
Bir Anzarane W. Sahara 96 B2
Birao Cent. Afr. Rep. 98 C2
Bi'r ar Rābiyah well Egypt 90 B5
Biratnagar Nepal 83 F4
Bi'r aṭ Ṭarfāwī well Libya 90 B5
Bi'r Başiri well Syria 85 C2
Bi'r Baydā' well Egypt 85 B4
Bi'r Baylī well Egypt 90 B5
Bi'r Beida well Egypt see Bi'r Baydā'
Bi'r Buṭaymān Syria 91 E3
Birch r. Canada 121 H3
Birch Hills Canada 121 J4
Birch Island Canada 120 G4
Birch Lake l. N.W.T. Canada 120 G1
Birch Lake l. Canada 121 J4
Birch Lake l. Sask. Canada 121 I4
Birch Mountains Canada 120 H3
Birch River U.S.A. 134 E4
Birch Run U.S.A. 134 D2
Bircot Turkey 59 L6
Birdaard Neth. see Burdaard
Bi'r Diqnāsh well Egypt see Bi'r Diqnash
Bi'r Diqnash well Egypt 90 B5
Birdseye U.S.A. 134 B4
Birdsville Australia 111 B5
Birecik Turkey 85 C1
Bir el 'Abd Egypt see Bi'r al 'Abd
Bir el Arbi well Alg. 57 I6
Bir el Istabl well Egypt see Bi'r Iṣṭabl

Bîr el Khamsa well Egypt see
Bi'r al Khamsah
Bîr el Nuṣṣ well Egypt see Bi'r an Nuṣṣ
Bîr el Obeiyid well Egypt see
Bi'r al Ubbayiḍ
Bîr el Qaṭrâni well Egypt see Bi'r al Qaṭrāni
Bîr el Râbia well Egypt see Bi'r ar Rābiyah
Birendranagar Nepal see Surkhet
Bir en Natrûn well Sudan 86 C6
Bireun Indon. 71 B6
Bi'r Fāḍil well Saudi Arabia 88 C6
Bi'r Fajr well Saudi Arabia 90 E5
Bi'r Fu'ād well Egypt 90 B5
Bi'r Gifgāfa well Egypt see Bi'r al Jifjāfah
Birhan mt. Eth. 98 D2
Bi'r Hasanah well Egypt 85 A4
Bi'r Hayzān well Saudi Arabia 90 E6
Bi'r Ibn Hirmās well Saudi Arabia see Al Bi'r
Bir Ibn Juhayyim Saudi Arabia 88 C6
Birigüi Brazil 145 A3
Birīn Syria 85 C2
Bi'r Isṭabl well Egypt 90 B5
Birjand Iran 88 E3
Birkat Hamad well Iraq 91 G5
Birkenfeld Germany 53 H5
Birkenhead U.K. 48 D5
Birkirkara Malta 58 F7
Birksgate Range hills Australia 109 E6
Bi'r Lahfān well Egypt 85 A4
Birlik Kazakh. 80 D3
Birmal reg. Afgh. 89 H3
Birmingham U.K. 49 F6
Birmingham U.S.A. 133 C5
Bi'r Mogrein Mauritania 96 B2
Bi'r Muḥaymid al Wazwaz well Syria 85 D2
Bi'r Nāḥid oasis Egypt 90 C5
Birnin-Gwari Nigeria 96 D3
Birnin-Kebbi Nigeria 96 D3
Birnin Konni Niger 96 D3
Birobidzhan Rus. Fed. 74 D2
Bi'r Qaṣir as Sirr well Egypt 90 B5
Birr Ireland 51 E4
Bi'r Rawḍ Sālim well Egypt 85 A4
Birrie r. Australia 112 C2
Birrindudu Australia 108 E4
Bi'r Rōḍ Sālim well Egypt see
Bi'r Rawḍ Sālim
Birsay U.K. 50 F1
Bi'r Shalatayn Egypt 86 E5
Bîr Shalatein Egypt see Bi'r Shalatayn
Birsk Rus. Fed. 41 R4
Birstall U.K. 49 F6
Birstein Germany 53 J4
Birthday Mount Australia 110 C2
Birtle Canada 121 K5
Biru China 76 B2
Birur India 84 B3
Bi'r Usaylilah well Saudi Arabia 88 B6
Biruxiong China see Biru
Biržai Lith. 45 N8
Bisa i. Indon. 69 H7
Bisa i. Indon. 69 H7
Bisalpur India 82 D3
Bisau India 82 C3
Bisbee U.S.A. 127 F7
Biscay, Bay of sea France/Spain 56 B4
Biscay Abyssal Plain sea feature
N. Atlantic Ocean 148 H3
Biscayne National Park U.S.A. 133 D7
Biscoe Islands Antarctica 152 L2
Biscotasi Lake Canada 122 E5
Biscotasing Canada 122 E5
Bisezhai China 76 D4
Bishan China 76 E2
Bishek Kyrg. see Bishkek
Bishenpur India see Bishnupur

▶Bishkek Kyrg. 80 D3
Capital of Kyrgyzstan.

Bishnath India 76 B3
Bishnupur Manipur India 83 H4
Bishnupur W. Bengal India 83 F5
Bisho S. Africa 101 H7
Bishop U.S.A. 128 D3
Bishop Auckland U.K. 48 F4
Bishop Lake Canada 120 G1
Bishop's Stortford U.K. 49 H7
Bishopville U.S.A. 133 D5
Bishrī, Jabal hills Syria 85 D2
Bishui Heilong. China 74 A1
Bishui Henan China see Biyang
Biskra Alg. 54 F5
Bislig Phil. 69 H5

▶Bismarck U.S.A. 130 C2
State capital of North Dakota.

Bismarck Archipelago is P.N.G. 69 L7
Bismarck Range mts P.N.G. 69 K7
Bismarck Sea P.N.G. 69 L7
Bismark (Altmark) Germany 53 L2
Bismil Turkey 91 F3
Bismo Norway 44 F6
Bison U.S.A. 130 C2
Bispgården Sweden 44 J5
Bispingen Germany 53 K1
Bissa, Djebel mt. Alg. 57 G5
Bissamcuttak India 84 D2

▶Bissau Guinea-Bissau 96 B3
Capital of Guinea-Bissau.

Bissaula Nigeria 96 E4
Bissett Canada 121 M5
Bistcho Lake Canada 120 G3
Bistrita Romania 59 K1
Bistrita r. Romania 59 L1
Bitburg Germany 52 G5
Bitche France 53 H5
Bithur India 82 E4
Bithynia reg. Turkey 59 M4
Bitkine Chad 97 E3
Bitlis Turkey 91 F3
Bitola Macedonia 59 I4
Bitolj Macedonia see Bitola
Bitonto Italy 58 G4
Bitrān, Jabal hill Saudi Arabia 88 B6

Bitra Par reef India 84 B4
Bitter Creek r. U.S.A. 129 I2
Bitterfeld Germany 53 M3
Bitterfontein S. Africa 100 D6
Bitter Lakes Egypt 90 D5
Bitterroot r. U.S.A. 126 E3
Bitterroot Range mts U.S.A. 126 E3
Bitterwater U.S.A. 128 C3
Bittkau Germany 53 L2
Bitung Indon. 69 H6
Biu Nigeria 96 E3
Biwa-ko l. Japan 75 D6
Biyang China 77 G1
Bīye K'obē Eth. 98 E2
Biysk Rus. Fed. 72 F2
Bizana S. Africa 101 I6
Bizerta Tunisia see Bizerte
Bizerte Tunisia 58 C6
Bīzhanābād Iran 88 E5

▶Bjargtangar hd Iceland 44 [inset]
Most westerly point of Europe.

Bjästa Sweden 44 K5
Bjelovar Croatia 58 G2
Bjerkvik Norway 44 J2
Bjerringbro Denmark 45 F8
Bjørgan Norway 44 F5
Björkliden Sweden 44 K2
Björklinge Sweden 45 J6
Bjorli Norway 44 F5
Björna Sweden 44 K5
Björneborg Fin. see Pori

▶Bjørnøya i. Arctic Ocean 64 C2
Part of Norway.

Bjurholm Sweden 44 K5
Bla Mali 96 C3
Black r. Man. Canada 121 L5
Black r. Ont. Canada 134 E1
Black r. AR U.S.A. 131 F5
Black r. AZ U.S.A. 129 H5
Black r. Vietnam 70 D2
Blackadder Water r. U.K. 50 G5
Blackbear r. Canada 121 N4
Black Birch Lake Canada 121 J3
Black Bourton U.K. 49 F7
Blackburn U.K. 48 E5
Blackbull Australia 110 C3
Blackbutt Australia 112 F1
Black Butte mt. U.S.A. 128 B2
Black Butte Lake U.S.A. 128 B2
Black Canyon gorge U.S.A. 129 F4
Black Canyon of the Gunnison National
Park U.S.A. 129 J2
Black Combe hill U.K. 48 D4
Black Creek watercourse U.S.A. 129 I4
Blackdown Tableland National Park
Australia 110 E4
Blackduck U.S.A. 130 E2
Blackfalds Canada 120 H4
Blackfoot U.S.A. 126 E4
Black Foot r. U.S.A. 126 E3
Black Hill hill U.K. 48 F5
Black Hills SD U.S.A. 124 G3
Black Hills SD U.S.A. 126 G3
Black Island Canada 121 L5
Black Lake Canada 121 J3
Black Lake l. Canada 121 J3
Black Lake l. U.S.A. 134 C1
Black Mesa mt. U.S.A. 129 I5
Black Mesa ridge U.S.A. 129 H3
Black Mountain hill P.N.G. 89 I3
Black Mountain hill U.K. 49 D7
Black Mountain AK U.S.A. 118 B3
Black Mountain CA U.S.A. 128 E4
Black Mountain KY U.S.A. 134 D5
Black Mountain NM U.S.A. 129 I5
Black Mountains hills U.K. 49 D7
Black Mountains U.S.A. 129 F4
Black Nossob watercourse Namibia 100 D2
Black Pagoda India see Konarka
Blackpool U.K. 48 D5
Black Range mts U.S.A. 129 I5
Black River MI U.S.A. 134 D1
Black River NY U.S.A. 135 H1
Black River Falls U.S.A. 130 F3
Black Rock hill Jordan see 'Unāb, Jabal al
Black Rock Desert U.S.A. 126 D4
Blacksburg U.S.A. 134 E5
Black Sea Asia/Europe 43 H8
Blacks Fork r. U.S.A. 126 F4
Blackshear U.S.A. 133 D6
Blacksod Bay Ireland 51 B3
Black Springs U.S.A. 128 D2
Blackstairs Mountains hills Ireland 51 F5
Blackstone U.S.A. 135 F5
Black Sugarloaf mt. Australia 112 E3
Black Tickle Canada 123 L3
Blackville Australia 112 E3
Blackwater Australia 110 E4
Blackwater Ireland 51 F5
Blackwater r. Ireland 51 E5
Blackwater r. Ireland/U.K. 51 F3
Blackwater watercourse U.S.A. 131 C5
Blackwater Reservoir U.K. 50 E4
Blackwood r. Australia 109 A8
Blackwood National Park Australia 110 D4
Bladensburg National Park Australia
110 C4
Blaenavon U.K. 49 D7
Blagodarnyy Rus. Fed. 91 F1
Blagoevgrad Bulg. 59 J3
Blagoveshchensk Amurskaya Oblast'
Rus. Fed. 74 C2
Blagoveshchensk Respublika Bashkortostan
Rus. Fed. 41 R4
Blaikiston, Mount Canada 120 H5
Blaine Lake Canada 121 J4
Blair U.S.A. 130 D3
Blair Athol Australia 110 D4
Blair Atholl U.K. 50 F4
Blairgowrie U.K. 50 F4
Blairsden U.S.A. 128 C2
Blairsville U.S.A. 133 D5

Blakang Mati, Pulau i. Sing. see Sentosa
Blakely U.S.A. 133 C6
Blakeney U.K. 49 I6

▶Blanc, Mont mt. France/Italy 56 H4
5th highest mountain in Europe.

Blanca, Bahía b. Arg. 144 D5
Blanca, Sierra mt. U.S.A. 127 G6
Blanca Peak U.S.A. 127 G5
Blanche, Lake salt flat S.A. Australia 111 B6
Blanche, Lake salt flat W.A.
Australia 108 C5
Blanchester U.S.A. 134 D4
Blanc Nez, Cap c. France 52 B4
Blanco r. Bol. 142 F6
Blanco U.S.A. 131 D6
Blanco, Cape U.S.A. 126 B4
Blanc-Sablon Canada 123 K4
Bland r. Australia 112 C4
Bland U.S.A. 134 E5
Blanda r. Iceland 44 [inset]
Blandford Forum U.K. 49 E8
Blanding U.S.A. 129 I3
Blanes Spain 57 H3
Blangah, Telok Sing. 71 [inset]
Blangkejeren Indon. 71 B7
Blangpidie Indon. 71 B7
Blankenberge Belgium 52 D3
Blankenheim Germany 52 G4
Blanquilla, Isla i. Venez. 142 F1
Blansko Czech Rep. 47 P6
Blantyre Malawi 99 D5
Blarney Ireland 51 D6
Blaubeuren Germany 53 J5
Blåviksjön Sweden 44 K4
Blaye France 56 D4
Blayney Australia 112 D4
Blaze, Point Australia 108 E3
Bleckede Germany 53 K1
Bleiburg Austria 47 O7
Bleichlochtalsperre resr Germany 53 L4
Blenheim Canada 134 E2
Blenheim N.Z. 113 D5
Blenheim Palace tourist site U.K. 49 F7
Blerick Neth. 52 G3
Blessington Lakes Ireland 51 F4
Bletchley U.K. 49 G6
Blida Alg. 57 H5
Blies r. Germany 53 H5
Bligh Water b. Fiji 107 H3
Blind River Canada 122 E5
Bliss U.S.A. 126 E4
Blissfield U.S.A. 134 D3
Blitta Togo 96 D4
Blocher U.S.A. 134 C4
Block Island U.S.A. 135 J3
Block Island Sound sea chan. U.S.A. 135 J3
Bloemfontein S. Africa 101 H5
Bloemhof S. Africa 101 G4
Bloemhof Dam S. Africa 101 G4
Bloemhof Dam Nature Reserve
S. Africa 101 G4
Blomberg Germany 53 J3
Blönduós Iceland 44 [inset]
Blongas Indon. 108 B2
Bloods Range mts Australia 109 E6
Bloodsworth Island U.S.A. 135 G4
Bloodvein r. Canada 121 L5
Bloody Foreland pt Ireland 51 D2
Bloomer U.S.A. 130 F2
Bloomfield Canada 135 G2
Bloomfield IA U.S.A. 130 E3
Bloomfield IN U.S.A. 134 B4
Bloomfield MO U.S.A. 131 F4
Bloomfield NM U.S.A. 129 J3
Blooming Prairie U.S.A. 130 E3
Bloomington IL U.S.A. 130 F3
Bloomington IN U.S.A. 134 B4
Bloomington MN U.S.A. 130 E2
Bloomsburg U.S.A. 135 G3
Blossburg U.S.A. 135 G3
Blosseville Kyst coastal area
Greenland 119 P3
Blouberg S. Africa 101 I2
Blouberg Nature Reserve S. Africa 101 I2
Blountstown U.S.A. 133 C6
Blountville U.S.A. 134 D5
Bloxham U.K. 49 F6
Blue r. Canada 120 D3
Blue watercourse U.S.A. 129 I5
Blue Bell Knoll mt. U.S.A. 129 H2
Blueberry r. Canada 120 F3
Blue Diamond U.S.A. 129 F3
Blue Earth U.S.A. 130 E3
Bluefield VA U.S.A. 132 D4
Bluefield WV U.S.A. 134 E5
Bluefields Nicaragua 137 H6
Blue Hills Turks and Caicos Is 133 F8
Blue Knob hill U.S.A. 135 F3
Blue Mesa Reservoir U.S.A. 129 J2
Blue Mountain India 83 H5
Blue Mountain hill Canada 123 N4
Blue Mountain Pass Lesotho 101 H5
Blue Mountains Australia 112 D4
Blue Mountains U.S.A. 126 D3
Blue Mountains National Park
Australia 112 E4
Blue Nile r. Eth./Sudan 86 D6
also known as Ābay Wenz (Ethiopia),
Bahr el Azraq (Sudan)
Bluenose Lake Canada 118 G3
Blue Ridge GA U.S.A. 133 C5
Blue Ridge VA U.S.A. 134 F5
Blue Ridge mts U.S.A. 134 F5
Blue Stack hill Ireland 51 D3
Blue Stack Mts hills Ireland 51 D3
Bluestone Lake U.S.A. 134 E5
Bluewater U.S.A. 129 J4
Bluff N.Z. 113 B8
Bluff U.S.A. 129 I3
Bluffdale U.S.A. 129 H1
Bluff Island H.K. China 77 [inset]
Bluff Knoll mt. Australia 109 B8
Bluffton IN U.S.A. 134 C3
Bluffton OH U.S.A. 134 D3
Blumenau Brazil 145 A4
Blustry Mountain Canada 120 F5
Blyde River Canyon Nature Reserve
S. Africa 101 J3
Blyth Canada 134 E2
Blyth England U.K. 48 F3

Blyth England U.K. 48 F5
Blythe U.S.A. 129 F5
Blytheville U.S.A. 131 F5
Bø Norway 45 F7
Bo Sierra Leone 96 B4
Boa Esperança Brazil 145 B3
Bo'ai Henan China 77 G1
Bo'ai Yunnan China 76 E4
Boali Cent. Afr. Rep. 98 B3
Boalsert Neth. see Bolsward
Boane Moz. 101 K4
Boa Nova Brazil 145 C1
Boardman U.S.A. 134 E3
Boatlaname Botswana 101 G2
Boa Viagem Brazil 143 K5
Boa Vista Brazil 142 F3
Boa Vista i. Cape Verde 96 [inset]
Bobadah Australia 112 C4
Bobai China 77 F4
Bobaomby, Tanjona c. Madag. 99 E5
Bobbili India 84 D2
Bobcaygeon Canada 135 F1
Bobo-Dioulasso Burkina 96 C3
Bobotov Kuk mt. Serb. and Mont. see
Durmitor
Bobriki Rus. Fed. see Novomoskovsk
Bobrinets Ukr. see Bobrynets'
Bobrov Rus. Fed. 43 I6
Bobrovitsa Ukr. see Bobrovytsya
Bobrovytsya Ukr. 43 F6
Bobruysk Belarus see Babruysk
Bobs Lake Canada 135 G1
Bobures Venez. 142 D2
Boby mt. Madag. 99 E6
Boca de Macareo Venez. 142 F2
Boca do Acre Brazil 142 E5
Boca do Jari Brazil 143 H4
Bocaiúva Brazil 145 C2
Bocaranga Cent. Afr. Rep. 98 B3
Boca Raton U.S.A. 133 D7
Bocas del Toro Panama 137 H7
Bochnia Poland 47 R6
Bocholt Germany 52 G3
Bochum Germany 53 H3
Bochum S. Africa 101 I2
Bockenem Germany 53 K2
Bocoio Angola 99 B5
Bocoyna Mex. 127 G8
Boda Cent. Afr. Rep. 98 B3
Bodalla Australia 112 E6
Bodallin Australia 109 B7
Bodaybo Rus. Fed. 65 M4
Boddam U.K. 50 H3
Bode r. Germany 53 L3
Bodega Head hd U.S.A. 128 B2
Bodélé reg. Chad 97 E3
Boden Sweden 44 L4
Bodenham U.K. 49 E6
Bodensee l. Germany/Switz. see
Constance, Lake
Bodenteich Germany 53 K2
Bodenwerder Germany 53 J3
Bodie U.S.A. 128 D2
Bodinayakkanur India 84 C4
Bodmin U.K. 49 C8
Bodmin Moor moorland U.K. 49 C8
Bodø Norway 44 I3
Bodoquena Brazil 143 G7
Bodoquena, Serra da hills Brazil 144 E2
Bodrum Turkey 59 L6
Bodträskfors Sweden 44 L3
Boechout Belgium 52 E3
Boende Dem. Rep. Congo 97 F5
Boerne U.S.A. 131 D6
Boeuf r. U.S.A. 131 F6
Boffa Guinea 96 B3
Bogalay Myanmar see Bogale
Bogale Myanmar 70 A3
Bogale r. Myanmar 70 A4
Bogalusa U.S.A. 131 F6
Bogan r. Australia 112 C2
Bogandé Burkina 96 C3
Bogan Gate Australia 112 C4
Bogcang Zangbo r. China 83 F3
Bogda Shan mts China 80 G3
Boggabilla Australia 112 E2
Boggabri Australia 112 E3
Boggeragh Mts hills Ireland 51 C5
Boghar Alg. 57 H6
Boghari Alg. see Ksar el Boukhari
Bognor Regis U.K. 49 G8
Bogodukhov Ukr. see Bohodukhiv
Bog of Allen reg. Ireland 51 E4
Bogong, Mount Australia 112 C6
Bogopol' Rus. Fed. 74 D3
Bogor Indon. 68 D8
Bogoroditsk Rus. Fed. 43 H5
Bogorodsk Rus. Fed. 42 I4
Bogorodskoye Khabarovskiy Kray
Rus. Fed. 74 F1
Bogorodskoye Kirovskaya Oblast'
Rus. Fed. 42 K4

▶Bogotá Col. 142 D3
Capital of Colombia and 5th most populous
city in South America.

Bogotol Rus. Fed. 64 J4
Bogoyavlenskoye Rus. Fed. see
Pervomayskiy
Bogra Bangl. 83 G4
Boguchany Rus. Fed. 65 K4
Boguchar Rus. Fed. 43 I6
Bogué Mauritania 96 B3
Bo Hai g. China 73 L5
Bohain-en-Vermandois France 52 D5
Bohai Wan b. China 66 D4
Bohemia reg. Czech Rep. 47 N6
Bohemian Forest mts Germany see
Böhmer Wald
Böhlen Germany 53 M3
Bohlokong S. Africa 101 I5
Böhme r. Germany 53 J2
Böhmer Wald mts Germany 53 M5
Bohmte Germany 53 I2
Bohodukhiv Ukr. 43 G6
Bohol i. Phil. 69 G5

Bohol Sea Phil. 69 G5
Böhöt Mongolia 73 J3
Bohu China 80 G3
Boiaçu Brazil 142 F4
Boichoko S. Africa 100 F5
Boigu Island Australia 69 K8
Boikhutso S. Africa 101 H4
Boileau, Cape Australia 108 C4
Boim Brazil 143 G4
Boipeba, Ilha i. Brazil 145 D1
Bois r. Brazil 145 A2
Bois Blanc Island U.S.A. 132 C2

▶Boise U.S.A. 126 D4
State capital of Idaho.

Boise City U.S.A. 131 C4
Boissevain Canada 121 K5
Boitumelong S. Africa 101 G4
Boizenburg Germany 53 K1
Bojd Iran 88 E3
Bojnürd Iran 88 E2
Bokaak atoll Marshall Is see Taongi
Bokajan India 83 H4
Bokaro India 83 F5
Bokaro Reservoir India 83 F5
Bokatola Dem. Rep. Congo 98 B4
Boké Guinea 96 B3
Bokele Dem. Rep. Congo 98 C4
Bokhara r. Australia 112 C2
Bo Kheo Cambodia see Bâ Kêv
Boknafjorden sea chan. Norway 45 D7
Bokoko Dem. Rep. Congo 98 C3
Bokoro Chad 97 E3
Bokovskaya Rus. Fed. 43 I6
Bokspits S. Africa 100 E4
Boktor Rus. Fed. 74 E2
Bokurdak Turkm. 88 E2
Bol Chad 97 E3
Bolaiti Dem. Rep. Congo 97 F5
Bolama Guinea-Bissau 96 B3
Bolangir India 84 D1
Bolan Pass Pak. 89 G4
Bolbec France 56 E2
Bole China 80 F3
Bole Ghana 96 C4
Boleko Dem. Rep. Congo 98 B4
Bolen Rus. Fed. 74 D2
Bolgar Rus. Fed. 43 K5
Bolgatanga Ghana 96 C3
Bolgrad Ukr. see Bolhrad
Bolhrad Ukr. 59 M2
Boli China 74 C3
Bolia Dem. Rep. Congo 98 B4
Boliden Sweden 44 L4
Bolingbrook U.S.A. 134 A3
Bolintin-Vale Romania 59 K2
Bolívar Peru 142 C5
Bolivar NY U.S.A. 135 F2
Bolivar TN U.S.A. 131 F5
Bolívar, Pico mt. Venez. 142 D2
Bolivia Cuba 133 E8

▶Bolivia country S. America 142 E7
5th largest country in South America.
South America 9, 140–141

Bolkhov Rus. Fed. 43 H5
Bollène France 56 G4
Bollnäs Sweden 45 J6
Bollon Australia 112 C2
Bollstabruk Sweden 44 J5
Bolmen l. Sweden 45 H8
Bolobo Dem. Rep. Congo 98 B4
Bologna Italy 58 D2
Bolognesi Peru 142 D5
Bologoye Rus. Fed. 42 G4
Bolokanang S. Africa 101 G5
Bolomba Dem. Rep. Congo 98 B3
Bolon' Rus. Fed. see Achan
Bolovens, Phouphieng plat. Laos 70 D4
Bolpur India 83 F5
Bolsena, Lago di l. Italy 58 D3
Bol'shakovo Rus. Fed. 45 L9
Bol'shaya Chernigovka Rus. Fed. 41 Q5
Bol'shaya Glushitsa Rus. Fed. 43 K5
Bol'shaya Imandra, Ozero l.
 Rus. Fed. 44 R3
Bol'shaya Martinovka Rus. Fed. 43 I7
Bol'shaya Tsarevshchina Rus. Fed. see
 Volzhskiy
Bol'shenarymskoye Kazakh. 80 F2
Bol'shevik, Ostrov i. Rus. Fed. 65 L2
Bol'shezemel'skaya Tundra lowland
 Rus. Fed. 42 L2
Bol'shiye Barsuki, Peski des. Kazakh. 80 A2
Bol'shiye Chirki Rus. Fed. 42 J3
Bol'shiye Kozly Rus. Fed. 42 H2
Bol'shoy Aluy r. Rus. Fed. 65 Q3
Bol'shoy Begichev, Ostrov i.
 Rus. Fed. 153 F2
Bol'shoye Murashkino Rus. Fed. 42 J5
Bol'shoy Irgiz r. Rus. Fed. 43 J6
Bol'shoy Kamen' Rus. Fed. 74 D4
Bol'shoy Kavkaz mts Asia/Europe see
 Caucasus
Bol'shoy Kundysh r. Rus. Fed. 42 J4
Bol'shoy Lyakhovskiy, Ostrov i.
 Rus. Fed. 65 P2
Bol'shoy Tokmak Kyrg. see Tokmok
Bol'shoy Tokmak Ukr. see Tokmak
Bolsward Neth. 52 F1
Bolton Canada 134 F2
Bolton U.K. 48 E5
Bolu Turkey 59 N4
Boluntay China 83 H1
Boluo China 77 G4
Bolus Head hd Ireland 51 B6
Bolvadin Turkey 59 N5
Bolzano Italy 58 D1
Boma Dem. Rep. Congo 99 B4
Bomaderry Australia 112 E5
Bombala Australia 112 D6
Bombay India see Mumbai
Bombay Beach U.S.A. 129 F5
Bomberai, Semenanjung pen.
 Indon. 69 I7
Bomboma Dem. Rep. Congo 98 B3
Bom Comércio Brazil 142 E5
Bomdila India 83 H4
Bomi China 76 B2
Bomili Dem. Rep. Congo 98 C3

Bom Jardim Brazil 145 D1
Bom Jardim de Goiás Brazil 145 A2
Bom Jesus Brazil 145 A5
Bom Jesus da Gurgueia, Serra do hills
 Brazil 143 J5
Bom Jesus da Lapa Brazil 145 C1
Bom Jesus do Norte Brazil 145 C3
Bømlo i. Norway 45 D7
Bomokandi r. Dem. Rep. Congo 98 C3
Bom Retiro Brazil 145 A4
Bom Sucesso Brazil 145 B3
Bon, Cap c. Tunisia 58 D6
Bon, Ko i. Thai. 71 B5
Bona Alg. see Annaba
Bona, Mount U.S.A. 120 A2
Bonāb Iran 88 B2
Bon Air U.S.A. 135 G5
Bonaire i. Neth. Antilles 137 K6
Bonanza Peak U.S.A. 126 C2
Bonaparte Archipelago is Australia 108 D3
Bonaparte Lake Canada 120 F5
Bonar Bridge U.K. 50 E3
Bonavista Canada 123 L4
Bonavista Bay Canada 123 L4
Bonchester Bridge U.K. 50 G5
Bondo Dem. Rep. Congo 98 C3
Bondokodi Indon. 68 F8
Bondoukou Côte d'Ivoire 96 C4
Bonduel U.S.A. 134 A1
Bondyuzhskiy Rus. Fed. see Mendeleyevsk
Bône Alg. see Annaba
Bone, Teluk b. Indon. 69 G8
Bönen Germany 53 H3
Bonerate, Kepulauan is Indon. 108 C1
Bo'ness U.K. 50 F4

▶Bonete, Cerro mt. Arg. 144 C3
3rd highest mountain in South America.

Bonga Eth. 98 D3
Bongaigaon India 83 G4
Bongandanga Dem. Rep. Congo 98 C3
Bongani S. Africa 100 F5
Bongao Phil. 68 F5
Bongba China 82 E2
Bong Co l. China 83 G3
Bongo, Massif des mts Cent. Afr. Rep.
 98 C3
Bongo, Serra do mts Angola 99 B4
Bongolava mts Madag. 99 E5
Bongor Chad 97 E3
Bông Sơn Vietnam 71 E4
Bonham U.S.A. 131 D5
Bonheiden Belgium 52 E3
Boni Mali 96 C3
Bonifacio Corsica France 56 I6
Bonifacio, Bocche di strait France/Italy see
 Bonifacio, Strait of
Bonifacio, Bouches de strait France/Italy
 see Bonifacio, Strait of
Bonifacio, Strait of France/Italy 56 I6

▶Bonin Islands Japan 75 F8
Part of Japan.

▶Bonn Germany 52 H4
Former capital of Germany.

Bonna Germany see Bonn
Bonnåsjøen Norway 44 I3
Bonners Ferry U.S.A. 126 D2
Bonnet, Lac du resr Canada 121 M5
Bonneville France 56 H3
Bonneville Salt Flats U.S.A. 129 G1
Bonnières-sur-Seine France 52 B5
Bonnie Rock Australia 109 B7
Bonnieville U.S.A. 134 C5
Bonnyrigg U.K. 50 F5
Bonnyville Canada 121 I4
Bonobono Phil. 68 F5
Bononia Italy see Bologna
Bonorva Sardinia Italy 58 C4
Bonshaw Australia 112 E2
Bontebok National Park S. Africa 100 E8
Bonthe Sierra Leone 96 B4
Bontoc Phil. 77 I5
Bontosunggu Indon. 68 F8
Bontrug S. Africa 101 G7
Bonvouloir Islands P.N.G. 110 E1
Bonwapitse Botswana 101 H2
Boo, Kepulauan is Indon. 69 H7
Book Cliffs U.S.A. 129 I2
Booker U.S.A. 131 C4
Boolba Australia 112 D2
Booligal Australia 112 B4
Boomi Australia 112 D2
Boon U.S.A. 134 C1
Boonah Australia 112 F1
Boone CO U.S.A. 127 G5
Boone IA U.S.A. 130 E3
Boone NC U.S.A. 132 D4
Boone Lake U.S.A. 134 D5
Boones Mill U.S.A. 134 F5
Booneville AR U.S.A. 131 E5
Booneville KY U.S.A. 134 D5
Booneville MS U.S.A. 131 F5
Böön Tsagaan Nuur salt l.
 Mongolia 80 I2
Boonville CA U.S.A. 128 B2
Boonville IN U.S.A. 134 B4
Boonville MO U.S.A. 130 E4
Boonville NY U.S.A. 135 H2
Boorabin National Park Australia 109 C7
Booraama Somalia 98 E3
Booroorban Australia 112 B5
Boorowa Australia 112 D5
Boort Australia 112 A6
Boothby, Cape Antarctica 152 D2
Boothia, Gulf of Canada 119 J3
Bootle U.K. 48 E5
Booué Gabon 98 B4
Boppard Germany 53 H4
Boqê China 83 G3
Boqueirão, Serra do hills Brazil 143 J6
Bor Czech Rep. 53 M5
Bor Rus. Fed. 42 J4
Bor Serb. and Mont. 59 J2
Bor Sudan 97 G4
Bor Turkey 90 D3

Boraha, Nosy i. Madag. 99 F5
Borah Peak U.S.A. 126 E3
Borai India 84 D1
Borakalalo Nature Reserve
 S. Africa 101 H3
Boran Kazakh. see Buran
Boraphet, Bung l. Thai. 70 C4
Boraphet, Nong l. Thai. see
 Boraphet, Bung
Borås Sweden 45 H8
Borasambar India 84 D1
Borāzjān Iran 88 C4
Borba Brazil 143 G4
Borba China 76 C1
Borborema, Planalto da plat. Brazil 143 K5
Borchen Germany 53 I3
Borçka Turkey 91 F2
Bor Dağı mt. Turkey 59 M6
Bordeaux France 56 D4
Borden Island Canada 119 G2
Borden Peninsula Canada 119 J2
Border Ranges National Park
 Australia 112 F2
Borðeyri Iceland 44 [inset]
Bordj Bou Arréridj Alg. 57 I5
Bordj Bounaama Alg. 57 G6
Bordj Flye Ste-Marie Alg. 96 C2
Bordj Messaouda Alg. 54 F5
Bordj Mokhtar Alg. 96 D2
Bordj Omar Driss Alg. 96 D2
Bordj Omer Driss Alg. see
 Bordj Omar Driss
Boreas Abyssal Plain sea feature
 Arctic Ocean 153 H1
Borel r. Canada 123 H2
Borgå Fin. see Porvoo
Borgarfjörður Iceland 44 [inset]
Borgarnes Iceland 44 [inset]
Børgefjell Nasjonalpark nat. park
 Norway 44 H4
Borger U.S.A. 131 C5
Borgholm Sweden 45 J8
Borgne, Lake b. U.S.A. 131 F6
Borgo San Lorenzo Italy 58 D3
Bori India 84 E1
Bori r. India 82 C6
Borikhan Laos 70 C3
Borislav Ukr. see Boryslav
Borisoglebsk Rus. Fed. 43 I6
Borisov Belarus see Barysaw
Borisovka Rus. Fed. 43 H6
Borispol' Ukr. see Boryspil'
Bo River Post Sudan 97 F4
Borja Peru 142 C4
Borken Germany 52 G3
Borkenes Norway 44 J2
Borkovskaya Rus. Fed. 42 K2
Borkum Germany 52 G1
Borkum i. Germany 52 G1
Borlänge Sweden 45 I6
Borlaug Norway 45 E6
Borlu Turkey 59 M5
Borna Germany 53 M3
Born-Berge hill Germany 53 K3
Borndiep sea chan. Neth. 52 F1
Borne Neth. 52 G2

▶Borneo i. Asia 68 E6
Largest island in Asia and 3rd in the world.
World 12–13

Bornheim Germany 52 H4
Bornholm county Denmark 153 H3
Bornholm i. Denmark 45 I9
Bornova Turkey 59 L5
Borodino Rus. Fed. 64 J3
Borodinskoye Rus. Fed. 45 P6
Borogontsy Rus. Fed. 65 O3
Borohoro Shan mts China 80 F3
Borok-Sulezhskiy Rus. Fed. 42 H4
Boromo Burkina 96 C3
Boron U.S.A. 128 E4
Borondi India 84 D1
Boroughbridge U.K. 48 F4
Borovichi Rus. Fed. 42 G4
Borovoy Kirovskaya Oblast' Rus. Fed. 42 K4
Borovoy Respublika Kareliya Rus. Fed. 44 R4
Borovoy Respublika Komi Rus. Fed. 42 L3
Borpeta India see Barpeta
Borrisokane Ireland 51 D5
Borroloola Australia 110 B3
Borsa Romania 43 E7
Borsakelmas sho'rxogi salt marsh
 Uzbek. 91 J2
Borshchiv Ukr. 43 E6
Borshchovochnyy Khrebet mts
 Rus. Fed. 73 L2
Bortala China see Bole
Borton U.S.A. 134 B4
Borūjen Iran 88 C4
Borūjerd Iran 88 C3
Borun Iran 88 E3
Borve U.K. 50 C3
Boryslav Ukr. 43 D6
Boryspil' Ukr. 43 G6
Borzna Ukr. 43 G6
Borzya Rus. Fed. 73 L2
Bosanska Dubica Bos.-Herz. 58 G2
Bosanska Gradiška Bos.-Herz. 58 G2
Bosanska Krupa Bos.-Herz. 58 G2
Bosanski Novi Bos.-Herz. 58 G2
Bosanski Samac Bos.-Herz. 58 G2
Bosanski Grahovo Bos.-Herz. 58 G2
Boscawen Island Tonga see Niuatoputapu
Bose China 76 E4
Boshof S. Africa 101 G5
Boshrūyeh Iran 88 E3
Bosna i Hercegovina country Europe see
 Bosnia-Herzegovina
Bosna Saray Bos.-Herz. see Sarajevo
▶Bosnia-Herzegovina country
 Europe 58 G2
 Europe 5, 38–39
Bosobogolo Pan salt pan Botswana 100 F3
Bosobolo Dem. Rep. Congo 98 B3
Bōsō-hantō pen. Japan 75 F6
Bosporus strait Turkey 59 M4
Bossaga Turkm. see Basaga
Bossangoa Cent. Afr. Rep. 98 B3
Bossembélé Cent. Afr. Rep. 98 B3
Bossier City U.S.A. 131 E5
Bossiesvlei Namibia 100 C3
Bossut, Cape Australia 108 C4

Bostan China 83 F1
Bostān Iran 88 B4
Bostan Pak. 89 G4
Bostāneh, Ra's-e pt Iran 88 D5
Bosten Hu l. China 80 G3
Boston U.K. 49 G6

▶Boston U.S.A. 135 J2
State capital of Massachusetts.

Boston Mountains U.S.A. 131 E5
Boston Spa U.K. 48 F5
Boswell U.S.A. 134 B3
Botad India 82 B5
Botany Bay Australia 112 E4
Botev mt. Bulg. 59 K3
Botevgrad Bulg. 59 J3
Bothaville S. Africa 101 H4
Bothnia, Gulf of Fin./Sweden 45 K6
Bothwell Canada 134 E2
Botkins U.S.A. 134 C3
Botlikh Rus. Fed. 91 G2
Botoşani Romania 43 E7
Botou China 73 L5
Botshabelo S. Africa 101 H5
▶Botswana country Africa 99 C6
 Africa 7, 94–95
Botte Donato, Monte mt. Italy 58 G5
Bottesford U.K. 48 G5
Bottrop Germany 52 G3
Botucatu Brazil 145 A3
Botuporã Brazil 145 C1
Botwood Canada 123 L4
Bouaflé Côte d'Ivoire 96 C4
Bouaké Côte d'Ivoire 96 C4
Bouar Cent. Afr. Rep. 98 B3
Bouârfa Morocco 54 D5
Bouba Ndjida, Parc National de nat. park
 Cameroon 97 E4
Bouca Cent. Afr. Rep. 98 B3
Boucaut Bay Australia 108 F3
Bouchain France 52 D4
Bouctouche Canada 123 I5
Boudh India 84 E1
Bougaa Alg. 57 I5
Bougainville, Cape Australia 108 D3
Bougainville Island P.N.G. 106 F2
Bougainville Reef Australia 110 D2
Boughessa Mali 96 D3
Bougie Alg. see Bejaïa
Bougouni Mali 96 C3
Bougtob Alg. 54 E5
Bouillon Belgium 52 F5
Bouira Alg. 57 H5
Bou Izakarn Morocco 96 C2
Boujdour W. Sahara 96 B2
Bou Naceur, Jbel mt. Morocco 54 D5
Boû Nâga Mauritania 96 B3
Boundary Mountains U.S.A. 135 J1
Boundary Peak U.S.A. 128 D3
Boundiali Côte d'Ivoire 96 C4
Boundji Congo 98 B4
Bountiful U.S.A. 129 H1
Bounty Islands N.Z. 107 H6
Bounty Trough sea feature
 S. Pacific Ocean 150 I9
Bourail New Caledonia 107 G4
Bourbon reg. France see Bourbonnais
Bourbon terr. Indian Ocean see Réunion
Bourbon U.S.A. 134 B3
Bourbonnais reg. France 56 F3
Bourem Mali 96 C3
Bouressa Mali see Boughessa
Bourg-Achard France 49 H9
Bourg-en-Bresse France 56 G3
Bourganeuf France 56 E4
Bourges France 56 F3
Bourget Canada 135 H1
Bourgogne reg. France see Burgundy
Bourgogne, Canal de France 56 G3
Bourke Australia 112 B3
Bourne U.K. 49 G6
Bournemouth U.K. 49 F8
Bourtoutou Chad 97 F3
Bou Saâda Alg. 57 I6
Bou Salem Tunisia 58 C6
Bouse U.S.A. 129 F5
Bouse Wash watercourse U.S.A. 129 F4
Boussu Belgium 52 D4
Boutilimit Mauritania 96 B3
Bouvet Island terr. S. Atlantic Ocean see
 Bouvetøya

▶Bouvetøya terr. S. Atlantic Ocean 148 I9
Dependency of Norway.

Bouy France 52 E5
Bova Marina Italy 58 F6
Bovenden Germany 53 J3
Bow r. Alta Canada 121 I5
Bow r. Alta Canada 126 F2
Bowa China see Muli
Bowbells U.S.A. 130 C1
Bowden U.S.A. 134 F4
Bowditch atoll Tokelau see Fakaofo
Bowen Australia 110 E4
Bowen, Mount Australia 112 D6
Bowenville Australia 112 E1
Bowers Ridge sea feature
 Bering Sea 150 H2
Bowie Australia 110 D4
Bowie AZ U.S.A. 129 I5
Bowie TX U.S.A. 131 D5
Bow Island Canada 121 I5
Bowling Green KY U.S.A. 134 B5
Bowling Green MO U.S.A. 130 F4
Bowling Green OH U.S.A. 134 D3
Bowling Green VA U.S.A. 135 G4

Bowling Green Bay National Park
 Australia 110 D3
Bowman U.S.A. 130 C2
Bowman, Mount Canada 126 C2
Bowman Island Antarctica 152 F2
Bowman Peninsula Antarctica 152 L2
Bowmore U.K. 50 C5
Bowo China see Bomi
Bowral Australia 112 E5
Bowser Lake Canada 120 D3
Boxberg Germany 53 J5
Box Elder U.S.A. 130 C2
Box Elder r. U.S.A. 130 C2
Boxtel Neth. 52 F3
Boyabat Turkey 90 D2
Boyana tourist site Bulg. 59 J3
Boyang China 77 H2
Boyd r. Australia 112 F2
Boyd Lagoon salt flat Australia 109 D6
Boyd Lake Canada 121 K2
Boydton U.S.A. 135 F5
Boyers U.S.A. 134 F3
Boykins U.S.A. 135 G5
Boyle Canada 121 H4
Boyle Ireland 51 D4
Boyne r. Ireland 51 F4
Boyne City U.S.A. 134 C1
Boysen Reservoir U.S.A. 126 F4
Boysun Uzbek. 89 G2
Boyuibe Bol. 142 F8
Böyük Qafqaz mts Asia/Europe see
 Caucasus

▶Bozcaada i. Turkey 59 L5
Most westerly point of Asia.

Bozdağ mt. Turkey 59 L5
Bozdağ mt. Turkey 85 C1
Boz Dağları mts Turkey 59 M5
Bozdoğan Turkey 59 M6
Bozeat U.K. 49 G6
Bozeman U.S.A. 126 F3
Bozen Italy see Bolzano
Bozhou China 77 G1
Bozoum Cent. Afr. Rep. 98 B3
Bozova Turkey 91 E3
Bozqūsh, Kūh-e mts Iran 88 B2
Bozüyük Turkey 59 N5
Bozyazı Turkey 85 A1

▶Bra Italy 58 B2
Brač i. Croatia 58 G3
Bracadale U.K. 50 C3
Bracadale, Loch b. U.K. 50 C3
Bracara Port. see Braga
Bracciano, Lago di l. Italy 58 E3
Bracebridge Canada 134 F1
Brachet, Lac au l. Canada 123 H4
Bräcke Sweden 44 I5
Brackenheim Germany 53 J5
Brackettville U.S.A. 131 C6
Bracknell U.K. 49 G7
Bradano r. Italy 58 G4
Bradenton U.S.A. 133 D7
Bradford Canada 134 F1
Bradford U.K. 48 F5
Bradford OH U.S.A. 134 C3
Bradford PA U.S.A. 135 F3
Bradley U.S.A. 134 B3
Brady U.S.A. 131 D6
Brady Glacier U.S.A. 120 B3
Brae U.K. 50 [inset]
Braemar U.K. 50 F3
Braga Port. 57 B3
Bragado Arg. 144 D5
Bragança Brazil 143 I4
Bragança Port. 57 C3
Bragança Paulista Brazil 145 B3
Brahin Belarus 43 F6
Brahlstorf Germany 53 K1
Brahmanbaria Bangl. 83 G5
Brahmapur India 84 E2
Brahmaputra r. Asia 83 H4
 *also known as Dihang (India) or Jamuna
 (Bangladesh) or Siang (India) or Yarlung
 Zangbo (China)*
Brahmaur India 82 D2
Brăila Romania 59 L2
Braine France 52 D5
Braine-le-Comte Belgium 52 E4
Brainerd U.S.A. 130 E2
Braintree U.K. 49 H7
Braithwaite Point Australia 108 F2
Brak r. S. Africa 101 I2
Brake (Unterweser) Germany 53 I1
Brakel Belgium 52 D4
Brakel Germany 53 J3
Brakwater Namibia 100 C2
Bramfield Australia 109 F8
Bramming Denmark 45 F9
Brampton Canada 134 F2
Brampton England U.K. 48 E4
Brampton England U.K. 49 I6
Bramsche Germany 53 I2
Bramwell Australia 110 C2
Brancaster U.K. 49 H6
Branch Canada 123 L5
Branco r. Brazil 142 F4
Brandberg mt. Namibia 99 B6
Brandbu Norway 45 G6
Brande Denmark 45 F9
Brandenburg Germany 53 M2
Brandenburg land Germany 53 N2
Brandenburg U.S.A. 134 B5
Brandfort S. Africa 101 H5
Brandis Germany 53 N3
Brandon Canada 121 L5
Brandon U.K. 49 H6
Brandon MS U.S.A. 131 F5
Brandon VT U.S.A. 135 I2
Brandon Head hd Ireland 51 B5
Brandon Mountain hill Ireland 51 B5
Brandvlei S. Africa 100 E6
Braniewo Poland 47 Q3
Bransfield Strait Antarctica 152 L2
Branson U.S.A. 131 E4
Branxton Australia 112 E4
Bras d'Or Lake Canada 123 J5
Brasil country S. America see Brazil
Brasil, Planalto do plat. Brazil 143 J7
Brasileia Brazil 142 E6

▶Brasília Brazil 145 B1
Capital of Brazil.

Brasília de Minas Brazil 145 B2
Braslav Belarus see Braslaw
Braslaw Belarus 45 O9
Braşov Romania 59 K2
Brassey, Mount Australia 109 F5
Brassey Range hills Australia 109 C6
Brasstown Bald mt. U.S.A. 133 D5

▶Bratislava Slovakia 47 P6
Capital of Slovakia.

Bratsk Rus. Fed. 72 I1
Bratskoye Vodokhranilishche resr
 Rus. Fed. 72 I1
Brattleboro U.S.A. 135 I2
Braunau am Inn Austria 47 N6
Braunfels Germany 53 I4
Braunlage Germany 53 K3
Braunsbedra Germany 53 L3
Braunschweig Germany 53 K2
Brava i. Cape Verde 96 [inset]
Brave U.S.A. 134 E4
Bråviken inlet Sweden 45 J7
Bravo, Cerro mt. Bol. 142 F7
Bravo del Norte, Río r. Mex. 124 H6
Bravo del Norte, Río r. Mex./U.S.A. 127 G7
 see Rio Grande
Brawley U.S.A. 129 F5
Bray Ireland 51 F4
Bray Island Canada 119 K3
Brazeau r. Canada 120 H4
Brazeau, Mount Canada 120 G4

▶Brazil country S. America 143 G5
*Largest country in South America and 5th
 in the world. Most populous country in
 South America and 5th in the world.*
South America 9, 140–141

Brazil U.S.A. 134 B4
Brazil Basin sea feature S. Atlantic Ocean
 148 G7
Brazos r. U.S.A. 131 E6

▶Brazzaville Congo 99 B4
Capital of Congo.

Brčko Bos.-Herz. 58 H2
Bré Ireland see Bray
Breadalbane Australia 110 B4
Breaksea Sound inlet N.Z. 113 A7
Bream Bay N.Z. 113 E3
Brechfa U.K. 49 C7
Brechin U.K. 50 G4
Brecht Belgium 52 E3
Breckenridge MI U.S.A. 134 C2
Breckenridge MN U.S.A. 130 D2
Breckenridge TX U.S.A. 131 D5
Břeclav Czech Rep. 47 P6
Brecon U.K. 49 D7
Brecon Beacons reg. U.K. 49 D7
Brecon Beacons National Park U.K. 49 D7
Breda Neth. 52 E3
Bredasdorp S. Africa 100 E8
Bredbo Australia 112 D5
Breddin Germany 53 M2
Bredevoort Neth. 52 G3
Bredviken Sweden 44 J4
Bree Belgium 52 F3
Breed U.S.A. 134 A1
Bregenz Austria 47 L7
Breiðafjörður b. Iceland 44 [inset]
Breiðdalsvík Iceland 44 [inset]
Breidenbach Germany 53 I4
Breien U.S.A. 130 C2
Breitenfelde Germany 53 K1
Breitengüßbach Germany 53 K5
Breiter Luzinsee l. Germany 53 N1
Breivikbotn Norway 44 M1
Breizh reg. France see Brittany
Brejo Velho Brazil 145 C1
Brekstad Norway 44 F5
Bremen Germany 53 I1
Bremen land Germany 53 I1
Bremen IN U.S.A. 134 B3
Bremen OH U.S.A. 134 D4
Bremer Bay Australia 109 B8
Bremerhaven Germany 53 I1
Bremer Range hills Australia 109 C8
Bremersdorp Swaziland see Manzini
Bremervörde Germany 53 J1
Bremm Germany 52 H4
Brenham U.S.A. 131 D6
Brenna Norway 44 H4
Brennero, Passo di pass Austria/Italy see
 Brenner Pass
Brennerpaß pass Austria/Italy see
 Brenner Pass
Brenner Pass Austria/Italy 58 D1
Brentwood U.K. 49 H7
Brescia Italy 58 D2
Breslau Poland see Wrocław
Bresle r. France 52 B4
Brésolles, Lac i. Canada 123 H3
Bressanone Italy 58 D1
Bressay i. U.K. 50 [inset]
Bressuire France 56 D3
Brest Belarus 45 M10
Brest France 56 B2
Brest-Litovsk Belarus see Brest
Bretagne reg. France see Brittany
Breteuil France 52 C5
Brétigny-sur-Orge France 52 C6
Breton Canada 120 H4
Breton Sound b. U.S.A. 131 F6
Brett, Cape N.Z. 113 E2
Bretten Germany 53 I5
Bretton U.K. 48 E5
Breueh, Pulau i. Indon. 71 A6
Brevard U.S.A. 133 D5
Breves Brazil 143 H4
Brewarrina Australia 112 C2
Brewer U.S.A. 132 G2
Brewster NE U.S.A. 130 D3
Brewster OH U.S.A. 134 E3
Brewster, Kap c. Greenland see Kangikajik
Brewster, Lake imp. l. Australia 112 B4
Brewton U.S.A. 133 C6

Byron Island Kiribati see Nikunau
Byrranga, Gory mts Rus. Fed. 65 K2
Byske Sweden 44 L4
Byssa Rus. Fed. 74 C1
Byssa r. Rus. Fed. 74 C1
Bytom Poland 47 Q5
Bytów Poland 47 P3
Byurgyutli Turkm. 88 D2
Byzantium Turkey see İstanbul

C

Ca, Sông r. Vietnam 70 D3
Caacupé Para. 144 E3
Caatinga Brazil 145 B2
Caazapá Para. 144 E3
Cabaiguán Cuba 133 E8
Caballas Peru 142 C6
Caballococha Peru 142 D4
Caballos Mesteños, Llano de los plain
 Mex. 131 B6
Cabanaconde Peru 142 D7
Cabanatuan Phil. 69 G3
Cabano Canada 123 H5
Cabdul Qaadir Somalia 98 E2
Cabeceira Rio Manso Brazil 143 G7
Cabeceiras Brazil 145 B1
Cabeza del Buey Spain 57 D4
Cabezas Bol. 142 F7
Cabimas Venez. 142 D1
Cabinda Angola 99 B4
Cabinda prov. Angola 99 B5
Cabinet Inlet Antarctica 152 L2
Cabinet Mountains U.S.A. 126 E2
Cabistra Turkey see Ereğli
Cabo Frio Brazil 145 C3
Cabo Frio, Ilha do i. Brazil 145 C3
Cabonga, Réservoir resr Canada 122 F5
Cabool U.S.A. 131 E4
Caboolture Australia 112 F1
Cabo Orange, Parque Nacional de
 nat. park Brazil 143 H3
Cabo Pantoja Peru 142 C4
Cabora Bassa, Lake resr Moz. 99 D5
Cabo Raso Arg. 144 C6
Caborca Mex. 127 E7
Cabot Head hd Canada 134 E1
Cabot Strait Canada 123 J5
Cabourg France 49 G9
Cabo Verde country N. Atlantic Ocean see
 Cape Verde
Cabo Verde, Ilhas do is N. Atlantic Ocean
 96 [inset]
Cabo Yubi Morocco see Tarfaya
Cabral, Serra do mts Brazil 145 B2
Cabrera, Illa de i. Spain 57 H4
Cabri Canada 121 I5
Cabullona Mex. 127 F7
Caçador Brazil 145 A4
Cacagoin China see Qagca
Čačak Serb. and Mont. 59 I3
Caccia, Capo c. Sardinia Italy 58 C4
Çâçe Turkm. 89 F2
Cacequi Brazil 144 F3
Cáceres Brazil 143 G7
Cáceres Spain 57 C4
Cache Creek Canada 120 F5
Cache Peak U.S.A. 126 E4
Cacheu Guinea-Bissau 96 B3
Cachi, Nevados de mts Arg. 144 C2
Cachimbo, Serra do hills Brazil 143 H5
Cachoeira Brazil 145 D1
Cachoeira Alta Brazil 145 A2
Cachoeira de Goiás Brazil 145 A2
Cachoeira do Arari Brazil 143 I4
Cachoeira de Itapemirim Brazil 145 C3
Cacine Guinea-Bissau 96 B3
Caciporé, Cabo c. Brazil 143 H3
Cacolo Angola 99 B5
Cacongo Angola 99 B4
Cactus U.S.A. 131 C4
Caçu Brazil 145 A2
Caculé Brazil 145 C1
Čadca Slovakia 47 Q6
Cadereyta Mex. 131 C7
Cadibarrawirracanna, Lake salt flat
 Australia 111 A6
Cadillac Canada 121 J5
Cadillac U.S.A. 134 C1
Cadiz Phil. 69 G4
Cádiz Spain 57 C5
Cadiz IN U.S.A. 134 C4
Cadiz KY U.S.A. 132 C4
Cadiz OH U.S.A. 134 E3
Cádiz, Golfo de g. Spain 57 C5
Cadiz Lake U.S.A. 129 F4
Cadomin Canada 120 G4
Cadotte r. Canada 120 G3
Cadotte Lake Canada 120 G3
Caen France 56 D2
Caerdydd U.K. see Cardiff
Caerffili U.K. see Caerphilly
Caerfyrddin U.K. see Carmarthen
Caergybi U.K. see Holyhead
Caernarfon U.K. 49 C5
Caernarfon Bay U.K. 49 C5
Caernarvon U.K. see Caernarfon
Caerphilly U.K. 49 D7
Caesaraugusta Spain see Zaragoza
Caesarea Alg. see Cherchell
Caesarea Cappadociae Turkey see Kayseri
Caesarea Philippi Syria see Bāniyās
Caesarodunum France see Tours
Caesaromagus U.K. see Chelmsford
Caetité Brazil 145 C1
Cafayate Arg. 144 C3
Cafelândia Brazil 145 A3
Caffa Ukr. see Feodosiya
Cagayan de Oro Phil. 69 G5
Cagayan de Tawi-Tawi i. Phil. 68 F5
Cagles Mill Lake U.S.A. 134 B4
Cagli Italy 58 E3
Cagliari Sardinia Italy 58 C5
Cagliari, Golfo di b. Sardinia Italy 58 C5
Çagyl Turkm. 91 I2
Cahama Angola 99 B5
Caha Mts hills Ireland 51 C6
Cahermore Ireland 51 B6

Cahersiveen Ireland see Cahirciveen
Cahir Ireland 51 E5
Cahirciveen Ireland 51 B6
Cahora Bassa, Lago de resr Moz. see
 Cabora Bassa, Lake
Cahore Point Ireland 51 F5
Cahors France 56 E4
Cahuapanas Peru 142 C5
Cahul Moldova 59 M2
Caia Moz. 99 D5
Caiabis, Serra dos hills Brazil 143 G6
Caianda Angola 99 C5
Caiapó r. Brazil 145 A1
Caiapó, Serra do hills Brazil 145 A2
Caiapônia Brazil 145 A2
Caibarién Cuba 133 E8
Cai Bầu, Đao i. Vietnam 70 D2
Caicara Venez. 142 E2
Caicos Islands Turks and Caicos Is 137 J4
Caicos Passage
 Bahamas/Turks and Caicos Is 133 F8
Caidian China 77 G2
Caiguna Australia 109 D8
Caimodoro mt. Spain 57 F3
Cainnyigoin China 76 D1
Cains Store U.S.A. 134 C5
Caipe Arg. 144 C2
Caird Coast Antarctica 152 B1
Cairngorm Mountains U.K. 50 F3
Cairngorms National Park 46 F2
Cairngorms National Park 48 D2
Cairngorms National Park 50 F3
Cairnryan U.K. 50 D6
Cairns Australia 110 D3
Cairnsmore of Carsphairn hill U.K. 50 E5

Cairo Egypt 90 C5
 Capital of Egypt and most populous city in
 Africa.

Cairo U.S.A. 133 C6
Caisleán an Bharraigh Ireland see
 Castlebar
Caiundo Angola 99 B5
Caiwarro Australia 112 B2
Caiyuanzhen China see Shengsi
Caizi Hu l. China 77 H2
Cajamarca Peru 142 C5
Cajati Brazil 145 A4
Cajuru Brazil 145 B3
Caka'lho China see Yanjing
Čakovec Croatia 58 G1
Çal Denizli Turkey 59 M5
Çal Hakkâri Turkey see Çukurca
Cala S. Africa 101 H6
Calabar Nigeria 96 D4
Calabogie Canada 135 G1
Calabria, Parco Nazionale della nat. park
 Italy 58 G5
Calafat Romania 59 J3
Calagua Mex. 127 F8
Calagurris Spain see Calahorra
Calahorra Spain 57 F2
Calai Angola 99 B5
Calais France 52 B4
Calais U.S.A. 123 I5
Calalasteo, Sierra de mts Arg. 144 C3
Calama Chile 144 C2
Calamajué Mex. 127 E7
Calamar Col. 142 D1
Calamian Group is Phil. 68 F4
Calamocha Spain 57 F3
Calandula Angola 99 B4
Calang Indon. 71 A6
Calapan Phil. 69 G4
Călărași Romania 59 L2
Calatayud Spain 57 F3
Calayan i. Phil. 69 G3
Calbayog Phil. 69 G4
Calbe (Saale) Germany 53 L3
Calçoene Brazil 143 H3
Calcutta India see Kolkata
Caldas da Rainha Port. 57 B4
Caldas Novas Brazil 143 I7
Calden Germany 53 J3
Calder r. Canada 120 G1
Caldera Chile 144 B3
Caldervale Australia 110 D5
Caldew r. U.K. 48 E4
Caldwell ID U.S.A. 126 D4
Caldwell KS U.S.A. 131 D4
Caldwell OH U.S.A. 134 E4
Caldwell TX U.S.A. 131 D6
Caledon r. Lesotho/S. Africa 101 H6
Caledon S. Africa 100 D8
Caledon Bay Australia 110 B2
Caledonia Canada 134 F2
Caledonia admin. div. U.K. see Scotland
Caledonia U.S.A. 135 G2
Caleta el Cobre Chile 144 B2
Calexico U.S.A. 129 F5
Calf of Man i. Isle of Man 48 C4
Calgary Canada 120 H5
Calhoun U.S.A. 134 B5
Cali Col. 142 C3
Calicut India 84 B4
Caliente U.S.A. 129 F3
California r. Canada 120 G1
California state U.S.A. 127 C4
California, Golfo de g. Mex. see
 California, Gulf of
California, Gulf of Mex. 127 E7
California Aqueduct canal U.S.A. 128 C3
Călilabad Azer. 91 H3
Calingasta Arg. 144 C4
Calipatria U.S.A. 129 F5
Calistoga U.S.A. 128 B2
Calkiní Mex. 136 F4
Callabonna, Lake salt flat Australia 111 C6
Callabonna Creek watercourse
 Australia 111 C6
Callaghan, Mount U.S.A. 128 E2
Callan Ireland 51 E5
Callan r. U.K. 51 F3
Callander Canada 122 F5
Callander U.K. 50 E4
Callang Phil. 77 I5
Callao Peru 142 C6
Callao U.S.A. 129 G2
Callicoon U.S.A. 135 H3
Calling Lake Canada 120 H4

Callington U.K. 49 C8
Calliope Australia 110 E5
Callipolis Turkey see Gallipoli
Calmar Arg. 144 D3
Caloosahatchee r. U.S.A. 133 D7
Caloundra Australia 112 F1
Caltagirone Sicily Italy 58 F6
Caltanissetta Sicily Italy 58 F6
Calucinga Angola 99 B5
Calulo Angola 99 B4
Calunga Angola 99 B5
Caluquembe Angola 99 B5
Caluula Somalia 98 F2
Calvert Hills Australia 110 B3
Calvert Island Canada 120 D5
Calvi Corsica France 56 I5
Calvinia S. Africa 100 D6
Calvo, Monte mt. Italy 58 F4
Cam r. U.K. 49 H6
Camaçari Brazil 145 D1
Camache Reservoir U.S.A. 128 C2
Camachigama r. Canada 122 F5
Camacho Mex. 131 C7
Camacuio Angola 99 B5
Camacupa Angola 99 B5
Camagüey Cuba 137 I4
Camagüey, Archipiélago de is Cuba 137 I4
Camah, Gunung mt. Malaysia 71 C6
Camamu Brazil 145 D1
Camana Peru 142 D7
Camanongue Angola 99 C5
Camapuã Brazil 143 H7
Camaquã Brazil 144 F4
Çamardı Turkey 90 D3
Camargo Bol. 142 E8
Camargue reg. France 56 G5
Camarillo U.S.A. 128 D4
Camarones Arg. 144 C6
Camarones, Bahía b. Arg. 144 C6
Camas r. U.S.A. 126 E4
Ca Mau Vietnam 71 D5
Cambay India see Khambhat
Cambay, Gulf of India see
 Khambhat, Gulf of
Camberley U.K. 49 G7
Cambodia country Asia 71 D4
 Asia 6, 62–63
Camboriú Brazil 145 A4
Camborne U.K. 49 B8
Cambrai France 52 D4
Cambria admin. div. U.K. see Wales
Cambrian Mountains hills U.K. 49 D6
Cambridge N.Z. 113 E3
Cambridge U.K. 49 H6
Cambridge MA U.S.A. 135 J2
Cambridge MD U.S.A. 135 G4
Cambridge MN U.S.A. 130 E2
Cambridge NY U.S.A. 135 I2
Cambridge OH U.S.A. 134 E3
Cambridge Bay Canada 119 H3
Cambridge City U.S.A. 134 C4
Cambridge Springs U.S.A. 134 E3
Cambrien, Lac l. Canada 123 H2
Cambulo Angola 99 C4
Cambundi-Catembo Angola 99 B5
Cambuquira Brazil 145 B3
Cam Co l. China 83 E2
Camden AL U.S.A. 133 C5
Camden AR U.S.A. 131 E5
Camden NJ U.S.A. 135 H4
Camden NY U.S.A. 135 H2
Camden SC U.S.A. 133 D5
Camdenton U.S.A. 130 E4
Cameia Angola 99 C5
Cameia, Parque Nacional da nat. park
 Angola 99 C5
Cameron AZ U.S.A. 129 H4
Cameron LA U.S.A. 131 E6
Cameron MO U.S.A. 130 E4
Cameron TX U.S.A. 131 D6
Cameron Highlands mts Malaysia 71 C6
Cameron Hills Canada 120 G3
Cameron Island Canada 119 H2
Cameron Park U.S.A. 128 C2
Cameroon country Africa 96 E4
 Africa 7, 94–95
Cameroon, Mount vol. Cameroon see
 Cameroun, Mont
Cameroon Highlands slope
 Cameroon/Nigeria 96 E4
Caméroun country Africa see Cameroon
Cameroun, Mont vol. Cameroon 96 D4
Cametá Brazil 143 I4
Camiña Chile 142 E7
Camiri Bol. 142 F8
Camisea Peru 142 D6
Camocim Brazil 143 J4
Camooweal Australia 110 B3
Camooweal Caves National Park
 Australia 110 B4
Camorta i. India 81 H10
Campana Mex. 131 C7
Campana, Isla i. Chile 144 A7
Campania Island Canada 120 D4
Campbell S. Africa 100 F5
Campbell, Cape N.Z. 113 E5
Campbell, Mount hill Australia 108 E5
Campbellford Canada 135 G1
Campbell Hill hill U.S.A. 134 D3
Campbell Island N.Z. 150 H9
Campbell Lake Canada 121 J2
Campbell Plateau sea feature
 S. Pacific Ocean 150 H9
Campbell Range hills Australia 108 D3
Campbell River Canada 120 E5
Campbellsville U.S.A. 134 C5
Campbellton Canada 123 I5
Campbelltown Australia 112 E5
Campbeltown U.K. 50 D5
Campeche Mex. 136 F5
Campeche, Bahía de g. Mex. 136 F5
Camperdown Australia 112 A7
Câmpina Romania 59 K2
Campina Grande Brazil 143 K5
Campinas Brazil 145 B3
Campina Verde Brazil 145 A2
Campo Cameroon 96 D4
Campobasso Italy 58 F4
Campo Belo Brazil 145 B3

Campo Belo do Sul Brazil 145 A4
Campo de Diauarum Brazil 143 H6
Campo Florido Brazil 145 A2
Campo Gallo Arg. 144 D3
Campo Grande Brazil 144 F2
Campo Largo Brazil 145 A4
Campo Maior Brazil 143 J4
Campo Maior Port. 57 C4
Campo Mourão Brazil 144 F2
Campos Brazil 145 C3
Campos Altos Brazil 145 B2
Campos Novos Brazil 145 A4
Campos Sales Brazil 143 J5
Campton U.S.A. 134 D5
Câmpulung Romania 59 K2
Câmpulung Moldovenesc Romania 59 K1
Camp Verde U.S.A. 129 H4
Camrose Canada 121 H4
Camrose U.K. 49 B7
Camsell Lake Canada 121 I2
Camsell Portage Canada 121 I3
Camsell Range mts Canada 120 F2
Camulodunum U.K. see Colchester
Çan Turkey 59 L4
Ca Na, Mui Vietnam 71 E5
Canaan r. Canada 123 I5
Canaan U.S.A. 135 I2
Canaan Peak U.S.A. 129 H3
Canabrava Brazil 145 B2
Canacona India 84 B3

Canada country N. America 118 H4
 Largest country in North America and 2nd
 in the world. 3rd most populous country in
 North America.
 North America 9, 116–117

Canada Basin sea feature Arctic Ocean
 153 A1
Canadian U.S.A. 131 C5
Canadian r. U.S.A. 131 E5
Canadian Abyssal Plain sea feature
 Arctic Ocean 153 A1
Canaima, Parque Nacional nat. park Venez.
 142 F2
Çanakkale Turkey 59 L4
Çanakkale Boğazı strait Turkey see
 Dardanelles
Canalejas Arg. 144 C5
Cañamares Spain 57 E3
Canandaigua U.S.A. 135 G2
Cananea Mex. 127 F7
Cananéia Brazil 145 B4
Canápolis Brazil 145 A2
Cañar Ecuador 142 C4
Canarias terr. N. Atlantic Ocean see
 Canary Islands
Canárias, Ilha das i. Brazil 143 J4
Canarias, Islas terr. N. Atlantic Ocean see
 Canary Islands

Canary Islands terr. N. Atlantic Ocean
 96 B2
 Autonomous Community of Spain.
 Africa 7, 94–95

Canaseraga U.S.A. 135 G2
Canastota U.S.A. 135 I2
Canastra, Serra da mts Brazil 145 B2
Canastra, Serra da mts Brazil 145 A1
Canatiba Brazil 145 C1
Canatlán Mex. 131 B7
Canaveral, Cape U.S.A. 133 D6
Cañaveras Spain 57 E3
Canavieiras Brazil 145 D1
Canbelego Australia 112 C3

Canberra Australia 112 D5
 Capital of Australia.

Cancún Mex. 137 G4
Çandar Turkey see Kastamonu
Çandarlı Turkey 59 L5
Candela Mex. 131 C7
Candela r. Mex. 131 C7
Candelaria Mex. 127 G7
Candia Greece see Iraklion
Cândido de Abreu Brazil 145 A4
Çandır Turkey 90 D2
Candle Lake Canada 121 J4
Candlewood, Lake U.S.A. 135 I3
Cando U.S.A. 130 D1
Candon Phil. 77 I5
Cane r. Australia 108 A5
Canea Greece see Chania
Canela Brazil 145 A5
Canelones Uruguay 144 E4
Cane Valley U.S.A. 134 C5
Cangallo Peru 142 D6
Cangamba Angola 99 B5
Cangandala, Parque Nacional de nat. park
 Angola 99 B4
Cango Caves S. Africa 100 F7
Cangola Angola 99 B4
Cangshan China 77 H1
Canguaretama Brazil 143 K5
Canguçu Brazil 144 F4
Canguçu, Serra do hills Brazil 144 F4
Cangwu China 77 F4
Cangzhou China 73 L5
Caniapiscau Canada 123 H3
Caniapiscau r. Canada 123 H2
Caniapiscau, Lac l. Canada 123 H3
Caniçado Moz. see Guija
Canicattì Sicily Italy 58 E6
Canim Lake Canada 120 F5
Canindé Brazil 143 K4
Canisteo U.S.A. 135 G2
Canisteo r. U.S.A. 135 G2
Canisteo Peninsula Antarctica 152 K2
Cañitas de Felipe Pescador Mex. 131 C8
Çankırı Turkey 90 D2
Canna Australia 109 A7
Canna i. U.K. 50 C3
Cannanore India 84 B4
Cannanore Islands India 84 B4
Cannelton U.S.A. 134 B5
Cannes France 56 H5
Cannock U.K. 49 E6
Cannon Beach U.S.A. 126 C3
Cann River Australia 112 D6

Canoas Brazil 145 A5
Canoas, Rio das r. Brazil 145 A4
Canoeiros Brazil 145 B2
Canoe Lake Canada 121 I4
Canoe Lake l. Canada 121 I4
Canoinhas Brazil 145 A4
Canon City U.S.A. 127 G5
Cañon Largo watercourse U.S.A. 129 J3
Canoona Australia 110 E4
Canora Canada 121 K5
Canowindra Australia 112 D4
Canso Canada 123 J5
Canso, Cape Canada 123 J5
Cantabrian Mountains Spain see
 Cantábrica, Cordillera
Cantábrica, Cordillera mts Spain 57 D2
Cantábrico, Mar sea Spain 57 C2
Canterbury U.K. 49 I7
Canterbury Bight b. N.Z. 113 C7
Canterbury Plains N.Z. 113 C6
Cần Thơ Vietnam 71 D5
Cantil U.S.A. 128 E4
Canton GA U.S.A. 133 C5
Canton IL U.S.A. 130 F3
Canton MO U.S.A. 130 F3
Canton MS U.S.A. 131 F5
Canton NY U.S.A. 135 H1
Canton OH U.S.A. 134 E3
Canton PA U.S.A. 135 G3
Canton SD U.S.A. 130 D3
Canton TX U.S.A. 131 E5
Canton Island atoll Kiribati see Kanton
Cantuaria U.K. see Canterbury
Canunda National Park Australia 111 C8
Canutama Brazil 142 F5
Canutillo Mex. 131 B7
Canvey Island U.K. 49 H7
Cany-Barville France 49 H9
Canyon Canada 120 D2
Canyon U.S.A. 131 C5
Canyon City U.S.A. 126 D3
Canyondam U.S.A. 128 C1
Canyon de Chelly National Monument
 nat. park U.S.A. 129 I3
Canyon Ferry Lake U.S.A. 126 F3
Canyon Lake U.S.A. 129 H5
Canyonlands National Park U.S.A. 129 I2
Canyon Ranges mts Canada 120 E2
Canyons of the Ancients National
 Monument nat. park U.S.A. 129 I3
Canyonville U.S.A. 126 C4
Cao Băng Vietnam 70 D2
Caocheng China see Caoxian
Caohai China see Weining
Caohe China see Qichun
Caohu China 80 F3
Caojiahe China see Qichun
Caojian China 76 C3
Caoshi China 74 B4
Caoxian China 77 G1
Caozhou China see Heze
Capac U.S.A. 134 D2
Çapakçur Turkey see Bingöl
Capanaparo r. Venez. 142 E2
Capanema Brazil 143 I4
Capão Bonito Brazil 145 A4
Caparaó, Serra do mts Brazil 145 C3
Cap aux Meules Canada 123 J5
Cap-de-la-Madeleine Canada 123 G5
Cape r. Australia 110 D4
Cape Arid National Park Australia 109 C8
Cape Barren Island Australia 111 [inset]
Cape Basin sea feature S. Atlantic Ocean
 148 I8
Cape Breton Highlands National Park
 Canada 123 J5
Cape Breton Island Canada 123 J5
Cape Charles Canada 123 L3
Cape Charles U.S.A. 135 G5
Cape Coast Ghana 96 C4
Cape Coast Castle Ghana see Cape Coast
Cape Cod Bay U.S.A. 135 J3
Cape Cod National Seashore nature res.
 U.S.A. 135 K3
Cape Coral U.S.A. 133 D7
Cape Crawford Australia 110 A3
Cape Dorset Canada 119 K3
Cape Fanshaw U.S.A. 120 C3
Cape Fear r. U.S.A. 133 E5
Cape George Canada 123 J5
Cape Girardeau U.S.A. 131 F4
Cape Johnson Depth sea feature
 N. Pacific Ocean 150 E5
Cape Juby Morocco see Tarfaya
Cape Krusenstern National Monument
 nat. park U.S.A. 118 B3
Cape Le Grand National Park
 Australia 109 C8
Cape May U.S.A. 135 H4
Cape May Court House U.S.A. 135 H4
Cape May Point U.S.A. 135 H4
Cape Melville National Park
 Australia 110 D2
Cape Palmerston National Park
 Australia 110 E4
Cape Range National Park Australia 108 A5
Cape St George Canada 123 K4

Cape Town S. Africa 100 D7
 Legislative capital of South Africa.

Cape Tribulation National Park
 Australia 110 D2
Cape Upstart National Park
 Australia 110 D3
Cape Verde country N. Atlantic Ocean
 96 [inset]
 Africa 7, 94–95
Cape Verde Basin sea feature
 N. Atlantic Ocean 148 F5
Cape Verde Plateau sea feature
 N. Atlantic Ocean 148 F4
Cape Vincent U.S.A. 135 G1

Cape York Peninsula Australia 110 C2
Cap-Haïtien Haiti 137 J5
Capim r. Brazil 143 I4
Capitán Arturo Prat research station
 Antarctica 152 A2

Capitol Hill N. Mariana Is 69 L3
 Capital of the Northern Mariana Islands, on
 Saipan.

Capitol Reef National Park U.S.A. 129 H2
Capivara, Represa resr Brazil 145 A3
Čapljina Bos.-Herz. 58 G3
Cappoquin Ireland 51 E5
Capraia, Isola d i. Italy 58 C3
Capraria, Punta pt Sardinia Italy 58 C4
Capri, Isola di i. Italy 58 F4
Capricorn Channel Australia 110 E4
Capricorn Group atolls Australia 110 E4
Caprivi Strip reg. Namibia 99 C5
Cap Rock Escarpment U.S.A. 131 C5
Capsa Tunisia see Gafsa
Captain Cook U.S.A. 127 [inset]
Captina r. U.S.A. 134 E4
Capuava Brazil 145 B4
Caquetá r. Col. 142 C4
Caracal Romania 59 K2

Caracas Venez. 142 E1
 Capital of Venezuela.

Caraguatatuba Brazil 145 B3
Caraí Brazil 145 C2
Carajás Brazil 143 H5
Carajás, Serra dos hills Brazil 143 H5
Carales Sardinia Italy see Cagliari
Caralis Sardinia Italy see Cagliari
Carandaí Brazil 145 C3
Caransebeş Romania 59 J2
Caraquet Canada 123 I5
Caratasca, Laguna de lag. Hond. 137 H5
Caratinga Brazil 145 C2
Carauari Brazil 142 E4
Caravaca de la Cruz Spain 57 F4
Caravelas Brazil 145 D2
Carberry Canada 121 L5
Carbó Mex. 127 F7
Carbonara, Capo c. Sardinia Italy 58 C5
Carbondale CO U.S.A. 129 J2
Carbondale PA U.S.A. 135 H3
Carboneras Mex. 131 D7
Carbonia Sardinia Italy 58 C5
Carbonita Brazil 145 C2
Carcaixent Spain 57 F4
Carcajou Canada 120 G3
Carcajou r. Canada 120 D1
Carcar Phil. 69 G4
Carcassonne France 56 F5
Cardamomes, Chaîne des mts
 Cambodia/Thai. see Cardamom Range
Cardamom Hills India 84 C4
Cardamom Range mts Cambodia/Thai.
 71 C4
Cárdenas Cuba 137 H4
Cárdenas Mex. 136 F4
Cardenyabba watercourse Australia 112 A2
Çardı Turkey see Harmancık
Cardiel, Lago l. Arg. 144 B7

Cardiff U.K. 49 D7
 Capital of Wales.

Cardiff U.S.A. 135 G4
Cardigan U.K. 49 C6
Cardigan Bay U.K. 49 C6
Cardinal Lake Canada 120 G3
Cardington U.S.A. 134 D3
Cardón, Cerro hill Mex. 127 E8
Cardoso Brazil 145 A3
Cardoso, Ilha do i. Brazil 145 B4
Cardston Canada 120 H5
Careen Lake Canada 121 I3
Carei Romania 59 J1
Carentan France 56 D2
Carey U.S.A. 134 D3
Carey, Lake salt flat Australia 109 C7
Carey Lake Canada 121 K2
Cargados Carajos Islands Mauritius 149 L7
Carhaix-Plouguer France 56 C2
Cariacica Brazil 145 C3
Cariamanga Ecuador 142 C4
Caribbean Sea N. Atlantic Ocean 137 H5
Cariboo Mountains Canada 120 F4
Caribou r. Man. Canada 121 M3
Caribou r. N.W.T. Canada 120 E2
Caribou U.S.A. 132 G2
Caribou Lake Canada 119 J4
Caribou Mountains Canada 120 H3
Carichic Mex. 127 G8
Carignan France 52 F5
Carinda Australia 112 C3
Cariñena Spain 57 F3
Carinhanha r. Brazil 145 C1
Carlabhagh U.K. see Carloway
Carleton U.S.A. 134 D2
Carleton, Mount hill Canada 123 I5
Carletonville S. Africa 101 H4
Carlin U.S.A. 128 E1
Carlingford Lough inlet
 Ireland/U.K. 51 F3
Carlinville U.S.A. 130 F4
Carlisle U.K. 48 E4
Carlisle IN U.S.A. 134 B4
Carlisle KY U.S.A. 134 C4
Carlisle NY U.S.A. 135 H2
Carlisle PA U.S.A. 135 G3
Carlisle Lakes salt flat Australia 109 D7
Carlit, Pic mt. France 56 E5
Carlos Chagas Brazil 145 C2
Carlow Ireland 51 F5
Carloway U.K. 50 C2
Carlsbad Czech Rep. see Karlovy Vary
Carlsbad CA U.S.A. 128 E5
Carlsbad NM U.S.A. 127 G6
Carlsbad Caverns National Park
 U.S.A. 127 G6
Carlsberg Ridge sea feature
 Indian Ocean 149 L5
Carlson Inlet Antarctica 152 L1
Carlton U.S.A. 130 E2
Carlton Hill Australia 108 E3
Carluke U.K. 50 F5

Carlyle Canada 121 K5
Carmacks Canada 120 B2
Carmagnola Italy 58 B2
Carman Canada 121 L5
Carmana Iran see Kermān
Carmarthen U.K. 49 C7
Carmarthen Bay U.K. 49 C7
Carmaux France 56 F4
Carmel IN U.S.A. 134 B4
Carmel NY U.S.A. 135 I3
Carmel, Mount hill Israel 85 B3
Carmel Head hill U.K. 48 C5
Carmel Valley U.S.A. 128 C3
Carmen r. Mex. 131 B6
Carmen i. Mex. 127 F8
Carmen U.S.A. 127 F7
Carmen de Patagones Arg. 144 D6
Carmi U.S.A. 130 F4
Carmichael U.S.A. 128 C2
Carmo da Cachoeira Brazil 145 B3
Carmo do Paranaíba Brazil 145 B2
Carmona Angola see Uíge
Carmona Spain 57 D5
Carnac France 56 C3
Carnamah Australia 109 A7
Carnarvon Australia 109 A6
Carnarvon S. Africa 100 F6
Carnarvon National Park Australia 110 D5
Carnarvon Range hills Australia 109 C6
Carnarvon Range hills Australia 110 E5
Carn Dearg hill U.K. 50 E3
Carndonagh Ireland 51 E2
Carnegie Australia 109 C6
Carnegie, Lake salt flat Australia 109 C6
Carn Eige mt. U.K. 50 D3
Carnes Australia 109 F7
Carney Island Antarctica 152 J2
Carnforth U.K. 48 E4
Carn Glas-choire hill U.K. 50 F3
Carnlough U.K. 51 G3
Carn nan Gabhar mt. U.K. 50 F4
Carn Odhar hill U.K. 50 E3
Carnot Cent. Afr. Rep. 98 B3
Carnoustie U.K. 50 G4
Carnsore Point Ireland 51 F5
Carnwath U.K. 50 F5
Caro U.S.A. 134 D2
Carola Cay reef Australia 110 F3
Carol City U.S.A. 133 D7
Carolina Brazil 143 I5
Carolina S. Africa 101 J4
Carolina Beach U.S.A. 133 E5
Caroline Canada 120 H4
Caroline Island atoll Kiribati 151 J6
Caroline Islands N. Pacific Ocean 69 K5
Caroline Peak N.Z. 113 A7
Caroline Range hills Australia 108 D4
Caroní r. Venez. 142 F2
Carp Canada 135 G1
Carpathian Mountains Europe 43 C6
Carpaţii mts Europe see
 Carpathian Mountains
Carpaţii Meridionali mts Romania see
 Transylvanian Alps
Carpaţii Occidentali mts Romania 59 J2
Carpentaria, Gulf of Australia 110 B2
Carpentras France 56 G4
Carpi Italy 58 D2
Carpina Italy 58 D4
Carpio U.S.A. 130 C1
Carra, Lough l. Ireland 51 C4
Carraig na Siuire Ireland see
 Carrick-on-Suir
Carrantuohill mt. Ireland 51 C6
Carrara Italy 58 D2
Carrasco, Parque Nacional nat. park Bol.
 142 F7
Carrathool Australia 112 B5
Carrhae Turkey see Harran
Carrickfergus U.K. 51 G3
Carrickmacross Ireland 51 F4
Carrick-on-Shannon Ireland 51 D4
Carrick-on-Suir Ireland 51 E5
Carrigallen Ireland 51 E4
Carrigtwohill Ireland 51 D6
Carrillo Mex. 131 C7
Carrington U.S.A. 130 D2
Carrizal Mex. 127 G7
Carrizal Bajo Chile 144 B3
Carrizo U.S.A. 129 H4
Carrizo Creek r. U.S.A. 131 C4
Carrizo Springs U.S.A. 131 D6
Carrizo Wash watercourse U.S.A. 129 I4
Carrizozo U.S.A. 127 G6
Carroll U.S.A. 130 E3
Carrollton AL U.S.A. 131 F5
Carrollton GA U.S.A. 133 C5
Carrollton IL U.S.A. 130 F4
Carrollton KY U.S.A. 134 C4
Carrollton MO U.S.A. 130 E4
Carrollton OH U.S.A. 134 E3
Carrolltown U.S.A. 135 F3
Carron r. U.K. 50 E3
Carrot r. Canada 121 K4
Carrothers U.S.A. 134 D3
Carrot River Canada 121 K4
Carrowmore Lake Ireland 51 C3
Carrsville U.S.A. 135 G5
Carruthers Lake Canada 121 K2
Carruthersville U.S.A. 131 F4
Carry Falls Reservoir U.S.A. 135 H1
Çarşamba Turkey 90 E2
Carson r. U.S.A. 128 D2
Carson City MI U.S.A. 134 C2

►Carson City NV U.S.A. 128 D2
 State capital of Nevada.

Carson Escarpment Australia 108 D3
Carson Lake U.S.A. 128 D2
Carson Sink l. U.S.A. 128 D2
Carstensz Pyramid mt. Indon. see
 Jaya, Puncak
Carstensz-top mt. Indon. see Jaya, Puncak
Carswell Lake Canada 121 I3
Cartagena Col. 142 C1
Cartagena Spain 57 F5
Carteret Group is P.N.G. see
 Kilinailau Islands
Carteret Island Solomon Is see Malaita
Cartersville U.S.A. 133 C5

Carthage tourist site Tunisia 58 D6
Carthage MO U.S.A. 131 E4
Carthage NC U.S.A. 133 E5
Carthage NY U.S.A. 135 H2
Carthage TX U.S.A. 131 E5
Carthage tourist site Tunisia see Carthage
Carthago Nova Spain see Cartagena
Cartier Island Australia 108 C3
Cartmel U.K. 48 E4
Cartwright Man. Canada 121 L5
Cartwright Nfld. and Lab. Canada 123 K3
Caruaru Brazil 143 K5
Carúpano Venez. 142 F1
Carver U.S.A. 134 D5
Carvin France 52 C4
Cary U.S.A. 132 E5
Caryapundy Swamp Australia 111 C6
Casablanca Morocco 54 C5
Casa Branca Brazil 145 B3
Casa de Piedra, Embalse resr Arg. 144 C5
Casa Grande U.S.A. 129 H5
Casale Monferrato Italy 58 C2
Casalmaggiore Italy 58 D2
Casas Grandes Mex. 127 G7
Casca Brazil 145 A5
Cascada de Bassaseachic, Parque Nacional
 nat. park Mex. 127 F7
Cascade Australia 109 C8
Cascade r. N.Z. 113 B7
Cascade ID U.S.A. 126 D3
Cascade MT U.S.A. 126 F3
Cascade Point N.Z. 113 B7
Cascade Range mts Canada/U.S.A. 126 C4
Cascade Reservoir U.S.A. 126 D3
Cascais Port. 57 B4
Cascavel Brazil 144 F2
Casco Bay U.S.A. 135 J2
Caserta Italy 58 F4
Casey research station Antarctica 152 F2
Casey Bay Antarctica 152 D2
Caseyr, Raas c. Somalia see
 Gwardafuy, Gees
Cashel Ireland 51 E5
Cashmere Australia 112 D1
Casino Australia 112 F2
Casita Mex. 127 F7
Caspe Spain 57 F3
Casper U.S.A. 126 G4

►Caspian Sea l. Asia/Europe 91 H1
 Largest lake in the world and in
 Asia/Europe. Lowest point in Europe.
 Asia 60–61

Cass U.S.A. 134 F4
Cass r. U.S.A. 134 D2
Cassacatiza Moz. 99 D5
Cassadaga U.S.A. 134 F2
Cassaigne Alg. see Sidi Ali
Cassamba Angola 99 C5
Cass City U.S.A. 134 D2
Cassel France 52 C4
Casselman Canada 135 H1
Cássia Brazil 145 B3
Cassiar Mountains Canada 120 D2
Cassilândia Brazil 145 A2
Cassilis Australia 112 D4
Cassino Italy 58 E4
Cassley r. U.K. 50 E3
Cassongue Angola 99 B5
Cassopolis U.S.A. 134 B3
Cassville U.S.A. 131 E4
Castanhal Brazil 143 I4
Castano Brazil 142 F5
Castaños Mex. 131 C7
Castelfranco Veneto Italy 58 D2
Castell-nedd U.K. see Neath
Castell Newydd Emlyn U.K. see
 Newcastle Emlyn
Castellón Spain see Castellón de la Plana
Castellón de la Plana Spain 57 F4
Castelo Branco Port. 57 C4
Castelo de Vide Port. 57 C4
Casteltermini Sicily Italy 58 E6
Castelvetrano Sicily Italy 58 E6
Castiglione della Pescaia Italy 58 D3
Castilla y León reg. Spain 56 B6
Castilla La Nueva reg. Spain see
 Castilla-La Mancha
Castlebar Ireland 51 C4
Castlebay U.K. 50 B4
Castlebellingham Ireland 51 F4
Castleblayney Ireland 51 F3
Castlebridge Ireland 51 F5
Castle Carrock U.K. 48 E4
Castle Cary U.K. 49 E7
Castle Dale U.S.A. 129 H2
Castledawson U.K. 51 F3
Castledermot Ireland 51 F5
Castle Dome Mountains U.S.A. 129 F5
Castle Donington U.K. 49 F6
Castle Douglas U.K. 50 F6
Castleford U.K. 48 F5
Castlegar Canada 120 G5
Castlegregory Ireland 51 B5
Castle Island Bahamas 133 F8
Castleisland Ireland 51 C5
Castlemaine Australia 112 B6
Castlemaine Ireland 51 C5
Castlemartyr Ireland 51 D6
Castle Mountain Alta
 Canada 120 H5
Castle Mountain Y.T.
 Canada 120 C1
Castle Mountain U.S.A. 128 C4
Castle Peak hill H.K. China 77 [inset]
Castle Peak Bay H.K. China 77 [inset]
Castlepoint N.Z. 113 F5
Castlepollard Ireland 51 E4
Castlerea Ireland 51 D4
Castlereagh r. Australia 112 C3
Castle Rock U.S.A. 126 F3
Castletown Ireland 51 E5
Castletown Isle of Man 48 C4
Castor Canada 121 I4
Castor r. U.S.A. 131 F4
Castor, Rivière du r. Canada 122 F3
Castra Regina Germany see Regensburg
Castres France 56 F5
Castricum Neth. 52 E2

►Castries St Lucia 137 L6
 Capital of St Lucia.

Castro Brazil 145 A4
Castro Chile 144 B6
Castro Alves Brazil 145 D1
Castro Verde Port. 57 B5
Castroville U.S.A. 128 C3
Çat Turkey 91 F3
Catacaos Peru 142 B5
Cataguases Brazil 145 C3
Catahoula Lake U.S.A. 131 E6
Çatak Turkey 91 F3
Catalão Brazil 145 B2
Çatalca Yarımadası pen. Turkey 59 M4
Catalina U.S.A. 129 H5
Catalonia aut. comm. Spain see Cataluña
Cataluña aut. comm. Spain 57 G3
Catalunya aut. comm. Spain see Cataluña
Catamarca Arg. 144 C3
Catana Sicily Italy see Catania
Catanduanes i. Phil. 69 G4
Catanduva Brazil 145 A3
Catania Sicily Italy 58 F6
Catanzaro Italy 58 G5
Cataract Creek watercourse U.S.A. 129 G3
Catarina U.S.A. 131 D6
Catarino Rodríguez Mex. 131 C7
Catarman Phil. 69 G4
Catastrophe, Cape Australia 111 A7
Catawba r. U.S.A. 133 D5
Cataxa Moz. 99 D5
Cat Ba, Đao i. Vietnam 70 D2
Catbalogan Phil. 69 G4
Catembe Moz. 101 K4
Catengue Angola 99 B5
Catete Angola 99 B4
Cathcart Australia 112 D6
Cathcart S. Africa 101 H7
Cathedral Peak S. Africa 101 I5
Cathedral Rock National Park
 Australia 112 F3
Catherdaniel Ireland 51 B6
Catherine, Mount U.S.A. 129 G2
Catheys Valley U.S.A. 128 C3
Cathlamet U.S.A. 126 C3
Catió Guinea-Bissau 96 B3
Catisimiña Venez. 142 F3
Cat Island Bahamas 133 F7
Cat Lake Canada 121 N5
Catlettsburg U.S.A. 134 D4
Catoche, Cabo c. Mex. 133 C8
Cato Island and Bank reef Australia 110 F4
Catriló Arg. 144 D5
Cats, Mont des hill France 52 C4
Catskill U.S.A. 135 I2
Catskill Mountains U.S.A. 135 H2
Catuane Moz. 101 K4
Cauayan Phil. 69 G5
Caubvick, Mount Canada 123 J2
Cauca r. Col. 137 J7
Caucaia Brazil 143 K4
Caucasia Col. 142 C2
Caucasus mts Asia/Europe 91 F2
Cauchon Lake Canada 121 L4
Caudry France 52 D4
Câu Giat Vietnam 70 D3
Caulonia Italy 58 G5
Caungula Angola 99 B4
Cauquenes Chile 144 B5
Causapscal Canada 123 I4
Cavaglià Italy 58 C2
Cavalcante, Serra da hills Brazil 145 B1
Cavalier U.S.A. 130 D1
Cavan Ireland 51 E4
Çavdır Turkey 59 M6
Cave City U.S.A. 134 C5
Cave Creek U.S.A. 129 H5
Caveira r. Brazil 145 C1
Cavern Island Myanmar 71 B5
Cave Run Lake U.S.A. 134 D4
Caviana, Ilha i. Brazil 143 H3
Cawdor U.K. 50 F3
Cawnpore India see Kanpur
Cawston U.K. 49 I6
Caxias Brazil 143 J4
Caxias do Sul Brazil 145 A5
Caxito Angola 99 B4
Çay Turkey 59 N5
Çaybaşı Turkey see Çayeli
Çaycuma Turkey 59 O4
Çayeli Turkey 91 F2
Cayenne Fr. Guiana 143 H3
 Capital of French Guiana.

Cayeux-sur-Mer France 52 B4
Çayırhan Turkey 59 N4
Cayman Brac i. Cayman Is 137 I5

►Cayman Islands terr. West Indies 137 H5
 United Kingdom Overseas Territory.
 North America 9, 116–117

Cayman Trench sea feature
 Caribbean Sea 148 C4
Caynabo Somalia 98 E3
Cay Sal i. Bahamas 133 D8
Cay Sal Bank sea feature Bahamas 133 D8
Cay Santo Domingo i. Bahamas 133 F8
Cayucos U.S.A. 128 C4
Cayuga Canada 134 F2
Cayuga Lake U.S.A. 135 G2
Cay Verde i. Bahamas 133 F8
Cazê China 83 F3
Cazenovia U.S.A. 135 H2
Cazombo Angola 99 C5
Ceadâr-Lunga Moldova see Ciadîr-Lunga
Ceanannus Mór Ireland see Kells
Ceann a Deas na Hearadh pen. U.K. see
 South Harris
Ceará Brazil see Fortaleza
Ceara Abyssal Plain sea feature
 S. Atlantic Ocean 148 F6
Ceatharlach Ireland see Carlow
Ceballos Mex. 131 B7
Cebu Phil. 69 G4
Cebu i. Phil. 69 G4
Cecil Plains Australia 112 E1
Cecil Rhodes, Mount hill Australia 109 C6

Cecina Italy 58 D3
Cedar r. ND U.S.A. 130 C2
Cedar r. NE U.S.A. 130 D3
Cedar City U.S.A. 129 G3
Cedaredge U.S.A. 129 J2
Cedar Falls U.S.A. 130 E3
Cedar Grove U.S.A. 134 B2
Cedar Hill NM U.S.A. 129 J3
Cedar Hill TN U.S.A. 134 B5
Cedar Island U.S.A. 133 E5
Cedar Lake Canada 121 K4
Cedar Rapids U.S.A. 130 F3
Cedar Run U.S.A. 135 H4
Cedar Springs U.S.A. 134 C2
Cedartown U.S.A. 133 C5
Cedarville S. Africa 101 I6
Cedros, Cerro mt. Mex. 127 E7
Cedros Mex. 127 F8
Cedros, Isla i. Mex. 127 E7
Ceduna Australia 109 F8
Ceelbuur Somalia see Ceeldheere
Ceeldheere Somalia 98 E3
Ceerigaabo Somalia 98 E2
Cefalù Sicily Italy 58 F5
Cegléd Hungary 59 H1
Cêgnê China 76 B1
Ceheng China 76 E3
Çekerek Turkey 90 D2
Celaya Mex. 136 F4
Celbridge Ireland 51 F4

►Celebes i. Indon. 69 G7
 4th largest island in Asia.

Celebes Basin sea feature
 Pacific Ocean 150 E5
Celebes Sea Indon./Phil. 69 G6
Celestún Mex. 136 F4
Celina OH U.S.A. 134 C3
Celina TN U.S.A. 134 C5
Celje Slovenia 58 F1
Celle Germany 53 K2
Celovec Austria see Klagenfurt
Celtic Sea Ireland/U.K. 46 D5
Celtic Shelf sea feature
 N. Atlantic Ocean 148 H2
Çemenibit Turkm. 89 F3
Çemişgezek Turkey 90 E3
Çendir r. Turkm. 88 D2
Centane S. Africa see Kentani
Centenary Zimbabwe 99 D5
Center NE U.S.A. 130 D3
Center TX U.S.A. 131 E6
Center Point U.S.A. 133 C5
Centereach U.S.A. 135 I3
Centerville IA U.S.A. 130 E3
Centerville MO U.S.A. 131 E4
Centerville TX U.S.A. 131 E6
Centerville WV U.S.A. 134 E4
Centrafricaine, République country Africa
 see Central African Republic
Central admin. dist. Botswana
 101 H2
Central U.S.A. 129 I5
Central, Cordillera mts Col. 142 C3
Central, Cordillera mts Peru 142 C6
Central African Empire country Africa see
 Central African Republic
►Central African Republic country Africa
 98 B3
 Africa 7, 94–95
Central Brahui Range mts Pak. 89 G4
Central Butte Canada 126 G2
Central City U.S.A. 130 D3
Centralia IL U.S.A. 130 F4
Centralia WA U.S.A. 126 C3
Central Kalahari Game Reserve nature res.
 Botswana 100 F2
Central Kara Rise sea feature
 Arctic Ocean 153 F1
Central Makran Range mts Pak. 89 G5
Central Mount Stuart hill Australia 108 F5
Central Pacific Basin sea feature
 Pacific Ocean 150 H5
Central Provinces state India see
 Madhya Pradesh
Central Range mts P.N.G. 69 K7
Central Russian Upland hills
 Rus. Fed. 43 H5
Central Siberian Plateau Rus. Fed. 65 M3
Central Square U.S.A. 135 G2
Centre U.S.A. 133 C5
Centreville AL U.S.A. 133 C5
Centreville U.S.A. 135 G4
Cenxi China 77 F4
Cenyang China see Hengfeng
Ceos i. Greece see Tzia
Ceos i. Notio Aigaio Greece see Tzia
Cephaloedium Sicily Italy see Cefalù
Cephalonia i. Greece 59 I5
Ceram i. Indon. see Seram
Ceram Sea Indon. see Seram, Laut
Cerbat Mountains U.S.A. 129 F4
Čerchov mt. Czech Rep. 53 M5
Ceres Arg. 144 D3
Ceres Brazil 145 A1
Ceres S. Africa 100 D7
Ceres U.S.A. 128 C3
Céret France 56 F6
Cerezo de Abajo Spain 57 E3
Cerignola Italy 58 F4
Cerigo i. Greece see Kythira
Çerkeş Turkey 90 D2
Çerkeşli Turkey 59 M4
Çermik Turkey 91 E3
Cernăuţi Ukr. see Chernivtsi
Cernavodă Romania 59 M2
Cerralvo, Isla i. Mex. 136 C4
Cêrrik Albania 59 H4
Cerritos Mex. 136 D4
Cerro Azul Brazil 145 A4
Cerro de Pasco Peru 142 C6
Cerros Colorados, Embalse resr
 Arg. 144 C5
Cervantes, Cerro mt. Arg. 144 B8
Cervati, Monte mt. Italy 58 F4
Cervione Corsica France 56 I5
Cervo Spain 57 C2
Cesena Italy 58 E2
Cēsis Latvia 45 N8

Chalkida Greece 59 J5
Challakere India 84 C3
Challans France 56 D3
Challapata Bol. 142 E7

►Challenger Deep sea feature
 N. Pacific Ocean 150 F5
 Deepest point in the world
 (Mariana Trench).

Challis U.S.A. 126 E3
Chalmette U.S.A. 131 F6
Châlons-en-Champagne France 52 E6
Châlons-sur-Marne France see
 Châlons-en-Champagne
Chalon-sur-Saône France 56 G3
Chaltan Pass Azer. 91 H2
Chālūs Iran 88 C2
Cham Germany 53 M5
Cham, Kûh-e hill Iran 88 C3
Chamaico Arg. 144 D5
Chamais Bay Namibia 100 B4
Chaman Pak. 78 F3
Chaman Bid Iran 88 E2
Chamao, Khao mt. Thai. 71 C4
Chamba India 82 D2
Chamba Tanz. 99 D5
Chambal r. India 82 D4
Chambas Cuba 133 E8
Chambeaux, Lac l. Canada 123 H3
Chamberlain r. Australia 108 D4
Chamberlain Canada 121 J5
Chamberlain U.S.A. 130 D3
Chamberlain Lake U.S.A. 132 G2
Chambers U.S.A. 129 I4
Chambers Island U.S.A. 134 B1
Chambersburg U.S.A. 135 G4
Chambéry France 56 G4
Chambeshi r. Zambia 99 C5
Chambi, Jebel mt. Tunisia 58 C7
Chamdo China see Qamdo
Chamechaude mt. France 56 G4
Chamiss Bay Canada 120 E5
Chamoli India see Gopeshwar
Chamonix-Mont-Blanc France 56 H4
Champa India 83 E5
Champagne-Ardenne admin. reg.
 France 52 E6
Champagne Castle mt. S. Africa 101 I5
Champagne Humide reg. France 56 G2
Champagne Pouilleuse reg. France 56 F2
Champagnole France 56 G3
Champaign Islands Australia 108 D3
Champaign U.S.A. 130 F3
Champdoré, Lac l. Canada 123 I3
Champhai India 83 H5
Champion Canada 120 H5
Champlain U.S.A. 135 G4
Champlain, Lake Canada/U.S.A. 135 I1
Champotón Mex. 136 F5
Chamrajnagar India 84 C4
Chamzinka Rus. Fed. 43 J5
Chana Thai. 71 C6
Chanak Turkey see Çanakkale
Chañaral Chile 144 B3
Chanārān Iran 88 E2
Chanda India see Chandrapur
Chandalar r. U.S.A. 118 D3
Chandausi India 82 D3
Chandbali India 83 F5
Chandeleur Islands U.S.A. 131 F6
Chanderi India 82 D4
Chandigarh India 82 D3
Chandil India 83 F5
Chandir Uzbek. 89 G2
Chandler Canada 123 I4
Chandler AZ U.S.A. 129 H5
Chandler IN U.S.A. 134 B4
Chandler OK U.S.A. 131 D5
Chandod India 82 C5
Chandos Lake Canada 135 G1
Chandpur Bangl. 83 G5
Chandpur India 82 D3
Chandragiri India 84 C3
Chandrapur India 84 C2
Chandvad India 84 B1
Chang, Ko i. Thai. 71 C4
Chang'an China see Rong'an
Changane r. Moz. 101 K3
Changbai China 74 C4
Changbai Shan mts China/N. Korea 74 B4
Chang Cheng research station Antarctica see
 Great Wall
Changcheng China 77 F5
Changchow Fujian China see Zhangzhou
Changchow Jiangsu China see Changzhou
Changchun China 74 B4
Changchunling China 74 B3
Changde China 77 F2
Changgang China 77 G3
Changge China 77 G1
Changgi-ap pt S. Korea 75 C5
Changgo China 83 F3
Chang Hu l. China 77 G2
Changhua Taiwan 77 I3
Changhŭng S. Korea 75 B6
Changhwa Taiwan see Changhua
Changi Sing. 71 [inset]
Changji China 80 G3
Changjiang China 77 F5
Chang Jiang r. China 77 I2 see Yangtze
Changjiang Kou China see
 Mouth of the Yangtze
Changjin-ho resr N. Korea 75 B4
Changli China 73 L5
Changling China 74 A3
Changleng China see Xinjian
Changling China 74 A3
Changlung Jammu and Kashmir 87 N3
Changma China 80 I4
Changning Jiangxi China see Xunwu
Changning Sichuan China 76 E2
Changnyŏn N. Korea 75 B5
Ch'ang-pai Shan mts China/N. Korea see
 Changbai Shan
Changpu China see Suining
Changp'yŏng S. Korea 75 C5
Changsan-got pt N. Korea 75 B5
Changsha China 77 G2
Changshan China 77 H2
Changshi China 76 E3

174

Changshoujie China 77 G2
Changshu China 77 I2
Changtai China 77 H3
Changteh China see Changde
Changting Fujian China 77 H3
Changting Heilong. China 74 C3
Ch'angwŏn S. Korea 75 C6
Changxing China 77 H2
Changyang China 77 F2
Changyŏn N. Korea 75 B5
Changyuan China 77 G1
Changzhi China 73 K5
Changzhou China 77 H2
Chañi, Nevado de mt. Arg. 144 C2
Chania Greece 59 K7
Chanion, Kolpos b. Greece 59 J7
Chankou China 76 E1
Channahon U.S.A. 134 A3
Channapatna India 84 C3
Channel Islands English Chan. 49 E9
Channel Islands U.S.A. 128 D5
Channel Islands National Park U.S.A. 128 D4
Channel Rock i. Bahamas 133 E8
Channel Tunnel France/U.K. 49 I7
Channing U.S.A. 131 C5
Chantada Spain 57 C2
Chanthaburi Thai. 71 C4
Chantilly France 52 C5
Chanumla India 71 A5
Chanute U.S.A. 131 E4
Chanuwala Pak. 89 I3
Chany, Ozero salt l. Rus. Fed. 64 I4
Chaohu China 77 H2
Chao Hu l. China 77 H2
Chaor He r. China see Qulin Gol
Chaowula Shan mt. China 76 C1
Chaoyang Guangdong China 77 H4
Chaoyang Heilong. China see Jiayin
Chaoyang Liaoning China 73 M4
Chaoyang Hu l. China 83 F2
Chaozhong China 74 A2
Chaozhou China 77 H4
Chapada Diamantina, Parque Nacional nat. park Brazil 145 C1
Chapada dos Veadeiros, Parque Nacional da nat. park Brazil 145 B1
Chapais Canada 122 G4
Chapak Guzar Afgh. 89 G2
Chapala, Laguna de l. Mex. 136 D4
Chāpāri, Kowtal-e Afgh. 89 G3
Chapayev Kazakh. 78 E1
Chapayevo Kazakh. see Chapayev
Chapayevsk Rus. Fed. 43 K5
Chapecó Brazil 144 F3
Chapecó r. Brazil 144 F3
Chapel-en-le-Frith U.K. 48 F5
Chapelle-lez-Herlaimont Belgium 52 E4
Chapeltown U.K. 48 F5
Chapleau Canada 122 E5
Chaplin Canada 121 J5
Chaplin Lake Canada 121 J5
Chaplygin Rus. Fed. 43 H5
Chapman, Mount Canada 120 G5
Chapmanville U.S.A. 134 D5
Chappell U.S.A. 130 C3
Chappell Islands Australia 111 [inset]
Chapra Bihar India see Chhapra
Chapra Jharkhand India see Chatra
Chaqmaqtin, Kowl-e Afgh. 89 I2
Charagua Bol. 142 F7
Charay Mex. 127 F8
Charcas Mex. 136 D4
Charcot Island Antarctica 152 L2
Chard Canada 121 I4
Chard U.K. 49 E8
Chardara Kazakh. see Shardara
Chardara, Step' plain Kazakh. 80 C3
Chardon U.S.A. 134 E3
Chardzhev Lebap Turkm. see Türkmenabat
Chardzhev Turkm. see Türkmenabat
Chardzhou Lebap Turkm. see Türkmenabat
Chardzhou Turkm. see Türkmenabat
Charef Alg. 57 H6
Charef, Oued watercourse Morocco 54 D5
Charente r. France 56 D4
Chārī Iran 88 E4
Chārīkār Afgh. 89 H3
Chariton U.S.A. 130 E3
Chärjew Lebap Turkm. see Türkmenabat
Chärjew Turkm. see Türkmenabat
Charkayuvom Rus. Fed. 42 L2
Chär Kent Afgh. 89 G2
Charkhlik China see Ruoqiang
Charleroi Belgium 52 E4
Charles, Cape U.S.A. 135 H5
Charlesbourg Canada 123 H5
Charles City IA U.S.A. 130 E3
Charles City VA U.S.A. 135 G5
Charles Hill Botswana 100 E2
Charles Island Galápagos Ecuador see Santa María, Isla
Charles Lake Canada 121 I3
Charles Point Australia 108 E3
Charleston N.Z. 113 C5
Charleston IL U.S.A. 130 F4
Charleston MO U.S.A. 131 F4
Charleston SC U.S.A. 133 E5

►Charleston WV U.S.A. 134 E4
State capital of West Virginia.

Charleston Peak U.S.A. 129 F3
Charlestown Ireland 51 D4
Charlestown IN U.S.A. 134 C4
Charlestown NH U.S.A. 135 I2
Charlestown RI U.S.A. 135 J3
Charles Town U.S.A. 135 G4
Charleville Australia 111 D5
Charleville Ireland see Rathluirc
Charleville-Mézières France 52 E5
Charlevoix U.S.A. 134 C1
Charlie Lake Canada 120 F3
Charlotte MI U.S.A. 134 C2
Charlotte NC U.S.A. 133 D5

Charlotte TN U.S.A. 134 B5

►Charlotte Amalie Virgin Is (U.S.A.) 137 L5
Capital of the U.S. Virgin Islands.

Charlotte Harbor b. U.S.A. 133 D7
Charlotte Lake Canada 120 E4
Charlottesville U.S.A. 135 F4

►Charlottetown Canada 123 J5
Provincial capital of Prince Edward Island.

Charlton Australia 112 A6
Charlton Island Canada 122 F3
Charron Lake Canada 121 M4
Charsadda Pak. 89 H3
Charshanga Turkm. see Köytendag
Charshangngy Turkm. see Köytendag
Charters Towers Australia 110 D4
Chartres France 56 E2
Chas India 83 F5
Chase Canada 120 G5
Chase U.S.A. 134 C2
Chase City U.S.A. 135 F5
Chashmeh Nūrī Iran 88 E3
Chashmeh-ye Ab-e Garm spring Iran 88 B3
Chashmeh-ye Garm Ab spring Iran 88 E3
Chashmeh-ye Magu well Iran 88 E3
Chashmeh-ye Mükik spring Iran 88 E3
Chashmeh-ye Palasi Iran 88 D3
Chashmeh-ye Safid spring Iran 88 E3
Chashmeh-ye Shotoran well Iran 88 D3
Chashniki Belarus 43 F5
Chaska U.S.A. 130 E2
Chaslands Mistake c. N.Z. 113 B8
Chasŏng N. Korea 74 B4
Chasseral mt. Switz. 47 K7
Chassiron, Pointe de pt France 56 D3
Chastab, Küh-e mts Iran 88 D3
Chāt Iran 88 D2
Chatanika U.S.A. 118 D3
Châteaubriant France 56 D3
Château-du-Loir France 56 E3
Châteaudun France 56 E2
Chateaugay U.S.A. 135 H1
Châteauguay Canada 135 I1
Châteauguay r. Canada 123 H2
Châteauguay, Lac l. Canada 123 H2
Châteaulin France 56 B2
Châteaumeillant France 56 F3
Châteauneuf-en-Thymerais France 52 B6
Châteauneuf-sur-Loire France 56 F3
Chateau Pond l. Canada 123 K3
Châteauroux France 56 E3
Château-Salins France 52 G6
Château-Thierry France 52 D5
Chateh Canada 120 G3
Châtelet Belgium 52 E4
Châtellerault France 56 E3
Chatfield U.S.A. 122 B6
Chatham Canada 134 D2
Chatham U.K. 49 H7
Chatham MA U.S.A. 135 K3
Chatham NY U.S.A. 135 I2
Chatham PA U.S.A. 135 H4
Chatham VA U.S.A. 134 F5
Chatham, Isla i. Chile 144 B8
Chatham Island Galápagos Ecuador see San Cristóbal, Isla
Chatham Island N.Z. 107 I6
Chatham Island Samoa see Savai'i
Chatham Islands N.Z. 107 I6
Chatham Rise sea feature S. Pacific Ocean 150 I8
Chatham Strait U.S.A. 120 C3
Châtillon-sur-Seine France 56 G3
Chatkal Range mts Kyrg./Uzbek. 80 D3
Chatom U.S.A. 131 F6
Chatra India 83 F4
Chatra Nepal 83 F4
Chatsworth Canada 134 E1
Chatsworth U.S.A. 135 H4
Chattagam Bangl. see Chittagong
Chattanooga U.S.A. 133 C5
Chattarpur India see Chhatarpur
Chatteris U.K. 49 H6
Chattisgarh state India see Chhattisgarh
Chatturat Thai. 70 C4
Chatyr-Tash Kyrg. 80 E3
Chauhtan India 82 B4
Chauk Myanmar 70 A2
Chaumont France 56 G2
Chauncey U.S.A. 134 D4
Chaungzon Myanmar 70 B3
Chaunskaya Guba b. Rus. Fed. 65 R3
Chauny France 52 D5
Chau Phu Vietnam see Châu Đốc
Chausy Belarus see Chavusy
Chautauqua, Lake U.S.A. 134 F2
Chauter Pak. 89 G4
Chauvin Canada 121 I4
Chavakachcheri Sri Lanka 84 C4
Chaves Port. 57 C3
Chavigny, Lac l. Canada 122 G2
Chavusy Belarus 43 F5
Chawal r. Pak. 89 G4
Chay, Sông r. Vietnam 70 D2
Chayatyn, Khrebet ridge Rus. Fed. 74 E1
Chayevo Rus. Fed. 42 H4
Chaykovskiy Rus. Fed. 41 Q4
Chazhegovo Rus. Fed. 42 L3
Chazy U.S.A. 135 I1
Cheadle U.K. 49 F6
Cheaha Mountain hill U.S.A. 133 C5
Cheat r. U.S.A. 134 F4
Cheatham Lake U.S.A. 134 B5
Cheb Czech Rep. 53 M4
Chebba Tunisia 58 D7
Cheboksarskoye Vodokhranilishche resr Rus. Fed. 42 J5
Cheboksary Rus. Fed. 42 J4
Cheboygan U.S.A. 132 C2
Chechen', Ostrov i. Rus. Fed. 91 G2
Chech'ŏn S. Korea 75 C5
Chedabucto Bay Canada 123 J5
Cheddar U.K. 49 E7
Cheduba Myanmar see Man-aung
Cheduba Island i. Myanmar see Man-aung Kyun
Chée r. France 52 E6
Cheektowaga U.S.A. 135 F2

Cheepie Australia 112 B1
Cheetham, Cape Antarctica 152 H2
Chefoo China see Yantai
Chefornak U.S.A. 118 B3
Chefu Moz. 101 K2
Chegdomyn Rus. Fed. 74 D2
Chegga Mauritania 96 C2
Chegutu Zimbabwe 99 D5
Chehalis U.S.A. 126 C3
Chehar Burj Iran 88 E2
Chehardeh Iran 88 E3
Chehel Chashmeh, Küh-e hill Iran 88 B3
Chehel Dokhtarān, Küh-e mt. Iran 89 F4
Chehell'āyeh Iran 88 E4
Cheju S. Korea 75 B6
Cheju-do i. S. Korea 75 B6
Cheju-haehyŏp sea chan. S. Korea 75 B6
Chek Chue H.K. China see Stanley
Chekhov Moskovskaya Oblast' Rus. Fed. 43 H5
Chekhov Sakhalinskaya Oblast' Rus. Fed. 74 F3
Chekiang prov. China see Zhejiang
Chekichler Turkm. see Çekiçler
Chek Lap Kok reg. H.K. China 77 [inset]
Chek Mun Hoi Hap H.K. China see Tolo Channel
Chekunda Rus. Fed. 74 D2
Chela, Serra da mts Angola 99 B5
Chelan, Lake U.S.A. 126 C2
Cheleken Turkm. see Hazar
Chélif, Oued r. Alg. 57 G5
Cheline Moz. 101 L2
Chelkar Kazakh. see Shalkar
Chełm Poland 43 D6
Chelmer r. U.K. 49 H7
Chełmno Poland 47 Q4
Chelmsford U.K. 49 H7
Chelsea MI U.S.A. 134 C2
Chelsea VT U.S.A. 135 I2
Cheltenham U.K. 49 E7
Chelva Spain 57 F4
Chelyabinsk Rus. Fed. 64 H4
Chelyuskin Rus. Fed. 153 E1
Chemba Moz. 99 D5
Chêm Co l. China 82 D2
Chemnitz Germany 53 M4
Chemulpo S. Korea see Inch'ŏn
Chenab r. India/Pak. 82 B3
Chenachane, Oued watercourse Alg. 96 C2
Chendir r. Turkm. see Çendir
Cheney U.S.A. 126 D3
Cheney Reservoir U.S.A. 130 D4
Chengalpattu India 84 D3
Chengbu China 77 F3
Chengchow China see Zhengzhou
Chengde China 73 L4
Chengdu China 76 E2
Chengele India 76 C2
Chenggong China 76 D3
Chenghai China 77 H4
Cheng Hai l. China 76 D3
Chengjiang China see Taihe
Chengmai China 77 F5
Chengtu China see Chengdu
Chengwu China 77 G1
Chengxian China 76 E1
Chengxiang Chongqing China see Wuxi
Chengxiang Jiangxi China see Quannan
Chengzhong China see Ningming
Cheniu Shan i. China 77 H1
Chenkaladi Sri Lanka 84 D5
Chennai India 84 D3
Chenqian Shan i. China 77 I3
Chenqing China 74 B2
Chenstokhov Poland see Częstochowa
Chentejn Nuruu mts Mongolia 73 J3
Chenxi China 77 F3
Chenyang China see Chenxi
Chenying China see Wannian
Chenzhou China 77 G3
Chepén Peru 142 C5
Chepes Arg. 144 C4
Chepo Panama 137 I7
Cheptsa r. Rus. Fed. 42 K4
Chequamegon Bay U.S.A. 130 F2
Cher r. France 56 E3
Chera state India see Kerala
Cheraw U.S.A. 133 E5
Cherbaniani Reef India 84 A3
Cherbourg France 56 D2
Cherchell Alg. 57 H5
Cherchen China see Qiemo
Cherdakly Rus. Fed. 43 K5
Cherdyn' Rus. Fed. 41 R3
Chereapani reef India see Byramgore Reef
Cheremkhovo Rus. Fed. 72 I2
Cheremshany Rus. Fed. 74 D3
Cheremukhovka Rus. Fed. 42 K4
Cherepanovo Rus. Fed. 72 E2
Cherepovets Rus. Fed. 42 H4
Cherevkovo Rus. Fed. 42 J3
Chergui, Chott ech imp. l. Alg. 54 D5
Chéria Alg. 58 B7
Cheriton U.S.A. 135 H5
Cheriyam atoll India 84 B4
Cherkasy Ukr. see Cherkasy
Cherkasy Ukr. 43 G6
Cherkessk Rus. Fed. 91 F1
Cherla India 84 D2
Chernaya Rus. Fed. 42 M1
Chernaya r. Rus. Fed. 42 M1
Chernigov Ukr. see Chernihiv
Chernigovka Rus. Fed. 74 D3
Cherninivka Ukr. 43 H7
Chernivtsi Ukr. 43 E6
Chernobyl' Ukr. see Chornobyl'
Chernogorsk Rus. Fed. 72 G2
Chernovtsy Ukr. see Chernivtsi
Chernoye More sea Asia/Europe see Black Sea
Chernushka Rus. Fed. 41 R4
Chernyakhiv Ukr. 43 F6
Chernyakhovsk Rus. Fed. 45 L9
Chernyanka Rus. Fed. 43 H6
Chernyayeve Rus. Fed. 74 B1
Chernyshevsk Rus. Fed. 73 L2
Chernyshevskiy Rus. Fed. 65 M3
Chernyshkovskiy Rus. Fed. 43 I6

Chernyye Zemli reg. Rus. Fed. 43 J7
Chernyy Irtysh r. China/Kazakh. see Ertix He
Chernyy Porog Rus. Fed. 42 G3
Chernyy Yar Rus. Fed. 43 J6
Cherokee U.S.A. 130 E3
Cherokee Sound Bahamas 133 E7

►Cherrapunji India 83 G4
Highest recorded annual rainfall in the world.

Cherry Creek r. U.S.A. 130 C2
Cherry Creek Mountains U.S.A. 129 F1
Cherry Hill U.S.A. 135 H4
Cherry Island Solomon Is 107 G3
Cherry Lake U.S.A. 128 D2
Cherskiy Rus. Fed. 153 C2
Cherskiy Range mts Rus. Fed. see Cherskogo, Khrebet
Cherskogo, Khrebet mts Rus. Fed. 65 P3
Cherskogo, Khrebet mts Rus. Fed. 73 K2
Chertkov Ukr. see Chortkiv
Chertkovo Rus. Fed. 43 I6
Cherven Bryag Bulg. 59 K3
Chervonoarmeyskoye Ukr. see Vil'nyans'k
Chervonoarmiys'k Donets'ka Oblast' Ukr. see Krasnoarmiys'k
Chervonoarmiys'k Rivnens'ka Oblast' Ukr. see Radyvyliv
Chervonograd Ukr. see Chervonohrad
Chervonohrad Ukr. 43 E6
Cherven' Belarus 43 F5
Cherwell r. U.K. 49 F7
Cherykaw Belarus 43 F5
Chesapeake U.S.A. 135 G5
Chesapeake Bay U.S.A. 135 G4
Chesham U.K. 49 G7
Cheshire Plain U.K. 48 E5
Cheshme 2-y Turkm. 89 F2
Cheshskaya Guba b. Rus. Fed. 42 J2
Cheshtebe Tajik. 89 I2
Cheshunt U.K. 49 G7
Chesnokovka Rus. Fed. see Novoaltaysk
Chester Canada 123 I5
Chester U.K. 48 E5
Chester CA U.S.A. 128 C1
Chester IL U.S.A. 130 F4
Chester MT U.S.A. 126 F2
Chester OH U.S.A. 134 E4
Chester SC U.S.A. 133 D5
Chester r. U.S.A. 135 G4
Chesterfield U.K. 48 F5
Chesterfield U.S.A. 135 G5
Chesterfield, Îles is New Caledonia 107 F3
Chesterfield Inlet Canada 121 N2
Chesterfield Inlet inlet Canada 121 M2
Chester-le-Street U.K. 48 F4
Chesterton Range hills Australia 110 D5
Chestertown MD U.S.A. 135 G4
Chestertown NY U.S.A. 135 I2
Chesterville Canada 135 H1
Chestnut Ridge U.S.A. 134 F3
Chesuncook Lake U.S.A. 132 G2
Chetaïbi Alg. 58 B6
Chéticamp Canada 123 J5
Chetlat i. India 84 B4
Chetumal Mex. 136 G5
Chetwynd Canada 120 F4
Cheung Chau H.K. China 77 [inset]
Chevelon Creek r. U.S.A. 129 H4
Cheviot N.Z. 113 D6
Cheviot Hills U.K. 48 E3
Cheviot Range hills Australia 110 C5
Chevreulx r. Canada 122 G3
Cheyenne OK U.S.A. 131 D5

►Cheyenne WY U.S.A. 126 G4
State capital of Wyoming.

Cheyenne r. U.S.A. 130 C2
Cheyenne Wells U.S.A. 130 C4
Cheyne Bay Australia 109 B8
Cheyur India 84 D3
Chezacut Canada 120 E4
Chhapra India 83 F4
Chhata India 82 D4
Chhatak Bangl. 83 G4
Chhatarpur Jharkhand India 83 F4
Chhatarpur Madh. Prad. India 82 D4
Chhatrapur India 84 E2
Chhay Arêng, Stœng r. Cambodia 71 C5
Chhindwara India 82 D5
Chhitkul India 82 D3
Chhukha Bhutan 83 G4
Chi, Lam r. Thai. 71 C4
Chi, Mae Nam r. Thai. 70 D4
Chiai Taiwan 77 I4
Chiamboni Somalia 98 E4
Chiange Angola 99 B5
Chiang Kham Thai. 70 C3
Chiang Khan Thai. 70 C3
Chiang Mai Thai. 70 B3
Chiang Rai Thai. 70 B3
Chiang Saen Thai. 70 C2
Chiari Italy 58 C2
Chiautla Mex. 136 E5
Chiavenno Italy 58 C1
Chiayi Taiwan see Chiai
Chiba Japan 75 F6
Chibi China 77 G2
Chibia Angola 99 B5
Chibizovka Rus. Fed. see Zherdevka
Chiboma Moz. 99 D6
Chibougamau Canada 122 G4
Chibougamau, Lac l. Canada 122 G4
Chibu-Sangaku National Park Japan 75 E5
Chibuto Moz. 101 K3
Chicacole India see Srikakulam

►Chicago U.S.A. 134 B3
4th most populous city in North America.

Chic-Chocs, Monts mts Canada 123 I4
Chichagof Island U.S.A. 120 B3
Chichagof Island U.S.A. 120 C3
Chichak r. Pak. 89 G5
Chichaoua Morocco 54 C5
Chichatka Rus. Fed. 74 A1
Chicheng China see Pengxi
Chichester U.K. 49 G8

Chichester Range mts Australia 108 B5
Chichgarh India 84 D1
Chichibu Japan 75 E6
Chichibu-Tama Kokuritsu-kōen Japan 75 E6
Chichijima-rettō is Japan 75 F8
Chickasha U.S.A. 131 D5
Chiclana de la Frontera Spain 57 C5
Chiclayo Peru 142 C5
Chico r. Arg. 144 C6
Chico r. Arg. 144 C8
Chico U.S.A. 128 C2
Chicomo Moz. 101 L3
Chicopee U.S.A. 135 I2
Chicoutimi Canada 123 H4
Chicualacuala Moz. 101 J2
Chidambaram India 84 C4
Chidenguele Moz. 101 L3
Chidley, Cape Canada 119 L3
Chido China see Sêndo
Chidoco Moz. 101 L3
Chiducane Moz. 101 L3
Chiefland U.S.A. 133 D6
Chiemsee l. Germany 47 N7
Chiengmai Thai. see Chiang Mai
Chiers r. France 52 F5
Chieti Italy 58 F3
Chifeng China 73 L4
Chifre, Serra do mts Brazil 145 C2
Chiganak Kazakh. 80 D2
Chiginagak Volcano, Mount U.S.A. 118 C4
Chigu China 83 G3
Chigubo Moz. 101 K2
Chigu Co l. China 83 G3
Chihli, Gulf of China see Bo Hai
Chihuahua Mex. 127 G7
Chihuahua state Mex. 127 G7
Chiili Kazakh. 80 C3
Chikan China 77 F4
Chikaskia r. U.S.A. 131 D4
Chikhali Kalan Parasia India 82 D5
Chikhli India 84 C1
Chikishlyar Turkm. see Çekiçler
Chikmagalur India 84 B3
Chikodi India 84 B2
Chilanko r. Canada 120 F4
Chilas Jammu and Kashmir 82 C2
Chilaw Sri Lanka 84 C5
Chilcotin r. Canada 120 F5
Childers Australia 110 F5
Childress U.S.A. 131 C5

►Chile country S. America 144 B4
South America 9, 140–141

Chile Basin sea feature S. Pacific Ocean 151 O8
Chile Chico Chile 144 B7
Chile Rise sea feature S. Pacific Ocean 151 O8
Chilgir Rus. Fed. 43 J7
Chilhowie U.S.A. 134 E5
Chilia-Nouă Ukr. see Kiliya
Chilik Kazakh. 80 E3
Chilika Lake India 84 E2
Chililabombwe Zambia 99 C5
Chilko r. Canada 120 F4
Chilko Lake Canada 120 E5
Chilkoot Pass Canada/U.S.A. 120 C3
Chilkoot Trail National Historic Site nat. park Canada 120 C3
Chillán Chile 144 B5
Chillicothe MO U.S.A. 130 E4
Chillicothe OH U.S.A. 134 D4
Chilliwack Canada 120 F5
Chilo India 82 C4
Chiloé, Isla de i. Chile 144 B6
Chiloé, Isla Grande de i. Chile see Chiloé, Isla de
Chilpancingo Mex. 136 E5
Chilpancingo de los Bravos Mex. see Chilpancingo
Chilpi Jammu and Kashmir 82 C2
Chiltern Hills U.K. 49 G7
Chilton U.S.A. 134 A1
Chiluage Angola 99 C4
Chilubi Zambia 99 C5
Chilung Taiwan 77 I3
Chilwa, Lake Malawi 99 D5
Chimala Tanz. 99 D4
Chimaltenango Guat. 136 F6
Chi Ma Wan H.K. China 77 [inset]
Chimay Belgium 52 E4
Chimbas Arg. 144 C4
Chimbay Uzbek. see Chimboy
Chimborazo mt. Ecuador 142 C4
Chimbote Peru 142 C5
Chimboy Uzbek. 80 A3
Chimian Pak. 89 I4
Chimishliya Moldova see Cimişlia
Chimkent Kazakh. see Shymkent
Chimney Rock U.S.A. 129 J3
Chimoio Moz. 99 D5
Chimtargha, Qullai mt. Tajik. 89 H2
Chimtorga, Gora mt. Tajik. see Chimtargha, Qullai

►China country Asia 72 H5
Most populous country in the world and in Asia. 2nd largest country in Asia and 4th largest in the world.
Asia 6, 62–63

China Mex. 131 D7
China, Republic of country Asia see Taiwan
China Bakir r. Myanmar see To
China Lake CA U.S.A. 128 E4
China Lake ME U.S.A. 135 K1
Chinandega Nicaragua 136 G6
China Point U.S.A. 128 D5
Chinati Peak U.S.A. 131 B6
Chincha Alta Peru 142 C6
Chinchaga r. Canada 120 G3
Chinchilla Australia 112 E1
Chincholi India 84 C2
Chinchorro, Banco sea feature Mex. 137 G5
Chincoteague Bay U.S.A. 135 H5
Chinde Moz. 99 D5
Chindo S. Korea 75 B6
Chin-do i. S. Korea 75 B6
Chindwin r. Myanmar 70 A2
Chinese Turkestan aut. reg. China see Xinjiang Uygur Zizhiqu
Chinghai prov. China see Qinghai

Chingiz-Tau, Khrebet mts Kazakh. 80 E2
Chingleput India see Chengalpattu
Chingola Zambia 99 C5
Chinguar Angola 99 B5
Chinguetti Mauritania 96 B2
Chinhae S. Korea 75 C6
Chinhoyi Zimbabwe 99 D5
Chini India see Kalpa
Chining China see Jining
Chiniot Pak. 89 I4
Chinipas Mex. 127 F8
Chinit, Stœng r. Cambodia 71 D4
Chinju S. Korea 75 C6
Chinle U.S.A. 129 I3
Chinmen Taiwan 77 H3
Chinmen Tao i. Taiwan 77 H3
Chinnamp'o N. Korea see Namp'o
Chinnur India 84 C2
Chino Creek watercourse U.S.A. 129 G4
Chinon France 56 E3
Chinook U.S.A. 126 F2
Chinook Trough sea feature N. Pacific Ocean 150 I3
Chino Valley U.S.A. 129 G4
Chin-shan China see Zhujing
Chintamani India 84 C3
Chioggia Italy 58 E2
Chios Greece 59 L5
Chios i. Greece 59 K5
Chipata Zambia 99 D5
Chiphu Cambodia 71 D5
Chipindo Angola 99 B5
Chipinga Zimbabwe see Chipinge
Chipinge Zimbabwe 99 D6
Chipley U.S.A. 133 C6
Chipman Canada 123 I5
Chippenham U.K. 49 E7
Chippewa, Lake U.S.A. 130 F2
Chippewa Falls U.S.A. 130 F2
Chipping Norton U.K. 49 F7
Chipping Sodbury U.K. 49 E7
Chipurupalle Andhra Prad. India 84 D2
Chipurupalle Andhra Prad. India 84 D2
Chiquilá Mex. 133 C8
Chiquinquira Col. 142 D2
Chir r. Rus. Fed. 43 I6
Chirada India 84 D3
Chirala India 84 D3
Chiras Afgh. 89 G3
Chirchiq Uzbek. 80 C3
Chiredzi Zimbabwe 99 D6
Chirfa Niger 96 E2
Chiricahua National Monument nat. park U.S.A. 129 I5
Chiricahua Peak U.S.A. 129 I6
Chirikof Island U.S.A. 118 C4
Chiriquí, Golfo de b. Panama 137 H7
Chiriquí, Volcán de vol. Panama see Barú, Volcán
Chiri-san mt. S. Korea 75 B6
Chirk U.K. 49 D6
Chirnside U.K. 50 G5
Chirripo mt. Costa Rica 137 H7
Chisamba Zambia 99 C5
Chisana r. U.S.A. 120 A2
Chisasibi Canada 122 F3
Chishima-retto is Rus. Fed. see Kuril Islands
Chisholm Canada 120 H4
Chishtian Mandi Pak. 89 I4
Chishui China 76 E3
Chishuihe China 76 E3
Chisimaio Somalia see Kismaayo

►Chişinău Moldova 59 M1
Capital of Moldova.

Chistopol' Rus. Fed. 42 K5
Chita Rus. Fed. 73 K2
Chitado Angola 99 B5
Chitaldrug India see Chitradurga
Chitalwana India 82 B4
Chitambo Zambia 99 D5
Chita Oblast admin. div. Rus. Fed. see Chitinskaya Oblast'
Chitato Angola 99 C4
Chitek Lake Canada 121 J4
Chitek Lake l. Canada 121 L5
Chitembo Angola 99 B5
Chitina U.S.A. 118 D3
Chitinskaya Oblast' admin. div. Rus. Fed. 73 L2
Chitipa Malawi 99 D4
Chitkul India see Chhitkul
Chitobe Moz. 99 D6
Chitoor India see Chittoor
Chitor India see Chittaurgarh
Chitose Japan 74 F4
Chitradurga India 84 C3
Chitrakoot India 82 E4
Chitrakut India see Chitrakoot
Chitral Pak. 89 H3
Chitral r. Pak. 89 H3
Chitravati r. India 84 C3
Chitré Panama 137 H7
Chitrod India 82 B5
Chittagong Bangl. 83 G5
Chittaurgarh India 82 C4
Chittoor India 84 C3
Chittor India see Chittoor
Chittorgarh India see Chittaurgarh
Chittur India 84 C4
Chitungwiza Zimbabwe 99 D5
Chiu Lung H.K. China see Kowloon
Chiume Angola 99 C5
Chivasso Italy 58 B2
Chívato, Punta pt Mex. 127 F8
Chivhu Zimbabwe 99 D5
Chixi China 77 G4
Chizarira National Park Zimbabwe 99 C5
Chizha Vtoraya Kazakh. 43 K6
Chizhou China 77 H2
Chizu Japan 75 D6
Chkalov Rus. Fed. see Orenburg
Chkalovsk Rus. Fed. 42 I4
Chkalovskoye Rus. Fed. 74 D3
Chlef Alg. 57 G5
Chloride U.S.A. 129 F4
Chlya, Ozero l. Rus. Fed. 74 F1
Choa Chu Kang Sing. 71 [inset]
Choa Chu Kang hill Sing. 71 [inset]

Columbia, Mount Canada 120 G4
Columbia, Sierra mts Mex. 127 E7
Columbia City U.S.A. 134 C3
Columbia Lake Canada 120 H5
Columbia Mountains Canada 120 F4
Columbia Plateau U.S.A. 126 D3
Columbine, Cape S. Africa 100 C7
Columbus GA U.S.A. 133 C5
Columbus IN U.S.A. 134 C4
Columbus MS U.S.A. 131 F5
Columbus MT U.S.A. 126 F3
Columbus NC U.S.A. 133 D5
Columbus NE U.S.A. 130 D3
Columbus NM U.S.A. 127 G7

▶Columbus OH U.S.A. 134 D4
State capital of Ohio.

Columbus TX U.S.A. 131 D6
Columbus Grove U.S.A. 134 C3
Columbus Salt Marsh U.S.A. 128 D2
Colusa U.S.A. 128 B2
Colville N.Z. 113 E3
Colville U.S.A. 126 D2
Colville r. U.S.A. 118 C2
Colville Channel N.Z. 113 E3
Colwyn Bay U.K. 48 D5
Comacchio Italy 58 E2
Comacchio, Valli di lag. Italy 58 E2
Comai China 83 G3
Comalcalco Mex. 136 F5
Comanche U.S.A. 131 D6
Comandante Ferraz research station
 Antarctica 152 A2
Comandante Salas Arg. 144 C4
Comăneşti Romania 59 L1
Combahee r. U.S.A. 133 D5
Combarbalá Chile 144 B4
Comber U.K. 51 G3
Combermere Bay Myanmar 70 A3
Combles France 52 C4
Comboì i. Indon. 71 C7
Combomune Moz. 101 K2
Comboyne Australia 112 F3
Comencho, Lac l. Canada 122 G4
Combol i. Indon. 71 C7
Comendador Dom. Rep. see Elías Piña
Comendador Gomes Brazil 145 A2
Comeragh Mountains hills Ireland 51 E5
Comercinho Brazil 145 C2
Cometela Moz. 101 L1
Comfort U.S.A. 131 D6
Comilla Bangl. 83 G5
Comines Belgium 52 C4
Comino, Capo c. Sardinia Italy 58 C4
Comitán de Domínguez Mex. 136 F5
Commack U.S.A. 135 I3
Commentry France 56 F3
Committee Bay Canada 119 J3
Commonwealth Territory admin. div.
 Australia see Jervis Bay Territory
Como Italy 58 C2
Como, Lago di Italy see Como, Lake
Como, Lake Italy 58 C2
Comodoro Rivadavia Arg. 144 C7
Comores country Africa see Comoros
Comorin, Cape India 84 C4
Comoro Islands country Africa see
 Comoros
▶Comoros country Africa 99 E5
 Africa 7, 94–95

Compiègne France 52 C5
Comprida, Ilha i. Brazil 145 B4
Comrat Moldova 59 M1
Comrie U.K. 50 F4
Comstock U.S.A. 131 C6
Con China 83 G4

▶Conakry Guinea 96 B4
 Capital of Guinea.

Cona Niyeo Arg. 144 C6
Conceição r. Brazil 145 B2
Conceição da Barra Brazil 145 D2
Conceição do Araguaia Brazil 143 I5
Conceição do Mato Dentro Brazil 145 C2
Concepción Chile 144 B5
Concepción Mex. 131 C7
Concepción r. Mex. 127 F8
Concepción Para. 144 E2
Concepción, Punta pt Mex. 127 F8
Concepción de la Vega Dom. Rep. see
 La Vega
Conception, Point U.S.A. 128 C4
Conception Island Bahamas 133 F8
Conchas U.S.A. 127 G6
Conchas Lake U.S.A. 127 G6
Concho U.S.A. 129 I4
Conchos r. Nuevo León/Tamaulipas
 Mex. 131 D7
Conchos r. Mex. 131 B6
Concord CA U.S.A. 128 B3
Concord NC U.S.A. 133 D5

▶Concord NH U.S.A. 135 J2
State capital of New Hampshire.

Concord VT U.S.A. 135 J1
Concordia Arg. 144 E4
Concordiá Mex. 131 B8
Concordia Peru 142 D4
Concordia S. Africa 100 C5
Concordia KS U.S.A. 130 D4
Concordia KY U.S.A. 134 B4
Concórdia 152 G2
Concord Peak Afgh. 89 I2
Con Cuông Vietnam 70 D3
Condamine Australia 112 E1
Condamine r. Australia 112 D1
Côn Đao Vietnam 71 D5
Condeúba Brazil 145 C1
Condobolin Australia 112 C4
Condom France 56 E5
Condor, Cordillera del mts Ecuador/Peru
 142 C4
Condroz reg. Belgium 52 E4
Conecuh r. U.S.A. 133 C6
Conejos Mex. 131 C7

Conejos U.S.A. 127 G5
Conemaugh r. U.S.A. 134 F3
Conestogo Lake Canada 134 E2
Conesus Lake U.S.A. 135 G2
Conflict Group i P.N.G. 110 E1
Confoederatio Helvetica country Europe
 see Switzerland
Confusion Range mts U.S.A. 129 G2
Congdü China 83 F3
Conghua China 77 G4
Congjiang China 77 F3
Congleton U.K. 48 E5
▶Congo country Africa 98 B4
 Africa 7, 94–95

▶Congo r. Congo/Dem. Rep. Congo 98 B4
 2nd longest river and largest drainage basin
 in Africa.
 Formerly known as Zaïre.
 Africa 92–93

Congo (Brazzaville) country Africa see
 Congo
Congo (Kinshasa) country Africa see
 Congo, Democratic Republic of the

▶Congo, Democratic Republic of the
 country Africa 98 C4
 3rd largest and 4th most populous country
 in Africa.
 Africa 7, 94–95

Congo, Republic of country Africa see
 Congo
Congo Basin Dem. Rep. Congo 98 C4
Congo Cone sea feature
 S. Atlantic Ocean 148 I6
Congo Free State country Africa see
 Congo, Democratic Republic of the
Congonhas Brazil 145 C3
Congress U.S.A. 129 G4
Conimbla National Park Australia 112 D4
Coningsby U.K. 49 G5
Coniston Canada 122 E5
Coniston U.K. 48 D4
Conjuboy Australia 110 D3
Conklin Canada 121 I4
Conn r. Canada 122 F3
Conn, Lough l. Ireland 51 C3
Connacht reg. Ireland see Connaught
Connaught reg. Ireland 51 C4
Conneaut U.S.A. 134 E3
Connecticut state U.S.A. 135 I3
Connemara reg. Ireland 51 C4
Connemara National Park Ireland 51 C4
Connersville U.S.A. 134 C4
Connolly, Mount Canada 120 C2
Connors Range hills Australia 110 E4
Conoble Australia 112 B4
Conquista Brazil 145 B2
Conrad U.S.A. 126 F2
Conrad Rise sea feature
 Southern Ocean 149 K9
Conroe U.S.A. 131 E6
Conselheiro Lafaiete Brazil 145 C3
Consett U.K. 48 F4
Consolación del Sur Cuba 133 D8
Côn Sơn, Đao i. Vietnam 71 D5
Consort Canada 121 I4
Constance Germany see Konstanz
Constance, Lake Germany/Switz. 47 L7
Constância dos Baetas Brazil 142 F5
Constanţa Romania 59 M2
Constantia tourist site Cyprus see Salamis
Constantia Germany see Konstanz
Constantina Spain 57 D5
Constantine Alg. 54 F4
Constantine, Cape U.S.A. 118 C4
Constantinople Turkey see İstanbul
Constitución de 1857, Parque Nacional
 nat. park Mex. 129 F5
Consul U.S.A. 121 I5
Contact U.S.A. 126 E4
Contagalo Brazil 145 C3
Contamana Peru 142 C5
Contas r. Brazil 145 D1
Contoy, Isla i. Mex. 133 C8
Contria Brazil 145 B2
Contwoyto Lake Canada 121 I1
Convención Col. 142 D2
Convent U.S.A. 131 F6
Conway U.K. see Conwy
Conway AR U.S.A. 131 E5
Conway ND U.S.A. 130 D1
Conway NH U.S.A. 135 J2
Conway SC U.S.A. 133 E5
Conway, Cape Australia 110 E4
Conway, Lake salt flat Australia 111 A6
Conway National Park Australia 110 E4
Conway Reef Fiji see Ceva-i-Ra
Conwy U.K. 48 D5
Conwy r. U.K. 49 D5
Coober Pedy Australia 109 F7
Cooch Behar India see Koch Bihar
Coochbehar India see Koch Bihar
Cook Australia 109 E7
Cook, Cape Canada 120 E5
Cook, Grand Récif de reef
 New Caledonia 107 G3
Cook, Mount N.Z. see Aoraki
Cook, Mount Mount N.Z. see Aoraki
Cookes Peak U.S.A. 127 G6
Cookeville U.S.A. 132 C4
Cookhouse S. Africa 101 H7
Cook Ice Shelf Antarctica 152 H2
Cook Inlet sea chan. U.S.A. 118 C3

▶Cook Islands terr. S. Pacific Ocean 150 J7
 Self-governing New Zealand Territory.
 Oceania 8, 104–105

Cooksburg U.S.A. 135 H2
Cooks Passage Australia 110 D2
Cookstown U.K. 51 F3
Cook Strait N.Z. 113 E5
Cooktown Australia 110 D2
Coolabah Australia 112 C3
Cooladdi Australia 112 B1
Coolah Australia 112 D3
Coolamon Australia 112 C5
Coolgardie Australia 109 C7
Coolibah Australia 108 E3

Coolidge U.S.A. 129 H5
Cooloola National Park Australia 111 F5
Coolum Beach Australia 111 F5
Cooma Australia 112 D6
Coombah Australia 111 C7
Coonabarabran Australia 112 D3
Coonamble Australia 112 D3
Coondambo Australia 111 A6
Coondapoor India see Kundapura
Coongoola Australia 112 B1
Coon Rapids U.S.A. 130 E2
Cooper Creek watercourse Australia 111 B6
Cooper Mountain Canada 120 G5
Coopernook Australia 112 F3
Cooper's Town Bahamas 133 E7
Cooperstown ND U.S.A. 130 D2
Cooperstown NY U.S.A. 135 H2
Coopracambra National Park
 Australia 112 D6
Coorabie Australia 109 F7
Coorong National Park Australia 111 B8
Coorow Australia 109 B7
Coosa r. U.S.A. 133 C5
Coos Bay U.S.A. 126 B4
Coos Bay b. U.S.A. 126 B4
Cootamundra Australia 112 D5
Cootehill Ireland 51 E3
Cooyar Australia 112 E1
Copala Mex. 136 E5
Cope U.S.A. 130 C4
Copemish U.S.A. 134 C1

▶Copenhagen Denmark 45 H9
 Capital of Denmark.

Copenhagen U.S.A. 135 H2
Copertino Italy 58 H4
Copeton Reservoir Australia 112 E2
Cô Pi, Phou mt. Laos/Vietnam 70 D3
Copiapó Chile 144 B3
Copley Australia 111 B6
Copparo Italy 58 D2
Copper Cliff Canada 122 E5
Copper Harbor U.S.A. 132 C2
Coppermine Canada see Kugluktuk
Coppermine r. Canada 120 H1
Coppermine Point Canada 122 D5
Copperton S. Africa 100 F5
Copp Lake Canada 120 H2
Coqên China 83 F3
Coqên Xizang China 83 F3
Coquilhatville Dem. Rep. Congo see
 Mbandaka
Coquille i. Micronesia see Pikelot
Coquille U.S.A. 126 B4
Coquimbo Chile 144 B3
Coquitlam Canada 120 F5
Corabia Romania 59 K3
Coração de Jesus Brazil 145 B2
Coracesium Turkey see Alanya
Coraki Australia 112 F2
Coral Bay Australia 109 A5
Coral Harbour Canada 119 J3
Coral Sea S. Pacific Ocean 106 F3
Coral Sea Basin S. Pacific Ocean 150 G6

▶Coral Sea Islands Territory terr. Australia
 106 F3
 Australian External Territory.

Corangamite, Lake Australia 112 A7
Corat Azer. 91 H2
Corbeny France 52 D5
Corbett Inlet Canada 121 M2
Corbett National Park India 82 D3
Corbie France 52 C5
Corbin U.S.A. 134 C5
Corby U.K. 49 G6
Corcaigh Ireland see Cork
Corcoran U.S.A. 128 D3
Corcovado, Golfo de sea chan.
 Chile 144 B6
Corcyra i. Greece see Corfu
Cordele U.S.A. 133 D6
Cordelia U.S.A. 128 B2
Cordell U.S.A. 131 D5
Cordilheiras, Serra das hills Brazil 143 I5
Cordillera Azul, Parque Nacional nat. park
 Peru 142 C5
Cordillera de los Picachos, Parque
 Nacional nat. park Col. 142 D3
Cordillo Downs Australia 111 C5
Cordisburgo Brazil 145 B2
Córdoba Arg. 144 D4
Córdoba Durango Mex. 131 C7
Córdoba Veracruz Mex. 136 E5
Córdoba Spain 57 D5
Córdoba, Sierras de mts Arg. 144 D4
Cordova Spain see Córdoba
Cordova U.S.A. 118 D3
Corduba Spain see Córdoba
Corfu i. Greece 59 H5
Coria Spain 57 C4
Coribe Brazil 145 B1
Coricudgy mt. Australia 112 E4
Corigliano Calabro Italy 58 G5
Coringa Islands Australia 110 E3
Corinium U.K. see Cirencester
Corinth Greece 59 J6
Corinth KY U.S.A. 134 C4
Corinth MS U.S.A. 131 F5
Corinth NY U.S.A. 135 I2
Corinth, Gulf of sea chan. Greece 59 J5
Corinthus Greece see Corinth
Corinto Brazil 145 B2
Cork Ireland 51 D6
Corleone Sicily Italy 58 E6
Çorlu Turkey 59 L4
Cormeilles France 49 H9
Cornelia S. Africa 101 I4
Cornélio Procópio Brazil 145 A3
Cornélios Brazil 145 A5
Cornell U.S.A. 130 F2
Corner Brook Canada 123 K4
Corner Inlet b. Australia 112 C7
Corner Seamounts sea feature
 N. Atlantic Ocean 148 E3
Corneto Italy see Tarquinia
Cornillet, Mont hill France 52 E5
Corning AR U.S.A. 131 F4
Corning CA U.S.A. 128 B2
Corning NY U.S.A. 135 G2

Cornish watercourse Australia 110 D4
Corn Islands is Nicaragua see
 Maíz, Islas del
Corno, Monte mt. Italy 58 E3
Corno di Campo mt. Italy/Switz. 56 J3
Cornwall Canada 135 H1
Cornwallis Island Canada 119 I2
Cornwall Island Canada 119 I2
Coro Venez. 142 E1
Coroaci Brazil 145 C2
Coroatá Brazil 143 J4
Corofin Ireland 51 C5
Coromandel Brazil 145 B2
Coromandel Coast India 84 D4
Coromandel Peninsula N.Z. 113 E3
Coromandel Range hills N.Z. 113 E3
Corona U.S.A. 128 E5
Corona NM U.S.A. 127 G6
Coronado, Bahía de b. Costa Rica 137 H7
Coronation Canada 121 I4
Coronation Gulf Canada 118 G3
Coronation Island S. Atlantic Ocean 152 A2
Coronda Arg. 144 D4
Coronel Fabriciano Brazil 145 C2
Coronel Oviedo Para. 144 E3
Coronel Pringles Arg. 144 D5
Coronel Suárez Arg. 144 D5
Corowa Australia 112 C5
Corpus Christi U.S.A. 131 D7
Corque Bol. 142 E7
Corral de Cantos mt. Spain 57 D4
Corrales Mex. 131 B7
Corralilla Cuba 133 D8
Corrandibby Range hills Australia 109 A6
Corrente Brazil 143 I6
Corrente r. Bahia Brazil 145 C1
Corrente r. Minas Gerais Brazil 145 A2
Correntes Brazil 145 B1
Correntina Brazil 145 B1
Correntina r. Brazil see Éguas
Corrib, Lough l. Ireland 51 C4
Corrientes Arg. 144 E3
Corrientes, Cabo c. Col. 142 C2
Corrientes, Cabo c. Cuba 133 C8
Corrientes, Cabo c. Mex. 136 C4
Corrigin Australia 109 B8
Corris U.K. 49 D6
Corry U.S.A. 134 F3
Corse i. France see Corsica
Corse, Cap c. Corsica France 56 I5
Corsham U.K. 49 E7
Corsica i. France 56 I5
Corsicana U.S.A. 131 D5
Corte Corsica France 56 I5
Cortegana Spain 57 C5
Cortes, Sea of g. Mex. see
 California, Gulf of
Cortez U.S.A. 129 I3
Cortina d'Ampezzo Italy 58 E1
Cortland U.S.A. 135 G2
Corton U.K. 49 I6
Cortona Italy 58 D3
Coruche Port. 57 B4
Çoruh Turkey see Artvin
Çoruh r. Turkey 91 F2
Çorum Turkey 90 D2
Corumbá Brazil 143 G7
Corumbá r. Brazil 145 A2
Corumbá de Goiás Brazil 145 A1
Corumbaíba Brazil 145 A2
Corumbaú, Ponta pt Brazil 145 D2
Corunna Spain see A Coruña
Corunna U.S.A. 134 C2
Corvallis U.S.A. 126 C3
Corwen U.K. 49 D6
Corydon IA U.S.A. 130 E3
Corydon IN U.S.A. 134 B4
Coryville U.S.A. 135 F3
Cos i. Greece see Kos
Cosentia Italy see Cosenza
Cosenza Italy 58 G5
Coshocton U.S.A. 134 E3
Cosne-Cours-sur-Loire France 56 F3
Costa Blanca coastal area Spain 57 F4
Costa Brava coastal area Spain 57 H3
Costa de la Luz coastal area Spain 57 C5
Costa del Sol coastal area Spain 57 D5
Costa de Miskitos coastal area Nicaragua
 see Costa de Mosquitos
Costa de Mosquitos coastal area
 Nicaragua 137 H6
Costa Marques Brazil 142 F6
▶Costa Rica country Central America
 137 H6
 North America 9, 116–117
Costa Rica Mex. 136 C4
Costa Verde coastal area Spain 57 C2
Costermansville Dem. Rep. Congo see
 Bukavu
Costeşti Romania 59 K2
Costigan Lake Canada 121 J3
Coswig Germany 53 M3
Cotabato Phil. 69 G5
Cotagaita Bol. 142 E8
Cotahuasi Peru 142 D7
Cote, Mount U.S.A. 120 D3
Coteau des Prairies slope U.S.A. 130 D2
Coteau du Missouri slope ND U.S.A.
 130 C1
Coteau du Missouri slope SD U.S.A.
 130 C2
Côte d'Azur coastal area France 56 H5
▶Côte d'Ivoire country Africa 96 C4
 Africa 7, 94–95
Côte Française de Somalis country Africa
 see Djibouti
Cotentin pen. France 49 F9
Côtes de Meuse ridge France 52 E5
Cothi r. U.K. 49 C7
Cotiaeum Turkey see Kütahya
Cotiella mt. Spain 57 G2
Cotonou Benin 96 D4
Cotopaxi, Volcán vol. Ecuador 142 C4
Cotswold Hills U.K. 49 E7
Cottage Grove U.S.A. 126 C4
Cottbus Germany 47 O5
Cottenham U.K. 49 H6
Cottian Alps mts France/Italy 56 H4
Cottica Suriname 143 H3

Cottiennes, Alpes mts France/Italy see
 Cottian Alps
Cottonwood AZ U.S.A. 129 G4
Cottonwood CA U.S.A. 128 B1
Cottonwood r. U.S.A. 130 D4
Cottonwood Falls U.S.A. 130 D4
Cotulla U.S.A. 131 D6
Coudersport U.S.A. 135 F3
Couedic, Cape du Australia 111 B8
Coulee City U.S.A. 126 D3
Coulee Dam U.S.A. 126 D3
Coulman Island Antarctica 152 H2
Coulogne France 52 B4
Coulommiers France 52 D6
Coulonge r. Canada 122 F5
Coulterville U.S.A. 128 C3
Council U.S.A. 126 D3
Council Bluffs U.S.A. 130 E3
Council Grove U.S.A. 130 D4
Councillor Island Australia 111 [inset]
Counselor U.S.A. 129 J3
Coupeville U.S.A. 126 C2
Courageous Lake Canada 121 I1
Courland Lagoon b. Lith./Rus. Fed. 45 L9
Courtenay Canada 120 E5
Courtland U.S.A. 135 G5
Courtmacsherry Ireland 51 D6
Courtmacsherry Bay Ireland 51 D6
Courtown Ireland 51 F5
Courtrai Belgium see Kortrijk
Coushatta U.S.A. 131 E5
Coutances France 56 D2
Coutts Canada 121 I5
Couture, Lac l. Canada 122 G2
Couvin Belgium 52 E4
Cove Fort U.S.A. 129 G2
Cove Island Canada 134 E1
Cove Mountains hills U.S.A. 135 F4
Coventry U.K. 49 F6
Covered Wells U.S.A. 129 G5
Covesville U.S.A. 135 F5
Covilhã Port. 57 C3
Covington GA U.S.A. 133 D5
Covington IN U.S.A. 134 B3
Covington KY U.S.A. 134 C4
Covington LA U.S.A. 131 F6
Covington MI U.S.A. 130 F2
Covington TN U.S.A. 131 F5
Covington VA U.S.A. 134 E5
Cowal, Lake dry lake Australia 112 C4
Cowan, Lake salt flat Australia 109 C7
Cowansville Canada 135 I1
Cowargarzê China 76 C1
Cowcowing Lakes salt flat Australia 109 B7
Cowdenbeath U.K. 50 F4
Cowell Australia 111 B7
Cowes U.K. 49 F8
Cowichan Lake Canada 120 E5
Cowley Australia 112 B1
Cowper Point Canada 119 G2
Cowra Australia 112 D4
Cox r. Australia 110 A2
Coxá r. Brazil 145 B1
Coxen Hole Hond. see Roatán
Coxilha de Santana hills Brazil/Uruguay
 144 E4
Coxilha Grande hills Brazil 144 F3
Coxim Brazil 143 H7
Cox's Bazar Bangl. 83 G5
Coyame Mex. 131 B6
Coyhaique Chile see Coihaique
Coyote Lake U.S.A. 128 E4
Coyote Peak hill U.S.A. 129 F5
Cozhê China 83 F2
Cozie, Alpi mts France/Italy see Cottian Alps
Cozumel Mex. 137 G4
Cozumel, Isla de i. Mex. 137 G4
Craboon Australia 112 D4
Cracovia Poland see Kraków
Cracow Australia 110 E5
Cracow Poland see Kraków
Cradle Mountain Lake St Clair National
 Park Australia 111 [inset]
Cradock S. Africa 101 G7
Craig U.K. 50 D3
Craig AK U.S.A. 120 C4
Craig CO U.S.A. 129 J1
Craigavon U.K. 51 F3
Craigieburn Australia 112 B6
Craig Island Taiwan see Mienhua Yü
Craignure U.K. 50 D4
Craigsville U.S.A. 134 E4
Crail U.K. 50 G4
Crailsheim Germany 53 K5
Craiova Romania 59 J2
Cramlington U.K. 48 F3
Cranberry Lake U.S.A. 135 H1
Cranberry Portage Canada 121 K4
Cranberne Chase for. U.K. 49 E8
Cranbourne Australia 112 B7
Cranbrook Canada 120 H5
Crandon U.S.A. 130 F2
Crane r. Canada 120 E3
Crane Lake Canada 121 I5
Cranston KY U.S.A. 134 D4
Cranston RI U.S.A. 135 J3
Cranz Rus. Fed. see Zelenogradsk
Crary Ice Rise Antarctica 152 I1
Crary Mountains Antarctica 152 J1
Crater Lake National Park U.S.A. 126 C4
Crater Peak U.S.A. 128 C1
Craters of the Moon National Monument
 nat. park U.S.A. 126 E4
Crateús Brazil 143 J5
Crato Brazil 143 K5
Crawford CO U.S.A. 129 J2
Crawford NE U.S.A. 130 C3
Crawfordsville U.S.A. 134 B3
Crawfordville FL U.S.A. 133 C6
Crawfordville GA U.S.A. 133 D5
Crawley U.K. 49 G7
Crazy Mountains U.S.A. 126 F3
Creag Meagaidh mt. U.K. 50 E4
Crécy-en-Ponthieu France 52 B4
Credenhill U.K. 49 E6
Crediton U.K. 49 D8
Cree r. Canada 121 J3
Creel Mex. 127 G8
Cree Lake Canada 121 J3
Creemore Canada 134 E1
Creighton Canada 121 K4
Creil France 52 C5
Creil Neth. 52 F2

Crema Italy 58 C2
Cremlingen Germany 53 K2
Cremona Canada 120 H5
Cremona Italy 58 D2
Crépy-en-Valois France 52 C5
Cres i. Croatia 58 F2
Crescent U.S.A. 126 C4
Crescent City CA U.S.A. 126 B4
Crescent City FL U.S.A. 133 D6
Crescent Group i. Paracel Is 68 E3
Crescent Head Australia 112 F3
Crescent Junction U.S.A. 129 I2
Crescent Valley U.S.A. 128 E1
Cressy Australia 112 A7
Crest Hill hill H.K. China 77 [inset]
Crestline U.S.A. 134 D3
Creston Canada 120 G5
Creston IA U.S.A. 130 E3
Creston WY U.S.A. 126 G4
Crestview U.S.A. 133 C6
Creswick Australia 112 A6
Creta i. Greece see Crete
Crete i. Greece 59 K7
Crete U.S.A. 130 D3
Creus, Cap de c. Spain 57 H2
Creuse r. France 56 E3
Creußen Germany 53 L5
Creutzwald France 52 G5
Creuzburg Germany 53 K3
Crevasse Valley Glacier Antarctica 152 J1
Crewe U.K. 49 E5
Crewe U.S.A. 135 F5
Crewkerne U.K. 49 E8
Crianlarich U.K. 50 E4
Criccieth U.K. 49 C6
Criciúma Brazil 145 A5
Crieff U.K. 50 F4
Criffel hill U.K. 50 F6
Criffell hill U.K. see Criffel
Crikvenica Croatia 58 F2
Crillon, Mount U.S.A. 120 B3
Crimea pen. Ukr. 90 D1
Crimmitschau Germany 53 M4
Crimond U.K. 50 H3
Crisfield U.S.A. 135 H5
Cristalândia Brazil 143 I6
Cristalina Brazil 145 B1
Cristalino r. Brazil see Mariembero
Cristóbal Colón, Pico mt. Col. 142 D1
Crixás Brazil 145 A1
Crixás Açu r. Brazil 145 A1
Crixás Mirim r. Brazil 145 A1
Crna Gora country Montenegro see
 Montenegro
Crni Vrh mt. Serb. and Mont. 59 J2
Črnomelj Slovenia 58 F2
Croagh Patrick hill Ireland 51 C4
Croajingolong National Park
 Australia 112 D6
▶Croatia country Europe 58 G2
 Europe 5, 38–39
Crocker, Banjaran mts Malaysia 68 E6
Crockett U.S.A. 131 E6
Crofton KY U.S.A. 134 B5
Crofton NE U.S.A. 130 D3
Croghan U.S.A. 135 H2
Croisilles France 52 C4
Croker, Cape Canada 134 E1
Croker Island Australia 108 F2
Cromarty U.K. 50 E3
Cromarty Firth est. U.K. 50 E3
Cromer U.K. 49 I6
Crook U.K. 48 F4
Crooked Harbour b. H.K. China 77 [inset]
Crooked Island Bahamas 133 F8
Crooked Island H.K. China 77 [inset]
Crooked Island Passage Bahamas 133 F8
Crookston U.S.A. 130 D2
Crooksville U.S.A. 134 D4
Crookwell Australia 112 D5
Croom Ireland 51 D5
Croppa Creek Australia 112 E2
Crosby U.K. 48 D5
Crosby MN U.S.A. 130 E2
Crosby ND U.S.A. 130 C1
Crosbyton U.S.A. 131 C5
Cross Bay Canada 121 M2
Cross City U.S.A. 133 D6
Cross Fell hill U.K. 48 E4
Crossfield Canada 120 H5
Crossgar U.K. 51 G3
Crosshaven Ireland 51 D6
Cross Inn U.K. 49 C6
Cross Lake Canada 121 L4
Cross Lake l. Canada 121 L4
Cross Lake l. U.S.A. 135 G2
Crossmaglen U.K. 51 F3
Crossman Peak U.S.A. 129 F4
Crossville U.S.A. 132 C5
Crotch Lake Canada 135 G1
Croton Italy see Crotone
Crotone Italy 58 G5
Crouch r. U.K. 49 H7
Crow r. Canada 120 E3
Crow Agency U.S.A. 126 G3
Crowal watercourse Australia 112 C3
Crowborough U.K. 49 H7
Crowdy Bay National Park Australia 112 F3
Crowell U.S.A. 131 D5
Crowland U.K. 49 G6
Crowley U.S.A. 131 E6
Crowley, Lake U.S.A. 128 D3
Crown Point IN U.S.A. 134 B3
Crownpoint U.S.A. 129 I4
Crown Point NY U.S.A. 135 I2
Crown Prince Olav Coast
 Antarctica 152 D2
Crown Princess Martha Coast
 Antarctica 152 B1
Crows Nest Australia 112 F1
Crowsnest Pass Canada 120 H5
Crowsnest Pass pass Canada 120 H5
Crow Wing r. U.S.A. 130 E2
Croydon Australia 110 C3
Crozet U.S.A. 135 F4
Crozet, Îles is Indian Ocean 149 L9
Crozet Basin sea feature
 Indian Ocean 149 M8
Crozet Plateau sea feature
 Indian Ocean 149 K8
Crozon France 56 B2
Cruces Cuba 133 D8
Cruden Bay U.K. 50 H3

Dawson Creek Canada 120 F4
Dawson Inlet Canada 121 M2
Dawson Range mts Canada 120 A2
Dawsons Landing Canada 120 E5
Dawu Hubei China 77 G2
Dawu Qinghai China see Maqên
Dawu Taiwan see Tawu
Dawukou China see Shizuishan
Dawu Shan hill China 77 G2
Dax France 56 D5
Daxian China see Dazhou
Daxiang Ling mts China 76 D2
Daxin China 76 E4
Daxing Yunnan China see Ninglang
Daxing Yunnan China see Lüchun
Daxing'an Ling mts China see
 Da Hinggan Ling
Da Xueshan mts China 76 D2
Dayan China see Lijiang
Dayangshu China 74 B2
Dayao China 76 D3
Dayao Shan mts China 77 F4
Daye China 77 G2
Daying China 76 E2
Daying Jiang r. China 76 C3
Dayishan China see Guanyun
Däykundī Afgh. 89 G3
Daylesford Australia 112 B6
Daylight Pass U.S.A. 128 E3
Dayong China see Zhangjiajie
Dayr Abū Sa'īd Jordan 85 B3
Dayr az Zawr Syria 91 F4
Dayr Ḥāfir Syria 85 C1
Daysland Canada 121 H4
Dayton OH U.S.A. 134 C3
Dayton TN U.S.A. 132 C5
Dayton VA U.S.A. 135 F4
Dayton WA U.S.A. 126 D3
Daytona Beach U.S.A. 133 D6
Dayu Ling mts China 77 G3
Da Yunhe canal China 77 H1
Dayyer Iran 88 C5
Dayyīna i. U.A.E. 88 D5
Dazhongji China see Dafeng
Dazhou China 76 E2
Dazhou Dao i. China 77 F5
Dazhu China 76 E2
Dazu China 76 E2
Dazu Rock Carvings tourist site
 China 76 E2
De Aar S. Africa 100 G6
Dead r. Ireland 51 D5
Deadman Lake U.S.A. 128 E4
Deadman's Cay Bahamas 133 F8
Dead Mountains U.S.A. 129 F4
▶Dead Sea salt l. Asia 85 B4
 Lowest point in the world and in Asia.
 Asia 60–61

Deadwood U.S.A. 130 C2
Deakin Australia 109 E7
Deal U.K. 49 I7
Dealesville S. Africa 101 G5
De'an China 77 G2
Dean r. Canada 120 D3
Dean, Forest of U.K. 49 E7
Deán Funes Arg. 144 D4
Deanuvuotna inlet Norway see Tanafjorden
Dearborn U.S.A. 134 D2
Dearne r. U.K. 48 F5
Deary U.S.A. 126 D3
Dease r. Canada 120 D3
Dease Lake Canada 120 D3
Dease Lake l. Canada 120 D3
Dease Strait Canada 118 H3
▶Death Valley depr. U.S.A. 128 E3
 Lowest point in the Americas.
 North America 114–115

Death Valley Junction U.S.A. 128 E3
Death Valley National Park U.S.A. 128 E3
Deauville France 56 E2
Deaver U.S.A. 126 F3
De Baai S. Africa see Port Elizabeth
Debao China 76 E4
Debar Macedonia 59 I4
Debden Canada 121 J4
Debenham U.K. 49 I6
De Beque U.S.A. 129 I2
De Biesbosch, Nationaal Park nat. park
 Neth. 52 E3
Débo, Lac l. Mali 96 C3
Deborah East, Lake salt flat
 Australia 109 B7
Deborah West, Lake salt flat
 Australia 109 B7
Debrecen Hungary 59 I1
Debre Markos Eth. 86 E7
Debre Tabor Eth. 86 E7
Debre Zeyit Eth. 98 D3
Decatur AL U.S.A. 133 C5
Decatur GA U.S.A. 133 C5
Decatur IL U.S.A. 130 F4
Decatur IN U.S.A. 134 C3
Decatur MI U.S.A. 134 C2
Decatur MS U.S.A. 131 F5
Decatur TX U.S.A. 131 D5
▶Deccan plat. India 84 C2
 Plateau making up most of southern and
 central India.

Deception Bay Australia 112 F1
Dechang China 76 D3
Děčín Czech Rep. 47 O5
Decker U.S.A. 126 G3
Decorah U.S.A. 130 F3
Dedap i. Indon. see Penasi, Pulau
Dedaye Myanmar 70 A3
Deddington U.K. 49 F7
Dedegöl Dağları mts Turkey 59 N6
Dedeleben Germany 53 K2
Dedelstorf Germany 53 K2
Dedemsvaart Neth. 52 G2
Dedo de Deus mt. Brazil 145 B4
Dédougou Burkina 96 C3
Dedovichi Rus. Fed. 42 F4
Dedu China see Wudalianchi
Dee r. Ireland 51 F4
Dee est. U.K. 48 D5
Dee r. England/Wales U.K. 49 D5

Dee r. Scotland U.K. 50 G3
Deel r. Ireland 51 D5
Deel r. Ireland 51 F4
Deep Bay H.K. China 77 [inset]
Deep Creek Lake U.S.A. 134 F4
Deep Creek Range mts U.S.A. 129 G2
Deep River Canada 122 F5
Deepwater Australia 112 E2
Deeri Somalia 98 E3
Deering U.S.A. 118 B3
Deering, Mount Australia 109 E6
Deer Island U.S.A. 118 B4
Deer Lake Canada 121 M4
Deer Lake l. Canada 121 M4
Deer Lodge U.S.A. 126 E3
Deesa India see Disa
Defeng China see Liping
Defensores del Chaco, Parque Nacional
 nat. park Para. 144 D2
Defiance U.S.A. 134 C3
Defiance Plateau U.S.A. 129 I4
Degana India see Degana
Degeh Bur Eth. 98 E3
Degema Nigeria 96 D4
Deggendorf Germany 53 M6
Degh r. Pak. 89 I4
De Grey r. Australia 108 B5
De Groote Peel, Nationaal Park nat. park
 Neth. 52 F3
Degtevo Rus. Fed. 43 I6
De Haan Belgium 52 D3
Dehak Iran 89 F4
De Hamert, Nationaal Park nat. park Neth.
 52 G3
Deh-Dasht Iran 88 C4
Dehej India 82 C5
Deheq Iran 88 C3
Dehestān Iran 88 D4
Deh Golān Iran 88 B3
Dehgon Afgh. 89 F3
Dehi Afgh. 89 G3
Dehkūyeh Iran 88 D5
Dehlorān Iran 88 B3
De Hoge Veluwe, Nationaal Park nat. park
 Neth. 52 F2
De Hoop Nature Reserve S. Africa 100 E8
Dehqonobod Uzbek. 89 G2
Dehra Dun India 82 D3
Dehradun India see Dehra Dun
Dehri India 83 F4
Deh Shū Afgh. 89 F4
Deim Zubeir Sudan 97 F4
Deinze Belgium 52 D4
Deir-ez-Zor Syria see Dayr az Zawr
Dej Romania 59 J1
Deji China see Rinbung
Dejiang China 77 F2
De Jouwer Neth. see Joure
De Kalb IL U.S.A. 130 F3
De Kalb MS U.S.A. 131 F5
De Kalb TX U.S.A. 131 E5
De Kalb Junction U.S.A. 135 H1
De-Kastri Rus. Fed. 74 F2
Dekemhare Eritrea 86 E6
Dekhkanabad Uzbek. see Dehqonobod
Dekina Nigeria 96 D4
Dékoa Cent. Afr. Rep. 98 B3
De Koog Neth. 52 E1
De Kooy Neth. 52 E2
Delaki Indon. 108 D2
Delamar Lake U.S.A. 129 F3
De Land U.S.A. 133 D6
Delano U.S.A. 128 D4
Delano Peak U.S.A. 129 G2

▶Delap-Uliga-Djarrit Marshall Is 150 H5
 Capital of the Marshall Islands,
 on Majuro atoll.

Delārām Afgh. 89 F3
Delareyville S. Africa 101 G4
Delaronde Lake Canada 121 J4
Delavan U.S.A. 122 C6
Delaware U.S.A. 134 D3
Delaware r. U.S.A. 135 H4
Delaware state U.S.A. 135 H4
Delaware, East Branch r. U.S.A. 135 H3
Delaware Bay U.S.A. 135 H4
Delaware Lake U.S.A. 134 D3
Delaware Water Gap National Recreational
 Area nat. park U.S.A. 135 H3
Delay r. Canada 123 H2
Delbarton U.S.A. 134 D5
Delbrück Germany 53 I3
Delburne Canada 120 H4
Dêlêg China 83 F3
Delegate Australia 112 D6
De Lemmer Neth. see Lemmer
Delémont Switz. 56 H3
Delevan CA U.S.A. 128 B2
Delevan NY U.S.A. 135 F2
Delfinópolis Brazil 145 B3
Delft Neth. 52 E2
Delfzijl Neth. 52 G1
Delgada, Point U.S.A. 128 A1
Delgado, Cabo c. Moz. 99 E5
Delhi Canada 134 E2
Delhi China 80 I4
Delhi India 82 D3
Delhi CO U.S.A. 127 G5
Delhi LA U.S.A. 131 F5
Delhi NY U.S.A. 135 H2
Delice Turkey 90 D3
Delice r. Turkey 90 D2
Delījān Iran 88 C3
Déljne Canada 120 F1
Delingha China see Delhi
Delisle Canada 121 J5
Dellys Alg. 57 H5
Del Mar U.S.A. 128 E5
Delmenhorst Germany 53 I1
Delnice Croatia 58 F2
Delong Rus. Fed. see Ande
De-Longa, Ostrova is Rus. Fed. 65 Q2
De Long Islands Rus. Fed. see
 De-Longa, Ostrova
De Long Mountains U.S.A. 118 B3
Dêqên Xizang China see Dagzê

De Long Strait Rus. Fed. see
 Longa, Proliv
Deloraine Canada 121 K5
Delphi U.S.A. 134 B3
Delphos U.S.A. 134 C3
Delportshoop S. Africa 100 G5
Delray Beach U.S.A. 133 D7
Delrey U.S.A. 134 A3
Del Río Mex. 127 F7
Del Rio U.S.A. 131 C6
Delsbo Sweden 45 J6
Delta CO U.S.A. 129 I2
Delta OH U.S.A. 134 C3
Delta UT U.S.A. 129 G2
Delta Downs Australia 110 C3
Delta Junction U.S.A. 118 D3
Deltona U.S.A. 133 D6
Delungra Australia 112 E2
Delvin Ireland 51 E4
Delvinë Albania 59 I5
Delwara India 82 C4
Demavend mt. Iran see
 Damāvand, Qolleh-ye
Demba Dem. Rep. Congo 99 C4
Dembî Dolo Eth. 86 D8
Demerara Guyana see Georgetown
Demerara Abyssal Plain sea feature
 S. Atlantic Ocean 148 E5
Demidov Rus. Fed. 43 F5
Deming U.S.A. 127 G6
Demirci Turkey 59 M5
Demirköy Turkey 59 L4
Demirtaş Turkey 85 A1
Demmin Germany 47 N4
Demopolis U.S.A. 133 C5
Demotte U.S.A. 134 B3
Dempo, Gunung vol. Indon. 68 C7
Dêmqog Jammu and Kashmir 82 D2
Demta Indon. 69 K7
Dem'yanovo Rus. Fed. 42 J3
Denakil reg. Africa 98 E2
Denali mt. U.S.A. see McKinley, Mount
Denali National Park and Preserve
 U.S.A. 118 C3
Denan Eth. 98 E3
Denbigh Canada 135 G1
Denbigh U.K. 48 D5
Den Bosch Neth. see 's-Hertogenbosch
Den Burg Neth. 52 E1
Den Chai Thai. 70 C3
Dendâra Mauritania 96 C3
Dendermonde Belgium 52 E3
Dendi mt. Eth. 98 D3
Dendre r. Belgium 52 E3
Dendron S. Africa see Mogwadi
Denezhkin Kamen', Gora mt.
 Rus. Fed. 41 R3
Dêngka China see Têwo
Dêngkagoin China see Têwo
Dengkou China 72 J4
Dêngqên China 76 B2
Dengta China 77 G4
Dengxian China see Dengzhou
Dengzhou China 77 G1
Den Haag Neth. see The Hague
Denham Australia 109 A6
Denham r. Australia 108 A3
Den Ham Neth. 52 G2
Denham Range mts Australia 110 E4
Den Helder Neth. 52 E2
Denholm Canada 121 I4
Denia Spain 57 G4
Denial Bay Australia 111 A7
Deniliquin Australia 112 B5
Denio U.S.A. 126 D4
Denison IA U.S.A. 130 E3
Denison TX U.S.A. 131 D5
Denison, Cape Antarctica 152 G2
Denison Plains Australia 108 E4
Deniyaya Sri Lanka 84 D5
Denizli Turkey 59 M6
Denman Australia 112 E4
Denman Glacier Antarctica 152 F2
Denmark Australia 106 B5
▶Denmark country Europe 45 G8
 Europe 5, 38–39
Denmark U.S.A. 134 B1
Denmark Strait Greenland/Iceland 40 A2
Dennis, Lake salt flat Australia 108 E5
Dennison IL U.S.A. 134 B4
Dennison OH U.S.A. 134 E3
Denny U.K. 50 F4
Denov Uzbek. 89 G2
Denow Uzbek. see Denov
Denpasar Indon. 108 A2
Denton MD U.S.A. 135 H4
Denton TX U.S.A. 131 D5
D'Entrecasteaux, Point Australia 109 A8
D'Entrecasteaux, Récifs reef
 New Caledonia 107 F3
D'Entrecasteaux Islands P.N.G. 106 F2
D'Entrecasteaux National Park
 Australia 109 A8

▶Denver CO U.S.A. 126 G5
 State capital of Colorado.

Denver PA U.S.A. 135 G3
Denys r. Canada 122 F3
Deo India 83 F5
Deoband India 82 D3
Deogarh Jharkhand India see Deoghar
Deogarh Orissa India 83 F5
Deogarh Rajasthan India 82 C4
Deogarh Uttar Prad. India 82 D4
Deogarh mt. India 83 E5
Deoghar India 83 F4
Deolali India 84 B2
Deoli India 83 F5
Deori Madh. Prad. India 82 D5
Deoria India 83 E4
Deosil India 83 E5
Deothang Bhutan 83 G4
De Panne Belgium 52 C3
De Pere U.S.A. 134 A1
Deposit U.S.A. 135 H2
Depsang Point hill Aksai Chin 82 D2
Deputatskiy Rus. Fed. 65 O3
Dêqên Xizang China see Dagzê

Dêqên Xizang China 83 G3
Dêqên Xizang China 83 G3
De Queen U.S.A. 131 E5
Dera Ghazi Khan Pak. 89 H4
Dera Ismail Khan Pak. 89 H4
Derajat reg. Pak. 89 H4
Derawar Fort Pak. 89 H4
Derbent Rus. Fed. 91 H2
Derbesiye Turkey see Şenyurt
Derbur China 74 A2
Derby Australia 108 C4
Derby U.K. 49 F6
Derby CT U.S.A. 135 I3
Derby KS U.S.A. 131 D4
Derby NY U.S.A. 135 F2
Dereham U.K. 49 H6
Derg r. Ireland/U.K. 51 E3
Derg, Lough l. Ireland 51 D5
Dergachi Rus. Fed. 43 K6
Dergachi Ukr. see Derhachi
Derhachi Ukr. 43 H6
De Ridder U.S.A. 131 E6
Derik Turkey 91 F3
Derm Namibia 100 D2
Derna Libya see Darnah
Dernberg, Cape Namibia 100 B4
Dêrong China 76 C2
Derravaragh, Lough l. Ireland 51 E4
Derry U.K. see Londonderry
Derry U.S.A. 135 J2
Derryveagh Mts hills Ireland 51 D3
Dêrub China 82 D2
Derudeb Sudan 86 E6
De Rust S. Africa 100 F7
Derventa Bos.-Herz. 58 G2
Derwent r. England U.K. 48 F6
Derwent r. England U.K. 48 F5
Derwent Water l. U.K. 48 D4
Derweze Turkm. 88 E1
Derzhavinsk Kazakh. 80 C1
Derzhavinskiy Kazakh. see Derzhavinsk
Desaguadero r. Arg. 144 C4
Désappointement, Îles du is
 Fr. Polynesia 151 K6
Desatoya Mountains U.S.A. 128 E2
Deschambault Lake Canada 121 K4
Deschutes r. U.S.A. 126 C3
Desē Eth. 98 D2
Deseado Arg. 144 C7
Deseado r. Arg. 144 C7
Desengaño, Punta pt Arg. 144 C7
Deseret U.S.A. 129 G2
Deseret Peak U.S.A. 129 G1
Deseronto Canada 135 G1
Desert Canal Pak. 89 H4
Desert Center U.S.A. 129 F5
Desert Lake U.S.A. 129 F3
Desert View U.S.A. 129 H3
Deshler U.S.A. 134 D3
De Smet U.S.A. 130 D2

▶Des Moines IA U.S.A. 130 E3
 State capital of Iowa.

Des Moines NM U.S.A. 131 C4
Des Moines r. U.S.A. 130 F3
Desna r. Rus. Fed./Ukr. 43 F6
Desnogorsk Rus. Fed. 43 G5
Desolación, Isla i. Chile 144 B8
Des Plaines r. U.S.A. 134 B2
Dessau Germany 53 M3
Dessye Eth. see Desē
Destelbergen Belgium 52 D3
Destruction Bay Canada 153 A2
Desvres France 52 B4
Detah Canada 120 H2
Dete Zimbabwe 99 C5
Detmold Germany 53 I3
Detrital Wash watercourse U.S.A. 129 F3
Detroit U.S.A. 134 D2
Detroit Lakes U.S.A. 130 E2
Dett Zimbabwe see Dete
Deua National Park Australia 112 D5
Deuben Germany 53 M3
Deurne Neth. 52 F3
Deutschland country Europe see Germany
Deutschlandsberg Austria 47 O7
Deutzen Germany 53 M3
Deva Romania 59 J2
Deva U.K. see Chester
Devana U.K. see Aberdeen
Devangere India see Davangere
Devanhalli India 84 C3
Deve Bair pass Bulg./Macedonia see
 Velbüzhdki Prohod
Develi Turkey 90 D3
Deventer Neth. 52 G2
Deveron r. U.K. 50 G3
Devét Skal hill Czech Rep. 47 P6
Devgarh India 84 B2
Devghar India see Deoghar
Devikot India 82 B4
Devil's Bridge U.K. 49 D6
Devil's Gate pass U.S.A. 128 D2
Devil's Lake U.S.A. 130 D1
Devil's Paw mt. U.S.A. 120 C3
Devil's Peak U.S.A. 128 D3
Devil's Point Bahamas 133 F7
Devine U.S.A. 131 D6
Devizes U.K. 49 F7
Devli India 82 C4
Devnya Bulg. 59 L3
Devon r. U.K. 50 F4
Devon Island Canada 119 I2
Devonport Australia 111 [inset]
Devrek Turkey 59 N4
Devrukh India 84 B2
Dewa, Tanjung pt Indon. 71 A7
Dewas India 82 D5
De Weerribben, Nationaal Park nat. park
 Neth. 52 G2
Dewetsdorp S. Africa 101 H5
De Witt AR U.S.A. 131 F5
De Witt IA U.S.A. 130 F3
Dewsbury U.K. 48 F5
Dexing China 77 H2
Dexter ME U.S.A. 135 K1
Dexter MI U.S.A. 134 D2
Dexter MO U.S.A. 131 F4
Dexter NM U.S.A. 127 G6
Dexter NY U.S.A. 135 G1
Deyang China 76 E2

Dey-Dey Lake salt flat Australia 109 E7
Deyhuk Iran 88 E3
Deyong, Tanjung pt Indon. 69 J8
Dez r. Iran 86 G3
Dezadeash Lake Canada 120 B2
Dezfūl Iran 88 C3

▶Dezhneva, Mys c. Rus. Fed. 65 T3
 Most easterly point of Asia.

Dezhou Shandong China 73 L5
Dezhou Sichuan China see Dechang
Dezh Shāhpūr Iran see Marīvān
Dhabarau India 83 E4
Dhahab, Wādī adh r. Syria 85 B3
Dhāhiriya West Bank 85 B4
Dhahran Saudi Arabia 88 C5

▶Dhaka Bangl. 83 G5
 Capital of Bangladesh.

Dhalbhum reg. India 83 F5
Dhalgaon India 84 B2
Dhamār Yemen 86 F7
Dhamoni India 82 D4
Dhamtari India 84 D1
Dhana Pak. 89 H5
Dhana Sar Pak. 89 H4
Dhanbad India 83 F5
Dhanera India 82 C4
Dhang Range mts Nepal 83 E3
Dhankuta Nepal 83 F4
Dhansia India 82 C3
Dhar India 82 C5
Dhar Adrar hills Mauritania 96 B3
Dharampur India 84 B1
Dharan Bazar Nepal 83 F4
Dharashiv India see Osmanabad
Dhari India 82 B5
Dharmapuri India 84 C3
Dharmavaram India 84 C3
Dharmsala Hima. Prad. India see
 Dharmshala
Dharmsala Orissa India 83 F5
Dharmshala India 82 D2
Dharnaoda India 82 D4
Dhar Oualâta hills Mauritania 96 C3
Dhar Tîchît hills Mauritania 96 C3
Dharug National Park Australia 112 E4
Dharur India 84 C2
Dharwad India 84 B3
Dharwar India see Dharwad
Dharwas India 82 D2
Dhasan r. India 82 D4
Dhāt al Ḥājj Saudi Arabia 90 E5
Dhaulagiri mt. Nepal 83 E3
Dhaulpur India see Dholpur
Dhaura India 82 D4
Dhaurahra India 82 E4
Dhawlagiri mt. Nepal see Dhaulagiri
Dhebar Lake India see Jaisamand Lake
Dhekelia Sovereign Base Area military base
 Cyprus 85 A2
Dhemaji India 83 H4
Dhenkanal India 84 E1
Dhībān Jordan 85 B4
Dhidhimótikhon Greece see Didymoteicho
Dhing India 83 H4
Dhirwah, Wādī adh watercourse
 Jordan 85 C4
Dhodhekánisos is Greece see Dodecanese
Dhola India 82 B5
Dholera India 82 C5
Dholpur India 82 D4
Dhomokós Greece see Domokos
Dhone India 84 C3
Dhoraji India 82 B5
Dhori India 82 B5
Dhrangadhra India 82 B5
Dhubāb Yemen 86 F7
Dhubri India 83 G4
Dhudial Pak. 89 I3
Dhule India 84 B1
Dhulia India see Dhule
Dhulian India 83 F4
Dhulian Pak. 89 I3
Dhuma India 82 D5
Dhund r. India 82 D4
Dhuraj India 82 B5
Dhurwai India 82 D4
Dhuusa Marreeb Somalia 98 E3
Dia i. Greece 59 K7
Diablo, Mount U.S.A. 128 C3
Diablo, Picacho del mt. Mex. 127 E7
Diablo Range mts U.S.A. 128 C3
Diagbe Dem. Rep. Congo 98 C3
Diamante Arg. 144 D4
Diamantina watercourse Australia 110 B5
Diamantina Brazil 145 C2
Diamantina, Chapada plat. Brazil 145 C1
Diamantina Deep sea feature
 Indian Ocean 149 O8
Diamantina Gates National Park
 Australia 110 C4
Diamantino Brazil 143 G6
Diamond Islets Australia 110 E3
Diamond Peak U.S.A. 129 F2
Dianbai China 77 F4
Diancang Shan mt. China 76 D3
Dian Chi l. China 76 D3
Diandioumé Mali 96 C3
Diane Bank sea feature Australia 110 E2
Dianjiang China 76 E2
Dianópolis Brazil 143 I6
Dianyang China see Shidian
Diaobingshan China 74 A4
Diaoling China 74 C3
Diapaga Burkina 96 D3
Diarizos r. Cyprus 85 A2
Diavolo, Mount hill India 71 A4
Diaz Point Namibia 100 B4
Dibaya Dem. Rep. Congo 99 C4
Dibella well Niger 96 E3
Dibeng S. Africa 100 F4
Dibete Botswana 101 H2
Dibrugarh India 83 H4
Dibse Syria see Dibsī
Dibsī Syria 85 D2
Dickens U.S.A. 131 C5
Dickinson U.S.A. 130 C2
Dicle r. Turkey 91 F3 see Tigris
Didésa Wenz r. Eth. 98 D3

Didiéni Mali 96 C3
Didsbury Canada 120 H5
Didwana India 82 C4
Didymoteicho Greece 59 L4
Die France 56 G4
Dieblich Germany 53 H4
Diébougou Burkina 96 C3
Dieburg Germany 53 I5
Diedenhofen France see Thionville
Diefenbaker, Lake Canada 121 I5
Diego de Almagro, Isla i. Chile 144 A8
Diégo Suarez Madag. see Antsiranana
Diekirch Lux. 52 G5
Diéma Mali 96 C3
Diemel r. Germany 53 J3
Diemen Neth. 52 E2
Điên Biên Vietnam see Điên Biên Phu
Điên Biên Phu Vietnam 70 C2
Diên Châu Vietnam 70 D3
Điên Khanh Vietnam 71 E4
Diepholz Germany 53 I2
Dieppe France 52 B5
Dierks U.S.A. 131 E5
Di'er Songhua Jiang r. China 74 B3
Diessen Neth. 52 F3
Diest Belgium 52 F4
Dietikon Switz. 56 I3
Diez Germany 53 I4
Diffa Niger 96 E3
Digby Canada 123 I5
Diggi India 82 C4
Diglur India 84 C2
Digne France see Digne-les-Bains
Digne-les-Bains France 56 H4
Digoin France 56 F3
Digos Phil. 69 H5
Digras India 84 C1
Digri Pak. 89 H5
Digul r. Indon. 69 K8
Digya National Park Ghana 96 C4
Dihang r. India 83 H4 see Brahmaputra
Dihôk Iraq see Dahūk
Dihourse, Lac l. Canada 123 I2
Diinsoor Somalia 98 E3
Dijon France 56 G3
Dik Chad 97 E4
Diken India 82 C4
Dikhil Djibouti 86 F7
Dikili Turkey 59 L5
Diklosmta mt. Rus. Fed. 43 J8
Dikson Rus. Fed. 64 J2
Dila Eth. 98 D3
Dilaram Iran 88 E4

▶Dili East Timor 108 D2
 Capital of East Timor.

Di Linh Vietnam 71 E5
Dillenburg Germany 53 I4
Dilley U.S.A. 131 D6
Dillingen (Saar) Germany 52 G5
Dillingen an der Donau Germany 47 M6
Dillingham U.S.A. 118 C4
Dillon r. Canada 121 I4
Dillon MT U.S.A. 126 E3
Dillon SC U.S.A. 133 E5
Dillwyn U.S.A. 135 F5
Dilolo Dem. Rep. Congo 99 C5
Dilsen Belgium 52 F3
Dimapur India 83 H4
Dimashq Syria see Damascus
Dimbokro Côte d'Ivoire 96 C4
Dimboola Australia 111 C8
Dimitrov Ukr. see Dymytrov
Dimitrovgrad Bulg. 59 K3
Dimitrovgrad Rus. Fed. 43 K5
Dimitrovo Bulg. see Pernik
Dimmitt U.S.A. 131 C5
Dimona Israel 85 B4
Dimpho Pan salt pan Botswana 100 E3
Dinagat i. Phil. 69 H4
Dinajpur Bangl. 83 G4
Dinan France 56 C2
Dinant Belgium 52 E4
Dinapur India 83 F4
Dinar Turkey 59 N5
Dīnār, Kūh-e mt. Iran 88 C4
Dinara Planina mts Bos.-Herz./Croatia see
 Dinaric Alps
Dinaric Alps mts Bos.-Herz./Croatia 58 G2
Dinbych U.K. see Denbigh
Dinbych-y-pysgod U.K. see Tenby
Dinder National Park Sudan 97 G3
Dindi r. India 84 C2
Dindigul India 84 C4
Dindima Nigeria 96 E3
Dindiza Moz. 101 K2
Dindori India 82 E5
Dingcheng China see Dingyuan
Dingelstädt Germany 53 K3
Dingla Nepal 83 F4
Dingle Ireland 51 B5
Dingle Bay Ireland 51 B5
Dingnan China 77 G3
Dingo Australia 110 E4
Dingolfing Germany 53 M6
Dingping China see Linshui
Dingtao China 77 G1
Dinguiraye Guinea 96 B3
Dingwall U.K. 50 E3
Dingxi China 76 E1
Dingyuan China 77 H1
Dinkelsbühl Germany 53 K5
Dinngyê China 83 F3
Dinokwe Botswana 101 H2
Dinosaur U.S.A. 129 I1
Dinosaur National Monument nat. park
 U.S.A. 129 I1
Dinslaken Germany 52 G3
Dinwiddie U.S.A. 135 G5
Dioïla Mali 96 C3
Dionísio Cerqueira Brazil 144 F3
Diorama Brazil 145 A2
Dioscurias Georgia see Sokhumi
Diouloulou Senegal 96 B3
Diourbel Senegal 96 B3
Dipayal 82 E3
Diphu India 83 H4
Dipkarpaz Cyprus see Rizokarpason
Diplo Pak. 89 H5
Dipperu National Park Australia 110 E4

Dipu China see Anji
Dir reg. Pak. 89 I3
Dirang India 83 H4
Diré Mali 96 C3
Direction, Cape Australia 110 C2
Dirè Dawa Eth. 98 E3
Dirico Angola 99 C5
Dirk Hartog Island Australia 109 A6
Dirranbandi Australia 112 D2
Ḍirs Saudi Arabia 98 E2
Dirschau Poland see Tczew
Dirty Devil r. U.S.A. 129 H3
Disa India 82 C4
Disang r. India 83 H4
Disappointment, Cape S. Georgia 144 I8
Disappointment, Cape U.S.A. 126 B3
Disappointment, Lake salt flat
 Australia 109 C6
Disappointment Islands Fr. Polynesia see
 Désappointement, Îles du
Disappointment Lake Canada 123 J3
Disaster Bay Australia 112 D6
Discovery Bay Australia 111 C8
Disko i. Greenland see Qeqertarsuaq
Disko Bugt b. Greenland see
 Qeqertarsuup Tunua
Dismal Swamp U.S.A. 132 E4
Dispur India 83 G4
Disputanta U.S.A. 135 G5
Disraëli Canada 123 H5
Diss U.K. 49 I6
Distrito Federal admin. dist. Brazil 145 B1
Disûq Egypt 90 C1
Ditloung S. Africa 100 F5
Dittaino r. Sicily Italy 58 F6
Diu India 84 A1
Dīvān Darreh Iran 88 B3
Divehi country Indian Ocean see Maldives
Divi, Point India 84 D4
Divichi Azer. see Dâvâçi
Divide Mountain U.S.A. 120 A2
Divinópolis Brazil 145 B3
Divnoye Rus. Fed. 43 I7
Divo Côte d'Ivoire 96 C4
Divriği Turkey 90 E3
Diwana Pak. 89 G5
Diwaniyah Iraq see Ad Dīwānīyah
Dixfield U.S.A. 135 J1
Dixon CA U.S.A. 128 C2
Dixon IL U.S.A. 134 A3
Dixon KY U.S.A. 134 B5
Dixon MT U.S.A. 126 E3
Dixon Entrance sea chan. Canada/U.S.A.
 120 C4
Dixonville Canada 120 G3
Dixville Canada 135 J1
Diyadin Turkey 91 F3
Diyarbakır Turkey 91 F3
Diz Pak. 89 F5
Diz Chah Iran 88 D3
Dīze Turkey see Yüksekova
Dizney U.S.A. 134 D5
Djado Niger 96 E2
Djado, Plateau du Niger 96 E2
Djaja, Puntjak mt. Indon. see Jaya, Puncak
Djakarta Indon. see Jakarta
Djakovica Serb. and Mont. see Đakovica
Djakovo Croatia see Đakovo
Djambala Congo 98 B4
Djanet Alg. 96 D2
Djarrit-Uliga-Dalap Marshall Is see
 Delap-Uliga-Djarrit
Djelfa Alg. 57 H6
Djéma Cent. Afr. Rep. 98 C3
Djenné Mali 96 C3
Djerdap nat. park Serb. and Mont. 59 J2
Djibo Burkina 96 C3
► Djibouti country Africa 86 F7
 Africa 7, 94–95

► Djibouti Djibouti 86 F7
 Capital of Djibouti.

Djidjelli Alg. see Jijel
Djizak Jizzax Uzbek. see Jizzax
Djougou Benin 96 D4
Djoum Cameroon 96 E4
Djourab, Erg du des. Chad 97 E3
Djúpivogur Iceland 44 [inset]
Djurås Sweden 45 I6
Djurdjura, Parc National du Alg. 57 I5
Dmitriya Lapteva, Proliv sea chan.
 Rus. Fed. 65 P2
Dmitriyev-L'govskiy Rus. Fed. 43 G5
Dmitriyevsk Ukr. see Makiyivka
Dmitrov Rus. Fed. 42 H4
Dmytriyevs'k Ukr. see Makiyivka
Dnepr r. Rus. Fed. 43 F5 see Dnieper
Dneprodzerzhinsk Ukr. see
 Dniprodzerzhyns'k
Dnepropetrovsk Ukr. see
 Dnipropetrovs'k

► Dnieper r. Europe 43 G7
 3rd longest river in Europe.
 Also called Dnepr (Rus. Fed.) or
 Dnipro (Ukraine) or Dnyapro (Belarus).

Dniester r. Ukr. 43 F6
 also spelt Dnister (Ukraine) or
 Nistru (Moldova)
Dnipro r. Ukr. 43 G7 see Dnieper
Dniprodzerzhyns'k Ukr. 43 G6
Dnipropetrovs'k Ukr. 43 G6
Dnister r. Ukr. 43 F6 see Dniester
Dno Rus. Fed. 42 F4
Dnyapro r. Belarus 43 F6 see Dnieper
Doâb Afgh. 89 G3
Doaba Pak. 89 H3
Doan Hung Vietnam 70 D2
Doba Chad 97 E4
Doba China see Toiba
Dobele Latvia 45 M8
Döbeln Germany 53 N3
Doberai, Jazirah pen. Indon. 69 I7
Doberai Peninsula Indon. see
 Doberai, Jazirah
Dobo Indon. 69 I8
Doboj Bos.-Herz. 58 H2
Do Borjī Iran 88 D4
Döbraberg hill Germany 53 L4

Dobrinka Rus. Fed. 43 I5
Dobroye Rus. Fed. 43 H5
Dobrudja reg. Romania see Dobruja
Dobrudja reg. Romania 59 L3
Dobrush Belarus 43 F5
Dobryanka Rus. Fed. 41 R4
Dobzha China 83 G3
Doce r. Brazil 145 D2
Dochart r. U.K. 50 E4
Do China Qala Afgh. 89 H4
Docking U.K. 49 H6
Doctor Hicks Range hills Australia 109 D7
Doctor Pedro P. Peña Para. 144 D2
Doda India 82 C2
Doda Betta mt. India 84 C4
Dod Ballapur India 84 C3
Dodecanese is Greece 59 L7
Dodekanisa is Greece see Dodecanese
Dodekanisos is Greece see Dodecanese
Dodge City U.S.A. 130 C4
Dodgeville U.S.A. 130 F3
Dodman Point U.K. 49 C8

► Dodoma Tanz. 99 D4
 Capital of Tanzania.

Dodsonville U.S.A. 134 D4
Doetinchem Neth. 52 G3
Dog r. Canada 122 C4
Dogai Coring salt l. China 83 G2
Dogaicoring Qangco salt l. China 83 G2
Doğanşehir Turkey 90 E3
Dogên Co l. Xizang China 83 G3
Dogên Co l. Xizang China see Bam Tso
Doghārūn Iran 89 F3
Dog Island Canada 123 J2
Dog Lake Man. Canada 121 L5
Dog Lake Ont. Canada 121 L5
Dog Lake Ont. Canada 122 C4
Dōgo i. Japan 75 D5
Dogondoutchi Niger 96 D3
Dog Rocks is Bahamas 133 E7
Doğubeyazıt Turkey 91 G3
Doğu Menteşe Dağları mts Turkey 59 M6
Dogxung Zangbo r. China 83 F3
Do'gyaling China 83 G3

► Doha Qatar 88 C5
 Capital of Qatar.

Dohad India see Dahod
Dohazari Bangl. 83 H5
Dohrighat India 83 E4
Doi i. Fiji 107 I4
Doi Inthanon National Park Thai. 70 B3
Doi Luang National Park Thai. 70 B3
Doire U.K. see Londonderry
Doi Saket Thai. 70 B3
Dois Irmãos, Serra dos hills Brazil 143 J5
Dokan, Sadd Iraq 91 G4
Dok-do i. N. Pacific Ocean see
 Liancourt Rocks
Dokhara, Dunes de des. Alg. 54 F5
Dokka Norway 45 F6
Dokog He r. China 76 D2
Dokri Pak. 89 H5
Dokshukino Rus. Fed. see Nartkala
Dokshytsy Belarus 45 O9
Dokuchayeva, Mys c. Rus. Fed. 74 G3
Dokuchayevka Kazakh. see Karamendy
Dokuchayevs'k Ukr. 43 H7
Dolbenmaen U.K. 49 C6
Dol-de-Bretagne France 56 D2
Dole France 56 G3
Dolgellau U.K. 49 D6
Dolgen Germany 53 N1
Dolgiy, Ostrov i. Rus. Fed. 42 L1
Dolgorukovo Rus. Fed. 43 H5
Dolina Ukr. see Dolyna
Dolinsk Rus. Fed. 74 F3
Dolisie Congo see Loubomo
Dolleman Island Antarctica 152 L2
Dollnstein Germany 53 L6
Dolok, Pulau i. Indon. 69 J8
Dolomites mts Italy 58 D2
Dolomiti mts Italy see Dolomites
Dolomiti Bellunesi, Parco Nazionale delle
 nat. park Italy 58 D2
Dolomitiche, Alpi mts Italy see Dolomites
Dolonnur China 73 L4
Dolo Odo Eth. 98 E3
Dolores Arg. 144 E5
Dolores Uruguay 144 E4
Dolores U.S.A. 129 I3
Dolores r. U.S.A. 129 I2
Dolphin and Union Strait Canada 118 G3
Dolphin Head hd Namibia 100 B3
Đô Lương Vietnam 70 D3
Dolyna Ukr. 43 D6
Domaila India 82 D3
Domaniç Turkey 59 M5
Domar China 80 F5
Domartang China 76 B2
Domažlice Czech Rep. 53 M5
Domba China 76 B1
Dom Bākh Iran 88 B3
Dombás Norway 44 F5
Dombóvár Hungary 58 H1
Dombrau Poland see Dąbrowa Górnicza
Dombrovitsa Ukr. see Dubrovytsya
Dombrowa Poland see
 Dąbrowa Górnicza
Domda China see Qingshuihe
Dome Argus ice feature Antarctica 152 E1
Dome Charlie ice feature
 Antarctica 152 F2
Dome Creek Canada 120 F4
Dome Rock Mountains U.S.A. 129 F5
Domeyko Chile 144 B3
Domfront France 56 D2
► Dominica country West Indies 137 L5
 North America 9, 116–117
Dominica, República country West Indies
 see Dominican Republic
► Dominican Republic country
 West Indies 137 J5
 North America 9, 116–117
Dominion, Cape Canada 119 K3
Dominique i. Fr. Polynesia see Hiva Oa
Dömitz Germany 53 L1
Dom Joaquim Brazil 145 C2
Dommel r. Neth. 52 F3

Domo Eth. 98 E3
Domokos Greece 59 J5
Dompu Indon. 108 B2
Domula China see Duomula
Domuyo, Volcán vol. Arg. 144 B5
Domville, Mount hill Australia 112 E2
Don Mex. 127 F8

► Don r. Rus. Fed. 43 H7
 5th longest river in Europe.

Don r. U.K. 50 G3
Don, Xé r. Laos 70 D4
Donaghadee U.K. 51 G3
Donaghmore U.K. 51 F3
Donald Australia 112 A6
Donaldsonville U.S.A. 131 F6
Donalsonville U.S.A. 133 C6
Doñana, Parque Nacional de nat. park
 Spain 57 C5
Donau r. Austria/Germany 47 P6 see
 Danube
Donauwörth Germany 53 K6
Don Benito Spain 57 D4
Doncaster U.K. 48 F5
Dondo Angola 99 B4
Dondo Moz. 99 D5
Dondo Moz. 99 D5
Dondra Head hd Sri Lanka 84 D5
Donegal Ireland 51 D3
Donegal Bay Ireland 51 D3
Donets' Ukr. 43 H6
Donetsk Rus. Fed. 43 H6
Donetsko-Amrovsiyevka Ukr. see
 Amvrosiyivka
Donets'kyy Kryazh hills Rus. Fed./Ukr.
 43 H6
Donga r. Cameroon/Nigeria 96 D4
Dong'an China 77 F3
Dongara Australia 109 A7
Dongbo China see Mêdog
Dongchuan Yunnan China 76 D3
Dongchuan Yunnan China see Yao'an
Dongco China 83 F2
Dong Co l. China 83 F2
Dongfang China 77 F5
Dongfanghong China 74 D3
Donggang China 75 B5
Donggang China Shandong China 77 H1
Donggou China see Donggang
Donggou China 77 G3
Dongguan China 77 G4
Dongguan China 77 G3
Dong Hai sea N. Pacific Ocean see
 East China Sea
Đông Hơi Vietnam 70 D3
Donghuang China see Xishui
Dongjiang Shuiku resr China 77 G3
Dongjug China 76 B2
Dongkou China 77 F3
Donglan China 76 E3
Dongliao He r. China 74 A4
Dongmen China see Luocheng
Dongminzhutun China 74 A3
Dongning China 74 C4
Dongo Angola 99 B5
Dongo Dem. Rep. Congo 98 B3
Dongola Sudan 86 D6
Dongou Congo 98 B3
Dong Phaya Yen esc. Thai. 70 C4
Dongping Guangdong China 77 G4
Dongping Hunan China see Anhua
Dongpo China see Meishan
Dongqiao China 83 G3
Dongshan Fujian China 77 H4
Dongshan Jiangsu China 77 I2
Dongshan Jiangxi China see Shangyou
Dongshao China 77 G3
Dongsha Qundao is China 68 F2
Dongsheng Nei Mongol China see Ordos
Dongsheng Sichuan China see Shuangliu
Dongshuan China see Tangdan
Dongtai China 77 I1
Dongting Hu l. China 77 G2
Dongtou China 77 I3
Đông Triều Vietnam 70 D2
Dong Ujimqin Qi China see Uliastai
Đông Văn Vietnam 70 D2
Dongxiang China 77 H2
Dongxi Liandao i. China 77 H1
Dongxing Guangxi China 76 E4
Dongxing Heilong. China 74 B3
Dongyang China 77 I2
Dongying China 73 L5
Dongzhi China 77 H2
Donkerbroek Neth. 52 G1
Donnacona Canada 123 H5
Donnellys Crossing N.Z. 113 D2
Donner Pass U.S.A. 128 C2
Donnersberg hill Germany 53 H5
Donostia-San Sebastián Spain 57 F2
Donousa i. Greece 59 K6
Donoussa i. Greece see Donousa
Donskoye Rus. Fed. 43 I7
Donyztau, Sor dry salt l. Kazakh. 80 A2
Dooagh Ireland 51 B4
Doomadgee Australia 110 B3
Doon r. U.K. 50 E5
Doon, Loch l. U.K. 50 E5
Doonbeg r. Ireland 51 C5
Doorn Neth. 52 F2
Door Peninsula U.S.A. 134 B1
Doornik Belgium see Tournai
Dooxo Nugaaleed valley Somalia 98 E3
Doqêmo China 76 B2
Dor watercourse Afgh. 89 F4
Dor Israel 85 B3
Dora U.S.A. 131 C5
Dora, Lake salt flat Australia 108 C5
Dorado Mex. 131 B7
Dorah Pass Pak. 89 H2
Doran Lake Canada 121 I2
Dorbiljin China see Emin
Dorbod Qi China see Ulan Hua
Dorchester U.K. 49 E8
Dordabis Namibia 100 C2
Dordogne r. France 56 D4
Dordrecht Neth. 52 E3
Dordrecht S. Africa 101 H6
Doreenville Namibia 100 D2
Doré Lake Canada 121 J4
Doré Lake l. Canada 121 J4

Dores do Indaiá Brazil 145 B2
Dorgê Co l. China 83 H2
Dori r. Afgh. 89 G4
Dori Burkina 96 C3
Doring r. S. Africa 100 D6
Doirsvale Australia 108 E3
Dorking U.K. 49 G7
Dormagen Germany 52 G3
Dormans France 52 D5
Dormidontovka Rus. Fed. 74 D3
Dornbirn Austria 47 L7
Dornoch U.K. 50 E3
Dornoch Firth est. U.K. 50 E3
Dornum Germany 53 H1
Doro Mali 96 C3
Dorogobuzh Rus. Fed. 43 G5
Dorogorskoye Rus. Fed. 42 J2
Dorohoi Romania 59 L1
Dörööö Nuur salt l. Mongolia 80 H2
Dorostol Bulg. see Silistra
Dorre Island Australia 109 A6
Dorrigo Australia 112 F3
Dorris U.S.A. 126 C4
Dorset Canada 135 F1
Dorsoidong Co l. China 83 G2
Dortmund Germany 53 H3
Dörtyol Turkey 85 C1
Dorum Germany 53 I1
Doruma Dem. Rep. Congo 98 C3
Dorylaeum Turkey see Eskişehir
Dos Bahías, Cabo c. Arg. 144 C6
Dos de Mayo Peru 142 C5
Doshakh, Koh-i- mt. Afgh. see
 Do Shākh, Kūh-e
Do Shākh, Kūh-e mt. Afgh. 89 F3
Đo Son Vietnam 70 D2
Dos Palos U.S.A. 128 C3
Dosse r. Germany 53 M2
Dosso Niger 96 D3
Dothan U.S.A. 133 C6
Dotnuva Lith. 45 M9
Dotsero U.S.A. 129 J2
Douai France 52 D4
Douala Cameroon 96 D4
Douarnenez France 56 B2
Double Headed Shot Cays is
 Bahamas 133 D8
Double Island H.K. China 77 [inset]
Double Island Point Australia 111 F5
Double Mountain Fork r. U.S.A. 131 C5
Double Peak U.S.A. 128 C4
Double Point Australia 110 D3
Double Springs U.S.A. 133 C5
Doubs r. France/Switz. 56 G3
Doubtful Sound inlet N.Z. 113 A7
Doubtless Bay N.Z. 113 D2
Douentza Mali 96 C3
Dougga tourist site Tunisia 58 C6

► Douglas Isle of Man 48 C4
 Capital of the Isle of Man.

Douglas S. Africa 100 F5
Douglas U.K. 50 F5
Douglas AZ U.S.A. 127 F7
Douglas GA U.S.A. 133 D6
Douglas WY U.S.A. 126 G4
Douglas Reef i. Japan see
 Okino-Tori-shima
Douglasville U.S.A. 133 C5
Douhudi China see Gong'an
Doulatpur Bangl. see Daulatpur
Douliu Taiwan see Touliu
Doullens France 52 C4
Douna Mali 96 C3
Doune U.K. 50 E4
Doupovské hory mts Czech Rep. 53 N4
Dourada, Serra hills Brazil 145 A2
Dourada, Serra mts Brazil 145 A1
Dourados Brazil 144 F2
Douro r. Port. 57 B3
 also known as Duero (Spain)
Doushi China see Gong'an
Doushui Shuiku resr China 77 G3
Douve r. France 49 F9
Douzy France 52 E5
Dove r. U.K. 49 F6
Dove Brook Canada 123 K3
Dove Creek U.S.A. 129 I3
Dover U.K. 49 I7

► Dover DE U.S.A. 135 H4
 State capital of Delaware.

Dover NH U.S.A. 135 J2
Dover NJ U.S.A. 135 H3
Dover OH U.S.A. 134 E3
Dover TN U.S.A. 132 C4
Dover, Strait of France/U.K. 56 E1
Dover-Foxcroft U.S.A. 135 K1
Dovey r. U.K. 49 D6
Dovrefjell Nasjonalpark nat. park
 Norway 44 F5
Dowagiac U.S.A. 134 B3
Dowi, Tanjung pt Indon. 71 B7
Dowlaiswaram India 84 D2
Dowlatābād Afgh. 89 F3
Dowlatābād Fārs Iran 88 D4
Dowlatābād Fārs Iran 88 D4
Dowlatābād Khorāsān Iran 88 E2
Dowlatābād Khorāsān Iran 89 F2
Dowl at Yār Afgh. 89 F3
Downieville U.S.A. 128 C2
Downpatrick U.K. 51 G3
Downsville U.S.A. 135 H2
Dow Rūd Iran 88 C3
Doyle U.S.A. 128 C1
Doylestown U.S.A. 135 H3
Dozdāb r. Iran 88 E5
Dōzen is Japan 75 D5
Dozois, Réservoir resr Canada 122 F5
Dozulé France 49 G9
Dracena Brazil 145 A3
Drachten Neth. 52 G1
Drăgăneşti-Olt Romania 59 K2
Drăgăşani Romania 59 K2
Dragonera, Isla i. Spain see Sa Dragonera
Dragoon U.S.A. 129 H5
Dragsfjärd Fin. 45 M6
Draguignan France 56 H5

Drahichyn Belarus 45 N10
Drake Australia 112 F2
Drake U.S.A. 130 C2
Drakensberg mts S. Africa 101 I3
Drake Passage S. Atlantic Ocean 148 D9
Drakes Bay U.S.A. 128 B3
Drama Greece 59 K4
Drammen Norway 45 G7
Drang, Prêk r. Cambodia 71 D4
Drangajökull Norway 45 F7
Dransfeld Germany 53 J3
Draper, Mount U.S.A. 120 B3
Draperstown U.K. 51 F3
Drapsaca Afgh. see Kunduz
Dras Jammu and Kashmir 82 C2
Drasan Pak. 89 I2
Drau r. Austria 47 O7 see Drava
Drava r. Europe 58 H2
 also known as Drau (Austria),
 Drave or Drava (Slovenia and Croatia),
 Dráva (Hungary)
Dráva r. Hungary see Drava
Drave r. Slovenia/Croatia see Drava
Dráva r. Slovenia/Croatia see Drava
Drayton Valley Canada 120 H4
Drazinda Pak. 89 H4
Dréan Alg. 58 B6
Dreistelzberge hill Germany 53 J4
Drentse Hoofdvaart canal Neth. 52 G2
Drepano, Akra pt Greece see
 Laimos, Akrotirio
Drepano, Akra pt Greece see
 Laimos, Akrotirio
Dresden Canada 134 D2
Dresden Germany 47 N5
Dreux France 52 B6
Drevsjø Norway 45 H6
Drewryville U.S.A. 135 G5
Dri China 76 D2
Driffield U.K. 48 G4
Driftwood U.S.A. 135 F3
Driggs U.S.A. 126 F4
Drillham Australia 112 E1
Drimoleague Ireland 51 C6
Drina r. Bos.-Herz./Serb. and Mont. 59 H2
Driniš Croatia 58 G3
Driscoll Island Antarctica 152 J1
Drissa Belarus see Vyerkhnyadzvinsk
Drniš Croatia 58 G3
Drobeta-Turnu Severin Romania 59 J2
Drochtersen Germany 53 J1
Drogheda Ireland 51 F4
Drogichin Belarus see Drahichyn
Drogobych Ukr. see Drohobych
Drohobych Ukr. 43 D6
Droichead Átha Ireland see Drogheda
Droichead Nua Ireland see Newbridge
Droitwich U.K. see Droitwich Spa
Droitwich Spa U.K. 49 E6
Dromedary, Cape Australia 112 E6
Dromod Ireland 51 E4
Dromore Northern Ireland U.K. 51 E3
Dromore Northern Ireland U.K. 51 F3
Dronfield U.K. 48 F5
Dronning Louise Land reg.
 Greenland 153 I1
Dronning Maud Land reg. Antarctica see
 Queen Maud Land
Dronten Neth. 52 F2
Druk-Yul country Asia see Bhutan
Drumheller Canada 121 H5
Drummond atoll Kiribati see Tabiteuea
Drummond U.S.A. 126 E3
Drummond, Lake U.S.A. 135 G5
Drummond Island U.S.A. see McKean
Drummondville Canada 123 G5
Drummore U.K. 50 E6
Drury Lake Canada 120 C2
Druskieniki Lith. see Druskininkai
Druskininkai Lith. 45 N10
Druzhina Rus. Fed. 65 P3
Druzhnaya Gorka Rus. Fed. 45 Q7
Dry r. Australia 108 E3
Dryanovo Bulg. 59 K3
Dryberry Lake Canada 121 M5
Dryden Canada 121 M5
Dryden U.S.A. 135 G2
Dry Fork r. U.S.A. 126 G4
Drygalski Ice Tongue Antarctica 152 H1
Drygalski Island Antarctica 152 F2
Dry Lake U.S.A. 129 F3
Dry Lake l. U.S.A. 130 D1
Drymen U.K. 50 E4
Dry Ridge U.S.A. 134 C4
Drysdale r. Australia 108 D3
Drysdale River National Park Australia
 108 D3
Dry Tortugas is U.S.A. 133 D7
Du'an China 77 F4
Duaringa Australia 110 E4
Duarte, Pico mt. Dom. Rep. 137 J5
Duartina Brazil 145 A3
Ḍubā Saudi Arabia 86 E4
Dubai U.A.E. 88 D5
Dubakella Mountain U.S.A. 128 B1
Dubawnt r. Canada 121 L2
Dubawnt Lake Canada 121 K2
Dubayy U.A.E. see Dubai
Dubbo Australia 112 D4

► Dublin Ireland 51 F4
 Capital of Ireland.

Dublin U.S.A. 133 D5
Dubna Rus. Fed. 42 H4
Dubno Ukr. 43 E6
Dubois ID U.S.A. 126 E3
Dubois IN U.S.A. 134 B4
Du Bois U.S.A. 135 F3
Dubovka Rus. Fed. 43 J6
Dubovskoye Rus. Fed. 43 I7
Dubréka Guinea 96 B4
Dubris U.K. see Dover
Dubrovnik Croatia 58 H3
Dubrovytsya Ukr. 43 E6
Dubuque U.S.A. 130 F3
Dubysa r. Lith. 45 M9
Đức Bôn Vietnam 71 E5
Duc de Gloucester, Îles du is
 Fr. Polynesia 151 K7
Duchang China 77 H2
Ducheng China see Yunan
Duchesne U.S.A. 129 H1

Duchesne r. U.S.A. 129 I1
Duchess Australia 110 B4
Duchess Canada 121 I5
Ducie Island atoll Pitcairn Is 151 L7
Duck Bay Canada 121 K4
Duck Creek r. Australia 108 B5
Duck Lake Canada 121 J4
Duckwater Peak U.S.A. 129 F2
Duc Tho Vietnam 70 D3
Dudelange Lux. 52 G5
Duderstadt Germany 53 K3
Dudhi India 83 E4
Dudhwa India 82 E3
Dudinka Rus. Fed. 64 J3
Dudley U.K. 49 E6
Dudleyville U.S.A. 129 H5
Dudna r. India 84 C2
Dudu India 82 C4
Duékoué Côte d'Ivoire 96 C4
Duen, Bukit vol. Indon. 68 C7
Duero r. Spain 57 C3
 also known as Douro (Portugal)
Duffel Belgium 52 E3
Dufferin, Cape Canada 122 F2
Duffer Peak U.S.A. 126 D4
Duff Islands Solomon Is 107 G2
Duffreboy, Lac l. Canada 123 H2
Dufftown U.K. 50 F3
Dufourspitze mt. Italy/Switz. 56 H4
Dugi Otok i. Croatia 58 F2
Dugi Rat Croatia 58 G3
Du He r. China 77 F1
Duida-Marahuaca, Parque Nacional
 nat. park Venez. 142 E3
Duisburg Germany 52 G3
Duiwelskloof S. Africa 101 J2
Dujiangyan China 76 D2
Dukathole S. Africa 101 H6
Duke Island U.S.A. 120 D4
Duke of Clarence atoll Tokelau see
 Nukunonu
Duke of Gloucester Islands Fr. Polynesia
 see Duc de Gloucester, Îles du
Duke of York atoll Tokelau see Atafu
Duk Fadiat Sudan 97 G4
Dukhovnitskoye Rus. Fed. 43 K5
Duki Pak. 89 H4
Duki r. Rus. Fed. 74 D2
Dukou China see Panzhihua
Dūkštas Lith. 45 O9
Dulac U.S.A. 131 F6
Dulan China 80 I4
Dulce r. Arg. 144 D4
Dulce U.S.A. 127 G5
Dul'durga Rus. Fed. 73 K2
Dulhunty r. Australia 110 C1
Dulishi Hu salt l. China 83 E2
Duliu Jiang r. China 77 F3
Dullewala Pak. 89 H4
Dullstroom S. Africa 101 J3
Dülmen Germany 53 H3
Dulmera India 82 C3
Dulovo Bulg. 59 L3
Duluth U.S.A. 130 E2
Dulverton U.K. 49 D7
Dūmā Syria 85 C3
Dumaguete Phil. 69 G5
Dumai Indon. 71 C7
Dumaran i. Phil. 68 G4
Dumaresq r. Australia 112 E2
Dumas AR U.S.A. 131 C5
Dumas TX U.S.A. 131 C5
Dumat al Jandal Saudi Arabia 91 F5
Ḍumayr Syria 85 C3
Ḍumayr, Jabal mts Syria 85 C3
Dumbarton U.K. 50 E5
Dumbe S. Africa 101 J4
Ḍûmbier mt. Slovakia 47 Q6
Dumchele Jammu and Kashmir 82 D2
Dumdum i. Indon. 71 D7
Dumfries U.K. 50 F5
Dumka India 83 F4
Dumont d'Urville research station
 Antarctica 152 G2
Dumont d'Urville Sea Antarctica 152 G2
Dümpelfeld Germany 52 G4
Dumyāt Egypt 90 C5
Dumyâţ Egypt see Dumyāt
Duna r. Hungary 58 H2 see Danube
Dünaburg Latvia see Daugavpils
Dunaj r. Slovakia see Danube
Dunajská Streda Slovakia 47 P7
Dunakeszi Hungary 59 H1
Dunării r. Romania see Danube
Dunării, Delta Romania/Ukr. see
 Danube Delta
Dunaújváros Hungary 58 H1
Dunav r. Bulg./Croatia/Serb./Mont.
 58 L2 see Danube
Dunay r. Ukr. see Danube
Dunayivtsi Ukr. 43 E6
Dunbar Australia 110 C3
Dunbar U.K. 50 G4
Dunblane U.K. 50 F4
Dunboyne Ireland 51 F4
Duncan Canada 120 F5
Duncan AZ U.S.A. 129 I5
Duncan OK U.S.A. 131 D5
Duncan, Cape Canada 122 E3
Duncan, Lac l. Canada 122 F4
Duncan Lake Canada 120 H2
Duncan Passage India 71 A5
Duncansby Head hd U.K. 50 F2
Duncan Town Bahamas 133 F8
Duncormick Ireland 51 F5
Dundaga Latvia 45 M8
Dundalk Ireland 51 F3
Dundalk U.S.A. 135 G4
Dundalk Bay Ireland 51 F4
Dundas Canada 134 F2
Dundas Greenland 119 L2
Dundas, Lake salt flat Australia 109 C8
Dundas Island Canada 120 D4
Dundas Strait Australia 108 E2
Dún Dealgan Ireland see Dundalk
Dundee S. Africa 101 J5
Dundee U.K. 50 G4
Dundee MI U.S.A. 134 D3

Florence WI U.S.A. 130 F2
Florence Junction U.S.A. 129 H5
Florencia Col. 142 C3
Florennes Belgium 52 E4
Florentia Italy see Florence
Florentino Ameghino, Embalse resr Arg. 144 C6
Flores r. Arg. 144 E5
Flores Guat. 136 G5
Flores i. Indon. 108 C2
Flores, Laut sea Indon. 108 B1
Flores Island Canada 123 K5
Flores Sea Indon. see Flores, Laut
Floresta Brazil 143 K5
Floresville U.S.A. 131 D6
Florianópolis Brazil 145 A4
Florida Uruguay 144 E4
Florida state U.S.A. 133 D6
Florida, Straits of Bahamas/U.S.A. 133 D8
Florida Bay U.S.A. 133 D7
Florida City U.S.A. 133 D7
Florida Islands Solomon Is 107 G2
Florida Keys is U.S.A. 133 D7
Florin U.S.A. 128 C2
Florina Greece 59 I4
Florissant U.S.A. 130 F4
Florø Norway 45 D6
Flour Lake Canada 123 I3
Floyd U.S.A. 134 E5
Floyd, Mount U.S.A. 129 G4
Floydada U.S.A. 131 C5
Fluessen l. Neth. 52 F2
Flushing Neth. see Vlissingen
Fly r. P.N.G. 69 K8
Flying Fish, Cape Antarctica 152 K2
Flying Mountain U.S.A. 129 I6
Flylân i. Neth. see Vlieland
Foam Lake Canada 121 K5
Foča Bos.-Herz. 58 H3
Foça Turkey 59 L5
Fochabers U.K. 50 F3
Focşani Romania 59 L2
Fogang China 77 G4
Foggia Italy 58 F4
Fogi Indon. 69 H7
Fogo i. Cape Verde 96 [inset]
Fogo Island Canada 123 L4
Foinaven hill U.K. 50 E2
Foix France 56 E5
Folda sea chan. Norway 44 I3
Foldereid Norway 44 H4
Foldfjorden sea chan. Norway 44 G4
Folegandros i. Greece 59 K6
Foleyet Canada 122 E4
Foley Island Canada 119 K3
Foligno Italy 58 E3
Folkestone U.K. 49 I7
Folkingham U.K. 49 G6
Folkston U.S.A. 133 D6
Folldal Norway 44 F5
Follonica Italy 58 D3
Folsom U.S.A. 128 C2
Folsom Lake U.S.A. 128 C2
Fomboni Comoros 99 E5
Fomento Cuba 133 E8
Fomin Rus. Fed. 43 I7
Fominskaya Rus. Fed. 42 K2
Fominskoye Rus. Fed. 42 I4
Fonda U.S.A. 135 H2
Fond-du-Lac Canada 121 J3
Fond du Lac r. Canada 121 J3
Fond du Lac U.S.A. 134 A2
Fondevila Spain 57 B3
Fondi Italy 58 E4
Fonni Sardinia Italy 58 C4
Fonsagrada Spain see A Fonsagrada
Fonseca, Golfo do b. Central America 136 G6
Fontaine Lake Canada 121 J3
Fontanges Canada 123 H3
Fontas Canada 120 F3
Fontas r. Canada 120 F3
Fonte Boa Brazil 142 E4
Fonteneau, Lac l. Canada 123 J4
Fontur pt Iceland 44 [inset]
Foochow China see Fuzhou
Foot's Bay Canada 134 F1
Foping China 77 F1
Foraker, Mount U.S.A. 118 C3
Foraulep atoll Micronesia see Faraulep
Forbes Australia 112 D4
Forbes, Mount Canada 120 G4
Forchheim Germany 53 L5
Ford r. U.S.A. 132 C2
Ford City U.S.A. 128 D4
Førde Norway 45 D6
Forde Lake Canada 121 L2
Fordham U.K. 49 H6
Fordingbridge U.K. 49 F8
Ford Range mts Antarctica 152 J1
Fords Bridge Australia 112 B2
Fordsville U.S.A. 134 B5
Fordyce U.S.A. 131 E5
Forécariah Guinea 96 B4
Forel, Mont mt. Greenland 119 O3
Foreland hd U.K. 49 F8
Foreland Point U.K. 49 D7
Foremost Canada 126 F2
Foresight Mountain Canada 120 E4
Forest Canada 134 E2
Forest MS U.S.A. 131 F5
Forest OH U.S.A. 134 D3
Forestburg Canada 121 H4
Forest Creek r. Australia 110 C3
Forest Ranch U.S.A. 128 C2
Forestville Canada 123 H4
Forestville CA U.S.A. 128 B2
Forestville MI U.S.A. 134 D2
Forfar U.K. 50 G4
Forgan U.S.A. 131 C4
Forges-les-Eaux France 52 B5
Forillon, Parc National de nat. park Canada 123 I4
Forked River U.S.A. 135 H4
Forks U.S.A. 126 B3
Fork Union U.S.A. 135 F5
Forlì Italy 58 E2
Forman U.S.A. 130 D2
Formby U.K. 48 D5
Formentera i. Spain 57 G4

Formentor, Cap de c. Spain 57 H4
Formerie France 52 B5
Former Yugoslav Republic of Macedonia country Europe see Macedonia
Formiga Brazil 145 B3
Formosa Brazil 145 B1
Formosa country Asia see Taiwan
Formosa Arg. 144 E3
Formosa, Serra hills Brazil 143 G6
Formosa Strait China/Taiwan see Taiwan Strait
Formoso r. Bahia Brazil 145 B1
Formoso r. Tocantins Brazil 145 A1
Fornos Moz. 101 L2
Forres U.K. 50 F3
Forrest Vic. Australia 112 A7
Forrest W.A. Australia 109 E7
Forrestal Range mts Antarctica 152 A1
Forrest City U.S.A. 131 F5
Forrest Lake Canada 121 I3
Forrest Lakes salt flat Australia 109 E7
Fors Sweden 45 J6
Forsayth Australia 110 C3
Forsnäs Sweden 44 M3
Forssa Fin. 45 M6
Forster Australia 112 F4
Forsyth GA U.S.A. 133 D5
Forsyth MT U.S.A. 126 G3
Forsyth Range hills Australia 110 C4
Fort Abbas Pak. 89 I4
Fort Albany Canada 122 E3
Fortaleza Brazil 143 K4
Fort Amsterdam S.A. see New York
Fort Archambault Chad see Sarh
Fort Ashby U.S.A. 135 F4
Fort Assiniboine Canada 120 H4
Fort Augustus U.K. 50 E3
Fort Beaufort S. Africa 101 H7
Fort Benton U.S.A. 126 F3
Fort Brabant Canada see Tuktoyaktuk
Fort Bragg U.S.A. 128 B2
Fort Branch U.S.A. 134 B4
Fort Carillon U.S.A. see Ticonderoga
Fort Charlet Alg. see Djanet
Fort Chimo Canada see Kuujjuaq
Fort Chipewyan Canada 121 I3
Fort Collins U.S.A. 126 G4
Fort-Coulonge Canada 122 F5
Fort Crampel Cent. Afr. Rep. see Kaga Bandoro
Fort Davis U.S.A. 131 C6

Fort de Kock Indon. see Bukittinggi
Fort de Polignac Alg. see Illizi
Fort Dodge U.S.A. 130 E3
Fort Duchesne U.S.A. 129 I1
Fort Edward U.S.A. 135 I2
Fortescue r. Australia 108 B5
Forte Veneza Brazil 143 H5
Fort Flatters Alg. see Bordj Omer Driss
Fort Foureau Cameroon see Kousséri
Fort Franklin Canada see Déline
Fort Garbel Alg. see Zaouatallaz
Fort Gay U.S.A. 134 D4
Fort George Canada see Chisasibi
Fort Good Hope Canada 118 F3
Fort Gouraud Mauritania see Fdérik
Forth r. U.K. 50 F4
Forth, Firth of est. U.K. 50 F4
Fort Hertz Myanmar see Putao
Fortification Range mts U.S.A. 129 F2
Fortín General Mendoza Para. 144 D2
Fortín Leonida Escobar Para. 144 D2
Fortín Madrejón Para. 144 E2
Fortín Pilcomayo Arg. 144 D2
Fortín Ravelo Bol. 142 F7
Fortín Sargento Primero Leyes Arg. 144 E2
Fortín Suárez Arana Bol. 142 F7
Fortín Teniente Juan Echauri López Para. 144 D2
Fort Jameson Zambia see Chipata
Fort Johnston Malawi see Mangochi
Fort Kent U.S.A. 132 G2
Fort Lamy Chad see Ndjamena
Fort Laperrine Alg. see Tamanrasset
Fort Laramie U.S.A. 126 G4
Fort Lauderdale U.S.A. 133 D7
Fort Liard Canada 120 F2
Fort Mackay Canada 121 I3
Fort Macleod Canada 120 H5
Fort Madison U.S.A. 130 F3
Fort Manning Malawi see Mchinji
Fort McMurray Canada 121 I3
Fort McPherson Canada 118 E3
Fort Meyers Beach U.S.A. 133 D7
Fort Morgan U.S.A. 130 C3
Fort Munro Pak. 89 H4
Fort Myers U.S.A. 133 D7
Fort Nelson Canada 120 F3
Fort Nelson r. Canada 120 F3
Fort Norman Canada see Tulita
Fort Orange U.S.A. see Albany
Fort Payne U.S.A. 133 C5
Fort Peck U.S.A. 126 G2
Fort Peck Reservoir U.S.A. 126 G3
Fort Pierce U.S.A. 133 D7
Fort Portal Uganda 98 D3
Fort Providence Canada 120 G2
Fort Randall U.S.A. see Cold Bay
Fort Resolution Canada 120 H2
Fortrose N.Z. 113 B8
Fortrose U.K. 50 E3
Fort Rosebery Zambia see Mansa
Fort Rousset Congo see Owando
Fort Rupert Canada see Waskaganish
Fort St James Canada 120 E4
Fort St John Canada 120 F3
Fort Sandeman Pak. see Zhob
Fort Saskatchewan Canada 120 H4
Fort Scott U.S.A. 130 E4
Fort Severn Canada 122 D2
Fort-Shevchenko Kazakh. 78 E2
Fort Simpson Canada 120 F2
Fort Smith Canada 121 H2
Fort Smith U.S.A. 131 E5
Fort Stockton U.S.A. 131 C6

Fort Sumner U.S.A. 127 G6
Fort Supply U.S.A. 131 D4
Fort Thomas U.S.A. 129 I5
Fort Trinquet Mauritania see Bîr Mogreïn
Fortuna U.S.A. 128 A1
Fortune Bay Canada 123 L5
Fort Valley U.S.A. 133 D5
Fort Vermilion Canada 120 G3
Fort Victoria Zimbabwe see Masvingo
Fort Ware Canada see Ware
Fort Wayne U.S.A. 134 C3
Fort William U.K. 50 D4
Fort Worth U.S.A. 131 D5
Fort Yates U.S.A. 130 C2
Fort Yukon U.S.A. 118 D3
Forum Iulii France see Fréjus
Forūr, Jazīreh-ye i. Iran 88 D5
Forvik Norway 44 H4
Foshan China 77 G4
Fo Shek Chau H.K. China see Basalt Island
Fossano Italy 58 B2
Fossil U.S.A. 126 C3
Fossil Downs Australia 108 D4
Foster Australia 112 C7
Foster U.S.A. 134 C4
Foster, Mount Canada/U.S.A. 120 C3
Foster Lakes Canada 121 J3
Fostoria U.S.A. 134 D3
Fotadrevo Madag. 99 E6
Fotherby U.K. 48 G5
Fotokol Cameroon 97 E3
Fotuna i. Vanuatu see Futuna
Fougères France 56 D2
Foula i. U.K. 50 [inset]
Foul Island Myanmar 70 A3
Foulness Point U.K. 49 H7
Foul Point Sri Lanka 84 D4
Foumban Cameroon 96 E4
Foundation Ice Stream glacier Antarctica 152 L1
Fount U.S.A. 134 D5
Fountains Abbey and Royal Water Garden (NT) tourist site U.K. 48 F4
Fourches, Mont des hill France 56 G2
Four Corners U.S.A. 129 I3
Fouriesburg S. Africa 101 I5
Fourmies France 52 E4
Fournier, Lac l. Canada 123 I4
Fournoi i. Greece 59 L6
Fourpeaked Mountain U.S.A. 118 C4
Fouta Djallon reg. Guinea 96 B3
Foveaux Strait N.Z. 113 A8
Fowey U.K. 49 C8
Fowler CO U.S.A. 127 G5
Fowler IN U.S.A. 134 B3
Fowler Ice Rise Antarctica 152 L1
Fowlers Bay Australia 106 D5
Fowlers Bay b. Australia 109 F8
Fowlerville U.S.A. 134 C2
Fox r. B.C. Canada 120 E3
Fox r. Man. Canada 121 M3
Fox r. U.S.A. 130 F3
Fox Creek Canada 120 G4
Fox Creek U.S.A. 134 C5
Foxdale Isle of Man 48 C4
Foxe Basin g. Canada 119 K3
Foxe Channel Canada 119 J3
Foxe Peninsula Canada 119 K3
Fox Glacier N.Z. 113 C6
Fox Islands U.S.A. 118 B4
Fox Lake Canada 120 H3
Fox Valley Canada 121 I5
Foyers U.K. 50 E3
Foyle r. Ireland/U.K. 51 E3
Foyle, Lough b. Ireland/U.K. 51 E2
Foynes Ireland 51 C5
Foz de Areia, Represa de resr Brazil 145 A4
Foz do Cunene Angola 99 B5
Foz do Iguaçu Brazil 144 F3
Fraga Spain 57 G3
Frakes, Mount Antarctica 152 K1
Framingham U.S.A. 135 J2
Framnes Mountains Antarctica 152 E2
Franca Brazil 145 B3
Français, Récif des reef New Caledonia 107 G3
Francavilla Fontana Italy 58 G4

Frances Australia 111 C8
Frances Lake Canada 120 D2
Frances Lake l. Canada 120 D2
Franceville Gabon 98 B4
Francis Canada 121 K5
Francis atoll Kiribati see Beru
Francis, Lake U.S.A. 135 J1
Francisco de Orellana Ecuador see Coca
Francisco de Orellana Orellana Ecuador see Coca
Francisco I. Madero Coahuila Mex. 131 C7
Francisco I. Madero Durango Mex. 131 B7
Francisco Zarco Mex. 128 E5
Francistown Botswana 99 C6
Francois Canada 123 K5
François Lake Canada 120 E4
Francois Peron National Park Australia 109 A6
Francs Peak U.S.A. 126 F4
Franeker Neth. 52 F1
Frankenberg Germany 53 N4
Frankenberg (Eder) Germany 53 I3
Frankenhöhe hills Germany 47 M6
Frankenmuth U.S.A. 134 D2
Frankenthal (Pfalz) Germany 53 I5
Frankenwald mts Germany 53 L4
Frankford U.S.A. 135 G1
Frankfort IN U.S.A. 134 B3

Frankfort MI U.S.A. 134 B1
Frankfort OH U.S.A. 134 D4
Frankfurt Germany see Frankfurt am Main

Frankfurt am Main Germany 53 I4
Frankfurt an der Oder Germany 47 O4
Frank Hann National Park Australia 109 C8
Frankin Lake U.S.A. 129 F1
Fränkische Alb hills Germany 53 K6
Fränkische Schweiz reg. Germany 53 L5
Frankland, Cape Australia 111 [inset]
Franklin AZ U.S.A. 129 I5
Franklin GA U.S.A. 133 C5
Franklin IN U.S.A. 134 B4
Franklin KY U.S.A. 134 B5
Franklin LA U.S.A. 131 F6
Franklin MA U.S.A. 135 J2
Franklin NC U.S.A. 133 D5
Franklin NH U.S.A. 135 J2
Franklin PA U.S.A. 134 F3
Franklin TN U.S.A. 132 C5
Franklin TX U.S.A. 131 D6
Franklin WV U.S.A. 134 F4
Franklin Bay Canada 153 A2
Franklin D. Roosevelt Lake resr U.S.A. 126 D2
Franklin Furnace U.S.A. 134 D4
Franklin-Gordon National Park Australia 111 [inset]
Franklin Island Antarctica 152 H1
Franklin Mountains Canada 120 F2
Franklin Strait Canada 119 I2
Franklinton U.S.A. 131 F6
Franklinville U.S.A. 135 F2
Frankston Australia 112 B7
Fränsta Sweden 44 J5
Frantsa-Iosifa, Zemlya is Rus. Fed. 64 G2
Franz Canada 122 D4
Franz Josef Glacier N.Z. 113 C6
Frasca, Capo della c. Sardinia Italy 58 C5
Frascati Italy 58 E4
Fraser r. Australia 108 C4
Fraser r. B.C. Canada 120 F5
Fraser r. Nfld. and Lab. Canada 123 J2
Fraser, Mount hill Australia 109 B6
Fraserburg S. Africa 100 E6
Fraserburgh U.K. 50 G3
Fraserdale Canada 122 E4
Fraser Island Australia 110 F5
Fraser Island National Park Australia 110 F5
Fraser Lake Canada 120 E4
Fraser National Park Australia 112 B6
Fraser Plateau Canada 120 E4
Fraser Range hills Australia 109 C8
Frauenfeld Switz. 56 I3
Fray Bentos Uruguay 144 E4
Frazeysburg U.S.A. 134 D3
Frechen Germany 52 G4
Freckleton U.K. 48 E5
Frederic U.S.A. 134 C1
Frederica U.S.A. 135 H4
Fredericia Denmark 45 F9
Frederick MD U.S.A. 135 G4
Frederick OK U.S.A. 131 D5
Frederick Reef Australia 110 F4
Fredericksburg TX U.S.A. 131 D6
Fredericksburg VA U.S.A. 135 G4
Fredericktown U.S.A. 130 F4

Frederikshåb Greenland see Paamiut
Frederikshavn Denmark 45 G8
Frederiksværk Denmark 45 H9
Fredonia AZ U.S.A. 129 G3
Fredonia KS U.S.A. 131 E4
Fredonia NY U.S.A. 134 F2
Fredonia WI U.S.A. 134 B2
Fredrika Sweden 44 K4
Fredrikshamn Fin. see Hamina
Fredrikstad Norway 45 G7
Freedom U.S.A. 135 H3
Freehold U.S.A. 135 H3
Freeland U.S.A. 135 H3
Freeling Heights hill Australia 111 B6
Freel Peak U.S.A. 128 D2
Freels, Cape Canada 123 L4
Freeman U.S.A. 130 D3
Freeman, Lake U.S.A. 134 B3
Freeport FL U.S.A. 133 C6
Freeport IL U.S.A. 130 F3
Freeport TX U.S.A. 131 E6
Freeport City Bahamas 133 E7
Freer U.S.A. 131 D7
Freesoil U.S.A. 134 B1
Free State prov. S. Africa 101 H5

Fregenal de la Sierra Spain 57 C4
Fregon Australia 109 F6
Fréhel, Cap c. France 56 C2
Freiberg Germany 53 N4
Freiburg Switz. see Fribourg
Freiburg im Breisgau Germany 47 K6
Freisen Germany 53 H5
Freising Germany 47 M6
Freistadt Austria 47 O6
Fréjus France 56 H5
Fremantle Australia 109 A8
Fremont CA U.S.A. 128 C3
Fremont IN U.S.A. 134 C3
Fremont MI U.S.A. 134 C2
Fremont NE U.S.A. 130 D3
Fremont OH U.S.A. 134 D3
Fremont r. U.S.A. 129 H2
Fremont Junction U.S.A. 129 H2
Frenchburg U.S.A. 134 D5
French Cay i. Turks and Caicos Is 133 F8
French Congo country Africa see Congo

French Guinea country Africa see Guinea
French Island Australia 112 B7
French Lick U.S.A. 134 B4
Frenchman r. Canada/U.S.A. 126 G2

Frenchman Lake CA U.S.A. 128 C2
Frenchman Lake NV U.S.A. 129 F3
Frenchpark Ireland 51 D4
French Pass N.Z. 113 D5

French Somaliland country Africa see Djibouti

French Sudan country Africa see Mali
French Territory of the Afars and Issas country Africa see Djibouti
Frenda Alg. 57 G6
Frentsjer Neth. see Franeker
Freren Germany 53 H2
Fresco r. Brazil 143 H5
Freshford Ireland 51 E5
Fresnillo Mex. 136 D4
Fresno U.S.A. 128 D3
Fresno r. U.S.A. 128 C3
Fresno Reservoir U.S.A. 126 F2
Fressel, Lac l. Canada 122 G4
Freu, Cap des c. Spain 57 H4
Freudenberg Germany 53 H4
Freudenstadt Germany 47 L6
Frévent France 52 C4
Frew watercourse Australia 110 A4
Frewena Australia 110 A3
Freycinet Estuary inlet Australia 109 A6
Freycinet Peninsula Australia 111 [inset]
Freyenstein Germany 53 M1
Freyming-Merlebach France 52 G5
Fria Guinea 96 B3
Fria, Cape Namibia 99 B5
Friant U.S.A. 128 D3
Frias Arg. 144 C3
Fribourg Switz. 56 H3
Friday Harbor U.S.A. 126 C2
Friedeburg Germany 53 H1
Friedens U.S.A. 135 F3
Friedland Rus. Fed. see Pravdinsk
Friedrichshafen Germany 47 L7
Friedrichskanal canal Germany 53 L2
Friend U.S.A. 130 D3
Friendly Islands country S. Pacific Ocean see Tonga
Friendship U.S.A. 130 F3
Friesack Germany 53 M2
Friese Wad tidal flat Neth. 52 F1
Friesoythe Germany 53 H1
Frinton-on-Sea U.K. 49 I7
Frio r. U.S.A. 131 D6
Frio watercourse U.S.A. 131 C5
Frisco Mountain U.S.A. 129 G2
Frissell, Mount hill U.S.A. 135 I2
Fritzlar Germany 53 J3
Frjentsjer Neth. see Franeker
Frobisher Bay Canada see Iqaluit
Frobisher Bay b. Canada 119 L3
Frobisher Lake Canada 121 I3
Frohavet b. Norway 44 F5
Frohburg Germany 53 M3
Froissy France 52 C5
Frolovo Rus. Fed. 43 I6
Frome U.K. 49 E7
Frome r. U.K. 49 E8
Frome, Lake salt flat Australia 111 B6
Frome Downs Australia 111 B6
Fröndenberg Germany 53 H3
Frontera Coahuila Mex. 131 C7
Frontera Tabasco Mex. 136 F5
Fronteras Mex. 127 F7
Front Royal U.S.A. 135 F4
Frosinone Italy 58 E4
Frostburg U.S.A. 135 F4
Frøya i. Norway 44 F5
Fruges France 52 C4
Fruita U.S.A. 129 I2
Fruitland U.S.A. 129 H1
Fruitvale U.S.A. 129 I2
Frunze Kyrg. see Bishkek
Frusino Italy see Frosinone
Fruska Gora nat. park Serb. and Mont. 59 H2
Frýdek-Místek Czech Rep. 47 Q6
Fu'an China 77 H3
Fucheng Anhui China see Fengyang
Fucheng Shaanxi China see Fuxian
Fuchuan China 77 F3
Fuchun Jiang r. China 77 I2
Fude China 77 H3
Fuding China 77 I3
Fudul reg. Saudi Arabia 88 B6
Fuente Olimpo Para. 144 E2
Fuerte r. Mex. 127 F8
Fuerteventura i. Canary Is 96 B2
Fufeng China 76 E1
Fuga i. Phil. 69 G3
Fugou China 77 G1
Fuhai China 80 G2
Fuḩaymī Iraq 91 F4
Fujairah U.A.E. 88 E5
Fujeira U.A.E. see Fujairah
Fuji Japan 75 E6
Fuji-Hakone-Izu Kokuritsu-kōen Japan 75 E6
Fujin China 74 C3
Fujinomiya Japan 75 E6
Fuji-san vol. Japan 75 E6
Fujiyoshida Japan 75 E6
Fukue-jima i. Japan 75 C6
Fukui Japan 75 E5
Fukuoka Japan 75 C6
Fukushima Japan 75 F5
Fukuyama Japan 75 C7
Fūl, Gebel hill Egypt see Fūl, Jabal

Fūl, Jabal hill Egypt 85 A5
Fulchhari Bangl. 83 G4
Fulda Germany 53 J4
Fulda r. Germany 53 J3
Fulham U.K. 49 G7
Fuli China see Jixian
Fuliji China 77 H1
Fuling China 76 E2
Fulitun China see Jixian
Fullerton CA U.S.A. 128 E5
Fullerton NE U.S.A. 130 D3
Fullerton, Cape Canada 121 N2
Fulton IN U.S.A. 134 B3
Fulton MO U.S.A. 130 F4
Fulton MS U.S.A. 131 F5
Fulton NY U.S.A. 135 G2
Fumane Moz. 101 K3
Fumay France 52 E5
Fumin China 76 D3
Funabashi Japan 75 E6
Funafuti atoll Tuvalu 107 H2
Funan China 77 G1

Fundão Brazil 145 C2
Fundão Port. 57 C3
Fundi Italy see Fondi
Fundición Mex. 127 F8
Fundy, Bay of g. Canada 123 I5
Fundy National Park Canada 123 I5
Fünen i. Denmark see Fyn
Funeral Peak U.S.A. 128 E3
Fünfkirchen Hungary see Pécs
Fung Wong Shan hill H.K. China see Lantau Peak
Funhalouro Moz. 101 L2
Funing Jiangsu China 77 H1
Funing Yunnan China 76 E4
Funiu Shan mts China 77 F1
Funtua Nigeria 96 D3
Funzie U.K. 50 [inset]
Fuqing China 77 H3
Fürgun, Küh-e mt. Iran 88 E5
Furmanov Rus. Fed. 42 I4
Furmanovka Kazakh. see Moyynkum
Furmanovo Kazakh. see Zhalpaktal
Furnás hill Spain 57 G4
Furnas, Represa resr Brazil 145 B3
Furneaux Group is Australia 111 [inset]
Furnes Belgium see Veurne
Furong China see Wan'an
Fürstenau Germany 53 H2
Fürstenberg Germany 53 N1
Fürstenwalde Germany 47 O4
Fürth Germany 53 K5
Furth im Wald Germany 53 M5
Furukawa Japan 75 F5
Fury and Hecla Strait Canada 119 J3
Fusan S. Korea see Pusan
Fushun China 74 A4
Fushuncheng China see Shuncheng
Fusong China 74 B4
Fu Tau Pun Chau i. H.K. China 77 [inset]
Futuna i. Vanuatu 107 H3
Futuna Islands Wallis and Futuna Is see Hoorn, Îles de
Fuxian Liaoning China see Wafangdian
Fuxian Shaanxi China 73 J5
Fuxian Hu l. China 76 D3
Fuxin China 73 M4
Fuxing China see Wangmo
Fuxinzhen China see Fuxin
Fuyang Anhui China 77 G1
Fuyang Guangxi China see Fuchuan
Fuyang Zhejiang China 77 H2
Fuying Dao i. China 77 I3
Fuyu Anhui China see Susong
Fuyu Heilong. China 74 B3
Fuyu Jilin China see Songyuan
Fuyu Jilin China 74 B3
Fuyuan Heilong. China 74 D2
Fuyuan Yunnan China 76 E3
Fuyun China 80 G2
Fuzhou Fujian China 77 H3
Fuzhou Jiangxi China 77 H3
Füzuli Azer. 91 G3
Fyn i. Denmark 45 G9
Fyne, Loch inlet U.K. 50 D5

G

Gaaf Atoll Maldives see Huvadhu Atoll
Gaâfour Tunisia 58 C6
Gaalkacyo Somalia 98 E3
Gabakly Turkm. 89 F2
Gabasumdo China see Tongde
Gabbs U.S.A. 128 E2
Gabbs Valley Range mts U.S.A. 128 D2
Gabd Pak. 89 F5
Gabela Angola 99 B5
Gaberones Botswana see Gaborone
Gabès Tunisia 54 G5
Gabès, Golfe de g. Tunisia 54 G5
Gabo Island Australia 112 D6

Gäbrik Iran 88 E5
Gabrovo Bulg. 59 K3
Gabú Guinea-Bissau 96 B3
Gadag India 84 B3
Gadaisu P.N.G. 110 E1
Gadchiroli India 84 D1
Gäddede Sweden 44 I4
Gadê China 76 C1
Gades Spain see Cádiz
Gadhap Pak. 89 G5
Gadhka India 89 H6
Gadhra India 82 B5
Gadra Pak. 89 H5
Gadsden U.S.A. 133 C5
Gadwal India 84 C2
Gadyach Ukr. see Hadyach
Gaer U.K. 49 D7

Găeşti Romania 59 K2
Gaeta Italy 58 E4
Gaeta, Golfo di g. Italy 58 E4
Gaferut i. Micronesia 69 L5
Gaffney U.S.A. 133 D5
Gafsa Tunisia 58 C7
Gagarin Rus. Fed. 43 G5
Gagnoa Côte d'Ivoire 96 C4
Gagnon Canada 123 H4
Gago Coutinho Angola see
 Lumbala N'guimbo
Gagra Georgia 43 I8
Gaiab watercourse Namibia 100 D5
Gaibanda Bangl. see Gaibandha
Gaibandha Bangl. 83 G4
Gaïdouronisi i. Greece 59 K7
Gaifi, Wādi al watercourse Egypt see
 Jayfī, Wādī al
Gail U.S.A. 131 C5
Gaildorf Germany 53 J6
Gaillac France 56 E5
Gaillimh Ireland see Galway
Gaillon France 52 B5
Gaindainqoinkor China 83 G3
Gainesboro U.S.A. 134 C5
Gainesville FL U.S.A. 133 D6
Gainesville GA U.S.A. 133 D5
Gainesville MO U.S.A. 131 E4
Gainesville TX U.S.A. 131 D5
Gainsborough U.K. 48 G5
Gairdner, Lake salt flat Australia
 111 A6
Gairloch U.K. 50 D3
Gair Loch b. U.K. 50 D3
Gajah Hutan, Bukit hill Malaysia/Thai.
 71 C6
Gajipur India see Ghazipur
Gajol India 83 G4
Gakarosa mt. S. Africa 100 F4
Gala China 83 G3
Galaasiya Uzbek. see Galaosiyo
Gala Co l. China 83 G3
Galâla el Baḥarīya, Gebel el plat. Egypt see
 Jalālah al Baḥrīyah, Jabal
Galana r. Kenya 98 E4
Galanta Slovakia 47 P6
Galaosiyo Uzbek. 89 G2

▶Galapagos Islands is Ecuador 151 O6
 Part of Ecuador. Most westerly point of
 South America.

Galapagos Rise sea feature
 Pacific Ocean 151 N6
Galashiels U.K. 50 G5
Galaţi Romania 59 M2
Galatina Italy 58 H4
Gala Water r. U.K. 50 G5
Galax U.S.A. 134 E5
Galaymor Turkm. see Galaýmor
Galaýmor Turkm. 89 F3
Galbally Ireland 51 D5
Galdhøpiggen mt. Norway 45 F6
Galeana Chihuahua Mex. 127 G7
Galeana Nuevo León Mex. 131 C7
Galena AK U.S.A. 118 C3
Galena IL U.S.A. 130 F3
Galena MD U.S.A. 135 H4
Galena MO U.S.A. 131 E4
Galera, Punta pt Chile 144 B6
Galesburg IL U.S.A. 130 F3
Galesville U.S.A. 130 F2
Galeshewe S. Africa 100 G5
Galeton U.S.A. 135 G3
Galey r. Ireland 51 C5
Galheirão r. Brazil 145 B1
Galiano Island Canada 120 F5
Galich Rus. Fed. 42 I4
Galichskaya Vozvyshennost' hills
 Rus. Fed. 42 I4
Galicia aut. comm. Spain 57 C2
Galičica nat. park Macedonia 59 I4
Galilee, Lake salt flat Australia 110 D4
Galilee, Sea of l. Israel 85 B3
Galion U.S.A. 134 D3
Galiuro Mountains U.S.A. 129 H5
Galizia aut. comm. Spain see Galicia
Gallabat Sudan 86 E7
G'allaorol Uzbek. 89 G1
Gallatin MO U.S.A. 130 E4
Gallatin TN U.S.A. 134 B5
Galle Sri Lanka 84 D5
Gallego Rise sea feature
 Pacific Ocean 151 M6
Gallegos r. Arg. 144 C8
Gallia country Europe see France

▶Gallinas, Punta pt Col. 142 D1
 Most northerly point of South America.

Gallipoli Italy 58 H4
Gallipoli Turkey 59 L4
Gallipolis U.S.A. 134 D4
Gällivare Sweden 44 L3
Gällö Sweden 44 I5
Gallo Island U.S.A. 135 G2
Gallo Mountains U.S.A. 129 I4
Gallup U.S.A. 129 I4
Galmisdale U.K. 50 C4
Galong Australia 112 D5
Galoya Sri Lanka 84 D4
Gal Oya National Park Sri Lanka 84 D5
Galston U.K. 50 E5
Galt U.S.A. 128 C2
Galtat Zemmour W. Sahara 96 B2
Galtee Mountains hills Ireland 51 D5
Galtymore hill Ireland 51 D5
Galūgāh, Kūh-e mts Iran 88 D4
Galveston IN U.S.A. 134 B3
Galveston TX U.S.A. 131 E6
Galveston Bay U.S.A. 131 E6
Galwa Nepal 83 E3
Galway Ireland 51 C4
Galway Bay Ireland 51 C4
Gām, Sông r. Vietnam 70 D2
Gamalakhe S. Africa 101 J6
Gamba Gabon 98 A4
Gamba China see Gongbalou
Gambēla Eth. 98 D3
Gambēla National Park Eth. 98 D3
Gambell U.S.A. 118 A3
Gambela Eth. see Gambēla

▶Gambia, The country Africa 96 B3
 Africa 7, 94–95
Gambier, Îles is Fr. Polynesia 151 L7
Gambier Islands Australia 111 B7
Gambier Islands Fr. Polynesia see
 Gambier, Îles
Gambo Canada 123 L4
Gamboma Congo 98 B4
Gamboola Australia 110 C3
Gamboula Cent. Afr. Rep. 98 B3
Gamda China see Zamtang
Gamlakarleby Fin. see Kokkola
Gamleby Sweden 45 J8
Gammelstaden Sweden 44 M4
Gammon Ranges National Park
 Australia 111 B6
Gamova, Mys pt Rus. Fed. 74 C4
Gamshadzai Kūh mts Iran 89 F4
Gamtog China 76 C2
Gamud mt. Eth. 98 D3
Gana China 76 D1
Ganado U.S.A. 129 I4
Gananoque Canada 135 G1
Gäncä Azer. 91 G2
Gancheng China 77 F5
Ganda Angola 99 B5
Gandaingoin China 83 G3
Gandajika Dem. Rep. Congo 99 C4
Gandak Barrage Nepal 83 E4
Gandari Mountain Pak. 89 H4
Gandava Pak. 89 G4
Gander Canada 123 L4
Ganderkesee Germany 53 I1
Gandesa Spain 57 G3
Gandhidham India 82 B5
Gandhinagar India 82 C5
Gandhi Sagar resr India 82 C4
Gandía Spain 57 F4
Gandzha Azer. see Gäncä
Ganga r. Bangl./India 83 G5 see
 Ganges
Ganga r. Rajasthan India 82 C5 see
 Ganges
Gangán Arg. 144 C6
Ganganagar India 82 C3
Gangapur India 82 D4
Ganga Sera India 82 B4
Gangaw Myanmar 70 A2
Gangawati India 84 C3
Gangaw Range mts Myanmar 70 B2
Gangca China 80 J4
Gangdisê Shan mts China 83 E3
Ganges r. Bangl./India 83 G5
 also known as Ganga
Ganges France 56 F5
Ganges, Mouths of the
 Bangl./India 83 G5
Ganges Cone sea feature
 Indian Ocean 149 N4
Gangouyi China 72 J5
Gangra Turkey see Çankırı
Gangtok India 83 G4
Gangu China 76 E1
Gani Indon. 69 H7
Gan Jiang r. China 77 H2
Ganjig China 73 M4
Ganluo China 76 D2
Ganmain Australia 112 C5
Gannan China 74 A3
Gannat France 56 F3
Gannett Peak U.S.A. 126 F4
Ganq China 80 H4
Ganshui China 76 E2
Gansu prov. China 76 D1
Gantheaume Point Australia 108 C4
Gantsevichi Belarus see Hantsavichy
Ganxian China 77 G3
Ganye Nigeria 96 E4
Ganyu China 77 H1
Ganyushkino Kazakh. 41 P6
Ganzhou China 77 G3
Ganzi Sudan 97 G4
Gao Mali 96 C3
Gaocheng China see Litang
Gaocun China see Mayang
Gaohe China see Huaining
Gaohebu China see Huaining
Gaoleshan China see Xianfeng
Gaoliangjian China see Hongze
Gaomutang China 77 F3
Gaoping China 77 G1
Gaotai China 80 I4
Gaoting China see Daishan
Gaotingzhen China see Daishan
Gaoua Burkina 96 C3
Gaoual Guinea 96 B3
Gaoxiong Taiwan see Kaohsiung
Gaoyao China see Zhaoqing
Gaoyou China 77 H1
Gaoyou Hu l. China 77 H1
Gap France 56 H4
Gap Carbon hd Alg. 57 F6
Gapuwiyak Australia 110 A2
Gaqoi China 83 E3
Gar China 82 E2
Gar Pak. 89 F5
Gar' r. Rus. Fed. 74 C1
Gara, Lough l. Ireland 51 D4
Garabekevyul Turkm. see Garabekewül
Garabekewül Turkm. 89 G2
Garabil Belentligi hills Turkm. 89 F2
Garabogaz Turkm. 91 I2
Garabogaz Aylagy b. Turkm. see
 Garabogazköl Aýlagy
Garabogazköl Aýlagy b. Turkm. see
 Garabogazköl Aýlagy
Garabogazköl Aýlagy b. Turkm. 91 I2
Garabogazköl Bogazy sea chan.
 Turkm. 91 I2
Garägheh Iran 89 F4
Garagum des. Turkm. 88 E2
Garagum des. Turkm. see
 Karakum Desert
Garagum Kanaly canal Turkm. 89 F2
Garah Australia 112 D2
Garalo Mali 96 C3
Garamätnyýaz Turkm. 89 G2
Garamätnyýaz Turkm. see Garamätnyýaz
Garamba r. Dem. Rep. Congo 98 C3
Garanhuns Brazil 143 K5
Ga-Rankuwa S. Africa 101 H3
Garapuava Brazil 145 B2

Gárasavvon Sweden see Karesuando
Garautha India 82 D4
Garba China see Jiulong
Garbahaarrey Somalia 98 E3
Garba Tula Kenya 98 D3
Garbo China see Lhozhag
Garbsen Germany 53 J2
Garça Brazil 145 A3
Garco China 83 G2
Garda, Lago di Italy see Garda, Lake
Garda, Lake Italy 58 D2
Garde, Cap de c. Alg. 58 B6
Gardelegen Germany 53 L2
Garden City U.S.A. 130 C4
Garden Hill Canada 121 M4
Garden Mountain U.S.A. 134 E5
Gardeyz Afgh. see Gardēz
Gardēz Afgh. 89 H3
Gardiner U.S.A. 135 K1
Gardiners Bay U.S.A. 135 I3
Gardinas Belarus see Hrodna
Gardiner, Mount Australia 108 F5
Gardiner Range hills Australia 108 E4
Gardiz Afgh. see Gardēz
Gardner atoll Micronesia see Faraulep
Gardner U.S.A. 135 J2
Gardner Inlet Antarctica 152 L1
Gardner Island atoll Kiribati see
 Nikumaroro
Gardner Pinnacles is U.S.A. 150 I4
Gáregasnjárga Fin. see Karigasniemi
Garelochhead U.K. 50 E4
Garet El Djenoun mt. Alg. 96 D2
Gargano, Parco Nazionale del nat. park
 Italy 58 F4
Gargantua, Cape Canada 122 D5
Gargunsa China see Gar
Gargždai Lith. 45 L9
Garhchiroli India see Gadchiroli
Garhi Madh. Prad. India 84 C1
Garhi Rajasthan India 82 C5
Garhi Khairo Pak. 89 G4
Garhwa India 83 E4
Gari Rus. Fed. 41 S4
Gariau Indon. 69 I7
Garibaldi, Mount Canada 120 F5
Gariep Dam resr S. Africa 101 G6
Garies S. Africa 100 C6
Garigliano r. Italy 58 E4
Garissa Kenya 98 D4
Garkalne Latvia 45 N8
Garkung Caka l. China 83 F2
Garland U.S.A. 131 D5
Garm Tajik. see Gharm
Garm Āb Iran 89 F3
Garmab Iran 88 E3
Garmeh Iran 88 E3
Garmī Iran 88 C2
Garmsar Iran 88 D3
Garmsel reg. Afgh. 89 F4
Garner IA U.S.A. 130 E3
Garner KY U.S.A. 134 D5
Garnett U.S.A. 130 E4
Garnpung Lake imp. l. Australia 112 A4
Garo Hills India 83 G4
Garonne r. France 56 D4
Garoowe Somalia 98 E3
Garopaba Brazil 145 A5
Garoua Cameroon 96 E4
Garoua Boulai Cameroon 97 E4
Garqêntang China see Sog
Garré Arg. 144 D5
Garrett U.S.A. 134 C3
Garrison U.S.A. 130 E2
Garruk Pak. 89 G4
Garry r. U.K. 50 E3
Garrycharla U.K. see Garryçyrla
Garryçyrla Turkm. 89 F2
Garry Lake Canada 121 K1
Garrynahine U.K. 50 C2
Garsen Kenya 98 E4
Garshy Turkm. see Garşy
Garsila Sudan 97 F3
Garstang U.K. 49 D6
Gartog China see Markam
Gartok China see Garyarsa
Gartow Germany 53 L1
Garub Namibia 100 C4
Garvagh U.K. 51 F3
Garve U.K. 50 E3
Garwa India see Garhwa
Garwha India see Garhwa
Gar Xincun China 82 E2
Gary IN U.S.A. 134 B3
Gary WV U.S.A. 134 E5
Garyarsa China 82 F3
Garyi China 76 C2
Garyū-zan mt. Japan 75 D6
Garza García Mex. 131 C7
Garzê China 76 C2
Gasan-Kuli Turkm. see Esenguly
Gas City U.S.A. 134 C3
Gascogne reg. France see Gascony
Gascogne, Golfe de g. France see
 Gascony, Gulf of
Gascony reg. France 56 D5
Gascony, Gulf of France 56 C4
Gascoyne r. Australia 109 A6
Gascoyne Junction Australia 109 A6
Gasherbrum I mt.
 China/Jammu and Kashmir 82 D2
Gashua Nigeria 96 E3
Gask Iran 89 E3
Gaspar Cuba 133 E8
Gaspar, Selat sea chan. Indon. 68 D7
Gaspé Canada 123 I4
Gaspé, Cap c. Canada 123 I4
Gaspé, Péninsule de pen. Canada 123 I4
Gassan vol. Japan 75 F5
Gasselte Neth. 52 G2
Gasteiz Spain see Vitoria-Gasteiz
Gastello Rus. Fed. 74 F2
Gaston U.S.A. 132 D4
Gaston, Lake U.S.A. 135 G5
Gastonia U.S.A. 133 D5
Gastre Arg. 144 C6
Gata, Cabo de c. Spain 57 E5
Gata, Cape Cyprus 85 A2
Gata, Sierra de mts Spain 57 C3
Gataga r. Canada 120 E3

Gatas, Akra c. Cyprus see Gata, Cape
Gatchina Rus. Fed. 45 Q7
Gate City U.S.A. 134 D5
Gatehouse of Fleet U.K. 50 E6
Gatentiri Indon. 69 K8
Gates of the Arctic National Park and
 Preserve U.S.A. 118 C3
Gatesville U.S.A. 131 D6
Gateway U.S.A. 129 I2
Gatineau Canada 135 H1
Gatineau r. Canada 122 G5
Gatong China see Jomda
Gatooma Zimbabwe see Kadoma
Gatton Australia 112 F1
Gatvand Iran 88 C3
Gatyana S. Africa see Willowvale
Gau i. Fiji 107 H3
Gauer Lake Canada 121 L3
Gauhati India see Guwahati
Gaujas nacionālais parks nat. park
 Latvia 45 N8
Gaul country Europe see France
Gaula r. Norway 44 G5
Gaume reg. Belgium 52 F5
Gaurama Brazil 145 A4
Gauribidanur India 84 C3
Gauteng prov. S. Africa 101 I4
Gavarr Armenia 91 G2
Gävbandī Iran 88 D5
Gävbūs, Kūh-e mts Iran 88 D5

▶Gavdos i. Greece 59 K7
 Most southerly point of Europe.

Gavião r. Brazil 145 C1
Gavileh Iran 88 B3
Gav Khūnī Iran 88 D3
Gävle Sweden 45 J6
Gavrilovka Vtoraya Rus. Fed. 43 I5
Gavrilov-Yam Rus. Fed. 42 H4
Gawachab Namibia 100 C4
Gawai Myanmar 76 B1
Gawan India 83 F4
Gawilgarh Hills India 82 D5
Gawler Australia 111 B7
Gawler Ranges hills Australia 111 A7
Gaxun Nur salt l. China 80 J3
Gaya India 83 F4
Gaya Niger 96 D3
Gaya He r. China 74 C4
Gayéri Burkina 96 D3
Gaylord U.S.A. 134 C1
Gayndah Australia 111 E5
Gayny Rus. Fed. 42 L3
Gaysin Ukr. see Haysyn
Gayutino Rus. Fed. 42 H4
Gaz Iran 88 C3

▶Gaza Gaza 85 B4
 Capital of Gaza.

Gaza prov. Moz. 101 K2
Gazan Pak. 89 G4
Gazandzhyk Turkm. see Bereket
Gaza Strip terr. Asia see Gaza
Gaziantep Turkey 90 E3
Gaziantep prov. Turkey 85 C1
Gazibenli Turkey see Yahyalı
Gazik Iran 89 F3
Gazimağusa Cyprus see Famagusta
Gazimurskiy Khrebet mts
 Rus. Fed. 73 L2
Gazimurskiy Zavod Rus. Fed. 73 L2
Gazipaşa Turkey 85 A1
Gazli Uzbek. 89 F1
Gaz Māhū Iran 88 E5
Gazojak Turkm. see Gökdepe
Gbanga Liberia 96 B4
Gboko Nigeria 96 D4
Gcuwa S. Africa see Butterworth
Gdańsk Poland 47 Q3
Gdańsk, Gulf of Poland/Rus. Fed. 47 Q3
Gdańsk, Zatoka g. Poland/Rus. Fed. see
 Gdańsk, Gulf of
Gdingen Poland see Gdynia
Gdov Rus. Fed. 45 O7
Gdynia Poland 47 Q3
Geaidnuvuohppi Norway 44 M2
Gearhart Mountain U.S.A. 126 C4
Gearraidh na h-Aibhne U.K. see
 Garrynahine
Gebe i. Indon. 69 H6
Gebesee Germany 53 K3
Geçitkale Cyprus see Lefkonikon
Gedaref Sudan 86 E7
Gedern Germany 53 J4
Gedinne Belgium 52 E5
Gediz r. Turkey 59 L5
Gedser Denmark 45 G9
Geel Belgium 52 F3
Geelong Australia 112 B7
Geelvink Channel Australia 109 A7
Geel Vloer salt pan S. Africa 100 E5
Gees Gwardafuy c. Somalia see
 Gwardafuy, Gees
Geeste Germany 53 H2
Geesthacht Germany 53 K1
Ge Hu l. China 77 H2
Geidam Nigeria 96 E3
Geiersberg hill Germany 53 J5
Geikie r. Canada 121 K3
Geilenkirchen Germany 52 G4
Geilo Norway 45 F6
Geiranger Norway 44 E5
Geislingen an der Steige Germany 53 J6
Geisûm, Gezā'ir is Egypt see
 Qaysūm, Juzur
Geita Tanz. 98 D4
Geithain Germany 53 M3
Gejiu China 76 D4
Gêkdepe Turkm. 88 E2
Gela Sicily Italy 58 F6
Gêladaindong mt. China 83 G2
Gêladi Eth. 98 E3

Gelang, Tanjung pt Malaysia 71 C7
Geldern Germany 52 G3
Gelendzhik Rus. Fed. 90 E1
Gelibolu Turkey see Gallipoli
Gelidonya Burnu pt Turkey see
 Yardımcı Burnu
Gelincik Dağı mt. Turkey 59 N5
Gelmord Iran 88 E3
Gelnhausen Germany 53 J4
Gelsenkirchen Germany 52 H3
Gemas Malaysia 71 C7
Gembloux Belgium 52 E4
Gemena Dem. Rep. Congo 98 B3
Geminokağı Cyprus see Karavostasi
Gemlik Turkey 59 M4
Gemona del Friuli Italy 58 E1
Gemsa Egypt see Jamsah
Gemsbok National Park Botswana
 100 E3
Gemsbokplein well S. Africa 100 E4
Genalē Wenz r. Eth. 98 E3
Genappe Belgium 52 E4
Genäveh Iran 88 C4
General Acha Arg. 144 D5
General Alvear Arg. 144 C5
General Belgrano II research station
 Antarctica see Belgrano II
General Bernardo O'Higgins
 research station Antarctica 152 A2
General Bravo Mex. 131 D7

▶General Carrera, Lago l. Arg./Chile
 144 B7
 Deepest lake in South America.

General Conesa Arg. 144 D6
General Freire Angola see Muxaluando
General Juan Madariaga Arg. 144 E5
General La Madrid Arg. 144 D5
General Machado Angola see Camacupa
General Pico Arg. 144 D5
General Pinedo Arg. 144 D3
General Roca Arg. 144 C5
General Salgado Brazil 145 A3
General San Martín research station
 Antarctica see San Martín
General Santos Phil. 69 H5
General Simón Bolívar Mex. 131 C7
General Trías Mex. 127 G7
General Villegas Arg. 144 D5
Genesee U.S.A. 135 G2
Geneseo U.S.A. 135 G2
Geneva S. Africa 101 H4
Geneva Switz. 56 H3
Geneva AL U.S.A. 133 C6
Geneva FL U.S.A. 133 D6
Geneva IL U.S.A. 134 A3
Geneva NE U.S.A. 130 D3
Geneva NY U.S.A. 135 G2
Geneva OH U.S.A. 134 E3
Geneva, Lake France/Switz. 56 H3
Genève Switz. see Geneva
Genf Switz. see Geneva
Gengda China see Gana
Gengma China 76 C4
Gengxuan China see Gengma
Genhe China 74 A2
Genichesk Ukr. see Heniches'k
Genil r. Spain 57 D5
Genji India 82 C5
Genk Belgium 52 F4
Gennep Neth. 52 F3
Genoa Italy 58 C2
Genoa, Gulf of Italy 58 C2
Genova Italy see Genoa
Genova, Golfo di Italy see Genoa, Gulf of
Gent Belgium see Ghent
Genthin Germany 53 M2
Gentioux, Plateau de France 56 F4
Genua Italy see Genoa
Geographe Bay Australia 109 A8
Geographical Society Ø i. Greenland
 119 P2
Geok-Tepe Turkm. see Gökdepe
Georga, Zemlya i. Rus. Fed. 64 F1
George r. Canada 123 I2
George S. Africa 100 F7
George, Lake Australia 112 D5
George, Lake FL U.S.A. 133 D6
George, Lake NY U.S.A. 135 I2
George Land r. Rus. Fed. see
 Georga, Zemlya
Georges Mills U.S.A. 135 I2
George Sound inlet N.Z. 113 A7
Georgetown Australia 110 C3

▶George Town Cayman Is 137 H5
 Capital of the Cayman Islands.

Georgetown Gambia 96 B3

▶Georgetown Guyana 143 G2
 Capital of Guyana.

George Town Malaysia 71 C6
Georgetown DE U.S.A. 135 H4
Georgetown GA U.S.A. 133 C6
Georgetown IL U.S.A. 134 B4
Georgetown KY U.S.A. 134 C4
Georgetown OH U.S.A. 134 D4
Georgetown SC U.S.A. 133 E5
Georgetown TX U.S.A. 131 D6
George VI Sound sea chan.
 Antarctica 152 L2
George V Land reg. Antarctica 152 G2
George West U.S.A. 131 D6

▶Georgia country Asia 91 F2
 Asia 6, 62–63

Georgia state U.S.A. 133 D5
Georgia, Strait of Canada 120 E5
Georgiana U.S.A. 133 C6
Georgian Bay Canada 134 E1
Georgian Bay Islands National Park
 Canada 134 F1
Georgienne, Baie b. Canada see
 Georgian Bay
Georgina watercourse Australia 110 B5
Georgiu-Dezh Rus. Fed. see Liski
Georgiyevka Vostochnyy Kazakhstan Kazakh.
 80 F2
Georgiyevka Zhambylskaya Oblast' Kazakh.
 see Korday
Georgiyevsk Rus. Fed. 91 F1
Georgiyevskoye Rus. Fed. 42 J4

Georg von Neumayer research station
 Antarctica see Neumayer
Gera Germany 53 M4
Geraardsbergen Belgium 52 D4
Geral, Serra mts Brazil 145 A4
Geral de Goiás, Serra hills Brazil 145 B1
Geraldine N.Z. 113 C7
Geral do Paraná, Serra hills Brazil 145 B1
Geraldton Australia 109 A7
Gerar watercourse Israel 85 B4
Gerber U.S.A. 128 C1
Gerciş Turkey 91 F3
Gerede Turkey 90 D2
Gereshk Afgh. 89 G4
Gerik Malaysia 71 C6
Gerlach U.S.A. 128 D1
Gerlachovský štít mt. Slovakia 47 R6
Germaine, Lac l. Canada 123 I3
Germania country Europe see Germany
Germanicea Turkey see
 Kahramanmaraş
Germansen Landing Canada 120 E4
German South-West Africa country
 Africa see Namibia
Germantown OH U.S.A. 134 C4
Germantown WI U.S.A. 134 A2

▶Germany country Europe 47 L5
 2nd most populous country in Europe.
 Europe 5, 38–39

Germersheim Germany 53 I5
Gernsheim Germany 53 I5
Gerolstein Germany 52 G4
Gerolzhofen Germany 53 K5
Gerona Spain see Girona
Gerrit Denys is P.N.G. see Lihir Group
Gers r. France 56 E4
Gersfeld (Rhön) Germany 53 J4
Gersoppa India 84 B3
Gerstungen Germany 53 K4
Gerwisch Germany 53 L2
Géryville Alg. see El Bayadh
Gêrzê China 83 F2
Gerze Turkey 90 D2
Gescher Germany 52 H3
Gesoriacum France see
 Boulogne-sur-Mer
Gessie U.S.A. 134 B3
Gete r. Belgium 52 F4
Gettysburg PA U.S.A. 135 G4
Gettysburg SD U.S.A. 130 D2
Gettysburg National Military Park nat. park
 U.S.A. 135 G4
Getz Ice Shelf Antarctica 152 J2
Geumpang Indon. 71 B6
Geureudong, Gunung vol. Indon. 71 B6
Geurie Australia 112 D4
Gevaş Turkey 91 F3
Gevgelija Macedonia 59 J4
Gexto Spain see Algorta
Gey Iran see Nikshahr
Geyikli Turkey 59 L5
Geylegphug Bhutan 83 G4
Geysdorp S. Africa 101 G4
Geyserville U.S.A. 128 B2
Geyve Turkey 59 N4
Gezīr Iran 88 D5
Ghaap Plateau S. Africa 100 F4
Ghāb, Wādī al r. Syria 85 C2
Ghabeish Sudan 86 C7
Ghadaf, Wādī al watercourse Jordan 85 C4
Ghadamés Libya see Ghadāmis
Ghadāmis Libya 53 G4
Ghaem Shahr Iran 88 D2
Ghaghara r. India 83 F4
Ghaibi Dero Pak. 89 G5
Ghalend Iran 89 F4
Ghalkarteniz, Solonchak salt marsh
 Kazakh. 80 B2
Ghallaorol Uzbek. see G'allaorol
▶Ghana country Africa 96 C4
 Africa 7, 94–95
Ghanādah, Rās pt U.A.E. 88 D5
Ghantila India 82 B5
Ghanwa Saudi Arabia 86 G4
Ghanzi Botswana 99 C6
Ghanzi admin. dist. Botswana 100 F2
Ghap'an Armenia see Kapan
Ghār, Ras al pt Saudi Arabia 88 C5
Ghardaïa Alg. 54 E5
Gharghoda India 84 D1
Ghārib, Gebel mt. Egypt see Ghārib, Jabal
Ghārib, Jabal mt. Egypt 90 D5
Gharm Tajik. 89 H2
Gharq Ābād Iran 88 C3
Gharwa India see Garhwa
Gharyān Libya 97 E1
Ghāt Libya 96 E2
Ghatgan India 83 F5
Ghatol India 82 C5
Ghawdex i. Malta see Gozo
Ghazal, Bahr el watercourse Chad 97 E3
Ghazaouet Alg. 57 F6
Ghaziabad India 82 D3
Ghazi Ghat Pak. 89 H4
Ghazipur India 83 E4
Ghazna Afgh. see Ghaznī
Ghaznī Afgh. 89 H3
Ghaznī r. Afgh. 89 G3
Ghazoor Afgh. 89 G3
Ghazzah Gaza see Gaza
Ghebar Gumbad Iran 88 E3
Ghent Belgium 52 D3
Gheorghe Gheorghiu-Dej Romania see
 Oneşti
Gheorgheni Romania 59 K1
Gherla Romania 59 J1
Ghijduwon Uzbek. see G'ijduvon
Ghilzai reg. Afgh. 89 G4
Ghinah, Wādī al watercourse
 Saudi Arabia 85 D4
Ghisonaccia Corsica France 56 I5
Ghorak Afgh. 89 G3
Ghost Lake Canada 120 H2
Ghotaru India 82 B4
Ghotki Pak. 89 H5
Ghudamis Libya see Ghadāmis
Ghugri r. India 83 F4
Ghūrī Iran 88 D4
Ghurayfah hill Saudi Arabia 85 C4

Ghurian Afgh. 89 F3
Ghurrab, Jabal hill Saudi Arabia 88 B5
Ghuzor Uzbek. see G'uzor
Ghyvelde France 52 C3
Giaginskaya Rus. Fed. 91 F1
Gialias r. Cyprus 85 A2
Gia Nghia Vietnam 71 D4
Gianisada i. Greece 59 L7
Giannitsa Greece 59 J4
Giant's Castle mt. S. Africa 101 I5
Gianysada i. Kriti Greece see
 Gianisada
Gianysada i. Kriti Greece see
 Gianisada
Gia Rai Vietnam 71 D5
Giarre Sicily Italy 58 F6
Gibb r. Australia 108 D3
Gibbonsville U.S.A. 126 E3
Gibeon Namibia 100 C3
Gibraltar terr. Europe 57 D5

▶Gibraltar Gibraltar 148 H3
United Kingdom Overseas Territory.
Europe 5, 38–39

Gibraltar, Strait of Morocco/Spain 57 C6
Gibraltar Range National Park
 Australia 112 F2
Gibson Australia 109 C8
Gibson City U.S.A. 134 A3
Gibson Desert Australia 109 C6
Gichgeniyn Nuruu mts Mongolia 80 H2
Gidar Pak. 89 G4
Giddalur India 84 C3
Giddi, Gebel el hill Egypt see Jiddī, Jabal al
Giddings U.S.A. 131 D6
Gīdolē Eth. 97 G4
Gien France 56 F3
Gießen Germany 53 I4
Gifford r. Canada 119 J2
Gifhorn Germany 53 K2
Gift Lake Canada 120 H4
Gifu Japan 75 E6
Giganta, Cerro mt. Mex. 127 F8
Gigha i. U.K. 50 D5
Gigiga Eth. see Jijiga
G'ijduvon Uzbek. 89 G1
Gijón Spain see Gijón-Xixón
Gijón-Xixón Spain 57 D2
Gila r. U.S.A. 129 F5
Gila Bend U.S.A. 129 G5
Gila Bend Mountains U.S.A. 129 G5
Gīlān-e Gharb Iran 88 B3
Gilbert r. Australia 110 C3
Gilbert AZ U.S.A. 129 H5
Gilbert WV U.S.A. 134 E4
Gilbert Islands Kiribati 150 H5
Gilbert Islands country Pacific Ocean see
 Kiribati
Gilbert Peak U.S.A. 129 H1
Gilbert Ridge sea feature
 Pacific Ocean 150 H6
Gilbert River Australia 110 C3
Gilbués Brazil 143 I5
Gil Chashmeh Iran 88 E3
Gilē Moz. 99 D5
Giles Creek r. Australia 108 E4
Gilford Island Canada 120 E5
Gilgai Australia 112 E2
Gilgandra Australia 112 D3
Gil Gil Creek r. Australia 112 D2
Gilgit Jammu and Kashmir 82 C2
Gilgit r. Jammu and Kashmir 87 L2
Gilgunnia Australia 112 C4
Gılındire Turkey see Aydıncık
Gillam Canada 121 M3
Gillen, Lake salt flat Australia 109 D6
Gilles, Lake salt flat Australia 111 B7
Gillett U.S.A. 135 G3
Gillette U.S.A. 126 G3
Gilliat Australia 110 C4
Gillingham England U.K. 49 E7
Gillingham England U.K. 49 H7
Gilling West U.K. 48 F4
Gilman U.S.A. 134 B3
Gilmer U.S.A. 131 E5
Gilmour Island Canada 122 F2
Gilroy U.S.A. 128 C3
Gīmbī Eth. 98 D3
Gimhae S. Korea see Kimhae
Gimli Canada 121 L5
Gimol'skoye, Ozero l. Rus. Fed. 42 G3
Ginebra, Laguna l. Bol. 142 E6
Gineifa Egypt see Junayfah
Gin Gin Australia 110 E5
Gingin Australia 109 A7
Gīnīr Eth. 98 E3
Ginosa Italy 58 G4
Ginzo de Limia Spain see Xinzo de Limia
Gioia del Colle Italy 58 G4
Gipouloux r. Canada 122 G3
Gippsland reg. Australia 112 B7
Girâ, Wâdi watercourse Egypt see
 Jirā', Wādī
Girān Rīg mt. Iran 88 E4
Girard U.S.A. 134 E2
Girardin, Lac l. Canada 123 I2
Girdab Iran 88 E3
Giresun Turkey 90 E2
Girgenti Sicily Italy see Agrigento
Giridih India see Giridih
Giridih India 83 F4
Girilambone Australia 112 C3
Girna r. India 82 C5
Gir National Park India 82 B5
Girne Cyprus see Kyrenia
Girón Ecuador 142 C4
Giron Sweden see Kiruna
Girona Spain 57 H3
Gironde est. France 56 D4
Girot Pak. 89 I3
Girral Australia 112 C4
Girvan U.K. 50 E5
Girvas Rus. Fed. 42 G3
Gisborne N.Z. 113 G4
Giscome Canada 120 F4
Gislaved Sweden 45 H8
Gisors France 52 B5
Gissar Tajik. see Hisor

Gissar Range mts Tajik./Uzbek. 89 G2
Gissarskiy Khrebet mts Tajik./Uzbek. see
 Gissar Range
Gitarama Rwanda 98 C4
Gitega Burundi 98 C4
Giuba r. Somalia see Jubba
Giulianova Italy 58 E3
Giurgiu Romania 59 K3
Giuvala, Pasul pass Romania 59 K2
Givar Iran 88 E2
Givet France 52 E4
Givors France 56 G4
Givry-en-Argonne France 52 E6
Giyani S. Africa 101 J2
Giza Egypt 90 C5
Gizhiga Rus. Fed. 65 R3
Gjakovë Serb. and Mont. see Đakovica
Gjilan Serb. and Mont. see Gnjilane
Gjoa Haven Canada 119 I3
Gjøra Norway 44 F5
Gjøvik Norway 45 G6
Gkinas, Akrotirio pt Greece 59 M6
Glace Bay Canada 123 K5
Glacier Bay National Park and Preserve
 U.S.A. 120 B3
Glacier National Park Canada 120 G5
Glacier National Park U.S.A. 126 E2
Glacier Peak vol. U.S.A. 126 C2
Gladstad Norway 44 G4
Gladstone Australia 110 E4
Gladstone Canada 121 L5
Gladwin U.S.A. 134 C2
Gladys U.S.A. 134 F5
Gladys Lake Canada 120 C3
Glamis U.K. 50 F4
Glamis U.S.A. 129 F5
Glamoč Bos.-Herz. 58 G2
Glan r. Germany 53 H5
Glandorf Germany 53 I2
Glanton U.K. 48 F3
Glasgow U.K. 50 E5
Glasgow KY U.S.A. 134 C5
Glasgow MT U.S.A. 126 G2
Glasgow VA U.S.A. 134 F5
Glaslyn Canada 121 I4
Glass, Loch l. U.K. 50 E3
Glass Mountain U.S.A. 128 D3
Glassboro U.S.A. 135 H4
Glastonbury U.K. 49 E7
Glauchau Germany 53 M4
Glazov Rus. Fed. 42 L4
Gleiwitz Poland see Gliwice
Glen U.S.A. 135 J1
Glen Allen U.S.A. 135 G5
Glen Alpine Dam S. Africa 101 I2
Glenamaddy Ireland 51 D4
Glenamoy r. Ireland 51 C3
Glen Arbor U.S.A. 134 C1
Glenboro Canada 121 L5
Glenbawn, Lake Australia 112 E4
Glen Canyon gorge U.S.A. 129 H3
Glen Canyon Dam U.S.A. 129 H3
Glencoe Canada 134 E2
Glencoe S. Africa 101 J5
Glencoe U.S.A. 130 E2
Glendale AZ U.S.A. 129 G5
Glendale CA U.S.A. 128 D4
Glendale UT U.S.A. 129 G3
Glendale Lake U.S.A. 135 F3
Glen Davis Australia 112 E4
Glenden Australia 110 E4
Glendive U.S.A. 126 G3
Glendo Reservoir U.S.A. 126 G4
Glenfield U.S.A. 135 H2
Glengavlen Ireland 51 E3
Glengyle Australia 110 B5
Glen Innes Australia 112 E2
Glenluce U.K. 50 E6
Glen Lyon U.S.A. 135 G3
Glenlyon Peak Canada 120 C2
Glen More valley U.K. 50 E3
Glenmorgan Australia 112 D1
Glenn U.S.A. 128 B2
Glennallen U.S.A. 118 D3
Glennie U.S.A. 134 D1
Glenns Ferry U.S.A. 126 E4
Glenora Canada 120 D3
Glenore Australia 110 C3
Glenormiston Australia 110 B4
Glenreagh Australia 112 F3
Glen Rose U.S.A. 131 D5
Glenrothes U.K. 50 F4
Glens Falls U.S.A. 135 I2
Glen Shee valley U.K. 50 F4
Glenties Ireland 51 D3
Glenveagh National Park Ireland 51 E2
Glenville U.S.A. 134 E4
Glenwood AR U.S.A. 131 E5
Glenwood IA U.S.A. 130 E3
Glenwood MN U.S.A. 130 D2
Glenwood NM U.S.A. 129 I5
Glenwood Springs U.S.A. 129 J2
Glevum U.K. see Gloucester
Glinde Germany 53 K1
Glittertinden mt. Norway 45 F6
Gliwice Poland 47 Q5
Globe U.S.A. 129 H5
Głogau Poland see Głogów
Głogów Poland 47 P5
Glomfjord Norway 44 H3
Glomma r. Norway 44 G4
Glommersträsk Sweden 44 K4
Glorieuses, Îles is Indian Ocean 99 E5
Glorioso Islands Indian Ocean see
 Glorieuses, Îles
Gloster U.S.A. 131 F6
Gloucester U.K. 49 E7
Gloucester MA U.S.A. 135 J2
Gloucester VA U.S.A. 135 G5
Gloucester Swaziland see Lavumisa
Glover Island Canada 123 K4
Gloversville U.S.A. 135 H2
Glovertown Canada 123 L4
Glöwen Germany 53 M2
Glubinnoye Rus. Fed. 74 D3
Glubokiy Krasnoyarskiy Kray
 Rus. Fed. 72 H2
Glubokiy Rostovskaya Oblast'
 Rus. Fed. 43 I6
Glubokoye Belarus see Hlybokaye
Glubokoye Kazakh. 80 F1

Gluggarnir hill Faroe Is 44 [inset]
Glukhov Ukr. see Hlukhiv
Glusburn U.K. 48 F5
Glynebwy U.K. see Ebbw Vale
Gmelinka Rus. Fed. 43 J6
Gmünd Austria 47 O6
Gmunden Austria 47 N7
Gnarp Sweden 45 J5
Gnarrenburg Germany 53 J1
Gnesen Poland see Gniezno
Gniezno Poland 47 P4
Gnjilane Serb. and Mont. 59 I3
Gnowangerup Australia 109 B8
Gnows Nest Range hills Australia 109 B7
Goa India 84 B3
Goa state India 84 B3
Goageb Namibia 100 C4
Goalen Head hd Australia 112 E6
Goalpara India 83 G4
Goat Fell hill U.K. 50 D5
Goba Eth. 98 E3
Gobabis Namibia 100 D2
Gobannium U.K. see Abergavenny
Gobas Namibia 100 D3
Gobi Desert des. China/Mongolia 72 J4
Gobindpur India 83 F5
Gobles U.S.A. 134 C2
Gobō Japan 75 D6
Gochas Namibia 100 D3
Go Công Vietnam 71 D5
Godalming U.K. 49 G7
Godavari r. India 84 D2
Godavari, Cape India 84 D2
Godda India 83 F4
Godē Eth. 98 E3
Godere Eth. 98 E3
Goderich Canada 134 E2
Goderville France 49 H9
Godhavn Greenland see Qeqertarsuaq
Godhra India 82 C5
Godia Creek b. India 89 H6
Gods r. Canada 121 M3
Gods Lake Canada 121 M4
God's Mercy, Bay of Canada 121 O2
Godthåb Greenland see Nuuk
Godwin-Austen, Mount
 China/Jammu and Kashmir see K2
Goedereede Neth. 52 D3
Goedgegun Swaziland see Nhlangano
Goegap Nature Reserve
 S. Africa 100 D5
Goélands, Lac aux l. Canada 123 J3
Goes Neth. 52 D3
Gogama Canada 122 E5
Gogebic Range hills U.S.A. 130 F2
Gogra r. India see Ghaghara
Goiana Brazil 143 L5
Goiandira Brazil 145 A2
Goianésia Brazil 145 A1
Goiânia Brazil 145 A2
Goiás Brazil 145 A1
Goiás state Brazil 145 A2
Goinsargoin China 76 C2
Goio-Erê Brazil 144 F2
Gojra Pak. 89 I4
Gokak India 84 B2
Gokarn India 84 B3
Gök Çay r. Turkey 85 A1
Gökçeada i. Turkey 59 K4
Gökdepe Turkm. see Gökdepe
Gökdere r. Turkey 85 A1
Goklenkuy, Solonchak salt l.
 Turkm. 88 E1
Gökova Körfezi b. Turkey 59 L6
Gokprosh Hills Pak. 89 F5
Göksun Turkey 90 E3
Goksu Parkı Turkey 85 A1
Gokteik Myanmar 70 B2
Gokwe Zimbabwe 99 C5
Gol Norway 45 F6
Golaghat India 83 H4
Golbāf Iran 88 E4
Gölbaşı Turkey 90 E3
Golconda U.S.A. 128 E1
Gölcük Turkey 59 M4
Gold U.S.A. 135 G3
Gołdap Poland 47 S3
Gold Beach U.S.A. 126 B4
Goldberg Germany 53 M1
Gold Coast Africa see Ghana
Gold Coast Australia 112 F2
Golden U.S.A. 126 G5
Golden Bay N.Z. 113 D5
Goldendale U.S.A. 126 C3
Goldene Aue reg. Germany 53 K3
Golden Gate Highlands National Park
 S. Africa 101 I5
Golden Hinde mt. Canada 120 E5
Golden Lake Canada 135 G1
Golden Prairie Canada 121 I5
Goldenstedt Germany 53 I2
Goldfield U.S.A. 128 E3
Goldsand Lake Canada 121 K3
Goldsboro U.S.A. 133 E5
Goldstone Lake U.S.A. 128 E4
Goldsworthy Australia 108 B5
Goldthwaite U.S.A. 131 D6
Goldvein U.S.A. 135 G4
Göle Turkey 91 F2
Goleniów Poland see Goleniów
Goleta U.S.A. 128 D4
Golets-Davydov, Gora mt. Rus. Fed. 73 J2
Golfo di Orosei Gennargentu e Asinara,
 Parco Nazionale del nat. park Sardinia
 Italy 58 C4
Gölgeli Dağları mts Turkey 59 M6
Goliad U.S.A. 131 D6
Golingka China see Gongbo'gyamda
Gölköy Turkey 90 E2
Gollel Swaziland see Lavumisa
Golm Germany 53 M2
Golmberg hill Germany 53 N2
Golmud China 80 H4
Golovnino Rus. Fed. 74 G4
Golpāyegān Iran 88 C3
Gölpazarı Turkey 59 N4
Golspie U.K. 50 F3
Gol Vardeh Iran 89 F3
Golyama Syutkya mt. Bulg. 59 K4
Golyam Persenk mt. Bulg. 59 K4
Golyshi Rus. Fed. see Vetluzhskiy

Golzow Germany 53 M2
Goma Dem. Rep. Congo 98 C4
Gomang Co salt l. China 83 G3
Gomati r. India 87 N4
Gombak, Bukit hill Sing. 71 [inset]
Gombe Nigeria 96 E3
Gombe r. Tanz. 99 D4
Gombi Nigeria 96 E3
Gombroon Iran see Bandar-e 'Abbās
Gomel' Belarus see Homyel'
Gómez Palacio Mex. 131 C7
Gomīshān Iran 88 D2
Gommern Germany 53 L2
Gomo Co salt l. China 83 F2
Gonābād Iran 88 E2
Gonaïves Haiti 137 J5
Gonarezhou National Park
 Zimbabwe 99 D6
Gonbad-e Kavus Iran 88 D2
Gonda India 83 E4
Gondal India 82 B5
Gondar Eth. see Gonder
Gonder Eth. 98 D2
Gondia India 82 E5
Gondiya India see Gondia
Gönen Turkey 59 L4
Gonfreville-l'Orcher France 49 H9
Gong'an China 77 G2
Gongbalou China 83 G3
Gongbo'gyamda China 76 B2
Gongchang China see Longxi
Gongcheng China 77 F3
Gongga Shan mt. China 76 D2
Gonghe Qinghai China 80 J4
Gonghe Yunnan China see Mouding
Gongjiang China see Yudu
Gongogi r. Brazil 145 D1
Gongolgon Australia 112 C3
Gongpoquan China 80 I3
Gongquan China 76 E2
Gongtang China see Damxung
Gongwang Shan mts China 76 D3
Gongxian China see Gongquan
Gonjo China see Coqên
Gonjog China see Kasha
Gonjo China see Coqên
Gonzales CA U.S.A. 128 C3
Gonzales TX U.S.A. 131 D6
Gonzha Rus. Fed. 74 B1
Goochland U.S.A. 135 G5
Goodenough, Cape Antarctica 152 G2
Goodenough Island P.N.G. 106 F2
Gooderham Canada 135 F1
Good Hope, Cape of S. Africa 100 D8
Good Hope Mountain Canada 126 B2
Gooding U.S.A. 126 E4
Goodland IN U.S.A. 134 B3
Goodland KS U.S.A. 130 C4
Goodlettsville U.S.A. 134 B5
Goodooga Australia 112 C2
Goodspeed Nunataks Antarctica 152 E2
Goole U.K. 48 G5
Goolgowi Australia 112 B5
Goolma Australia 112 D4
Gooloogong Australia 112 D4
Goomalling Australia 109 B7
Goombalie Australia 112 B2
Goondiwindi Australia 112 E2
Goongarrie, Lake salt flat Australia 109 C7
Goongarrie National Park
 Australia 109 C7
Goonyella Australia 110 D4
Goorly, Lake salt flat Australia 109 B7
Goose Bay Canada see
 Happy Valley-Goose Bay
Goose Creek U.S.A. 133 D5
Goose Lake U.S.A. 126 C4
Gooty India 84 C3
Gopalganj Bangl. 83 G5
Gopalganj India 83 F4
Gopeshwar India 82 D3
Göppingen Germany 53 J6
Gorakhpur India 83 E4
Goražde Bos.-Herz. 58 H3
Gorbernador r. Arg. 129 J3
Gorczański Park Narodowy nat. park
 Poland 47 R6
Gorda, Punta pt U.S.A. 128 A1
Gördes Turkey 59 M5
Gordil Cent. Afr. Rep. 98 C3
Gordon U.K. 50 G5
Gordon r. Australia 111 [inset]
Gordon Downs Australia 108 E4
Gordon Lake Canada 121 I3
Gordon Lake Canada 121 I3
Gordonsville U.S.A. 135 F4
Goré Chad 97 E4
Gorē Eth. 98 D3
Gore N.Z. 113 B8
Gore U.S.A. 134 F4
Gorebridge U.K. 50 F5
Gore Point U.S.A. 118 C4
Gorey Ireland 51 F5
Gorg Iran 89 E4
Gorgān Iran 88 D2
Gorgān, Khalīj-e Iran 88 D2
Gorge Range hills Australia 108 B5
Gorgona, Isla i. Col. 142 C3
Gorham U.S.A. 135 J1
Gori Georgia 86 F1
Gorinchem Neth. 52 E3
Goris Armenia 91 G3
Gorizia Italy 58 E2
Gorki Belarus see Horki
Gor'kiy Rus. Fed. see Nizhniy Novgorod
Gor'kovskoye Vodokhranilishche resr
 Rus. Fed. 42 I4
Gorlice Poland 43 D6
Görlitz Germany 47 O5
Gorlovka Ukr. see Horlivka
Gorna Dzhumaya Bulg. see Blagoevgrad
Gorna Oryakhovitsa Bulg. 59 K3
Gornji Milanovac Serb. and Mont. 59 I2
Gornji Vakuf Bos.-Herz. 58 G3
Gorno-Altaysk Rus. Fed. 80 F1
Gornotrakiyska Nizina lowland
 Bulg. 59 K3
Gornozavodsk Permskaya Oblast'
 Rus. Fed. 41 R4
Gornozavodsk Sakhalinskaya Oblast'
 Rus. Fed. 74 F3

Gornyak Rus. Fed. 80 F1
Gornye Klyuchi Rus. Fed. 74 D3
Gornyy Rus. Fed. 43 K6
Goro i. Fiji see Koro
Gorodenka Ukr. see Horodenka
Gorodets Rus. Fed. 42 I4
Gorodishche Penzenskaya Oblast'
 Rus. Fed. 43 J5
Gorodishche Volgogradskaya Oblast'
 Rus. Fed. 43 J6
Gorodok Belarus see Haradok
Gorodok Rus. Fed. see Zakamensk
Gorodok Khmel'nyts'ka Oblast' Ukr. see
 Horodok
Gorodok L'viv'ska Oblast' Ukr. see
 Horodok
Gorodovikovsk Rus. Fed. 43 I7
Goroka P.N.G. 69 L8
Gorokhovets Rus. Fed. 42 I4
Gorom Gorom Burkina 96 C3
Gorong, Kepulauan is Indon. 69 I7
Gorongosa mt. Moz. 99 D5
Gorongosa, Parque Nacional de nat. park
 Moz. 99 D5
Gorontalo Indon. 69 G6
Gorshechnoye Rus. Fed. 43 H6
Gort Ireland 51 D4
Gortahork Ireland 51 D2
Gorutuba r. Brazil 145 C1
Gorveh Iran 88 E4
Goryachiy Klyuch Rus. Fed. 91 E1
Görzke Germany 53 M2
Gorzów Wielkopolski Poland 47 O4
Gosainthan mt. China see
 Xixabangma Feng
Gosforth U.K. 48 F3
Goshen CA U.S.A. 128 D3
Goshen IN U.S.A. 134 C3
Goshen NH U.S.A. 135 I2
Goshen NY U.S.A. 135 H3
Goshen VA U.S.A. 134 F5
Goshoba Turkm. see Goşoba
Goslar Germany 53 K3
Goşoba Turkm. 91 I2
Gospić Croatia 58 F2
Gosport U.K. 49 F8
Gossi Mali 96 C3
Gostivar Macedonia 59 I4
Gosu China 76 C1
Göteborg Sweden see Gothenburg
Gōtene Sweden 45 H7
Gotenhafen Poland see Gdynia
Gotha Germany 53 K4
Gothenburg Sweden 45 G8
Gothenburg U.S.A. 130 C3
Gotland i. Sweden 45 K8
Gotō-rettō is Japan 75 C6
Gotse Delchev Bulg. 59 J4
Gotska Sandön i. Sweden 45 K7
Götsu Japan 75 D6
Göttingen Germany 53 J3
Gott Peak Canada 120 F5
Gottwaldov Czech Rep. see Zlín
Gouda Neth. 52 E2
Goudiri Senegal 96 B3
Goudoumaria Niger 96 E3
Goûgaram Niger 96 D3

▶Gough Island S. Atlantic Ocean 148 H8
Dependency of St Helena.

Gouin, Réservoir resr Canada 122 G4
Goulburn Australia 112 D5
Goulburn r. N.S.W. Australia 112 E4
Goulburn r. Vic. Australia 112 B6
Goulburn Islands Australia 108 F2
Goulburn River National Park
 Australia 112 E4
Gould Coast Antarctica 152 J1
Goulou atoll Micronesia see Ngulu
Goundam Mali 96 C3
Goundi Chad 97 E4
Goupil, Lac l. Canada 123 H3
Gouraya Alg. 57 G5
Gourcy Burkina 96 C3
Gourdon France 56 E4
Gouré Niger 96 E3
Gouripur Bangl. 83 G4
Gourma-Rharous Mali 96 C3
Gournay-en-Bray France 52 B5
Goussainville France 52 C5
Gouverneur U.S.A. 135 H1
Governador Valadares Brazil 145 C2
Governor's Harbour Bahamas 133 E7
Govĭ Altayn Nuruu mts Mongolia 80 I3
Govind Ballash Pant Sagar resr
 India 83 E4
Gowanda U.S.A. 135 F2
Gowan Range hills Australia 110 D5
Gowärän Afgh. 89 G4
Gowd-e Mokh l. Iran 88 D4
Gowd-e Zereh plain Afgh. 89 F4
Gowmal Kalay Afgh. 89 H3
Gowna, Lough l. Ireland 51 E4
Goya Arg. 144 E3
Göýçay Azer. 91 G2
Goyder watercourse Australia 109 F6
Goýmatdag hills Turkm. 88 D1
Goymatdag hills Turkm. see Goýmatdag
Göynük Turkey 59 N4
Goyoum Cameroon 96 E4
Gozareh Afgh. 89 F3
Goz-Beïda Chad 97 F3
Gozha Co salt l. China 82 E2
Gozo i. Malta 58 F6
Graaff-Reinet S. Africa 100 G7
Grabfeld plain Germany 53 K4
Grabo Côte d'Ivoire 96 C4
Grabow Germany 53 L1
Gračac Croatia 58 F2
Gračanica Bos.-Herz. 58 H2
Gracefield Canada 122 F5
Gracey U.S.A. 134 B5
Gradaús, Serra dos hills Brazil 143 H5
Gradiška Bos.-Herz. see
 Bosanska Gradiška
Grady U.S.A. 131 C5
Gräfenhainichen Germany 53 M3
Grafenwöhr Germany 53 L5
Grafton Australia 112 F2

Grafton ND U.S.A. 130 D1
Grafton WI U.S.A. 134 B2
Grafton WV U.S.A. 134 E4
Grafton, Cape Australia 110 D3
Grafton, Mount U.S.A. 129 F2
Grafton Passage Australia 110 D3
Graham NC U.S.A. 132 E4
Graham TX U.S.A. 131 D5
Graham, Mount U.S.A. 129 I5
Graham Bell Island Rus. Fed. see
 Greem-Bell, Ostrov
Graham Island B.C. Canada 120 C4
Graham Island Nunavut Canada 119 I2
Graham Land reg. Antarctica 152 L2
Grahamstown S. Africa 101 H7
Grahovo Bos.-Herz. see
 Bosansko Grahovo
Graigue Ireland 51 F5
Grajaú Brazil 143 I5
Grajaú r. Brazil 143 J4
Grammont Belgium see Geraardsbergen
Grammos mt. Greece 59 I4
Grampian Mountains U.K. 50 E4
Grampians National Park Australia 111 C8
Granada Nicaragua 137 G6
Granada Spain 57 E5
Granada U.S.A. 130 C4
Granard Ireland 51 E4
Granbury U.S.A. 131 D5
Granby Canada 123 G5
Gran Canaria i. Canary Is 96 B2
Gran Chaco reg. Arg./Para. 144 D3
Grand r. MO U.S.A. 130 E4
Grand r. SD U.S.A. 130 C2
Grand Atlas mts Morocco see Haut Atlas
Grand Bahama i. Bahamas 133 E7
Grand Ballon mt. France 47 K7
Grand Bank Canada 123 L5
Grand Banks of Newfoundland sea feature
 N. Atlantic Ocean 148 E3
Grand-Bassam Côte d'Ivoire 96 C4
Grand-Bay-Westfield Canada 123 I5
Grand Bend Canada 134 E2
Grand Blanc U.S.A. 134 D2
Grand Canal Ireland 51 E4
Grand Canary i. Canary Is see
 Gran Canaria
Grand Canyon U.S.A. 129 G3
Grand Canyon gorge U.S.A. 129 G3
Grand Canyon National Park U.S.A. 129 G3
Grand Canyon - Parashant National
 Monument nat. park U.S.A. 129 G3
Grand Cayman i. Cayman Is 137 H5
Grand Drumont mt. France 47 K7
Grande r. Bahia Brazil 145 B1
Grande r. São Paulo Brazil 145 A3
Grande r. Nicaragua 137 H6
Grande, Bahía b. Arg. 144 C8
Grande, Ilha i. Brazil 145 B3
Grande Cache Canada 120 G4
Grande Comore i. Comoros see Njazidja
Grande Prairie Canada 120 G4
Grand Erg de Bilma des. Niger 96 E3
Grand Erg Occidental des. Alg. 54 D5
Grand Erg Oriental des. Alg. 54 F5
Grande-Rivière Canada 123 J4
Grandes, Salinas salt marsh Arg. 144 C4
Grande-Vallée Canada 123 J4
Grand Falls N.B. Canada 123 I5
Grand Falls-Windsor Nfld. and Lab.
 Canada 123 L4
Grand Forks Canada 120 G5
Grand Forks U.S.A. 130 D2
Grand Gorge U.S.A. 135 H2
Grand Haven U.S.A. 134 B2
Grandin, Lac l. Canada 120 G1
Grandioznyy, Pik mt. Rus. Fed. 72 H2
Grand Island U.S.A. 130 D3
Grand Isle U.S.A. 131 F6
Grand Junction U.S.A. 129 I2
Grand Lac Germain l. Canada 123 J4
Grand-Lahou Côte d'Ivoire 96 C4
Grand Lake N.B. Canada 123 I5
Grand Lake Nfld. and Lab. Canada 123 J3
Grand Lake Nfld. and Lab. Canada 123 K4
Grand Lake LA U.S.A. 131 E6
Grand Lake MI U.S.A. 134 D1
Grand Lake MI U.S.A. 134 D1
Grand Lake St Marys U.S.A. 134 C3
Grand Ledge U.S.A. 134 C2
Grand Manan Island Canada 123 I5
Grand Marais MI U.S.A. 132 C2
Grand Marais MN U.S.A. 130 F2
Grand-Mère Canada 123 G5
Grand Mesa U.S.A. 129 J2
Grand Passage New Caledonia 107 G3
Grand Rapids Canada 121 L4
Grand Rapids MI U.S.A. 134 C2
Grand Rapids MN U.S.A. 130 E2
Grand-Sault Canada see Grand Falls
Grand St-Bernard, Col du pass Italy/Switz.
 see Great St Bernard Pass
Grand Teton mt. U.S.A. 126 F4
Grand Teton National Park U.S.A. 126 F4
Grand Traverse Bay U.S.A. 134 C1

▶Grand Turk Turks and Caicos Is 137 J4
Capital of the Turks and Caicos Islands.

Grandville U.S.A. 134 C2
Grandvilliers France 52 B5
Grant Wash Cliffs mts U.S.A. 129 F4
Grange Ireland 51 E6
Grängesberg Sweden 45 I6
Grangeville U.S.A. 126 D3
Granisle Canada 120 E4
Granite Falls U.S.A. 130 E2
Granite Mountain U.S.A. 128 E1
Granite Mountains CA U.S.A. 129 F5
Granite Mountains CA U.S.A. 129 F5
Granite Peak MT U.S.A. 126 F3
Granite Peak AK U.S.A. 129 G1
Granite Peak UT U.S.A. 129 G1
Granite Range mts AK U.S.A. 120 A2
Granite Range mts NV U.S.A. 128 D1
Granitola, Capo c. Sicily Italy 58 E6
Granja Brazil 143 J4
Gran Laguna Salada l. Arg. 144 C6
Gränna Sweden 45 I7
Gran Paradiso mt. Italy 58 B2
Gran Paradiso, Parco Nazionale del
 nat. park Italy 58 B2
Gran Pilastro mt. Austria/Italy 47 M7

Gran San Bernardo, Colle del *pass* Italy/Switz. *see* Great St Bernard Pass
Gran Sasso e Monti della Laga, Parco Nazionale del *nat. park* Italy **58** E3
Granschütz Germany **53** M3
Gransee Germany **53** N1
Grant U.S.A. **130** C3
Grant, Mount U.S.A. **128** E2
Grantham U.K. **49** G6
Grant Island Antarctica **152** J2
Grant Lake Canada **120** J2
Grantown-on-Spey U.K. **50** F3
Grant Range *mts* U.S.A. **129** F2
Grants U.S.A. **129** J4
Grants Pass U.S.A. **126** C4
Grantsville *UT* U.S.A. **129** G1
Grantsville *WV* U.S.A. **134** E4
Granville Canada **120** B2
Granville France **56** D2
Granville *AZ* U.S.A. **129** I5
Granville *NY* U.S.A. **135** I2
Granville *TN* U.S.A. **134** C5
Granville Lake Canada **121** K3
Grão Mogol Brazil **145** C2
Grapevine Mountains U.S.A. **128** E3
Gras, Lac de *l.* Canada **121** I1
Graskop S. Africa **101** J3
Grasplatz Namibia **100** B4
Grass *r.* Canada **121** L3
Grass *r.* U.S.A. **135** H1
Grasse France **56** H5
Grassflat U.S.A. **135** F3
Grassington U.K. **48** F4
Grasslands National Park Canada **121** J5
Grassrange U.S.A. **126** F3
Grass Valley U.S.A. **128** C2
Grassy Butte U.S.A. **130** C2
Grästorp Sweden **45** H7
Gratz U.S.A. **134** C4
Graudenz Poland *see* Grudziądz
Graus Spain **57** G2
Gravatai Brazil **145** A5
Grave, Pointe de *pt* France **56** D4
Gravelbourg Canada **121** J5
Gravel Hill Lake Canada **121** K2
Gravelines France **52** C4
Gravelotte S. Africa **101** J2
Gravenhurst Canada **134** F1
Grave Peak U.S.A. **126** E3
Gravesend Australia **112** E2
Gravesend U.K. **49** H7
Gravina in Puglia Italy **58** G4
Grawn U.S.A. **134** C1
Gray France **56** G3
Gray *GA* U.S.A. **133** D5
Gray *KY* U.S.A. **134** C5
Gray *ME* U.S.A. **135** J2
Grayback Mountain U.S.A. **126** C4
Gray Lake Canada **121** I2
Grayling *r.* Canada **120** E3
Grayling U.S.A. **134** C1
Grays U.K. **49** H7
Grays Harbor *inlet* U.S.A. **126** B3
Grays Lake U.S.A. **126** F4
Grayson U.S.A. **134** D4
Graz Austria **47** O7
Greasy Lake Canada **120** F2
Great Abaco *i.* Bahamas **133** E7
Great Australian Bight *g.* Australia **109** E8
Great Baddow U.K. **49** H7
Great Bahama Bank *sea feature* Bahamas **133** E7
Great Barrier Island N.Z. **113** E3
►Great Barrier Reef Australia **110** D1
Great Barrier Reef Marine Park (Cairns Section) Australia **110** D3
Great Barrier Reef Marine Park (Capricorn Section) Australia **110** E4
Great Barrier Reef Marine Park (Central Section) Australia **110** E3
Great Barrier Reef Marine Park (Far North Section) Australia **110** D2
Great Barrington U.S.A. **135** I2
Great Basalt Wall National Park Australia **110** D3
Great Basin U.S.A. **128** E2
Great Basin National Park U.S.A. **129** F2
Great Bear *r.* Canada **120** E1
─────
►Great Bear Lake Canada **120** G1
4th largest lake in North America.
─────
Great Belt *sea chan.* Denmark **45** G9
Great Bend U.S.A. **130** D4
Great Bitter Lake Egypt **85** A4
Great Blasket Island Ireland **51** B5
─────
►Great Britain *i.* U.K. **46** G4
Largest island in Europe.
Europe **36–37**
─────
Great Clifton U.K. **48** D4
Great Coco Island Cocos Is **68** A4
Great Cumbrae *i.* U.K. **50** E5
Great Dismal Swamp National Wildlife Refuge *nature res.* U.S.A. **135** G5
Great Dividing Range *mts* Australia **112** B6
Great Eastern Erg *des.* Alg. *see* Grand Erg Oriental
Greater Antarctica *reg.* Antarctica *see* East Antarctica
Greater Antilles *is* Caribbean Sea **137** H4
Greater Khingan Mountains China *see* Da Hinggan Ling
Greater St Lucia Wetland Park *nature res.* S. Africa **101** K4
Greater Tunb *i.* The Gulf **88** D5
Great Exuma *i.* Bahamas **133** F8
Great Falls U.S.A. **126** F3
Great Fish *r.* S. Africa **101** H7
Great Fish Point S. Africa **101** H7
Great Fish River Reserve Complex *nature res.* S. Africa **101** H7
Great Gandak *r.* India **83** F4
Great Guana Cay *i.* Bahamas **133** E7
Great Inagua *i.* Bahamas **137** J4
Great Karoo *plat.* S. Africa **100** F7
Great Kei *r.* S. Africa **101** I7
Great Lake Australia **111** [inset]
Great Malvern U.K. **49** E6
─────
Great Meteor Tablemount *sea feature* N. Atlantic Ocean **148** G4
Great Namaqualand *reg.* Namibia **100** C4
Great Nicobar *i.* India **71** A6
Great Ormes Head *hd* U.K. **48** D5
Great Ouse *r.* U.K. **49** H6
Great Oyster Bay Australia **111** [inset]
Great Palm Islands Australia **110** D3
Great Plain of the Koukdjuak Canada **119** K3
Great Plains U.S.A. **130** C3
Great Point U.S.A. **135** J3
Great Rift Valley Africa **98** D4
Great Ruaha *r.* Tanz. **99** D4
Great Sacandaga Lake U.S.A. **135** H2
Great St Bernard Pass Italy/Switz. **58** B2
Great Salt Lake U.S.A. **129** G1
Great Salt Lake Desert U.S.A. **129** G1
Great Sand Hills Canada **121** I5
Great Sand Sea *des.* Egypt/Libya **90** B5
Great Sandy Desert Australia **108** C5
Great Sandy Island Australia *see* Fraser Island
Great Sea Reef Fiji **107** H3
─────
►Great Slave Lake Canada **120** H2
Deepest and 5th largest lake in North America.
─────
Great Smoky Mountains U.S.A. **133** C5
Great Smoky Mountains National Park U.S.A. **132** D5
Great Snow Mountain Canada **120** E3
Greatstone-on-Sea U.K. **49** H8
Great Stour *r.* U.K. **49** I7
Great Torrington U.K. **49** C8
Great Victoria Desert Australia **109** E7
Great Wall *research station* Antarctica **152** A2
Great Wall *tourist site* China **73** L4
Great Waltham U.K. **49** H7
Great Western Erg *des.* Alg. *see* Grand Erg Occidental
Great West Torres Islands Myanmar **71** B5
Great Whernside *hill* U.K. **48** F4
Great Yarmouth U.K. **49** I6
Grebenkovskiy Ukr. *see* Hrebinka
Grebyonka Ukr. *see* Hrebinka
Greco, Cape Cyprus *see* Greko, Cape
Gredos, Sierra de *mts* Spain **57** D3
►Greece *country* Europe **59** I5
Europe **5, 38–39**
Greece U.S.A. **135** G2
Greeley U.S.A. **126** G4
Greely Center U.S.A. **130** D3
Greem-Bell, Ostrov *i.* Rus. Fed. **64** H1
Green *r. KY* U.S.A. **134** B5
Green *r. WY* U.S.A. **129** I2
Green Bay U.S.A. **134** A1
Green Bay *b.* U.S.A. **134** B1
Greenbrier U.S.A. **134** B5
Greenbrier *r.* U.S.A. **134** E5
Green Cape Australia **112** E6
Greencastle Bahamas **133** E7
Greencastle U.K. **51** F3
Greencastle U.S.A. **134** B4
Green Cove Springs U.S.A. **133** D6
Greene *ME* U.S.A. **135** J1
Greene *NY* U.S.A. **135** H2
Greeneville U.S.A. **132** D4
Greenfield *CA* U.S.A. **128** C3
Greenfield *IN* U.S.A. **134** C4
Greenfield *MA* U.S.A. **135** I2
Greenfield *OH* U.S.A. **134** D4
Green Head *hd* Australia **109** A7
Greenhill Island Australia **108** F2
Green Island Taiwan *see* Lü Tao
Green Lake Canada **121** J4
─────
►Greenland *terr.* N. America **119** N3
Self-governing Danish Territory. Largest island in the world and in North America.
World **12–13**
─────
Greenland Basin *sea feature* Arctic Ocean **153** I2
Greenland Fracture Zone *sea feature* Arctic Ocean **153** I1
Greenland Sea Greenland/Svalbard **64** A2
Greenlaw U.K. **50** G5
Green Mountains U.S.A. **135** I1
Greenock U.K. **50** E5
Greenore Ireland **51** F3
Greenport U.S.A. **135** I3
Green River P.N.G. **69** K7
Green River *UT* U.S.A. **129** H2
Green River *WY* U.S.A. **126** F4
Green River Lake U.S.A. **134** C5
Greensboro U.S.A. **133** D5
Greensburg *IN* U.S.A. **134** C4
Greensburg *KS* U.S.A. **130** D4
Greensburg *KY* U.S.A. **134** C5
Greensburg *LA* U.S.A. **131** F6
Greensburg *PA* U.S.A. **134** F3
Greens Peak U.S.A. **129** I4
Greenstone Point U.K. **50** D3
Green Swamp U.S.A. **133** E5
Greentown U.S.A. **134** C3
Greenup *IL* U.S.A. **130** F4
Greenup *KY* U.S.A. **134** D4
Green Valley Canada **135** H1
Greenville Canada **120** D4
Greenville Liberia **96** C4
Greenville *AL* U.S.A. **133** C6
Greenville *IL* U.S.A. **130** F4
Greenville *KY* U.S.A. **134** B5
Greenville *ME* U.S.A. **132** G2
Greenville *MI* U.S.A. **134** C2
Greenville *MS* U.S.A. **131** F5
Greenville *NC* U.S.A. **132** E5
Greenville *NH* U.S.A. **135** J2
Greenville *OH* U.S.A. **134** C3
Greenville *PA* U.S.A. **134** E3
Greenville *SC* U.S.A. **133** D5
Greenville *TX* U.S.A. **131** D5
Greenwich *atoll* Micronesia *see* Kapingamarangi
Greenwich U.K. **49** G7
Greenwich *CT* U.S.A. **135** I3
Greenwich *OH* U.S.A. **134** D3
─────
Greenwood *AR* U.S.A. **131** E5
Greenwood *IN* U.S.A. **134** B4
Greenwood *MS* U.S.A. **131** F5
Greenwood *SC* U.S.A. **133** D5
Gregory *r.* Australia **110** B3
Gregory, Lake *salt flat S.A.* Australia **111** B6
Gregory, Lake *salt flat W.A.* Australia **108** D5
Gregory, Lake *salt flat W.A.* Australia **109** B6
Gregory Downs Australia **110** B3
Gregory National Park Australia **108** E4
Gregory Range *hills* Qld Australia **110** C3
Gregory Range *hills W.A.* Australia **108** C5
Greifswald Germany **47** N3
Greiz Germany **53** M4
Greko, Cape Cyprus **85** B2
Gremikha Rus. Fed. **153** G2
Gremyachinsk Rus. Fed. **41** R4
Grená Denmark **45** G8
Grenaa Denmark *see* Grená
Grenada U.S.A. **131** F5
►Grenada *country* West Indies **137** L6
North America **9, 116–117**
Grenade France **56** E5
Grenen *spit* Denmark **45** G8
Grenfell Australia **112** D4
Grenfell Canada **121** K5
Grenoble France **56** G4
Grense-Jakobselv Norway **44** Q2
Grenville, Cape Australia **110** C1
Grenville Island Fiji *see* Rotuma
Greshak Pak. **89** G5
Gresham U.S.A. **126** C3
Greußen Germany **53** K3
Grevelingen *sea chan.* Neth. **52** D3
Greven Germany **53** H2
Grevena Greece **59** I4
Grevenbicht Neth. **52** F3
Grevenbroich Germany **52** G3
Grevenmacher Lux. **52** G5
Grevesmühlen Germany **47** M4
Grey, Cape Australia **110** B2
Greybull U.S.A. **126** F3
Greybull *r.* U.S.A. **126** F3
Grey Hunter Peak Canada **120** C2
Grey Islands Canada **123** L4
Greylock, Mount U.S.A. **135** I2
Greymouth N.Z. **113** C6
Grey Range *hills* Australia **112** A2
Grey's Plains Australia **109** A6
Greytown S. Africa **101** J5
Grez-Doiceau Belgium **52** E4
Gribanovskiy Rus. Fed. **43** I6
Gridley U.S.A. **128** C2
Griffin U.S.A. **133** C5
Griffith Australia **112** C5
Grigan *i.* N. Mariana Is *see* Agrihan
Grik Malaysia *see* Gerik
Grim, Cape Australia **111** [inset]
Grimari Cent. Afr. Rep. **98** C3
Grimma Germany **53** M3
Grimmen Germany **47** N3
Grimnitzsee *l.* Germany **53** N2
Grimsby U.K. **48** G5
Grímsey *i.* Iceland **44** [inset]
Grimshaw Canada **120** G3
Grímsstaðir Iceland **44** [inset]
Grimstad Norway **45** F7
Grindavík Iceland **44** [inset]
Grindsted Denmark **45** F9
Grind Stone City U.S.A. **134** D1
Grindul Chituc *spit* Romania **59** M2
Grinnell Peninsula Canada **119** I2
Griqualand East *reg.* S. Africa **101** I6
Griqualand West *reg.* S. Africa **100** F5
Griquatown S. Africa **100** F5
Grise Fiord Canada **119** J2
Grishino Ukr. *see* Krasnoarmiys'k
Gris Nez, Cap *c.* France **52** B4
Gritley U.K. **50** G2
Grizzly Bear Mountain *hill* Canada **120** F1
Grmeč *mts* Bos.-Herz. **58** G2
Grobbendonk Belgium **52** E3
Groblersdal S. Africa **101** I3
Groblershoop S. Africa **100** F5
Groen *watercourse* S. Africa **100** F6
Groen *watercourse* S. Africa **100** C6
Groix, Île de *i.* France **56** C3
Grombalia Tunisia **58** D6
Gronau (Westfalen) Germany **52** H2
Grong Norway **44** H4
Groningen Neth. **52** G1
Groninger Wad *tidal flat* Neth. **52** G1
Grønland *terr.* N. America *see* Greenland
Groom Lake U.S.A. **129** F3
Groot-Aar Pan *salt pan* S. Africa **100** E4
Groot Berg *r.* S. Africa **100** D7
Groot Brakrivier S. Africa **100** F8
Grootdraaidam *dam* S. Africa **101** I4
Grootdrink S. Africa **100** E5
Groote Eylandt *i.* Australia **110** B2
Grootfontein Namibia **99** B5
Groot Karas Berg *plat.* Namibia **100** D4
Groot Letaba *r.* S. Africa **101** J2
Groot Marico S. Africa **101** H3
Groot Swartberge *mts* S. Africa **100** E7
Grootvloer *salt pan* S. Africa **100** E5
Groot Winterberg *mt.* S. Africa **101** H7
Gros Barmen Namibia **100** C2
Gros Morne National Park Canada **123** K4
─────
Großer Rachel *mt.* Germany **47** N6
Grosser Speikkogel *mt.* Austria **47** O7
Grosseto Italy **58** D3
Groß-Gerau Germany **53** I5
Großglockner *mt.* Austria **47** N7
Groß Oesingen Germany **53** K2
Groß Schönebeck Germany **53** N2
Gross Ums Namibia **100** D2
Großvenediger *mt.* Austria **47** N7
Gros Ventre Range *mts* U.S.A. **126** F4
Groswater Bay Canada **123** K3
Groton U.S.A. **130** D2
Grottoes U.S.A. **135** F4
Grou Neth. **52** F1
Groundhog *r.* Canada **122** E4
Grouw Neth. *see* Grou
Grove U.S.A. **131** E4
Grove City U.S.A. **134** D4
Grove Hill U.S.A. **133** C6
Grove Mountains Antarctica **152** E2
Grover Beach U.S.A. **128** C4
Grovertown U.S.A. **134** B3
Groveton *NH* U.S.A. **135** J1
Groveton *TX* U.S.A. **131** E6
Growler Mountains U.S.A. **129** G5
Groznyy Rus. Fed. **91** G2
Grubišno Polje Croatia **58** G2
Grudovo Bulg. *see* Sredets
Grudziądz Poland **47** Q4
Grünau Namibia **100** D4
Grünberg Poland *see* Zielona Góra
Grundarfjörður Iceland **44** [inset]
Grundy U.S.A. **134** D5
Gruñidora Mex. **131** C7
Grünstadt Germany **53** I5
Gruver U.S.A. **131** C4
Gruzinskaya S.S.R. *country* Asia *see* Georgia
Gryazi Rus. Fed. **43** H5
Gryazovets Rus. Fed. **42** I4
Gryfice Poland **47** O4
Gryfino Poland **47** O4
Gryfów Śląski Poland **47** O5
Gryllefjord Norway **44** J2
Grytviken S. Georgia **144** I8
Gua India **83** F5
Guacanayabo, Golfo de *b.* Cuba **137** I4
Guachochi Mex. **127** G8
Guadajoz *r.* Spain **57** D5
Guadalajara Mex. **136** D4
Guadalajara Spain **57** E3
Guadalcanal *i.* Solomon Is **107** G2
Guadalete *r.* Spain **57** C5
Guadalope *r.* Spain **57** F3
Guadalquivir *r.* Spain **57** C5
Guadalupe Mex. **131** C7
Guadalupe *i.* Mex. **127** D7
Guadalupe *watercourse* Mex. **128** E5
Guadalupe U.S.A. **128** C4
Guadalupe, Sierra de *mts* Spain **57** D4
Guadalupe Bravos Mex. **127** G7
Guadalupe Mountains National Park U.S.A. **127** G7
Guadalupe Peak U.S.A. **127** G7
Guadalupe Victoria *Baja California* Mex. **129** F5
Guadalupe Victoria *Durango* Mex. **131** B7
Guadarrama, Sierra de *mts* Spain **57** D3
─────
►Guadeloupe *terr.* West Indies **137** L5
French Overseas Department.
North America **9, 116–117**
─────
Guadeloupe Passage Caribbean Sea **137** L5
Guadiana *r.* Port./Spain **57** C5
Guadix Spain **57** E5
Guafo, Isla *i.* Chile **144** B6
Guaiba Brazil **145** A5
Guaiçuí Brazil **145** B2
Guaíra Brazil **144** F2
Guajaba, Cayo *i.* Cuba **133** E8
Guaje, Llano de *plain* Mex. **131** C7
Gualala U.S.A. **128** B2
Gualeguay Arg. **144** E4
Gualeguaychu Arg. **144** E4
Gualicho, Salina *salt flat* Arg. **144** C6
─────
►Guam *terr.* N. Pacific Ocean **69** K4
United States Unincorporated Territory.
Oceania **8, 104–105**
─────
Guamblín, Isla *i.* Chile **144** A6
Guampí, Sierra de *mts* Venez. **142** E2
Guamúchil Mex. **127** F8
Guanabacoa Cuba **133** D8
Guanacevi Mex. **131** B7
Guanahacabibes, Península de *pen.* Cuba **133** C8
Guanajay Cuba **133** D8
Guanajuato Mex. **136** D4
Guanambi Brazil **145** C1
Guanare Venez. **142** E2
Guandu China **77** G3
Guane Cuba **137** H4
Guang'an China **76** E2
Guangchang China **77** H3
Guangdong *prov.* China **77** [inset]
Guanghai China **77** G4
Guanghan China **76** E2
Guanghua China *see* Laohekou
Guangming China *see* Xide
Guangming Ding *mt.* China **77** H2
Guangshan China **77** G2
Guangxi *aut. reg.* China *see* Guangxi Zhuangzu Zizhiqu
Guangxi Zhuangzu Zizhiqu *aut. reg.* China **76** E4
Guangyuan China **76** E1
Guangze China **77** H3
Guangzhou China **77** G4
Guanhães Brazil **145** C2
Guanhe Kou *r. mouth* China **77** H1
Guanipa *r.* Venez. **142** F2
Guanling China **76** E3
Guanmian Shan *mts* China **77** F2
Guannan China **77** H1
Guanpo China **77** F1
Guanshui China **74** B4
─────
Guansuo China *see* Guanling
Guantánamo Cuba **137** I4
Guanxian China *see* Dujiangyan
Guanyang China **77** F3
Guanyinqiao China **76** D2
Guanyun China **77** H1
Guapé Brazil **145** B3
Guapi Col. **142** C3
Guaporé *r.* Bol./Brazil **142** E6
Guaporé Brazil **145** A5
Guaqui Bol. **142** E7
Guará *r.* Brazil **145** B1
Guarabira Brazil **143** K5
Guaranda Ecuador **142** C4
Guarapari Brazil **145** C3
Guarapuava Brazil **145** A4
Guararapes Brazil **145** A3
Guaratinguetá Brazil **145** B3
Guaratuba, Baía de *b.* Brazil **145** A4
Guarda Port. **57** C3
Guardafui, Cape Somalia *see* Gwardafuy, Gees
Guardiagrele Italy **58** F3
Guardo Spain **57** D2
Guárico, del Embalse *resr* Venez. **142** E2
Guarujá Brazil **145** B3
Guasave Mex. **127** F8
Guasdualito Venez. **142** D2
─────
►Guatemala *country* Central America **136** F5
4th most populous country in Central and North America.
North America **9, 116–117**
─────
Guatemala Guat. *see* Guatemala City
─────
►Guatemala City Guat. **136** F6
Capital of Guatemala.
─────
Guaviare *r.* Col. **142** E3
Guaxupé Brazil **145** B3
Guayaquil Ecuador **142** C4
Guayaquil, Golfo de *g.* Ecuador **142** B4
Guaymas Mex. **127** F8
Guba Eth. **98** D2
Gubakha Rus. Fed. **41** R4
Gubbi India **84** C3
Gubio Nigeria **96** E3
Gubkin Rus. Fed. **43** H6
Gucheng China **77** F1
Gudari India **84** D2
Gudbrandsdalen *valley* Norway **45** F6
Gudermes Rus. Fed. **91** G2
Gudivada India **84** D2
Gudiyattam India **84** C3
Gudur *Andhra Prad.* India **84** C3
Gudur *Andhra Prad.* India **84** C3
Gudvangen Norway **45** E6
Gudzhal *r.* Rus. Fed. **74** D2
Gué, Rivière du *r.* Canada **123** I2
Guecho Spain *see* Algorta
Guéckédou Guinea **96** B4
Guelma Alg. **58** B6
Guelmine Morocco **96** B2
Guelph Canada **134** E2
Guémez Mex. **131** D8
Guénange France **52** G5
Guerara Alg. **54** E5
Guérard, Lac *l.* Canada **123** I2
Guercif Morocco **54** D5
Guéret France **56** E3
─────
►Guernsey *terr.* Channel Is **49** E9
United Kingdom Crown Dependency.
Europe **5, 38–39**
─────
Guernsey U.S.A. **126** G4
Guérou Mauritania **96** B3
Guerrah Et-Tarf *salt pan* Alg. **58** B7
Guerrero Negro Mex. **127** E8
Guers, Lac *l.* Canada **123** I2
Gueugnon France **56** G3
Gufeng China *see* Pingnan
Gufu China *see* Xingshan
Gügë *mt.* Eth. **98** D3
Gügerd, Küh-e *mts* Iran **88** D3
Guguan *i.* N. Mariana Is **69** L3
Guhakolak, Tanjung *pt* Indon. **68** D8
Guhe China **77** H2
Güh Küh *mt.* Iran **88** E5
Guhuai China *see* Pingyu
Guiana Basin *sea feature* N. Atlantic Ocean **148** E5
Guichi China *see* Chizhou
Guidan-Roumji Niger **96** D3
Guide China **76** D1
Guider Cameroon **97** E4
Guiding China **76** E3
Guidong China **77** G3
Guidonia-Montecelio Italy **58** E4
Guigang China **77** F4
Guiglo Côte d'Ivoire **96** C4
Guignicourt France **52** D5
Guija Moz. **101** K3
Guiji Shan *mts* China **77** I2
Guildford U.K. **49** G7
Guilford U.S.A. **132** G2
Guilherme Capelo Angola *see* Cacongo
Guilin China **77** F3
Guillaume-Delisle, Lac *l.* Canada **122** F2
Guimarães Brazil **143** J4
Guimarães Port. **57** B3
Guinan China **76** D1
─────
►Guinea *country* Africa **96** B3
Africa **7, 94–95**
─────
Guinea, Gulf of Africa **96** D4
Guinea Basin *sea feature* N. Atlantic Ocean **148** H5
─────
►Guinea-Bissau *country* Africa **96** B3
Africa **7, 94–95**
─────
Guinea-Conakry *country* Africa *see* Guinea
Guinea Ecuatorial *country* Africa *see* Equatorial Guinea
Guiné-Bissau *country* Africa *see* Guinea-Bissau
Guinée *country* Africa *see* Guinea
Güines Cuba **137** H4
Guînes France **52** B4
Guines, Lac *l.* Canada **123** J3
─────
Guingamp France **56** C2
Guipavas France **56** B2
Guiping China **77** F4
Güira de Melena Cuba **133** D8
Guiratinga Brazil **143** H7
Guiscard France **52** D5
Guise France **52** D5
Guishan China *see* Xinping
Guishun China **76** E3
Guixi Chongqing China *see* Dianjiang
Guixi *Jiangxi* China **77** H2
Guiyang Guizhou China **76** E3
Guiyang Hunan China **77** G3
Guizhou *prov.* China **76** E3
Guizi China **77** F4
Gujarat *state* India **82** C5
Gujar Khan Pak. **89** I3
Gujerat *state* India *see* Gujarat
Gujranwala Pak. **89** I3
Gujrat Pak. **89** I3
Gukovo Rus. Fed. **43** H6
Gulabgarh Jammu and Kashmir **82** D2
Gulbarga India **84** C2
Gulbene Latvia **45** O8
Gul'cha Kyrg. *see* Gülchö
Gülchö Kyrg. **80** D3
Gülcihan Turkey **85** B1
Gülek Boğazı *pass* Turkey **90** D3
Gulfport U.S.A. **131** F6
Gulian China **74** A1
Gulin China **76** E3
─────
►Guliston Uzbek. *see* Guliston
136 F5
Guliston Uzbek. **80** C3
Gülitz Germany **53** L1
Guliya Shan *mt.* China **74** A2
Gulja China *see* Yining
Gul Kach Pak. **89** H4
Gull Lake Canada **121** I5
Gullrock Lake Canada **121** M5
Gullträsk Sweden **44** L3
Güllük Körfezi *b.* Turkey **59** L6
Gülnar Turkey **85** A1
Gulö China *see* Xincai
Gulu Uganda **98** D3
Guluwuru Island Australia **110** B1
Gulyayevskiye Koshki, Ostrova *is* Rus. Fed. **42** L1
Guma China *see* Pishan
Gumal *r.* Pak. **89** H4
Gumare Botswana **99** C5
Gumbaz Pak. **89** H4
Gumbinnen Rus. Fed. *see* Gusev
Gumdag Turkm. **88** D2
Gumel Nigeria **96** D3
Gümgüm Turkey *see* Varto
Gumla India **83** F5
Gummersbach Germany **53** H3
Gümüşhacıköy Turkey **90** D2
Gümüşhane Turkey **91** E2
Guna India **82** D4
Gunan China *see* Qijiang
Guna Terara *mt.* Eth. **86** E7
Gunbar Australia **112** B5
Gunbower Australia **112** B5
Güncang China **76** B2
Gund *r.* Tajik. *see* Gunt
Gundagai Australia **112** D5
Gundelsheim Germany **53** J5
Güney Turkey **59** M5
Güneydoğu Toroslar *plat.* Turkey **90** F3
Gungliap Myanmar **70** B1
Gungu Dem. Rep. Congo **99** B4
Gunib Rus. Fed. **91** G2
Gunisao *r.* Canada **121** L4
Gunisao Lake Canada **121** L4
Gunnaur India **82** D3
Gunnbjørn Fjeld *nunatak* Greenland **119** P3
Gunnedah Australia **112** E3
Gunning Australia **112** D5
Gunnison U.S.A. **127** G5
Gunnison *r.* U.S.A. **129** I2
Güns Hungary *see* Kőszeg
Gunt *r.* Tajik. **89** I2
Guntakal India **84** C3
Güntersberge Germany **53** K3
Guntur India **84** D2
Gunung Gading National Park Malaysia **71** E7
Gunung Leuser, Taman Nasional Indon. **71** B7
Gunung Nyiut, Suaka Margasatwa *nature res.* Indon. **71** E7
Gunung Palung, Taman Nasional Indon. **68** E7
Gunungsitoli Indon. **71** B7
Günyüzü Turkey **90** C3
Gunza Angola *see* Porto Amboim
Günzburg Germany **47** M6
Gunzenhausen Germany **53** K5
Guo He *r.* China **77** H1
Guovdageaidnu Norway *see* Kautokeino
Guozhen China *see* Baoji
Gupis Jammu and Kashmir **82** C1
Gurbantünggüt Shamo *des.* China **80** G3
Gurdaspur India **82** C2
Gurdon U.S.A. **131** E5
Gurdzhaani Georgia *see* Gurjaani
Güre Turkey **59** M5
Gurgan Iran *see* Gorgān
Gurgaon India **82** D3
Gurgei, Jebel *mt.* Sudan **97** F3
Gurha India **82** B4
Guri, Embalse de *resr* Venez. **142** F2
Gurig National Park Australia **108** F2
Gurinhatã Brazil **145** A2
Gurjaani Georgia **91** G2
Gur Khar Iran **89** E4
Guro Moz. **99** D5
Gurşunmagdan Kärhanasy Turkm. **89** G2
Guru China **83** G3
Gürün Turkey **90** E3
Gurupá Brazil **143** H4
Gurupi Brazil **143** I6
Gurupi *r.* Brazil **143** I4
Guru Sikhar *mt.* India **82** C4
Guruzala India **84** C2
Gur'yev Kazakh. *see* Atyrau
Gur'yevsk Rus. Fed. **45** L9

Harts r. S. Africa 101 G5
Härtsfeld hills Germany 53 K6
Harts Range mts Australia 109 F5
Hartsville U.S.A. 131 E4
Hartswater S. Africa 100 G4
Hartville U.S.A. 134 B5
Hartwell U.S.A. 133 D5
Har Us Nuur l. Mongolia 80 H2
Harvard, Mount U.S.A. 126 G5
Harvey Australia 109 A8
Harvey U.S.A. 130 C2
Harvey Mountain U.S.A. 128 C1
Harwich U.K. 49 I7
Haryana state India 82 D3
Harz hills Germany 47 M5
Har Zin Israel 85 B4
Ḥasāh, Wādī al watercourse Jordan 85 B4
Ḥaṣāh, Wādī al watercourse
 Jordan/Saudi Arabia 85 C4
Hasalbag China 89 J2
Hasan Dağı mts Turkey 90 D3
Hasan Guli Turkm. see Esenguly
Hasankeyf Turkey 91 F3
Hasan Küleh Afgh. 89 F3
Hasanur India 84 C4
Hasardag mt. Turkm. 88 E2
Hasbaïya Lebanon 85 B3
Hasbaya Lebanon see Hasbaïya
Hase r. Germany 53 H2
Haselünne Germany 53 H2
Hashak Iran 89 F5
HaSharon plain Israel 85 B3
Hashtgerd Iran 88 C3
Hashtpar Iran 88 C2
Hashtrud Iran 88 B2
Haskell U.S.A. 131 D5
Haslemere U.K. 49 G7
Ḥaṣ, Jabal al hills Syria 85 C1
Hasse r. Germany 53 H2
Hassayampa watercourse U.S.A. 129 G5
Haßberge hills Germany 53 K4
Hasselt Belgium 52 F4
Hasselt Neth. 52 G2
Hassi Bel Guebbour Alg. 96 D2
Hassi Messaoud Alg. 54 F5
Hässleholm Sweden 45 H8
Hastings Australia 112 B7
Hastings r. Australia 112 F3
Hastings Canada 135 G1
Hastings N.Z. 113 F4
Hastings U.K. 49 H8
Hastings MI U.S.A. 134 C2
Hastings MN U.S.A. 130 E2
Hastings NE U.S.A. 130 D3
Hata India 83 E4
Hatay Turkey see Antakya
Hatay prov. Turkey 85 C1
Hatch U.S.A. 129 C3
Hatches Creek Australia 110 A4
Hatchet Lake Canada 121 K3
Hatfield Australia 112 A4
Hatfield U.K. 48 G5
Hatgal Mongolia 80 J1
Hath India 84 D1
at Head National Park Australia 112 F3
Hathras India 82 D4
Ha Tiên Vietnam 71 D5
Ha Tinh Vietnam 70 D3
Hatisar Bhutan see Geylegphug
Hatod India 82 C5
Hato Hud East Timor see Hatudo
Hatra Iraq 91 F4
Hattah Australia 111 C7
Hatteras, Cape U.S.A. 133 F5
Hatteras Abyssal Plain sea feature
 S. Atlantic Ocean 148 D5
Hattfjelldal Norway 44 H4
Hattiesburg U.S.A. 131 F6
Hattingen Germany 53 H3
Hattras Passage Myanmar 71 B4
Hatudo East Timor 108 D2
Hat Yai Thai. 71 C6
Hau Bon Vietnam see A Yun Pa
Haubstadt U.S.A. 134 B4
Haud reg. Eth. 98 E3
Hauge Norway 45 E7
Haugesund Norway 45 D7
Haukeligrend Norway 45 E7
Haukipudas Fin. 44 N4
Haukivesi l. Fin. 44 P5
Haultain r. Canada 121 J4
Hauraki Gulf N.Z. 113 E3
Haute-Normandie admin. reg.
 France 52 B5
Haute-Volta country Africa see Burkina
Haut-Folin hill France 56 G3
Hauts Plateaux Alg. 54 D5

Havana Cuba 137 H4
Capital of Cuba.

Havana U.S.A. 130 F3
Havant U.K. 49 G8
Havasu, Lake U.S.A. 129 F4
Havel r. Germany 53 L2
Havelange Belgium 52 F4
Havelberg Germany 53 M2
Havelock Canada 135 G1
Havelock N.Z. 113 C6
Havelock Swaziland see Bulembu
Havelock U.S.A. 133 E5
Havelock Falls Australia 108 F3
Havelock Island India 71 A5
Havelock North N.Z. 113 F4
Haverfordwest U.K. 49 C7
Haverhill U.K. 49 H6
Haveri India 84 B3
Haversin Belgium 52 F4
Havixbeck Germany 53 H3
Havlíčkův Brod Czech Rep. 47 O6
Havøysund Norway 44 N1
Havran Turkey 59 L5
Havre U.S.A. 126 F2
Havre Aubert, Île du i. Canada 123 J5
Havre Rock i. Kermadec Is 107 I5
Havre-St-Pierre Canada 123 J4
Havza Turkey 90 D2
Hawai'i i. U.S.A. 127 [inset]

Hawai'ian Islands N. Pacific Ocean 150 I4
Hawaiian Ridge sea feature
 N. Pacific Ocean 150 I4
Hawai'i Volcanoes National Park U.S.A.
 127 [inset]
Hawalli Kuwait 88 C4
Hawar i. Bahrain see Ḩuwār
Hawarden U.K. 48 D5
Hawea, Lake N.Z. 113 B7
Hawera N.Z. 113 E4
Hawes U.K. 48 E4
Hawesville U.S.A. 134 B5
Ḩāwī U.S.A. 127 [inset]
Hawick U.K. 50 G5
Ḩawīzah, Hawr al imp. l. Iraq 91 G5
Hawke r. Canada 120 F2
Hawke Bay N.Z. 113 F4
Hawkes Bay Canada 123 K4
Hawkins Peak U.S.A. 129 G3
Hawlēr Iraq see Arbīl
Hawley U.S.A. 135 H3
Hawng Luk Myanmar 70 B2
Ḩawrān, Wādī watercourse Iraq 91 F4
Ḩawshah, Jibāl al mts Saudi Arabia 88 B6
Hawston S. Africa 100 D8
Hawthorne U.S.A. 128 D2
Haxat China 89 J2
Haxby U.K. 48 F4
Hay Australia 112 B5
Hay watercourse Australia 110 B5
Hay r. Canada 120 H2
Hayachine-san mt. Japan 75 F5
Hayastan country Asia see Armenia
Haydān, Wādī al r. Jordan 85 B4
Hayden AZ U.S.A. 129 H5
Hayden CO U.S.A. 129 J1
Hayden IN U.S.A. 134 C4
Hayes r. Man. Canada 121 N4
Hayes r. Nunavut Canada 119 I3
Hayes Halvø pen. Greenland 119 L2
Hayfield Reservoir U.S.A. 129 F5
Hayfork U.S.A. 128 B1
Hayl, Wādī watercourse Syria 85 C3
Hayl, Wādī al watercourse Syria 85 D2
Hayle U.K. 49 B8
Haymā' Oman 87 I6
Haymana Turkey 90 D3
Haymarket U.S.A. 135 G4
Hay-on-Wye U.K. 49 D6
Hayrabolu Turkey 59 L4
Hay River Canada 118 G2
Hay River Reserve Canada 120 H2
Hays KS U.S.A. 130 D4
Hays MT U.S.A. 126 F2
Hays Yemen 86 F7
Haysville U.S.A. 131 D4
Haysyn Ukr. 43 F6
Hayward CA U.S.A. 128 B3
Hayward WI U.S.A. 130 F2
Haywards Heath U.K. 49 G8
Hazar Turkm. 88 D2
Hazarajat reg. Afgh. 89 G3
Hazard U.S.A. 134 D5
Hazaribag India see Hazaribagh
Hazaribagh India 83 F5
Hazaribagh Range mts India 83 E5
Hazār Masjed, Kūh-e mts Iran 88 E2
Hazebrouck France 52 C4
Hazelton Canada 120 E4
Hazen Strait Canada 119 G2
Hazerswoude-Rijndijk Neth. 52 E2
Hazhdanahr reg. Afgh. 89 G2
Hazleton IN U.S.A. 134 B4
Hazleton PA U.S.A. 135 H3
Hazlett, Lake salt flat Australia 108 E5
Hazrat Sultan Afgh. 89 G2
H. Bouchard Arg. 144 D4
Headford Ireland 51 C4
Headingly Australia 110 B4
Head of Bight b. Australia 109 E7
Healdsburg U.S.A. 128 B2
Healesville Australia 112 B6
Healy U.S.A. 118 D3
Heanor U.K. 49 F5

Heard and McDonald Islands terr.
Indian Ocean 149 M9
Australian External Territory.

Heard Island Indian Ocean 149 M9
Hearne U.S.A. 131 D6
Hearne Lake Canada 121 H2
Hearrenfean Neth. see Heerenveen
Hearst Canada 122 E4
Hearst Island Antarctica 152 L2
Heart r. U.S.A. 130 C2
Heart of Neolithic Orkney tourist site
U.K. 50 F1
Heathcote Australia 112 B6
Heathfield U.K. 49 H8
Heathsville U.S.A. 135 G5
Hebbardsville U.S.A. 134 B5
Hebbronville U.S.A. 131 D7
Hebei prov. China 73 L5
Hebel Australia 112 C2
Heber U.S.A. 129 H4
Heber City U.S.A. 129 H1
Heber Springs U.S.A. 131 E5
Hebi China 73 K5
Hebron Canada 123 J2
Hebron U.S.A. 130 D3
Hebron West Bank 85 B4
Hecate Strait Canada 120 D4
Hecheng Jiangxi China see Zixi
Hecheng Zhejiang China see Qingtian
Hechi China 77 F3
Hechuan Chongqing China 76 E2
Hechuan Jiangxi China see Yongxing
Hecla Island Canada 121 L5
Hede China see Sheyang
Hede Sweden 44 H5
Hedemora Sweden 45 I6
He Devil Mountain U.S.A. 126 D3
Hedi Shuiku resr China 77 F4
Heech Neth. see Heeg
Heeg Neth. 52 F2
Heek Germany 52 H2
Heer Belgium 52 E4
Heerde Neth. 52 G2
Heerenveen Neth. 52 F2
Heerhugowaard Neth. 52 E2

Heerlen Neth. 52 F4
Hefa Israel see Haifa
Hefa, Mifraz Israel see Haifa, Bay of
Hefei China 77 H2
Hefeng China 77 F2
Heflin U.S.A. 133 C5
Hegang China 74 C3
Heho Myanmar 70 B2
Heidan r. Jordan see Haydān, Wādī al
Heidberg hill Germany 53 L3
Heide Germany 47 L3
Heide Namibia 100 C2
Heidelberg Germany 53 I5
Heidelberg S. Africa 101 I4
Heidenheim an der Brenz Germany 53 K6
Heihe China 74 B2
Heilbron S. Africa 101 H4
Heilbronn Germany 53 J5
Heiligenhafen Germany 47 M3
Hei Ling Chau i. H.K. China 77 [inset]
Heilongjiang prov. China 74 C3
Heilong Jiang r. China 74 C2
 also known as Amur (Rus. Fed.)
Heilong Jiang r. China/Rus. Fed. see Amur
Heilsbronn Germany 53 K5
Heilungkiang prov. China see Heilongjiang
Heinola Fin. 45 O6
Heinze Islands Myanmar 71 B4
Heirnkut Myanmar 70 A1
Heishi Beihu l. China 83 E2
Heishui China 76 D1
Heisker Islands U.K. see Monach Islands
Heist-op-den-Berg Belgium 52 E3
Ḩeiṭān, Gebel hill Egypt see Ḩayṭān, Jabal
Hejaz reg. Saudi Arabia see Hijaz
Hejiang China 76 E2
He Jiang r. China 77 F4
Hejing China 80 G3
Hekimhan Turkey 90 E3
Hekla vol. Iceland 44 [inset]
Hekou Gansu China 72 I5
Hekou Hubei China 77 G2
Hekou Jiangxi China see Yanshan
Hekou Sichuan China see Yajiang
Hekou Yunnan China 76 D4
Helagsfjället mt. Sweden 44 H5
Helam India 76 B3
Helan Shan mts China 72 J5
Helbra Germany 53 L3
Helen atoll Palau 69 I6
Helena AR U.S.A. 131 F5

Helena MT U.S.A. 126 E3
State capital of Montana.

Helen Reef Palau 69 I6
Helensburgh U.K. 50 E4
Helen Springs Australia 108 F4
Ḩeleẕ Israel 85 B4
Helgoland i. Germany 47 K3
Helgoländer Bucht g. Germany 47 L3
Heligoland i. Germany see Helgoland
Heligoland Bight g. Germany see
 Helgoländer Bucht
Heliopolis Lebanon see Ba'albek
Helixi China see Ningguo
Hella Iceland 44 [inset]
Helland Norway 44 J2
Hellas country Europe see Greece
Helleh r. Iran 88 C4
Hellespont strait Turkey see Dardanelles
Hellevoetsluis Neth. 52 E3
Hellhole Gorge National Park
 Australia 110 D5
Hellín Spain 57 F4
Hellinikon tourist site Greece 90 A3
Hells Canyon gorge U.S.A. 126 D3
Hell-Ville Madag. see Andoany
Helmand r. Afgh. 89 F4
Helmantica Spain see Salamanca
Helmbrechts Germany 53 L4
Helme r. Germany 53 L3
Helmeringhausen Namibia 100 C3
Helmond Neth. 52 F3
Helmsdale U.K. 50 F2
Helmsdale r. U.K. 50 F2
Helmstedt Germany 53 L2
Helong China 74 C4
Helper U.S.A. 129 H2
Helpter Berge hills Germany 53 N1
Helsingborg Sweden 45 H8
Helsingfors Fin. see Helsinki
Helsingør Denmark 45 H8

Helsinki Fin. 45 N6
Capital of Finland.

Helston U.K. 49 B8
Helvécia Brazil 145 D2
Helvetic Republic country Europe see
 Switzerland
Ḩelwân Egypt see Ḩulwân
Hemel Hempstead U.K. 49 G7
Hemet U.S.A. 128 E5
Hemingford U.S.A. 130 C3
Hemlock Lake U.S.A. 135 G2
Hemmingen Germany 53 J2
Hemmingford Canada 135 I1
Hemmoor Germany 53 J1
Hempstead U.S.A. 131 D6
Hemse Sweden 45 K8
Henan China 76 D1
Henan prov. China 77 G1
Henares r. Spain 57 E3
Henashi-zaki pt Japan 75 E4
Henbury Australia 109 F6
Hendek Turkey 59 N4
Henderson KY U.S.A. 134 B5
Henderson NC U.S.A. 132 E4
Henderson NV U.S.A. 129 F3
Henderson NY U.S.A. 135 G2
Henderson TX U.S.A. 131 E5
Henderson Island Pitcairn Is 151 L7
Hendersonville NC U.S.A. 133 D5
Hendersonville TN U.S.A. 134 B5
Henderville atoll Kiribati see Aranuka
Hendon U.K. 49 G7
Hendorābī i. Iran 88 D5
Hendy-Gwyn U.K. see Whitland
Hengām Iran 89 E5

Hengduan Shan mts China 76 C2
Hengelo Neth. 52 G2
Hengfeng China 77 H2
Hengnan China see Hengyang
Hengshan China 74 C3
Heng Shan mt. China 77 G3
Hengshui Hebei China 73 L5
Hengshui Jiangxi China see Chongyi
Hengxian China 77 F4
Hengyang Hunan China 77 G3
Hengyang Hunan China 77 G3
Hengzhou China see Hengxian
Heniches'k Ukr. 43 G7
Henley N.Z. 113 C7
Henley-on-Thames U.K. 49 G7
Henlopen, Cape U.S.A. 135 H4
Hennebont France 56 C3
Hennef (Sieg) Germany 53 H4
Hennenman S. Africa 101 H4
Hennepin U.S.A. 130 F3
Hennessey U.S.A. 131 D4
Hennigsdorf Berlin Germany 53 N2
Henniker U.S.A. 135 J2
Henning U.S.A. 134 B3
Henrietta U.S.A. 131 D5
Henrietta Maria, Cape Canada 122 E3
Henrieville U.S.A. 129 H3
Henrique de Carvalho Angola see Saurimo
Henry, Cape U.S.A. 135 G5
Henry Ice Rise Antarctica 152 A1
Henry Kater, Cape Canada 119 L3
Henry Mountains U.S.A. 129 H2
Hensall Canada 134 E2
Henshaw, Lake U.S.A. 128 E5
Hentiesbaai Namibia 100 B2
Henty Australia 112 C5
Henzada Myanmar see Hinthada
Heping Guangdong China 77 G3
Heping Guizhou China see Huishui
Heping Guizhou China see Yanhe
Hepo China see Jiexi
Heppner U.S.A. 126 D3
Heptanesus is Ionia Nisia Greece see
 Ionian Islands
Heptanesus is Greece see Ionian Islands
Hepu China 77 F4
Heqing China 76 D3
Hequ China 73 K5
Heraclea Turkey see Ereğli
Heraclea Pontica Turkey see Ereğli
Heraklion Greece see Iraklion
Herald Cays atolls Australia 110 E3
Herāt Afgh. 89 F3
Hérault r. France 56 F5
Herbertabad India 71 A5
Herbert Downs Australia 110 B4
Herbert River Falls National Park
 Australia 110 D3
Herbert Wash salt flat Australia 109 D6
Herborn Germany 53 I4
Herbstein Germany 53 J4
Hercules Dome ice feature
 Antarctica 152 K1
Herdecke Germany 53 H3
Herdorf Germany 53 H4
Hereford U.K. 49 E6
Hereford U.S.A. 131 C5
Héréhérétué atoll Fr. Polynesia 151 K7
Herent Belgium 52 E4
Herford Germany 53 I2
Heringen (Werra) Germany 53 K4
Herington U.S.A. 130 D4
Heris Iran 88 B2
Herisau Switz. 56 I3
Herkimer U.S.A. 135 H2
Herlen Gol r. China/Mongolia 73 L3
Herlen He r. China/Mongolia see
 Herlen Gol
Herleshausen Germany 53 K3
Herlong U.S.A. 128 C1
Herm i. Channel Is 49 E9
Hermanas Mex. 131 C7
Herma Ness hd U.K. 50 [inset]
Hermann U.S.A. 130 F4
Hermannsburg Germany 53 K2
Hermanus S. Africa 100 D8
Hermel Lebanon 85 C2
Hermes, Cape S. Africa 101 I6
Hermidale Australia 112 C3
Herminston U.S.A. 126 D3
Hermitage MO U.S.A. 130 E4
Hermitage PA U.S.A. 134 E3
Hermitage Bay Canada 123 K5
Hermite, Islas is Chile 144 C9
Hermit Islands P.N.G. 69 L7
Hermon, Mount Lebanon/Syria 85 B3
Hermonthis Egypt see Armant
Hermopolis Magna Egypt see
 Al Ashmūnayn
Hermosa Brazil 145 D2
Hermosa U.S.A. 129 J3
Hermosillo Mex. 127 F7
Hernandarias Para. 144 F3
Hernando U.S.A. 131 F5
Herndon CA U.S.A. 128 D3
Herndon PA U.S.A. 135 G3
Herndon WV U.S.A. 134 E5
Herne Germany 53 H3
Herne Bay U.K. 49 I7
Herning Denmark 45 F8
Heroica Nogales Mex. see Nogales
Heroica Puebla de Zaragoza Mex. see
 Puebla
Hérouville-St-Clair France 49 G9
Herrera del Duque Spain 57 D4
Hershey U.S.A. 135 G3
Hertford U.K. 49 G7
Hertzogville S. Africa 101 G5
Herve Belgium 52 F4
Hervé, Lac l. Canada 123 H3
Hervey Islands Cook Is 151 J7
Herzberg Brandenburg Germany 53 M2
Herzberg Brandenburg Germany 53 N3
Herzlake Germany 53 H2
Herzliyya Israel 85 B3
Herzogenaurach Germany 53 K5
Herzsprung Germany 53 M1
Ḩeşār Iran 88 C4
Ḩeşār Iran 88 D5
Hesdin France 52 C4
Hesel Germany 53 H1

Heshan China 77 F4
Heshengqiao China 77 G2
Heshui China see Hengyang
Hesperia U.S.A. 128 E4
Hesperus U.S.A. 129 I3
Hesperus Peak U.S.A. 129 I3
Hesquiat Canada 120 E5
Hess r. Canada 120 C2
Heßdorf Germany 53 K5
Hesse land Germany see Hessen
Hesselberg hill Germany 53 K5
Hessen land Germany 53 I4
Hessisch Lichtenau Germany 53 J3
Hess Mountains Canada 120 C2
Het r. Laos 70 D2
Heteren Neth. 52 F3
Hetou China 77 F4
Hettinger U.S.A. 130 C2
Hetton U.K. 48 E4
Hettstedt Germany 53 L3
Heung Kong Tsai H.K. China see
 Aberdeen
Hevron r. West Bank see Hebron
Hexham U.K. 48 E4
Hexian Anhui China 77 H2
Hexian Guangxi China see Hezhou
Heyang China 77 F1
Ḩeydarābād Iran 88 B2
Ḩeydarābād Iran 88 B3
Heydebreck Poland see Kędzierzyn-Koźle
Heysham U.K. 48 E4
Heyshope Dam S. Africa 101 J4
Heyuan China 77 G4
Heywood U.K. 48 E5
Heze China 77 G1
Hezhang China 76 E3
Hezheng China 76 D1
Hezhou China 77 F3
Hezuo China 76 D1
Hezuozhen China see Hezuo
Hialeah U.S.A. 133 D7
Hiawassee U.S.A. 133 D5
Hiawatha U.S.A. 130 E4
Hibbing U.S.A. 130 E2
Hibbs, Point Australia 111 [inset]
Hibernia Reef Australia 108 C3
Hīchān Iran 89 F5
Hicks, Point Australia 112 D6
Hicks Bay N.Z. 113 G3
Hicks Lake Canada 121 K2
Hicksville U.S.A. 134 C3
Hico U.S.A. 131 D5
Hidaka-sanmyaku mts Japan 74 F4
Hidalgo Mex. 131 D7
Hidalgo del Parral Mex. 131 B7
Hidrolândia Brazil 145 A2
Hierosolyma Israel/West Bank see
 Jerusalem
Higashi-suidō sea chan. Japan 75 C6
Higgins U.S.A. 131 C4
Higgins Bay U.S.A. 135 H2
Higgins Lake U.S.A. 134 C1
High Atlas mts Morocco see Haut Atlas
High Desert U.S.A. 126 C4
High Island i. H.K. China 77 [inset]
High Island U.S.A. 131 E6
High Island Reservoir H.K. China 77 [inset]
Highland Peak CA U.S.A. 128 D2
Highland Peak NV U.S.A. 129 F3
Highlands U.S.A. 133 I3
Highland Springs U.S.A. 135 G5
High Level Canada 120 G3
Highmore U.S.A. 130 D2
High Point U.S.A. 132 E5
High Point hill U.S.A. 135 H3
High Prairie Canada 120 G4
High River Canada 120 H5
Highrock Lake Man. Canada 121 K4
Highrock Lake Sask. Canada 121 J3
High Springs U.S.A. 133 D6
High Tatras mts Poland/Slovakia see
 Tatra Mountains
High Wycombe U.K. 49 G7
Higuera de Zaragoza Mex. 127 F8
Higüey Dom. Rep. 137 K5
Hiiumaa i. Estonia 45 M7
Ḩijānah, Buḩayrat al imp. l. Syria 85 C3
Hijaz reg. Saudi Arabia 86 E4
Ḩikmah, Ra's al pt Egypt 90 B5
Hiko U.S.A. 129 F3
Hikone Japan 75 E6
Hikurangi mt. N.Z. 113 G3
Hila Indon. 108 D1
Hilal, Jabal hill Egypt 85 A4
Hilāl, Ra's al pt Libya 86 B3
Hilary Coast Antarctica 152 H1
Hildale U.S.A. 129 G3
Hildburghausen Germany 53 K4
Hilders Germany 53 K4
Hildesheim Germany 53 J2
Hillah Iraq see Al Ḩillah
Hill City U.S.A. 130 D4
Hillegom Neth. 52 E2
Hill End Australia 112 D4
Hillerød Denmark 45 H9
Hillgrove Australia 112 E3
Hill Island Lake Canada 121 I2
Hillman U.S.A. 134 D1
Hillsboro ND U.S.A. 130 D2
Hillsboro NM U.S.A. 127 G6
Hillsboro OH U.S.A. 134 D4
Hillsboro OR U.S.A. 126 C3
Hillsboro TX U.S.A. 131 D5
Hillsdale MI U.S.A. 134 C3
Hillside Australia 108 B5
Hillston Australia 112 B4
Hillsville U.S.A. 134 E5
Hilo U.S.A. 127 [inset]
Hilton U.S.A. 135 G2
Hilton S. Africa 101 J5
Hilton U.S.A. 135 G2
Hilton Head Island U.S.A. 133 D5
Hilvan Turkey 90 E3
Hilversum Neth. 52 F2
Himachal Pradesh state India 82 D3
Himalaya mts Asia 82 D3
Himalchul mt. Nepal 83 F3
Himanka Fin. 44 M4
Ḩimār, Wādī al watercourse Syria/Turkey
 85 D1
Himare Albania 59 H4
Himatnagar India 82 C5

Himeji Japan 75 D6
Ḩimş Syria see Homs
Ḩimş, Baḩrat resr Syria see
 Qaṭṭīnah, Buḩayrat
Hinchinbrook Island Australia 110 D3
Hinckley U.K. 49 F6
Hinckley MN U.S.A. 130 E2
Hinckley UT U.S.A. 129 G2
Hinckley Reservoir U.S.A. 135 H2
Hindaun India 82 D4
Hinderwell U.K. 48 G4
Hindley U.K. 48 E5
Hindman U.S.A. 134 D5
Hindmarsh, Lake dry lake Australia 111 C8
Hindu Kush mts Afgh./Pak. 89 G3
Hindupur India 84 C3
Hines Creek Canada 120 G3
Hinesville U.S.A. 133 D6
Hinganghat India 84 C1
Hingoli India 84 C2
Hınıs Turkey 91 F3
Hinnøya i. Norway 44 I2
Hinojosa del Duque Spain 57 D4
Hinsdale U.S.A. 135 I2
Hinte Germany 53 H1
Hinthada Myanmar 70 A3
Hinton Canada 120 G4
Hinton U.S.A. 134 E5
Hiort i. U.K. see St Kilda
Hippolytushoef Neth. 52 E2
Hipponium Italy see Vibo Valentia
Hippo Regius Alg. see Annaba
Hippo Zarytus Tunisia see Bizerte
Hirabit Dağ mt. Turkey 91 G3
Hirakud Dam India 83 E5
Hirakud Reservoir India 83 E5
Hirapur India 82 D4
Hiriyur India 84 C3
Hirosaki Japan 74 F4
Hiroshima Japan 75 D6
Hirschaid Germany 53 L5
Hirschberg Germany 53 L4
Hirschberg mt. Germany 47 M7
Hirschberg Poland see Jelenia Góra
Hirschenstein mt. Germany 53 M6
Hirson France 52 E5
Hîrşova Romania see Hârşova
Hirta i. U.K. see St Kilda
Hirtshals Denmark 45 F8
Hisar India 82 C3
Hisar Iran 88 C3
Hisarköy Turkey see Domaniç
Hisarönü Turkey 59 O4
Ḩisb, Sha'īb watercourse Iraq 91 G5
Ḩisbān Jordan 85 B4
Hisiu P.N.G. 69 L8
Hisor Tajik. 89 H2
Hisor Tizmasi mts Tajik./Uzbek. see
 Gissar Range
Hispalis Spain see Seville
Hispania country Europe see Spain

Hispaniola i. Caribbean Sea 137 J4
Consists of the Dominican Republic and
Haiti.

Hispur Glacier Jammu and Kashmir 82 C1
Hissar India see Hisar
Hisua India 83 F4
Ḩisyah Syria 85 C2
Hīt Iraq 91 F4
Hitachi Japan 75 F5
Hitachinaka Japan 75 F5
Hitra i. Norway 44 F5
Hitzacker Germany 53 L1
Hiva Oa i. Fr. Polynesia 151 K6
Hixon Canada 120 F4
Hixson Cay reef Australia 110 F3
Hiyon watercourse Israel 85 B4
Hizan Turkey 91 F3
Hjälmaren l. Sweden 45 I7
Hjerkinn Norway 44 F5
Hjo Sweden 45 I7
Hjørring Denmark 45 G8
Hkakabo Razi mt. China/Myanmar 76 C2
Hlaingdet Myanmar 70 B2
Hlako Kangri mt. China see
 Lhagoi Kangri
Hlane Royal National Park
 Swaziland 101 J4
Hlatikulu Swaziland 101 J4
Hlegu Myanmar 70 B3
Hlohlowane S. Africa 101 H5
Hlotse Lesotho 101 I5
Hluhluwe-Umfolozi Park nature res.
 S. Africa 101 J5
Hlukhiv Ukr. 43 G6
Hlusha Belarus 43 F5
Hlybokaye Belarus 45 O9
Ho Ghana 96 D4
Hoa Binh Vietnam 70 D2
Hoa Binh Vietnam 70 D3
Hoachanas Namibia 100 D2
Hoagland U.S.A. 134 C3
Hoang Liên Sơn mts Vietnam 70 C2
Hoang Sa is S. China Sea see
 Paracel Islands
Hoan Lao Vietnam 70 D3

Hobart Australia 111 [inset]
State capital of Tasmania.

Hobart U.S.A. 131 D5
Hobbs U.S.A. 131 C5
Hobbs Coast Antarctica 152 J1
Hobe Sound U.S.A. 133 D7
Hobiganj Bangl. see Habiganj
Hobro Denmark 45 F8
Hobyo Somalia 98 E3
Hoceima, Baie d'Al b. Morocco 57 E6
Höchberg Germany 53 J5
Hochfeiler mt. Austria/Italy see
 Gran Pilastro
Hochfeld Namibia 99 B6
Hochharz nat. park Germany 53 K3
Hô Chi Minh Vietnam see
 Ho Chi Minh City
Ho Chi Minh City Vietnam 71 D5
Hochschwab mt. Austria 47 O7
Hochschwab mts Austria 47 O7
Hockenheim Germany 53 I5

Hyndman Peak U.S.A. 126 E4
Hyōno-sen mt. Japan 75 D6
Hyrcania Iran see Gorgān
Hyrynsalmi Fin. 44 P4
Hysham U.S.A. 126 G3
Hythe Canada 120 G4
Hythe U.K. 49 I7
Hyūga Japan 75 C6
Hyvinkää Fin. 45 N6

I

Iaciara Brazil 145 B1
Iaco r. Brazil 142 E5
Iaçu Brazil 145 C1
Iadera Croatia see Zadar
Iaeger U.S.A. 134 E5
Iakora Madag. 99 E6
Ialomiţa r. Romania 59 L2
Ianca Romania 59 L2
Iaşi Romania 59 L1
Iba Phil. 69 F3
Ibadan Nigeria 96 D4
Ibagué Col. 142 C3
Ibaiti Brazil 145 A3
Ibapah U.S.A. 129 G1
Ibarra Ecuador 142 C3
Ibb Yemen 86 F7
Ibbenbüren Germany 53 H2
Iberá, Esteros del marsh Arg. 144 E3
Iberia Peru 142 E6

▶Iberian Peninsula Europe 57
Consists of Portugal, Spain and Gibraltar.

Iberville, Lac d' l. Canada 123 G3
Ibeto Nigeria 96 D3
Ibhayi S. Africa see Port Elizabeth
Ibi Indon. 71 B6
Ibi Nigeria 96 D4
Ibiá Brazil 145 B2
Ibiaí Brazil 145 B2
Ibiapaba, Serra da hills Brazil 143 J4
Ibiassucê Brazil 145 C1
Ibicaraí Brazil 145 D1
Ibicuí Brazil 145 C1
Ibirama Brazil 145 A4
Ibiranhém Brazil 145 C2
Ibitinga Brazil 145 A3
Ibiza Spain 57 G4
Ibiza i. Spain 57 G4
Iblei, Monti mts Sicily Italy 58 F6
Ibn Buşayyiş well Saudi Arabia 88 B5
Ibotirama Brazil 143 J6
Iboundji, Mont hill Gabon 98 B4
Ibrā' Oman 88 E6
Ibradı Turkey 90 C3
Ibrī Oman 88 E6
Ica Peru 142 C6
Içá r. Peru see Putumayo
Içana r. Brazil 142 E3
Icaria i. Greece see Ikaria
Icatu Brazil 143 J4
Iceberg Canyon gorge U.S.A. 129 F3
İçel Mersin Turkey see Mersin

▶Iceland country Europe 44 [inset]
2nd largest island in Europe.
Europe 5, 38–39

Iceland Basin sea feature
N. Atlantic Ocean 148 G2
Icelandic Plateau sea feature
N. Atlantic Ocean 153 I2
Ichalkaranji India 84 B2
Ichifusa-yama mt. Japan 75 C6
Ichinomiya Japan 75 E6
Ichinoseki Japan 75 F5
Ichinskiy, Vulkan vol. Rus. Fed. 65 Q4
Ichkeul, Parc National de l'
Tunisia 58 C6
Ichnya Ukr. 43 G6
Ichtegem Belgium 52 D3
Ichtershausen Germany 53 K4
Içó Brazil 143 K5
Iconha Brazil 145 C3
Iconium Turkey see Konya
Icosium Alg. see Algiers
Iculisma France see Angoulême
Icy Cape U.S.A. 118 B2
Id Turkey see Narman
Idabel U.S.A. 131 E5
Ida-Viru Rus. Fed. 130 E3
Idah Nigeria 96 D4
Idaho state U.S.A. 126 E3
Idaho City U.S.A. 126 E4
Idaho Falls U.S.A. 126 E4
Idalia National Park Australia 110 D5
Idar India 82 C5
Idar-Oberstein Germany 53 H5
Ider/Ideriyn Gol r. Mongolia 80 J2
Idfu Egypt 86 D5
Idhān Awbārī des. Libya 96 E2
Idhān Murzūq des. Libya 96 E2
Idhra i. Greece see Ydra
Idi Amin Dada, Lake
Dem. Rep. Congo/Uganda see
Edward, Lake
Idiofa Dem. Rep. Congo 99 B4
Idivuoma Sweden 44 M2
Idkū Egypt 90 C5
Idle r. U.K. 48 G5
Idlewild airport U.S.A. see
John F. Kennedy
Idlib Syria 85 C2
Idra i. Greece see Ydra
Idre Sweden 45 H6
Idstein Germany 53 I4
Idutywa S. Africa 101 I7
Idzhevan Armenia see Ijevan
Iecava Latvia 45 N8
Iepê Brazil 145 A3
Ieper Belgium 52 C4
Ierapetra Greece 59 K7
Ierissou, Kolpos b. Greece 59 J4
Iešjávri l. Norway 44 N1
Ifakara Tanz. 99 D4
Ifalik atoll Micronesia 69 K5

Ifaluk atoll Micronesia see Ifalik
Ifanadiana Madag. 99 E6
Ife Nigeria 96 D4
Ifenat Chad 97 E3
Iferouâne Niger 96 D3
Iffley Australia 110 C3
Ifjord Norway 44 O1
Ifôghas, Adrar des hills Mali 96 D3
Iforas, Adrar des hills Mali see
Ifôghas, Adrar des
Igan Sarawak Malaysia 68 E6
Iganga Uganda 97 G4
Igarapava Brazil 145 B3
Igarka Rus. Fed. 64 J3
Igatpuri India 84 B2
Igbeti Nigeria see Igbetti
Igbetti Nigeria 96 D4
Iğdır Turkey 91 G3
Iggesund Sweden 45 J6
Igikpak, Mount U.S.A. 118 C3
Igizyar China 89 J2
Iglesias Sardinia Italy 58 C5
Iglesiente reg. Sardinia Italy 58 C5
Igloolik Canada 119 J3
Igluligaarjuk Canada see
Chesterfield Inlet
Ignace Canada 121 N5
Ignacio Zaragoza Mex. 127 G7
Ignacio Zaragoza Mex. 131 C8
Ignalina Lith. 45 O9
İğneada Turkey 59 L4
İğneada Burnu pt Turkey 59 M4
Ignoitijala India 71 A6
iGoli S. Africa see Johannesburg
Igoumenitsa Greece 59 I5
Igra Rus. Fed. 41 Q4
Igrim Rus. Fed. 41 S3
Iguaçu r. Brazil 145 A4
Iguaçu, Saltos do waterfall Arg./Brazil see
Iguaçu Falls
Iguaçu Falls Arg./Brazil 144 F3
Iguaí Brazil 145 C1
Iguala Mex. 136 E5
Igualada Spain 57 G3
Iguape Brazil 145 B4
Iguaraçu Brazil 145 A3
Iguatama Brazil 145 B3
Iguatemi Brazil 144 F2
Iguatu Brazil 143 K5
Iguazú, Cataratas do waterfall Arg./Brazil
see Iguaçu Falls
Iguéla Gabon 98 A4
Igunga Tanz. 99 D4
Iharaña Madag. 99 E5
Ihavandhippolhu Atoll Maldives 84 B5
Ihavandiffulu Atoll Maldives see
Ihavandhippolhu Atoll
Ih Bogd Uul mt. Mongolia 80 J3
Ihosy Madag. 99 E6
Iide-san mt. Japan 75 E5
Iijärvi l. Fin. 44 O2
Iijoki r. Fin. 44 N4
Iisalmi Fin. 44 O5
Iizuka Japan 75 C6
Ijebu-Ode Nigeria 96 D4
Ijevan Armenia 91 G2
IJmuiden Neth. 52 E2
IJssel r. Neth. 52 F2
IJsselmeer l. Neth. 52 F2
IJzer r. Belgium see Yser
Ikaahuk Canada see Sachs Harbour
Ikaalinen Fin. 45 M6
Ikageleng S. Africa 101 H3
Ikageng S. Africa 101 H4
iKapa S. Africa see Cape Town
Ikare Nigeria 96 D4
Ikaria i. Greece 59 L6
Ikast Denmark 45 F8
Ikeda Japan 74 F4
Ikela Dem. Rep. Congo 98 C4
Ikhtiman Bulg. 59 J3
Ikhutseng S. Africa 100 G5
Iki-Burul Rus. Fed. 43 J7
Ikom Nigeria 96 D4
Iksan S. Korea 75 B6
Ikungu Tanz. 99 D4
Ilagan Phil. 77 I5
Ilaisamis Kenya 98 D3
Īlām Iran 88 B3
Ilam Nepal 83 F4
Ilan Taiwan 77 I3
Ilave Peru 142 E7
Iława Poland 47 Q4
Ilazārān, Kūh-e mt. Iran 88 E4
Île-à-la-Crosse Canada 121 J4
Île-à-la-Crosse, Lac l. Canada 121 J4
Ilebo Dem. Rep. Congo 98 C4
Île-de-France admin. reg. France 52 C6
Île Europa i. Indian Ocean see
Europa, Île
Ilek Kazakh. 41 Q5
Ilen r. Ireland 51 C6
Ileret Kenya 98 D3
Ileza Rus. Fed. 42 I3
Ilfeld Germany 53 K3
Ilford Canada 121 M3
Ilford U.K. 49 H7
Ilfracombe Australia 110 D4
Ilfracombe U.K. 49 C7
Ilgaz Turkey 90 D2
Ilgın Turkey 90 D3
Ilha Grande, Represa resr Brazil 144 F2
Ilha Solteíra, Represa resr Brazil 145 A3
Ílhavo Port. 57 B3
Ilhéus Brazil 145 D1
Ili Kazakh. see Kapchagay
Iliamna Lake U.S.A. 118 C4
İliç Turkey 90 E3
Il'ichevsk Azer. see Şärur
Il'ichevsk Ukr. see Illichivs'k
Ilici Spain see Elche-Elx
Iligan Phil. 69 G5
Ilimananngip Nunaa i. Greenland 119 P2
Il'inka Rus. Fed. 43 I7
Il'inskiy Permskaya Oblast' Rus. Fed. 41 R4
Il'inskiy Sakhalinskaya Oblast'
Rus. Fed. 74 F3
Il'insko-Podomskoye Rus. Fed. 42 J3
Ilion U.S.A. 135 H2
Ilium tourist site Turkey see Troy
Ilkal India 84 C3

Iliysk Kazakh. see Kapchagay
Ilkal India 84 C3
Ilkeston U.K. 49 F6
Ilkley U.K. 48 F5
Illapel Chile 144 B4
Illéla Niger 96 D3
Iller r. Germany 47 L6
Illichivs'k Ukr. 59 N1
Illimani, Nevado de mt. Bol. 142 E7
Illinois r. U.S.A. 130 F4
Illinois state U.S.A. 134 A3
Illizi Alg. 96 D2
Illogwa watercourse Australia 110 A5
Ilm r. Germany 53 L3
Ilmajoki Fin. 44 M5
Il'men', Ozero l. Rus. Fed. 42 F4
Ilmenau Germany 53 K4
Ilmenau r. Germany 53 K1
Ilminster U.K. 49 E8
Ilo Peru 142 D7
Iloilo Phil. 69 G4
Ilomantsi Fin. 44 Q5
Ilong India 76 B3
Ilorin Nigeria 96 D4
Ilovlya Rus. Fed. 43 I6
Ilsede Germany 53 K2
Iluka Australia 112 F2
Ilulissat Greenland 119 M3
Iluppur India 84 C4
Ilva i. Italy see Elba, Isola d'
Imabari Japan 75 D6
Imaichi Japan 75 E5
Imala Moz. 99 D5
Imam-baba Turkm. 89 F2
İmamoğlu Turkey 90 D3
Iman Rus. Fed. see Dal'nerechensk
Iman r. Rus. Fed. 74 D3
Imari Japan 75 C6
Imaruí Brazil 145 A5
Imataca, Serranía de mts Venez. 142 F2
Imatra Fin. 45 P6
Imbituba Brazil 145 A5
Imbituva Brazil 145 A4
imeni 26 Bakinskikh Komissarov Azer. see
Uzboy
imeni Babushkina Rus. Fed. 42 I4
imeni S. Africa 101 H6
imeni Chapayevka Turkm. see
S. A. Nyýazow Adyndaky
imeni Kalinina Tajik. see Cheshtebe
imeni Kirova Kazakh. see Kopbirlik
imeni Petra Stuchki Latvia see
Aizkraukle
imeni Poliny Osipenko Rus. Fed. 74 E1
imeni Tel'mana Rus. Fed. 74 D2
Īmī Eth. 98 E3
Imishli Azer. see İmişli
İmişli Azer. 91 H3
Imit Jammu and Kashmir 82 C1
Imja-do i. S. Korea 75 B6
Imlay U.S.A. 128 D1
Imlay City U.S.A. 134 D2
Imola Italy 58 D2
iMonti S. Africa see East London
Impendle S. Africa 101 I5
Imperatriz Brazil 143 I5
Imperia Italy 58 C3
Imperial CA U.S.A. 129 F5
Imperial NE U.S.A. 130 C3
Imperial Beach U.S.A. 128 E5
Imperial Dam U.S.A. 129 F5
Imperial Valley plain U.S.A. 129 F5
Impérieuse Reef Australia 108 B4
Imphal India 83 H4
İmralı Adası i. Turkey 59 M4
İmroz Turkey 59 K4
İmroz i. Turkey see Gökçeada
Imtān Syria 85 C3
Imuris Mex. 127 F7
In r. Rus. Fed. 74 D2
Ina Japan 75 E6
Inambari r. Peru 142 E6
Inari Fin. 44 O2
Inarijärvi l. Fin. 44 O2
Inarijoki r. Fin./Norway 44 N2
Inca Spain 57 H4
İnce Burnu pt Turkey 59 L4
İnce Burun pt Turkey 90 D2
Inch Ireland 51 F5
Incheon S. Korea 75 B5
Inchicronan Lough l. Ireland 51 D5
Inch'ŏn S. Korea 75 B5
Incirli Turkey see Karasu
Indaal, Loch b. U.K. 50 C5
Indalsälven r. Sweden 44 J5
Indalstø Norway 45 D6
Inda Silasē Eth. 98 D2
Indaw Myanmar 70 A2
Indawgyi, Lake Myanmar 76 C3
Indé Mex. 131 B7
Indefatigable Island Galápagos Ecuador see
Santa Cruz, Isla
Independence CA U.S.A. 128 D3
Independence IA U.S.A. 130 F3
Independence KS U.S.A. 131 E4
Independence KY U.S.A. 134 C4
Independence MO U.S.A. 130 E4
Independence VA U.S.A. 134 E5
Independence Mountains U.S.A. 126 D4
Inder China 74 A3
Indi India 84 C2

▶India country Asia 81 E7
2nd most populous country in the world
and in Asia. 3rd largest country in Asia.
Asia 6, 62–63

Indian r. Canada 120 B2
Indiana U.S.A. 134 F3
Indiana state U.S.A. 134 B3
Indian-Antarctic Ridge sea feature
Southern Ocean 150 D9

Indian Cabins Canada 120 G3
Indian Desert India/Pak. see Thar Desert
Indian Harbour Canada 123 K3
Indian Head Canada 121 K5
Indian Lake U.S.A. 135 H2

Indian Lake l. NY U.S.A. 135 H2
Indian Lake l. OH U.S.A. 134 D3
Indian Lake l. PA U.S.A. 135 F3

▶Indian Ocean 149
3rd largest ocean in the world.

Indianola IA U.S.A. 130 E3
Indianola MS U.S.A. 131 F5
Indian Peak U.S.A. 129 G2
Indian Springs IN U.S.A. 134 B4
Indian Springs NV U.S.A. 129 F3
Indian Wells U.S.A. 129 H4
Indiga Rus. Fed. 42 K2
Indigirka r. Rus. Fed. 65 P2
Indigskaya Guba b. Rus. Fed. 42 K2
Indija Serb. and Mont. 59 I2
Indin Lake Canada 120 H1
Indio U.S.A. 128 E5
Indira Point India see Pygmalion Point
Indira Priyadarshini Pench National Park
India 82 D5
Indispensable Reefs Solomon Is 107 G3
Indjija Serb. and Mont. see Indija
Indo-China reg. Asia 70 D3

▶Indonesia country Asia 68 E7
4th most populous country in the world and
3rd in Asia.
Asia 6, 62–63

Indore India 82 C5
Indragiri r. Indon. 68 C7
Indrapura, Gunung vol. Indon. see
Kerinci, Gunung
Indravati r. India 84 D2
Indre France 56 E3
Indre r. France 56 E3
Indulkana Australia 109 F6
Indur India see Nizamabad
Indus r. China/Pak. 89 G6
also known as Sênggê Zangbo or
Shiquan He
Indus, Mouths of the Pak. 89 G5
Indus Cone sea feature
Indian Ocean 149 M4
Indwe S. Africa 101 H6
Indwe r. S. Africa 101 H6
İnebolu Turkey 90 D2
İnegöl Turkey 59 M4
Inez U.S.A. 134 D5
Infantes Spain see
Villanueva de los Infantes
Infiernillo, Presa resr Mex. 136 D5
Ing, Nam Mae r. Thai. 70 C2
Inga Rus. Fed. 44 S3
Ingalls, Mount U.S.A. 128 C2
Ingelheim Germany 53 I5
Ingelmunster Belgium 52 D4
Ingersoll Canada 134 E2
Ingham Australia 110 D3
Ingichka Uzbek. 89 G2
Ingleborough hill U.K. 48 E4
Inglefield Land reg. Greenland 119 K2
Ingleton U.K. 48 E4
Inglewood Qld Australia 112 E2
Inglewood Vic. Australia 112 A6
Inglewood U.S.A. 128 D5
Ingoka Pum mt. Myanmar 70 B1
Ingoldmells U.K. 48 H5
Ingolstadt Germany 53 L6
Ingomar Australia 109 F7
Ingomar U.S.A. 126 G3
Ingonish Canada 123 J5
Ingraj Bazar India 83 G4
Ingram U.S.A. 134 F5
Ingray Lake Canada 120 G1
Ingrid Christensen Coast
Antarctica 152 E2
Ingwavuma S. Africa 101 K4
Ingwavuma r. S. Africa/Swaziland see
Ngwavuma
Ingwiller France 53 H6
Inhaca Moz. 101 K3
Inhaca, Península pen. Moz. 101 K4
Inhambane Moz. 101 L2
Inhambane prov. Moz. 101 L2
Inhaminga Moz. 99 D5
Inharrime Moz. 101 L3
Inhassoro Moz. 99 D6
Inhaúmas Brazil 145 B1
Inhobim Brazil 145 C1
Inhumas Brazil 145 A2
Inis Ireland see Ennis
Inis Córthaidh Ireland see Enniscorthy
Inishark i. Ireland 51 B4
Inishbofin i. Ireland 51 B4
Inisheer i. Ireland 51 C4
Inishkea North i. Ireland 51 B3
Inishkea South i. Ireland 51 B3
Inishmaan i. Ireland 51 C4
Inishmore i. Ireland 51 C4
Inishmurray i. Ireland 51 D3
Inishowen pen. Ireland 51 E2
Inishowen Head hd Ireland 51 F2
Inishtrahull i. Ireland 51 E2
Inishturk i. Ireland 51 B4
Injune Australia 111 E5
Inkerman Australia 110 C3
Inklin Canada 120 C3
Inklin r. Canada 120 C3
Inkylap Turkm. 89 F2
Inland Kaikoura Range mts N.Z. 113 D6
Inlet U.S.A. 135 H2
Inn r. Europe 47 M7
Innamincka Australia 111 C5
Innamincka Regional Reserve nature res.
Australia 111 C5
Inndyr Norway 44 I3
Inner Sound sea chan. U.K. 50 D3
Innes National Park Australia 111 B7
Innisfail Australia 110 D3
Innisfail Canada 120 H4
Innokent'yevka Rus. Fed. 74 D2
Innoko r. U.S.A. 118 C3
Innsbruck Austria 47 M7
Innuksuak r. Canada 122 F2
Inny r. Ireland 51 E4
Inocência Brazil 145 A2
Inongo Dem. Rep. Congo 98 B4
Inönü Turkey 59 N5
Inoucdjouac Canada see Inukjuak

Inowrocław Poland 47 Q4
In Salah Alg. 96 D2
Insch U.K. 50 G3

▶Inscription, Cape Austr. 110 B3
Most westerly point of Oceania.

Insein Myanmar 70 B3
Insterburg Rus. Fed. see Chernyakhovsk
Inta Rus. Fed. 41 S2
Interamna Italy see Teramo
Interlaken Switz. 56 H3
International Falls U.S.A. 130 E1
Interview Island India 71 A4
Intracoastal Waterway canal U.S.A. 131 E6
Intutu Peru 142 D4
Inubō-zaki pt Japan 75 F6
Inukjuak Canada 122 F2
Inuvik Canada 118 E3
Inveraray U.K. 50 D4
Inverbervie U.K. 50 G4
Invercargill N.Z. 113 B8
Inverell Australia 112 E2
Invergordon U.K. 50 E3
Inverkeithing U.K. 50 F4
Inverleigh Australia 110 C3
Invermay Canada 121 K5
Inverness Canada 123 J5
Inverness U.K. 50 E3
Inverness CA U.S.A. 128 B2
Inverness FL U.S.A. 133 D6
Inverurie U.K. 50 G3
Investigator Channel Myanmar 71 B4
Investigator Group is Australia 109 F8
Investigator Ridge sea feature
Indian Ocean 149 O6
Investigator Strait Australia 111 B7
Inwood U.S.A. 135 F4
Inya Rus. Fed. 80 G1
Inyanga Zimbabwe see Nyanga
Inyangani mt. Zimbabwe 99 D5
Inyokern U.S.A. 128 E4
Inyo Mountains U.S.A. 128 D3
Inyonga Tanz. 99 D4
Inza Rus. Fed. 43 J5
Inzhavino Rus. Fed. 43 I5
Iolgo, Khrebet mts Rus. Fed. 80 G1
Iolotan' Turkm. see Ýöloten
Iona Canada 123 J5
Iona i. U.K. 50 C4
Iona, Parque Nacional do nat. park
Angola 99 B5
Ione U.S.A. 128 E2
Iongo Angola 99 B4
Ionia U.S.A. 134 C2
Ionia Nisia is Ionia Nisia Greece see
Ionian Islands
Ionian Islands Greece 59 H5
Ionian Sea Greece/Italy 58 H5
Ioniko Pelagos sea Greece see
Ionian Islands
Ionioi Nisoi is Ionia Nisia Greece see
Ionian Islands
Ionioi Nisoi is Greece see Ionian Islands
Ios i. Greece 59 K6
Iowa state U.S.A. 130 E3
Iowa City U.S.A. 130 F3
Iowa Falls U.S.A. 130 E3
Ipameri Brazil 145 A2
Ipanema Brazil 145 C2
Iparía Peru 142 D5
Ipatinga Brazil 145 C2
Ipatovo Rus. Fed. 43 I7
Ipelegeng S. Africa 101 G4
Ipiales Col. 142 C3
Ipiaú Brazil 145 D1
Ipirá Brazil 145 D1
Ipiranga Brazil 145 A4
iPitoli S. Africa see Pretoria
Ipixuna r. Brazil 142 F5
Ipoh Malaysia 71 C6
Iporá Brazil 145 A2
Ippy Cent. Afr. Rep. 98 C3
Ipsala Turkey 59 L4
Ipswich Australia 112 F1
Ipswich U.K. 49 I6
Ipswich U.S.A. 130 D2
Ipu Brazil 143 J4

▶Iqaluit Canada 119 L3
Territorial capital of Nunavut.

Iquique Chile 144 B2
Iquiri r. Brazil see Ituxi
Iquitos Peru 142 D4
Irafshān reg. Iran 89 F5
Irai Brazil 144 F3
Irakleio Greece see Iraklion
Iraklion Greece 59 K7
Iramaia Brazil 145 C1

▶Iran country Asia 88 D3
Asia 6, 62–63

Iran, Pegunungan mts Indon. 68 E6
Īrānshahr Iran 89 F5
Irapuato Mex. 136 D4

▶Iraq country Asia 91 F4
Asia 6, 62–63

Irara Brazil 145 D1
Irati Brazil 145 A4
Irayel' Rus. Fed. 42 L2
Irazú, Volcán vol. Costa Rica 137 H7
Irbid Jordan 85 B3
Irbil Iraq see Arbīl
Irbit Rus. Fed. 64 H4
Irecê Brazil 143 J6

▶Ireland country Europe 51 E4
Europe 5, 38–39

▶Ireland i. Ireland/U.K. 51
4th largest island in Europe.

Irema Dem. Rep. Congo 98 C4
Irgiz Kazakh. 80 B2
Irgiz r. Kazakh. 80 B2
Iri S. Korea see Iksan
Irian, Teluk b. Indon. see
Cenderawasih, Teluk
Iriba Chad 97 F3
Īrī Dāgh mt. Iran 88 B3
İnönü Turkey 59 N5
Iriga Phil. 69 G4
Irīgui reg. Mali/Mauritania 96 C3

Iringa Tanz. 99 D4
Iriri r. Brazil 143 H4
Irish Sea Ireland/U.K. 51 G4
Irituia Brazil 143 I4
'Irj well Saudi Arabia 88 C5
Irkutsk Rus. Fed. 72 I2
Irma Canada 121 I4
Irmak Turkey 90 D3
Irminger Basin sea feature
N. Atlantic Ocean 148 F2
Iron Baron Australia 111 B7
Irondequoit U.S.A. 135 G2
Iron Mountain U.S.A. 130 C2
Iron Mountain mt. U.S.A. 129 I3
Iron Range National Park Australia 110 C2
Iron River U.S.A. 130 C2
Ironton MO U.S.A. 130 F4
Ironton OH U.S.A. 134 D4
Ironwood Forest National Monument
nat. park U.S.A. 129 H5
Iroquois r. U.S.A. 134 B3
Iroquois Falls Canada 122 E4
Irosin Phil. 69 G4
Irpen' Ukr. see Irpin'
Irpin' Ukr. 43 F6
'Irq al Ḥarūrī des. Saudi Arabia 88 B5
'Irq Banbān des. Saudi Arabia 88 B5
Irrawaddy r. Myanmar 70 A4
Irrawaddy, Mouths of the Myanmar 70 A4
Irshad Pass Afgh./Jammu and Kashmir
89 I2
Irta Rus. Fed. 42 K3
Irthing r. U.K. 48 E4

▶Irtysh r. Kazakh./Rus. Fed. 80 E1
5th longest river in Asia. Part of the 2nd
longest river in Asia (Ob'-Irtysh).

Irun Spain 57 F2
Iruña Spain see Pamplona
Iruñea Spain see Pamplona
Irvine U.K. 50 E5
Irvine CA U.S.A. 128 E5
Irvine KY U.S.A. 134 D5
Irvine Glacier Antarctica 152 L2
Irving U.S.A. 131 D5
Irwin r. Australia 109 A7
Irwinton U.S.A. 133 D5
Isa Nigeria 96 D3
Isaac r. Australia 110 E4
Isabel U.S.A. 130 C2
Isabela Phil. 69 G5
Isabela, Isla i. Galápagos Ecuador
142 [inset]
Isabelia, Cordillera mts Nicaragua 137 G6
Isabella Lake U.S.A. 128 D4
Isachsen, Cape Canada 119 H2
Ísafjarðardjúp est. Iceland 44 [inset]
Ísafjörður Iceland 44 [inset]
Isa Khel Pak. 89 H3
Isar r. Germany 53 M6
Isbister U.K. 50 [inset]
Ischia, Isola d' i. Italy 58 E4
Ise Japan 75 E6
Isère r. France 56 G4
Isère, Pointe pt Fr. Guiana 143 H2
Iserlohn Germany 53 H3
Isernhagen Germany 53 K2
Isernia Italy 58 F4
Ise-shima Kokuritsu-kōen Japan 75 E6
Ise-wan b. Japan 75 E6
Iseyin Nigeria 96 D4
Isfahan Iran see Esfahān
Isfana Kyrg. 89 H2
Isheyevka Rus. Fed. 43 K5
Ishigaki Japan 73 M8
Ishikari-wan b. Japan 74 F4
Ishim r. Kazakh./Rus. Fed. 80 D1
Ishinomaki Japan 75 F5
Ishinomaki-wan b. Japan 73 Q5
Ishioka Japan 75 F5
Ishkoshim Tajik. 89 H2
Ishpeming U.S.A. 132 C2
Ishtikhon Uzbek. see Ishtixon
Ishtiragh Afgh. 89 H2
Ishtixon Uzbek. 89 G2
Ishurdi Bangl. 83 G4
Isiboro Sécure, Parque Nacional nat. park
Bol. 142 E7
Isigny-sur-Mer France 49 F9
Işıklar Dağı mts Turkey 59 L4
Işıklı Turkey 59 M5
Isil'kul' Rus. Fed. 64 I4
Isipingo S. Africa 101 J5
Isiro Dem. Rep. Congo 98 C3
Isisford Australia 110 D5
Iskateley Rus. Fed. 42 L2
İskenderun Turkey 85 C1
İskenderun Körfezi b. Turkey 85 B1
İskilip Turkey 90 D2
Iskitim Rus. Fed. 64 J4
Iskŭr r. Bulg. 59 K3
Iskushuban Somalia 98 F2
Isla r. Scotland U.K. 50 F4
Isla r. Scotland U.K. 50 G3
Isla Gorge National Park Australia 110 E5
İslahiye Turkey 90 E3
Islamabad India see Anantnag

▶Islamabad Pak. 89 I3
Capital of Pakistan.

Islamgarh Pak. 89 H5
Islamkot Pak. 89 H5
Island r. Canada 120 F2
Ísland country Europe see Iceland
Island U.S.A. 134 B5
Island Falls U.S.A. 132 G2
Island Lagoon salt flat Australia 111 B6
Island Lake Canada 121 M4
Island Lake l. Canada 121 M4
Island Magee pen. U.K. 51 G3
Island Pond U.S.A. 135 J1
Islands, Bay of N.Z. 113 E2
Islay i. U.K. 50 C5

▶Isle of Man terr. Irish Sea 48 C4
United Kingdom Crown Dependency.
Europe 5

Kalinino Armenia see Tashir
Kalinino Rus. Fed. 42 I4
Kalininsk Rus. Fed. 43 J6
Kalininskaya Rus. Fed. 43 H7
Kalinjara India 82 C5
Kalinkavichy Belarus 43 F5
Kalinkovichi Belarus see Kalinkavichy
Kalisch Poland see Kalisz
Kalispell U.S.A. 126 E2
Kalisz Poland 47 Q5
Kalitva r. Rus. Fed. 43 I6
Kaliua Tanz. 99 D4
Kaliujar India 82 E4
Kalix Sweden 44 M4
Kalkalighat India 83 H4
Kalkalpen, Nationalpark nat. park
 Austria 47 O7
Kalkan Turkey 59 M6
Kalkaska U.S.A. 134 C1
Kalkfeld Namibia 99 B6
Kalkfonteindam dam S. Africa 101 G5
Kalkudah Sri Lanka 84 D5
Kall Germany 52 G4
Kallang r. Sing. 71 [inset]
Kallaste Estonia 45 O7
Kallavesi l. Fin. 44 O5
Kallsedet Sweden 44 H5
Kallsjön l. Sweden 44 H5
Kallur India 84 C2
Kalmar Sweden 45 J8
Kalmarsund sea chan. Sweden 45 J8
Kalmit hill Germany 53 I5
Kalmükh Qal'eh Iran 88 E2
Kalmunai Sri Lanka 84 D5
Kalmykia aut. rep. Rus. Fed. see
 Kalmykiya-Khalm'g-Tangch, Respublika
Kalmykiya-Khalm'g-Tangch, Respublika
 aut. rep. Rus. Fed. 91 G1
Kalmykovo Kazakh. see Taypak
Kalmytskaya Avtonomnaya Oblast' aut. rep.
 Rus. Fed. see
 Kalmykiya-Khalm'g-Tangch, Respublika
Kalnai India 83 E5
Kalodnaye Belarus 45 O11
Kalol India 82 C5
Kalomo Zambia 99 C5
Kalone Peak Canada 120 E4
Kalpa India 82 D3
Kalpeni atoll India 84 B4
Kalpetta India 84 C4
Kalpi India 82 D4
Kaltag U.S.A. 118 C3
Kaltensundheim Germany 53 K4
Kaltukatjara Australia 109 E6
Kalu India 89 I4
Kaluga Rus. Fed. 43 H5
Kalukalukuang i. Indon. 68 F8
Kalundborg Denmark 45 G9
Kalush Ukr. 43 E6
Kalvakol India 84 C2
Kälviä Fin. 44 N5
Kal'ya Rus. Fed. 41 R3
Kalyan India 84 B2
Kalyandurg India 87 M7
Kalyansingapuram India 84 D2
Kalyazin Rus. Fed. 42 H4
Kalymnos i. Greece 59 L6
Kama Dem. Rep. Congo 98 C4
Kama Myanmar 70 A3

▶Kama r. Rus. Fed. 42 L4
 4th longest river in Europe.

Kamaishi Japan 75 F5
Kamalia Pak. 89 I4
Kaman Turkey 90 D3
Kamaniskeg Lake Canada 135 G1
Kamanjab Namibia 99 B5
Kamarān i. Yemen 86 F6
Kamaran Island Yemen see Kamarān
Kamard r. Afgh. 89 G3
Kamarod Pak. 89 F5
Kamaron Sierra Leone 96 B4
Kamashi Uzbek. see Qamashi
Kamasin India 82 E4
Kambaiti Myanmar 70 B1
Kambalda Australia 109 C7
Kambam India 84 C4
Kambara i. Fiji see Kabara
Kambia Sierra Leone 96 B4
Kambing, Pulau i. East Timor see
 Ataúro, Ilha de
Kambo-san mt. N. Korea see
 Kwanmo-bong
Kambove Dem. Rep. Congo 99 C5
Kambüt Libya 90 B5
Kamchatka, Poluostrov pen. Rus. Fed. see
 Kamchatka Peninsula
Kamchatka Basin sea feature Bering Sea
 150 H2
Kamchatka Peninsula Rus. Fed. 65 Q4
Kamchiya r. Bulg. 59 L3
Kameia, Parque Nacional da nat. park
 Angola see Cameia, Parque Nacional da
Kamelik r. Rus. Fed. 43 K5
Kamen Germany 53 H3
Kamen', Gory mt. Rus. Fed. 64 K3
Kamenets-Podol'skiy Ukr. see
 Kam"yanets'-Podil's'kyy
Kamenitsa mt. Bulg. 59 J4
Kamenjak, Rt pt Croatia 58 E2
Kamenka Arkhangel'skaya Oblast'
 Rus. Fed. 42 J2
Kamenka Penzenskaya Oblast'
 Rus. Fed. 43 J5
Kamenka Primorskiy Kray
 Rus. Fed. 74 E3
Kamenka-Bugskaya Ukr. see
 Kam"yanka-Buz'ka
Kamenka-Strumilovskaya Ukr. see
 Kam"yanka-Buz'ka
Kamen'-na-Obi Rus. Fed. 72 E2
Kamennogorsk Rus. Fed. 45 P6
Kamenolomni Rus. Fed. 43 I7
Kamenongue Angola see Camanongue
Kamen'-Rybolov Rus. Fed. 74 D3
Kamenskoye Rus. Fed. 65 R3
Kamenskoye Ukr. see
 Dniprodzerzhyns'k
Kamensk-Shakhtinskiy Rus. Fed. 43 I6

Kamensk-Ural'skiy Rus. Fed. 64 H4
Kamet mt. China 82 D3
Kamiesberge mts S. Africa 100 D6
Kamieskroon S. Africa 100 C6
Kamileroi Australia 110 C3
Kamilukuak Lake Canada 121 K2
Kamina Dem. Rep. Congo 99 C4
Kaminak Lake Canada 121 M2
Kaminuriak Lake Canada see
 Qamanirjuaq Lake
Kamishihoro Japan 74 F4
Kamloops Canada 120 F5
Kamo Armenia see Gavarr
Kamoke Pak. 89 I4
Kamonia Dem. Rep. Congo 99 C4

▶Kampala Uganda 98 D3
 Capital of Uganda.

Kampar r. Indon. 68 C6
Kampar Malaysia 71 C6
Kampara India 84 D1
Kampen Neth. 52 F2
Kampene Dem. Rep. Congo 98 C4
Kamphaeng Phet Thai. 70 B3
Kampinoski Park Narodowy nat. park
 Poland 47 R4
Kâmpóng Cham Cambodia 71 D5
Kâmpóng Chhnăng Cambodia 71 D4
Kâmpóng Khleăng Cambodia 71 D4
Kâmpóng Saôm Cambodia see
 Sihanoukville
Kâmpóng Spœ Cambodia 71 D5
Kâmpóng Thum Cambodia 71 D4
Kâmpóng Trâbêk Cambodia 71 D5
Kâmpôt Cambodia 71 D5
Kampuchea country Asia see Cambodia
Kamrau, Teluk b. Indon. 69 I7
Kamsack Canada 121 K5
Kamskoye Vodokhranilishche resr
 Rus. Fed. 41 R4
Kamsuuma Somalia 98 E3
Kamuchawie Lake Canada 121 K3
Kamuli Uganda 98 D3
Kam"yanets'-Podil's'kyy Ukr. 43 E6
Kam"yanka-Buz'ka Ukr. 43 E6
Kamyanyets Belarus 45 M10
Kāmyārān Iran 88 B3
Kamyshin Rus. Fed. 43 J6
Kamyslybas, Ozero l. Kazakh. 80 B2
Kamyzyak Rus. Fed. 43 K7
Kamzar Oman 88 E5
Kanaaupscow r. Canada 122 F3
Kanab U.S.A. 129 G3
Kanab Creek r. U.S.A. 129 G3
Kanairiktok r. Canada 123 K3
Kanak Pak. 89 G4
Kananga Dem. Rep. Congo 99 C4
Kanangio, Mount vol. P.N.G. 69 L7
Kanangra-Boyd National Park
 Australia 112 E4
Kanarak India see Konarka
Kanarraville U.S.A. 129 G3
Kanas watercourse Namibia 100 C4
Kanash Rus. Fed. 42 J5
Kanauj India see Kannauj
Kanazawa Japan 75 E5
Kanbalu Myanmar 70 A2
Kanchanaburi Thai. 71 B4
Kanchanjanga mt. India/Nepal see
 Kangchenjunga
Kanchipuram India 84 C3
Kand mt. Pak. 89 G4
Kanda Pak. 89 G4
Kandahār Afgh. 89 G4
Kandalaksha Rus. Fed. 44 R3
Kandalakshskiy Zaliv g. Rus. Fed. 44 R3
Kandang Indon. 71 B7
Kandar Indon. 108 C2
Kandavu i. Fiji see Kadavu
Kandavu Passage Fiji see
 Kadavu Passage
Kandé Togo 96 D4
Kandhkot Pak. 89 H4
Kandi Benin 96 D3
Kandi India 84 C2
Kandiaro Pak. 89 H5
Kandıra Turkey 59 N4
Kandos Australia 112 D4
Kandreho Madag. 99 E5
Kandrian P.N.G. 69 L8
Kandukur India 84 C3
Kandy Sri Lanka 84 D5
Kandyagash Kazakh. 80 A2
Kane U.S.A. 135 F3
Kane Bassin b. Greenland 153 K1
Kaneh watercourse Iran 88 D5
Kāne'ohe U.S.A. 127 [inset]
Kaneti Pak. 89 G4
Kanevskaya Rus. Fed. 43 H7
Kang Afgh. 89 F4
Kang Botswana 100 F2
Kangaamiut Greenland 119 M3
Kangaarsussuaq c. Greenland 119 K2
Kangaba Mali 96 C3
Kangal Turkey 90 E3
Kangān Būshehr Iran 88 D5
Kangān Hormozgan Iran 88 E5
Kangandala, Parque Nacional de nat. park
 Angola see
 Cangandala, Parque Nacional de
Kangar Malaysia 71 C6
Kangaroo Island Australia 111 B7
Kangaroo Point Australia 110 B3
Kangaslampi Fin. 44 O6
Kangasniemi Fin. 44 O6
Kangāvar Iran 88 B3

▶Kangchenjunga mt. India/Nepal 83 G4
 3rd highest mountain in the world and in
 Asia.
 World 12–13

Kangding China 76 D2
Kangean, Kepulauan is Indon. 68 F8
Kangen r. Sudan 97 G4
Kangerlussuaq Greenland 119 M3
Kangerlussuaq inlet Greenland 119 M3
Kangerlussuaq inlet Greenland 153 J2
Kangersuatsiaq Greenland 119 M2
Kangertittivaq sea chan. Greenland 119 P2
Kanggye N. Korea 74 B4

Kanghwa S. Korea 75 B5
Kangikajik c. Greenland 119 P2
Kangiqsualujjuaq Canada 123 I2
Kangirsuk Canada 123 H1
Kang Krung National Park Thai. 71 B5
Kangle Gansu China 76 D1
Kangle Jiangxi China see Wanzai
Kanglong China 76 C1
Kangmar China 83 F3
Kangnŭng S. Korea 75 C5
Kango Gabon 98 B3
Kangping China 74 A4
Kangri Karpo Pass China/India 83 I3
Kangrinboqê Feng mt. China 82 E3
Kangsangdobdê China see Xainza
Kangto mt. China/India 83 H4
Kangtog China 83 F2
Kangxian China 76 E1
Kanhing Gambia 96 B3
Kanigiri India 84 C3
Kanin, Poluostrov pen. Rus. Fed. 42 J2
Kanin Nos Rus. Fed. 153 G2
Kanin Nos, Mys c. Rus. Fed. 42 I1
Kaninskiy Bereg coastal area
 Rus. Fed. 42 I2
Kanjiroba mt. Nepal 83 E3
Kankaanpää Fin. 45 M6
Kankakee U.S.A. 134 B3
Kankan Guinea 96 C3
Kanker India 84 D1
Kankesanturai Sri Lanka 84 D4
Kankossa Mauritania 96 B3
Kanmaw Kyun i. Myanmar 71 B5
Kannauj India 82 D4
Kanniya Kumari c. India see
 Comorin, Cape
Kannonkoski Fin. 44 N5
Kannur India see Cannanore
Kannus Fin. 44 M5
Kano Nigeria 96 D3
Kanonpunt pt S. Africa 100 E8
Kanosh U.S.A. 129 G2
Kanovlei Namibia 99 B5
Kanoya Japan 75 C7
Kanpur Orissa India 84 E1
Kanpur Uttar Prad. India 82 E4
Kanpur Pak. 89 G5
Kanrach reg. Pak. 89 G5
Kansai airport Japan 75 D6
Kansas U.S.A. 134 B4
Kansas r. U.S.A. 130 E4
Kansas state U.S.A. 130 D4
Kansas City KS U.S.A. 130 E4
Kansas City MO U.S.A. 130 E4
Kansk Rus. Fed. 65 K4
Kansu prov. China see Gansu
Kantang Thai. 71 B6
Kantara hill Cyprus 85 A2
Kantaralak Thai. 71 D4
Kantavu i. Fiji see Kadavu
Kantchari Burkina 96 D3
Kantemirovka Rus. Fed. 43 H6
Kanthi India 83 F5
Kantishna r. U.S.A. 118 C3
Kanton atoll Kiribati 107 I2
Kantulong Myanmar 70 B3
Kanturk Ireland 51 D5
Kanuku Mountains Guyana 143 G3
Kanur India 84 C3
Kanus Namibia 100 D4
Kanyakubja India see Kannauj
Kanyamazane S. Africa 101 J3
Kanye Botswana 101 G3
Kaôh Pring i. Cambodia 71 C5
Kaohsiung Taiwan 77 I4
Kaôh Smăch i. Cambodia 71 C5
Kaôh Tang i. Cambodia 71 C5
Kaokoveld plat. Namibia 99 B5
Kaolack Senegal 96 B3
Kaoma Zambia 99 C5
Kaouadja Cent. Afr. Rep. 98 C3
Kapa S. Africa see Cape Town
Kapa'a U.S.A. 127 [inset]
Kapa'au U.S.A. 127 [inset]
Kapan Armenia 91 G3
Kapanga Dem. Rep. Congo 99 C4
Kaparhā Iran 88 C4
Kapatu Zambia 99 D4
Kapchagay Kazakh. 80 E3
Kapchagayskoye Vodokhranilishche resr
 Kazakh. 80 E3
Kap Dan Greenland see Kulusuk
Kapellen Belgium 52 E3
Kapello, Akra pt Attiki Greece see
 Kapello, Akrotirio
Kapello, Akrotirio pt Greece 59 J6
Kapellskär Sweden 45 K7
Kapelskär Sweden see Kapellskär
Kapili r. India 83 G4
Kapingamarangi atoll Micronesia 150 G5
Kapingamarangi Rise sea feature
 N. Pacific Ocean 150 G5
Kapıorman Dağları mts Turkey 59 N4
Kapip Pak. 89 H4
Kapiri Mposhi Zambia 99 C5
Kapisillit Greenland 119 M3
Kapiskau r. Canada 122 E3
Kapit Sarawak Malaysia 68 E6
Kapiti Island N.Z. 113 E5
Kaplankyr, Chink hills Asia 91 I2
Kaplankyr Dŏwlet Gorugy nature res.
 Turkm. 88 E1
Kapoeta Sudan 97 G4
Kapondai, Tanjung pt Indon. 69 G8
Kaposvár Hungary 58 G1
Kappel Germany 53 H5
Kappeln Germany 47 L3
Kapsukas Lith. see Marijampolė
Kaptai Bangl. 83 H5
Kapuas r. Indon. 68 D7
Kapuriya India 82 C4
Kapurthala India 82 C3
Kapuskasing Canada 122 E4
Kapustin Yar Rus. Fed. 43 J6
Kaputar mt. Australia 112 E3
Kaputir Kenya 98 D3
Kapuvár Hungary 58 G1
Kapydzhik, Gora mt. Armenia/Azer. see
 Qazangödağ
Kapyl' Belarus 45 O10
Kaqung China 89 J2

Kara India 82 E4
Kara Togo 96 D4
Kara r. Turkey 91 F3
Kara Art Pass China/Tajik. 89 I2
Kara-Balta Kyrg. 80 D3
Karabalyk Kazakh. 78 F1
Karabekaul' Turkm. see Garabekewül
Karabiga Turkey 59 L4
Karabil', Vozvyshennost' hills Turkm. see
 Garabil Belentligi
Kara-Bogaz-Gol, Proliv sea chan. Turkm. see
 Garabogazköl Bogazy
Kara-Bogaz-Gol'skiy Zaliv b. Turkm. see
 Garabogazköl Aýlagy
Karabük Turkey 90 D2
Karaburun Turkey 59 L5
Karabutak Kazakh. 80 B2
Karacabey Turkey 59 M4
Karacaköy Turkey 59 M4
Karacalı Dağ mt. Turkey 91 E3
Karaçal Tepe mt. Turkey 85 A1
Karacasu Turkey 59 M6
Karaca Yarımadası pen. Turkey 59 N6
Karachayevsk Rus. Fed. 91 F2
Karachev Rus. Fed. 43 G5
Karachi Pak. 89 G5
Karacurun Turkey see Hilvan
Karad India 84 B2
Kara Dağ hill Turkey 85 D1
Kara Dağ mt. Turkey 90 D3
Kara-Dar'ya China see Moyu
Kara Deniz sea Asia/Europe see Black Sea
Karagan Rus. Fed. 74 A1
Karaganda Kazakh. 80 D2
Karagayly Kazakh. 80 E2
Karaginskiy Zaliv b. Rus. Fed. 65 R4
Karagiye, Vpadina depr. Kazakh. 91 H2
Karagola India 83 F4
Karahallı Turkey 59 M5
Karahasanlı Turkey 90 D3
Karaikal India 84 C4
Karaikkudi India 84 C4
Karaisalı Turkey 90 D3
Karaj Iran 88 C3
Karak Jordan see Al Karak
Karakalli Turkey see Özalp
Karakax China see Moyu
Karakax He r. China 82 E1
Karakax Shan mts China 82 E2
Karakelong i. Indon. 69 H6
Karaki China 82 E1
Karaklis Armenia see Vanadzor
Karakoçan Turkey 91 F3
Kara-Köl Kyrg. 79 G2
Karakol Kyrg. 80 E3
Karakoram Pass
 China/Jammu and Kashmir 82 D2
Karakoram Range mts Asia 79 G3
Karakoram Range mts Asia 89 I2
Kara K'orê Eth. 98 D2
Karakorum mts Asia see
 Karakoram Range
Karakorum mts Asia see
 Karakoram Range
Karaköse Turkey see Ağrı
Kara Köl' Kyrg. see Kara-Köl
Karakul', Ozero l. Tajik. see Qarokŭl
Kara Kum des. Turkm. see Garagum
Kara Kum des. Turkm. see
 Karakum Desert
Karakum, Peski Kazakh. see
 Karakum Desert
Karakum Desert Kazakh. 78 E2
Karakum Desert Turkm. see Garagum
Karakum Desert Turkm. see Garagum
Karakumskiy Kanal canal Turkm. see
 Garagum Kanaly
Kara Kumy des. Turkm. see Garagum
Karakurt Turkey 91 F2
Karakuş Dağı ridge Turkey 59 N5
Karal Chad 97 E3
Karala Estonia 45 L7
Karalundi Australia 109 B6
Karama r. Indon. 68 F7
Karaman Turkey 90 D3
Karaman prov. Turkey 85 A1
Karamanlı Turkey 59 M5
Karamay China 80 F2
Karambar Pass Afgh./Pak. 89 I2
Karamea N.Z. 113 D5
Karamea Bight b. N.Z. 113 C5
Karamendy Kazakh. 80 B1
Karamiran China 83 F1
Karamiran Shankou pass China 83 F1
Karamürsel Turkey 59 M4
Karamyshevo Rus. Fed. 45 P8
Karān i. Saudi Arabia 88 C5
Karanja India 84 C1
Karanjia India 82 E5
Karapınar Gaziantep Turkey 85 C1
Karapınar Konya Turkey 90 D3
Karas admin. reg. Namibia 100 C4
Karasay China 83 E1
Karasburg Namibia 100 D5
Karasjok Norway 44 N2
Karasu r. Syria/Turkey 85 C1
Karasu Bitlis Turkey see Hizan
Karasu Sakarya Turkey 59 N4
Karasu r. Turkey 91 F3
Karasubazar Ukr. see Bilohirs'k
Karasuk Rus. Fed. 64 I4
Karāt Iran 89 F3
Karataş Turkey 85 B1
Karataş Burnu hd Turkey see Fener Burnu
Karatau Kazakh. 80 D3
Karatau, Khrebet mts Kazakh. 80 C3
Karatepe Turkey 85 A1
Karathuri Myanmar 71 B5
Karativu i. Sri Lanka 84 C4
Karatsu Japan 75 C6
Karaudanawa Guyana 143 G3
Karauli India 82 D4
Karavan Kyrg. see Kerben
Karavostasi Cyprus 85 A2
Karawang Indon. 68 D8
Karayılan Turkey 85 C1

Karayulgan China 80 F3
Karazhal Kazakh. 80 D2
Karbala' Iraq 91 G4
Karben Germany 53 I4
Karcag Hungary 59 I1
Karden Germany 53 H4
Kardhitsa Greece see Karditsa
Karditsa Greece 59 I5
Kärdla Estonia 45 M7
Karee S. Africa 101 H5
Kareeberge mts S. Africa 100 E6
Kareima Sudan 86 D6
Kareli India 82 D5
Karelia aut. rep. Rus. Fed. see
 Kareliya, Respublika
Kareliya, Respublika aut. rep.
 Rus. Fed. 44 R3
Karel'skaya A.S.S.R. aut. rep. Rus. Fed. see
 Kareliya, Respublika
Karel'skiy Bereg coastal area
 Rus. Fed. 44 R3
Karema Tanz. 99 D4
Karera India 82 D4
Karesuando Sweden 44 M2
Kärevändar Iran 89 F5
Kargalinski Rus. Fed. see Kargalinskaya
Kargalinskaya Rus. Fed. 91 G2
Karghalik China see Yecheng
Kargı Turkey 90 D2
Kargil India 82 D2
Kargilik China see Yecheng
Kargopol' Rus. Fed. 42 H3
Kari Nigeria 96 E3
Kariān Iran 88 E5
Kariba Zimbabwe 99 C5
Kariba, Lake resr Zambia/Zimbabwe 99 C5
Kariba Dam Zambia/Zimbabwe 99 C5
Kariba-yama vol. Japan 74 E4
Karibib Namibia 100 B1
Karigasniemi Fin. 44 N2
Karijini National Park Australia 109 B5
Karijoki Fin. 44 L5
Karikari, Cape N.Z. 113 D2
Karimata, Pulau-pulau is Indon. 68 D7
Karimata, Selat strait Indon. 68 D7
Karimganj India 83 H4
Karimnagar India 84 C2
Karimunjawa, Pulau-pulau is Indon. 68 E8
Káristos Greece see Karystos
Karjat Mahar. India 84 B2
Karjat Mahar. India 84 B2
Karkaralinsk Kazakh. 80 E2
Karkar Island P.N.G. 69 L7
Karkh Pak. 89 G5
Karkinits'ka Zatoka g. Ukr. 59 O2
Kärkölä Fin. 45 N6
Karkonoski Park Narodowy nat. park
 Czech Rep./Poland see
 Krkonošský narodní park
Karksi-Nuia Estonia 45 N7
Karkük Iraq see Kirkūk
Karlachi Pak. 89 H3
Karlholmsbruk Sweden 45 J6
Karlik Shan mt. China 80 H3
Karlıova Turkey 91 F3
Karlivka Ukr. 43 G6
Karl Marks, Qullai mt. Tajik. 89 I2
Karlovac Croatia 58 F2
Karlovka Ukr. see Karlivka
Karlovo Bulg. 59 K3
Karlovy Vary Czech Rep. 53 M4
Karlsbad Germany see Karlovy Vary
Karlsborg Sweden 45 I7
Karlsburg Romania see Alba Iulia
Karlshamn Sweden 45 I8
Karlskoga Sweden 45 I7
Karlskrona Sweden 45 I8
Karlsruhe Germany 53 I5
Karlstad Sweden 45 H7
Karlstad U.S.A. 130 D1
Karlstadt Germany 53 J5
Karluk U.S.A. 118 C4
Karlyk Turkm. 89 G2
Karmala India 84 B2
Karmel, Har hill Israel see
 Carmel, Mount
Karmona Spain see Córdoba
Karmøy i. Norway 45 D7
Karnafuli Reservoir Bangl. 83 H5
Karnal India 82 D3
Karnataka state India 84 B3
Karnes City U.S.A. 131 D6
Karnobat Bulg. 59 L3
Karodi Pak. 89 G5
Karoi Zimbabwe 99 C5
Karokpi Myanmar 70 B4
Karo La pass China 83 G3
Karong India 83 H4
Karonga Malawi 99 D4
Karonie Australia 109 C7
Karoo National Park S. Africa 100 F7
Karoo Nature Reserve S. Africa 100 G7
Karoonda Australia 111 B7
Karora Eritrea 86 E6
Karossa, Tanjung pt Indon. 108 B2
Karow Germany 53 M1
Karpas Peninsula Cyprus see Karpasia
Karpasia pen. Cyprus 85 B2
Karpathos i. Greece 59 L7
Karpathou, Steno sea chan. Greece 59 L6
Karpaty mts Europe see
 Carpathian Mountains
Karpenisi Greece 59 I5
Karpilovka Belarus see Aktsyabrski
Karpinsk Rus. Fed. 41 S4
Karpogory Rus. Fed. 42 J2
Karpuz r. Turkey 85 A1
Karratha Australia 108 B5
Karrat plat. S. Africa see Great Karoo
Karrychirla Turkm. see Garrygyrla
Kars Turkey 91 F2
Kärsämäki Fin. 44 N5
Kärsava Latvia 45 O8

Karshi Qashqadaryo Uzbek. see Qarshi
Karskiye Vorota, Proliv strait
 Rus. Fed. 64 G3
Karskoye More sea Rus. Fed. see Kara Sea
Karstädt Germany 53 L1
Karstula Fin. 44 N5
Karsu Turkey 85 C1
Karsun Rus. Fed. 43 J5
Kartal Turkey 59 M4
Kartaly Rus. Fed. 64 H4
Kartayel' Rus. Fed. 42 L2
Karttula Fin. 44 O5
Karumba Australia 110 C3
Karumbhar Island India 82 B5
Karun, Küh-e hill Iran 88 C4
Kārūn, Rüd-e r. Iran 88 C4
Karuni Indon. 108 B2
Karur India 84 C4
Karvia Fin. 44 M5
Karviná Czech Rep. 47 Q6
Karwar India 84 B3
Karyagino Azer. see Füzuli
Karymskaya Rus. Fed. 73 K2
Karynzharyk, Peski des. Kazakh. 91 I2
Karystos Greece 59 K5
Kaş Turkey 59 M6
Kasa India 84 B2
Kasaba Turkey see Turgutlu
Kasabonika Canada 122 C3
Kasabonika Lake Canada 122 C3
Kasai r. Dem. Rep. Congo 98 B4
 also known as Kwa
Kasaï, Plateau du Dem. Rep. Congo
 99 C4
Kasaji Dem. Rep. Congo 99 C5
Kasama Zambia 99 D5
Kasan Uzbek. see Koson
Kasane Botswana 99 C5
Kasaragad India 84 B3
Kasargod India see Kasaragod
Kasargode India see Kasaragod
Kasatkino Rus. Fed. 74 C2
Kasba Lake Canada 121 K2
Kasba Tadla Morocco 54 C5
Kasenga Dem. Rep. Congo 99 C5
Kasengu Dem. Rep. Congo 98 C4
Kasese Dem. Rep. Congo 98 C4
Kasese Uganda 98 D3
Kasevo Rus. Fed. see Neftekamsk
Kasganj India 82 D4
Kasha China 76 C2
Kashabowie Canada 122 C4
Kāshān Iran 88 C3
Kashary Rus. Fed. 43 I6
Kashechewan Canada 122 E3
Kashgar China see Kashi
Kashi China 80 E4
Kashihara Japan 75 D6
Kashima-nada b. Japan 75 F5
Kashin Rus. Fed. 42 H4
Kashipur India 82 D3
Kashira Rus. Fed. 43 H5
Kashiwazaki Japan 75 E5
Kashkarantsy Rus. Fed. 42 H2
Kashku'iyeh Iran 88 D4
Kāshmar Iran 88 E3
Kashmir terr. Asia see
 Jammu and Kashmir
Kashmir, Vale of reg. India 82 C2
Kashyukulu Dem. Rep. Congo 99 C4
Kasi India see Varanasi
Kasigar Afgh. 89 H3
Kasimov Rus. Fed. 43 I5
Kaskattama r. Canada 121 N3
Kaskinen Fin. 44 L5
Kas Klong i. Cambodia see Kŏng, Kaôh
Kaskö Fin. see Kaskinen
Kaslo Canada 120 G5
Kasmere Lake Canada 121 K3
Kasongo Dem. Rep. Congo 99 C4
Kasongo-Lunda Dem. Rep. Congo 99 B4
Kasos i. Greece 59 L7
Kaspiy Mangy Oypaty lowland
 Kazakh./Rus. Fed. see Caspian Lowland
Kaspiysk Rus. Fed. 91 G2
Kaspiyskoye More l. Asia/Europe see
 Caspian Sea
Kassa Slovakia see Košice
Kassala Sudan 86 E6
Kassandras, Akra pt Greece see
 Kassandras, Akrotirio
Kassandras, Akra pt Greece see
 Kassandras, Akrotirio
Kassandras, Akrotirio pt Greece 59 J5
Kassandras, Kolpos b. Greece 59 J4
Kassel Germany 53 J3
Kasserine Tunisia 58 C7
Kastag Pak. 89 F5
Kastamonu Turkey 90 D2
Kastellaun Germany 53 H4
Kastelli Kriti Greece see Kissamos
Kastéllion Greece see Kissamos
Kastelli Kriti Greece see Kissamos
Kastéllion Greece see Kissamos
Kastellorizon i. Greece see Megisti
Kasterlee Belgium 52 E3
Kastoria Greece 59 I4
Kastornoye Rus. Fed. 43 H6
Kastsyukovichy Belarus 43 G5
Kasulu Tanz. 99 D4
Kasumkent Rus. Fed. 91 H2
Kasungu Malawi 99 D5
Kasungu National Park Malawi 99 D5
Kasur Pak. 89 I4
Katâdhelveti Nunât terr. N. America see
 Greenland
Katahdin, Mount U.S.A. 132 G2
Kataklik Jammu and Kashmir 82 D2
Katako-Kombe Dem. Rep. Congo 98 C4
Katakwi Uganda 98 D3
Katana India 82 C5
Katangi India 82 D5
Katanning Australia 109 B8
Katavi National Park Tanz. 99 D4
Katawaz reg. Afgh. 89 G3
Katchall i. India 71 A6
Katea Dem. Rep. Congo 99 C4
Katerini Greece 59 J4
Katesh Tanz. 99 D4
Kate's Needle mt. Canada/U.S.A.
 120 C3
Katete Zambia 99 D5

Kholm Rus. Fed. 42 F4
Kholmsk Rus. Fed. 74 F3
Kholon Israel see Holon
Khomas admin. reg. Namibia 100 C2
Khomas Highland hills Namibia 100 B2
Khomeyn Iran 88 C3
Khomeynīshahr Iran 88 C3
Khong, Mae Nam r. Laos/Thai. 70 D4 see Mekong
Khonj Iran 88 D5
Khonj, Kūh-e mts Iran 88 D5
Khon Kaen Thai. 70 C3
Khon Kriel Cambodia see Phumĭ Kon Kriel
Khonsa India 83 H4
Khonuu Rus. Fed. 65 P3
Khoper r. Rus. Fed. 43 I6
Khor Rus. Fed. 74 D3
Khor r. Rus. Fed. 74 D3
Khorat Plateau Thai. 70 C3
Khorda India see Khurda
Khordha India see Khurda
Khoreyver Rus. Fed. 42 M2
Khorinsk Rus. Fed. 73 J2
Khorixas Namibia 99 B6
Khormūj, Kūh-e mt. Iran 88 C4
Khorog Tajik. see Khorugh
Khorol Rus. Fed. 74 D3
Khorol Ukr. 43 G6
Khoroslū Dāgh hills Iran 88 B2
Khorramābād Iran 88 C3
Khorramshahr Iran 88 C4
Khorugh Tajik. 89 H2
Khosheutovo Rus. Fed. 43 J7
Khosūyeh Iran 88 D4
Khotan China see Hotan
Khouribga Morocco 54 C5
Khovaling Tajik. 89 H2
Khowrjān Iran 88 D4
Khowst reg. Afgh./Pak. 89 H3
Khowst 89 H3
Khreum Myanmar 70 A2
Khroma r. Rus. Fed. 65 P2
Khromtau Kazakh. 80 A1
Khrushchev Ukr. see Svitlovods'k
Khrysokhou Bay Cyprus see Chrysochou Bay
Khrystynivka Ukr. 43 F6
Khuar Pak. 89 I3
Khudumelapye Botswana 100 G2
Khudzhand Tajik. see Khŭjand
Khufaysah, Khashm al hill Saudi Arabia 88 B6
Khugiana Afgh. see Pirzada
Khuis Botswana 100 E4
Khŭjand Tajik. 80 C3
Khŭjayli Qoraqalpog'iston Respublikasi Uzbek. see Xo'jayli
Khŭjayli Uzbek. see Xo'jayli
Khu Khan Thai. 71 D4
Khulays Saudi Arabia 86 E5
Khulkhuta Rus. Fed. 43 J7
Khulm r. Afgh. 89 G2
Khulo Georgia 91 F2
Khuma S. Africa 101 H4
Khutu r. Rus. Fed. 74 E2
Khvāf Iran 89 F3
Khvāf reg. Iran 89 F3
Khvājeh Iran 88 B2
Khvalynsk Rus. Fed. 43 K5
Khvodrān Iran 88 D4
Khvord Nārvan Iran 88 E3
Khvormūj Iran 88 C4
Khvoy Iran 88 B2
Khvoynaya Rus. Fed. 42 G4
Khwaja Amran mt. Pak. 89 G4
Khwaja Muhammad Range mts Afgh. 89 H2
Khyber Pass Afgh./Pak. 89 H3
Kiama Australia 112 E5
Kiamichi r. U.S.A. 131 E5
Kiangsi prov. China see Jiangxi
Kiangsu prov. China see Jiangsu
Kiantajärvi l. Fin. 44 P4
Kiäseh Iran 88 D2
Kiatassuaq i. Greenland 119 M2
Kibaha Tanz. 99 D4
Kibali r. Dem. Rep. Congo 98 C3
Kibangou Congo 98 B4
Kibaya Tanz. 99 D4
Kibombo Dem. Rep. Congo 98 C4
Kibondo Tanz. 98 D4
Kibre Mengist Eth. 97 G4
Kibris country Asia see Cyprus
Kibungo Rwanda 98 D4
Kičevo Macedonia 59 I4
Kichmengskiy Gorodok Rus. Fed. 42 J4
Kiçik Qafqaz mts Asia see Lesser Caucasus
Kicking Horse Pass Canada 120 G5
Kidal Mali 96 D3

Kidderminster U.K. 49 E6
Kidepo Valley National Park Uganda 98 D3
Kidira Senegal 96 B3
Kidmang Jammu and Kashmir 82 D2
Kidnappers, Cape N.Z. 113 F4
Kidsgrove U.K. 49 E5
Kiel Germany 47 M3
Kiel U.S.A. 134 A2
Kiel Canal Germany 47 L3
Kielce Poland 47 R5
Kielder Water resr U.K. 48 E3
Kieler Bucht b. Germany 47 M3
Kienge Dem. Rep. Congo 99 C5
Kierspe Germany 53 H3

▶ Kiev Ukr. 43 F6
Capital of Ukraine.

Kiffa Mauritania 96 B3
Kifisia Greece 59 J5
Kifrī Iraq 91 G4

▶ Kigali Rwanda 98 D4
Capital of Rwanda.

Kiğı Turkey 91 F3
Kiglapait Mountains Canada 123 J2
Kigoma Tanz. 99 C4
Kihlanki Fin. 44 M3
Kihniö Fin. 44 M5
Kiholo U.S.A. 127 [inset]
Kiiminki Fin. 44 N4
Kii-sanchi mts Japan 75 D6
Kii-suidō sea chan. Japan 75 D6
Kikerino Rus. Fed. 45 P7
Kikinda Serb. and Mont. 59 I2
Kikki Pak. 89 F5
Kikládhes is Greece see Cyclades
Kiknur Rus. Fed. 42 J4
Kikonai Japan 74 F4
Kikori P.N.G. 69 K8
Kikori r. P.N.G. 69 K8
Kikwit Dem. Rep. Congo 99 B4
Kilafors Sweden 45 J6
Kilar India 82 D2
Kilauea U.S.A. 127 [inset]
Kilauea Crater U.S.A. 127 [inset]
Kilchu N. Korea 74 C4
Kilcoole Ireland 51 F4
Kilcormac Ireland 51 E4
Kilcoy Australia 112 F1
Kildare Ireland 51 F4
Kil'dinstroy Rus. Fed. 44 R2
Kildonan Zimbabwe see Mvurwi
Kilembe Dem. Rep. Congo 99 B4
Kilfinan U.K. 50 D5
Kilgore U.S.A. 131 E5
Kilham U.K. 48 E3
Kilia Ukr. see Kiliya
Kılıç Dağı mt. Syria/Turkey see Aqra', Jabal al
Kilifi Kenya 98 D4
Kilik Pass China/Jammu and Kashmir 82 C1

▶ Kilimanjaro vol. Tanz. 98 D4
Highest mountain in Africa.
Africa 92–93

Kilimanjaro National Park Tanz. 98 D4
Kilinailau Islands P.N.G. 106 F2
Kilindoni Tanz. 99 D4
Kilingi-Nõmme Estonia 45 N7
Kilis Turkey 85 C1
Kilis prov. Turkey 85 C1
Kiliya Ukr. 59 M2
Kilkee Ireland 51 C5
Kilkeel U.K. 51 G3
Kilkenny Ireland 51 E5
Kilkhampton U.K. 49 C8
Kilkis Greece 59 J4
Killala Ireland 51 C3
Killala Bay Ireland 51 C3
Killaloe Ireland 51 D5
Killam Canada 121 I4
Killarney N.T. Australia 108 E4
Killarney Qld Australia 112 F2
Killarney Canada 122 E5
Killarney Ireland 51 C5
Killarney National Park Ireland 51 C6
Killary Harbour b. Ireland 51 C4
Killbuck U.S.A. 134 E3
Killeen U.S.A. 131 D6
Killenaule Ireland 51 E5
Killimor Ireland 51 D4
Killin U.K. 50 E4
Killinchy U.K. 51 G3
Killini mt. Greece see Kyllini
Killinick Ireland 51 F5
Killorglin Ireland 51 C5
Killurin Ireland 51 F5
Killybegs Ireland 51 D3
Kilmacrenan Ireland 51 E2
Kilmaine Ireland 51 C4
Kilmallock Ireland 51 D5
Kilmaluag U.K. 50 C3
Kilmarnock U.K. 50 E5
Kilmelford U.K. 50 D4
Kil'mez' Rus. Fed. 42 K4
Kil'mez' r. Rus. Fed. 42 K4
Kilmona Ireland 51 D6
Kilmore Australia 112 B6
Kilmore Quay Ireland 51 F5
Kilosa Tanz. 99 D4
Kilpisjärvi Fin. 44 L2
Kilrea U.K. 51 F3
Kilrush Ireland 51 C5
Kilsyth U.K. 50 E5
Kiltan atoll India 84 B4
Kiltullagh Ireland 51 D4
Kilwa Masoko Tanz. 99 D4
Kilwinning U.K. 50 E5
Kim U.S.A. 131 C4
Kimba Australia 109 G8
Kimba Congo 98 B4
Kimball U.S.A. 130 C3
Kimball, Mount U.S.A. 118 D3
Kimbe P.N.G. 106 F2
Kimberley S. Africa 100 G5
Kimberley Plateau Australia 108 D4
Kimberley Range hills Australia 109 B6

Kimch'aek N. Korea 75 C4
Kimch'ŏn S. Korea 75 C5
Kimhae S. Korea 75 C6
Kimhandu mt. Tanz. 99 D4
Kími Greece see Kymi
Kimito Fin. 45 M6
Kimmirut Canada 119 L3
Kimolos i. Greece 59 K6
Kimovsk Rus. Fed. 43 H5
Kimpese Dem. Rep. Congo 99 B4
Kimpoku-san mt. Japan see Kinpoku-san
Kimry Rus. Fed. 42 H4
Kimsquit Canada 120 E4
Kimvula Dem. Rep. Congo 99 B4
Kinabalu, Gunung mt. Sabah Malaysia 68 F5
Kinango Kenya 99 D4
Kinaskan Lake Canada 120 D3
Kinbasket Lake Canada 120 G4
Kinbrace U.K. 50 F2
Kincaid Canada 121 J5
Kincardine Canada 134 E1
Kincardine U.K. 50 F4
Kinchega National Park Australia 111 C7
Kincolith Canada 120 D4
Kinda Dem. Rep. Congo 99 C4
Kindat Myanmar 70 A2
Kinde U.S.A. 134 D2
Kinder Scout hill U.K. 48 F5
Kindersley Canada 121 I5
Kindia Guinea 96 B3
Kindu Dem. Rep. Congo 98 C4
Kinel' Rus. Fed. 43 K5
Kineshma Rus. Fed. 42 I4
Kingaroy Australia 112 E1
King Christian Island Canada 119 H2
King City U.S.A. 128 C3
King Edward VII Land pen. Antarctica see Edward VII Peninsula
Kingfield U.S.A. 135 J1
Kingfisher U.S.A. 131 D5
King George U.S.A. 135 G4
King George, Mount Canada 126 E2
King George Island Antarctica 152 A2
King George Islands Canada 122 F2
King George Islands Fr. Polynesia see Roi Georges, Îles du
King Hill Australia 108 C5
Kingisepp Rus. Fed. 45 P7
King Island Australia 111 [inset]
King Island Canada 120 E4
King Island Myanmar see Kadan Kyun
Kingisseppa Estonia see Kuressaare
Kinglake National Park Australia 112 B6
King Leopold and Queen Astrid Coast Antarctica 152 E2
King Leopold Range National Park Australia 108 D4
King Leopold Ranges hills Australia 108 D4
Kingman U.S.A. 129 F4

▶ Kingman Reef terr. N. Pacific Ocean 150 J5
United States Unincorporated Territory.

King Mountain Canada 120 D3
King Mountain hill U.S.A. 131 C6
Kingoonya Australia 111 A6
King Peak Antarctica 152 L1
King Peninsula Antarctica 152 K2
Kingri Pak. 89 H4
Kings r. Ireland 51 E5
Kings r. CA U.S.A. 128 D3
Kings r. NV U.S.A. 126 D4
King Salmon U.S.A. 118 C4
Kingsbridge U.K. 49 D8
Kingsburg U.S.A. 128 D3
Kings Canyon National Park U.S.A. 128 D3
Kingscliff Australia 112 F2
Kingscote Australia 111 B7
Kingscourt Ireland 51 F4
Kingsland U.S.A. 133 D5
King Sejong research station Antarctica 152 A2
King's Lynn U.K. 49 H6
Kingsmill Group is Kiribati 107 H2
Kingsnorth U.K. 49 H7
King Sound b. Australia 108 C4
Kings Peak U.S.A. 129 H1
Kingsport U.S.A. 132 D4
Kingston Australia 111 [inset]
Kingston Canada 135 G1

▶ Kingston Jamaica 137 I5
Capital of Jamaica.

▶ Kingston Norfolk I. 107 G4
Capital of Norfolk Island.

Kingston MO U.S.A. 130 E4
Kingston NY U.S.A. 135 H3
Kingston OH U.S.A. 134 D4
Kingston PA U.S.A. 135 H3
Kingston Peak U.S.A. 129 F4
Kingston South East Australia 111 B8
Kingston upon Hull U.K. 48 G5

▶ Kingstown St Vincent 137 L6
Capital of St Vincent.

Kingstree U.S.A. 133 E5
Kingsville U.S.A. 131 D7
Kingswood U.K. 49 E7
Kington U.K. 49 D6
Kingungi Dem. Rep. Congo 99 B4
Kingurutik r. Canada 123 J2
Kingussie U.K. 50 E3
King William I. U.S.A. 135 G5
King William Island Canada 119 I3
King William's Town S. Africa 101 H7
Kingwood TX U.S.A. 131 E6
Kingwood WV U.S.A. 134 F4
Kinloch N.Z. 113 B7
Kinloss U.K. 50 F3
Kinmen Taiwan see Chinmen
Kinmen i. Taiwan see Chinmen Tao
Kinmount Canada 135 F1
Kinna Sweden 45 H8
Kinnegad Ireland 51 E4
Kinneret, Yam l. Israel see Galilee, Sea of

Kinniyai Sri Lanka 84 D4
Kinnula Fin. 44 N5
Kinoje r. Canada 122 E3
Kinoosao Canada 121 K3
Kinpoku-san mt. Japan 75 E5
Kinross U.K. 50 F4
Kinsale Ireland 51 D6
Kinsale U.S.A. 135 G4

▶ Kinshasa Dem. Rep. Congo 99 B4
Capital of the Democratic Republic of the Congo, and 3rd most populous city in Africa.

Kinsley U.S.A. 130 D4
Kinsman U.S.A. 134 E3
Kinston U.S.A. 133 E5
Kintore U.K. 50 G3
Kintyre pen. U.K. 50 D5
Kin-U Myanmar 70 A2
Kinushseo r. Canada 122 E3
Kinyeti mt. Sudan 97 G4
Kinzig r. Germany 53 I4
Kiowa CO U.S.A. 126 G5
Kiowa KS U.S.A. 131 D4
Kipahigan Lake Canada 121 K4
Kiparissia Greece see Kyparissia
Kipawa, Lac l. Canada 122 F5
Kipembawe Tanz. 99 D4
Kipengere Range mts Tanz. 99 D4
Kipili Tanz. 99 D4
Kipini Kenya 98 E4
Kipling Canada 121 K5
Kipling Station Canada see Kipling
Kipnuk U.S.A. 118 B4
Kiptopeke U.S.A. 135 H5
Kipungo Angola see Quipungo
Kipushi Dem. Rep. Congo 99 C5
Kirakira Solomon Is 107 G3
Kirandul India 84 D2
Kingaroy Australia 112 E1
Kirchdorf Germany 53 I2
Kirchheim-Bolanden Germany 53 I5
Kirchheim unter Teck Germany 53 J6
Kircubbin U.K. 51 G3
Kirdimi Chad 97 E3
Kirenga r. Rus. Fed. 73 J1
Kirensk Rus. Fed. 65 L4
Kireyevsk Rus. Fed. 43 H5
Kirghizia country Asia see Kyrgyzstan
Kirghiz Range mts Kazakh./Kyrg. 80 D3
Kirgizskaya S.S.R. country Asia see Kyrgyzstan
Kirgizstan country Asia see Kyrgyzstan
Kiri Dem. Rep. Congo 98 B4
Kiribati country Pacific Ocean 150 I6
Kirikhan Turkey 85 C1
Kirikkale Turkey 90 D3
Kirillov Rus. Fed. 42 H4
Kirillovo Rus. Fed. 74 F3
Kirin China see Jilin
Kirin prov. China see Jilin
Kirinda Sri Lanka 84 D5
Kirinyaga mt. Kenya see Kenya, Mount
Kirishi Rus. Fed. 42 G4
Kirishima-Yaku Kokuritsu-kōen Japan 75 C7
Kirishima-yama vol. Japan 75 C7
Kiritimati atoll Kiribati 151 J5
Kiriwina Islands P.N.G. see Trobriand Islands
Kırkağaç Turkey 59 L5
Kirk Bulāg Dāgi mt. Iran 88 B2
Kirkby U.K. 48 E5
Kirkby in Ashfield U.K. 49 F5
Kirkby Lonsdale U.K. 48 E4
Kirkby Stephen U.K. 48 E4
Kirkcaldy U.K. 50 F4
Kirkcolm U.K. 50 D6
Kirkcudbright U.K. 50 E6
Kirkenær Norway 45 H6
Kirkenes Norway 44 Q2
Kirkfield Canada 135 F1
Kirkintilloch U.K. 50 E5
Kirkkonummi Fin. 45 N6
Kirkland U.S.A. 129 G4
Kirkland Lake Canada 122 E4
Kırklareli Turkey 59 L4
Kirklin U.S.A. 134 B3
Kirk Michael Isle of Man 48 C4
Kirkoswald U.K. 48 E4
Kirkpatrick, Mount Antarctica 152 H1
Kirksville U.S.A. 130 E3
Kirkūk Iraq 91 G4
Kirkwall U.K. 50 G2
Kirkwood S. Africa 101 G7
Kirman Iran see Kermān
Kirn Germany 53 H5
Kirov Kaluzhskaya Oblast' Rus. Fed. 43 G5
Kirov Kirovskaya Oblast' Rus. Fed. 42 K4
Kirova, Zaliv b. Azer. see Qızılağac Körfäzi
Kirovabad Azer. see Gäncä
Kirovabad Tajik. see Panj
Kirovakan Armenia see Vanadzor
Kirovo Ukr. see Kirovohrad
Kirovo-Chepetsk Rus. Fed. 42 K4
Kirovo-Chepetskiy Rus. Fed. see Kirovo-Chepetsk
Kirovograd Ukr. see Kirovohrad
Kirovohrad Ukr. 43 G6
Kirovsk Leningradskaya Oblast' Rus. Fed. 42 G4
Kirovsk Murmanskaya Oblast' Rus. Fed. 44 R3
Kirovs'ke Ukr. 90 D1
Kirovskiy Rus. Fed. 74 D3
Kirovskoye Ukr. see Kirovs'ke
Kırpaşa pen. Cyprus see Karpasia
Kirpili Turkm. 88 E2
Kirriemuir U.K. 50 F4
Kirs Rus. Fed. 42 L4
Kirsanov Rus. Fed. 43 I5
Kırşehir Turkey 90 D3
Kirthar National Park Pak. 89 G5
Kirthar Range mts Pak. 89 G5
Kirtland U.S.A. 129 I3
Kiruna Sweden 44 L3
Kirundu Dem. Rep. Congo 98 C4
Kirwan Escarpment Antarctica 152 B2
Kiryū Japan 75 E5
Kisa Sweden 45 I8

Kisama, Parque Nacional de nat. park Angola see Quiçama, Parque Nacional do
Kisandji Dem. Rep. Congo 99 B4
Kisangani Dem. Rep. Congo 98 C3
Kisantu Dem. Rep. Congo 99 B4
Kisar i. Indon. 108 D2
Kisaran Indon. 71 B7
Kiselevsk Rus. Fed. 72 F2
Kisel'ovka Rus. Fed. 74 E2
Kish i. Iran 88 D5
Kishanganj India 83 F4
Kishangarh Madh. Prad. India 82 D4
Kishangarh Rajasthan India 82 B4
Kishangarh Rajasthan India 82 C4
Kishangarh Rajasthan India 82 D4
Kishi Nigeria 96 D4
Kishinev Moldova see Chişinău
Kishkenekol' Kazakh. 79 G1
Kishoreganj Bangl. 83 G4
Kishorganj Bangl. see Kishoreganj
Kisi Nigeria see Kishi
Kisii Kenya 98 D4
Kiska Island U.S.A. 65 S4
Kiskittogisu Lake Canada 121 L4
Kiskitto Lake Canada 121 L4
Kiskunfélegyháza Hungary 59 H1
Kiskunhalas Hungary 59 H1
Kiskunsági nat. park Hungary 59 H1
Kislovodsk Rus. Fed. 91 F2
Kismaayo Somalia 98 E4
Kismayu Somalia see Kismaayo
Kisoro Uganda 97 F5
Kispiox Canada 120 E4
Kispiox r. Canada 120 E4
Kissamos Greece 59 J7
Kisseraing Island Myanmar see Kanmaw Kyun
Kissidougou Guinea 96 B4
Kissimmee U.S.A. 133 D6
Kissimmee, Lake U.S.A. 133 D7
Kississing Lake Canada 121 K4
Kistendey Rus. Fed. 43 I5
Kistigan Lake Canada 121 M4
Kistna r. India see Krishna
Kisumu Kenya 98 D4
Kisykkamys Kazakh. see Dzhangala
Kita Mali 96 C3
Kitab Uzbek. see Kitob
Kita-Daitō-jima i. Japan 73 O7
Kitaibaraki Japan 75 F5
Kita-lō-jima vol. Japan 69 K1
Kitakami Japan 75 F5
Kita-Kyūshū Japan 75 C6
Kitale Kenya 98 D3
Kitami Japan 74 F4
Kit Carson U.S.A. 130 C4
Kitchener Canada 134 E2
Kitchigama r. Canada 122 F4
Kitee Fin. 44 Q5
Kitgum Uganda 98 D3
Kíthira i. Greece see Kythira
Kíthnos i. Greece see Kythnos
Kiti, Cape Cyprus see Kition, Cape
Kitimat Canada 120 D4
Kitinen r. Fin. 44 O3
Kition, Cape Cyprus 85 A2
Kitiou, Akra c. Cyprus see Kition, Cape
Kitkatla Canada 120 D4
Kitob Uzbek. 89 G2
Kitsault Canada 120 D4
Kittanning U.S.A. 134 F3
Kittatinny Mountains hills U.S.A. 135 H3
Kittery U.S.A. 135 J2
Kittilä Fin. 44 N3
Kittur India 84 B3
Kitty Hawk U.S.A. 132 F4
Kitui Kenya 98 D4
Kitwanga Canada 120 D4
Kitwe Zambia 99 C5
Kitzbühel Austria 47 N7
Kitzbüheler Alpen mts Austria 47 N7
Kitzingen Germany 53 K5
Kiu Lom Reservoir Thai. 70 B3
Kiunga P.N.G. 69 K8
Kiuruvesi Fin. 44 O5
Kivalina U.S.A. 118 B3
Kivijärvi Fin. 44 N5
Kiviöli Estonia 45 O7
Kivu, Lake Dem. Rep. Congo/Rwanda 98 C4
Kiwaba N'zogi Angola 99 B4
Kiwai Island P.N.G. 69 K8
Kiyev Ukr. see Kiev
Kiyevskoye Vodokhranilishche resr Ukr. see Kyyivs'ke Vodoskhovyshche
Kıyıköy Turkey 59 M4
Kizel Rus. Fed. 41 R4
Kizema Rus. Fed. 42 J3
Kızılcadağ Turkey 59 M6
Kızılca Dağ mt. Turkey 90 C3
Kızılcahamam Turkey 90 D2
Kızıldağ mt. Turkey 85 A1
Kızıldağ mt. Turkey 85 B1
Kızıl Dağı mt. Turkey 90 E3
Kızılırmak Turkey 90 D2
Kızılırmak r. Turkey 90 D2
Kızıltepe Turkey 91 F3
Kizilyurt Rus. Fed. 91 G2
Kizlyar Rus. Fed. 91 G2
Kizlyarskiy Zaliv b. Rus. Fed. 91 G2
Kizner Rus. Fed. 42 K4
Kizyl-Arbat Turkm. see Serdar
Kizyl-Atrek Turkm. see Etrek
Kjøllefjord Norway 44 O1
Kjøpsvik Norway 44 J2
Kladno Czech Rep. 47 O5
Klagenfurt Austria 47 O7
Klagetoh U.S.A. 129 I4
Klaipėda Lith. 45 L9
Klaksvík Faroe Is 44 [inset]
Klamath U.S.A. 126 B4
Klamath r. U.S.A. 118 F5
Klamath Falls U.S.A. 126 C4
Klamath Mountains U.S.A. 126 C4
Klang Malaysia 71 C7
Klarälven r. Sweden 45 H7
Klatovy Czech Rep. 47 N6
Klawer S. Africa 100 D6
Klawock U.S.A. 120 C4
Klazienaveen Neth. 52 G2
Kleides Islands Cyprus 85 B2
Kleinbegin S. Africa 100 E5

Klein Karas Namibia 100 D4
Klein Nama Land reg. S. Africa see Namaqualand
Klein Roggeveldberge mts S. Africa 100 E7
Kleinsee S. Africa 100 C5
Klemtu Canada 120 D4
Klerksdorp S. Africa 101 H4
Kletnya Rus. Fed. 43 G5
Kletsk Belarus see Klyetsk
Kletskaya Rus. Fed. 43 I6
Kletskiy Rus. Fed. see Kletskaya
Kleve Germany 52 G3
Klidhes Islands Cyprus see Kleides Islands
Klimkovka Rus. Fed. 42 K4
Klimovo Rus. Fed. 43 G5
Klin Rus. Fed. 42 H4
Klingenberg am Main Germany 53 J5
Klingenthal Germany 53 M4
Klingkang, Banjaran mts Indon./Malaysia 68 E6
Klink Germany 53 M1
Klínovec mt. Czech Rep. 53 N4
Klintehamn Sweden 45 K8
Klintsy Rus. Fed. 43 G5
Ključ Bos.-Herz. 58 G2
Kłodzko Poland 47 P5
Klondike r. Canada 120 B1
Klondike Gold Rush National Historical Park nat. park U.S.A. 120 C3
Kloosterhaar Neth. 52 G2
Klosterneuburg Austria 47 P6
Klötze (Altmark) Germany 53 L2
Kluane Lake Canada 120 B2
Kluane National Park Canada 120 B2
Kluang Malaysia see Keluang
Kluczbork Poland 47 Q5
Klukhori Rus. Fed. see Karachayevsk
Klukhorskiy, Pereval Rus. Fed. 91 F2
Klukwan U.S.A. 120 C3
Klupro Pak. 89 H5
Klyetsk Belarus 45 O10
Klyuchevskaya, Sopka vol. Rus. Fed. 65 R4
Klyuchi Rus. Fed. 74 F3
Knäda Sweden 45 I6
Knaresborough U.K. 48 F4
Knee Lake Man. Canada 121 M4
Knee Lake Sask. Canada 121 J4
Knetzgau Germany 53 K5
Knife r. U.S.A. 130 C2
Knight Inlet Canada 120 E5
Knighton U.K. 49 D6
Knights Landing U.S.A. 128 C2
Knightstown U.S.A. 134 C4
Knin Croatia 58 G2
Knittelfeld Austria 47 O7
Knjaževac Serb. and Mont. 59 J3
Knob Lake Canada see Schefferville
Knob Lick U.S.A. 134 C5
Knob Peak hill Australia 108 E3
Knock Ireland 51 D4
Knockaboy hill Ireland 51 C6
Knockalongy hill Ireland 51 D3
Knockalough Ireland 51 C5
Knockanaffrin hill Ireland 51 E5
Knock Hill hill U.K. 50 G3
Knockmealdown Mts hills Ireland 51 D5
Knocknaskagh hill Ireland 51 D5
Knokke-Heist Belgium 52 D3
Knorrendorf Germany 53 N1
Knowle U.K. 49 F6
Knowlton Canada 135 I1
Knox IN U.S.A. 134 B3
Knox PA U.S.A. 134 F3
Knox, Cape Canada 120 C4
Knox Coast Antarctica 152 F2
Knoxville GA U.S.A. 133 D5
Knoxville TN U.S.A. 132 D5
Knud Rasmussen Land reg. Greenland 119 J2
Knysna S. Africa 100 F8
Ko, Gora mt. Rus. Fed. 74 E3
Koartac Canada see Quaqtaq
Koba Indon. 68 D7
Kōbe Japan 75 D6
København Denmark see Copenhagen
Kobenni Mauritania 96 C3
Koblenz Germany 53 H4
Koboldo Rus. Fed. 74 D1
Kobrin Belarus see Kobryn
Kobroör i. Indon. 69 I8
Kobryn Belarus 45 N10
Kobuk Valley National Park U.S.A. 118 C3
K'obulet'i Georgia 91 F2
Kocaeli Turkey see İzmit
Kocaeli prov. Turkey see İzmit
Kocaeli Yarımadası pen. Turkey 59 M4
Kočani Macedonia 59 J4
Kocasu r. Turkey 59 M4
Kočevje Slovenia 58 F2
Koch Bihar India 83 G4
Kocher r. Germany 53 J5
Kochevo Rus. Fed. 41 Q4
Kochi India see Cochin
Kōchi Japan 75 D6
Kochkor Kyrg. 80 E3
Kochkorka Kyrg. see Kochkor
Kochkurovo Rus. Fed. 43 J5
Kochubeyevskoye Rus. Fed. 91 F1
Kod India 84 B3
Kodala India 84 E2
Kodarma India see Kodarma
Kodiak U.S.A. 118 C4
Kodiak Island U.S.A. 118 C4
Kodibeleng Botswana 101 H2
Kodino Rus. Fed. 42 H3
Kodiyakkarai India 84 C4
Kodok Sudan 86 D8
Kodyma Ukr. 43 F6
Kodzhaele mt. Bulg./Greece 59 K4
Koedoesberg mts S. Africa 100 E7
Koegrabie S. Africa 100 E5
Koekenaap S. Africa 100 D6
Koersel Belgium 52 F3
Koës Namibia 100 D3
Kofa Mountains U.S.A. 129 G5
Koffiefontein S. Africa 100 G5
Koforidua Ghana 96 C4

Kōfu Japan 75 E6
Kogaluc r. Canada 122 F2
Kogaluc, Baie de b. Canada 122 F2
Kogaluk r. Canada 123 J2
Kogan Australia 112 E1
Køge Denmark 45 H9
Kogon r. Guinea 96 B3
Kogon Uzbek. 89 G2
Kohan Pak. 89 G5
Kohat Pak. 89 H3
Kohestanät Afgh. 89 G3
Kohila Estonia 45 N7
Kohima India 83 H4
Kohistan reg. Afgh. 89 H3
Kohistan reg. Pak. 89 I3
Kohler Range mts Antarctica 152 K2
Kohlu Pak. 89 H4
Kohsan Afgh. 89 F3
Kohtla-Järve Estonia 45 O7
Kohŭng S. Korea 75 B6
Koidern Mountain Canada 120 A2
Koidu Sierra Leone see Sefadu
Koihoa India 71 A5
Koilkonda India 84 C2
Koin N. Korea 75 B4
Koin r. Rus. Fed. 42 K3
Koi Sanjaq Iraq 91 G3
Kōje-do i. S. Korea 75 C6
Kojonup Australia 109 B8
Kokand Farg'ona Uzbek. see Qo'qon
Kōkar Fin. 45 L7
Kokchetav Kazakh. see Kokshetau
Kokemäenjoki r. Fin. 45 L6
Kokerboom Namibia 100 D5
Ko Kha Thai. 70 B3
Kokkilai Sri Lanka 84 D4
Kokkola Fin. 44 M5
Koko Nigeria 96 D3
Kokomo U.S.A. 134 B3
Kokong Botswana 100 F3
Kokos i. Indon. 71 A7
Kokosi S. Africa 101 H4
Kokpekti Kazakh. 80 F2
Koksan N. Korea 75 B5
Kokshaal-Tau, Khrebet mts China/Kyrg. see
 Kakshaal-Too
Koksharka Rus. Fed. 42 J4
Kokshetau Kazakh. 79 F1
Koksoak r. Canada 123 H2
Kokstad S. Africa 101 I6
Koktal Kazakh. 80 E3
Kokterek Kazakh. 43 K6
Koktokay China see Fuyun
Kola i. Indon. 69 I8
Kola Rus. Fed. 44 R2
Kolachi r. Pak. 89 G5
Kolahoi mt. Jammu and Kashmir
 82 C2
Kolaka Indon. 69 G7
Ko Lanta Thai. 71 B6
Kola Peninsula Rus. Fed. 42 H2
Kolar Chhattisgarh India 84 D2
Kolar Karnataka India 84 C3
Kolaras India 82 D4
Kolar Gold Fields India 84 C3
Kolari Fin. 44 M3
Kolarovgrad Bulg. see Shumen
Kolasib India 83 H4
Kolayat India 82 C4
Kolberg Poland see Kołobrzeg
Kol'chugino Rus. Fed. 42 H4
Kolda Senegal 96 B3
Kolding Denmark 45 F9
Kole Kasaï-Oriental Dem. Rep. Congo
 98 C4
Kole Orientale Dem. Rep. Congo 98 C3
Koléa Alg. 57 H5
Kolekole U.S.A. 127 [inset]
Koler Sweden 44 L4
Kolguyev, Ostrov i. Rus. Fed. 42 K1
Kolhan reg. India 83 F5
Kolhapur India 84 B2
Kolhumadulu Atoll Maldives 81 D11
Kolikata India see Kolkata
Kõljala Estonia 45 M7
Kolkasrags pt Latvia 45 M8

▶Kolkata India 83 G5
 4th most populous city in Asia, and 7th in
 the world.

Kolkhozabad Khatlon Tajik. see Vose
Kolkhozabad Khatlon Tajik. see
 Kolkhozobod
Kolkhozobod Tajik. 89 H2
Kollam India see Quilon
Kolleru Lake India 84 D2
Kollum Neth. 52 G1
Kolmanskop Namibia 100 B4
Köln Germany see Cologne
Köln-Bonn airport Germany 53 H4
Köln-Bonn airport Germany see Kaliningrad
Kołobrzeg Poland 47 O3
Kologriv Rus. Fed. 42 J4
Kolokani Mali 96 C3
Kolombangara i. Solomon Is 107 F2
Kolomea Ukr. see Kolomyya
Kolomna Rus. Fed. 43 H5
Kolomyja Ukr. see Kolomyya
Kolomyya Ukr. 43 E6
Kolondiéba Mali 96 C3
Kolonedale Indon. 69 G7
Koloni Cyprus 85 A2
Kolonkwaneng Botswana 100 E4
Kolozsvár Romania see
 Cluj-Napoca
Kolpashevo Rus. Fed. 64 J4
Kolpos Messaras b. Greece 59 K7
Kol'skiy Poluostrov pen. Rus. Fed. see
 Kola Peninsula
Kölük Turkey see Kâhta
Koluli Eritrea 86 F7
Kolumadulu Atoll Maldives see
 Kolhumadulu Atoll
Kolva r. Rus. Fed. 42 M2
Kolvan India 84 B2
Kolvereid Norway 44 G4
Kolvik Norway 44 N1
Kolvitskoye, Ozero i. Rus. Fed. 44 R3
Kolwa reg. Pak. 89 G5
Kolwezi Dem. Rep. Congo 99 C5
Kolyma r. Rus. Fed. 65 R3
Kolyma Lowland Rus. Fed. see
 Kolymskaya Nizmennost'

Kolyma Range mts Rus. Fed. see
 Kolymskiy, Khrebet
Kolymskaya Nizmennost' lowland
 Rus. Fed. 65 Q3
Kolymskiy, Khrebet mts Rus. Fed. 65 R3
Kolyshley Rus. Fed. 43 J5
Kom mt. Bulg. 59 J3
Komadugu-gana watercourse Nigeria 96 E3
Komaggas S. Africa 100 C5
Komaio P.N.G. 69 K8
Komaki Japan 75 E6
Komandnaya, Gora mt. Rus. Fed. 74 E2
Komandorskiye Ostrova is Rus. Fed. 65 R4
Komárno Slovakia 47 Q7
Komati r. Swaziland 101 J4
Komatipoort S. Africa 101 J3
Komatsu Japan 75 E5
Komba i. Indon. 108 C1
Komga S. Africa 101 H7
Komintern Ukr. see Marhanets'
Kominternivs'ke Ukr. 59 N1
Komiža Croatia 58 G3
Komló Hungary 58 H1
Kommunarsk Ukr. see Alchevs'k
Komodo, Taman Nasional
 Indon. 108 B2
Kôm Ombo Egypt see Kawm Umbū
Komono Congo 98 B4
Komoran i. Indon. 69 J8
Komotini Greece 59 K4
Kompong Cham Cambodia see
 Kâmpóng Cham
Kompong Chhnang Cambodia see
 Kâmpóng Chhnăng
Kompong Kleang Cambodia see
 Kâmpóng Khleăng
Kompong Som Cambodia see
 Sihanoukville
Kompong Speu Cambodia see
 Kâmpóng Spœ
Kompong Thom Cambodia see
 Kâmpóng Thum
Komrat Moldova see Comrat
Komsberg mts S. Africa 100 E7
Komsomol Kazakh. see Karabalyk
Komsomolabad Tajik. see
 Komsomolobod
Komsomolets Kazakh. see Karabalyk
Komsomolets, Ostrov i. Rus. Fed. 64 K1
Komsomolobod Tajik. 89 H2
Komsomol's'k Ukr. 43 G6
Komsomol'skiy Chukotskiy Avtonomnyy
 Okrug Rus. Fed. 153 C2
Komsomol'skiy Khanty-Mansiyskiy
 Avtonomnyy Okrug Rus. Fed. see Yugorsk
Komsomol'skiy Respublika Kalmykiya -
 Khalm'g-Tangch Rus. Fed. 43 J7
Komsomol'sk-na-Amure Rus. Fed. 74 E2
Komsomol'skoye Kazakh. 80 B1
Komsomol'skoye Rus. Fed. 43 J6
Kömürlü Turkey 91 F2
Kon India 83 E4
Konacık Turkey 85 B1
Konada India 84 D2
Konarak India see Konarka
Konarka India 83 F6
Konch India 82 D4
Kondagaon India 84 D2
Kondinin Australia 109 B8
Kondinskoye Rus. Fed. see
 Oktyabr'skoye
Kondoa Tanz. 99 D4
Kondol' Rus. Fed. 43 J5
Kondopoga Rus. Fed. 42 G3
Kondoz Afgh. see Kunduz
Kondrovo Rus. Fed. 43 G5
Köneürgenç Turkm. 87 I1
Köneürgenç Turkm. see Köneürgenç
Kong Cameroon 96 E4
Köng, Kaôh i. Cambodia 71 C5
Kông, Tônlé r. Cambodia 71 D4
Kong, Xé r. Laos 70 D4
Kong Christian IX Land reg.
 Greenland 119 O3
Kong Christian X Land reg.
 Greenland 119 P2
Kongelab atoll Marshall Is see
 Rongelap
Kong Frederik IX Land reg.
 Greenland 119 M3
Kong Frederik VI Kyst coastal area
 Greenland 119 N3
Kongolo Dem. Rep. Congo 99 C4
Kongor Sudan 97 G4
Kong Oscars Fjord inlet
 Greenland 119 P2
Kongoussi Burkina 96 C3
Kongsberg Norway 45 F7
Kongsvinger Norway 45 H6
Kongur Shan mt. China 80 D3
Königsberg Rus. Fed. see Kaliningrad
Königsee Germany 53 L4
Königswinter Germany 53 H4
Königs Wusterhausen Germany 53 N2
Konimekh Uzbek. see Konimex
Konimex Uzbek. 89 G1
Konin Poland 47 Q4
Konjic Bos.-Herz. 58 G3
Konkiep watercourse Namibia 100 C5
Könnern Germany 53 L3
Konnevesi Fin. 44 O5
Konosha Rus. Fed. 42 I3
Konotop Ukr. 43 G6
Konpara India 83 E5
Kon Plông Vietnam 71 E4
Konqi He r. China 80 G3
Konso Eth. 98 D3
Konstantinograd Ukr. see
 Krasnohrad
Konstantinovka Rus. Fed. 74 B2
Konstantinovka Ukr. see
 Kostyantynivka
Konstantinovy Lázně Czech Rep. 53 M5
Konstanz Germany 47 L7
Kontha Myanmar 70 B2
Kontiolahti Fin. 44 P5
Konttila Fin. 44 O4
Konya Turkey 90 D3
Konz Germany 52 G5

Konzhakovskiy Kamen', Gora mt.
 Rus. Fed. 41 R4
Koocanusa, Lake resr Canada/U.S.A.
 120 H5
Kooch Bihar India see Koch Bihar
Kookynie Australia 109 C7
Koolyanobbing Australia 109 B7
Koondrook Australia 112 B5
Koorawatha Australia 112 D5
Kootenay r. Canada 120 G5
Kootenay Lake Canada 120 G5
Kootenay National Park Canada 120 G5
Kootjieskolk S. Africa 100 E6
Kópasker Iceland 44 [inset]
Kopbirlik Kazakh. 80 E2
Koper Slovenia 58 E2
Kopet Dag mts Iran/Turkm. 88 E2
Kopet-Dag, Khrebet mts Iran/Turkm. see
 Kopet Dag
Köpetdag Gershi mts Iran/Turkm. see
 Kopet Dag
Köping Sweden 45 J7
Köpmanholmen Sweden 44 K5
Kopong Botswana 101 G3
Koppal India 84 C3
Koppang Norway 45 G6
Kopparberg Sweden 45 I7
Koppeh Dägh mts Iran/Turkm. see
 Kopet Dag
Köppel hill Germany 53 H4
Koppi r. Rus. Fed. 74 F2
Koppies S. Africa 101 H4
Koppieskraal Pan salt pan
 S. Africa 100 E4
Koprivnica Croatia 58 G1
Köprülü Turkey 85 A1
Köprülü Kanyon Milli Parkı nat. park
 Turkey 59 N6
Kopyl' Belarus see Kapyl'
Kora India 82 E4
Korablino Rus. Fed. 43 I5
K'orahē Eth. 98 E3
Korak Pak. 89 G5
Koramlik China 83 F1
Korangal India 84 C2
Korangi Pak. 89 G5
Korän va Monjan Afgh. 89 H2
Koraput India 84 D2
Korat Thai. see Nakhon Ratchasima
Koratla India 84 C2
Korba India 83 E5
Korbach Germany 53 I3
Korçë Albania 59 I4
Korčula Croatia 58 G3
Korčula i. Croatia 58 G3
Korčulanski Kanal sea chan.
 Croatia 58 G3
Korday Kazakh. 80 D3
Kord Küv Iran 88 D2
Kords reg. Iran 89 F5
▶Korea, North country Asia 75 B5
 Asia 6, 62–63
▶Korea, South country Asia 75 B5
 Asia 6, 62–63
Korea Bay g. China/N. Korea 75 B5
Korea Strait Japan/S. Korea 75 C6
Koregaon India 84 B2
Korenovsk Rus. Fed. 91 E1
Korenovskaya Rus. Fed. see Korenovsk
Korepino Rus. Fed. 41 R3
Korets' Ukr. 43 E6
Körfez Turkey 59 M4
Korff Ice Rise Antarctica 152 L1
Korfovskiy Rus. Fed. 74 D2
Korgalzhyn Kazakh. 80 D1
Korgen Norway 44 H3
Korhogo Côte d'Ivoire 96 C4
Koribundu Sierra Leone 96 B4
Kori Creek inlet India 82 B5
Korinthiakos Kolpos sea chan. Greece see
 Corinth, Gulf of
Korinthos Greece see Corinth
Kőris-hegy hill Hungary 58 G1
Koritnik mt. Albania 59 I3
Koritsa Albania see Korçë
Kōriyama Japan 75 F5
Korkuteli Turkey 59 N6
Korla China 80 G3
Kormakitis, Cape Cyprus 85 A2
Körmend Hungary 58 G1
Kornat nat. park Croatia 58 F3
Korneyevka Rus. Fed. 43 K6
Koro Côte d'Ivoire 96 C4
Koro i. Fiji 107 H3
Koro Mali 96 C3
Koroc r. Canada 123 I2
Köroğlu Dağları mts Turkey 59 O4
Köroğlu Tepesi mt. Turkey 90 D2
Korogwe Tanz. 99 D4
Korong Vale Australia 112 A6
Koronia, Limni l. Greece see
 Koroneia, Limni

▶Koror Palau 69 I5
 Capital of Palau.

Koro Sea b. Fiji 107 H3
Korosten' Ukr. 43 F6
Korostyshiv Ukr. 43 F6
Koro Toro Chad 97 E3
Korpilahti Fin. 44 N5
Korpo Fin. 45 L6
Korppoo Fin. see Korpo
Korsakov Rus. Fed. 74 F3
Korsnäs Fin. 44 L5
Korsør Denmark 45 G9
Korsun'-Shevchenkivs'kyy Ukr. 43 F6
Korsun'-Shevchenkovskiy Ukr. see
 Korsun'-Shevchenkivs'kyy
Korsze Poland 47 R3
Kortesjärvi Fin. 44 M5
Korti Sudan 86 D6
Kortkeros Rus. Fed. 42 K3
Kortrijk Belgium 52 D4
Korvala Fin. 44 O3
Koryakskaya, Sopka vol. Rus. Fed. 65 R4
Koryakskiy Khrebet mts Rus. Fed. 65 S3
Koryazhma Rus. Fed. 42 J3
Koryŏng S. Korea 75 C6
Kos i. Greece 59 L6
Kosa Rus. Fed. 41 Q4

Kosam India 82 E4
Kosan N. Korea 75 B5
Kościan Poland 47 P4
Kosciusko, Mount Australia see
 Kosciuszko, Mount
Kosciuszko, Mount Australia 112 D6
Kosciuszko National Park
 Australia 112 D6
Köse Turkey 91 E2
Köseçobanlı Turkey 85 A1
Kosgi India 84 C2
Kosh-Agach Rus. Fed. 80 G2
Koshikijima-rettō is Japan 75 C7
Koshk Afgh. 89 F3
Koshk-e Kohneh Afgh. 89 F3
Koshki Rus. Fed. 43 K5
Kosi Bay S. Africa 101 K4
Košice Slovakia 43 D6
Kosigi India 84 C3
Koskullskulle Sweden 44 L3
Köslin Poland see Koszalin
Kosma r. Rus. Fed. 42 K2
Koson Uzbek. 89 G2
Kosŏng N. Korea 75 C5
Kosova prov. Serb. and Mont. see Kosovo
Kosovo prov. Serb. and Mont. 59 I3
Kosovo-Metohija prov. Serb. and Mont. see
 Kosovo
Kosovska Mitrovica Serb. and Mont. 59 I3
Kosrae atoll Micronesia 150 G5
Kosrap China 89 J2
Kösseine hill Germany 53 L5
Kosta-Khetagurovo Rus. Fed. see Nazran'
Kostanay Kazakh. 78 F1
Kostenets Bulg. 59 J3
Kosti Sudan 86 D7
Kostinbrod Bulg. 59 J3
Kostino Rus. Fed. 64 J3
Kostomuksha Rus. Fed. 44 Q4
Kostroma Rus. Fed. 42 I4
Kostrzyn Poland 47 O4
Kostyantynivka Ukr. 43 H6
Kostyukovichi Belarus see
 Kastsyukovichy
Kos'yu Rus. Fed. 41 R2
Koszalin Poland 47 P3
Kőszeg Hungary 58 G1
Kota Andhra Prad. India 84 D3
Kota Chhattisgarh India 83 E5
Kota Rajasthan India 82 C4
Kota Baharu Malaysia see Kota Bharu
Kotabaru Aceh Indon. 71 B7
Kotabaru Kalimantan Selatan
 Indon. 68 F7
Kota Bharu Malaysia 71 C6
Kotabumi Indon. 68 C7
Kot Addu Pak. 89 H4
Kota Kinabalu Sabah Malaysia 68 F5
Kotamobagu Indon. 69 G6
Kotaparh India 84 D2
Kotapinang Indon. 71 C7
Kotatengah Indon. 71 C7
Kota Tinggi Malaysia 71 C7
Kotcho r. Canada 120 F3
Kotcho Lake Canada 120 F3
Kot Diji Pak. 89 H5
Kotel'nich Rus. Fed. 42 K4
Kotel'nikovo Rus. Fed. 43 I7
Kotel'nyy, Ostrov i. Rus. Fed. 65 O2
Kotgar India 82 D3
Kotgarh India 82 D3
Kothagudem India see Kottagudem
Köthen (Anhalt) Germany 53 L3
Kotido Uganda 97 G4
Kotikovo Rus. Fed. 74 D3
Kot Imamgarh Pak. 89 H5
Kotka Fin. 45 O6
Kot Kapura India 82 C3
Kotkino Rus. Fed. 42 K2
Kotlas Rus. Fed. 42 J3
Kotli Pak. 89 I3
Kotlik U.S.A. 118 B3
Kötlutangi pt Iceland 44 [inset]
Kotly Rus. Fed. 45 P7
Kotorkoshi Nigeria 96 D3
Kotovo Rus. Fed. 43 J6
Kotovsk Rus. Fed. 43 I5
Kotra India 82 C4
Kotra Pak. 89 G4
Kotri r. India 84 D2
Kot Sarae Pak. 89 G6
Kottagudem India 84 D2
Kottarakara India 84 C4
Kottayam India 84 C4
Kotte Sri Lanka see
 Sri Jayewardenepura Kotte
Kotto r. Cent. Afr. Rep. 98 C3
Kotturu India 84 C3
Kotuy r. Rus. Fed. 65 L2
Kotzebue U.S.A. 118 B3
Kotzebue Sound sea chan. U.S.A. 118 B3
Kötzting Germany 53 M5
Kouango Cent. Afr. Rep. 98 C3
Koubia Guinea 96 B3
Kouchibouguac National Park
 Canada 123 I5
Koudougou Burkina 96 C3
Kouebokkeveld mts S. Africa 100 D7
Koufey Niger 96 E3
Koufonisi i. Greece 59 L7
Kougaberge mts S. Africa 100 F7
Koukourou r. Cent. Afr. Rep. 98 B3
Koulen Cambodia see Kulen
Koulikoro Mali 96 C3
Koumac New Caledonia 107 G4
Koumpentoum Senegal 96 B3
Koundâra Guinea 96 B3
Kountze U.S.A. 131 E6
Koupéla Burkina 96 C3
Kourou Fr. Guiana 143 H2
Kouroussa Guinea 96 C3
Kousséri Cameroon 97 E3
Koutiala Mali 96 C3
Kouvola Fin. 45 O6
Kovallberget Sweden 44 J4
Kovdor Rus. Fed. 44 Q3
Kovdozero, Ozero l. Rus. Fed. 44 R3
Kovel' Ukr. 43 E6
Kovernino Rus. Fed. 42 I4
Kovilpatti India 84 C4

Kovno Lith. see Kaunas
Kovriga, Gora hill Rus. Fed. 42 K2
Kovrov Rus. Fed. 42 I4
Kovylkino Rus. Fed. 43 I5
Kovzhskoye, Ozero l. Rus. Fed. 42 H3
Kowanyama Australia 110 C2
Kowloon H.K. China 77 [inset]
Kowloon Peak hill H.K. China 77 [inset]
Kowloon Peninsula H.K. China 77 [inset]
Kowŏn N. Korea 75 B5
Kōyama-misaki pt Japan 75 C6
Köyceğiz Turkey 59 M6
Koygorodok Rus. Fed. 42 K3
Koyna Reservoir India 84 B2
Kōytendag Turkm. 89 G2
Koyuk U.S.A. 118 B3
Koyukuk r. U.S.A. 118 C3
Koyulhisar Turkey 90 E2
Kozağacı Turkey see Günyüzü
Kö-zaki pt Japan 75 C6
Kozan Turkey 90 D3
Kozani Greece 59 I4
Kozara mts Bos.-Herz. 58 G2
Kozara nat. park Bos.-Herz. 58 G2
Kozarska Dubica Bos.-Herz. see
 Bosanska Dubica
Kozelets' Ukr. 43 F6
Kozhikode India see Calicut
Kozhva Rus. Fed. 42 M2
Kozlu Turkey 59 N4
Koz'modem'yansk Rus. Fed. 42 J4
Kožuf mts Greece/Macedonia 59 J4
Közu-shima i. Japan 75 E6
Kozyatyn Ukr. 43 F6
Kpalimé Togo 96 D4
Kpandae Ghana 96 C4
Kpungan Pass India/Myanmar 70 B1
Kra, Isthmus of Thai. 71 B5
Krabi Thai. 71 B5
Kra Buri Thai. 71 B5
Krâchéh Cambodia 71 D4
Kraddsele Sweden 44 J4
Kragerø Norway 45 F7
Kraggenburg Neth. 52 F2
Kragujevac Serb. and Mont. 59 I2
Krakatau vol. Indon. 68 D8
Krakau Poland see Kraków
Kraków Poland 47 Q5
Krakower See l. Germany 53 M1
Krâlänh Cambodia 71 C4
Kralendijk Neth. Antilles 137 K6
Kramators'k Ukr. 43 H6
Kramfors Sweden 44 J5
Kranidi Greece 59 J6
Kranj Slovenia 58 F1
Kranji Reservoir Sing. 71 [inset]
Kranskop S. Africa 101 J5
Krasavino Rus. Fed. 42 J3
Krasilov Ukr. see Krasyliv
Krasino Rus. Fed. 64 G2
Kraskino Rus. Fed. 74 C4
Kräslava Latvia 45 O9
Kraslice Czech Rep. 53 M4
Krasnaya Gorbatka Rus. Fed. 42 I5
Krasnaya Zarya Rus. Fed. 43 H5
Krasnoarmeysk Rus. Fed. 43 J6
Krasnoarmeysk Ukr. see Krasnoarmiys'k
Krasnoarmiys'k Ukr. 43 H6
Krasnoborsk Rus. Fed. 42 J3
Krasnodar Rus. Fed. 90 E1
Krasnodar Kray admin. div. Rus. Fed. see
 Krasnodarskiy Kray
Krasnodarskiy Kray admin. div.
 Rus. Fed. 90 E1
Krasnodon Rus. Fed. 43 H6
Krasnogorodskoye Rus. Fed. 45 P8
Krasnogorsk Rus. Fed. 74 F2
Krasnogorskoye Rus. Fed. 42 L4
Krasnograd Ukr. see Krasnohrad
Krasnogvardeysk Uzbek. see Bulung'ur
Krasnogvardeyskoye Rus. Fed. 43 I7
Krasnohrad Ukr. 43 G6
Krasnohvardiys'ke Ukr. 43 G7
Krasnokamsk Rus. Fed. 41 R4
Krasnoperekops'k Ukr. 43 G7
Krasnopol'ye Rus. Fed. 74 F2
Krasnorechenskiy Rus. Fed. 74 D3
Krasnoslobodsk Rus. Fed. 43 I5
Krasnotur'insk Rus. Fed. 41 S4
Krasnoufimsk Rus. Fed. 41 R4
Krasnovishersk Rus. Fed. 41 R3
Krasnovodsk Turkm. see Türkmenbaşy
Krasnovodsk, Mys pt Turkm. 88 D2
Krasnovodskoye Plato plat.
 Turkm. 91 I2
Krasnowodsk Aylagy b. Turkm. see
 Türkmenbaşy Aýlagy
Krasnoyarovo Rus. Fed. 74 C2
Krasnoyarsk Rus. Fed. 64 K4
Krasnoyarskoye Vodokhranilishche resr
 Rus. Fed. 72 G2
Krasnoye Lipetskaya Oblast'
 Rus. Fed. 43 H5
Krasnoye Respublika Kalmykiya - Khalm'g-
 Tangch Rus. Fed. see Ulan Erge
Krasnoznamenskiy Kazakh. see
 Yegindykol'
Krasnoznamenskoye Kazakh. see
 Yegindykol'
Krasnyy Rus. Fed. 43 F5
Krasnyy Chikoy Rus. Fed. 73 J2
Krasnyy Kut Rus. Fed. 43 J6
Krasnyy Luch Ukr. 43 H6
Krasnyy Lyman Ukr. 43 H6
Krasnyy Yar Rus. Fed. 43 K7
Krasyliv Ukr. 43 E6
Kratie Cambodia see Krâchéh
Kratke Range mts P.N.G. 69 L8
Kraulshavn Greenland see Nuussuaq
Krâvanh, Chuŏr Phnum mts
 Cambodia/Thai. see Cardamom Range
Kraynovka Rus. Fed. 91 G2
Krefeld Germany 52 G3
Kremenchug Ukr. see Kremenchuk
Kremenchugskoye Vodokhranilishche resr
 Ukr. see
 Kremenchuts'ka Vodoskhovyshche

Kremenchuk Ukr. 43 G6
Kremenchuts'ka Vodoskhovyshche resr
 Ukr. 43 G6
Křemešník hill Czech Rep. 47 O6
Kremges Ukr. see Svitlovods'k
Kremmidi, Akra pt Greece see
 Kremmydi, Akrotirio
Kremmydi, Akrotirio pt Greece 59 J6
Krems Austria see Krems an der Donau
Krems an der Donau Austria 47 O6
Kresta, Zaliv g. Rus. Fed. 65 T3
Kresttsy Rus. Fed. 42 G4
Kretinga Lith. 45 L9
Kreuzau Germany 52 G4
Kreuztal Germany 53 H4
Kreva Belarus 45 O9
Kribi Cameroon 96 D4
Krichev Belarus see Krychaw
Kriel S. Africa 101 I4
Krikellos Greece 59 I5
Kril'on, Mys c. Rus. Fed. 74 F3
Krishna India 84 D2
Krishna r. India 84 D2
Krishnagar India 83 G5
Krishnaraja Sagara l. India 84 C3
Kristiania Norway see Oslo
Kristiansand Norway 45 E7
Kristianstad Sweden 45 I8
Kristiansund Norway 44 E5
Kristiinankaupunki Fin. see
 Kristinestad
Kristinehamn Sweden 45 I7
Kristinestad Fin. 44 L5
Kristinopol' Ukr. see Chervonohrad
Kriti i. Greece see Crete
Kritiko Pelagos sea Greece 59 K6
Krivoy Rog Ukr. see Kryvyy Rih
Križevci Croatia 58 G1
Krk i. Croatia 58 F2
Krkonošský narodní park nat. park
 Czech Rep./Poland 47 O5
Krokom Sweden 44 I5
Krokstadøra Norway 44 F5
Krokstrand Norway 44 I3
Krolevets' Ukr. 43 G6
Kronach Germany 53 L4
Krŏng Kaôh Kŏng Cambodia 71 C5
Kronoby Fin. 44 M5
Kronprins Christian Land reg.
 Greenland 153 I1
Kronprins Frederik Bjerge nunataks
 Greenland 119 O3
Kronshtadt Rus. Fed. 45 P7
Kronstadt Romania see Braşov
Kronstadt Rus. Fed. see Kronshtadt
Kronwa Myanmar 70 B4
Kroonstad S. Africa 101 H4
Kropotkin Rus. Fed. 91 F1
Kropstädt Germany 53 M3
Krosno Poland 43 D6
Krotoszyn Poland 47 P5
Kruger National Park S. Africa 101 J2
Kruglikovo Rus. Fed. 74 D2
Kruglyakov Rus. Fed. see Oktyabr'skiy
Krui Indon. 68 C8
Kruisfontein S. Africa 100 G8
Kruja Albania see Krujë
Krujë Albania 59 H4
Krumovgrad Bulg. 59 K4
Krungkao Thai. see Ayutthaya
Krung Thep Thai. see Bangkok
Krupa Bos.-Herz. see Bosanska Krupa
Krupa na Uni Bos.-Herz. see
 Bosanska Krupa
Krupki Belarus 43 F5
Krusenstern, Cape U.S.A. 118 B3
Kruševac Serb. and Mont. 59 I3
Krušné hory mts Czech Rep. 53 M4
Kruzof Island U.S.A. 120 C3
Krychaw Belarus 43 F5
Krylov Seamount sea feature
 N. Atlantic Ocean 148 G4
Krym' pen. Ukr. see Crimea
Krymsk Rus. Fed. 90 E1
Krymskaya Rus. Fed. see Krymsk
Kryms'kyy Pivostriv pen. Ukr. see
 Crimea
Krystynopol Ukr. see Chervonohrad
Krytiko Pelagos sea Greece see
 Kritiko Pelagos
Kryvyy Rih Ukr. 43 G7
Ksabi Alg. 54 D6
Ksar Chellala Alg. 57 H6
Ksar el Boukhari Alg. 57 H6
Ksar el Kebir Morocco 57 D6
Ksar-es-Souk Morocco see
 Er Rachidia
Ksenofontova Rus. Fed. 41 R3
Kshirpai India 83 F5
Ksour Essaf Tunisia 58 D7
Kstovo Rus. Fed. 42 J4
Kū', Jabal al hill Saudi Arabia 86 G4
Kuah Malaysia 71 B6
Kuaidamao China see Tonghua
Kuala Belait Brunei 68 E6
Kuala Dungun Malaysia see Dungun
Kuala Kangsar Malaysia 71 C6
Kualakapuas Indon. 68 E7
Kuala Kerai Malaysia 71 C6
Kuala Lipis Malaysia 71 C6

▶Kuala Lumpur Malaysia 71 C7
 Joint capital of Malaysia, with Putrajaya.

Kuala Nerang Malaysia 71 C6
Kuala Pilah Malaysia 71 C7
Kuala Rompin Malaysia 71 C7
Kuala Selangor Malaysia 71 C7
Kuala Terengganu Malaysia 71 C6
Kualatungal Indon. 68 C7
Kuamut Sabah Malaysia 68 F5
Kuandian China 74 B4
Kuantan Malaysia 71 C7
Kuba Azer. see Quba
Kuban' r. Rus. Fed. 43 H7
Kubär Syria 91 E4
Kubaybat Syria 85 C2
Kubaysah Iraq 91 F4
Kubbum Sudan 97 F3
Kubenskoye, Ozero l. Rus. Fed. 42 H4
Kubrat Bulg. 59 L3
Kubuang Indon. 68 F6
Kuchaman Road India 89 I5

Lajanurpekhi Georgia 91 F2
Lajeado Brazil 145 A5
Lajes Rio Grande do Norte Brazil 143 K5
Lajes Santa Catarina Brazil 145 A4
La Junta Mex. 127 G7
La Junta U.S.A. 130 C4
La Juventud, Isla de i. Cuba 137 H4
Lakadiya India 82 B5
L'Akagera, Parc National de nat. park
 Rwanda see Akagera National Park
La Kagera, Parc National de nat. park
 Rwanda see Akagera National Park
Lake U.S.A. 134 D5
Lake Andes U.S.A. 130 D3
Lakeba i. Fiji 107 I3
Lake Bardawil Reserve nature res.
 Egypt 85 A4
Lake Bolac Australia 112 A6
Lake Butler U.S.A. 133 D6
Lake Cargelligo Australia 112 C4
Lake Cathie Australia 112 F3
Lake Charles U.S.A. 131 E6
Lake City CO U.S.A. 129 J3
Lake City FL U.S.A. 133 D6
Lake City MI U.S.A. 134 C1
Lake Clark National Park and Preserve
 U.S.A. 118 C3
Lake Clear U.S.A. 135 H1
Lake District National Park U.K. 48 D4
Lake Eyre National Park Australia 111 B6
Lakefield Australia 110 D2
Lakefield Canada 135 F1
Lakefield National Park Australia 110 D2
Lake Forest U.S.A. 134 B2
Lake Gairdner National Park
 Australia 111 B7
Lake Geneva U.S.A. 130 F3
Lake George MI U.S.A. 134 C2
Lake George NY U.S.A. 135 I2
Lake Grace Australia 109 B8
Lake Harbour Canada see Kimmirut
Lake Havasu City U.S.A. 129 F4
Lakehurst U.S.A. 135 H3
Lake Isabella U.S.A. 128 D4
Lake Jackson U.S.A. 131 E6
Lake King Australia 109 B8
Lake Kopiago P.N.G. 69 K8
Lakeland FL U.S.A. 133 D7
Lakeland GA U.S.A. 133 D6
Lakeland U.S.A. 134 C1
Lakemba i. Fiji see Lakeba
Lake Louise Canada 120 G5
Lake Mills U.S.A. 130 E3
Lake Nash Australia 110 B4
Lake Odessa U.S.A. 134 C2
Lake Paringa N.Z. 113 B6
Lake Placid FL U.S.A. 133 D7
Lake Placid NY U.S.A. 135 I1
Lake Pleasant U.S.A. 135 H2
Lakeport CA U.S.A. 128 B2
Lakeport MI U.S.A. 134 D2
Lake Providence U.S.A. 131 F5
Lake Range mts U.S.A. 128 D1
Lake River Canada 122 E3
Lakes Entrance Australia 112 D6
Lakeside AZ U.S.A. 129 I4
Lakeside U.S.A. 135 G5
Lake Tabourie Australia 112 E5
Lake Tekapo N.Z. 113 C7
Lake Torrens National Park
 Australia 111 B6
Lakeview MI U.S.A. 134 C2
Lakeview OH U.S.A. 134 D3
Lakeview OR U.S.A. 126 C4
Lake Village U.S.A. 131 F5
Lake Wales U.S.A. 133 D7
Lakewood CO U.S.A. 126 G5
Lakewood NJ U.S.A. 135 H3
Lakewood NY U.S.A. 134 F2
Lakewood OH U.S.A. 134 E3
Lake Worth U.S.A. 133 D7
Lakha India 82 B4
Lakhdenpokh'ya Rus. Fed. 44 Q6
Lakhimpur Assam India see
 North Lakhimpur
Lakhimpur Uttar Prad. India 82 E4
Lakhisarai India 83 F4
Lakhish r. Israel 85 B4
Lakhnadon India 82 D5
Lakhpat India 82 B5
Lakhtar India 82 B5
Lakin U.S.A. 130 C4
Lakitusaki r. Canada 122 E3
Lakki Pak. 89 H3
Lakonikos Kolpos b. Greece 59 J6
Lakor i. Indon. 108 E2
Lakota Côte d'Ivoire 96 C4
Lakota U.S.A. 130 D1
Laksefjorden sea chan. Norway 44 O1
Lakselv Norway 44 N1
Lakshadweep is India see
 Laccadive Islands
Lakshadweep union terr. India 84 B4
Lakshettipet India 84 C2
Lakshmipur Bangl. 83 G5
Lakshmipur Bangl. see Lakshmipur
Lalaghat India 83 H4
La Laguna, Picacho de mt. Mex. 136 B4
Lalbara India 84 D1
L'Alcora Spain 57 F3
Lāleh Zār, Kūh-e mt. Iran 88 E4
Lalganj India 83 F4
Lālī Iran 88 C3
La Ligua Chile 144 B4
Laliki Indon. 108 D1
Lalín Spain 57 B2
La Línea de la Concepción Spain 57 D5
Lalin He r. China 74 B3
Lalitpur India 82 D4
Lalitpur Nepal see Patan
Lalmanirhat Bangl. see Lalmonirhat
Lalmonirhat Bangl. 83 G4
La Loche Canada 121 I3
La Loche, Lac l. Canada 121 I3
La Louvière Belgium 52 E4
Lal'sk Rus. Fed. 42 J3
Lalung La pass China 83 F3
Lama Bangl. 83 H5
La Macarena, Parque Nacional nat. park
 Col. 142 D3
La Maddalena Sardinia Italy 58 C4
La Madeleine, Îles de is Canada 123 J5

La Madeleine, Monts de mts
 France 56 F3
Lamadian China 74 B3
Lamadianzi China see Lamadian
La Maiko, Parc National de nat. park
 Dem. Rep. Congo 98 C4
La Malbaie Canada 123 H5
Lamam Laos 70 D4
La Mancha Mex. 131 C7
La Mancha reg. Spain 57 E4
La Manche strait France/U.K. see
 English Channel
La Máquina Mex. 131 B6
Lamar CO U.S.A. 130 C4
Lamar MO U.S.A. 131 E4
Lamard Iran 88 D5
La Margeride, Monts de mts France 56 F4
La Marmora, Punta mt. Sardinia Italy 58 C5
La Marne au Rhin, Canal de France 52 G6
La Marque U.S.A. 131 E6
La Martre, Lac l. Canada 120 G2
Lamas r. Turkey 85 B1
La Mauricie, Parc National de nat. park
 Canada 123 G5
Lambaréné Gabon 98 B4
Lambasa Fiji see Labasa
Lambayeque Peru 142 C5
Lambay Island Ireland 51 G4
Lambert atoll Marshall Is see Ailinglaplap

▶Lambert Glacier Antarctica 152 E2
 Largest series of glaciers in the world.

Lambert's Bay S. Africa 100 D7
Lambeth Canada 134 E2
Lambi India 82 C3
Lambourn Downs hills U.K. 49 F7
Lame Indon. 71 B7
La Medjerda, Monts de mts Alg. 58 B6
Lamego Port. 57 C3
Lamèque, Île i. Canada 123 I5
La Merced Arg. 144 C3
La Merced Peru 142 C6
Lameroo Australia 111 C7
La Mesa U.S.A. 128 E5
Lamesa U.S.A. 131 C5
Lamia Greece 59 J5
Lamington National Park Australia 112 F2
La Misión Mex. 128 E5
Lamma Island H.K. China 77 [inset]
Lammerlaw Range mts N.Z. 113 B7
Lammermuir Hills U.K. 50 G5
Lammhult Sweden 45 I8
Lammi Fin. 45 N6
Lamont CA U.S.A. 128 D4
Lamont WY U.S.A. 126 G4
La Montagne d'Ambre, Parc National de
 nat. park Madag. 99 E5
La Montaña de Covadonga, Parque
 Nacional de nat. park Spain see
 Los Picos de Europa, Parque Nacional de
La Mora Mex. 131 C7
La Morita Chihuahua Mex. 131 B6
La Morita Coahuila Mex. 131 C6
Lamotrek atoll Micronesia 69 L5
La Moure U.S.A. 130 D2
Lampang Thai. 70 B3
Lam Pao Reservoir Thai. 70 C3
Lampasas U.S.A. 131 D6
Lampazos Mex. 131 C7
Lampedusa, Isola di i. Sicily Italy 58 E7
Lampeter U.K. 49 C6
Lamphun Thai. 70 B3
Lampsacus Turkey see Lâpseki
Lam Tin H.K. China 77 [inset]
Lamu Kenya 98 E4
Lamu Myanmar 70 A3
Lāna'i i. U.S.A. 127 [inset]
Lāna'i City U.S.A. 127 [inset]
La Nao, Cabo de c. Spain 57 G4
Lanao, Lake Phil. 69 G5
Lanark Canada 135 G1
Lanark U.K. 50 F5
Lanbi Kyun i. Myanmar 71 B5
Lancang China 76 C4
Lancaster Canada 135 H1
Lancaster U.K. 48 E4
Lancaster CA U.S.A. 128 D4
Lancaster KY U.S.A. 134 C5
Lancaster MO U.S.A. 130 E3
Lancaster NH U.S.A. 135 J1
Lancaster OH U.S.A. 134 D4
Lancaster PA U.S.A. 135 G3
Lancaster SC U.S.A. 133 D5
Lancaster VA U.S.A. 135 G5
Lancaster WI U.S.A. 130 F3
Lancaster Canal U.K. 48 E5
Lancaster Sound strait Canada 119 J2
Lanchow China see Lanzhou
Landana Angola see Cacongo
Landau an der Isar Germany 53 M6
Landau in der Pfalz Germany 53 I5
Landeck Austria 47 M7
Lander watercourse Australia 108 E5
Lander U.S.A. 126 F4
Landesbergen Germany 53 J2
Landfall Island India 71 A4
Landhi Pak. 89 G5
Landis Canada 121 I4
Landor Australia 109 B6
Landsberg Poland see
 Gorzów Wielkopolski
Landsberg am Lech Germany 47 M6
Land's End U.K. 49 B8
Landshut Germany 53 M6
Landskrona Sweden 45 H9
Landstuhl Germany 53 H5
Land Wursten reg. Germany 53 I1
Lanesborough Ireland 51 E4
La'nga Co l. China 82 E3
Langao China 77 F1
Langar Afgh. 89 H3
Langberg mts S. Africa 100 F5
Langdon U.S.A. 130 D1
Langeac France 56 F4
Langeberg mts S. Africa 100 D7
Langeland i. Denmark 45 G9
Längelmäki Fin. 45 N6
Langelsheim Germany 53 K3
Langen Germany 53 I1
Langenburg Canada 121 K5
Langenhagen Germany 53 J2

Langenhahn Germany 53 H4
Langenlonsheim Germany 53 H5
Langenthal Switz. 56 H3
Langenweddingen Germany 53 L2
Langeoog Germany 53 H1
Langesund Norway 45 F7
Langfang China 73 L5
Langgapayung Indon. 71 B7
Langgar China 76 B2
Langgöns Germany 53 I4
Langjan Nature Reserve S. Africa 101 I2
Langjökull ice cap Iceland 44 [inset]
Langka Indon. 71 B6
Langkawi i. Malaysia 71 B6
Lang Kha Toek, Khao mt. Thai. 71 B5
Langklip S. Africa 100 E5
Langley Canada 120 F5
Langley U.S.A. 134 D5
Langlo Crossing Australia 111 D5
Langmusi China see Dagcanglhamo
Langnong, Xé r. Laos 70 D3
Langphu mt. China 83 F3
Langport U.K. 49 E7
Langên Zangbo r. China 82 D3
Langqi China 77 H3
Langres France 56 G3
Langres, Plateau de France 56 G3
Langru China 82 D1
Langsa Indon. 71 B6
Langsa, Teluk b. Indon. 71 B6
Lângsele Sweden 44 J5
Lang Sơn Vietnam 70 D2
Langtang National Park Nepal 83 F3
Langtao Myanmar 70 B1
Langting India 83 H4
Langtoft U.K. 48 G4
Langtry U.S.A. 131 C6
Languan China see Lantian
Languedoc reg. France 56 E5
Langwedel Germany 53 J2
Langxi China 77 H2
Langzhong China 76 E2
Lanigan Canada 121 J5
Lanín, Parque Nacional nat. park
 Arg. 144 B5
Lanín, Volcán vol. Arg./Chile 144 B5
Lanji India 82 E5
Lanka country Asia see Sri Lanka
Länkäran Azer. 91 H3
Lannion France 56 C2
Lanping China 76 C3
Lansán Sweden 44 M3
L'Anse U.S.A. 130 F2
Lanshan China 77 G3

▶Lansing U.S.A. 134 C2
 State capital of Michigan.

Lanta, Ko i. Thai. 71 B6
Lantau Island H.K. China 77 [inset]
Lantau Peak hill H.K. China 77 [inset]
Lantian China 77 F1
Lanxi Heilong. China 74 B3
Lanxi Zhejiang China 77 H2
Lan Yü i. Taiwan 77 I4
Lanzarote i. Canary Is 96 B2
Lanzhou China 72 I5
Lanzijing China 74 A3
Laoag Phil. 69 G2
Laoang Phil. 69 H4
Laobie Shan mts China 76 C4
Laobukou China 77 F3
Lao Cai Vietnam 70 C2
Laodicea Syria see Latakia
Laodicea Turkey see Denizli
Laodicea ad Lycum Turkey see Denizli
Laodicea ad Mare Syria see Latakia
Laohekou China 77 F1
Laohupo China see Logpung
Laojie China see Yongping
Laojunmiao China see Yumen
La Okapi, Parc National de nat. park
 Dem. Rep. Congo 98 C3
Lao Ling mts China 74 B4
Laon France 52 D5
La Oroya Peru 142 C6
▶Laos country Asia 70 C3
 Asia 6, 62–63
Laotougou China 74 C4
Laotuding Shan hill China 74 B4
Laowohi pass Jammu and Kashmir see
 Khardung La
Laoye Ling mts Heilongjiang/Jilin
 China 74 B4
Laoye Ling mts Heilongjiang/Jilin
 China 74 C4
Lapa Brazil 145 A4
La Palma i. Canary Is 96 B2
La Palma Panama 137 I7
La Palma U.S.A. 129 H5
La Palma del Condado Spain 57 C5
La Panza Range mts U.S.A. 128 C4
La Paragua Venez. 142 F2
La Parilla Mex. 131 B8
La Paya, Parque Nacional nat. park Col.
 142 D3
La Paz Arg. 144 E4

▶La Paz Bol. 142 E7
 Official capital of Bolivia.

La Paz Hond. 136 G6
La Paz Mex. 136 B4
La Pedrera Col. 142 E4
Lapeer U.S.A. 134 D2
La Pendjari, Parc National de nat. park
 Benin 96 D3
La Perla Mex. 131 B6
La Pérouse Strait Japan/Rus. Fed. 74 F3
La Pesca Mex. 131 D8
Lapinlahti Fin. 44 O5
Lapithos Cyprus 85 A2
Lap Lae Thai. 70 C3
La Plant U.S.A. 130 C2
La Plata Arg. 144 E4
La Plata MD U.S.A. 135 G4
La Plata MO U.S.A. 130 E3
La Plata, Isla i. Ecuador 142 B4
La Plata, Río de sea chan. Arg./Uruguay
 144 E4

La Plonge, Lac l. Canada 121 J4
La Spezia Italy 58 C2
Las Piedras, Río de r. Peru 142 E6
Las Plumas Arg. 144 C6
Laspur Pak. 89 I2
Lassance Brazil 145 B2
Lassen Peak vol. U.S.A. 128 C1
Lassen Volcanic National Park U.S.A.
 128 C1
Las Tablas Panama 137 H7
Las Tablas de Daimiel, Parque Nacional de
 nat. park Spain 57 E4
Last Chance U.S.A. 130 C4
Last Mountain Lake Canada 121 J5
Las Termas Arg. 144 D3
Last Mountain Lake Canada 121 J5
Las Tórtolas, Cerro mt. Chile 144 C3
Lastoursville Gabon 98 B4
Lastovo i. Croatia 58 G3
Las Tres Vírgenes, Volcán vol.
 Mex. 127 E8
Lastrup Germany 53 H2
Las Tunas Cuba 137 I4
Las Varas Chihuahua Mex. 127 G7
Las Varas Nayarit Mex. 136 C4
Las Varillas Arg. 144 D4
Las Vegas NM U.S.A. 127 G6
Las Vegas NV U.S.A. 129 F3
Las Viajas, Isla de i. Peru 142 C6
Las Villuercas mt. Spain 57 D4
La Tabatière Canada 123 K4
Latacunga Ecuador 142 C4
Latady Island Antarctica 152 L2
Latakia Syria 85 B2
La Teste-de-Buch France 56 D4
Latham Australia 109 B7
Lathen Germany 53 H2
Latheron U.K. 50 F2
Lathi India 82 B4
Latho Jammu and Kashmir 82 D2
Lärbro Sweden 45 K8
Latina Italy 58 E4
La Tortuga, Isla i. Venez. 142 E1
Latrobe U.S.A. 134 F3
Latrun West Bank 85 B4
Lattaquié Syria see Latakia
Lattrop Neth. 52 G2
La Tuque Canada 123 G5
Latur India 84 C2
▶Latvia country Europe 45 N8
 Europe 5, 38–39
Latvia country Europe see Latvia
Latviyskaya S.S.R. country Europe see
 Latvia
Lauca, Parque Nacional nat. park Chile
 142 E7
Lauchhammer Germany 47 N5
Lauder U.K. 50 G5
Laudio Spain see Llodio
Lauenbrück Germany 53 J1
Lauenburg (Elbe) Germany 53 K1
Lauf an der Pegnitz Germany 53 L5
Laufen Switz. 56 H3
Lauge Koch Kyst reg. Greenland 119 L2
Laughlen, Mount Australia 109 F5
Laughlin Peak U.S.A. 127 G5
Lauka Estonia 45 M7
Launceston Australia 111 [inset]
Launceston U.K. 49 C8
Laune r. Ireland 51 C5
Launggyaung Myanmar 70 B1
Launglon Myanmar 71 B4
Launglon Bok Islands Myanmar 71 B4
La Unión Bol. 142 F7
La Unión Chile 144 B6
Laura Australia 110 D2
Laurel DE U.S.A. 135 H4
Laurel MS U.S.A. 131 F6
Laurel MT U.S.A. 126 F3
Laureldale U.S.A. 135 H3
Laurel Hill hills U.S.A. 134 F4
Laurencekirk U.K. 50 G4
Laurieton Australia 112 F3
Laurinburg U.S.A. 133 E5
Lauru i. Solomon Is see Choiseul
Lausanne Switz. 56 H3
Laut i. Indon. 68 F7
Laut i. Indon. 71 C6
Lautem East Timor 108 D2
Lautersbach (Hessen) Germany 53 J4
Laut Kecil, Kepulauan is Indon. 68 F8
Lautoka Fiji 107 H3
Lauvsnes Norway 44 G4
Las Adjuntas, Presa de resr Mex. 131 D8
La Sal U.S.A. 129 I2
La Salle Canada 135 I1
La Salle U.S.A. 122 C6
La Salonga Nord, Parc National de
 nat. park Dem. Rep. Congo 98 C4
La Sambre à l'Oise, Canal de
 France 52 D5
Las Animas U.S.A. 130 C4
La Sarre Canada 122 F4
Las Avispas Mex. 127 F7
La Savonnière, Lac l. Canada 123 G3
La Scie Canada 123 L4
Las Cruces CA U.S.A. 128 C4
Las Cruces NM U.S.A. 127 G6
La Vega Dom. Rep. 137 J5
La Serena Chile 144 B3
Las Esperanças Mex. 131 C7
Las Flores Arg. 144 E5
Las Guacamatas, Cerro mt. Mex. 127 F7
Lashburn Canada 121 I4
Las Heras Arg. 144 C4
Lashio Myanmar 70 B2
Lashkar India 82 D4
Lashkar Gāh Afgh. 89 G4
Las Juntas Chile 144 C3
Las Lomitas Arg. 144 D2
Las Marismas marsh Spain 57 C5
Las Martinetas Arg. 144 C7
Las Mesteñas Mex. 131 B6
Las Minas, Cerro mt. Hond. 136 G6
Las Nopaleras, Cerro mt. Mex. 131 C7
La Société, Archipel de is Fr. Polynesia see
 Society Islands
Lastrup see
Lawn Hill National Park Australia 110 B3
La Woëvre, Plaine de plain France 52 F5
La Somme, Canal de France 52 C5
Las Palmas watercourse Mex. 128 E5

▶Las Palmas de Gran Canaria Canary Is
 96 B2
 Joint capital of the Canary Islands.

Las Petas Bol. 143 G7
La Spezia Italy 58 C2
Las Piedras, Río de r. Peru 142 E6
Las Plumas Arg. 144 C6
Laspur Pak. 89 I2
Lassance Brazil 145 B2
Lassen Peak vol. U.S.A. 128 C1
Lassen Volcanic National Park U.S.A.
 128 C1
Las Tablas Panama 137 H7

Lawrenceville GA U.S.A. 133 D5
Lawrenceville IL U.S.A. 134 B4
Lawrenceville VA U.S.A. 135 G5
Lawrence Wells, Mount hill
 Australia 109 C6
Lawton U.S.A. 131 D5
Lawz, Jabal al mt. Saudi Arabia 90 D5
Laxå Sweden 45 I7
Laxey Isle of Man 48 C4
Lax Kw'alaams Canada 120 D4
Laxo U.K. 50 [inset]
Laya r. Rus. Fed. 42 M2
Laydennyy, Mys c. Rus. Fed. 42 J1
Laylá Saudi Arabia 86 G5
Layla salt pan Saudi Arabia 85 D4
Laysan Island U.S.A. 150 I4
Laytonville U.S.A. 128 B2
Laza Myanmar 70 B1
Lazarev Rus. Fed. 74 F1
Lázaro Cárdenas Mex. 136 D5
Lazcano Uruguay 144 F4
Lazdijai Lith. 45 M9
Lazikou China 76 D1
Lazo Primorskiy Kray Rus. Fed. 74 D4
Lazo Respublika Sakha (Yakutiya)
 Rus. Fed. 65 O3
Lead U.S.A. 130 C2
Leader Water r. U.K. 50 G5
Leadville Australia 112 D4
Leaf r. U.S.A. 131 F6
Leaf Bay Canada see Tasiujaq
Leaf Rapids Canada 121 K3
Leakey U.S.A. 131 D6
Leaksville U.S.A. see Eden
Leamington Canada 134 D2
Leamington Spa, Royal U.K. 49 F6
Leane, Lough l. Ireland 51 C5
Leap Ireland 51 C6
Leatherhead U.K. 49 G7
L'Eau Claire, Lac à l. Canada 122 G2
L'Eau Claire, Rivière à r. Canada 122 G2
L'Eau d'Heure l. Belgium 52 E4
Leavenworth IN U.S.A. 134 B4
Leavenworth KS U.S.A. 130 E4
Leavenworth WA U.S.A. 126 C3
Leavitt Peak U.S.A. 128 D2
Lebach Germany 52 G5
▶Lebanon country Asia 85 B2
 Asia 6, 62–63
Lebanon IN U.S.A. 134 B3
Lebanon KY U.S.A. 134 C5
Lebanon MO U.S.A. 130 E4
Lebanon NH U.S.A. 135 I2
Lebanon OH U.S.A. 134 C4
Lebanon OR U.S.A. 126 C3
Lebanon PA U.S.A. 135 G3
Lebanon TN U.S.A. 132 C4
Lebanon VA U.S.A. 134 D5
Lebanon Junction U.S.A. 134 C5
Lebanon Mountains Lebanon see
 Liban, Jebel
Lebbeke Belgium 52 E3
Lebec U.S.A. 128 D4
Lebedyan' Rus. Fed. 43 H5
Lebel-sur-Quévillon Canada 122 F4
Le Blanc France 56 E3
Lębork Poland 47 P3
Lebowakgomo S. Africa 101 I3
Lebrija Spain 57 C5
Łebsko, Jezioro lag. Poland 47 P3
Lebu Chile 144 B5
Lebyazh'ye Kazakh. see Akku
Lebyazh'ye Rus. Fed. 42 K4
Le Caire Egypt see Cairo
Le Cateau-Cambrésis France 52 D4
Le Catelet France 52 D4
Lecce Italy 58 H4
Lecco Italy 58 C2
Lech r. Austria/Germany 47 M7
Lechaina Greece 59 I6
Lechang China 77 G3
Le Chasseron mt. Switz. 56 H3
Le Chesne France 52 E5
Lechtaler Alpen mts Austria 47 M7
Leck Germany 47 L3
Lecompte U.S.A. 131 E6
Le Creusot France 56 G3
Le Crotoy France 52 B4
Lectoure France 56 E5
Ledang, Gunung mt. Malaysia 71 C7
Ledbury U.K. 49 E6
Ledesma Spain 57 D3
Ledmore U.K. 50 E2
Ledmozero Rus. Fed. 44 R4
Ledong Hainan China 70 E3
Ledong Hainan China 77 F5
Le Dorat France 56 E3
Leduc Canada 120 H4
Lee r. Ireland 51 D6
Lee IN U.S.A. 134 B3
Lee MA U.S.A. 135 I2
Leech Lake U.S.A. 130 E2
Leeds U.K. 48 F5
Leedstown U.K. 49 B8
Leek Neth. 52 G1
Leek U.K. 49 E5
Leende Neth. 52 F3
Leer (Ostfriesland) Germany 53 H1
Leesburg FL U.S.A. 133 D6
Leesburg GA U.S.A. 133 C6
Leesburg OH U.S.A. 134 D4
Leesburg VA U.S.A. 135 G4
Leese Germany 53 J2
Lee Steere Range hills Australia 109 C6
Leesville U.S.A. 131 E6
Leesville Lake OH U.S.A. 134 E3
Leesville Lake VA U.S.A. 134 F5
Leeton Australia 112 C5
Leetonia U.S.A. 134 E3
Leeu-Gamka S. Africa 100 E7
Leeuwarden Neth. 52 F1
Leeuwin, Cape Australia 109 A8
Leeuwin-Naturaliste National Park
 Australia 109 A8
Lee Vining U.S.A. 128 D3
Leeward Islands Caribbean Sea 137 L5
Lefka Cyprus 85 A2
Lefkada Greece 59 I5
Lefkáda i. Greece 59 I5
Lefkas Greece see Lefkada
Lefke Cyprus see Lefka
Lefkimmi Greece 59 I5

Lipsoí *i.* Greece *see* Leipsoi
Lipti Lekh *pass* Nepal 82 E3
Liptrap, Cape Australia 112 B7
Lipu China 77 F4
Lira Uganda 98 D3
Liranga Congo 98 B4
Lircay Peru 142 D6
Lisala Dem. Rep. Congo 98 C3
L'Isalo, Massif de *mts* Madag. 99 E6
L'Isalo, Parc National de *nat. park* Madag. 99 E6
Lisbellaw U.K. 51 E3
Lisboa Port. *see* Lisbon

▶Lisbon Port. 57 B4
 Capital of Portugal.

Lisbon ME U.S.A. 135 J1
Lisbon NH U.S.A. 135 J1
Lisbon OH U.S.A. 134 E3
Lisburn U.K. 51 F3
Liscannor Bay Ireland 51 C5
Lisdoonvarna Ireland 51 C4
Lishan Taiwan 77 I3
Lishe Jiang *r.* China 76 D3
Lishi *Jiangxi* China *see* Dingnan
Lishi *Shanxi* China 73 K5
Lishu China 74 B4
Lishui China 77 H2
Li Shui *r.* China 77 F2
Lisichansk Ukr. *see* Lysychans'k
Lisieux France 56 E2
Liskeard U.K. 49 C8
Liski Rus. Fed. 43 H6
L'Isle-Adam France 52 C5
Lismore Australia 112 F2
Lismore Ireland 51 E5
Lisnarrick U.K. 51 E3
Lisnaskea U.K. 51 E3
Liss *mt.* Saudi Arabia 85 D4
Lissa Poland *see* Leszno
Lister, Mount Antarctica 152 H1
Listowel Canada 134 E2
Listowel Ireland 51 C5
Lit Sweden 44 I5
Litang *Guangxi* China 77 F4
Litang *Sichuan* China 76 D2
Lîtâni, Nahr el *r.* Lebanon 85 B3
Litchfield CA U.S.A. 128 C1
Litchfield CT U.S.A. 135 I3
Litchfield IL U.S.A. 130 F4
Litchfield MI U.S.A. 134 C2
Litchfield MN U.S.A. 130 E2
Lit-et-Mixe France 56 D4
Lithgow Australia 112 E4
Lithino, Akra *pt* Kriti Greece *see* Lithino, Akrotirio
Lithino, Akrotirio *pt* Greece 59 K7

▶Lithuania *country* Europe 45 M9
 Europe 5, 38–39

Lititz U.S.A. 135 G3
Litoměřice Czech Rep. 47 O5
Litovko Rus. Fed. 74 D2
Litovskaya S.S.R. *country* Europe *see* Lithuania
Little *r.* U.S.A. 131 E6
Little Abaco *i.* Bahamas 133 E7
Little Abitibi *r.* Canada 122 E4
Little Abitibi Lake Canada 122 E4
Little Andaman *i.* India 71 A5
Little Bahama Bank *sea feature* Bahamas 133 E7
Little Barrier *i.* N.Z. 113 E3
Little Belt *sea chan.* Denmark 45 F9
Little Belt Mountains U.S.A. 126 F3
Little Bitter Lake Egypt 85 A4
Little Cayman *i.* Cayman Is 137 H5
Little Churchill *r.* Canada 121 M3
Little Chute U.S.A. 134 A1
Little Coco Island Cocos Is 71 A4
Little Colorado *r.* U.S.A. 129 H3
Little Creek Peak U.S.A. 129 G3
Little Current Canada 122 E5
Little Current *r.* Canada 122 D4
Little Desert National Park Australia 111 C8
Little Egg Harbor *inlet* U.S.A. 135 H4
Little Exuma *i.* Bahamas 133 F8
Little Falls U.S.A. 130 E2
Littlefield AZ U.S.A. 129 G3
Littlefield TX U.S.A. 131 C5
Little Fork *r.* U.S.A. 130 E1
Little Grand Rapids Canada 121 M4
Littlehampton U.K. 49 G8
Little Inagua Island Bahamas 133 F8
Little Karas Berg *plat.* Namibia 100 D4
Little Karoo *plat.* S. Africa 100 E7
Little Lake U.S.A. 128 E4
Little Mecatina Canada *see* Petit Mécatina, Île du
Little Minch *sea chan.* U.K. 50 B3
Little Missouri *r.* U.S.A. 130 C2
Little Namaqualand *reg.* S. Africa *see* Namaqualand
Little Nicobar *i.* India 71 A6
Little Ouse *r.* U.K. 49 H6
Little Pamir *mts* Asia 89 I2
Little Rancheria *r.* Canada 120 D2
Little Rann *marsh* India 82 B5

▶Little Rock U.S.A. 131 E5
 State capital of Arkansas.

Littlerock U.S.A. 128 E4
Little Sable Point U.S.A. 134 B2
Little Salmon Lake Canada 120 C2
Little Salt Lake U.S.A. 129 G3
Little Sandy Desert Australia 109 B5
Little San Salvador *i.* Bahamas 133 F7
Little Smoky Canada 120 G4
Little Tibet *reg.* Jammu and Kashmir *see* Ladakh
Littleton U.S.A. 126 G5
Little Valley U.S.A. 135 F2
Little Wind *r.* U.S.A. 126 F4
Litunde Moz. 99 D5
Liu'an China *see* Lu'an
Liuba China 76 E1
Liucheng China 77 F3
Liuchiu Yü *i.* Taiwan 77 I4
Liuchong He *r.* China 76 E3

Liuchow China *see* Liuzhou
Liuhe China 74 B4
Liuheng Dao *i.* China 77 I2
Liujiachang China 77 F2
Liujiaxia Shuiku *resr* China 76 D1
Liukesong China 74 B3
Liulin China *see* Jonê
Liupan Shan *mts* China 76 E1
Liupanshui China *see* Lupanshui
Liuquan China 77 H1
Liuwa Plain National Park Zambia 99 C5
Liuyang China 77 G2
Liuzhan China 74 B2
Liuzhou China 77 F3
Livadeia Greece 59 J5
Līvāni Latvia 45 O8
Live Oak U.S.A. 133 D6
Liveringa Australia 106 C4
Livermore CA U.S.A. 128 C3
Livermore, Mount U.S.A. 131 B6
Livermore Falls U.S.A. 135 J1
Liverpool U.K. 48 E5
Liverpool Canada 123 I5
Liverpool Bay Canada 118 E3
Liverpool Plains Australia 112 E3
Liverpool Range *mts* Australia 112 D3
Livia U.S.A. 134 B5
Livingston U.K. 50 F5
Livingston AL U.S.A. 131 F5
Livingston KY U.S.A. 134 C5
Livingston MT U.S.A. 126 F3
Livingston TN U.S.A. 134 C5
Livingston TX U.S.A. 131 E6
Livingston, Lake U.S.A. 131 E6
Livingstone Zambia 99 C5
Livingston Island Antarctica 152 A2
Livingston Manor U.S.A. 135 H3
Livno Bos.-Herz. 58 G3
Livny Rus. Fed. 43 H5
Livojoki *r.* Fin. 44 O4
Livonia MI U.S.A. 134 D2
Livonia NY U.S.A. 135 G2
Livorno Italy 58 D3
Livramento do Brumado Brazil 145 C1
Liwā Oman 88 E5
Liwā', Wādī al *watercourse* Syria 85 C3
Liwale Tanz. 99 D4
Lixian *Gansu* China 76 E1
Lixian *Sichuan* China 76 D2
Lixus Morocco *see* Larache
Liyang China *see* Hexian
Liyuan China *see* Sangzhi
Lizard U.K. 49 B9
Lizarda Brazil 143 I5
Lizard Point U.K. 49 B9
Lizarra Spain *see* Estella
Lizemores U.S.A. 134 E4
Liziping China 76 D2
Lizy-sur-Ourcq France 52 D5
Ljouwert Neth. *see* Leeuwarden

▶Ljubljana Slovenia 58 F1
 Capital of Slovenia.

Ljugarn Sweden 45 K8
Ljungan *r.* Sweden 44 J5
Ljungaverk Sweden 44 J5
Ljungby Sweden 45 H8
Ljusdal Sweden 45 J6
Ljusnan *r.* Sweden 45 J6
Ljusne Sweden 45 J6
Llaima, Volcán *vol.* Chile 144 B5
Llanandras U.K. *see* Presteigne
Llanbadarn Fawr U.K. *see* Lampeter
Llanbister U.K. 49 D6
Llandeilo U.K. 49 D7
Llandissilio U.K. 49 C7
Llandovery U.K. 49 D6
Llandudno U.K. 48 D5
Llandysul U.K. 49 C6
Llanegwad U.K. 49 D7
Llanelli U.K. 49 C7
Llanfair Caereinion U.K. 49 D6
Llanfair-ym-Muallt U.K. *see* Builth Wells
Llangefni U.K. 48 C5
Llangollen U.K. 49 D6
Llangurig U.K. 49 D6
Llanllyfni U.K. 48 C5
Llannor U.K. 48 C5
Llano Mex. 127 F7
Llano U.S.A. 131 D6
Llano *r.* U.S.A. 131 D6
Llano Estacado *plain* U.S.A. 131 C5
Llanos *plain* Col./Venez. 142 E2
Llanquihue, Lago *l.* Chile 144 B6
Llanrhystud U.K. 49 C6
Llantrisant U.K. 49 D7
Llanuwchllyn U.K. 49 D6
Llanwnog U.K. 49 D6
Llanymddyfri U.K. *see* Llandovery
Llay U.K. 49 D5
Lleida Spain 57 G3
Llerena Spain 57 C4
Lliria Spain 57 F4
Llodio Spain 57 E2
Llofelden Germany *see* Lohfelden
Lloyd, Mount U.S.A. 128 C2
Lloyd George, Mount Canada 120 E3
Lloyd Lake Canada 121 I3
Lloydminster Canada 121 I4
Lluchmayor Spain *see* Llucmajor
Llucmajor Spain 57 H4
Llullaillaco, Volcán *vol.* Chile 144 C2
Lô, Sông *r.* China/Vietnam 70 D2
Loa *r.* Chile 144 B2
Loa U.S.A. 129 H2
Loban' *r.* Rus. Fed. 42 K4
Lobatejo *mt.* Spain 57 D5
Lobatse Botswana 101 G3
Lobaye *r.* Cent. Afr. Rep. 98 B3
Löbejün Germany 53 L3
Loberia Arg. 144 E5
Lobito Angola 99 B5
Lobos Arg. 144 E5
Lobos, Cabo *c.* Mex. 127 E7

Lobos, Isla *i.* Mex. 127 F8
Lobos de Tierra, Isla *i.* Peru 142 B5
Loburg Germany 53 M2
Lôc Binh Vietnam 70 D2
Lochaline U.K. 50 D4
Loch Baghasdail U.K. *see* Lochboisdale
Lochboisdale U.K. 50 B3
Lochcarron U.K. 50 D3
Lochearnhead U.K. 50 E4
Lochem Neth. 52 G2
Lochern National Park Australia 110 C5
Loches France 56 E3
Loch Garman Ireland *see* Wexford
Lochgelly U.K. 50 F4
Lochgilphead U.K. 50 D4
Lochinver U.K. 50 D2
Loch Lomond and Trossachs National Park U.K. 50 E4
Lochmaddy U.K. 50 B3
Lochnagar *mt.* U.K. 50 F4
Loch nam Madadh U.K. *see* Lochmaddy
Loch Raven Reservoir U.S.A. 135 G4
Lochy, Loch *l.* U.K. 50 E4
Lock Australia 111 A7
Lock Haven U.S.A. 135 G3
Lockerbie U.K. 50 F5
Lockhart Australia 112 C5
Lockhart U.S.A. 131 D6
Lock Haven U.S.A. 135 G3
Lockport U.S.A. 135 F2
Lôc Ninh Vietnam 71 D5
Lod Israel 85 B4
Loddon *r.* Australia 112 A5
Lodève France 56 F5
Lodeynoye Pole Rus. Fed. 42 G3
Lodge, Mount Canada/U.S.A. 120 B3
Lodhikheda India 82 D5
Lodhran Pak. 89 H4
Lodi Italy 58 C2
Lodi CA U.S.A. 128 C2
Lodi OH U.S.A. 134 D3
Lødingen Norway 44 I2
Lodja Dem. Rep. Congo 98 C4
Lodomeria Rus. Fed. *see* Vladimir
Lodrani India 82 B5
Lodwar Kenya 98 D3
Łódź Poland 47 Q5
Loei Thai. 70 C3
Loeriesfontein S. Africa 100 D6
Lofoten *is* Norway 44 H2
Lofusa Sudan 97 G4
Log Rus. Fed. 43 I6
Loga Niger 96 D3
Logan IA U.S.A. 130 E3
Logan OH U.S.A. 134 D4
Logan UT U.S.A. 126 F4
Logan WV U.S.A. 134 E5

▶Logan, Mount Canada 120 A2
 2nd highest mountain in North America.

Logan, Mount U.S.A. 126 C2
Logan Creek *r.* Australia 110 D4
Logan Lake Canada 120 F5
Logan Mountains Canada 120 D2
Logansport IN U.S.A. 134 B3
Logansport LA U.S.A. 131 E6
Logatec Slovenia 58 F2
Logpung China 76 D1
Logroño Spain 57 E2
Logtak Lake India 83 H4
Lohardaga India 83 F5
Loharu India 82 C3
Lohatlha S. Africa 100 F5
Lohawat India 82 C4
Lohil *r.* China/India *see* Zayü Qu
Lohiniva Fin. 44 N3
Lohjanjärvi *l.* Fin. 45 M6
Löhne Germany 53 I2
Lohne (Oldenburg) Germany 53 I2
Lohtaja Fin. 44 M4
Loi, Nam *r.* Myanmar 70 C2
Loikaw Myanmar 70 B3
Loi Lan *mt.* Myanmar/Thai. 70 B3
Loi-lem Myanmar 70 B2
Loi Lun Myanmar 70 B2
Loimaa Fin. 45 M6
Loipyet Hills Myanmar 70 B1
Loire *r.* France 56 C3
Loi Sang *mt.* Myanmar 70 B2
L'Oise à l'Aisne, Canal de France 52 D5
Loi Song *mt.* Myanmar 70 B2
Loja Ecuador 142 C4
Loja Spain 57 D5
Lokan tekojärvi *l.* Fin. 44 O3
Lokchim *r.* Rus. Fed. 42 K3
Lokeren Belgium 52 E3
Lokgwabe Botswana 100 E3
Lokichar Kenya 78 C6
Lokichokio Kenya 98 D3
Lokilalaki, Gunung *mt.* Indon. 69 G7
Løkken Denmark 45 F8
Løkken Norway 44 F5
Loknya Rus. Fed. 42 G4
Lokoja Nigeria 96 D4
Lokolama Dem. Rep. Congo 98 B4
Lokossa Benin 96 D4
Lokot' Rus. Fed. 43 G5
Lol Sudan 97 F4
Lola, Mount U.S.A. 128 C2
Lola Guinea 96 C4
Loleta U.S.A. 128 A1
Lolland *i.* Denmark 45 G9
Lollondo Tanz. 98 D4
Lolo U.S.A. 126 E3
Loloda Indon. 69 H6
Lolo Pass U.S.A. 126 E3
Lolowau Indon. 71 B7
Lolwane S. Africa 100 F4
Lom Bulg. 59 J3
Lom Norway 45 F6
Loma U.S.A. 129 I2
Lomami *r.* Dem. Rep. Congo 98 C3
Lomar Pass Afgh. 89 G3
Lomas, Bahía de *b.* Chile 144 C8
Lomas de Zamora Arg. 144 E4
Lombarda, Serra *hills* Brazil 143 H3
Lomblen *i.* Indon. 108 B2

Lombok Indon. 108 B2
Lombok *i.* Indon. 108 B2
Lombok, Selat *sea chan.* Indon. 108 A2

▶Lomé Togo 96 D4
 Capital of Togo.

Lomela Dem. Rep. Congo 98 C4
Lomela *r.* Dem. Rep. Congo 97 F5
Lomira U.S.A. 130 A2
Lomme France 52 C4
Lommel Belgium 52 F3
Lomond Canada 123 K4
Lomond, Loch *l.* U.K. 50 E4
Lomonosov Rus. Fed. 45 P7
Lomonosov Ridge *sea feature* Arctic Ocean 153 B1
Lomovoye Rus. Fed. 42 I2
Lomphat Cambodia *see* Lumphät
Lompoc U.S.A. 128 C4
Lom Sak Thai. 70 C3
Łomża Poland 47 S4
Lon, Hon *i.* Vietnam 71 E4
Lonar India 84 C2
Londa Bangl. 83 G5
Londa India 84 B3
Londinières France 52 B5
Londinium U.K. *see* London
Londoko Rus. Fed. 74 D2
London Canada 134 E2

▶London U.K. 49 G7
 Capital of the United Kingdom and of England. 4th most populous city in Europe.

London KY U.S.A. 134 C5
London OH U.S.A. 134 D4
Londonderry U.K. 51 E3
Londonderry OH U.S.A. 134 D4
Londonderry VT U.S.A. 135 I2
Londonderry, Cape Australia 108 D3
Londrina Brazil 145 A3
Lone Pine U.S.A. 128 D3
Longa Angola 99 B5
Longa, Proliv *sea chan.* Rus. Fed. 65 S2
Long'an China 76 E4
Long Ashton U.K. 49 E7
Long Bay U.S.A. 133 E5
Long Beach N.Z. 113 C7
Long Beach U.S.A. 128 D5
Long Branch U.S.A. 135 I3
Longbo China *see* Shuangpai
Long Creek *r.* Canada 121 K5
Long Creek U.S.A. 126 C3
Long Eaton U.K. 49 F6
Longford Ireland 51 E4
Longgang *Chongqing* China *see* Dazu
Longgang *Guangdong* China 77 G4
Longhoughton U.K. 48 F3
Longhui China 77 F3
Longhurst, Mount Antarctica 152 H1
Long Island Bahamas 133 F8
Long Island N.S. Canada 123 I5
Long Island Nunavut Canada 122 F3
Long Island India 71 A4
Long Island P.N.G. 69 L8
Long Island U.S.A. 135 I3
Long Island Sound *sea chan.* U.S.A. 135 I3
Longjiang China 74 A3
Longjin China *see* Qingliu
Longju China 76 B2
Longlac Canada 122 D4
Long Lake *l.* Canada 122 D4
Long Lake U.S.A. 135 H2
Long Lake *l.* ME U.S.A. 132 G2
Long Lake *l.* MI U.S.A. 134 D1
Long Lake *l.* ND U.S.A. 130 C2
Long Lake *l.* NY U.S.A. 135 H1
Longli China 76 E3
Longlin China 76 E3
Longling China 76 C3
Longmeadow U.S.A. 135 I2
Long Melford U.K. 49 H6
Longmen *Guangdong* China 77 G4
Longmen *Heilong.* China 74 B2
Longmen Shan *hill* China 77 F1
Longmen Shan *mts* China 76 E1
Longming China 76 E4
Longmont U.S.A. 126 G4
Longnan China 77 G3
Longnan China 77 G3
Long Phu Vietnam 71 D5
Longping China *see* Luodian
Longquan *Guizhou* China *see* Danzhai
Longquan *Hunan* China *see* Xintian
Longquan *Zhejiang* China 77 H2
Long Range Mountains Nfld. and Lab. Canada 123 K4
Long Range Mountains Nfld. and Lab. Canada 123 K5
Longreach Australia 110 D4
Longriba China 76 D1
Longshan *Hunan* China 77 F2
Longshan *Yunnan* China *see* Longling
Long Shan *mts* China 76 E1
Longsheng China 77 F3
Longs Peak U.S.A. 126 G4
Long Stratton U.K. 49 I6
Longtan *China* 76 E3
Longtom Lake Canada 120 G1
Longtown U.K. 48 E3
Longue-Pointe Canada 123 I4
Longueuil Canada 122 G4
Longuyon France 52 F5
Longvale U.S.A. 128 B2

Longview TX U.S.A. 131 E5
Longview WA U.S.A. 126 C3
Longwangmiao China 74 D3
Longwei Co *l.* China 83 G2
Longxi China 76 E1
Longxian *Guangdong* China *see* Wengyuan
Longxian *Shaanxi* China 76 E1
Longxingchang China *see* Wuyuan
Longxu China *see* Cangwu
Long Xuyên Vietnam 71 D5
Longyan China 77 H3

▶Longyearbyen Svalbard 64 C2
 Capital of Svalbard.

Longzhen China 74 B2
Longzhou China 76 E4
Longzhouping China *see* Changyang
Löningen Germany 53 H2
Lonoke U.S.A. 131 F5
Lönsboda Sweden 45 I8
Lons-le-Saunier France 56 G3
Lonton Myanmar 70 B1
Looc Phil. 69 G4
Loochoo Islands Japan *see* Ryukyu Islands
Loogootee U.S.A. 134 B4
Lookout, Cape Canada 122 E3
Lookout, Cape U.S.A. 133 E5
Lookout, Point Australia 112 F1
Lookout, Point U.S.A. 134 D1
Lookout Mountain U.S.A. 129 I4
Lookout Point Australia 109 B8
Loolmalasin *vol. crater* Tanz. 98 D4
Loon Canada 122 C4
Loon *r.* Canada 120 H3
Loongana Australia 109 D7
Loon Lake Canada 121 I4
Loop Head *hd* Ireland 51 C5
Lop China 82 E1
Lopasnya Rus. Fed. *see* Chekhov
Lopatina, Gora *mt.* Rus. Fed. 74 F2
Lop Buri Thai. 70 C4
Lopez Phil. 69 G4
Lopez, Cap *c.* Gabon 98 A4
Lop Nur *salt flat* China 80 H3
Lopphavet *b.* Norway 44 L1
Loptyuga Rus. Fed. 42 K3
Lora *r.* Venez. 142 D2
Lora del Río Spain 57 D5
Loraín U.S.A. 134 D3
Loralai Pak. 89 H4
Loralai *r.* Pak. 89 H4
Loramie, Lake U.S.A. 134 C3
Lorca Spain 57 F5
Lorch Germany 53 H4
Lordegân Iran 88 C4
Lord Howe Atoll Solomon Is *see* Ontong Java Atoll
Lord Howe Island Australia 107 F5
Lord Howe Rise *sea feature* S. Pacific Ocean 150 F8
Lord Loughborough Island Myanmar 71 B5
Lordsburg U.S.A. 129 I5
Lore East Timor 108 D2
Lore Lindu, Taman Nasional Indon. 68 G7
Lorena Brazil 145 B3
Lorengau P.N.G. 69 L7
Lorentz, Taman Nasional Indon. 69 J7
Loreto Brazil 143 I5
Loreto Mex. 127 F8
Lorient France 56 C3
Lorillard *r.* Canada 121 N1
Loring U.S.A. 126 G2
Lorn, Firth of *est.* U.K. 50 D4
Lorne *watercourse* Australia 110 B3
Lorne Australia 110 B3
Lorrain, Plateau France 53 G6
Lorraine Australia 110 B3
Lorraine *admin. reg.* France 52 G6
Lorraine *reg.* France 52 G5
Lorsch Germany 53 I5
Lorup Germany 53 H2
Losal India 82 C4
Los Alamítos, Sierra de *mt.* Mex. 131 C7
Los Alamos CA U.S.A. 128 C4
Los Alamos NM U.S.A. 127 G6
Los Alerces, Parque Nacional *nat. park* Arg. 144 B6
Los Ángeles Chile 144 B5

▶Los Angeles U.S.A. 128 D4
 3rd most populous city in North America.

Los Angeles Aqueduct *canal* U.S.A. 128 D4
Los Arabos Cuba 133 D8
Los Banos U.S.A. 128 C3
Los Blancos Arg. 144 D2
Los Canarreos, Archipiélago de *is* Cuba 137 H4
Los Cerritos *watercourse* Mex. 127 F8
Los Chonos, Archipiélago de *is* Chile 144 A6
Los Coronados, Islas *is* Mex. 128 E5
Los Desventurados, Islas de *is* S. Pacific Ocean 151 O7
Los Estados, Isla de *i.* Arg. 144 D8
Los Gigantes, Llanos de *plain* Mex. 131 B7
Los Glaciares, Parque Nacional *nat. park* Arg. 144 B8
Los Hoyos Mex. 127 F7
Lošinj *i.* Croatia 58 F2
Los Jardines de la Reina, Archipiélago de *is* Cuba 137 I4
Los Juríes Arg. 144 D3
Los Katios, Parque Nacional *nat. park* Col. 137 I7
Loskop Dam S. Africa 101 I3
Los Lunas U.S.A. 127 G6
Los Menucos Arg. 144 C6
Los Mexicanos, Lago de *l.* Mex. 127 G7
Los Mochis Mex. 127 F8
Los Molinos U.S.A. 128 B1
Los Mosquitos, Golfo de *b.* Panama 137 H7

Los Palacios Cuba 133 D8
Los Picos de Europa, Parque Nacional de *nat. park* Spain 57 D2
Los Remedios *r.* Mex. 131 B7
Los Roques, Islas *is* Venez. 142 E1
Losser Neth. 52 G2
Lossie *r.* U.K. 50 F3
Lossiemouth U.K. 50 F3
Lößnitz Germany 53 M4
Lost Creek KY U.S.A. 134 D5
Lost Creek WV U.S.A. 134 E4
Los Teques Venez. 142 E1
Los Testigos *is* Venez. 142 F1
Lost Hills U.S.A. 128 D4
Lost Trail Pass U.S.A. 126 E3
Lostwithiel U.K. 49 C8
Los Vidrios Mex. 129 G6
Los Vilos Chile 144 B4
Lot *r.* France 56 E4
Lota Chile 144 B5
Lotfābād Turkm. 88 E2
Lothringen *reg.* France *see* Lorraine
Lotikipi Plain Kenya/Sudan 98 D3
Loto Dem. Rep. Congo 98 C4
Lotsane *r.* Botswana 101 I2
Lot's Wife *i.* Japan *see* Sōfu-gan
Lotta *r.* Fin./Rus. Fed. 44 Q2
 also known as Lutto
Lotte Germany 53 H2
Louangnamtha Laos 70 C2
Louangphabang Laos 70 C3
Loubomo Congo 99 B4
Loudéac France 56 C2
Loudi China 77 F3
L'Ouest, Pointe de *pt* Canada 123 I4
Louga Senegal 96 B3
Loughborough U.K. 49 F6
Lougheed Island Canada 119 H2
Loughor *r.* U.K. 49 C7
Loughrea Ireland 51 D4
Loughton U.K. 49 H7
Louhans France 56 G3
Louisa KY U.S.A. 134 D4
Louisa VA U.S.A. 135 G4
Louisbourg Canada 123 K5
Louisburg Ireland 51 C4
Louise Falls Canada *see* Louisbourg
Louis-Gentil Morocco *see* Youssoufia
Louisiade Archipelago *is* P.N.G. 110 F1
Louisiana U.S.A. 130 F4
Louisiana *state* U.S.A. 131 F6
Louis Trichardt S. Africa *see* Makhado
Louisville GA U.S.A. 133 D5
Louisville IL U.S.A. 130 F4
Louisville KY U.S.A. 134 C4
Louisville MS U.S.A. 131 F5
Louisville Ridge *sea feature* S. Pacific Ocean 150 I8
Louis-XIV, Pointe *pt* Canada 122 F3
Loukhi Rus. Fed. 44 R3
Loukoléla Congo 98 B4
Loukouo Congo 97 E5
Loulé Port. 57 B5
Loum Cameroon 96 D4
Louny Czech Rep. 47 N5
Loup *r.* U.S.A. 130 D3
Loups Marins, Lacs des *lakes* Canada 122 G2
Loups Marins, Petit lac des *l.* Canada 123 G2
L'Our, Vallée de *valley* Germany/Lux. 52 G5
Lourdes Canada 123 K4
Lourdes France 56 D5
Lourenço Marques Moz. *see* Maputo
Lousã Port. 57 B3
Loushan China 74 C3
Loushanguan China *see* Tongzi
Louth Australia 112 B3
Louth U.K. 48 G5
Loutra Aidipsou Greece 59 J5
Louvain Belgium *see* Leuven
Louviers France 52 B5
Louwater-Suid Namibia 100 C2
Louwsburg S. Africa 101 J4
Lövånger Sweden 44 L4
Lovat' *r.* Rus. Fed. 42 F4
Lovech Bulg. 59 K3
Lovell U.S.A. 135 J1
Lovelock U.S.A. 128 D1
Lovendegem Belgium 52 D3
Lovers' Leap *mt.* U.S.A. 134 E5
Loviisa Fin. 45 O6
Lovington U.S.A. 131 C5
Lovozero Rus. Fed. 42 G1
Lóvua Angola 99 C4
Lôvua Angola 99 C4
Low, Cape Canada 119 J3
Lowa Dem. Rep. Congo 98 C4
Lowa *r.* Dem. Rep. Congo 98 C4
Lowarai Pass Pak. 89 H3
Lowell IN U.S.A. 134 B3
Lowell MA U.S.A. 135 J2
Lower Arrow Lake Canada 120 G5
Lower California *pen.* Mex. *see* Baja California
Lower Glenelg National Park Australia 111 C8
Lower Hutt N.Z. 113 E5
Lower Laberge Canada 120 C2
Lower Lake U.S.A. 128 B2
Lower Lough Erne *l.* U.K. 51 E3
Lower Post Canada 120 D3
Lower Red Lake U.S.A. 130 E2
Lower Saxony *land* Germany *see* Niedersachsen
Lower Tunguska *r.* Rus. Fed. *see* Nizhnyaya Tunguska
Lower Zambezi National Park Zambia 99 C5
Lowestoft U.K. 49 I6
Łowicz Poland 47 Q4
Low Island Kiribati *see* Starbuck Island
Lowkhi Afgh. 89 F4
Lowther Hills U.K. 50 F5
Lowville U.S.A. 135 H2
Loxstedt Germany 53 I1
Loxton Australia 111 C7
Loyal, Loch *l.* U.K. 50 E2
Loyalsock Creek *r.* U.S.A. 135 G3
Loyalton U.S.A. 128 C2

M

Maghnia Alg. 57 F6
Maghor Afgh. 89 F3
Maghull U.K. 48 E5
Magilligan Point U.K. 51 F2
Magma U.S.A. 129 H5
Magna Grande mt. Sicily Italy 58 F6
Magnetic Island Australia 110 D3
Magnetic Passage Australia 110 D3
Magnetity Rus. Fed. 44 R2
Magnitogorsk Rus. Fed. 64 G4
Magnolia China 76 E4
Magnolia AR U.S.A. 131 E5
Magnolia MS U.S.A. 131 F6
Magny-en-Vexin France 52 B5
Magny Rus. Fed. 74 F1
Màgoé Moz. 99 D5
Magog Canada 135 I1
Mago National Park Eth. 98 D3
Magosa Cyprus see Famagusta
Magpie r. Canada 123 I4
Magpie, Lac l. Canada 123 I4
Magta' Lahjar Mauritania 96 B3
Magu Tanz. 98 D4
Magu, Khrebet mts Rus. Fed. 74 E1
Maguan China 76 E4
Magude Moz. 101 K3
Magueyal Mex. 131 C7
Magura Bangl. 83 G5
Maguse Lake Canada 121 M2
Magway Myanmar see Magwe
Magwe Myanmar 70 A2
Magyar Köztársaság country Europe see
 Hungary
Magyichaung Myanmar 70 A2
Mahābād Iran 88 B2
Mahabharat Range mts Nepal 83 F4
Mahaboobnagar India see Mahbubnagar
Mahad India 84 B2
Mahadeo Hills India 82 D5
Mahaffey U.S.A. 135 F3
Mahajan India 82 C3
Mahajanga Madag. 99 E5
Mahakam r. Indon. 68 F7
Mahalapye Botswana 101 H2
Mahale Mountains National Park
 Tanz. 99 C4
Mahalevona Madag. 99 E5
Mahallāt Iran 88 C3
Mahān Iran 88 E4
Mahanadi r. India 84 E1
Mahanoro Madag. 99 E5
Maha Oya Sri Lanka 84 D5
Maharashtra state India 84 B2
Maha Sarakham Thai. 70 C3
Mahasham, Wâdi el watercourse Egypt see
 Muhashshsam, Wādī al
Mahaxai Laos 70 D3
Mahbubabad India 84 D2
Mahbubnagar India 84 C2
Mahd adh Dhahab Saudi Arabia 86 F5
Mahdia Alg. 57 G6
Mahdia Guyana 143 G2
Mahdia Tunisia 58 D7
Mahe China 76 E1
Mahé i. Seychelles 149 L6
Mahendragiri mt. India 84 E2
Mahenge Tanz. 99 D4
Mahesana India 82 C5
Mahi r. India 82 C5
Mahia Peninsula N.Z. 113 F4
Mahilyow Belarus 43 F5
Mahim India 84 B2
Mah Jān Iran 88 D4
Mahlabatini S. Africa 101 J5
Mahlsdorf Germany 53 L2
Mahmudabad Iran 88 D2
Maḥmūd-e 'Erāqī Afgh. see
 Maḥmūd-e Rāqī
Maḥmūd-e Rāqī Afgh. 89 H3
Mahnomen U.S.A. 130 D2
Maho Sri Lanka 84 D5
Mahoba India 82 D4
Maholi India 82 E4
Mahón Spain 57 I4
Mahony Lake Canada 120 E1
Mahrauni India 82 D4
Mahrès Tunisia 58 D7
Māhrūd Iran 89 F3
Mahsana India see Mahesana
Mahudaung mts Myanmar 70 A2
Māhukona U.S.A. 127 [inset]
Mahur India 84 C2
Mahuva India 82 B5
Mahwa India 82 D4
Mahya Daği mt. Turkey 59 L4
Mai i. Vanuatu see Émaé
Maiaia Moz. see Nacala
Maibang India 70 A1
Maicao Col. 142 D1
Maicasagi r. Canada 122 F4
Maicasagi, Lac l. Canada 122 F4
Maichen China 77 F4
Maidenhead U.K. 49 G7
Maidstone Canada 121 I4
Maidstone U.K. 49 H7
Maiduguri Nigeria 96 E3
Maiella, Parco Nazionale della nat. park
 Italy 58 F3
Mai Gudo mt. Eth. 98 D3
Maigue r. Ireland 51 D5
Maihar India 82 E4
Maiji Shan mt. China 76 E1
Maikala Range hills India 82 E5
Maiko r. Dem. Rep. Congo 98 C3
Mailan Hill mt. India 83 E5
Mailly-le-Camp France 52 E6
Mailsi Pak. 89 I4
Main r. Germany 53 I4
Main r. U.K. 51 F3
Main Brook Canada 123 L4
Mainburg Germany 53 L6
Main Channel lake channel Canada 134 E1
Maindargi India 84 C2
Mai-Ndombe, Lac l. Dem. Rep. Congo
 98 B4
Main-Donau-Kanal canal Germany 53 K5
Maindong Xizang China see Coqên
Main Duck Island Canada 135 G2
Maine state U.S.A. 135 K1
Maine, Gulf of Canada/U.S.A. 135 K2
Mainé Hanari, Cerro hill Col. 142 D4
Mainé-Soroa Niger 96 E3
Maingkaing Myanmar 70 A1

Maingkwan Myanmar 70 B1
Maingy Island Myanmar 71 B4
Mainhardt Germany 53 J5
Mainkung China 76 C2
Mainland i. Scotland U.K. 50 F1
Mainland i. Scotland U.K. 50 [inset]
Mainleus Germany 53 L4
Mainoru Australia 108 F3
Mainpat reg. India 83 E5
Mainpuri India 82 D4
Main Range National Park Australia 112 F2
Maintenon France 52 B6
Maintirano Madag. 99 E5
Mainz Germany 53 I4
Maio i. Cape Verde 96 [inset]
Maipú Arg. 144 E5
Maiskhal Island Bangl. 83 G5
Maisons-Laffitte France 52 C6
Maitengwe Botswana 99 C6
Maitland N.S.W. Australia 112 E4
Maitland S.A. Australia 111 B7
Maitland r. Australia 108 B5
Maitri research station Antarctica 152 C2
Maiwo i. Vanuatu see Maéwo
Maiyu, Mount hill Australia 108 E4
Maíz, Islas del is Nicaragua 137 H6
Maizar Pak. 89 H3
Maizuru Japan 75 D6
Maja Jezercë mt. Albania 59 H3
Majdel Aanjar tourist site Lebanon 85 B3
Majene Indon. 68 F7
Majestic U.S.A. 134 D5
Maịhūd well Saudi Arabia 88 C6
Majī Eth. 98 D3
Majiang Guangxi China 77 F4
Majiang Guizhou China 76 E3
Majiazi China 74 B2
Majōl country N. Pacific Ocean see
 Marshall Islands
Major, Puig mt. Spain 57 H4
Majorca i. Spain 57 H4
Mājro atoll Marshall Is see Majuro
Majunga Madag. see Mahajanga
Majuro atoll Marshall Is 150 H5
Majwemasweu S. Africa 101 H5
Makabana Congo 98 B4
Makale Indon. 69 F7

▶Makalu mt. China/Nepal 83 F4
 5th highest mountain in the world and in
 Asia.
 World 12–13

Makalu Barun National Park Nepal 83 F4
Makanchi Kazakh. 80 F2
Makanpur India 82 E4
Makari Mountain National Park Tanz. see
 Mahale Mountains National Park
Makarov Rus. Fed. 74 F2
Makarov Basin sea feature
 Arctic Ocean 153 B1
Makarska Croatia 58 G3
Makarwal Pak. 89 H3
Makar'ye Rus. Fed. 42 K4
Makar'yev Rus. Fed. 42 I4
Makasar, Selat strait Indon. see
 Makassar, Selat
Makassar Indon. 68 F8
Makassar, Selat strait Indon. 68 F7
Makassar Strait Indon. see
 Makassar, Selat
Makat Kazakh. 78 E2
Makatini Flats lowland S. Africa 101 K4
Makedonija country Europe see
 Macedonia
Makeni Sierra Leone 96 B4
Makete Tanz. 99 D4
Makeyevka Ukr. see Makiyivka
Makgadikgadi depr. Botswana 99 C6
Makgadikgadi Pans National Park
 Botswana 99 C6
Makhachkala Rus. Fed. 91 G2
Makhad Pak. 89 H3
Makhado S. Africa 101 I2
Makhāzin, Kathīb al des. Egypt 85 A4
Makhāzin, Kathīb al des. Egypt see
 Makhāzin, Kathīb al
Makhazine, Barrage El dam
 Morocco 57 D6
Makhmūr Iraq 91 F4
Makhtal India 84 C2
Makin atoll Kiribati see Butaritari
Makindu Kenya 98 D4
Makinsk Kazakh. 79 G1
Makira i. Solomon Is see San Cristobal
Makiyivka Ukr. 43 H6
Makkah Saudi Arabia see Mecca
Makkovik Canada 123 K3
Makkovik, Cape Canada 123 K3
Makkum Neth. 52 F1
Makó Hungary 59 I1
Makokou Gabon 98 B3
Makopong Botswana 100 F3
Makotipoko Congo 97 E5
Makrana India 82 C4
Makri India 84 D2
Maksatikha Rus. Fed. 42 G4
Maksi India 82 D5
Maksimovka Rus. Fed. 74 E3
Maksudangarh India 82 D5
Mākū Iran 88 B2
Makungwuro Tanz. 99 D5
Makurdi Nigeria 96 D4
Makwassie S. Africa 101 G4
Mal India 83 G4
Mala Ireland see Mallow
Mala i. Solomon Is see Malaita
Malá Sweden 44 K4
Mala, Punta pt Panama 137 H7
Malabar Coast India 84 B3

▶Malabo Equat. Guinea 96 D4
 Capital of Equatorial Guinea.

Malaca Spain see Málaga
Malacca Malaysia see Melaka
Malacca, Strait of Indon./Malaysia 71 B6
Malad City U.S.A. 126 E4
Maladzyechna Belarus 45 O9

Malá Fatra nat. park Slovakia 47 Q6
Málaga Spain 57 D5
Malaga U.S.A. 131 B5
Malagasy Republic country Africa see
 Madagascar
Malaita i. Solomon Is 107 G2
Malakal Sudan 86 D8
Malakanagiri India see Malkangiri
Malakheti Nepal 82 E3
Malakula i. Vanuatu 107 G3
Malan, Ras pt Pak. 89 G5
Malang Indon. 68 E8
Malangana Nepal see Malangwa
Malange Angola see Malanje
Malangwa Nepal 83 F4
Malanje Angola 99 B4
Malappuram India 84 B4
Mālaren l. Sweden 45 J7
Malargüe Arg. 144 C5
Malartic Canada 122 F4
Malaspina Glacier U.S.A. 120 A3
Malatya Turkey 90 E3
Malavalli India 84 C3

▶Malawi country Africa 99 D5
 Africa 7, 94–95
Malawi, Lake Africa see Nyasa, Lake
Malawi National Park Zambia see
 Nyika National Park
Malaya pen. Rus. Fed. 42 L2
Malaya Pera Rus. Fed. 42 L2
Malaya Vishera Rus. Fed. 42 G4
Malaybalay Phil. 69 H5
Malāyer Iran 88 C3
Malay Peninsula Asia 71 B4
Malay Reef Australia 110 E3
Malaysia country Asia 68 D5
 Asia 6, 62–63
Malaysia, Semenanjung pen. Malaysia see
 Peninsular Malaysia
Malazgirt Turkey 91 F3
Malbon Australia 110 C4
Malbork Poland 47 Q3
Malborn Germany 52 G5
Malchin Germany 47 N4
Malcolm Australia 109 C7
Malcolm, Point Australia 109 C8
Malcolm Island Myanmar 71 B5
Maldegem Belgium 52 D3
Malden U.S.A. 131 F4
Malden Island Kiribati 151 J6

▶Maldives country Indian Ocean
 81 D10
 Asia 6, 62–63
Maldon Australia 112 B6
Maldon U.K. 49 H7
Maldonado Uruguay 144 F4

▶Male Maldives 81 D11
 Capital of the Maldives.

Maleas, Akra pt Peloponnisos Greece see
 Maleas, Akrotirio
Maleas, Akrotirio pt Greece 59 J6
Male Atoll Maldives 81 D11
Malebogo S. Africa 101 G5
Malegaon Mahar. India 84 C1
Malegaon Mahar. India 84 C2
Malé Karpaty hills Slovakia 47 P6
Malek Siāh, Kūh-e mt. Afgh. 89 F4
Malele Dem. Rep. Congo 99 B4
Maler Kotla India 82 C3
Maleševe Planine mts Bulg./Macedonia
 59 J4
Malgobek Rus. Fed. 91 G2
Malgomaj l. Sweden 44 J4
Malha, Naqb mt. Egypt see
 Mālḥah, Naqb
Malhada Brazil 145 C1
Malheur r. U.S.A. 126 D3
Malheur Lake U.S.A. 126 D4

▶Mali country Africa 96 C3
 Africa 7, 94–95
Mali Dem. Rep. Congo 98 C4
Mali Guinea 96 B3
Maliana East Timor 108 D2
Malianjing China 80 I3
Mālḥah, Naqb mt. Egypt 85 A5
Malik Naro mt. Pak. 89 F4
Mali Kyun i. Myanmar 71 B4
Malili Indon. 69 G7
Malin Ukr. see Malyn
Malindi Kenya 98 E4
Malines Belgium see Mechelen
Malin Head hd Ireland 51 E2
Malin More Ireland 51 D3
Malipo China 76 E4
Mali Raginac mt. Croatia 58 F2
Malita Phil. 69 H5
Malka r. Rus. Fed. 91 G2
Malkangiri India 84 D2
Malkapur India 84 B2
Malkara Turkey 59 L4
Mal'kavichy Belarus 45 O10
Malko Tûrnovo Bulg. 59 L4
Mallacoota Australia 112 D6
Mallacoota Inlet b. Australia 112 D6
Mallaig U.K. 50 D4
Mallani reg. India 89 H5
Mallawī Egypt 90 C6
Mallery Lake Canada 121 L1
Mallét Brazil 145 A4
Mallorca i. Spain see Majorca
Mallow Ireland 51 D5
Mallowa Well Australia 108 D5
Mallwyd U.K. 49 D6
Malm Norway 44 G4
Malmberget Sweden 44 L3
Malmédy Belgium 52 G4
Malmesbury S. Africa 100 D7
Malmesbury U.K. 49 E7
Malmö Sweden 45 H9
Malmyzh Rus. Fed. 42 K4
Maloca Brazil 143 G3
Malone U.S.A. 135 H1
Malonje mt. Tanz. 99 D4
Maloshuyka Rus. Fed. 42 H3
Maloyaroslavets Rus. Fed. 43 H5

Maloyaroslavets Rus. Fed. 43 H5
Malozemel'skaya Tundra lowland
 Rus. Fed. 42 K2
Malpelo, Isla de i. N. Pacific Ocean 137 H8
Malprabha r. India 84 C2

▶Malta country Europe 58 F7
 Europe 5, 38–39
Malta ID U.S.A. 126 E4
Malta MT U.S.A. 126 G2
Malta Channel Italy/Malta 58 F6
Maltahöhe Namibia 100 C3
Maltby U.K. 48 F5
Maltby le Marsh U.K. 48 H5
Malton U.K. 48 G4
Malukken is Indon. see Moluccas
Maluku is Indon. see Moluccas
Maluku, Laut sea Indon. 69 H6
Ma'lūlā, Jabal mts Syria 85 C3
Malung Sweden 45 H6
Maluti Mountains Lesotho 101 I5
Malu'u Solomon Is 107 G2
Malvan India 84 B2
Malvasia Greece see Monemvasia
Malvern U.K. see Great Malvern
Malvern U.S.A. 131 E5
Malvérnia Moz. see Chicualacuala
Malvinas, Islas terr. S. Atlantic Ocean see
 Falkland Islands
Malyn Ukr. 43 F6
Malyy Anyuy r. Rus. Fed. 65 R3
Malyye Derbety Rus. Fed. 43 J7
Malyy Kavkaz mts Asia see
 Lesser Caucasus
Malyy Lyakhovskiy, Ostrov i.
 Rus. Fed. 65 P2
Malyy Uzen' r. Kazakh./Rus. Fed. 43 K6
Mama r. Rus. Fed. 65 P3
Mamadysh Rus. Fed. 42 K5
Mamafubedu S. Africa 101 I4
Mamatān Nāvar l. Afgh. 89 G4
Mamba China 76 B2
Mambai Brazil 145 B1
Mambasa Dem. Rep. Congo 98 C3
Mamburao Phil. 69 G4
Mamelodi S. Africa 101 I3
Mamfe Cameroon 96 D4
Mamison Pass Georgia/Rus. Fed. 91 F2
Mamit India 83 H5
Mammoth U.S.A. 129 H5
Mammoth Cave National Park
 U.S.A. 134 B5
Mammoth Reservoir U.S.A. 128 D3
Mamonas Brazil 145 C1
Mamoré r. Bol./Brazil 142 E6
Mamou Guinea 96 B3
Mampikony Madag. 99 E5
Mampong Ghana 96 C4
Mamuju Indon. 68 F7
Mamuno Botswana 100 E2
Man Côte d'Ivoire 96 C4
Man r. India 84 B2
Man r. India 84 B2
Man U.S.A. 134 E5

▶Man, Isle of terr. Irish Sea 48 C4
 United Kingdom Crown Dependency.
 Europe 5

Manacapuru Brazil 142 F4
Manacor Spain 57 H4
Manado Indon. 69 G6

▶Managua Nicaragua 137 G6
 Capital of Nicaragua.

Manakara Madag. 99 E6
Manakau mt. N.Z. 113 D6
Manākhah Yemen 86 F6

▶Manama Bahrain 88 C5
 Capital of Bahrain.

Manamadurai India 84 C4
Mana Maroka National Park
 S. Africa 101 H5
Manamelkudi India 84 C4
Manam Island P.N.G. 69 L7
Manambolo r. Madag. 99 E5
Manangoora Australia 110 B3
Mananjary Madag. 99 E6
Manantali, Lac de l. Mali 96 B3
Manantenina Madag. 99 E6
Mana Pass China/India 82 D3
Mana Pools National Park Zimbabwe
 99 C5

▶Manapouri, Lake N.Z. 113 A7
 Deepest lake in Oceania.

Manasa India 82 C4
Manas He r. China 80 G2
Manas Hu l. China 80 G2
Manāşīr reg. U.A.E. 88 D6
Manaslu mt. Nepal 83 F3
Manassas U.S.A. 135 G4
Manastir Macedonia see Bitola
Manas Wildlife Sanctuary nature res.
 Bhutan 83 G4
Man-aung Myanmar 70 A3
Man-aung Kyun Myanmar 70 A3
Manaus Brazil 142 F4
Manavgat Turkey 90 C3
Manbazar India 83 F5
Manbij Syria 85 C1
Manby U.K. 48 H5
Mancelona U.S.A. 134 C1
Manchar India 84 B2
Manchester U.K. 48 E5
Manchester IA U.S.A. 130 F3
Manchester KY U.S.A. 134 D5
Manchester MD U.S.A. 135 G4
Manchester MI U.S.A. 134 C2
Manchester NH U.S.A. 135 J2
Manchester OH U.S.A. 134 D4
Manchester TN U.S.A. 132 C5
Manchester VT U.S.A. 135 I2
Manchhar Lake India 89 H5
Manch Pak. 89 H5
Mand, Rūd-e r. Iran 88 C4
Manda Tanz. 99 D4

Manda, Jebel mt. Sudan 97 F4
Manda, Parc National de nat. park
 Chad 97 E4
Mandabe Madag. 99 E6
Mandai Sing. 71 [inset]
Mandal Iraq 91 G4
Mandal Norway 45 E7

▶Mandala, Puncak mt. Indon. 69 K7
 3rd highest mountain in Oceania.

Mandalay Myanmar 70 B2
Mandale Myanmar see Mandalay
Mandalgovĭ Mongolia 72 J3
Mandalī Iraq 91 G4
Mandalt China 73 K4
Mandan U.S.A. 130 C2
Mandas Sardinia Italy 58 C5
Mandasa India 84 E2
Mandasor India see Mandsaur
Mandav Hills India 82 B5
Mandera Kenya 98 E3
Manderfield U.S.A. 129 G2
Manderscheid Germany 52 G4
Mandeville Jamaica 137 I5
Mandeville U.S.A. 131 B7
Mandha India 82 B4
Mandhoúdhíon Greece see Mantoudi
Mandi India 82 D3
Mandiana Guinea 96 C3
Mandi Burewala Pak. 89 I4
Mandié Moz. 99 D5
Mandini S. Africa 101 J5
Mandira Dam India 83 F5
Mandla India 82 E5
Mandleshwar India 82 C5
Mandrael India 82 D4
Mandritsara Madag. 99 E5
Mandsaur India 82 C4
Mandurah Australia 109 A8
Manduria Italy 58 G4
Mandvi India 82 B5
Mandya India 84 C3
Manerbio Italy 58 D2
Manevychi Ukr. 43 E6
Manfalūţ Egypt 90 C6
Manfredonia Italy 58 G4
Manfredonia, Golfo di g. Italy 58 G4
Manga Brazil 145 C1
Manga Burkina 96 C3
Mangabeiras, Serra das hills Brazil 143 I6
Mangai Dem. Rep. Congo 98 B4
Mangaia i. Cook Is 151 J7
Mangakino N.Z. 113 E4
Mangalagiri India 84 D2
Mangaldai India 70 A1
Mangaldoi India see Mangaldai
Mangalia Romania 59 M3
Mangalmé Chad 97 E3
Mangalore India 84 B3
Mangaon India 84 B2
Mangareva Islands Fr. Polynesia see
 Gambier, Îles
Manganui Free State S. Africa 101 H5
Manganui Free State S. Africa see
 Bloemfontein
Mangawan India 83 E4
Mangaweka mt. N.Z. 113 E4
Mangea i. Cook Is see Mangaia
Manggyshlaq Kazakh. see Mangystau
Manggyshlaū Kazakh. see Mangystau
Manggyhstaū admin. div. Kazakh. see
 Mangistauskaya Oblast'
Manggyhst Uzbek. see Mang'it
Manghit Uzbek. see Mang'it
Mangin Range mts Myanmar see
 Mingin Range
Mangistau Kazakh. see Mangystau
Mangistauskaya Oblast' admin. div.
 Kazakh. 91 I2
Mang'it Uzbek. 80 B3
Mangla Bangl. see Mongla
Mangla r. Madag. 99 E6
Mangla Pak. 89 I3
Manglaqiongtuo China see Guinan
Mangnai China 80 H4
Mangnai Zhen China 80 H4
Mangochi Malawi 99 D5
Mangoky r. Madag. 99 E6
Mangole i. Indon. 69 H7
Mangoli India 84 B2
Mangotsfield U.K. 49 E7
Mangqystau Shyghanaghy b. Kazakh. see
 Mangyshlakskiy Zaliv
Mangrol India 82 B5
Mangrol India 82 B5
Mangshi China see Luxi
Mangualde Port. 57 C3
Manguéni, Plateau du Niger 96 E2
Mangui China 74 A2
Mangula Zimbabwe see Mhangura
Mangum U.S.A. 131 D5
Mangyshlak Kazakh. see Mangystau
Mangyshlak, Poluostrov pen. Kazakh.
 91 H1
Mangystau Kazakh. 91 H2
Manhã Brazil 145 C1
Manhattan U.S.A. 130 D4
Manhica Moz. 101 K4
Manhoca Moz. 101 K4
Manhuaçu Brazil 145 C3
Manhuaçu r. Brazil 145 C2
Mani China 83 F2
Mania r. Madag. 99 E5
Maniago Italy 58 E1
Manicoré Canada 123 H4
Manicouagan r. Canada 123 H4
Manicouagan, Réservoir resr
 Canada 123 H4
Manic Trois, Réservoir resr Canada 123 H4
Manifah Saudi Arabia 88 C5
Maniganggo China 76 C2
Manigotagan Canada 121 L5
Manihiki atoll Cook Is 150 J6
Maniitsoq Greenland 119 M3
Manikchhari Bangl. 83 H5

Manikgarh India see Rajura

▶Manila Phil. 69 G4
 Capital of the Philippines.

Manila U.S.A. 126 F4
Manildra Australia 112 D4
Manilla Australia 112 E3
Maningrida Australia 108 F3
Manipur India see Imphal
Manipur state India 83 H4
Manisa Turkey 59 L5
Manistee U.S.A. 134 B1
Manistee r. U.S.A. 134 B1
Manistique U.S.A. 132 C2
Manitoba prov. Canada 121 L4
Manitoba, Lake Canada 121 L5
Manito Lake Canada 121 I4
Manitou Canada 121 L5
Manitou, Lake U.S.A. 134 B3
Manitou Beach U.S.A. 135 G2
Manitou Falls Canada 121 M5
Manitou Islands U.S.A. 134 B1
Manitoulin Island Canada 122 C5
Manitouwadge Canada 122 D4
Manitowoc U.S.A. 134 B1
Maniwaki Canada 122 G5
Manizales Col. 142 C2
Manja Madag. 99 E6
Manjarabad India 84 B3
Manjeri India 84 C4
Manjhand Pak. 89 H5
Manjhi India 83 F4
Manjra r. India 84 C2
Man Kabat Myanmar 70 B1
Mankaiana Swaziland see Mankayane
Mankato KS U.S.A. 130 D4
Mankato MN U.S.A. 130 E2
Mankayane Swaziland 101 J4
Mankera Pak. 89 H4
Mankono Côte d'Ivoire 96 C4
Mankota Canada 121 J5
Manley Hot Springs U.S.A. 118 C3
Manmad India 84 B1
Mann r. Australia 108 F3
Mann, Mount Australia 109 E6
Manna Indon. 68 C7
Man Na Myanmar 70 B2
Mannahill Australia 111 B7
Mannar Sri Lanka 84 C4
Mannar, Gulf of India/Sri Lanka 84 C4
Manneru r. India 84 D3
Mannessier, Lac l. Canada 123 H3
Mannheim Germany 53 I5
Mannicolo Islands Solomon Is see
 Vanikoro Islands
Manning r. Australia 112 F3
Manning Canada 120 G3
Manning U.S.A. 133 D5
Mannington U.S.A. 134 E4
Manningtree U.K. 49 I7
Mann Ranges mts Australia 109 E6
Mannsville KY U.S.A. 134 C5
Mannsville NY U.S.A. 135 G2
Mannu, Capo c. Sardinia Italy 58 C4
Mannville Canada 121 I4
Man-of-War Rocks is U.S.A. see
 Gardner Pinnacles
Manoharpur India 82 D4
Manohar Thana India 82 D4
Manokotak U.S.A. 118 C4
Manokwari Indon. 69 I7
Manoron Myanmar 71 B5
Manosque France 56 G5
Manouane r. Canada 123 H4
Manouane, Lac l. Canada 123 H4
Man Pan Myanmar 70 B2
Manp'o N. Korea 74 B4
Manra i. Kiribati 107 I2
Manresa Spain 57 G3
Mansa Gujarat India 82 C5
Mansa Punjab India 82 C3
Mansa Zambia 99 C5
Mansa Konko Gambia 96 B3
Man Sam Myanmar 70 B2
Mansehra Pak. 87 I3
Mansel Island Canada 119 K3
Mansfield Australia 112 C6
Mansfield U.K. 49 F5
Mansfield LA U.S.A. 131 E5
Mansfield OH U.S.A. 134 D3
Mansfield PA U.S.A. 135 G3
Mansfield, Mount U.S.A. 135 I1
Man Si Myanmar 70 B1
Mansi Myanmar 70 A1
Manso r. Brazil see Mortes, Rio das
Manta Ecuador 142 B4
Mantaro r. Peru 142 D6
Manteca U.S.A. 128 C3
Mantena Brazil 145 C2
Manteo U.S.A. 132 F5
Mantes-la-Jolie France 52 B6
Mantiqueira, Serra da mts Brazil 145 B3
Manton U.S.A. 134 C1
Mantoudi Greece 59 J5
Mantova Italy see Mantua
Mäntsälä Fin. 45 N6
Mänttä Fin. 44 N5
Mantua Cuba 133 D4
Mantua Italy 58 D2
Mantuan Downs Australia 110 D5
Manturovo Rus. Fed. 42 J4
Mäntyharju Fin. 45 O6
Mäntyjärvi Fin. 44 O3
Manú Peru 142 D6
Manú, Parque Nacional nat. park
 Peru 142 D6
Manuae atoll Fr. Polynesia 151 J7
Manu'a Islands American Samoa 107 I3
Manuel Ribas Brazil 145 A4
Manuel Vitorino Brazil 145 C1
Manuelzinho Brazil 143 H5
Manui i. Indon. 69 G7
Manukau N.Z. 113 E3
Manukau Harbour N.Z. 113 E3
Manunda watercourse Australia 111 B7
Manusela, Taman Nasional Indon. 69 H7
Manus Island P.N.G. 69 L7
Manvi India 84 C3
Manville U.S.A. 131 E6
Manyana Botswana 101 G3
Manyas Turkey 59 L4

Manyas Gölü *l.* Turkey *see* Kuş Gölü
Manych-Gudilo, Ozero *l.* Rus. Fed. 43 I7
Many Island Lake Canada 121 I5
Manyoni Tanz. 99 D4
Manzai Pak. 89 H3
Manzanares Spain 57 E4
Manzanillo Cuba 137 I4
Manzanillo Mex. 136 D5
Manzhouli China 73 L3
Manzini Swaziland 101 J4
Mao Chad 97 E3
Maó Spain *see* Mahón
Maoba *Guizhou* China 76 E3
Maoba *Hubei* China 77 F2
Maocifan China 77 G2
Mao'ergai China 76 D1
Maoke, Pegunungan *mts* Indon. 69 J7
Maokeng S. Africa 101 H4
Maokui Shan *mt.* China 74 A4
Maolin China 74 A4
Maoming China 77 F4
Ma On Shan *hill* H.K. China 77 [inset]
Maopi T'ou *c.* Taiwan 77 I4
Maopora *i.* Indon. 108 E2
Maotou Shan *mt.* China 76 D3
Mapai Moz. 101 J2
Mapam Yumco *l.* China 83 E3
Mapanza Zambia 99 C5
Maphodi S. Africa 101 G6
Mapimí Mex. 131 C7
Mapimí, Bolsón de *des.* Mex. 131 B7
Mapinhane Moz. 101 L2
Mapiri Bol. 142 E7
Maple *r. MI* U.S.A. 134 C2
Maple *r. ND* U.S.A. 130 D2
Maple Creek Canada 121 I5
Maple Heights U.S.A. 134 E3
Maple Peak U.S.A. 129 I5
Mapmakers Seamounts *sea feature*
 N. Pacific Ocean 150 H4
Mapoon Australia 110 C1
Mapor *i.* Indon. 71 D7
Mapoteng Lesotho 101 H5
Maprik P.N.G. 69 K7
Mapuera *r.* Brazil 143 G4
Mapulanguene Moz. 101 K3

► Maputo Moz. 101 K3
 Capital of Mozambique.

Maputo *prov.* Moz. 101 K3
Maputo *r.* Moz./S. Africa 101 K4
Maputo, Baía de *b.* Moz. 101 K4
Maputsoe Lesotho 101 H5
Maqanshy Kazakh. *see* Makanchi
Maqar an Na'am *well* Iraq 91 F5
Maqat Kazakh. *see* Makat
Maqên China 76 D1
Maqên Kangri *mt.* China 76 C1
Maqnā Saudi Arabia 90 D5
Maqteïr *reg.* Mauritania 96 B2
Maqu China 76 D1
Ma Qu *r.* China *see* Yellow
Maquan He *r.* China 83 F3
Maquela do Zombo Angola 99 B4
Maquinchao Arg. 144 C6
Mar *r.* Pak. 89 G5
Mar, Serra do *mts Rio de Janeiro/São Paulo*
 Brazil 145 B3
Mar, Serra do *mts Rio Grande do Sul/Santa*
 Catarina Brazil 145 A5
Mara *r.* Canada 121 I1
Mara India 83 E5
Mara S. Africa 101 I2
Maraã Brazil 142 E4
Marabá Brazil 143 I5
Maraboon, Lake *resr* Australia 110 E4
Maracá, Ilha de *i.* Brazil 143 H3
Maracaibo Venez. 142 D1
Maracaibo, Lago de Venez. *see*
 Maracaibo, Lake
Maracaibo, Lake Venez. 142 D2
Maracaju Brazil 144 F2
Maracaju, Serra de *hills* Brazil 144 E2
Maracanda Uzbek. *see* Samarqand
Maracás Brazil 145 C1
Maracás, Chapada de *hills* Brazil 145 C1
Maracay Venez. 142 E1
Marādah Libya 97 E2
Maradi Niger 96 D3
Marāgheh Iran 88 B2
Marahuaca, Cerro *mt.* Venez. 142 E3
Marajó, Baía de *est.* Brazil 143 I4
Marajó, Ilha de *i.* Brazil 143 H4
Marakele National Park S. Africa 101 H3
Maralal Kenya 98 D3
Maralbashi China *see* Bachu
Maralinga Australia 109 E7
Maralwexi China *see* Bachu
Maramasike *i.* Solomon Is 107 G2
Maramba Zambia *see* Livingstone
Marambio *research station*
 Antarctica 152 A2
Maran Malaysia 71 C7
Maran *mt.* Pak. 89 G4
Marana U.S.A. 129 H5
Marand Iran 88 B2
Marandellas Zimbabwe *see* Marondera
Marang Malaysia 71 C6
Marang Myanmar 71 B5
Maranhão Brazil 143 A5
Maranhão *r.* Australia 112 D1
Marañón *r.* Peru 142 D4
Marão Moz. 101 L3
Marão *mt.* Port. 57 C3
Mara Rosa Brazil 145 A1
Maraş Turkey *see* Kahramanmaraş
Marathon Canada 122 D4
Marathon *FL* U.S.A. 133 D7
Marathon *NY* U.S.A. 135 G2
Marathon *TX* U.S.A. 131 C6
Maratua *i.* Indon. 68 F6
Maraú Brazil 145 D1
Maravilhas Creek *watercourse*
 U.S.A. 131 C6
Märäzä Azer. 91 H2
Marbella Spain 57 D5
Marble Bar Australia 108 B5
Marble Canyon U.S.A. 129 H3
Marble Canyon *gorge* U.S.A. 129 H3
Marble Hall S. Africa 101 I3
Marble Hill U.S.A. 131 F4

Marble Island Canada 121 N2
Marbul Pass Jammu and Kashmir 82 C2
Marburg S. Africa 101 J6
Marburg Slovenia *see* Maribor
Marburg an der Lahn Germany 53 I4
Marca, Ponta do *pt* Angola 99 B5
Marcali Hungary 58 G1
Marcelino Ramos Brazil 145 A4
March U.K. 49 H6
Marche *reg.* France 56 E3
Marche-en-Famenne Belgium 52 F4
Marchena Spain 57 D5
Marchinbar Island Australia 110 B1
Mar Chiquita, Laguna *l.* Arg. 144 D4
Marchtrenk Austria 47 O6
Marco U.S.A. 133 D7
Marcoing France 52 D4
Marcona Peru 142 C7
Marcopeet Islands Canada 122 F2
Marcus Baker, Mount U.S.A. 118 D3
Marcy, Mount U.S.A. 135 I1
Mardan Pak. 89 I3
Mar del Plata Arg. 144 E5
Mardiān Afgh. 89 G2
Mardin Turkey 91 F3
Maré *i.* New Caledonia 107 G4
Maree, Loch *l.* U.K. 50 D3
Mareh Iran 89 E5
Marengo *r.* Australia 130 E3
Marengo *IN* U.S.A. 134 B4
Marevo Rus. Fed. 42 G4
Marfa U.S.A. 131 B6
Marganets Ukr. *see* Marhanets'
Margao India *see* Madgaon
Margaret *r.* Australia 108 D4
Margaret *watercourse* Australia 111 B6
Margaret, Mount *hill* Australia 108 B5
Margaret Lake *Alta* Canada 120 H3
Margaret Lake *N.W.T.* Canada 120 G1
Margaret River Australia 109 A8
Margaretville U.S.A. 135 H2
Margarita, Isla de *i.* Venez. 142 F1
Margaritovo Rus. Fed. 74 D4
Margate S. Africa 101 J6
Margate U.K. 49 I7

► Margherita Peak
 Dem. Rep. Congo/Uganda 98 C3
 3rd highest mountain in Africa.

Marghilon Uzbek. *see* Marg'ilon
Marg'ilon Uzbek. 80 D3
Märgo, Dasht-i *des.* Afgh. *see*
 Mārgow, Dasht-e
Margog Caka *l.* China 83 F2
Mārgow, Dasht-e *des.* Afgh. 89 F4
Margraten Neth. 52 F4
Marguerite Canada 120 F4
Marguerite, Pic *mt.*
 Dem. Rep. Congo/Uganda *see*
 Margherita Peak
Marguerite Bay Antarctica 152 L2
Margyang China 83 G3
Marhaj Khalil Iraq 91 G4
Marhanets' Ukr. 43 G7
Marhoum Alg. 54 E5
Mari Myanmar 70 B1
Maria *atoll Fr.* Polynesia 151 J7
María Elena Chile 144 C2
Maria Island Australia 110 A2
Maria Island Myanmar 71 B5
Maria Island National Park Australia
 111 [inset]
Mariala National Park Australia 111 D5
Mariana Brazil 145 C3
Marianao Cuba 133 D8
Mariana Ridge *sea feature* N. Pacific Ocean
 150 F4

► Mariana Trench *sea feature*
 N. Pacific Ocean 150 F5
 Deepest trench in the world.

Mariani India 83 H4
Mariánica, Cordillera *mts* Spain *see*
 Morena, Sierra
Marian Lake Canada 120 G2
Marianna *AR* U.S.A. 131 F5
Marianna *FL* U.S.A. 133 C6
Mariano Machado Angola *see* Ganda
Mariánské Lázně Czech Rep. 53 M5
Marias *r.* U.S.A. 126 F3
Marías, Islas *is* Mex. 136 C4

► Mariato, Punta *pt* Panama 137 H7
 Most southerly point of North America.

Maria van Diemen, Cape N.Z. 113 D2
Ma'rib Yemen 86 G6
Maribor Slovenia 58 F1
Marica *r.* Bulg. *see* Maritsa
Maricopa *AZ* U.S.A. 129 G5
Maricopa *CA* U.S.A. 128 D4
Maricopa Mountains U.S.A. 129 G5
Maridi Sudan 97 F4
Marie Byrd Land *reg.* Antarctica 152 J1
Marie-Galante *i.* Guadeloupe 137 L5
Mariehamn Fin. 45 K6
Mariembero *r.* Brazil 145 A1
Marienbad Czech Rep. *see*
 Mariánské Lázně
Marienberg Germany 53 N4
Marienburg Poland *see* Malbork
Marienhafe Germany 53 H1
Mariental Namibia 100 C3
Marienwerder Poland *see* Kwidzyn
Mariestad Sweden 45 H7
Mariet *r.* Canada 122 F2
Marietta *GA* U.S.A. 133 C5
Marietta *OH* U.S.A. 134 E4
Marietta *OK* U.S.A. 131 D5
Marignane France 56 G5
Marii, Mys *pt* Rus. Fed. 66 G2
Mariinsk Rus. Fed. 64 J4
Mariinskiy Posad Rus. Fed. 42 J4
Marijampolė Lith. 45 M9
Marília Brazil 145 A3
Marillana Australia 108 B5
Marimba Angola 99 B4
Marín Spain 57 B2
Marina U.S.A. 128 C3
Marina di Gioiosa Ionica Italy 58 G5

Mar'ina Gorka Belarus *see*
 Mar"ina Horka
Mar"ina Horka Belarus 45 P10
Marinduque *i.* Phil. 69 G4
Marinette U.S.A. 134 B1
Maringá Brazil 145 A3
Maringa *r.* Dem. Rep. Congo 98 B3
Maringo U.S.A. 134 D3
Marinha Grande Port. 57 B4
Marion *AL* U.S.A. 133 C5
Marion *AR* U.S.A. 131 F5
Marion *IL* U.S.A. 130 F4
Marion *IN* U.S.A. 134 C3
Marion *KS* U.S.A. 130 D4
Marion *MI* U.S.A. 134 C1
Marion *NY* U.S.A. 135 G2
Marion *OH* U.S.A. 134 D3
Marion *SC* U.S.A. 133 E5
Marion *VA* U.S.A. 134 E5
Marion, Lake U.S.A. 133 D5
Marion Reef Australia 110 F3
Maripa Venez. 142 E2
Mariposa U.S.A. 128 D3
Marisa Indon. 69 G7
Mariscal José Félix Estigarribia Para.
 144 D2
Maritime Alps *mts* France/Italy 56 H4
Maritime Kray *admin. div.* Rus. Fed. *see*
 Primorskiy Kray
Maritimes, Alpes *mts* France/Italy *see*
 Maritime Alps
Maritsa *r.* Bulg. 59 L4
 also known as Evros (Greece), Marica
 (Bulgaria), Meriç (Turkey)
Marittime, Alpi *mts* France/Italy *see*
 Maritime Alps
Mariupol' Ukr. 43 H7
Mariusa *nat. park* Venez. 142 F2
Marīvān Iran 88 B3
Marjan Afgh. *see* Wazi Khwa
Marjayoûn Lebanon 85 B3
Marka Somalia 98 E3
Markala Mali 96 C3
Markam China 76 C2
Markaryd Sweden 45 H8
Markdale Canada 134 E1
Marken S. Africa 101 I2
Markermeer *l.* Neth. 52 E2
Market Deeping U.K. 49 G6
Market Drayton U.K. 49 E6
Market Harborough U.K. 49 G6
Markethill U.K. 51 F3
Market Weighton U.K. 48 G5
Markha *r.* Rus. Fed. 65 M3
Markit China 80 E4
Markkleeberg Germany 53 M3
Markleeville U.S.A. 128 D2
Marklohe Germany 53 J2
Markog Qu *r.* China 76 D1
Markounda Cent. Afr. Rep. 98 B3
Markovo Rus. Fed. 65 S3
Markranstädt Germany 53 M3
Marks Rus. Fed. 43 J6
Marks U.S.A. 131 F5
Marksville U.S.A. 131 E6
Marktheidenfeld Germany 53 J5
Marktredwitz Germany 53 M4
Marl Germany 52 H3
Marla Australia 109 F6
Marlborough Downs *hills* U.K. 49 F7
Marle France 52 D5
Marlette U.S.A. 134 D2
Marlin U.S.A. 131 D6
Marlinton U.S.A. 134 E4
Marlo Australia 112 D6
Marmagao India 84 B3
Marmande France 56 E4
Marmara, Sea of *g.* Turkey 59 M4
Marmara Denizi *g.* Turkey *see*
 Marmara, Sea of
Marmara Gölü *l.* Turkey 59 M5
Marmarica *reg.* Libya 90 B5
Marmaris Turkey 59 M6
Marmarth U.S.A. 130 C2
Marmet U.S.A. 134 E4
Marmion, Lake *salt l.* Australia 109 C7
Marmion Lake Canada 121 N5
Marmolada *mt.* Italy 58 D1
Marne *r.* France 52 C6
Marne France 52 C6
Marne-la-Vallée France 52 C6
Marnitz Germany 53 L1
Maroantsetra Madag. 99 E5
Maroc *country* Africa *see* Morocco
Marol Jammu and Kashmir 82 D2
Marol Pak. 89 I4
Maroldsweisach Germany 53 K4
Maromokotro *mt.* Madag. 99 E5
Marondera Zimbabwe 99 D5
Maroochydore Australia 112 F1
Maroonah Australia 109 A5
Maroon Peak U.S.A. 126 G5
Marosvás>0la>rhely Romania *see*
 Târgu Mureş
Maroua Cameroon 97 E3
Marovoay Madag. 99 E5
Marqādah Syria 91 F4
Mar Qu *r.* China *see* Markog Qu
Marquard S. Africa 101 H5
Marquesas Islands *Fr.* Polynesia 151 K6
Marquesas Keys *is* U.S.A. 133 D7
Marquês de Valença Brazil 145 C3
Marquette U.S.A. 132 C2
Marquez U.S.A. 131 D6
Marquise France 52 B4
Marquises, Îles *is* Fr. Polynesia *see*
 Marquesas Islands
Marra Australia 112 A3
Marra *r.* Australia 112 C3
Marracuene Moz. 101 K3
Marrakech Morocco 54 C5
Marrakesh Morocco *see* Marrakech
Marrangua, Lagoa *l.* Moz. 101 L3
Marrar Australia 112 C5
Marrawah Australia 111 [inset]
Marrawah 111 [inset]
Marree Australia 111 B6
Marrowbone U.S.A. 134 C5
Marruecos *country* Africa *see* Morocco
Marsa Indon. 108 E2

Marrupa Moz. 99 D5
Marryat Australia 109 F6
Marsá al 'Alam Egypt 86 D4
Marsa 'Alam Egypt *see*
 Marsá al 'Alam
Marsa al Burayqah Libya 97 E1
Marsabit Kenya 98 D3
Marsala *Sicily* Italy 58 E6
Marsá Maţrūḥ Egypt 90 B5
Marsberg Germany 53 I3
Marsciano Italy 58 E3
Marsden Australia 112 C4
Marsden Canada 121 I4
Marsdiep *sea chan.* Neth. 52 E2
Marseille France 56 G5
Marseilles France *see* Marseille
Marsfjället *mt.* Sweden 44 I4
Marshall *watercourse* Australia 110 B4
Marshall *AR* U.S.A. 131 E5
Marshall *IL* U.S.A. 134 B4
Marshall *MI* U.S.A. 134 C2
Marshall *MN* U.S.A. 130 E2
Marshall *MO* U.S.A. 130 E4
Marshall *TX* U.S.A. 131 E5
► Marshall Islands *country* N. Pacific Ocean
 150 H5
 Oceania 8, 104–105
Marshalltown U.S.A. 130 E3
Marshfield *MO* U.S.A. 131 E4
Marshfield *WI* U.S.A. 130 F2
Marsh Harbour Bahamas 133 E7
Mars Hill U.S.A. 132 H2
Marsh Island U.S.A. 131 F6
Marsh Peak U.S.A. 129 I1
Marsh Point Canada 121 M3
Marsing U.S.A. 126 D4
Märsta Sweden 45 J7
Marsyaty Rus. Fed. 41 S3
Martaban, Gulf of *g.* Myanmar *see*
 Mottama, Gulf of
Martapura Indon. 68 E7
Marten River Canada 122 F5
Marte R. Gómez, Presa *resr* Mex. 131 D7
Martha's Vineyard *i.* U.S.A. 135 J3
Martigny Switz. 56 H3
Martim Vaz, Ilhas *is* S. Atlantic Ocean *see*
 Martin Vaz, Ilhas
Martin Slovakia 47 Q6
Martin *MI* U.S.A. 134 C2
Martin *SD* U.S.A. 130 C3
Martin *TN* U.S.A. 131 F4
Martinho Campos Brazil 145 B2

► Martinique *terr.* West Indies 137 L6
 French Overseas Department.
 North America 9, 116–117

Martinique Passage Dominica/Martinique
 137 L5
Martin Peninsula Antarctica 152 K2
Martins Ferry U.S.A. 134 E3
Martinsville *IL* U.S.A. 134 B4
Martinsville *IN* U.S.A. 134 B4
Martinsville *VA* U.S.A. 134 F5

► Martin Vaz, Ilhas *is* S. Atlantic Ocean
 148 G7
 Most easterly point of South America.

Martin Vaz Islands S. Atlantic Ocean *see*
 Martin Vaz, Ilhas
Martók Kazakh. *see* Martuk
Marton N.Z. 113 E5
Martorell Spain 57 G3
Martos Spain 57 E5
Martuk Kazakh. 78 E1
Martuni Armenia 91 G2
Maruf Afgh. 89 G4
Maruim Brazil 143 K6
Marukhis Ughelt'ekhili *pass*
 Georgia/Rus. Fed. 91 F2
Marulan Australia 112 D5
Marungu *reg.* India 89 H5
Marvast Iran 88 D4
Marv Dasht Iran 88 D4
Marvine, Mount U.S.A. 129 H2
Marwayne Canada 121 I4
Mary *r.* Australia 108 E3
Mary Turkm. 89 F2
Maryborough *Qld* Australia 111 F5
Maryborough *Vic.* Australia 112 A6
Marydale S. Africa 100 F5
Maryland *state* U.S.A. 135 G4
Maryport U.K. 48 D4
Mary's Harbour Canada 123 L3
Mary Lake Canada 121 K2
Mary Frances Lake Canada 121 J2
Maryvale *N.T.* Australia 109 F6
Maryvale *Qld* Australia 110 D3
Maryville *MO* U.S.A. 130 E3
Maryville *TN* U.S.A. 132 D5
Marzagão Brazil 145 A2
Marzahna Germany 53 M2
Masada *tourist site* Israel 85 B4
Masāhūn, Kūh-e *mt.* Iran 88 D4
Masai Steppe *plain* Tanz. 99 D4
Masaka Uganda 98 D4
Masakhane S. Africa 101 H6
Masalembu Besar *i.* Indon. 68 E8
Masalli Azer. 91 H3
Masan S. Korea 75 C6
Masasi Tanz. 99 D5
Masavi Bol. 142 F7
Masbate Phil. 69 G4
Masbate *i.* Phil. 69 G4
Mascara Alg. 57 G6
Mascarene Basin *sea feature* Indian Ocean
 149 L7
Mascarene Plain *sea feature* Indian Ocean
 149 L7
Mascarene Ridge *sea feature* Indian Ocean
 149 L6
Mascote Brazil 145 D1
Masein Myanmar 70 A2
Masela Indon. 108 E2

Masela *i.* Indon. 108 E2

► Maseru Lesotho 101 H5
 Capital of Lesotho.

Mashai Lesotho 101 I5
Mashan China 77 F4
Mashhad Iran 89 E2
Mashket *r.* Pak. 89 F5
Mashki Chah Pak. 89 F4
Masi Norway 44 M2
Masiáca Mex. 127 F8
Masibambane S. Africa 101 H6
Masilah, Wādī al *watercourse*
 Yemen 86 H6
Masilo S. Africa 101 H5
Masi-Manimba Dem. Rep. Congo 99 B4
Masindi Uganda 98 D3
Masinyusane S. Africa 100 F6
Masira, Jazīrat *i.* Oman 87 I5
Masira, Khalīj
Masīrah, Jazīrat *i.* Oman 87 I5
Masīrah, Khalīj *b.* Oman 87 I6
Masira Island Oman *see*
 Masīrah, Jazīrat
Masjed Soleymān Iran 88 C4
Mask, Lough *l.* Ireland 51 C4
Maskūtān Iran 89 E5
Maslovo Rus. Fed. 41 S3
Mason *MI* U.S.A. 134 C2
Mason *OH* U.S.A. 134 C4
Mason *TX* U.S.A. 131 D6
Mason, Lake *salt flat* Australia 109 B6
Mason Bay N.Z. 113 A8
Mason City U.S.A. 130 E3
Masontown U.S.A. 134 F4
Masqat Oman *see* Muscat
Masqaţ *reg.* Oman *see* Muscat
'Masrūg *well* Oman 88 D6
Massa Italy 58 D2
Massachusetts *state* U.S.A. 135 I2
Massachusetts Bay U.S.A. 135 J2
Massadona U.S.A. 129 I1
Massafra Italy 58 G4
Massa Marittimo Italy 58 D3
Massakory Chad 97 E3
Massangena Moz. 99 D6
Massango Angola 99 B4
Massawa Eritrea 86 E6
Massawippi, Lac *l.* Canada 135 I1
Massena U.S.A. 135 H1
Massenya Chad 97 E3
Masset Canada 120 C4
Massieville U.S.A. 134 D4
Massif Central *mts* France 56 F4
Massilia France *see* Marseille
Massillon U.S.A. 134 E3
Massina Mali 96 C3
Massinga Moz. 101 L2
Massingir Moz. 101 K2
Massingir, Barragem de *resr*
 Moz. 101 K2
Masson Island Antarctica 152 F2
Mastchoh Tajik. 89 H2
Masterton N.Z. 113 E5
Masticho, Akra *pt Voreio Aigaio* Greece *see*
 Oura, Akrotirio
Mastung Pak. 78 F4
Mastūrah Saudi Arabia 86 E5
Masty Belarus 45 N10
Masuda Japan 75 C6
Masuku Gabon *see* Franceville
Masulipatam India *see*
 Machilipatnam
Masulipatnam India *see*
 Machilipatnam
Masuna *i.* American Samoa *see* Tutuila
Masvingo Zimbabwe 99 D6
Masvingo *prov.* Zimbabwe 101 J1
Maswa Tanz. 98 D4
Maswaar *i.* Indon. 69 I7
Maşyāf Syria 85 C2
Mat, Nam *r.* Laos 70 D3
Mata Myanmar 70 A2
Matabeleland South *prov.* Zimbabwe
 101 I1
Matachewan Canada 122 E5
Matadi Dem. Rep. Congo 99 B4
Matador U.S.A. 131 C5
Matagalpa Nicaragua 137 G6
Matagami Canada 122 F4
Matagami, Lac *l.* Canada 122 F4
Matagorda Island U.S.A. 131 D6
Matak *i.* Indon. 71 D7
Matakana Island N.Z. 113 F3
Matala Angola 99 B5
Maţāli', Jabal *hill* Saudi Arabia 91 F6
Matam Senegal 96 B3
Matamey Niger 96 D3
Matamoras U.S.A. 135 H3
Matamoros *Coahuila* Mex. 131 C7
Matamoros *Tamaulipas* Mex. 131 D7
Matandu *r.* Tanz. 99 D4
Matane Canada 123 I4
Matanzas Cuba 137 H4
Matapan, Cape *pt* Greece *see*
 Tainaro, Akrotirio
Matapédia, Lac *l.* Canada 123 I4
Mataram Indon. 108 B2
Matarani Peru 142 D7
Mataranka Australia 108 F3
Mataripe Brazil 145 D1
Mataró Spain 57 H3
Matasiri *i.* Indon. 68 E7
Matatiele S. Africa 101 I6
Matatila Dam India 82 D4
Mataura N.Z. 113 B8

Mategua Bol. 142 F6
Matehuala Mex. 131 C8
Matemanga Tanz. 99 D5
Matera Italy 58 G4
Mateur Tunisia 58 C6
Mathaji India 82 B4
Matheson Canada 122 E4
Mathews U.S.A. 135 G5
Mathis U.S.A. 131 D6
Mathoura Australia 112 B5
Mathura India 82 D4
Mati Phil. 69 H5
Matiali India 83 G4
Matias Cardoso Brazil 145 C1
Matías Romero Mex. 136 E5
Matimekosh Canada 123 I3
Matin India 83 E5
Matinenda Lake Canada 122 E5
Matizi China 76 D1
Matla *r.* India 83 G5
Matlabas *r.* S. Africa 101 H2
Matli Pak. 89 H5
Matlock U.K. 49 F5
Mato, Cerro *mt.* Venez. 142 E2
Matobo Hills Zimbabwe 99 C6
Mato Grosso Brazil 143 G6
Mato Grosso *state* Brazil 145 A1
Mato Grosso, Planalto do *plat.*
 Brazil 143 H7
Matopo Hills Zimbabwe *see* Matobo Hills
Matos Costa Brazil 145 A4
Mato Verde Brazil 145 C1
Matosinhos Port. 57 B3
Maţrah Oman 88 E6
Matroosberg *mt.* S. Africa 100 D7
Matroosberg *mt.* S. Africa 100 D7
Matsesta Rus. Fed. 91 E2
Matsue Japan 75 D6
Matsumoto Japan 75 E5
Matsu Tao *i.* Taiwan 77 I3
Matsuyama Japan 75 D6
Mattagami *r.* Canada 122 E4
Mattamuskeet, Lake U.S.A. 132 E5
Mattawa Canada 122 F5
Matterhorn *mt.* Italy/Switz. 58 B2
Matterhorn *mt.* U.S.A. 126 E4
Matthew Town Bahamas 137 J4
Maţţī, Sabkhat *salt pan* Saudi Arabia 88 D6
Mattoon U.S.A. 130 F4
Matturai Sri Lanka *see* Matara
Matuku *i.* Fiji 107 H3
Matumbo Angola 99 B5
Maturín Venez. 142 F2
Matusadona National Park
 Zimbabwe 99 C5
Matwabeng S. Africa 101 H5
Maty Island P.N.G. *see* Wuvulu Island
Mau India *see* Maunath Bhanjan
Maúa Moz. 99 D5
Maubeuge France 52 D4
Maubin Myanmar 70 A3
Ma-ubin Myanmar 70 A3
Maubourguet France 56 E5
Mauchline U.K. 50 E5
Maudaha India 82 E4
Maude Australia 111 D7
Maud Seamount *sea feature*
 S. Atlantic Ocean 148 I10
Mau-é-ele Moz. *see* Marão
Maués Brazil 143 G4
Maughold Head *hd* Isle of Man 48 C4
Maug Islands N. Mariana Is 69 L3
Maui *i.* U.S.A. 127 [inset]
Maukkadaw Myanmar 70 A2
Maulbronn Germany 53 I6
Maule *r.* Chile 144 B5
Maulvi Bazar Bangl. *see* Moulvibazar
Maumee U.S.A. 134 D3
Maumee Bay U.S.A. 134 D3
Maumere Indon. 108 C2
Maumturk Hills Ireland 51 C4
Maun Botswana 99 C5
Mauna Kea *vol.* U.S.A. 127 [inset]
Mauna Loa *vol.* U.S.A. 127 [inset]
Maunath Bhanjan India 83 E4
Maunatlala Botswana 101 H2
Maungaturoto N.Z. 113 E3
Maungdaw Myanmar 70 A2
Maungmagan Islands Myanmar 71 B4
Maurepas, Lake U.S.A. 131 F6
Mauriac France 56 F4
Maurice *country* Indian Ocean *see*
 Mauritius
Maurice, Lake *salt flat* Australia 109 E7
Maurik Neth. 52 F3
► Mauritania *country* Africa 96 B3
 Africa 7, 94–95
Mauritanie *country* Africa *see*
 Mauritania
► Mauritius *country* Indian Ocean 149 L7
 Africa 7, 94–95
Maurs France 56 F4
Mauston U.S.A. 130 F3
Mava Dem. Rep. Congo 98 C3
Mavago Moz. 99 D5
Mavan, Kūh-e *hill* Iran 88 E3
Mavanza Moz. 101 L2
Mavinga Angola 99 C5
Mavrovo *nat. park* Macedonia 59 I4
Mavume Moz. 101 L2
Mavuya S. Africa 101 I6
Ma Wan *i.* H.K. China 77 [inset]
Mäwän, Khashm *hill* Saudi Arabia 88 B4
Mawana India 82 D3
Mawanga Dem. Rep. Congo 99 B4
Ma Wang Dui *tourist site* China 77 G2
Mawei China 77 H3
Mawjib, Wādī al *r.* Jordan 85 B4
Mawkmai Myanmar 70 B2
Mawlaik Myanmar 70 A2
Mawlamyaing Myanmar 70 B3
Mawlamyine Myanmar *see*
 Mawlamyaing
Mawqaq Saudi Arabia 91 F6
Mawson *research station*
 Antarctica 152 E2
Mawson Coast Antarctica 152 E2
Mawson Escarpment Antarctica 152 E2
Mawson Peninsula Antarctica 152 H2
Maw Taung *mt.* Myanmar 71 B5
Mawza Yemen 86 F7
Maxán Arg. 144 C3
Maxhamish Lake Canada 120 F3

Maxia, Punta *mt. Sardinia* Italy 58 C5
Maxixe Moz. 101 L2
Maxmo Fin. 44 M5
May, Isle of *i.* U.K. 50 G4
Maya *r.* Rus. Fed. 65 O3
Mayaguana *i.* Bahamas 133 F8
Mayaguana Passage Bahamas 133 F8
Mayagüez Puerto Rico 137 K5
Mayahi Niger 96 D3
Mayak Rus. Fed. 74 E2
Mayakovskiy, Qullai *mt.* Tajik. 89 H2
Mayakovskogo, Pik *mt.* Tajik. *see*
 Mayakovsky, Qullai
Mayama Congo 98 B4
Maya Mountains Belize/Guat. 136 G5
Mayang China 77 F3
Mayan China *see* Mayanhe
Mayanhe China 76 E1
Mayar *hill* U.K. 50 F4
Mayasan India 84 B2
Maybell U.S.A. 129 G4
Maybeury U.S.A. 134 E5
Maybole U.K. 50 E5
Maych'ew Eth. 98 D2
Maydän Shahr Afgh. *see* Meydän Shahr
Maydh Somalia 86 G7
Maydos Turkey *see* Eceabat
Mayen Germany 53 H4
Mayenne France 56 D2
Mayenne *r.* France 56 D3
Mayer U.S.A. 129 G4
Mayêr Kangri *mt.* China 83 F2
Mayersville U.S.A. 131 F5
Mayerthorpe Canada 120 H4
Mayfield N.Z. 113 C6
Mayi He *r.* China 74 C3
Maykop Rus. Fed. 91 F1
Mayna *Respublika Khakasiya*
 Rus. Fed. 64 K4
Mayna *Ul'yanovskaya Oblast'*
 Rus. Fed. 43 J5
Mayni India 84 B2
Maynooth Canada 135 G1
Mayo Canada 120 C2
Mayo U.S.A. 133 D6
Mayo Alim Cameroon 96 E4
Mayoko Congo 98 B4
Mayo Lake Canada 120 C2
Mayo Landing Canada *see* Mayo
Mayor, Puig *mt.* Spain *see* Major, Puig
Mayor Island N.Z. 113 F3
Mayor Pablo Lagerenza Para. 144 D1

▶Mayotte *terr.* Africa 99 E5
 French Departmental Collectivity.
 Africa 7, 94–95

Mayskiy *Amurskaya Oblast'*
 Rus. Fed. 74 C1
Mayskiy *Kabardino-Balkarskaya Respublika*
 Rus. Fed. 91 G2
Mays Landing U.S.A. 135 H4
Mayson Lake Canada 121 J3
Maysville U.S.A. 134 D4
Mayumba Gabon 98 B4
Mayuram India 84 C4
Mayville *MI* U.S.A. 134 D2
Mayville *ND* U.S.A. 130 D2
Mayville *NY* U.S.A. 134 F2
Mayville *WI* U.S.A. 134 A2
Mazabuka Zambia 99 C5
Mazaca Turkey *see* Kayseri
Mazagan Morocco *see* El Jadida
Mazar China 82 D1
Mazar, Koh-i- *mt.* Afgh. 89 G3
Mazara, Val di *valley Sicily* Italy 58 E6
Mazara del Vallo *Sicily* Italy 58 E6
Mazär-e Sharif Afgh. 89 G2
Mazarr' *reg.* U.A.E. 88 D6
Mazatán Mex. 127 F7
Mazatlán Mex. 136 C4
Mazatzal Peak U.S.A. 129 H4
Mazdaj Iran 91 H4
Mažeikiai Lith. 45 M8
Mazhür, 'Irq al *des.* Saudi Arabia 88 A5
Mazim Oman 88 E6
Mazocahui Mex. 127 F7
Mazocruz Peru 142 F7
Mazomora Tanz. 99 D4
Mazu Dao *i.* Taiwan *see* Matsu Tao
Mazunga Zimbabwe 99 C6
Mazyr Belarus 43 F5
Mazzouna Tunisia 58 C7

▶Mbabane Swaziland 101 J4
 Capital of Swaziland.

Mbahiakro Côte d'Ivoire 96 C4
Mbaïki Cent. Afr. Rep. 98 B3
Mbakaou, Lac de *l.* Cameroon 96 E4
Mbala Zambia 99 D4
Mbale Uganda 98 D3
Mbalmayo Cameroon 96 E4
Mbam *r.* Cameroon 96 E4
Mbandaka Dem. Rep. Congo 98 B4
M'banza Congo Angola 99 B4
Mbarara Uganda 97 G5
Mbari *r.* Cent. Afr. Rep. 98 C3
Mbaswana S. Africa 101 K4
Mbemkuru *r.* Tanz. 99 D4
Mbeya Tanz. 99 D4
Mbinga Tanz. 99 D4
Mbini Equat. Guinea 96 D4
Mbizi Zimbabwe 99 D6
Mbomo Congo 98 B3
Mbouda Cameroon 96 E4
Mbour Senegal 96 B3
Mbout Mauritania 96 B3
Mbozi Tanz. 99 D4
Mbrès Cent. Afr. Rep. 98 B3
Mbuji-Mayi Dem. Rep. Congo 99 C4
Mburucuyá Arg. 144 E3
McAdam Canada 123 I5
McAlester U.S.A. 131 E5
McAlister *mt.* Australia 112 D5
McAllen U.S.A. 131 D7
McArthur *r.* Australia 110 B2
McArthur U.S.A. 134 D4
McArthur Mills Canada 135 G1
McBain U.S.A. 134 C1
McBride Canada 120 F4

McCall U.S.A. 126 D3
McCamey U.S.A. 131 C6
McCammon U.S.A. 126 E4
McCauley Island Canada 120 D4
McClintock, Mount Antarctica 152 H1
McClintock Channel Canada 119 H2
McClintock Range *hills* Australia 108 D4
McClure, Lake U.S.A. 128 C3
McClure Strait Canada 118 G2
McClusky U.S.A. 130 C2
McComb U.S.A. 131 F6
McConaughy, Lake U.S.A. 130 C3
McConnellsburg U.S.A. 135 G4
McConnelsville U.S.A. 134 E4
McCook U.S.A. 130 C3
McCormick U.S.A. 133 D5
McCreary Canada 121 L5
McDame Canada 120 D3
McDermitt U.S.A. 126 D4
McDonald Islands Indian Ocean 149 M9
McDonald Peak U.S.A. 126 E3
McDonough U.S.A. 133 C5
McDougall's Bay S. Africa 100 C5
McDowell Peak U.S.A. 129 H5
McFarland U.S.A. 128 D4
McGill U.S.A. 129 F2
McGivney Canada 123 I5
McGrath *AK* U.S.A. 118 C3
McGrath *MN* U.S.A. 130 E2
McGraw U.S.A. 135 G2
McGregor *r.* Canada 120 F4
McGregor S. Africa 100 D7
McGregor, Lake Canada 120 H5
McGregor Range *hills* Australia 111 C5
McGuire, Mount U.S.A. 126 E3
Mchinga Tanz. 99 D4
Mchinji Malawi 99 D5
McIlwraith Range *hills* Australia 110 C2
McInnes Lake Canada 121 M4
McIntosh U.S.A. 130 C2
McKay Range *hills* Australia 108 C5
McKean *i.* Kiribati 107 I2
McKee U.S.A. 134 C5
McKenzie *r.* Canada 120 E2
McKinlay *r.* Australia 110 C4

▶McKinley, Mount U.S.A. 118 C3
 Highest mountain in North America.
 North America 114–115

McKinney U.S.A. 131 D5
McKittrick U.S.A. 128 D4
McLaughlin U.S.A. 130 C2
McLeansboro U.S.A. 130 F4
McLeod *r.* Canada 120 G4
McLeod *i.* Australia 109 A6
McLeod Bay Canada 121 I2
McLeod Lake Canada 120 F4
McLoughlin, Mount U.S.A. 126 C4
McMillan, Lake U.S.A. 131 B5
McMinnville *OR* U.S.A. 126 C3
McMinnville *TN* U.S.A. 132 C5
McMurdo *research station*
 Antarctica 152 H1
McMurdo Sound *b.* Antarctica 152 H1
McNary U.S.A. 129 I4
McNaughton Lake Canada *see*
 Kinbasket Lake
McPherson U.S.A. 130 D4
McQuesten *r.* Canada 120 B2
McRae U.S.A. 133 D5
McTavish Arm *b.* Canada 120 G1
McVeytown U.S.A. 135 G3
McVicar Arm *b.* Canada 120 F1
M'dantsane S. Africa 101 H7
M'Daourouch Alg. 58 B6
M'Drak Vietnam 71 E4
Mê, Hon *i.* Vietnam 70 D3
Mead, Lake *resr* U.S.A. 129 F3
Meade U.S.A. 131 C4
Meade *r.* U.S.A. 118 C2
Meadow *r.* Australia 109 A6
Meadow *SD* U.S.A. 130 C2
Meadow *UT* U.S.A. 129 G2
Meadow Lake Canada 121 I4
Meadville *MS* U.S.A. 131 F6
Meadville *PA* U.S.A. 134 E3
Meaford Canada 134 E1
Meaken-dake *vol.* Japan 74 G4
Mealhada Port. 57 B3
Mealy Mountains Canada 123 K3
Meandarra Australia 112 D1
Meander River Canada 120 G3
Meaux France 52 C6
Mecca Saudi Arabia 86 E5
Mecca *CA* U.S.A. 128 E5
Mecca *OH* U.S.A. 134 E3
Mechanic Falls U.S.A. 135 J1
Mechanicsville U.S.A. 135 G5
Mechelen Belgium 52 E3
Mechelen Neth. 52 F4
Mecherchar *i.* Palau *see* Eil Malk
Mecheria Alg. 54 D5
Mechernich Germany 52 G4
Mecitözü Turkey 90 D2
Meckenheim Germany 52 H4
Mecklenburger Bucht *b.* Germany 47 M3
Mecklenburg-Vorpommern *land*
 Germany 53 M1
Mecklenburg - West Pomerania *land*
 Germany *see*
 Mecklenburg-Vorpommern
Meda *r.* Australia 108 C4
Meda Port. 57 C3
Medak India 84 C2
Medan Indon. 71 B7
Medanosa, Punta *pt* Arg. 144 C7
Médanos de Coro, Parque Nacional
 nat. park Venez. 142 E1
Medawachchiya Sri Lanka 84 C4
Médéa Alg. 57 H5
Medellín Col. 142 C2
Meden *r.* U.K. 48 G5
Medenine Tunisia 54 G5
Mederdra Mauritania 96 B3
Medford *NY* U.S.A. 135 I3
Medford *OK* U.S.A. 131 D4
Medford *OR* U.S.A. 126 C4
Medford *WI* U.S.A. 130 F2
Medgidia Romania 59 M2

Media U.S.A. 135 H4
Mediaş Romania 59 K1
Medicine Bow *r.* U.S.A. 126 G4
Medicine Bow Mountains U.S.A. 126 G4
Medicine Bow Peak U.S.A. 126 G4
Medicine Hat Canada 121 I5
Medicine Lake U.S.A. 126 G2
Medicine Lodge U.S.A. 131 D4
Medina Brazil 145 C2
Medina Saudi Arabia 86 E5
Medina *ND* U.S.A. 130 D2
Medina *NY* U.S.A. 135 F2
Medina *OH* U.S.A. 134 D3
Medinaceli Spain 57 E3
Medina del Campo Spain 57 D3
Medina de Rioseco Spain 57 D3
Medinipur India 83 F5
Mediolanum Italy *see* Milan
Mediterranean Sea 54 A4
Mednyy, Ostrov *i.* Rus. Fed. 150 H2
Médoc *reg.* France 56 D4
Medora U.S.A. 130 C2
Medstead Canada 121 I4
Meduro *atoll* Marshall Is *see* Majuro
Medvedevo Rus. Fed. 42 J4
Medveditsa *r.* Rus. Fed. 43 I6
Medvednica *mts* Croatia 58 F2
Medvezh'i, Ostrova *is* Rus. Fed. 65 R2
Medvezh'ya, Gora *mt.* Rus. Fed. 74 E3
Medvezh'yegorsk Rus. Fed. 42 G3
Medway *r.* U.K. 49 H7
Meekatharra Australia 109 B6
Meeker *CO* U.S.A. 129 J1
Meeker *OH* U.S.A. 134 D3
Meelpaeg Reservoir Canada 123 K4
Meemu *atoll* Maldives *see* Mulaku Atoll
Meerane Germany 53 M4
Meerlo Neth. 52 G3
Meerut India 82 D3
Mega Escarpment Eth./Kenya 98 D3
Megalopoli Greece 59 J6
Megamo Indon. 69 I7
Megara Greece 59 J5
Megezez *mt.* Eth. 98 D3

▶Meghalaya *state* India 83 G4
 Highest mean annual rainfall in the world.

Meghasani *mt.* India 83 F5
Meghri Armenia 91 G3
Megin Turkm. 88 E2
Megisti *i.* Greece 59 M6
Megri Armenia *see* Meghri
Mehamn Norway 44 O1
Mehar Pak. 89 G5
Meharry, Mount Australia 109 B5
Mehbubnagar India *see* Mahbubnagar
Mehdia Tunisia *see* Mahdia
Meherpur Bangl. 83 G5
Meherrin U.S.A. 135 F5
Meherrin *r.* U.S.A. 135 G5
Mehlville U.S.A. 130 F4
Mehräkän *salt marsh* Iran 88 D5
Mehrän *Hormozgan* Iran 88 D5
Mehrän *Īlām* Iran 88 B3
Mehren Germany 52 G4
Mehriz Iran 88 D4
Mehsana India *see* Mahesana
Mehtar Läm Afgh. 89 H3
Meia Ponte *r.* Brazil 145 A2
Meicheng China *see* Minqing
Meiganga Cameroon 97 E4
Meighen Island Canada 119 I2
Meigu China 76 D2
Meihekou China 74 B4
Meikeng China 77 G3
Meikle *r.* Canada 120 G3
Meikle Says Law *hill* U.K. 50 G5
Meiktila Myanmar 70 A2
Meilin China *see* Ganxian
Meilleur *r.* Canada 120 E2
Meine Germany 53 K2
Meinersen Germany 53 K2
Meiningen Germany 53 K4
Meishan *Anhui* China *see* Jinzhai
Meishan *Sichuan* China 76 D2
Meishan Shuiku *resr* China 77 G2
Meißen Germany 47 N5
Meister *r.* Canada 120 D2
Meitan China 76 E3
Meixi China 74 C3
Meixian China *see* Meizhou
Meixing China *see* Xiaojin
Meizhou China 77 H3
Mej *r.* India 82 D4
Mejicana *mt.* Arg. 144 C3
Mejillones Chile 144 B2
Mékambo Gabon 98 B3
Mek'elē Eth. 98 D2
Mekelle Eth. *see* Mek'elē
Mékhé Senegal 96 B3
Mekhtar Pak. 89 H4
Meknassy Tunisia 58 C7
Meknès Morocco 54 C5
Mekong *r.* China 76 C2
 also known as Mae Nam Khong
 (Laos/Thailand)
Mekong *r.* Laos/Thai. 70 D4
Mekong, Mouths of the Vietnam 71 D5
Mekoryuk U.S.A. 118 B3
Melaka Malaysia 71 C7
Melanau, Gunung *hill* Indon. 71 E7
Melanesia *is* Pacific Ocean 150 G6
Melanesian Basin *sea feature* Pacific Ocean
 150 G5

▶Melbourne Australia 112 B6
 State capital of Victoria. 2nd most
 populous city in Oceania.

Melbourne U.S.A. 133 D6
Melby U.K. 50 [inset]
Meldorf Germany 47 L3
Melekess Rus. Fed. *see* Dimitrovgrad
Melenki Rus. Fed. 43 I5
Melet Turkey *see* Mesudiye
Mélèzes, Rivière aux *r.* Canada 123 H2
Melfa U.S.A. 135 H5

Melfi Chad 97 E3
Melfi Italy 58 F4
Melfort Canada 121 J4
Melhus Norway 44 G5
Meliadine Lake Canada 121 M2
Melide Spain 57 C2

▶Melilla N. Africa 57 E6
 Spanish Territory.

Melimoyu, Monte *mt.* Chile 144 B6
Meliskerke Neth. 52 D3
Melita Canada 121 K5
Melitene Turkey *see* Malatya
Melitopol' Ukr. 43 G7
Melk Austria 47 O6
Melka Guba Eth. 98 D3
Melksham U.K. 49 E7
Mellakoski Fin. 44 N3
Mellansel Sweden 44 K5
Melle Germany 53 I2
Mellerud Sweden 45 H7
Mellette U.S.A. 130 D2
Mellid Spain *see* Melide
Mellilia N. Africa *see* Melilla
Mellor Glacier Antarctica 152 E2
Mellrichstadt Germany 53 K4
Mellum *i.* Germany 53 I1
Melmoth S. Africa 101 J5
Mel'nichoye Rus. Fed. 74 D3
Melo Uruguay 144 F4
Meloco Moz. 99 D5
Melolo Indon. 108 C2
Melozitna *r.* U.S.A. 118 C3
Melrhir, Chott *salt l.* Alg. 54 F5
Melrose Australia 109 C6
Melrose U.K. 50 G5
Melrose U.S.A. 130 E2
Melsungen Germany 53 J3
Melton Australia 112 B6
Melton Mowbray U.K. 49 G6
Melun France 56 F2
Melville Canada 121 K5
Melville, Cape Australia 110 D2
Melville, Lake Canada 123 K3
Melville Bugt *b.* Greenland *see*
 Qimusseriarsuaq
Melville Island Australia 108 E2
Melville Island Canada 119 H2
Melville Peninsula Canada 119 J3
Melvin U.S.A. 134 A3
Melvin, Lough *l.* Ireland/U.K.
 51 D3
Mêmar Co *salt l.* China 83 E2
Memba Moz. 99 E5
Memberamo *r.* Indon. 69 J7
Memel Lith. *see* Klaipėda
Memel S. Africa 101 I4
Memmelsdorf Germany 53 K5
Memmingen Germany 47 M7
Mempawah Indon. 68 D6
Memphis *tourist site* Egypt 90 C5
Memphis *MI* U.S.A. 134 D2
Memphis *TN* U.S.A. 131 F5
Memphis *TX* U.S.A. 131 F5
Memphrémagog, Lac *l.* Canada 135 I1
Mena Ukr. 43 G6
Mena U.S.A. 131 E5
Menado Indon. *see* Manado
Ménaka Mali 96 D3
Menasha U.S.A. 134 A1
Mendanha *r.* Brazil 145 C2
Mendarik *i.* Indon. 71 D7
Mende France 56 F4
Mendefera Eritrea 86 E7
Mendeleyev Ridge *sea feature*
 Arctic Ocean 153 B1
Mendeleyevsk Rus. Fed. 42 L5
Mendenhall U.S.A. 131 F6
Mendenhall, Cape U.S.A. 118 B4
Mendenhall Glacier U.S.A. 120 C3
Méndez Mex. 131 D7
Mendi Eth. 98 D3
Mendi P.N.G. 69 K8
Mendip Hills U.K. 49 E7
Mendocino, Cape U.S.A. 128 A1
Mendocino, Lake U.S.A. 128 B2
Mendooran Australia 112 D3
Mendota *CA* U.S.A. 128 C3
Mendota *IL* U.S.A. 130 F3
Mendoza Arg. 144 C4
Menemen Turkey 59 L5
Ménerville Alg. *see* Thenia
Mengban China 76 D4
Mengcheng China 77 H1
Menghai China 76 D4
Mengjin China 77 G1
Mengla China 76 D4
Menglang China *see* Lancang
Menglie China *see* Jiangcheng
Mengyang China *see* Mingshan
Mengzi China 76 D4
Menihek Canada 123 I3
Menihek Lakes Canada 123 I3
Menindee Australia 111 C7
Menindee, Lake Australia 111 C7
Ménistouc, Lac *l.* Canada 123 I3
Menkere Rus. Fed. 65 N3
Mennecy France 52 C6
Menominee U.S.A. 134 B1
Menomonee Falls U.S.A. 134 A2
Menomonie U.S.A. 130 F2
Menongue Angola 99 B5
Menorca *i.* Spain *see* Minorca
Mentawai, Kepulauan *is* Indon. 68 B7
Mentawai, Selat *sea chan.* Indon. 68 C7
Menteroda Germany 53 K3
Mentmore U.S.A. 129 I4
Menton France 56 H5
Mentone U.S.A. 131 C6
Menuf Egypt *see* Minūf
Menzel Bourguiba Tunisia 58 C6
Menzelet Baraji *resr* Turkey 90 E3
Menzelinsk Rus. Fed. 41 Q4
Menzel Temime Tunisia 58 D6
Menzies Australia 109 C7
Menzies, Mount Antarctica 152 E2
Meobbaai *b.* Namibia 100 B3
Meoqui Mex. 131 B6
Meppel Neth. 52 G2

Meppen Germany 53 H2
Mepuze Moz. 101 K2
Meqheleng S. Africa 101 H5
Mequon U.S.A. 134 B2
Merak Indon. 68 D8
Meråker Norway 44 G5
Merano Italy 58 D1
Meratswe *r.* Botswana 100 G2
Merauke Indon. 69 K8
Merca Somalia *see* Marka
Mercantour, Parc National du *nat. park*
 France 56 H4
Merced U.S.A. 128 C3
Merced *r.* U.S.A. 128 C3
Mercedes Arg. 144 E3
Mercedes Uruguay 144 E4
Mercer *ME* U.S.A. 135 K1
Mercer *PA* U.S.A. 134 E3
Mercer *WI* U.S.A. 130 F2
Mercês Brazil 145 C3
Mercury Islands N.Z. 113 E3
Mercy, Cape Canada 119 L3
Merdenik Turkey *see* Göle
Mere Belgium 52 D4
Mere U.K. 49 E7
Meredith U.S.A. 135 J2
Meredith, Lake U.S.A. 131 C5
Merefa Ukr. 43 H6
Merga Oasis Sudan 86 C6
Mergui Myanmar *see* Myeik
Mergui Archipelago *is* Myanmar
 71 B5
Meriç *r.* Turkey 59 L4
 also known as Evros (Greece), Marica,
 Maritsa (Bulgaria)
Mérida Mex. 136 G4
Mérida Spain 57 C4
Mérida Venez. 142 D2
Mérida, Cordillera de *mts*
 Venez. 142 D2
Meriden U.S.A. 135 I3
Meridian *MS* U.S.A. 131 F5
Meridian *TX* U.S.A. 131 D6
Mérignac France 56 D4
Merijärvi Fin. 44 N4
Merikarvia Fin. 45 L6
Merimbula Australia 112 D6
Merín, Laguna *l.* Brazil/Uruguay *see*
 Mirim, Lagoa
Meringur Australia 111 C7
Merir *i.* Palau 69 I6
Merjayoun Lebanon *see* Marjayoûn
Merkel U.S.A. 131 C5
Merluna Australia 110 C2
Mermaid Reef Australia 108 B4
Meron, Har *mt.* Israel 85 B3
Merowe Sudan 86 D6
Mêrqung Co *l.* China 83 F3
Merredin Australia 109 B7
Merrick *hill* U.K. 50 E5
Merrickville Canada 135 H1
Merrill *MI* U.S.A. 134 C2
Merrill *WI* U.S.A. 130 F2
Merrill, Mount Canada 120 E2
Merrillville U.S.A. 134 B3
Merriman U.S.A. 130 C3
Merritt Canada 120 F5
Merritt Island U.S.A. 133 D6
Merriwa Australia 112 E4
Merrygoen Australia 112 D3
Mersa Fatma Eritrea 86 F7
Mersa Maţrūḩ Egypt *see* Marsá Maţrūḩ
Mersch Lux. 52 G5
Merseburg (Saale) Germany 53 L3
Mersey *r.* U.K. 48 E5
Mersin Turkey 85 B1
Mersin *prov.* Turkey 85 A1
Mersing Malaysia 71 C7
Mêrsrags Latvia 45 M8
Merta India 82 C4
Merthyr Tydfil U.K. 49 D7
Mértola Port. 57 C5
Mertz Glacier Antarctica 152 G2
Mertz Glacier Tongue Antarctica 152 G2
Mertzon U.S.A. 131 C6
Méru France 52 C5

▶Meru *vol.* Tanz. 98 D4
 4th highest mountain in Africa.

Merui Pak. 89 F4
Merv Turkm. *see* Mary
Merweville S. Africa 100 E7
Merzifon Turkey 90 D2
Merzig Germany 52 G5
Merz Peninsula Antarctica 152 L2
Mesa *AZ* U.S.A. 129 H5
Mesa *NM* U.S.A. 127 G6
Mesabi Range *hills* U.S.A. 130 E2
Mesagne Italy 58 G4
Mesa Negra *mt.* U.S.A. 129 J4
Mesara, Ormos *b. Kriti* Greece *see*
 Kolpos Messaras
Mesa Verde National Park U.S.A. 129 I3
Meschede Germany 53 I3
Mese Myanmar 70 B3
Meselefors Sweden 44 J4
Mesgouez, Lac Canada 122 G4
Meshed Iran *see* Mashhad
Meshkän Iran 88 E2
Meshra'er Req Sudan 86 C8
Mesick U.S.A. 134 C1
Mesimeri Greece 59 J4
Mesolongi Greece 59 I5
Mesológion Greece *see*
 Mesolongi
Mesquita Brazil 145 C2
Mesquite *NV* U.S.A. 129 F3
Mesquite *TX* U.S.A. 131 D5
Mesquite Lake U.S.A. 129 F4
Messaad Alg. 54 E5
Messalo *r.* Moz. 99 D5
Messana *Sicily* Italy *see* Messina
Messina *Sicily* Italy 58 F5
Messina, Strait of Italy 58 F5
Messina, Stretta di Italy *see*
 Messina, Strait of
Messini Greece 59 J6
Messiniakos Kolpos *b.* Greece 59 J6
Mesta *r.* Bulg. 59 K4
Mesta *r.* Greece *see* Nestos
Mesta, Akrotirio *pt* Greece 59 K5
Mestghanem Alg. *see* Mostaganem

Mestlin Germany 53 L1
Meston, Akra *pt Voreio Aigaio* Greece *see*
 Mesta, Akrotirio
Mestre Italy 58 E2
Mesudiye Turkey 90 E2
Meta *r.* Col./Venez. 142 E2
Métabetchouan Canada 123 H4
Meta Incognita Peninsula Canada 119 L3
Metairie U.S.A. 131 F6
Metallifere, Colline *mts* Italy 58 D3
Metán Arg. 144 C3
Meteghan Canada 123 I5
Meteor Depth *sea feature*
 S. Atlantic Ocean 148 G9
Methoni Greece 59 I6
Methuen U.S.A. 135 J2
Methven U.K. 50 F4
Metionga Lake Canada 122 C4
Metković Croatia 58 G3
Metlaoui Tunisia 54 F5
Metoro Moz. 99 D5
Metro Indon. 68 D8
Metropolis U.S.A. 131 F4
Metsada *tourist site Israel see* Masada
Metter U.S.A. 133 D5
Mettet Belgium 52 E4
Mettingen Germany 53 H2
Mettler U.S.A. 128 D4
Mettur India 84 C4
Metu Eth. 98 D3
Metz France 52 G5
Metz U.S.A. 134 C3
Meulaboh Indon. 71 B6
Meureudu Indon. 71 B6
Meuse *r.* Belgium/France 52 F3
 also known as Maas (Netherlands)
Meuselwitz Germany 53 M3
Mevagissey U.K. 49 C8
Mêwa China 76 D1
Mexia U.S.A. 131 D6
Mexiana, Ilha *i.* Brazil 143 I3
Mexicali Mex. 129 F5
Mexican Hat U.S.A. 129 I3
Mexican Water U.S.A. 129 I3

▶Mexico *country* Central America 136 D4
 2nd most populous and 3rd largest country
 in Central and North America.
 North America 9, 116–117

México Mex. *see* Mexico City
Mexico *ME* U.S.A. 135 J1
Mexico *MO* U.S.A. 130 F4
Mexico *NY* U.S.A. 135 G2
Mexico, Gulf of Mex./U.S.A. 125 H6

▶Mexico City Mex. 136 E5
 Capital of Mexico. Most populous city in
 North America and 2nd in the world.

Meybod Iran 88 D3
Meydanī, Ra's-e *pt* Iran 88 E5
Meydän Shahr Afgh. 89 H3
Meyenburg Germany 53 M1
Meyersdale U.S.A. 134 F4
Meymaneh Afgh. 89 G3
Meymeh Iran 88 C3
Meynypil'gyno Rus. Fed. 153 C2
Mezada *tourist site Israel see*
 Masada
Mezdra Bulg. 59 J3
Mezen' Rus. Fed. 42 J2
Mezen' *r.* Rus. Fed. 42 J2
Mézenc, Mont *mt.* France 56 G4
Mezenskaya Guba *b.* Rus. Fed. 42 I2
Mezhdurechensk *Kemerovskaya Oblast'*
 Rus. Fed. 72 F2
Mezhdurechensk *Respublika Komi*
 Rus. Fed. 42 K3
Mezhdurechnye Rus. Fed. *see* Shali
Mezhdusharskiy, Ostrov *i.*
 Rus. Fed. 64 G2
Mezitli Turkey 85 B1
Mezőtúr Hungary 59 I1
Mežvišli Latvia 45 O8
Mhäil, Rubh' a' *pt* U.K. 50 C5
Mhangura Zimbabwe 99 D5
Mhlume Swaziland 101 J4
Mhow India 82 C5
Mi *r.* Myanmar 83 H5
Miahuatlán Mex. 136 E5
Miajadas Spain 57 D4
Miaméré Cent. Afr. Rep. 98 B3
Miami *AZ* U.S.A. 129 H5

▶Miami *FL* U.S.A. 133 D7
 5th most populous city in North America.

Miami *OK* U.S.A. 131 E4
Miami Beach U.S.A. 133 D7
Miancaowan China 76 C1
Miändehī Iran 88 E3
Miändowäb Iran 88 B2
Miandrivazo Madag. 99 E5
Miäneh Iran 88 B2
Miang, Phu *mt.* Thai. 70 C3
Miani India 89 I4
Miani Hor *b.* Pak. 89 G5
Mianjoi Afgh. 89 G3
Mianning China 76 D2
Mianwali Pak. 89 H3
Mianxian China 76 E1
Mianyang China *see* Xiantao
Mianyang *Shaanxi* China *see* Mianxian
Mianyang *Sichuan* China 76 E2
Mianzhu China 76 E2
Miaoli Taiwan 77 I3
Miarinarivo Madag. 99 E5
Miarritze France *see* Biarritz
Miass Rus. Fed. 64 H4
Mica Creek Canada 120 G4
Mica Mountain U.S.A. 129 H5
Micang Shan *mts* China 76 E1
Michalovce Slovakia 43 D6
Michel Canada 121 I4
Michelau in Oberfranken
 Germany 53 L4
Michelson, Mount U.S.A. 118 D3
Michelstadt Germany 53 J5
Michendorf Germany 53 N2
Micheng China *see* Midu
Michigan *state* U.S.A. 134 C2

▶Michigan, Lake U.S.A. 134 B2
3rd largest lake in North America and 5th
in the world.
World 12–13

Michigan City U.S.A. 134 B3
Michinberi India 84 D2
Michipicoten Bay Canada 122 D5
Michipicoten Island Canada 122 D5
Michipicoten River Canada 122 D5
Michurin Bulg. see Tsarevo
Michurinsk Rus. Fed. 43 I5
Micronesia country N. Pacific Ocean see
Micronesia, Federated States of
Micronesia is Pacific Ocean 150 F5
▶Micronesia, Federated States of country
N. Pacific Ocean 150 G5
Oceania 8, 104–105
Midai i. Indon. 71 D7
Mid-Atlantic Ridge sea feature
Atlantic Ocean 148 E4
Mid-Atlantic Ridge sea feature
Atlantic Ocean 148 G8
Middelburg Neth. 52 D3
Middelburg E. Cape S. Africa 101 G6
Middelburg Mpumalanga
S. Africa 101 I3
Middelfart Denmark 45 F9
Middelharnis Neth. 52 E3
Middelwit S. Africa 101 H3
Middle Alkali Lake U.S.A. 126 C4
Middle America Trench sea feature
N. Pacific Ocean 151 N5
Middle Andaman i. India 71 A4
Middle Atlas mts Morocco see
Moyen Atlas
Middle Bay Canada 123 K4
Middlebourne U.S.A. 134 E4
Middleburg U.S.A. 135 G3
Middleburgh U.S.A. 135 H2
Middlebury IN U.S.A. 134 C3
Middlebury VT U.S.A. 135 I1
Middle Caicos i. Turks and Caicos Is
133 G8
Middle Concho r. U.S.A. 131 C6
Middle Congo country Africa see Congo
Middle Island Thai. see Tasai, Ko
Middle Loup r. U.S.A. 130 D3
Middlemarch N.Z. 113 C7
Middlemount Australia 110 E4
Middle River U.S.A. 135 G4
Middlesbrough U.K. 48 F4
Middle Strait India see Andaman Strait
Middleton Australia 110 C4
Middleton Canada 123 I5
Middleton Island atoll American Samoa see
Rose Island
Middletown CA U.S.A. 128 B2
Middletown CT U.S.A. 135 I3
Middletown NY U.S.A. 135 H3
Middletown VA U.S.A. 135 F4
Midelt Morocco 54 D5
Midhurst U.K. 49 G8
Midi, Canal du France 56 F5
Mid-Indian Basin sea feature
Indian Ocean 149 N6
Mid-Indian Ridge sea feature
Indian Ocean 149 M7
Midland Canada 135 F1
Midland CA U.S.A. 129 F5
Midland IN U.S.A. 134 B4
Midland MI U.S.A. 134 C2
Midland SD U.S.A. 130 C2
Midland TX U.S.A. 131 C5
Midleton Ireland 51 D6
Midnapore India see Medinipur
Midnapur India see Medinipur
Midongy Atsimo Madag. 99 E6
Mid-Pacific Mountains sea feature
N. Pacific Ocean 150 G4
Midu China 76 D3
Miðvágur Faroe Is 44 [inset]
Midway Oman see Thamarīt

▶Midway Islands terr. N. Pacific Ocean
150 I4
United States Unincorporated Territory.

Midway Well Australia 109 C5
Midwest U.S.A. 126 G4
Midwest City U.S.A. 131 D5
Midwoud Neth. 52 F2
Midyat Turkey 91 F3
Midye Turkey see Kıyıköy
Mid Yell U.K. 50 [inset]
Midzhur mt. Bulg./Serb. and Mont. 90 A2
Miehikkälä Fin. 45 O6
Miekojärvi l. Fin. 44 N3
Mielec Poland 43 D6
Mienhua Yü i. Taiwan 77 I3
Mieraslompolo Fin. 44 O2
Mierašluoppal Fin. see Mieraslompolo
Mieres Spain 57 D2
Mieres del Camín Spain see Mieres
Mi'ēso Eth. 98 E3
Mieste Germany 53 L2
Mifflinburg U.S.A. 135 G3
Mifflintown U.S.A. 135 G3
Migang Shan mt. China 76 E1
Migdol S. Africa 101 G4
Miging India 76 B2
Migriggyangzham Co l. China 83 G2
Miguel Auza Mex. 131 C7
Miguel Hidalgo, Presa resr Mex. 127 F8
Mihaliçcık Turkey 59 N5
Mihara Japan 75 D6
Mihintale Sri Lanka 84 D4
Mihmandar Turkey 85 B1
Mijares r. Spain see Millárs
Mijdrecht Neth. 52 E2
Mikhaylov Rus. Fed. 43 H5
Mikhaylovgrad Bulg. see Montana
Mikhaylovka Amurskaya Oblast'
Rus. Fed. 74 C2
Mikhaylovka Primorskiy Kray
Rus. Fed. 74 D4
Mikhaylovka Tul'skaya Oblast' Rus. Fed. see
Kimovsk
Mikhaylovka Volgogradskaya Oblast'
Rus. Fed. 43 I6

Mikhaylovskiy Rus. Fed. 80 E1
Mikhaylovskoye Rus. Fed. see
Shpakovskoye
Mikhaytov Island Antarctica 152 E2
Mikhrot Timna Israel 85 B5
Mikir Hills India 83 H4
Mikkeli Fin. 45 O6
Mikkelin mlk Fin. 45 O6
Mikkwa r. Canada 120 H3
Mikonos i. Greece see Mykonos
Mikoyan Armenia see
Yeghegnadzor
Mikulkin, Mys c. Rus. Fed. 42 J2
Mikumi National Park Tanz. 99 D4
Mikun' Rus. Fed. 42 K3
Mikuni-sanmyaku mts Japan 75 E5
Mikura-jima i. Japan 75 E6
Milaca U.S.A. 130 E2
Miladhunmadulu Atoll
Maldives 84 B5
Miladummadulu Atoll Maldives see
Miladhunmadulu Atoll
Milan Italy 58 C2
Milan MI U.S.A. 134 D2
Milan MO U.S.A. 130 E3
Milan OH U.S.A. 134 D3
Milange Moz. 99 D5
Milano Italy see Milan
Milas Turkey 59 L6
Milazzo Sicily Italy 58 F5
Milazzo, Capo di c. Sicily Italy 58 F5
Milbank U.S.A. 130 D2
Milbridge U.S.A. 132 H2
Milde r. Germany 53 L2
Mildenhall U.K. 49 H6
Mildura Australia 111 C7
Mile China 76 D3
Mileiz, Wâdi el watercourse Egypt see
Mulayz, Wādī al
Miles Australia 112 E1
Miles City U.S.A. 126 G3
Milestone Ireland 51 D5
Miletto, Monte mt. Italy 58 F4
Mileura Australia 109 B6
Milford Ireland 51 E2
Milford DE U.S.A. 135 H4
Milford IL U.S.A. 134 B3
Milford MA U.S.A. 135 J2
Milford MI U.S.A. 134 D2
Milford NE U.S.A. 130 D3
Milford NH U.S.A. 135 J2
Milford PA U.S.A. 135 H3
Milford UT U.S.A. 129 G2
Milford VA U.S.A. 135 G4
Milford Sound N.Z. 113 A7
Milford Sound inlet N.Z. 113 A7
Milgarra Australia 110 C3
Miliana Alg. 57 H5
Milid Turkey see Malatya
Milikapiti Australia 108 E2
Miling Australia 109 B7
Milk r. U.S.A. 126 G2
Milk, Wadi el watercourse Sudan 86 D6
Mil'kovo Rus. Fed. 65 Q4
Millaa Millaa Australia 110 D3
Millárs r. Spain 57 F4
Millau France 56 F4
Millbrook Canada 135 F1
Mill Creek r. U.S.A. 128 B1
Milledgeville U.S.A. 133 D5
Mille Lacs lakes U.S.A. 130 E2
Mille Lacs, Lac des l. Canada 119 I5
Millen U.S.A. 133 D5
Millennium Island atoll Kiribati see
Caroline Island
Miller U.S.A. 130 D2
Miller Lake Canada 134 E1
Millerovo Rus. Fed. 43 I6
Millersburg OH U.S.A. 134 E3
Millersburg PA U.S.A. 135 G3
Millers Creek U.S.A. 134 D5
Millersville U.S.A. 135 G4
Millerton Lake U.S.A. 128 D3
Millet Canada 120 H4
Milleur Point U.K. 50 D5
Mill Hall U.S.A. 135 G3
Millicent Australia 111 C8
Millington MI U.S.A. 134 D2
Millington TN U.S.A. 131 F5
Millinocket U.S.A. 132 G2
Mill Island Canada 119 K3
Millmerran Australia 112 E1
Millom U.K. 48 D4
Millport U.K. 50 E5
Millsboro U.S.A. 135 H4
Mills Creek watercourse
Australia 110 C4
Mills Lake Canada 120 G2
Millstone KY U.S.A. 134 D5
Millstone WV U.S.A. 134 E4
Millstream-Chichester National Park
Australia 108 B5
Millthorpe Australia 112 D4
Milltown Canada 123 I5
Milltown U.S.A. 126 E3
Milltown Malbay Ireland 51 C5
Millungera Australia 110 C3
Millville U.S.A. 135 H4
Millwood U.S.A. 134 D4
Millwood Lake U.S.A. 131 E5
Milly Milly Australia 109 B6
Milne Land i. Greenland see
Ilimananngip Nunaa
Milner U.S.A. 129 J1
Milo r. Guinea 96 C3
Milogradovo Rus. Fed. 74 D4
Mílolı'i U.S.A. 127 [inset]
Milos i. Greece 59 K6
Milparinka Australia 111 C6
Milpitas U.S.A. 128 C3
Milroy U.S.A. 135 G3
Milton N.Z. 113 B8
Milton DE U.S.A. 135 H4
Milton NH U.S.A. 135 J2
Milton WV U.S.A. 134 D4
Milton Keynes U.K. 49 G6
Miluo China 77 G2
Milverton Canada 134 E2
Milwaukee U.S.A. 134 B2

▶Milwaukee Deep sea feature
Caribbean Sea 148 D4
Deepest point in the Atlantic Ocean
(Puerto Rico Trench).

Mimbres watercourse U.S.A. 129 J5
Mimili Australia 109 F6
Mimisal India 84 C4
Mimizan France 56 D4
Mimongo Gabon 98 B4
Mimosa Rocks National Park
Australia 112 E6
Mina Mex. 131 C7
Mina U.S.A. 128 D2
Minaçu Brazil 145 A1
Minahasa, Semenanjung pen.
Indon. 69 G6
Minahasa Peninsula Indon. see
Minahasa, Semenanjung
Minaker Canada see Prophet River
Minakh Syria 85 C1
Minaki Canada 121 M5
Minamia Australia 108 F3
Minami-Daitō-jima i. Japan 73 O7
Minami-Iō-jima vol. Japan 69 K2
Min'an China see Longshan
Minaret of Jam tourist site Afgh. 89 G3
Minas Indon. 71 C7
Minas Uruguay 144 E4
Minas de Matahambre Cuba 133 D8
Minas Gerais state Brazil 145 B2
Minas Novas Brazil 145 C2
Minatitlán Mex. 136 F5
Minbu Myanmar 70 A2
Minbya Myanmar 70 A2
Minchinmávida vol. Chile 144 B6
Mindanao i. Phil. 69 H5
Mindanao Trench sea feature
N. Pacific Ocean see
Philippine Trench
Mindelo Cape Verde 96 [inset]
Minden Canada 135 F1
Minden Germany 53 I2
Minden LA U.S.A. 131 E5
Minden NE U.S.A. 124 H3
Minden NV U.S.A. 128 D2
Mindon Myanmar 70 A3
Mindoro i. Phil. 69 G4
Mindoro Strait Phil. 69 F4
Mindouli Congo 98 B4
Mine Head hd Ireland 51 E6
Minehead U.K. 49 D7
Mineola U.S.A. 135 I3
Mineral U.S.A. 134 C1
Mineral'nyye Vody Rus. Fed. 91 F1
Mineral Wells U.S.A. 131 D5
Mineralwells U.S.A. 134 E4
Minersville PA U.S.A. 135 G3
Minersville UT U.S.A. 129 G2
Minerva U.S.A. 134 E3
Minerva Reefs Fiji 107 I4
Minfeng China 83 E1
Minga Dem. Rep. Congo 99 C5
Mingäçevir Azer. 91 G2
Mingäçevir Su Anbarı resr Azer. 91 G2
Mingala Cent. Afr. Rep. 98 C3
Mingan, Îles de i. Canada 123 J4
Mingan Archipelago National Park Reserve
Canada see
L'Archipélago de Mingan, Réserve du Pa
rc National de
Mingbuloq Uzbek. 80 B3
Mingechaur Azer. see Mingäçevir
Mingechaurskoye Vodokhranilishche resr
Azer. see Mingäçevir Su Anbarı
Mingenew Australia 109 A7
Mingfeng China see Yuan'an
Minggang China 77 G1
Mingguang China 77 H1
Mingin Range mts Myanmar 70 A2
Minglanilla Spain 57 F4
Mingoyo Tanz. 99 D5
Mingshan China 76 D2
Mingshui Gansu China 80 I3
Mingshui Heilong. China 74 B3
Mingteke China 82 C1
Mingulay i. U.K. 50 B4
Mingxi China 77 H3
Mingzhou China see Suide
Minhe China see Jinxian
Minhla Magwe Myanmar 70 A3
Minhla Pegu Myanmar 70 A3
Minho r. Port./Spain see Miño
Minicoy atoll India 84 B4
Minigwal, Lake salt flat U.S.A.
109 C7
Minilya Australia 109 A5
Minilya r. Australia 109 A5
Minipi Lake Canada 123 J3
Miniss Lake Canada 121 N5
Minitonas Canada 121 K4
Minjian China see Mabian
Min Jiang r. Sichuan China 76 E2
Min Jiang r. Fujian China 77 H3
Minna Nigeria 96 D4
Minna Bluff pt Antarctica 152 H1
Minne Sweden 44 I5
Minneapolis KS U.S.A. 130 D4
Minneapolis MN U.S.A. 130 E2
Minnedosa Canada 121 L5
Minnehaha Springs U.S.A. 134 F4
Minneola U.S.A. 131 C4
Minnesota state U.S.A. 130 E2
Minnewaukan U.S.A. 130 D1
Minnitaki Lake Canada 121 N5
Miño r. Port./Spain 57 B3
also known as Minho
Minorca i. Spain 57 H3
Minot U.S.A. 130 C1
Minqār, Ghadīr imp. l. Syria 85 C3
Minqing China 77 H3
Minquan China 77 G1
Min Shan mts China 76 D1
Minsin Myanmar 70 A1

▶Minsk Belarus 45 O10
Capital of Belarus.

Mińsk Mazowiecki Poland 47 R4

Minsterley U.K. 49 E6
Mintaka Pass China/Jammu and Kashmir
82 C1
Minto, Lac l. Canada 122 G2
Minto, Mount Antarctica 152 H2
Minto Inlet Canada 118 G2
Minton Canada 121 J5
Mīnūdasht Iran 88 D2
Minūf Egypt 90 C5
Minusinsk Rus. Fed. 72 G2
Minvoul Gabon 98 B3
Minxian China 76 E1
Minya Konka mt. China see
Gongga Shan
Minywa Myanmar 70 A2
Minzong India 83 I4
Mio U.S.A. 134 C1
Miquelon Canada 122 F4
Miquelon i. St Pierre and Miquelon
123 K5
Mirabad Afgh. 89 F4
Mirabela Brazil 145 B2
Mirador, Parque Nacional de nat. park
Brazil 143 I5
Miraí Brazil 145 C3
Miraj India 84 B2
Miramar Arg. 144 E5
Miramichi Canada 123 I5
Miramichi Bay Canada 123 I5
Mirampellou, Kolpos b. Greece 59 K7
Mirampellou, Kolpos b. Kriti Greece see
Mirampellou, Kolpos
Miranda Brazil 144 E2
Miranda Moz. see Macaloge
Miranda, Lake salt flat
Australia 109 C6
Miranda de Ebro Spain 57 E2
Mirandela Port. 57 C3
Mirandola Italy 58 D2
Mirante Brazil 145 C1
Mirante, Serra do hills Brazil 145 A3
Mirassol Brazil 145 A3
Mir-Bashir Azer. see Tärtär
Mirbāţ Oman 87 H6
Mirboo North Australia 112 C7
Mirepoix France 56 E5
Mirgarh Pak. 89 I4
Miri mt. Pak. 89 F4
Mirialguda India 84 C2
Miri Hills India 83 H4
Mirim, Lagoa l. Brazil/Uruguay 144 F4
Mirim, Lagoa do l. Brazil 145 A5
Mirintu watercourse Australia 112 A2
Mirjan Pak. 89 G5
Mirny research station
Antarctica 152 F2
Mirnyy Arkhangel'skaya Oblast'
Rus. Fed. 42 I3
Mirnyy Respublika Sakha (Yakutiya)
Rus. Fed. 65 M3
Mirond Lake Canada 121 K4
Mironovka Ukr. see Myronivka
Mirow Germany 53 M1
Mirpur Khas Pak. 89 H5
Mirpur Sakro Pak. 89 G5
Mirs Bay H.K. China 77 [inset]
Mirtoan Sea sea Greece see
Myrtoo Pelagos
Mirtoö Pelagos sea Greece see
Myrtoo Pelagos
Miryalaguda India see Mirialguda
Miryang S. Korea 75 C6
Mirzachirla Turkm. see Murzechirla
Mirzachul Uzbek. see Guliston
Mirzapur India 83 E4
Mirzawal India 82 C3
Misaw Lake Canada 121 K3
Miscou Island Canada 123 I5
Misehkow r. Canada 122 C4
Mīsh, Kūh-e hill Iran 88 E3
Misha India 71 A6
Mishāsh al Ashāwī well
Saudi Arabia 88 C5
Mishāsh az Zuayyinī well
Saudi Arabia 88 C5
Mishawaka U.S.A. 134 B3
Mishicot U.S.A. 134 B1
Mi-shima i. Japan 75 C6
Mishmi Hills India 83 H3
Mishvan' Rus. Fed. 42 L2
Misima Island P.N.G. 110 F1
Miskin Oman 88 E6
Miskitos, Cayos is Nicaragua 137 H6
Miskolc Hungary 43 D6
Mismā, Tall al hill Jordan 85 C3
Misoöl i. Indon. 69 I7
Misquah Hills U.S.A. 130 F2
Misr country Africa see Egypt
Misraç Turkey see Kurtalan
Misrātah Libya 97 E1
Missanabie Canada 122 E4
Mission Beach Australia 110 D3
Mission Viejo U.S.A. 128 E5
Missisa r. Canada 122 D3
Missisa Lake Canada 122 D3
Missisicabi r. Canada 122 F4
Mississauga Canada 134 F2
Mississinewa Lake U.S.A. 134 C3

▶Mississippi r. U.S.A. 131 F6
4th longest river in North America.
Part of the longest (Mississippi-Missouri).

Mississippi state U.S.A. 131 F5
Mississippi Delta U.S.A. 131 F6
Mississippi Lake Canada 135 G1

▶Mississippi-Missouri r. U.S.A. 125 I4
Longest river and largest drainage basin in
North America and
4th longest river in the world.
World 12–13

Mississippi Sound sea chan.
U.S.A. 131 F6
Missolonghi Greece see Mesolongi

Missoula U.S.A. 126 E3

▶Missouri r. U.S.A. 130 F4
3rd longest river in North America. Part of
the longest (Mississippi-Missouri).

Missouri state U.S.A. 130 E4
Mistanipisipou r. Canada 123 J4
Mistassibi r. Canada 119 K5
Mistassini Canada 123 G4
Mistassini r. Canada 123 G4
Mistassini, Lac l. Canada 122 G4
Mistastin Lake Canada 123 J3
Mistelbach Austria 47 P6
Mistinibi, Lac l. Canada 123 J2
Mistissini Canada 122 G4
Misty Fiords National Monument
Wilderness nat. park U.S.A. 120 D4
Misumba Dem. Rep. Congo 99 C4
Misuratah Libya see Mişrātah
Mit Ghamr Egypt 90 C5
Mit Ghamr Egypt see Mit Ghamr
Mithi Pak. 89 H5
Mithrau Pak. 89 H5
Mitiaro i. Cook Is see Mauke
Mitilíni Greece see Mytilini
Mitkof Island U.S.A. 120 C3
Mito Japan 75 F5
Mitole Tanz. 99 D4
Mitre mt. N.Z. 113 E5
Mitre Island Solomon Is 107 H3
Mitrofanovka Rus. Fed. 43 H6
Mitrovica Serb. and Mont. see
Kosovska Mitrovica
Mitrovicë Serb. and Mont. see
Kosovska Mitrovica
Mitsinjo Madag. 99 E5
Mits'iwa Eritrea see Massawa
Mitta Mitta Australia 112 C6
Mittellandkanal canal Germany 53 I2
Mitterteich Germany 53 M5
Mittimatalik Canada see Pond Inlet
Mittweida Germany 53 M4
Mitú Col. 142 D3
Mitumba, Chaîne des mts
Dem. Rep. Congo 99 C5
Mitzic Gabon 98 B3
Miura Japan 75 E6
Mixian China see Xinmi
Miyake-jima i. Japan 75 E6
Miyako Japan 75 F5
Miyakonojō Japan 75 C7
Miyang China see Mile
Miyani India 82 B5
Miyazaki Japan 75 C7
Miyazu Japan 75 D6
Miyi China 76 D3
Miyoshi Japan 75 D6
Miyun China 73 L4
Mizan Teferī Eth. 98 D3
Mizdah Libya 97 E1
Mizen Head hd Ireland 51 C6
Mizhhir"ya Ukr. 43 D6
Mizo Hills state India see Mizoram
Mizoram state India 83 H5
Mizpe Ramon Israel 85 B4
Mizusawa Japan 75 F5
Mjölby Sweden 45 I7
Mjøsa l. Norway 45 G6
Mkata Tanz. 99 D4
Mkushi Zambia 99 C5
Mladá Boleslav Czech Rep. 47 O5
Mladenovac Serb. and Mont. 59 I2
Mława Poland 47 R4
Mlilwane Nature Reserve Swaziland 101 J4
Mljet i. Croatia 58 G3
Mlungisi S. Africa 101 H6
Mmabatho S. Africa 101 G3
Mmamabula Botswana 101 H3
Mmathethe Botswana 101 H3
Mo Norway 45 D6
Moa i. Indon. 108 D2
Moab reg. Jordan 85 B4
Moab U.S.A. 129 I2
Moa Island Australia 110 C1
Moala i. Fiji 107 H3
Mo'alla Iran 88 D3
Moamba Moz. 101 K3
Moanda Gabon 98 B4
Moapa U.S.A. 129 F3
Moate Ireland 51 E4
Mobārakeh Iran 88 C3
Mobayi-Mbongo Dem. Rep. Congo see
Mobayi-Mbongo
Mobayi-Mbongo Dem. Rep. Congo
98 C3
Moberly U.S.A. 130 E4
Moberly Lake Canada 120 F4
Mobha India 82 C5
Mobile U.S.A. 131 F6
Mobile AZ U.S.A. 129 G5
Mobile Bay U.S.A. 131 F6
Moble watercourse Australia 112 B1
Mobridge U.S.A. 130 C2
Mobutu, Lake Dem. Rep. Congo/Uganda
see Albert, Lake
Mobutu Sese Seko, Lake
Dem. Rep. Congo/Uganda see
Albert, Lake
Moca Geçidi pass Turkey 85 A1
Moçambique country Africa see
Mozambique
Moçambique Moz. 99 E5
Moçâmedes Angola see Namibe
Môc Châu Vietnam 70 D2
Mocha Yemen 86 F7
Mocha, Isla i. Chile 144 B5

Mochirma, Parque Nacional nat. park
Venez. 142 F1
Mochudi Botswana 101 H3
Mochudi admin. dist. Botswana see
Kgatleng
Mocímboa da Praia Moz. 99 E5
Möckern Germany 53 L2
Möckmühl Germany 53 J5
Mockträsk Sweden 44 L4
Mocoa Col. 142 C3
Mococa Brazil 145 B3
Mocoduene Moz. 101 L2
Mocorito Mex. 127 G8
Moctezuma Chihuahua Mex. 127 G7
Moctezuma San Luis Potosí Mex. 136 D4
Moctezuma Sonora Mex. 127 F7
Mocuba Moz. 99 D5
Mocun China 77 G4
Modan Indon. 69 I7
Modane France 56 H4
Modder r. S. Africa 101 G5
Modena Italy 58 D2
Modena U.S.A. 129 G3
Modesto U.S.A. 128 C3
Modesto Lake U.S.A. 128 C3
Modimolle S. Africa 101 I3
Modot Mongolia 73 J3
Modung China 76 C2
Moe Australia 112 C7
Moel Sych hill U.K. 49 D6
Moelv Norway 45 G6
Moenkopi U.S.A. 129 H3
Moenkopi Wash r. U.S.A. 129 H4
Moeraki Point N.Z. 113 C7
Moero, Lake Dem. Rep. Congo/Zambia see
Mweru, Lake
Moers Germany 52 G3
Moffat U.K. 50 F5
Moga India 82 C3

▶Mogadishu Somalia 98 E3
Capital of Somalia.

Mogador Morocco see Essaouira
Mogadore Reservoir U.S.A. 134 E3
Moganyaka S. Africa 101 I3
Mogaung Myanmar 70 B1
Mogdy Rus. Fed. 74 D2
Mögelin Germany 53 M2
Mogi-Mirim Brazil 145 B3
Mogiquiçaba Brazil 145 D2
Mogocha Rus. Fed. 73 L2
Mogod mts Tunisia 58 C6
Mogoditshane Botswana 101 G3
Mogollon Mountains U.S.A. 129 I5
Mogollon Plateau U.S.A. 129 H4
Mogontiacum Germany see Mainz
Mogroum Chad 97 E3
Moguqi China 74 A3
Mogwadi S. Africa 101 I2
Mogwase S. Africa 101 H3
Mogzon Rus. Fed. 73 K2
Mohács Hungary 58 H2
Mohaka r. N.Z. 113 F4
Mohala India 84 D1
Mohale Dam Lesotho 101 I5
Mohale's Hoek Lesotho 101 H6
Mohall U.S.A. 130 C1
Mohammad Iran 88 E3
Mohammadia Alg. 57 G6
Mohan r. India/Nepal 82 E3
Mohana India 84 D1
Mohave, Lake U.S.A. 129 F4
Mohawk r. U.S.A. 135 I2
Mohawk Mountains U.S.A. 129 G5
Mohenjo Daro tourist site Pak. 89 H5
Moher, Cliffs of Ireland 51 C5
Mohill Ireland 51 E4
Möhne r. Germany 53 H3
Möhnetalsperre resr Germany 53 I3
Mohon Peak U.S.A. 129 G4
Mohoro Tanz. 99 D4
Mohylniv Podil's'kyy Ukr. 43 E6
Moi Norway 45 E7
Moijabana Botswana 101 H2
Moincêr China 82 E3
Moinda China 83 G3
Moine Moz. 101 K3
Moineşti Romania 59 L1
Mointy Kazakh. see Moyynty
Mo i Rana Norway 44 I3
Moirang India 76 B3
Mōisakūla Estonia 45 N7
Moisie Canada 123 I4
Moisie r. Canada 123 I4
Moissac France 56 E4
Mojave U.S.A. 128 D4
Mojave r. U.S.A. 128 E4
Mojave Desert U.S.A. 128 E4
Mojiang China 76 D4
Moji das Cruzes Brazil 145 B3
Mojos, Llanos de plain Bol. 142 E6
Moju r. Brazil 143 I4
Mokama India 83 F4
Mokau N.Z. 113 E4
Mokau r. N.Z. 113 E4
Mokelumne r. U.S.A. 128 C2
Mokelumne Aqueduct canal
U.S.A. 128 C2
Mokhoabong Pass Lesotho 101 I5
Mokhotlong Lesotho 101 I5
Mokhtārān Iran 88 E3
Moknine Tunisia 58 D7
Mokohinau Islands N.Z. 113 E2
Mokokchung India 83 H4
Mokolo Cameroon 97 E3
Mokolo r. S. Africa 101 I2
Mokopane S. Africa 101 I2
Mokp'o S. Korea 75 B6
Mokrous Rus. Fed. 43 J6
Moksha r. Rus. Fed. 43 I5
Mokshan Rus. Fed. 43 J5
Möksy Fin. 44 N5
Möktama Myanmar see Mottama
Möktama, Gulf of g. Myanmar see
Mottama, Gulf of
Mokundurra India see Mukandwara
Mokwa Nigeria 96 D4

Molatón mt. Spain 57 F4
Moldavia country Europe see Moldova
Moldavskaya S.S.R. country Europe see Moldova
Molde Norway 44 E5
Moldjord Norway 44 I3
►Moldova country Europe 43 F7
 Europe 5, 38–39
Moldoveanu, Vârful mt. Romania 59 K2
Moldovei de Sud, Cîmpia plain Moldova 59 M1
Molega Lake Canada 123 I5
Molen r. S. Africa 101 I4
Mole National Park Ghana 96 C4
Molepolole Botswana 101 G3
Molfetta Italy 58 G4
Molière Alg. see Bordj Bounaama
Molihong Shan mt. China see Morihong Shan
Molina de Aragón Spain 57 F3
Moline U.S.A. 131 D4
Molkom Sweden 45 H7
Mollagara Turkm. 88 D2
Mollakara Turkm. see Mollagara
Mol Len mt. India 83 H4
Möllenbeck Germany 53 N1
Mollendo Peru 142 D7
Mölln Germany 53 K1
Mölnlycke Sweden 45 H8
Molochnyy Rus. Fed. 44 R2
Molodechno Belarus see Maladzyechna
Molodezhnaya research station Antarctica 152 D2
Moloka'i i. U.S.A. 127 [inset]
Moloma r. Rus. Fed. 42 K4
Molong Australia 112 D4
Molopo watercourse Botswana/S. Africa 100 E5
►Molotov Rus. Fed. see Perm'
Molotovsk Kyrg. see Kayyngdy
►Molotovsk Arkhangel'skaya Oblast' Rus. Fed. see Severodvinsk
►Molotovsk Kirovskaya Oblast' Rus. Fed. see Nolinsk
Moloundou Cameroon 97 E4
Molson Lake Canada 121 L4
Molu i. Indon. 69 I8
Moluccas is Indon. 69 H7
Molucca Sea sea Indon. see Maluku, Laut
Moma Moz. 99 D5
Momba Australia 112 A3
Mombaça Brazil 143 K5
Mombasa Kenya 98 D4
Mombetsu Hokkaidō Japan see Monbetsu
Mombi New India 83 H4
Mombum Indon. 69 J8
Momchilgrad Bulg. 59 K4
Momence U.S.A. 134 B3
Momi, Ra's pt Yemen 87 H7
Mompós Col. 142 D2
Møn i. Denmark 45 H9
Mon India 83 H4
Mona terr. Irish Sea see Isle of Man
Mona U.S.A. 129 H2
Monaca U.S.A. 134 E3
Monach, Sound of sea chan. U.K. 50 B3
Monach Islands U.K. 50 B3
►Monaco country Europe 56 H5
 Europe 5, 38–39
Monaco Basin sea feature N. Atlantic Ocean 148 G4
Monadhliath Mountains U.K. 50 E3
Monaghan Ireland 51 F3
Monahans U.S.A. 131 C5
Mona Passage Dom. Rep./Puerto Rico 137 K5
Monapo Moz. 99 E5
Monar, Loch l. U.K. 50 D3
Monarch Mountain Canada 120 E5
Monarch Pass U.S.A. 127 G5
Mona Reservoir U.S.A. 129 H2
Monashee Mountains Canada 120 G5
Monastir Macedonia see Bitola
Monastir Tunisia 58 D7
Monastyrishche Ukr. see Monastyryshche
Monastyryshche Ukr. 43 F6
►Monbetsu Hokkaidō Japan 74 F3
►Monbetsu Hokkaidō Japan 74 F4
Moncalieri Italy 58 B2
Monchegorsk Rus. Fed. 44 R3
Mönchengladbach Germany 52 G3
Monchique Port. 57 B5
Moncks Corner U.S.A. 133 D5
Monclova Mex. 131 C7
Moncouche, Lac l. Canada 123 H4
Moncton Canada 123 I5
Mondego r. Port. 57 B3
Mondlo S. Africa 101 J4
Mondo Chad 97 E3
Mondoví Italy 58 B2
Mondragone Italy 58 E4
Mondy Rus. Fed. 72 I2
Monemvasia Greece 59 J6
Monessen U.S.A. 134 F3
Moneta U.S.A. 126 G4
Moneygall Ireland 51 E5
Moneymore U.K. 51 F3
Monfalcone Italy 58 E2
Monfalut Egypt see Manfalūţ
Monforte de Lemos Spain 57 C2
Monga Dem. Rep. Congo 98 C3
Mongala r. Dem. Rep. Congo 98 B3
Mongar Bhutan 83 G4
Mongbwalu Dem. Rep. Congo 98 D3
Mông Cai Vietnam 70 D2
Mongers Lake salt flat Australia 109 B7
Mong Hang Myanmar 70 B2
Mong Hkan Myanmar 70 B2
Mong Hpayak Myanmar 70 B2
Mong Hsat Myanmar 70 B2
Mong Hsawk Myanmar 70 B2
Mong Hsu Myanmar 70 B2
Monghyr India see Munger
Mong Kung Myanmar 70 B2
Mong Kyawt Myanmar 70 B3
Mongla Bangl. 83 G5
Mong Lin Myanmar 70 C2
Mong Loi Myanmar 70 C2
Mong Long Myanmar 70 B2
Mong Nai Myanmar 70 B2

Mong Nawng Myanmar 70 B2
Mongo Chad 97 E3
►Mongolia country Asia 72 I3
 Asia 6, 62–63
Mongol Uls country Asia see Mongolia
Mongonu Nigeria 96 E3
Mongora Pak. 89 I3
Mongour hill U.K. 50 G4
Mong Pan Myanmar 70 B2
Mong Ping Myanmar 70 B2
Mong Pu Myanmar 70 B2
Mong Pu-awn Myanmar 70 B2
Mong Si Myanmar 70 B2
Mongu Zambia 99 C5
Mong Un Myanmar 70 C2
Mong Yai Myanmar 70 B2
Mong Yang Myanmar 70 B2
Mong Yawn Myanmar 70 B2
Mong Yawng Myanmar 70 B2
Mönh Hayrhan Uul mt. Mongolia 80 H2
Moniaive U.K. 50 F5
Monitor Mountain U.S.A. 128 E2
Monitor Range mts U.S.A. 128 E2
Monivea Ireland 51 D4
Monkey Bay Malawi 99 D5
Monkira Australia 110 C5
Monkton Canada 134 E2
Monmouth U.K. 49 E7
Monmouth U.S.A. 130 F3
Monmouth Mountain Canada 120 F5
Monnow r. U.K. 49 E7
Mono, Punta del pt Nicaragua 137 H6
Mono Lake U.S.A. 128 D2
Monolithos Greece 59 L6
Monomoy Point U.S.A. 135 J3
Monon U.S.A. 134 B3
Monopoli Italy 58 G4
Monreal del Campo Spain 57 F3
Monreale Sicily Italy 58 E5
Monroe IN U.S.A. 134 C3
Monroe LA U.S.A. 131 E5
Monroe MI U.S.A. 134 D3
Monroe NC U.S.A. 133 D5
Monroe WI U.S.A. 130 F3
Monroe Center U.S.A. 130 F2
Monroe Lake U.S.A. 134 B4
Monroeton U.S.A. 135 G3
►Monrovia Liberia 96 B4
 Capital of Liberia.
Mons Belgium 52 D4
Monschau Germany 52 G4
Monselice Italy 58 D2
Montabaur Germany 53 H4
Montagu S. Africa 100 E7
Montague Canada 123 J5
Montague MI U.S.A. 134 B2
Montague TX U.S.A. 131 D5
Montague Range hills Australia 109 B6
Montalto mt. Italy 58 F5
Montalto Uffugo Italy 58 G5
Montana Bulg. 59 J3
Montana state U.S.A. 126 F3
Montanhas do Tumucumaque, Parque Nacional 143 H3
Montargis France 56 F3
Montauban France 56 E4
Montauk U.S.A. 135 J3
Montauk Point U.S.A. 135 J3
Mont-aux-Sources mt. Lesotho 101 I5
Montbard France 56 F3
Montblanc Spain 57 G3
Montblanch Spain see Montblanc
Montbrison France 56 G4
Montceau-les-Mines France 56 G3
Montcornet France 52 E5
Mont-de-Marsan France 56 D5
Montdidier France 52 C5
Monte Alegre Brazil 143 H4
Monte Alegre de Goiás Brazil 145 B1
Monte Alegre de Minas Brazil 145 A2
Monte Azul Brazil 145 C1
Monte Azul Paulista Brazil 145 A3
Montebello Canada 122 G5
Montebello Islands Australia 108 A5
Montebelluna Italy 58 E2
Monte-Carlo Monaco 56 H5
Monte Cristi Dom. Rep. 137 J5
Monte Cristo S. Africa 101 H2
Monte Dourado Brazil 143 H4
Montego Bay Jamaica 137 I5
Monte Lindo r. Para. 144 E2
Montello U.S.A. 130 F3
Montemorelos Mex. 131 D7
Montemor-o-Novo Port. 57 B4
►Montenegro country Europe 59 H3
 World's newest independent country. Gained independence from Serbia in June 2006.
 Europe 5, 38–39
Montepulciano Italy 58 D3
Monte Quemado Arg. 144 D3
Montereau-fault-Yonne France 56 F2
Monterey Mex. see Monterrey
Monterey CA U.S.A. 128 C3
Monterey VA U.S.A. 134 F4
Monterey Bay U.S.A. 128 B3
Montería Col. 142 C2
Monteros Arg. 144 C3
Monterrey Baja California Mex. 129 F5
Monterrey Nuevo León Mex. 131 C7
Montervary hd Ireland 51 C6
Montesano U.S.A. 126 C3
Montesano sulla Marcellana Italy 58 F4
Monte Santo Brazil 143 K6
Monte Santu, Capo di c. Sard. Italy 58 C4
Montes Claros Brazil 145 C2
Montesilvano Italy 58 F3
Montevarchi Italy 58 D3
►Montevideo Uruguay 144 E4
 Capital of Uruguay.
Montevideo U.S.A. 130 E2
Montezuma U.S.A. 130 E3
Montezuma Creek U.S.A. 129 I3
Montezuma Peak U.S.A. 128 E3
Montfort Neth. 52 F3
Montgomery U.K. 49 D6

►Montgomery AL U.S.A. 133 C5
 State capital of Alabama.
Montgomery WV U.S.A. 134 E4
Montgomery Islands Australia 108 C3
Monthey Switz. 56 H3
Monticello AR U.S.A. 131 F5
Monticello FL U.S.A. 133 D6
Monticello IN U.S.A. 134 B3
Monticello KY U.S.A. 134 C5
Monticello MO U.S.A. 130 F3
Monticello NY U.S.A. 135 H3
Monticello UT U.S.A. 129 I3
Montignac France 56 E4
Montignies-le-Tilleul Belgium 52 E4
Montigny-lès-Metz France 52 G5
Montilla Spain 57 D5
Monti Sibillini, Parco Nazionale dei nat. park Italy 58 E3
Montividiu Brazil 145 A2
Montivilliers France 49 H9
Mont-Joli Canada 123 H4
Mont-Laurier Canada 122 G5
Montluçon France 56 F3
Montmagny Canada 123 H5
Montmédy France 52 F5
Montmirail France 52 D6
Montmorillon France 56 E3
Montmort-Lucy France 52 D6
Monto Australia 110 E5
Montour Falls U.S.A. 135 G2
Montoursville U.S.A. 135 G3
Montpelier ID U.S.A. 126 F4
►Montpelier VT U.S.A. 135 I1
 State capital of Vermont.
Montpellier France 56 F5
Montréal Canada 122 G5
Montreal r. Ont. Canada 122 D5
Montreal r. Ont. Canada 122 F5
Montreal Lake Canada 121 J4
Montreal Lake l. Canada 121 J4
Montréal-Mirabel airport Canada 122 G5
Montreal River Canada 122 G5
Montréal-Trudeau airport Canada 122 G5
Montreuil France 52 B4
Montreux Switz. 56 H3
Montrose well S. Africa 100 E4
Montrose U.K. 50 G4
Montrose CO U.S.A. 129 J2
Montrose PA U.S.A. 135 H3
Montross U.S.A. 135 G4
Monts, Pointe des pt Canada 123 I4
Mont-St-Aignan France 49 I9
►Montserrat terr. West Indies 137 L5
 United Kingdom Overseas Territory.
 North America 9, 116–117
Montviel, Lac l. Canada 123 H3
Monument Valley reg. U.S.A. 129 H3
Monywa Myanmar 70 A2
Monza Italy 58 C2
Monze, Cape c. Pak. see Muari, Ras
Monzón Spain 57 G3
Mooi r. S. Africa 101 J5
Mooifontein Namibia 100 C4
Mookane Botswana 101 H2
Mookgopong S. Africa see Naboomspruit
Moolawatana Australia 111 B6
Moomba Australia 111 C6
Moomin Creek r. Australia 112 D2
Moonaree Australia 111 A6
Moonbi Range mts Australia 112 E3
Moonda Lake salt flat Australia 111 C5
Moonie Australia 112 E1
Moonie r. Australia 112 D2
Moora Australia 109 B7
Mooraberree Australia 110 C5
Moorcroft U.S.A. 126 G3
Moore r. Australia 109 A7
Moore, Lake salt flat Australia 109 B7
Moore Embayment b. Antarctica 152 H1
Moorefield U.S.A. 135 F4
Moore Haven U.S.A. 133 D7
Moore Reef Australia 110 E3
Moore Reservoir U.S.A. 135 J1
Moore River National Park Australia 109 A7
Moores Island Bahamas 133 E7
Moorfoot Hills U.K. 50 F5
Moorhead U.S.A. 130 D2
Moorman U.S.A. 134 B5
Moornanyah Lake imp. l. Australia 112 A4
Mooroopna Australia 112 B6
Moorrinya National Park Australia 110 D4
Moose r. Canada 122 E4
Moose Factory Canada 122 E4
Moosehead Lake U.S.A. 132 G2
Moose Jaw Canada 121 J5
Moose Lake Canada 121 J5
Moose Lake U.S.A. 130 E2
Mooselookmeguntic Lake U.S.A. 135 J1
Moose Mountain Creek r. Canada 121 K5
Moosilauke, Mount U.S.A. 135 J1
Moosomin Canada 121 K5
Moosonee Canada 122 E4
Mootwingee National Park Australia 111 C6
Mopane S. Africa 101 I2
Mopeia Moz. 99 D5
Mopipi Botswana 99 C6
Mopti Mali 96 C3
Moqor Afgh. 89 G3
Moquegua Peru 142 D7
Mora Cameroon 97 E3
Mora Spain 57 E4
Mora Sweden 45 I6
Mora MN U.S.A. 130 E2
Mora NM U.S.A. 127 G6
Mora r. U.S.A. 127 G6
Moradabad India 82 D3
Morada Nova Brazil 143 K5
Moraine Lake Canada 121 J1
Moraleda, Canal sea chan. Chile 144 B6

Moram India 84 C2
Moramanga Madag. 99 E5
Moran U.S.A. 126 F4
Moranbah Australia 110 E4
Morang Nepal see Biratnagar
Morar, Loch l. U.K. 50 D4
Morari, Tso l. Jammu and Kashmir 82 D2
Moratuwa Sri Lanka 84 C5
Moravia reg. Czech Rep. 47 P6
Moravia U.S.A. 135 G2
Morawa Australia 109 A7
Moray Firth b. U.K. 50 E3
Moray Range hills Australia 108 E3
Morbach Germany 52 H5
Morbi India 82 B5
Morcenx France 56 D4
Morcillo Mex. 131 B7
Mordaga China 73 M2
Mor Daği mt. Turkey 91 G3
Morden Canada 121 L5
Mordovo Rus. Fed. 43 I5
Moreau r. U.S.A. 130 C2
Moreau, South Fork r. U.S.A. 130 C2
Morecambe U.K. 48 E4
Morecambe Bay U.K. 48 D4
Moree Australia 112 D2
Morehead P.N.G. 69 K8
Morehead U.S.A. 134 D4
Morehead City U.S.A. 137 I2
Moreland U.S.A. 134 C5
More Laptevykh sea Rus. Fed. see Laptev Sea
Morelia Mex. 136 D5
Morella Australia 110 C4
Morella Spain 57 F3
Morena India 82 D4
Morena, Sierra mts Spain 57 C5
Morenci AZ U.S.A. 129 I5
Morenci MI U.S.A. 134 C3
Moreni Romania 59 K2
Moreno Mex. 127 F7
Moreno Valley U.S.A. 128 E5
Moresby, Mount Canada 120 C4
Moresby Island Canada 120 C4
Moreswe Pan salt pan Botswana 100 G2
Moreton Bay Australia 112 F1
Moreton-in-Marsh U.K. 49 F7
Moreton Island Australia 112 F1
Moreton Island National Park Australia 112 F1
Moreuil France 52 C5
Morez France 56 H3
Morfou Cyprus 85 A2
Morfou Bay Cyprus 85 A2
Morgan Australia 111 B7
Morgan City U.S.A. 131 F6
Morgan Hill U.S.A. 128 C3
Morganton U.S.A. 132 D5
Morgantown KY U.S.A. 134 B5
Morgantown WV U.S.A. 134 F4
Morgenzon S. Africa 101 I4
Morges Switz. 56 H3
Morgh, Kowtal-e Afgh. 89 H3
Morhar r. India 83 F4
Mori China 80 H3
Mori Japan 74 F4
Moriah, Mount U.S.A. 129 F2
Moriarty's Range hills Australia 112 B2
Morice Lake Canada 120 E4
Morichal Col. 142 D3
Morihong Shan mt. China 74 B4
Morija Lesotho 101 H5
Morin Dawa China see Nirji
Moringen Germany 53 J3
Morioka Japan 75 F5
Moris Mex. 127 F7
Morisset Australia 112 E4
Moriyoshi-zan mt. Japan 75 F5
Morjärv Sweden 44 M3
Morjen r. Pak. 89 F4
Morki Rus. Fed. 42 K4
Morlaix France 56 C2
Morley U.K. 48 F5
Mormam Flat Dam U.S.A. 129 H5
Mormant France 52 C6
Mormon Lake U.S.A. 129 H4
Mormugao India see Marmagao
Morne Diablotins vol. Dominica 137 L5
Morney watercourse Australia 110 C5
Mornington, Isla i. Chile 144 A7
Mornington Abyssal Plain sea feature S. Atlantic Ocean 148 C9
Mornington Island Australia 110 B3
Mornington Peninsula National Park Australia 112 B7
Moro Pak. 89 G5
Moro U.S.A. 126 C3
Morobe P.N.G. 69 L8
►Morocco country Africa 96 C1
 Africa 7, 94–95
Morocco U.S.A. 134 B3
Morococala mt. Bol. 142 E7
Morogoro Tanz. 99 D4
Morojaneng S. Africa 101 H5
Morokweng S. Africa 100 F4
Morombe Madag. 99 E6
Morón Cuba 133 E8
Mörön Mongolia 80 J2
Morondava Madag. 99 E6
Morón de la Frontera Spain 57 D5
►Moroni Comoros 99 E5
 Capital of the Comoros.
Moroni U.S.A. 129 H2
Moron Us He r. China see Tongtian He
Morotai i. Indon. 69 H6
Moroto Uganda 98 D3
Morozovsk Rus. Fed. 43 I6
Morpeth Canada 134 E2
Morpeth U.K. 48 F3
Morphou Cyprus see Morfou
Morrill U.S.A. 134 C5
Morrilton U.S.A. 131 E5
Morrin Canada 121 H5
Morrinhos Brazil 145 A2
Morris Canada 121 L5
Morris IL U.S.A. 130 F3
Morris MN U.S.A. 130 E2

Morris PA U.S.A. 135 G3
►Morris Jesup, Kap c. Greenland 153 I1
 Most northerly point of North America.
Morrison U.S.A. 130 F3
Morristown AZ U.S.A. 129 G5
Morristown NJ U.S.A. 135 H3
Morristown NY U.S.A. 135 H1
Morristown TN U.S.A. 132 D4
Morrisville U.S.A. 135 H2
Morro Brazil 145 B2
Morro Bay U.S.A. 128 C4
Morro d'Anta Brazil 145 D2
Morro do Chapéu Brazil 143 J6
Morro Grande hill Brazil 143 H4
Morrumbene Moz. 101 L2
Morschen Germany 53 J3
Morse Canada 121 J5
Morse U.S.A. 131 C4
Morse, Cape Antarctica 152 G2
Morse Reservoir U.S.A. 134 B3
Morshansk Rus. Fed. 43 I5
Morshanka Rus. Fed. see Morshansk
Morsott Alg. 58 C7
Mort watercourse Australia 110 C4
Mortagne-au-Perche France 56 E2
Mortagne-sur-Sèvre France 56 D3
Mortara Italy 58 C2
Mortehoe U.K. 49 C7
Morteros Arg. 144 D4
Mortes, Rio das r. Brazil 145 A1
Mortlake Australia 112 A7
Mortlock Islands Micronesia 150 G5
Mortlock Islands P.N.G. see Takuu Islands
Morton TX U.S.A. 131 C5
Morton WA U.S.A. 126 C3
Morton National Park Australia 112 E5
Morundah Australia 112 C5
Morupule Botswana 101 H2
Moruroa atoll Fr. Polynesia see Mururoa
Moruya Australia 112 E5
Morven Australia 111 D5
Morven hill U.K. 50 F2
Morvern reg. U.K. 50 D4
Morvi India see Morbi
Morwara India 82 E4
Morwell Australia 112 C7
Morzhovets, Ostrov i. Rus. Fed. 42 I2
Mosbach Germany 53 J5
Mosborough U.K. 48 F5
Mosby U.S.A. 126 G3
►Moscow Rus. Fed. 42 H5
 Capital of the Russian Federation, and most populous city in Europe.
Moscow ID U.S.A. 126 D3
Moscow PA U.S.A. 135 H3
Moscow University Ice Shelf Antarctica 152 G2
Mosel r. Germany 53 H4
Moselebe watercourse Botswana 100 F3
Moselle r. France 52 G5
Möser Germany 53 L2
Moses, Mount U.S.A. 128 E1
Moses Lake U.S.A. 126 D3
Mosgiel N.Z. 113 C7
Moshaweng watercourse S. Africa 100 F4
Moshchnyy, Ostrov i. Rus. Fed. 45 O7
Moshi Tanz. 98 D4
Mosh'yuga Rus. Fed. 42 L2
Mosi-oa-Tunya waterfall Zambia/Zimbabwe see Victoria Falls
Mosjøen Norway 44 H4
Moskal'vo Rus. Fed. 74 F1
Moskenesøy i. Norway 44 H3
Moskva Rus. Fed. see Moscow
Moskva Tajik. 89 H2
Mosonmagyaróvár Hungary 47 P7
Mosquera Col. 142 C3
Mosquero U.S.A. 127 G6
Mosquito r. Brazil 145 C1
Mosquito Creek Lake U.S.A. 134 E3
Mosquito Lake Canada 121 K2
Moss Norway 45 G7
Mossâmedes Angola see Namibe
Mossbank U.K. 50 [inset]
Mossburn N.Z. 113 B7
Mosselbaai S. Africa see Mossel Bay
Mossel Bay S. Africa 100 F8
Mossel Bay b. S. Africa 100 F8
Mossgiel Australia 112 B4
Mossman Australia 110 D3
Mossoró Brazil 143 K5
Moss Vale Australia 112 E5
Mossy r. Canada 121 K4
Most Czech Rep. 47 N5
Mostaganem Alg. 57 G5
Mostar Bos.-Herz. 58 G3
Mostoos Hills Canada 121 I4
Mostovskoy Rus. Fed. 91 F1
Mosty Belarus see Masty
Mosul Iraq 91 F3
Motala Sweden 45 I7
Motaze Moz. 101 K3
Motetema S. Africa 101 I3
Moth India 82 D4
Motherwell U.K. 50 F5
Motian Ling hill China 74 A4
Motihari India 83 F4
Motilla del Palancar Spain 57 F4
Motiti Island N.Z. 113 F3
Motokwe Botswana 100 F3
Motril Spain 57 E5
Motru Romania 59 J2
Mott U.S.A. 130 C2
Mottama Gulf of Myanmar 70 B3
Mottama, Gulf of Myanmar 70 B3
Motu Ihupuku i. N.Z. see Campbell Island
Motul Mex. 136 G4
Mouanda Gabon see Moanda
Mouding China 76 D3
Moudjéria Mauritania 96 B3
Moudros Greece 59 K5
Mouhijärvi Fin. 45 M6
Mouila Gabon 98 B4
Moulamein Australia 112 B5

Moulamein Creek r. Australia 112 A5
Moulavibazar Bangl. see Moulvibazar
Mould Bay Canada 118 G2
Moulèngui Binza Gabon 98 B4
Moulins France 56 F3
Moulmein Myanmar see Mawlamyaing
Moulouya, Oued r. Morocco 54 D4
Moultrie U.S.A. 133 D6
Moultrie, Lake U.S.A. 133 E5
Moulvibazar Bangl. 83 G4
Mound City KS U.S.A. 130 E4
Mound City SD U.S.A. 130 C2
Moundou Chad 97 E4
Moundsville U.S.A. 134 E4
Moûng Roessei Cambodia 71 C4
Mountain r. Canada 120 D1
Mountainair U.S.A. 127 G6
Mountain Brook U.S.A. 133 C5
Mountain City U.S.A. 134 E5
Mountain Home AR U.S.A. 131 E4
Mountain Home ID U.S.A. 126 E4
Mountain Home UT U.S.A. 129 H1
Mountain Lake Park U.S.A. 134 F4
Mountain View U.S.A. 131 E5
Mountain Zebra National Park S. Africa 101 G7
Mount Abu India 82 C4
Mount Airy U.S.A. 132 E4
Mount Aspiring National Park N.Z. 113 B7
Mount Assiniboine Provincial Park Canada 120 H5
Mount Ayliff S. Africa 101 I6
Mount Ayr U.S.A. 130 E3
Mount Bellew Ireland 51 D4
Mount Buffalo National Park Australia 112 C6
Mount Carmel U.S.A. 134 B4
Mount Carmel Junction U.S.A. 129 G3
Mount Coolon Australia 110 D4
Mount Darwin Zimbabwe 99 D5
Mount Denison Australia 108 F5
Mount Desert Island U.S.A. 132 G2
Mount Dutton Australia 111 A5
Mount Eba Australia 111 A6
Mount Elgon National Park Uganda 98 D3
Mount Fletcher S. Africa 101 I6
Mount Forest Canada 134 E2
Mount Frankland National Park Australia 109 B8
Mount Frere S. Africa 101 I6
Mount Gambier Australia 111 C8
Mount Gilead U.S.A. 134 D3
Mount Hagen P.N.G. 69 K8
Mount Holly U.S.A. 135 H4
Mount Hope Australia 112 B4
Mount Hope U.S.A. 134 E5
Mount Howitt Australia 111 C5
Mount Isa Australia 110 B4
Mount Jackson U.S.A. 135 F4
Mount Jewett U.S.A. 135 F3
Mount Joy U.S.A. 135 G3
Mount Kaputar National Park Australia 112 E3
Mount Keith Australia 109 C6
Mount Lofty Range mts Australia 111 B7
Mount Magnet Australia 109 B7
Mount Manara Australia 112 A4
Mount McKinley National Park U.S.A. see Denali National Park and Preserve
Mount Meadows Reservoir U.S.A. 128 C1
Mountmellick Ireland 51 E4
Mount Moorosi Lesotho 101 H6
Mount Morgan Australia 110 E4
Mount Morris MI U.S.A. 134 D2
Mount Morris NY U.S.A. 135 G2
Mount Murchison Australia 112 A3
Mount Nebo U.S.A. 134 E4
Mount Olivet U.S.A. 134 C4
Mount Pearl Canada 123 L5
Mount Pleasant Canada 123 I5
Mount Pleasant IA U.S.A. 130 F3
Mount Pleasant MI U.S.A. 134 C2
Mount Pleasant TX U.S.A. 131 E5
Mount Pleasant UT U.S.A. 129 H2
Mount Rainier National Park U.S.A. 126 C3
Mount Remarkable National Park Australia 111 B7
Mount Revelstoke National Park Canada 120 G5
Mount Robson Provincial Park Canada 120 G4
Mount Rogers National Recreation Area park U.S.A. 134 E5
Mount St Helens National Volcanic Monument nat. park U.S.A. 126 C3
Mount Sanford Australia 108 E4
Mount's Bay U.K. 49 B8
Mount Shasta U.S.A. 126 C4
Mountsorrel U.K. 49 F6
Mount Sterling U.S.A. 134 D4
Mount Swan Australia 110 A4
Mount Union U.S.A. 135 G3
Mount Vernon Australia 109 B6
Mount Vernon IL U.S.A. 130 F4
Mount Vernon IN U.S.A. 132 C4
Mount Vernon KY U.S.A. 134 C5
Mount Vernon OH U.S.A. 134 D3
Mount Vernon TX U.S.A. 131 E5
Mount Vernon WA U.S.A. 126 C2
Mount William National Park Australia 111 [inset]
Mount Willoughby Australia 109 F6
Moura Australia 110 E5
Moura Brazil 142 F4
Moura Port. 57 C4
Mourdi, Dépression du depr. Chad 97 F3
Mourdiah Mali 96 C3
Mourne r. U.K. 51 E3
Mourne Mountains hills U.K. 51 F3
Mousa i. U.K. 50 [inset]
Mouscron Belgium 52 D4
Mousgougou Chad 97 E3
Moussafoyo Chad 97 E4
Moussoro Chad 97 E3
Moutamba Congo 98 B4
Mouth of the Yangtze China 77 I2
Moutong Indon. 69 G6
Mouy France 52 C5
Mouydir, Monts du plat. Alg. 96 D2
Mouzon France 52 F5
Movas Mex. 127 F7

Mowbullan, Mount Australia 112 E1
Moxey Town Bahamas 133 E7
Moy r. Ireland 51 C3
Moyale Eth. 98 D3
Moyen Atlas mts Morocco 54 C5
Moyeni Lesotho 101 H6
Moynalyk Rus. Fed. 80 I1
Moynaq Uzbek. see Mo'ynoq
Mo'ynoq Uzbek. 80 A3
Moyo i. Indon. 108 B2
Moyobamba Peru 142 C5
Moyock U.S.A. 135 G5
Moyola r. U.K. 51 F3
Moyu China 82 D1
Moyynkum Kazakh. 80 D3
Moyynkum, Peski des. Kazakh. 80 C3
Moyynty Kazakh. 80 D2
▶Mozambique country Africa 99 D6
 Africa 7, 94–95
Mozambique Channel Africa 99 E6
Mozambique Ridge sea feature
 Indian Ocean 149 K7
Mozdok Rus. Fed. 91 G2
Mozdūrān Iran 89 F2
Mozhaysk Rus. Fed. 43 H5
Mozhga Rus. Fed. 42 L4
Mozhnābād Iran 89 F3
Mozo Myanmar 76 B4
Mozyr' Belarus see Mazyr
Mpaathutlwa Pan salt pan Botswana
 100 E3
Mpanda Tanz. 99 D4
Mpen India 83 I4
Mpika Zambia 99 D5
Mporokoso Zambia 99 D4
Mpulungu Zambia 99 D4
Mpumalanga prov. S. Africa 101 I4
Mpunde mt. Tanz. 99 D4
Mpwapwa Tanz. 99 D4
Mqanduli S. Africa 101 I6
Mqinvartsveri mt. Georgia/Rus. Fed. see
 Kazbek
Mrauk-U Myanmar 70 A2
Mrewa Zimbabwe see Murehwa
Mrkonjić-Grad Bos.-Herz. 58 G2
Mshinskaya Rus. Fed. 45 P7
M'Saken Tunisia 58 D7
Msta r. Rus. Fed. 42 F4
Mstislavl' Belarus see Mstsislaw
Mstsislaw Belarus 43 F5
Mtelo Kenya 98 D3
Mtoko Zimbabwe see Mutoko
Mtorwi Tanz. 99 D4
Mtsensk Rus. Fed. 43 H5
Mts'ire Kavkasioni Asia see
 Lesser Caucasus
Mtubatuba S. Africa 101 K5
Mtunzini S. Africa 101 J5
Mtwara Tanz. 99 E5
Mu r. Myanmar 70 A2
Mu'āb, Jibāl reg. Jordan see Moab
Muanda Dem. Rep. Congo 99 B4
Muang Ham Laos 70 C2
Muang Hiam Laos 70 C2
Muang Hinboun Laos 70 D3
Muang Hôngsa Laos 70 C3
Muang Khi Laos 70 C3
Muang Khôngxédôn Laos 71 D4
Muang Khoua Laos 70 C2
Muang Lamam Laos see Lamam
Muang Mok Laos 70 D3
Muang Ngoy Laos 70 C2
Muang Ou Nua Laos 70 C2
Muang Pakbeng Laos 70 C3
Muang Paktha Laos 70 C2
Muang Pakxan Laos see Pakxan
Muang Phalan Laos 68 D3
Muang Phin Laos 70 D3
Muang Phôn-Hông Laos 70 C3
Muang Sam Sip Thai. 70 D4
Muang Sing Laos 70 C2
Muang Soum Laos 70 C3
Muang Souy Laos 70 C3
Muang Thadua Laos 70 C3
Muang Thai country Asia see Thailand
Muang Va Laos 70 C2
Muang Vangviang Laos 70 C3
Muang Xon Laos 70 C2
Muar Malaysia 71 C7
Muarabungo Indon. 68 C7
Muarateweh Indon. 68 E7
Muari, Ras pt Pak. 89 G5
Mu'ayqil, Khashm al hill Saudi Arabia
 88 C5
Mubarek Uzbek. see Muborak
Mubarraz well Saudi Arabia 91 F5
Mubende Uganda 98 D3
Mubi Nigeria 96 E3
Muborak Uzbek. 89 G2
Mubur i. Indon. 71 D7
Mucajaí, Serra do mts Brazil 142 F3
Mucalic r. Canada 123 I2
Muccan Australia 108 C5
Muchinga Escarpment Zambia 99 D5
Much Germany 53 H4
Muchuan China 76 D2
Muck i. U.K. 50 C4
Mucojo Moz. 99 E5
Muconda Angola 99 C5
Mucubela Moz. 99 D5
Mucugê Brazil 145 C1
Mucur Turkey 90 D3
Mucuri Brazil 145 D2
Mucuri r. Brazil 145 D2
Mudabidri India 84 B3
Mudan China see Heze
Mudanjiang China 74 C3
Mudan Jiang r. China 74 C3
Mudan Ling mts China 74 B4
Mudanya Turkey 59 M4
Mudaybī Oman 88 E6
Mudaysīsāt, Jabal al hill
 Jordan 85 C4
Muddus nationalpark nat. park
 Sweden 44 K3
Muddy r. U.S.A. 129 F3
Muddy Gap U.S.A. 126 G4
Muddy Peak U.S.A. 129 F3
Müd-e Dahanāb Iran 88 E3

Mudersbach Germany 53 H4
Mudgal India 84 C3
Mudgee Australia 112 D4
Mudhol India 84 B2
Mudigere India 84 B3
Mudjatik r. Canada 121 J3
Mud Lake U.S.A. 128 E3
Mudraya country Africa see Egypt
Mudurnu Turkey 59 N4
Mud'yuga Rus. Fed. 42 H3
Mueda Moz. 99 D5
Mueller Range hills Australia 108 D4
Muertos Cays is Bahamas 133 D7
Muftyuga Rus. Fed. 42 J2
Mufulira Zambia 99 C5
Mufumbwe Zambia 99 C5
Mufu Shan mts China 77 G2
Muğan Düzü lowland Azer. 91 H3
Mugarripug China 83 F2
Mughalbhin Pak. see Jati
Mughal Kot Pak. 89 H4
Mughal Sarai India 83 E4
Müghār Iran 88 C3
Mughayrā' Saudi Arabia 85 C5
Mughayrā' well Saudi Arabia 88 B5
Muğla Turkey 59 M6
Mugodzhary, Gory mts Kazakh. 80 A2
Mugxung China 76 B2
Mūḩ, Sabkhat imp. l. Syria 85 D2
Muhammad Ashraf Pak. 89 H5
Muhammad Qol Sudan 86 E5
Muhammaran Iran see Khorramshahr
Muhashsham, Wādī al watercourse
 Egypt 85 B4
Muhaysh, Wādī al watercourse Jordan 85 C5
Muhaysin Syria 85 D1
Mühlanger Germany 53 M3
Mühlberg Germany 53 N3
Mühlhausen (Thüringen) Germany 53 K3
Mühlig-Hofmann Mountains Antarctica
 152 C2
Muhos Fin. 44 N4
Muḩradah Syria 85 C2
Muhri Pak. 89 G4
Mui Bai Bung c. Vietnam see Mui Ca Mau
Mui Ba Lang An pt Vietnam 70 E4
Mui Ca Mau c. Vietnam 71 D5
Mui Đôc c. Vietnam 70 D3
Muié Angola 99 C5
Muineachán Ireland see Monaghan
Muine Bheag Ireland 51 F5
Muir U.S.A. 134 C2
Muirkirk U.K. 50 E5
Muir of Ord U.K. 50 E3
Mui Ron hd Vietnam 70 D3
Muite Moz. 99 D5
Muji China 82 D1
Muju S. Korea 75 B5
Mukacheve Ukr. 43 D6
Mukachevo Ukr. see Mukacheve
Mukah Sarawak Malaysia 68 E6
Mukalla Yemen 86 G7
Mukandwara India 82 D4
Mukdahan Thai. 70 D3
Mukden China see Shenyang
Muketei r. Canada 122 D3
Mukhen Rus. Fed. 74 E2
Mukhino Rus. Fed. 74 B1
Mukhtuya Rus. Fed. see Lensk
Mukinbudin Australia 109 B7
Mu Ko Chang Marine National Park
 Thai. 71 C5
Mukojima-rettō is Japan 75 F8
Mukry Turkm. 89 G2
Muktsar India 82 C3
Mukutawa r. Canada 121 L4
Mukwonago U.S.A. 134 A2
Mula r. India 84 B2
Mulakatholhu Maldives see
 Mulaku Atoll
Mulaku Atoll Maldives 81 D11
Mulan China 74 C3
Mulanje, Mount Malawi 99 D5
Mulapula, Lake salt flat Australia 111 B6
Mulatos Mex. 127 F7
Mulayḩ Saudi Arabia 85 B5
Mulayḩah, Jabal hill U.A.E. 88 D5
Mulayz, Wādī al watercourse Egypt 85 A4
Mulchatna r. U.S.A. 118 C3
Mulde r. Germany 53 M3
Mule Creek NM U.S.A. 129 I5
Mule Creek WY U.S.A. 126 G4
Mulegé Mex. 127 E8
Mules i. Indon. 108 C2
Muleshoe U.S.A. 131 C5
Mulga Park Australia 109 E6
Mulgathing Australia 109 F7
Mulhacén mt. Spain 57 E5
Mülhausen France see Mulhouse
Mülheim an der Ruhr Germany 52 G3
Mulhouse France 56 H3
Muli China 76 D3
Muli Rus. Fed. see Vysokogorniy
Mulia Indon. 69 J7
Muling Heilong. China 74 C3
Muling Heilong. China 74 C3
Muling He r. China 74 D3
Mull i. U.K. 50 D4
Mull, Sound of sea chan. U.K. 50 C4
Mullaghcleevaun hill Ireland 51 F4
Mullaittivu Sri Lanka 84 D4
Mullaley Australia 112 D3
Mullengudgery Australia 112 C3
Mullens U.S.A. 134 E5
Muller watercourse Australia 108 F5
Muller, Pegunungan mts Indon. 68 E6
Mullett Lake U.S.A. 134 C1
Mullewa Australia 109 A7
Mullica r. U.S.A. 135 H4
Mullingar Ireland 51 E4
Mullion Creek Australia 112 D4
Mull of Galloway c. U.K. 50 E6
Mull of Kintyre hd U.K. 50 D5
Mull of Oa hd U.K. 50 C5
Mullumbimby Australia 112 F2
Mulobezi Zambia 99 C5
Mulshi Lake India 84 B2
Multai India 82 D5
Multan Pak. 89 H4
Multia Fin. 44 N5
Multien reg. France 52 C6
Mulug India 84 C2

▶Mumbai India 84 B2
 2nd most populous city in Asia,
 and 4th in the world.

Mumbil Australia 112 D4
Mumbwa Zambia 99 C5
Muminabad Tajik. see Leningrad
Mū'minobod Tajik. see Leningrad
Mun, Mae Nam r. Thai. 70 D4
Muna i. Indon. 69 G8
Muna r. Mex. 136 G4
Muna r. Rus. Fed. 65 N3
Munabao Pak. 89 H5
Munaðarnes Iceland 44 [inset]
München Germany see Munich
München-Gladbach Germany see
 Mönchengladbach
Münchhausen Germany 53 I4
Muncho Lake Canada 120 E3
Muncie U.S.A. 134 C3
Muncoonie West, Lake salt flat Australia 110 B5
Muncy U.S.A. 135 G3
Munda Pak. 89 H4
Mundel Lake Sri Lanka 84 C5
Mundesley U.K. 49 I6
Mundford U.K. 49 H6
Mundiwindi Australia 109 C5
Mundra India 82 B5
Mundrabilla Australia 106 C5
Munds Park U.S.A. 129 H4
Mundubbera Australia 111 E5
Mundwa India 82 C4
Munering watercourse Australia 109 D5
Mungana Australia 110 D3
Mungári Moz. 99 D5
Mungbere Dem. Rep. Congo 98 C3
Mungeli India 83 E5
Munger India 83 F4
Mungeranie Australia 111 B5
Mungindi Australia 112 D2
Mungo Angola 99 B5
Mungo, Lake Australia 112 A4
Mungo National Park Australia 112 A4
Munich Germany 47 M6
Munising U.S.A. 132 C2
Munjpur India 82 B5
Munkács Ukr. see Mukacheve
Munkebakken Norway 44 P2
Munkedal Sweden 45 G7
Munkfors Sweden 45 H7
Munkhafaḑ al Qaṭṭārah depr. Egypt see
 Qattara Depression
Munku-Sardyk, Gora mt.
 Mongolia/Rus. Fed. 72 I2
Münnerstadt Germany 53 K4
Munnik S. Africa 101 I2
Munroe Lake Canada 121 L3
Munsan S. Korea 75 B5
Münster Hessen Germany 53 I5
Münster Niedersachsen Germany 53 K2
Münster Nordrhein-Westfalen
 Germany 53 H3
Munster reg. Ireland 51 D5
Münsterland reg. Germany 53 H3
Muntadgin Australia 109 B7
Munyal-Par sea feature India see
 Bassas de Pedro Padua Bank
Munzur Vadisi Milli Parkı nat. park
 Turkey 55 L4
Muojärvi l. Fin. 44 P4
Muojärvi l. Fin. 44 P4
Muong Sai Laos see Xay
Muonio Fin. 44 M3
Muonioälven r. Fin./Sweden 44 M3
Muonionjoki r. Fin./Sweden see
 Muonioälven
Mupa, Parque Nacional da nat. park
 Angola 99 B5
Muping China see Baoxing
Muqaynimah well Saudi Arabia 88 C6
Muqdisho Somalia see Mogadishu
Muquem Brazil 145 A1
Muqui Brazil 145 C3
Mur r. Austria 47 P7
 also known as Mura (Croatia/Slovenia)
Mura r. Croatia/Slovenia see Mur
Murai, Tanjong pt Sing. 71 [inset]
Murakami Japan 75 E5
Murallón, Cerro mt. Chile 144 B7
Muramvya Burundi 98 C4
Murashi Rus. Fed. 42 K4
Murat r. Turkey 91 F3
Muratlı Turkey 59 L4
Muraysah, Ra's al pt Libya 90 B5
Murchison watercourse Australia 109 A6
Murchison, Mount Antarctica 152 H2
Murchison, Mount hill Australia 109 B6
Murchison Falls National Park
 Uganda 98 D3
Murcia Spain 57 F5
Murcia aut. comm. Spain 57 F5
Murdo U.S.A. 130 C3
Murehwa Zimbabwe 99 D5
Mureşul r. Romania 59 I1
Muret France 56 E5
Murewa Zimbabwe see Murehwa
Murfreesboro AR U.S.A. 131 E5
Murfreesboro NC U.S.A. 132 E4
Murfreesboro TN U.S.A. 132 C5
Murg r. Germany 53 I6
Murgab Tajik. see Murghob
Murgab Turkm. see Murgap
Murgap Turkm. 89 F2
Murgap r. Turkm. 87 J2
Murghab reg. Afgh. 89 F3
Murgha Kibzai Pak. 89 H4
Murghob Tajik. 89 I2
Murgon Australia 111 E5
Murgoo Australia 109 B6
Muri India 83 F5
Muriaé Brazil 145 C3
Murid Mex. 89 G4
Muriege Angola 99 C4
Müritz l. Germany 53 M1
Müritz, Nationalpark nat. park Germany
 53 N1

Murmansk Rus. Fed. 44 R2
Murmanskaya Oblast' admin. div.
 Rus. Fed. 44 S2
Murmanskiy Bereg coastal area
 Rus. Fed. 42 G2
Murmansk Oblast admin. div. Rus. Fed. see
 Murmanskaya Oblast'
Muro, Capo di c. Corsica France 56 I6
Murom Rus. Fed. 42 I5
Muroran Japan 74 F4
Muros Spain 57 B2
Muroto Japan 75 D6
Muroto-zaki pt Japan 75 D6
Murphy ID U.S.A. 126 D4
Murphy NC U.S.A. 133 D5
Murphysboro U.S.A. 130 F4
Murrah reg. Saudi Arabia 88 C6
Murrah al Kubrá, Al Buḩayrah al l. Egypt
 see Great Bitter Lake
Murrah aş Şughrá, Al Buḩayrah al l. Egypt
 see Little Bitter Lake
Murramarang National Park 112 I5
Murra Murra Australia 112 C2
Murrat el Kubra, Buheirat l. Egypt see
 Great Bitter Lake
Murrat el Sughra, Buheirat l. Egypt see
 Little Bitter Lake

▶Murray r. S.A. Australia 111 B7
 3rd longest river in Australia. Part of the
 longest (Murray-Darling).

Murray r. W.A. Australia 109 A8
Murray KY U.S.A. 131 F4
Murray UT U.S.A. 129 H1
Murray, Lake P.N.G. 69 K8
Murray, Lake U.S.A. 133 D5
Murray, Mount Canada 120 D2
Murray Bridge Australia 111 B7
Murray Downs Australia 108 F5
Murray Range hills Australia 109 E6
Murraysburg S. Africa 100 F6
Murray Sunset National Park Australia
 111 C7
Murrhardt Germany 53 J6
Murrieta U.S.A. 128 E5
Murringo Australia 112 D5
Murrisk Ireland 51 C4
Murroogh Ireland 51 C4

▶Murrumbidgee r. Australia 112 A5
 4th longest river in Oceania.

Murrumburrah Australia 112 D5
Murrurundi Australia 112 E3
Mursan India 82 D4
Murshidabad India 83 G4
Murska Sobota Slovenia 58 G1
Mürt Iran 89 F5
Murtoa Australia 111 C8
Murua i. P.N.G. see Woodlark Island
Murud India 84 B2
Murud, Gunung mt. Indon. 68 F6
Murunkan Sri Lanka 84 D4
Murupara N.Z. 113 F4
Mururoa atoll Fr. Polynesia 151 K7
Murviedro Spain see Sagunto
Murwara India 82 E5
Murwillumbah Australia 112 F2
Murzechirla Turkm. 89 F2
Murzūq Libya 97 E2
Mürzzuschlag Austria 47 O7
Muş Turkey 91 F3
Müsā, Khowr-e b. Iran 88 C4
Musa Khel Bazar Pak. 89 H4
Musala mt. Bulg. 59 J3
Musala i. Indon. 71 B7
Musan N. Korea 74 C4
Musandam Peninsula Oman/U.A.E. 88 E5
Müsá Qal'eh, Rūd-e r. Afgh. 89 G3
Musay'īd Qatar see Umm Sa'id

▶Muscat Oman 88 E6
 Capital of Oman.

Muscat reg. Oman 88 E5
Muscat and Oman country Asia see Oman
Muscatine U.S.A. 130 F3
Musgrave Australia 110 C2
Musgrave Harbour Canada 123 L4
Musgrave Ranges mts Australia 109 E6
Mushāsh al Kabīd well Jordan 85 C4
Mushayyish, Wādī al watercourse Jordan
 85 C4
Mushie Dem. Rep. Congo 98 B4
Mushkaf Pak. 89 G4
Music Mountain U.S.A. 129 G4
Musina S. Africa 101 J2
Musinia Peak U.S.A. 129 H2
Muskeg r. Canada 120 F2
Muskeget Channel U.S.A. 135 J3
Muskegon MI U.S.A. 134 B2
Muskegon MI U.S.A. 134 B2
Muskegon r. U.S.A. 134 B2
Muskegon Heights U.S.A. 134 B2
Muskeg River Canada 120 G4
Muskogee U.S.A. 131 E5
Muskoka, Lake Canada 134 F1
Muskrat Dam Lake Canada 121 N4
Musmar Sudan 86 E6
Musoma Tanz. 98 D4
Musquanousse, Lac l. Canada 123 J4
Musquaro, Lac l. Canada 123 J4
Mussau Island P.N.G. 69 L7
Musselburgh U.K. 50 F5
Musselkanaal Neth. 52 H2
Musselshell r. U.S.A. 126 G3
Mussende Angola 99 B5
Mustafakemalpaşa Turkey 59 M4
Mustjala Estonia 45 M7
Mustla Estonia 45 O7
Mustvee Estonia 45 O7
Musu-dan pt N. Korea 74 C4
Murid Japan 75 D6
Muswellbrook Australia 112 E4
Mūţ Egypt 86 C5
Mut Turkey 85 A1
Mutá, Ponta do pt Brazil 145 D1

Mutare Zimbabwe 99 D5
Mutayr reg. Saudi Arabia 88 B5
Mutina Italy see Modena
Muting Indon. 69 K8
Mutis, Col. 142 G1
Mutis mt. Indon. 108 D2
Mutnyy Materik Rus. Fed. 42 L2
Mutoko Zimbabwe 99 D5
Mutsamudu Comoros 99 E5
Mutsu Japan 74 F4
Muttaburra Australia 110 D4
Mutton Island Ireland 51 C5
Muttukuru India 84 D3
Muttupet India 84 C4
Mutum Brazil 145 C2
Mutúnopolis Brazil 145 A1
Mutur Sri Lanka 84 D4
Mutusjärvi r. Fin. 44 O2
Muurola Fin. 44 N3
Mu Us Shamo des. China 73 J5
Muxaluando Angola 99 B4
Muxi China see Muchuan
Muxima Angola 99 B4
Muyezerskiy Rus. Fed. 44 R5
Muyinga Burundi 98 D4
Muyumba Dem. Rep. Congo 99 C4
Muyunkum, Peski des. Kazakh. see
 Moyynkum, Peski
Muyuping China 77 F2
Muzaffarabad Pak. 89 I3
Muzaffargarh Pak. 89 H4
Muzaffarnagar India 82 D3
Muzaffarpur India 83 F4
Muzamane Moz. 101 K2
Muzhi Rus. Fed. 41 S2
Muzón, Cape U.S.A. 120 C4
Múzquiz Mex. 131 C7
Muztag mt. China 82 E2
Muz Tag mt. China 83 F1
Muztagata mt. China 89 I2
Muztor Kyrg. see Toktogul
Mvadi Gabon 98 B3
Mvolo Sudan 97 F4
Mvuma Zimbabwe 99 D5
Mvurwi Zimbabwe 99 D5
Mwali i. Comoros see Mohéli
Mwanza Dem. Rep. Congo 99 C4
Mwanza Malawi 99 D5
Mwanza Tanz. 98 D4
Mweelrea hill Ireland 51 C4
Mweka Dem. Rep. Congo 99 C4
Mwenda Zambia 99 C5
Mwene-Ditu Dem. Rep. Congo 99 C4
Mwenga Dem. Rep. Congo 98 C4
Mweru, Lake Dem. Rep. Congo/Zambia
 99 C4
Mweru Wantipa National Park
 Zambia 99 C4
Mwimba Dem. Rep. Congo 99 C4
Mwinilunga Zambia 99 C5
Mwitikira Tanz. 99 D4
Myadaung Myanmar 70 B2
Myadzyel Belarus 45 O9
Myajlar India 82 B4
Myall Lakes National Park Australia 112 F4
Myanaung Myanmar 70 A3
▶Myanmar country Asia 70 A2
 Asia 6, 62–63
Myauk-U Myanmar see Mrauk-U
Myaungmya Myanmar 70 A3
Myawadi Thai. 70 B3
Mybster U.K. 50 F2
Myebon Myanmar 70 A2
Myede Myanmar see Aunglan
Myeik Myanmar 71 B4
Myingyan Myanmar 70 A2
Myinkyado Myanmar 70 B2
Myinmoletkat mt. Myanmar 71 B4
Myitson Myanmar 70 B2
Myitkyina Myanmar 70 B1
Myitta Myanmar 71 B4
Myittha Myanmar 70 B2
Mykolayiv Ukr. 59 O1
Myla r. Rus. Fed. 42 K2
Mylae Sicily Italy see Milazzo
Mylasa Turkey see Milas
Mymensing Bangl. see Mymensingh
Mymensingh Bangl. 83 G4
Mynämäki Fin. 45 M6
Myŏnggan N. Korea 74 C4
Myory Belarus 45 O9
My Phuóc Vietnam 70 C2
Mýrdalsjökull ice cap Iceland 44 [inset]
Myre Norway 44 I2
Myrheden Sweden 44 L4
Myrnam Canada 121 I4
Myronivka Ukr. 43 F6
Myrtle Beach U.S.A. 133 E5
Myrtleford Australia 112 C6
Myrtle Point U.S.A. 126 B4
Myrtoo Pelagos sea Greece 59 J6
Mys Articheskiy c. Rus. Fed. 153 E1
Mysia reg. Turkey 59 L5
Mys Lazareva Rus. Fed. see Lazarev
Mýslibórz Poland 47 O4
My Son Sanctuary tourist site
 Vietnam 70 E4
Mysore India 84 C3
Mysore state India see Karnataka
Mys Shmidta Rus. Fed. 65 T3
Mysy Rus. Fed. 42 L3
My Tho Vietnam 71 D5
Mytikas mt. Greece see Olympus, Mount
Mytilene i. Greece see Lesbos
Mytilini Greece 59 L5
Mytilini Strait Greece/Turkey 59 L5
Mytishchi Rus. Fed. 42 H5
Myton U.S.A. 129 H1
Myyeldino Rus. Fed. 42 L3
Mzamomhle S. Africa 101 H6
Mže r. Czech Rep. 53 M5
Mzimba Malawi 99 D5
Mzuzu Malawi 99 D5

N

Naab r. Germany 53 M5
Nā'ālehu U.S.A. 127 [inset]
Naantali Fin. 45 M6

Naas Ireland 51 F4
Naba Myanmar 70 B1
Nababeep S. Africa 100 C5
Nababganj Bangl. see Nawabganj
Nabadwip India see Navadwip
Nabarangapur India 84 D2
Nabarangpur India see Nabarangapur
Nabari Japan 75 E6
Nabatîyé et Tahta Lebanon 85 B3
Nabatiyet et Tahta Lebanon see
 Nabatîyé et Tahta
Nabberu, Lake salt flat Australia 109 C6
Nabburg Germany 53 M5
Naberera Tanz. 99 D4
Naberezhnyye Chelny Rus. Fed. 41 Q4
Nabesna U.S.A. 120 A2
Nabeul Tunisia 58 D6
Nabha India 82 D3
Nabi'skiy Zaliv lag. Rus. Fed. 74 F2
Nabire Indon. 69 J7
Nabi Younés, Ras pt Lebanon 85 B3
Nablus West Bank 85 B3
Naboomspruit S. Africa 101 I3
Nabq Reserve nature res. Egypt 90 D5
Nābulus West Bank see Nablus
Nacala Moz. 99 E5
Nachalovo Rus. Fed. 43 K7
Nachicapau, Lac l. Canada 123 I2
Nachingwea Tanz. 99 D5
Nachna India 71 A5
Nachuge India 71 A5
Nacimiento Reservoir U.S.A. 128 C4
Naco U.S.A. 127 F7
Nacogdoches U.S.A. 131 E6
Nada China see Danzhou
Nadaleen r. Canada 120 C2
Nádendal Fin. see Naantali
Nadezhdinskoye Rus. Fed. 74 D2
Nadiad India 82 C5
Nadol India 82 C4
Nador Morocco 57 E6
Nadqān, Qalamat well Saudi Arabia 88 C6
Nadūshan Iran 88 D3
Nadvirna Ukr. 43 E6
Nadvoitsy Rus. Fed. 42 G3
Nadvornaya Ukr. see Nadvirna
Nadym Rus. Fed. 64 I3
Næstved Denmark 45 G9
Nafarroa aut. comm. Spain see Navarra
Nafas, Ra's an mt. Egypt 85 B5
Nafha, Har hill Israel 85 B4
Nafpaktos Greece 59 I5
Nafplio Greece 59 J6
Naftalan Azer. 91 G2
Naft-e Safid Iran 88 C4
Naft-e Shāh Iran see Naft Shahr
Naft Shahr Iran 88 B3
Nafūd ad Daḩl des. Saudi Arabia 88 B6
Nafūd al Ghuwayṭah des.
 Saudi Arabia 85 D5
Nafūd al Jur'ā des. Saudi Arabia 88 B5
Nafūd as Sirr des. Saudi Arabia 88 B5
Nafūd as Surrah des. Saudi Arabia 88 B5
Nafūd Qunayfidhah des. Saudi Arabia
 88 B5
Nafūsah, Jabal hills Libya 96 E1
Nafy Saudi Arabia 86 F4
Nag, Co l. China 83 G2
Naga Phil. 69 G4
Nagagami r. Canada 122 D4
Nagagami Lake Canada 122 D4
Nagahama Japan 75 D6
Naga Hills India 83 H4
Naga Hills state India see Nagaland
Nagaland state India 83 H4
Nagamangala India 84 C3
Nagambie Australia 112 B6
Nagano Japan 75 E5
Nagaoka Japan 75 E5
Nagaon India 83 H4
Nagapatam India see Nagapattinam
Nagapattinam India 84 C4
Nagar Hima. Prad. India 87 M3
Nagar Karnataka India 84 B3
Nagaram India 84 D2
Nagari Hills India 84 C3
Nagarjuna Sagar Reservoir India 84 C2
Nagar Parkar Pak. 89 H5
Nagasaki Japan 75 C6
Nagato Japan 75 C6
Nagbhir India 84 C1
Nagda India 82 C5
Nageezi U.S.A. 129 J3
Nagercoil India 84 C4
Nagha Kalat Pak. 89 G5
Nag' Ḥammādī Egypt see Naj' Ḩammādī
Nagina India 82 D3
Nagold r. Germany 53 I6
Nagong Chu r. China see Parlung Zangbo
Nagorno-Karabakh aut. reg. Azer. see
 Dağlıq Qarabağ
Nagornyy Karabakh aut. reg. Azer. see
 Dağlıq Qarabağ
Nagorsk Rus. Fed. 42 K4
Nagoya Japan 75 E6
Nagpur India 82 D5
Nagqu China 76 B2
Nag Qu r. China 76 B2
Nagurskoye Rus. Fed. 64 F1
Nagyatád Hungary 58 G1
Nagybecskerek Serb. and Mont. see
 Zrenjanin
Nagyenyed Romania see Aiud
Nagykanizsa Hungary 58 G1
Nagyvárad Romania see Oradea
Naha Japan 73 N7
Nahan India 82 D3
Nahanni Butte Canada 120 F2
Nahanni National Park Reserve
 Canada 120 E2
Nahanni Range mts Canada 120 F2
Nahārāyim Jordan 85 B3
Nahariyya Israel 85 B3
Nahāvand Iran 88 C3
Nahr Dijlah r. Iraq/Syria 91 G5 see Tigris
Nahuel Huapi, Parque Nacional nat. park
 Arg. 144 B6
Nahunta U.S.A. 133 D6
Naica Mex. 131 B7
Nai Ga Myanmar 76 C3
Naij Tal China 83 H2

Naikliu Indon. 108 C2
Nain Canada 123 J2
Nā'īn Iran 88 D3
Nainital India 82 D3
Naini Tal India see Nainital
Nairn U.K. 50 F3
Nairn r. U.K. 50 F3
► Nairobi Kenya 98 D4
Capital of Kenya.
Naissus Serb. and Mont. see Niš
Naivasha Kenya 98 D4
Najafābād Iran 88 C3
Na'jān Saudi Arabia 88 B5
Najd reg. Saudi Arabia 86 F4
Nájera Spain 57 E2
Naj' Ḥammādī Egypt 86 D4
Naji China 74 A2
Najibabad India 82 D3
Najin N. Korea 74 C4
Najitun China see Naji
Nakadōri-shima i. Japan 75 C6
Na Kae Thai. 70 D3
Nakambé r. Burkina/Ghana see White Volta
Nakanbe r. Burkina/Ghana see White Volta
Nakanno Rus. Fed. 65 L3
Nakano-shima i. Japan 75 D5
Nakasongola Uganda 97 G4
Nakatsu Japan 75 C6
Nakatsugawa Japan 75 E6
Nakfa Eritrea 86 E6
Nakhichevan' Azer. see Naxçivan
Nakhl Egypt 85 A5
Nakhodka Rus. Fed. 74 D4
Nakhola India 83 H4
Nakhon Nayok Thai. 71 C4
Nakhon Pathom Thai. 71 C4
Nakhon Phanom Thai. 70 D3
Nakhon Ratchasima Thai. 70 C4
Nakhon Sawan Thai. 70 C4
Nakhon Si Thammarat Thai. 71 B5
Nakhtarana India 82 B5
Nakina Canada 122 D4
Nakina r. Canada 120 C3
Naknek U.S.A. 118 C4
Nakonde Zambia 99 D4
Nakskov Denmark 45 G9
Naktong-gang r. S. Korea 75 C6
Nakuru Kenya 98 D4
Nakusp Canada 120 G5
Nal Pak. 89 G5
Nal r. Pak. 89 G5
Na-lang Myanmar 70 B2
Nalázi Moz. 101 K3
Nalbari India 83 G4
Nal'chik Rus. Fed. 91 F2
Naldurg India 84 C2
Nalgonda India 84 C2
Naliya India 82 B5
Nallamala Hills India 84 C3
Nallıhan Turkey 59 N4
Nālūt Libya 96 E1
Namaacha Moz. 101 K3
Namacurra Moz. 99 D5
Namadgi National Park Australia 112 D5
Namahadi S. Africa 101 I4
Namak, Daryācheh-ye salt flat Iran 88 C3
Namak, Kavīr-e salt flat Iran 88 E3
Namakkal India 84 C4
Namakwaland reg. Namibia see
 Great Namaqualand
Namakzar-e Shadad salt flat Iran 88 E4
Namaland reg. Namibia see
 Great Namaqualand
Namangan Uzbek. 80 D3
Namaqualand reg. S. Africa 100 C5
Namaqua National Park S. Africa 100 C6
Namas Indon. 69 K8
Namatanai P.N.G. 106 F2
Nambour Australia 112 F1
Nambucca Heads Australia 112 F3
Nambung National Park Australia 109 A7
Năm Căn Vietnam 71 D5
Namcha Barwa mt. China see
 Namjagbarwa Feng
Namche Bazar Nepal 83 F4
Nam Co salt l. China 83 G3
Namdalen valley Norway 44 H4
Namdalseid Norway 44 G4
Nam Đinh Vietnam 70 D2
Namen Belgium see Namur
Nam-gang r. N. Korea 75 B5
Namhae-do i. S. Korea 75 B6
Namhsan Myanmar 70 B2
Namib Desert Namibia 100 B3
Namibe Angola 99 B5
► Namibia country Africa 99 B6
 Africa 7, 94–95
Namibia Abyssal Plain sea feature
 N. Atlantic Ocean 148 I8
Namib-Naukluft Game Park nature res.
 Namibia 100 B3
Namie Japan 75 F5
Namin Iran 91 H3
Namjagbarwa Feng mt. China 76 B2
Namlan Myanmar 70 B2
Namlang r. Myanmar 70 B2
Nam Loi r. Myanmar see Nanlei He
Nam Nao National Park Thai. 70 C3
Nam Ngum Reservoir Laos 70 C3
Namoi r. Australia 112 D3
Namonuito atoll Micronesia 69 L5
Nampa mt. Nepal 82 E3
Nampa U.S.A. 128 D4
Nampala Mali 96 C3
Nam Phong Thai. 70 C3
Nampo N. Korea 75 B5
Nampula Moz. 99 D5
Namrup India 70 B1
Namsang Myanmar 70 B2
Namsen r. Norway 44 H4
Nam She Tsim hill H.K. China see
 Sharp Peak
Namsos Norway 44 G4
Namti Myanmar 70 B1
Namtok Myanmar 70 B3
Namtok Chattakan National Park
 Thai. 70 C3

Namton Myanmar 70 B2
Namtsy Rus. Fed. 65 N3
Namtu Myanmar 70 B2
Namu Canada 120 E5
Namuli, Monte mt. Moz. 99 D5
Namuno Moz. 99 D5
Namur Belgium 52 E4
Namutoni Namibia 99 B5
Namwŏn S. Korea 75 B6
Namya Ra Myanmar 70 B1
Namyit Island S. China Sea 68 E4
Nan Thai. 70 C3
Nana Bakassa Cent. Afr. Rep. 98 B3
Nanaimo Canada 120 F5
Nanam N. Korea 74 C4
Nan'an China 77 H3
Nanango Australia 112 F1
Nananib Plateau Namibia 100 C3
Nanao Japan 75 E5
Nanatsu-shima i. Japan 75 E5
Nanbai China see Zunyi
Nanbin China see Shizhu
Nanbu China 76 E2
Nancha China 74 C3
Nanchang Jiangxi China 77 G2
Nanchong China 76 E2
Nanchuan China 76 E2
Nancowry i. India 71 A6
Nancun China 77 G1
Nancy France 52 G6
Nancy (Essey) airport France 52 G6
Nanda Devi mt. India 82 E3
Nanda Kot mt. India 82 E3
Nandan China 76 E3
Nandapur India 84 D2
Nanded India 84 C2
Nandewar Range mts Australia 112 E3
Nandod India 84 B1
Nandurbar India 84 C5
Nandyal India 84 C3
Nanfeng Guangdong China 77 F4
Nanfeng Jiangxi China 77 H3
Nang China 76 B2
Nanga Eboko Cameroon 96 E4
Nanga Parbat mt. Jammu and
 Kashmir 82 C2
Nangar National Park Australia 112 D4
Nangatayap Indon. 68 E7
Nangin Myanmar 71 B5
Nangnim-sanmaek mts N. Korea 75 B4
Nangqên China 76 C1
Nangulangwa Tanz. 99 D4
Nanhua China 76 D3
Nanhui China 77 I2
Nanjian China 76 D3
Nanjiang China 76 E1
Nanjing China 77 H1
Nanji Shan i. China 77 I3
Nanka Jiang r. China 76 C4
Nankang China 77 G3
Nanking China see Nanjing
Nankova Angola 99 B5
Nanlei He r. China 76 C4
 also known as Nam Loi (Myanmar)
Nanling China 77 H2
Nan Ling mts China 77 F3
Nanliu Jiang r. China 77 F4
Nanlong China see Nanbu
Nannilam India 84 C4
Nannine Australia 109 B6
Nanning China 77 F4
Nannup Australia 109 A8
Na Noi Thai. 70 C3
Nanortalik Greenland 119 N3
Nanouki atoll Kiribati see Nonouti
Nanouti atoll Kiribati see Nonouti
Nanpan Jiang r. China 76 E3
Nanping China 77 H3
Nanpu China see Pucheng
Nanri Dao i. China 77 H3
Nansei-shotō is Japan see Ryukyu Islands
Nansei-shotō Trench sea feature
 N. Pacific Ocean see Ryukyu Trench
Nansen Basin sea feature
 Arctic Ocean 153 H1
Nansen Sound sea chan. Canada 119 I1
Nan-sha Ch'ün-tao is S. China Sea see
 Spratly Islands
Nanshan Island S. China Sea 68 E4
Nansha Qundao is S. China Sea see
 Spratly Islands
Nansio Tanz. 98 D4
Nantes France 56 D3
Nantes à Brest, Canal de France 56 C3
Nanteuil-le-Haudouin France 52 C5
Nanthi Kadal lag. Sri Lanka 84 D4
Nanticoke Canada 134 E2
Nanticoke U.S.A. 135 H4
Nantong China 77 I2
Nantou Taiwan 77 I4
Nant'ou Taiwan 77 [inset]
Nantucket U.S.A. 135 J3
Nantucket Island U.S.A. 135 K3
Nantucket Sound g. U.S.A. 135 J3
Nantwich U.K. 49 E5
Nanumaga i. Tuvalu see Nanumanga
Nanumanga i. Tuvalu 107 H2
Nanumea atoll Tuvalu 107 H2
Nanuque Brazil 145 C2
Nanusa, Kepulauan is Indon. 69 H6
Nanxi China 76 E2
Nanxian China 77 G2
Nanxiong China 77 G3
Nanyang China 77 G1
Nanyuki Kenya 98 D4
Nanzhang China 77 F2
Nanzhao China see Zhao'an
Nanzhou China see Nanxian
Naococane, Lac l. Canada 123 H3
Naoero country S. Pacific Ocean see Nauru
Naogaon Bangl. 83 G4
Naokot Pak. 89 H5
Naoli He r. China 74 D3
Naomid, Dasht-e des. Afgh./Iran 89 F3
Naoshera Jammu and Kashmir 82 C2
Napa U.S.A. 128 B2
Napaktulik Lake Canada 121 H1
Napanee Canada 135 G1
Napasoq Greenland 119 M3
Naperville U.S.A. 134 A3

Napier N.Z. 113 F4
Napier Range hills Australia 108 D4
Napierville Canada 135 I1
Naples Italy 58 F4
Naples FL U.S.A. 133 D7
Naples ME U.S.A. 135 J2
Naples TX U.S.A. 131 E5
Naples UT U.S.A. 129 I1
Napo China 76 E4
Napoleon IN U.S.A. 134 C4
Napoleon ND U.S.A. 130 D2
Napoleon OH U.S.A. 134 C3
Napoli Italy see Naples
Naqadeh Iran 88 B2
Nara India 82 B5
Nara Japan 75 D6
Nara Mali 96 C3
Naracoorte Australia 111 C8
Naradhan Australia 112 C4
Narainpur India 84 D2
Naralua India 83 F4
Naranjal Ecuador 142 C4
Naranjo Mex. 127 F8
Narasapur India 84 D2
Narasaraopet India 84 D2
Narasinghapur India 84 E1
Narathiwat Thai. 71 C6
Nara Visa U.S.A. 131 C5
Narayanganj Bangl. 83 G5
Narayanganj India 82 E5
Narayangarh India 82 C4
Narbada r. India see Narmada
Narberth U.K. 49 C7
Narbo France see Narbonne
Narbonne France 56 F5
Narborough Island Galápagos Ecuador see
 Fernandina, Isla
Narcea r. Spain 57 C2
Narcondam Island India 71 A4
Nardò Italy 58 H4
Narechi r. Pak. 89 H4
Narembeen Australia 109 B8
Nares Abyssal Plain sea feature
 S. Atlantic Ocean 148 D4
Nares Deep sea feature N. Atlantic Ocean
 148 D4
Nares Strait Canada/Greenland 119 K2
Naretha Australia 109 D7
Narew r. Poland 47 R4
Narib Namibia 100 C3
Narikel Jinjira i. Bangl. see
 St Martin's Island
Narimanov Rus. Fed. 43 J7
Narimskiy Khrebet mts Kazakh. see
 Narymskiy Khrebet
Narin Afgh. 89 H2
Narin reg. Afgh. 89 H2
Narince Turkey 90 E3
Narin Gol watercourse China 83 H1
Narizon, Punta pt Mex. 127 F8
Narkher India 82 D5
Narmada r. India 82 C5
Narman Turkey 91 F2
Narnaul India 82 D3
Narni Italy 58 E3
Narnia Italy see Narni
Narodnaya, Gora mt. Rus. Fed. 41 S3
Naro-Fominsk Rus. Fed. 43 H5
Narok Kenya 98 D4
Narooma Australia 112 E6
Narovchat Rus. Fed. 43 I5
Narowlya Belarus 43 F6
Närpes Fin. 44 L5
Narrabri Australia 112 D3
Narragansett Bay U.S.A. 135 J3
Narran r. Australia 112 C2
Narrandera Australia 112 C5
Narran Lake Australia 112 C2
Narrogin Australia 109 B8
Narromine Australia 112 D4
Narrows U.S.A. 134 E5
Narrowsburg U.S.A. 135 H3
Narsapur India 84 C2
Narsaq Greenland 119 N3
Narshingdi Bangl. see Narsingdi
Narsimhapur India see Narsinghpur
Narsingdi Bangl. 83 G5
Narsinghgarh India 82 D5
Narsinghpur India 82 D5
Narsipatnam India 84 D2
Nartkala Rus. Fed. 91 F2
Naruto Japan 75 D6
Narva Estonia 45 P7
Narva Bay Estonia/Rus. Fed. 45 O7
Narva laht b. Estonia/Rus. Fed. see
 Narva Bay
Narva Reservoir resr Estonia/Rus. Fed. see
 Narvskoye Vodokhranilishche
Narva veehoidla resr Estonia/Rus. Fed. see
 Narvskoye Vodokhranilishche
Narvik Norway 44 J2
Narvskiy Zaliv b. Estonia/Rus. Fed. see
 Narva Bay
Narvskoye Vodokhranilishche resr
 Estonia/Rus. Fed. 45 P7
Narwana India 82 D3
Nar'yan-Mar Rus. Fed. 42 L2
Narymskiy Khrebet mts Kazakh. 80 F2
Naryn Kyrg. 80 E3
Nāsāker Sweden 44 J5
Nashik India 84 B1
Nashua U.S.A. 135 J2
Nashville AR U.S.A. 131 E5
Nashville GA U.S.A. 133 D6
Nashville IN U.S.A. 134 B4
Nashville NC U.S.A. 132 E5
Nashville OH U.S.A. 134 D3
► Nashville TN U.S.A. 132 C4
State capital of Tennessee.
Naşīb Syria 85 C3
Näsijärvi l. Fin. 45 M6
Nasik India see Nashik
Nasir Pak. 89 H4
Nasir Sudan 86 D8
Nasirabad Bangl. see Mymensingh
Nasirabad India 82 C4
Naskaupi r. Canada 123 J3
Nasr Egypt 90 C5
Nasratabad Iran see Zābol
Naşrīān-e Pā'īn Iran 88 B3

Nass r. Canada 120 D4
Nassau r. Australia 110 C2
► Nassau Bahamas 133 E7
Capital of The Bahamas.
Nassau i. Cook Is 107 J3
Nassawadox U.S.A. 135 H5
Nasser, Lake resr Egypt 86 D5
Nässjö Sweden 45 I8
Nassuttooq inlet Greenland 119 M3
Nastapoca r. Canada 122 F2
Nastapoka Islands Canada 122 F2
Nasugbu Phil. 69 G4
Nasva Rus. Fed. 42 F4
Nata Botswana 99 C6
Natal Brazil 143 K5
Natal Indon. 68 B6
Natal prov. S. Africa see KwaZulu-Natal
Natal Basin sea feature Indian Ocean
 149 K8
Naţanz Iran 88 C3
Natashquan Canada 123 J4
Natashquan r. Canada 123 J4
Natchez U.S.A. 131 F6
Natchitoches U.S.A. 131 E6
Nathalia Australia 112 B6
Nathia Gali Pak. 89 I3
Nati, Punta pt Spain 57 H3
Natillas Mex. 131 C7
National City U.S.A. 128 E5
National West Coast Tourist Recreation
 Area park Namibia 100 B2
Natitingou Benin 96 D3
Natividad, Isla i. Mex. 127 E8
Natividade Brazil 143 I6
Natkyizin Myanmar 70 B4
Natla r. Canada 120 E2
Natmauk Myanmar 70 A2
Nator Bangl. see Natore
Nátora Mex. 127 F7
Natore Bangl. 83 G4
Natori Japan 75 F5
Natron, Lake salt l. Tanz. 98 D4
Nattalin Myanmar 70 A3
Nattaung mt. Myanmar 70 B3
Na'tū Iran 89 F3
Natuashish 123 J3
Natuna Besar i. Indon. 71 E6
Natuna, Kepulauan is Indon. 71 D6
Natural Bridges National Monument
 nat. park U.S.A. 129 H3
Naturaliste, Cape Australia 109 A8
Naturaliste Plateau sea feature
 Indian Ocean 149 P8
Naturita U.S.A. 129 I2
Nauchas Namibia 100 C2
Nau Co l. China 83 E2
Nauen Germany 53 M2
Naujoji Akmenė Lith. 45 M8
Naukh India 82 C4
Naumburg (Hessen) Germany 53 J3
Naumburg (Saale) Germany 53 L3
Naunglon Myanmar 70 B4
Naungpale Myanmar 70 B3
Naupada India 84 E2
Na'ūr Jordan 85 B4
Nauroz Kalat Pak. 89 G4
Naurskaya Rus. Fed. 91 G2
► Nauru country S. Pacific Ocean 107 G2
 Oceania 8, 104–105
Naustdal Norway 45 D6
Nauta Peru 142 D4
Nautaca Uzbek. see Qarshi
Naute Dam Namibia 100 C4
Nauzad Afgh. 89 G3
Nava Mex. 131 C6
Navadwip India 83 G5
Navahrudak Belarus 45 N10
Navajo Lake U.S.A. 129 J3
Navajo Mountain U.S.A. 129 H3
Navalmoral de la Mata Spain 57 D4
Navalvillar de Pela Spain 57 D4
Navan Ireland 51 F4
Navangar India see Jamnagar
Navapolatsk Belarus 45 P9
Năvar, Dasht-e depr. Afgh. 89 G3
Navarin, Mys c. Rus. Fed. 65 S3
Navarra aut. comm. Spain 57 F2
Navarra, Comunidad Foral de aut. comm.
 Spain see Navarra
Navarre Australia 112 A6
Navarre aut. comm. Spain see Navarra
Navarro r. U.S.A. 128 C2
Navashino Rus. Fed. 42 I5
Navasota U.S.A. 131 D6
► Navassa Island terr. West Indies 137 I5
United States Unincorporated Territory.
Naver r. U.K. 50 E2
Näverede Sweden 44 I5
Navi 84 B2
Navi 87 C6
Navlakhi India 82 B5
Navlya Rus. Fed. 43 G5
Năvodari Romania 59 M2
Navoi Uzbek. see Navoiy
Navoiy Uzbek. 89 G1
Navojoa Mex. 127 F8
Navolato Mex. 136 C4
Návpaktos Greece see Nafpaktos
Návplion Greece see Nafplio
Navşar Turkey see Şemdinli
Navsari India 84 B1
Nawá Syria 85 C3
Nawabganj Bangl. 83 G4
Nawabshah Pak. 89 H5
Nawada India 83 F4
Nāwah Afgh. 89 G3
Nawalgarh India 82 C4
Nawanshahr India 82 D3
Nawan Shehar India see Nawanshahr
Nawar, Dasht-i depr. Afgh. see
 Năvar, Dasht-e
Nawarangpur India see Nabarangapur
Nawngcho Myanmar see Nawnghkio
Nawnghkio Myanmar 70 B2

Nawng Hpa Myanmar 70 B2
Nawngleng Myanmar 70 B2
Nawoiy Uzbek. see Navoiy
Naxçivan Azer. 91 G3
Naxos i. Greece 59 K6
Nayagarh India 84 E1
Nayak Afgh. 89 G3
Nayar Mex. 136 D4
Nāy Band, Kūh-e mt. Iran 88 E3
Nayong China 76 E3
Nayoro Japan 74 F3
Nazaré Brazil 145 D1
Nazareno Mex. 131 C7
Nazareth Israel 85 B3
Nazário Brazil 145 A2
Nazas Mex. 131 B7
Nazas r. Mex. 131 B7
Nazca Peru 142 D6
Nazca Ridge sea feature S. Pacific Ocean
 151 O7
Nāzil Iran 89 F4
Nazilli Turkey 59 M6
Nazimabad Pak. 89 G5
Nazımiye Turkey 91 E3
Nazir Hat Bangl. 83 G5
Nazko Canada 120 F4
Nazran' Rus. Fed. 91 G2
Nazrēt Eth. 98 D3
Nazwá Oman 88 E6
Ncojane Botswana 100 E2
N'dalatando Angola 99 B4
Ndélé Cent. Afr. Rep. 98 C3
Ndendé Gabon 98 B4
Ndende i. Solomon Is see Ndeni
Ndeni i. Solomon Is 107 G3
► Ndjamena Chad 97 E3
Capital of Chad.
N'Djamena Chad see Ndjamena
Ndjouani i. Comoros see Nzwani
Ndoi i. Fiji see Doi
Ndola Zambia 99 C5
Nduke i. Solomon Is see Kolombangara
Ndwedwe S. Africa 101 J5
Ne, Hon i. Vietnam 70 D3
Neabul Creek r. Australia 112 C1
Neagh, Lough l. U.K. 51 F3
Neah Bay U.S.A. 126 B3
Neale, Lake salt flat Australia 109 E6
Nea Liosia Greece 59 J5
Nea Roda Greece 59 J4
Neapoli Greece 59 J6
Neapolis Italy see Naples
Neath U.K. 49 D7
Neath r. U.K. 49 D7
Nebbi Uganda 98 D3
Nebine Creek r. Australia 112 C2
Neblina, Pico da mt. Brazil 142 E3
Nebo Australia 110 E4
Nebo, Mount U.S.A. 129 H2
Nebolchi Rus. Fed. 42 G4
Nebraska state U.S.A. 130 C3
Nebraska City U.S.A. 130 E3
Nebrodi, Monti mts Sicily Italy 58 F6
Neches r. U.S.A. 131 E6
Nechisar National Park Eth. 98 D3
Nechranice, Vodní nádrž resr
 Czech Rep. 53 N4
Neckar r. Germany 53 I5
Neckarsulm Germany 53 J5
Necker Island U.S.A. 150 J4
Necochea Arg. 144 E5
Nederland Europe see Netherlands
Nederlandse Antillen terr. West Indies see
 Netherlands Antilles
Neder Rijn r. Neth. 52 F3
Nedlouc, Lac l. Canada 123 G2
Nedluk Lake Canada see Nedlouc, Lac
Nêdong China see Zêtang
Nedre Soppero Sweden 44 L2
Nédroma Alg. 57 F6
Needle Mountain U.S.A. 126 F3
Needles U.S.A. 129 F4
Neemach India see Neemuch
Neemuch India 82 C4
Neenah U.S.A. 134 A1
Neepawa Canada 121 L5
Neergaard Lake Canada 119 J2
Neerijnen Neth. 52 F3
Neerpelt Belgium 52 F3
Neftçala Azer. 91 H3
Neftechala Azer. see Uzboy
Neftechala Azer. see Neftçala
Neftegorsk Sakhalinskaya Oblast'
 Rus. Fed. 74 F1
Neftegorsk Samarskaya Oblast'
 Rus. Fed. 43 K5
Neftekamsk Rus. Fed. 41 Q4
Neftekumsk Rus. Fed. 91 G2
Nefteyugansk Rus. Fed. 64 I3
Neftezavodsk Turkm. see Seýdi
Nefyn U.K. 49 C5
Nefza Tunisia 58 C6
Negage Angola 99 B4
Negār Iran 88 E4
Negara Indon. 108 A2
Negēlē Eth. 98 D3
Negev des. Israel 85 B4
Negomane Moz. 99 D5
Negombo Sri Lanka 84 C5
Negotino Macedonia 59 J4
Negra, Cordillera mts Peru 142 C5
Negra, Punta pt Peru 142 B5
Negra, Serra mts Brazil 145 C2
Negrais, Cape Myanmar 70 A4
Négrine Alg. 58 B7
Negro r. Arg. 144 D6
Negro r. Brazil 143 G7
Negro r. Brazil 145 A4
Negro r. S. America 142 G4
Negro, Cabo c. Morocco 57 D6
Negros i. Phil. 69 G5
Negru Vodă, Podişul plat. Romania 59 M3
Nehbandān Iran 89 F4
Nehe China 74 B2
Neijiang China 76 E2
Neilburg Canada 121 I4

Neimenggu aut. reg. China see
 Nei Mongol Zizhiqu
Nei Mongol Zizhiqu aut. reg. China 74 A2
Neinstedt Germany 53 L3
Neiva Col. 142 C3
Neixiang China 77 F1
Nejanilini Lake Canada 121 L3
Nejd reg. Saudi Arabia see Najd
Neka Iran 88 D2
Nek'emtē Eth. 98 D3
Nekrasovskoye Rus. Fed. 42 I4
Neksø Denmark 45 I9
Nelang India 82 D3
Nelia Australia 110 C4
Nelidovo Rus. Fed. 42 G4
Neligh U.S.A. 130 D3
Nel'kan Rus. Fed. 65 P3
Nellore India 84 C3
Nelluz watercourse Turkey 85 D1
Nel'ma Rus. Fed. 74 E3
Nelson Canada 120 G5
Nelson r. Canada 121 M3
Nelson N.Z. 113 D5
Nelson U.K. 48 E5
Nelson U.S.A. 129 G4
Nelson, Cape Australia 111 C8
Nelson, Cape P.N.G. 69 L8
Nelson, Estrecho strait Chile 144 A8
Nelson Bay Australia 112 F4
Nelson Forks Canada 120 F3
Nelsonia U.S.A. 135 H5
Nelson Lakes National Park N.Z. 113 D6
Nelson Reservoir U.S.A. 126 G2
Nelspruit S. Africa 101 J3
Néma Mauritania 96 C3
Nema Rus. Fed. 42 K4
Neman r. Belarus/Lith. see Nyoman
Neman Rus. Fed. 45 M9
Nemausus France see Nîmes
Nemawar India 82 D5
Nemed Rus. Fed. 42 L3
Nementcha, Monts des mts Alg. 58 B7
Nemetocenna France see Arras
Nemetskiy, Mys c. Rus. Fed. 44 Q2
Nemirov Ukr. see Nemyriv
Nemiscau r. Canada 122 F4
Nemiscau, Lac l. Canada 122 F4
Nemor He r. China 74 B2
Nemours Alg. see Ghazaouet
Nemours France 52 F4
Nemrut Dağı mt. Turkey 91 F3
Nemunas r. Lith. see Nyoman
Nemuro Japan 74 G4
Nemuro-kaikyō sea chan. Japan/Rus. Fed.
 74 G4
Nemyriv Ukr. 43 F6
Nenagh Ireland 51 D5
Nenana U.S.A. 118 D3
Nene r. U.K. 49 H6
Nenjiang China 74 B3
Nen Jiang r. China 74 B3
Neosho U.S.A. 131 E4
► Nepal country Asia 83 E3
 Asia 6, 62–63
Nepalganj Nepal 83 E3
Nepean Canada 135 H1
Nepean, Point Australia 112 B7
Nephi U.S.A. 129 H2
Nephin hill Ireland 51 C3
Nephin Beg Range hills Ireland 51 C3
Nepisiguit r. Canada 123 I5
Nepoko r. Dem. Rep. Congo 98 C3
Nérac France 56 E4
Nerang Australia 112 F1
Nera Tso l. China 83 H3
Nerchinsk Rus. Fed. 73 L2
Nerekhta Rus. Fed. 42 I4
Néret, Lac l. Canada 123 H3
Neretva r. Bos.-Herz./Croatia 58 G3
Nêri Pünco l. China 83 G3
Neriquinha Angola 99 C5
Neris r. Lith. 45 M9
 also known as Viliya (Belarus/Lithuania)
Nerl' r. Rus. Fed. 42 H4
Nerópolis Brazil 145 A2
Neryungri Rus. Fed. 65 N4
Nes Neth. 52 F1
Nes Norway 45 F6
Nes' Rus. Fed. 42 J2
Nesbyen Norway 45 F6
Neskaupstaður Iceland 44 [inset]
Nesle France 52 C5
Nesna Norway 44 H3
Nesri India 84 B2
Ness r. U.K. 50 E3
Ness, Loch l. U.K. 50 E3
Ness City U.S.A. 130 D4
Nesse r. Germany 53 K4
Nesselrode, Mount Canada/U.S.A. 120 C3
Nestor Falls Canada 121 M5
Nestos r. Greece 59 K4
 also known as Mesta
Nesvizh Belarus see Nyasvizh
Netanya Israel 85 B3
► Netherlands country Europe 52 F2
 Europe 5, 38–39
► Netherlands Antilles terr. West Indies
 137 K6
Self-governing Netherlands Territory.
 North America 9, 116–117
Netphen Germany 53 I4
Netrakona Bangl. 83 G4
Netrokona Bangl. see Netrakona
Nettilling Lake Canada 119 K3
Neubrandenburg Germany 53 N1
Neuburg an der Donau Germany 53 L6
Neuchâtel Switz. 56 H3
Neuchâtel, Lac de l. Switz. 56 H3
Neuendettelsau Germany 53 K5
Neuenhaus Germany 52 G2
Neuenkirchen Germany 53 J1
Neuenkirchen (Oldenburg) Germany 53 I2
Neufchâteau Belgium 52 F5
Neufchâteau France 56 G2
Neufchâtel-en-Bray France 52 B5
Neufchâtel-Hardelot France 52 B4
Neuharlingersiel Germany 53 H1
Neuhausen Rus. Fed. see Gur'yevsk
Neuhof Germany 53 J4
Neu Kaliß Germany 53 L1

Neukirchen *Hessen* Germany 53 J4
Neukirchen *Sachsen* Germany 53 M4
Neukuhren Rus. Fed. *see* Pionerskiy
Neumarkt in der Oberpfalz
 Germany 53 L5
Neumayer *research station*
 Antarctica 152 B2
Neumünster Germany 47 L3
Neunburg vorm Wald Germany 53 M5
Neunkirchen Austria 47 P7
Neunkirchen Germany 53 H5
Neuquén Arg. 144 C5
Neuruppin Germany 53 M2
Neu Sandez Poland *see* Nowy Sącz
Neuse r. U.S.A. 133 E5
Neusiedler See *l.* Austria/Hungary 47 P7
Neusiedler See Seewinkel, Nationalpark
 nat. park Austria 47 P7
Neuss Germany 52 G3
Neustadt (Wied) Germany 53 H4
Neustadt am Rübenberge Germany 53 J2
Neustadt an der Aisch Germany 53 K5
Neustadt an der Hardt Germany *see*
 Neustadt an der Weinstraße
Neustadt an der Waldnaab
 Germany 53 M5
Neustadt an der Weinstraße
 Germany 53 I5
Neustadt bei Coburg Germany 53 L4
Neustadt-Glewe Germany 53 L1
Neustrelitz Germany 53 N1
Neutraubling Germany 53 M6
Neuville-lès-Dieppe France 52 B5
Neuwied Germany 53 H4
Neu Wulmstorf Germany 53 J1
Nevada *IA* U.S.A. 130 E3
Nevada *MO* U.S.A. 130 E4
Nevada *state* U.S.A. 126 D5
Nevada, Sierra *mts* Spain 57 E5
Nevada, Sierra *mts* U.S.A. 128 C1
Nevada City U.S.A. 128 C2
Nevado, Cerro *mt.* Arg. 144 C5
Nevado, Sierra del *mts* Arg. 144 C5
Nevasa India 84 B2
Nevatim Israel 85 B4
Nevdubstroy Rus. Fed. *see* Kirovsk
Nevel' Rus. Fed. 42 F4
Nevel'sk Rus. Fed. 74 F3
Never Rus. Fed. 74 B1
Nevers France 56 F3
Nevertire Australia 112 C3
Nevesinje Bos.-Herz. 58 H3
Nevinnomyssk Rus. Fed. 91 F1
Nevşehir Turkey 90 D3
Nevskoye Rus. Fed. 74 D3
New r. *CA* U.S.A. 129 F5
New r. *WV* U.S.A. 134 E5
Newala Tanz. 99 D5
New Albany *IN* U.S.A. 134 C4
New Albany *MS* U.S.A. 131 F5
New Amsterdam Guyana 143 G2
New Amsterdam U.S.A. *see* New York
New Angledool Australia 112 C2
Newark *DE* U.S.A. 135 H4
Newark *NJ* U.S.A. 135 H3
Newark *NY* U.S.A. 135 G2
Newark *OH* U.S.A. 134 D3
Newark *airport* U.S.A. 132 F3
Newark Lake U.S.A. 129 F2
Newark-on-Trent U.K. 49 G5
New Bedford U.S.A. 135 J3
Newberg U.S.A. 126 C3
New Berlin U.S.A. 135 H2
New Bern U.S.A. 133 E5
Newberry *IN* U.S.A. 134 B4
Newberry *MI* U.S.A. 132 C2
Newberry *SC* U.S.A. 133 D5
Newberry National Volcanic Monument
 nat. park U.S.A. 126 C4
Newberry Springs U.S.A. 128 E4
New Bethlehem U.S.A. 134 F3
Newbiggin-by-the-Sea U.K. 48 F3
New Bight Bahamas 133 F7
New Bloomfield U.S.A. 135 G3
Newboro Canada 135 G1
New Boston *OH* U.S.A. 134 D4
New Boston *TX* U.S.A. 131 E5
New Braunfels U.S.A. 131 D6
Newbridge Ireland 51 F4
New Britain *i.* P.N.G. 69 L8
New Britain U.S.A. 135 I3
New Britain Trench *sea feature*
 S. Pacific Ocean 150 G6
New Brunswick *prov.* Canada 123 I5
New Brunswick U.S.A. 135 H3
New Buffalo U.S.A. 134 B3
Newburgh Canada 135 G1
Newburgh U.S.A. 135 H3
Newburgh U.K. 50 G3
Newburgh U.S.A. 135 H3
Newbury U.K. 49 F7
Newburyport U.S.A. 135 J2
Newby Bridge U.K. 48 E4

▶New Caledonia *terr.* S. Pacific Ocean
 107 G4
 French Overseas Country.
 Oceania 8, 104–105

New Caledonia Trough *sea feature*
 Tasman Sea 150 G7
New Carlisle Canada 123 I4
Newcastle Australia 112 E4
Newcastle Canada 135 F2
Newcastle Ireland 51 F4
Newcastle S. Africa 101 I4
Newcastle U.K. 51 G3
New Castle *CO* U.S.A. 129 J2
New Castle *IN* U.S.A. 134 C4
New Castle *KY* U.S.A. 134 C4
New Castle *PA* U.S.A. 134 E3
New Castle *UT* U.S.A. 129 G3
New Castle *VA* U.S.A. 134 E5
Newcastle *WY* U.S.A. 126 G4
Newcastle Emlyn U.K. 49 C6
Newcastle-under-Lyme U.K. 49 E5
Newcastle upon Tyne U.K. 48 F4
Newcastle Waters Australia 108 F4
Newcastle West Ireland 51 C5
Newchwang China *see* Yingkou
New City U.S.A. 135 I3
Newcomb U.S.A. 129 I3
New Concord U.S.A. 134 E4

New Cumberland U.S.A. 134 E3
New Cumnock U.K. 50 E5
New Deer U.K. 50 G3
▶New Delhi India 82 D3
 Capital of India.

New Don Pedro Reservoir U.S.A. 128 C3
Newell U.S.A. 130 C2
Newell, Lake *salt flat* Australia 109 D6
Newell, Lake Canada 121 I5
New England National Park
 Australia 112 F3
New England Range *mts* Australia 112 E3
New England Seamounts *sea feature*
 N. Atlantic Ocean 148 E3
Newenham, Cape U.S.A. 118 B4
Newent U.K. 49 E7
New Era U.S.A. 134 B2
Newfane *NY* U.S.A. 135 F2
Newfane *VT* U.S.A. 135 I2
New Forest National Park 49 F8
Newfoundland *i.* Canada 123 K4
Newfoundland *prov.* Canada *see*
 Newfoundland and Labrador
Newfoundland and Labrador *prov.*
 Canada 123 K3
Newfoundland Evaporation Basin *salt l.*
 U.S.A. 129 G1
New Galloway U.K. 50 E5
New Georgia *i.* Solomon Is 107 F2
New Georgia Islands Solomon Is 107 F2
New Georgia Sound *sea chan.*
 Solomon Is 107 F2
New Glasgow Canada 123 J5
▶New Guinea *i.* Indon./P.N.G. 69 K8
 Largest island in Oceania and
 2nd in the world.
 World 12–13

New Halfa Sudan 86 E6
New Hampshire *state* U.S.A. 135 J1
New Hampton U.S.A. 130 E3
New Hanover *r.* P.N.G. 106 F2
New Haven *CT* U.S.A. 135 I3
New Haven *IN* U.S.A. 134 C3
New Haven *WV* U.S.A. 134 E4
New Hebrides *country* S. Pacific Ocean *see*
 Vanuatu
New Hebrides Trench *sea feature*
 S. Pacific Ocean 150 H7
New Holstein U.S.A. 134 A2
New Iberia U.S.A. 131 F6
Newington S. Africa 101 J3
Newinn Ireland 51 E5
New Ireland *i.* P.N.G. 106 F2
New Jersey *state* U.S.A. 135 H4
New Kensington U.S.A. 134 F3
New Kent U.S.A. 135 G5
Newkirk U.S.A. 131 D4
New Lanark U.K. 50 F5
Newland Range *hills* Australia 109 C7
New Lexington U.S.A. 134 D4
New Liskeard Canada 122 F5
New London *CT* U.S.A. 135 I3
New London *MO* U.S.A. 130 F4
New Madrid U.S.A. 131 F4
Newman Australia 109 B5
Newman U.S.A. 128 C3
Newmarket Canada 134 F1
Newmarket Ireland 51 C5
Newmarket U.K. 49 H6
New Market U.S.A. 135 F4
Newmarket-on-Fergus Ireland 51 D5
New Martinsville U.S.A. 134 E4
New Meadows U.S.A. 126 D3
New Mexico *state* U.S.A. 127 G6
New Miami U.S.A. 134 C4
New Milford U.S.A. 135 H3
Newnan U.S.A. 133 C5
New Orleans U.S.A. 131 F6
New Paris *IN* U.S.A. 134 C3
New Paris *OH* U.S.A. 134 C4
New Philadelphia U.S.A. 134 E3
New Pitsligo U.K. 50 G3
New Plymouth N.Z. 113 E4
Newport *Mayo* Ireland 51 C4
Newport *Tipperary* Ireland 51 D5
Newport *England* U.K. 49 E6
Newport *England* U.K. 49 F8
Newport *Wales* U.K. 49 D7
Newport *AR* U.S.A. 131 F5
Newport *IN* U.S.A. 134 B4
Newport *KY* U.S.A. 134 C4
Newport *MI* U.S.A. 134 D3
Newport *NH* U.S.A. 135 I2
Newport *NJ* U.S.A. 135 H4
Newport *OR* U.S.A. 126 B3
Newport *RI* U.S.A. 135 J3
Newport *VT* U.S.A. 135 I1
Newport *WA* U.S.A. 126 D2
Newport Beach U.S.A. 128 E5
Newport News U.S.A. 135 G5
Newport Pagnell U.K. 49 G6
New Port Richey U.S.A. 133 D6
Newquay U.K. 49 B8
New Roads U.S.A. 131 F6
New Rochelle U.S.A. 135 I3
New Rockford U.S.A. 130 D2
New Romney U.K. 49 H8
New Ross Ireland 51 F5
Newry Australia 108 E4
Newry U.K. 51 F3
New Siberia Islands Rus. Fed. 65 P2
New Smyrna Beach U.S.A. 133 D6
New South Wales *state* Australia 112 C4
New Stanton U.S.A. 134 F3
Newton U.K. 48 E5
Newton *GA* U.S.A. 133 C6
Newton *IA* U.S.A. 130 E3
Newton *IL* U.S.A. 130 F4
Newton *KS* U.S.A. 130 D4
Newton *MA* U.S.A. 135 J2
Newton *MS* U.S.A. 131 F5
Newton *NC* U.S.A. 132 D5
Newton *NJ* U.S.A. 135 H3
Newton *TX* U.S.A. 131 E6
Newton Abbot U.K. 49 D8
Newton Mearns U.K. 50 E5
Newton Stewart U.K. 50 E6

Newtown Ireland 51 D5
Newtown *England* U.K. 49 E6
Newtown *Wales* U.K. 49 D6
Newtown U.S.A. 134 C4
New Town U.S.A. 130 C1
Newtownabbey U.K. 51 G3
Newtownards U.K. 51 G3
Newtownbarry Ireland *see* Bunclody
Newtownbutler U.K. 51 E3
Newtownmountkennedy Ireland 51 F4
Newtown St Boswells U.K. 50 G5
Newtownstewart U.K. 51 E3
New Ulm U.S.A. 130 E2
Newville U.S.A. 135 G3
New World Island Canada 123 L4

▶New York U.S.A. 135 I3
 2nd most populous city in North America,
 and 3rd in the world.

New York *state* U.S.A. 135 H2

▶New Zealand *country* Oceania 113 D5
 3rd largest and 3rd most populous country
 in Oceania.
 Oceania 8, 104–105

Neya Rus. Fed. 42 I4
Ney Bīd Iran 88 E4
Neyrīz Iran 88 E2
Neyshābūr Iran 88 E2
Nezhin Ukr. *see* Nizhyn
Nezperce U.S.A. 126 D3
Ngabé Congo 98 B4
Nga Chong, Khao *mt.* Myanmar/Thai.
 70 B4
Ngagahtawng Myanmar 76 C3
Ngagau *mt.* Tanz. 99 D4
Ngalu Indon. 108 C2
Ngamring China 83 F3
Ngangla Ringco *salt l.* China 83 E3
Nganglong Kangri *mt.* China 82 E2
Ngangzê Co *salt l.* China 83 F3
Ngangzê Shan *mts* China 83 F3
Ngân Sơn Vietnam 70 D2
Ngaoundal Cameroon 96 E4
Ngaoundéré Cameroon 97 E4
Ngape Myanmar 70 A2
Ngaputaw Myanmar 70 A3
Ngarrab China *see* Gyaca
Ngathainggyaung Myanmar 70 A3
Ngau *i.* Fiji *see* Gau
Ngawa China *see* Aba
Ngeaur *i.* Palau *see* Angaur
Ngeruangel *i.* Palau 69 I5
Ngga Pulu *mt.* Indon. *see* Jaya, Puncak
Ngiap r. Laos 70 C3
Ngilmina Indon. 108 D2
Ngiva Angola *see* Ondjiva
Ngo Congo 98 B4
Ngoako Ramalepe S. Africa *see*
 Duiwelskloof
Ngoin, Co *salt l.* China 83 G3
Ngok Linh *mt.* Vietnam 70 D4
Ngoko r. Cameroon/Congo 97 E4
Ngola Shankou *pass* China 76 C1
Ngom Qu r. China *see* Ji Qu
Ngong Shuen Chau *pen.* H.K. China *see*
 Stonecutters' Island
Ngoqumaima China 83 F2
Ngoring China 76 C1
Ngoring Hu *l.* China 76 C1
Ngourti Niger 96 E3
Nguigmi Niger 96 E3
Nguiu Australia 108 E2
Ngükang China 76 B2
Ngukurr Australia 108 F3
Ngulu *atoll* Micronesia 69 J5
Ngunza Angola *see* Sumbe
Ngunza-Kabolu Angola *see* Sumbe
Nguru Nigeria 96 E3
Ngwaketse *admin. dist.* Botswana *see*
 Southern
Ngwane *country* Africa *see* Swaziland
Ngwathe S. Africa 101 H4
Ngwavuma r. S. Africa/Swaziland 101 K4
Ngwelezana S. Africa 101 J5
Nhachengue Moz. 101 L2
Nhamalabué Moz. 99 D5
Nha Trang Vietnam 71 E4
Nhecolândia Brazil 143 G7
Nhill Australia 111 C8
Nhlangano Swaziland 101 J4
Nho Quan Vietnam 70 D2
Nhow *i.* Fiji *see* Gau
Nhulunbuy Australia 110 B2
Niacam Canada 121 J4
Niafounké Mali 96 C3
Niagara U.S.A. 132 C2
Niagara Falls Canada 134 F2
Niagara Falls U.S.A. 134 F2
Niagara-on-the-Lake Canada 134 F2
Niagzu Aksai Chin 82 D2
Niah Sarawak Malaysia 68 E6
Niakaramandougou Côte d'Ivoire 96 C4

▶Niamey Niger 96 D3
 Capital of Niger.

Niam Kand Iran 88 E5
Niampak Indon. 69 H6
Niangara Dem. Rep. Congo 98 C3
Niangay, Lac *l.* Mali 96 C3
Nianzishan China 74 A3
Nias *i.* Indon. 71 B7
Niassa, Lago *l.* Africa *see* Nyasa, Lake
Niaur *i.* Palau *see* Angaur
Niäzäbäd Iran 89 F3
Nibil Well Australia 108 D5
Nīca Latvia 45 L8

▶Nicaragua *country* Central America
 137 G6
 4th largest country in Central and North
 America.
 North America 9, 116–117

Nicaragua, Lago de Nicaragua *see*
 Nicaragua, Lake
Nicaragua, Lake Nicaragua 137 G6
Nicastro Italy 58 G5
Nice France 56 H5

Nice U.S.A. 128 B2
Nicephorium Syria *see* Ar Raqqah
Niceville U.S.A. 133 C6
Nichicun, Lac *l.* Canada 123 H3
Nicholas Channel Bahamas/Cuba 133 D8
Nicholasville U.S.A. 134 C5
Nichols U.S.A. 134 A1
Nicholson r. Australia 110 B3
Nicholson Lake Canada 121 K2
Nicholson Range *hills* Australia 109 B6
Nicholville U.S.A. 135 H1
Nicobar Islands India 71 A5
Nicolaus U.S.A. 128 C2
Nicomedia Kocaeli Turkey *see* İzmit
▶Nicosia Cyprus 85 A2
 Capital of Cyprus.

Nicoya, Península de *pen.* Costa Rica
 137 G7
Nida Lith. 45 L9
Nidagunda India 84 C2
Nidd r. U.K. 48 F4
Nidda Germany 53 J4
Nidder r. Germany 53 I4
Nidzica Poland 47 R4
Niebüll Germany 47 L3
Nied r. France 52 G5
Niederanven Lux. 52 G5
Niederaula Germany 53 J4
Niedere Tauern *mts* Austria 47 N7
Niedersachsen *land* Germany 53 I2
Niedersächsisches Wattenmeer,
 Nationalpark *nat. park* Germany 52 G1
Niefang Equat. Guinea 96 E4
Niellé Côte d'Ivoire 96 C3
Nienburg (Weser) Germany 53 J2
Niers r. Germany 52 F3
Nierstein Germany 53 I5
Nieuwe-Niedorp Neth. 52 E2
Nieuwerkerk aan de IJssel Neth. 52 E3
Nieuw Nickerie Suriname 143 G2
Nieuwolda Neth. 52 G1
Nieuwoudtville S. Africa 100 D6
Nieuwpoort Belgium 52 C3
Nieuw-Vossemeer Neth. 52 E3
Niğde Turkey 90 D3
▶Niger *country* Africa 96 D3
 Africa 7, 94–95

▶Niger r. Africa 96 D4
 3rd longest river in Africa.

Niger, Mouths of the Nigeria 96 D4
Niger Cone *sea feature* S. Atlantic Ocean
 148 I5

▶Nigeria *country* Africa 96 D4
 Most populous country in Africa.
 Africa 7, 94–95

Nighthawk Lake Canada 122 E4
Nigrita Greece 59 J4
Nihing Pak. 89 G4
Nihon *country* Asia *see* Japan
Niigata Japan 75 E5
Niihama Japan 75 D6
Ni'ihau *i.* U.S.A. 127 [inset]
Nii-jima *i.* Japan 75 E6
Niimi Japan 75 D6
Niitsu Japan 75 E5
Nijil, Wādī *watercourse* Jordan 85 B4
Nijkerk Neth. 52 F2
Nijmegen Neth. 52 F3
Nijverdal Neth. 52 G2
Nikel' Rus. Fed. 44 Q2
Nikki Benin 96 D4
Nikkō Kokuritsu-kōen Japan 75 E5
Nikolayev Ukr. *see* Mykolayiv
Nikolayevsk Rus. Fed. 43 J5
Nikolayevsk Rus. Fed. 43 J6
Nikolayevskiy Rus. Fed. *see* Nikolayevsk
Nikolayevsk-na-Amure Rus. Fed. 74 F1
Nikol'sk Rus. Fed. 42 J4
Nikol'skiy Kazakh. *see* Satpayev
Nikol'skoye *Kamchatskaya Oblast'* Rus. Fed.
 65 R4
Nikol'skoye *Vologod. Obl.* Rus. Fed. *see*
 Sheksna
Nikopol' Ukr. 43 G7
Niksar Turkey 90 E2
Nīkshahr Iran 89 F5
Nikšić Serb. and Mont. 58 H3
Nīkū Jahān Iran 89 F3
Nikumaroro *atoll* Kiribati 107 I2
Nikunau *i.* Kiribati 107 H2
Nīl, Bahr el r. Africa *see* Nile
Nilagiri India 83 F5
Niland U.S.A. 129 F5
Nilande Atoll Maldives *see* Nilandhoo Atoll
Nilandhe Atoll Maldives *see*
 Nilandhoo Atoll
Nilandhoo Atoll Maldives 81 D11
Nilang India *see* Nelang
Nilanga India 84 C2
Nilaveli Sri Lanka 84 D4
▶Nile r. Africa 90 C5
 Longest river in the world and in Africa.
 Africa 92–93

Niles *MI* U.S.A. 134 B3
Niles *OH* U.S.A. 134 E3
Nilgiri Hills India 84 C4
Nīlī r. China 83 H1
Nīl Kowtal Afgh. 89 G3
Nilphamari Bangl. 83 G4
Nilsiä Fin. 44 P5
Nimach India *see* Neemuch
Nīmān r. Rus. Fed. 74 D2
Nimba, Monts *mts* Africa *see*
 Nimba, Mount
Nimba, Mount Africa 96 C4
Nimbal India 84 B2
Nimberra Well Australia 109 C5
Nimelen r. Rus. Fed. 74 E1
Nîmes France 56 G5
Nimmitabel Australia 111 E8
Nimrod Glacier Antarctica 152 H1
Nimu Jammu and Kashmir 82 D2
Nimule Sudan 97 G4
Nimwegen Neth. *see* Nijmegen

Nindigully Australia 112 D2
Nine Degree Channel India 84 B4
Nine Islands P.N.G. *see* Kilinailau Islands
Ninepyast Ridge *sea feature*
 Indian Ocean 149 N8
Ninety Mile Beach Australia 112 C7
Ninety Mile Beach N.Z. 113 D2
Nineveh U.S.A. 135 H2
Ning'an China 74 C3
Ningbo China 77 I2
Ningde China 77 H3
Ningdu China 77 H3
Ning'er China *see* Pu'er
Ningguo China 77 H2
Ninghai China 77 I2
Ninghsia Hui Autonomous Region *aut. reg.*
 China *see* Ningxia Huizu Zizhiqu
Ninghua China 77 H3
Ninging India 83 H3
Ningjiang China *see* Songyuan
Ningjing Shan *mts* China 76 C2
Ninglang China 76 D3
Ningming China 76 E4
Ningnan China 76 D3
Ningqiang China 76 E1
Ningwu China 73 K5
Ningxia *aut. reg.* China *see*
 Ningxia Huizu Zizhiqu
Ningxia Huizu Zizhiqu *aut. reg.*
 China 76 E1
Ningxian China 73 J5
Ningxiang China 77 G2
Ningzhou China *see* Huaning
Ninh Binh Vietnam 70 D2
Ninh Hoa Vietnam 71 E4
Ninigo Group *atolls* P.N.G. 69 K7
Ninnis Glacier Antarctica 152 G2
Ninnis Glacier Tongue Antarctica 152 H2
Ninohe Japan 75 F4
Niobrara r. U.S.A. 130 D3
Noelville Canada 122 E5
Niokolo Koba, Parc National du *nat. park*
 Senegal 96 B3
Niono Mali 96 C3
Nioro Mali 96 C3
Niort France 56 D3
Nipani India 84 B2
Nipawin Canada 121 J4
Niphad India 84 B1
Nipigon Canada 119 J5
Nipigon, Lake Canada 119 J5
Nipishish Lake Canada 123 J3
Nipissing, Lake Canada 122 F5
Nipton U.S.A. 129 F4
Niquelândia Brazil 145 A1
Nir *Ardabīl* Iran 88 B2
Nir *Yazd* Iran 88 D4
Nira r. India 84 B2
Nirji China 74 B2
Nirmal India 84 C2
Nirmali India 83 F4
Nirmal Range *hills* India 84 C2
Niš Serb. and Mont. 59 I3
Nisa Port. 57 C4
Nisarpur India 84 B1
Niscemi Sicily Italy 58 F6
Nīshāpūr Iran *see* Neyshābūr
Nishino-shima *vol.* Japan 75 F8
Nishi-Sonogi-hantō *pen.* Japan 75 C6
Nisibis Turkey *see* Nusaybin
Nísiros *i.* Greece *see* Nisyros
Niskibi r. Canada 121 N4
Nisling r. Canada 120 B2
Nispen Neth. 52 E3
Nissan r. Sweden 45 H8
Nistru r. Moldova 59 N1 *see* Dniester
Nisutlin r. Canada 120 C2
Nisyros *i.* Greece 59 L6
Niţā Saudi Arabia 88 C5
Nitchequon Canada 123 H3
Nitendi *i.* Solomon Is *see* Ndeni
Niterói Brazil 145 C3
Nith r. U.K. 50 F5
Nitibe East Timor 108 D2
Niti Pass China/India 82 D3
Niti Shankou *pass* China/India *see*
 Niti Pass
Nitmiluk National Park Australia 108 F3
Nitra Slovakia 47 Q6
Nitro U.S.A. 134 E4
Niuafo'ou *i.* Tonga 107 I3
Niuatoputapu *i.* Tonga 107 I3
▶Niue *terr.* S. Pacific Ocean 107 J3
 Self-governing New Zealand Overseas
 Territory.
 Oceania 8, 104–105

Niujing China *see* Binchuan
Niulakita *i.* Tuvalu 107 H3
Niutao *i.* Tuvalu 107 H2
Niutoushan China 77 H2
Nivala Fin. 44 N5
Nive *watercourse* Australia 110 D5
Nivelles Belgium 52 E4
Niwai India 82 C4
Niwas India 82 E5
Nixia China *see* Sêrxü
Nixon U.S.A. 128 D2
Niya China *see* Minfeng
Niya He r. China 83 F1
Nizamabad India 84 C2
Nizam Sagar *l.* India 84 C2
Nizh Aydere Turkm. 88 E2
Nizhnedevitsk Rus. Fed. 43 H6
Nizhnekamsk Rus. Fed. 42 K5
Nizhnekamskoye Vodokhranilishche *resr*
 Rus. Fed. 42 L5
Nizhnekolymsk Rus. Fed. 65 R3
Nizhnetambovskoye Rus. Fed. 74 E2
Nizhneudinsk Rus. Fed. 72 H2
Nizhnevartovsk Rus. Fed. 64 I3
Nizhnevolzhsk Rus. Fed. *see* Narimanov
Nizhneyansk Rus. Fed. 65 O2
Nizhniy Baskunchak Rus. Fed. 43 J6
Nizhniye Kresty Rus. Fed. *see* Cherskiy
Nizhniy Lomov Rus. Fed. 43 I5
Nizhniy Novgorod Rus. Fed. 42 I4
Nizhniy Odes Rus. Fed. 42 L3
Nizhniy Pyandzh Tajik. *see* Panji Poyon

Nizhniy Tagil Rus. Fed. 41 R4
Nizhnyaya Mola Rus. Fed. 42 J2
Nizhnyaya Omra Rus. Fed. 42 L3
Nizhnyaya Pirenga, Ozero *l.* Rus. Fed.
 44 R3
Nizhnyaya Tunguska r. Rus. Fed. 64 J3
Nizhnyaya Tura Rus. Fed. 41 R4
Nizhyn Ukr. 43 F6
Nizina r. U.S.A. 120 A2
Nizina Mazowiecka *reg.* Poland 47 R4
Nizip Turkey 85 C1
Nízke Tatry *nat. park* Slovakia 47 Q6
Nizwá Oman *see* Nazwá
Nizza France *see* Nice
Njallavarri *mt.* Norway 44 L2
Njavve Sweden 44 K3
Njazidja *i.* Comoros 99 E5
Njombe Tanz. 99 D4
Njurundabommen Sweden 44 J5
Nkambe Cameroon 96 E4
Nkandla S. Africa 101 J5
Nkawkaw Ghana 96 C4
Nkhata Bay Malawi 99 D5
Nkhotakota Malawi 99 D5
Nkondwe Tanz. 99 D4
Nkongsamba Cameroon 96 D4
Nkuleleko S. Africa 101 H6
Nkwenkwezi S. Africa 101 H7
Noakhali Bangl. 83 G5
Noatak r. U.S.A. 118 B3
Nobber Ireland 51 F4
Nobeoka Japan 75 C6
Noblesville U.S.A. 134 B3
Noboribetsu Japan 74 F4
Noccundra Australia 111 C5
Nockatunga Australia 111 C5
Nocona U.S.A. 131 D5
Noel Kempff Mercado, Parque Nacional
 nat. park Bol. 142 F6
Noelville Canada 122 E5
Nogales Mex. 127 F7
Nogales U.S.A. 127 F7
Nōgata Japan 75 C6
Nogent-le-Rotrou France 56 E2
Nogent-sur-Oise France 52 C5
Noginsk Rus. Fed. 42 H5
Nogliki Rus. Fed. 74 F2
Nogoa r. Australia 110 E4
Nohar India 82 C3
Noheji Japan 74 F4
Nohfelden Germany 52 H5
Noida India 82 D3
Noirmoutier, Île de *i.* France 56 C3
Noirmoutier-en-l'Île France 56 C3
Noisseville France 52 G5
Nokhowch, Kūh-e *mt.* Iran 89 F5
Nökis Uzbek. *see* Nukus
Nok Kundi Pak. 89 F4
Nokomis Canada 121 J5
Nokomis Lake Canada 121 K3
Nokou Chad 97 E3
Nokrek Peak India 83 G4
Nola Cent. Afr. Rep. 98 B3
Nolin River Lake U.S.A. 134 B5
Nolinsk Rus. Fed. 42 K4
No Mans Land *i.* U.S.A. 135 J3
Nome U.S.A. 118 B3
Nomgon Mongolia 72 J4
Nomhon China 80 I4
Nomoi Islands Micronesia *see*
 Mortlock Islands
Nomonde S. Africa 101 H6
Nomzha Rus. Fed. 42 I4
Nonacho Lake Canada 121 I2
Nondweni S. Africa 101 J5
Nong'an China 74 B3
Nonghui China *see* Guang'an
Nong Khai Thai. 70 C3
Nongoma S. Africa 101 J4
Nongstoin India 83 G4
Nonidas Namibia 100 B2
Nonni r. China *see* Nen Jiang
Nonning Australia 111 B7
Nonnweiler Germany 52 G5
Nonoava Mex. 127 G8
Nonouti *atoll* Kiribati 107 H2
Nonthaburi Thai. 71 C4
Nonzwakazi S. Africa 100 G6
Noolyeanna Lake *salt flat* Australia 111 B5
Noondie, Lake *salt flat* Australia 109 B7
Noonkanbah Australia 108 D4
Noonthorangee Range *hills*
 Australia 111 C6
Noorama Creek *watercourse*
 Australia 112 B1
Noordbeveland *i.* Neth. 52 D3
Noorderhaaks *i.* Neth. 52 E2
Noordoost Polder Neth. 52 F2
Noordwijk-Binnen Neth. 52 E2
Nootka Island Canada 120 E5
Nora r. Rus. Fed. 74 C2
Norak Tajik. 89 H2
Norak, Obanbori *resr* Tajik. 89 H2
Norala Phil. 69 G5
Noranda Canada 122 F4
Nor-Bayazet Armenia *see* Gavarr
Norberg Sweden 45 I6
Nord Greenland *see* Station Nord
Nord, Canal du France 52 D4
Nordaustlandet *i.* Svalbard 64 D2
Nordegg Canada 120 G4
Norden Germany 53 H1
Nordenshel'da, Arkhipelag *is*
 Rus. Fed. 64 F2
Nordenskjold Archipelago *is* Rus. Fed. *see*
 Nordenshel'da, Arkhipelag
Norderney Germany 53 H1
Norderstedt Germany 53 K1
Nordfjordeid Norway 44 D6
Nordfold Norway 44 I3
Nordfriesische Inseln Germany *see*
 North Frisian Islands
Nordhausen Germany 53 K3
Nordholz Germany 53 I1
Nordhorn Germany 52 H2
Nordkapp c. Norway *see* North Cape
Nordkinnhalvøya *i.* Norway 44 O1
Nordkjosbotn Norway 44 K2
Nordli Norway 44 H4
Nördlingen Germany 53 K6
Nordmaling Sweden 44 K5

Nord- og Østgrønland, Nationalparken i *nat. park* Greenland 119 O2

▶Nordøstrundingen *c.* Greenland 153 I1
Most easterly point of North America.

Nord-Ostsee-Kanal Germany *see* Kiel Canal
Norðoyar *i.* Faroe Is 40 E3
Nord-Pas-de-Calais *admin. reg.* France 52 G4
Nordpfälzer Bergland *reg.* Germany 53 H5
Nordre Strømfjord *inlet* Greenland *see* Nassuttooq
Nordrhein-Westfalen *land* Germany 53 H3
Nordvik Rus. Fed. 65 M2
Nore *r.* Ireland 51 F5
Nore, Pic *de mt.* France 56 F5
Noreg *country* Europe *see* Norway
Norfolk *NE* U.S.A. 130 D3
Norfolk *NY* U.S.A. 135 H1
Norfolk *VA* U.S.A. 135 G5

▶Norfolk Island *terr.* S. Pacific Ocean 107 G4
Territory of Australia.
Oceania 8, 104–105

Norfolk Island Ridge *sea feature* Tasman Sea 150 H7
Norfolk Lake U.S.A. 131 E4
Norg Neth. 52 G1
Norge *country* Europe *see* Norway
Norheimsund Norway 45 E6
Noril'sk Rus. Fed. 64 J3
Norkyung China 83 G3
Norma Co *l.* China 83 G2
Norman U.S.A. 131 D5
Norman, Lake *resr* U.S.A. 132 D5
Normanby Island P.N.G. 110 E1
Normandes, Îles *is* English Chan. *see* Channel Islands
Normandia Brazil 143 G3
Normandie *reg.* France *see* Normandy
Normandie, Collines de *hills* France 56 D2
Normandy *reg.* France 56 D2
Normanton Australia 110 C3
Norquay Canada 121 K5
Ñorquinco Arg. 144 B6
Norra Kvarken *strait* Fin./Sweden 44 L5
Norra Storfjället *mts* Sweden 44 I4
Norrent-Fontes France 52 C4
Norris Lake U.S.A. 134 D5
Norristown U.S.A. 135 H3
Norrköping Sweden 45 J7
Norrtälje Sweden 45 K7
Norseman Australia 109 C8
Norsjö Sweden 44 K4
Norsk Rus. Fed. 74 C1
Norsup Vanuatu 107 G3
Norte, Punta *pt* Arg. 144 E5
Norte, Serra do *hills* Brazil 143 G6
Nortelândia Brazil 143 G6
Nörten-Hardenberg Germany 53 J3
North, Cape Antarctica 152 H2
North, Cape Canada 123 J5
Northallerton U.K. 48 F4
Northam Australia 109 B7
Northampton Australia 106 B4
Northampton U.K. 49 G6
Northampton *MA* U.S.A. 135 I2
Northampton *PA* U.S.A. 135 H3
North Andaman *i.* India 71 A4
North Anna *r.* U.S.A. 135 G5
North Arm *b.* Canada 120 H2
North Atlantic Ocean Atlantic Ocean 125 O4
North Augusta U.S.A. 133 D5
North Aulatsivik Island Canada 123 J2
North Australian Basin *sea feature* Indian Ocean 149 P6
North Baltimore U.S.A. 134 D3
North Battleford Canada 121 I4
North Bay Canada 122 F5
North Belcher Islands Canada 122 F2
North Berwick U.K. 50 G4
North Berwick U.S.A. 135 J2
North Bourke Australia 112 B3
North Branch U.S.A. 130 E2
North Caicos *i.* Turks and Caicos Is 133 G8
North Canton U.S.A. 134 E3
North Cape Canada 123 I5
North Cape Norway 44 N1
North Cape N.Z. 113 D2
North Cape U.S.A. 118 C4
North Caribou Lake Canada 121 N4
North Carolina *state* U.S.A. 132 E4
North Cascades National Park U.S.A. 126 C2
North Channel *lake channel* Canada 122 E5
North Channel U.K. 51 G2
North Charleston U.S.A. 133 E5
North Chicago U.S.A. 134 B2
Northcliffe Glacier Antarctica 152 F2
North Collins U.S.A. 135 F2
North Concho *r.* U.S.A. 131 C6
North Conway U.S.A. 135 J1
North Dakota *state* U.S.A. 130 C2
North Downs *hills* U.K. 49 G7
North East U.S.A. 134 F2
Northeast Foreland *c.* Greenland *see* Nordostrundingen
North-East Frontier Agency *state* India *see* Arunachal Pradesh
Northeast Pacific Basin *sea feature* N. Pacific Ocean 151 J4
Northeast Providence Channel Bahamas 133 E7
North Edwards U.S.A. 128 E4
Nortleim Germany 53 J3
Northern *prov.* S. Africa *see* Limpopo
Northern Areas *admin.* Pak. 89 I2
Northern Cape *prov.* S. Africa 100 D5
Northern Donets *r.* Rus. Fed./Ukr. *see* Severskiy Donets
Northern Dvina *r.* Rus. Fed. *see* Severnaya Dvina
Northern Indian Lake Canada 121 L3
Northern Ireland *prov.* U.K. 51 F3

Northern Lau Group *is* Fiji 107 I3
Northern Light Lake Canada 122 C4

▶Northern Mariana Islands *terr.* N. Pacific Ocean 69 K3
United States Commonwealth.
Oceania 8, 104–105

Northern Rhodesia *country* Africa *see* Zambia
Northern Sporades *is* Greece *see* Voreies Sporades
Northern Territory *admin. div.* Australia 106 D3
Northern Transvaal *prov.* S. Africa *see* Limpopo
North Esk *r.* U.K. 50 G4
Northfield *MN* U.S.A. 130 E2
Northfield *VT* U.S.A. 135 I1
North Foreland *c.* U.K. 49 I7
North Fork U.S.A. 128 D3
North Fork Pass Canada 118 E3
North French *r.* Canada 122 E4
North Frisian Islands Germany 47 L3
North Geomagnetic Pole Arctic Ocean 119 K2
North Grimston U.K. 48 G4
North Haven U.S.A. 135 I3
North Head *hd* U.K. 51 I3
North Henik Lake Canada 121 L2
North Hero U.S.A. 135 I1
North Horr Kenya 98 D3
North Island India 84 B4

▶North Island N.Z. 113 D4
3rd largest island in Oceania.

North Jadito Canyon *gorge* U.S.A. 129 H4
North Judson U.S.A. 134 B3
North Kingsville U.S.A. 134 E3
North Knife *r.* Canada 121 M3
North Knife Lake Canada 121 L3
▶North Korea *country* Asia 75 B5
Asia 6, 62–63
North Lakhimpur India 83 H4
North Las Vegas U.S.A. 129 F3
North Little Rock U.S.A. 131 E5
North Loup *r.* U.S.A. 130 D3
North Luangwa National Park Zambia 99 D5
North Maalhosmadulu Atoll Maldives 84 B5
North Magnetic Pole Canada 153 A1
North Malosmadulu Atoll Maldives *see* North Maalhosmadulu Atoll
North Mam Peak U.S.A. 129 J2
North Muskegon U.S.A. 134 B2
North Palisade *mt.* U.S.A. 128 D3
North Perry U.S.A. 134 E3
North Platte U.S.A. 130 C3
North Platte *r.* U.S.A. 130 C3
North Pole Arctic Ocean 153 I1
North Port U.S.A. 133 D7
North Reef Island India 71 A4
North Rhine - Westphalia *land* Germany *see* Nordrhein-Westfalen
North Rim U.S.A. 129 G3
North Rona *i.* U.K. *see* Rona
North Ronaldsay *i.* U.K. 50 G1
North Ronaldsay Firth *sea chan.* U.K. 50 G1
North Saskatchewan *r.* Canada 121 J4
North Schell Peak U.S.A. 129 F2
North Sea Europe 46 H2
North Seal *r.* Canada 121 L3
North Sentinel Island India 71 A5
North Shields U.K. 48 F3
North Shoal Lake Canada 121 M4
North Shoshone Peak U.S.A. 128 E2
North Siberian Lowland Rus. Fed. 64 L2
North Simlipal National Park India 83 F5
North Sinai *governorate* Egypt *see* Shamāl Sīnā'
North Slope *plain* U.S.A. 118 D3
North Somercotes U.K. 48 H5
North Spirit Lake Canada 121 M4
North Stradbroke Island Australia 112 F1
North Sunderland U.K. 48 F3
North Syracuse U.S.A. 135 G2
North Taranaki Bight *b.* N.Z. 113 E4
Northton U.K. 50 B3
North Tonawanda U.S.A. 135 F2
North Troy U.S.A. 135 I1
North Tyne *r.* U.K. 48 E4
North Uist *i.* U.K. 50 B3
Northumberland National Park U.K. 48 E3
Northumberland Strait Canada 123 I5
North Vancouver Canada 120 F5
North Vernon U.S.A. 134 C4
Northville U.S.A. 135 H2
North Wabasca Lake Canada 120 H3
North Walsham U.K. 49 I6
Northway *prov.* S. Africa 100 E4
Northway Junction U.S.A. 120 A2
Northwest Atlantic Mid-Ocean Channel N. Atlantic Ocean 148 E1
North West Cape Australia 108 A5
North West Frontier *prov.* Pak. 89 H3
North West Nelson Forest Park *nat. park* N.Z. *see* Kahurangi National Park
Northwest Pacific Basin *sea feature* N. Pacific Ocean 150 G3
Northwest Providence Channel Bahamas 133 E7
North West River Canada 123 K3
Northwest Territories *admin. div.* Canada 120 J2
Northwich U.K. 48 E5
North Wildwood U.S.A. 135 H4
North Windham U.S.A. 135 J2
Northwind Ridge *sea feature* Arctic Ocean 153 B1
Northwood U.S.A. 135 J2
North York Canada 134 F2
North York Moors *moorland* U.K. 48 G4
North York Moors National Park U.K. 48 G4
Norton U.K. 48 G4
Norton *KS* U.S.A. 130 D4
Norton *VA* U.S.A. 134 D5

Norton *VT* U.S.A. 135 J1
Norton de Matos Angola *see* Balombo
Norton Shores U.S.A. 134 B2
Norton Sound *sea chan.* U.S.A. 118 B3
Nortonville U.S.A. 134 B5
Norvegia, Cape Antarctica 152 B2
Norwalk *CT* U.S.A. 135 I3
Norwalk *OH* U.S.A. 134 D3
▶Norway *country* Europe 44 E6
Europe 5, 38–39
Norway House Canada 121 L4
Norwegian Basin *sea feature* N. Atlantic Ocean 148 H1
Norwegian Bay Canada 119 I2
Norwegian Sea N. Atlantic Ocean 153 H2
Norwich Canada 134 E2
Norwich U.K. 49 I6
Norwich *CT* U.S.A. 135 I3
Norwich *NY* U.S.A. 135 H2
Norwood U.S.A. 135 H1
Norwood *CO* U.S.A. 129 I2
Norwood *NY* U.S.A. 135 H1
Norwood *OH* U.S.A. 134 C4
Nose Lake Canada 121 I1
Noshiro Japan 75 F4
Nosovaya Rus. Fed. 42 L1
Noşratābād Iran 89 E4
Noss, Isle of *i.* U.K. 50 [inset]
Nossebro Sweden 45 H7
Nossen Germany 53 N3
Nossob *watercourse* Africa 100 D2
also known as Nosop
Notakwanon *r.* Canada 123 J2
Notch Peak U.S.A. 129 G2
Noteć *r.* Poland 47 O4
Noto, Golfo di *g.* Sicily Italy 58 F6
Notodden Norway 45 F7
Noto-hantō *pen.* Japan 75 E5
Notre Dame, Monts *mts* Canada 123 H5
Notre Dame Bay Canada 123 L4
Notre-Dame-de-Koartac Canada *see* Quaqtaq
Nottawasaga Bay Canada 134 E1
Nottaway *r.* Canada 122 F4
Nottingham U.K. 49 F6
Nottingham Island Canada 119 K3
Nottoway *r.* U.S.A. 135 G5
Nottuln Germany 53 H3
Notukeu Creek *r.* Canada 121 J5
Nouabalé-Ndoki, Parc National *nat. park* Congo 98 B3
Nouâdhibou Mauritania 96 B2
Nouâdhibou, Râs *c.* Mauritania 96 B2

▶Nouakchott Mauritania 96 B3
Capital of Mauritania.

Nouâmghâr Mauritania 96 B3
Nouei Vietnam 70 D4

▶Nouméa New Caledonia 107 G4
Capital of New Caledonia.

Nouna Burkina 96 C3
Noupoort S. Africa 100 G6
Nousu Fin. 44 P3
Nouveau-Brunswick *prov.* Canada *see* New Brunswick
Nouveau-Comptoir Canada *see* Wemindji
Nouvelle Calédonie *i.* S. Pacific Ocean 107 G4
Nouvelle Calédonie *terr.* S. Pacific Ocean *see* New Caledonia
Nouvelle-France, Cap de *c.* Canada 119 K3
Nouvelles Hébrides *country* S. Pacific Ocean *see* Vanuatu
Nova América Brazil 145 A1
Nova Chaves Angola *see* Muconda
Nova Freixa Moz. *see* Cuamba
Nova Friburgo Brazil 145 C3
Nova Gaia Angola *see* Cambundi-Catembo
Nova Goa India *see* Panaji
Nova Gradiška Croatia 58 G2
Nova Iguaçu Brazil 145 C3
Nova Kakhovka Ukr. 59 O1
Nova Lima Brazil 145 C2
Nova Lisboa Angola *see* Huambo
Nova Mambone Moz. 99 D6
Nova Nabúri Moz. 99 D5
Nova Odesa Ukr. 43 F7
Nova Paraíso Brazil 142 F3
Nova Pilão Arcado Brazil 143 J5
Nova Ponte Brazil 145 B2
Nova Ponte, Represa *resr* Brazil 145 B2
Novara Italy 58 C2
Nova Roma Brazil 145 B1
Nova Scotia *prov.* Canada 123 I6
Nova Sento Sé Brazil 143 J5
Novato U.S.A. 128 B2
Nova Trento Brazil 145 A4
Nova Venécia Brazil 145 C2
Nova Xavantino Brazil 143 H6
Novaya Kakhovka Ukr. *see* Nova Kakhovka
Novaya Kazanka Kazakh. 41 P6
Novaya Ladoga Rus. Fed. 42 F3
Novaya Lyalya Rus. Fed. 41 S4
Novaya Odessa Ukr. *see* Nova Odesa
Novaya Sibir', Ostrov *i.* Rus. Fed. 65 P2
Novaya Ussura Rus. Fed. 74 E2

▶Novaya Zemlya *is* Rus. Fed. 64 G2
3rd largest island in Europe.

Nova Zagora Bulg. 59 L3
Novelda Spain 57 F4
Nové Zámky Slovakia 47 Q7
Novgorod Rus. Fed. *see* Velikiy Novgorod
Novgorod-Severskiy Ukr. *see* Novhorod-Sivers'kyy
Novgorod-Volynskiy Ukr. *see* Novohrad-Volyns'kyy
Novi Grad Bos.-Herz. *see* Bosanski Novi
Novi Iskŭr Bulg. 59 J3
Novikovo Rus. Fed. 74 F3
Novi Kritsim Bulg. *see* Stamboliyski
Novi Ligure Italy 58 C2

Novi Pazar Bulg. 59 L3
Novi Pazar Serb. and Mont. 59 I3
Novi Sad Serb. and Mont. 59 H2
Novo Acre Brazil 145 D1
Novoalekseyevka Kazakh. *see* Khobda
Novoaltaysk Rus. Fed. 72 E2
Novoanninskiy Rus. Fed. 43 I6
Novo Aripuanã Brazil 142 F5
Novoazovs'k Ukr. 43 H7
Novo Cruzeiro Brazil 145 C2
Novodugino Rus. Fed. 42 G5
Novodvinsk Rus. Fed. 42 I2
Novoekonomicheskoye Ukr. *see* Dymytrov
Novogeorgiyevka Rus. Fed. 74 B2
Novogrudok Belarus *see* Navahrudak
Novo Hamburgo Brazil 145 A5
Novohradské hory *mts* Czech Rep. 47 O6
Novohrad-Volyns'kyy Ukr. 43 E6
Novokhopersk Rus. Fed. 43 I6
Novokiyevskiy Uval Rus. Fed. 74 C2
Novokubansk Rus. Fed. 91 F1
Novokubanskiy Rus. Fed. *see* Novokubansk
Novokuybyshevsk Rus. Fed. 43 K5
Novokuznetsk Rus. Fed. 72 F2
Novolazarevskaya *research station* Antarctica 152 C2
Novolukoml' Belarus *see* Novalukoml'
Novo Mesto Slovenia 58 F2
Novomikhaylovskiy Rus. Fed. 90 E1
Novomoskovsk Rus. Fed. 43 H5
Novomoskovs'k Ukr. 43 G6
Novonikolayevsk Rus. Fed. *see* Novosibirsk
Novonikolayevskiy Rus. Fed. 43 I6
Novooleksiyivka Ukr. 43 G7
Novopashiyskiy Rus. Fed. *see* Gornozavodsk
Novopokrovka Rus. Fed. 74 D3
Novopokrovskaya Rus. Fed. 43 I7
Novopolotsk Belarus *see* Navapolatsk
Novopskov Ukr. 43 H6
Novo Redondo Angola *see* Sumbe
Novorossiysk Rus. Fed. 74 C1
Novorossiysk Rus. Fed. 90 E1
Novorybnaya Rus. Fed. 65 L2
Novorzhev Rus. Fed. 42 F4
Novoselovo Rus. Fed. 72 G1
Novoselovo Rus. Fed. *see* Achkhoy-Martan
Novosel'ye Rus. Fed. 45 P7
Novosergiyevka Rus. Fed. 41 Q5
Novoshakhtinsk Rus. Fed. 43 H7
Novosheshminsk Rus. Fed. 42 K5
Novosibirsk Rus. Fed. 64 J4
Novosibirskiye Ostrova *is* Rus. Fed. *see* New Siberia Islands
Novosil' Rus. Fed. 43 H5
Novoskol'niki Rus. Fed. 42 F4
Novospasskoye Rus. Fed. 43 J5
Novotroyits'ke Ukr. 43 G7
Novoukrainka Ukr. *see* Novoukrayinka
Novoukrayinka Ukr. 43 F6
Novouzensk Rus. Fed. 43 K6
Novovolyns'k Ukr. 43 E6
Novovoronezh Rus. Fed. 43 H6
Novovoronezhskiy Rus. Fed. *see* Novovoronezh
Novo-Voskresenovka Rus. Fed. 74 B1
Novozybkov Rus. Fed. 43 F5
Nový Jičín Czech Rep. 47 P6
Novyy Afon Georgia *see* Akhali Ap'oni
Novyy Bor Rus. Fed. 42 L2
Novyy Donbass Ukr. *see* Dymytrov
Novyye Petushki Rus. Fed. *see* Petushki
Novyy Kholmogory Rus. Fed. *see* Archangel
Novyy Margelan Uzbek. *see* Farg'ona
Novyy Nekouz Rus. Fed. 42 H4
Novyy Oskol Rus. Fed. 43 H6
Novyy Port Rus. Fed. 64 I3
Novyy Urengoy Rus. Fed. 64 I3
Novyy Urgal Rus. Fed. 74 D2
Novyy Uzen' Kazakh. *see* Zhanaozen
Novyy Zay Rus. Fed. 42 L5
Now Iran 88 D2
Nowabad Bangl. *see* Nawabganj
Nowata U.S.A. 131 E4
Nowdī Iran 88 C2
Nowgong India *see* Nagaon
Now Kharegan Iran 88 D2
Nowleye Lake Canada 121 K2
Nowra Australia 112 E5
Nowrangapur India *see* Nabarangapur
Nowshera Pak. 89 I3
Nowyak Lake Canada 121 L2
Nowy Sącz Poland 47 R6
Nowy Targ Poland 47 R6
Noxen U.S.A. 135 G3
Noy, Xé *r.* Laos 70 D3
Noyabr'sk Rus. Fed. 64 I3
Noyes Island U.S.A. 120 C4
Noyon France 52 C5
Nozizwe S. Africa 101 G6
Nqamakwe S. Africa 101 H7
Nqutu S. Africa 101 J5
Nsanje Malawi 99 D5
Nsombo Zambia 99 C5
Nsukka Nigeria 96 D4
Ntha S. Africa 101 H5
Ntoro, Kavo *pt* Greece 59 K5
Ntoum Gabon 98 A3
Ntungamo Uganda 98 D4
Nuanetsi Zimbabwe *see* Mwenezi
Nu'aym *reg.* Oman 88 D6
Nuba Mountains Sudan 86 D7
Nubian Desert Sudan 86 D5
Nudo Coropuna *mt.* Peru 142 D7
Nueces *r.* U.S.A. 131 D7
Nueltin Lake Canada 121 L2
Nueva Ciudad Guerrero Mex. 131 D7
Nueva Gerona Cuba 137 H4
Nueva Harberton Arg. 144 C8
Nueva Imperial Chile 144 B5
Nueva Loja Ecuador *see* Lago Agrio
Nueva Rosita Mex. 131 C7

Nueva San Salvador El Salvador 136 G6
Nueva Villa de Padilla Mex. 131 D7
Nueve de Julio Arg. *see* 9 de Julio
Nuevitas Cuba 137 I4
Nuevo, Golfo *g.* Arg. 144 D6
Nuevo Casas Grandes Mex. 127 G7
Nuevo Ideal Mex. 131 B7
Nuevo Laredo Mex. 131 D7
Nuevo León Mex. 129 F5
Nuevo León *state* Mex. 131 D7
Nuevo Rocafuerte Ecuador 142 C4
Nugaal *watercourse* Somalia 98 E3
Nugget Point N.Z. 113 B8
Nugur India 84 D2
Nuguria Islands P.N.G. 106 F2
Nuh, Ras *pt* Pak. 89 F5
Nuhaka N.Z. 113 F4
Nui *atoll* Tuvalu 107 H2
Nui Con Voi *r.* Vietnam *see* Red
Nui Thanh Vietnam 70 E4
Nui Ti On *mt.* Vietnam 70 D4
Nujiang China 76 C2
Nu Jiang *r.* China/Myanmar *see* Salween
Nukey Bluff *hill* Australia 111 A7
Nukha Azer. *see* Şäki

▶Nuku'alofa Tonga 107 I4
Capital of Tonga.

Nukufetau *atoll* Tuvalu 107 H2
Nukuhiva *i.* Fr. Polynesia *see* Nuku Hiva
Nuku Hiva *i.* Fr. Polynesia 151 K6
Nukuhu P.N.G. 69 L8
Nukulaelae *atoll* Tuvalu 107 H2
Nukulailai *atoll* Tuvalu *see* Nukulaelae
Nukumanu Islands P.N.G. 107 F2
Nukunau *i.* Kiribati *see* Nikunau
Nukunono *atoll* Tokelau *see* Nukunonu
Nukunonu *atoll* Tokelau 107 I2
Nukus Uzbek. 80 A3
Nulato U.S.A. 118 C3
Nullagine Australia 108 C5
Nullarbor Australia 109 E7
Nullarbor National Park Australia 109 E7
Nullarbor Plain Australia 109 E7
Nullarbor Regional Reserve *park* Australia 109 E7
Nuluarniavik, Lac *l.* Canada 122 F2
Nulu'erhu Shan *mts* China 73 L4
Num *i.* Indon. 69 J7
Numalla, Lake *salt flat* Australia 112 B2
Numan Nigeria 96 E4
Numanuma P.N.G. 110 E1
Numazu Japan 75 E6
Numbulwar Australia 110 A2
Numedal *valley* Norway 45 F6
Numfoor *i.* Indon. 69 I7
Numin He *r.* China 74 B3
Numto Rus. Fed. 41 T3
Numurkah Australia 112 B6
Nunaksaluk Island Canada 123 J3
Nunakuluut *i.* Greenland 119 N3
Nunap Isua *c.* Greenland *see* Farewell, Cape
Nunarsuit *i.* Greenland *see* Nunakuluut
Nunavik *reg.* Canada 122 G1
Nunavut *admin. div.* Canada 121 L2
Nunda U.S.A. 135 G2
Nundle Australia 112 E3
Nuneaton U.K. 49 F6
Nungba India 83 H4
Nungesser Lake Canada 121 M5
Nungnain Sum China 73 L3
Nunivak Island U.S.A. 118 B4
Nunkapasi India 84 E1
Nunkun *mt.* Jammu and Kashmir 82 D2
Nunligran Rus. Fed. 65 T3
Nuñomoral Spain 57 C3
Nunspeet Neth. 52 F2
Nuojiang China *see* Tongjiang
Nuoro *Sardinia* Italy 58 C4
Nupani *i.* Solomon Is 107 G3
Nuqrah Saudi Arabia 86 F4
Nur *r.* Iran 88 D2
Nūrābād Iran 88 C3
Nurakita *i.* Tuvalu *see* Niulakita
Nurata Uzbek. *see* Nurota
Nur Dağları *mts* Turkey 85 B1
Nurek Tajik. *see* Norak
Nurek Reservoir Tajik. *see* Norak, Obanbori
Nureksoye Vodokhranilishche *resr* Tajik. *see* Norak, Obanbori
Nuremberg Germany 53 L5
Nuri Mex. 127 F7
Nurla Jammu and Kashmir 82 D2
Nurlat Rus. Fed. 43 K5
Nurmes Fin. 44 P5
Nurmo Fin. 44 M5
Nürnberg Germany *see* Nuremberg
Nurota Uzbek. 80 C3
Nurri, Mount *hill* Australia 112 C3
Nusawulan Indon. 69 I7
Nusaybin Turkey 91 F3
Nu Shan *mts* China 76 C3
Nushki Pak. 89 G4
Nusratiye Turkey 85 D1
Nutak Canada 123 J2
Nutarawit Lake Canada 121 L2
Nutrioso U.S.A. 129 I5
Nuttal Pak. 89 H4
Nutwood Downs Australia 108 F3
Nutzotin Mountains U.S.A. 120 A2

▶Nuuk Greenland 119 M3
Capital of Greenland.

Nuupas Fin. 44 O3
Nuussuaq Greenland 119 M2
Nuussuaq *pen.* Greenland 119 M2
Nuwaybi' al Muzayyinah Egypt 90 D5
Nuweiba el Muzeina Egypt *see* Nuwaybi' al Muzayyinah
Nuwerus S. Africa 100 D6
Nuweveldberge *mts* S. Africa 100 E7
Nuyts, Point Australia 109 B8
Nuyts Archipelago *is* Australia 109 F8
Nuzvid India 84 D2
Nwanedi Nature Reserve S. Africa 101 J2
Nxai Pan National Park Botswana 99 C5
Nyagan' Rus. Fed. 41 T3

Nyagquka China *see* Yajiang
Nyagrong China *see* Xinlong
Nyahururu Kenya 98 D3
Nyah West Australia 112 A5
Nyainqêntanglha Feng *mt.* China 83 G3
Nyainqêntanglha Shan *mts* China 83 G3
Nyainrong China 76 B1
Nyainronglung China *see* Nyainrong
Nyåker Sweden 44 K5
Nyakh Rus. Fed. *see* Nyagan'
Nyaksimvol' Rus. Fed. 41 S3
Nyala Sudan 97 F3
Nyalam China *see* Congdü
Nyalikungu Tanz. *see* Maswa
Nyamandhlovu Zimbabwe 99 C5
Nyamtumbo Tanz. 99 D5
Nyande Zimbabwe *see* Masvingo
Nyandoma Rus. Fed. 42 I3
Nyandomskiy Vozvyshennost' *hills* Rus. Fed. 42 H3
Nyanga Congo 98 B4
Nyanga Zimbabwe 99 D5
Nyangbo China 76 B2
Nyarling *r.* Canada 120 H2

▶Nyasa, Lake Africa 99 D4
3rd largest lake in Africa.

Nyasaland *country* Africa *see* Malawi
Nyashabozh Rus. Fed. 42 L2
Nyasvizh Belarus 45 O10
Nyaungdon Myanmar *see* Yandoon
Nyaunglebin Myanmar 70 B3
Nyborg Denmark 45 G9
Nyborg Norway 44 P1
Nybro Sweden 45 I8
Nyeboe Land *reg.* Greenland 119 M1
Nyêmo China 83 G3
Nyenchen Tangla Range *mts* China *see* Nyainqêntanglha Shan
Nyeri Kenya 98 D4
Nyi, Co *l.* China 83 F3
Nyika National Park Zambia 99 D5
Nyima China 83 F3
Nyimba Zambia 99 D5
Nyingchi China 76 B2
Nyinma China *see* Maqu
Nyíregyháza Hungary 43 D7
Nyiru, Mount Kenya 98 D3
Nykarleby Fin. 44 M5
Nykøbing Denmark 45 G9
Nykøbing Sjælland Denmark 45 G9
Nyköping Sweden 45 J7
Nyland Sweden 44 J5
Nylsvley *nature res.* S. Africa 101 I3
Nymagee Australia 112 C4
Nymboida National Park Australia 112 F2
Nynäshamn Sweden 45 J7
Nyngan Australia 112 C3
Nyogzê China 83 E3
Nyoman *r.* Belarus/Lith. 45 M10
also known as Neman or Nemunas
Nyon Switz. 56 H3
Nyons France 56 G4
Nýřany Czech Rep. 53 N5
Nyrob Rus. Fed. 41 R3
Nysa Poland 47 P5
Nysh Rus. Fed. 74 F2
Nyssa U.S.A. 126 D4
Nystad Fin. *see* Uusikaupunki
Nytva Rus. Fed. 41 R4
Nyuksenitsa Rus. Fed. 42 J3
Nyunzu Dem. Rep. Congo 99 C4
Nyurba Rus. Fed. 65 M3
Nyyskiy Zaliv *lag.* Rus. Fed. 74 F1
Nzambi Congo 98 B4
Nzega Tanz. 99 D4
Nzérékoré Guinea 96 C4
N'zeto Angola 99 B4
Nzwani *i.* Comoros 99 E5

Oahe, Lake U.S.A. 130 C2
O'ahu *i.* U.S.A. 127 [inset]
Oaitupu *i.* Tuvalu *see* Vaitupu
Oak Bluffs U.S.A. 135 J3
Oak City U.S.A. 129 G2
Oak Creek U.S.A. 129 J1
Oakdale U.S.A. 131 E6
Oakes U.S.A. 130 D2
Oakey Australia 112 E1
Oak Grove *KY* U.S.A. 134 B5
Oak Grove *LA* U.S.A. 131 F5
Oak Grove *MI* U.S.A. 134 C1
Oakham U.K. 49 G6
Oak Harbor U.S.A. 134 D3
Oak Hill *OH* U.S.A. 134 D4
Oak Hill *WV* U.S.A. 134 E4
Oakhurst U.S.A. 128 D3
Oak Lake Canada 121 K5
Oakland *CA* U.S.A. 128 B3
Oakland *MD* U.S.A. 134 F4
Oakland *ME* U.S.A. 135 K1
Oakland *NE* U.S.A. 130 D3
Oakland *OR* U.S.A. 126 C4
Oakland *airport* U.S.A. 128 B3
Oakland City U.S.A. 134 B4
Oaklands Australia 112 C5
Oak Lawn U.S.A. 134 B3
Oakley U.S.A. 130 C4
Oakover *r.* Australia 108 C5
Oak Park *IL* U.S.A. 134 B3
Oak Park *MI* U.S.A. 134 C2
Oak Park Reservoir U.S.A. 129 I1
Oakridge U.S.A. 126 C4
Oak Ridge U.S.A. 132 C4
Oakvale Australia 111 C7
Oak View U.S.A. 128 D4
Oakville Canada 134 F2
Oakwood *OH* U.S.A. 134 C3
Oakwood *TN* U.S.A. 134 B5
Oamaru N.Z. 113 C7
Oaro N.Z. 113 D6
Oasis *CA* U.S.A. 128 E3
Oasis *NV* U.S.A. 126 E4
Oates Coast *reg.* Antarctica *see* Oates Land
Oates Land *reg.* Antarctica 152 H2
Oaxaca Mex. 136 E5

Orono U.S.A. 132 G2
Orontes r. Asia 90 E3 see 'Āşī, Nahr al
Orontes r. Lebanon/Syria 85 C2
Oroqen Zizhiqi China see Alihe
Oroquieta Phil. 69 G5
Orós, Açude resr Brazil 143 K5
Orosei, Golfo di b. Sardinia Italy 58 C4
Orosháza Hungary 59 I1
Oroville U.S.A. 128 C2
Oroville, Lake U.S.A. 128 C2
Orqohan China 74 A2
Orr U.S.A. 130 E1
Orsa Sweden 45 I6
Orsha Belarus 43 F5
Orshanka Rus. Fed. 42 J4
Orsk Rus. Fed. 64 G4
Ørsta Norway 44 E5
Ørta Toroslar plat. Turkey 85 A1
Ortegal, Cabo c. Spain 57 C2
Orthez France 56 D5
Ortigueira Spain 57 C2
Ortiz Mex. 127 F7
Ortles mt. Italy 58 D1
Orton U.K. 48 E4
Ortona Italy 58 F3
Ortonville U.S.A. 130 D2
Ortospana Afgh. see Kābul
Orulgan, Khrebet mts Rus. Fed. 65 N3
Orumbo Namibia 100 C2
Orūmīyeh Iran see Urmia
Oruro Bol. 142 E7
Orūzgān Afgh. 89 G3
Orvieto Italy 58 E3
Orville Coast Antarctica 152 L1
Orwell OH U.S.A. 134 E3
Orwell VT U.S.A. 135 I2
Oryol Rus. Fed. see Orel
Os Norway 44 G5
Osa, Península de pen. Costa Rica 137 H7
Osage IA U.S.A. 130 E3
Osage WV U.S.A. 134 E4
Osage WY U.S.A. 128 G3
Ōsaka Japan 75 D6
Osakarovka Kazakh. 80 D1
Osawatomie U.S.A. 130 E4
Osborne U.S.A. 130 D4
Osby Sweden 45 H8
Osceola IA U.S.A. 130 E3
Osceola MO U.S.A. 130 E4
Osceola NE U.S.A. 130 D3
Oschatz Germany 53 N3
Oschersleben (Bode) Germany 53 L2
Oschiri Sardinia Italy 58 C4
Ösel i. Estonia see Hiiumaa
Osetr r. Rus. Fed. 43 H5
Ose-zaki pt Japan 75 C6
Osgoode Canada 135 H1
Osgood Mountains U.S.A. 126 D4
Osh Kyrg. 80 D3
Oshakati Namibia 99 B5
Oshawa Canada 135 F2
Oshika-hantō pen. Japan 75 F5
Ō-shima i. Japan 74 E4
Ō-shima i. Japan 75 E6
Oshkosh NE U.S.A. 130 C3
Oshkosh WI U.S.A. 134 A1
Oshmyany Belarus see Ashmyany
Oshnoviyeh Iran 88 B2
Oshtorān Kūh mt. Iran 88 C3
Oshwe Dem. Rep. Congo 98 B4
Osijek Croatia 58 H2
Osilinka r. Canada 120 E3
Osimo Italy 58 E3
Osipenko Ukr. see Berdyans'k
Osipovichi Belarus see Asipovichy
Osiyan India 82 C4
Osizweni S. Africa 101 J4
Osječenica mts Bos.-Herz. 58 G2
Osjön l. Sweden 44 I5
Oskaloosa U.S.A. 130 E3
Oskarshamn Sweden 45 J8
Oskemen Kazakh. see
 Ust'-Kamenogorsk

▶Oslo Norway 45 G7
 Capital of Norway.

Oslofjorden sea chan. Norway 45 G7
Osmanabad India 84 C2
Osmancık Turkey 90 D2
Osmaneli Turkey 59 M4
Osmaniye Turkey 90 E3
Osmannagar India 84 C2
Os'mino Rus. Fed. 45 P7
Osnabrück Germany 53 I2
Osnaburg atoll Fr. Polynesia see Mururoa
Osogbo Nigeria see Oshogbo
Osogovska Planina mts Bulg./Macedonia
 59 J3
Osogovske Planine mts Bulg./Macedonia
 see Osogovska Planina
Osogovski Planini mts Bulg./Macedonia see
 Osogovska Planina
Osorno Chile 144 B6
Osorno Spain 57 D2
Osoyoos Canada 120 G5
Osøyri Norway 45 D6
Osprey Reef Australia 110 D2
Oss Neth. 52 F3
Ossa, Mount Australia 111 [inset]
Osseo U.S.A. 122 C5
Ossineke U.S.A. 134 D1
Ossining U.S.A. 135 I3
Oßmannstedt Germany 53 L3
Ossora Rus. Fed. 65 R4
Ostashkov Rus. Fed. 42 G4
Ostbevern Germany 53 H2
Oste r. Germany 53 J1
Ostend Belgium 52 C3
Ostende Belgium see Ostend
Osterburg (Altmark) Germany 53 L2
Osterbymo Sweden 45 I8
Osterdalälven l. Sweden 45 H6
Østerdalen valley Norway 45 G5
Osterfeld Germany 53 L3
Osterholz-Scharmbeck Germany 53 I1
Osterode am Harz Germany 53 K3

Österreich country Europe see Austria
Östersund Sweden 44 I5
Osterwieck Germany 53 K3
Ostfriesische Inseln Germany see
 East Frisian Islands
Ostfriesland reg. Germany 53 H1
Östhammar Sweden 45 K6
Ostrava Czech Rep. 47 Q6
Ostróda Poland 47 Q4
Ostrogozhsk Rus. Fed. 43 H6
Ostrov Czech Rep. 53 M4
Ostrov Rus. Fed. 45 P8
Ostrovets Poland see
 Ostrowiec Świętokrzyski
Ostrovskoye Rus. Fed. 42 I4
Ostrov Vrangelya i. Rus. Fed. see
 Wrangel Island
Ostrów Poland see
 Ostrów Wielkopolski
Ostrowiec Poland see
 Ostrowiec Świętokrzyski
Ostrowiec Świętokrzyski
 Poland 43 D6
Ostrów Mazowiecka Poland 47 R4
Ostrowo Poland see
 Ostrów Wielkopolski
Ostrów Wielkopolski Poland 47 P5
O'Sullivan Lake Canada 122 D4
Osūm r. Bulg. 59 K3
Ōsumi-shotō is Japan 75 C7
Osuna Spain 57 D5
Oswego KS U.S.A. 131 E4
Oswego NY U.S.A. 135 G2
Oswestry U.K. 49 D6
Otago Peninsula N.Z. 113 C7
Otahiti i. Fr. Polynesia see Tahiti
Otaki N.Z. 113 E5
Otanmäki Fin. 44 O4
Otaru Japan 74 F4
Otavi Namibia 99 B5
Ōtawara Japan 75 F5
Otdia atoll Marshall Is see Wotje
Otelnuc, Lac l. Canada 123 H2
Otematata N.Z. 113 C7
Otepää Estonia 45 O7
Otgon Tenger Uul mt. Mongolia 80 I2
Otinapa Mex. 131 B7
Otira N.Z. 113 C6
Otis U.S.A. 130 C3
Otish, Monts hills Canada 123 H4
Otjinene Namibia 99 B6
Otjiwarongo Namibia 99 B6
Otjozondjupa admin. reg.
 Namibia 100 C1
Otley U.K. 48 F5
Otorohanga N.Z. 113 E4
Otoskwin r. Canada 121 N4
Otpan, Gora hill Kazakh. 91 H1
Otpor Rus. Fed. see Zabaykal'sk
Otradnoye Rus. Fed. see Otradnyy
Otradnyy Rus. Fed. 43 K5
Otranto Italy 58 H4
Otranto, Strait of Albania/Italy 58 H4
Otrogovo Rus. Fed. see Stepnoye
Otrozhnyy Rus. Fed. 65 S3
Otsego Lake U.S.A. 135 H2
Ōtsu Japan 75 D6
Otta Norway 45 F6

▶Ottawa Canada 135 H1
 Capital of Canada.

Ottawa r. Canada 122 G5
 also known as Rivière des Outaouais
Ottawa IL U.S.A. 130 F3
Ottawa KS U.S.A. 130 E4
Ottawa OH U.S.A. 134 C3
Ottawa Islands Canada 122 E2
Otter r. Canada 122 D4
Otter r. U.K. 49 D8
Otterbein U.S.A. 134 B3
Otterburn U.K. 48 E3
Otter Rapids Canada 122 E4
Ottersberg Germany 53 J1
Ottignies Belgium 52 E4
Ottumwa U.S.A. 130 E3
Ottweiler Germany 53 H5
Otukpa Nigeria 96 D4
Otukpo Nigeria see Otukpo
Otuzco Peru 142 C5
Otway, Cape Australia 112 A7
Otway National Park Australia 112 A7
Ouachita r. U.S.A. 131 F6
Ouachita, Lake U.S.A. 131 E5
Ouachita Mountains Arkansas/Oklahoma
 U.S.A. 131 E5
Ouadda Cent. Afr. Rep. 98 C3
Ouaddaï reg. Chad 97 F3

▶Ouagadougou Burkina 96 C3
 Capital of Burkina.

Ouahigouya Burkina 96 C3
Ouahran Alg. see Oran
Ouaka r. Cent. Afr. Rep. 98 B3
Oualâta Mauritania 96 C3
Ouallam Niger 96 D3
Ouanda-Djailé Cent. Afr. Rep. 98 C3
Ouando Cent. Afr. Rep. 98 C3
Ouango Cent. Afr. Rep. 98 C3
Ouara r. Cent. Afr. Rep. 98 C3
Ouarâne reg. Mauritania 96 C2
Ouargaye Burkina 96 D3
Ouargla Alg. 54 F5
Ouarra r. Cent. Afr. Rep. 98 C3
Ouarzazate Morocco 54 C5
Oubangui r.
 Cent. Afr. Rep./Dem. Rep. Congo see
 Ubangi
Oubergpas pass S. Africa 100 G7
Oudenaarde Belgium 52 D4
Oudtshoorn S. Africa 100 F7
Oud-Turnhout Belgium 52 E3
Ouessant, Île d' i. France 56 B2
Ouesso Congo 98 B3
Ouezzane Morocco 57 D6
Oughter, Lough l. Ireland 51 E3
Ouguati Namibia 100 B1
Ouistreham France 49 G9
Oujda Morocco 57 F6

Oujeft Mauritania 96 B3
Oulainen Fin. 44 N4
Oulangan kansallispuisto nat. park
 Fin. 44 P3
Ouled Djellal Alg. 57 I6
Ouled Farès Alg. 57 G5
Ouled Naïl, Monts des mts Alg. 57 H6
Oulu Fin. 44 N4
Oulujärvi l. Fin. 44 O4
Oulujoki r. Fin. 44 N4
Oulunsalo Fin. 44 N4
Oulx Italy 58 B2
Oum-Chalouba Chad 97 F3
Oum el Bouaghi Alg. 58 B7
Oum-Hadjer Chad 97 E3
Oundle U.K. 49 G6
Oungre Canada 121 K5
Ounianga Kébir Chad 97 F3
Oupeye Belgium 52 F4
Our r. Lux. 52 G5
Oura, Akrotirio pt Greece 59 L5
Ouray CO U.S.A. 129 J2
Ouray UT U.S.A. 129 I1
Ourcq r. France 52 D5
Ourense Spain 57 C2
Ouricuri Brazil 143 J5
Ourinhos Brazil 145 A3
Ouro r. Brazil 145 A1
Ouro Preto Brazil 145 C3
Ourthe r. Belgium 52 F4
Ous Rus. Fed. 41 S3
Ouse r. England U.K. 48 G5
Ouse r. England U.K. 49 H8
Outaouais, Rivière des r. Canada 122 G5
 see Ottawa
Outardes r. Canada 123 H4
Outardes Quatre, Réservoir resr Canada
 123 H4
Outer Hebrides is U.K. 50 B3
Outer Mongolia country Asia see
 Mongolia
Outer Santa Barbara Channel U.S.A.
 128 D5
Outjo Namibia 99 B6
Outlook Canada 121 J5
Outokumpu Fin. 44 P5
Out Skerries is U.K. 50 [inset]
Ouvéa atoll New Caledonia 107 G4
Ouyanghai Shuiku resr China 77 G3
Ouyen Australia 111 C7
Ouzel r. U.K. 49 G7
Ovace, Punta d' mt. Corsica France 56 I6
Ovada Italy 58 C2
Ovalle Chile 144 B4
Ovamboland reg. Namibia 99 B5
Ovan Gabon 98 B3
Ovar Port. 57 B3
Overath Germany 53 H4
Överkalix Sweden 44 M3
Overlander Roadhouse Australia 109 A6
Overland Park U.S.A. 130 E4
Overton U.S.A. 129 F3
Övertorneå Sweden 44 M3
Överum Sweden 45 J8
Overveen Neth. 52 E2
Ovid CO U.S.A. 130 C3
Ovid NY U.S.A. 135 G2
Oviedo Spain 57 D2
Ovoot Mongolia 73 K3
Øvre Anárjohka Nasjonalpark nat. park
 Norway 44 N2
Øvre Dividal Nasjonalpark nat. park
 Norway 44 K2
Øvre Rendal Norway 45 G6
Ovruch Ukr. 43 F6
Ovsyanka Rus. Fed. 74 B1
Owa Rafa i. Solomon Is see Santa Ana
Owando Congo 98 B4
Owase Japan 75 E6
Owatonna U.S.A. 130 E2
Owbeh Afgh. 89 F3
Owego U.S.A. 135 G2
Owel, Lough l. Ireland 51 E4
Owen Island Myanmar 71 B5
Owenmore r. Ireland 51 C3
Owenmore r. Ireland 51 D3
Owenreagh r. U.K. 51 E3
Owen River N.Z. 113 D5
Owens r. U.S.A. 128 E3
Owensboro U.S.A. 134 B5
Owen Sound Canada 134 E1
Owen Sound inlet Canada 134 E1
Owenton U.S.A. 134 C4
Owerri Nigeria 96 D4
Owikeno Lake Canada 120 E5
Owingsville U.S.A. 134 D4
Owl r. Canada 121 M3
Owl Creek Mountains U.S.A. 126 F4
Owo Nigeria 96 D4
Owosso U.S.A. 134 C2
Owyhee U.S.A. 126 D4
Owyhee r. U.S.A. 126 D4
Owyhee Mountains U.S.A. 126 D4
Öxarfjörður b. Iceland 44 [inset]
Oxbow Canada 121 K5
Ox Creek r. U.S.A. 130 C1
Oxelösund Sweden 45 J7
Oxford N.Z. 113 D6
Oxford U.K. 49 F7
Oxford IN U.S.A. 134 B3
Oxford MD U.S.A. 135 G4
Oxford MS U.S.A. 131 F5
Oxford NC U.S.A. 132 E4
Oxford NY U.S.A. 135 H2
Oxford OH U.S.A. 134 C4
Oxford House Canada 121 M4
Oxford Lake Canada 121 M4
Oxley Australia 112 B5
Oxleys Peak Australia 112 E3
Oxley Wild Rivers National Park
 Australia 112 F3
Ox Mountains hills Ireland see
 Slieve Gamph
Oxnard U.S.A. 128 D4
Oxtongue Lake Canada 135 F1
Oxus r. Asia see Amudar'ya
Øya Norway 44 H3
Oya Norway 44 H3

Oyama Japan 75 E5
Oyapock r. Brazil/Fr. Guiana 143 H3
Oyem Gabon 98 B3
Oyen Canada 121 I5
Oygon Mongolia 80 I2
Oykel r. U.K. 50 E3
Oymyakon Rus. Fed. 65 P3
Oyo Nigeria 96 D4
Oyonnax France 56 G3
Oyster Rocks is India 84 B3
Oyten Germany 53 J1
Oytograk China 83 E1
Oyukludağı mt. Turkey 85 A1
Özalp Turkey 91 G3
Ozamiz Phil. 69 G5
Ozark AL U.S.A. 133 C6
Ozark AR U.S.A. 131 E5
Ozark MO U.S.A. 131 E4
Ozark Plateau U.S.A. 131 E4
Ozarks, Lake of the U.S.A. 130 E4
O'zbekiston country Asia see Uzbekistan
Özen Kazakh. see Kyzylsay
Ozernovskiy Rus. Fed. 65 Q4
Ozernyy Rus. Fed. 43 G5
Ozerpakh Rus. Fed. 74 F1
Ozersk Rus. Fed. 45 M9
Ozerskiy Rus. Fed. 74 F3
Ozery Rus. Fed. 43 H5
Ozeryane Rus. Fed. 74 C2
Ozieri Sardinia Italy 58 C4
Ozinki Rus. Fed. 43 K6
Oznachennoye Rus. Fed. see
 Sayanogorsk
Ozona U.S.A. 131 C6
Ozuki Japan 75 C6

 P

Paamiut Greenland 119 N3
Pa-an Myanmar see Hpa-an
Paanopa i. Kiribati see Banaba
Paarl S. Africa 100 D7
Paatsjoki r. Europe see Patsoyoki
Paballelo S. Africa 100 E5
P'abal-li N. Korea 74 C4
Pabbay i. U.K. 50 B3
Pabianice Poland 47 Q5
Pabianitz Poland see Pabianice
Pabna Bangl. 83 G4
Pabradė Lith. 45 N9
Pab Range mts Pak. 89 G5
Pacaás Novos, Parque Nacional nat. park
 Brazil 142 F6
Pacaraima, Serra mts S. America see
 Pakaraima Mountains
Pacasmayo Peru 142 C5
Pachagarh Bangl. see Panchagarh
Pacheco Chihuahua Mex. 127 F7
Pacheco Zacatecas Mex. 131 C7
Pachikha Rus. Fed. 42 J3
Pachino Sicily Italy 58 F6
Pachmarhi India 82 D5
Pachora India 84 B1
Pachpadra India 82 C4
Pachuca Mex. 136 E4
Pachuca de Soto Mex. see Pachuca
Pacific-Antarctic Ridge sea feature
 S. Pacific Ocean 151 I9
Pacific Grove U.S.A. 128 C3

▶Pacific Ocean 150
 Largest ocean in the world.

Pacific Rim National Park Canada 120 E5
Pacitan Indon. 68 E8
Packsaddle Australia 111 C6
Pacoval Brazil 143 H4
Pacuí r. Brazil 145 B2
Padali Rus. Fed. see Amursk
Padang Indon. 68 C7
Padang i. Indon. 71 C7
Padang Endau Malaysia 71 C7
Padangpanjang Indon. 68 C7
Padangsidimpuan Indon. 71 B7
Padany Rus. Fed. 42 R4
Padatha, Küh-e mt. Iran 88 C3
Padauung Myanmar 70 A3
Padcaya Bol. 142 F8
Paddington Australia 112 B4
Paden City U.S.A. 134 E4
Paderborn Germany 53 I3
Paderborn/Lippstadt airport
 Germany 53 I3
Padeșu, Vârful mt. Romania 59 J2
Padibyu Myanmar 70 A2
Padilla Bol. 142 F7
Padjelanta nationalpark nat. park
 Sweden 44 J3
Padova Italy see Padua
Padrão, Ponta pt Angola 99 B4
Padrauna India 83 F4
Padre Island U.S.A. 131 D7
Padstow U.K. 49 C8
Padsvillye Belarus 45 O9
Padua India 84 D2
Padua Italy 58 D2
Paducah KY U.S.A. 131 F4
Paducah TX U.S.A. 131 C5
Padum Jammu and Kashmir 82 D2
Paegam N. Korea 74 C4
Paektu-san mt. China/N. Korea see
 Baotou Shan
Paengnyŏng-do i. S. Korea 75 B5
Pafos Cyprus see Paphos
Pafuri Moz. 101 J2
Pag Croatia 58 F2
Pag i. Croatia 58 F2
Paga Indon. 108 C2
Pagadian Phil. 69 G5
Pagai Selatan i. Indon. 68 C7
Pagai Utara i. Indon. 68 C7
Pagalu i. Equat. Guinea see Annobón
Pagan i. N. Mariana Is 69 L3
Pagasitikos Kolpos b. Greece 59 J5
Pagatan Indon. 68 F7
Page U.S.A. 129 H3
Paget, Mount S. Georgia 144 I8
Paget Cay reef Australia 110 F3

Pagon i. N. Mariana Is see Pagan
Pagosa Springs U.S.A. 127 G5
Pagqên China see Gadê
Pagwa River Canada 122 D4
Pagwi P.N.G. 69 K7
Pahala U.S.A. 127 [inset]
Pahang r. Malaysia 71 C7
Pahlgam Jammu and Kashmir 82 C2
Pāhoa U.S.A. 127 [inset]
Pahokee U.S.A. 133 D7
Pahra Kariz Afgh. 89 F3
Pahranagat Range mts U.S.A. 129 F3
Pahrump U.S.A. 129 F3
Pahuj r. India 82 D4
Pahute Mesa plat. U.S.A. 128 E3
Pai Thai. 70 B3
Paicines U.S.A. 128 C3
Paide Estonia 45 N7
Paignton U.K. 49 D8
Paiko r. Fin. 45 N6
Paikü Co l. China 83 F3
Pailin Cambodia 71 C4
Paimio Fin. 45 M6
Painel Brazil 145 A4
Painesville U.S.A. 134 E3
Painted Desert U.S.A. 129 H3
Painted Rock Dam U.S.A. 129 G5
Paint Hills Canada see Wemindji
Paint Rock U.S.A. 131 D6
Paintsville U.S.A. 134 D5
Paisley U.K. 50 E5
Paita Peru 142 B5
Paitou China 77 I2
Paiva Couceiro Angola see Quipungo
Paizhou China 77 G2
Pajala Sweden 44 M3
Paka Malaysia 71 C6
Pakala India 84 C3
Pakanbaru Indon. see Pekanbaru
Pakangyi Myanmar 70 A2
Pakaraima Mountains
 S. America 142 F3
Pakaur India 83 F4
Pakesley Canada 122 E5
Pakhachi Rus. Fed. 65 R3
Pakhoi China see Beihai
Paki Nigeria 96 D3

▶Pakistan country Asia 89 H4
 4th most populous country in Asia.
 Asia 6, 62–63

Pakkat Indon. 71 B7
Paknampho Thai. see Nakhon Sawan
Pakokku Myanmar 70 A2
Pakowki Lake imp. l. Canada 121 I5
Pakpattan Pak. 89 I4
Pak Phanang Thai. 71 C5
Pak Phayun Thai. 71 C6
Pakruojis Lith. 45 M9
Paks Hungary 59 H1
Pakse Laos see Pakxe
Pak Tam Chung H.K. China 77 [inset]
Pak Thong Chai Thai. 70 C4
Pakur India see Pakaur
Pakxan Laos 70 C3
Pakxé Laos 70 D4
Pakxeng Laos 70 C3
Pala Chad 97 E4
Pala Myanmar 71 B4
Palaestina reg. Asia see Palestine
Palaiochora Greece 59 J7
Palaiseau France 52 C6
Palakkad India 84 C4
Palakkat India see Palghat
Palamakoloi Botswana 100 F2
Palamós Spain 57 H3
Palamu India 83 F5
Palana Rus. Fed. 65 Q4
Palandur India 84 D1
Palangān, Kūh-e mts Iran 89 F4
Palangkaraya Indon. 68 E7
Palani India 84 C4
Palanpur India 82 C4
Palapye Botswana 101 H2
Palatka Rus. Fed. 65 Q3
Palatka U.S.A. 133 D6

▶Palau country N. Pacific Ocean 69 I5
 Asia 6, 62–63

Palau Islands Palau 69 I5
Palauk Myanmar 71 B4
Palaw Myanmar 71 B4
Palawan i. Phil. 68 F5
Palawan Passage strait Phil. 68 E5
Palawan Trough sea feature
 N. Pacific Ocean 150 D5
Palayankottai India 84 C4
Palchal Lake India 84 D2
Paldiski Estonia 45 N7
Palekh Rus. Fed. 42 I4
Palembang Indon. 68 C7
Palena Chile 144 B6
Palencia Spain 57 D2
Palermo Sicily Italy 58 E5
Palestine reg. Asia 85 B3
Palestine U.S.A. 131 E6
Paletwa Myanmar 70 A2
Palezgir Chauki Pak. 89 H4
Palghat India 84 C4
Palgrave, Mount hill Australia 109 A5
Palhoça Brazil 145 A4
Pali Chhattisgarh India 84 D1
Pali Mahar. India 84 B2
Pali Rajasthan India 82 C4

Palk Bay Sri Lanka 84 C4
Palkino Rus. Fed. 45 P8
Palkonda Range mts India 84 C3
Palk Strait India/Sri Lanka 84 C4
Palla Bianca mt. Austria/Italy see
 Weißkugel
Pallamallawa Australia 112 E2
Pallas Green Ireland 51 D5
Pallas ja Ounasturin kansallispuisto
 nat. park Fin. 44 M2
Pallasovka Rus. Fed. 43 J6
Pallavaram India 84 D3
Palliser, Cape N.Z. 113 E5
Palliser, Îles is Fr. Polynesia 151 K7
Palliser Bay N.Z. 113 E5
Pallu India 82 C3
Palma r. Brazil 145 B1
Palma del Río Spain 57 D5
Palmaner India 84 C3
Palma de Mallorca Spain 57 H4
Palmares Brazil 143 K5
Palmares do Sul Brazil 145 A5
Palmas Brazil 145 A4
Palmas 142 I6
Palmas, Cape Liberia 96 C4
Palm Bay U.S.A. 133 D7
Palmdale U.S.A. 128 D4
Palmeira Brazil 145 A4
Palmeira das Missões Brazil 144 F3
Palmeira dos Índios Brazil 143 K5
Palmeiras Brazil 143 J5
Palmeiras Brazil 145 C3
Palmeirinhas, Ponta das pt
 Angola 99 B4
Palmer research station Antarctica 152 L2
Palmer r. Australia 110 C3
Palmer watercourse Australia 109 F6
Palmer U.S.A. 118 D3
Palmer Land reg. Antarctica 152 L2
Palmerston N.T. Australia 108 E3
Palmerston N.T. Australia see Darwin
Palmerston Canada 134 E2
Palmerston atoll Cook Is 107 J3
Palmerston N.Z. 113 C7
Palmerston North N.Z. 113 E5
Palmerton U.S.A. 135 H3
Palmerville Australia 110 D2
Palmetto Point Bahamas 133 E7
Palmi Italy 58 F5
Palmira Col. 142 C3
Palmira Cuba 133 D8
Palm Springs U.S.A. 128 E5
Palmyra Syria see Tadmur
Palmyra MO U.S.A. 130 F4
Palmyra PA U.S.A. 135 G3
Palmyra VA U.S.A. 135 F5

▶Palmyra Atoll terr. N. Pacific Ocean
 150 J5
 United States Unincorporated Territory.

Palmyras Point India 83 F5
Palni Hills India 84 C4
Palo Alto U.S.A. 128 B3
Palo Blanco Mex. 131 C7
Palo Chino watercourse Mex. 127 E7
Palo Duro watercourse U.S.A. 131 C5
Paloich Sudan 86 D7
Palojärvi Fin. 44 M2
Palojoensuu Fin. 44 M2
Palomaa Fin. 44 O2
Palomar Mountain U.S.A. 128 E5
Paloncha India 84 D2
Palo Pinto U.S.A. 131 D5
Palopo Indon. 69 G7
Palos, Cabo de c. Spain 57 F5
Palo Verde U.S.A. 129 F5
Paltamo Fin. 44 O4
Palu Indon. 68 F7
Palu i. Indon. 108 C2
Palu Turkey 91 E3
Pal'vart Turkm. 89 G2
Palwal India 82 D3
Palwancha India see Paloncha
Palyeskaya Nizina marsh Belarus/Ukr. see
 Pripet Marshes

▶Pamana i. Indon. 108 C2
 Most southerly point of Asia.

Pambarra Moz. 101 L1
Pambula Australia 112 D6
Pamidi India 84 C3
Pamiers France 56 E5
Pamir mts Asia 89 I2
Pamlico Sound sea chan. U.S.A. 133 E5
Pamouscachiou, Lac l. Canada 123 H4
Pampa U.S.A. 131 C5
Pampa de Infierno Arg. 144 D3
Pampas reg. Arg. 144 D5
Pampeluna Spain see Pamplona
Pamphylia reg. Turkey 59 N6
Pamplin U.S.A. 135 F5
Pamplona Col. 142 D2
Pamplona Spain 57 F2
Pampow Germany 53 L1
Pamukova Turkey 59 N4
Pamzal Jammu and Kashmir 82 D2
Pana U.S.A. 130 F4
Panaca U.S.A. 129 F3
Panache, Lake Canada 122 E5
Panagyurishte Bulg. 59 K3
Panaitan i. Indon. 68 D8
Panaji India 84 B3

▶Panama country Central America 137 H7
 North America 9, 116–117

Panamá Panama see Panama City
Panamá, Canal de Panama 137 I7
Panamá, Golfo de Panama see
 Panama, Gulf of
Panama, Gulf of Panama 137 I7
Panama, Isthmus of Panama 137 I7
Panamá, Istmo de Panama see
 Panama, Isthmus of

▶Panama City Panama 137 I7
 Capital of Panama.

Panama City U.S.A. 133 C6
Panamint Range mts U.S.A. 128 E3
Panamint Valley U.S.A. 128 E3
Panao Peru 142 C5

Placerville CA U.S.A. 128 C2
Placerville CO U.S.A. 129 I2
Placetas Cuba 133 E8
Plácido de Castro Brazil 142 E6
Plain Dealing U.S.A. 131 E5
Plainfield CT U.S.A. 135 J3
Plainfield IN U.S.A. 134 B4
Plainfield VT U.S.A. 135 I1
Plains KS U.S.A. 131 C4
Plains TX U.S.A. 131 C5
Plainview U.S.A. 131 C5
Plainville IN U.S.A. 134 B4
Plainville KS U.S.A. 130 D4
Plainwell U.S.A. 134 C2
Plaka, Akra pt Kriti Greece see
 Plaka, Akrotirio
Plaka, Akrotirio pt Greece 59 L7
Plakoti, Cape Cyprus 85 B2
Plamondon Canada 121 H4
Planá Czech Rep. 53 M5
Plana Cays is Bahamas 133 F8
Planada U.S.A. 128 C3
Planaltina Brazil 145 B1
Plane r. Germany 53 M2
Plankinton U.S.A. 130 D3
Plano U.S.A. 131 D5
Planura Brazil 145 A3
Plaquemine U.S.A. 131 F6
Plasencia Spain 57 C3
Plaster City U.S.A. 129 F5
Plaster Rock Canada 123 I5
Plastun Rus. Fed. 74 E3
Platani r. Sicily Italy 58 E6
Platberg mt. S. Africa 101 I5

▶Plateau Antarctica
 Lowest recorded annual mean temperature
 in the world.
 World 16–17

Platina U.S.A. 128 B1
Platinum U.S.A. 153 B3
Plato Col. 142 D2
Platte r. U.S.A. 130 E3
Platte City U.S.A. 130 E4
Plattling Germany 53 M6
Plattsburgh U.S.A. 135 I1
Plattsmouth U.S.A. 130 E3
Plau Germany 53 M1
Plauen Germany 53 M4
Plauer See l. Germany 53 M1
Plavsk Rus. Fed. 43 H5
Playa Noriega, Lago l. Mex. 127 F7
Playas Ecuador 142 B4
Playas Lake U.S.A. 129 I6
Plây Ku Vietnam 71 E4
Pleasant, Lake U.S.A. 129 G5
Pleasant Bay U.S.A. 135 K3
Pleasant Grove U.S.A. 129 H1
Pleasant Hill Lake U.S.A. 134 D3
Pleasanton U.S.A. 131 D6
Pleasant Point N.Z. 113 C7
Pleasantville U.S.A. 135 H4
Pleasure Ridge Park U.S.A. 134 C4
Pleaux France 56 F4
Pledger Lake Canada 122 E4
Plei Doch Vietnam 71 E4
Plei Kần Vietnam 70 D4
Pleinfeld Germany 53 K5
Pleiße r. Germany 53 M3
Plenty watercourse Australia 110 B5
Plenty, Bay of g. N.Z. 113 F3
Plentywood U.S.A. 126 G2
Plesetsk Rus. Fed. 42 I3
Pleshchentsy Belarus see Plyeshchanitsy
Plétipi, Lac l. Canada 123 H4
Plettenberg Germany 53 H3
Plettenberg Bay S. Africa 100 F8
Pleven Bulg. 59 K3
Plevna Bulg. see Pleven
Pljevlja Serb. and Mont. 59 H3
Płock Poland 47 Q4
Pločno mt. Bos.-Herz. 58 G3
Plodovoye Rus. Fed. 42 F3
Ploemeur France 56 C3
Ploieşti Romania see Ploieşti
Ploieşti Romania 59 L2
Plomb du Cantal mt. France 56 F4
Ploskoye Rus. Fed. see Stanovoye
Płoty Poland 47 O4
Ploudalmézeau France 56 B2
Plouzané France 56 B2
Plovdiv Bulg. 59 K3
Plover Cove Reservoir H.K. China 77 [inset]
Płozk Poland see Płock
Plum U.S.A. 134 F4
Plumridge Lakes salt flat Australia 109 D7
Plungė Lith. 45 L9
Plutarco Elías Calles, Presa resr
 Mex. 127 F7
Pluto, Lac l. Canada 123 H3
Plyeshchanitsy Belarus 45 O9
Ply Huey Wati, Khao mt. Myanmar/Thai.
 70 B3

▶Plymouth Montserrat 137 L5
 Capital of Montserrat, largely abandoned in
 1997 owing to volcanic activity.

Plymouth U.K. 49 C8
Plymouth CA U.S.A. 128 C2
Plymouth IN U.S.A. 134 B3
Plymouth MA U.S.A. 135 J3
Plymouth NC U.S.A. 132 E5
Plymouth NH U.S.A. 135 J2
Plymouth WI U.S.A. 134 B2
Plymouth Bay U.S.A. 135 J3
Plynlimon hill U.K. 49 D6
Plyussa Rus. Fed. 45 P7
Plzeň Czech Rep. 47 N6
Pô Burkina 96 C3
Po r. Italy 58 E2
Pô, Parc National de nat. park
 Burkina 96 C3
Pobeda Peak China/Kyrg. 80 F3
Pobedy, Pik mt. China/Kyrg. see
 Pobeda Peak
Pocahontas U.S.A. 131 F4
Pocatello U.S.A. 126 E4
Pochala Sudan 97 G3
Pochayiv Ukr. 43 E6
Pochep Rus. Fed. 43 G5

Pochinki Rus. Fed. 43 J5
Pochinok Rus. Fed. 43 G5
Pochutla Mex. 136 E5
Pocking Germany 47 N6
Pocklington U.K. 48 G5
Poções Brazil 145 C1
Pocomoke City U.S.A. 135 H4
Pocomoke Sound b. U.S.A. 135 H5
Poconé Brazil 143 G7
Pocono Mountains hills U.S.A. 135 H3
Pocono Summit U.S.A. 135 H3
Poços de Caldas Brazil 145 B3
Podanur India 84 C4
Poddor'ye Rus. Fed. 42 F4
Podgorenskiy Rus. Fed. 43 H6

▶Podgorica Montenegro 59 H3
 Capital of Montenegro.

Podgornoye Rus. Fed. 64 J4
Podile India 84 C3
Podişul Transilvaniei plat. Romania see
 Transylvanian Basin
Podkamennaya Tunguska r.
 Rus. Fed. 65 K3
Podocarpus, Parque Nacional nat.
 park Ecuador 142 C4
Podol'sk Rus. Fed. 43 H5
Podporozh'ye Rus. Fed. 42 G3
Podujevë Serb. and Mont. see Podujevo
Podujevo Serb. and Mont. 59 I3
Podz' Rus. Fed. 42 K3
Poelela, Lagoa l. Moz. 101 L3
Poeppel Corner salt flat Australia 111 B5
Poetovio Slovenia see Ptuj
Pofadder S. Africa 100 D5
Pogar Rus. Fed. 43 G5
Poggibonsi Italy 58 D3
Poggio di Montieri mt. Italy 58 D3
Pogradec Albania 59 I4
Pogranichnik Afgh. 89 F3
Pogranichnyy Rus. Fed. 74 C3
Po Hai g. China see Bo Hai
P'ohang S. Korea 75 C5
Pohnpei atoll Micronesia 150 G5
Pohri India 82 D4
Poi India 83 H4
Poiana Mare Romania 59 J3
Poinsett, Cape Antarctica 152 F2
Point Arena U.S.A. 128 B2
Point au Fer Island U.S.A. 131 F6
Pointe a la Hache U.S.A. 131 F6
Pointe-à-Pitre Guadeloupe 137 L5
Pointe-Noire Congo 99 B4
Point Hope U.S.A. 118 B3
Point Lake Canada 120 H1
Point of Rocks U.S.A. 126 F4
Point Pelee National Park Canada 134 D3
Point Pleasant NJ U.S.A. 135 H3
Point Pleasant WV U.S.A. 134 D4
Poitiers France 56 E3
Poitou reg. France 56 E3
Poix-de-Picardie France 52 B5
Pojuca r. Brazil 145 D1
Pokaran India 82 B4
Pokataroo Australia 112 D2
Pokcha Rus. Fed. 41 R3
Pokhara Nepal 83 E3
Pokhvistnevo Rus. Fed. 41 Q5
Pok Liu Chau i. H.K. China see
 Lamma Island
Poko Dem. Rep. Congo 98 C3
Pokosnoye Rus. Fed. 72 I1
Pokran Pak. 89 G5
P'ok'r Kovkas mts Asia see Lesser Caucasus
Pokrovka Chitinskaya Oblast' Rus. Fed. 74 A1
Pokrovka Primorskiy Kray Rus. Fed. 74 C4
Pokrovsk Respublika Sakha Rus. Fed. 65 N3
Pokrovsk Saratovskaya Oblast' Rus. Fed. see
 Engel's
Pokrovskoye Rus. Fed. 43 H7
Pokshen'ga r. Rus. Fed. 42 J3
Pol India 82 C5
Pola Croatia see Pula
Polacca Wash watercourse U.S.A. 129 H4
Pola de Lena Spain 57 D2
Pola de Siero Spain 57 D2
▶Poland country Europe 40 J5
 Europe 5, 38–39
Poland NY U.S.A. 135 H2
Poland OH U.S.A. 134 E3
Polar Plateau Antarctica 152 A1
Polatlı Turkey 90 D3
Polatsk Belarus 45 P9
Polavaram India 84 D2
Polcirkeln Sweden 44 L3
Pol-e 'Alam 89 H3
Pol-e Fāsā Iran 88 D4
Pol-e Khātūn Iran 89 F2
Pol-e Khomrī Afgh. 89 H3
Pol-e Safīd Iran 88 D2
Polessk Rus. Fed. 45 L9
Poles'ye marsh Belarus/Ukr. see
 Pripet Marshes
Polgahawela Sri Lanka 84 D5
Poli Cyprus see Polis
Poliaigos i. Greece see Polyaigos
Police Poland 47 O4
Policoro Italy 58 G4
Poligny France 56 G3
Polikastron Greece see Polykastro
Polillo Islands Phil. 69 G3
Polis Cyprus 85 A2
Polis'ke Ukr. 43 F6
Polis'kyy Zapovidnyk nature res. Ukr. 43 F6
Politovo Rus. Fed. 42 K2
Políyiros Greece see Polygyros
Polkowice Poland 47 P5
Pollachi India 84 C4
Pollard Islands U.S.A. see
 Gardner Pinnacles
Polle Germany 53 J3
Pollino, Monte mt. Italy 58 G5
Pollino, Parco Nazionale del Italy 58 G5
Pollock Pines U.S.A. 128 C2
Pollock Reef Australia 109 C8
Polmak Norway 44 O1
Polnovat Rus. Fed. 41 T3
Polo Fin. 44 P4
Poloat atoll Micronesia see Puluwat
Pologi Ukr. see Polohy
Polohy Ukr. 43 H7

Polokwane S. Africa 101 I2
Polonne Ukr. 43 E6
Polonnoye Ukr. see Polonne
Polotsk Belarus see Polatsk
Polperro U.K. 49 C8
Polska country Europe see Poland
Polson U.S.A. 126 E3
Polta r. Rus. Fed. 42 I2
Poltava Ukr. 43 G6
Poltoratsk Ahal Turkm. see Aşgabat
Poltoratsk Turkm. see Aşgabat
Põltsamaa Estonia 45 N7
Polunochnoye Rus. Fed. 41 S3
Põlva Estonia 45 O7
Polvadera U.S.A. 127 G6
Polvijärvi Fin. 44 P5
Polyaigos i. Greece 59 K6
Polyanovgrad Bulg. see Karnobat
Polyarnyy Chukotskiy Avtonomnyy Okrug
 Rus. Fed. 65 S3
Polyarnyy Murmanskaya Oblast'
 Rus. Fed. 44 R2
Polyarnyye Zori Rus. Fed. 44 R3
Polyarnyy Ural mts Rus. Fed. 41 S2
Polygyros Greece 59 J4
Polykastro Greece 59 J4
Polynesia is Pacific Ocean 150 I6
Polynésie Française terr. S. Pacific Ocean
 see French Polynesia
Pom Indon. 69 J7
Pomarkku Fin. 45 M6
Pombal Pará Brazil 143 H4
Pombal Paraíba Brazil 143 K5
Pombal Port. 57 B4
Pomene Moz. 101 L2
Pomeranian Bay Poland 47 O3
Pomeroy S. Africa 101 J5
Pomeroy U.K. 51 F3
Pomeroy OH U.S.A. 134 D4
Pomeroy WA U.S.A. 126 D3
Pomezia Italy 58 E4
Pomfret S. Africa 100 F3
Pomona Namibia 100 B4
Pomona U.S.A. 128 E4
Pomorie Bulg. 59 L3
Pomorskie, Pojezierze reg. Poland 47 O4
Pomorskiy Bereg coastal area
 Rus. Fed. 42 G2
Pomorskiy Proliv sea chan. Rus. Fed. 42 K1
Pomos Point Cyprus 85 A2
Pomo Tso l. China see Puma Yumco
Pomou, Akra pt Cyprus see Pomos Point
Pomozdino Rus. Fed. 42 L3
Pompain China 76 B2
Pompano Beach U.S.A. 133 D7
Pompei Italy 58 F4
Pompéia Brazil 145 A3
Pompey France 52 G6
Pompeyevka Rus. Fed. 74 C2
Ponape atoll Micronesia see Pohnpei
Ponask Lake Canada 121 M4
Ponazyrevo Rus. Fed. 42 J4
Ponca City U.S.A. 131 D4
Ponce Puerto Rico 137 K5
Ponce de Leon Bay U.S.A. 133 D7
Poncheville, Lac l. Canada 122 F4
Pondicherry India 84 C4
Pondicherry union terr. India 84 C4
Pondichéry India see Pondicherry
Pond Inlet Canada 153 K2
Ponds Bay Canada see Pond Inlet
Ponente, Riviera di coastal area Italy 58 B3
Poneto U.S.A. 134 C3
Ponferrada Spain 57 C2
Pongara, Pointe pt Gabon 98 A3
Pongaroa N.Z. 113 F5
Pongo watercourse Sudan 97 F4
Pongola r. S. Africa 101 J4
Pongolapoort Dam l. S. Africa 101 J4
Ponnagyun Myanmar 70 A2
Ponnaivar r. India 84 C4
Ponnampet India 84 B3
Ponnani India 84 B4
Ponnyadaung Range mts Myanmar 70 A2
Pono Indon. 69 I8
Ponoka Canada 120 H4
Ponoy r. Rus. Fed. 42 I2
Pons r. Canada 123 H2

▶Ponta Delgada Arquipélago dos Açores
 148 G3
 Capital of the Azores.

Ponta Grossa Brazil 145 A4
Pontal Brazil 145 A3
Pontalina Brazil 145 A2
Pont-à-Mousson France 52 G6
Ponta Porã Brazil 144 E2
Pontarfynach U.K. see Devil's Bridge
Pont-Audemer France 49 H9
Pontault-Combault France 52 C6
Pontax r. Canada 122 F4
Pont-de-Loup Belgium 52 E4
Ponte Alta do Norte Brazil 143 I6
Ponte de Sor Port. 57 B4
Ponte Firme Brazil 145 B2
Pontefract U.K. 48 F5
Ponteix Canada 121 J5
Ponteland U.K. 48 F3
Ponte Nova Brazil 145 C3
Pontes-e-Lacerda Brazil 143 G7
Pontevedra Spain 57 B2
Ponthierville Dem. Rep. Congo see Ubundu
Pontiac IL U.S.A. 130 F3
Pontiac MI U.S.A. 134 D2
Pontiae is Italy see Ponziane, Isole
Pontianak Indon. 68 D7
Pontine Islands is Italy see Ponziane, Isole
Pont-l'Abbé France 56 B3
Pontoise France 52 C5
Ponton watercourse Australia 109 C7
Ponton Canada 121 L4
Pontotoc U.S.A. 131 F5
Pont-Ste-Maxence France 52 C5
Pontypool U.K. 49 D7
Pontypridd U.K. 49 D7
Ponza, Isola di i. Italy 58 E4
Ponziane, Isole is Italy 58 E4
Poochera Australia 109 F8
Poole U.K. 49 F8
Poole U.S.A. 134 B5

Poolowanna Lake salt flat Australia 111 B5
Poona India see Pune
Pooncarie Australia 111 C7
Poonch India see Punch
Poopelloe Lake salt l. Australia 112 B3
Poopó, Lago de l. Bol. 142 E7
Poor Knights Islands N.Z. 113 E2
Popayán Col. 142 C3
Poperinge Belgium 52 C4
Popigay r. Rus. Fed. 65 L2
Popiltah Australia 111 C7
Popilta Lake imp. l. Australia 111 C7
Poplar r. Canada 121 L4
Poplar U.S.A. 126 G2
Poplar Bluff U.S.A. 131 F4
Poplar Camp U.S.A. 134 E5
Poplarville U.S.A. 131 F6

▶Popocatépetl, Volcán vol. Mex. 136 E5
 5th highest mountain in North America.

Popokabaka Dem. Rep. Congo 99 B4
Popondetta P.N.G. 69 L8
Popovichskaya Rus. Fed. see Kalininskaya
Popovo Bulg. 59 L3
Popovo Polje plain Bos.-Herz. 58 G3
Poppberg hill Germany 53 L5
Poppenberg hill Germany 53 K3
Poprad Slovakia 47 R6
Poquoson U.S.A. 135 G5
Porali r. Pak. 89 G5
Porangahau N.Z. 113 F5
Porangatu Brazil 145 A1
Porbandar India 82 B5
Porcher Island Canada 120 D4
Porcos r. Brazil 145 B1
Porcupine, Cape Canada 123 K3
Porcupine Abyssal Plain sea feature
 N. Atlantic Ocean 148 E2
Porcupine Gorge National Park Australia
 110 D4
Porcupine Hills Canada 121 K4
Porcupine Mountains U.S.A. 130 F2
Poreč Croatia 58 E2
Porecatu Brazil 145 A3
Pori Fin. 45 L6
Porirua N.Z. 113 E5
Porkhov Rus. Fed. 45 P8
Porlamar Venez. 142 F1
Pormpuraaw Australia 110 C2
Pornic France 56 C3
Poronaysk Rus. Fed. 74 F2
Porong China 83 G3
Poros Greece 59 J6
Porosozero Rus. Fed. 42 G3
Porpoise Bay Antarctica 152 G2
Porsangerfjorden sea chan. Norway 44 N1
Porsangerhalvøya pen. Norway 44 N1
Porsgrunn Norway 45 F7
Porsuk r. Turkey 59 N5
Portadown U.K. 51 F3
Portaferry U.K. 51 G3
Portage MI U.S.A. 134 C2
Portage PA U.S.A. 135 F3
Portage WI U.S.A. 130 F3
Portage Lakes U.S.A. 134 E3
Portage la Prairie Canada 121 L5
Portal U.S.A. 130 C1
Port Alberni Canada 120 E5
Port Albert Australia 112 C7
Portalegre Port. 57 C4
Portales U.S.A. 131 C5
Port-Alfred Canada see La Baie
Port Alfred S. Africa 101 H7
Port Alice Canada 120 E5
Port Allegany U.S.A. 135 F3
Port Allen U.S.A. 131 F6
Port Alma Australia 110 E4
Port Angeles U.S.A. 126 C2
Port Antonio Jamaica 137 I5
Portarlington Ireland 51 E4
Port Arthur Australia 111 [inset]
Port Arthur U.S.A. 131 E6
Port Askaig U.K. 50 C5
Port Augusta Australia 111 B7

▶Port-au-Prince Haiti 137 J5
 Capital of Haiti.

Port Austin U.S.A. 134 D1
Port aux Choix Canada 123 K4
Portavogie U.K. 51 G3
Port Beaufort S. Africa 100 E8
Port Blair India 71 A5
Port Bolster Canada 134 F1
Portbou Spain 57 H2
Port Burwell Canada 134 E2
Port Campbell Australia 112 A7
Port Campbell National Park Australia
 112 A7
Port Carling Canada 134 F1
Port-Cartier Canada 123 I4
Port Chalmers N.Z. 113 C7
Port Charlotte U.S.A. 133 D7
Port Clements Canada 120 D4
Port Clinton U.S.A. 134 D3
Port Credit Canada 134 F2
Port-de-Paix Haiti 137 J5
Port Dickson Malaysia 71 C7
Port Douglas Australia 110 D3
Port Edward Canada 120 D4
Port Edward S. Africa 101 J6
Porteirinha Brazil 145 C1
Porteira Brazil 143 G4
Portel Brazil 143 H4
Port Elizabeth S. Africa 101 G7
Port Ellen U.K. 50 C5
Port Erin Isle of Man 48 C4
Porter Lake N.W.T. Canada 121 J2
Porter Lake Sask. Canada 121 J3
Porter Landing Canada 120 D3
Porterville S. Africa 100 D7
Porterville U.S.A. 128 D3
Port Étienne Mauritania see Nouâdhibou
Port Everglades U.S.A. see Fort Lauderdale
Port Fitzroy N.Z. 113 E3
Port Francqui Dem. Rep. Congo see Ilebo
Port-Gentil Gabon 98 A4
Port Glasgow U.K. 50 E5
Port Harcourt Nigeria 96 D4

Port Harrison Canada see Inukjuak
Porthcawl U.K. 49 D7
Port Hedland Australia 108 B5
Port Henry U.S.A. 135 I1
Port Herald Malawi see Nsanje
Porthleven U.K. 49 B8
Porthmadog U.K. 49 C6
Port Hope Canada 135 F2
Port Hope Simpson Canada 123 L3
Port Hueneme U.S.A. 128 D4
Port Huron U.S.A. 134 D2
Portimão Port. 57 B5
Port Jackson Australia see Sydney
Port Jackson inlet Australia 112 E4
Port Keats Australia see Wadeye
Port Klang Malaysia see Pelabuhan Klang
Port Läirge Ireland see Waterford
Portland N.S.W. Australia 112 D4
Portland Vic. Australia 111 C8
Portland IN U.S.A. 134 C3
Portland ME U.S.A. 135 J2
Portland MI U.S.A. 134 C2
Portland OR U.S.A. 126 C3
Portland TN U.S.A. 134 B5
Portland, Isle of pen. U.K. 49 E8
Portland Bill hd U.K. see Bill of Portland
Portland Creek Pond l. Canada 123 K4
Portland Roads Australia 110 C2
Port-la-Nouvelle France 56 F5
Portlaoise Ireland 51 E4
Port Lavaca U.S.A. 131 D6
Portlaw Ireland 51 E5
Portlethen U.K. 50 G3
Port Lincoln Australia 111 A7
Port Loko Sierra Leone 96 B4

▶Port Louis Mauritius 149 L7
 Capital of Mauritius.

Port-Lyautrey Morocco see Kénitra
Port Macquarie Australia 112 F3
Portmadoc U.K. see Porthmadog
Port McNeill Canada 120 E5
Port-Menier Canada 123 I4

▶Port Moresby P.N.G. 69 L8
 Capital of Papua New Guinea.

Portnaguran U.K. 50 C2
Portnahaven U.K. 50 C5
Port nan Giúran U.K. see Portnaguran
Port Neill Australia 111 A7
Portneuf r. Canada 123 H4
Port Nis U.K. see Port of Ness
Port Nis Scotland U.K. see Port of Ness
Port Noarlunga Australia 111 B7
Port Nolloth S. Africa 100 C5
Port Norris U.S.A. 135 H4
Port-Nouveau-Québec Canada see
 Kangiqsualujjuaq
Porto Port. see Oporto
Porto Acre Brazil 142 E5
Porto Alegre Brazil 145 A5
Porto Alexandre Angola see Tombua
Porto Amboim Angola 99 B5
Porto Amélia Moz. see Pemba
Porto Artur Brazil 143 G6
Porto Belo Brazil 145 A4
Porto de Moz Brazil 143 H4
Porto de Santa Cruz Brazil 145 C1
Portos dos Gaúchos Óbidos Brazil 143 G6
Porto Esperança Brazil 143 G7
Porto Esperidião Brazil 143 G7
Portoferraio Italy 58 D3
Portofino Italy 58 C2
Port of Ness U.K. 50 C2
Port Franco Brazil 143 I5

▶Port of Spain Trin. and Tob. 137 L6
 Capital of Trinidad and Tobago.

Porto Grande Brazil 143 H3
Portogruaro Italy 58 E2
Porto Jofre Brazil 143 G7
Portola U.S.A. 128 C2
Portomaggiore Italy 58 D2
Porto Mendes Brazil 144 F2
Porto Murtinho Brazil 144 E2
Porto Nacional Brazil 143 I6

▶Porto-Novo Benin 96 D4
 Capital of Benin.

Porto Novo Cape Verde 96 [inset]
Porto Primavera, Represa resr Brazil 144 F2
Port Orchard U.S.A. 126 C3
Port Orford U.S.A. 126 B4
Porto Rico Angola 99 B4
Porto Santo, Ilha de i. Madeira 96 B1
Porto Seguro Brazil 145 D2
Porto Tolle Italy 58 E2
Porto Torres Sardinia Italy 58 C4
Porto União Brazil 145 A4
Porto-Vecchio Corsica France 56 I6
Porto Velho Brazil 142 F5
Portoviejo Ecuador 142 B4
Portpatrick U.K. 50 D6
Port Perry Canada 135 F1
Port Phillip Bay Australia 112 B7
Port Pirie Australia 111 B7
Port Radium Canada see Echo Bay
Portreath U.K. 49 B8
Portree U.K. 50 C3
Port Rexton Canada 123 L4
Port Royal U.S.A. 135 G4
Port Royal Sound inlet U.S.A. 133 D5
Portrush U.K. 51 F2
Port Safaga Egypt see Būr Safājah
Port Said Egypt 85 A4
Port St Joe U.S.A. 133 C6
Port St Johns S. Africa 101 I6
Port St Lucie City U.S.A. 133 D7
Port St Mary Isle of Man 48 C4
Portsalon Ireland 51 E2
Port Sanilac U.S.A. 134 D2
Port Severn Canada 134 F1
Port Shepstone S. Africa 101 J6
Port Simpson Canada see Lax Kw'alaams
Portsmouth U.K. 49 F8
Portsmouth NH U.S.A. 135 J2
Portsmouth OH U.S.A. 134 D4
Portsmouth VA U.S.A. 135 G5
Portsoy U.K. 50 G3

Port Stanley Falkland Is see Stanley
Port Stephens b. Australia 112 F4
Portstewart U.K. 51 F2
Port Sudan Sudan 86 E6
Port Swettenham Malaysia see
 Pelabuhan Klang
Port Talbot U.K. 49 D7
Porttipahdan tekojärvi l. Fin. 44 O2
Port Townsend U.S.A. 126 C2

▶Portugal country Europe 57 C4
 Europe 5, 38–39

Portugália Angola see Chitato
Portuguese East Africa country Africa see
 Mozambique
Portuguese Guinea country Africa see
 Guinea-Bissau
Portuguese Timor country Asia see
 East Timor
Portuguese West Africa country Africa see
 Angola
Portumna Ireland 51 D4
Portus Herculis Monoeci country Europe
 see Monaco
Port-Vendres France 56 F5

▶Port Vila Vanuatu 107 G3
 Capital of Vanuatu.

Portville U.S.A. 135 F2
Port Vladimir Rus. Fed. 44 R2
Port Waikato N.Z. 113 E3
Port Washington U.S.A. 134 B2
Port William U.K. 50 E6
Porvenir Bol. 142 E6
Porvenir Chile 144 B8
Porvoo Fin. 45 N6
Posada Spain 57 D2
Posada de Llanera Spain see Posada
Posadas Arg. 144 E3
Posen Poland see Poznań
Posen U.S.A. 134 D1
Poseyville U.S.A. 134 B4
Poshekhon'ye Rus. Fed. 42 H4
Poshekon'ye-Volodarsk Rus. Fed. see
 Poshekhon'ye
Posht-e Badam Iran 88 D3
Poshteh-ye Chaqvir hill Iran 88 E4
Posht-e Kūh mts Iran 88 B3
Posht-e Rūd-e Zamindavar reg. Afgh. see
 Zamīndāvar
Posht Kūh hill Iran 88 C2
Posio Fin. 44 P3
Poso Indon. 69 G7
Posof Turkey 91 F2
Poşöng S. Korea 75 B6
Possession Island Namibia 100 B4
Pößneck Germany 53 L4
Post U.S.A. 131 C5
Postavy Belarus see Pastavy
Poste-de-la-Baleine Canada see
 Kuujjuarapik
Postmasburg S. Africa 100 F5
Poston U.S.A. 129 F4
Postville Canada 123 K3
Postville U.S.A. 122 C6
Post Weygand Alg. 96 D2
Postysheve Ukr. see Krasnoarmiys'k
Pota Indon. 108 C2
Pótam Mex. 127 F8
Poté Brazil 145 C2
Poteau U.S.A. 131 E5
Potegaon India 84 D2
Potentia Italy see Potenza
Potenza Italy 58 F4
Poth U.S.A. 131 D6
P'ot'i Georgia 91 F2
Potikal India 84 D2
Potiraguá Brazil 145 D1
Potiskum Nigeria 96 E3
Potlatch U.S.A. 126 D3
Pot Mountain U.S.A. 126 E3
Po Toi i. H.K. China 77 [inset]
Potomac r. U.S.A. 135 G4
Potosí Bol. 142 E7
Potosi U.S.A. 130 F4
Potosi Mountain U.S.A. 129 F4
Potrerillos Chile 144 C3
Potrero del Llano Mex. 131 B6
Potsdam Germany 53 N2
Potsdam U.S.A. 135 H1
Potter U.S.A. 130 C3
Potterne U.K. 49 E7
Potters Bar U.K. 49 G7
Potter Valley U.S.A. 128 B2
Pottstown U.S.A. 135 H3
Pottsville U.S.A. 135 G3
Pottuvil Sri Lanka 84 D5
Potwar reg. Pak. 89 I3
Pouch Cove Canada 123 L5
Poughkeepsie U.S.A. 135 I3
Poulin de Courval, Lac l. Canada 123 H4
Poulton-le-Fylde U.K. 48 E5
Pouso Alegre Brazil 145 B3
Poŭthǐsăt Cambodia 71 C4
Poŭthǐsăt, Stœng r. Cambodia 71 C4
Považská Bystrica Slovakia 47 Q6
Povenets Rus. Fed. 42 G3
Poverty Bay N.Z. 113 F4
Povlen mt. Serb. and Mont. 59 H2
Póvoa de Varzim Port. 57 B3
Povorino Rus. Fed. 43 I6
Povorotnyy, Mys hd Rus. Fed. 74 D4
Poway U.S.A. 128 E5
Powder r. U.S.A. 126 G3
Powder, South Fork r. U.S.A. 126 G4
Powell r. U.S.A. 134 D5
Powell, Lake resr U.S.A. 129 H3
Powell Lake Canada 120 E5
Powell Mountain U.S.A. 128 E2
Powell Point Bahamas 133 E7
Powell River Canada 120 E5
Powhatan AR U.S.A. 131 F4
Powhatan VA U.S.A. 135 G5
Powo China 76 C1
Pöwrize Turkm. 88 E2
Poxoréu Brazil 143 H7
Poyang China see Boyang
Poyang Hu l. China 77 H2
Poyan Reservoir Sing. 71 [inset]
Poyarkovo Rus. Fed. 74 C2
Pozanti Turkey 90 D3

Raymond U.S.A. **135** J2
Raymond Terrace Australia **112** E4
Raymondville U.S.A. **131** D7
Raymore Canada **121** J5
Rayner Glacier Antarctica **152** D2
Rayong Thai. **71** C4
Raystown Lake U.S.A. **135** F3
Raz, Pointe du *pt* France **56** B2
Razan Iran **88** C3
Rāzān Iran **88** C3
Razani Pak. **89** H3
Razāzah, Buḥayrat ar *l.* Iraq **91** F4
Razdan Armenia *see* Hrazdan
Razdel'naya Ukr. *see* Rozdil'na
Razdol'noye Rus. Fed. **74** C4
Razeh Iran **88** C3
Razgrad Bulg. **59** L3
Razim, Lacul *lag.* Romania **59** M2
Razisi China **76** D1
Razlog Bulg. **59** J4
Razmak Pak. **89** H3
Raz″yezd 3km Rus. Fed. *see* Novyy Urgal
Ré, Île de *i.* France **56** D3
Reading U.K. **49** G7
Reading *MI* U.S.A. **134** C3
Reading *OH* U.S.A. **134** D3
Reading *PA* U.S.A. **135** H3
Reagile S. Africa **101** H3
Realicó Arg. **144** D5
Réalmont France **56** F5
Reăng Kesei Cambodia **71** C4
Reate Italy *see* Rieti
Rebais France **52** D6
Rebecca, Lake *salt flat* Australia **109** C7
Rebiana Sand Sea *des.* Libya **97** F2
Reboly Rus. Fed. **44** Q5
Rebrikha Rus. Fed. **72** E2
Rebun-tō *i.* Japan **74** F3
Recherche, Archipelago of the *is*
 Australia **109** C8
Rechitsa Belarus *see* Rechytsa
Rechna Doab *lowland* Pak. **89** I4
Rechytsa Belarus **43** F5
Recife Brazil **143** L5
Recife, Cape S. Africa **101** G8
Recklinghausen Germany **53** H3
Reconquista Arg. **144** E3
Recreo Arg. **144** C3
Rectorville U.S.A. **134** D4
Red *r.* Australia **110** C3
Red *r.* Canada **120** E3
Red *r.* Canada/U.S.A. **130** D1
Red *r. TN* U.S.A. **134** B5
Red *r.* U.S.A. **131** F6
Red *r.* Vietnam **70** D2
Redang *i.* Malaysia **71** C6
Red Bank *NJ* U.S.A. **135** H3
Red Bank *TN* U.S.A. **133** C5
Red Basin China *see* Sichuan Pendi
Red Bay Canada **123** K4
Redberry Lake Canada **121** J4
Red Bluff U.S.A. **128** B1
Red Bluff Lake U.S.A. **131** C6
Red Butte *mt.* U.S.A. **129** G4
Redcar U.K. **48** F4
Redcliff Canada **126** F2
Redcliffe, Mount *hill* Australia **109** C7
Red Cliffs Australia **111** C7
Red Cloud U.S.A. **130** D3
Red Deer Canada **120** H4
Red Deer *r. Alberta/Saskatchewan*
 Canada **121** I5
Red Deer *r. Man./Sask.* Canada **121** K4
Red Deer Lake Canada **121** K4
Reddersburg S. Africa **101** H5
Redding U.S.A. **128** B1
Redditch U.K. **49** F6
Rede *r.* U.K. **48** E3
Redenção Brazil **143** H5
Redeyef Tunisia **58** C7
Redfield U.S.A. **130** D2
Red Granite Mountain Canada **120** B2
Red Hills U.S.A. **131** D4
Red Hook U.S.A. **135** I3
Red Indian Lake Canada **123** K4
Redkey U.S.A. **134** C3
Redkino Rus. Fed. **42** H4
Redknife *r.* Canada **120** G2
Red Lake U.S.A. **121** M5
Red Lake U.S.A. **129** G4
Red Lake *r.* U.S.A. **134** E5
Red Lake Falls U.S.A. **121** L6
Red Lakes U.S.A. **130** E1
Redlands U.S.A. **128** E4
Red Lion U.S.A. **135** G4
Red Lodge U.S.A. **126** F3
Redmesa U.S.A. **129** I3
Redmond *OR* U.S.A. **126** C3
Redmond *UT* U.S.A. **129** H2
Red Oak U.S.A. **130** E3
Redonda Island Canada **120** E5
Redondo Port. **57** C4
Redondo Beach U.S.A. **128** D5
Red Peak U.S.A. **126** E3
Red River, Mouths of the Vietnam **70** D2
Red Rock Canada **122** C4
Red Rock *AZ* U.S.A. **129** H5
Redrock U.S.A. **129** I5
Red Rock *PA* U.S.A. **135** G3
Redrock Lake Canada **120** H1
Red Sea Africa/Asia **86** D4
Redstone *r.* Canada **120** E1
Red Sucker Lake Canada **121** M4
Reduzum Neth. **52** F1
Redwater Canada **120** H4
Redway U.S.A. **128** B1
Red Wing U.S.A. **130** E2
Redwood City U.S.A. **128** B3
Redwood Falls U.S.A. **130** E2
Redwood National Park U.S.A. **126** B4
Redwood Valley U.S.A. **128** B2
Ree, Lough *l.* Ireland **51** E4
Reed U.S.A. **134** B5
Reed City U.S.A. **134** C2
Reedley U.S.A. **128** D3
Reedsport U.S.A. **126** B4
Reedsville U.S.A. **134** E4
Reedville U.S.A. **135** G5
Reedy U.S.A. **134** E4
Reedy Glacier Antarctica **152** J1
Reefton N.Z. **113** C6
Rees Germany **52** G3

Reese U.S.A. **134** D2
Reese *r.* U.S.A. **128** E1
Refahiye Turkey **90** E3
Refugio U.S.A. **131** D6
Regen Germany **53** N6
Regen *r.* Germany **53** M5
Regência Brazil **145** D2
Regensburg Germany **53** M5
Regenstauf Germany **53** M5
Reggane Alg. **96** D2
Reggio *Calabria* Italy *see*
 Reggio di Calabria
Reggio *Emilia-Romagna* Italy *see*
 Reggio nell'Emilia
Reggio di Calabria Italy **58** F5
Reggio Emilia Italy *see* Reggio nell'Emilia
Reggio nell'Emilia Italy **58** D2
Reghin Romania **59** K1
Regi Afgh. **89** G3
▶Regina Canada **121** J5
 Provincial capital of Saskatchewan.

Régina Fr. Guiana **143** H3
Registān *reg.* Afgh. **89** G4
Registro Brazil **144** G2
Registro do Araguaia Brazil **145** A1
Regium Lepidum Italy *see*
 Reggio nell'Emilia
Regozero Rus. Fed. **44** Q4
Rehau Germany **53** M4
Rehburg (Rehburg-Loccum)
 Germany **53** J2
Rehli India **82** D5
Rehoboth Namibia **100** C2
Rehoboth Bay U.S.A. **135** H4
Rehovot Israel **85** B4
Reibell Alg. *see* Ksar Chellala
Reibitz Germany **53** M3
Reichenbach Germany **53** M4
Reichshoffen France **53** H6
Reid Australia **109** E7
Reidh, Rubha *pt* U.K. **50** D3
Reidsville U.S.A. **132** E4
Reigate U.K. **49** G7
Reiley Peak U.S.A. **129** H5
Reims France **52** E5
Reinbek Germany **53** K1
Reindeer *r.* Canada **121** K4
Reindeer Island Canada **121** L4
Reindeer Lake Canada **121** K3
Reine Norway **44** H3
Reinosa Spain **57** D2
Reinsfeld Germany **52** G5
Reiphólsfjöll *hill* Iceland **44** [inset]
Reisaelva *r.* Norway **44** L2
Reisa Nasjonalpark *nat. park*
 Norway **44** M2
Reisjärvi Fin. **44** N5
Reitz S. Africa **101** I4
Rekapalle India **84** D2
Reken Germany **52** H3
Reliance Canada **121** I2
Relizane Alg. **57** G6
Rellano Mex. **131** B7
Rellingen Germany **53** J1
Remagen Germany **53** H4
Remarkable, Mount *hill* Australia **111** B7
Remedios Cuba **133** E8
Remeshk Iran **88** E5
Remhoogte Pass Namibia **100** C2
Remi France *see* Reims
Remmel Mountain U.S.A. **126** C2
Remscheid Germany **53** H3
Rena Norway **45** G6
Renaix Belgium *see* Ronse
Renam Myanmar **76** C3
Renapur India **84** C2
Rendsburg Germany **47** L3
René-Levasseur, Île *i.* Canada **123** H4
Renews Canada **123** L5
Renfrew Canada **135** G1
Renfrew U.K. **50** E5
Rengali Reservoir India **83** F5
Rengat Indon. **68** C7
Rengo Chile **144** B4
Ren He *r.* China **77** F1
Renheji China **77** G2
Renhua China **77** G3
Reni Ukr. **59** M2
Renick U.S.A. **134** E5
Renland *reg.* Greenland *see*
 Tuttut Nunaat
Rennell *i.* Solomon Is **107** G3
Rennerod Germany **53** I4
Rennes France **56** D2
Rennick Glacier Antarctica **152** H2
Rennie Canada **121** M5
Reno *r.* Italy **58** E2
Reno U.S.A. **128** D2
Renovo U.S.A. **135** G3
Rensselaer U.S.A. **134** B3
Renswoude Neth. **52** F2
Renton U.S.A. **126** C3
Réo Burkina **96** C3
Reo Indon. **108** C2
Repalle India **84** D2
Repetek Turkm. **89** F2
Repetek Döwlet Gorugy *nature res.*
 Turkm. **89** F2
Repolka Rus. Fed. **45** P7
Republic U.S.A. **126** D2
Republican *r.* U.S.A. **130** D4
▶Republic of South Africa *country* Africa
 100 F5
 5th most populous country in Africa.
 Africa 7, 94–95

Repulse Bay *b.* Australia **110** E4
Repulse Bay Canada **119** J3
Requena Peru **142** D5
Requena Spain **57** F4
Reşadiye Turkey **90** E2
Reserva Brazil **145** A4
Reserve U.S.A. **129** I5
Reshi China **77** F2
Reshteh-ye *Alburz mts* Iran *see*
 Elburz Mountains
Resistencia Arg. **144** E3
Reşita Romania **59** I2
Resolute Canada **119** I2

Resolute Bay *Nunavut* Can. *see* Resolute
Resolution Island Canada **119** L3
Resolution Island N.Z. **113** A7
Resplendor Brazil **145** C2
Restigouche *r.* Canada **123** I5
Resülayn Turkey *see* Ceylanpınar
Retalhuleu Guat. **136** F6
Retezat, Parcul Naţional *nat. park*
 Romania **59** J2
Retford U.K. **48** G5
Rethel France **52** E5
Rethem (Aller) Germany **53** J2
Réthimnon Greece *see* Rethymno
Rethymno Greece **59** K7
Retreat Australia **110** C5
Reuden Germany **53** M2
▶Réunion *terr.* Indian Ocean **149** L7
 French Overseas Department.
 Africa 7, 94–95

Reus Spain **57** G3
Reusam, Pulau *i.* Indon. **71** B7
Reutlingen Germany **47** L6
Reval Estonia *see* Tallinn
Revda Rus. Fed. **44** S3
Revel Estonia *see* Tallinn
Revel France **56** F5
Revelstoke Canada **120** G5
Revigny-sur-Ornain France **52** E6
Revillagigedo, Islas *is* Mex. **136** B5
Revillagigedo Island U.S.A. **120** D4
Revin France **52** E5
Revivim Israel **85** B4
Revolyutsii, Pik *mt.* Tajik. *see*
 Revolyutsiya, Qullai
Revolyutsiya, Qullai *mt.* Tajik. **89** I2
Rewa India **82** E4
Rewari India **82** D3
Rexburg U.S.A. **126** F4
Rexton Canada **123** I5
Reyes, Point U.S.A. **128** B2
Reyhanlı Turkey **85** C1
Reykir Iceland **44** [inset]
Reykjanes Ridge *sea feature*
 N. Atlantic Ocean **148** F2
Reykjanestá *pt* Iceland **44** [inset]
▶Reykjavík Iceland **44** [inset]
 Capital of Iceland.

Reyneke, Ostrov *i.* Rus. Fed. **74** E1
Reynoldsburg U.S.A. **134** D4
Reynolds Range *mts* Australia **108** F5
Reynosa Mex. **131** D7
Rezā Iran **88** D3
Rezā'īyeh Iran *see* Urmia
Rezā'īyeh, Daryācheh-ye *salt l.* Iran *see*
 Urmia, Lake
Rēzekne Latvia **45** O8
Rezvān Iran **89** F4
Rezvāndeh Iran *see* Rezvānshahr
Rezvānshahr Iran **88** C2
Rhaeader Gwy U.K. *see* Rhayader
Rhayader U.K. **49** D6
Rheda-Wiedenbrück Germany **53** I3
Rhede Germany **52** G3
Rhegium Italy *see* Reggio di Calabria
Rheims France *see* Reims
Rhein *r.* Germany **53** G3 *see* Rhine
Rheine Germany **53** H2
Rheinsberg Germany **53** M1
Rheinstetten Germany **53** I6
Rhemilès *well* Alg. **96** C2
Rhin *r.* France **53** I6 *see* Rhine
Rhine *r.* Germany **53** G3
 also spelt Rhein (Germany) or
 Rhin (France)
Rhinebeck U.S.A. **135** I3
Rhinelander U.S.A. **130** F2
Rhineland-Palatinate *land* Germany *see*
 Rheinland-Pfalz
Rhinkanal *canal* Germany **53** M2
Rhinow Germany **53** M2
Rhiwabon U.K. *see* Ruabon
Rho Italy **58** C2
Rhode Island *state* U.S.A. **135** J3
Rhodes Greece **59** M6
Rhodes *i.* Greece **59** M6
Rhodesia *country* Africa *see* Zimbabwe
Rhodes Peak U.S.A. **126** E3
Rhodope Mountains Bulg./Greece **59** J4
Rhodus *i.* Greece *see* Rhodes
Rhône *r.* France/Switz. **56** G5
Rhum *i.* U.K. *see* Rum
Rhuthun U.K. *see* Ruthin
Rhydaman U.K. *see* Ammanford
Rhyl U.K. **48** D5
Riachão Brazil **143** I5
Riacho Brazil **145** C2
Riacho de Santana Brazil **145** C1
Riacho dos Machados Brazil **145** C1
Rialma Brazil **145** A1
Rialto U.S.A. **128** E4
Riasi Jammu and Kashmir **82** C2
Riau, Kepulauan *is* Indon. **68** C6
Ribadeo Spain **57** C2
Ribadesella Spain **57** D2
Ribas do Rio Pardo Brazil **144** F2
Ribat Afgh. **89** H2
Ribat-i-Shur *waterhole* Iran **88** E3
Ribáuè Moz. **99** D5
Ribble *r.* U.K. **48** E5
Ribe Denmark **45** F9
Ribécourt-Dreslincourt France **52** C5
Ribeira *r.* Brazil **145** B4
Ribeirão Preto Brazil **145** B3
Ribemont France **52** D5
Ribérac France **56** E4
Riberalta Bol. **142** E6
Ribnita Moldova **43** F7
Ribnitz-Damgarten Germany **47** N3
Říčany Czech Rep. **47** O6
Rice U.S.A. **135** F5
Rice Lake Canada **135** F1
Richards Bay S. Africa **101** K5
Richards Inlet Antarctica **152** H1
Richards Island Canada **118** E3
Richardson *r.* Canada **121** I3
Richardson U.S.A. **131** D5

Richardson Island Canada **120** G1
Richardson Lakes U.S.A. **135** J1
Richardson Mountains Canada **118** E3
Richardson Mountains N.Z. **113** B7
Richfield U.S.A. **129** G2
Richfield Springs U.S.A. **135** H2
Richford *NY* U.S.A. **135** G2
Richford *VT* U.S.A. **135** I1
Richgrove U.S.A. **128** D4
Richland U.S.A. **126** D3
Richland Center U.S.A. **130** F3
Richmond *N.S.W.* Australia **112** E4
Richmond *Qld* Australia **110** C4
Richmond Canada **135** H1
Richmond N.Z. **113** D5
Richmond *Kwazulu-Natal* S. Africa **101** J5
Richmond *N. Cape* S. Africa **100** F6
Richmond U.K. **48** F4
Richmond *CA* U.S.A. **128** B3
Richmond *IN* U.S.A. **134** C4
Richmond *KY* U.S.A. **134** C5
Richmond *MI* U.S.A. **134** D2
Richmond *MO* U.S.A. **130** E4
Richmond *TX* U.S.A. **131** E6
▶Richmond *VA* U.S.A. **135** G5
 State capital of Virginia.

Richmond Dale U.S.A. **134** D4
Richmond Hill U.S.A. **133** D6
Richmond Range *hills* Australia **112** F2
Richtersveld National Park S. Africa **100** C5
Richvale U.S.A. **128** C2
Richwood U.S.A. **134** E4
Rico U.S.A. **129** I3
Ricomagus France *see* Riom
Riddell Nunataks Antarctica **152** E2
Rideau Lakes Canada **135** G1
Ridge *r.* Canada **122** D4
Ridgecrest U.S.A. **128** E4
Ridge Farm U.S.A. **134** B4
Ridgeland *MS* U.S.A. **131** F5
Ridgeland *SC* U.S.A. **133** D5
Ridgetop U.S.A. **134** B5
Ridgetown Canada **134** E2
Ridgeway *OH* U.S.A. **134** D3
Ridgeway *VA* U.S.A. **134** F5
Ridgway *CO* U.S.A. **129** J2
Ridgway *PA* U.S.A. **135** F3
Riding Mountain National Park
 Canada **121** K5
Riecito Venez. **142** E1
Riemst Belgium **52** F4
Riesa Germany **53** N3
Riesco, Isla *i.* Chile **144** B8
Riet *watercourse* S. Africa **100** E6
Rietfontein S. Africa **100** E4
Rieti Italy **58** E3
Rifā'ī, Tall *mt.* Jordan/Syria **85** C3
Rifeng China *see* Lichuan
Rifle U.S.A. **129** J2
Rifstangi *pt* Iceland **44** [inset]
Rift Valley Lakes National Park Eth. *see*
 Abijatta-Shalla National Park

▶Rīga Latvia **45** N8
 Capital of Latvia.

Riga, Gulf of Estonia/Latvia **45** M8
Rīgain Pünco *l.* China **83** F2
Rīgān Iran **88** E4
Rīgas jūras līcis *b.* Estonia/Latvia *see*
 Riga, Gulf of
Rigby U.S.A. **126** F4
Rīgestān *reg.* Afgh. *see* Registān
Rigolet Canada **123** K3
Rigside U.K. **50** F5
Riia laht *b.* Estonia/Latvia *see* Riga, Gulf of
Riihimäki Fin. **45** N6
Riiser-Larsen Ice Shelf Antarctica **152** B2
Riito Mex. **129** F5
Rijau Nigeria **96** D3
Rijeka Croatia **58** F2
Rīkā, Wādī ar *watercourse*
 Saudi Arabia **88** B5
Rikitgaib Indon. **71** B6
Rikor India **76** B2
Rikubetsu Japan **74** F4
Rikuchū-kaigan Kokuritsu-kōen
 Japan **75** F5
Rikuzen-takata Japan **75** F5
Rila mts Bulg. **59** J3
Rila China **83** F3
Riley U.S.A. **126** D4
Rileyville U.S.A. **135** F4
Rillieux-la-Pape France **56** G4
Rillito U.S.A. **129** H5
Rimah, Wādī al *watercourse*
 Saudi Arabia **86** F4
Rimavská Sobota Slovakia **47** R6
Rimbey Canada **120** H4
Rimini Italy **58** E2
Rîmnicu Sărat Romania *see*
 Râmnicu Sărat
Rîmnicu Vîlcea Romania *see*
 Râmnicu Vâlcea
Rimouski Canada **123** H4
Rimpar Germany **53** J5
Rimsdale, Loch *l.* U.K. **50** E2
Rinbung China **83** G3
Rincão Brazil **145** A3
Rindal Norway **44** F5
Ringarooma Bay Australia **111** [inset]
Ringas India **82** C4
Ringe Germany **52** G2
Ringebu Norway **45** G6
Ringhkung Myanmar **70** B1
Ringkøbing Denmark **45** F8
Ringsend U.K. **51** F2
Ringsted Denmark **45** G9
Ringtor China **83** E3
Ringvassøya *i.* Norway **44** K2
Ringwood Australia **112** B6
Ringwood U.K. **49** F8
Rinjani, Gunung *vol.* Indon. **68** F8
Rinns Point U.K. **50** C5
Rinqênzê China **83** G3
Rinteln Germany **53** J2
Río Abiseo, Parque Nacional *nat. park*
 Peru **142** C5
Rio Azul Brazil **145** A4
Riobamba Ecuador **142** C4

Rio Blanco U.S.A. **129** J2
Rio Bonito Brazil **145** C3
Rio Branco Brazil **142** E6
Rio Branco, Parque Internacional do *nat. park*
 Brazil **142** F3
Río Bravo, Parque Internacional del
 nat. park Mex. **131** C6
Rio Brilhante Brazil **144** F2
Rio Casca Brazil **145** C3
Rio Claro Brazil **145** B3
Río Colorado Arg. **144** D5
Río Cuarto Arg. **144** D4
Rio das Pedras Moz. **101** L2
Rio de Contas Brazil **145** C1
▶Rio de Janeiro Brazil **145** C3
 3rd most populous city in South America.
 Former capital of Brazil.

Rio de Janeiro *state* Brazil **145** C3
▶Río de la Plata-Paraná *r.* S. America
 144 E4
 2nd longest river in South America.

Rio Dell U.S.A. **128** A1
Rio do Sul Brazil **145** A4
Río Gallegos Arg. **144** C8
Río Grande Arg. **144** C8
Rio Grande Brazil **144** F4
Río Grande Mex. **131** C8
 also known as Río Bravo del Norte
Rio Grande *r.* Mex./U.S.A. **127** G5
Rio Grande City U.S.A. **131** D7
Rio Grande do Sul *state* Brazil **145** A5
Rio Grande Rise *sea feature*
 S. Atlantic Ocean **148** F8
Ríohacha Col. **142** D1
Río Hondo, Embalse *resr* Arg. **144** C3
Rioja Peru **142** C5
Río Lagartos Mex. **133** B8
Rio Largo Brazil **143** K5
Riom France **56** F4
Rio Manso, Represa do *resr* Brazil **143** G6
Río Mulatos Bol. **142** E7
Río Muni *reg.* Equat. Guinea **96** E4
Río Negro, Embalse del *resr* Uruguay **144** E4
Rioni *r.* Georgia **91** F2
Rio Novo Brazil **145** C3
Rio Pardo de Minas Brazil **145** C1
Rio Preto Brazil **145** C3
Rio Preto, Serra do *hills* Brazil **145** B2
Rio Rancho U.S.A. **127** G6
Río Tigre Ecuador **142** C4
Riou Lake Canada **121** J3
Rio Verde Brazil **145** A2
Rio Verde de Mato Grosso Brazil **143** H7
Rio Vista U.S.A. **128** C2
Ripky Ukr. **43** F6
Ripley *England* U.K. **48** F4
Ripley *England* U.K. **49** F5
Ripley *NY* U.S.A. **134** F2
Ripley *OH* U.S.A. **134** D4
Ripley *WV* U.S.A. **134** E4
Ripoll Spain **57** H2
Ripon U.K. **48** F4
Ripon U.S.A. **128** C3
Ripu India **83** G4
Risca U.K. **49** D7
Rishiri-tō *i.* Japan **74** F3
Rishon Le Ziyyon Israel **85** B4
Rish Pish Iran **89** F5
Rising Sun *IN* U.S.A. **134** C4
Rising Sun *MD* U.S.A. **135** G4
Risle *r.* France **49** H9
Risør Norway **45** F7
Rissa Norway **44** F5
Ristiina Fin. **45** O6
Ristijärvi Fin. **44** P4
Ristikent Rus. Fed. **44** Q2
Risum China **82** D2
Ritchie S. Africa **100** G5
Ritchie's Archipelago *is* India **71** A4
Ritscher Upland *mts* Antarctica **152** B2
Ritsem Sweden **44** J3
Ritter, Mount U.S.A. **128** D3
Ritterhude Germany **53** I1
Ritzville U.S.A. **126** D3
Riu, Laem *pt* Thai. **71** B5
Riva del Garda Italy **58** D2
Rivadavia Arg. **144** D5
Rivas Nicaragua **137** G6
Rivera Arg. **144** D5
Rivera Uruguay **144** E4
River Cess Liberia **96** C4
Riverhead U.S.A. **135** I3
Riverhurst Canada **121** J5
Riverina Australia **109** C7
Riverina *reg.* Australia **112** B5
Riversdale S. Africa **100** E8
Riverside U.S.A. **128** E5
Rivers Inlet Canada **120** E5
Riversleigh Australia **110** B3
Riverton N.Z. **113** A8
Riverton *VA* U.S.A. **135** F4
Riverton *WY* U.S.A. **126** F4
Riverview Canada **123** I5
Rivesaltes France **56** F5
Riviera Beach U.S.A. **133** D7
Rivière-du-Loup Canada **123** H5
Rivière-Pentecôte Canada **123** I4
Rivière-Pigou Canada **123** I4
Rivne Ukr. **43** E6
Rivungo Angola **99** C5
Riwaka N.Z. **113** D5
▶Riyadh Saudi Arabia **86** G5
 Capital of Saudi Arabia.

Riyan India **89** I5
Riza *well* Iran **88** D3
Rize Turkey **91** F2
Rizhao *Shandong* China *see* Donggang
Rizhao *Shandong* China **73** L5
Rizokarpaso Cyprus *see* Rizokarpason
Rizokarpason Cyprus **85** B2
Rīzū *well* Iran **88** E3
Rīzū'īyeh Iran **88** E4
Rjukan Norway **45** F7
Rjuvbrokkene *mt.* Norway **45** E7
Rkîz Mauritania **96** B3

Roa Norway **45** G6
Roachdale U.S.A. **134** B4
Roach Lake U.S.A. **129** F4
Roade U.K. **49** G6
Roads U.S.A. **134** D4
▶Road Town Virgin Is (U.K.) **137** L5
 Capital of the British Virgin Islands.

Roan Norway **44** G4
Roan Fell *hill* U.K. **50** G5
Roan High Knob *mt.* U.S.A. **132** D4
Roanne France **56** G3
Roanoke *IN* U.S.A. **134** C3
Roanoke *VA* U.S.A. **134** F5
Roanoke *r.* U.S.A. **132** E4
Roanoke Rapids U.S.A. **132** E4
Roan Plateau U.S.A. **129** I2
Roaring Spring U.S.A. **135** F3
Roaringwater Bay Ireland **51** C6
Roatán Hond. **137** G5
Röbäck Sweden **44** L5
Robat *r.* Afgh. **89** F4
Robāṭe Tork Iran **88** C3
Robāṭ Karīm Iran **88** C3
Robāt-Sang Iran **88** E3
Robb Canada **120** G4
Robbins Island Australia **111** [inset]
Robbinsville U.S.A. **133** D5
Robe Australia **111** B8
Robe *r.* Australia **108** A5
Robe *r.* Ireland **51** C4
Röbel Germany **53** M1
Robert Glacier Antarctica **152** D2
Robert Lee U.S.A. **131** C6
Roberts U.S.A. **126** E4
Roberts, Mount Australia **112** F2
Robertsburg U.S.A. **134** E4
Roberts Butte *mt.* Antarctica **152** H2
Roberts Creek Mountain U.S.A. **128** E2
Robertsfors Sweden **44** L4
Robertsganj India **83** E4
Robertson S. Africa **100** D8
Robertson, Lac *l.* Canada **123** K4
Robertson Bay Antarctica **152** H2
Robertson Island Antarctica **152** A2
Robertson Range *hills* Australia **109** C5
Robertsport Liberia **96** B4
Roberval Canada **123** G4
Robhanais, Rubha *hd* U.K. *see* Butt of Lewis
Robin Hood's Bay U.K. **48** G4
Robin's Nest *hill* H.K. China **77** [inset]
Robinson Canada **120** C2
Robinson U.S.A. **134** B4
Robinson Range *hills* Australia **109** B6
Robinson River Australia **110** B3
Robles Pass U.S.A. **129** H5
Roblin Canada **121** K5
Robsart Canada **121** I5
Robson, Mount Canada **120** G4
Robstown U.S.A. **131** D7
Roby U.S.A. **131** C5
Roçadas Angola *see* Xangongo
Rocca Busambra *mt. Sicily* Italy **58** E6
Rocha Uruguay **144** F4
Rochdale U.K. **48** E5
Rochechouart France **56** E4
Rochefort France **56** D4
Rochefort Belgium **52** F4
Rochefort, Lac *l.* Canada **123** G2
Rochegda Rus. Fed. **42** I3
Rochester Australia **112** B6
Rochester U.K. **49** H7
Rochester *IN* U.S.A. **134** B3
Rochester *MN* U.S.A. **130** E2
Rochester *NH* U.S.A. **135** J2
Rochester *NY* U.S.A. **135** G2
Rochford U.K. **49** H7
Rochlitz Germany **53** M3
Roc'h Trévezel *hill* France **56** C2
Rock *r.* Canada **120** E2
Rockall *i.* N. Atlantic Ocean **40** D4
Rockall Bank *sea feature* N. Atlantic Ocean
 148 G2
Rock Creek Canada **120** B1
Rock Creek U.S.A. **134** E3
Rock Creek *r.* U.S.A. **126** C4
Rockdale U.S.A. **131** D6
Rockefeller Plateau Antarctica **152** J1
Rockford *AL* U.S.A. **133** C5
Rockford *IL* U.S.A. **130** F3
Rockford *MI* U.S.A. **134** C2
Rockglen Canada **121** J5
Rockhampton Australia **110** E4
Rockhampton Downs Australia **108** F4
Rock Hill U.S.A. **133** D5
Rockingham Australia **109** A8
Rockingham U.S.A. **133** E5
Rockingham Bay Australia **110** D3
Rockinghorse Lake Canada **121** H1
Rock Island U.S.A. **135** I1
Rock Island U.S.A. **130** F3
Rocklake U.S.A. **130** D1
Rockland *MA* U.S.A. **135** J2
Rockland *ME* U.S.A. **132** G2
Rocknest Lake Canada **120** H1
Rockport *IN* U.S.A. **134** B5
Rockport *TX* U.S.A. **131** D7
Rock Rapids U.S.A. **130** D3
Rock River U.S.A. **126** G4
Rock Sound Bahamas **133** E7
Rock Springs *MT* U.S.A. **126** G3
Rocksprings U.S.A. **131** C6
Rock Springs *WY* U.S.A. **126** F4
Rockstone Guyana **143** G2
Rockville *CT* U.S.A. **135** I3
Rockville *IN* U.S.A. **134** B4
Rockville *MD* U.S.A. **135** G4
Rockwell City U.S.A. **130** E3
Rockwood *MI* U.S.A. **134** D2
Rockwood *PA* U.S.A. **134** F4
Rockyford Canada **120** H5
Rocky Harbour Canada **123** K4
Rocky Hill U.S.A. **134** D4
Rocky Island Lake Canada **122** E5
Rocky Lane Canada **120** G3
Rocky Mount U.S.A. **134** F5
Rocky Mountain House Canada **120** H4
Rocky Mountain National Park
 U.S.A. **126** G4
Rocky Mountains Canada/U.S.A. **124** F3
Rocourt-St-Martin France **52** D5

Rocroi France 52 E5
Rodberg Norway 45 F6
Rødbyhavn Denmark 45 G9
Roddickton Canada 123 L4
Rodeio Brazil 145 A4
Rodel U.K. 50 C3
Roden Neth. 52 G1
Rödental Germany 53 L4
Rodeo Arg. 144 C4
Rodeo Mex. 131 B7
Rodeo U.S.A. 127 F7
Rodez France 56 F4
Ródhos i. Greece see Rhodes
Rodi i. Greece see Rhodes
Roding Germany 53 M5
Rodney, Cape U.S.A. 118 B3
Rodniki Rus. Fed. 42 I4
Rodopi Planina mts Bulg./Greece see
 Rhodope Mountains
Rodos Greece see Rhodes
Rodos i. Greece see Rhodes
Rodosto Turkey see Tekirdağ
Rodrigues Island Mauritius 149 M7
Roe r. U.K. 51 F2
Roebourne Australia 108 B5
Roebuck Bay Australia 108 C4
Roedtan S. Africa 101 I3
Roe Plains Australia 109 D7
Roermond Neth. 52 F3
Roeselare Belgium 52 D4
Roes Welcome Sound sea chan.
 Canada 119 J3
Rogachev Belarus see Rahachow
Rogätz Germany 53 L2
Rogers U.S.A. 131 E4
Rogers, Mount U.S.A. 134 E5
Rogers City U.S.A. 134 D1
Rogerson U.S.A. 126 E4
Rogersville U.S.A. 134 D5
Roggan r. Canada 122 F3
Roggan, Lac l. Canada 122 F3
Roggeveen Basin sea feature
 S. Pacific Ocean 151 O8
Roggeveld plat. S. Africa 100 E7
Roggeveldberge esc. S. Africa 100 E7
Roghadal U.K. see Rodel
Rognan Norway 44 I3
Rögnitz r. Germany 53 K1
Rogue r. U.S.A. 126 B4
Roha India 84 B2
Rohnert Park U.S.A. 128 B2
Rohrbach in Oberösterreich
 Austria 47 N6
Rohrbach-lès-Bitche France 53 H5
Rohri Sangar Pak. 89 H5
Rohtak India 82 D3
Roi Et Thai. 70 C3
Roi Georges, Îles du is Fr. Polynesia 151 K6
Rois-Bheinn hill U.K. 50 D4
Roisel France 52 D5
Roja Latvia 45 M8
Rojas Arg. 144 D4
Rokeby Australia 110 C2
Rokeby National Park Australia 110 C2
Rokiškis Lith. 45 N9
Roknäs Sweden 44 L4
Rokytne Ukr. 43 E6
Rolagang China 83 G2
Rola Kangri mt. China 83 G2
Rolândia Brazil 145 A3
Rolim de Moura Brazil 142 F6
Roll AZ U.S.A. 129 G5
Roll IN U.S.A. 134 C3
Rolla MO U.S.A. 130 F4
Rolla ND U.S.A. 130 D1
Rollag Norway 45 F6
Rolleston Australia 110 E5
Rolleville Bahamas 133 F8
Rolling Fork U.S.A. 131 F5
Rollins U.S.A. 126 E3
Roma Australia 111 E5
Roma Italy see Rome
Roma Lesotho 101 H5
Roma Sweden 45 K8
Romain, Cape U.S.A. 133 E5
Romaine r. Canada 123 J4
Roman Romania 59 L1
Română, Câmpia plain Romania 59 J2
Romanche Gap sea feature
 S. Atlantic Ocean 148 G6
Romanet, Lac l. Canada 123 I2
Romang, Pulau i. Indon. 108 E1
▶Romania country Europe 59 K2
 Europe 5, 38–39
Roman-Kosh mt. Ukr. 90 D1
Romano, Cape U.S.A. 133 D7
Romanovka Rus. Fed. 73 K2
Romans-sur-Isère France 56 G4
Romanzof, Cape U.S.A. 118 B3
Rombas France 52 G5
Romblon Phil. 69 G4
▶Rome Italy 58 E4
 Capital of Italy.

Rome GA U.S.A. 133 C5
Rome ME U.S.A. 135 K1
Rome NY U.S.A. 135 H2
Rome TN U.S.A. 134 B5
Rome City U.S.A. 134 C3
Romeo U.S.A. 134 D2
Romford U.K. 49 H7
Romilly-sur-Seine France 56 F2
Romiton Uzbek. 89 G2
Romney U.S.A. 135 F4
Romney Marsh reg. U.K. 49 H7
Romny Ukr. 43 G6
Rømø i. Denmark 45 F9
Romodanovo Rus. Fed. 43 J5
Romorantin-Lanthenay France 56 E3
Rompin r. Malaysia 71 C7
Romsey U.K. 49 F8
Romulus U.S.A. 134 D2
Rona i. U.K. 50 D1
Ronas Hill hill U.K. 50 [inset]
Roncador, Serra do hills Brazil 143 H6
Ronda Spain 57 D5
Ronda, Serranía de mts Spain 57 D5

Rondane Nasjonalpark nat. park
 Norway 45 F6
Rondon Brazil 144 F2
Rondonópolis Brazil 143 H7
Rondout Reservoir U.S.A. 135 H3
Rong Chu r. China 83 G3
Rongcheng Anhui China see Qingyang
Rongcheng Guangxi China see Rongxian
Rongcheng Hubei China see Jianli
Rong Chu r. China 83 G3
Rongelap atoll Marshall Is 150 H5
Rongjiang Guizhou China 77 F3
Rongjiang Jiangxi China see Nankang
Rongjiawan China see Yueyang
Rongklang Range mts Myanmar 70 A2
Rongmei China see Hefeng
Rongwo China see Tongren
Rongxian China 77 F4
Rongyul China 77 F4
Rongzhag China see Danba
Rönlap atoll Marshall Is see Rongelap
Rønne Denmark 45 I9
Ronneby Sweden 45 I8
Ronne Entrance strait Antarctica 152 L2
Ronne Ice Shelf Antarctica 152 L1
Ronnenberg Germany 53 J2
Ronse Belgium 52 D4
Roodeschool Neth. 52 G1
Rooke Island P.N.G. see Umboi
Roordahuizum Neth. see Reduzum
Roorkee India 82 D3
Roosendaal Neth. 52 E3
Roosevelt r. Brazil 142 F5
Roosevelt UT U.S.A. 129 H1
Roosevelt, Mount Canada 120 E3
Roosevelt Island Antarctica 152 I1
Root r. Canada 120 F2
Root r. U.S.A. 130 F3
Ropar India see Rupnagar
Roper r. Australia 110 A2
Roper Bar Australia 108 F3
Roquefort France 56 D4
Roraima, Mount Guyana 142 F2
Rori India 82 C3
Rori Indon. 69 J7
Roro i. Indon. see Rote
Roros Norway 44 G5
Rørvik Norway 44 G4
Rosa, Punta pt Mex. 127 F8
Rosalia U.S.A. 126 D3
Rosamond U.S.A. 128 D4
Rosamond Lake U.S.A. 128 D4
Rosario Arg. 144 D4
Rosário Brazil 143 J4
Rosario Baja California Mex. 127 E7
Rosario Coahuila Mex. 131 C7
Rosario Sinaloa Mex. 131 B7
Rosario Sonora Mex. 124 F6
Rosario Zacatecas Mex. 131 C7
Rosario Venez. 142 D1
Rosário do Sul Brazil 144 F4
Rosário Oeste Brazil 143 G6
Rosarito Baja California Mex. 127 E7
Rosarito Baja California Mex. 128 E5
Rosarito Baja California Sur Mex. 127 F8
Rosarno Italy 58 F5
Roscoff France 56 C2
Roscommon Ireland 51 D4
Roscommon U.S.A. 134 C1
Roscrea Ireland 51 E5
Rose r. Australia 110 A2
Rose, Mount U.S.A. 128 D2
Rose Atoll American Samoa see
 Rose Island
▶Roseau Dominica 137 L5
 Capital of Dominica.

Roseau U.S.A. 130 E1
Roseau r. U.S.A. 130 D1
Roseberth Australia 111 B5
Rose Blanche Canada 123 K5
Rosebud r. Canada 120 H5
Rosebud U.S.A. 126 G3
Roseburg U.S.A. 126 C4
Rose City U.S.A. 134 C1
Rosedale U.S.A. 131 F5
Rosedale Abbey U.K. 48 G4
Rôsette Egypt see Rashid
Rose Valley Canada 121 K4
Roseville CA U.S.A. 128 C2
Roseville MI U.S.A. 134 D2
Roseville OH U.S.A. 134 D4
Rosewood Australia 111 E5
Roshchino Rus. Fed. 45 P6
Rosh Pinah Namibia 100 C4
Roshtkala Tajik. see Roshtqal'a
Roshtqal'a Tajik. 89 H2
Rosignano Marittimo Italy 58 D3
Roşiori de Vede Romania 59 K2
Roskilde Denmark 45 H9
Roskruge Mountains U.S.A. 129 H5
Roslavl' Rus. Fed. 43 G5
Roslyakovo Rus. Fed. 44 R2
Roslyatino Rus. Fed. 42 J4
Ross N.Z. 113 C6
Ross, Mount hill N.Z. 113 E5
Rossano Italy 58 G5
Rossan Point Ireland 51 D3
Ross Barnett Reservoir U.S.A. 131 F5
Ross Bay Junction Canada 123 I3
Ross Carbery Ireland 51 C6
Ross Dependency reg. Antarctica 152 I2
Rosseau, Lake Canada 134 F1
Rossel Island P.N.G. 110 F1
Ross Ice Shelf Antarctica 152 I1
Rossignol, Lac l. Canada 122 F3
Rössing Namibia 100 B2
Ross Island Antarctica 152 H1
Rossiyskaya Sovetskaya Federativnaya
 Sotsialisticheskaya Respublika country
 Asia/Europe see Russian Federation
Rossland Canada 120 G5

Rosslare Ireland 51 F5
Rosslare Harbour Ireland 51 F5
Roßlau Germany 53 M3
Rosso Mauritania 96 B3
Ross-on-Wye U.K. 49 E7
Rossony Belarus see Rasony
Rossosh' Rus. Fed. 43 H6
Ross River Canada 120 C2
Ross Sea Antarctica 152 H1
Røssvatnet l. Norway 44 I4
Roßtal Germany 53 K5
Rossville U.S.A. 134 B3
Roßwein Germany 53 N3
Rosswood Canada 120 D4
Rostāq Afgh. 89 H2
Rosthern Canada 121 J4
Rostock Germany 47 N3
Rostov Rus. Fed. 42 H4
Rostov-na-Donu Rus. Fed. 43 H7
Rostov-on-Don Rus. Fed. see
 Rostov-na-Donu
Rosvik Sweden 44 L4
Roswell U.S.A. 127 G6
Rota i. N. Mariana Is 69 L4
Rot am See Germany 53 K5
Rotch Island Kiribati see Tamana
Rote i. Indon. 108 C2
Rotenburg (Wümme) Germany 53 J1
Roth Germany 53 L5
Rothaargebirge hills Germany 53 I4
Rothbury U.K. 48 F3
Rothenburg ob der Tauber Germany 53 K5
Rother r. U.K. 49 G8
Rothera research station Antarctica 152 L2
Rotherham U.K. 48 F5
Rothes U.K. 50 F3
Rothesay U.K. 50 D5
Rothwell U.K. 49 G6
Roti i. Indon. see Rote
Roto Australia 112 B4
Rotomagus France see Rouen
Rotomanu N.Z. 113 C6
Rotondo, Monte mt. Corsica France 56 I5
Rotorua N.Z. 113 F4
Rotorua, Lake N.Z. 113 F4
Röttenbach Germany 53 L5
Rottendorf Germany 53 K5
Rottenmann Austria 47 O7
Rotterdam Neth. 52 E3
Rottleberode Germany 53 K3
Rottnest Island Australia 109 A8
Rottumeroog i. Neth. 52 G1
Rottweil Germany 47 L6
Rötviken Sweden 44 I5
Rötz Germany 53 M5
Roubaix France 52 D4
Rouen France 52 B5
Rough River Lake U.S.A. 134 B5
Roulers Belgium see Roeselare
Roumania country Europe see Romania
Roundeyed Lake Canada 123 H3
Round Hill hill U.K. 48 F4
Round Mountain Australia 112 F3
Round Rock U.S.A. 129 I3
Round Rock TX U.S.A. 131 D6
Roundup U.S.A. 126 F3
Rousay i. U.K. 50 F1
Rouses Point U.S.A. 135 I1
Rouxville S. Africa 101 H6
Rouyn-Noranda Canada 122 F4
Rovaniemi Fin. 44 N3
Roven'ki Rus. Fed. 43 H6
Rovereto Italy 58 D2
Rôviĕng Tbong Cambodia 71 D4
Rovigo Italy 58 D2
Rovinj Croatia 58 E2
Rovno Ukr. see Rivne
Rovnoye Rus. Fed. 43 J6
Rovuma r. Moz./Tanz. see Ruvuma
Rowena Australia 112 D2
Rowley Island Canada 119 K3
Rowley Shoals sea feature Australia 108 B4
Rôwne Ukr. see Rivne
Roxas Mindoro Phil. 69 G4
Roxas Palawan Phil. 68 F4
Roxas Panay Phil. 69 G4
Roxboro U.S.A. 132 E4
Roxburgh N.Z. 113 B7
Roxburgh Island Cook Is see Rarotonga
Roxby Downs Australia 111 B6
Roxo, Cabo c. Senegal 96 B3
Roy MT U.S.A. 126 F3
Roy NM U.S.A. 127 G5
Royal Canal Ireland 51 E4
Royal Chitwan National Park Nepal 83 F4
Royale, Île i. Canada see
 Cape Breton Island
Royale, Isle i. U.S.A. 130 F1
Royal Natal National Park S. Africa 101 I5
Royal Oak U.S.A. 134 D2
Royal National Park Australia 112 E5
Royal Sukla Phanta Wildlife Reserve
 Nepal 82 E3
Royan France 56 D4
Roye France 52 C5
Roy Hill Australia 108 B5
Royston U.K. 49 G6
Rozdil'na Ukr. 59 N1
Rozivka Ukr. 43 H7
Rtishchevo Rus. Fed. 43 I5
Ruabon U.K. 49 D6
Ruaha National Park Tanz. 99 D4
Ruahine Range mts N.Z. 113 F4
Ruanda country Africa see Rwanda
Ruapehu, Mount vol. N.Z. 113 E4
Ruapuke Island N.Z. 113 B8
Ruatoria N.Z. 113 G3
Ruba Belarus 43 F5
▶Rub' al Khālī des. Saudi Arabia 86 G6
 Largest uninterrupted stretch of sand in
 the world.

Rubaydā reg. Saudi Arabia 88 C5
Rubtsovsk Rus. Fed. 80 F1
Ruby U.S.A. 118 C3
Ruby Dome mt. U.S.A. 129 F1
Ruby Mountains U.S.A. 129 F1

Rubys Inn U.S.A. 129 G3
Ruby Valley U.S.A. 129 F1
Rucheng China 77 G3
Ruckersville U.S.A. 135 F4
Rudall River National Park Australia 108 C5
Rudarpur India 83 E4
Ruda Śląska Poland 47 Q5
Rudauli India 83 E4
Rūdbār Iran 88 C2
Rudkøbing Denmark 45 G9
Rudnaya Pristan' Rus. Fed. 74 D3
Rudnichnyy Rus. Fed. 42 L4
Rudnik Ingichka Uzbek. see Ingichka
Rudnya Smolenskaya Oblast'
 Rus. Fed. 43 F5
Rudnya Volgogradskaya Oblast'
 Rus. Fed. 43 J6
Rudnyy Kazakh. 78 F1
▶Rudol'fa, Ostrov i. Rus. Fed. 64 G1
 Most northerly point of Europe.

Rudolph Island Rus. Fed. see
 Rudol'fa, Ostrov
Rudolstadt Germany 53 L4
Rudong China 77 I1
Rüdsar Iran 88 C2
Rue France 52 B4
Rufiji r. Tanz. 99 D4
Rufino Arg. 144 D4
Rufisque Senegal 96 B3
Rufrufua Indon. 69 I7
Rugao China 77 I1
Rugby U.K. 49 F6
Rugby U.S.A. 130 C1
Rugeley U.K. 49 F6
Rügen i. Germany 47 N3
Rügland Germany 53 K5
Ruḩayyat al Ḩamr'ā' waterhole
 Saudi Arabia 88 B5
Ruhengeri Rwanda 98 C4
Ruhnu i. Estonia 45 M8
Ruhr r. Germany 53 I3
Ruhuna National Park Sri Lanka 84 D5
Rui'an China 77 I3
Rui Barbosa Brazil 145 C1
Ruicheng China 77 F1
Ruijin China 77 G3
Ruili China 76 C3
Ruin Point Canada 121 P2
Ruipa Tanz. 99 D4
Ruiz Mex. 136 C4
Ruiz, Nevado del vol. Col. 142 C3
Rujaylah, Ḩarrat ar lava field Jordan 85 C3
Rüjiena Latvia 45 N8
Ruk is Micronesia see Chuuk
Rukanpur Pak. 89 I4
Rukumkot Nepal 83 E3
Rukwa, Lake Tanz. 99 D4
Rulin China see Chengbu
Rulong China see Xinlong
Rum, Jebel mts Jordan see Ramm, Jabal
Ruma Serb. and Mont. 59 H2
Rumāh Saudi Arabia 86 G4
Rumania country Europe see Romania
Rumbek Sudan 97 F4
Rumberpon i. Indon. 69 I7
Rum Cay i. Bahamas 133 F8
Rum Jungle Australia 108 E3
Rummah, hill Syria 85 D3
Rumphi Malawi 99 D5
Runan China 77 G1
Runanga N.Z. 113 C6
Runaway, Cape N.Z. 113 F3
Runcorn U.K. 48 E5
Rundu Namibia 99 B5
Rundvik Sweden 44 K5
Runheji China 77 H1
Runing China see Runan
Runton Range hills Australia 109 C5
Ruokolahti Fin. 45 P6
Ruoqiang China 80 G4
Rupa India 83 H4
Rupat i. Indon. 71 C7
Rupert r. Canada 122 F4
Rupert ID U.S.A. 126 E4
Rupert WV U.S.A. 134 E5
Rupert Bay Canada 122 F4
Rupert Coast Antarctica 152 J1
Rupert House Canada see Waskaganish
Rupnagar India 82 D3
Rupshu reg. Jammu and Kashmir 82 D2
Ruqqād, Wādī ar watercourse Israel 85 B3
Rural Retreat U.S.A. 134 E5
Rusaddir N. Africa see Melilla
Rusape Zimbabwe 99 D5
Ruschuk Bulg. see Ruse
Ruse Bulg. 59 K3
Rusera India 83 F4
Rush U.S.A. 134 D4
Rush Creek r. U.S.A. 130 C4
Rushden U.K. 49 G6
Rushinga Zimbabwe 99 D5
Rushville IL U.S.A. 130 F3
Rushville IN U.S.A. 134 C4
Rushville NE U.S.A. 130 C3
Rushworth Australia 112 B6
Rusk U.S.A. 131 E6
Russell Man. Canada 121 K5
Russell Ont. Canada 135 H1
Russell N.Z. 113 E2
Russell KS U.S.A. 130 D4
Russell PA U.S.A. 134 F3
Russell Lake Sask. Canada 121 J3
Russell Lake N.W.T. Canada 120 H2
Russell Lake Sask. Canada 121 J3
Russell Bay Antarctica 152 J2
Russell Island Canada 121 K3
Russell Range hills Australia 109 C8
Russell Springs U.S.A. 134 C5
Russellville AL U.S.A. 131 C5
Russellville AR U.S.A. 131 E5
Russellville KY U.S.A. 134 B5
Rüsselsheim Germany 53 I4
Russia country Asia/Europe see
 Russian Federation

Russian r. U.S.A. 128 B2
▶Russian Federation country Asia/Europe
 64 I3
 Largest country in the world. Most populous
 country in Europe and 5th in Asia.
 Europe 5, 38–39

Russian Soviet Federal Socialist Republic
 country Asia/Europe see
 Russian Federation
Russkiy, Ostrov i. Rus. Fed. 74 C4
Russkiy Kameshkir Rus. Fed. 43 J5
Rust'avi Georgia 91 G2
Rustburg U.S.A. 134 F5
Rustenburg S. Africa 101 H3
Ruston U.S.A. 131 E5
Rutanzige, Lake Dem. Rep. Congo/Uganda
 see Edward, Lake
Ruteng Indon. 108 C2
Ruth U.S.A. 129 F2
Rüthen Germany 53 I3
Rutherglen Australia 112 C6
Ruther Glen U.S.A. 135 G5
Ruthin U.K. 49 D5
Ruthiyai India 82 D4
Ruth Reservoir U.S.A. 128 B1
Rutka r. Rus. Fed. 42 J4
Rutland U.S.A. 135 I2
Rutland Water resr U.K. 49 G6
Rutledge Lake Canada 121 I2
Rutog Xizang China 76 B2
Rutög China see Dêrub
Rutog Xizang China 83 F3
Rutul Rus. Fed. 91 G2
Ruvuma r. Moz./Tanz. 99 E5
 also known as Rovuma
Ruwayshid, Wādī watercourse
 Jordan 85 C3
Ruwayţah, Wādī watercourse Jordan 85 C5
Ruweis U.A.E. 88 D5
Ruwenzori National Park Uganda see
 Queen Elizabeth National Park
Ruza Rus. Fed. 42 H5
Ruzayevka Kazakh. 78 F1
Ruzayevka Rus. Fed. 43 J5
Ruzhou China 77 G1
Ružomberok Slovakia 47 Q6
Rwanda country Africa 98 C4
 Africa 7, 94–95
Ryābād Iran 88 D2
Ryan, Loch b. U.K. 50 D5
Ryazan' Rus. Fed. 43 H5
Ryazhsk Rus. Fed. 43 I5
Rybachiy, Poluostrov pen. Rus. Fed. 44 R2
Rybach'ye Kyrg. see Balykchy
Rybinsk Rus. Fed. 42 H4
Rybinskoye Vodokhranilishche resr
 Rus. Fed. 42 H4
Rybnik Poland 47 Q5
Rybnitsa Moldova see Rîbniţa
Rybnoye Rus. Fed. 43 H5
Rybreka Rus. Fed. 42 G3
Ryd Sweden 45 I8
Rydberg Peninsula Antarctica 152 L2
Ryde U.K. 49 F8
Rye U.K. 49 H8
Rye r. U.K. 48 G4
Rye Bay U.K. 49 H8
Rye Patch Reservoir U.S.A. 128 D1
Ryegate U.S.A. 126 F3
Rykovo Ukr. see Yenakiyeve
Ryl'sk Rus. Fed. 43 G6
Rylstone Australia 112 D4
Ryn-Peski des. Kazakh. 41 P6
Ryukyu Islands Japan 75 B8
Ryūkyū-rettō is Japan see Ryukyu Islands
Ryukyu Trench sea feature N. Pacific Ocean
 150 F2
Rzeszów Poland 43 D6
Rzhaksa Rus. Fed. 43 I5
Rzhev Rus. Fed. 42 G4

S

Sa'ādah al Barşā' pass Saudi Arabia 85 C5
Sa'ādatābād Iran 88 D4
Saal an der Donau Germany 53 L6
Saale r. Germany 53 L3
Saalfeld Germany 53 L4
Saanich Canada 120 F5
Saar land Germany see Saarland
Saar r. Germany 52 G5
Saarbrücken Germany 52 G5
Saaremaa i. Estonia 45 M7
Saarenkylä Fin. 44 N3
Saargau reg. Germany 52 G5
Saarijärvi Fin. 44 N5
Saari-Kämä Fin. 44 O3
Saarikoski Fin. 44 L2
Saaristomeren kansallispuisto nat. park
 Fin. see Skärgårdshavets nationalpark
Saarland land Germany 52 G5
Saarlouis Germany 52 G5
Saatlı Azer. 91 H3
Saatly Azer. see Saatlı
Saba i. Neth. Antilles 137 L5
Saba'ah Egypt see Saba'ah
Saba'ah Egypt 85 A4
Sab' Ābār Syria 85 C3
Šabac Serb. and Mont. 59 H2
Sabadell Spain 57 H3
Sabae Japan 75 E6
Sabak Malaysia 71 C7
Sabalana i. Indon. 68 F8
Sabalana, Kepulauan is Indon. 68 F8
Sabana, Archipiélago de is Cuba 137 H4
Sabang Indon. 71 A6
Şabanözü Turkey 90 D2
Sabará Brazil 145 C2
Sabastiya West Bank 85 B3
Sab'atayn, Ramlat as des. Yemen 86 G6
Sabaudia Italy 58 E4
Sabaya Bol. 142 E7
Sabdê China 76 D2
Sabelo S. Africa 100 F6
Sāberi, Hāmūn-e marsh Afgh./Iran 89 F4
Şabḩā Jordan 85 C3
Sabhā Libya 97 E2

Şabbā' Saudi Arabia 88 B6
Sabhrai India 82 B5
Sabi r. India 82 D3
Sabi r. Moz./Zimbabwe see Save
Sabie Moz. 101 K3
Sabie r. S. Africa 101 J3
Sabie S. Africa 101 J3
Sabina U.S.A. 134 D4
Sabinal Mex. 127 G7
Sabinal, Cayo i. Cuba 133 E8
Sabinas Mex. 131 C7
Sabinas r. Mex. 131 C7
Sabinas Hidalgo Mex. 131 C7
Sabine r. U.S.A. 131 E6
Sabine Lake U.S.A. 131 E6
Sabine Pass U.S.A. 131 E6
Sabini, Monti mts Italy 58 E3
Sabkhat al Bardawil Reserve nature res.
 Egypt see Lake Bardawil Reserve
Sable, Cape Canada 123 I6
Sable, Cape U.S.A. 133 D7
Sable, Lac du l. Canada 123 J2
Sable Island Canada 123 K6
Sabon Kafi Niger 96 D3
Sabrina Coast Antarctica 152 F2
Sabugal Port. 57 C3
Sabzawar Afgh. see Shīndand
Sabzevār Iran 88 E2
Sabzvārān Iran see Jīroft
Sacalinul Mare, Insula i. Romania 59 M2
Sacaton U.S.A. 129 H5
Sac City U.S.A. 130 E3
Săcele Romania 59 K2
Sachigo r. Canada 121 N4
Sachigo Lake Canada 121 M4
Sachin India 82 C5
Sach'on S. Korea 75 C6
Sach Pass India 82 D2
Sachsen land Germany 53 N3
Sachsen-Anhalt land Germany 53 L2
Sachsenheim Germany 53 J6
Sachs Harbour Canada 118 F2
Sacirsuyu r. Syria/Turkey see Säjür, Nahr
Sackpfeife hill Germany 53 I4
Sackville Canada 123 I5
Saco ME U.S.A. 135 J2
Saco MT U.S.A. 126 G2
Sacramento Brazil 145 B2
▶Sacramento U.S.A. 128 C2
 State capital of California.

Sacramento r. U.S.A. 128 C2
Sacramento Mountains U.S.A. 127 G6
Sacramento Valley U.S.A. 128 B1
Sada S. Africa 101 H7
Sádaba Spain 57 F2
Sá da Bandeira Angola see Lubango
Şadad Syria 85 C2
Şa'dah Yemen 86 F6
Sadao Thai. 71 C6
Saddat al Hindīyah Iraq 91 G4
Saddleback Mesa mt. U.S.A. 131 C5
Saddle Hill hill Australia 110 D2
Saddle Peak hill India 71 A4
Sa Đec Vietnam 71 D5
Sadêng China 76 B2
Sadieville U.S.A. 134 C4
Sadij watercourse Iran 88 E5
Sadiola Mali 96 B3
Sadiqabad Pak. 89 H4
Sad Istragh mt. Afgh./Pak. 89 I2
Sa'dīyah, Hawr as imp. l. Iraq 91 G4
Sa'diyyat i. U.A.E. 88 D5
Sado r. Port. 57 B4
Sadoga-shima i. Japan 75 E5
Sadot Egypt see Sadūt
Sadovoye Rus. Fed. 43 J7
Sa Dragonera i. Spain 57 H4
Sadras India 84 D3
Sadūt Egypt 85 B4
Sadūt Egypt see Sadūt
Sæby Denmark 45 G8
Saena Julia Italy see Siena
Safad Israel see Zefat
Safāshahr Iran 88 D4
Safayal Maqūf well Iraq 91 G5
Safed Khirs mts Afgh. 89 H2
Safed Koh mts Afgh. 89 H3
Safed Koh mts Afgh./Pak. 89 H3
Saffānīyah, Ra's as pt Saudi Arabia 88 C4
Säffle Sweden 45 H7
Safford U.S.A. 129 I5
Saffron Walden U.K. 49 H6
Safi Morocco 54 C5
Safīdār, Kūh-e mt. Iran 88 D4
Safīd Kūh mts Afgh. see Paropamisus
Safīd Sagak Iran 89 F3
Safiras, Serra das mts Brazil 145 C2
Şāfītā Syria 85 C2
Safonovo Arkhangel'skaya Oblast'
 Rus. Fed. 42 K2
Safonovo Smolenskaya Oblast'
 Rus. Fed. 43 G5
Safrā' al Asyāḩ esc. Saudi Arabia 88 A5
Safrā' as Sark esc. Saudi Arabia 86 F4
Safranbolu Turkey 90 D2
Saga China 83 F3
Saga Japan 75 C6
Saga Kazakh. 80 B1
Sagaing Myanmar 70 A2
Sagami-nada g. Japan 75 E6
Sagamore U.S.A. 134 F3
Saganthit Kyun i. Myanmar 71 B4
Sagar Karnataka India 84 B3
Sagar Karnataka India 84 B2
Sagar Madh. Prad. India 82 D5
Sagaredzho Georgia see Sagarejo
Sagarejo Georgia 91 G2
Sagar Island India 83 G5
Sagarmatha National Park Nepal 83 F4
Sagastyr Rus. Fed. 65 N2
Sagavanirktok r. U.S.A. 118 D3
Sage U.S.A. 126 F4
Saggi, Har mt. Israel 85 B4
Saghand Iran 88 D3
Saginaw U.S.A. 134 D2
Saginaw Bay U.S.A. 134 D2
Saglek Bay Canada 123 J2
Saglouc Canada see Salluit
Sagone, Golfe de b. Corsica France 56 I5

Sagres Port. 57 B5
Sagthale India 82 C5
Saguache U.S.A. 127 G5
Sagua la Grande Cuba 137 H4
Saguaro Lake U.S.A. 129 H5
Saguaro National Park U.S.A. 129 H5
Saguenay r. Canada 123 H4
Sagunt Spain see Sagunto
Sagunto Spain 57 F4
Saguntum Spain see Sagunto
Sahagún Spain 57 D2
Sahand, Küh-e mt. Iran 88 B2

►Sahara des. Africa 96 D3
Largest desert in the world.

Şahara el Gharbîya des. Egypt see
Western Desert
Şahara el Sharqîya des. Egypt see
Eastern Desert
Saharan Atlas mts Alg. see Atlas Saharien
Saharanpur India 82 D3
Sahara Well Australia 108 C5
Saharsa India 83 F4
Sahaswan India 82 D3
Sahat, Küh-e hill Iran 88 D3
Sahatwar India 83 F4
Şahbuz Azer. 91 G3
Sahdol India see Shahdol
Sahebganj India see Sahibganj
Sahebgunj India see Sahibganj
Saheira, Wâdi el watercourse Egypt see
Suhaymî, Wâdî as
Sahel reg. Africa 96 C3
Sahibganj India 83 F4
Sahiwal Pak. 89 I4
Sahlābād Iran 89 E3
Şahm Oman 88 E5
Şahneh Iran 88 B3
Şahrā al Ḥijārah reg. Iraq 91 G5
Sahuaripa Mex. 127 F7
Sahuayo Mex. 136 D4
Sahuteng China see Zadoi
Sa Huynh Vietnam 71 E4
Sahyadri mts India see Western Ghats
Sahyadriparvat Range hills India 84 B1
Sai r. India 83 E4
Sai Buri Thai. 71 C6
Saïda Alg. 57 G6
Saïda Lebanon see Sidon
Sai Dao Tai, Khao mt. Thai. 71 C4
Saïdia Morocco 57 E6
Sa'īdīyeh Iran see Soltānīyeh
Saidpur Bangl. 83 G4
Saiha India 83 H5
Saihan Tal China 73 K4
Saijō Japan 75 D6
Saikai National Park Japan 75 C6
Saiki Japan 75 C6
Sai Kung H.K. China 77 [inset]
Sailana India 82 C5
Saimaa l. Fin. 45 P6
Saimbeyli Turkey 90 E3
Saindak Pak. 89 F4
Sa'indezh Iran 88 B2
Sa'in Qal'eh Iran see Sa'indezh
St Abb's Head hd U.K. 50 G5
St Agnes U.K. 49 B8
St Agnes i. U.K. 49 A9
St Alban's Canada 123 L5
St Albans U.K. 49 G7
St Albans VT U.S.A. 135 I1
St Albans WV U.S.A. 134 E4
St Alban's Head hd England U.K. see
St Aldhelm's Head
St Albert Canada 120 H4
St Aldhelm's Head hd U.K. 49 E8
St-Amand-les-Eaux France 52 D4
St-Amand-Montrond France 56 F3
St-Amour France 56 G3
St-André, Cap pt Madag. see
Vilanandro, Tanjona
St Andrews U.K. 50 G4
St Andrew Sound inlet U.S.A. 133 D6
St Anne U.S.A. 134 B3
St Ann's Bay Jamaica 137 I5
St Anthony Canada 123 L4
St Anthony U.S.A. 126 F4
St-Arnaud Alg. see El Eulma
St Arnaud Australia 112 A6
St Arnaud Range mts N.Z. 113 D6
St-Arnoult-en-Yvelines France 52 B6
St-Augustin Canada 123 K4
St Augustin r. Canada 123 K4
St Augustine U.S.A. 133 D6
St Austell U.K. 49 C8
St-Avertin France 56 E3
St-Avold France 52 G5
St Barbe Canada 123 K4
St-Barthélemy i. West Indies 137 L5
St Bees U.K. 48 D4
St Bees Head hd U.K. 48 D4
St Bride's Bay U.K. 49 B7
St-Brieuc France 56 C2
St Catharines Canada 134 F2
St Catherines Island U.S.A. 133 D6
St Catherine's Point U.K. 49 F8
St-Céré France 56 E4
St-Chamond France 56 G4
St Charles ID U.S.A. 126 F4
St Charles MD U.S.A. 135 G4
St Charles MI U.S.A. 134 C2
St Charles MO U.S.A. 130 F4
St-Chély-d'Apcher France 56 F4
St Christopher and Nevis country
West Indies see St Kitts and Nevis
St Clair r. Canada/U.S.A. 134 D2
St Clair, Lake Canada/U.S.A. 134 D2
St-Claude France 56 G3
St Clears U.K. 49 C7
St Cloud U.S.A. 130 E2
St Croix r. U.S.A. 122 B5
St Croix i. U.S.A. 137 L5
St Croix Falls U.S.A. 130 E2
St David U.S.A. 129 H6
St David's Head hd U.K. 49 B7
St-Denis France 52 C6

►St-Denis Réunion 149 L7
Capital of Réunion.

St-Denis-du-Sig Alg. see Sig
St-Dié France 56 H2

St-Dizier France 52 E6
St-Domingue country West Indies see
Haiti
Sainte Anne Canada 121 L5
Ste-Anne, Lac l. Canada 123 I4
St Elias, Cape U.S.A. 118 D4

►St Elias, Mount U.S.A. 120 A2
4th highest mountain in North America.

St Elias Mountains Canada 120 A2
Ste-Marguerite r. Canada 123 I4
Ste-Marie, Cap c. Madag. see
Vohimena, Tanjona
Sainte-Marie, Île i. Madag. see
Boraha, Nosy
Ste-Maxime France 56 H5
Sainte Rose du Lac Canada 121 L5
Saintes France 56 D4
Sainte Thérèse, Lac l. Canada 120 F1
St-Étienne France 56 G4
St-Étienne-du-Rouvray France 52 B5
St-Fabien Canada 123 H4
St-Félicien Canada 123 G4
Saintfield U.K. 51 G3
St-Florent Corsica France 56 I5
St-Florent-sur-Cher France 56 F3
St Floris, Parc National nat. park
Cent. Afr. Rep. 98 C3
St-Flour France 56 F4
St Francesville U.S.A. 131 F6
St Francis U.S.A. 130 C4
St Francis r. U.S.A. 131 F5
St Francis Isles Australia 109 F8
St-François r. Canada 123 G5
St-François, Lac l. Canada 123 H5
St-Gaudens France 56 E5
St George Australia 112 D2
St George r. Australia 110 D3
St George AK U.S.A. 118 B4
St George SC U.S.A. 133 D5
St George UT U.S.A. 129 G3
St George, Point U.S.A. 126 B4
St George Head hd Australia 112 F5
St George Island U.S.A. 118 B4
St George Range hills Australia 108 D4
St-Georges Canada 123 H5

►St George's Grenada 137 L6
Capital of Grenada.

St George's Bay Nfld. and Lab.
Canada 123 K4
St George's Bay N.S. Canada 123 J5
St George's Channel P.N.G. 106 F2
St George's Channel Ireland/U.K. 51 F6
St Gotthard Hungary see Szentgotthárd
St Gotthard Pass Switz. 56 I3
St Govan's Head hd U.K. 49 C7
St Helen U.S.A. 134 C1
St Helena i. S. Atlantic Ocean 148 H7
St Helena U.S.A. 128 B2

►St Helena and Dependencies terr.
S. Atlantic Ocean 148 H7
United Kingdom Overseas territory.
Consists of St Helena, Ascension,
Tristan da Cunha and Gough Island.
Africa 7, 94–95

St Helena Bay S. Africa 100 D7
St Helens Australia 111 [inset]
St Helens U.K. 48 E5
St Helens U.S.A. 126 C3
St Helens, Mount vol. U.S.A. 126 C3
St Helens Point Australia 111 [inset]

►St Helier Channel Is 49 E9
Capital of Jersey.

Sainthiya India 83 F5
St-Hubert Belgium 52 F4
St-Hyacinthe Canada 123 G5
St Ignace U.S.A. 132 C2
St Ignace Island Canada 122 D4
St Ishmael U.K. 49 C7
St Ives England U.K. 49 B8
St Ives England U.K. 49 G6
St-Jacques, Cap Vietnam see Vung Tau
St-Jacques-de-Dupuy Canada 122 F4
St James MN U.S.A. 130 E3
St James MO U.S.A. 130 F4
St James, Cape Canada 120 D5
St-Jean r. Canada 123 I4
St-Jean, Lac l. Canada 123 G4
St-Jean-d'Acre Israel see 'Akko
St-Jean-d'Angély France 56 D4
St-Jean-de-Monts France 56 C3
St-Jean-sur-Richelieu Canada 135 I1
St-Jérôme Canada 122 G5
St Joe r. U.S.A. 126 D3
Saint John Canada 123 I5
St John U.S.A. 130 D4
St John r. U.S.A. 132 H2
St John, Cape Canada 123 L4
St John Bay Canada 123 K4
St John Island Canada 123 K4

►St John's Antigua and Barbuda 137 L5
Capital of Antigua and Barbuda.

►St John's Canada 123 L5
Provincial capital of Newfoundland and
Labrador.

St Johns AZ U.S.A. 129 I4
St Johns MI U.S.A. 134 C2
St Johns OH U.S.A. 134 C3
St Johns r. U.S.A. 133 D6
St Johnsbury U.S.A. 135 I1
St John's Chapel U.K. 48 E4
St Joseph IL U.S.A. 134 A3
St Joseph LA U.S.A. 131 F6
St Joseph MI U.S.A. 134 B2
St Joseph MO U.S.A. 130 E4
St Joseph r. U.S.A. 134 C3
St Joseph, Lake Canada 121 N5
St-Joseph-d'Alma Canada see Alma
St Joseph Island Canada 122 E5
St-Junien France 56 E4
St Just U.K. 49 B8

St-Just-en-Chaussée France 52 C5
St Keverne U.K. 49 B8
St Kilda i. U.K. 40 E4
St Kilda is U.K. 46 C2
►St Kitts and Nevis country
West Indies 137 L5
North America 9, 116–117
St-Laurent inlet Canada see St Lawrence
St-Laurent, Golfe du g. Canada see
St Lawrence, Gulf of
St-Laurent-du-Maroni Fr. Guiana 143 H2
St Lawrence Canada 123 L5
St Lawrence inlet Canada 123 H4
St Lawrence, Cape Canada 123 J5
St Lawrence, Gulf of Canada 123 J4
St Lawrence Island U.S.A. 118 B3
St Lawrence Islands National Park
Canada 135 H1
St Lawrence Seaway sea chan.
Canada/U.S.A. 135 H1
St-Léonard Canada 123 G5
St Leonard U.S.A. 135 G4
St Lewis r. Canada 123 K3
St-Lô France 56 D2
St-Louis Senegal 96 B3
St Louis MI U.S.A. 134 C2
St Louis MO U.S.A. 130 F4
St Louis r. U.S.A. 122 B5
►St Lucia country West Indies 137 L6
North America 9, 116–117
St Lucia, Lake S. Africa 101 K5
St Lucia Estuary S. Africa 101 K5
St Luke's Island Myanmar see
Zadetkale Kyun
St Magnus Bay U.K. 50 [inset]
St-Maixent-l'École France 56 D3
St-Malo France 56 C2
St-Malo, Golfe de g. France 56 C2
St-Marc Haiti 137 J5
St Maries U.S.A. 126 D3
St Marks S. Africa 101 H7
St Mark's S. Africa see Cofimvaba
St-Martin i. Neth. Antilles see Sint Maarten

►St-Martin i. West Indies 137 L5
Dependency of Guadeloupe (France). The
southern part of the island is the Dutch
territory of Sint Maarten.

St Martin, Cape S. Africa 100 C7
St Martin, Lake Canada 121 L5
St Martin's i. U.K. 49 A9
St Martin's Island Bangl. 70 A2
St Mary Peak Australia 111 B6
St Mary Reservoir Canada 120 H5
St Mary's Canada 134 E2
St Mary's U.K. 50 G2
St Mary's i. U.K. 49 A9
St Marys PA U.S.A. 135 F3
St Marys WV U.S.A. 134 E4
St Marys r. U.S.A. 134 C3
St Mary's, Cape Canada 123 L5
St Mary's Bay Canada 123 L5
St Marys City U.S.A. 135 G4
St Matthew Island U.S.A. 118 A3
St Matthews U.S.A. 134 C4
St Matthew's Island Myanmar see
Zadetkyi Kyun
St Matthias Group is P.N.G. 69 L7
St-Maurice r. Canada 123 G5
St Mawes U.K. 49 B8
St-Médard-en-Jalles France 56 D4
St Meinrad U.S.A. 134 B4
St Michaels U.S.A. 135 G4
St Michael's Bay Canada 123 L3
St-Mihiel France 52 F6
St-Nazaire France 56 C3
St Neots U.K. 49 G6
St-Nicolas Belgium see Sint-Niklaas
St-Nicolas, Mont hill Lux. 52 G5
St-Nicolas-de-Port France 56 H2
St-Omer France 52 C4
Saintonge reg. France 56 D4
St-Pacôme Canada 123 H5
St-Palais France 56 D5
St Paris U.S.A. 134 D3
St-Pascal Canada 123 H5
St Paul r. Canada 123 K4
St-Paul atoll Fr. Polynesia see Héréhérétué
St Paul AK U.S.A. 118 A4

►St Paul MN U.S.A. 130 E2
State capital of Minnesota.

St Paul NE U.S.A. 130 D3
St-Paul, Île i. Indian Ocean 149 N8
St Paul Island U.S.A. 118 A4
St Peter and St Paul Rocks is
N. Atlantic Ocean see
São Pedro e São Paulo

►St Peter Port Channel Is 49 E9
Capital of Guernsey.

St Peter's N.S. Canada 123 J5
St Peters P.E.I. Canada 123 J5
St Petersburg Rus. Fed. 45 Q7
St Petersburg U.S.A. 133 D7
St-Pierre mt. France 56 H5

►St-Pierre St Pierre and Miquelon 123 L5
Capital of St Pierre and Miquelon.

►St Pierre and Miquelon terr. N. America
123 K5
French Territorial Collectivity.
North America 9, 116–117

St-Pierre-d'Oléron France 56 D4
St-Pierre-le-Moûtier France 56 F3
St-Pol-sur-Ternoise France 52 C4
St-Pourçain-sur-Sioule France 56 F3
St-Quentin France 52 D5
St Regis U.S.A. 126 E3
St Regis Falls U.S.A. 135 H1
St-Rémi Canada 135 I1
St-Saëns France 52 B5
St Sebastian Bay S. Africa 100 E8
St-Siméon Canada 123 H5
St Simons Island U.S.A. 133 D6
St Theresa Point Canada 121 M4

St Thomas Canada 134 E2
St-Trond Belgium see Sint-Truiden
St-Tropez France 56 H5
St-Tropez, Cap de c. France 56 H5
St-Vaast-la-Hougue France 49 F9
St-Valery-en-Caux France 49 H9
St-Véran France 56 H4
St Vincent U.S.A. 130 D1
St Vincent country West Indies see
St Vincent and the Grenadines
St Vincent, Cape Australia 111 [inset]
St Vincent, Cape Port. see
São Vicente, Cabo de
St Vincent, Gulf Australia 111 B7
►St Vincent and the Grenadines country
West Indies 137 L6
North America 9, 116–117
St Vincent Passage St Lucia/St Vincent
137 L6
St-Vith Belgium 52 G4
St Walburg Canada 121 I4
St Williams Canada 134 E2
St-Yrieix-la-Perche France 56 E4
Sain Us China 72 J4
Saioa mt. Spain 57 F2
Saipal mt. Nepal 82 E3
Saipan i. N. Mariana Is 69 L3
Sai Pok Liu Hoi Hap H.K. China see
West Lamma Channel
Saiteli Turkey see Kadınhanı
Saitlai Myanmar 70 A2
Saittanulkki hill Fin. 44 N3
Sai Yok National Park Thai. 71 B4
Sajam Indon. 69 I7
Sajama, Nevado mt. Bol. 142 E7
Säjir Saudi Arabia 88 B5
Säjür, Nahr r. Syria/Turkey 85 D1
Sajzī Iran 88 D3
Sak watercourse S. Africa 100 E5
Sakaide Japan 75 D6
Sakākah Saudi Arabia 91 F5
Sakakawea, Lake U.S.A. 130 C2
Sakami Canada 122 G3
Sakami r. Canada 122 F3
Sakami Lake Canada 122 F3
Sakar mts Bulg. 59 L4
Sakaraha Madag. 99 E6
Sak'art'velo country Asia see Georgia
Sakarya Sakarya Turkey see Adapazarı
Sakarya r. Turkey 59 N4
Sakassou Côte d'Ivoire 96 C4
Sakata Japan 75 E5
Sakchu N. Korea 75 B4
Sakesar Pak. 89 I3
Sakhalin i. Rus. Fed. 74 F2
Sakhalin Oblast admin. div. Rus. Fed. see
Sakhalinskaya Oblast'
Sakhalinskaya Oblast' admin. div.
Rus. Fed. 74 F2
Sakhalinskiy Zaliv b. Rus. Fed. 74 F1
Sakhi India 82 C3
Sakhile S. Africa 101 I4
Şäki Azer. 91 G2
Saki Nigeria see Shaki
Saki Ukr. see Saky
Šakiai Lith. 45 M9
Sakir mt. Pak. 89 G4
Sakishima-shotō is Japan 73 M8
Sakoli India 82 D5
Sakon Nakhon Thai. 70 D3
Sakrivier S. Africa 100 E6
Sakura Japan 75 F6
Saky Ukr. 90 D1
Sakylä Fin. 45 M6
Sal i. Cape Verde 96 [inset]
Sal r. Rus. Fed. 43 I7
Sala Sweden 45 J7
Salaberry-de-Valleyfield Canada 135 H1
Salacgrīva Latvia 45 N8
Sala Consilina Italy 58 F4
Salada, Laguna salt l. Mex. 129 F5
Saladas Arg. 144 E3
Salado r. Buenos Aires Arg. 144 E5
Salado r. Santa Fé Arg. 144 D4
Salado r. Arg. 144 C5
Salado r. Mex. 131 D7
Salaga Ghana 96 C4
Salairskiy Kryazh ridge Rus. Fed. 72 E2
Salajwe Botswana 100 G2
Şalālah Oman 87 H6
Salamanca Mex. 136 D4
Salamanca Spain 57 D3
Salamanca U.S.A. 135 F2
Salamanga Moz. 101 K4
Salamantica Spain see Salamanca
Salamat, Bahr r. Chad 97 E4
Salāmī Iran 89 E3
Salamina i. Greece 59 J6
Salamis tourist site Cyprus 85 A2
Salamís i. Greece see Salamina
Salamīyah Syria 85 C2
Salamonie r. U.S.A. 134 C3
Salamonie Lake U.S.A. 134 C3
Salang Tunnel Afgh. 89 H3
Salantai Lith. 45 L8
Salar de Pocitos Arg. 144 C2
Salari Pak. 89 G5
Salas Spain 57 C2
Salaspils Latvia 45 N8
Salavan Laos 70 D4
Salawati i. Indon. 69 I7
Salawin, Mae Nam r. China/Myanmar see
Salween
Salaya India 82 B5
Salayar i. Indon. 69 G8
►Sala y Gómez, Isla i. S. Pacific Ocean
151 M7
Most easterly point of Oceania.

Salazar Angola see N'dalatando
Salbris France 56 F3
Šalčininkai Lith. 45 N9
Salcombe U.K. 49 D8
Saldae Alg. see Bejaïa
Saldaña Spain 57 D2
Saldanha S. Africa 100 C7
Saldanha Bay S. Africa 100 C7
Saldus Latvia 45 M8
Sale Australia 112 C7
Salé Morocco 54 C5
Salekhard Rus. Fed. 64 H3
Salem India 84 C4
Salem AR U.S.A. 131 F4
Salem IL U.S.A. 130 F4
Salem IN U.S.A. 134 B4
Salem MA U.S.A. 135 J2
Salem MO U.S.A. 130 F4
Salem NJ U.S.A. 135 H4
Salem NY U.S.A. 135 I2
Salem OH U.S.A. 134 E3

►Salem OR U.S.A. 126 C3
State capital of Oregon.

Salem SD U.S.A. 130 D3
Salem VA U.S.A. 134 E5
Salen Scotland U.K. 50 D4
Salerno Italy 58 F4
Salerno, Golfo di g. Italy 58 F4
Salernum Italy see Salerno
Salford U.K. 48 E5
Salgótarján Hungary 47 Q6
Salgueiro Brazil 143 K5
Salian Afgh. 89 F4
Salibabu i. Indon. 69 H6
Salida U.S.A. 127 G5
Salies-de-Béarn France 56 D5
Salihli Turkey 59 M5
Salihorsk Belarus 45 O10
Salima Malawi 99 D5
Salina KS U.S.A. 130 D4
Salina UT U.S.A. 129 H2
Salina, Isola i. Italy 58 F5
Salina Cruz Mex. 136 E5
Salinas Brazil 145 C2
Salinas Ecuador 142 B4
Salinas Mex. 136 D4
Salinas r. Mex. 131 D7
Salinas U.S.A. 128 C3
Salinas r. U.S.A. 128 C3
Salinas, Cabo de c. Spain see
Ses Salines, Cap de
Salinas, Ponta das pt Angola 99 B5
Salinas Peak U.S.A. 127 G6
Saline r. U.S.A. 134 D2
Saline r. U.S.A. 130 D4
Saline Valley depr. U.S.A. 128 E3
Salinópolis Brazil 143 I4
Salinosó Lachay, Punta pt Peru 142 C6
Salisbury U.K. 49 F7
Salisbury MD U.S.A. 135 H4
Salisbury NC U.S.A. 132 D5
Salisbury Zimbabwe see Harare
Salisbury Plain U.K. 49 E7
Şalkhad Syria 85 C3
Salla Fin. 44 P3
Sallisaw U.S.A. 131 E5
Salluit Canada 153 K2
Sallum, Khalīj as b. Egypt 90 B5
Sallyana Nepal see Salyan
Salmäs Iran 88 B2
Salmi Rus. Fed. 42 F3
Salmo Canada 120 G5
Salmon U.S.A. 126 E3
Salmon r. U.S.A. 126 D3
Salmon Arm Canada 120 G5
Salmon Falls Creek r. U.S.A. 126 E4
Salmon Gums Australia 109 C8
Salmon Reservoir U.S.A. 135 H2
Salmon River Mountains U.S.A. 126 E3
Salmtal Germany 52 G5
Salo Fin. 45 M6
Salome U.S.A. 129 G5
Salon India 82 E4
Salon-de-Provence France 56 G5
Salonica Greece see Thessaloniki
Salonika Greece see Thessaloniki
Salpausselkä reg. Fin. 45 N6
Salqin Syria 85 C1
Sal'sk Rus. Fed. 43 I7
Salsomaggiore Terme Italy 58 C2
Salt Jordan see As Salt
Salt watercourse S. Africa 100 F7
Salt r. U.S.A. 129 G5
Salta Arg. 144 C2
Saltaire U.K. 48 F5
Saltash U.K. 49 C8
Saltcoats U.K. 50 E5
Saltee Islands Ireland 51 F5
Saltfjellet Svartisen Nasjonalpark nat. park
Norway 44 I3
Saltfjorden sea chan. Norway 44 H3
Salt Fork Arkansas r. U.S.A. 131 D4
Salt Fork Lake U.S.A. 134 E3
Saltillo Mex. 131 C7
Salt Lake India 89 I5

►Salt Lake City U.S.A. 129 H1
State capital of Utah.

Salt Lick U.S.A. 134 D4
Salto Brazil 145 B3
Salto Uruguay 144 F4
Salto da Divisa Brazil 145 D2
Salto Grande Brazil 145 A3
Salton Sea salt l. U.S.A. 129 F5
Salto Santiago, Represa de resr
Brazil 144 F3
Salt Range hills Pak. 89 I3
Salt River Canada 121 H2
Saluda U.S.A. 135 G5
Salûm Egypt see As Sallûm
Salûm, Khalîj a b. Egypt see
Sallum, Khalīj as
Saluq, Küh-e mt. Iran 88 E2
Salur India 84 D2
Saluzzo Italy 58 B2
Salvador Brazil 145 D1
Salvador country Central America see
El Salvador
Salvador, Lake U.S.A. 131 F6
Salvaleón de Higüey Dom. Rep. see Higüey
Salvation Creek r. U.S.A. 129 H2
Salwah S. Africa 98 F1
Salwah, Dawḥat b. Qatar/Saudi Arabia
88 C5
Salween r. China/Myanmar 76 C5
also known as Mae Nam Khong or Mae
Nam Salwin or Nu Jiang (China) or
Thanlwin (Myanmar)

Salyan Azer. 91 H3
Salyan Nepal see Sallyana
Sal'yany Azer. see Salyan
Salyersville U.S.A. 134 D5
Salzbrunn Namibia 100 C3
Salzburg Austria 47 N7
Salzgitter Germany 53 K2
Salzhausen Germany 53 K1
Salzkotten Germany 53 I3
Salzmünde Germany 53 L3
Salzwedel Germany 53 L2
Sam India 82 B4
Samae San, Ko i. Thai. 71 C4
Samagaltay Rus. Fed. 80 H1
Samāh well Saudi Arabia 88 B4
Samaida Iran see Someydeh
Samaixung China 83 E2
Samakhixai Laos see Attapu
Samalanga Indon. 71 B6
Samalayuca Mex. 127 G7
Samalkot India 84 D2
Samālūṭ Egypt 90 C5
Samālūṭ Egypt see Samālūṭ
Samana Cay i. Bahamas 133 F8
Samanala mt. Sri Lanka see Adam's Peak
Samandaği Turkey 85 B1
Samangān Iran 89 F4
Samani Japan 74 F4
Samanlı Dağları mts Turkey 59 M4
Samar Kazakh. see Samarskoye
Samar i. Phil. 69 H4
Samara Rus. Fed. 43 K5
Samara r. Rus. Fed. 41 Q5
Samarga Rus. Fed. 74 E3
Samarinda Indon. 68 F7
Samarka Rus. Fed. 74 D3
Samarkand Uzbek. see Samarqand
Samarkand, Pik mt. Tajik. see
Samarqand, Qullai
Samarobriva France see Amiens
Samarqand Uzbek. 89 G2
Samarqand, Qullai mt. Tajik. 89 H2
Sämarrā' Iraq 91 F4
Samarskoye Kazakh. 80 F2
Samasata Pak. 89 H4
Samastipur India 83 F4
Şamaxı Azer. 91 H2
Samba Jammu and Kashmir 82 C2
Sambalung mts Indon. 68 F6
Sambalpur India 83 E5
Sambar, Tanjung pt Indon. 68 E7
Sambas Indon. 71 E7
Sambat Ukr. see Kiev
Sambava Madag. 99 F5
Sambha India 83 G4
Sambhajinagar India see Aurangabad
Sambhal India 82 D3
Sambhar Lake India 82 C4
Sambir Ukr. 43 D6
Sambito r. Brazil 143 J5
Sâmbor Cambodia 71 D4
Sambor Ukr. see Sambir
Samborombón, Bahía b. Arg. 144 E5
Sambre r. Belgium/France 52 E4
Samch'ŏk S. Korea 75 C5
Samch'ŏnp'o S. Korea see Sach'on
Same Tanz. 98 D4
Samer France 52 B4
Sami India 82 B5
Samīrah Saudi Arabia 86 F4
Samirum Iran see Yazd-e Khvāst
Samjiyŏn N. Korea 74 C4
Şämkir Azer. 91 G2
Sam Neua Laos see Xam Nua
►Samoa country S. Pacific Ocean 107 I3
Oceania 8, 104–105
Samoa Basin sea feature S. Pacific Ocean
150 I7
Samoa i Sisifo country S. Pacific Ocean see
Samoa
Samobor Croatia 58 F2
Samoded Rus. Fed. 42 I3
Samokov Bulg. 59 J3
Šamorín Slovakia 47 P6
Samos i. Greece 59 L6
Samosir i. Indon. 71 B7
Samothrace i. Greece see Samothraki
Samothraki i. Greece 59 K4
Samoylovka Rus. Fed. 43 I6
Sampê China see Xiangcheng
Sampit Indon. 68 E7
Sampit, Teluk b. Indon. 68 E7
Sam Rayburn Reservoir U.S.A. 131 E6
Samrong Cambodia see Phumĭ Sâmraông
Samsang China 83 E3
Sam Sao, Phou mts Laos/Vietnam 70 C2
Samson U.S.A. 133 C6
Sâm Sơn Vietnam 70 D3
Samsun Turkey 90 E2
Samti Afgh. 89 H2
Samui, Ko i. Thai. 71 C5
Samut Prakan Thai. 71 C4
Samut Sakhon Thai. 71 C4
Samut Songkhram Thai. 71 C4
Samyai China 83 G3
San Mali 96 C3
San, Phou mt. Laos 70 C3
San, Tônlé r. Cambodia 71 D4

►Şan'ā' Yemen 86 F6
Capital of Yemen.

Sanaa Yemen see Şan'ā'
SANAE research station Antarctica 152 B2
San Agustín U.S.A. see St Augustine
San Agustin, Cape Phil. 69 H5
San Agustin, Plains of U.S.A. 129 I5
Sanak Island U.S.A. 118 B4
Sanandaj Iran 88 B3
San Andreas U.S.A. 128 C2
San Andrés, Isla de i. Caribbean Sea
137 H6
San Andres Mountains U.S.A. 127 G6
San Angelo U.S.A. 131 C6
San Antonio Chile 144 B4
San Antonio NM U.S.A. 127 G6
San Antonio TX U.S.A. 131 D6
San Antonio r. U.S.A. 131 D6
San Antonio, Cabo c. Cuba 137 H4
San Antonio del Mar Mex. 127 D7
San Antonio Oeste Arg. 144 D6

San Antonio Reservoir U.S.A. 128 C4
San Augustín de Valle Fértil Arg. 144 C4
San Augustine U.S.A. 131 E6
San Benedetto del Tronto Italy 58 E3
San Benedicto, Isla i. Mex. 136 B5
San Benito U.S.A. 131 D7
San Benito r. U.S.A. 128 C3
San Benito Mountain U.S.A. 128 C3
San Bernardino U.S.A. 128 E4
San Bernardino Mountains U.S.A. 128 E4
San Bernardo Chile 144 B4
San Blas Mex. 127 F8
San Blas, Cape U.S.A. 133 C6
San Borja Bol. 142 E6
Sanbornville U.S.A. 135 J2
San Buenaventura Mex. 131 C7
San Carlos Chile 144 B5
San Carlos Equat. Guinea see Luba
San Carlos Coahuila Mex. 131 C6
San Carlos Tamaulipas Mex. 131 D7
San Carlos U.S.A. 129 H5
San Carlos Venez. 142 E2
San Carlos de Bariloche Arg. 144 B6
San Carlos de Bolívar Arg. 144 D5
San Carlos Lake U.S.A. 129 H5
Sancha China 76 E1
Sanchahe China see Fuyu
Sancha He r. China 76 E3
Sanchi India 82 D5
San Chien Mau mt. Laos 70 C2
Sanchor India 82 B4
San Clemente U.S.A. 128 E5
San Clemente Island U.S.A. 128 D5
Sanclêr U.K. see St Clears
San Cristóbal Arg. 144 D4
San Cristóbal i. Solomon Is 107 G3
San Cristóbal, Isla i. Galápagos Ecuador 142 [inset]
San Cristóbal de las Casas Mex. 136 F5
Sancti Spíritus Cuba 137 I4
Sand r. S. Africa 101 J2
Sandagou Rus. Fed. 74 D4
Sanda Island U.K. 50 D5
Sandakan Sabah Malaysia 68 F5
Sândăn Cambodia 71 D4
Sandane Norway 44 E6
Sandanski Bulg. 59 J4
Sandaré Mali 96 B3
Sandau Germany 53 M2
Sanday i. U.K. 50 G1
Sandbach U.K. 49 E5
Sandborn U.S.A. 134 B4
Sand Cay reef India 84 B4
Sandefjord Norway 45 G7
Sandercock Nunataks Antarctica 152 D2
Sanders U.S.A. 129 I4
Sandersleben Germany 53 L3
Sanderson U.S.A. 131 C6
Sandfire Roadhouse Australia 108 C4
Sand Fork U.S.A. 134 E4
Sandgate Australia 112 F1
Sandhead U.K. 50 E6
Sand Hill r. U.S.A. 130 D2
Sand Hills U.S.A. 130 C3
Sandia Peru 142 E6
San Diego Mex. 131 B6
San Diego CA U.S.A. 128 E5
San Diego TX U.S.A. 131 D7
San Diego, Sierra mts Mex. 127 F7
Sandıklı Turkey 59 N5
Sandila India 82 E4
Sand Lake l. Canada 121 M5
Sand Lake l. Canada 122 D5
Sandnes Norway 45 D7
Sandnessjøen Norway 44 H3
Sandoa Dem. Rep. Congo 99 C4
Sandomierz Poland 43 D6
San Donà di Piave Italy 58 E2
Sandover watercourse Australia 110 B4
Sandovo Rus. Fed. 42 H4
Sandoway Myanmar see Thandwè
Sandown U.K. 49 F8
Sandoy i. Faroe Is 44 [inset]
Sand Point U.S.A. 118 B4
Sandpoint U.S.A. 126 D2
Sandray i. U.K. 50 B4
Sandringham Australia 110 B5
Şandrul Mare, Vârful mt. Romania 59 L1
Sandsjö Sweden 45 I6
Sandspit Canada 120 D4
Sand Springs U.S.A. 131 D4
Sand Springs Salt Flat U.S.A. 128 D2
Sandstone Australia 109 B6
Sandstone U.S.A. 130 E2
Sandu Guizhou China 76 E3
Sandu Hunan China 77 G3
Sandur Faroe Is 44 [inset]
Sandusky MI U.S.A. 134 D2
Sandusky OH U.S.A. 134 D3
Sandveld mts S. Africa 100 D6
Sandverhaar Namibia 100 C4
Sandvika Akershus Norway 45 G7
Sandvika Nord-Trøndelag Norway 44 H5
Sandviken Sweden 45 J6
Sandwich Bay Canada 123 K3
Sandwich Island Vanuatu see Éfaté
Sandwich Islands N. Pacific Ocean see Hawai'ian Islands
Sandwick U.K. 50 [inset]
Sandwip Bangl. 83 G5
Sandy r. U.S.A. 129 H1
Sandy r. U.S.A. 135 K1
Sandy Bay Canada 121 K4
Sandy Cape Qld Australia 110 F5
Sandy Cape Tas. Australia 111 [inset]
Sandy Hook U.S.A. 134 D4
Sandy Hook pt U.S.A. 135 H3
Sandy Island Australia 108 C3
Sandygachy Turkm. see Sandykgaçy
Sandykgaçy Turkm. 89 F2
Sandykly Gumy des. Turkm. 89 F2
Sandy Lake Alta Canada 120 H4
Sandy Lake l. Ont. Canada 121 M4
Sandy Lake l. Canada 121 M4
Sandy Springs U.S.A. 133 C5
San Estanislao Para. 144 E2
San Esteban, Isla i. Mex. 127 E7
San Felipe Chile 144 B4
San Felipe Baja California Mex. 127 E7
San Felipe Chihuahua Mex. 127 G8

San Felipe Venez. 142 E1
San Felipe, Cayos de is Cuba 133 D8
San Felipe de Puerto Plata Dom. Rep. see Puerto Plata
San Fernando Chile 144 B4
San Fernando Mex. 131 D7
San Fernando watercourse Mex. 127 E7
San Fernando Phil. 69 G3
San Fernando Spain 57 C5
San Fernando Trin. and Tob. 137 L6
San Fernando U.S.A. 128 D4
San Fernando de Apure Venez. 142 E2
San Fernando de Atabapo Venez. 142 E3
San Fernando de Monte Cristi Dom. Rep. see Monte Cristi
Sanford FL U.S.A. 133 D6
Sanford ME U.S.A. 135 J2
Sanford MI U.S.A. 134 C2
Sanford NC U.S.A. 132 E5
Sanford, Mount U.S.A. 118 D3
Sanford Lake U.S.A. 134 C2
San Francisco Arg. 144 D4
San Francisco U.S.A. 128 B3
San Francisco, Cabo de c. Ecuador 142 B3
San Francisco, Passo de pass Arg./Chile 144 C3
San Francisco Bay inlet U.S.A. 128 B3
San Francisco del Oro Mex. 131 B7
San Francisco de Paula, Cabo c. Arg. 144 C7
San Francisco Javier Spain 57 G4
San Gabriel, Punta pt Mex. 127 E7
San Gabriel Mountains U.S.A. 128 D4
Sangachaly Azer. see Sanqaçal
Sangameshwar India 84 B2
Sangamon r. U.S.A. 130 F3
Sangan, Koh-i- mt. Afgh. see Sangān, Kūh-e
Sangān, Kūh-e mt. Afgh. 89 G3
Sangar Rus. Fed. 65 N3
Sangareddi India 84 C2
Sangareddy India see Sangareddi
San Gavino Monreale Sardinia Italy 58 C5
Sangay, Parque Nacional nat. park Ecuador 142 C4
Sangbur Afgh. 89 F3
Sangeang i. Indon. 108 B2
Sanger U.S.A. 128 D3
Sangerfield U.S.A. 135 H2
Sang-e Surakh Iran 88 D2
Sanggarmai China 76 D1
Sanggau Indon. 68 E6
Sangilen, Nagor'ye mts Rus. Fed. 80 I1
San Giovanni in Fiore Italy 58 G5
Sangir i. Indon. 69 H6
Sangir, Kepulauan is Indon. 69 G6
Sangiyn Dalay Mongolia 72 I3
Sangkapura Indon. 68 E8
Sangkulirang Indon. 68 F6
Sangli India 84 B2
Sangmai China see Dêrong
Sangmélima Cameroon 96 E4
Sanggagqoiling China 76 B2
Sango Zimbabwe 99 D6
Sangole India 84 B2
San Gorgonio Mountain U.S.A. 128 E4
Sangpi China see Xiangcheng
Sangre de Cristo Range mts U.S.A. 127 G5
Sangrur r. Bangl. 83 G5
Sangu r. Bangl. 83 G5
Sanguem India 84 B3
Sangutane r. Moz. 101 K3
Sangzhi China 77 F2
Sanhe China see Sandu
San Hipólito, Punta pt Mex. 127 E8
Sanhûr Egypt see Sanhûr
Sanhûr Egypt 90 C5
San Ignacio Beni Bol. 142 E6
San Ignacio Santa Cruz Bol. 142 F7
San Ignacio Baja California Mex. 127 E7
San Ignacio Durango Mex. 131 C7
San Ignacio Sonora Mex. 127 F7
San Ignacio Para. 144 E3
San Ignacio, Laguna l. Mex. 127 E8
Sanikiluaq Canada 122 F2
Sanin-kaigan Kokuritsu-köen Japan 75 D6
San Jacinto U.S.A. 128 E5
San Jacinto Peak U.S.A. 128 E5
San Javier Bol. 142 F7
Sanjeli India 82 C5
Sanjiang Guangdong China see Liannan
Sanjiang Guangxi China 77 F3
Sanjiang Guizhou China see Jinping
Sanjiangkou China 74 A4
Sanjiaocheng China see Haiyan
Sanjiaoping China 77 F2
Sanjō Japan 75 E5
San Joaquin r. U.S.A. 128 C2
San Joaquin Valley U.S.A. 128 C3
San Jon U.S.A. 131 C5
San Jorge, Golfo de g. Arg. 144 C7
San Jorge, Golfo de g. Spain see Sant Jordi, Golf de

▶San José Costa Rica 137 H7
Capital of Costa Rica.

San José Phil. 69 G3
San Jose U.S.A. 128 C3
San Jose NM U.S.A. 127 G6
San Jose watercourse U.S.A. 129 J4
San José, Isla i. Mex. 136 B4
San José de Amacuro Venez. 142 F2
San José de Bavicora Mex. 127 G7
San José de Buenavista Phil. 69 G4
San José de Chiquitos Bol. 142 F7
San José de Comondú Mex. 127 F8
San José de Gracia Mex. 127 E7
San Joséde la Brecha Mex. 127 E7
San José del Cabo Mex. 136 C4
San José del Guaviare Col. 142 D3
San José de Mayo Uruguay 144 E4
San José de Raíces Mex. 131 C7
San Juan Arg. 144 C4
San Juan r. Costa Rica/Nicaragua 137 H6
San Juan mt. Cuba 133 D8

San Juan Mex. 127 G8
San Juan r. Mex. 131 D7

▶San Juan Puerto Rico 137 K5
Capital of Puerto Rico.

San Juan U.S.A. 129 J5
San Juan r. U.S.A. 129 H3
San Juan, Cabo c. Arg. 144 D8
San Juan, Cabo c. Equat. Guinea 96 D4
San Juan Bautista Para. 144 E3
San Juan Bautista de las Misiones Para. see San Juan Bautista
San Juan de Guadalupe Mex. 131 C7
San Juan de los Morros Venez. 142 E2
San Juan Mountains U.S.A. 129 J3
San Juan y Martínez Cuba 133 D8
San Julián Arg. 144 C7
San Justo Arg. 144 D4
Sankari Drug India 84 C4
Sankh r. India 81 F7
Sankhu India 82 C3
Sankra Chhattisgarh India 84 D1
Sankra Rajasthan India 82 B4
Sankt Augustin Germany 53 H4
Sankt Gallen Switz. 56 I3
Sankt-Peterburg Rus. Fed. see St Petersburg
Sankt Pölten Austria 47 O6
Sankt Veit an der Glan Austria 47 O7
Sankt Vith Belgium see St-Vith
Sankt Wendel Germany 53 H5
Sanku Jammu and Kashmir 82 D2
San Lorenzo Arg. 144 D4
San Lorenzo Beni Bol. 142 E7
San Lorenzo Tarija Bol. 142 F8
San Lorenzo Ecuador 142 C3
San Lorenzo Mex. 131 B7
San Lorenzo, Cerro mt. Arg./Chile 144 B7
San Lorenzo, Isla i. Mex. 127 E7
Sanlúcar de Barrameda Spain 57 C5
San Lucas Baja California Sur Mex. 127 E8
San Lucas, Serranía de mts Col. 142 D2
San Luis Arg. 144 C4
San Luis AZ U.S.A. 129 F5
San Luis AZ U.S.A. 129 H5
San Luis CO U.S.A. 131 B4
San Luís, Isla i. Mex. 127 E7
San Luisito Mex. 127 E7
San Luis Obispo U.S.A. 128 C4
San Luis Obispo Bay U.S.A. 128 C4
San Luis Potosí Mex. 136 D4
San Luis Reservoir U.S.A. 128 C3
San Luis Río Colorado Mex. 129 F5
San Manuel U.S.A. 129 H5
San Marcial, Punta pt Mex. 127 F8
San Marcos U.S.A. 131 D6
San Marcos, Isla i. Mex. 127 E8

▶San Marino country Europe 58 E3
Europe 5, 38–39

▶San Marino San Marino 58 E3
Capital of San Marino.

San Martín research station Antarctica 152 L2
San Martín Catamarca Arg. 144 C3
San Martín Mendoza Arg. 144 C4
San Martín, Lago l. Arg./Chile 144 B7
San Martín de los Andes Arg. 144 B6
San Mateo U.S.A. 128 B3
San Mateo Mountains U.S.A. 129 J4
San Matías Bol. 143 G7
San Matías, Golfo g. Arg. 144 D6
Sanmen China 77 I2
Sanmen Wan b. China 77 I2
Sanmenxia China 77 F1
San Miguel El Salvador 136 G6
San Miguel U.S.A. 128 C4
San Miguel r. U.S.A. 129 I2
San Miguel de Huachi Bol. 142 E7
San Miguel de Tucumán Arg. 144 C3
San Miguel do Araguaia Brazil 145 A1
San Miguel Island U.S.A. 128 C4
Sanming China 77 H3
Sanndatti India 84 B3
Sanndraigh i. U.K. see Sandray
Sannicandro Garganico Italy 58 F4
San Nicolás Durango Mex. 131 B7
San Nicolas Tamaulipas Mex. 131 D7
San Nicolas Island U.S.A. 128 D5
Sannieshof S. Africa 101 G4
Sanok Poland 43 D6
San Pablo Bol. 142 E8
San Pablo Phil. 69 G4
San Pablo de Manta Ecuador see Manta
San Pedro Arg. 144 D2
San Pedro Bol. 142 F7
San Pedro Chile 144 C2
San-Pédro Côte d'Ivoire 96 C4
San Pedro Chihuahua Mex. 127 G7
San Pedro Para. see San Pedro de Ycuamandyyú
San Pedro watercourse U.S.A. 129 H5
San Pedro, Sierra de mts Spain 57 C4
San Pedro Channel U.S.A. 128 D5
San Pedro de Arimena Col. 142 D3
San Pedro de las Colonias Mex. 131 C7
San Pedro de Macorís Dom. Rep. 137 K5
San Pedro de Ycuamandyyú Para. 144 E2
San Pedro Martir, Parque Nacional nat. park Mex. 127 E7
San Pedro Sula Hond. 136 G5
San Pierre U.S.A. 134 B3
San Pietro, Isola di i. Sardinia Italy 58 C5
San Pitch r. U.S.A. 129 H2
Sanqaçal Azer. 91 H2
Sanquhar U.K. 50 F5
Sanquianga, Parque Nacional nat. park Col. 142 C3

San Rafael Mountains U.S.A. 128 C4
San Ramón Bol. 142 F6
Sanrao China 77 H3
San Remo Italy 58 B3
San Roque Spain 57 D5
San Roque, Punta pt Mex. 127 E8
San Saba U.S.A. 131 D6
San Salvador i. Bahamas 133 F7

▶San Salvador El Salvador 136 G6
Capital of El Salvador.

San Salvador, Isla i. Galápagos Ecuador 142 [inset]
San Salvador de Jujuy Arg. 144 C2
Sansanné-Mango Togo 96 D3
San Sebastián Arg. 144 C8
San Sebastián Spain see Donostia-San Sebastián
San Sebastián de los Reyes Spain 57 E3
Sansepolcro Italy 58 E3
San Severo Italy 58 F4
San Simon U.S.A. 129 I5
Sanski Most Bos.-Herz. 58 G2
Sansoral Islands Palau see Sonsorol Islands
Sansui China 77 F3
Santa r. Peru 142 C5
Santa Ana Bol. 142 E7
Santa Ana El Salvador 136 G6
Santa Ana Mex. 127 F7
Santa Ana i. Solomon Is 107 G3
Santa Ana U.S.A. 128 E5
Santa Ana de Yacuma Bol. 142 E6
Santa Anna U.S.A. 131 D6
Santa Bárbara Brazil 145 C2
Santa Bárbara Cuba see La Demajagua
Santa Bárbara Mex. 131 B7
Santa Barbara U.S.A. 128 D4
Santa Bárbara, Ilha i. Brazil 145 D2
Santa Bárbara d'Oeste Brazil 145 B3
Santa Barbara Channel U.S.A. 128 C4
Santa Barbara Island U.S.A. 128 D5
Santa Catalina, Gulf of U.S.A. 128 E5
Santa Catalina, Isla i. Mex. 127 F8
Santa Cataliña de Armada Spain 57 B2
Santa Catalina Island U.S.A. 128 D5
Santa Catarina state Brazil 145 A4
Santa Catarina Baja California Mex. 127 E7
Santa Catarina Nuevo León Mex. 131 C7
Santa Catarina, Ilha de i. Brazil 145 A4
Santa Clara Col. 142 E4
Santa Clara Cuba 137 I4
Santa Clara Mex. 131 B6
Santa Clara CA U.S.A. 128 C3
Santa Clara UT U.S.A. 129 G3
Santa Clarita U.S.A. 128 D4
Santa Clotilde Peru 142 D4
Santa Comba Angola see Waku-Kungo
Santa Croce, Capo c. Sicily Italy 58 F6
Santa Cruz Bol. 142 F7
Santa Cruz Brazil 143 K5
Santa Cruz Costa Rica 142 A1
Santa Cruz U.S.A. 128 B3
Santa Cruz watercourse U.S.A. 129 G5
Santa Cruz, Isla i. Galápagos Ecuador 142 [inset]
Santa Cruz, Isla i. Mex. 127 F8
Santa Cruz Cabrália Brazil 145 D2
Santa Cruz de Goiás Brazil 145 A2
Santa Cruz de la Palma Canary Is 96 B2
Santa Cruz del Sur Cuba 137 I4
Santa Cruz de Moya Spain 57 F4

▶Santa Cruz de Tenerife Canary Is 96 B2
Joint capital of the Canary Islands.

Santa Cruz do Sul Brazil 144 F3
Santa Cruz Island U.S.A. 128 D4
Santa Cruz Islands Solomon Is 107 G3
Santa Elena, Cabo c. Costa Rica 137 G6
Santa Elena, Punta pt Ecuador 142 B4
Santa Eudóxia Brazil 145 B3
Santa Eufemia, Golfo di g. Italy 58 G5
Santa Fé Arg. 144 D4
Santa Fé Cuba 133 D8

▶Santa Fe U.S.A. 127 G6
State capital of New Mexico.

Santa Fé de Bogotá Col. see Bogotá
Santa Fé de Minas Brazil 145 B2
Santa Fé do Sul Brazil 145 A3
Santa Helena Brazil 143 I4
Santa Helena de Goiás Brazil 145 A2
Santai Sichuan China 76 E2
Santai Yunnan China 76 D3
Santa Inês Brazil 143 I4
Santa Inés, Isla i. Chile 152 I1
Santa Isabel Arg. 144 C5
Santa Isabel Equat. Guinea see Malabo
Santa Isabel i. Solomon Is 107 F2
Santalpur India 82 B5
Santa Lucia Range mts U.S.A. 128 C3
Santa Margarita U.S.A. 128 C4
Santa Margarita, Isla i. Mex. 136 B4
Santa María Arg. 144 C3
Santa Maria Amazonas Brazil 143 G4
Santa Maria Rio Grande do Sul Brazil 144 F3
Santa María r. Mex. 127 G7
Santa Maria Peru 142 D4
Santa Maria U.S.A. 128 C4
Santa Maria i. Vanuatu 107 G3
Santa Maria, Cabo de c. Moz. 101 K4
Santa Maria, Cabo de c. Port. 57 C5
Santa Maria, Chapada de hills Brazil 145 B1
Santa María, Isla i. Galápagos Ecuador 142 [inset]

Santa Marta Col. 142 D1
Santa Marta, Cabo de c. Angola 99 B5
Santa Marta Grande, Cabo de c. Brazil 145 A5
Santa Maura i. Greece see Lefkada
Santa Monica U.S.A. 128 D4
Santa Monica, Pico mt. Mex. 127 E8
Santa Monica Bay U.S.A. 128 D5
Santan Indon. 68 F7
Santana Brazil 145 C1
Santana r. Brazil 145 A2
Santana da Araguaia Brazil 143 H5
Santander Phil. 69 G5
Santander Spain 57 E2
Santan Mountain hill U.S.A. 129 H5
Sant'Antioco Sardinia Italy 58 C5
Sant'Antioco, Isola di i. Sardinia Italy 58 C5
Sant Antoni de Portmany Spain 57 G4
Santapilly India 84 D2
Santaquin U.S.A. 129 H2
Santarém Brazil 143 H4
Santarém Port. 57 B4
Santa Rita Mex. 131 C7
Santa Rosa Bol. 142 E7
Santa Rosa Acre Brazil 142 D5
Santa Rosa Rio Grande do Sul Brazil 144 F3
Santa Rosa CA U.S.A. 128 B2
Santa Rosa NM U.S.A. 127 G6
Santa Rosa de Copán Hond. 136 G6
Santa Rosa de la Roca Bol. 142 F7
Santa Rosa Island U.S.A. 128 C5
Santa Rosalía Mex. 127 E8
Santa Rosa Range mts U.S.A. 126 D4
Santa Rosa Wash watercourse U.S.A. 129 G5
Santa Sylvina Arg. 144 D3
Santa Teresa Australia 109 F6
Santa Teresa r. Brazil 145 A1
Santa Teresa Mex. 131 D7
Santa Vitória Brazil 145 A2
Santa Vitória do Palmar Brazil 144 F4
Santa Ynez r. U.S.A. 128 C4
Santa Ysabel i. Solomon Is see Santa Isabel
Santee U.S.A. 128 E5
Santee r. U.S.A. 133 E5
Santiago Brazil 144 F3
Santiago i. Cape Verde 96 [inset]

▶Santiago Chile 144 B4
Capital of Chile.

Santiago Dom. Rep. 137 J5
Santiago Panama 137 H7
Santiago Phil. 69 G3
Santiago de Compostela Spain 57 B2
Santiago de Cuba 137 I4
Santiago del Estero Arg. 144 D3
Santiago de los Caballeros Dom. Rep. see Santiago
Santiago de Veraguas Panama see Santiago
Santiaguillo, Laguna de l. Mex. 131 B7
Santianna Point Canada 121 P2
Santipur India see Shantipur
Sant Jordi, Golf de g. Spain 57 G3
Santo Amaro Brazil 145 D1
Santo Amaro de Campos Brazil 145 C3
Santo Anastácio Brazil 145 A3
Santo André Brazil 145 B3
Santo Angelo Brazil 144 F3

▶Santo Antão i. Cape Verde 96 [inset]
Most westerly point of Africa.

Santo Antônio Brazil 142 F4
Santo Antônio r. Brazil 145 C2
Santo António São Tomé and Príncipe 96 D4
Santo Antônio, Cabo c. Brazil 145 D1
Santo Antônio da Platina Brazil 145 A3
Santo Antônio de Jesus Brazil 145 D1
Santo Antônio do Içá Brazil 142 E4
Santo Corazón Bol. 143 G7
Santo Domingo Cuba 133 G7

▶Santo Domingo Dom. Rep. 137 K5
Capital of the Dominican Republic.

Santo Domingo Baja California Mex. 127 E7
Santo Domingo Baja California Sur Mex. 127 F8
Santo Domingo country West Indies see Dominican Republic
Santo Domingo de Guzmán Dom. Rep. see Santo Domingo
Santo Hipólito Brazil 145 B2
Santorini i. Greece 59 K6
Santos Brazil 145 B3
Santos Dumont Brazil 145 C3
Santos Plateau sea feature S. Atlantic Ocean 148 E7
Santo Tomás Mex. 127 E7
Santo Tomás Peru 142 D6
Santo Tomé Arg. 144 E3
Sanup Plateau U.S.A. 129 G3
San Valentín, Cerro mt. Chile 144 B7
San Vicente El Salvador 136 G6
San Vicente de Baracaldo Spain see Barakaldo
San Vicente de Cañete Peru 142 C6
San Vincenzo Italy 58 D3
San Vito, Capo c. Sicily Italy 58 E5
Sanwer India 82 C5
Sanya China 77 F5
Sanyuan China 77 F1
S. A. Nyyazow Adyndaky Turkm. see Shatlyk
Sanza Pombo Angola 99 B4
Sao, Phou mt. Laos 70 C3
São Bernardo do Campo Brazil 145 B3
São Borja Brazil 144 E3
São Carlos Brazil 145 B3
São Domingos Brazil 145 B1
São Felipe, Serra de hills Brazil 145 B1
São Félix Bahia Brazil 145 D1
São Félix Mato Grosso Brazil 143 H6
São Félix Pará Brazil 143 H5

São Fidélis Brazil 145 C3
São Francisco Brazil 145 B1

▶São Francisco r. Brazil 145 C1
5th longest river in South America.

São Francisco, Ilha de i. Brazil 145 A4
São Francisco de Paula Brazil 145 A5
São Francisco de Sales Brazil 145 A2
São Francisco do Sul Brazil 145 A4
São Gabriel Brazil 144 F4
São Gonçalo Brazil 145 C3
São Gonçalo do Abaeté Brazil 145 B2
São Gonçalo do Sapucaí Brazil 145 B3
São Gotardo Brazil 145 B2
São João, Ilhas de is Brazil 143 J4
São João da Barra Brazil 145 C3
São João da Boa Vista Brazil 145 B3
São João da Madeira Port. 57 B3
São João da Ponte Brazil 145 B1
São João del Rei Brazil 145 B3
São João do Paraíso Brazil 145 C1
São Joaquim Brazil 145 A5
São Joaquim da Barra Brazil 145 B3
São José Amazonas Brazil 142 E4
São José Santa Catarina Brazil 145 A4
São José do Rio Preto Brazil 145 A3
São José dos Campos Brazil 145 B3
São José dos Pinhais Brazil 145 A4
São Leopoldo Brazil 145 A5
São Lourenço Brazil 145 B3
São Lourenço r. Brazil 143 G7
São Luís Brazil 143 J4
São Luís de Montes Belos Brazil 145 A2
São Manuel Brazil 145 A3
São Marcos r. Brazil 145 B2
São Mateus Brazil 145 D2
São Mateus do Sul Brazil 145 A4
São Miguel i. Arquipélago dos Açores 148 G3
São Miguel r. Brazil 145 B2
São Miguel do Tapuio Brazil 143 J5
Saône r. France 56 G4
Saoner India 82 D5
São Nicolau i. Cape Verde 96 [inset]

▶São Paulo Brazil 145 B3
Most populous city in South America, and 5th in the world.

São Paulo state Brazil 145 A3
São Paulo de Olivença Brazil 142 E4
São Pedro da Aldeia Brazil 145 C3
São Pedro e São Paulo is N. Atlantic Ocean 148 G5
São Pires r. Brazil see Teles Pires
São Raimundo Nonato Brazil 143 J5
São Romão Amazonas Brazil 142 E5
São Romão Minas Gerais Brazil 145 B2
São Roque Brazil 145 B3
São Roque, Cabo de c. Brazil 143 K5
São Salvador Angola see M'banza Congo
São Salvador do Congo Angola see M'banza Congo
São Sebastião Brazil 145 B3
São Sebastião, Ilha do i. Brazil 145 B3
São Sebastião do Paraíso Brazil 145 B3
São Sebastião dos Poções Brazil 145 B1
São Simão Minas Gerais Brazil 143 H7
São Simão São Paulo Brazil 145 B3
São Simão, Barragem de resr Brazil 145 A2
São Tiago i. Cape Verde see Santiago

▶São Tomé São Tomé and Príncipe 96 D4
Capital of São Tomé and Príncipe.

São Tomé i. São Tomé and Príncipe 96 D4
São Tomé, Cabo de c. Brazil 145 C3
São Tomé, Pico de mt. São Tomé and Príncipe 96 D4

▶São Tomé and Príncipe country Africa 96 D4
Africa 7, 94–95

São Vicente Brazil 145 B3
São Vicente i. Cape Verde 96 [inset]
São Vicente, Cabo de c. Port. 57 B5
Sapanca Turkey 59 N4
Sapaul India see Supaul
Şaphane Dağı mt. Turkey 59 N5
Sapo National Park Liberia 96 C4
Sapouy Burkina 96 C3
Sapozhok Rus. Fed. 43 I5
Sapporo Japan 74 F4
Sapulpa U.S.A. 131 D4
Sapulut Sabah Malaysia 68 F6
Saputang China see Zadoi
Sāqī Iran 88 B2
Saqqez Iran 88 B2
Sarā Iran 88 B2
Sarāb Iran 88 B2
Sara Buri Thai. 71 C4
Saradiya India 82 B5
Saragossa Spain see Zaragoza
Saragt Turkm. 89 F2
Saraguro Ecuador 142 C4
Sarahs Turkm. see Saragt

▶Sarajevo Bos.-Herz. 58 H3
Capital of Bosnia-Herzegovina.

Sarakhs Iran 89 F2
Saraktash Rus. Fed. 64 G4
Saraland U.S.A. 131 F6
Saramati mt. India/Myanmar 70 A1
Saran' Kazakh. 80 D2
Saranac U.S.A. 134 C2
Saranac r. U.S.A. 135 I1
Saranac Lake U.S.A. 135 H1
Saranda Albania see Sarandë
Sarandë Albania 59 I5
Sarandib country Asia see Sri Lanka
Sarangani Islands Phil. 69 H5
Sarangpur India 82 D5
Saransk Rus. Fed. 43 J5
Sara Peak Nigeria 96 D4

Saraphi Thai. 70 B3
Sarapul Rus. Fed. 41 Q4
Sarāqib Syria 85 C2
Sarasota U.S.A. 133 D7
Saraswati r. India 89 H6
Sarata Ukr. 59 M1
Saratoga CA U.S.A. 128 B3
Saratoga WY U.S.A. 126 G4
Saratoga Springs U.S.A. 132 F3
Saratok Sarawak Malaysia 68 E6
Saratov Rus. Fed. 43 J6
Saratovskoye Vodokhranilishche resr
 Rus. Fed. 43 J5
Saratsina, Akrotirio pt Greece 59 K5
Saravan Iran 89 F5
Saray Turkey 59 L4
Sarayköy Turkey 59 M6
Sarayönü Turkey 90 D3
Sarbāz Iran 87 J4
Sarbāz reg. Iran 89 F5
Sarbhang Bhutan 83 G4
Sarbīsheh Iran 87 I3
Sarda r. Nepal 83 E3
Sard Āb Afgh. 89 H2
Sardarshahr India 82 C3
Sar Dasht Iran 88 B2
Sardegna i. Sardinia Italy see Sardinia
Sardica Bulg. see Sofia
Sardinia i. Sardinia Italy 58 C4
Sardis MS U.S.A. 131 F5
Sardis WV U.S.A. 134 E4
Sardis Lake resr U.S.A. 131 F5
Sar-e Büm Afgh. 89 G3
Sareks nationalpark nat. park
 Sweden 44 J3
Sarektjåkkå mt. Sweden 44 J3
Sar-e Pol Afgh. 89 G2
Sar-e Pol-e Zahāb Iran 88 B3
Sar Eskandar Iran see Hashtrud
Sare Yazd Iran 88 D4
Sargasso Sea N. Atlantic Ocean 151 P4
Sargodha Pak. 89 I3
Sarh Chad 97 E4
Sarhad reg. Iran 89 F4
Sārī Iran 88 D2
Saria i. Greece 59 L7
Sar-i-Bum Afgh. see Sar-e Büm
Sáric Mex. 127 F7
Sarigan i. N. Mariana Is 69 L3
Sarigh Jilganang Kol salt l. Aksai Chin
 82 D2
Sarıgöl Turkey 59 M5
Sarıkamış Turkey 91 F2
Sarikei Sarawak Malaysia 68 E6
Sarikül, Qatorkühi mts China/Tajik. see
 Sarykol Range
Sarila India 82 D4
Sarina Australia 110 E4
Sarıoğlan Kayseri Turkey 90 D3
Sarıoğlan Konya Turkey see Belören
Sariqamish Kuli salt l. Turkm./Uzbek. see
 Sarykamyshskoye Ozero
Sarīr Tibesti des. Libya 97 E2
Sarita U.S.A. 131 D7
Sarıveliler Turkey 85 A1
Sariwŏn N. Korea 75 B5
Sarıyar Barajı resr Turkey 59 N5
Sarıyer Turkey 59 M4
Sarız Turkey 90 E3
Sark i. Channel Is 49 E9
Sarkand Kazakh. 80 E2
Şarkikaraağaç Turkey 59 N5
Şarkışla Turkey 90 E3
Şarköy Turkey 59 L4
Sarlath Range mts Afgh./Pak. 89 G4
Sarmi Indon. 69 J7
Särna Sweden 45 H6
Sarneh Iran 88 B3
Sarnen Switz. 56 I3
Sarni India see Amla
Sarnia Canada 134 D2
Sarny Ukr. 43 E6
Sarolangun Indon. 68 C7
Saroma-ko l. Japan 74 F3
Saronikos Kolpos g. Greece 59 J6
Saros Körfezi b. Turkey 59 L4
Sarova Rus. Fed. 43 I5
Sarowbī Afgh. 89 H3
Sarpa, Ozero l. Rus. Fed. 43 J6
Sarpan i. N. Mariana Is see Rota
Sarpsborg Norway 45 G7
Sarqant Kazakh. see Sarkand
Sarre r. France 52 H5
Sarrebourg France 52 H6
Sarreguemines France 52 H5
Sarria Spain 57 C2
Sarry France 52 E6
Sartana Ukr. 43 H7
Sartanahu Pak. 89 H5
Sartène Corsica France 56 I6
Sarthe r. France 56 D3
Sartu China see Daqing
Saruna Pak. 89 G5
Sarupsar India 82 C3
Sārūr Azer. 91 G3
Saru Tara tourist site Afgh. 89 F4
Sarv Iran 88 D3
Sarvābād Iran 88 B3
Sárvár Hungary 58 G1
Sarwar India 82 C4
Sarygamysh Köli salt l. Turkm./Uzbek. see
 Sarykamyshskoye Ozero
Sary-Ishikotrau, Peski des. Kazakh. see
 Saryyesik-Atyrau, Peski
Sarykamyshskoye Ozero salt l.
 Turkm./Uzbek. 91 J2
Sarykol Range mts China/Tajik. 89 I2
Saryozek Kazakh. 80 E3
Saryshagan Kazakh. 80 D2
Saryshagan Kazakh. 91 H1
Sary-Tash Kyrg. 89 I2
Sarýýazy Suw Howdany resr
 Turkm. 89 F2
Saryyesik-Atyrau, Peski des.
 Kazakh. 80 E2
Sarzha Kazakh. 91 H2
Sasar, Tanjung pt Indon. 108 B2
Sasebo Japan 75 C6
Saskatchewan prov. Canada 121 J4
Saskatchewan r. Canada 121 K4

Saskatoon Canada 121 J4
Saskylakh Rus. Fed. 72 G2
Saslaya mt. Nicaragua 137 H6
Sasoi r. India 82 B5
Sasolburg S. Africa 101 H4
Sasovo Rus. Fed. 43 I5
Sass r. Canada 120 H2
Sassandra Côte d'Ivoire 96 C4
Sassari Sardinia Italy 58 C4
Sassenberg Germany 53 I3
Sassnitz Germany 47 N3
Sass Town Liberia 96 C4
Sasykkol', Ozero l. Kazakh. 80 F2
Sasykoli Rus. Fed. 43 J7
Sasyqköl l. Kazakh. see
 Sasykkol', Ozero
Satahual i. Micronesia see Satawal
Sata-misaki c. Japan 75 C7
Satana India 84 B1
Satan Pass U.S.A. 129 I4
Satara India 84 B2
Satara S. Africa 101 J3
Satawal i. Micronesia 69 L5
Sätbaev Kazakh. see Satpayev
Satevó Mex. 131 B7
Satevo r. Mex. 127 G8
Satırlar Turkey see Yeşilova
Satkania Bangl. 83 H5
Satkhira Bangl. 83 G5
Satluj r. India/Pak. see Sutlej
Satmala Range hills India 84 C2
Satna India 82 E4
Satpayev Kazakh. 80 C2
Satpura Range mts India 82 C5
Satsuma-hantō pen. Japan 75 C7
Sattahip Thai. 71 C4
Satteldorf Germany 53 K5
Satthwa Myanmar 70 A3
Satu Mare Romania 43 D7
Satun Thai. 71 C6
Satwas India 82 D5
Sauceda Mountains U.S.A. 129 G5
Saucillo Mex. 131 B6
Sauda Norway 45 E7
Sauðárkrókur Iceland 44 [inset]
▶Saudi Arabia country Asia 86 F4
 Asia 6, 62–63
Sauer r. France 53 I6
Saugatuck U.S.A. 134 B2
Saugeen r. Canada 134 E1
Säüjbolägh Iran see Mahābād
Sauk Center U.S.A. 130 E2
Saulieu France 56 G3
Saulnois reg. France 52 G6
Sault Sainte Marie Canada 122 D5
Sault Sainte Marie U.S.A. 132 C2
Saumalkol' Kazakh. 78 F1
Saumarez Reef Australia 110 F4
Saumlakki Indon. 108 E2
Saumur France 56 D3
Saunders, Mount hill Australia 108 E3
Saunders Coast Antarctica 152 J1
Saurimo Angola 99 C4
Sautar Angola 99 B5
Sauvolles, Lac l. Canada 123 G3
Sava r. Europe 58 I2
Savage River Australia 111 [inset]
Savai'i i. Samoa 107 I3
Savala r. Rus. Fed. 43 I6
Savalou Benin 96 D4
Savanat Iran see Eştahbān
Savane r. Canada 123 H4
Savanna U.S.A. 130 F3
Savannah GA U.S.A. 133 D5
Savannah OH U.S.A. 134 D3
Savannah TN U.S.A. 131 F5
Savannah r. U.S.A. 133 D5
Savannah Sound Bahamas 133 E7
Savannakhét Laos 70 D3
Savanna-la-Mar Jamaica 137 I5
Savant Lake Canada 122 C4
Savant Lake l. Canada 122 C4
Savanur India 84 B3
Sävar Sweden 44 L5
Savaştepe Turkey 59 L5
Savè Benin 96 D4
Save r. Moz./Zimbabwe 99 D6
Säveh Iran 88 C3
Saverne France 53 H6
Saverne, Col de pass France 53 H6
Saviaho Fin. 44 P5
Savinskiy Rus. Fed. 42 I3
Savitri r. India 84 B2
Savli India 82 C5
Savoie reg. France see Savoy
Savona Italy 58 C2
Savonlinna Fin. 44 P6
Savonranta Fin. 44 P5
Savoy reg. France 56 H3
Şavşat Turkey 91 F2
Sävsjö Sweden 45 I8
Savu i. Indon. 108 C2
Savukoski Fin. 44 P3
Savur Turkey 91 F3
Savu Sea Indon. see Sawu, Laut
Saw Myanmar 70 A2
Sawai Madhopur India 82 D4
Sawan Myanmar 70 B1
Sawar India 82 C4
Sawatch Range mts U.S.A. 126 G5
Sawel Mountain hill U.K. 51 E3
Sawhāj Egypt 86 D4
Sawi, Ao b. Thai. 71 B5
Sawn Myanmar 70 B2
Sawtell Australia 112 F3
Sawtooth Range mts U.S.A. 126 C2
Sawu Indon. 108 C2
Sawu, Laut sea Indon. 108 C2
Sawu i. Indon. see Savu
Sawye Myanmar 70 B2
Sawyer U.S.A. 134 B3
Saxilby U.K. 48 G5
Saxmundham U.K. 49 I6
Saxnäs Sweden 44 I4
Saxony land Germany see Sachsen
Saxony-Anhalt land Germany see
 Sachsen-Anhalt
Saxton U.S.A. 135 F3
Say Niger 96 D3
Sayabouri Laos see Xaignabouli
Sayak Kazakh. 80 E2
Sayanogorsk Rus. Fed. 72 G2

Sayano-Shushenskoye Vodokhranilishche
 resr Rus. Fed. 72 G2
Sayansk Rus. Fed. 72 I2
Sayaq Kazakh. see Sayak
Sayat Turkm. see Saýat
Saýat Turkm. 89 F2
Şaydā Lebanon see Sidon
Säyen Iran 88 D4
Sayer Island Thai. see Similan, Ko
Sayghān Afgh. 89 G3
Sayhūt Yemen 86 H6
Sayingpan China 76 D3
Saykhin Kazakh. 41 P6
Saylac Somalia 97 H3
Saylan country Asia see Sri Lanka
Saynshand Mongolia 73 K4
Sayn-Ust Mongolia 80 H2
Sayoa mt. Spain see Saioa
Sayot Turkm. see Saýat
Şayqal, Bahr imp. l. Syria 85 C3
Sayqyn Kazakh. see Saykhin
Sayre OK U.S.A. 131 D5
Sayre PA U.S.A. 135 G3
Sayreville U.S.A. 135 H3
Sayula Mex. 136 F5
Sayyod Turkm. see Saýat
Sazdy Kazakh. 43 K7
Sazin Pak. 89 I3
Sbaa Alg. 54 D6
Sbeïtla Tunisia 58 C7
Scaddan Australia 109 C8
Scafell Pike hill U.K. 48 D4
Scalasaig U.K. 50 C4
Scalea Italy 58 F5
Scalloway U.K. 50 [inset]
Scalpaigh, Eilean i. U.K. see Scalpay
Scalpay i. U.K. 50 C3
Scapa Flow inlet U.K. 50 F2
Scarba i. U.K. 50 D4
Scarborough Canada 134 F2
Scarborough Trin. and Tob. 137 L6
Scarborough U.K. 48 G4
Scarborough Shoal sea feature
 S. China Sea 68 F3
Scariff Island Ireland 51 B6
Scarp i. U.K. 50 B2
Scarpanto i. Greece see Karpathos
Schaale r. Germany 53 K1
Schaalsee l. Germany 53 K1
Schaerbeek Belgium 52 E4
Schaffhausen Switz. 56 I3
Schafstädt Germany 53 L3
Schagen Neth. 52 E2
Schagerbrug Neth. 52 E2
Schakalskuppe Namibia 100 C4
Schärding Austria 47 N6
Scharendijke Neth. 52 D3
Scharteberg hill Germany 52 G4
Schaumburg U.S.A. 134 A2
Schebheim Germany 53 K5
Scheeßel Germany 53 J1
Schefferville Canada 123 I3
Scheibbs Austria 47 O6
Schelde r. Belgium see Scheldt
Scheldt r. Belgium 52 E3
Schell Creek Range mts U.S.A. 129 F2
Schellerten Germany 53 K2
Schellville U.S.A. 128 B2
Schenectady U.S.A. 135 I2
Schenefeld Germany 53 J1
Schermerhorn Neth. 52 E2
Schertz U.S.A. 131 D6
Schierling Germany 53 M6
Schiermonnikoog Neth. 52 G1
Schiermonnikoog i. Neth. 52 G1
Schiermonnikoog Nationaal Park nat. park
 Neth. 52 G1
Schiffdorf Germany 53 I1
Schinnen Neth. 52 F4
Schio Italy 58 D2
Schkeuditz Germany 53 M3
Schleiden Germany 52 G4
Schleiz Germany 53 L4
Schleswig Germany 47 L3
Schleswig-Holstein land Germany 53 K1
Schleswig-Holsteinisches Wattenmeer,
 Nationalpark nat. park Germany 47 L3
Schleusingen Germany 53 K4
Schlitz Germany 53 J4
Schloss Holte-Stukenbrock Germany 53 I3
Schloss Wartburg tourist site
 Germany 53 K3
Schlüchtern Germany 53 J4
Schlüsselfeld Germany 53 K5
Schmallenberg Germany 53 I3
Schmidt Island Rus. Fed. see
 Shmidta, Ostrov
Schmidt Peninsula Rus. Fed. see
 Shmidta, Poluostrov
Schneeberg Germany 53 M4
Schneidemühl Poland see Piła
Schneidlingen Germany 53 L3
Schneverdingen Germany 53 J1
Schoharie U.S.A. 135 H2
Schönebeck Germany 53 M1
Schönebeck (Elbe) Germany 53 L2
Schönefeld airport Germany 53 N2
Schöningen Germany 53 K2
Schöntal Germany 53 J5
Schoolcraft U.S.A. 134 C2
Schoonhoven Neth. 52 E3
Schopfloch Germany 53 K5
Schöppenstedt Germany 53 K2
Schortens Germany 53 H1
Schouten Island Australia 111 [inset]
Schouten Islands P.N.G. 69 K7
Schrankogel mt. Austria 47 M7
Schreiber Canada 122 D4
Schroon Lake U.S.A. 135 I2
Schrötersburg Poland see Płock
Schulenburg U.S.A. 131 D6
Schuler Canada 121 I5
Schull Ireland 51 C6
Schultz Lake Canada 121 L1
Schuyler U.S.A. 130 D3
Schuyler Lake U.S.A. 135 H2
Schuylkill Haven U.S.A. 135 G3
Schwabach Germany 53 L5
Schwäbische Alb mts Germany 47 L7
Schwäbisch Gmünd Germany 53 J6
Schwäbisch Hall Germany 53 J5

Sayano-Shushenskoye Vodokhranilishche
Schwafōrden Germany 53 I2
Schwalm r. Germany 53 J3
Schwalmstadt-Ziegenhain Germany 53 J4
Schwandorf Germany 53 M5
Schwaner, Pegunungan mts Indon. 68 E7
Schwanewede Germany 53 I1
Schwarmstedt Germany 53 J2
Schwarze Elster r. Germany 53 M3
Schwarzenbek Germany 53 K1
Schwarzenberg Germany 53 M4
Schwarzer Mann hill Germany 52 G4
Schwarzrand mts Namibia 100 C3
Schwarzwald mts Germany see
 Black Forest
Schwatka Mountains U.S.A. 118 C3
Schwaz Austria 47 M7
Schwedt an der Oder Germany 47 O4
Schwegenheim Germany 53 I5
Schweich Germany 52 G5
Schweinfurt Germany 53 K4
Schweinitz Germany 53 N3
Schweinrich Germany 53 M1
Schweiz country Europe see
 Switzerland
Schweizer-Reneke S. Africa 101 G4
Schwelm Germany 53 H3
Schwerin Germany 53 L1
Schweriner See l. Germany 53 L1
Schwetzingen Germany 53 I5
Schwyz Switz. 56 I3
Sciacca Sicily Italy 58 E6
Scicli Sicily Italy 58 F6
Science Hill U.S.A. 134 C5
Scilla Italy 58 F5
Scilly, Île atoll Fr. Polynesia see Manuae
Scilly, Isles of U.K. 49 A9
Scioto r. U.S.A. 134 D4
Scipio U.S.A. 129 G2
Scobey U.S.A. 126 G2
Scodra Albania see Shkodër
Scofield Reservoir U.S.A. 129 H2
Scole U.K. 49 I6
Scone Australia 112 E4
Scone U.K. 50 F4
Scoresby Land reg. Greenland 119 P2
Scoresbysund Greenland see
 Ittoqqortoormiit
Scoresby Sund sea chan. Greenland see
 Kangertittivaq
Scorno, Punta dello pt Sardinia Italy see
 Caprara, Punta
Scorpion Bight b. Australia 109 D8
Scotia Ridge sea feature S. Atlantic Ocean
 148 E9
Scotia Sea S. Atlantic Ocean 148 F9
Scotland Canada 134 E2
Scotland admin. div. U.K. 50 F3
Scotland U.S.A. 135 G4
Scotstown Canada 123 H5
Scott U.S.A. 134 C3
Scott, Cape Australia 108 E3
Scott, Cape Canada 120 D5
Scott, Mount hill U.S.A. 131 D5
Scott Base research station
 Antarctica 152 H1
Scottburgh S. Africa 101 J6
Scott City U.S.A. 130 C4
Scott Coast Antarctica 152 H1
Scott Glacier Antarctica 152 I1
Scott Island Antarctica 152 H2
Scott Islands Canada 120 D5
Scott Mountains Antarctica 152 D2
Scott Reef Australia 108 C3
Scottsbluff U.S.A. 130 C3
Scottsboro U.S.A. 133 C5
Scottsburg U.S.A. 134 C4
Scottsville KY U.S.A. 134 B5
Scottsville VA U.S.A. 135 F5
Scourie U.K. 50 D2
Scousburgh U.K. 50 [inset]
Scranton U.S.A. 135 H3
Scunthorpe U.K. 48 G5
Scuol Switz. 56 J3
Scupi Macedonia see Skopje
Scutari Albania see Shkodër
Scutari, Lake Albania/Serb. and Mont.
 59 H3
Seaboard U.S.A. 135 G5
Seabrook, Lake salt flat Australia 109 B7
Seaford U.K. 49 H8
Seaforth Canada 134 E2
Seal r. Canada 121 M3
Seal, Cape S. Africa 100 F8
Sea Lake Australia 111 C7
Seal Lake Canada 123 J3
Sealy U.S.A. 131 D6
Seaman U.S.A. 134 D4
Seaman Range mts U.S.A. 129 F3
Seamer U.K. 48 G4
Searchlight U.S.A. 129 F4
Searcy U.S.A. 131 F5
Searles Lake U.S.A. 128 E4
Seaside CA U.S.A. 127 C5
Seaside OR U.S.A. 126 C3
Seaside Park U.S.A. 135 H4
Seattle U.S.A. 126 C3
Seaview Range mts Australia 110 D3
Seba Indon. 108 C2
Sebago Lake U.S.A. 135 J2
Sebastea Turkey see Sivas
Sebastian U.S.A. 133 D7
Sebastián Vizcaíno, Bahía b.
 Mex. 127 E7
Sebastiancook r. U.S.A. 135 K1
Sebasticook Lake U.S.A. 135 K1
Sebastopol Ukr. see Sevastopol'
Sebastopol U.S.A. 128 B2
Sebatik i. Indon. 68 F6
Sebba Burkina 96 D3
Seben Turkey 59 N4
Sebenico Croatia see Šibenik
Sebeş Romania 59 J2
Sebewaing U.S.A. 134 D2
Sebezh Rus. Fed. 45 P8
Sebovo Rus. Fed. 43 I6
Sebta N. Africa see Ceuta
Sebuku i. Indon. 68 F7
Sechelt Canada 120 F5

Sechenovo Rus. Fed. 43 J5
Sechura Peru 142 B5
Sechura, Bahía de b. Peru 142 B5
Seckach Germany 53 J5
Second Mesa U.S.A. 129 H4
Secretary Island N.Z. 113 A7
Secunda S. Africa 101 I4
Secunderabad India 84 C2
Sedalia U.S.A. 130 E4
Sedam India 84 C2
Sedan France 52 E5
Sedan U.S.A. 131 D4
Sedan Dip Australia 110 C3
Seddon N.Z. 113 E5
Seddonville N.Z. 113 C5
Sedeh Iran 88 E3
Sederot Israel 85 B4
Sedlčany Czech Rep. 47 O6
Sedlets Poland see Siedlce
Sedom Israel 85 B4
Sedona U.S.A. 129 H4
Sédrata Alg. 58 B6
Šeduva Lith. 45 M9
Seedorf Germany 53 K1
Seehausen Germany 53 L2
Seehausen (Altmark) Germany 53 L2
Seeheim Namibia 100 C4
Seeheim-Jugenheim Germany 53 I5
Seelig, Mount Antarctica 152 K1
Seelze Germany 53 J2
Seenu Atoll Maldives see Addu Atoll
Sées France 56 E2
Seesen Germany 53 K3
Seevetal Germany 53 K1
Sefadu Sierra Leone 96 B4
Sefare Botswana 101 H2
Seferihisar Turkey 59 L5
Sefid, Küh-e mt. Iran 88 C3
Sefophe Botswana 101 H2
Segalstad Norway 45 G6
Segamat Malaysia 71 C7
Ségbana Benin 96 D3
Segeletz Germany 53 M2
Segezha Rus. Fed. 42 G3
Seghnān Afgh. 89 H2
Segontia U.K. see Caernarfon
Segontium U.K. see Caernarfon
Segorbe Spain 57 F4
Ségou Mali 96 C3
Segovia r. Hond./Nicaragua see Coco
Segovia Spain 57 D3
Segozerskoye, Ozero resr
 Rus. Fed. 42 G3
Seguam Island U.S.A. 118 A4
Séguédine Niger 96 E2
Séguéla Côte d'Ivoire 96 C4
Seguin U.S.A. 131 D6
Segura r. Spain 57 F4
Segura, Sierra de mts Spain 57 E5
Sehithwa Botswana 99 C6
Sehlabathebe National Park
 Lesotho 101 I5
Sehore India 82 D5
Sehwan Pak. 89 G5
Seibert U.S.A. 130 C4
Seignelay r. Canada 123 H4
Seikphyu Myanmar 70 A2
Seiland i. Norway 44 M1
Seille r. France 52 G5
Seinäjoki Fin. 44 M5
Seine r. Canada 121 N5
Seine r. France 52 E5
Seine, Baie de b. France 56 D2
Seine, Val de valley France 56 F2
Seistan reg. Iran see Sīstān
Sejny Poland 45 M9
Sekayu Indon. 68 C7
Seke China see Sêrtar
Sekoma Botswana 100 F3
Sekondi Ghana 96 C4
Sek'ot'a Eth. 98 D2
Sekura Indon. 71 E7
Şela Rus. Fed. see Shali
Selama Malaysia 71 C6
Selaru i. Indon. 108 E2
Selassi Indon. 69 I7
Selatan, Tanjung pt Indon. 68 E7
Selat Makassar strait Indon. see
 Makassar, Selat
Selatpanjang Indon. 71 C7
Selawik U.S.A. 118 B3
Selb Germany 53 M4
Selbekken Norway 44 F5
Selbu Norway 44 G5
Selby U.K. 48 F5
Selby U.S.A. 130 C2
Selbyville U.S.A. 135 H4
Selden U.S.A. 130 C4
Selebi-Phikwe Botswana 99 C6
Selebi-Pikwe Botswana see
 Selebi-Phikwe
Selemdzha r. Rus. Fed. 74 C1
Selemdzhinsk Rus. Fed. 74 C1
Selemdzhinskiy Khrebet mts
 Rus. Fed. 74 C1
Selendi Turkey 59 M5

▶Selenga r. Mongolia/Rus. Fed. 72 J2
Part of the Yenisey-Angara-Selenga,
3rd longest river in Asia.
Also known as Selenga Mörön.

Selenga Mörön r. Mongolia see Selenga
Seletar Sing. 71 [inset]
Seletar Reservoir Sing. 71 [inset]
Selety r. Kazakh. see Sileti
Seletyteniz, Ozero salt l. Kazakh. see
 Siletiteniz, Ozero
Seleucia Turkey see Silifke
Seleucia Pieria Turkey see Samandağı
Selfridge U.S.A. 130 C2
Sel'gon Stantsiya Rus. Fed. 74 D2
Selib Rus. Fed. 42 K3
Sélibabi Mauritania 96 B3
Selibe-Phikwe Botswana see
 Selebi-Phikwe
Seligenstadt Germany 53 I4
Seliger, Ozero l. Rus. Fed. 42 G4
Seligman U.S.A. 129 G4
Selikhino Rus. Fed. 74 E2
Selīma Oasis Sudan 86 C5
Selimiye Turkey 59 L6

Selinsgrove U.S.A. 135 G3
Selizharovo Rus. Fed. 42 G4
Seljord Norway 45 F7
Selkirk Canada 121 L5
Selkirk U.K. 50 G5
Selkirk Mountains Canada 120 G4
Sellafield U.K. 48 D4
Sellersburg U.S.A. 134 C4
Sellore Island Myanmar see
 Saganthit Kyun
Sells U.S.A. 129 H6
Selm Germany 53 H3
Selma AL U.S.A. 133 C5
Selma CA U.S.A. 128 D3
Selmer U.S.A. 131 F5
Selous, Mount Canada 120 C2
Selseleh-ye Pīr Shūrān mts Iran 89 F4
Selsey Bill hd U.K. 49 G8
Sel'tso Rus. Fed. 43 G5
Selty Rus. Fed. 42 L4
Selu i. Indon. 108 E2
Seluan i. Indon. 71 D6
Selvas reg. Brazil 142 D5
Selvin U.S.A. 134 B4
Selway r. U.S.A. 126 E3
Selwyn Lake Canada 121 J2
Selwyn Mountains Canada 120 D1
Selwyn Range hills Australia 110 B4
Selz r. Germany 53 I5
Semarang Indon. 68 E8
Semau i. Indon. 108 C2
Sembawang Sing. 71 [inset]
Sembé Congo 98 B3
Şemdinli Turkey 91 G3
Semendire Serb. and Mont. see
 Smederevo
Semenivka Ukr. 43 G5
Semenov Rus. Fed. 42 J4
Semenovka Ukr. see Semenivka
Semey Kazakh. see Semipalatinsk
Semidi Islands U.S.A. 118 C4
Semikarakorsk Rus. Fed. 43 I7
Semiluki Rus. Fed. 43 H6
Seminoe Reservoir U.S.A. 126 G4
Seminole U.S.A. 131 C5
Seminole, Lake U.S.A. 133 C6
Semipalatinsk Kazakh. 80 F1
Semirara Islands Phil. 69 G4
Semïrom Iran 88 C4
Sem Kolodezey Ukr. see Lenine
Semnān Iran 88 D3
Semois r. Belgium/France 52 E5
Semois, Vallée de la valley Belgium/France
 52 E5
Semyonovskoye Arkhangel'skaya Oblast'
 Rus. Fed. see Bereznik
Semyonovskoye Kostromskaya Oblast'
 Rus. Fed. see Ostrovskoye
Sena Bol. 142 E6
Sena Madureira Brazil 142 E5
Senanga Zambia 99 C5
Sendai Kagoshima Japan 75 C7
Sendai Miyagi Japan 75 F5
Sêndo China 76 B2
Senebui, Tanjung pt Indon. 71 C7
Seneca KS U.S.A. 130 D4
Seneca OR U.S.A. 126 D3
Seneca Lake U.S.A. 135 G2
Seneca Rocks U.S.A. 134 F4
Senecaville Lake U.S.A. 134 E4
▶Senegal country Africa 96 B3
 Africa 7, 94–95
Sénégal r. Mauritania/Senegal 96 B3
Seney U.S.A. 130 G2
Senftenberg Germany 47 O5
Senga Hill Zambia 99 D4
Sengerema Tanz. 98 D4
Sengeyskiy, Ostrov i. Rus. Fed. 42 K1
Sengiley Rus. Fed. 43 K5
Sengirli, Mys pt Kazakh. see
 Syngyrli, Mys
Senhor do Bonfim Brazil 143 J6
Senigallia Italy 58 E3
Senj Croatia 58 F2
Senja i. Norway 44 J2
Sen'kina Rus. Fed. 42 K2
Şenköy Turkey 85 C1
Senlac S. Africa 100 F3
Senlin Shan mt. China 74 C4
Senlis France 52 C5
Senmonorom Cambodia 71 D4
Sennar Sudan 86 D7
Sennen U.K. 49 B8
Senneterre Canada 122 F4
Senqu r. Lesotho 101 H6
Sens France 56 F2
Sensuntepeque El Salvador 136 G6
Senta Serb. and Mont. 59 I2
Senthal India 82 D3
Sentinel U.S.A. 129 G5
Sentinel Peak Canada 120 F4
Sentosa i. Sing. 71 [inset]
Senwabarwana S. Africa see Bochum
Şenyurt Turkey 91 F3
Seo de Urgell Spain see
 Le Seu d'Urgell
Seonath r. India 84 D1
Seoni India 82 D5
Seorinarayan India 83 E5

▶Seoul S. Korea 75 B5
Capital of South Korea.

Separation Well Australia 108 C5
Sepik r. P.N.G. 69 K7
Sep'o N. Korea 75 B5
Sepon India 83 H4
Seppa India 83 H4
Sept-Îles Canada 123 I4
Sequoia National Park U.S.A. 128 D3
Serafimovich Rus. Fed. 43 I6
Şêraitang China see Baima
Serakhs Akhal'skaya Oblast' Turkm. see
 Saragt
Seram i. Indon. 69 H7
Seram, Laut sea Indon. 69 I7
Serang Indon. 68 D8
Serangoon Harbour b. Sing. 71 [inset]
Serapi, Gunung hill Indon. 71 E7
Serapong, Mount hill Sing. 71 [inset]
Serasan i. Indon. 71 E7
Serasan, Selat sea chan. Indon. 71 E7
Seraya i. Indon. 71 E7

Serbâl, Gebel mt. Egypt see Sirbâl, Jabal

▶Serbia country Europe 59 I2
Formerly known as Yugoslavia and as Serbia
and Montenegro. Up to 1993 included
Bosnia-Herzegovina, Croatia, Macedonia,
Montenegro and Slovenia. Became
independent from Montenegro in June 2006.
Europe 5, 38–39

Sêrbug Co l. China 83 G2
Sêrca China 76 B2
Serchhip India 83 H5
Serdar Turkm. 88 E2
Serdica Bulg. see Sofia
Serdo Eth. 98 E2
Serdoba r. Rus. Fed. 43 J5
Serdobsk Rus. Fed. 43 J5
Serebryansk Kazakh. 80 F2
Seredka Rus. Fed. 45 P7
Şereflikoçhisar Turkey 90 D3
Seremban Malaysia 71 C7
Serengeti National Park Tanz. 98 D4
Serenje Zambia 99 D5
Serezha r. Rus. Fed. 42 I5
Sergach Rus. Fed. 42 J5
Sergeyevka Rus. Fed. 74 B2
Sergiyev Posad Rus. Fed. 42 H4
Sergo Ukr. see Stakhanov
Serh China 80 I4
Serhetabat Turkm. 89 F3
Serifos i. Greece 59 K6
Sérigny r. Canada 123 H3
Sérigny, Lac l. Canada 123 H3
Serik Turkey 90 C5
Seringapatam Reef Australia 108 C3
Sêrkang China see Nyainrong
Sermata i. Indon. 69 H8
Sermata, Kepulauan is Indon. 108 E2
Sermersuaq glacier Greenland 119 M2
Sermilik inlet Greenland 119 O3
Sernovodsk Rus. Fed. 43 K5
Sernur Rus. Fed. 42 K4
Sernyy Zavod Turkm. see Kükürtli
Seronga Botswana 99 C5
Serov Rus. Fed. 41 S4
Serowe Botswana 101 H2
Serpa Port. 57 C5
Serpa Pinto Angola see Menongue
Serpentine Lakes salt flat Australia 109 E7
Serpukhov Rus. Fed. 43 H5
Serra Brazil 145 C3
Serra Alta Brazil 145 A4
Serrachis r. Cyprus 85 A2
Serra da Bocaina, Parque Nacional da
nat. park Brazil 145 B3
Serra da Canastra, Parque Nacional da
nat. park Brazil 145 B3
Serra da Mesa, Represa resr Brazil 145 A1
Serra das Araras Brazil 145 B1
Serra do Divisor, Parque Nacional da
nat. park Brazil 142 D5
Sérrai Greece see Serres
Serranía de la Neblina, Parque Nacional
nat. park Venez. 142 E3
Serraria, Ilha i. Brazil see Queimada, Ilha
Serra Talhada Brazil 143 K5
Serre r. France 52 D5
Serres Greece 59 J4
Serrinha Brazil 143 K6
Sêrro Brazil 145 C2
Sers Tunisia 58 C6
Sertanópolis Brazil 145 A3
Sertãozinho Brazil 145 B3
Sêrtar China 76 D1
Sertavul Geçidi pass Turkey 85 A1
Sertolovo Rus. Fed. 45 Q6
Seruai Indon. 71 B6
Serui Indon. 69 J7
Serule Botswana 99 C6
Seruna India 82 C3
Sêrwolungwa China 76 B1
Sêrxü China 76 C1
Seseganaga Lake Canada 122 C4
Sese Islands Uganda 98 D4
Sesel country Indian Ocean see
Seychelles
Sesfontein Namibia 99 B5
Seshachalam Hills India 84 C3
Sesheke Zambia 99 C5
Sesostris Bank sea feature India 84 A3
Ses Salines, Cap de c. Spain 57 H4
Sestri Levante Italy 58 C2
Sestroretsk Rus. Fed. 45 P6
Set, Phou mt. Laos 70 D4
Sète France 56 F5
Sete Lagoas Brazil 145 B2
Setermoen Norway 44 K2
Setesdal valley Norway 45 E7
Seti r. Nepal 82 E3
Sétif Alg. 54 F4
Seto Japan 75 E6
Seto-naikai sea Japan 73 O6
Seto-naikai Kokuritsu-kōen Japan 75 D6
Setsan Myanmar 70 A3
Settat Morocco 54 C5
Settepani, Monte mt. Italy 58 C2
Settle U.K. 48 E4
Setúbal Port. 57 B4
Setúbal, Baía de b. Port. 57 B4
Seul, Lac l. Canada 121 M5
Sevan Armenia 91 G2
Sevan, Lake Armenia 91 G2
Sevan, Ozero l. Armenia see
Sevan, Lake
Sevana Lich l. Armenia see Sevan, Lake
Sevastopol' Ukr. 90 D1
Seven Islands Canada see Sept-Îles
Seven Islands Bay Canada 123 J2
Sevenoaks U.K. 49 H7
Seventy Mile House Canada see
70 Mile House
Sévérac-le-Château France 56 F4
Severn r. Australia 112 E2
Severn r. Canada 122 D3
Severn S. Africa 100 F4
Severn r. U.K. 49 E7
also known as Hafren
Severnaya Dvina r. Rus. Fed. 42 I2
Severnaya Sos'va r. Rus. Fed. 41 T3
Severnaya Zemlya is Rus. Fed. 65 L1
Severn Lake Canada 121 N4

Severnoye Rus. Fed. 41 Q5
Severnyy Nenetskiy Avtonomnyy Okrug
Rus. Fed. 42 K1
Severnyy Respublika Komi Rus. Fed. 64 H3
Severo-Baykal'skoye Nagor'ye mts
Rus. Fed. 65 M4
Severodonetsk Ukr. see Syeverodonets'k
Severodvinsk Rus. Fed. 42 H2
Severo-Kuril'sk Rus. Fed. 65 Q4
Severomorsk Rus. Fed. 44 R2
Severoonezhsk Rus. Fed. 42 H3
Severo-Sibirskaya Nizmennost' lowland
Rus. Fed. see North Siberian Lowland
Severoural'sk Rus. Fed. 41 R3
Severo-Yeniseyskiy Rus. Fed. 64 K3
Severskaya Rus. Fed. 90 E1
Severskiy Donets r. Rus. Fed./Ukr. 43 I7
also known as Northern Donets,
Sivers'kyy Donets'
Sevier U.S.A. 129 G2
Sevier r. U.S.A. 129 G2
Sevier Desert U.S.A. 129 G2
Sevier Lake U.S.A. 129 G2
Sevierville U.S.A. 132 D5
Sevilla Col. 142 C3
Sevilla Spain see Seville
Seville Spain 57 D5
Sevlyush Ukr. see Vynohradiv
Sewani India 82 C3
Seward AK U.S.A. 118 D3
Seward NE U.S.A. 130 D3
Seward Mountains Antarctica 152 L2
Seward Peninsula U.S.A. 118 B3
Sexi Nigeria 96 D4
Sexsmith Canada 120 G4
Sextín Mex. 131 B7
Seyah Band Koh mts Afgh. 89 F3
Seyakha Rus. Fed. 153 F2
Seydi Turkm. 89 F2
Seydişehir Turkey 90 C3
Seyðisfjörður Iceland 44 [inset]
Seyhan Turkey see Adana
Seyhan r. Turkey 85 B1
Seyitgazi Turkey 59 N5
Seym r. Rus. Fed./Ukr. 43 G6
Seymchan Rus. Fed. 65 Q3
Seymour Australia 112 B6
Seymour S. Africa 101 H7
Seymour IN U.S.A. 134 C4
Seymour TX U.S.A. 131 D5
Seymour Inlet Canada 120 E5
Seymour Range mts Australia 109 F6
Seypan i. N. Mariana Is see Saipan
Seyyedābād Afgh. 89 H3
Sézanne France 52 D6
Sfakia Kriti Greece see Chora Sfakion
Sfântu Gheorghe Romania 59 K2
Sfax Tunisia 58 D7
Sfikia, Limni resr Greece see
Sfikias, Limni
Sfikias, Limni resr Greece 59 J4
Sfîntu Gheorghe Romania see
Sfântu Gheorghe
Sgiersch Poland see Zgierz
's-Graveland Neth. 52 I2
's-Gravenhage Neth. see The Hague
Sgurr Alasdair hill U.K. 50 C3
Sgurr Dhomhnuill hill U.K. 50 D4
Sgurr Mòr mt. U.K. 50 D3
Sgurr na Ciche mt. U.K. 50 D3
Shaanxi prov. China 76 F1
Shaartuz Tajik. see Shahrtuz
Shaban Pak. 89 G4
Shabani Zimbabwe see Zvishavane
Shabestar Iran 88 B2
Shabibī, Jabal ash mt. Jordan 85 B5
Shabla, Nos pt Bulg. 59 M3
Shabogamo Lake Canada 123 I3
Shabunda Dem. Rep. Congo 98 C4
Shache China 80 E4
Shackleton Coast Antarctica 152 H1
Shackleton Glacier Antarctica 152 I1
Shackleton Ice Shelf Antarctica 152 F2
Shackleton Range mts Antarctica 152 A1
Shadaogou China 77 F2
Shadaw Myanmar 70 B3
Shādegān Iran 88 C4
Shadihar Pak. 89 G5
Shady Grove U.S.A. 126 C4
Shady Spring U.S.A. 134 E5
Shafer, Lake U.S.A. 134 B3
Shafer Peak Antarctica 152 H2
Shafter U.S.A. 128 D4
Shaftesbury U.K. 49 E7
Shagamu Nigeria 96 D4
Shagamu r. Canada 122 D3
Shagedu China 73 K5
Shageluk U.S.A. 118 C3
Shaghyray Üstirti plat. Kazakh. see
Shagyray, Plato
Shagonar Rus. Fed. 80 H1
Shag Point N.Z. 113 C7
Shag Rocks is S. Georgia 144 H8
Shagyray, Plato plat. Kazakh. 80 A2
Shahabad Karnataka India 84 C2
Shahabad Rajasthan India 82 D4
Shahabad Uttar Prad. India 82 E4
Shāhābād see Eslāmābād-e Gharb
Shah Alam Malaysia 71 C7
Shahbandar Pak. 89 G5
Shahdād Iran 88 E4
Shahdol India 82 E5
Shahe China 77 F2
Shahejie China see Jiujiang
Shahezhen China see Jiujiang
Shah Fuladi mt. Afgh. 89 G3
Shahid, Ras pt Pak. 89 G3
Shāhīn Dezh Iran see Sa'indezh
Shah Ismail Afgh. 89 G4
Shahjahanpur India 82 D4
Shāh Jehān, Küh-e mts Iran 88 E2
Shāh Jūy Afgh. 89 G3
Shāh Kūh mt. Iran 88 D4
Shāhpūr Iran see Salmās
Shahrak Afgh. 89 G3
Shāhrakht Iran 89 F3
Shahr-e Bābak Iran 88 D4
Shahr-e Kord Iran 88 C3
Shahreza Iran 88 C3

Shahrig Pak. 89 G4
Shahrisabz Uzbek. 89 G2
Shahriston Tajik. 89 H2
Shahr Rey Iran 88 C3
Shahr Sultan Pak. 89 H4
Shahrtuz Tajik. 89 H2
Shāhrūd Iran see Emāmrūd
Shāhrūd, Rūdkhāneh-ye r. Iran 88 C2
Shahrud Bustam reg. Iran 88 D3
Shāh Savārān, Kūh-e mts Iran 89 E4
Shāh Taqī Iran see Emām Taqī
Shaighalu Pak. 89 H4
Shaikh Husain mt. Pak. 89 G4
Shaikhpura India see Sheikhpura
Shā'ir, Jabal mts Syria 85 C2
Sha'īra, Gebel mt. Egypt see
Sha'irah, Jabal
Shaj'ah, Jabal hill governorate Saudi Arabia 88 C5
Shajapur India 82 D5
Shajianzi China 74 B4
Shakaville S. Africa 101 J5
Shakh Tajik. see Shoh
Shakhbuz Azer. see Şahbuz
Shākhen Iran 89 E3
Shakhovskaya Rus. Fed. 42 G4
Shakhrisabz Uzbek. see Shahrisabz
Shakhristan Tajik. see Shahriston
Shakhtinsk Kazakh. 80 D2
Shakhty Respublika Buryatiya Rus. Fed. see
Gusinoozersk
Shakhty Rostovskaya Oblast'
Rus. Fed. 43 I7
Shakhun'ya Rus. Fed. 42 J4
Shaki Nigeria 96 D4
Shakotan-hantō pen. Japan 74 F4
Shakshuka Rus. Fed. 42 I3
Shalang China 77 F4
Shali Rus. Fed. 91 G2
Shaliuhe China see Gangca
Shalkar India 82 D3
Shalkar Kazakh. 80 A2
Shalqar Kazakh. see Shalkar
Shaluli Shan mts China 76 C2
Shaluni mt. India 83 I3
Shama r. Tanz. 99 D4
Shamāl Sīnā' governorate Egypt see
Shamāl Sīnā'
Shamāl Sīnā' governorate Egypt 85 A4
Shamalzā'ī Afgh. 89 G4
Shāmat al Akbād des. Saudi Arabia 91 F5
Shamattawa Canada 121 N4
Shamattawa r. Canada 122 D3
Shambār Iran 88 C4
Shamgong Bhutan see Shemgang
Shamil Iran 88 E5
Shāmīyah des. Iraq/Syria 85 D2
Shamkhor Azer. see Şämkir
Shamrock U.S.A. 131 C5
Shanacrane Ireland 51 C6
Shancheng Fujian China see Taining
Shancheng Shandong China see Shanxian
Shand Afgh. 89 F4
Shandan China 80 J4
Shandong prov. China 77 H1
Shandong Bandao pen. China 73 M5
Shandur Pass Pak. 89 I2
Shangchao China 77 F3
Shangcheng China 77 G2
Shangchuan Dao i. China 77 G4
Shangdu China 73 K4
Shangganling China 74 C3
Shanghai China 77 I2
Shanghai municipality China 77 I2
Shangji China see Xichuan
Shangjie China see Yangbi
Shangjin China 77 F1
Shangluo China 77 F1
Shangmei China see Xinhua
Shangnan China 77 F1
Shangpa China see Fugong
Shangpai China see Feixi
Shangpaihe China see Feixi
Shangqiu Henan China 77 G1
Shangqiu Henan China see Suiyang
Shangrao China 77 H2
Shangshui China 77 G1
Shangyou China 77 G3
Shangyou Shuiku resr China 80 F3
Shangyu China 77 I2
Shangzhi China 74 B3
Shangzhou Shaanxi China see Shangluo
Shanhe China see Zhengning
Shanhetun China 74 B3
Shankou China 77 F4
Shannon airport Ireland 51 D5
Shannon est. Ireland 51 D5
Shannon r. Ireland 51 D5
Shannon, Mouth of the Ireland 51 C5
Shannon National Park Australia 109 B8
Shannon Ø i. Greenland 153 I1
Shan Plateau Myanmar 70 B2
Shansi prov. China see Shanxi
Shan Teng hill H.K. China see
Victoria Peak
Shantipur India 83 G5
Shantou China 77 H4
Shantung prov. China see Shandong
Shanwei China 77 H4
Shanxi prov. China 77 F1
Shanxian China 77 H1
Shanyang China 77 F1
Shaodong China 77 F3
Shaoguan China 77 G3
Shaowu China 77 H3
Shaoxing China 77 I2
Shaoyang China 77 F3
Shap U.K. 48 E4
Shapa China see Ebian
Shaping China see Ebian
Shapinsay i. U.K. 50 G1
Shapkina r. Rus. Fed. 42 L2
Shapshal'skiy Khrebet mts
Rus. Fed. 80 G1
Shaqrā' Saudi Arabia 86 G4
Shār, Jabal mt. Saudi Arabia 90 D6
Sharaf well Iraq 91 F5
Sharan 89 H3
Sharan Jogizai Pak. 89 H4
Shārī Māh Iran 88 E4
Sharbulag Mongolia 80 H2
Shardara Kazakh. 80 C3

Shardara, Step' plain Kazakh. see
Chardara, Step'
Sharga Mongolia 80 I2
Sharhulsan Mongolia 72 I4
Shari r. Cameroon/Chad see Chari
Shārī, Buḩayrat imp. l. Iraq 91 G4
Shari-dake vol. Japan 74 G4
Sharīfah Syria 85 C2
Sharjah U.A.E. 88 D5
Sharka-leb La pass China 83 G3
Sharkawshchyna Belarus 45 O9
Shark Bay Australia 109 A6
Shark Reef Australia 110 D2
Sharlyk Rus. Fed. 41 Q5
Sharm ash Shaykh Egypt 90 D6
Sharm el Sheikh Egypt see
Sharm ash Shaykh
Sharon U.S.A. 134 E3
Sharon Springs U.S.A. 130 C4
Sharpe Lake Canada 121 M4
Sharp Peak hill H.K. China 77 [inset]
Sharqāṭ Iraq see Ash Sharqāṭ
Sharqī, Jabal ash mts Lebanon/Syria 85 B3
Sharqīy Ustyurt Chink esc. Uzbek. 80 A3
Sharur Azer. see Şärur
Shar'ya Rus. Fed. 42 J4
Shashe r. Botswana/Zimbabwe 99 C6
Shashemenē Eth. 98 D3
Shashi China see Jingzhou
Shasta, Mount vol. U.S.A. 126 C4
Shasta Lake U.S.A. 128 B1
Shatkhty Kazakh. see Chu
Shatoy Rus. Fed. 91 G2
Shatsk Rus. Fed. 43 I5
Shaṭṭ al 'Arab r. Iran/Iraq 91 H5
Shatura Rus. Fed. 43 H5
Shaubak Jordan see Ash Shawbak
Shaunavon Canada 121 I5
Shaver Lake U.S.A. 128 D3
Shaw r. Australia 108 B5
Shawangunk Mountains hills U.S.A.
135 H3
Shawano U.S.A. 134 A1
Shawano Lake U.S.A. 134 A1
Shawinigan Canada 123 G5
Shawnee OK U.S.A. 131 D5
Shawnee WY U.S.A. 126 G4
Shawneetown U.S.A. 130 F4
Shaxian China 77 H3
Shay Gap Australia 108 C5
Shaykh, Jabal ash mt. Lebanon/Syria see
Hermon, Mount
Shaykh Miskīn Syria 85 C3
Shaytūr Iran 88 D4
Shāzand Iran 88 C3
Shazaīq, Jabal mts Saudi Arabia 91 F5
Shazud Tajik. 89 I2
Shchekino Rus. Fed. 43 H5
Shchel'yayur Rus. Fed. 42 L2
Shcherbakov Rus. Fed. see Rybinsk
Shchigry Rus. Fed. 43 H6
Shchors Ukr. 43 F6
Shchuchin Belarus see Shchuchyn
Shchuchyn Belarus 45 N10
Shebalino Rus. Fed. 80 G1
Shebekino Rus. Fed. 43 H6
Sheberghān Afgh. 89 G2
Sheboygan U.S.A. 134 B2
Shebshi Mountains Nigeria 96 E4
Shebunino Rus. Fed. 74 F3
Shediac Canada 123 I5
Shedin Peak Canada 120 E4
Shedok Rus. Fed. 91 F1
Sheelin, Lough l. Ireland 51 E4
Sheep Haven b. Ireland 51 E2
Sheepmoor S. Africa 101 J4
Sheep Mountain U.S.A. 129 J2
Sheep Peak U.S.A. 129 F3
Sheep's Head hd Ireland see Muntervary
Sheerness U.K. 49 H7
Sheet Harbour Canada 123 J5
Shefar'am Israel 85 B3
Sheffield N.Z. 113 D6
Sheffield U.K. 48 F5
Sheffield AL U.S.A. 133 C5
Sheffield PA U.S.A. 134 F3
Sheffield TX U.S.A. 131 C6
Sheffield Lake Canada 123 K4
Shegah Afgh. 89 G4
Shegmas Rus. Fed. 42 K2
Shehong China 76 E2
Sheikh, Jebel esh mt. Lebanon/Syria see
Hermon, Mount
Sheikhpura India 83 F4
Sheikhupura Pak. 89 I4
Shekak r. Canada 122 D4
Shekār Āb Iran 88 D3
Shekhawati reg. India 82 C3
Shekhem West Bank see Nāblus
Shekhupura India see Sheikhpura
Sheki Azer. see Şäki
Shekka Ch'ün-Tao H.K. China see
Soko Islands
Shek Kwu Chau i. H.K. China 77 [inset]
Shekou China see Rizhao
Shek Uk Shan mt. H.K. China 77 [inset]
Sheksna Rus. Fed. 42 H4
Shekhsninskoye Vodokhranilishche resr
Rus. Fed. 42 H4
Shek Uk Shan mt. H.K. China 77 [inset]
Shela China 76 E2
Shelagskiy, Mys pt Rus. Fed. 65 S2
Shelbina U.S.A. 130 E4
Shelburn U.S.A. 134 B4
Shelburne N.S. Canada 123 I6
Shelburne Ont. Canada 134 E1
Shelburne Bay Australia 110 C1
Shelby MI U.S.A. 134 B2
Shelby MS U.S.A. 131 F5
Shelby MT U.S.A. 126 F2
Shelby NC U.S.A. 133 D5
Shelbyville IL U.S.A. 130 F4
Shelbyville IN U.S.A. 134 C4
Shelbyville KY U.S.A. 134 C4
Shelbyville TN U.S.A. 132 C5

Sheldon IL U.S.A. 134 B3
Sheldrake Canada 123 I4
Shelek Kazakh. see Chilik
Shelikhova, Zaliv g. Rus. Fed. 65 Q3
Shelikof Strait U.S.A. 118 C4
Shell U.S.A. 130 B2
Shellbrook Canada 121 J4
Shelley U.S.A. 126 E4
Shellharbour Australia 112 E5
Shell Lake U.S.A. 121 J4
Shell Lake U.S.A. 130 F2
Shell Mountain U.S.A. 128 B1
Shelter Bay Canada see Port-Cartier
Shelter Island U.S.A. 135 I3
Shelter Point N.Z. 113 B8
Shelton U.S.A. 126 C3
Shemakha Azer. see Şamaxı
Shemgang Bhutan 83 G4
Shemordan Rus. Fed. 42 K4
Shenandoah IA U.S.A. 130 E3
Shenandoah PA U.S.A. 135 G3
Shenandoah Mountains U.S.A. 134 F4
Shenandoah National Park
U.S.A. 135 F4
Shendam Nigeria 96 D4
Shending Shan hill China 74 D3
Shengena mt. Tanz. 99 D4
Shengli China 77 G2
Shengli Feng mt. China/Kyrg. see
Pobeda Peak
Shengping China 74 B3
Shengrenjian China see Pinglu
Shengsi China 77 I2
Shengsi Liedao is China 77 I2
Shenjiamen China 77 I2
Shenkursk Rus. Fed. 42 I3
Shenmu China 73 K5
Shennong Ding mt. China 77 F2
Shennongjia China 77 F2
Shenqiu China 77 G1
Shenshu China 74 C3
Shensi prov. China see Shaanxi
Shentala Rus. Fed. 43 K5
Shenton, Mount hill Australia 109 C7
Shenyang China 74 A4
Shenzhen China 77 G4
Shenzhen Wan b. H.K. China see Deep Bay
Sheopur India 82 D4
Shepetivka Ukr. 43 E6
Shepetovka Ukr. see Shepetivka
Shepherd Islands Vanuatu 107 G3
Shepparton Australia 112 B6
Sheppey, Isle of i. U.K. 49 H7
Sheqi China 77 G1
Sherabad Uzbek. see Sherobod
Sherborne U.K. 49 E8
Sherbro Island Sierra Leone 96 B4
Sherbrooke Canada 123 H5
Sherburne U.S.A. 135 H2
Shercock Ireland 51 F4
Shereiq Sudan 86 D6
Shergaon India 83 H4
Shergarh India 82 C4
Shergol India 82 D2
Sheridan AR U.S.A. 131 E5
Sheridan WY U.S.A. 126 G3
Sheringham U.K. 49 I6
Sherman U.S.A. 131 D5
Sherman Mountain U.S.A. 129 F1
Sherobod Uzbek. 89 G2
Sherpur Dhaka Bangl. 83 G4
Sherpur Rajshahi Bangl. 83 G4
Sherridon Canada 121 K4
's-Hertogenbosch Neth. 52 F3
Sherwood Forest reg. U.K. 49 F5
Sherwood Lake Canada 121 K2
Sheryshevo Rus. Fed. 74 C2
Sheslay Canada 120 D3
Sheslay r. Canada 120 C3
Shethanei Lake Canada 121 L3
Shetland Islands is U.K. 50 [inset]
Shetpe Kazakh. 78 E2
Sheung Shui H.K. China 77 [inset]
Sheung Sze Mun sea chan. H.K.
China 77 [inset]
Shevchenko Kazakh. see Aktau
Shevli r. Rus. Fed. 74 D1
Shexian China 77 H2
Sheyang China 77 I1
Sheyenne r. U.S.A. 130 D2
Shey Phoksundo National Park
Nepal 83 E3
Shiant Islands U.K. 50 C3
Shiashkotan, Ostrov i. Rus. Fed. 65 Q5
Shibām Yemen 86 G6
Shibar, Kowtal-e Afgh. 89 H3
Shibata Japan 75 E5
Shibazhan China 74 B1
Shibīn Jazīrat Sīnā' pen. Egypt see Sinai
Shibīn al Kawm Egypt 90 C5
Shibīn el Kôm Egypt see Shibīn al Kawm
Shibogama Lake Canada 122 C3
Shibotsu-jima i. Rus. Fed. see
Zelenyy, Ostrov
Shicheng Fujian China see Zhouning
Shicheng Jiangxi China 77 H3
Shidād al Mismā' hill Saudi Arabia 85 D4
Shidao China 73 M5
Shidian China 76 C3
Shiel, Loch l. U.K. 50 D4
Shīeli Kazakh. see Chiili
Shifa, Jabal ash mts Saudi Arabia 90 D5
Shifang China 76 E2
Shigatse China see Xigazê
Shiḩan mt. Jordan 85 B4
Shihezi China 80 G3
Shihkiachwang China see Shijiazhuang
Shijiao China see Fogang
Shijiazhuang China 73 K5
Shijiu Hu l. China 77 H2
Shijiusuo China see Rizhao
Shikag Lake Canada 122 C4
Shikar r. Pak. 89 G4
Shikarpur Pak. 89 H5
Shikengkong mt. China 77 G3
Shikhany Rus. Fed. 43 J5
Shikohabad India 82 D4
Shikoku i. Japan 75 D6
Shikoku-sanchi mts Japan 75 D6
Shikotan, Ostrov i. Rus. Fed. 74 G4

Shikotan-tō i. Rus. Fed. see
Shikotan, Ostrov
Shikotsu-Tōya Kokuritsu-kōen Japan 74 F4
Shildon U.K. 48 F4
Shilega Rus. Fed. 42 J2
Shiliguri India 83 G4
Shilin China 76 D3
Shilipu China 77 G2
Shiliu China see Changjiang
Shilla mt. Jammu and Kashmir 82 D2
Shillelagh Ireland 51 F5
Shillo r. Israel 85 B3
Shillong India 83 G4
Shilovo Rus. Fed. 43 I5
Shimada Japan 75 E6
Shimanovsk Rus. Fed. 74 B1
Shimbiris mt. Somalia 98 E2
Shimen Gansu China 76 D1
Shimen Hunan China 77 F2
Shimen Yunnan China see Yunlong
Shimla India 82 D3
Shimoda Japan 75 E6
Shimoga India 84 B3
Shimokita-hantō pen. Japan 74 F4
Shimoni Kenya 99 D4
Shimonoseki Japan 75 C6
Shimsk Rus. Fed. 42 F4
Shin, Loch l. U.K. 50 E2
Shinafiyah Iraq see Ash Shanāfiyah
Shinan China see Xingye
Shīndand Afgh. 89 F3
Shingbwiyang Myanmar 70 B1
Shing-gai Myanmar 70 B1
Shinghshal Pass Pak. 89 I2
Shingletown U.S.A. 128 C1
Shingū Japan 75 D6
Shingwedzi S. Africa 101 J2
Shingwedzi r. S. Africa 101 J2
Shīnkāy Afgh. 89 G4
Shīnkay Ghar Afgh. 89 H3
Shinnston U.S.A. 134 E4
Shinshār Syria 85 C2
Shinyanga Tanz. 98 D4
Shiocton U.S.A. 134 A1
Shiogama Japan 75 F5
Shiono-misaki c. Japan 75 D6
Shipai China 77 H2
Shiping China 76 D4
Shipki Pass China/India 82 D3
Shipman U.S.A. 135 F5
Shippegan Island Canada 123 I5
Shippensburg U.S.A. 135 G3
Shiprock U.S.A. 129 I3
Shiprock Peak U.S.A. 129 I3
Shipu China 77 I2
Shipunovo Rus. Fed. 72 E2
Shiqian China 77 F3
Shiqiao China see Panyu
Shiqizhen China see Zhongshan
Shiquan China 77 F1
Shiquanhe Xizang China see Ali
Shiquanhe Xizang China see Gar
Shiquan Shuiku resr China 77 F1
Shira Rus. Fed. 72 F2
Shīrābād Iran 88 C2
Shirakawa-Go and Gokayama tourist site
Japan 75 E5
Shirane-san vol. Japan 75 E5
Shirase Coast Antarctica 152 J1
Shirase Glacier Antarctica 152 D2
Shīrāz Iran 88 D4
Shire r. Malawi 99 D5
Shireza Pak. 89 G5
Shirīn Tagāb Afgh. 89 G2
Shiriya-zaki c. Japan 74 F4
Shirkala reg. Kazakh. 80 A2
Shīr Kūh mt. Iran 88 D4
Shiroro Reservoir Nigeria 96 D3
Shirpur India 82 C5
Shirten Holoy Gobi des. China 80 I3
Shīrvān Iran 88 E2
Shisanzhan China 74 B2
Shishaldin Volcano U.S.A. 118 B4
Shisha Pangma mt. China see
Xixabangma Feng
Shishou China 77 G2
Shitan China 77 G3
Shitang China 77 I2
Shithāthah Iraq 91 F4
Shiv India 82 B4
Shiveluch, Sopka vol. Rus. Fed. 65 R4
Shivpuri India 82 D4
Shivwits U.S.A. 129 G3
Shivwits Plateau U.S.A. 129 G3
Shiwan Dashan mts China 76 E4
Shiwa Ngandu Zambia 99 D5
Shixing China 77 G3
Shiyan China 77 F1
Shizhu China 77 F2
Shizilu China see Junan
Shizipu China 77 H2
Shizong China 76 D3
Shizuishan China 72 J5
Shizuoka Japan 75 E6

▶Shkhara mt. Georgia/Rus. Fed. 91 F2
3rd highest mountain in Europe.

Shklov Belarus see Shklow
Shklow Belarus 43 F5
Shkodër Albania 59 H3
Shkodra Albania see Shkodër
Shkodrës, Liqeni i l.
Albania/Serb. and Mont. see
Scutari, Lake
Shmidta, Ostrov i. Rus. Fed. 64 K1
Shmidta, Poluostrov pen. Rus. Fed. 74 F1
Shoal Lake Canada 121 K5
Shoals U.S.A. 134 B4
Shōbara Japan 75 D6
Shoh Tajik. 89 H2
Shohi Pass Pak. see Tal Pass
Shokanbetsu-dake mt. Japan 74 F4
Sholakkorgan Kazakh. 80 C3
Sholapur India see Solapur
Sholaqorghan Kazakh. see
Sholakkorgan
Shomba r. Rus. Fed. 44 R4
Shomvukva Rus. Fed. 42 K3
Shona Ridge sea feature S. Atlantic Ocean
148 I9
Shonzha Kazakh. see Chundzha
Shor India 82 D2

Shorap Pak. 89 G5
Shorapur India 84 C2
Shorawak reg. Afgh. 89 G4
Sho'rchi Uzbek. 89 G2
Shorewood IL U.S.A. 134 A3
Shorewood WI U.S.A. 134 B2
Shorkot Pak. 89 I4
Shorkozakhly, Solonchak salt flat
 Turkm. 91 J2
Shoshone CA U.S.A. 128 E4
Shoshone ID U.S.A. 126 E4
Shoshone r. U.S.A. 126 F3
Shoshone Mountains U.S.A. 128 E2
Shoshone Peak U.S.A. 128 E3
Shoshong Botswana 101 H2
Shoshoni U.S.A. 126 F4
Shostka Ukr. 43 G6
Shotor Khūn Afgh. 89 G3
Shouyang Shan mt. China 77 F1
Show Low U.S.A. 129 H4
Shoyna Rus. Fed. 42 J2
Shpakovskoye Rus. Fed. 91 F1
Shpola Ukr. 43 F6
Shqipëria country Europe see Albania
Shreve U.S.A. 134 D3
Shreveport U.S.A. 131 E5
Shrewsbury U.K. 49 E6
Shri Lanka country Asia see Sri Lanka
Shri Mohangarh India 82 B4
Shrirampur India 83 G5
Shu Kazakh. 80 D3
Shū r. Kazakh./Kyrg. see Chu
Shu'ab, Ra's pt Yemen 87 H7
Shuajingsi China 76 D1
Shuangbai China 76 D3
Shuangcheng Fujian China see Zherong
Shuangcheng Heilong. China 74 B3
Shuanghe China 77 G2
Shuanghechang China 76 E2
Shuanghedagang China 74 C2
Shuangjiang Guizhou China see
 Jiangkou
Shuangjiang Hunan China see Tongdao
Shuangjiang Yunnan China see Eshan
Shuangliao China 74 A4
Shuangliu China 76 D2
Shuangpai China 77 F3
Shuangshipu China see Fengxian
Shuangxi China see Shunchang
Shuangyang China 74 B4
Shuangyashan China 74 C3
Shubarkuduk Kazakh. 80 A2
Shubayḩ well Saudi Arabia 85 D4
Shugozero Rus. Fed. 42 G4
Shuicheng China see Lupanshui
Shuidong China see Dianbai
Shuijing China 76 E1
Shuikou China 77 F3
Shuikouguan China 76 E4
Shuikoushan China 77 G3
Shuiluocheng China see Zhuanglang
Shuizhai China see Wuhua
Shulan China 74 B3
Shumagin Islands U.S.A. 118 B4
Shumba Zimbabwe 99 C5
Shumen Bulg. 59 L3
Shumerlya Rus. Fed. 42 J5
Shumilina Belarus 43 F5
Shumyachi Rus. Fed. 43 G5
Shunchang China 77 H3
Shuncheng China 74 A4
Shunde China 77 G4
Shunsen China see Shuozhou
Shuozhou China 73 K5
Shuoxian China see Shuozhou
Shuqrah Yemen 86 G7
Shūr r. Iran 88 D4
Shūr r. Iran 89 F3
Shūr watercourse Iran 88 D5
Shūr watercourse Iran 88 E3
Shūr, Rūd-e watercourse Iran 88 E4
Shūr Āb watercourse Iran 88 D4
Shūrjestān Iran 88 D4
Shūrū Iran 89 F4
Shuryshkarskiy Sor, Ozero l.
 Rus. Fed. 41 T2
Shūsh Iran 88 C4
Shusha Azer. see Şuşa
Shushtar Iran 88 C3
Shutfah, Qalamat well Saudi Arabia 88 D6
Shuwaysh, Tall ash hill Jordan 85 C4
Shuya Ivanovskaya Oblast'
 Rus. Fed. 42 I4
Shuya Respublika Kareliya Rus. Fed. 42 G3
Shuyskoye Rus. Fed. 42 I4
Shwebo Myanmar 70 A2
Shwedwin Myanmar 70 A1
Shwegun Myanmar 70 B3
Shwegyin Myanmar 70 B3
Shweudaung mt. Myanmar 70 B2
Shyghanaq Kazakh. see Chiganak
Shymkent Kazakh. 80 C3
Shyok Jammu and Kashmir 82 D2
Shypuvate Ukr. 43 H6
Shyroke Ukr. 43 G7
Sia Indon. 69 I8
Siabu Indon. 71 B7
Siahan Range mts Pak. 89 F5
Siah Chashmeh Iran 88 B2
Siahgird Afgh. 89 G2
Siah Koh mts Afgh. 89 G3
Sialkot Pak. 89 I3
Siam country Asia see Thailand
Sian China see Xi'an
Sian Rus. Fed. 74 B1
Siang r. India see Brahmaputra
Siantan i. Indon. 71 D7
Siargao i. Phil. 69 H5
Siau i. Indon. 69 H6
Siauliai Lith. 45 M9
Si Bai, Lam r. Thai. 70 C4
Sibasa S. Africa 101 J2
Sibaya, Lake S. Africa 101 K4
Sibda China 76 C2
Šibenik Croatia 58 F3
Siberia reg. Rus. Fed. 65 M3
Siberut i. Indon. 68 B7
Siberut, Selat sea chan. Indon. 68 B7
Sibi Pak. 89 G4
Sibidiri P.N.G. 69 K8
Sibigo Indon. 71 A7

Sibiloi National Park Kenya 98 D3
Sibir' reg. Rus. Fed. see Siberia
Sibiti Congo 98 B4
Sibiu Romania 59 K2
Sibley U.S.A. 130 E3
Siboa Indon. 69 G6
Sibolga Indon. 71 B7
Siborongborong Indon. 71 B7
Sibsagar India 83 H4
Sibu Sarawak Malaysia 68 E6
Sibut Cent. Afr. Rep. 98 B3
Sibuyan i. Phil. 69 G4
Sibuyan Sea Phil. 69 G4
Sicamous Canada 120 G5
Sicca Veneria Tunisia see Le Kef
Siccus watercourse Australia 111 B6
Sicheng Anhui China see Sixian
Sicheng Guangxi China see Lingyun
Sichon Thai. 71 B5
Sichuan prov. China 76 D2
Sichuan Pendi basin China 76 E2
Sicié, Cap c. France 56 G5
Sicilia i. Italy see Sicily
Sicilian Channel Italy/Tunisia 58 E6
Sicily i. Italy 58 F5
Sicuani Peru 142 D6
Siddhapur India 82 C5
Siddipet India 84 C2
Sideros, Akra pt Kriti Greece see
 Sideros, Akrotirio
Sideros, Akrotirio pt Greece 59 L7
Sidesaviwa S. Africa 100 F7
Sidhauli India 82 E4
Sidhi India 83 E4
Sidhpur India see Siddhapur
Sidi Aïssa Alg. 57 H6
Sidi Ali Alg. 57 G5
Sīdī Barrānī Egypt 90 B5
Sidi Bel Abbès Alg. 57 F6
Sidi Bennour Morocco 54 C5
Sidi Bou Sa'id Tunisia see Sidi Bouzid
Sidi Bouzid Tunisia 58 C7
Sidi el Barráni Egypt see Sīdī Barrānī
Sidi El Hani, Sebkhet de salt pan
 Tunisia 58 D7
Sidi Ifni Morocco 96 B2
Sidi Kacem Morocco 54 C5
Sidikalang Indon. 71 B7
Sidi Khaled Alg. 54 E5
Sidlaw Hills U.K. 50 F4
Sidley, Mount Antarctica 152 J1
Sidli India 83 G4
Sidmouth U.K. 49 D8
Sidney IA U.S.A. 130 E3
Sidney MT U.S.A. 126 G3
Sidney NE U.S.A. 130 C3
Sidney OH U.S.A. 134 C3
Sidney Lanier, Lake U.S.A. 133 D5
Sidoktaya Myanmar 70 A2
Sidon Lebanon 85 B3
Sidr Egypt see Sudr
Siedlce Poland 43 D5
Sieg r. Germany 53 H4
Siegen Germany 53 I4
Siĕmréab Cambodia 71 C4
Siem Reap Cambodia see Siĕmréab
Si'en China see Huanjiang
Siena Italy 58 D3
Sieradz Poland 47 Q5
Si'erdingka China 76 D3
Sierra Blanca U.S.A. 127 G7
Sierra Colorada Arg. 144 C6
Sierra Grande Arg. 144 C6
Sierra Leone country Africa 96 B4
 Africa 7, 94–95
Sierra Leone Basin sea feature
 N. Atlantic Ocean 148 G5
Sierra Leone Rise sea feature
 N. Atlantic Ocean 148 G5
Sierra Madre Mountains U.S.A. 128 C4
Sierra Mojada Mex. 131 C7
Sierra Nevada, Parque Nacional nat. park
 Venez. 142 D2
Sierra Nevada de Santa Marta, Parque
 Nacional nat. park Col. 142 D1
Sierraville U.S.A. 128 C2
Sierra Vista U.S.A. 127 F7
Sierre Switz. 56 H3
Sievi Fin. 44 N5
Sifang Ling mts China 76 E4
Sifangtai China 74 B3
Sifenī Eth. 98 E2
Sifnos i. Greece 59 K6
Sig Alg. 57 F6
Siggup Nunaa pen. Greenland 119 M2
Sighetu Marmaţiei Romania 43 D7
Sighişoara Romania 59 K1
Siglap Sing. 71 [inset]
Sigli Indon. 71 A6
Siglufjörður Iceland 44 [inset]
Signal de Botrange hill Belgium 52 G4
Signal de la Ste-Baume mt.
 France 56 G5
Signal Peak U.S.A. 129 F5
Signy-l'Abbaye France 52 E5
Sigourney U.S.A. 130 E3
Sigri, Akra pt Voreio Aigaio Greece see
 Saratsina, Akrotirio
Sigsbee Deep sea feature G. of Mexico
 151 N4
Sigüenza Spain 57 E3
Siguiri Guinea 96 C3
Sigulda Latvia 45 N8
Sigurd U.S.A. 129 H2
Sihanoukville Cambodia 71 C5
Sihaung Myauk Myanmar 70 A2
Sihawa India 84 D1
Sihong China 77 H1
Sihora India 82 E5
Sihui China 77 G4
Siikajoki Fin. 44 N4
Siilinjärvi Fin. 44 O5
Siirt Turkey 91 F3
Sijawal Pak. 82 B4
Sika India 82 B5
Sikaka Saudi Arabia see Sakākah
Sikandra Rao India 82 D4
Sikanni Chief Canada 120 F3
Sikanni Chief r. Canada 120 F3
Sikar India 82 C4
Sikaram mt. Afgh. 89 H3

Sikasso Mali 96 C3
Sikaw Myanmar 70 B2
Sikeston U.S.A. 131 F4
Sikhote-Alin' mts Rus. Fed. 74 D4
Sikhote-Alinskiy Zapovednik nature res.
 Rus. Fed. 74 E3
Sikinos i. Greece 59 K6
Sikkim state India 83 G4
Siksjö Sweden 44 J4
Sil r. Spain 57 C2
Šila' i. Saudi Arabia 90 D6
Šilalė Lith. 45 M9
Si Lanna National Park Thai. 70 B3
Silao Mex. 131 F6
Silas U.S.A. 131 F6
Silatvaturai Sri Lanka 84 C4
Silawaih Agam vol. Indon. 71 A6
Silberg hill Germany 53 J1
Silchar India 83 H4
Şile Turkey 59 M4
Sileru r. India 84 D2
Silesia reg. Czech Rep./Poland 47 P5
Sileti r. Kazakh. 72 C2
Siletiteniz, Ozero salt l. Kazakh. 79 G1
Silghat India 83 H4
Siliana Tunisia 58 C6
Silifke Turkey 85 A1
Siliguri India see Shiliguri
Siling Co salt l. China 83 G3
Silipur India 82 D4
Silistra Bulg. 59 L2
Silistria Bulg. see Silistra
Silivri Turkey 59 M4
Siljan l. Sweden 45 I6
Silkeborg Denmark 45 F8
Sillajhuay mt. Chile 142 E7
Sillamäe Estonia 45 O7
Sille Turkey 90 D3
Silli India 83 F5
Sillod India 84 B1
Silobela S. Africa 101 J4
Silsby Lake Canada 121 M4
Silt U.S.A. 129 J2
Siltaharju Fin. 44 O3
Šilūp r. Iran 89 F5
Šilutė Lith. 45 L9
Silvan Turkey 91 F3
Silvânia Brazil 145 A2
Silvassa India 84 B1
Silver Bank Passage Turks and Caicos Is
 137 J4
Silver Bay U.S.A. 130 F2
Silver City Canada 120 B2
Silver City NM U.S.A. 129 I5
Silver City NV U.S.A. 128 D2
Silver Creek r. U.S.A. 129 H4
Silver Lake U.S.A. 126 C4
Silver Lake l. U.S.A. 128 E4
Silvermine Mts hills Ireland 51 D5
Silver Peak Range mts U.S.A. 128 E3
Silver Spring U.S.A. 135 G4
Silver Springs U.S.A. 128 D2
Silverthrone Mountain Canada 120 E5
Silvertip Mountain Canada 120 F5
Silverton U.K. 49 D8
Silverton CO U.S.A. 129 J3
Silverton TX U.S.A. 131 C5
Sima China 83 G3
Simanggang Sarawak Malaysia see
 Sri Aman
Simao China 76 D4
Simárd, Lac l. Canada 122 F5
Simaria India 83 F4
Simav Turkey 59 M5
Simav Dağları mts Turkey 59 M5
Simba Dem. Rep. Congo 98 C3
Simbirsk Rus. Fed. see Ul'yanovsk
Simcoe Canada 134 E2
Simcoe, Lake Canada 134 F1
Simdega India 84 E1
Simēn mts Eth. 98 D2
Simēn Mountains Eth. see Simēn
Simeulue i. Indon. 71 B7
Simferopol' Ukr. 90 D1
Sími i. Greece see Symi
Simikot Nepal 83 E3
Similan, Ko i. Thai. 71 B5
Simi Valley U.S.A. 128 D4
Simla India see Shimla
Simla U.S.A. 126 G5
Şimleu Silvaniei Romania 59 J1
Simmerath Germany 52 G4
Simmern (Hunsrück) Germany 53 H5
Simmesport U.S.A. 131 F6
Simms U.S.A. 126 F3
Simojärvi l. Fin. 44 O3
Simon Mex. 131 C7
Simonette r. Canada 120 G4
Simon Wash watercourse U.S.A. 129 I5
Simoom Sound Canada 120 E5
Simoom Sound Canada see
 Simoom Sound
Simpang Indon. 68 C7
Simpang Mangayau, Tanjung pt
 Malaysia 68 F5
Simplício Mendes Brazil 143 J5
Simplon Pass Switz. 56 I3
Simpson Canada 121 J5
Simpson U.S.A. 126 F2
Simpson Desert Australia 110 B5
Simpson Desert National Park
 Australia 110 B5
Simpson Desert Regional Reserve
 nature res. Australia 111 B5
Simpson Islands Canada 121 H2
Simpson Park Mountains U.S.A. 128 E2
Simpson Peninsula Canada 119 J3
Simrishamn Sweden 45 I9
Simushir, Ostrov i. Rus. Fed. 73 S3
Sina r. India 84 B2
Sinabang Indon. 71 B7
Sinabung vol. Indon. 71 B7
Sinai pen. Egypt 85 A5
Sinai, Mont hill France 52 E5
Sinai al Janūbīya governorate Egypt see
 Janūb Sīnā'
Sinai ash Shamālīya governorate Egypt see
 Shamāl Sīnā'
Si Nakarin Reservoir Thai. 70 B4
Sinaloa state Mex. 127 F8
Sinalunga Italy 58 D3
Sinan China 77 F3
Sinancha Rus. Fed. see Cheremshany

Sinbo Myanmar 70 B1
Sinbyubyin Myanmar 71 B4
Sinbyugyun Myanmar 70 A2
Sincan Turkey 90 E3
Sincelejo Col. 142 C2
Sinchu Taiwan see T'aoyüan
Sinclair Mills Canada 120 F4
Sincora, Serra do hills Brazil 145 C1
Sind r. India 82 D4
Sind Pak. see Thul
Sind prov. Pak. see Sindh
Sinda Rus. Fed. 74 E2
Sindari India 82 B4
Sindelfingen Germany 53 I6
Sindh prov. Pak. 89 H5
Sindhuli Garhi Nepal 83 F4
Sindhulimadi Nepal see Sindhuli Garhi
Sindirgi Turkey 59 M5
Sindor Rus. Fed. 42 K3
Sindou Burkina 96 C3
Sindri India 83 F5
Sind Sagar Doab lowland Pak. 89 H4
Sinel'nikovo Ukr. see Synel'nykove
Sines Port. 57 B5
Sines, Cabo de c. Port. 57 B5
Sinettä Fin. 44 N3
Sinfra Côte d'Ivoire 96 C4
Sing Myanmar 70 B2
Singa Sudan 86 D7
Singanallur India 84 C4
▶Singapore country Asia 71 [inset]
 Asia 6, 62–63

▶Singapore Sing. 71 [inset]
 Capital of Singapore.

Singapore r. Sing. 71 [inset]
Singapore, Strait of Indon./Sing. 71 [inset]
Singapura country Asia see Singapore
Singapura Sing. see Singapore
Singapuru India 84 D2
Singaraja Indon. 108 A2
Sing Buri Thai. 70 C4
Singhampton Canada 134 E1
Singhana India 82 C3
Singida Tanz. 99 D4
Singidunum Serb. and Mont. see
 Belgrade
Singkaling Hkamti Myanmar 70 A1
Singkawang Indon. 68 D6
Singkep i. Indon. 68 C7
Singkil Indon. 71 B7
Singkuang Indon. 71 B7
Singleton Australia 112 E4
Singleton, Mount hill N.T. Australia 108 E5
Singleton, Mount hill W.A. Australia 109 B7
Singora Thai. see Songkhla
Sin'gosan N. Korea see Kosan
Singra India 83 H4
Singri India 83 H4
Singu Myanmar 76 B4
Singwara India 84 D1
Sin'gye N. Korea 75 B5
Sinhala country Asia see Sri Lanka
Sinhkung Myanmar 70 B1
Sining China see Xining
Siniscola Sardinia Italy 58 C4
Sinj Croatia 58 G3
Sinjai Indon. 69 G8
Sinjār, Jabal mt. Iraq 91 F3
Sinkat Sudan 86 E6
Sinkiang aut. reg. China see
 Xinjiang Uygur Zizhiqu
Sinkiang Uighur Autonomous Region
 aut. reg. China see
 Xinjiang Uygur Zizhiqu
Sinmi-do i. N. Korea 75 B5
Sinn Germany 53 I4
Sinnamary Fr. Guiana 143 H2
Sinn Bishr, Gebel hill Egypt see
 Sinn Bishr, Jabal
Sinn Bishr, Jabal hill Egypt 85 A5
Sinneh Iran see Sanandaj
Sinoia Zimbabwe see Chinhoyi
Sinop Brazil 143 G6
Sinop Turkey 90 D2
Sinope Turkey see Sinop
Sinp'a N. Korea 74 B4
Sinp'o N. Korea 75 C4
Sinsang N. Korea 75 B5
Sinsheim Germany 53 I5
Sintang Indon. 68 E6
Sint Eustatius i. Neth. Antilles 137 L5
Sint-Laureins Belgium 52 D3

▶Sint Maarten i. Neth. Antilles 137 L5
 Part of the Netherlands Antilles. The
 northern part of the island is the French
 territory of St Martin.

Sint-Niklaas Belgium 52 E3
Sinton U.S.A. 131 D6
Sintra Port. 57 B4
Sint-Truiden Belgium 52 F4
Sinŭiju N. Korea 75 B4
Sinzig Germany 53 H4
Siófok Hungary 58 H1
Sioma Ngwezi National Park
 Zambia 99 C5
Sion Switz. 56 H3
Sion Mills U.K. 51 E3
Siorapaluk Greenland 119 K2
Sioux Center U.S.A. 125 H3
Sioux City U.S.A. 130 D3
Sioux Falls U.S.A. 130 D3
Sioux Lookout Canada 121 N5
Siphageni S. Africa see Flagstaff
Siping China 74 B4
Sipiwesk Canada 121 L4
Sipiwesk Lake Canada 121 L4
Siple, Mount Antarctica 152 J2
Siple Coast Antarctica 152 J1
Siple Island Antarctica 152 J2
Siponj Tajik. see Bartang
Sipsey r. U.S.A. 131 F5
Sipura i. Indon. 68 B7
Siq, Wādī as watercourse Egypt 85 A5
Sir r. Pak. 89 H6
Sir, Dar"yoi r. Asia see Syrdar'ya
Sira India 84 C3
Sira r. Norway 45 E7
Şīr Abū Nu'ayr i. U.A.E. 88 D5

Siracusa Sicily Italy see Syracuse
Siraha Nepal see Sirha
Sirajganj Bangl. 83 G4
Siran Turkey 90 E3
Sirbāl, Jabal mt. Egypt 90 D5
Sircilla India see Sirsilla
Sird r. Asia see Syrdar'ya
Sirdaryo Uzbek. 80 D3
Sirdingka China see Si'erdingka
Sirha Nepal 83 F4
Sirhān, Wādī as watercourse
 Jordan/Saudi Arabia 85 C4
Sirik Iran 88 E5
Sirik, Tanjung pt Malaysia 68 E6
Sirina r. Greece see Syrna
Sirjā Iran 89 F5
Sirjan Iran 88 D4
Sirjān salt flat Iran 88 D4
Sirkazhi India 84 C4
Sirmilik National Park Canada 119 K2
Şırnak Turkey 91 F3
Sirohi India 82 C4
Sirombu Indon. 71 B7
Sironj India 82 D4
Síros i. Greece see Syros
Sirpur India 84 C2
Sirretta Peak U.S.A. 128 D4
Sirrī, Jazīreh-ye i. Iran 88 D5
Sirsa India 82 C3
Sir Sandford, Mount Canada 120 G5
Sirsi Karnataka India 84 B3
Sirsi Madh. Prad. India 82 D4
Sirsi Uttar Prad. India 82 D3
Sirsilla India 84 C2
Sirte Libya 97 E1
Sirte, Gulf of Libya 97 E1
Sir Thomas, Mount hill Australia 109 E6
Siruguppa India 84 C3
Sirur India 84 B2
Şirvan Turkey 91 F3
Sirvel India 84 C3
Širvintai Lith. see Širvintos
Širvintos Lith. 45 N9
Sirwān r. Iraq 91 G4
Sir Wilfrid Laurier, Mount Canada 120 G4
Sis Turkey see Kozan
Sisak Croatia 58 G2
Sisaket Thai. 70 D4
Sishen S. Africa 100 F4
Sishilipu China 77 F1
Sishuang Liedao is China 77 I3
Sisian Armenia 91 G3
Sisimiut Greenland 119 M3
Sisipuk Lake Canada 121 K4
Sisŏphôn Cambodia 71 C4
Sissano P.N.G. 69 K7
Sisseton U.S.A. 130 D2
Sīstān reg. Iran 89 F4
Sisteron France 56 G4
Sisters is India 71 A5
Sīt Iran 88 E5
Sitamarhi India 83 F4
Sitang China see Sinan
Sitapur India 82 E4
Siteia Greece 59 L7
Siteki Swaziland 101 J4
Sithonia pen. Greece see
 Sithonias, Chersonisos
Sithonias, Chersonisos pen. Greece 59 J4
Sitía Greece see Siteia
Sitidgi Lake Canada 118 E3
Sitila Moz. 101 L2
Siting China 78 B3
Sítio do Mato Brazil 145 C1
Sitka U.S.A. 120 C3
Sitka National Historical Park nat. park
 U.S.A. 120 C3
Sitra oasis Egypt see Sitrah
Sitrah oasis Egypt 90 B5
Sittang r. Myanmar see Sittaung
Sittard Neth. 52 F4
Sittaung Myanmar 70 A1
Sittaung r. Myanmar 70 B3
Sittensen Germany 53 J1
Sittingbourne U.K. 49 H7
Sittoung r. Myanmar see Sittaung
Sittwe Myanmar 70 A2
Situbondo Indon. 68 E8
Siumpu i. Indon. 69 G8
Siuri India 83 F5
Sivaganga India 84 C4
Sivakasi India 84 C4
Sivaki Rus. Fed. 74 B1
Sivan India see Siwan
Sivas Turkey 90 E3
Sivaslı Turkey 59 M5
Siverek Turkey 91 E3
Siverskiy Rus. Fed. 45 Q7
Sivers'ky Donets' r. Rus. Fed./Ukr. see
 Severskiy Donets
Sivomaskinskiy Rus. Fed. 41 S2
Sivrice Turkey 91 E3
Sivrihisar Turkey 59 N5
Sivukile S. Africa 101 H4
Sīwah Egypt 90 B5
Siwah, Wāḩāt oasis Egypt 90 B5
Siwalik Range mts India/Nepal 82 D3
Siwan India 83 F4
Siwana India 82 C4
Siwa Oasis oasis Egypt see Sīwah, Wāḩāt
Sixian China 77 H1
Sixmilecross U.K. 51 E3
Siyabuswa S. Africa 101 I3
Siyäzän Azer. 91 H2
Siyunī Iran 88 D3
Siziwang Qi China see Ulan Hua
Sjælland i. Denmark see Zealand
Sjenica Serb. and Mont. 59 I3
Sjöbo Sweden 45 H9
Sjøvegan Norway 44 J2

Skaftáros r. mouth Iceland 44 [inset]
Skagafjörður inlet Iceland 44 [inset]
Skagen Denmark 45 G8
Skagerrak strait Denmark/Norway 45 F8
Skagit r. U.S.A. 126 C2
Skagway U.S.A. 153 A3
Skaidi Norway 44 N1
Skaland Norway 44 J2
Skalmodal Sweden 44 I4
Skanderborg Denmark 45 F8
Skaneateles Lake U.S.A. 135 G2
Skara Sweden 45 H7
Skardarsko Jezero l.
 Albania/Serb. and Mont. see
 Scutari, Lake
Skardu Jammu and Kashmir 82 C2
Skärgårdshavets nationalpark nat. park
 Fin. 45 L7
Skarnes Norway 45 G6
Skarżysko-Kamienna Poland 47 R5
Skaulo Sweden 44 L3
Skawina Poland 47 Q6
Skeena r. Canada 120 D4
Skeena Mountains Canada 120 D3
Skegness U.K. 48 H5
Skellefteå Sweden 44 L4
Skellefteälven r. Sweden 44 J4
Skellefteahamn Sweden 44 L4
Skellig Rocks is Ireland 51 B6
Skelmersdale U.K. 48 E5
Skerries Ireland 51 F4
Ski Norway 45 G7
Skiathos i. Greece 59 J5
Skibbereen Ireland 51 C6
Skibotn Norway 44 L2
Skiddaw hill U.K. 48 D4
Skien Norway 45 F7
Skiermûntseach Neth. see
 Schiermonnikoog
Skiermûntseach i. Neth. see
 Schiermonnikoog
Skierniewice Poland 47 R5
Skikda Alg. 58 B6
Skipsea U.K. 48 G5
Skipton Australia 112 A6
Skipton U.K. 48 E5
Skirlaugh U.K. 48 G5
Skíros i. Greece see Skyros
Skive Denmark 45 F8
Skjern Denmark 45 F9
Skjolden Norway 45 E6
Skobelev Uzbek. see Farg'ona
Skobeleva, Pik mt. Kyrg. 89 I2
Skodje Norway 44 E6
Skoganvarri Norway 44 N2
Skokie U.S.A. 134 B2
Skomer Island U.K. 49 B7
Skopelos i. Greece 59 J5
Skopin Rus. Fed. 43 H5

▶Skopje Macedonia 59 I4
 Capital of Macedonia.

Skoplje Macedonia see Skopje
Skövde Sweden 45 H7
Skovorodino Rus. Fed. 74 A1
Skowhegan U.S.A. 135 K1
Skrunda Latvia 45 M8
Skukum, Mount Canada 120 C2
Skukuza S. Africa 101 J3
Skull Valley U.S.A. 129 G4
Skuodas Lith. 45 L8
Skurup Sweden 45 H9
Skutskär Sweden 45 J6
Skvyra Ukr. 43 F6
Skye i. U.K. 50 C3
Skylge i. Neth. see Terschelling
Skyring, Seno b. Chile 144 B8
Skyros Greece 59 K5
Skyros i. Greece 59 K5
Skytrain Ice Rise Antarctica 152 L1
Slættaratindur hill Faroe Is 44 [inset]
Slagelse Denmark 45 G9
Slagnäs Sweden 44 K4
Slane Ireland 51 F4
Slaney r. Ireland 51 F5
Slantsy Rus. Fed. 45 P7
Slapovi Krke nat. park Croatia 58 F3
Slashers Reefs Australia 110 D3
Slatina Croatia 58 G2
Slatina Romania 59 K2
Slaty Fork U.S.A. 134 E4
Slava Rus. Fed. 74 C1
Slave r. Canada 121 H2
Slave Coast Africa 96 D4
Slave Lake Canada 120 H4
Slave Point Canada 120 H2
Slavgorod Belarus see Slawharad
Slavgorod Rus. Fed. 72 D2
Slavkovichi Rus. Fed. 45 P8
Slavonska Požega Croatia see Požega
Slavonski Brod Croatia 58 H2
Slavuta Ukr. 43 E6
Slavutych Ukr. 43 F6
Slavyanka Rus. Fed. 74 C4
Slavyansk Ukr. see Slov"yans'k
Slavyanskaya Rus. Fed. see
 Slavyansk-na-Kubani
Slavyansk-na-Kubani Rus. Fed. 90 E1
Slawharad Belarus 43 F5
Sławno Poland 47 P3
Slayton U.S.A. 130 E3
Sleaford U.K. 48 G5
Slea Head hd Ireland 51 B5
Sleat Neth. see Sloten
Sled Lake Canada 121 J4
Sleeper Islands Canada 122 F2
Sleeping Bear Dunes National Lakeshore
 nature res. U.S.A. 134 B1
Slessor Glacier Antarctica 152 B1
Slick Rock U.S.A. 129 I2
Slide Mountain U.S.A. 135 H3
Slieve Bloom Mts hills Ireland 51 E5
Slieve Car hill Ireland 51 C3
Slieve Donard hill U.K. 51 G3
Slieve Gamph hills Ireland 51 C4
Slieve Mish Mts hills Ireland 51 B5
Slieve Snaght hill Ireland 51 E2
Sligachan U.K. 50 C3
Sligeach Ireland see Sligo

Sligo Ireland 51 D3
Sligo U.S.A. 134 D3
Sligo Bay Ireland 51 D3
Slinger U.S.A. 134 A2
Slippery Rock U.S.A. 134 E3
Slite Sweden 45 K8
Sliven Bulg. 59 L3
Sloan U.S.A. 129 F4
Sloat U.S.A. 128 C2
Sloboda Rus. Fed. see Ezhva
Slobodchikovo Rus. Fed. 42 K3
Slobodskoy Rus. Fed. 42 K4
Slobozia Romania 59 L2
Slochteren Neth. 52 G1
Slonim Belarus 45 N10
Slootdorp Neth. 52 E2
Sloten Neth. 52 F2
Slough U.K. 49 G7
▶Slovakia *country* Europe 40 J6
 Europe 5, 38–39
▶Slovenia *country* Europe 58 F2
 Europe 5, 38–39
Slovenia *country* Europe *see* Slovenia
Slovenj Gradec Slovenia 58 F1
Slovensko *country* Europe *see* Slovakia
Slovenský raj *nat. park* Slovakia 47 R6
Slov'yans'k Ukr. 43 H6
Słowiński Park Narodowy *nat. park* Poland 47 P3
Sluch *r.* Ukr. 43 E6
S'Lung, B'Nom *mt.* Vietnam 71 D5
Słupsk Poland 47 P3
Slussfors Sweden 44 J4
Slutsk Belarus 45 O10
Slyne Head *hd* Ireland 51 B4
Slyudyanka Rus. Fed. 72 I2
Small Point U.S.A. 135 K2
Smallwood Reservoir Canada 123 I3
Smalyavichy Belarus 45 P9
Smalyenskaya Wzwyshsha *hills* Belarus/Rus. Fed. *see* Smolensko-Moskovskaya Vozvyshennost'
Smarhon' Belarus 45 O9
Smeaton Canada 121 J4
Smederevo Serb. and Mont. 59 I2
Smederevska Palanka Serb. and Mont. 59 I2
Smela Ukr. *see* Smila
Smethport U.S.A. 135 F3
Smidovich Rus. Fed. 74 D2
Smila Ukr. 43 F6
Smilde Neth. 52 G2
Smiltene Latvia 45 N8
Smirnykh Rus. Fed. 74 F2
Smith Canada 120 H4
Smith Center U.S.A. 130 D4
Smithfield S. Africa 101 H6
Smithfield NC U.S.A. 132 E5
Smithfield UT U.S.A. 126 F4
Smith Glacier Antarctica 152 K1
Smith Island India 71 A4
Smith Island MD U.S.A. 135 G4
Smith Island VA U.S.A. 135 G5
Smith Mountain Lake U.S.A. 134 F5
Smith River Canada 120 E3
Smiths Falls Canada 135 G1
Smithton Australia 111 [inset]
Smithtown Australia 112 F3
Smithville OK U.S.A. 131 E5
Smithville WV U.S.A. 134 E4
Smoke Creek Desert U.S.A. 128 D1
Smoky Bay Australia 109 F8
Smoky Cape Australia 112 F3
Smoky Falls Canada 122 E4
Smoky Hill *r.* U.S.A. 130 D4
Smoky Hills KS U.S.A. 124 H4
Smoky Hills KS U.S.A. 130 D4
Smoky Lake Canada 121 H4
Smoky Mountains U.S.A. 126 E4
Smøla *i.* Norway 44 E5
Smolenka Rus. Fed. 43 K6
Smolensk Rus. Fed. 43 G5
Smolensk-Moscow Upland *hills* Belarus/Rus. Fed. *see* Smolensko-Moskovskaya Vozvyshennost'
Smolensko-Moskovskaya Vozvyshennost' *hills* Belarus/Rus. Fed. 43 G5
Smolevichi Belarus *see* Smalyavichy
Smolyan Bulg. 59 K4
Smooth Rock Falls Canada 122 E4
Smoothrock Lake Canada 122 C4
Smoothstone Lake Canada 121 J4
Smørfjord Norway 44 N1
Smorgon' Belarus *see* Smarhon'
Smyley Island Antarctica 152 L2
Smyrna Turkey *see* İzmir
Smyrna U.S.A. 135 H4
Smyth Island *atoll* Marshall Is *see* Taongi
Snæfell *mt.* Iceland 44 [inset]
Snaefell *hill* Isle of Man 48 C4
Snag Canada 120 A2
Snake *r.* Canada 120 C1
Snake *r.* U.S.A. 126 D3
Snake Island Australia 112 C7
Snake Range *mts* U.S.A. 129 F2
Snake River Canada 120 F3
Snake River Plain U.S.A. 126 E4
Snare *r.* Canada 120 G2
Snare Lake Canada 121 J3
Snare Lakes Canada *see* Wekweètì
Snares Islands N.Z. 107 G6
Snåsa Norway 44 H4
Sneedville U.S.A. 134 D5
Sneek Neth. 52 F1
Sneem Ireland 51 C6
Sneeuberge *mts* S. Africa 100 G6
Snegamook Lake Canada 123 J3
Snegurovka Ukr. *see* Tetiyiv
Snelling U.S.A. 128 C3
Snettisham U.K. 49 H6
Snezhnogorsk Rus. Fed. 64 J3
Snežnik *mt.* Slovenia 58 F2
Sniečkus Lith. *see* Visaginas
Snihurivka Ukr. 43 G7
Snits Neth. *see* Sneek
Snizort, Loch *b.* U.K. 50 C3
Snoqualmie Pass U.S.A. 126 C3
Snøtinden *mt.* Norway 44 H3
Snoul Cambodia *see* Snuôl
Snover U.S.A. 134 D2
Snovsk Ukr. *see* Shchors
Snowbird Lake Canada 121 K2

Snowcrest Mountain Canada 120 G5
Snowdon U.K. 49 F6
Snowdonia National Park U.K. 49 D6
Snowdrift Canada *see* Łutselk'e
Snowdrift *r.* Canada 121 I2
Snowflake U.S.A. 129 H4
Snow Hill U.S.A. 135 H4
Snow Lake Canada 121 K4
Snowville U.S.A. 126 E4
Snow Water Lake U.S.A. 129 F1
Snowy *r.* Australia 112 D6
Snowy Mountain U.S.A. 135 H2
Snowy Mountains Australia 112 C6
Snowy River National Park Australia 112 D6
Snug Corner Bahamas 133 F8
Snug Harbour Nfld. and Lab. Canada 123 L3
Snug Harbour Ont. Canada 134 E1
Snuôl Cambodia 71 D4
Snyder U.S.A. 131 C5
Soalala Madag. 99 E5
Soalara Madag. 99 E6
Soanierana-Ivongo Madag. 99 E5
Soan-kundo *i.* S. Korea 75 B6
Soavinandriana Madag. 99 E5
Sobat *r.* Sudan 86 D8
Sobger *r.* Indon. 69 K7
Sobinka Rus. Fed. 42 I5
Sobradinho, Barragem de *resr* Brazil 143 J6
Sobral Brazil 143 J4
Sochi Rus. Fed. 91 E2
Society Islands Fr. Polynesia 151 J7
Socorro Brazil 145 B3
Socorro Col. 142 D2
Socorro U.S.A. 127 G6
Socorro, Isla *i.* Mex. 136 B5
Socotra *i.* Yemen 87 H7
Soc Trăng Vietnam 71 D5
Socuéllamos Spain 57 E4
Soda Lake CA U.S.A. 128 D4
Soda Lake CA U.S.A. 128 E4
Sodankylä Fin. 44 O3
Soda Plains Aksai Chin 82 D2
Soda Springs U.S.A. 126 F4
Söderhamn Sweden 45 J6
Söderköping Sweden 45 J7
Södertälje Sweden 45 J7
Sodiri Sudan 86 C7
Sodo Eth. 98 D3
Sodus U.S.A. 135 G2
Soë Indon. 69 G8
Soekarno, Puntjak *mt.* Indon. *see* Jaya, Puncak
Soekmekaar S. Africa 101 I2
Soerabaia Indon. *see* Surabaya
Soerendonk Neth. 52 F3
Soest Germany 53 I3
Soest Neth. 52 F2
Sofala Australia 112 D4
▶Sofia Bulg. 59 J3
 Capital of Bulgaria.
Sofiya Bulg. *see* Sofia
Sofiyevka Ukr. *see* Vil'nyans'k
Sofiysk Khabarovskiy Kray Rus. Fed. 74 D1
Sofiysk Khabarovskiy Kray Rus. Fed. 74 E2
Sofporog Rus. Fed. 44 Q4
Sofrana *i.* Greece *see* Sofrana
Softa Kalesi *tourist site* Turkey 85 A1
Sog China 76 B2
Soğanlı Dağları *mts* Turkey 91 E2
Sogda Rus. Fed. 74 D2
Sogma China 82 E2
Sögel Germany 53 H2
Sognefjorden *inlet* Norway 45 D6
Sogruma China 76 C1
Söğüt Turkey 59 N4
Söğüt Dağı *mts* Turkey 59 M6
Soh Iran 88 C3
Sohâg Egypt *see* Sawhāj
Sohagpur India 82 D5
Soham U.K. 49 H6
Sohan *r.* Pak. 89 H3
Sohano P.N.G. 106 F2
Sohar Oman *see* Şuḩār
Sohawal India 82 E4
Sohela India 83 E5
Sohng Gwe, Khao *hill* Myanmar/Thai. 71 B4
Söho-ri N. Korea 75 C4
Sohüksan-do *i.* S. Korea 75 B6
Soignies Belgium 52 E4
Soila China 76 C2
Soini Fin. 44 N5
Soissons France 52 D5
Sojat India 82 C4
Sojat Road India 82 C4
Sok *r.* Rus. Fed. 43 K5
Sokal' Ukr. 43 E6
Sokch'o S. Korea 75 C5
Söke Turkey 59 L6
Sokhor, Gora *mt.* Rus. Fed. 72 J2
Sokhumi Georgia 91 F2
Sokiryany Ukr. *see* Sokyryany
Sokodé Togo 96 D4
Soko Islands H.K. China 77 [inset]
Sokol Rus. Fed. 42 I4
Sokolo Mali 96 C3
Sokolov Czech Rep. 53 M4
Sokoto Nigeria 96 D3
Sokoto *r.* Nigeria 96 D3
Sokyryany Ukr. 43 E6
Sola Cuba 133 E8
Sola *i.* Tonga *see* Ata
Solan India 82 D3
Solana Beach U.S.A. 128 E5
Solander Island N.Z. 113 A8
Solapur India 84 B2
Soledad Brazil 144 F3
Soledad U.S.A. 128 C3
Soledade Brazil 144 F3
Solenoye Rus. Fed. 43 I7
Solfjellsjøen Norway 44 H3
Solginskiy Rus. Fed. 42 I3
Solhan Turkey 91 F3
Soligalich Rus. Fed. 42 I4

Soligorsk Belarus *see* Salihorsk
Solihull U.K. 49 F6
Solikamsk Rus. Fed. 41 R4
Sol'-Iletsk Rus. Fed. 64 G4
Solimões *r.* S. America *see* Amazon
Solingen Germany 52 H3
Solitaire Namibia 100 B2
Sol-Karmala Rus. Fed. *see* Severnoye
Sollefteå Sweden 44 J5
Şollar Azer. 91 H2
Sollichau Germany 53 M3
Solling *hills* Germany 53 J3
Sollstedt Germany 53 K3
Solms Germany 53 I4
Sollum, Gulf of Egypt *see* Sallum, Khalīj as
Solnechnogorsk Rus. Fed. 42 H4
Solnechnyy Amurskaya Oblast' Rus. Fed. 74 A1
Solnechnyy Khabarovskiy Kray Rus. Fed. 74 E2
Solok Indon. 68 C7
Solomon U.S.A. 129 I5
Solomon, North Fork *r.* U.S.A. 130 D4
▶Solomon Islands *country* S. Pacific Ocean 107 G2
 4th largest and 5th most populous country in Oceania.
 Oceania 8, 104–105
Solomon Sea S. Pacific Ocean 106 F2
Solon U.S.A. 135 K1
Solon Springs U.S.A. 130 F2
Solor *i.* Indon. 108 C2
Solor, Kepulauan *is* Indon. 108 C2
Solothurn Switz. 56 H3
Solovetskiye Ostrova *is* Rus. Fed. 42 G2
Solov'yevsk Rus. Fed. 74 B1
Šolta *i.* Croatia 58 G3
Soltānābād *Kermān* Iran 88 E4
Soltānābād *Khorāsān* Iran 89 E3
Soltānābād Iran 88 C3
Soltānīyeh Iran 88 C2
Soltau Germany 53 J2
Sol'tsy Rus. Fed. 42 F4
Solvay U.S.A. 135 G2
Sölvesborg Sweden 45 I8
Solway Firth *est.* U.K. 50 F6
Solwezi Zambia 99 C5
Soma Turkey 59 L5
Somain France 52 D4
▶Somalia *country* Africa 98 E3
 Africa 7, 94–95
Somali Basin *sea feature* Indian Ocean 149 L6
Somali Republic *country* Africa *see* Somalia
Sombo Angola 99 C4
Sombor Serb. and Mont. 59 H2
Sombrero Channel India 71 A6
Sombrio, Lago do *l.* Brazil 145 A5
Somero Fin. 45 M6
Somerset KY U.S.A. 134 C5
Somerset MI U.S.A. 134 C2
Somerset OH U.S.A. 134 D4
Somerset PA U.S.A. 134 F4
Somerset, Lake Australia 112 F1
Somerset East S. Africa 101 G7
Somerset Island Canada 119 I2
Somerset Reservoir U.S.A. 135 I2
Somerset West S. Africa 100 D8
Somersworth U.S.A. 135 J2
Somerton U.S.A. 129 F5
Somerville NJ U.S.A. 135 H3
Somerville TN U.S.A. 131 F5
Someydeh Iran 88 B3
Somme *r.* France 52 B4
Sommen *l.* Sweden 45 I7
Sömmerda Germany 53 L3
Sommet, Lac du *l.* Canada 123 H3
Somnath India 82 B5
Somutu Myanmar 70 B1
Son *r.* India 83 F4
Sonag China *see* Zêkog
Sonapur India 84 D1
Sonar *r.* India 82 D4
Sönch'ön N. Korea 75 B5
Sönch'ön N. Korea 75 B5
Söngch'ön N. Korea 75 B5
Songbai China *see* Shennongjia
Songbu China 77 G2
Sông Câu Vietnam 71 E5
Songcheng China *see* Xiapu
Sông Da, Hô *resr* Vietnam 70 D2
Songea Tanz. 99 D5
Songhua Hu *resr* China 74 B4
Songhua Jiang *r. Heilongjiang/Jilin* China 74 D3
Songhua Jiang *r. Jilin* China *see* Di'er Songhua Jiang
Songjiang China 77 I2
Songjianghe China 74 B4
Sŏngjin N. Korea *see* Kimch'aek
Songkan China 76 E2
Songkhla Thai. 71 C6
Songling China *see* Ta'erqi
Songlong Myanmar 70 B2
Söngnam S. Korea 75 B5
Songnim N. Korea 75 B5
Songo Angola 99 B4
Songo Moz. 99 D5
Songpan China 76 D1
Songshan China *see* Ziyun
Song Shan *mt.* China 77 G1
Songtao China 77 F2
Songxi China 77 H3
Songxian China 77 G1
Songyuan *Fujian* China *see* Songxi
Songyuan *Jilin* China 74 B3
Songzi China 77 F2
Sơn Hai Vietnam 71 E5
Sonid Youqi China *see* Saihan Tal
Sonid Zuoqi China *see* Mandalt
Sonipat India 82 D3
Sonkajärvi Fin. 44 O5
Sonkovo Rus. Fed. 42 H4

Sơn La Vietnam 70 C2
Sonmiani Pak. 89 G5
Sonmiani Bay Pak. 89 G5
Sonneberg Germany 53 L4
Sono *r. Minas Gerais* Brazil 145 B2
Sono *r. Tocantins* Brazil 143 I5
Sonoma U.S.A. 128 B2
Sonoma Peak U.S.A. 128 E1
Sonora *r.* Mex. 127 F7
Sonora *state* Mex. 127 F7
Sonora CA U.S.A. 128 C3
Sonora TX U.S.A. 131 C6
Sonoran Desert U.S.A. 129 G5
Sonoran Desert National Monument *nat. park* U.S.A. 127 E6
Sonqor Iran 88 B3
Sonsonate El Salvador 136 G6
Sonsorol Islands Palau 69 I5
Sonwabile S. Africa 101 I6
Soochow China *see* Suzhou
Soomaaliya *country* Africa *see* Somalia
Sopi, Tanjung *pt* Indon. 69 H6
Sopo *watercourse* Sudan 97 F4
Sopot Bulg. 59 K3
Sopot Poland 47 Q3
Sopron Hungary 58 G1
Sopur Jammu and Kashmir 82 C2
Sora Italy 58 E4
Sorab India 84 B3
Sorada India 84 E2
Söråker Sweden 44 J5
Sorak-san S. Korea 75 C5
Sorak-san National Park S. Korea 75 C5
Sorel Canada 123 G5
Soreq *r.* Israel 85 B4
Sorgun Turkey 90 D3
Sorgun *r.* Turkey 85 B1
Soria Spain 57 E3
Sorkh, Küh-e *mts* Iran 88 D3
Sorkhān Iran 88 E4
Sorkheh Iran 88 D3
Sørli Norway 44 H4
Soro India 83 F5
Soroca Moldova 43 F6
Sorocaba Brazil 145 B3
Soroki Moldova *see* Soroca
Sorol *atoll* Micronesia 69 K5
Sorong Indon. 69 I7
Soroti Uganda 98 D3
Sørøya *i.* Norway 44 M1
Sorraia *r.* Port. 57 B4
Sørreisa Norway 44 K2
Sorrento Italy 58 F4
Sorsele Sweden 44 J4
Sorsogon Phil. 69 G4
Sortavala Rus. Fed. 44 Q6
Sortland Norway 44 I2
Sortopolovskaya Rus. Fed. 42 K3
Sorvizhi Rus. Fed. 42 K4
Sôsan S. Korea 75 B5
Sosenskiy Rus. Fed. 43 G5
Soshanguve S. Africa 101 I3
Sosna *r.* Rus. Fed. 43 H5
Sosneado *mt.* Arg. 144 C5
Sosnogorsk Rus. Fed. 42 L3
Sosnovka Arkhangel'skaya Oblast' Rus. Fed. 42 J3
Sosnovka Kaliningradskaya Oblast' Rus. Fed. 45 L9
Sosnovka Murmanskaya Oblast' Rus. Fed. 42 I2
Sosnovka Tambovskaya Oblast' Rus. Fed. 43 I5
Sosnovo Rus. Fed. 45 Q6
Sosnovo-Ozerskoye Rus. Fed. 73 K2
Sosnovyy Rus. Fed. 44 R4
Sosnovyy Bor Rus. Fed. 45 P7
Sosnowiec Poland 47 Q5
Sosnowitz Poland *see* Sosnowiec
Sos'va Khanty-Mansiyskiy Avtonomnyy Okrug Rus. Fed. 41 S3
Sos'va Sverdlovskaya Oblast' Rus. Fed. 41 S4
Sotang China 76 B2
Sotara, Volcán *vol.* Col. 142 C3
Sotkamo Fin. 44 P4
Sotteville-lès-Rouen France 52 B5
Souanké Congo 98 B3
Soubré Côte d'Ivoire 96 C4
Souderton U.S.A. 135 H3
Soufflenheim France 53 H6
Soufli Greece 59 L4
Soufrière St Lucia 137 L6
Soufrière *vol.* St Vincent 137 L6
Sougueur Alg. 57 G6
Souillac France 56 E4
Souilly France 52 F5
Souk Ahras Alg. 58 B6
Souk el Arbaâ du Rharb Morocco 54 C5
Soûl S. Korea *see* Seoul
Soulac-sur-Mer France 56 D4
Soulom France 56 D5
Sounding Creek *r.* Canada 121 I4
Souni Cyprus 85 A2
Soûr Lebanon *see* Tyre
Soure Brazil 143 I4
Sour el Ghozlane Alg. 57 H5
Souris Canada 121 K5
Souris *r.* Canada 121 K5
Souriya *country* Asia *see* Syria
Sousa Brazil 143 K5
Sousa Lara Angola *see* Bocoio
Sousse Tunisia 58 D7
Soustons France 56 D5

South Australia *state* Australia 106 D5
South Australian Basin *sea feature* Indian Ocean 149 P8
Southaven U.S.A. 131 F5
South Baldy *mt.* U.S.A. 127 G6
South Bank U.K. 48 F4
South Bass Island U.S.A. 134 D3
South Bend IN U.S.A. 134 B3
South Bend WA U.S.A. 126 C3
South Bluff *pt* Bahamas 133 F8
South Boston U.S.A. 135 F5
South Brook Canada 123 K4
South Cape *pt* U.S.A. *see* Ka Lae
South Carolina *state* U.S.A. 133 D5
South Charleston OH U.S.A. 134 D4
South Charleston WV U.S.A. 134 E4
South China Sea N. Pacific Ocean 68 F4
South Coast Town Australia *see* Gold Coast
South Dakota *state* U.S.A. 130 C2
South Downs *hills* U.K. 49 G8
South-East *admin. dist.* Botswana 101 G3
Southeast Cape U.S.A. 118 B3
Southeast Indian Ridge *sea feature* Indian Ocean 149 N8
South East Isles Australia 109 C8
Southeast Pacific Basin *sea feature* S. Pacific Ocean 151 M10
South East Point Australia 112 C7
Southend Canada 121 K3
Southend U.K. 50 D5
Southend-on-Sea U.K. 49 H7
Southern *admin. dist.* Botswana 100 G3
Southern Alps *mts* N.Z. 113 C6
Southern Cross Australia 109 B7
Southern Indian Lake Canada 121 L3
Southern Lau Group *is* Fiji 107 I3
Southern National Park Sudan 97 F4
Southern Ocean 152 C2
Southern Pines U.S.A. 133 E5
Southern Rhodesia *country* Africa *see* Zimbabwe
Southern Uplands *hills* U.K. 50 E5
South Esk *r.* U.K. 50 F4
South Esk Tableland *reg.* Australia 108 D4
Southey Canada 121 J5
Southfield U.S.A. 134 D2
South Fiji Basin *sea feature* S. Pacific Ocean 150 H7
South Fork U.S.A. 128 B1
South Geomagnetic Pole Antarctica 152 F1
▶South Georgia *i.* S. Atlantic Ocean 144 I8
▶South Georgia and the South Sandwich Islands *terr.* S. Atlantic Ocean 144 I8
 United Kingdom Overseas Territory.
South Harris *pen.* U.K. 50 B3
South Haven U.S.A. 134 B2
South Henik Lake Canada 121 L2
South Hill U.S.A. 135 F5
South Honshu Ridge *sea feature* N. Pacific Ocean 150 F3
South Indian Lake Canada 121 L3
South Island India 84 B4
▶South Island N.Z. 113 D7
 2nd largest island in Oceania.
South Junction Canada 121 M5
▶South Korea *country* Asia 75 B5
 Asia 6, 62–63
South Lake Tahoe U.S.A. 128 C2
South Luangwa National Park Zambia 99 D5
South Magnetic Pole Antarctica 152 G2
South Mills U.S.A. 135 G5
Southminster U.K. 49 H7
South Mountains *hills* U.S.A. 135 G4
South New Berlin U.S.A. 135 H2
South Orkney Islands S. Atlantic Ocean 148 F2
South Paris U.S.A. 135 J1
South Platte *r.* U.S.A. 130 C3
South Point Bahamas 133 F8
South Pole Antarctica 152 C1
Southport *Qld* Australia 112 F1
Southport *Tas.* Australia 111 [inset]
Southport U.K. 48 D5
Southport U.S.A. 135 G2
South Portland U.S.A. 135 J2
South Ronaldsay *i.* U.K. 50 G2
South Royalton U.S.A. 135 I2
South Salt Lake U.S.A. 129 H1
South Sand Bluff *pt* S. Africa 101 J6
South Sandwich Islands S. Atlantic Ocean 148 G9
South Sandwich Trench *sea feature* S. Atlantic Ocean 148 G9
South San Francisco U.S.A. 128 B3
South Saskatchewan *r.* Canada 121 J4
South Seal *r.* Canada 121 L3
South Shetland Islands Antarctica 152 A2
South Shetland Trough *sea feature* S. Atlantic Ocean 152 A2
South Shields U.K. 48 F3
South Sinai *governorate* Egypt *see* Janūb Sīnā'
South Solomon Trench *sea feature* S. Pacific Ocean 150 G6
South Taranaki Bight *b.* N.Z. 113 E4
South Tasman Rise *sea feature* Southern Ocean 150 E9
South Tent *mt.* U.S.A. 129 H2
South Twin Island Canada 122 F3
South Tyne *r.* U.K. 48 E4
South Uist *i.* U.K. 50 B3
South Wellesley Islands Australia 110 B3
South West Cape N.Z. 113 A8
South West Entrance *sea chan.* P.N.G. 110 E1
Southwest Indian Ridge *sea feature* Indian Ocean 149 K8
Southwest National Park Australia 111 [inset]
Southwest Pacific Basin *sea feature* S. Pacific Ocean 150 I8
Southwest Peru Ridge *sea feature* S. Pacific Ocean *see* Nazca Ridge

South West Rocks Australia 112 F3
South Whitley U.S.A. 134 C3
South Wichita *r.* U.S.A. 131 D5
South Windham U.S.A. 135 J2
Southwold U.K. 49 I6
Southwood National Park Australia 112 E1
Soutpansberg *mts* S. Africa 101 I2
Soverato Italy 58 G5
Sovetsk Kaliningradskaya Oblast' Rus. Fed. 45 L9
Sovetsk Kirovskaya Oblast' Rus. Fed. 42 K4
Sovetskaya Gavan' Rus. Fed. 74 F2
Sovetskiy Khanty-Mansiyskiy Avtonomnyy Okrug Rus. Fed. 41 S3
Sovetskiy Leningradskaya Oblast' Rus. Fed. 45 P6
Sovetskiy Respublika Mariy El Rus. Fed. 42 K4
Sovetskoye Chechenskaya Respublika Rus. Fed. *see* Shatoy
Sovetskoye Stavropol'skiy Kray Rus. Fed. *see* Zelenokumsk
Sovyets'kyy Ukr. 90 D1
Sowa China 76 C2
Soweto S. Africa 101 H4
So'x Tajik. 89 H2
Sōya-kaikyō *strait* Japan/Rus. Fed. *see* La Pérouse Strait
Sōya-misaki *c.* Japan 74 F3
Soyana *r.* Rus. Fed. 42 I2
Soyma *r.* Rus. Fed. 42 K2
Soyopa Mex. 127 F7
Sozh *r.* Europe 43 F6
Sozopol Bulg. 59 L3
Spa Belgium 52 F4
▶Spain *country* Europe 57 E3
 4th largest country in Europe.
 Europe 5, 38–39
Spalato Croatia *see* Split
Spalatum Croatia *see* Split
Spalding U.K. 49 G6
Spanish Canada 122 E5
Spanish Fork U.S.A. 129 H1
Spanish Guinea *country* Africa *see* Equatorial Guinea
Spanish Netherlands *country* Europe *see* Belgium
Spanish Sahara *terr.* Africa *see* Western Sahara
Spanish Town Jamaica 137 I5
Sparks U.S.A. 128 D2
Sparta Greece *see* Sparti
Sparta GA U.S.A. 133 D5
Sparta KY U.S.A. 134 C4
Sparta MI U.S.A. 134 C2
Sparta NC U.S.A. 134 E5
Sparta TN U.S.A. 132 C5
Spartanburg U.S.A. 133 D5
Sparti Greece 59 J6
Spartivento, Capo *c.* Italy 58 G6
Spas-Demensk Rus. Fed. 43 G5
Spas-Klepiki Rus. Fed. 43 I5
Spassk-Dal'niy Rus. Fed. 74 D3
Spassk-Ryazanskiy Rus. Fed. 43 I5
Spata (Eleftherios Venizelos) *airport* Greece 59 J6
Spatha, Akrotirio *pt* Greece 59 J7
Spearman U.S.A. 131 C4
Speedway U.S.A. 134 B4
Spence Bay Canada *see* Taloyoak
Spencer IA U.S.A. 130 E3
Spencer ID U.S.A. 126 E3
Spencer IN U.S.A. 134 B4
Spencer NE U.S.A. 130 D3
Spencer WV U.S.A. 134 E4
Spencer, Cape U.S.A. 120 B3
Spencer Bay Namibia 100 B3
Spencer Gulf *est.* Australia 111 B7
Spencer Range *hills* Australia 108 C3
Spennymoor U.K. 48 F4
Sperrin Mountains *hills* U.K. 51 E3
Sperryville U.S.A. 135 F4
Spessart *reg.* Germany 53 J5
Spétsai *i.* Greece *see* Spetses
Spetses *i.* Greece 59 J6
Spey *r.* U.K. 50 F3
Speyer Germany 53 I5
Spezand Pak. 89 H4
Spice Islands Indon. *see* Moluccas
Spijk Neth. 52 G1
Spijkenisse Neth. 52 E3
Spilimbergo Italy 58 E1
Spilsby U.K. 48 H5
Spīn Būldak Afgh. 89 G4
Spintangi Pak. 89 H4
Spirit Lake U.S.A. 130 E3
Spirit River Canada 120 G4
Spirovo Rus. Fed. 42 G4
Spišská Nová Ves Slovakia 43 D6
Spiti *r.* India 82 D3
▶Spitsbergen *i.* Svalbard 64 C2
 5th largest island in Europe.
Spittal an der Drau Austria 47 N7
Spitzbergen *i.* Svalbard *see* Spitsbergen
Split Croatia 58 G3
Split Lake Canada 121 L3
Split Lake *l.* Canada 121 L3
Spokane U.S.A. 126 D3
Spoletium Italy *see* Spoleto
Spoleto Italy 58 E3
Spóng Cambodia 71 D4
Spoon *r.* U.S.A. 130 F3
Spooner U.S.A. 130 F2
Spornitz Germany 53 L1
Spotsylvania U.S.A. 135 G4
Spotted Horse U.S.A. 126 G3
Spranger, Mount Canada 120 F4
Spratly Islands S. China Sea 68 E4
Spray U.S.A. 126 D3
Spree *r.* Germany 47 N4
Sprimont Belgium 52 F4
Springbok S. Africa 100 C5
Springdale Canada 123 L4
Springdale U.S.A. 131 E4
Springe Germany 53 J2

Springer U.S.A. **127** G5
Springerville U.S.A. **129** I4
Springfield CO U.S.A. **130** C4

▶Springfield IL U.S.A. **130** F4
State capital of Illinois.

Springfield KY U.S.A. **134** C5
Springfield MA U.S.A. **135** I2
Springfield MO U.S.A. **131** E4
Springfield OH U.S.A. **134** D4
Springfield OR U.S.A. **126** C3
Springfield TN U.S.A. **134** B5
Springfield VT U.S.A. **135** I2
Springfield WV U.S.A. **135** F4
Springfontein S. Africa **101** G6
Spring Glen U.S.A. **129** H2
Spring Grove U.S.A. **134** A2
Springhill Canada **123** I5
Spring Hill U.S.A. **133** D6
Springhouse Canada **120** F5
Spring Mountains U.S.A. **129** F3
Springs Junction N.Z. **113** D6
Springsure Australia **110** E5
Spring Valley MN U.S.A. **130** E3
Spring Valley NY U.S.A. **135** H3
Springview **130** D3
Springville CA U.S.A. **128** D3
Springville NY U.S.A. **135** F2
Springville PA U.S.A. **135** H3
Springville UT U.S.A. **129** H1
Sprowston U.K. **49** I6
Spruce Grove Canada **120** H4
Spruce Mountain CO U.S.A. **129** I2
Spruce Mountain NV U.S.A. **129** F1
Spurn Head hd U.K. **48** H5
Spuzzum Canada **120** F5
Squam Lake U.S.A. **135** J2
Square Lake U.S.A. **123** H5
Squillace, Golfo di g. Italy **58** G5
Squires, Mount hill Australia **109** D6
Srbija see Serbia
Srbinje Bos.-Herz. see Foča
Srê Âmbêl Cambodia **71** C5
Srebrenica **59** H2
Sredets Burgas Bulg. **59** L3
Sredets Sofiya-Grad Bulg. see Sofia
Sredinnyy Khrebet mts Rus. Fed. **65** Q4
Sredna Gora mts Bulg. **59** J3
Srednekolymsk Rus. Fed. **65** Q3
Sredne-Russkaya Vozvyshennost' hills
 Rus. Fed. see Central Russian Upland
Sredne-Sibirskoye Ploskogor'ye plat.
 Rus. Fed. see Central Siberian Plateau
Sredneye Kuyto, Ozero l. Rus. Fed. **44** Q4
Sredniy Ural mts Rus. Fed. **41** R4
Srednogorie Bulg. **59** K3
Srednyaya Akhtuba Rus. Fed. **43** J6
Sreepur Bangl. see Sripur
Sre Khtum Cambodia **71** D4
Srê Noy Cambodia **71** D4
Sretensk Rus. Fed. **73** L2
Sri Aman Sarawak Malaysia **68** E6
Sriharikota Island India **84** D3

▶Sri Jayewardenepura Kotte Sri Lanka
84 C5
Capital of Sri Lanka.

Srikakulam India **84** E2
Sri Kalahasti India **84** C3
▶Sri Lanka country Asia **84** D5
Asia 6, 62–63
Srinagar India **82** C2
Sri Pada mt. Sri Lanka see Adam's Peak
Sripur Bangl. **83** G4
Srirangam India **84** C4
Sri Thep tourist site Thai. **70** C3
Srivardhan India **84** B2
Staaten r. Australia **110** C3
Staaten River National Park Australia
 110 C3
Stabroek Guyana see Georgetown
Stade Germany **53** J1
Staden Belgium **52** D4
Stadskanaal Neth. **52** G2
Stadtallendorf Germany **53** J4
Stadthagen Germany **53** J2
Stadtilm Germany **53** L4
Stadtlohn Germany **52** G3
Stadtoldendorf Germany **53** J3
Stadtroda Germany **53** L4
Staffa i. U.K. **50** C4
Staffelberg hill Germany **53** L4
Staffelstein Germany **53** K4
Stafford U.K. **49** E6
Stafford U.S.A. **135** G4
Stafford Creek Bahamas **133** E7
Stafford Springs U.S.A. **135** I3
Stagg Lake Canada **120** H2
Staicele Latvia **45** N8
Staines U.K. **49** G7
Stakhanov Ukr. **43** H6
Stakhanovo Rus. Fed. see Zhukovskiy
Stalbridge U.K. **49** E8
Stalham U.K. **49** I6
Stalin Bulg. see Varna
Stalinabad Tajik. see Dushanbe
Stalingrad Rus. Fed. see Volgograd
Staliniri Georgia see Ts'khinvali
Stalino Ukr. see Donets'k
Stalinogorsk Rus. Fed. see Novomoskovsk
Stalinogród Poland see Katowice
Stalinsk Rus. Fed. see Novokuznetsk
Stalowa Wola Poland **43** D6
Stamboliyski Bulg. **59** K3
Stamford Australia **110** C4
Stamford U.K. **49** G6
Stamford CT U.S.A. **135** I3
Stamford NY U.S.A. **135** H2
Stampalia i. Greece see Astypalaia
Stampriet Namibia **100** D3
Stamsund Norway **44** H2
Stanardsville U.S.A. **135** F4
Stanberry U.S.A. **130** E3
Stancomb-Wills Glacier Antarctica **152** B1
Standard Canada **120** H5
Standdaarbuiten Neth. **52** E3
Standerton S. Africa **101** I4
Standish U.S.A. **134** D2
Stanford U.S.A. **129** H5

Stanford KY U.S.A. **134** C5
Stanford MT U.S.A. **126** F3
Stanger S. Africa **101** J5
Stanislaus r. U.S.A. **128** C3
Stanislav Ukr. see Ivano-Frankivs'k
Stanke Dimitrov Bulg. see Dupnitsa
Staňkov Czech Rep. **53** N5
Stanley Australia **111** [inset]
Stanley H.K. China **77** [inset]

▶Stanley Falkland Is **144** E8
Capital of the Falkland Islands.

Stanley U.K. **48** F4
Stanley ID U.S.A. **126** E3
Stanley KY U.S.A. **134** B5
Stanley ND U.S.A. **130** C1
Stanley VA U.S.A. **135** F4
Stanley, Mount hill N.T. Australia **108** E5
Stanley, Mount hill Tas.
 Australia **111** [inset]
Stanley, Mount Dem. Rep. Congo/Uganda
 see Margherita Peak
Stanleyville Dem. Rep. Congo see
 Kisangani
Stann Creek Belize see Dangriga
Stannington U.K. **48** F3
Stanovoye Rus. Fed. **43** H5
Stanovoye Nagor'ye mts
 Rus. Fed. **73** L1
Stanovoy Khrebet mts Rus. Fed. **65** N4
Stansmore Range hills Australia **108** E5
Stanthorpe Australia **112** E2
Stanton U.K. **49** H6
Stanton KY U.S.A. **134** D5
Stanton MI U.S.A. **134** C2
Stanton ND U.S.A. **130** C2
Stanton TX U.S.A. **131** C5
Stapleton U.S.A. **130** C3
Starachowice Poland **47** R5
Stara Planina mts Bulg./Serb. and Mont.
 see Balkan Mountains
Staraya Russa Rus. Fed. **42** F4
Stara Zagora Bulg. **59** K3
Starbuck Island Kiribati **151** J6
Star City U.S.A. **134** B3
Starcke National Park Australia **110** D2
Stargard in Pommern Poland see
 Stargard Szczeciński
Stargard Szczeciński Poland **47** O4
Staritsa Rus. Fed. **42** G4
Starke U.S.A. **133** D6
Starkville U.S.A. **131** F5
Star Lake U.S.A. **135** H1
Starnberger See l. Germany **47** M7
Starobel'sk Ukr. see Starobil's'k
Starobil's'k Ukr. **43** H6
Starogard Gdański Poland **47** Q4
Starokonstantinov Ukr. see
 Starokostyantyniv
Starokostyantyniv Ukr. **43** E6
Starominskaya Rus. Fed. **43** H7
Staroshcherbinovskaya Rus. Fed. **43** H7
Star Peak U.S.A. **128** D1
Start Point U.K. **49** D8
Starve Island Kiribati see Starbuck Island
Staryya Darohi Belarus **43** F5
Staryye Dorogi Belarus see Staryya Darohi
Staryy Kayak Rus. Fed. **65** L2
Staryy Oskol Rus. Fed. **43** H6
Stittsville Canada **135** H1
Stjørdalshalsen Norway **44** G5
Stockbridge U.S.A. **134** C2
Stockerau Austria **47** P6
Stockheim Germany **53** L4

▶Stockholm Sweden **45** K7
Capital of Sweden.

Stockinbingal Australia **112** C5
Stockport U.K. **48** E5
Stockton CA U.S.A. **128** C3
Stockton KS U.S.A. **130** D4
Stockton MO U.S.A. **130** E4
Stockton UT U.S.A. **129** G1
Stockton Lake U.S.A. **130** E4
Stockton-on-Tees U.K. **48** F4
Stockville U.S.A. **130** C3
Stod Czech Rep. **53** N5
Stoer, Point of U.K. **50** D2
Stoke-on-Trent U.K. **49** E5
Stokesley U.K. **48** F4
Stokes Point Australia **111** [inset]
Stokes Range hills Australia **108** E4
Stokkseyri Iceland **44** [inset]
Stokkvågen Norway **44** H3
Stokmarknes Norway **44** I2
Stolac Bos.-Herz. **58** G3
Stolberg (Rheinland) Germany **52** G4
Stolbovoy Rus. Fed. **153** G2
Stolbtsy Belarus see Stowbtsy
Stolin Belarus **45** O11
Stollberg Germany **53** M4
Stolp Poland see Słupsk
Stolzenau Germany **53** J2
Stone U.K. **49** E6
Stoneboro U.S.A. **134** E3
Stonecliffe Canada **122** F5
Stonecutters' Island pen. H.K. China
 77 [inset]
Stonehaven U.K. **50** G4
Stonehenge Australia **110** C5
Stonehenge tourist site U.K. **49** F7
Stoner U.S.A. **129** I3
Stonewall Canada **121** L5
Stonewall Jackson Lake U.S.A. **134** E4
Stony Creek U.S.A. **135** G5
Stony Lake Canada **121** L3
Stony Point U.S.A. **135** G2
Stony Rapids Canada **121** J3
Stony River U.S.A. **118** C3
Stooping r. Canada **122** E3
Stora Lulevatten l. Sweden **44** K3
Stora Sjöfallets nationalpark nat. park
 Sweden **44** J3
Storavan l. Sweden **44** K4
Store Bælt sea chan. Denmark see
 Great Belt
Støren Norway **44** G5
Storfjordbotn Norway **44** O1
Storforshei Norway **44** I3
Storjord Norway **44** I3

Stendal Germany **53** L2
Stenhousemuir U.K. **50** F4
Stenungsund Sweden **45** G7
Steòrnabhagh U.K. see Stornoway
Stepanakert Azer. see Xankändi
Stephens, Cape N.Z. **113** D5
Stephens City U.S.A. **135** F4
Stephens Lake Canada **121** M3
Stephenville Canada **123** D5
Stephenville U.S.A. **131** D5
Stepnoy Rus. Fed. see Elista
Stepnoye Rus. Fed. **43** J6
Sterkfontein Dam resr S. Africa **101** I5
Sterkstroom S. Africa **101** H6
Sterlet Lake Canada **121** I1
Sterlibashevo Rus. Fed. **41** R5
Sterling S. Africa **100** E6
Sterling CO U.S.A. **130** C3
Sterling IL U.S.A. **130** F3
Sterling MI U.S.A. **134** C1
Sterling UT U.S.A. **129** H2
Sterling City U.S.A. **131** C6
Sterling Heights U.S.A. **134** D2
Sterlitamak Rus. Fed. **64** G4
Stettin Poland see Szczecin
Stettler Canada **121** H4
Steubenville KY U.S.A. **134** C5
Steubenville OH U.S.A. **134** E3
Stevenage U.K. **49** G7
Stevenson U.S.A. **126** C3
Stevenson Lake Canada **121** L4
Stevens Point U.S.A. **130** F2
Stevens Village U.S.A. **118** D3
Stevensville MI U.S.A. **134** B2
Stevensville PA U.S.A. **135** G3
Stewart Canada **120** D4
Stewart r. Canada **120** B2
Stewart, Isla i. Chile **144** B8
Stewart Crossing Canada **120** B2
Stewart Islands Solomon Is **107** G2
Stewart Lake Canada **119** J3
Stewarton U.K. **50** E5
Stewarts Point U.S.A. **128** B2
Stewiacke Canada **123** J5
Steynsburg S. Africa **101** G6
Steyr Austria **47** O6
Steytlerville S. Africa **100** G7
Stiens Neth. **52** F1
Stif Alg. see Sétif
Stigler U.S.A. **131** E5
Stikine r. Canada **120** C3
Stikine Plateau Canada **120** D3
Stikine Strait U.S.A. **120** C3
Stilbaai S. Africa **100** E8
Stiles U.S.A. **134** A1
Stillwater MN U.S.A. **130** E2
Stillwater OK U.S.A. **131** D4
Stillwater Range mts U.S.A. **128** D2
Stillwell U.S.A. **134** B3
Stilton U.K. **49** G6
Stilwell U.S.A. **131** E5
Stinnett U.S.A. **131** C5
Štip Macedonia **59** J4
Stirling Australia **108** F5
Stirling Canada **135** G1
Stirling U.K. **50** F4
Stirling Creek r. Australia **108** E4
Stirling Range National Park Australia
 109 B8
Stiti Alg. see Sétif
Stir Alg. see Sétif

Storkerson Peninsula Canada **119** H2
Storm Bay Australia **111** [inset]
Stormberg S. Africa **101** H6
Storm Lake U.S.A. **130** E3
Stornosa mt. Norway **44** E6
Stornoway U.K. **50** C2
Storozhevsk Rus. Fed. **42** L3
Storozhynets' Ukr. **43** E6
Storrs U.S.A. **135** I3
Storseleby Sweden **44** J4
Storsjön l. Sweden **44** I5
Storskrymten mt. Norway **44** F5
Storslett Norway **44** L2
Stortemelk sea chan. Neth. **52** F1
Storuman Sweden **44** J4
Storuman l. Sweden **44** J4
Storvik Sweden **45** J6
Storvorde Denmark **45** G8
Storvreta Sweden **45** J7
Story U.S.A. **126** G3
Stotfold U.K. **49** G6
Stoughton Canada **121** K5
Stour r. England U.K. **49** F6
Stour r. England U.K. **49** F8
Stour r. England U.K. **49** I7
Stour r. England U.K. **49** I7
Stourbridge U.K. **49** E6
Stourport-on-Severn U.K. **49** E6
Stout Lake Canada **121** M4
Stowbtsy Belarus **45** O10
Stowe U.S.A. **135** I1
Stowmarket U.K. **49** H6
Stoyba Rus. Fed. **74** C1
Strabane U.K. **51** E3
Stradbally Ireland **51** E4
Stradbroke U.K. **49** I6
Stradella Italy **58** C2
Strakonice Czech Rep. **47** N6
Stralsund Germany **47** N3
Strand S. Africa **100** D8
Stranda Norway **44** E5
Strangford U.K. **51** G3
Strangford Lough inlet U.K. **51** G3
Strangways r. Australia **108** F3
Stranraer U.K. **50** D6
Strasbourg France **56** H2
Strasburg Germany **53** N1
Strasburg U.S.A. **135** F4
Strassburg France see Strasbourg
Stratford Australia **112** C6
Stratford Canada **134** E2
Stratford CA U.S.A. **128** D3
Stratford TX U.S.A. **131** C4
Stratford-upon-Avon U.K. **49** F6
Strathaven U.K. **50** E5
Strathmore Canada **120** H5
Strathmore r. U.K. **50** E2
Strathnaver Canada **120** F4
Strathroy Canada **134** E2
Strathspey valley U.K. **50** F3
Strathy U.K. **50** F2
Stratton U.K. **49** C8
Stratton U.S.A. **135** J1
Stratton Mountain U.S.A. **135** I2
Straubing Germany **53** M6
Straumen pt Iceland **44** [inset]
Strawberry U.S.A. **129** H4
Strawberry Mountain U.S.A. **126** D3
Strawberry Reservoir U.S.A. **129** H1
Streaky Bay Australia **109** F8
Streaky Bay b. Australia **109** F8
Streator U.S.A. **130** F3
Street U.K. **49** E7
Streetsboro U.S.A. **134** E3
Strehaia Romania **59** J2
Strehla Germany **53** N3
Streich Mound hill Australia **109** C7
Strelka Rus. Fed. **65** Q3
Strel'na r. Rus. Fed. **42** H2
Strenči Latvia **45** N8
Streymoy i. Faroe Is **44** [inset]
Stříbro Czech Rep. **53** M5
Strichen U.K. **50** G3
Strimonas r. Greece see Strymonas
Stroeder Arg. **144** D6
Strokestown Ireland **51** D4
Stroma i. U.K. **50** F2
Stromberg U.K. **50** F2
Stromboli, Isola i. Italy **58** F5
Stromness Orkney Canada **124** I8
Stromness U.K. **50** F2
Strömstad Sweden **45** G7
Strömsund Sweden **44** I5
Strongsville U.S.A. **134** E3
Stronsay i. U.K. **50** G1
Stroud Australia **112** E4
Stroud U.K. **49** E7
Stroud Road Australia **112** E4
Stroudsburg U.S.A. **135** H3
Struer Denmark **45** F8
Struga Macedonia **59** I4
Strugi-Krasnyye Rus. Fed. **45** P7
Struis Bay S. Africa **100** E8
Strullendorf Germany **53** K5
Struma r. Bulg. **59** J4
 also known as Strymonas (Greece)
Strumble Head hd U.K. **49** B6
Strumica Macedonia **59** J4
Struthers U.S.A. **134** E3
Stryama r. Bulg. **59** K3
Strydenburg S. Africa **100** F5
Strymonas r. Greece **59** J4
 also known as Struma (Bulgaria)
Stryn Norway **44** E6
Stryy Ukr. **43** D6
Strzelecki, Mount hill Australia **108** F5
Strzelecki Regional Reserve nature res.
 Australia **111** B6
Stuart FL U.S.A. **133** D7
Stuart NE U.S.A. **130** D3
Stuart VA U.S.A. **134** E5
Stuart Lake Canada **120** E4
Stuart Range hills Australia **111** A6
Stuarts Draft U.S.A. **134** F4
Stuart Town Australia **112** D4
Stuchka Latvia see Aizkraukle
Stučka Latvia see Aizkraukle
Studholme Junction N.Z. **113** C7
Studsviken Sweden **44** K5
Stukely, Lac l. Canada **135** I1
Stung Treng Cambodia see
 Stœng Trêng
Stupart r. Canada **121** M4

Stupino Rus. Fed. **43** H5
Sturge Island Antarctica **152** H2
Sturgeon r. Ont. Canada **122** F5
Sturgeon r. Sask. Canada **121** J4
Sturgeon Bay b. Canada **121** L4
Sturgeon Bay U.S.A. **134** B1
Sturgeon Bay Canal lake channel U.S.A.
 134 B1
Sturgeon Falls Canada **122** F5
Sturgeon Lake Ont. Canada **121** N5
Sturgeon Lake Ont. Canada **135** F1
Sturgis MI U.S.A. **134** C3
Sturgis SD U.S.A. **130** C2
Sturt, Mount hill Australia **111** C6
Sturt Creek watercourse Australia **108** D4
Sturt National Park Australia **111** C6
Sturt Stony Desert Australia **111** C6
Stutterheim S. Africa **101** H7
Stuttgart Germany **53** J6
Stuttgart U.S.A. **131** F5
Stykkishólmur Iceland **44** [inset]
Styr r. Belarus/Ukr. **43** E5
Styria reg. Austria see Steiermark
Suaçuí Grande r. Brazil **145** C2
Suai East Timor **108** D2
Suakin Sudan **86** E6
Suao Taiwan **77** I3
Suaqui Grande Mex. **127** F7
Suau P.N.G. **110** E1
Subačius Lith. **45** N9
Subankhata India **83** G4
Subarnapur India see Sonapur
Subāshi Iran **88** C3
Subay reg. Saudi Arabia **88** B5
Subayḩah Saudi Arabia **85** D4
Subei China **80** H4
Subi Besar i. Indon. **71** E7
Subi Kecil i. Indon. **71** E7
Sublette U.S.A. **131** C4
Subotica Serb. and Mont. **59** H1
Success, Lake U.S.A. **128** D3
Succiso, Alpi di mts Italy **58** D2
Suceava Romania **43** E7
Suchan Rus. Fed. see Partizansk
Suck r. Ireland **51** D4
Suckling, Mount P.N.G. **110** E1
Suckow Germany **53** L1

▶Sucre Bol. **142** E7
Legislative capital of Bolivia.

Suczawa Romania see Suceava
Sud, Grand Récif du reef New Caledonia
 107 G4
Suda Rus. Fed. **42** H4
Sudak Ukr. **90** D1

▶Sudan country Africa **97** F3
Largest country in Africa.
Africa 7, 94–95

Suday Rus. Fed. **42** I4
Sudayr reg. Saudi Arabia **88** B5
Sudbury Canada **122** E5
Sudbury U.K. **49** H6
Sudd swamp Sudan **86** C8
Sude r. Germany **53** K1
Sudest Island P.N.G. see Tagula Island
Sudetenland mts Czech Rep./Poland see
 Sudety
Sudety mts Czech Rep./Poland **47** O5
Sudislavl' Rus. Fed. **42** I4
Sudlersville U.S.A. **135** H4
Süd-Nord-Kanal canal Germany **52** H2
Sudogda Rus. Fed. **42** I5
Sudr Egypt **85** A5
Suðuroy i. Faroe Is **44** [inset]
Sue watercourse Sudan **97** F4
Sueca Spain **57** F4
Suez Egypt **85** A5
Suez, Gulf of Egypt **85** A5
Suez Bay Egypt **85** A5
Suez Canal Egypt **85** A4
Suffolk U.S.A. **135** G5
Sugarbush Hill hill U.S.A. **130** F2
Sugarloaf Mountain U.S.A. **135** J1
Sugarloaf Point Australia **112** F4
Sugun China **80** E4
Sühäj Egypt see Sawhāj
Şuḩār Oman **88** E5
Suhaymī, Wādī as watercourse Egypt **85** A4
Sühbaatar Mongolia **72** J2
Suheli Par i. India **84** B4
Suhl Germany **53** K4
Suhlendorf Germany **53** K2
Suhul reg. Saudi Arabia **88** B6
Suḩūl al Kidan plain Saudi Arabia **88** D6
Şuhut Turkey **59** N5
Sui Pak. **89** H4
Sui, Laem pt Thai. **71** B5
Suibin China **74** C3
Suid-Afrika country Africa see
 Republic of South Africa
Suide China **73** K5
Suidzhikurmsy Turkm. see Madaw
Suifenhe China **74** C3
Suihua China **74** B3
Suileng China **74** B3
Suining Hunan China **77** F3
Suining Jiangsu China **77** H1
Suining Sichuan China **76** E2
Suippes France **52** E5
Suir r. Ireland **51** E5
Suisse country Europe see Switzerland
Sui Vehar Pak. **89** H4
Suixi China **77** H1
Suixian Henan China **77** G1
Suixian Hubei China see Suizhou
Suiyang Guizhou China **76** E3
Suiyang Heilong. China **77** G1
Suiza country Europe see Switzerland
Suizhong China **73** M4
Suizhou China **77** G2
Sujangarh India **82** C4
Sujawal Pak. **89** H5
Suk atoll Micronesia see Pulusuk
Sukabumi Indon. **68** D8
Sukagawa Japan **75** F5
Sukarnapura Indon. see Jayapura
Sukarno, Puncak mt. Indon. see
 Jaya, Puncak
Sukchŏn N. Korea **75** B5
Sukhinichi Rus. Fed. **43** G5

Sukhona r. Rus. Fed. **42** J3
Sukhothai Thai. **70** B3
Sukhumi Georgia see Sokhumi
Sukhum-Kale Georgia see Sokhumi
Sukkertoppen Greenland see Maniitsoq
Sukkozero Rus. Fed. **42** G3
Sukkur Pak. **89** H5
Sukma India **84** D2
Sukpay Rus. Fed. **74** E3
Sukpay r. Rus. Fed. **74** E3
Sukri r. India **82** C4
Sukri r. India **82** C4
Suktel r. India **84** D1
Sukun i. Indon. **108** C2
Sula i. Norway **45** D6
Sula r. Rus. Fed. **42** K2
Sula, Kepulauan is Indon. **69** H7
Sulaiman Range mts Pak. **89** H4
Sulak Rus. Fed. **91** G2
Sülär Iran **88** C4
Sula Sgeir i. U.K. **50** C1
Sulawesi i. Indon. see Celebes
Sulaymān Beg Iraq **91** G4
Sulayyimah Saudi Arabia **88** B6
Sulci Sardinia Italy see Sant'Antioco
Sulcis Sardinia Italy see Sant'Antioco
Suledeh Iran **88** C2
Sule Skerry i. U.K. **50** E1
Sule Stack i. U.K. **50** E1
Sulingen Germany **53** I2
Sulitjelma Norway **44** J3
Sulkava Fin. **44** P6
Sullana Peru **142** B4
Sullivan IL U.S.A. **130** F4
Sullivan IN U.S.A. **134** B4
Sullivan Bay Canada **120** E5
Sullivan Island Myanmar see
 Lanbi Kyun
Sullivan Lake Canada **121** I5
Sulmo Italy see Sulmona
Sulmona Italy **58** E3
Sulphur LA U.S.A. **131** E6
Sulphur OK U.S.A. **131** D5
Sulphur r. U.S.A. **131** E5
Sulphur Springs U.S.A. **131** E5
Sultan Canada **122** E5
Sultan, Koh-i- mts Pak. **89** F4
Sultanabad India see Osmannagar
Sultanabad Iran see Arāk
Sultan Dağları mts Turkey **59** N5
Sultanıye Turkey see Karapınar
Sultanpur India **83** E4
Sulu Archipelago is Phil. **69** G5
Sulu Basin sea feature N. Pacific Ocean
 150 G5
Sülüklü Turkey **90** D3
Sülüktü Kyrg. **89** H2
Sulu Sea N. Pacific Ocean **68** F5
Suluvvaulik, Lac l. Canada **123** G2
Sulyukta Kyrg. see Sülüktü
Sulzbach-Rosenberg Germany **53** L5
Sulzberger Bay Antarctica **152** I1
Sumāil Oman **88** E6
Sumampa Arg. **144** D3
Sumapaz, Parque Nacional nat. park Col.
 142 D3
Sümär Iran **88** B3
Sumatera i. Indon. see Sumatra

▶Sumatra i. Indon. **71** B7
2nd largest island in Asia.

Šumava nat. park Czech Rep. **47** N6
Sumba i. Indon. **108** B2
Sumba, Selat sea chan. Indon. **108** B2
Sumbar r. Turkm. **88** D2
Sumbawa i. Indon. **108** B2
Sumbawabesar Indon. **108** B2
Sumbawanga Tanz. **99** D4
Sumbe Angola **99** B5
Sumbu National Park Zambia **99** D4
Sumburgh U.K. **50** [inset]
Sumburgh Head hd U.K. **50** [inset]
Sumdo China **76** D2
Sumdum, Mount U.S.A. **120** C3
Sume'eh Sarā Iran **88** C2
Sumeih Sudan **86** C8
Sumenep Indon. **68** E8
Sumgait Azer. see Sumqayıt
Sumisu-jima i. Japan **73** Q6
Summel Iraq **91** F3
Summer Beaver Canada **122** C3
Summerford Canada **123** L4
Summer Island U.S.A. **132** C2
Summer Isles U.K. **50** D2
Summerland Canada **120** G5
Summersville U.S.A. **134** E4
Summit Lake Canada **120** F4
Summit Mountain U.S.A. **128** E2
Summit Peak U.S.A. **127** G5
Sumnal Aksai Chin **82** D2
Sumner N.Z. **113** D6
Sumner, Lake N.Z. **113** D6
Sumon-dake mt. Japan **75** F5
Šumperk Czech Rep. **47** P6
Sumpu Japan see Shizuoka
Sumqayıt Azer. **91** H2
Sumskiy Posad Rus. Fed. **42** G2
Sumter U.S.A. **133** D5
Sumur Jammu and Kashmir **82** D2
Sumy Ukr. **43** G6
Sumzom China **76** C2
Suna Rus. Fed. **42** K4
Sunaj India **82** D4
Sunamganj Bangl. **83** G4
Sunart, Loch inlet U.K. **50** D4
Şunaynah Oman **88** D6
Sunburst U.S.A. **126** F2
Sunbury Australia **112** B6
Sunbury OH U.S.A. **134** D3
Sunbury PA U.S.A. **135** G3
Sunch'ŏn S. Korea **75** B6
Sun City S. Africa **101** H3
Sun City AZ U.S.A. **129** G5
Sun City CA U.S.A. **128** E5
Sunda, Selat strait Indon. **68** C8
Sunda Kalapa Indon. see Jakarta
Sundance U.S.A. **126** G3
Sundarbans coastal area Bangl./India
 83 G5

Sundarbans National Park
Bangl./India 83 G5
Sundargarh India 83 F5
Sunda Shelf sea feature
Indian Ocean 149 P5
Sunda Strait Indon. see Sunda, Selat
Sunda Trench sea feature Indian Ocean see
Java Trench
Sunderland U.K. 48 F4
Sundern (Sauerland) Germany 53 I3
Sündiken Dağları mts Turkey 59 N5
Sundown National Park
Australia 112 E2
Sundre Canada 120 H5
Sundridge Canada 122 F5
Sundsvall Sweden 44 J5
Sundukli, Peski des. Turkm. see
Sandykly Gumy
Sundumbili S. Africa 101 J5
Sungaipenuh Indon. 68 C7
Sungai Petani Malaysia 71 C6
Sungari r. China see Songhua Jiang
Sungei Seletar Reservoir Sing. 71 [inset]
Sungkiang China see Songjiang
Sung Kong i. H.K. China 77 [inset]
Sungqu China see Songpan
Sungsang Indon. 68 C7
Sungurlu Turkey 90 D2
Sun Kosi r. Nepal 83 F4
Sunman U.S.A. 134 C4
Sunndal Norway 45 E6
Sunndalsøra Norway 44 F5
Sunne Sweden 45 H7
Sunnyside U.S.A. 126 D3
Sunnyvale U.S.A. 128 B3
Sun Prairie U.S.A. 130 F3
Sunset House Canada 120 G4
Sunset Peak hill H.K. China 77 [inset]
Suntar Rus. Fed. 65 M3
Suntsar Pak. 89 F5
Sunwi-do i. N. Korea 75 B5
Sunwu China 74 B2
Sunyani Ghana 96 C4
Suolijärvet l. Fin. 44 P3
Suomi country Europe see Finland
Suomussalmi Fin. 44 P4
Suō-nada b. Japan 75 C6
Suonenjoki Fin. 44 O5
Suong r. Laos 70 C3
Suoyarvi Rus. Fed. 42 G3
Supa India 84 B3
Supaul India 83 F4
Superior AZ U.S.A. 129 H5
Superior MT U.S.A. 126 E3
Superior NE U.S.A. 130 D3
Superior WI U.S.A. 130 E2

▶Superior, Lake Canada/U.S.A. 125 J2
Largest lake in North America and 2nd in
the world.
World 12–13

Suphan Buri Thai. 71 C4
Süphan Dağı mt. Turkey 91 F3
Supiori i. Indon. 69 J7
Suponevo Rus. Fed. 43 G5
Support Force Glacier Antarctica 152 A1
Sūq ash Shuyūkh Iraq 91 G5
Suqian China 77 H1
Suquṭrā i. Yemen see Socotra
Şūr Oman 89 E6
Sur, Point U.S.A. 128 C3
Sur, Punta pt Arg. 144 E5
Sura r. Rus. Fed. 43 J4
Şuraabad Azer. 91 H2
Surabaya Indon. 68 E8
Sūrak Iran 88 E5
Surakarta Indon. 68 E8
Sūran Iran 89 F5
Şūrān Syria 85 C2
Surat Australia 112 D1
Surat India 82 C5
Suratgarh India 82 C3
Surat Thani Thai. 71 B5
Surazh Rus. Fed. 43 G5
Surbiton Australia 110 D4
Surdulica Serb. and Mont. 59 J3
Sûre r. Lux. 52 G5
Surendranagar India 82 B5
Surf U.S.A. 128 C4
Surgut Rus. Fed. 64 I3
Suri India see Siuri
Suriapet India 84 C2
Surigao Phil. 69 H5
Surin Thai. 70 C4
Surinam country S. America see
Suriname
▶Suriname country S. America 143 G3
South America 9, 140–141
Surin Nua, Ko i. Thai. 71 B5
Surkhduz Afgh. 89 G4
Surkhet Nepal 83 E3
Surkhon Uzbek. see Surxon
Sürmene Turkey 91 F2
Surovikino Rus. Fed. 43 I6
Surpura India 82 C4
Surrey Canada 120 F5
Surry U.S.A. 135 G5
Surskoye Rus. Fed. 43 J5
Surt Libya see Sirte
Surtsey i. Iceland 44 [inset]
Sūrū Hormozgan Iran 88 E5
Sūrū Sīstān va Balūchestān Iran 88 E5
Suruç Turkey 85 D1
Surud, Raas pt Somalia 98 E2
Surud Ad mt. Somalia see Shimbiris
Suruga-wan b. Japan 75 E6
Surulangun Indon. 68 C7
Surwold Germany 53 H2
Surxon Uzbek. 89 G2
Suryapet India see Suriapet
Şuşa Azer. 91 G3
Susah Tunisia see Sousse
Susaki Japan 75 D6
Susan U.S.A. 135 G5
Süsangerd Iran 88 C4
Susanino Rus. Fed. 74 F1
Susanville U.S.A. 128 C1
Susehri Turkey 90 E2
Susong China 77 H2
Susquehanna U.S.A. 135 H3

Susquehanna r. U.S.A. 135 G4
Susquehanna, West Branch r.
U.S.A. 135 G3
Sussex U.S.A. 135 D5
Susuman Rus. Fed. 65 P3
Susupu Indon. 69 H6
Susurluk Turkey 59 M5
Sutak Jammu and Kashmir 82 D2
Sutherland Australia 112 E5
Sutherland S. Africa 100 E7
Sutherland U.S.A. 130 C3
Sutherland Range hills Australia
109 D6
Sutjeska nat. park Bos.-Herz. 58 H3
Sutlej r. India/Pak. 82 B3
Sütlüce Turkey 85 A1
Sutter U.S.A. 128 C2
Sutterton U.K. 49 H6
Sutton Canada 135 I1
Sutton r. Canada 122 E3
Sutton U.K. 49 H6
Sutton NE U.S.A. 130 D3
Sutton WV U.S.A. 134 E4
Sutton Coldfield U.K. 49 F6
Sutton in Ashfield U.K. 49 F5
Sutton Lake Canada 122 D3
Sutton Lake U.S.A. 134 E4
Suttor r. Australia 110 D4
Suttsu Japan 74 F4
Sutwik Island U.S.A. 118 C4
Sutyr' r. Rus. Fed. 74 D2

▶Suva Fiji 107 H3
Capital of Fiji.

Suvadiva Atoll Maldives see
Huvadhu Atoll
Suvalki Poland see Suwałki
Suvorov atoll Cook Is see Suwarrow
Suvorov Rus. Fed. 43 H5
Suwa Japan 75 E5
Suwałki Poland 43 D5
Suwannaphum Thai. 70 C4
Suwannee r. U.S.A. 133 D6
Suwanose-jima i. Japan 75 C7
Suwarrow atoll Cook Is 107 J3
Suwayliḥ Jordan 85 B3
Suwayr well Saudi Arabia 91 F5
Suways, Khalīj as g. Egypt see
Suez, Gulf of
Suweilih Jordan see Suwayliḥ
Suweis, Khalīg el g. Egypt see
Suez, Gulf of
Suweis, Qanâ el canal Egypt see
Suez Canal
Suwŏn S. Korea 75 B5
Suyül Ḥanīsh i. Yemen 86 F7
Suz, Mys pt Kazakh. 91 I2
Suzaka Japan 75 E5
Suzdal' Rus. Fed. 42 I4
Suzhou Anhui China 77 H1
Suzhou Gansu China see Jiuquan
Suzhou Jiangsu China 77 I2
Suzi He r. China 74 B4
Suzuka Japan 75 E6
Suzu-misaki pt Japan 75 E5
Sværholthalvøya pen. Norway 44 O1

▶Svalbard terr. Arctic Ocean 64 C2
Part of Norway.

Svappavaara Sweden 44 L3
Svartenhuk Halvø pen. Greenland see
Sigguup Nunaa
Svatove Ukr. 43 H6
Svay Chék Cambodia 71 C4
Svay Riĕng Cambodia 71 D5
Svecha Rus. Fed. 42 J4
Sveg Sweden 45 I5
Sveki Latvia 45 O8
Svelgen Norway 44 D6
Svellingen Norway 44 D6
Švenčionėliai Lith. 45 N9
Švenčionys Lith. 45 O9
Svendborg Denmark 45 G9
Svensby Norway 44 K2
Svenstavik Sweden 44 I5
Sverdlovsk Rus. Fed. see
Yekaterinburg
Sverdlov's Ukr. 43 H6
Sverdrup Islands Canada 119 I2
Sveti Nikole Macedonia 59 I4
Svetlaya Rus. Fed. 74 E3
Svetlogorsk Belarus see Svyetlahorsk
Svetlogorsk Kaliningradskaya Oblast'
Rus. Fed. 45 L9
Svetlogorsk Krasnoyarskiy Kray
Rus. Fed. 64 J3
Svetlograd Rus. Fed. 91 F1
Svetlovodsk Ukr. see Svitlovods'k
Svetlyy Kaliningradskaya Oblast'
Rus. Fed. 45 L9
Svetlyy Orenburgskaya Oblast'
Rus. Fed. 80 B1
Svetlyy Yar Rus. Fed. 43 J6
Svetogorsk Rus. Fed. 45 P6
Svíahnúkar vol. Iceland 44 [inset]
Svilaja mts Croatia 58 G3
Svilengrad Bulg. 59 L4
Svinecea Mare, Vârful mt.
Romania 59 J2
Svir Belarus 45 O9
Svir' r. Rus. Fed. 42 G3
Svishtov Bulg. 59 K3
Svitava r. Czech Rep. 47 P6
Svitavy Czech Rep. 47 P6
Svitlovods'k Ukr. 43 G6
Sviyaga r. Rus. Fed. 43 K5
Svizzer, Parc Naziunal Switz. 58 D1
Svizzera country Europe see Switzerland
Svobodnyy Rus. Fed. 74 C2
Svolvær Norway 44 I2
Svrljiške Planine mts Serb. and Mont.
59 J3
Svyatoy Nos, Mys c. Rus. Fed. 42 K2
Svyetlahorsk Belarus 43 F5
Swadlincote U.K. 49 F6
Swaffham U.K. 49 H6

Swain Reefs Australia 110 F4
Swainsboro U.S.A. 133 D5
Swains Island atoll American Samoa
107 I3
Swakop watercourse Namibia 100 B2
Swakopmund Namibia 100 B2
Swale r. U.K. 48 F4
Swallow Islands Solomon Is 107 G3
Swamihalli India 84 C3
Swampy r. Canada 123 H2
Swan r. Australia 109 A7
Swan r. Man./Sask. Canada 121 K4
Swan r. Ont. Canada 122 E4
Swanage U.K. 49 F8
Swandale U.S.A. 134 E4
Swan Hill Australia 112 A5
Swan Hills Canada 120 H4
Swan Islands is Caribbean Sea 137 H5
Swan Lake B.C. Canada 120 E4
Swan Lake Man. Canada 121 K4
Swanley U.K. 49 H7
Swanquarter U.S.A. 133 E5
Swan Reach Australia 111 B7
Swan River Canada 121 K4
Swansea U.K. 49 D7
Swansea Bay U.K. 49 D7
Swanton CA U.S.A. 128 B3
Swanton VT U.S.A. 135 I1
Swartbergpas pass S. Africa 100 F7
Swart Nossob watercourse Namibia see
Black Nossob
Swartruggens S. Africa 101 H3
Swartz Creek U.S.A. 134 D2
Swasey Peak U.S.A. 129 G2
Swat Kohistan reg. Pak. 89 I3
Swatow China see Shantou
Swayzee U.S.A. 134 C3
▶Swaziland country Africa 101 J4
Africa 7, 94–95
Sweden country Europe 44 I5
5th largest country in Europe.
Europe 5, 38–39

Sweet Home U.S.A. 126 C3
Sweet Springs U.S.A. 134 E5
Sweetwater U.S.A. 131 C5
Sweetwater r. U.S.A. 126 G4
Swellendam S. Africa 100 E8
Swellengrebel U.S.A. 134 E4
Świdnica Poland 47 P5
Świdwin Poland 47 O4
Świebodzin Poland 47 O4
Świecie Poland 47 Q4
Swift Current Canada 121 J5
Swiftcurrent Creek r. Canada 121 J5
Swilly r. Ireland 51 E3
Swilly, Lough inlet Ireland 51 E2
Swindon U.K. 49 F7
Swinford Ireland 51 D4
Świnoujście Poland 47 O4
Swinton U.K. 50 G5
Swiss Confederation country Europe see
Switzerland
▶Switzerland country Europe 56 I3
Europe 5, 38–39
Swords Ireland 51 F4
Swords Range hills Australia 110 C4
Syamozero, Ozero l. Rus. Fed. 42 G3
Syamzha Rus. Fed. 42 I3
Syang Nepal 83 E3
Syas'troy Rus. Fed. 42 G3
Sychevka Rus. Fed. 42 G5
Sydenham atoll Kiribati see Nonouti

▶Sydney Australia 112 E4
State capital of New South Wales.
Most populous city in Oceania.

Sydney Canada 123 J5
Sydney Island Kiribati see Manra
Sydney Lake Canada 121 M5
Sydney Mines Canada 123 J5
Syedra tourist site Turkey 85 A1
Syeverodonets'k Ukr. 43 H6
Syke Germany 53 I2
Sykesville U.S.A. 135 F3
Syktyvkar Rus. Fed. 42 K3
Sylarna mt. Norway/Sweden 44 H5
Sylhet Bangl. 83 G4
Syloga Rus. Fed. 42 I3
Sylt i. Germany 47 L3
Sylva r. Rus. Fed. 41 R4
Sylva U.S.A. 133 D5
Sylvania GA U.S.A. 133 D5
Sylvania OH U.S.A. 134 D3
Sylvan Lake Canada 120 H4
Sylvester U.S.A. 133 D6
Sylvester, Lake salt flat Australia 110 A3
Sylvia, Mount Canada 120 E3
Symerton U.S.A. 134 A3
Symi i. Greece 59 L6
Synel'nykove Ukr. 43 G6
Syngyrli, Mys pt Kazakh. 91 I2
Synya Rus. Fed. 41 R2
Syowa research station Antarctica
152 D2
Syracusae Sicily Italy see Syracuse
Syracuse Sicily Italy 58 F6
Syracuse KS U.S.A. 130 C4
Syracuse NY U.S.A. 135 G2
Syrdar'ya r. Asia 80 C3
Syrdar'ya Uzbek. see Sirdaryo
Syrdaryinskiy Uzbek. see Sirdaryo
▶Syria country Asia 90 E4
Asia 6, 62–63
Syriam Myanmar see Thanlyin
Syrian Desert Asia 90 E4
Syrna i. Greece 59 L6
Syros i. Greece 59 K6
Syrskiy Rus. Fed. 43 H5
Sysmä Fin. 45 N6
Sysola r. Rus. Fed. 42 K3
Syumsi Rus. Fed. 42 L4
Syurkum Rus. Fed. 74 F2
Syurkum, Mys pt Rus. Fed. 74 F2
Syzran' Rus. Fed. 43 K5
Szabadka Serb. and Mont. see Subotica
Szczecin Poland 47 O4
Szczecinek Poland 47 P4
Szczytno Poland 47 R4
Szechwan prov. China see Sichuan
Szeged Hungary 59 I1
Székesfehérvár Hungary 58 H1

Szekszárd Hungary 58 H1
Szentes Hungary 59 I1
Szentgotthárd Hungary 58 G1
Szigetvár Hungary 58 G1
Szolnok Hungary 59 I1
Szombathely Hungary 58 G1
Sztálinváros Hungary see Dunaújváros

T

Taagga Duudka reg. Somalia 98 E3
Tābah Saudi Arabia 86 F4
Tabajara Brazil 142 F5
Tabalo P.N.G. 69 L7
Tabanan Indon. 108 A2
Tabankulu S. Africa 101 I6
Ṭabaqah Ar Raqqah Syria 85 D2
Ṭabaqah Ar Raqqah Syria see
Madīnat ath Thawrah
Tabar Islands P.N.G. 106 F2
Tabarka Tunisia 58 C6
Ṭabas Iran 89 F3
Tabāsīn Iran 88 E4
Tabask, Kūh-e mt. Iran 88 C4
Tabatinga Amazonas Brazil 142 E4
Tabatinga São Paulo Brazil 145 A3
Tabatinga, Serra da hills Brazil 143 J6
Tabatsquri, Tba l. Georgia 91 F2
Tabayin Myanmar 70 A2
Tabbita Australia 112 B5
Tabelbala Alg. 54 D6
Taber Canada 121 H5
Tabet, Nam r. Myanmar 70 B1
Tabia Tsaka salt l. China 83 F3
Tabiteuea atoll Kiribati 107 H2
Tabivere Estonia 45 O7
Table Cape N.Z. 113 F4
Tabligbo Togo 96 D4
Tábor Czech Rep. 47 O6
Tabora Tanz. 99 D4
Tabou Côte d'Ivoire 96 C4
Tabrīz Iran 88 B2
Tabuaeran atoll Kiribati 151 J5
Tabūk Saudi Arabia 90 D5
Tabulam Australia 112 F2
Tabuyung Indon. 71 B7
Täby Sweden 45 K7
Tacalé Brazil 143 H3
Tacheng China 80 F2
Tachie Canada 120 E4
Tachov Czech Rep. 53 M5
Tacloban Phil. 69 H4
Tacna Peru 142 D7
Tacoma U.S.A. 126 C3
Taco Pozo Arg. 144 D3
Tacuarembó Uruguay 144 E4
Tacupeto Mex. 127 F7
Tadcaster U.K. 48 F5
Tademaït, Plateau du Alg. 54 E6
Tadin New Caledonia 107 G4
Tadjikistan country Asia see Tajikistan
Tadjoura Djibouti 86 F7
Tadmur Syria 85 D2
Tadohae Haesang National Park
S. Korea 75 B6
Tadoule Lake Canada 121 L3
Tadoussac Canada 123 H4
Tadpatri India 84 C3
Tadwale India 84 C2
Tadzhikskaya S.S.R. country Asia see
Tajikistan
T'aean Haean National Park
S. Korea 75 B5
Taech'ŏng-do i. S. Korea 75 B5
Taedasa-do N. Korea 75 B5
Taedong-man b. N. Korea 75 B5
Taegu S. Korea 75 C6
Taehan-min'guk country Asia see
South Korea
Taehŭksan-kundo is S. Korea 75 B6
Taejŏn S. Korea 75 B5
Taejŏng S. Korea 75 B6
T'aepaek S. Korea 75 C5
Ta'erqi China 73 M3
Tafahi i. Tonga 107 I3
Tafalla Spain 57 F2
Tafeng China see Lanshan
Tafila Jordan see Aṭ Ṭafīlah
Tafi Viejo Arg. 144 C3
Tafresh Iran 88 C3
Taft Iran 88 D4
Taft U.S.A. 128 D4
Taftān, Kūh-e mt. Iran 89 F4
Taftanāz Syria 85 C2
Tafwap India 71 A6
Taganrog Rus. Fed. 43 H7
Taganrog, Gulf of Rus. Fed./Ukr. 43 H7
Taganrogskiy Zaliv b. Rus. Fed./Ukr. see
Taganrog, Gulf of
Tagarev, Gora mt. Iran/Turkm. 88 E2
Tagarkaty, Pereval pass Tajik. 89 I2
Tagaung Myanmar 70 B2
Tagchagpu Ri mt. China 83 E2
Tagdempt Alg. see Tiaret
Taghmon Ireland 51 F5
Tagish Canada 120 C2
Tagtabazar Turkm. 89 F3
Tagula P.N.G. 110 F1
Tagula Island P.N.G. 110 F1
Tagus r. Port. 57 B4
also known as Tajo (Portugal) or
Tejo (Spain)
Taha China 74 B3
Tahaetkun Mountain Canada 120 G5
Tahan, Gunung mt. Malaysia 71 C6
Tahanroz'ka Zatoka b. Rus. Fed./Ukr. see
Taganrog, Gulf of
Tahat, Mont mt. Alg. 96 D2
Tahaurawe i. HI U.S.A. see Kaho'olawe
Tahe China 74 B1
Taheke N.Z. 113 D2
Tahiti i. Fr. Polynesia 151 K7
Tahlab r. Iran/Pak. 89 F4
Tahlab, Dasht-i- plain Pak. 89 F4
Tahlequah U.S.A. 131 E5
Tahltan Canada 120 D3

Tahoe, Lake U.S.A. 128 C2
Tahoe Lake Canada 119 H3
Tahoe Vista U.S.A. 128 C2
Tahoka U.S.A. 131 C5
Tahoua Niger 96 D3
Tahrūd Iran 88 E4
Tahrūd r. Iran 88 E4
Tahtsa Peak Canada 120 E4
Tahuna Indon. 69 H6
Taï, Parc National de nat. park
Côte d'Ivoire 96 C4
Tai'an China 73 L5
Taibai China 76 E1
Taibai Shan mt. China 76 E1
Taibei Taiwan see T'aipei
Taibus Qi China see Baochang
T'aichung Taiwan 77 I3
Taigong China see Taijiang
Taihang Shan mts Hebei China 73 K5
Taihang Shan mts China 73 K5
Taihape N.Z. 113 E4
Taihe Jiangxi China 77 G3
Taihe Sichuan China see Shehong
Taihezhen China see Shehong
Tai Ho Wan H.K. China 77 [inset]
Taihu China 77 H2
Tai Hu l. China 77 I2
Taijiang China 77 F3
Taikang China 77 G1
Tailai China 74 A3
Tai Lam Chung Shui Tong resr H.K.
China 77 [inset]
Tailem Bend Australia 111 B7
Tai Long Wan b. H.K. China 77 [inset]
Taimani reg. Afgh. 89 F3
Tai Mo Shan hill H.K. China 77 [inset]
Tain U.K. 50 E3
T'ainan Taiwan 77 I4
T'ainan Taiwan see Hsinying
Tainaro, Akra pt Greece see
Tainaro, Akrotirio
Tainaro, Akrotirio pt Greece 59 J6
Taining China 77 H3
Tai O H.K. China 77 [inset]
Tai Pang Wan b. H.K. China see Mirs Bay
Taiping Guangdong China see Shixing
Taiping Guangxi China see Chongzuo
Taiping Guangxi China 77 F4
Taiping Malaysia 71 C6
Taipingchuan China 74 A3
Tai Po H.K. China 77 [inset]
Tai Po Hoi b. H.K. China see Tolo Harbour
Tai Poutini National Park N.Z. see
Westland National Park
Tairbeart U.K. see Tarbert
Tai Rom Yen National Park Thai. 71 B5
Tairuq Iran 88 B3
Tais P.N.G. 69 K8
Taishan China 77 G4
Taishun China 77 H3
Tai Siu Mo To is H.K. China see
The Brothers
Taissy France 52 E5
Taitanu N.Z. 113 D6
Taitao, Península de pen. Chile 144 B7
Tai To Yan mt. H.K. China 77 [inset]
T'aitung Taiwan 77 I4
Tai Tung Shan hill H.K. China see
Sunset Peak
Taivalkoski Fin. 44 P4
Taivaskero hill Fin. 44 N2
▶Taiwan country Asia 77 I4
Asia 6, 62–63
T'aiwan Haihsia strait China/Taiwan see
Taiwan Strait
Taiwan Haixia strait China/Taiwan see
Taiwan Strait
Taiwan Shan mts Taiwan see
Chungyang Shanmo
Taiwan Strait China/Taiwan 77 H4
Taixian China see Jiangyan
Taixing China 77 I1
Taiyuan China 73 K5
Taizhao China 76 B2
Taizhong Taiwan see T'aichung
Taizhong Taiwan see Fengyüan
Taizhou Jiangsu China 77 H1
Taizhou Zhejiang China 77 I2
Taizhou Liedao i. China 77 I2
Taizhou Wan b. China 77 I2
Taizi He r. China 74 B4
Ta'izz Yemen 86 F7
Tājābād Iran 88 E4
Tajal Pak. 89 G5
▶Tajikistan country Asia 89 H2
Asia 6, 62–63
Tajitos Mex. 127 E7
Tajo r. Spain see Tagus
Tajrīsh Iran 88 C3
Tak Thai. 70 B3
Takāb Iran 88 B2
Takabba Kenya 98 E3
Takahashi Japan 75 D6
Takamatsu Japan 75 D6
Takaoka Japan 75 E5
Takapuna N.Z. 113 E3
Ta karpo China 83 G4
Takatokwane Botswana 100 G3
Takatshwaane Botswana 100 D2
Takatsuki-yama mt. Japan 75 D6
Takayama Japan 75 E5
Tak Bai Thai. 71 C6
Takefu Japan 75 E6
Takengon Indon. 71 B6
Takeo Cambodia see Takêv
Take-shima i. N. Pacific Ocean see
Liancourt Rocks
Takestān Iran 88 C2
Takêv Cambodia 71 D5
Takhemaret Alg. 57 G6
Takhini Hotspring Canada 120 C2

Ta Khli Thai. 70 C4
Ta Khmau Cambodia 71 D5
Takhta-Bazar Turkm. see Tagtabazar
Takht Apān, Kūh-e mt. Iran 88 C4
Takhteh Iran 88 D4
Takhteh Pol Afgh. 89 G4
Takht-e Soleymān mt. Iran 88 C2
Takht-e Soleymān 88 B2
Takht-i-Bahi tourist site Pak. 89 H3
Takht-i-Sulaiman mt. Pak. 89 H4
Takijuq Lake Canada see
Napaktulik Lake
Takingeun Indon. see Takengon
Takinoue Japan 74 F3
Takla Lake Canada 120 E4
Takla Landing Canada 120 E4
Takla Makan des. China see
Taklimakan Desert
Taklimakan Desert China 82 E1
Taklimakan Shamo des. China see
Taklimakan Desert
Takpa Shiri mt. China 76 B2
Taku Canada 120 C3
Takum Nigeria 96 D4
Takuu Islands P.N.G. 107 F2
Talachyn Belarus 43 F5
Talaja India 82 C5
Talakan Amurskaya Oblast'
Rus. Fed. 74 C2
Talakan Khabarovskiy Kray
Rus. Fed. 74 D2
Talandzha Rus. Fed. 74 C2
Talangbatu Indon. 68 D7
Talara Peru 142 B4
Talar-i-Band mts Pak. see
Makran Coast Range
Talas Kyrg. 80 D3
Talas Ala-Too mts Kyrg. 80 D3
Talas Range mts Kyrg. see Talas Ala-Too
Talasskiy Alatau, Khrebet mts Kyrg. see
Talas Ala-Too
Ṭal'at Mūsá mt. Lebanon/Syria 85 C2
Talaud, Kepulauan is Indon. 69 H6
Talavera de la Reina Spain 57 D4
Talawgyi Myanmar 70 B1
Talaya Rus. Fed. 65 Q3
Talbehat India 82 D4
Talbīsah Syria 85 C2
Talbot, Mount hill Australia 109 D6
Talbotton U.S.A. 133 C5
Talca Chile 144 B5
Talcahuano Chile 144 B5
Taldan Rus. Fed. 74 B1
Taldom Rus. Fed. 42 H4
Taldykorgan Kazakh. 80 E3
Taldy-Kurgan Kazakh. see Taldykorgan
Taldyqorghan Kazakh. see Taldykorgan
Tälesh Iran see Hashtpar
Talgarth U.K. 49 D7
Talguppa India 84 B3
Talia Australia 111 A7
Taliabu i. Indon. 69 G7
Talikota India 84 C2
Talimardzhan Uzbek. see Tollimarjon
Talin Hiag China 74 B3
Taliparamba India 84 B3
Talisay Phil. 69 G4
Talış Dağları mts Azer./Iran 88 C2
Talitsa Rus. Fed. 42 J4
Taliwang Indon. 108 B2
Talkeetna U.S.A. 118 C3
Talkeetna Mountains U.S.A. 118 D3
Talkh Āb Iran 88 D2
Tallacootra, Lake salt flat
Australia 109 F7
▶Tallahassee U.S.A. 133 C6
State capital of Florida.

Tall al Aḥmar Syria 85 D1
Tall Baydar Syria 91 F3
Tall-e Ḥalāl Iran 88 D4
▶Tallinn Estonia 45 N7
Capital of Estonia.

Tall Kalakh Syria 85 C2
Tall Kayf Iraq 91 F3
Tall Kūjik Syria 91 F3
Tallow Ireland 51 D5
Tallulah U.S.A. 131 F5
Tall 'Uwaynāt Iraq 91 F3
Talmenau Uzbek. see Tollimarjon
Talmont-St-Hilaire France 56 D3
Tal'ne Ukr. 43 F6
Tal'noye Ukr. see Tal'ne
Taloda India 82 C5
Talodi Sudan 86 D7
Taloga U.S.A. 131 D4
Talon, Lac l. Canada 123 J4
Ta-long Myanmar 70 B2
Tāloqān Afgh. 89 H2
Talos Dome ice feature
Antarctica 152 H2
Ta Loung San mt. Laos 70 C2
Talovaya Rus. Fed. 43 I6
Taloyoak Canada 119 J3
Tal Pass Pak. 89 I3
Talsi Latvia 45 M8
Tal Sīyāh Iran 89 F4
Taltal Chile 144 B3
Taltson r. Canada 121 I2
Talu China 76 B2
Talvik Norway 44 M1
Talwood Australia 112 D2
Talyshskiye Gory mts Azer./Iran see
Talış Dağları
Talyy Rus. Fed. 42 L2
Tama U.S.A. 130 E3
Tamala Australia 109 A6
Tamala Rus. Fed. 43 I5
Tamale Ghana 96 C4
Tamana i. Kiribati 107 H2
Tamanh Myanmar 70 A1
Taman Negara National Park Malaysia
71 C6
Tamano Japan 75 D6
Tamanrasset Alg. 96 D2
Tamanthi Myanmar 70 A1
Tamaqua U.S.A. 135 H3
Tamar India 83 F5
Tamar Syria see Tadmur

Tamar r. U.K. 49 C8
Tamarugal, Pampa de plain Chile 142 E7
Tamasane Botswana 101 H2
Tamatave Madag. see Toamasina
Tamaulipas state Mex. 131 D7
Tambacounda Senegal 96 B3
Tambaqui Brazil 142 F5
Tambar Springs Australia 112 D3
Tambelan, Kepulauan is Indon. 71 D7
Tambelan Besar i. Indon. 71 D7
Tambo r. Australia 112 C6
Tambohorano Madag. 99 E5
Tambora, Gunung vol. Indon. 108 B2
Tamboritha mt. Australia 112 C6
Tambov Rus. Fed. 43 I5
Tambovka Rus. Fed. 74 C2
Tambura Sudan 97 F4
Tamburi Brazil 145 C1
Tâmchekket Mauritania 96 B3
Tamdybulak Uzbek. see Tomdibuloq
Tâmega r. Port. 57 B3
Tamenghest Alg. see Tamanrasset
Tamenglong India 83 H4
Tamerza Tunisia 58 B7
Tamgak, Adrar mt. Niger 96 D3
Tamgué, Massif du mt. Guinea 96 B3
Tamiahua, Laguna de lag. Mex. 136 E4
Tamiang, Ujung pt Indon. 71 B6
Tamil Nadu state India 84 C4
Tamitsa Rus. Fed. 42 H2
Tâmîya Egypt see Tāmīyah
Tāmīyah Egypt 90 C5
Tamkuhi India 83 F4
Tam Ky Vietnam 70 E4
Tammarvi r. Canada 121 K1
Tammerfors Fin. see Tampere
Tammisaari Fin. see Ekenäs
Tampa U.S.A. 133 D7
Tampa Bay U.S.A. 133 D7
Tampere Fin. 45 M6
Tampico Mex. 136 E4
Tampin Malaysia 71 C7
Tampines Sing. 71 [inset]
Tamsagbulag Mongolia 73 L3
Tamsweg Austria 47 N7
Tamu Myanmar 70 A1
Tamworth Australia 112 E3
Tamworth U.K. 49 F6
Tana r. Fin./Norway see Tenojoki
Tana r. Kenya 98 E4
Tana Madag. see Antananarivo
Tana i. Vanuatu see Tanna
Tana, Lake Eth. 98 D2
Tana Japan 75 D6
Tanabe Japan 75 D6
Tanabi Brazil 145 A3
Tana Bru Norway 44 P1
Tanada Lake U.S.A. 120 A2
Tanafjorden inlet Norway 44 P1
Tanah, Tanjung pt Indon. 68 D8
T'ana Häyk' l. Eth. see Tana, Lake
Tanahgrogot Indon. 68 F7
Tanah Merah Malaysia 71 C6
Tanahputih Indon. 71 C7
Tanakeke i. Indon. 68 F8
Tanami Australia 108 E4
Tanami Desert Australia 108 E4
Tân An Vietnam 71 D5
Tanana r. U.S.A. 120 A2
Tananarive Madag. see Antananarivo
Tanandava Madag. 99 E6
Tancheng China see Pingtan
Tanch'ŏn N. Korea 75 C4
Tanda Côte d'Ivoire 96 C4
Tanda Uttar Prad. India 82 D3
Tanda Uttar Prad. India 83 E4
Tandag Phil. 69 H5
Ţăndărei Romania 59 L2
Tandaué Angola 99 B5
Tandi India 82 D2
Tandil Arg. 144 E5
Tando Adam Pak. 89 H5
Tando Alahyar Pak. 89 H5
Tando Bago Pak. 89 H5
Tandou Lake imp. l. Australia 111 C7
Tandragee U.K. 51 F3
Tandur India 84 C2
Tanduri Pak. 89 G4
Tanega-shima i. Japan 75 C7
Tanen Taunggyi mts Thai. 70 B3
Tanezrouft reg. Alg./Mali 96 C2
Ţanf, Jabal aţ hill Syria 85 D3
Tang, Ra's-e pt Iran 89 E5
Tanga Tanz. 99 D4
Tangail Bangl. 83 G4
Tanga Islands P.N.G. 106 F2
Tanganyika country Africa see Tanzania

▶Tanganyika, Lake Africa 99 C4
Deepest and 2nd largest lake in Africa.

Tangará Brazil 145 A4
Tangasseri India 84 C4
Tangdan China 76 D3
Tangeli Iran 88 D2
Tanger Morocco see Tangier
Tangerhütte Germany 53 L2
Tangermünde Germany 53 L2
Tang-e Sarkheh Iran 89 E5
Tanggor China 76 D1
Tanggulashan China 76 B1
Tanggula Shan mt. China 83 G2
Tanggula Shan mts China 83 G2
Tanggula Shankou pass China 83 G2
Tangguo China 83 F3
Tanghe China 77 G1
Tangier Morocco 57 D6
Tangiers Morocco see Tangier
Tang La pass China 83 G4
Tangla India 83 G4
Tanglag China 76 C1
Tanglin Sing. 71 [inset]
Tangmai China 76 B2
Tangnag China 76 D1
Tangorin Australia 110 D4
Tangra Yumco salt l. China 83 F3
Tangse Indon. 71 A6
Tangshan Guizhou China see Shiqian
Tangshan Hebei China 73 L5
Tangte mt. Myanmar 70 B2
Tangtse Jammu and Kashmir see Tanktse
Tangwan China 77 F3
Tangwanghe China 74 C2

Tangyuan China 74 C3
Tangyung Tso salt l. China 83 F3
Tanhaçu Brazil 145 C1
Tanhua Fin. 44 O3
Tani Cambodia 71 D5
Taniantaweng Shan mts China 76 B2
Tanimbar, Kepulauan is Indon. 108 E1
Tanintharyi Myanmar see Tenasserim
Tanintharyi Myanmar see Tenasserim
Tanintharyi Myanmar see Tenasserim
Tanjah Morocco see Tangier
Tanjay Phil. 69 G5
Tanjore India see Thanjavur
Tanjung Indon. 68 F7
Tanjungbalai Indon. 71 B7
Tanjungkarang-Telukbetung Indon. see
Bandar Lampung
Tanjungpandan Indon. 68 D7
Tanjungpinang Indon. 71 D7
Tanjungpura Indon. 71 B7
Tanjung Puting, Taman Nasional
Indon. 68 E7
Tanjungredeb Indon. 68 F6
Tanjungselor Indon. 68 F6
Tankse Jammu and Kashmir see
Tanktse
Tanktse Jammu and Kashmir 82 D2
Tankwa-Karoo National Park S. Africa
100 D7
Tanna i. Vanuatu 107 G3
Tannadice U.K. 50 G4
Tännäs Sweden 44 H5
Tanner, Mount Canada 120 G5
Tannu-Ola, Khrebet mts Rus. Fed. 80 H1
Tanot India 82 B4
Tanout Niger 96 D3
Tansen Nepal 83 E4
Tanshui Taiwan 77 I3
Ţanţa Egypt 90 C5
Ţanţa Egypt see Ţanţā
Tan-Tan Morocco 96 B2
Tantu China 74 A3
Tanuku India 84 D2
Tanumbirini Australia 108 F4
Tanumshede Sweden 45 G7
▶Tanzania country Africa 99 D4
Africa 7, 94–95
Tanzilla r. Canada 120 D3
Tao, Ko i. Thai. 71 B5
Tao'an China see Taonan
Taobh Tuath U.K. see Northton
Taocheng China see Daxin
Tao He r. China 76 D1
Taohong China see Longhui
Taohuajiang China see Taojiang
Taohuaping China see Longhui
Taojiang China 77 G2
Taolanaro Madag. see Tôlañaro
Taonan China 74 A3
Taongi atoll Marshall Is 150 H5
Taos U.S.A. 127 G5
Taounate Morocco 54 D5
Taourirt Morocco 54 D5
Taoxi China 77 H3
Taoyang China see Lintao
Taoyuan China 77 F2
T'aoyüan Taiwan 77 I3
Tapa Estonia 45 N7
Tapachula Mex. 136 F6
Tapah Malaysia 71 C6
Tapajós r. Brazil 143 H4
Tapaktuan Indon. 71 B7
Tapauá Brazil 142 F5
Tapauá r. Brazil 142 F5
Taperoá Brazil 145 D1
Tapi r. India 82 C5
Tapiau Rus. Fed. see Gvardeysk
Tapis, Gunung mt. Malaysia 71 C6
Tapisuelas Mex. 127 F8
Taplejung Nepal 83 F4
Tap Mun Chau i. H.K. China 77 [inset]
Ta-pom Myanmar 70 B2
Tappahannock U.S.A. 135 G5
Tappeh, Küh-e hill Iran 88 C3
Taprobane country Asia see Sri Lanka
Tapuaenuku mt. N.Z. 113 D5
Tapulonanjing mt. Indon. 71 B7
Tapurucuara Brazil 142 E4
Taputeouea atoll Kiribati see
Tabiteuea
Ţaqţaq Iraq 91 G4
Taquara Brazil 145 A5
Taquari Rio Grande do Sul Brazil 145 A5
Taquari r. Brazil 143 G7
Taquaritinga Brazil 145 A3
Tar r. Ireland 51 E5
Tara Australia 112 E1
Ţarābulus Lebanon see Tripoli
Ţarābulus Libya see Tripoli
Tarahuwan India 82 E4
Tarai reg. India 83 G4
Tarakan Indon. 68 F6
Tarakan i. Indon. 68 F6
Tarakki reg. Afgh. 89 G3
Taraklı Turkey 59 N4
Taran, Mys pt Rus. Fed. 45 K9
Tarana Australia 112 D4
Taranagar India 82 C3
Taranaki, Mount vol. N.Z. 113 E4
Tarancón Spain 57 E3
Tarangambadi India 84 C4
Tarangire National Park Tanz. 98 D4
Taranto Italy 58 G4
Taranto, Golfo di g. Italy 58 G4
Taranto, Gulf of Italy see
Taranto, Golfo di
Tarapoto Peru 142 C5
Tarapur India 84 B2
Tararua Range mts N.Z. 113 E5
Tarascon-sur-Ariège France 56 E5
Tarasovskiy Rus. Fed. 43 I6
Tarauacá Brazil 142 D5
Tarauacá r. Brazil 142 E5
Tarawera N.Z. 113 F4
Tarawera, Mount vol. N.Z. 113 F4
Taraz Kazakh. 80 D3
Tarazona Spain 57 F3
Tarazona de la Mancha Spain 57 F4
Tarbagatay, Khrebet mts Kazakh. 80 F2
Tarbat Ness pt U.K. 50 F3
Tarbert Ireland 51 C5
Tarbert Scotland U.K. 50 C3

Tarbert Scotland U.K. 50 D5
Tarbes France 56 E5
Tarboro U.S.A. 132 E5
Tarcoola Australia 109 F7
Tarcoon Australia 112 C3
Tarcoonyinna watercourse Australia
109 F6
Tarcutta Australia 112 C5
Tardoki-Yani, Gora mt. Rus. Fed. 74 E2
Taree Australia 112 F3
Tarella Australia 111 C6
Tarentum Italy see Taranto
Ţarfā', Baţn aţ depr. Saudi Arabia 88 C6
Tarfaya Morocco 96 B2
Targa well Niger 96 D3
Targan China see Talin Hiag
Targhee Pass U.S.A. 126 F3
Târgovişte Romania 59 K2
Targuist Morocco 57 D6
Târgu Jiu Romania 59 J2
Târgu Mureş Romania 59 K1
Târgu Neamţ Romania 59 L1
Târgu Secuiesc Romania 59 L1
Targyailing China 83 F3
Tari P.N.G. 69 K8
Tarif U.A.E. 88 D5
Tarifa Spain 57 D5
Tarifa, Punta de pt Spain 57 D5
Tarija Bol. 142 F8
Tarikere India 84 B3
Tariku r. Indon. 69 J7
Tarīm Yemen 86 G6
Tarim Basin China 80 F4
Tarime Tanz. 98 D4
Tarim He r. China 80 G3
Tarim Pendi basin China see
Tarim Basin
Tarīn Kowt Afgh. 89 G3
Taritatu r. Indon. 69 J7
Tarka r. S. Africa 101 G7
Tarkastad S. Africa 101 H7
Tarkio U.S.A. 130 E3
Tarko-Sale Rus. Fed. 64 I3
Tarkwa Ghana 96 C4
Tarlac Phil. 69 G3
Tarlo River National Park Australia 112 D5
Tarma Peru 142 C6
Tarmstedt Germany 53 J1
Tarn r. France 56 E4
Tärnaby Sweden 44 I4
Tarnak r. Afgh. 89 G4
Târnăveni Romania 59 K1
Tarnobrzeg Poland 43 D6
Tarnogskiy Gorodok Rus. Fed. 42 I3
Tarnopol Ukr. see Ternopil'
Tarnów Poland 43 D6
Tarnowitz Poland see Tarnowskie Góry
Tarnowskie Góry Poland 47 Q5
Taro Co salt l. China 83 F3
Ţārom Iran 88 D4
Taroom Australia 111 E5
Taroudannt Morocco 54 C5
Tarpaulin Swamp Australia 110 B3
Tarq Iran 88 C3
Tarquinia Italy 58 D3
Tarquinii Italy see Tarquinia
Tarrabool Lake salt flat Australia 110 A3
Tarraco Spain see Tarragona
Tarrafal Cape Verde 96 [inset]
Tarragona Spain 57 G3
Tàrrajaur Sweden 44 K3
Tarran Hills hill Australia 112 C4
Tarrant Point Australia 110 B3
Tàrrega Spain 57 G3
Tarrong China see Nyêmo
Tarso Emissi mt. Chad 97 E2
Tarsus Turkey 85 B1
Tart China 83 H1
Tärtär Azer. 91 G2
Tartu Estonia 45 O7
Ţarţūs Syria 85 B2
Tarumovka Rus. Fed. 91 G1
Tarung Hka r. Myanmar 70 B1
Tarutao, Ko i. Thai. 71 B6
Tarutao National Park Thai. 71 B6
Tarutung Indon. 71 B7
Tarvisium Italy see Treviso
Tarz Iran 88 E4
Tasai, Ko i. Thai. 71 B5
Taschereau Canada 122 F4
Taseko Mountain Canada 120 F5
Tashauz Turkm. see Daşoguz
Tashigang Bhutan 83 G4
Tashino Rus. Fed. see Pervomaysk
Tashir Armenia 91 G2
Tashk, Daryächeh-ye l. Iran 88 D4
Tashkent Toshkent Uzbek. see Toshkent
Tāshqurghān Afgh. see Kholm
Tashtagol Rus. Fed. 72 F2
Tashtyp Rus. Fed. 72 F2
Tasialujjuaq, Lac l. Canada 123 G2
Tasiat, Lac l. Canada 122 G2
Tasiilap Karra c. Greenland 119 O3
Tasiilaq Greenland see Ammassalik
Tasil Syria 85 B3
Tasiujaq Canada 123 H2
Tasiusaq Greenland 119 M2
Taşkent Turkey 85 A1
Tasker Niger 96 E3
Taskesken Kazakh. 80 F2
Taşköprü Turkey 90 D2
Tasman Abyssal Plain sea feature
Tasman Sea 150 G8
Tasman Bay N.Z. 113 D5

▶Tasmania state Australia 111 [inset]
4th largest island in Oceania.

Tasman Islands P.N.G. see
Nukumanu Islands
Tasman Mountains N.Z. 113 D5
Tasman Peninsula Australia 111 [inset]
Tasman Sea S. Pacific Ocean 106 H6
Taşova Turkey 90 D2
Tassara Niger 96 D3
Tassialouc, Lac l. Canada 122 G2
Tassili du Hoggar plat. Alg. 96 D3
Tassili n'Ajjer plat. Alg. 96 D2

Tasty Kazakh. 80 C3
Taşucu Turkey 85 A1
Tas-Yuryakh Rus. Fed. 65 M3
Tata Morocco 54 C6
Tatabánya Hungary 58 H1
Tatamailau, Foho mt. East Timor
108 D2
Tataouine Tunisia 54 G5
Tatarbunary Ukr. 59 M2
Tatarsk Rus. Fed. 64 I4
Tatarskiy Proliv strait Rus. Fed. 74 F2
Tatar Strait Rus. Fed. see Tatarskiy Proliv
Tate r. Australia 110 C3
Tateyama Japan 75 E6
Tathlina Lake Canada 120 G2
Tathlīth Saudi Arabia 86 F6
Tathlīth, Wādī watercourse Saudi Arabia
86 F5
Tathra Australia 112 D6
Tatinnai Lake Canada 121 L2
Tatishchevo Rus. Fed. 43 J6
Tatkon Myanmar 70 B2
Tatla Lake Canada 120 E5
Tatla Lake l. Canada 120 E5
Tatlayoko Lake Canada 120 E5
Tatnam, Cape Canada 121 N3
Tatra Mountains Poland/Slovakia 47 Q6
Tatry mts Poland/Slovakia see
Tatra Mountains
Tatrzański Park Narodowy nat. park
Poland 47 Q6
Tatshenshini-Alsek Provincial Wilderness
Park Canada 120 B3
Tatsinskiy Rus. Fed. 43 I6
Tatta Pak. 89 G5
Tatu Brazil 145 B3
Tatuk Mountain Canada 120 E4
Tatum U.S.A. 131 C5
Tatvan Turkey 91 F3
Tau Norway 45 D7
Taua Brazil 143 J5
Tauapeçaçu Brazil 142 F4
Taubaté Brazil 145 B3
Tauber r. Germany 53 J5
Tauberbischofsheim Germany 53 J5
Taucha Germany 53 M3
Taufstein hill Germany 53 J4
Taukum, Peski des. Kazakh. 80 D3
Taumarunui N.Z. 113 E4
Taumaturgo Brazil 142 D5
Taung S. Africa 100 G4
Taungdwingyi Myanmar 70 A2
Taunggyi Myanmar 70 B2
Taunglau Myanmar 70 B2
Taung-ngu Myanmar 70 B3
Taungnyo Range mts Myanmar 70 B3
Taungtha Myanmar 70 A2
Taungup Myanmar 76 B5
Taunton U.K. 49 D7
Taunton U.S.A. 135 J3
Taunus hills Germany 53 H4
Taupo N.Z. 113 F4
Taupo, Lake N.Z. 113 E4
Tauragė Lith. 45 M9
Tauranga N.Z. 113 F3
Taurasia Italy see Turin
Taureau, Réservoir resr Canada 122 G5
Taurianova Italy 58 G5
Tauroa Point N.Z. 113 D2
Taurus Mountains Turkey 85 A1
Taute r. France 49 F9
Tauz Azer. see Tovuz
Tavas Turkey 59 M6
Tavastehus Fin. see Hämeenlinna
Taverham U.K. 49 I6
Taveuni i. Fiji 107 I3
Tavildara Tajik. 89 H2
Tavira Port. 57 C5
Tavistock Canada 134 E2
Tavistock U.K. 49 C8
Tavoy Myanmar 71 B4
Tavoy r. mouth Myanmar 71 B4
Tavoy Island Myanmar see Mali Kyun
Tavoy Point Myanmar 71 B4
Tavşanlı Turkey 59 M5
Taw r. U.K. 49 C7
Tawang India 83 G4
Tawas City U.S.A. 134 D1
Tawau Sabah Malaysia 68 F6
Tawè Myanmar see Tavoy
Tawe r. U.K. 49 D7
Tawī Ḩafir well U.A.E. 88 D5
Ţawī Murra well U.A.E. 88 D5
Tawitawi i. Phil. 69 G5
Tawu Taiwan 77 I4
Taxco Mex. 136 E5
Taxkorgan China 80 E4
Tay r. Canada 120 C2
Tay r. U.K. 50 F4
Tay, Firth of est. U.K. 50 F4
Tay, Lake salt flat Australia 109 C8
Tay, Loch l. U.K. 50 E4
Tayandu, Kepulauan is Indon. 69 I8
Taybola Rus. Fed. 44 R2
Taycheedah U.S.A. 134 A2
Tayinloan U.K. 50 D5
Taylor Canada 120 F3
Taylor AK U.S.A. 118 B3
Taylor MI U.S.A. 134 D2
Taylor NE U.S.A. 130 D3
Taylor TX U.S.A. 131 D6
Taylor, Mount U.S.A. 129 J4
Taylorsville U.S.A. 134 C4
Taylorville U.S.A. 130 F4
Taymā' Saudi Arabia 90 E6
Taymura r. Rus. Fed. 65 K3
Taymyr, Ozero l. Rus. Fed. 65 L2
Taymyr, Poluostrov pen. Rus. Fed.
see Taymyr Peninsula
Taymyr Peninsula Rus. Fed. 64 J2
Tây Ninh Vietnam 71 D5
Taypak Kazakh. 41 Q6
Taypaq Kazakh. see Taypak
Tayshet Rus. Fed. 72 H1
Taytay Phil. 68 F4
Tayuan China 74 B2
Tayyebäd Iran 89 F3
Taz r. Rus. Fed. 64 I3
Taza Morocco 54 D5
Tāza Khurmātū Iraq 91 G4
Taze Myanmar 70 A2
Tazewell TN U.S.A. 134 D5
Tazewell VA U.S.A. 134 E5

Tazin r. Canada 121 I2
Tazin Lake Canada 121 I3
Tāzirbū Libya 97 F2
Tazmalt Alg. 57 I5
Tazovskaya Guba sea chan.
Rus. Fed. 64 I3
Tbessa Alg. see Tébessa

▶T'bilisi Georgia 91 G2
Capital of Georgia.

Tbilisskaya Rus. Fed. 43 I7
Tchabal Mbabo mt. Cameroon 96 E4
Tchad country Africa see Chad
Tchamba Togo 96 D4
Tchibanga Gabon 98 B4
Tchigaï, Plateau du Niger 97 E2
Tchin-Tabaradene Niger 96 D3
Tchollire Cameroon 97 E4
Tchula U.S.A. 131 F5
Tczew Poland 47 Q3
Te, Prêk r. Cambodia 71 D4
Teague, Lake salt flat Australia 109 C6
Te Anau N.Z. 113 A7
Te Anau, Lake N.Z. 113 A7
Teapa Mex. 136 F5
Te Araroa N.Z. 113 G3
Teate Italy see Chieti
Te Awamutu N.Z. 113 E4
Teba Indon. 69 J7
Tébarat Niger 96 D3
Tebas Indon. 71 E7
Tebay U.K. 48 E4
Tebesjuak Lake Canada 121 L2
Tébessa Alg. 58 C7
Tébessa, Monts de mts Alg. 58 C7
Tebingtinggi Indon. 71 B7
Tébourba Tunisia 58 C6
Téboursouk Tunisia 58 C6
Tebulos Mt'a Georgia/Rus. Fed. 91 G2
Tecate Mex. 128 E5
Tece Turkey 85 B1
Techiman Ghana 96 C4
Tecka Arg. 144 B6
Tecklenburger Land reg. Germany
53 H2
Tecoripa Mex. 127 F7
Técpan Mex. 136 D5
Tecuala Mex. 136 C4
Tecuci Romania 59 L2
Tecumseh MI U.S.A. 134 D3
Tecumseh NE U.S.A. 130 D3
Tedzhen Turkm. see Tejen
Teec Nos Pos U.S.A. 129 I3
Tees r. U.K. 48 F4
Teeswater Canada 134 E1
Tefé r. Brazil 142 F4
Tefenni Turkey 59 M6
Tegal Indon. 68 D8
Tegel airport Germany 53 N2
Tegid, Llyn l. Wales U.K. see Bala Lake

▶Tegucigalpa Hond. 137 G6
Capital of Honduras.

Teguidda-n-Tessoumt Niger 96 D3
Tehachapi U.S.A. 128 D4
Tehachapi Mountains U.S.A. 128 D4
Tehachapi Pass U.S.A. 128 D4
Tehek Lake Canada 121 M1
Teheran Iran see Tehrān
Tehery Lake Canada 121 M1
Téhini Côte d'Ivoire 96 C4

▶Tehrān Iran 88 C3
Capital of Iran.

Tehri India see Tikamgarh
Tehuacán Mex. 136 E5
Tehuantepec, Golfo de Mex. see
Tehuantepec, Gulf of
Tehuantepec, Gulf of Mex. 136 F5
Tehuantepec, Istmo de isthmus Mex.
136 F5
Teide, Pico del vol. Canary Is 96 B2
Teifi r. U.K. 49 C6
Teignmouth U.K. 49 D8
Teixeira de Sousa Angola see Luau
Teixeiras Brazil 145 C3
Teixeira Soares Brazil 145 A4
Tejakula Indon. 108 A2
Tejen Turkm. 89 F2
Tejo r. Port. 57 B4 see Tagus
Tejon Pass U.S.A. 128 D4
Tekapo, Lake N.Z. 113 C6
Tekax Mex. 136 G4
Tekeli Kazakh. 80 E3
Tekes China 80 F3
Tekezē r. Eritrea/Eth. see Setit
Tekirdağ Turkey 59 L4
Tekka India 84 D2
Tekkali India 84 E2
Teknaf Bangl. 83 H5
Tekong Kechil, Pulau i. Sing. 71 [inset]
Te Kuiti N.Z. 113 E4
Tel r. India 84 D1
Télagh Alg. 57 F6
Telanaipura Indon. see Jambi
Tel Ashqelon tourist site Israel 85 B4
Télataï Mali 96 D3
Tel Aviv-Yafo Israel 85 B3
Telč Czech Rep. 47 O6
Telchac Puerto Mex. 136 G4
Telegraph Creek Canada 120 D3
Telekhany Belarus see Tsyelyakhany
Telêmaco Borba Brazil 145 A4
Teleorman r. Romania 59 K3
Telescope Peak U.S.A. 128 E3
Teles Pires r. Brazil 143 G5
Telford U.K. 49 E6
Telgte Germany 53 H3
Télimélé Guinea 96 B3
Teljo, Jebel mt. Sudan 86 C7
Telkwa Canada 120 E4
Tell Atlas mts Alg. see Atlas Tellien
Tell City U.S.A. 134 B5
Teller U.S.A. 118 B3
Tell es Sultan West Bank see Jericho
Tellicherry India 84 B4
Tellin Belgium 52 F4
Telloh Iraq 91 G5

Telluride U.S.A. 129 J3
Tel'novskiy Rus. Fed. 74 F2
Telok Anson Malaysia see Teluk Intan
Telo Martius France see Toulon
Tel'pos-Iz, Gora mt. Rus. Fed. 41 R3
Telsen Arg. 144 C6
Telšiai Lith. 45 M9
Teltow Germany 53 N2
Teluk Anson Malaysia see Teluk Intan
Telukbetung Indon. see
Bandar Lampung
Teluk Cenderawasih, Taman Nasional
Indon. 69 I7
Teluk Intan Malaysia 71 C6
Temagami Lake Canada 122 F5
Temanggung Indon. 68 E8
Têmarxung China 83 G2
Temba S. Africa 101 I3
Tembagapura Indon. 69 J7
Tembenchi r. Rus. Fed. 65 K3
Tembilahan Indon. 68 C7
Tembisa S. Africa 101 I4
Tembo Aluma Angola 99 B4
Teme r. U.K. 49 E6
Temecula U.S.A. 128 E5
Temerloh Malaysia see Temerluh
Temerluh Malaysia 71 C7
Teminabuan Indon. 69 I7
Temirtau Kazakh. 80 D1
Témiscamie r. Canada 123 G4
Témiscamie, Lac l. Canada 123 G4
Témiscamingue Canada 122 F5
Témiscamingue, Lac l. Canada 122 F5
Témiscouata, Lac l. Canada 123 H5
Temmes Fin. 44 N4
Temnikov Rus. Fed. 43 I5
Temora Australia 112 C5
Temósachic Mex. 127 G7
Tempe U.S.A. 129 H5
Tempe Downs Australia 109 F6
Tempelhof airport Germany 53 N2
Temple MI U.S.A. 134 C1
Temple TX U.S.A. 131 D6
Temple Bar U.K. 49 C6
Temple Dera Pak. 89 H4
Templemore Ireland 51 E5
Temple Sowerby U.K. 48 E4
Templeton watercourse Australia 110 B4
Templin Germany 53 N1
Tempué Angola 99 B5
Temryuk Rus. Fed. 90 E1
Temryukskiy Zaliv b. Rus. Fed. 43 H7
Temuco Chile 144 B5
Temuka N.Z. 113 C7
Temuli China see Butuo
Tena Ecuador 142 C4
Tenabo Mex. 136 F4
Tenabo, Mount U.S.A. 128 E1
Tenali India 84 D2
Tenasserim Myanmar 71 B4
Tenasserim r. Myanmar 71 B4
Tenbury Wells U.K. 49 E6
Tenby U.K. 49 C7
Tendaho Eth. 98 E2
Tende, Col de pass France/Italy 56 H4
Ten Degree Channel India 71 A5
Tendô Japan 75 F5
Tenedos i. Turkey see Bozcaada
Ténenkou Mali 96 C3
Ténéré reg. Niger 96 D2
Ténéré du Tafassâsset des. Niger 96 E2
Tenerife i. Canary Is 96 B2
Ténès Alg. 57 G5
Teng, Nam r. Myanmar 70 B3
Tengah, Kepulauan is Indon. 68 F8
Tengah, Sungai r. Sing. 71 [inset]
Tengcheng China see Tengxian
Tengchong China 76 C3
Tengeh Reservoir Sing. 71 [inset]
Tengger Shamo des. China 72 I5
Tenggul i. Malaysia 71 C6
Tengiz, Ozero salt l. Kazakh. 80 C1
Tengqiao China 77 F5
Tengréla Côte d'Ivoire 96 C3
Ten'gushevo Rus. Fed. 43 I5
Tengxian China 77 F4
Teni India see Theni
Teniente Jubany research station Antarctica
see Jubany
Tenille U.S.A. 133 D6
Tenke Dem. Rep. Congo 99 C5
Tenkeli Rus. Fed. 65 P2
Tenkodogo Burkina 96 C3
Ten Mile Lake salt flat Australia 109 C6
Ten Mile Lake Canada 123 K4
Tennant Creek Australia 108 F4
Tennessee r. U.S.A. 131 F4
Tennessee state U.S.A. 134 C5
Tennessee Pass U.S.A. 126 G5
Tennevoll Norway 44 J2
Tenojoki r. Fin./Norway 44 P1
Tenosique Mex. 136 F5
Tenteno Indon. 69 G7
Tenterden U.K. 49 H7
Tenterfield Australia 112 F2
Ten Thousand Islands U.S.A. 133 D7
Tentudia mt. Spain 57 C4
Tentulia Bangl. see Tetulia
Teodoro Sampaio Brazil 144 F2
Teófilo Otôni Brazil 145 C2
Tepa Indon. 108 E1
Tepache Mex. 127 F7
Te Paki N.Z. 113 D2
Tepatitlán Mex. 136 D4
Tepehuanes Mex. 131 B7
Tepeköy Turkey see Karakoçan
Tepelenë Albania 59 I4
Tepelská vrchovina hills
Czech Rep. 53 M5
Tepequem, Serra mts Brazil 137 L8
Tepic Mex. 136 D4
Te Pirita N.Z. 113 C6
Teplá r. Czech Rep. 53 M4
Teplice Czech Rep. 47 N5
Teplogorka Rus. Fed. 42 L3
Teploozersk Rus. Fed. 74 C2
Teploye Rus. Fed. 43 H5
Teploye Ozero Rus. Fed. see
Teploozersk
Tepoca, Cabo c. Mex. 127 E7
Tepopa, Punta pt Mex. 127 E7
Tequila Mex. 136 D4

Toad r. Canada **120** E3
Toad River Canada **120** E3
Toamasina Madag. **99** E5
Toana mts U.S.A. **129** F1
Toano U.S.A. **135** G5
Toa Payoh Sing. **71** [inset]
Toba China **76** C2
Toba, Danau l. Indon. **71** B7
Toba, Lake Indon. see **Toba, Danau**
Toba and Kakar Ranges mts Pak. **89** G4
Toba Gargaji Pak. **89** I4
Tobago i. Trin. and Tob. **137** L6
Tobelo Indon. **69** H6
Tobermorey Australia **110** B4
Tobermory Australia **112** A1
Tobermory Canada **134** E1
Tobermory U.K. **50** C4
Tobi i. Palau **69** I6
Tobin, Lake salt flat Australia **108** D5
Tobin, Mount U.S.A. **128** E1
Tobin Lake Canada **121** K4
Tobin Lake l. Canada **121** K4
Tobi-shima i. Japan **75** E5
Tobol r. Kazakh./Rus. Fed. **78** F1
Tobol'sk Rus. Fed. **64** H4
Tobruk Libya see **Tubruq**
Tobseda Rus. Fed. **42** L1
Tobyl r. Kazakh./Rus. Fed. see **Tobol**
Tobysh r. Rus. Fed. **42** K2
Tocache Nuevo Peru **142** C5
Tocantinópolis Brazil **143** I5
Tocantins r. Brazil **145** A1
Tocantins state Brazil **145** A1
Tocantinzinha r. Brazil **145** A1
Toccoa U.S.A. **133** D5
Tochi r. Pak. **89** H3
Töcksfors Sweden **45** G7
Tocopilla Chile **144** B2
Tocumwal Australia **112** B5
Tod, Mount Canada **120** G5
Todd watercourse Australia **110** A5
Todi Italy **58** E3
Todoga-saki pt Japan **75** F5
Todos Santos Mex. **136** B4
Toe Head hd U.K. **50** B3
Tofino Canada **120** E5
Toft U.K. **50** [inset]
Tofua i. Tonga **107** I3
Togatax China **82** E2
Togian i. Indon. **69** G7
Togian, Kepulauan is Indon. **69** G7
Togliatti Rus. Fed. see **Tol'yatti**
▶Togo country Africa **96** D4
Africa 7, 94–95
Togtoh China **73** K4
Togton He r. China **83** H2
Togton Heyan China see **Tanggulashan**
Tohatchi U.S.A. **129** I4
Toholampi Fin. **44** N5
Toiba China **83** G3
Toibalewe India **71** A5
Toijala Fin. **45** M6
Toili Indon. **69** G7
Toi-misaki pt Japan **75** C7
Toivakka Fin. **44** O5
Toiyabe Range mts U.S.A. **128** E2
Tojikiston country Asia see **Tajikistan**
Tok U.S.A. **120** A2
Tokar Sudan **86** E6
Tokara-rettō is Japan **75** C7
Tokarevka Rus. Fed. **43** I6
Tokat Turkey **90** E2
Tŏkchŏk-to i. S. Korea **75** B5
Tokdo i. N. Pacific Ocean see **Liancourt Rocks**
▶Tokelau terr. S. Pacific Ocean **107** I2
New Zealand Overseas Territory.
Oceania 8, 104–105
Tokmak Kyrg. see **Tokmok**
Tokmak Ukr. **43** G7
Tokmok Kyrg. **80** E3
Tokomaru Bay N.Z. **113** G4
Tokoroa N.Z. **113** E4
Tokoza S. Africa **101** I4
Toksun China **80** G3
Tok-tō i. N. Pacific Ocean see **Liancourt Rocks**
Toktogul Kyrg. **80** D3
Tokto-ri i. N. Pacific Ocean see **Liancourt Rocks**
Tokur Rus. Fed. **74** D1
Tokushima Japan **75** D6
Tokuyama Japan **75** C6
▶Tōkyō Japan **75** E6
Capital of Japan. Most populous city in the world and in Asia.
Tokzār Afgh. **89** G3
Tolaga Bay N.Z. **113** G4
Tôlañaro Madag. **99** E6
Tolbo Mongolia **80** H2
Tolbukhin Bulg. see **Dobrich**
Tolbuzino Rus. Fed. **74** B1
Toledo Brazil **144** F2
Toledo Spain **57** D4
Toledo IA U.S.A. **130** E3
Toledo OH U.S.A. **134** D3
Toledo OR U.S.A. **126** C3
Toledo, Montes de mts Spain **57** D4
Toledo Bend Reservoir U.S.A. **131** E6
Toletum Spain see **Toledo**
Toliara Madag. **99** E6
Tolitoli Indon. **69** G6
Tol'ka Rus. Fed. **64** J3
Tolleson U.S.A. **129** G5
Tollimarjon Uzbek. **89** G2
Tolmachevo Rus. Fed. **45** P7
Tolo Dem. Rep. Congo **98** B4
Tolo Channel H.K. China **77** [inset]
Tolochin Belarus see **Talachyn**
Tolo Harbour b. H.K. China **77** [inset]
Tolosa France see **Toulouse**
Tolosa Spain **57** E2
Toluca Mex. **136** E5
Toluca de Lerdo Mex. see **Toluca**
To-lun Nei Mongol China see **Dolonnur**
Tol'yatti Rus. Fed. **43** K5
Tom' r. Rus. Fed. **74** B2
Tomah U.S.A. **130** F3

Tomakomai Japan **74** F4
Tomales U.S.A. **128** B2
Tomali Indon. **69** G7
Tomamae Japan **74** F3
Tomanivi mt. Fiji **107** H3
Tomar Brazil **142** F4
Tomar Port. **57** B4
Tomari Rus. Fed. **74** F3
Tomarza Turkey **90** D3
Tomaszów Lubelski Poland **43** D6
Tomaszów Mazowiecki Poland **47** R5
Tomatin U.K. **50** F3
Tomatlán Mex. **136** C5
Tomazina Brazil **145** A3
Tombador, Serra do hills Brazil **143** G6
Tombigbee r. U.S.A. **133** C6
Tomboco Angola **99** B4
Tombouctou Mali see **Timbuktu**
Tombstone U.S.A. **127** F7
Tombua Angola **99** B5
Tom Burke S. Africa **101** H2
Tomdibuloq Uzbek. **80** B3
Tome Moz. **101** L2
Tomelilla Sweden **45** H9
Tomelloso Spain **57** E4
Tomi Romania see **Constanța**
Tomingley Australia **112** D4
Tomini, Teluk g. Indon. **69** G7
Tominian Mali **96** C3
Tomintoul U.K. **50** F3
Tomislavgrad Bos.-Herz. **58** G3
Tomkinson Ranges mts Australia **109** E6
Tømmerneset Norway **44** I3
Tommot Rus. Fed. **65** N4
Tomo r. Col. **142** E2
Tomóchic Mex. **127** G7
Tomortei China **73** K4
Tompkinsville U.S.A. **134** C5
Tom Price Australia **108** B5
Tomra China **83** F3
Tomsk Rus. Fed. **64** J4
Toms River U.S.A. **135** H4
Tomtabacken hill Sweden **45** I8
Tomtor Rus. Fed. **65** P3
Tomur Feng mt. China/Kyrg. see **Pobeda Peak**
Tomuzlovka r. Rus. Fed. **43** J7
Tom White, Mount U.S.A. **118** D3
Tonalá Mex. **136** F5
Tonantins Brazil **142** E4
Tonb-e Bozorg, Jazīreh-ye i. The Gulf see **Greater Tunb**
Tonb-e Kūchek, Jazīreh-ye i. The Gulf see **Lesser Tunb**
Tonbridge U.K. **49** H7
Tondano Indon. **69** G6
Tønder Denmark **45** F9
Tondi India **84** C4
Tone r. U.K. **49** E7
Toney Mountain Antarctica **152** K1
▶Tonga country S. Pacific Ocean **107** I4
Oceania 8, 104–105
Tongaat S. Africa **101** J5
Tongariro National Park N.Z. **113** E4
Tongatapu Group is Tonga **107** I4
▶Tonga Trench sea feature S. Pacific Ocean **150** I7
2nd deepest trench in the world.
Tongbai Shan mts China **77** G1
Tongcheng China **77** H2
T'ongch'ŏn N. Korea **75** B5
Tongchuan Shaanxi China **77** F1
Tongchuan Sichuan China see **Santai**
Tongdao China **77** F3
Tongde China **76** D1
Tongduch'ŏn S. Korea **75** B5
Tongeren Belgium **52** F4
Tonggu China **77** G2
Tonggu Zui pt China **77** F5
Tonghae S. Korea **75** C5
Tonghai China **76** D3
Tonghe China **74** C3
Tonghua Jilin China **74** B4
Tonghua Jilin China **74** B4
Tongi Bangl. see **Tungi**
Tongjiang Heilong. China **74** D3
Tongjiang Sichuan China **76** E2
Tongking, Gulf of China/Vietnam **70** E2
Tongle China see **Leye**
Tongliang China **76** E2
Tongliao China **73** M4
Tongling China **77** H2
Tonglu China **77** H2
Tongo Australia **112** A3
Tongo Lake salt flat Australia **112** A3
Tongren Guizhou China **77** F3
Tongren Qinghai China **76** D1
Tongres Belgium see **Tongeren**
Tongsa Bhutan **83** G4
Tongshan Jiangsu China see **Xuzhou**
Tongshi Hainan China see **Wuzhishan**
Tongta Myanmar **70** B2
Tongtian He r. Qinghai China **76** B1
Tongtian He r. Qinghai China **76** C1 see **Yangtze**
Tongue U.K. **50** E2
Tongue r. U.S.A. **126** G3
Tongue of the Ocean sea chan. Bahamas **133** E7
Tongxin China **72** J5
T'ongyŏng S. Korea **75** C6
Tongzi China **76** E2
Tónichi Mex. **127** F7
Tonk India **82** C4
Tonkābon Iran **88** C2
Tonkin reg. Vietnam **70** D2
Tônle Repou r. Laos **71** D4
Tônlé Sab l. Cambodia see **Tonle Sap**
▶Tonle Sap l. Cambodia **71** C4
Largest lake in Southeast Asia.
Tonopah AZ U.S.A. **129** G5
Tonopah NV U.S.A. **128** E2
Tønsberg Norway **45** G7
Tonstad Norway **45** E7
Tonto Creek watercourse U.S.A. **129** H5
Tonvarjeh Iran **88** E3
Tonzang Myanmar **70** A2

Tonzi Myanmar **70** A1
Toobeah Australia **112** D2
Toobli Liberia **96** C4
Tooele U.S.A. **129** G1
Toogoolawah Australia **112** F1
Tooma r. Australia **112** D6
Toompine Australia **112** B1
Toora Australia **112** C7
Tooraweenah Australia **112** D3
Toorberg mt. S. Africa **100** G7
Toowoomba Australia **112** E1
Tooxin Somalia **98** F2
Top Afgh. **89** H3
Top Boğazı Geçidi pass Turkey **85** C1
▶Topeka U.S.A. **130** E4
State capital of Kansas.
Topia Mex. **127** G8
Töplitz Germany **53** M2
Topolčany Slovakia **47** Q6
Topolobampo Mex. **127** F8
Topolovgrad Bulg. **59** L3
Topozero, Ozero l. Rus. Fed. **44** R4
Topsfield U.S.A. **132** H2
Tor Eth. **97** G4
Tor Baldak mt. Afgh. **89** G4
Torbalı Turkey **59** L5
Torbat-e Heydarīyeh Iran **88** E3
Torbat-e Jām Iran **89** F3
Torbay Bay Australia **109** B8
Torbert, Mount U.S.A. **118** C3
Torbeyevo Rus. Fed. **43** I5
Torch r. Canada **121** K4
Tordesillas Spain **57** D3
Tordesilos Spain **57** F3
Töre Sweden **44** M4
Torelló Spain **57** H2
Torenberg hill Neth. **52** F2
Toretam Kazakh. see **Baykonur**
Torgau Germany **53** M3
Torghay Kazakh. see **Turgay**
Torgun r. Rus. Fed. **43** J6
Torhout Belgium **52** D3
Torino Italy see **Turin**
Tori-shima i. Japan **75** F7
Torit Sudan **97** G4
Torkamān Iran **88** B2
Torkovichi Rus. Fed. **42** F4
Tormes r. Spain **57** C3
Tornado Mountain Canada **120** H5
Torneå Fin. see **Tornio**
Torneälven r. Sweden **44** N4
Torneträsk l. Sweden **44** L2
Torngat, Monts mts Canada see **Torngat Mountains**
Torngat Mountains Canada **123** I2
Tornio Fin. **44** N4
Toro Spain **57** D3
Toro, Pico del mt. Mex. **131** C7
Torom Rus. Fed. **74** D1
Toro Peak U.S.A. **128** E5
Toropets Rus. Fed. **42** F4
Tororo Uganda **98** D3
Toros Dağları mts Turkey see **Taurus Mountains**
Torphins U.K. **50** G3
Torquay Australia **112** B7
Torquay U.K. **49** D8
Torrance U.S.A. **128** D5
Torrão Port. **57** B4
Torre mt. Port. **57** C3
Torreblanca Spain **57** G3
Torre Blanco, Cerro mt. Mex. **127** E6
Torrecerredo mt. Spain **57** D2
Torre del Greco Italy **58** F4
Torre de Moncorvo Port. **57** C3
Torrelavega Spain **57** D2
Torremolinos Spain **57** D5
▶Torrens, Lake imp. l. Australia **111** B6
2nd largest lake in Oceania.
Torrens Creek Australia **110** D4
Torrent Spain **57** F4
Torrente Spain see **Torrent**
Torreón Mex. **131** C7
Torres Brazil **145** A5
Torres Mex. **127** F7
Torres del Paine, Parque Nacional nat. park Chile **144** B8
Torres Islands Vanuatu **107** G3
Torres Novas Port. **57** B4
Torres Strait Australia **106** E2
Torres Vedras Port. **57** B4
Torrevieja Spain **57** F5
Torrey U.S.A. **129** H2
Torridge r. U.K. **49** C8
Torridon, Loch b. U.K. **50** D3
Torrijos Spain **57** D4
Torrington Australia **112** E2
Torrington CT U.S.A. **132** F3
Torrington WY U.S.A. **126** G4
Torsby Sweden **45** H6
▶Tórshavn Faroe Is **44** [inset]
Capital of the Faroe Islands.
Tortilla Flat U.S.A. **129** H5
To'rtko'l Uzbek. **80** B3
Törtköl Uzbek. see **To'rtko'l**
Tortoli Sardinia Italy **58** C5
Tortona Italy **58** C2
Tortosa Spain **57** G3
Tortum Turkey **91** F2
Ţorūd Iran **88** D3
Torugart, Pereval pass China/Kyrg. see **Turugart Pass**
Torul Turkey **91** F2
Toruń Poland **47** Q4
Tory Island Ireland **51** D2
Tory Sound sea chan. Ireland **51** D2
Torzhok Rus. Fed. **42** G4
Tosa Japan **75** D6
Tosa-wan b. Japan **75** D6
Tosca S. Africa **100** F3
Toscano, Arcipelago is Italy **58** C3
Tosham India **82** C3
Töshima-yama mt. Japan **75** F4

▶Toshkent Uzbek. **80** C3
Capital of Uzbekistan.
Tosno Rus. Fed. **42** F4
Toson Hu l. China **83** I1
Tostado Arg. **144** D3
Tostedt Germany **53** J1
Tosya Turkey **90** D2
Totapola mt. Sri Lanka **84** D5
Tôtes France **52** B5
Tot'ma Rus. Fed. **42** I4
Totness Suriname **143** G2
Tottenham Australia **112** C4
Totton U.K. **49** F8
Tottori Japan **75** D6
Touba Côte d'Ivoire **96** C4
Touba Senegal **96** B3
Toubkal, Jbel mt. Morocco **54** C5
Toubkal, Parc National nat. park Morocco **54** C5
Touboro Cameroon **97** E4
Tougan Burkina **96** C3
Touggourt Alg. **54** F5
Tougué Guinea **96** B3
Touil Mauritania **96** B3
Toul France **52** F6
Touliu Taiwan **77** I4
Toulon France **56** G5
Toulon U.S.A. **130** F3
Toulouse France **56** E5
Toumodi Côte d'Ivoire **96** C4
Toupai China **77** F3
Tourane Vietnam see **Đa Nang**
Tourcoing France **52** D4
Tourgis Lake Canada **121** J1
Tourlaville France **49** F9
Tournai Belgium **52** D4
Tournon-sur-Rhône France **56** G4
Tournus France **58** A1
Touros Brazil **143** K5
Tours France **56** E3
Tousside, Pic mt. Chad **97** E2
Toussoro, Mont mt. Cent. Afr. Rep. **98** C3
Toutai China **74** B3
Touwsrivier S. Africa **100** E7
Toužim Czech Rep. **53** M4
Tovarkovo Rus. Fed. **43** H5
Tovil'-Dora Tajik. see **Tavildara**
Tovuz Azer. **91** G2
Towada Japan **74** F4
Towak Mountain hill U.S.A. **118** B3
Towanda U.S.A. **135** G3
Towaoc U.S.A. **129** I3
Towcester U.K. **49** G6
Tower Ireland **51** D6
Towner U.S.A. **130** C1
Townes Pass U.S.A. **128** E3
Townsend, Mount Australia **112** D6
Townshend Island Australia **110** E4
Townsville Australia **110** D3
Towot Sudan **97** G4
Towr Kham Afgh. **89** H3
Towson U.S.A. **135** G4
Towyn U.K. see **Tywyn**
Toy U.S.A. **128** D1
Toyah U.S.A. **131** C6
Toyama Japan **75** E5
Toyama-wan b. Japan **75** E5
Toyohashi Japan **75** E6
Toyokawa Japan **75** E6
Toyonaka Japan **75** D6
Toyooka Japan **75** D6
Toyota Japan **75** E6
Tozanlı Turkey see **Almus**
Tozê Kangri mt. China **83** E2
Tozeur Tunisia **54** F5
Tozi, Mount U.S.A. **118** C3
Tqibuli Georgia **91** F2
Traben Germany **52** H5
Trâblous Lebanon see **Tripoli**
Trabotivište Macedonia **59** J4
Trabzon Turkey **91** E2
Tracy CA U.S.A. **128** C3
Tracy MN U.S.A. **130** E2
Trading r. Canada **122** C4
Traer U.S.A. **130** E3
Trafalgar U.S.A. **134** B4
Trafalgar, Cabo c. Spain **57** C5
Traffic Mountain Canada **120** D2
Trail Canada **120** G5
Traill, Rubha na pt U.K. **50** D5
Traill Island Greenland see **Traill Ø**
Traill Ø i. Greenland **119** P2
Trainor Lake Canada **120** F2
Trajectum Neth. see **Utrecht**
Trakai Lith. **45** N9
Tra Khuc, Sông r. Vietnam **70** E4
Trakiya reg. Europe see **Thrace**
Traiguá reg. Europe see **Thrace**
Trakt Rus. Fed. **42** K3
Trakya reg. Europe see **Thrace**
Tralee Ireland **51** C5
Tralee Bay Ireland **51** C5
Trá Lí Ireland see **Tralee**
Tramandaí Brazil **145** A5
Tramán Tepui mt. Venez. **142** F2
Trá Mhór Ireland see **Tramore**
Tramore Ireland **51** E5
Tranås Sweden **45** I7
Trancas Arg. **144** C3
Trancoso Brazil **145** D2
Tranemo Sweden **45** H8
Tranent U.K. **50** G5
Trang Thai. **71** B6
Trangan i. Indon. **108** F1
Trangie Australia **112** C4
Trần Ninh, Cao Nguyên Laos **70** C3
Transantarctic Mountains Antarctica **152** H1
Trans Canada Highway Canada **121** H5
Transylvanian Alps mts Romania **59** J2
Transylvanian Basin plat. Romania **59** K1
Trapani Sicily Italy **58** E5
Trapezus Turkey see **Trabzon**
Trapper Peak U.S.A. **126** E3
Trappes France **52** C6
Traralgon Australia **112** C7

Traunsee l. Austria **47** N7
Traunstein Germany **47** N7
Travellers Lake imp. l. Australia **111** C7
Travers, Mount N.Z. **113** D6
Traverse City U.S.A. **134** C1
Tra Vinh Vietnam **71** D5
Travnik Bos.-Herz. **58** G2
Trbovlje Slovenia **58** F1
Tre, Hon i. Vietnam **71** E5
Treasury Islands Solomon Is **106** F2
Trebbin Germany **53** N2
Trebebvić nat. park Bos.-Herz. **58** H3
Třebíč Czech Rep. **47** O6
Trebinje Bos.-Herz. **58** H3
Trebišov Slovakia **43** D6
Trebnje Slovenia **58** F2
Trebon Turkey see **Trabzon**
Trebur Germany **53** I5
Tree Island India **84** B4
Trefaldwyn U.K. see **Montgomery**
Treffurt Germany **53** K3
Treffynnon U.K. see **Holywell**
Trefyclawdd U.K. see **Knighton**
Trefynwy U.K. see **Monmouth**
Tregosse Islets and Reefs Australia **110** E3
Treinta y Tres Uruguay **144** F4
Trelew Arg. **144** C6
Trelleborg Sweden **45** H9
Trélon France **52** E4
Tremblant, Mont hill Canada **122** G5
Trembleur Lake Canada **120** E4
Tremiti, Isole is Italy **58** F3
Tremont U.S.A. **135** G3
Tremonton U.S.A. **126** E4
Tremp Spain **57** G2
Trenance U.K. **49** B8
Trenary U.S.A. **132** C2
Trenche r. Canada **123** G5
Trenčín Slovakia **47** Q6
Trendelburg Germany **53** J3
Trêng Cambodia **71** C4
Trenque Lauquén Arg. **144** D5
Trent Italy see **Trento**
Trent r. U.K. **48** G5
Trento Italy **58** D1
Trenton Canada **135** G1
Trenton FL U.S.A. **133** D6
Trenton GA U.S.A. **133** C5
Trenton KY U.S.A. **134** B5
Trenton MO U.S.A. **130** E3
Trenton NC U.S.A. **133** E5
Trenton NE U.S.A. **130** C3
▶Trenton NJ U.S.A. **135** H3
State capital of New Jersey.
Treorchy U.K. **49** D7
Trepassey Canada **123** L5
Tres Arroyos Arg. **144** D5
Tresco i. U.K. **49** A9
Três Corações Brazil **145** B3
Tres Esquinas Col. **142** C3
Três Lagoas Brazil **145** A3
Três Marias, Represa resr Brazil **145** B2
Tres Picachos, Sierra mts Mex. **127** G7
Tres Picos, Cerro mt. Arg. **144** D5
Três Pontas Brazil **145** B3
Tres Puntas, Cabo c. Arg. **144** C7
Três Rios Brazil **145** C3
Tretten Norway **45** G6
Tretya Severnyy Rus. Fed. see **3-y Severnyy**
Treuchtlingen Germany **53** K6
Treuenbrietzen Germany **53** M2
Treungen Norway **45** F7
Treves Germany see **Trier**
Treviglio Italy **58** C2
Treviso Italy **58** E2
Trevose Head hd U.K. **49** B8
Tri An, Hồ resr Vietnam **71** D5
Triánda Greece see **Trianta**
Triangle U.S.A. **135** G4
Trianta Greece **59** M6
Tri Brata, Gora hill Rus. Fed. **74** F1
Tribune U.S.A. **130** C4
Tricase Italy **58** H5
Trichinopoly India see **Tiruchchirappalli**
Trichur India **84** C4
Tricot France **52** C5
Trida Australia **112** B4
Tridentum Italy see **Trento**
Trier Germany **52** G5
Trieste Italy **58** E2
Trieste, Golfo di g. Europe see **Trieste, Gulf of**
Trieste, Gulf of Europe **58** E2
Triglav mt. Slovenia **58** E1
Triglavski narodni park nat. park Slovenia **58** E1
Trikala Greece **59** I5
Tríkkala Greece see **Trikala**
▶Trikora, Puncak mt. Indon. **69** J7
2nd highest mountain in Oceania.
Trim Ireland **51** F4
Trincomalee Sri Lanka **84** D4
Trindade Brazil **145** A2
Trindade, Ilha da i. S. Atlantic Ocean **148** G7
Trinidad Bol. **142** F6
Trinidad Cuba **137** I4
Trinidad i. Trin. and Tob. **137** L6
Trinidad Uruguay **144** E4
Trinidad U.S.A. **127** G5
Trinidad country West Indies see **Trinidad and Tobago**
▶Trinidad and Tobago country West Indies **137** L6
North America 9, 116–117
Trinity U.S.A. **131** E6
Trinity r. CA U.S.A. **128** B1
Trinity r. TX U.S.A. **131** E6
Trinity Bay Canada **123** L5
Trinity Islands U.S.A. **118** C4
Trinity Range mts U.S.A. **128** E1
Trinkat Island India **71** A5
Trionto, Capo c. Italy **58** G5
Tripa r. Indon. **71** B7

Tripkau Germany **53** L1
Tripoli Greece **59** J6
Tripoli Lebanon **85** B2
▶Tripoli Libya **97** E1
Capital of Libya.
Trípolis Greece see **Tripoli**
Trípolis Lebanon see **Tripoli**
Tripunittura India **84** C4
Tripura state India **83** G5
▶Tristan da Cunha i. S. Atlantic Ocean **148** H8
Dependency of St Helena.
Trisul mt. India **82** D3
Triton Canada **123** L4
Triton Island atoll Paracel Is **68** E3
Trittau Germany **53** K1
Trittenheim Germany **52** G5
Trivandrum India **84** C4
Trivento Italy **58** F4
Trnava Slovakia **47** P6
Trnovo Bos.-Herz. **58** H3
Trochu Canada **120** H5
Trofors Norway **44** H4
Trogir Croatia **58** G3
Troia Italy **58** F4
Troisdorf Germany **53** H4
Trois Fourches, Cap des c. Morocco **57** E6
Trois-Ponts Belgium **52** F4
Trois-Rivières Canada **123** G5
Troitsko-Pechorsk Rus. Fed. **41** R3
Troitskoye Altayskiy Kray Rus. Fed. **72** E2
Troitskoye Khabarovskiy Kray Rus. Fed. **74** E2
Troitskoye Respublika Kalmykiya - Khalm'g-Tangch Rus. Fed. **43** J7
Troll **152** B2
Trollhättan Sweden **45** H7
Trombetas r. Brazil **143** G4
Tromelin, Île i. Indian Ocean **149** L7
Tromelin Island Micronesia see **Fais**
Tromen, Volcán vol. Arg. **144** B5
Tromie r. U.K. **50** E3
Trompsburg S. Africa **101** G6
Tromsø Norway **44** K2
Trona U.S.A. **128** E4
Tronador, Monte mt. Arg. **144** B6
Trondheim Norway **44** G5
Trondheimsfjorden sea chan. Norway **44** F5
Trongsa Bhutan see **Tongsa**
Tro̅o̅dos, Mount Cyprus **85** A2
Tro̅o̅dos Mountains Cyprus **85** A2
Troon U.K. **50** E5
Tropeiros, Serra dos hills Brazil **145** B1
Tropic U.S.A. **129** G3
Tropic of Cancer **131** B8
Tropic of Capricorn **110** G4
Trosh Rus. Fed. **42** L2
Trostan hill U.K. **51** F2
Trotus r. Romania **59** L1
Trout r. B.C. Canada **120** E3
Trout r. N.W.T. Canada **120** G2
Trout Lake Alta Canada **120** H3
Trout Lake N.W.T. Canada **120** F2
Trout Lake l. N.W.T. Canada **120** F2
Trout Lake l. Ont. Canada **121** M5
Trout Peak U.S.A. **126** F3
Trout Run U.S.A. **135** G3
Trouville-sur-Mer France **49** H9
Trowbridge U.K. **49** E7
Troy tourist site Turkey see **Truva**
Troy AL U.S.A. **133** C6
Troy KS U.S.A. **130** E4
Troy MI U.S.A. **134** D2
Troy MO U.S.A. **130** F4
Troy MT U.S.A. **126** E2
Troy NH U.S.A. **135** I2
Troy NY U.S.A. **135** I2
Troy OH U.S.A. **134** C3
Troy PA U.S.A. **135** G3
Troyan Bulg. **59** K3
Troyes France **56** G2
Troy Lake U.S.A. **128** E4
Troy Peak U.S.A. **129** F2
Trstenik Serb. and Mont. **59** I3
Truc Giang Vietnam see **Bên Tre**
Trucial Coast country Asia see **United Arab Emirates**
Trucial States country Asia see **United Arab Emirates**
Trud Rus. Fed. **42** G4
Trufanovo Rus. Fed. **42** J2
Trujillo Hond. **137** G6
Trujillo Peru **142** C5
Trujillo Spain **57** D4
Trujillo Venez. **142** D2
Trujillo, Monte mt. Dom. Rep. see **Duarte, Pico**
Truk is Micronesia see **Chuuk**
Trulben Germany **53** H5
Trumbull, Mount U.S.A. **129** G3
Trumon Indon. **71** B7
Trundle Australia **112** C4
Trừng Hiệp Vietnam **70** D2
Trung Khanh Vietnam **70** D2
Truong Sa is S. China Sea see **Spratly Islands**
Truro Canada **123** J5
Truro U.K. **49** B8
Truskmore hill Ireland **51** D3
Trutch Canada **120** F3
Truth or Consequences U.S.A. **127** G6
Trutnov Czech Rep. **47** O5
Truuli Peak U.S.A. **118** C4
Truva tourist site Turkey see **Troy**
Trypiti, Akra pt Kriti Greece see **Trypiti, Akrotirio**
Trypiti, Akrotirio pt Greece **59** K7
Trysil Norway **45** H6
Trzebiatów Poland **47** O3
Tsagaannuur Mongolia **80** G2
Tsagaan-Uul Mongolia see **Sharga**
Tsagan Aman Rus. Fed. **43** J7
Tsagan-Nur Rus. Fed. **43** J7
Tsaidam Basin China see **Qaidam Pendi**
Tsaka La pass China/Jammu and Kashmir **82** D2
Tsalenjikha Georgia **91** F2
Tsaratanana, Massif du mts Madag. **99** E5

Tsarevo Bulg. 59 L3
Tsaris Mountains Namibia 100 C3
Tsaritsyn Rus. Fed. see Volgograd
Tsaukaib Namibia 100 B4
Tsavo East National Park Kenya 98 D4
Tsavo West National Park Africa 98 D3
Tsefat Israel see Zefat
Tselinograd Kazakh. see Astana
Tsenogora Rus. Fed. 42 J2
Tses Namibia 100 C3
Tsetsegnuur Mongolia 80 H2
Tsetseng Botswana 100 F2
Tsetserleg Arhangay Mongolia 80 J2
Tsetserleg Hövsgöl Mongolia see Halban
Tshabong Botswana 100 F4
Tshane Botswana 100 E3
Tshela Dem. Rep. Congo 99 B4
Tshibala Dem. Rep. Congo 99 C4
Tshikapa Dem. Rep. Congo 99 C4
Tshing S. Africa 101 H4
Tshipise S. Africa 101 J2
Tshitanzu Dem. Rep. Congo 99 C4
Tshofa Dem. Rep. Congo 99 C4
Tshokwane S. Africa 101 J3
Tsholotsho Zimbabwe 99 C5
Tshootsha Botswana 100 E2
Tshuapa r. Dem. Rep. Congo 97 F5
Tshwane S. Africa see Pretoria
Tsil'ma r. Rus. Fed. 42 K2
Tsimlyansk Rus. Fed. 43 I7
Tsimlyanskoye Vodokhranilishche resr
 Rus. Fed. 43 I7
Tsimmermanovka Rus. Fed. 74 E2
Tsinan China see Jinan
Tsineng S. Africa 100 F4
Tsinghai prov. China see Qinghai
Tsing Shan Wan H.K. China see
 Castle Peak Bay
Tsingtao China see Qingdao
Tsing Yi i. H.K. China 77 [inset]
Tsining China see Jining
Tsiombe Madag. 99 E6
Tsiroanomandidy Madag. 99 E5
Tsitsihar China see Qiqihar
Tsitsikamma Forest and Coastal National
 Park S. Africa 100 F8
Tsitsutl Peak Canada 120 E4
Tsivil'sk Rus. Fed. 42 J5
Tskhaltubo Georgia see Tsqaltubo
Ts'khinvali Georgia 91 F2
Tsna r. Rus. Fed. 43 I5
Tsnori Georgia 91 G2
Tsokar Chumo l. Jammu and Kashmir
 82 D2
Tsolo S. Africa 101 I6
Tsomo S. Africa 101 H7
Tsona China see Cona
Tsqaltubo Georgia 91 F2
Tsu Japan 75 E6
Tsuchiura Japan 75 F5
Tsuen Wan H.K. China 77 [inset]
Tsugarū-kaikyō strait Japan 74 F4
Tsugaru Strait Japan see Tsugarū-kaikyō
Tsumeb Namibia 99 B5
Tsumis Park Namibia 100 C2
Tsumkwe Namibia 99 C5
Tsuruga Japan 75 E6
Tsuruga'ga r. Rus. Fed. see Priargunsk
Tsuruoka Japan 75 E5
Tsurugi-san mt. Japan 75 D6
Tsushima is Japan 75 C6
Tsushima-kaikyō strait Japan/S. Korea see
 Korea Strait
Tsuyama Japan 75 D6
Tswaane Botswana 100 E2
Tswaraganang S. Africa 101 G5
Tswelelang S. Africa 101 G4
Tsyelyakhany Belarus 45 N10
Tsyp-Navolok Rus. Fed. 44 R2
Tsyurupyns'k Ukr. 59 O1
Tthenaagoo Canada see Nahanni Butte
Tua Dem. Rep. Congo 98 B4
Tual Indon. 69 I8
Tuam Ireland 51 D4
Tuamotu, Archipel des is Fr. Polynesia see
 Tuamotu Islands
Tuamotu Islands Fr. Polynesia 151 K6
Tuân Giao Vietnam 70 C2
Tuangku i. Indon. 71 B7
Tuapse Rus. Fed. 90 E1
Tuas Sing. 71 [inset]
Tuath, Loch a' b. U.K. 50 C2
Tuba City U.S.A. 129 H3
Tubarão Brazil 145 A5
Tubarjal Saudi Arabia 85 D4
Tübingen Germany 47 L6
Tubmanburg Liberia 96 B4
Tubruq Libya 90 A4
Tubuai i. Fr. Polynesia 151 K7
Tubuai Islands Fr. Polynesia 151 J7
Tucano Brazil 143 K6
Tucavaca Bol. 143 G7
Tüchen Germany 53 M1
Tuchheim Germany 53 M2
Tuchitua Canada 120 D2
Tuchodí r. Canada 120 F3
Tuckerton U.S.A. 135 H4
Tucopia i. Solomon Is see Tikopia
Tucson U.S.A. 129 H5
Tucson Mountains U.S.A. 129 H5
Tuctuc r. Canada 123 I2
Tucumán Arg. see
 San Miguel de Tucumán
Tucumcari U.S.A. 131 C5
Tucupita Venez. 142 F2
Tucuruí Brazil 143 I4
Tucuruí, Represa resr Brazil 143 I4
Tudela Spain 57 F2
Tuder Italy see Todi
Tuela r. Port. 57 C3
Tuen Mun H.K. China 77 [inset]
Tuensang India 83 H4
Tufts Abyssal Plain sea feature
 N. Pacific Ocean 151 L2
Tugela r. S. Africa 101 J5
Tuglung China 76 B2
Tuguegarao Phil. 69 G3
Tugur Rus. Fed. 74 E1
Tuhemberua Indon. 71 B7
Tujiabu China see Yongxiu

Tukangbesi, Kepulauan is Indon. 69 G8
Tukarak Island Canada 122 F2
Ţukhmān, Banī reg. Saudi Arabia 88 C6
Tukituki r. N.Z. 113 F4
Tuktoyaktuk Canada 118 E3
Tuktut Nogait National Park Canada
 118 F3
Tukums Latvia 45 M8
Tukuringra, Khrebet mts Rus. Fed. 74 B1
Tukuyu Tanz. 99 D4
Tula Rus. Fed. 43 H5
Tulach Mhór Ireland see Tullamore
Tulagt Ar Gol r. China 83 H1
Tulak Afgh. 89 F3
Tulameen Canada 120 F5
Tulancingo Mex. 136 E4
Tulare U.S.A. 128 D3
Tulare Lake Bed U.S.A. 128 D4
Tularosa Mountains U.S.A. 129 I5
Tulasi mt. India 84 D2
Tulcán Ecuador 142 C3
Tulcea Romania 59 M2
Tule r. U.S.A. 131 C5
Tuléar Madag. see Toliara
Tulemalu Lake Canada 121 L2
Tulia U.S.A. 131 C5
Tulihe China 74 A2
Tulita Canada 120 F2
Tulkarem West Bank see Ţulkarm
Ţulkarm West Bank 85 B3
Tulla Ireland 51 D5
Tullahoma U.S.A. 132 C5
Tullamore Australia 112 C4
Tullamore Ireland 51 E4
Tulle France 56 E4
Tullerāsen Sweden 44 I5
Tullibigeal Australia 112 C4
Tullow Ireland 51 F5
Tully Australia 110 D3
Tully r. Australia 110 D3
Tully U.K. 51 E3
Tulos Rus. Fed. 44 Q5
Tulsa U.S.A. 131 E4
Tulsipur Nepal 83 E3
Tuluá Col. 142 C3
Tuluksak U.S.A. 153 B2
Tulūl al Ashāqif hills Jordan 85 C3
Tulun Rus. Fed. 72 I2
Tulu-Tuloi, Serra hills Brazil 142 F3
Tuma r. Rus. Fed. 43 I5
Tumaco Col. 142 C3
Tumahole S. Africa 101 H4
Tumain China 83 G2
Tumannyy Rus. Fed. 44 S2
Tumasik Sing. see Singapore
Tumba Dem. Rep. Congo 98 C4
Tumba Sweden 45 J7
Tumba, Lac l. Dem. Rep. Congo 98 B4
Tumbarumba Australia 112 D5
Tumbes Peru 142 B4
Tumbler Ridge Canada 120 F4
Tumby Bay Australia 111 B7
Tumcha r. Fin./Rus. Fed. 44 Q3
 also known as Tuntsajoki
Tumen Jilin China 74 C4
Tumen Shaanxi China 77 F1
Tumereng Guyana 142 F2
Tumindao i. Phil. 68 F6
Tumiritinga Brazil 145 C2
Tumkur India 84 C3
Tummel r. U.K. 50 F4
Tummel, Loch l. U.K. 50 F4
Tumnin r. Rus. Fed. 74 F2
Tump Pak. 89 F5
Tumpat Malaysia 71 C6
Tumpôr, Phnum mt. Cambodia 71 C4
Tumshuk China see China
Tumu Ghana 96 C3
Tumucumaque, Serra hills Brazil 143 G3
Tumudibandh India 84 D2
Tumut Australia 112 D5
Tuna India 82 B5
Ţunb al Kubrá i. The Gulf see
 Greater Tunb
Ţunb aş Şughrá i. The Gulf see
 Lesser Tunb
Tunbridge Wells, Royal U.K. 49 H7
Tunceli Turkey 91 E3
Tunchang China 77 F5
Tuncurry Australia 112 F4
Tundun-Wada Nigeria 96 D3
Tunduru Tanz. 99 D5
Tunes Tunisia see Tunis
Tunga Nigeria 96 D4
Tungabhadra Reservoir India 84 C3
Tungi Bangl. 83 G5
Tung Lung Island H.K. China 77 [inset]
Tungnaá r. Iceland 44 [inset]
Tungor Rus. Fed. 74 F1
Tung Pok Liu Hoi Hap H.K. China see
 East Lamma Channel
T'ung-shan Jiangsu China see Xuzhou
Tung-sheng Nei Mongol China see Ordos
Tungsten Canada 120 D2
Tung Wan b. H.K. China 77 [inset]
Tuni India 84 D2
Tunica U.S.A. 131 F5
Tūnis country Africa see Tunisia
▶Tunis Tunisia 58 D6
 Capital of Tunisia.
Tunis, Golfe de g. Tunisia 58 D6
▶Tunisia country Africa 54 F5
 Africa 7, 94–95
Tunja Col. 142 D2
Tunkhannock U.S.A. 135 H3
Tunnsjøen l. Norway 44 H4
Tunstall U.K. 49 I6
Tuntsa Fin. 44 P3
Tuntsajoki r. Fin./Rus. Fed. see Tumcha
Tununak U.S.A. 118 B3
Tunungayualok Island Canada 123 J2
Tunxi China see Huangshan
Tuodian China see Shuangbai
Tuojiang China see Fenghuang
Tuŏl Khpos Cambodia 71 D5

Tuoniang Jiang r. China 76 E3
Tuotuo He r. China see Togton He
Tuotuoheyan China see Tanggulashan
Tüp Kyrg. 80 E3
Tupã Brazil 145 A3
Tupelo U.S.A. 131 F5
Tupik Rus. Fed. 73 L2
Tupinambarama, Ilha i. Brazil 143 G4
Tupiraçaba Brazil 145 A1
Tupiza Bol. 142 E8
Tupper Canada 120 F4
Tupper Lake U.S.A. 135 H1
Tupper Lake l. U.S.A. 135 H1
▶Tupungato, Cerro mt. Arg./Chile 144 C4
 5th highest mountain in South America.

Tuqayyid well Iraq 88 B4
Tuquan China 73 M3
Tuqu Wan b. China see Lingshui Wan
Tura China 83 F1
Tura India 83 G4
Tura r. Rus. Fed. 65 L3
Turabah Saudi Arabia 86 F5
Turakina N.Z. 113 E5
Turan Rus. Fed. 72 G2
Turana, Khrebet mts Rus. Fed. 74 C2
Turan Lowland Asia 80 A4
Turan Oypaty lowland Asia see
 Turan Lowland
Turan Pasttekisligi lowland Asia see
 Turan Lowland
Turan Pesligi lowland Asia see
 Turan Lowland
Turanskaya Nizmennost' lowland Asia see
 Turan Lowland
Ţurāq al 'Ilab hills Syria 85 D3
Turar Ryskulov Kazakh. 80 D3
Tura-Ryskulova Kazakh. see
 Turar Ryskulov
Ţurayf Saudi Arabia 85 D4
Turba Estonia 45 N7
Turbat Pak. 89 F5
Turbo Col. 142 C2
Turda Romania 59 J1
Türeh Iran 88 C3
Turfan China see Turpan
Turfan Basin depr. China see
 Turpan Pendi
Turfan Depression China see
 Turpan Pendi
Turgay Kazakh. 80 B2
Turgayskaya Dolina valley Kazakh. 80 B2
Türgovishte Bulg. 59 L3
Turgutlu Turkey 59 L5
Turhal Turkey 90 E2
Türi Estonia 45 N7
Turia r. Spain 57 F4
Turin Canada 121 H5
Turin Italy 58 B2
Turiy Rog Rus. Fed. 74 C3
Turkana, Lake salt l. Eth./Kenya 98 D3
 5th largest lake in Africa.

Turkestan Kazakh. 80 C3
Turkestan Range mts Asia 89 G2
▶Turkey country Asia/Europe 90 D3
 Asia 6, 62–63
Turkey U.S.A. 134 D5
Turkey r. U.S.A. 130 F3
Turki Rus. Fed. 43 I6
Türkistan Kazakh. see Turkestan
Türkiye country Asia/Europe see Turkey
Turkmenabat Lebap Turkm. see
 Türkmenabat
Türkmenabat Turkm. 89 F2
Türkmen Aylagy Turkm. see
 Ogurjaly Adasy
Türkmen Aýlagy b. Turkm. 88 D2
Türkmen Aýlagy b. Turkm. 88 D2
Türkmenbaşy Turkm. 88 D1
Türkmenbaşy Turkm. see Türkmenbaşy
Türkmenbaşy Aýlagy b. Turkm. see
 Türkmenbaşy Aýlagy
Türkmenbaşy Aýlagy b. Turkm. 88 D2
Türkmenbaşy Döwlet Gorugy nature res.
 Turkm. 88 D2
Türkmen Daği mt. Turkey 59 N5
▶Turkmenistan country Asia 87 I2
 Asia 6, 62–63
Turkmeniya country Asia see
 Turkmenistan
Türkmenostan country Asia see
 Turkmenistan
Turkmenskaya S.S.R. country Asia see
 Turkmenistan
Türkoğlu Turkey 90 E3
▶Turks and Caicos Islands terr.
 West Indies 137 J4
 United Kingdom Overseas Territory.
 North America 9, 116–117
Turks Island Passage Turks and Caicos Is
 133 G8
Turks Islands Turks and Caicos Is 137 J4
Turku Fin. 45 M6
Turkwel watercourse Kenya 98 D3
Turlock U.S.A. 128 C3
Turlock Lake U.S.A. 128 C3
Turmalina Brazil 145 C2
Turnagain r. Canada 120 E3
Turnagain, Cape N.Z. 113 F5
Turnberry U.K. 50 E5
Turnbull, Mount U.S.A. 129 H5
Turneffe Islands atoll Belize 136 G5
Turner U.S.A. 134 D1
Turner Valley Canada 120 H5
Turnhout Belgium 52 E3
Turnor Lake Canada 121 I3
Turnu Măgurele Romania see Turnu Măgurele
Turnu Severin Romania see
 Drobeta-Turnu Severin
Turon r. Australia 112 D4
Turones France see Tours
Turovets Rus. Fed. 42 I4
Turpan China 80 G3

▶Turpan Pendi depr. China 80 G3
 Lowest point in northern Asia.

Turquino, Pico mt. Cuba 137 I4
Turriff U.K. 50 G3
Turris Libisonis Sardinia Italy see
 Porto Torres
Tursāq Iraq 91 G4
Turtle Island Fiji see Vatoa
Turtle Lake Canada 121 I4
Turugart Pass China/Kyrg. 80 E3
Turugart Shankou pass China/Kyrg. see
 Turugart Pass
Turvo r. Brazil 145 A2
Turvo r. Brazil 145 A2
Turuvanur India 84 C3
Tusayan U.S.A. 129 G4
Tuscaloosa U.S.A. 133 C5
Tuscarawas r. U.S.A. 134 E3
Tuscarora Mountains hills U.S.A. 135 G3
Tuscola IL U.S.A. 130 F4
Tuscola TX U.S.A. 131 D5
Tuscumbia U.S.A. 133 C5
Tuskegee U.S.A. 133 C5
Tussey Mountains hills U.S.A. 135 F3
Tustin U.S.A. 134 C1
Tutak Turkey 91 F3
Tutayev Rus. Fed. 42 H4
Tutera Spain see Tudela
Tuticorin India 84 C4
Tutong Brunei 68 E6
Tuttle Creek Reservoir U.S.A. 130 D4
Tuttlingen Germany 47 L7
Tuttut Nunaat reg. Greenland 119 P2
Tutuala East Timor 108 D2
Tutubu P.N.G. 110 E1
Tutubu Tanz. 99 D4
Tutuila i. American Samoa 107 I3
Tutume Botswana 99 C6
Tutwiler U.S.A. 131 F5
Tuun-bong mt. N. Korea 74 B4
Tuupovaara Fin. 44 Q5
Tuusniemi Fin. 44 P5
▶Tuvalu country S. Pacific Ocean 107 H2
 Oceania 8, 104–105
Tuwayq, Jabal hills Saudi Arabia 86 G4
Tuwayq, Jabal mts Saudi Arabia 86 G5
Ţuwayyil ash Shihāq mt. Jordan 85 C4
Tuwwal Saudi Arabia 86 E5
Tuxpan Mex. 136 E4
Tuxtla Gutiérrez Mex. 136 F5
Tuya Lake Canada 120 D3
Tuyên Quang Vietnam 70 D2
Tuy Hoa Vietnam 71 E4
Tuz, Lake salt l. Turkey 90 D3
Tuz Gölü salt l. Turkey see Tuz, Lake
Tuzha Rus. Fed. 42 J4
Tuz Khurmātū Iraq 91 G4
Tuzla Bos.-Herz. 58 H2
Tuzla Turkey 85 B1
Tuzla Gölü lag. Turkey 59 L4
Tuzlov r. Rus. Fed. 43 I7
Tuzu r. Myanmar 70 A1
Tvedestrand Norway 45 F7
Tver' Rus. Fed. 42 G4
Twain Harte U.S.A. 128 C2
Tweed Canada 135 G1
Tweed r. U.K. 50 G5
Tweed Heads Australia 112 F2
Tweedie Canada 121 I4
Tweefontein S. Africa 100 D7
Twee Rivier Namibia 100 D3
Twentekanaal canal Neth. 52 G2
Twentynine Palms U.S.A. 128 E4
Twin Bridges CA U.S.A. 128 C2
Twin Bridges MT U.S.A. 126 E3
Twin Buttes Reservoir U.S.A. 131 C6
Twin Falls Canada 123 I3
Twin Falls U.S.A. 126 E4
Twin Heads hill Australia 108 D5
Twin Peak U.S.A. 128 C2
Twistringen Germany 53 I2
Twitchen Reservoir U.S.A. 128 C4
Twitya r. Canada 120 D1
Twizel 113 C7
Twofold Bay Australia 112 D6
Two Harbors U.S.A. 130 F2
Two Hills Canada 121 I4
Two Rivers U.S.A. 134 B1
Tyan' Shan' mts China/Kyrg. see Tien Shan
Tyao r. India/Myanmar 76 B3
Tyatya, Vulkan vol. Rus. Fed. 74 G3
Tydal Norway 44 G5
Tygart Valley U.S.A. 134 F4
Tygda Rus. Fed. 74 B1
Tygda r. Rus. Fed. 74 B1
Tyler U.S.A. 131 E5
Tylertown U.S.A. 131 F6
Tym' r. Rus. Fed. 74 F2
Tymovskoye Rus. Fed. 74 F2
Tynda Rus. Fed. 73 M1
Tyndall U.S.A. 130 D3
Tyndinskiy Rus. Fed. see Tynda
Tyne r. U.K. 48 F3
Tynemouth U.K. 48 F3
Tynset Norway 44 G5
Tyoploozersk Rus. Fed. see Teploozersk
Tyoploye Ozero Rus. Fed. see Teploozersk
Tyr Lebanon see Tyre
Tyras Ukr. see Bilhorod-Dnistrovs'kyy
Tyre Lebanon 85 B3
Tyree, Mount Antarctica 152 L1
Tyrma Rus. Fed. 74 D2
Tyrma r. Rus. Fed. 74 D2
Tyrnävä Fin. 44 N4
Tyrnavos Greece 59 J5
Tyrnyauz Rus. Fed. 91 F2
Tyrone U.S.A. 135 F3
Tyrrell r. Australia 112 A5
Tyrrell, Lake dry lake Australia 111 C7
Tyrrell Lake Canada 121 J2
Tyrrhenian Sea France/Italy 58 D4
Tyrus Lebanon see Tyre
Tysa r. Ukr. see Tisa
Tyukalinsk Rus. Fed. see Tyukalinsk
Tyulen'i Ostrova is Kazakh. 91 H1
Tyumen' Rus. Fed. 64 H4
Tyup Kyrg. see Tüp
Tyuratam Kazakh. see Baykonur
Tywi r. U.K. 49 C7
Tywyn U.K. 49 C6

Tzaneen S. Africa 101 J2
Tzia i. Greece 59 K6

U

Uaco Congo Angola see Waku-Kungo
Ualan atoll Micronesia see Kosrae
Uamanda Angola 99 C5
Uarc, Ras c. Morocco see
 Trois Fourches, Cap des
Uaroo Australia 109 A5
Uatumã r. Brazil 143 G4
Uauá Brazil 143 K5
Uaupés r. Brazil 142 E3
U'aylī, Wādī al watercourse
 Saudi Arabia 88 B5
U'aywij well Saudi Arabia 88 B4
U'aywij, Wādī al watercourse
 Saudi Arabia 91 F4
Ubá Brazil 145 C3
Ubaí Brazil 145 B2
Ubaitaba Brazil 145 D1
Ubangi r. Cent. Afr. Rep./Dem. Rep. Congo
 98 B4
Ubangi-Shari country Africa see
 Central African Republic
Ubauro Pak. 89 H4
Ubayyid, Wādī al watercourse
 Iraq/Saudi Arabia 91 F4
Ube Japan 75 C6
Úbeda Spain 57 E4
Uberaba Brazil 145 B2
Uberlândia Brazil 145 A2
Ubin, Pulau i. Sing. 71 [inset]
Ubly U.S.A. 134 D2
Ubolratna Reservoir Thai. 70 C3
Ubombo S. Africa 101 K4
Ubon Ratchathani Thai. 70 D4
Ubstadt-Weiher Germany 53 I5
Ubundu Dem. Rep. Congo 97 F5
Üçajy Turkm. 89 F2
Ucar Azer. 91 G2
Uçan Turkey 85 A1
Ucayali r. Peru 142 D4
Uch Pak. 89 H4
Üchajy Turkm. see Üçajy
Üchān Iran 88 C2
Ucharal Kazakh. 80 F2
Uchkeken Rus. Fed. 91 F2
Uchkuduk Uzbek. see Uchquduq
Uchquduq Uzbek. 80 B3
Uchte Germany 53 I2
Uchte r. Germany 53 L2
Uchto r. Pak. 89 G5
Uchur r. Rus. Fed. 65 O4
Uckermark reg. Germany 53 N1
Uckfield U.K. 49 H8
Ucluelet Canada 120 E5
Ucross U.S.A. 126 G3
Uda r. Rus. Fed. 73 J2
Uda r. Rus. Fed. 74 D1
Udachnoye Rus. Fed. 43 J7
Udachnyy Rus. Fed. 153 E2
Udagamandalam India see
 Udagamandalam
Udaipur Rajasthan India 82 C4
Udaipur Tripura India 83 G5
Udanti r. India/Myanmar 83 E5
Uday r. Ukr. 43 G6
Udayagiri India 84 C2
Udaygarh India 82 C5
Udhagamandalam India see
 Udagamandalam
Udhampur India 82 C2
Udia-Milai atoll Marshall Is see Bikini
Udimskiy Rus. Fed. 42 J3
Udine Italy 58 E1
Udit India 89 I5
Udjuktok Bay Canada 123 J3
Udmalaippettai India see Udumalaippettai
Udomlya Rus. Fed. 42 G4
Udon Thani Thai. 70 C3
Udskaya Guba b. Rus. Fed. 65 O4
Udskoye Rus. Fed. 74 D1
Udumalaippettai India 84 C4
Udupi India 84 B3
Udyl', Ozero l. Rus. Fed. 74 E1
Udzhary Azer. see Ucar
Udzungwa Mountains National Park
 Tanz. 99 D4
Uéa atoll New Caledonia see Ouvéa
Ueckermünde Germany 47 O4
Ueda Japan 75 E5
Uele r. Dem. Rep. Congo 98 C3
Uelen Rus. Fed. 65 U3
Uelzen Germany 53 K2
Uetersen Germany 53 J1
Uettingen Germany 53 J5
Uetze Germany 53 K2
Ufa Rus. Fed. 41 R5
Ufa r. Rus. Fed. 41 R5
Uffenheim Germany 53 K5
Ugab watercourse Namibia 99 B6
Ugalla r. Tanz. 99 D4
▶Uganda country Africa 98 D3
 Africa 7, 94–95
Ugie S. Africa 101 I6
Ŭiginak Iran 89 F5
Uglegorsk Rus. Fed. 74 F2
Uglich Rus. Fed. 42 H4
Ugljan i. Croatia 58 F2
Uglovoye Rus. Fed. 74 C2
Ugol'noye Rus. Fed. 65 P3
Ugol'nyye Kopi Rus. Fed. 65 S3
Ugra r. Rus. Fed. 43 G5
Uherské Hradiště Czech Rep. 47 P6
Úhlava r. Czech Rep. 53 N5
Uhrichsville U.S.A. 134 E3
Uíge Angola 99 B4

Ûijŏngbu S. Korea 75 B5
Ûiju N. Korea 75 B4
Uimaharju Fin. 44 Q5
Uinta Mountains U.S.A. 129 H1
Uis Mine Namibia 99 B6
Uitenhage S. Africa 101 G7
Uithoorn Neth. 52 E2
Uithuizen Neth. 52 G1
Uivak, Cape Canada 123 J2
Ujhani India 82 D4
Uji Japan 75 D6
Uji-guntō is Japan 75 C7
Ujiji Tanz. 99 D4
Ujjain India 82 C5
Ujung Pandang Indon. see Makassar
Újvidék Serb. and Mont. see Novi Sad
Ukal Sagar r. Brazil 82 C5
Ukata Nigeria 96 D3
'Ukayrishah well Saudi Arabia 88 B5
uKhahlamba-Drakensberg Park nat. park
 S. Africa 101 I5
Ukholovo Rus. Fed. 43 I5
Ukhrul India 83 H4
Ukhta Respublika Kareliya Rus. Fed. see
 Kalevala
Ukhta Respublika Komi Rus. Fed. 42 L3
Ukiah CA U.S.A. 128 B2
Ukiah OR U.S.A. 126 D3
Ukkusiksalik National Park 119 J3
Ukkusissat Greenland 119 M2
Ukmergė Lith. 45 N9
▶Ukraine country Europe 43 F6
 2nd largest country in Europe.
 Europe 5, 38–39

Ukrainskaya S.S.R. country Europe see
 Ukraine
Ukrayina country Europe see Ukraine
Uku-jima i. Japan 75 C6
Ukwi Botswana 100 E2
Ukwi Pan salt pan Botswana 100 E2
Ulaanbaatar Mongolia see Ulan Bator
Ulaangom Mongolia 80 H2
Ulan Australia 112 D4

▶Ulan Bator Mongolia 72 J3
 Capital of Mongolia.

Ulanbel' Kazakh. 80 D3
Ulan Erge Rus. Fed. 43 J7
Ulanhad China see Chifeng
Ulanhot China 74 A3
Ulan Hua China 73 K4
Ulan-Khol Rus. Fed. 43 J7
Ulan-Ude Rus. Fed. 73 J2
Ulan Ul Hu l. China 83 G2
Ulaş Turkey 90 E3
Ulawa Island Solomon Is 107 G2
Ulayyah reg. Saudi Arabia 88 B6
Ul'banskiy Zaliv b. Rus. Fed. 74 E1
Ulchin S. Korea 75 C5
Uldz r. Mongolia 73 L3
Uleåborg Fin. see Oulu
Ulefoss Norway 45 F7
Ülenurme Estonia 45 O7
Ulety Rus. Fed. 73 K2
Ulhasnagar India 84 B2
Uliastai China 73 L3
Uliastay Mongolia 80 I2
Uliatea i. Fr. Polynesia see Raiatea
Ulicoten Neth. 52 E3
Ulie atoll Micronesia see Woleai
Ulita r. Rus. Fed. 44 R2
Ulithi atoll Micronesia 69 J4
Ulladulla Australia 112 E5
Ullapool U.K. 50 D3
Ulla Ulla, Parque Nacional nat. park
 Bol. 142 E6
Ullava Fin. 44 M5
Ullersuaq c. Greenland 119 K2
Ullswater l. U.K. 48 E4
Ullŭng-do i. S. Korea 75 C5
Ulm Germany 47 L6
Ulmarra Australia 112 F2
Ulmen Germany 52 G4
Ulooowaranie, Lake salt flat
 Australia 111 B5
Ulricehamn Sweden 45 H8
Ulrum Neth. 52 G1
Ulsan S. Korea 75 C6
Ulsberg Norway 44 F5
Ulster reg. Ireland/U.K. 51 E3
Ulster U.S.A. 135 G3
Ulster Canal Ireland/U.K. 51 E3
Ultima Australia 112 A5
Ulubat Gölü l. Turkey 59 M4
Ulubey Turkey 59 M5
Uluborlu Turkey 59 N5
Uludağ mt. Turkey 59 M4
Uludağ Milli Parkı nat. park Turkey 59 M4
Ulugqat China see Wuqia
Ulu Kali, Gunung mt. Malaysia 71 C7
Ulukışla Turkey 90 D3
Ulundi S. Africa 101 J5
Ulungur Hu l. China 80 G2
Ulunkhan Rus. Fed. 73 K2
Uluqsaqtuuq Canada see Holman
Uluru hill Australia 109 E6
Uluru-Kata Tjuṯa National Park
 Australia 109 E6
Uluru National Park Australia see
 Uluru-Kata Tjuṯa National Park
Ulutau Kazakh. see Ulytau
Ulutau, Gory mts Kazakh. see
 Ulytau, Gory
Uluyatır Turkey 85 C1
Ulva i. U.K. 50 C4
Ulvenhout Neth. 52 E3
Ulverston U.K. 48 D4
Ulvsjön Sweden 45 I6
Ül'yanov Kazakh. see Ul'yanovskiy
Ul'yanovsk Rus. Fed. 43 K5
Ul'yanovskiy Kazakh. 80 D1
Ul'yanovskoye Kazakh. see Ul'yanovskiy
Ulysses U.S.A. 130 C4
Ulysses KY U.S.A. 134 D5
Ulytau Kazakh. 80 C2
Ulytau, Gory mts Kazakh. 80 C2
Uma Rus. Fed. 74 A1
Umalinskiy Rus. Fed. 74 D2
'Umān country Asia see Oman

Uman' Ukr. 43 F6
Umarao Pak. 89 G4
'Umarī, Qā' al salt pan Jordan 85 C4
Umaria India 82 E5
Umarkhed India 84 C2
Umarkot India 84 D2
Umarkot Pak. 89 H5
Umaroona, Lake salt flat Australia 111 B5
Umarpada India 82 C5
Umatilla U.S.A. 126 D3
Umba Rus. Fed. 42 G2
Umbagog Lake U.S.A. 135 J1
Umbeara Australia 109 F6
Umboi i. P.N.G. 69 L8
Umeå Sweden 44 L5
Umeälven r. Sweden 44 L5
Umfolozi r. S. Africa 101 K5
Umfreville Lake Canada 121 M5
Umhlanga Rocks S. Africa 101 J5
Umiiviip Kangertiva inlet Greenland
 119 N3
Umingmaktok Canada 153 L2
Umirzak Kazakh. 91 H2
Umiujaq Canada 122 F2
Umkomaas S. Africa 101 J6
Umlaiteng India 83 H4
Umlazi S. Africa 101 J5
Umm ad Daraj, Jabal mt. Jordan 85 B3
Umm al 'Amad Syria 85 C2
Umm al Jamājim well Saudi Arabia 88 B5
Umm al Qaywayn U.A.E. 88 D5
Umm al Qaiwain U.A.E. see
 Umm al Qaywayn
Umm ar Raqabah, Khabrat imp. l.
 Saudi Arabia 85 C5
Umm at Qalbān Saudi Arabia 91 F6
Umm az Zumūl well Oman 88 D6
Umm Bāb Qatar 88 C5
Umm Bel Sudan 86 C7
Umm Keddada Sudan 86 C7
Umm Lajj Saudi Arabia 86 E4
Umm Nukhaylah hill Saudi Arabia 85 D5
Umm Qaşr Iraq 91 G5
Umm Quşūr i. Saudi Arabia 90 D6
Umm Ruwaba Sudan 86 D7
Umm Sa'ad Libya 90 B5
Umm Sa'id Qatar 88 C5
Umm Shugeira Sudan 86 C7
Umm Wa'āl hill Saudi Arabia 85 D4
Umm Wazir well Saudi Arabia 88 B6
Umnak Island U.S.A. 118 B4
Um Phang Wildlife Reserve nature res.
 Thai. 70 B4
Umpqua r. U.S.A. 126 B4
Umpulo Angola 99 B5
Umraniye Turkey 59 N5
Umred India 84 C1
Umri India 82 D4
Umtali Zimbabwe see Mutare
Umtata S. Africa 101 I6
Umtentweni S. Africa 101 J6
Umuahia Nigeria 96 D4
Umuarama Brazil 144 F2
Umvuma Zimbabwe see Mvuma
Umzimkulu S. Africa 101 I6
Una r. Bos.-Herz./Croatia 58 G2
Una Brazil 145 D1
Una India 82 D3
'Unāb, Jabal al hill Jordan 85 C5
'Unāb, Wādī al watercourse Jordan 85 C4
Unaí Brazil 145 B2
Unalaska Island U.S.A. 118 B4
Unapool U.K. 50 D2
'Unayzah Saudi Arabia 86 F4
'Unayzah, Jabal hill Iraq 91 E4
Uncia Bol. 142 E7
Uncompahgre Peak U.S.A. 129 J2
Uncompahgre Plateau U.S.A. 129 I2
Undara National Park Australia 110 D3
Underberg S. Africa 101 I5
Underbool Australia 111 C7
Underwood U.S.A. 134 C4
Undur Indon. 69 I7
Unecha Rus. Fed. 43 G5
Ungama Bay Kenya see Ungwana Bay
Ungarie Australia 112 C4
Ungava, Baie d' b. Canada see Ungava Bay
Ungava, Péninsule d' pen. Canada 122 G1
Ungava Bay Canada 123 I2
Ungava Peninsula Canada see
 Ungava, Péninsule d'
Ungeny Moldova see Ungheni
Unggi N. Korea 74 C4
Ungheni Moldova 59 L1
Unguana Moz. 101 L2
Unguja i. Tanz. see Zanzibar Island
Unguz, Solonchakovyye Vpadiny salt flat
 Turkm. 88 E2
Üngüz Angyrsyndaky Garagum des.
 Turkm. 88 E1
Ungvár Ukr. see Uzhhorod
Ungwana Bay Kenya 98 E4
Uni Rus. Fed. 42 K4
União Brazil 143 J4
União da Vitória Brazil 145 A4
União dos Palmares Brazil 143 K5
Unimak Island U.S.A. 118 B4
Unini r. Brazil 142 F4
Union MO U.S.A. 130 F4
Union WV U.S.A. 134 E5
Union, Mount U.S.A. 129 G4
Union City OH U.S.A. 134 C3
Union City PA U.S.A. 134 F3
Union City TN U.S.A. 131 F4
Uniondale S. Africa 100 F7
Unión de Reyes Cuba 133 D8
▶Union of Soviet Socialist Republics
 Divided in 1991 into 15 independent
 nations: Armenia, Azerbaijan, Belarus,
 Estonia, Georgia, Kazakhstan, Kyrgyzstan,
 Latvia, Lithuania, Moldova, the Russian
 Federation, Tajikistan, Turkmenistan,
 Ukraine and Uzbekistan.

Union Springs U.S.A. 133 C5
Uniontown U.S.A. 134 F4
Unionville U.S.A. 135 G3
▶United Arab Emirates country Asia 88 D6
 Asia 6, 62–63
United Arab Republic country Africa see
 Egypt

Urisino Australia 112 A2
Urjala Fin. 45 M6
Urk Neth. 52 F2
Urkan Rus. Fed. 74 B1
Urkan r. Rus. Fed. 74 B1
Urla Turkey 59 L5
Urlingford Ireland 51 E5
Urluk Rus. Fed. 73 J2
Urmā aş Şughrá Syria 85 C1
Urmai China 83 F3
Urmia Iran 88 B2
Urmia, Lake salt l. Iran 88 B2
Urmston Road sea chan. H.K. China
 77 [inset]
Uromi Nigeria 96 D4
Uroševac Serb. and Mont. 59 I3
Urosozero Rus. Fed. 42 G3
Üroteppa Tajik. 89 H2
Urru Co salt l. China 83 F3
Urt Moron China 80 H4
Uruáchic Mex. 124 F6
Uruaçu Brazil 145 A1
Uruana Brazil 145 A1
Uruapan Baja California Mex. 127 D7
Uruapan Michoacán Mex. 136 D5
Urubamba r. Peru 142 D6
Urucara Brazil 143 G4
Urucu r. Brazil 142 F4
Uruçuca Brazil 145 D1
Uruçuí Brazil 143 J5
Uruçuí, Serra do hills Brazil 143 I5
Urucuia Brazil 145 B2
Urucurituba Brazil 143 G4
Uruguai r. Arg./Uruguay see Uruguay
Uruguaiana Brazil 144 E3
Uruguay r. Arg./Uruguay 144 E4
 also known as Uruguai
▶Uruguay country S. America 144 E4
 South America 9, 140–141
Uruhe China 74 B2
Urumchi China see Ürümqi
Ürümqi China 80 G3
Urundi country Africa see Burundi
Urup, Ostrov i. Rus. Fed. 73 S3
Urusha Rus. Fed. 74 A1
Urutaí Brazil 145 A2
Uryl' Kazakh. 80 G2
Uryupino Rus. Fed. 73 M2
Uryupinsk Rus. Fed. 43 I6
Ürzhar Kazakh. see Urdzhar
Urzhum Rus. Fed. 42 K4
Urziceni Romania 59 L2
Usa Japan 75 C6
Usa r. Rus. Fed. 42 M2
Uşak Turkey 59 M5
Usakos Namibia 100 B1
Usarp Mountains Antarctica 152 H2
Usborne, Mount hill Falkland Is 144 E8
Ushakova, Ostrov i. Rus. Fed. 64 I1
Ushant i. France see Ouessant, Île d'
Usharal Kazakh. see Ucharal
Ush-Bel'dyr Rus. Fed. 72 H2
Ushibuka Japan 75 C7
Ushtobe Kazakh. 80 E2
Ush-Tyube Kazakh. see Ushtobe
Ushuaia Arg. 144 C8
Ushumun Rus. Fed. 74 B1
Usingen Germany 53 I4
Usinsk Rus. Fed. 41 R2
Usk U.K. 49 E7
Usk r. U.K. 49 E7
Uskhodni Belarus 45 O10
Uskoplje Bos.-Herz. see Gornji Vakuf
Üsküdar Turkey 59 M4
Uslar Germany 53 J3
Usman' Rus. Fed. 43 H5
Usmanabad India see Osmanabad
Usmas ezers l. Latvia 45 M8
Usogorsk Rus. Fed. 42 K3
Usol'ye-Sibirskoye Rus. Fed. 72 I2
Uspenovka Rus. Fed. 74 B1
Ussel France 56 F4
Ussuri r. China/Rus. Fed. 74 D2
Ussuriysk Rus. Fed. 74 C4
Ust'-Abakanskoye Rus. Fed. see Abakan
Usta Muhammad Pak. 89 H4
Ust'-Balyk Rus. Fed. see Nefteyugansk
Ust'-Donetskiy Rus. Fed. 43 I7
Ust'-Dzheguta Rus. Fed. 91 F1
Ust'-Dzhegutinskaya Rus. Fed. see
 Ust'-Dzheguta
Ustica, Isola di i. Sicily Italy 58 E5
Ust'-Ilimsk Rus. Fed. 65 L4
Ust'-Ilimskiy Vodokhranilishche resr
 Rus. Fed. 65 L4
Ust'-Ilych Rus. Fed. 42 R3
Ústí nad Labem Czech Rep. 47 O5
Ustinov Rus. Fed. see Izhevsk
Üstirt plat. Kazakh./Uzbek. see
 Ustyurt Plateau
Ustka Poland 47 P3
Ust'-Kamchatsk Rus. Fed. 65 R4
Ust'-Kamenogorsk Kazakh. 80 F2
Ust'-Kan Rus. Fed. 80 F1
Ust'-Koksa Rus. Fed. 80 G1
Ust'-Kulom Rus. Fed. 42 L3
Ust'-Kut Rus. Fed. 65 L4
Ust'-Kuyga Rus. Fed. 65 O2
Ust'-Labinsk Rus. Fed. 91 E1
Ust'-Labinskaya Rus. Fed. see
 Ust'-Labinsk
Ust'-Lyzha Rus. Fed. 42 M2
Ust'-Maya Rus. Fed. 65 O3
Ust'-Nera Rus. Fed. 65 P3
Ust'-Ocheya Rus. Fed. 42 K3
Ust'-Olenek Rus. Fed. 65 M2
Ust'-Omchug Rus. Fed. 65 P3
Ust'-Ordynskiy Rus. Fed. 72 I2
Ust'-Penzhino Rus. Fed. see
 Kamenskoye
Ust'-Port Rus. Fed. 64 J3
Ustrem Rus. Fed. 41 T3
Ust'-Tsil'ma Rus. Fed. 42 L2
Ust'-Uda Rus. Fed. 72 I2
Ust'-Umalta Rus. Fed. 74 D2
Ust'-Undurga Rus. Fed. 73 L2
Ust'-Ura Rus. Fed. 42 J3
Ust'-Urgal Rus. Fed. 74 D2
Ust'-Vayen'ga Rus. Fed. 42 I3
Ust'-Voya Rus. Fed. 41 R3
Ust'-Vyyskaya Rus. Fed. 42 J3
Ust'ya r. Rus. Fed. 42 I3

Ust'ye Rus. Fed. 42 H4
Ustyurt, Plato plat. Kazakh./Uzbek. see
 Ustyurt Plateau
Ustyurt Plateau Kazakh./Uzbek. 78 E2
Ustyurt Platosi plat. Kazakh./Uzbek. see
 Ustyurt Plateau
Ustyuzhna Rus. Fed. 42 H4
Usu China 80 F3
Usulután El Salvador 136 G6
Usumbura Burundi see Bujumbura
Usvyaty Rus. Fed. 42 F5
Utah state U.S.A. 126 F5
Utah Lake U.S.A. 129 H1
Utajärvi Fin. 44 O4
Utashinai Rus. Fed. see Yuzhno-Kuril'sk
'Utaybah, Buḩayrat al imp. l. Syria 85 C3
Utena Lith. 45 N9
Uterlai India 82 B4
Uthai Thani Thai. 70 C4
Uthal Pak. 89 G5
'Uthmānīyah Syria 85 C2
Utiariti Brazil 143 G6
Utica NY U.S.A. 135 H2
Utica OH U.S.A. 134 D3
Utiel Spain 57 F4
Utikuma Lake Canada 120 H4
Utlwanang S. Africa 101 G4
Utrecht Neth. 52 F2
Utrecht S. Africa 101 J4
Utrera Spain 57 D5
Utsjoki Fin. 44 O2
Utsunomiya Japan 75 E5
Utta Rus. Fed. 43 J7
Uttaradit Thai. 70 C3
Uttarakhand state India see Uttaranchal
Uttaranchal state India 82 D3
Uttarkashi India 82 D3
Uttar Kashi India see Uttarkashi
Uttar Pradesh state India 82 D4
Uttoxeter U.K. 49 F6
Uttranchal state India see Uttaranchal
Utubulak China 80 G2
Utupua i. Solomon Is 107 G3
Uummannaq Greenland see Dundas
Uummannaq Fjord inlet Greenland 153 J2
Uummannarsuaq c. Greenland see
 Farewell, Cape
Uurainen Fin. 44 N5
Uusikaarlepyy Fin. see Nykarleby
Uusikaupunki Fin. 45 L6
Uutapi Namibia 99 B5
Uva Rus. Fed. 42 L4
Uvalde U.S.A. 131 D6
Uval Karabaur hills Kazakh./Uzbek. 91 I2
Uval Muzbel' hills Kazakh. 91 I2
Uvarovo Rus. Fed. 43 I6
Uvéa atoll New Caledonia see Ouvéa
Uvinza Tanz. 99 D4
Uvs Nuur salt l. Mongolia 80 H1
Uwajima Japan 75 D6
'Uwayriḍ, Ḩarrat al lava field
 Saudi Arabia 86 E4
Uwaysiṭ well Saudi Arabia 85 D4
Uweinat, Jebel mt. Sudan 86 C6
Uwi i. Indon. 71 D7
Uxbridge Canada 134 F1
Uxbridge U.K. 49 G7
Uxin Qi China see Dabqig
Uyaly Kazakh. 80 B3
Uyar Rus. Fed. 72 G1
Üydzin Mongolia 72 J4
Uyo Nigeria 96 D4
Uyu Chaung r. Myanmar 70 A1
Uyuni Bol. 142 E8
Uyuni, Salar de salt flat Bol. 142 E8
Uza r. Rus. Fed. 43 J5
▶Uzbekistan country Asia 80 B3
 Asia 6, 62–63
Uzbekiston country Asia see Uzbekistan
Uzbekskaya S.S.R. country Asia see
 Uzbekistan
Uzbek S.S.R. country Asia see Uzbekistan
Uzboy Azer. 91 H3
Uzboý Turkm. 88 D2
Uzen' Kazakh. see Kyzylsay
Uzhgorod Ukr. see Uzhhorod
Uzhhorod Ukr. 43 D6
Užhorod Ukr. see Uzhhorod
Užice Serb. and Mont. 59 H3
Uzlovaya Rus. Fed. 43 H5
Üzümlü Turkey 59 M6
Uzun Uzbek. 89 H2
Uzunköprü Turkey 59 L4
Uzynkair Kazakh. 80 B3

V

Vaaf Atoll Maldives see Felidhu Atoll
Vaajakoski Fin. 44 N5
Vaal r. S. Africa 101 F5
Vaala Fin. 44 O4
Vaalbos National Park S. Africa 100 G5
Vaal Dam S. Africa 101 I4
Vaalwater S. Africa 101 I3
Vaasa Fin. 44 L5
Vaavu Atoll Maldives see Felidhu Atoll
Vác Hungary 47 Q7
Vacaria Brazil 145 A5
Vacaria, Campo da plain Brazil 145 A5
Vacaville U.S.A. 128 C2
Vachon r. Canada 123 H1
Vad Rus. Fed. 42 I5
Vad r. Rus. Fed. 43 I5
Vada India 84 B2
Vadla Norway 45 E7
Vadodara India 82 C5
Vadsø Norway 44 P1
▶Vaduz Liechtenstein 56 I3
 Capital of Liechtenstein.

Værøy i. Norway 44 H3
Vaga r. Rus. Fed. 42 I3
Vågåmo Norway 45 F6
Vaganski Vrh mt. Croatia 58 F2
Vágar i. Faroe Is 44 [inset]
Vägsele Sweden 44 K4
Vågur Faroe Is 44 [inset]
Váh r. Slovakia 47 Q7
Vähäkyrö Fin. 44 M5

▶Vaiaku Tuvalu 107 H2
 Capital of Tuvalu, on Funafuti atoll.

Vaida Estonia 45 N7
Vaiden U.S.A. 131 F5
Vail U.S.A. 124 F4
Vailly-sur-Aisne France 52 D5
Vaitupu i. Tuvalu 107 H2
Vajrakarur India see Kanur
Vakhsh Tajik. 89 H2
Vakhsh r. Tajik. 89 H2
Vakhstroy Tajik. see Vakhsh
Vakilābād Iran 88 E4
Valbo Sweden 45 J6
Valcheta Arg. 144 C6
Valdai Hills Rus. Fed. see
 Valdayskaya Vozvyshennost'
Valday Rus. Fed. 42 G4
Valdayskaya Vozvyshennost' hills
 Rus. Fed. 42 G4
Valdecañas, Embalse de resr Spain 57 D4
Valdemārpils Latvia 45 M8
Valdemarsvik Sweden 45 J7
Valdepeñas Spain 57 E4
Val-de-Reuil France 52 B5
▶Valdés, Península pen. Arg. 144 D6
 Lowest point in South America.
 South America 138–139

Valdez U.S.A. 118 D3
Valdivia Chile 144 B5
Val-d'Or Canada 122 F4
Valdosta U.S.A. 133 D6
Valdres valley Norway 45 F6
Vale Georgia 91 F2
Vale U.S.A. 126 D3
Valemount Canada 120 G4
Valença Brazil 145 D1
Valence France 56 G4
Valencia Spain 57 F4
València Spain see Valencia
Valencia reg. Spain 57 F4
Valencia Venez. 142 E1
Valencia, Golfo de g. Spain 57 G4
Valencia de Don Juan Spain 57 D2
Valencia Island Ireland 51 B6
Valenciennes France 52 D4
Valentia Spain see Valencia
Valentin Rus. Fed. 74 D4
Valentine U.S.A. 130 C3
Väler Norway 45 G6
Valera Venez. 142 D2
Vale Verde Brazil 145 D2
Valga Estonia 45 O7
Valhalla, Parco Nazionale della nat. park
 Italy 58 C1
Valjevo Serb. and Mont. 59 H2
Valka Latvia 45 O8
Valkeakoski Fin. 45 N6
Valkenswaard Neth. 52 F3
Valky Ukr. 43 G6
Valkyrie Dome ice feature Antarctica 152 D1
Valladolid Mex. 136 G4
Valladolid Spain 57 D3
Vallard, Lac l. Canada 123 H3
Valle Norway 45 E7
Vallecillos Mex. 131 D7
Vallecito Reservoir U.S.A. 129 J3
Valle de la Pascua Venez. 142 E2
Valledupar Col. 142 D1
Vallée-Jonction Canada 123 H5
Vallée Fértil, Sierra de mts Arg. 144 C4
Valle Grande Bol. 142 F7
Valle Hermoso Mex. 131 D7
Vallejo U.S.A. 128 B2
Vallenar Chile 144 B3
▶Valletta Malta 58 F7
 Capital of Malta.

Valley r. Canada 121 L5
Valley U.K. 48 C5
Valley City U.S.A. 130 D2
Valleyview Canada 120 G4
Valls Spain 57 G3
Val Marie Canada 121 J5
Valmiera Latvia 45 N8
Valmy U.S.A. 128 E1
Valnera mt. Spain 57 E2
Valognes France 49 F9
Valona Albania see Vlorë
Val-Paradis Canada 122 F4
Valparai India 84 C4
Valparaíso Chile 144 B4
Valparaiso U.S.A. 134 B3
Valpoi India 84 B3
Valréas France 56 G4
Vals, Tanjung c. Indon. 69 J8
Valsad India 84 B1
Valspan S. Africa 100 G4
Val'tevo Rus. Fed. 42 J2
Valtimo Fin. 44 P5
Valuyevka Rus. Fed. 43 I7
Valuyki Rus. Fed. 43 H6
Vammala Fin. 45 M6
Van Turkey 91 F3
Van, Lake salt l. Turkey 91 F3
Vanadzor Armenia 91 G2
Van Buren AR U.S.A. 131 E5
Van Buren MO U.S.A. 131 F4
Van Buren OH U.S.A. see Kettering
Vanceburg U.S.A. 134 D4
Vanch Tajik. see Vanj
Vancleve U.S.A. 134 D5
Vancouver Canada 120 F5
Vancouver U.S.A. 126 C3
Vancouver, Mount U.S.A./Canada 120 B2
Vancouver Island Canada 120 E5
Vanda Fin. see Vantaa
Vandalia IL U.S.A. 130 F4
Vandalia OH U.S.A. 134 C4
Vandekerckhove Lake Canada 121 K3
Vanderbijlpark S. Africa 101 H4
Vanderbilt U.S.A. 134 C1
Vandergrift U.S.A. 134 F3
Vanderhoof Canada 120 E4
Vanderkloof Dam resr S. Africa 100 G5
Vanderlin Island Australia 110 B2
Vanderwagen U.S.A. 129 I4

Van Diemen, Cape N.T. Australia 108 E2
Van Diemen, Cape Qld Australia 110 B3
Van Diemen Gulf Australia 108 F2
Van Diemen's Land state Australia see
 Tasmania
Vändra Estonia 45 N7
Väner, Lake Sweden see Vänern
▶Vänern l. Sweden 45 H7
 4th largest lake in Europe.

Vänersborg Sweden 45 H7
Vangaindrano Madag. 99 E6
Van Gia Vietnam 71 E4
Van Gölü salt l. Turkey see Van, Lake
Van Horn U.S.A. 127 G7
Vanikoro Islands Solomon Is 107 G3
Vanimo P.N.G. 69 K7
Vanino Rus. Fed. 74 F2
Vanivilasa Sagara resr India 84 C3
Vaniyambadi India 84 C3
Vanj Tajik. 89 H2
Vännäs Sweden 44 K5
Vannes France 56 C3
Vannes, Lac l. Canada 123 I3
Vannovka Kazakh. see Turar Ryskulov
Vannøya i. Norway 44 K1
Van Rees, Pegunungan mts Indon. 69 J7
Vanrhynsdorp S. Africa 100 D6
Vansant U.S.A. 134 D5
Vansbro Sweden 45 I6
Vansittart Island Canada 119 J3
Van Starkenborgh Kanaal canal
 Neth. 52 G1
Vantaa Fin. 45 N6
Van Truer Tableland reg. Australia 109 C6
Vanua Lava i. Vanuatu 107 G3
Vanua Levu i. Fiji 107 H3
▶Vanuatu country S. Pacific Ocean 107 G3
 Oceania 8, 104–105
Van Wert U.S.A. 134 C3
Vanwyksvlei S. Africa 100 E6
Vanwyksvlei l. S. Africa 100 E6
Vän Yên Vietnam 70 D2
Van Zylsrus S. Africa 100 F4
Varadero Cuba 133 D8
Varahi India 82 B5
Varakļāni Latvia 45 O8
Varalé Côte d'Ivoire 96 C4
Varāmīn Iran 88 C3
Varanasi India 83 E4
Varandey Rus. Fed. 42 M1
Varangerfjorden sea chan. Norway 44 P1
Varangerhalvøya pen. Norway 41 L1
Varangerhalvøya pen. Norway 44 P1
Varaždin Croatia 58 G1
Varberg Sweden 45 H8
Vardar r. Macedonia 59 J4
Varde Denmark 45 F9
Vardenis Armenia 91 G2
Vardø Norway 44 Q1
Varel Germany 53 I1
Vārēna Lith. 45 N9
Varese Italy 58 C2
Varfolomeyevka Rus. Fed. 74 D3
Vårgårda Sweden 45 H7
Varginha Brazil 145 B3
Varik Neth. 52 F3
Varillas Chile 144 B2
Varkana Iran see Gorgān
Varkaus Fin. 44 O5
Varna Bulg. 59 L3
Värnamo Sweden 45 I8
Värnäs Sweden 45 H6
Varnavino Rus. Fed. 42 J4
Várnjárg pen. Norway see Varangerhalvøya
Varpaisjärvi Fin. 44 O5
Várpalota Hungary 58 H1
Varsaj Afgh. 89 H2
Varsh, Ozero l. Rus. Fed. 42 J2
Varto Turkey 91 F3
Várzea da Palma Brazil 145 B2
Vasa Fin. see Vaasa
Vasai India 84 B2
Vashka r. Rus. Fed. 42 J2
Vasht Iran see Khāsh
Vasilkov Ukr. see Vasyl'kiv
Vasknarra Estonia 45 O7
Vaslui Romania 59 L1
Vassar U.S.A. 134 D2
Vas-Soproni-síkság hills Hungary 58 G1
Vastan Turkey see Gevaş
Västerås Sweden 45 J7
Västerdalälven r. Sweden 45 I6
Västerfjäll Sweden 44 J3
Västerhaninge Sweden 45 K7
Västervik Sweden 45 J8
Vasto Italy 58 F3
Vasyl'kiv Ukr. 43 F6
Vatan France 56 E3
Vaté i. Vanuatu see Éfaté
Vatersay i. U.K. 50 B4
Vathar India 84 B2
Vathí Greece see Vathy
Vathy Greece 59 L6

▶Vatican City Europe 58 E4
 Independent papal state, the smallest
 country in the world.
 Europe 5, 38–39

Vaticano, Città del Europe see Vatican City
Vatnajökull ice cap Iceland 44 [inset]
Vatoa i. Fiji 107 I3
Vatra Dornei Romania 59 K1
Vätter, Lake Sweden see Vättern
Vättern l. Sweden 45 I7
Vaughn U.S.A. 127 G6
Vaupés r. Col. 142 E3
Vauquelin r. Canada 122 F3
Vauvert France 56 G5
Vauxhall Canada 121 H5
Vavatenina Madag. 99 E5
Vava'u Group is Tonga 107 I3
Vavitao i. Fr. Polynesia see Raivavae
Vavoua Côte d'Ivoire 96 C4
Vavozh Rus. Fed. 42 K4
Vavuniya Sri Lanka 84 C4
Vawkavysk Belarus 45 N10
Växjö Sweden 45 I8
Vay, Đao i. Vietnam 71 C5
Vayenga Rus. Fed. see Severomorsk

Vazante Brazil 145 B2
Vazáš Sweden see Vittangi
Veaikevárri Sweden see Svappavaara
Veal Vêng Cambodia 71 C4
Vecht r. Neth. 52 G2
also known as Vechte (Germany)
Vechta Germany 53 I2
Vechte r. Germany 53 G2
also known as Vecht (Netherlands)
Veckerhagen (Reinhardshagen)
Germany 53 J3
Vedaranniyam India 84 C4
Vedasandur India 84 C4
Veddige Sweden 45 H8
Vedea r. Romania 59 K3
Veedersburg U.S.A. 134 B3
Veendam Neth. 52 G2
Veenendaal Neth. 52 F2
Vega i. Norway 44 G4
Vega U.S.A. 131 C5
Vegreville Canada 121 H4
Vehkalahti Fin. 45 O6
Vehoa Pak. 89 H4
Veinticinco de Mayo Buenos Aires Arg. see
25 de Mayo
Veinticinco de Mayo La Pampa Arg. see
25 de Mayo
Veirwaro Pak. 89 H5
Veitshöchheim Germany 53 J5
Vejle Denmark 45 F9
Vekil'bazar Turkm. see Wekilbazar
Velbûzhdki Prokhod pass Bulg./Macedonia
59 J3
Velddrif S. Africa 100 D7
Velebit mts Croatia 58 F2
Velen Germany 52 G3
Velenje Slovenia 58 F1
Veles Macedonia 59 I4
Vélez-Málaga Spain 57 D5
Vélez-Rubio Spain 57 E5
Velhas r. Brazil 145 B2
Velibaba Turkey see Aras
Velika Gorica Croatia 58 G2
Velika Plana Serb. and Mont. 59 I2
Velikaya r. Rus. Fed. 42 K4
Velikaya r. Rus. Fed. 45 P8
Velikaya r. Rus. Fed. 65 S3
Velikaya Kema Rus. Fed. 74 E3
Veliki Preslav Bulg. 59 L3
Velikiye Luki Rus. Fed. 42 F4
Velikiy Novgorod Rus. Fed. 42 F4
Velikiy Ustyug Rus. Fed. 42 J3
Velikonda Range hills India 84 C3
Veliko Tŭrnovo Bulg. 59 K3
Velikoye Rus. Fed. 42 H4
Velikoye, Ozero l. Rus. Fed. 43 I5
Veli Lošinj Croatia 58 F2
Velizh Rus. Fed. 42 F5
Vella Lavella i. Solomon Is 107 F2
Vellar r. India 84 C4
Vellberg Germany 53 J5
Vellmar Germany 53 J3
Vellore India 84 C3
Velpke Germany 53 K2
Vel'sk Rus. Fed. 42 I3
Velsuna Italy see Orvieto
Velten Germany 53 N2
Veluwezoom, Nationaal Park nat. park
Neth. 52 F2
Velykyy Tokmak Ukr. see Tokmak
Vel'yu r. Rus. Fed. 42 L3
Vemalwada India 84 C2
Vema Seamount sea feature
S. Atlantic Ocean 148 I8
Vema Trench sea feature Indian Ocean
149 M6
Vempalle India 84 C3
Venado Tuerto Arg. 144 D4
Venafro Italy 58 F4
Vendinga Rus. Fed. 42 J3
Vendôme France 56 E3
Venegas Mex. 131 C8
Venetia Italy see Venice
Venetie Landing U.S.A. 118 D3
Venev Rus. Fed. 43 H5
Venezia Italy see Venice
Venezia, Golfo di g. Europe see
Venice, Gulf of

▶Venezuela country S. America 142 E2
5th most populous country in
South America.
South America 9, 140–141

Venezuela, Golfo de g. Venez. 142 D1
Venezuelan Basin sea feature
S. Atlantic Ocean 148 D4
Vengurla India 84 B3
Veniaminof Volcano U.S.A. 118 C4
Venice Italy 58 E2
Venice U.S.A. 133 D7
Venice, Gulf of Europe 58 E2
Vénissieux France 56 G4
Venkatapalem India 84 D2
Venkatapuram India 84 D2
Venlo Neth. 52 G3
Vennesla Norway 45 E7
Venray Neth. 52 F3
Venta r. Latvia/Lith. 45 M8
Venta Lith. 45 M8
Ventersburg S. Africa 101 H5
Ventersdorp S. Africa 101 H4
Venterstad S. Africa 101 G6
Ventnor U.K. 49 F8
Ventotene, Isola i. Italy 58 E4
Ventspils Latvia 45 L8
Ventoux, Mont mt. France 56 G4
Ventura U.S.A. 128 C4
Venus Bay Australia 112 B7
Venustiano Carranza Mex. 131 C7
Venustiano Carranza, Presa resr
Mex. 131 C7
Vera Arg. 144 D3
Vera Cruz Brazil 145 A3
Vera Cruz Mex. see Veracruz
Veracruz Mex. 136 E5
Veraval India 82 B5
Verbania Italy 58 C2
Vercelli Italy 58 C2

Vercors reg. France 56 G4
Verdalsøra Norway 44 G5
Verde r. Goiás Brazil 145 A2
Verde r. Goiás Brazil 145 A2
Verde r. Goiás Brazil 145 B2
Verde r. Minas Gerais Brazil 145 A2
Verde r. Mex. 127 G8
Verde r. U.S.A. 129 H5
Verde Pequeno r. Brazil 145 C1
Verdi U.S.A. 128 D2
Verdon r. France 56 G5
Verdun France 52 F5
Vereeniging S. Africa 101 H4
Vereshchagino Rus. Fed. 41 Q4
Vergennes U.S.A. 135 I1
Véria Greece see Veroia
Verín Spain 57 C3
Veríssimo Brazil 145 A2
Verkhneimbatsk Rus. Fed. 64 J3
Verkhnekolvinsk Rus. Fed. 42 M2
Verkhnespasskoye Rus. Fed. 42 J4
Verkhnetulomskiy Rus. Fed. 44 Q2
Verkhnetulomskoye Vodokhranilishche res.
Rus. Fed. 44 Q2
Verkhnevilyuysk Rus. Fed. 65 N3
Verkhneye Kuyto, Ozero l. Rus. Fed. 44 Q4
Verkhnezeysk Rus. Fed. 73 N2
Verkhniy Vyalozerskiy Rus. Fed. 42 G2
Verkhnyaya Khava Rus. Fed. 43 H6
Verkhnyaya Salda Rus. Fed. 41 S4
Verkhnyaya Tunguska Rus. Fed. see
Angara
Verkhnyaya Tura Rus. Fed. 41 R4
Verkhoshizhem'ye Rus. Fed. 42 K4
Verkhovazh'ye Rus. Fed. 42 I3
Verkhov'ye Rus. Fed. 43 H5
Verkhoyansk Rus. Fed. 65 O3
Verkhoyanskiy Khrebet mts
Rus. Fed. 65 N2
Vermand France 52 D5
Vermelho r. Brazil 145 A1
Vermilion Canada 121 I4
Vermilion Bay U.S.A. 131 F6
Vermilion Cliffs AZ U.S.A. 129 G3
Vermilion Cliffs UT U.S.A. 129 G3
Vermilion Cliffs National Monument
nat. park U.S.A. 129 H3
Vermilion, Lake U.S.A. 130 E2
Vermillion U.S.A. 130 D3
Vermillion Bay Canada 121 M5
Vermont state U.S.A. 135 I1
Vernadsky research station Antarctica
152 L2
Vernal U.S.A. 129 I1
Verner Canada 122 E5
Verneuk Pan salt pan S. Africa 100 E5
Vernon Canada 120 G5
Vernon France 52 B5
Vernon AL U.S.A. 131 F5
Vernon IN U.S.A. 134 C4
Vernon TX U.S.A. 131 D5
Vernon UT U.S.A. 129 G1
Vernon Islands Australia 108 E3
Vernoye Rus. Fed. 74 C2
Vernyy Kazakh. see Almaty
Vero Beach U.S.A. 133 D7
Veroia Greece 59 J4
Verona Italy 58 D2
Verona U.S.A. 134 F4
Versailles France 52 C6
Versailles IN U.S.A. 134 C4
Versailles KY U.S.A. 134 C4
Versailles OH U.S.A. 134 C3
Versec Serb. and Mont. see Vršac
Versmold Germany 53 I2
Vert, Île i. Canada 123 H4
Vertou France 56 D3
Verulam S. Africa 101 J5
Verulamium U.K. see St Albans
Verviers Belgium 52 F4
Vervins France 52 D5
Verwood Canada 121 J5
Verzy France 52 E5
Vescovato Corsica France 56 I5
Vesele Ukr. 43 G7
Veselyy Rus. Fed. 43 I7
Veshenskaya Rus. Fed. 43 I6
Vesle r. France 52 D5
Veslyana r. Rus. Fed. 42 L3
Vesontio France see Besançon
Vesoul France 56 H3
Vesselyy Yar Rus. Fed. 74 D4
Vessem Neth. 52 F3
Vesterålen is Norway 44 H2
Vesterålsfjorden sea chan. Norway 44 H2
Vestertana Norway 44 O1
Vestfjorddalen valley Norway 45 F7
Vestfjorden sea chan. Norway 44 H3
Véstia Brazil 145 A3
Vestmanna Faroe Is 44 [inset]
Vestmannaeyjar Iceland 44 [inset]
Vestmannaeyjar is Iceland 44 [inset]
Vestnes Norway 44 E5
Vesturhorn hd Iceland 44 [inset]
Vesuvio vol. Italy see Vesuvius
Vesuvius vol. Italy 58 F4
Ves'yegonsk Rus. Fed. 42 H4
Veszprém Hungary 58 G1
Veteli Fin. 44 M5
Veteran Canada 121 I4
Vetlanda Sweden 45 I8
Vetluga Rus. Fed. 42 J4
Vetluga r. Rus. Fed. 42 J4
Vetluzhskiy Kostromskaya Oblast'
Rus. Fed. 42 J4
Vetluzhskiy Nizhegorodskaya Oblast'
Rus. Fed. 42 J4
Vettore, Monte mt. Italy 58 E3
Veurne Belgium 52 C3
Vevay U.S.A. 134 C4
Vevey Switz. 56 H3
Vexin Normand reg. France 52 B5
Veyo U.S.A. 129 G3
Vézère r. France 56 E4
Vezirköprü Turkey 90 D2
Vhembe Dongola National Park
S. Africa 101 I2
Vialar Alg. see Tissemsilt
Viamão Brazil 145 A5
Viana Espírito Santo Brazil 145 C3
Viana Maranhão Brazil 143 J4

Viana do Castelo Port. 57 B3
Vianen Neth. 52 F3
Viangchan Laos see Vientiane
Viangphoukha Laos 70 C2
Viannos Greece 59 K7
Vianópolis Brazil 145 A2
Viareggio Italy 58 D3
Viborg Denmark 45 F8
Viborg Rus. Fed. see Vyborg
Vic Spain 57 H3
Vicam Mex. 127 F8
Vicecomodoro Marambio research station
Antarctica see Marambio
Vicente, Point U.S.A. 128 D5
Vicente Guerrero Mex. 127 D7
Vicenza Italy 58 D2
Vich Spain see Vic
Vichada r. Col. 142 E3
Vichadero Uruguay 144 F4
Vichy France 56 F3
Vicksburg AZ U.S.A. 129 G5
Vicksburg MS U.S.A. 131 F5
Viçosa Brazil 145 C3
Victor, Mount Antarctica 152 D2
Victor Harbor Australia 111 B7
Victoria Arg. 144 D4
Victoria r. Australia 108 E3
Victoria state Australia 112 B6

▶Victoria Canada 120 F5
Provincial capital of British Columbia.

Victoria Chile 144 B5
Victoria Malaysia see Labuan
Victoria Malta 58 F6

▶Victoria Seychelles 149 L6
Capital of the Seychelles.

Victoria TX U.S.A. 131 D6
Victoria VA U.S.A. 135 F5
Victoria prov. Zimbabwe see Masvingo

▶Victoria, Lake Africa 98 D4
Largest lake in Africa and 3rd in the world.
World 12–13

Victoria, Lake Australia 111 C7
Victoria, Mount Fiji see Tomanivi
Victoria, Mount Myanmar 70 A2
Victoria, Mount P.N.G. 69 L8
Victoria and Albert Mountains
Canada 119 K2
Victoria Falls Zambia/Zimbabwe 99 C5
Victoria Harbour sea chan. H.K. China see
Hong Kong Harbour

▶Victoria Island Canada 118 H2
3rd largest island in North America.

Victoria Land coastal area Antarctica
152 H2
Victoria Peak Belize 136 G5
Victoria Peak hill H.K. China 77 [inset]
Victoria Range mts N.Z. 113 D6
Victoria River Downs Australia 108 E4
Victoriaville Canada 123 H5
Victoria West S. Africa 100 F6
Victorica Arg. 144 C5
Victorville U.S.A. 128 E4
Victory Downs Australia 109 F6
Vidalia U.S.A. 131 F6
Vidal Junction U.S.A. 129 F4
Videle Romania 59 K2
Vidisha India 82 D5
Vidin U.K. 50 [inset]
Vidlitsa Rus. Fed. 42 G3
Viechtach Germany 53 M5
Viedma Arg. 144 D6
Viedma, Lago l. Arg. 144 B7
Viejo, Cerro mt. Mex. 127 E7
Vielank Germany 53 L1
Vielsalm Belgium 52 F4
Vienenburg Germany 53 K3

▶Vienna Austria 47 P6
Capital of Austria.

Vienna MO U.S.A. 130 F4
Vienna WV U.S.A. 134 E4
Vienne France 56 G4
Vienne r. France 56 E3

▶Vientiane Laos 70 C3
Capital of Laos.

Vieques i. Puerto Rico 137 K5
Vieremä Fin. 44 O5
Viersen Germany 52 G3
Vierzon France 56 F3
Viesca Mex. 131 C7
Viesīte Latvia 45 N8
Vieste Italy 58 G4
Vietas Sweden 44 K3
Viêt Nam country Asia see Vietnam

▶Vietnam country Asia 70 D3
Asia 6, 62–63

Viêt Quang Vietnam 70 D2
Viêt Tri Vietnam 70 D2
Vieux Comptoir, Lac du l. Canada 122 F3
Vieux-Fort Canada 123 K4
Vieux Poste, Pointe du pt Canada 123 J4
Vigan Phil. 69 G3
Vigevano Italy 58 C2
Vigia Brazil 143 I4
Vignacourt France 52 C4
Vignemale mt. France 54 D3
Vignola Italy 58 D2
Vigo Spain 57 B2
Vihanti Fin. 44 N4
Vihari Pak. 89 I4
Vihti Fin. 45 N6
Viipuri Rus. Fed. see Vyborg
Viitasaari Fin. 44 N5
Vijayadurg India 84 B2
Vijayanagaram India see Vizianagaram
Vijayapati India 84 C4
Vijayawada India 84 D2
Vík Iceland 44 [inset]
Vikajärvi Fin. 44 O3
Vikeke East Timor see Viqueque

Viking Canada 121 I4
Vikna i. Norway 44 G4
Vikøyri Norway 45 E6
Vila Vanuatu see Port Vila
Vila Alferes Chamusca Moz. see Guija
Vila Bittencourt Brazil 142 E4
Vila Bugaço Angola see Camanongue
Vila Cabral Moz. see Lichinga
Vila da Ponte Angola see Kuvango
Vila de Aljustrel Angola see Cangamba
Vila de Almoster Angola see Chiange
Vila de João Belo Moz. see Xai-Xai
Vila de María Arg. 144 D3
Vila de Trego Morais Moz. see Chókwé
Vila Fontes Moz. see Caia
Vila Franca de Xira Port. 57 B4
Vilagarcía de Arousa Spain 57 B2
Vila Gomes da Costa Moz. 101 K3
Vilalba Spain 57 C2
Vila Luísa Moz. see Marracuene
Vila Marechal Carmona Angola see Uíge
Vila Miranda Moz. see Macaloge
Vilanandro, Tanjona pt Madag. 99 E5
Vilanculos Moz. 101 L1
Vila Nova de Gaia Port. 57 B3
Vilanova i la Geltrú Spain see Caia
Vila Pery Moz. see Chimoio
Vila Real Port. 57 C3
Vilar Formoso Port. 57 C3
Vila Salazar Angola see N'dalatando
Vila Salazar Zimbabwe see Sango
Vila Teixeira de Sousa Angola see Luau
Vila Velha Brazil 145 C3
Vilcabamba, Cordillera mts Peru 142 D6
Vil'cheka, Zemlya i. Rus. Fed. 64 H1
Viled' r. Rus. Fed. 42 J3
Vileyka Belarus see Vilyeyka
Vil'gort Rus. Fed. 42 K3
Vilhelmina Sweden 44 J4
Vilhena Brazil 142 F6
Viliya r. Belarus/Lith. see Neris
Viljandi Estonia 45 N7
Viljoenskroon S. Africa 101 H4
Vilkaviškis Lith. 45 M9
Vilkija Lith. 45 M9
Vil'kitskogo, Proliv strait Rus. Fed. 65 K2
Vilkovo Ukr. see Vylkove
Villa Abecia Bol. 142 E8
Villa Ahumada Mex. 127 G7
Villa Ángela Arg. 144 D3
Villa Bella Bol. 142 E6
Villablino Spain 57 C2
Villacañas Spain 57 E4
Villacidro Sardinia Italy 58 C5
Villach Austria 47 N7
Villa Cisneros W. Sahara see Ad Dakhla
Villa Constitución Mex. see
Ciudad Constitución
Villa Dolores Arg. 144 C4
Villagarcía de Arosa Spain see
Vilagarcía de Arousa
Villagrán Mex. 131 D7
Villaguay Arg. 144 E4
Villahermosa Mex. 136 F5
Villa Insurgentes Mex. 127 F8
Villajoyosa Spain see
Villajoyosa-La Vila Joiosa
Villajoyosa-La Vila Joiosa Spain 57 F4
Villaldama Mex. 131 C7
Villa Mainero Mex. 131 D7
Villa María Arg. 144 D4
Villa Montes Bol. 142 F8
Villa Nora S. Africa 101 I2
Villa Ocampo Arg. 144 E3
Villa Ocampo Mex. 131 B7
Villa Ojo de Agua Arg. 144 D3
Villaputzu Sardinia Italy 58 C5
Villa Regina Arg. 144 C5
Villarrica Para. 144 E3
Villarrica, Lago l. Chile 144 B5
Villarrica, Parque Nacional nat. park
Chile 144 B5
Villarrobledo Spain 57 E4
Villas U.S.A. 135 H4
Villasalazar Zimbabwe see Sango
Villa San Giovanni Italy 58 F5
Villa San Martín Arg. 144 D3
Villa Unión Arg. 144 C4
Villa Unión Coahuila Mex. 131 C6
Villa Unión Durango Mex. 131 B8
Villa Unión Sinaloa Mex. 136 C4
Villa Valeria Arg. 144 D4
Villavicencio Col. 142 D3
Villazon Bol. 142 E8
Villefranche-sur-Saône France 56 G4
Ville-Marie Canada see Montréal
Villena Spain 57 F4
Villeneuve-sur-Lot France 56 E4
Villeneuve-sur-Yonne France 56 F2
Villers-Bretonneux France 52 C5
Villers-sur-Mer France 49 G9
Villerupt France 52 F5
Villeurbanne France 56 G4
Villiers S. Africa 101 I4
Villingen Germany 47 L6
Villupuram India see Villuppuram
Villupuram India 84 C4
Vilna Canada 121 I4
Vilna Lith. see Vilnius

▶Vilnius Lith. 45 N9
Capital of Lithuania.

Vil'nyans'k Ukr. 43 G7
Vilppula Fin. 44 N5
Vils r. Germany 53 L5
Vils r. Germany 53 N6
Vilvoorde Belgium 52 E4
Vilyeyka Belarus 45 O9
Vilyuy r. Rus. Fed. 65 N3
Vilyuyskoye Vodokhranilishche resr
Rus. Fed. 65 M3

▶Vilnius Lith. 45 N9
Capital of Lithuania.

Vil'nyans'k Ukr. 43 G7
Vilppula Fin. 44 N5
Vils r. Germany 53 L5
Vils r. Germany 53 N6
Vilvoorde Belgium 52 E4
Vilyeyka Belarus 45 O9
Vilyuy r. Rus. Fed. 65 N3
Vilyuyskoye Vodokhranilishche resr
Rus. Fed. 65 M3

Viña del Mar Chile 144 B4
Vinalhaven Island U.S.A. 132 G2
Vinaròs Spain 57 G3
Vinaroz Spain see Vinaròs
Vincelotte, Lac l. Canada 123 G3
Vincennes U.S.A. 134 B4
Vincennes Bay Antarctica 152 F2
Vinchina Arg. 144 C3
Vindelälven r. Sweden 44 K5
Vindeln Sweden 44 K4
Vindhya Range hills India 82 C5
Vindobona Austria see Vienna
Vine Grove U.S.A. 134 C5
Vineland U.S.A. 135 H4
Vinh Vietnam 70 D3
Vinh Loc Vietnam 70 D2
Vinh Long Vietnam 71 D5
Vinh Thực, Đao i. Vietnam 70 D2
Vinita U.S.A. 131 E4
Vinjhan India 82 B5
Vinland i. Canada see Newfoundland
Vinnitsa Ukr. see Vinnytsya
Vinnytsya Ukr. 43 F6
Vinogradov Ukr. see Vynohradiv

▶Vinson Massif mt. Antarctica 152 L1
Highest mountain in Antarctica.

Vinstra Norway 45 F6
Vinton U.S.A. 130 E3
Vinukonda India 84 C2
Violeta Cuba see Primero de Enero
Vipperow Germany 53 M1
Viqueque East Timor 108 D2
Virac Phil. 69 G4
Viramgam India 82 C5
Viranşehir Turkey 91 E3
Virawah Pak. 89 H5
Virdel India 82 C5
Virden Canada 121 K5
Virden U.S.A. 129 I5
Vire France 56 D2
Virei Angola 99 B5
Virgem da Lapa Brazil 145 C2
Virgilina U.S.A. 135 F5
Virgin r. U.S.A. 129 F3
Virginia Ireland 51 F3
Virginia S. Africa 101 H5
Virginia U.S.A. 130 E2
Virginia state U.S.A. 134 F5
Virginia Beach U.S.A. 135 H5
Virginia City MT U.S.A. 126 F3
Virginia City NV U.S.A. 128 D2
Virginia Falls Canada 120 E2

▶Virgin Islands (U.K.) terr. West Indies
137 L5
United Kingdom Overseas Territory.
North America 9, 116–117

▶Virgin Islands (U.S.A.) terr. West Indies
137 L5
United States Unincorporated Territory.
North America 9, 116–117

Virgin Mountains U.S.A. 129 F3
Virginópolis Brazil 145 C2
Virkkala Fin. 45 N6
Viróchey Cambodia 71 D4
Viroqua U.S.A. 130 F3
Virovitica Croatia 58 G2
Virrat Fin. 44 M5
Virton Belgium 52 F5
Virtsu Estonia 45 M7
Virudhunagar India see Virudhunagar
Virudunagar India see Virudhunagar
Virunga, Parc National des nat. park
Dem. Rep. Congo 98 C4
Vis i. Croatia 58 G3
Visaginas Lith. 45 O9
Visakhapatnam India see
Vishakhapatnam
Visalia U.S.A. 128 D3
Visapur India 84 B2
Visayan Sea Phil. 69 G4
Visbek Germany 53 I2
Visby Sweden 45 K8
Viscount Melville Sound sea chan.
Canada 119 G2
Visé Belgium 52 F4
Vise, Ostrov i. Rus. Fed. 64 I2
Viseu Brazil 143 I4
Viseu Port. 57 C3
Vishakhapatnam India 84 D2
Vishera r. Rus. Fed. 41 R4
Vishera r. Rus. Fed. 42 L3
Viški Latvia 45 O8
Visnagar India 82 C5
Viso, Monte mt. Italy 58 B2
Visoko Bos.-Herz. 58 H3
Visp Switz. 56 H3
Visselhövede Germany 53 J2
Vista U.S.A. 128 E5
Vista Lake U.S.A. 128 D4
Vistonida, Limni lag. Greece 59 K4
Vistula r. Poland 47 Q3
Vitebsk Belarus see Vitsyebsk
Viterbo Italy 58 E3
Vitichi Bol. 142 E8
Viti Levu i. Fiji 107 H3
Vitimskoye Ploskogor'ye plat.
Rus. Fed. 73 K2
Vitória Brazil 145 C3
Vitória da Conquista Brazil 145 C1
Vitoria-Gasteiz Spain 57 E2
Vitória Seamount sea feature
S. Atlantic Ocean 148 F7
Vitré France 56 D2
Vitry-en-Artois France 52 C4
Vitry-le-François France 52 E6
Vitsyebsk Belarus 43 F5
Vittangi Sweden 44 L3
Vittel France 52 F6
Vittoria Sicily Italy 58 F6
Vittorio Veneto Italy 58 E2
Viveiro Spain 57 C2
Vivero Spain see Viveiro
Vivo S. Africa 101 I2
Vizagapatam India see Vishakhapatnam

Vizcaíno, Desierto de des. Mex. 127 E8
Vizcaíno, Sierra mts Mex. 127 E8
Vize Turkey 59 L4
Vizhas r. Rus. Fed. 42 J2
Vizianagaram India 84 D2
Vizinga Rus. Fed. 42 K3
Vlaardingen Neth. 52 E3
Vlădeasa, Vârful mt. Romania 59 J1
Vladikavkaz Rus. Fed. 91 G2
Vladimir Primorskiy Kray Rus. Fed. 74 D4
Vladimir Vladimirskaya Oblast'
Rus. Fed. 42 I4
Vladimiro-Aleksandrovskoye
Rus. Fed. 74 D4
Vladimir-Volynskiy Ukr. see
Volodymyr-Volyns'kyy
Vladivostok Rus. Fed. 74 C4
Vlakte S. Africa 101 I3
Vlasotince Serb. and Mont. 59 J3
Vlas'yevo Rus. Fed. 74 F1
Vlieland i. Neth. 52 E1
Vlissingen Neth. 52 D3
Vlora Albania 59 H4
Vlorë Albania see Vlorë
Vlorë Albania 59 H4
Vlotho Germany 53 I2
Vlotslavsk Poland see Włocławek
Vltava r. Czech Rep. 47 O5
Vobkent Uzbek. 89 G1
Vöcklabruck Austria 47 N6
Vodlozero, Ozero l. Rus. Fed. 42 H3
Voe U.K. 50 [inset]
Voerendaal Neth. 52 F4
Vogelkop Peninsula Indon. see
Doberai, Jazirah
Vogelsberg hills Germany 53 I4
Voghera Italy 58 C2
Vohburg an der Donau Germany 53 L6
Vohémar Madag. see Iharaña
Vohenstrauß Germany 53 M5
Vohibinany Madag. see Ampasimanolotra
Vohimarina Madag. see Iharaña
Vohimena, Tanjona c. Madag. 99 E6
Vohipeno Madag. 99 E6
Vöhl Germany 53 I3
Võhma Estonia 45 N7
Voinjama Liberia 96 C4
Vojens Denmark 45 F9
Vojvodina prov. Serb. and Mont. 59 H2
Vokhma Rus. Fed. 42 J4
Voknavolok Rus. Fed. 44 Q4
Vol' r. Rus. Fed. 42 L3
Volcano Bay Japan see Uchiura-wan

▶Volcano Islands Japan 69 K2
Part of Japan.

Volda Norway 44 E5
Vol'dino Rus. Fed. 42 L3
Volendam Neth. 52 F2
Volga Rus. Fed. 42 H4

▶Volga r. Rus. Fed. 43 J7
Longest river and largest drainage basin in
Europe.
Europe 36–37

Volga Upland hills Rus. Fed. see
Privolzhskaya Vozvyshennost'
Volgodonsk Rus. Fed. 43 I7
Volgograd Rus. Fed. 43 J6
Volgogradskoye Vodokhranilishche resr
Rus. Fed. 43 J6
Völkermarkt Austria 47 O7
Volkhov Rus. Fed. 42 G4
Volkhov r. Rus. Fed. 42 G3
Völklingen Germany 52 G5
Volkovysk Belarus see Vawkavysk
Volksrust S. Africa 101 I4
Vol'no-Nadezhdinskoye Rus. Fed. 74 C4
Volnovakha Ukr. 43 H7
Vol'nyansk Ukr. see Vil'nyans'k
Volochanka Rus. Fed. 64 K2
Volochisk Ukr. see Volochys'k
Volochys'k Ukr. 43 E6
Volodars'ke Ukr. 43 H7
Volodarskoye Kazakh. see Saumalkol'
Volodymyr-Volyns'kyy Ukr. 43 E6
Vologda Rus. Fed. 42 H4
Volokolamsk Rus. Fed. 42 G4
Volokovaya Rus. Fed. 42 K2
Volos Greece 59 J5
Volosovo Rus. Fed. 45 P7
Volot Rus. Fed. 42 F4
Volovo Rus. Fed. 43 H5
Volozhin Belarus see Valozhyn
Volsini Italy see Orvieto
Vol'sk Rus. Fed. 43 J5

▶Volta, Lake resr Ghana 96 D4
4th largest lake in Africa.

Volta Blanche r. Burkina/Ghana see
White Volta
Voltaire, Cape Australia 108 D3
Volta Redonda Brazil 145 B3
Volturno r. Italy 58 E4
Volubilis tourist site Morocco 54 C5
Volvi, Limni l. Greece 59 J4
Volzhsk Rus. Fed. 42 K5
Volzhskaya Samarskaya Oblast'
Rus. Fed. 43 K5
Volzhskiy Volgogradskaya Oblast'
Rus. Fed. 43 J6
Vondanka Rus. Fed. 42 J4
Vontimitta India 84 C3
Vopnafjörður Iceland 44 [inset]
Vopnafjörður b. Iceland 44 [inset]
Võrå Fin. 44 M5
Voranava Belarus 45 N9
Voreies Sporades is Greece 59 J5
Voreioi Sporades is Greece see
Voreies Sporades
Voríai Sporádhes is Greece see
Voreies Sporades
Voring Plateau sea feature
N. Atlantic Ocean 148 I1
Vorjing mt. India 83 H3
Vorkuta Rus. Fed. 64 H3
Vormsi i. Estonia 45 M7
Vorona r. Rus. Fed. 43 I6
Voronezh Rus. Fed. 43 H6
Voronezh r. Rus. Fed. 43 H6

Voronov, Mys pt Rus. Fed. 42 I2
Vorontsovo-Aleksandrovskoye Rus. Fed. see Zelenokumsk
Voroshilov Rus. Fed. see Ussuriysk
Voroshilovgrad Ukr. see Luhans'k
Voroshilovsk Rus. Fed. see Stavropol'
Voroshilovsk Ukr. see Alchevs'k
Vorotynets Rus. Fed. 42 J4
Vorozhba Ukr. 43 G6
Vorpommersche Boddenlandschaft, Nationalpark nat. park Germany 47 N3
Vorskla r. Rus. Fed. 43 G6
Vörtsjärv l. Estonia 45 N7
Vorukh Tajik. 89 H2
Vosburg S. Africa 100 F6
Vose Tajik. 89 H2
Vosges mts France 56 H3
Voskresensk Rus. Fed. 43 H5
Voskresenskoye Rus. Fed. 42 H4
Voss Norway 45 E6
Vostochno-Sakhalinskiy Gory mts Rus. Fed. 74 F2
Vostochno-Sibirskoye More sea Rus. Fed. see East Siberian Sea
Vostochnyy Kirovskaya Oblast' Rus. Fed. 42 L4
Vostochnyy Sakhalinskaya Oblast' Rus. Fed. 74 F2
Vostochnyy Sayan mts Rus. Fed. 72 G2

▶Vostok research station Antarctica 152 F1
Lowest recorded screen temperature in the world.

Vostok Primorskiy Kray Rus. Fed. 74 D3
Vostok Sakhalinskaya Oblast' Rus. Fed. see Neftegorsk
Vostok Island Kiribati 151 J6
Vostroye Rus. Fed. 42 J3
Votkinsk Rus. Fed. 41 Q4
Votkinskoye Vodokhranilishche resr Rus. Fed. 41 R4
Votuporanga Brazil 145 A3
Vouziers France 52 E5
Voves France 56 E2
Voyageurs National Park U.S.A. 130 E1
Voynitsa Rus. Fed. 44 Q4
Võyri Fin. see Vörå
Voyvozh Rus. Fed. 42 L3
Vozhayel' Rus. Fed. 42 K3
Vozhe, Ozero l. Rus. Fed. 42 H3
Vozhega Rus. Fed. 42 I3
Vozhgaly Rus. Fed. 42 K4
Voznesens'k Ukr. 43 F7
Vozonin Trough sea feature Arctic Ocean 153 F1
Vozrozhdenya Island i. Uzbek. 80 A3
Vozzhayevka Rus. Fed. 74 C2
Vrangel' Rus. Fed. 74 D4
Vrangelya, Mys pt Rus. Fed. 74 E1
Vranje Serb. and Mont. 59 I3
Vratnik pass Bulg. 59 L3
Vratsa Bulg. 59 J3
Vrbas Serb. and Mont. 59 H2
Vrede S. Africa 101 I4
Vredefort S. Africa 101 H4
Vredenburg S. Africa 100 C7
Vredendal S. Africa 100 D6
Vresse Belgium 52 E5
Vriddhachalam India 84 C4
Vries Neth. 52 G1
Vrigstad Sweden 45 I8
Vryburg S. Africa 100 G4
Vryheid S. Africa 101 J4
Vsevidof, Mount vol. U.S.A. 118 B4
Vsevolozhsk Rus. Fed. 42 F3
Vu Ban Vietnam 70 D2
Vučitrn Serb. and Mont. 59 I3
Vukovar Croatia 59 H2
Vuktyl' Rus. Fed. 41 R3
Vukuzakhe S. Africa 101 I4
Vulcan Canada 120 H5
Vulcan Island P.N.G. see Manam Island
Vulcano, Isola i. Italy 58 F5
Vulture Mountains U.S.A. 129 G5
Vung Tau Vietnam 71 D5
Vuohijärvi Fin. 45 O6
Vuolijoki Fin. 44 O4
Vuollerim Sweden 44 L3
Vuostimo Fin. 44 O3
Vurnary Rus. Fed. 42 J5
Vushtri Serb. and Mont. see Vučitrn
Vvedenovka Rus. Fed. 74 C2
Vyara India 82 C5
Vyarkhowye Belarus see Ruba
Vyatka Rus. Fed. see Kirov
Vyatka r. Rus. Fed. 42 K5
Vyazemskiy Rus. Fed. 74 D3
Vyaz'ma Rus. Fed. 43 G5
Vyazniki Rus. Fed. 42 I4
Vyazovka Rus. Fed. 43 J5
Vyborg Rus. Fed. 45 P6
Vychegda r. Rus. Fed. 42 J3
Vychegodskiy Rus. Fed. 42 J3
Vyerkhnyadzvinsk Belarus 45 O9
Vyetryna Belarus 45 P9
Vygozero, Ozero l. Rus. Fed. 42 G3
Vyksa Rus. Fed. 43 I5
Vylkove Ukr. 59 M2
Vym' r. Rus. Fed. 42 K3
Vynohradiv Ukr. 43 N6
Vypin Island India 84 C4
Vypolzovo Rus. Fed. 42 G4
Vyritsa Rus. Fed. 45 Q7
Vyrnwy, Lake U.K. 49 D6
Vyselki Rus. Fed. 43 H7
Vysha Rus. Fed. 43 I5
Vyshhorod Ukr. 43 F6
Vyshnevolotskaya Gryada ridge Rus. Fed. 42 G4
Vyshniy-Volochek Rus. Fed. 42 G4
Vyškov Czech Rep. 47 P6
Vysokaya Gora Rus. Fed. 42 K5
Vysokogorniy Rus. Fed. 74 E2
Vystupovychi Rus. Fed. 43 F6

Vytegra Rus. Fed. 42 H3
Vyya r. Rus. Fed. 42 J3
Vyžuona r. Lith. 45 N9

Wa Ghana 96 C3
Waal r. Neth. 52 E3
Waalwijk Neth. 52 F3
Waat Sudan 86 D8
Wabag P.N.G. 69 K8
Wabakimi Lake Canada 122 C4
Wabasca r. Canada 120 H3
Wabasca-Desmarais Canada 120 H4
Wabash U.S.A. 134 C3
Wabash r. U.S.A. 134 A5
Wabasha U.S.A. 130 E2
Wabassi r. Canada 122 D4
Wabatongushi Lake Canada 122 D4
Wabě Gestro r. Eth. 78 D6
Wabē Shebelē Wenz r. Eth. 98 E3
Wabigoon Lake Canada 121 M5
Wabowden Canada 121 L4
Wabrah well Saudi Arabia 88 B5
Wabu China 77 H1
Wabush Canada 123 I3
Waccasassa Bay U.S.A. 133 D6
Wächtersbach Germany 53 J4
Waco Canada 123 I4
Waco U.S.A. 131 D6
Waconda Lake U.S.A. 130 D4
Wad Pak. 89 G5
Wadbilliga National Park Australia 112 D6
Waddān Libya 55 H6
Waddell Dam U.S.A. 129 G5
Waddeneilanden Neth. 52 E1
Waddenzee sea chan. Neth. 52 E2
Waddington, Mount Canada 120 E5
Waddinxveen Neth. 52 E2
Wadebridge U.K. 49 C8
Wadena Canada 121 K5
Wadena U.S.A. 130 E2
Wadern Germany 52 G5
Wadesville U.S.A. 134 B4
Wadeye Australia 108 E3
Wadgassen Germany 52 G5
Wadhwan India see Surendranagar
Wadi India 84 C2
Wādī as Sīr Jordan 85 B4
Wadi Halfa Sudan 86 D5
Wad Medani Sudan 86 D7
Wad Rawa Sudan 86 D6
Wadsworth U.S.A. 128 D2
Waenhuiskrans S. Africa 100 E8
Wafangdian China 73 M5
Wafra Kuwait see Al Wafrah
Wagenfeld Germany 53 I2
Wagenhoff Germany 53 K2
Wagga Wagga Australia 112 C5
Wagner U.S.A. 130 D3
Wagoner U.S.A. 131 E4
Wagon Mound U.S.A. 127 G5
Wah Pak. 89 I3
Wahai Indon. 69 H7
Wāḥāt Jālū Libya 97 F2
Wahemen, Lac l. Canada 123 H3
Wahiawā U.S.A. 127 [inset]
Wahlhausen Germany 53 J3
Wahpeton U.S.A. 130 D2
Wahran Alg. see Oran
Wah Wah Mountains U.S.A. 129 G2
Wai India 84 B2
Waialua U.S.A. 127 [inset]
Waiau N.Z. see Franz Josef Glacier
Waiau r. N.Z. 113 D6
Waiblingen Germany 53 J6
Waidhofen an der Ybbs Austria 47 O7
Waigeo i. Indon. 69 I7
Waiheke Island N.Z. 113 E3
Waikabubak Indon. 108 B2
Waikaia r. N.Z. 113 B7
Waikari N.Z. 113 D6
Waikerie Australia 111 E5
Waikouaiti N.Z. 113 C7
Wailuku U.S.A. 127 [inset]
Waimangaroa N.Z. 113 C5
Waimarama N.Z. 113 F4
Waimate N.Z. 113 C7
Waimea U.S.A. 127 [inset]
Wainganga r. India 84 C2
Waingapu Indon. 108 C2
Wainhouse Corner U.K. 49 C8
Waini Point Guyana 143 G2
Wainwright Canada 121 I4
Wainwright U.S.A. 118 C2
Waiouru N.Z. 113 E4
Waipahi N.Z. 113 B8
Waipaoa r. N.Z. 113 F4
Waipara N.Z. 113 D6
Waipawa N.Z. 113 F4
Waipukurau N.Z. 113 F4
Wairarapa, Lake N.Z. 113 E5
Wairau r. N.Z. 113 E5
Wairoa N.Z. 113 F4
Wairoa r. N.Z. 113 F4
Waitahanui N.Z. 113 F4
Waitahuna N.Z. 113 B7
Waitakaruru N.Z. 113 E3
Waitaki r. N.Z. 113 C7
Waitangi N.Z. 107 I6
Waite River Australia 108 F5
Waiuku N.Z. 113 E3
Waiwera South N.Z. 113 B8
Waiyang China 77 H3
Wajima Japan 75 E5
Wajir Kenya 98 E3
Waka Indon. 108 C2
Wakasa-wan b. Japan 75 D6
Wakatipu, Lake N.Z. 113 B7
Wakaw Canada 121 J4
Wakayama Japan 75 D6
Wake Atoll terr. N. Pacific Ocean see Wake Island
WaKeeney U.S.A. 130 D4
Wakefield N.Z. 113 D5
Wakefield U.K. 48 F5
Wakefield MI U.S.A. 130 F2

Wakefield RI U.S.A. 135 J3
Wakefield VA U.S.A. 135 G5

▶Wake Island terr. N. Pacific Ocean 150 H4
United States Unincorporated Territory.

Wakema Myanmar 70 A3
Wakhan r. Afgh. 89 I2
Wakkanai Japan 74 F3
Wakkerstroom S. Africa 101 J4
Wakool Australia 112 B5
Wakool r. Australia 112 A5
Wakuach, Lac l. Canada 123 I3
Waku-Kungo Angola 99 B5
Wałbrzych Poland 47 P5
Walcha Australia 112 E3
Walcott U.S.A. 126 G4
Walcourt Belgium 52 E4
Wałcz Poland 47 P4
Waldburg Range mts Australia 109 B6
Walden U.S.A. 135 H3
Waldenbuch Germany 53 J6
Waldenburg Poland see Wałbrzych
Waldkraiburg Germany 47 N6
Waldo U.S.A. 134 D3
Waldoboro U.S.A. 135 K1
Waldorf U.S.A. 135 G4
Waldport U.S.A. 126 B3
Waldron U.S.A. 131 E5
Waldron, Cape Antarctica 152 F2
Walebing Australia 109 B7
Walêg China 76 D2
Wales admin. div. U.K. 49 D6
Walgaon India 82 D5
Walgett Australia 112 D3
Walgreen Coast Antarctica 152 K1
Walhalla MI U.S.A. 134 B2
Walhalla ND U.S.A. 130 D1
Walikale Dem. Rep. Congo 97 F5
Walingai P.N.G. 69 L8
Walker watercourse Australia 109 F6
Walker MI U.S.A. 134 C2
Walker MN U.S.A. 130 E2
Walker r. U.S.A. 128 D2
Walker Bay S. Africa 100 D8
Walker Creek r. Australia 110 C3
Walker Lake Canada 121 L4
Walker Lake U.S.A. 128 D2
Walker Pass U.S.A. 128 D4
Walkersville U.S.A. 135 G4
Walkerton Canada 134 E1
Walkerton U.S.A. 134 B3
Wall, Mount hill Australia 108 B5
Wallaby Island Australia 110 C2
Wallace ID U.S.A. 126 D3
Wallace NC U.S.A. 133 E5
Wallace VA U.S.A. 134 D5
Wallaceburg Canada 134 D2
Wallal Downs Australia 108 C4
Wallangarra Australia 112 E2
Wallaroo Australia 111 B7
Wallasey U.K. 48 D5
Walla Walla Australia 112 C5
Walla Walla U.S.A. 126 D3
Walldürn Germany 53 J5
Wallekraal S. Africa 100 C6
Wallendbeen Australia 112 D5
Wallingford U.K. 49 F7
Wallis, Îles is Wallis and Futuna Is 107 I3

▶Wallis and Futuna Islands terr. S. Pacific Ocean 107 I3
French Overseas Territory.
Oceania 8, 104–105

Wallis et Futuna, Îles terr. S. Pacific Ocean see Wallis and Futuna Islands
Wallis Islands Wallis and Futuna Is see Wallis, Îles
Wallis Lake inlet Australia 112 F4
Wallops Island U.S.A. 135 H5
Wallowa Mountains U.S.A. 126 D3
Walls U.K. 50 [inset]
Walls of Jerusalem National Park Australia 111 [inset]
Wallumbilla Australia 111 E5
Walmsley Lake Canada 121 I2
Walney, Isle of i. U.K. 48 D4
Walnut Creek U.S.A. 128 B3
Walnut Grove U.S.A. 128 C2
Walnut Ridge U.S.A. 131 F4
Walong India 83 I3
Walpole U.S.A. 135 I2
Walpole r. Australia 84 C2
Walsall U.K. 49 F6
Walsenburg U.S.A. 127 G5
Walsh r. Australia 110 C3
Walsh U.S.A. 131 C4
Walsrode Germany 53 J2
Waltair India 84 D2
Walterboro U.S.A. 133 D5
Walters U.S.A. 131 D5
Walter's Range hills Australia 112 B2
Walthall U.S.A. 131 F5
Waltham U.S.A. 135 J2
Walton IN U.S.A. 134 B3
Walton KY U.S.A. 134 C4
Walton NY U.S.A. 135 H2
Walton WV U.S.A. 134 E4
Walvisbaai Namibia see Walvis Bay
Walvisbaai b. Namibia see Walvis Bay
Walvis Bay Namibia 100 B2
Walvis Bay b. Namibia 100 B2
Walvis Ridge sea feature S. Atlantic Ocean 148 H8
Wama Afgh. 89 H3
Wamba Équateur Dem. Rep. Congo 97 F5
Wamba Orientale Dem. Rep. Congo 98 C3
Wamba Nigeria 96 D4
Wampum U.S.A. 134 E3
Wampusirpi Hond. 137 H5
Wamsutter U.S.A. 126 G4
Wana Pak. 89 H3
Wanaaring Australia 112 B2
Wanaka N.Z. 113 B7
Wanaka, Lake N.Z. 113 B7
Wan'an China 77 G3
Wanapitei Lake Canada 122 D5
Wanbi Australia 111 C7
Wanbrow, Cape N.Z. 113 C7

Wanda Shan mts China 74 D3
Wandering River Canada 121 H4
Wandersleben Germany 53 K4
Wandlitz Germany 53 N2
Wando S. Korea 75 B6
Wandoan Australia 111 E5
Wanganui N.Z. 113 E4
Wanganui r. N.Z. 113 E4
Wangaratta Australia 112 C6
Wangcang China 76 E1
Wangda China see Zogang
Wangdain China 83 G3
Wangdi Phodrang Bhutan 83 G4
Wanggamet, Gunung mt. Indon. 108 C2
Wanggao China 77 F3
Wang Gaxun China 83 I1
Wangguan China 76 E1
Wangiwangi i. Indon. 69 G8
Wangkui China 74 B3
Wangmo China 76 E3
Wangqing China 74 C4
Wangwu Shan mts China 77 F1
Wangying China see Huaiyin
Wanham Canada 120 G4
Wan Hsa-la Myanmar 70 B2
Wanie-Rukula Dem. Rep. Congo 98 C3
Wankaner India 82 B5
Wankie Zimbabwe see Hwange
Wanlaweyn Somalia 98 E3
Wanna Germany 53 I1
Wanna Lakes salt flat Australia 109 E7
Wannian China 77 H2
Wanning China 77 F5
Wanroij Neth. 52 F3
Wanshan China 77 F3
Wanshan Qundao is China 77 G4
Wansheng China 76 E2
Wanshengchang China see Wansheng
Wantage U.K. 49 F7
Wanxian Chongqing China 77 F2
Wanxian Chongqing China see Shahe
Wanyuan China 77 F1
Wanzai China 77 G2
Wanze Belgium 52 F4
Wapakoneta U.S.A. 134 C3
Wapawekka Lake Canada 121 J4
Wapello U.S.A. 130 F3
Wapikaimaski Lake Canada 122 C4
Wapikopa Lake Canada 122 C3
Wapiti r. Canada 120 G4
Wapusk National Park Canada 121 M3
Waqên China 76 D1
Waqf aş Şawwān, Jibāl hills Jordan 85 C4
War U.S.A. 134 E5
Warab Sudan 86 C8
Warangal India 84 C2
Waranga Reservoir Australia 112 B6
Waratah Bay Australia 112 B7
Warbreccan Australia 110 C4
Warburg Germany 53 J3
Warburton Australia 109 D6
Warburton watercourse Australia 111 B5
Warburton Bay Canada 121 I2
Warche r. Belgium 52 F4
Ward, Mount N.Z. 113 B6
Warden S. Africa 101 I4
Wardenburg Germany 53 I1
Wardha India 84 C1
Wardha r. India 84 C2
Ward Hill hill U.K. 50 F2
Ward Hunt, Cape P.N.G. 69 L8
Ware Canada 120 E3
Ware U.S.A. 135 I2
Wareham U.K. 49 E8
Waremme Belgium 52 F4
Waren Germany 53 M1
Warendorf Germany 53 H3
Warginburra Peninsula Australia 110 E4
Wargla Alg. see Ouargla
Warialda Australia 112 E2
Warin Chamrap Thai. 70 D4
Warkum Neth. see Workum
Warli China see Walêg
Warloy-Baillon France 52 C4
Warman Canada 121 J4
Warmbad Namibia 100 D5
Warmbad S. Africa 101 I3
Warmbaths S. Africa see Warmbad
Warminster U.K. 49 E7
Warminster U.S.A. 135 H3
Warmond Neth. 52 E2
Warm Springs NV U.S.A. 128 E2
Warm Springs VA U.S.A. 134 F4
Warmwaterberg mts S. Africa 100 E7
Warner Canada 121 H5
Warner Lakes U.S.A. 126 D4
Warner Mountains U.S.A. 126 C4
Warnes Bol. 142 F7
Warning, Mount Australia 112 F2
Waronda India 84 C2
Warora India 84 C1
Warra Australia 112 E1
Warragamba Reservoir Australia 112 E4
Warragul Australia 112 B7
Warrandirinna, Lake salt flat Australia 111 B5
Warrandyte Australia 112 B6
Warrawagine Australia 108 C5
Warrego r. Australia 112 B3
Warrego Range hills Australia 110 D5
Warren Australia 112 C3
Warren AR U.S.A. 131 E5
Warren MI U.S.A. 134 D2
Warren MN U.S.A. 130 D1
Warren OH U.S.A. 134 E3
Warren PA U.S.A. 134 F3
Warrenpoint U.K. 51 F3
Warrensburg MO U.S.A. 130 E4
Warrensburg NY U.S.A. 135 I2
Warrenton S. Africa 100 G5
Warrenton GA U.S.A. 133 D5
Warrenton MO U.S.A. 130 F4
Warrenton VA U.S.A. 135 G4
Warri Nigeria 96 D4
Warriners Creek watercourse Australia 111 B6
Warrington N.Z. 113 C7

Warrington U.K. 48 E5
Warrington U.S.A. 133 C6
Warrnambool Australia 111 C8
Warroad U.S.A. 130 E1
Warrumbungle National Park Australia 112 D3

▶Warsaw Poland 47 R4
Capital of Poland.

Warsaw IN U.S.A. 134 C3
Warsaw KY U.S.A. 134 C4
Warsaw MO U.S.A. 130 E4
Warsaw NY U.S.A. 135 F2
Warsaw VA U.S.A. 135 G5
Warshiikh Somalia 98 E3
Warstein Germany 53 I3
Warszawa Poland see Warsaw
Warta r. Poland 47 O4
Warwick Australia 112 F2
Warwick U.K. 49 F6
Warwick U.S.A. 135 J3
Warzhong China 76 D2
Wasaga Beach Canada 134 E1
Wasatch Range mts U.S.A. 126 F5
Wasbank S. Africa 101 J5
Wasco U.S.A. 128 D4
Waseca U.S.A. 130 E2
Washburn ND U.S.A. 130 C2
Washburn WI U.S.A. 130 F2
Washim India 82 B5
Washimeska r. Canada 123 G4

▶Washington DC U.S.A. 135 G4
Capital of the United States of America.

Washington GA U.S.A. 133 D5
Washington IA U.S.A. 130 F3
Washington IN U.S.A. 134 B4
Washington MO U.S.A. 130 F4
Washington NC U.S.A. 132 E5
Washington NJ U.S.A. 135 H3
Washington PA U.S.A. 134 E3
Washington UT U.S.A. 129 G3
Washington state U.S.A. 126 C2
Washington, Cape Antarctica 152 H2
Washington, Mount U.S.A. 135 J1
Washington Court House U.S.A. 134 D4
Washington Island U.S.A. 130 D3
Washington Land reg. Greenland 119 L2
Washir Afgh. 89 F3
Washita r. U.S.A. 131 D5
Washpool National Park Australia 112 F2
Washtucna U.S.A. 126 D3
Washuk Pak. 89 G5
Wasi India 84 C2
Wasi' Saudi Arabia 88 B5
Wasi' well Saudi Arabia 88 C6
Waskaganish Canada 122 F4
Waskagheganish Canada see Waskaganish
Waskaiowaka Lake Canada 121 L3
Waskey, Mount U.S.A. 118 C4
Wassenaar Neth. 52 E2
Wasser Namibia 100 D4
Wasserkuppe hill Germany 53 J4
Wassertrüdingen Germany 53 K5
Wassuk Range mts U.S.A. 128 D2
Wasua P.N.G. 69 K8
Wasum P.N.G. 69 L8
Waswanipi r. Canada 122 F4
Waswanipi, Lac l. Canada 122 F4
Watam P.N.G. 69 K7
Watampone Indon. 69 G7
Watapi Lake Canada 121 J3
Watarrka National Park Australia 109 E6
Watenstedt-Salzgitter Germany see Salzgitter
Waterbury CT U.S.A. 135 I3
Waterbury VT U.S.A. 135 I1
Waterbury Lake Canada 121 J3
Water Cays i. Bahamas 133 E8
Waterdown Canada 134 F2
Wateree r. U.S.A. 133 D5
Waterfall U.S.A. 120 C4
Waterford Ireland 51 E5
Waterford PA U.S.A. 134 F3
Waterford WI U.S.A. 134 A2
Waterford Harbour Ireland 51 F5
Watergrasshill Ireland 51 D5
Waterhen Lake Canada 121 L4
Waterloo Australia 108 E4
Waterloo Belgium 52 E4
Waterloo Ont. Canada 134 E2
Waterloo Que. Canada 135 I1
Waterloo IA U.S.A. 130 E3
Waterloo IL U.S.A. 130 F4
Waterloo NY U.S.A. 135 G2
Waterlooville U.K. 49 F8
Waterton Lakes National Park Canada 120 H5
Watertown NY U.S.A. 135 H2
Watertown SD U.S.A. 130 D2
Watertown WI U.S.A. 130 F3
Waterval Boven S. Africa 101 J3
Water Valley U.S.A. 131 F5
Waterville ME U.S.A. 135 K1
Waterville WA U.S.A. 126 C3
Watford Canada 134 E2
Watford U.K. 49 G7
Watford City U.S.A. 130 C2
Wathaman r. Canada 121 K3
Wathaman Lake Canada 121 K3
Watheroo National Park Australia 109 A7
Wathlingen Germany 53 K2
Watino Canada 120 G4
Watir, Wādī watercourse Egypt 85 B5
Watkins Glen U.S.A. 135 G2
Watling Island Bahamas see San Salvador
Watmuri Indon. 108 E1
Watonga U.S.A. 131 D5
Watrous Canada 121 J5
Watrous U.S.A. 127 G6
Watseka U.S.A. 134 B3
Watsi Kengo Dem. Rep. Congo 97 F5
Watson r. Australia 110 C2
Watson Canada 121 J4
Watson Lake Canada 120 D2
Watsontown U.S.A. 135 G3
Watsonville U.S.A. 128 C3
Watten U.K. 50 F2

Watterson Lake Canada 121 L2
Watton U.K. 49 H6
Watts Bar Lake resr U.S.A. 132 C5
Wattsburg U.S.A. 134 F2
Watubela, Kepulauan is Indon. 69 I7
Wau P.N.G. 69 L8
Wau Sudan 86 C8
Waubay Lake U.S.A. 130 D2
Wauchope N.S.W. Australia 112 F3
Wauchope N.T. Australia 108 F5
Waukaringa Australia 111 B7
Waukarlycarly, Lake salt flat Australia 108 C5
Waukegan U.S.A. 134 B2
Waukesha U.S.A. 134 A2
Waupaca U.S.A. 130 F2
Waupun U.S.A. 130 F3
Waurika U.S.A. 131 D5
Wausau U.S.A. 130 F2
Wausaukee U.S.A. 132 C2
Wauseon U.S.A. 134 C3
Wautoma U.S.A. 130 F2
Wave Hill Australia 108 E4
Waveney r. U.K. 49 I6
Waverly IA U.S.A. 130 E3
Waverly NY U.S.A. 135 G2
Waverly OH U.S.A. 134 D4
Waverly TN U.S.A. 132 C4
Waverly VA U.S.A. 135 G5
Wavre Belgium 52 E4
Waw Myanmar 70 B3
Wawa Canada 122 D5
Wawalalindu Indon. 69 G7
Wāw al Kabīr Libya 97 E2
Wawasee, Lake U.S.A. 134 C3
Wawo Indon. 69 G7
Waxahachie U.S.A. 131 D5
Waxü China 80 D1
Waxxari China 80 G4
Way, Lake salt flat Australia 109 C6
Waycross U.S.A. 133 D6
Wayland KY U.S.A. 134 D5
Wayland MI U.S.A. 134 C2
Wayne NE U.S.A. 130 D3
Wayne WV U.S.A. 134 D4
Waynesboro GA U.S.A. 133 D5
Waynesboro MS U.S.A. 131 F6
Waynesboro TN U.S.A. 132 C5
Waynesboro VA U.S.A. 135 F4
Waynesburg U.S.A. 134 E4
Waynesville MO U.S.A. 130 E4
Waynesville NC U.S.A. 132 D5
Waynoka U.S.A. 131 D4
Waza, Parc National de nat. park Cameroon 97 E3
Wäzah Khwāh Afgh. see Wazi Khwa
Wazi Khwa Afgh. 89 H3
Wazirabad Pak. 89 I3
W du Niger, Parcs Nationaux du nat. park Niger 96 D3
We, Pulau i. Indon. 71 A6
Weagamow Lake Canada 121 N4
Weam P.N.G. 69 K8
Wear r. U.K. 48 F4
Weare U.S.A. 135 J2
Weatherford U.S.A. 131 D5
Weaver Lake Canada 121 L4
Weaverville U.S.A. 126 C4
Webb, Mount hill Australia 108 E5
Webequie Canada 122 D3
Weber, Mount Canada 120 D4
Weber Basin sea feature Laut Banda 150 E6

▶Webi Shabeelle r. Somalia 98 E3
5th longest river in Africa.

Webster IN U.S.A. 134 C4
Webster MA U.S.A. 135 J2
Webster SD U.S.A. 130 D2
Webster City U.S.A. 130 E3
Webster Springs U.S.A. 134 E4
Wecho Lake Canada 120 H2
Wedau P.N.G. 110 E1
Weddell Abyssal Plain sea feature Southern Ocean 152 A2
Weddell Island Falkland Is 144 D8
Weddell Sea Antarctica 152 A2
Wedderburn Australia 112 A6
Weddin Mountains National Park Australia 112 D4
Wedel (Holstein) Germany 53 J1
Wedge Mountain Canada 120 F5
Wedowee U.S.A. 133 C5
Weedville U.S.A. 135 F3
Weenen S. Africa 101 J5
Weener Germany 53 H1
Weert Neth. 52 F3
Weethalle Australia 112 C4
Wee Waa Australia 112 D3
Wegberg Germany 52 G3
Węgorzewo Poland 47 R3
Weichang China 73 L4
Weida Germany 53 M4
Weidenberg Germany 53 L5
Weiden in der Oberpfalz Germany 53 M5
Weidongmen China see Qianjin
Weifang China 73 L5
Weihai China 73 M5
Wei He r. Shaanxi China 76 F1
Wei He r. China 77 G1
Weilburg Germany 53 I4
Weilmoringle Australia 112 C2
Weimar Germany 53 L4
Weinan China 77 F1
Weinheim Germany 53 I5
Weining China 76 E3
Weinsberg Germany 53 J5
Weipa Australia 110 C2
Weiqu China see Chang'an
Weir r. Australia 112 D2
Weir River Canada 121 M3
Weirton U.S.A. 134 E3
Weiser U.S.A. 126 D3
Weishan China 76 D3
Weishan Hu l. China 77 H1
Weishi China 77 G1
Weiße Elster r. Germany 53 L3
Weißenburg in Bayern Germany 53 K5
Weißenfels Germany 53 L3
Weißkugel mt. Austria/Italy 47 M7
Weissrand Mountains Namibia 100 D3
Weiterstadt Germany 53 I5

Weitzel Lake Canada 121 J3
Weixi China 76 C3
Weixin China 76 E3
Weiya China 80 H3
Weiyuan Gansu China 76 E1
Weiyuan Sichuan China 76 E2
Weiyuan Yunnan China see Jinggu
Weiyuan Jiang r. China 76 D4
Weiz Austria 47 O7
Weizhou China see Wenchuan
Weizhou Dao i. China 77 F4
Wejherowo Poland 47 Q3
Wekilbazar Turkm. 89 F2
Wekusko Canada 121 L4
Wekusko Lake Canada 121 L4
Wekweti Canada 120 H1
Welatam Myanmar 70 B1
Welbourn Hill Australia 109 F6
Welch U.S.A. 135 J1
Weldiya Eth. 98 D2
Welford National Park Australia 110 C5
Welk'it'ē Eth. 98 D3
Welkom S. Africa 101 H4
Welland Canada 134 F2
Welland r. U.K. 49 G6
Welland Canal Canada 134 F2
Wellesley Canada 134 E2
Wellesley Islands Australia 110 B3
Wellesley Lake Canada 120 B2
Wellfleet U.S.A. 135 J3
Wellin Belgium 52 F4
Wellingborough U.K. 49 G6
Wellington Australia 112 D4
Wellington Canada 135 G2

▶Wellington N.Z. 113 E5
Capital of New Zealand.

Wellington S. Africa 100 D7
Wellington England U.K. 49 D8
Wellington England U.K. 49 E6
Wellington CO U.S.A. 126 G4
Wellington IL U.S.A. 134 B3
Wellington KS U.S.A. 131 D4
Wellington NV U.S.A. 128 D2
Wellington OH U.S.A. 134 D3
Wellington TX U.S.A. 131 C5
Wellington UT U.S.A. 129 H2
Wellington, Isla i. Chile 144 B7
Wellington Range hills N.T.
 Australia 108 F3
Wellington Range hills W.A.
 Australia 109 C6
Wells Canada 120 F4
Wells U.K. 49 E7
Wells U.S.A. 126 E4
Wells, Lake salt flat Australia 109 C6
Wellsboro U.S.A. 135 G3
Wellsburg U.S.A. 134 E3
Wellsford N.Z. 113 E3
Wells-next-the-Sea U.K. 49 H6
Wellston U.S.A. 134 C1
Wellsville U.S.A. 135 G2
Wellton U.S.A. 129 F5
Wels Austria 47 O6
Welshpool U.K. 49 D6
Welsickendorf Germany 53 N3
Welwitschia Namibia see Khorixas
Welwyn Garden City U.K. 49 G7
Welzheim Germany 53 J6
Wem U.K. 49 E6
Wembesi S. Africa 101 I5
Wembley Canada 120 G4
Wemindji Canada 122 F3
Wenatchee U.S.A. 126 C3
Wenatchee Mountains U.S.A. 126 C3
Wenbu China see Nyima
Wenchang Hainan China 77 F5
Wenchang Sichuan China see Zitong
Wenchow China see Wenzhou
Wenchuan China 76 D2
Wendelstein Germany 53 L5
Wenden U.S.A. 129 G5
Wenden Latvia see Cēsis
Wendeng China 76 H4
Wendo Eth. 98 D3
Wendover U.S.A. 129 F1
Weng'an China 76 E3
Wengshui China 76 C2
Wengyuan China 77 G3
Wenhua China see Weishan
Wenlan China see Mengzi
Wenling China 77 I2
Wenlock r. Australia 110 C2
Wenping China see Ludian
Wenquan Guizhou China 76 E2
Wenquan Henan China see Wenxian
Wenquan Hubei China see Yingshan

▶Wenquan Qinghai China 83 G2
Highest settlement in the world.

Wenquan Xinjiang China 80 F3
Wenshan China 76 E4
Wenshui China 76 E2
Wensum r. U.K. 49 I6
Wentorf bei Hamburg Germany 53 K1
Wentworth Australia 111 C7
Wenxi China 77 F1
Wenxian Gansu China 76 E1
Wenxian Henan China 77 G1
Wenzhou China see Xiangyin
Wenzhou China 77 I3
Wenzlow Germany 53 M2
Wepener S. Africa 101 H5
Wer India 82 D4
Werben (Elbe) Germany 53 L2
Werda Botswana 100 F3
Werdau Germany 53 M4
Werdēr Eth. 98 E3
Werder Germany 53 M2
Werdohl Germany 53 H3
Werl Germany 53 H3
Wernberg-Köblitz Germany 53 M5
Werne Germany 53 H3
Wernecke Mountains Canada 120 B1
Wernigerode Germany 53 K3
Werra r. Germany 53 J3
Werris Creek Australia 112 E3
Wertheim Germany 53 J5
Wervik Belgium 52 D4
Wesel Germany 52 G3

Wesel-Datteln-Kanal canal
 Germany 52 G3
Wesenberg Germany 53 M1
Wesendorf Germany 53 K2
Weser r. Germany 53 I1
Weser sea chan. Germany 53 I1
Wesergebirge hills Germany 53 I2
Weslaco U.S.A. 131 D7
Weslemkoon Lake Canada 135 G1
Wesleyville Canada 123 L4
Wessel, Cape Australia 110 B1
Wessel Islands Australia 110 B1
Wesselsbron S. Africa 101 H4
Wesselton S. Africa 101 I4
Wessington Springs U.S.A. 130 D2
Westall, Point Australia 109 F8
West Allis U.S.A. 134 A2
West Antarctica reg. Antarctica 152 J1
West Australian Basin sea feature
 Indian Ocean 149 O7

▶West Bank terr. Asia 85 B3
Territory occupied by Israel.
Asia 6

West Bay Canada 123 K3
West Bay inlet U.S.A. 133 C6
West Bend U.S.A. 134 A2
West Bengal state India 83 F5
West Branch U.S.A. 134 C1
West Bromwich U.K. 49 F6
Westbrook U.S.A. 135 J2
West Burke U.S.A. 135 J1
West Burra i. U.K. see Burra
Westbury U.K. 49 E7
West Caicos i. Turks and Caicos Is 133 F8
West Cape Howe Australia 109 B8
West Caroline Basin sea feature
 N. Pacific Ocean 150 F5
West Chester U.S.A. 135 H4
Westcliffe U.S.A. 127 G5
West Coast National Park S. Africa 100 D7
West End Bahamas 133 E7
Westerburg Germany 53 H4
Westerholt Germany 53 H1
Westerland Germany 47 L3
Westerlo Belgium 52 E3
Westerly U.S.A. 135 J3
Western r. Canada 121 J1
Western Australia state Australia 109 C6
Western Cape prov. S. Africa 100 E7
Western Desert Egypt 90 C6
Western Dvina r. Europe see
 Zapadnaya Dvina
Western Ghats mts India 84 B3
Western Port b. Australia 112 B7

▶Western Sahara terr. Africa 96 B2
Disputed territory (Morocco).
Africa 7, 94–95

Western Samoa country S. Pacific Ocean
 see Samoa
Western Sayan Mountains reg. Rus. Fed.
 see Zapadnyy Sayan
Westerschelde est. Neth. 52 D3
Westerstede Germany 53 H1
Westerville U.S.A. 134 D3
Westerwald hills Germany 53 H4
West Falkland i. Falkland 144 D8
West Fargo U.S.A. 130 D2
West Fayu atoll Micronesia 69 L5
Westfield IN U.S.A. 134 B3
Westfield MA U.S.A. 135 I2
Westfield NY U.S.A. 134 F2
Westfield PA U.S.A. 135 G3
West Frisian Islands Neth. see
 Waddeneilanden
Westgat sea chan. Neth. 52 G1
Westgate Australia 112 C1
West Glacier U.S.A. 126 F2
West Grand Lake U.S.A. 132 H2
West Hartford U.S.A. 135 I3
Westhausen Germany 53 K6
West Haven U.S.A. 135 I3
Westhill U.K. 50 G3
Westhope U.S.A. 130 C1
West Ice Shelf Antarctica 152 E2
West Indies is Caribbean Sea 137 J4
West Island India 71 A4
Westkapelle Neth. 52 D3
West Kazakhstan Oblast admin. div.
 Kazakh. see Zapadnyy Kazakhstan
West Kingston U.S.A. 135 J3
West Lafayette U.S.A. 134 B3
West Lamma Channel H.K.
 China 77 [inset]
Westland U.S.A. 134 D2
Westland National Park N.Z. 113 C6
Westleigh S. Africa 101 H4
Westleton U.K. 49 I6
West Liberty U.S.A. 134 D5
West Linton U.K. 50 F5
West Loch Roag b. U.K. 50 C2
Westlock Canada 120 H4
West Lorne Canada 134 E2
West Lunga National Park Zambia 99 C5
West MacDonnell National Park
 Australia 109 E5
West Malaysia pen. Malaysia see
 Peninsular Malaysia
Westmalle Belgium 52 E3
Westmar Australia 112 D1
West Mariana Basin sea feature
 N. Pacific Ocean 150 F4
West Memphis U.S.A. 131 F5
Westminster U.S.A. 135 G4
Westmoreland Australia 110 B3
Westmoreland U.S.A. 134 B5
Westmorland U.S.A. 129 F5
Weston OH U.S.A. 134 D3
Weston WV U.S.A. 134 E4
Weston-super-Mare U.K. 49 E7
West Palm Beach U.S.A. 133 D7
West Plains U.S.A. 131 F4
West Point pt Australia 111 [inset]
West Point CA U.S.A. 128 C2
West Point KY U.S.A. 134 C5
West Point MS U.S.A. 131 F5
West Point NE U.S.A. 130 D3
West Point VA U.S.A. 135 G5
West Point Lake resr U.S.A. 133 C5

Westport Canada 135 G1
Westport Ireland 51 C4
Westport U.S.A. 135 I4
Westport CA U.S.A. 128 B2
Westport KY U.S.A. 134 C4
Westport NY U.S.A. 135 I1
Westray Canada 121 K4
Westray i. U.K. 50 F1
Westray Firth sea chan. U.K. 50 F1
Westree Canada 122 E5
West Rutland U.S.A. 135 I2
West Salem U.S.A. 134 D3
West Siberian Plain Rus. Fed. 64 J3
West-Skylge Neth. see
 West-Terschelling
West Stewartstown U.S.A. 135 J1
West-Terschelling Neth. 52 F1
West Topsham U.S.A. 135 I1
West Union IA U.S.A. 130 F3
West Union IL U.S.A. 134 B4
West Union OH U.S.A. 134 D4
West Union WV U.S.A. 134 E4
West Valley City U.S.A. 129 H1
Westville U.S.A. 134 B3
Westwood U.S.A. 128 C1
West Wyalong Australia 112 C4
West York U.S.A. 135 G4
Westzaan Neth. 52 E2
Wetar i. Indon. 108 D1
Wetar, Selat sea chan. East Timor/Indon.
 108 D2
Wetaskiwin Canada 120 H4
Wete Tanz. 99 D4
Wetter r. Germany 53 I4
Wettin Germany 53 L3
Wetumpka U.S.A. 133 C5
Wetwun Myanmar 70 B2
Wetzlar Germany 53 I4
Wewahitchka U.S.A. 133 C6
Wewak P.N.G. 69 K7
Wewoka U.S.A. 131 D5
Wexford Ireland 51 F5
Wexford Harbour b. Ireland 51 F5
Weyakwin Canada 121 J4
Weybridge U.K. 49 G7
Weyburn Canada 121 K5
Weyhe Germany 53 I2
Weymouth U.K. 49 E8
Weymouth U.S.A. 135 J2
Wezep Neth. 52 G2
Whakaari i. N.Z. 113 F3
Whakatane N.Z. 113 F3
Whalan Creek r. Australia 112 D2
Whale r. Canada see La Baleine, Rivière à
Whalsay i. U.K. 50 [inset]
Whampoa China see Huangpu
Whangamata N.Z. 113 E3
Whanganui National Park N.Z. 113 E4
Whangarei N.Z. 113 E2
Whapmagoostui Canada 122 F3
Wharfe r. U.K. 48 F5
Wharfedale valley U.K. 48 F4
Wharton U.S.A. 131 D6
Wha Ti Canada 120 G2
Wheatland IN U.S.A. 134 B4
Wheatland WY U.S.A. 126 G4
Wheaton IL U.S.A. 134 A3
Wheaton MN U.S.A. 130 D2
Wheaton-Glenmont U.S.A. 135 G4
Wheeler U.S.A. 131 C5
Wheeler Lake Canada 120 H2
Wheeler Lake resr U.S.A. 133 C5
Wheeler Peak NM U.S.A. 127 G5
Wheeler Peak NV U.S.A. 129 F2
Wheelersburg U.S.A. 134 D4
Wheeling U.S.A. 134 E3
Whernside hill U.K. 48 E4
Whinham, Mount Australia 109 E6
Whiskey Jack Lake Canada 121 K3
Whitburn U.K. 50 F5
Whitby Canada 135 F2
Whitby U.K. 48 G4
Whitchurch U.K. 49 E6
Whitchurch-Stouffville Canada 134 F2
White r. Canada 122 D4
White r. Canada/U.S.A. 120 B2
White r. AR U.S.A. 125 I5
White r. AR U.S.A. 131 F5
White r. CO U.S.A. 129 I1
White r. IN U.S.A. 134 B4
White r. MI U.S.A. 134 B2
White r. NV U.S.A. 129 F3
White r. SD U.S.A. 130 D3
White r. VT U.S.A. 135 I2
White watercourse U.S.A. 129 H5
White, Lake salt flat Australia 108 E5
White Bay Canada 123 K4
White Butte mt. U.S.A. 130 C2
White Canyon U.S.A. 129 H3
White Cloud U.S.A. 134 C2
Whitecourt Canada 120 H4
Whiteface Mountain U.S.A. 135 I1
Whitefield U.S.A. 135 J1
Whitefish r. Canada 120 H2
Whitefish U.S.A. 126 E2
Whitefish Bay U.S.A. 134 B1
Whitefish Lake Canada 121 J2
Whitefish Point U.S.A. 132 C2
Whitehall Ireland 51 E5
Whitehall U.K. 50 G1
Whitehall NY U.S.A. 135 I2
Whitehall WI U.S.A. 130 F2
Whitehaven U.K. 48 D4
Whitehead U.K. 51 G3
White Hill hill Canada 123 J5
Whitehill U.K. 49 G7

▶Whitehorse Canada 120 C2
Territorial capital of Yukon.

White Horse U.S.A. 129 J4
White Horse, Vale of valley U.K. 49 F7
White Horse Pass U.S.A. 129 F1
White House U.S.A. 134 B5
White Island Antarctica 152 D2
White Island N.Z. see Whakaari
Whitelaw Australia 112 B7
White Lake Ont. Canada 122 D4
White Lake Ont. Canada 135 G1
White Lake LA U.S.A. 131 E6
White Lake MI U.S.A. 134 B2

Whitemark Australia 111 [inset]
White Mountain Peak U.S.A. 128 D3
White Mountains U.S.A. 135 J1
White Mountains National Park
 Australia 110 D4
Whitemouth Lake Canada 121 M5
Whitemud r. Canada 120 G3
White Nile r. Sudan/Uganda 86 D6
 also known as Bahr el Abiad or
 Bahr el Jebel
White Nossob watercourse
 Namibia 100 D2
White Oak U.S.A. 134 D5
White Otter Lake Canada 121 N5
White Pass Canada/U.S.A. 120 C3
White Pine Range mts U.S.A. 129 F2
White Plains U.S.A. 135 I3
White River Canada 122 D4
Whiteriver U.S.A. 129 I5
White River U.S.A. 130 C3
White River Valley U.S.A. 129 F2
White Rock Peak U.S.A. 129 F2
White Russia country Europe see Belarus
Whitesail Lake Canada 120 E4
White Salmon U.S.A. 126 C3
Whitesand r. Canada 120 C1
White Sands National Monument nat. park
 U.S.A. 127 G6
Whitesburg U.S.A. 134 D5
White Sea Rus. Fed. 42 H2
White Stone U.S.A. 135 G5
White Sulphur Springs MT U.S.A. 126 F3
White Sulphur Springs WV U.S.A. 134 E5
Whitesville U.S.A. 134 E5
Whiteville U.S.A. 133 E5
White Volta r. Burkina/Ghana 96 C4
 also known as Nakambé or Nakanbe or
 Volta Blanche
Whitewater U.S.A. 129 I2
Whitewater Baldy mt. U.S.A. 129 I5
Whitewater Lake Canada 122 C4
Whitewood U.S.A. 130 C2
Whitewood Canada 121 K5
Whitfield U.K. 49 I7
Whithorn U.K. 50 E6
Whitianga N.Z. 113 E3
Whitland U.K. 49 C7
Whitley Bay U.K. 48 F3
Whitmore Mountains Antarctica 152 K1
Whitney Canada 135 F1
Whitney, Mount U.S.A. 128 D3
Whitney Point U.S.A. 135 H2
Whitstable U.K. 49 I7
Whitsunday Group is Australia 110 E4
Whitsunday Island National Park
 Australia 110 E4
Whitsun Island Vanuatu see
 Pentecost Island
Whittemore U.S.A. 134 D1
Whittier U.S.A. 128 D4
Whittlesea Australia 112 B6
Whittlesey U.K. 49 G6
Whitton Australia 112 C5
Wholdaia Lake Canada 121 J2
Why U.S.A. 129 G5
Whyalla Australia 111 B7
Wiang Sa Thai. 70 C3
Wiarton Canada 134 E1
Wibaux U.S.A. 126 G3
Wichelen Belgium 52 D3
Wichita U.S.A. 131 D4
Wichita r. U.S.A. 131 D5
Wichita Falls U.S.A. 131 D5
Wichita Mountains U.S.A. 131 D5
Wick U.K. 50 F2
Wick r. U.K. 50 F2
Wickenburg U.S.A. 129 G5
Wickes U.S.A. 131 E5
Wickford U.K. 49 H7
Wickham r. Australia 108 D4
Wickham, Cape Australia 111 [inset]
Wickham, Mount hill Australia 108 E4
Wickliffe U.S.A. 134 B5
Wicklow Ireland 51 F5
Wicklow Head hd Ireland 51 G5
Wicklow Mountains Ireland 51 F5
Wicklow Mountains National Park
 Ireland 51 F4
Widerøe, Mount Antarctica 152 C2
Widerøefjellet mt. Antarctica see
 Widerøe, Mount
Widgeegoara watercourse Australia 112 B1
Widgiemooltha Australia 109 C7
Widnes U.K. 48 E5
Wi-do i. S. Korea 75 B6
Wied r. Germany 53 H4
Wiehengebirge hills Germany 53 I2
Wiehl Germany 53 H4
Wielkopolski Park Narodowy nat. park
 Poland 47 P4
Wieluń Poland 47 Q5
Wien Austria see Vienna
Wiener Neustadt Austria 47 P7
Wierden Neth. 52 G2
Wieren Germany 53 K2
Wieringerwerf Neth. 52 F2
Wiesbaden Germany 53 I4
Wiesenfelden Germany 53 M5
Wiesentheid Germany 53 K5
Wiesloch Germany 53 I5
Wiesmoor Germany 53 H1
Wietze Germany 53 J2
Wietzendorf Germany 53 J2
Wieżyca hill Poland 47 Q3
Wigan U.K. 48 E5
Wiggins U.S.A. 131 F6
Wight, Isle of i. England U.K. 49 F8
Wigierski Park Narodowy nat. park
 Poland 45 M9
Wignes Lake Canada 121 J2
Wigston U.K. 49 F6
Wigton U.K. 48 D4
Wigtown U.K. 50 E6
Wigtown Bay U.K. 50 E6
Wijchen Neth. 52 F3
Wijhe Neth. 52 G2
Wilberforce, Cape Australia 110 B1
Wilbur U.S.A. 126 D3
Wilburton U.S.A. 131 E5
Wilcannia Australia 112 A3
Wilcox U.S.A. 135 F3

Wilczek Land i. Rus. Fed. see
 Vil'cheka, Zemlya
Wildberg Germany 53 M2
Wildcat Peak U.S.A. 128 E2
Wild Coast S. Africa 101 I6
Wilderness National Park S. Africa
 100 F8
Wildeshausen Germany 53 I2
Wild Horse Hill mt. U.S.A. 130 C3
Wildspitze mt. Austria 47 M7
Wildwood FL U.S.A. 133 D6
Wildwood NJ U.S.A. 135 H4
Wilge r. S. Africa 101 I4
Wilge r. S. Africa 101 I3
Wilgena Australia 109 F7

▶Wilhelm, Mount P.N.G. 69 L8
5th highest mountain in Oceania.

Wilhelm II Land reg. Antarctica see
 Kaiser Wilhelm II Land
Wilhelmina Gebergte mts Suriname
 143 G3
Wilhelmina Kanaal canal Neth. 52 F3
Wilhelmshaven Germany 53 I1
Wilhelmstal Namibia 100 C1
Wilkes-Barre U.S.A. 135 H3
Wilkesboro U.S.A. 132 D4
Wilkes Coast Antarctica 152 G2
Wilkes Land reg. Antarctica 152 G2
Wilkie Canada 121 I4
Wilkins Coast Antarctica 152 L2
Wilkins Ice Shelf Antarctica 152 L2
Wilkinson Lakes salt flat Australia
 109 F7
Will, Mount Canada 120 D3
Willand U.K. 49 D8
Willandra Billabong watercourse
 Australia 112 B4
Willandra National Park Australia 112 B4
Willapa Bay U.S.A. 126 B3
Willard Mex. 127 F7
Willard NM U.S.A. 127 G6
Willard OH U.S.A. 134 D3
Willcox U.S.A. 129 I5
Willcox Playa salt flat U.S.A. 129 I5
Willebadessen Germany 53 J3
Willebroek Belgium 52 E3

▶Willemstad Neth. Antilles 137 K6
Capital of the Netherlands Antilles.

Willeroo Australia 108 E3
Willette U.S.A. 134 C5
William, Mount Australia 111 C8
William Creek Australia 111 B6
William Lake Canada 121 L4
Williams AZ U.S.A. 129 G4
Williams CA U.S.A. 128 B2
Williamsburg KY U.S.A. 134 C5
Williamsburg OH U.S.A. 134 C4
Williamsburg VA U.S.A. 135 G5
Williams Lake Canada 120 F4
Williamson NY U.S.A. 135 G2
Williamson WV U.S.A. 134 D5
Williamsport IN U.S.A. 134 B3
Williamsport PA U.S.A. 135 G3
Williamston U.S.A. 132 E5
Williamstown KY U.S.A. 134 C4
Williamstown NJ U.S.A. 135 H4
Williamstown WV U.S.A. 134 E4
Willimantic U.S.A. 135 I3
Willis Group atolls Australia 110 E3
Williston S. Africa 100 E6
Williston ND U.S.A. 130 C1
Williston SC U.S.A. 133 D5
Williston Lake Canada 120 F4
Williton U.K. 49 D7
Willits U.S.A. 128 B2
Willmar U.S.A. 130 E2
Willoughby, Lake U.S.A. 135 I1
Willow Beach U.S.A. 129 F4
Willow Bunch Canada 121 J5
Willow Hill U.S.A. 135 G3
Willow Lake Canada 120 G2
Willowlake r. Canada 120 F2
Willowmore S. Africa 100 F7
Willowra Australia 108 F5
Willows U.S.A. 128 B2
Willow Springs U.S.A. 131 F4
Willowvale S. Africa 101 I7
Wills, Lake salt flat Australia 108 E5
Wilma U.S.A. 133 C6
Wilmington DE U.S.A. 135 H4
Wilmington NC U.S.A. 133 E5
Wilmington OH U.S.A. 134 D4
Wilmore U.S.A. 134 C5
Wilmslow U.K. 48 E5
Wilno Lith. see Vilnius
Wilnsdorf Germany 53 I4
Wilpattu National Park Sri Lanka 84 D4
Wilson watercourse Australia 111 C5
Wilson atoll Micronesia see Ifalik
Wilson KS U.S.A. 130 D4
Wilson NC U.S.A. 132 E5
Wilson NY U.S.A. 135 F2
Wilson, Mount CO U.S.A. 129 J3
Wilson, Mount NV U.S.A. 129 F2
Wilson, Mount OR U.S.A. 126 C3
Wilsonia U.S.A. 128 D3
Wilson's Promontory pen.
 Australia 112 C7
Wilson's Promontory National Park
 Australia 112 C7
Wilsum Germany 52 G2
Wilton U.K. 49 F7
Wilton U.S.A. 135 J1
Wiltz Lux. 52 F5
Wiluna Australia 109 C6
Wimereux France 52 B4
Wina r. Cameroon see Vina
Winamac U.S.A. 134 B3
Winbin watercourse Australia 111 D5
Winburg S. Africa 101 H5
Wincanton U.K. 49 E7
Winchendon U.S.A. 135 I2
Winchester Canada 135 H1
Winchester U.K. 49 F7
Winchester IN U.S.A. 134 C3
Winchester KY U.S.A. 134 C5
Winchester NH U.S.A. 135 I2
Winchester TN U.S.A. 133 C5

Winchester VA U.S.A. 135 F4
Wind r. Canada 120 C1
Wind r. U.S.A. 126 F4
Windau Latvia see Ventspils
Windber U.S.A. 135 F3
Wind Cave National Park U.S.A. 130 C3
Windermere U.K. 48 E4
Windermere l. U.K. 48 E4
Windham U.S.A. 120 C3

▶Windhoek Namibia 100 C2
Capital of Namibia.

Windigo Lake Canada 121 N4
Windlestraw Law hill U.K. 50 G5
Wind Mountain U.S.A. 127 G6
Windom U.S.A. 130 E3
Windom Peak U.S.A. 129 J3
Windorah Australia 110 C5
Window Rock U.S.A. 129 I4
Wind Point U.S.A. 134 B2
Wind River Range mts U.S.A. 126 F4
Windrush r. U.K. 49 F7
Windsbach Germany 53 K5
Windsor Australia 112 E4
Windsor N.S. Canada 123 I5
Windsor Ont. Canada 134 D2
Windsor U.K. 49 G7
Windsor NC U.S.A. 132 E4
Windsor NY U.S.A. 135 H2
Windsor VA U.S.A. 135 G5
Windsor VT U.S.A. 135 I2
Windsor Locks U.S.A. 135 I3
Windward Islands Caribbean Sea 137 L5
Windward Passage Cuba/Haiti 137 J5
Windy U.S.A. 118 C3
Winefred Lake Canada 121 I4
Winfield KS U.S.A. 131 D4
Winfield WV U.S.A. 134 E4
Wingate U.K. 48 F4
Wingen Australia 112 E3
Wingene Belgium 52 D3
Wingen-sur-Moder France 53 H6
Wingham Australia 112 F3
Wingham Canada 134 E2
Winisk Canada 122 D3
Winisk r. Canada 122 D3
Winisk Lake Canada 122 D3
Winkana Myanmar 70 B4
Winkelman U.S.A. 129 H5
Winkler Canada 121 L5
Winlock U.S.A. 126 C3
Winneba Ghana 96 C4
Winnebago, Lake U.S.A. 134 A1
Winnecke Creek watercourse
 Australia 108 E4
Winnemucca U.S.A. 128 E1
Winnemucca Lake U.S.A. 128 D1
Winner U.S.A. 130 C3
Winnett U.S.A. 126 F3
Winnfield U.S.A. 131 E6
Winnibigoshish, Lake U.S.A. 130 E2
Winnie U.S.A. 131 E6
Winning Australia 109 A5

▶Winnipeg Canada 121 L5
Provincial capital of Manitoba.

Winnipeg r. Canada 121 L5
Winnipeg, Lake Canada 121 L5
Winnipegosis Canada 121 L5
Winnipegosis, Lake Canada 121 K4
Winnipesaukee, Lake U.S.A. 135 J2
Winona AZ U.S.A. 129 H4
Winona MN U.S.A. 130 F2
Winona MO U.S.A. 131 F4
Winona MS U.S.A. 131 F5
Winschoten Neth. 52 H1
Winsen (Aller) Germany 53 J2
Winsen (Luhe) Germany 53 K1
Winsford U.K. 48 E5
Winslow AZ U.S.A. 129 H4
Winslow ME U.S.A. 135 K1
Winsop, Tanjung pt Indon. 69 I7
Winsted U.S.A. 135 I3
Winston-Salem U.S.A. 132 D4
Winterberg Germany 53 I3
Winter Haven U.S.A. 133 D6
Winters CA U.S.A. 128 C2
Winters TX U.S.A. 131 D6
Wintersville U.S.A. 134 E3
Winterswijk Neth. 52 G3
Winterthur Switz. 56 I3
Winterton S. Africa 101 I5
Winthrop U.S.A. 135 K1
Winton Australia 110 C4
Winton N.Z. 113 B8
Winton U.S.A. 132 E4
Winwick U.K. 49 G6
Wirral pen. U.K. 48 D5
Wirrulla Australia 111 A7
Wisbech U.K. 49 H6
Wiscasset U.S.A. 135 K1
Wisconsin r. U.S.A. 130 F3
Wisconsin state U.S.A. 134 A1
Wisconsin Rapids U.S.A. 130 F2
Wise U.S.A. 134 D5
Wiseman U.S.A. 118 C3
Wishaw U.K. 50 F5
Wisher U.S.A. 130 D2
Wisil Dabarow Somalia 98 E3
Wisła r. Poland see Vistula
Wismar Germany 47 M4
Wistaria Canada 120 E4
Witbank S. Africa 101 I3
Witbooisvlei Namibia 100 D3
Witham U.K. 49 H7
Witham r. U.K. 49 H6
Witherbee U.S.A. 135 I1
Withernsea U.K. 48 H5
Witjira National Park Australia 111 A5
Witmarsum Neth. 52 F1
Witney U.K. 49 F7
Witrivier S. Africa 101 J3
Witteberge mts S. Africa 101 H6
Wittenberg Germany see
 Lutherstadt Wittenberg
Wittenberge Germany 53 L1
Wittenburg Germany 53 L1
Wittingen Germany 53 K2
Wittlich Germany 52 G5

Column 1:

Yanji China 74 C4
Yanjiang China see Ziyang
Yanjin Henan China 77 G1
Yanjin Yunnan China 76 E2
Yanjing Sichuan China see Yanyuan
Yanjing Xizang China 76 C2
Yanjing Yunnan China see Yanjin
Yankara National Park Nigeria 96 E4
Yankton U.S.A. 130 D3
Yanling Hunan China 77 G3
Yanling Sichuan China see Weiyuan
Yannina Greece see Ioannina
Yano-Indigirskaya Nizmennost' lowland Rus. Fed. 65 P2
Yanovski, Mount U.S.A. 120 C3
Yanrey r. Australia 109 A5
Yanshan Jiangxi China 77 H2
Yanshan Yunnan China 76 E4
Yanshi 77 G1
Yanshiping China 76 B1
Yanskiy Zaliv g. Rus. Fed. 65 O2
Yantabulla Australia 112 B2
Yantai China 73 M5
Yanting China 76 E2
Yantongshan China 74 B4
Yantou China 77 I2
Yanwa China 76 C2
Yany-Kurgan Kazakh. see Zhanakorgan
Yanyuan China 76 D3
Yao Chad 97 E3
Yao'an China 76 D3
Yaodu China see Dongzhi
Yaoli China 77 H2

Yaoundé Cameroon 96 E4
Capital of Cameroon.

Yaoxian Shaanxi China see Yaozhou
Yaoxiaoling China 74 B2
Yao Yai, Ko i. Thai. 71 B6
Yaozhou China 77 F1
Yap i. Micronesia 69 J5
Yapen i. Indon. 69 J7
Yappar r. Australia 110 C3
Yap Trench sea feature N. Pacific Ocean 150 F5
Yaqui r. Mex. 127 F8
Yar Rus. Fed. 42 L4
Yaradzha Turkm. see Ýarajy
Ýarajy Turkm. 88 E2
Yaraka Australia 110 D5
Yarangüme Turkey see Tavas
Yaransk Rus. Fed. 42 J4
Yardea Australia 111 A7
Yardımcı Burnu pt Turkey 59 N6
Yardımlı Azer. 91 H3
Yare r. U.K. 49 I6
Yarega Rus. Fed. 42 L3

Yaren Nauru 107 G2
Capital of Nauru.

Yarensk Rus. Fed. 42 K3
Yariga-take mt. Japan 75 E5
Yarim Yemen 86 F7
Yarımca Turkey see Körfez
Yarkand China see Shache
Yarkant China see Shache
Yarkant He r. China 80 E4
Yarker Canada 135 G1
Yarkhun r. Pak. 89 I2
Yarlung Zangbo r. China 76 B2 see Brahmaputra
Yarmouth Canada 123 I6
Yarmouth England U.K. 49 F8
Yarmouth England U.K. see Great Yarmouth
Yarmouth U.S.A. 135 J2
Yarmuk r. Asia 85 B3
Yarnell U.S.A. 129 G4
Yaroslavl' Rus. Fed. 42 H4
Yaroslavskiy Rus. Fed. 74 D3
Yarra r. Australia 112 B6
Yarra Junction Australia 112 B6
Yarram Australia 112 C7
Yarraman Australia 112 E1
Yarrawonga Australia 112 B6
Yarronvale Australia 112 B1
Yarrowmere Australia 110 D4
Yartö Tra La pass China 83 H3
Yartsevo Krasnoyarskiy Kray Rus. Fed. 64 J3
Yartsevo Smolenskaya Oblast' Rus. Fed. 43 G5
Yarumal Col. 142 C2
Yarwa China 76 C2
Yarzhong China 76 C2
Yaş Romania see Iaşi
Yasawa Group is Fiji 107 H3
Yashilkül l. Tajik. 89 I2
Yashkul' Rus. Fed. 43 J7
Yasin Jammu and Kashmir 82 C1
Yasnogorsk Rus. Fed. 43 H5
Yasnyy Rus. Fed. 74 C1
Yasothon Thai. 70 D4
Yass Australia 112 D5
Yass r. Australia 112 D5
Yassı Burnu c. Cyprus see Plakoti, Cape
Yāsūj Iran 88 C4
Yasuní, Parque Nacional nat. park Ecuador 142 C4
Yatağan Turkey 59 M6
Yates r. Canada 120 H2
Yates Center U.S.A. 130 E4
Yathkyed Lake Canada 121 L2
Yatsushiro Japan 75 C6
Yatta West Bank 85 B4
Yatton U.K. 49 E7
Yauca Peru 142 D7
Yau Tong b. H.K. China 77 [inset]
Yavan Tajik. see Yovon
Yavari r. Brazil/Peru 142 D4
also known as Javari (Brazil/Peru)
Yávaros Mex. 127 F8
Yavatmal India 84 C1
Yavi Turkey 91 F3
Yaví, Cerro mt. Venez. 142 E2
Yavoriv Ukr. 43 D6
Yavuzlu Turkey 85 C1

Column 2:

Yawatongguzlangar China 83 E1
Yaw Chaung r. Myanmar 76 B4
Yaxian China see Sanya
Yay Myanmar see Ye
Yaylādağı Turkey 85 C2
Yazd Iran 88 D4
Yazdān Iran 89 F3
Yazd-e Khvāst Iran 88 D4
Yazıhan Turkey 90 E3
Yazoo City U.S.A. 131 F5
Y Bala U.K. see Bala
Yding Skovhøj hill Denmark 47 L3
Ydra i. Greece 59 J6
Y Drenewydd U.K. see Newtown
Ye Myanmar 70 B4
Yea Australia 112 B6
Yealmpton U.K. 49 D8
Yebawmi Myanmar 70 A1
Yebbi-Bou Chad 97 E2
Yecheng China 80 E4
Yécora Mex. 127 F7
Yedashe Myanmar 70 B3
Yedatore India 84 C3
Yedi Burun Başı pt Turkey 59 M6
Yeeda River Australia 108 C4
Yefremov Rus. Fed. 43 H5
Yeğainnyin China see Henan
Yeghegnadzor Armenia 91 G3
Yegindykol' Kazakh. 80 C1
Yegorlykskaya Rus. Fed. 43 I7
Yegorova, Mys pt Rus. Fed. 74 E3
Yegor'yevsk Rus. Fed. 43 H5
Yei Sudan 97 G4
Yei r. Sudan 97 G4
Yeji China 77 G2
Yejiaji China see Yeji
Yekaterinburg Rus. Fed. 64 H4
Yekaterinodar Rus. Fed. see Krasnodar
Yekaterinoslav Ukr. see Dnipropetrovs'k
Yekaterinoslavka Rus. Fed. 74 C2
Yekhegnadzor Armenia see Yeghegnadzor
Ye Kyun i. Myanmar 70 A3
Yelabuga Khabarovskiy Kray Rus. Fed. 74 D2
Yelabuga Respublika Tatarstan Rus. Fed. 42 K5
Yelan' Rus. Fed. 43 I6
Yelan' r. Rus. Fed. 43 I6
Yelandur India 84 C3
Yelantsy Rus. Fed. 72 J2
Yelarbon Australia 112 E1
Yelbarsli Turkm. 89 F2
Yelenovskiye Kar'yery Ukr. see Dokuchayevs'k
Yelets Rus. Fed. 43 H5
Yélimané Mali 96 B3
Yelizavetgrad Ukr. see Kirovohrad
Yelkhovka Rus. Fed. 43 K5
Yell i. U.K. 50 [inset]
Yellabina Regional Reserve nature res. Australia 109 F7
Yellandu India 84 D2
Yellapur India 84 B3

Yellow r. China 77 G1
4th longest river in Asia.

Yellowhead Pass Canada 120 G4

Yellowknife Canada 120 H2
Capital of Northwest Territories.

Yellowknife r. Canada 120 H2
Yellow Mountain hill Australia 112 C4
Yellow Sea N. Pacific Ocean 73 N5
Yellowstone r. U.S.A. 130 C2
Yellowstone Lake U.S.A. 126 F3
Yellowstone National Park U.S.A. 126 F3
Yell Sound strait U.K. 50 [inset]
Yeloten Turkm. see Ýölöten
Yelovo Rus. Fed. 41 Q4
Yel'sk Belarus 43 F6
Yelva r. Rus. Fed. 42 K3
Yematan China 76 C1
Yemen country Asia 86 G6
Asia 6, 62–63
Yemetsk Rus. Fed. 42 I3
Yemişenbükü Turkey see Taşova
Yemmiganur India see Emmiganuru
Yemtsa Rus. Fed. 42 I3
Yemva Rus. Fed. 42 K3
Yena r. Rus. Fed. 44 Q3
Yenagoa Nigeria 96 D4
Yenakiyeve Ukr. 43 H6
Yenakiyevo Ukr. see Yenakiyeve
Yenangyat Myanmar 70 A2
Yenangyaung Myanmar 70 A2
Yenanma Myanmar 70 A3
Yenda Australia 112 C5
Yêndum China see Zhag'yab
Yengisar China 80 E4
Yengo National Park Australia 112 E4
Yenice Turkey 59 L5
Yenidamlar Turkey see Demirtaş
Yenihan Turkey see Yıldızeli
Yenije-i-Vardar Greece see Giannitsa
Yenişehir Greece see Larisa
Yenişehir Turkey 59 M4
Yenisey r. Rus. Fed. 64 J2

Yenisey-Angara-Selenga r. Rus. Fed. 64 J2
3rd longest river in Asia.

Yeniseysk Rus. Fed. 64 K4
Yeniseyskiy Kryazh ridge Rus. Fed. 64 K4
Yeniseyskiy Zaliv inlet Rus. Fed. 153 F2
Yeniyol Turkey see Borça
Yên Minh Vietnam 70 D2
Yenotayevka Rus. Fed. 43 J7
Yeola India 84 B1
Yeotmal India see Yavatmal
Yeoval Australia 112 C7
Yeovil U.K. 49 E8
Yeo Yeo r. Australia see Bland
Yeo Lake salt flat Australia 109 D6
Yeppoon Australia 110 E4
Yeraliyev Kazakh. see Kuryk
Yerbent Turkm. 88 E2
Yerbogachen Rus. Fed. 65 L3



Yercaud India 84 C4

Yerevan Armenia 91 G2
Capital of Armenia.

Yergara India 84 C2
Yergeni hills Rus. Fed. 43 J7
Yergoğu Romania see Giurgiu
Yeriho West Bank see Jericho
Yerilla Australia 109 C7
Yerington U.S.A. 128 D2
Yerköy Turkey 90 D3
Yerla r. India 84 B2
Yermak Kazakh. see Aksu
Yermakovo Rus. Fed. 74 B1
Yermak Plateau sea feature Arctic Ocean 153 H1
Yermentau Kazakh. see Yereymentau
Yermo Mex. 131 B7
Yermo U.S.A. 128 E4
Yerofey Pavlovich Rus. Fed. 74 A1
Yeroham Israel 85 B4
Yerres r. France 52 C6
Yersa r. Rus. Fed. 42 L2
Yertsevo Rus. Fed. 42 I3
Yerupaja mt. Peru 142 C6
Yerushalayim Israel/West Bank see Jerusalem
Yeruslan r. Rus. Fed. 43 J6
Yesagyo Myanmar 70 A2
Yesan S. Korea 75 B5
Yesil' Kazakh. 78 F1
Yeşilhisar Turkey 90 D3
Yeşilırmak r. Turkey 90 E2
Yeşilova Burdur Turkey 59 M6
Yeşilova Yozgat Turkey see Sorgun
Yessentuki Rus. Fed. 91 F1
Yessey Rus. Fed. 65 L3
Yes Tor hill U.K. 49 C8
Yêtatang China see Baqên
Yetman Australia 112 E2
Ye-U Myanmar 70 A2
Yeu, Île d' i. France 56 C3
Yevdokimovskoye Rus. Fed. see Krasnogvardeyskoye
Yevlakh Azer. see Yevlax
Yevlax Azer. 91 G2
Yevpatoriya Ukr. 90 D1
Yevreyskaya Avtonomnaya Oblast' admin. div. Rus. Fed. 74 D2
Yexian China see Laizhou
Yeyik China 83 E1
Yeysk Rus. Fed. 43 H7
Yeyungou China 80 G3
Yezhuga r. Rus. Fed. 42 J2
Yezo i. Japan see Hokkaidō
Yezyaryshcha Belarus 42 F5
Y Fenni U.K. see Abergavenny
Y Fflint U.K. see Flint
Y Gelli Gandryll U.K. see Hay-on-Wye
Yialí i. Greece see Gyali
Yialousa Cyprus see Aigialousa
Yi'an China 74 B3
Yianisádha i. Greece see Gianisada
Yianisádha i. Kriti Greece see Gianisada
Yiannitsá Greece see Giannitsa
Yibin Sichuan China 76 E2
Yibin Sichuan China 76 E2
Yibug Caka salt l. China 83 F2
Yichang Hubei China 77 F2
Yicheng Henan China see Zhumadian
Yicheng Hubei China 77 G2
Yicheng Shanxi China 77 F1
Yichun Heilong. China 74 C3
Yichun Jiangxi China 77 G3
Yidu China see Zhicheng
Yidun China 76 C2
Yifeng China 77 G2
Yi He r. Henan China 77 G1
Yi He r. Shandong China 77 H1
Yihuang China 77 H3
Yijun China 77 F1
Yilaha China 74 B2
Yilan China 74 C3
Yıldız Dağları mts Turkey 59 L4
Yıldızeli Turkey 90 E3
Yilehuli Shan mts China 74 A2
Yiliang China 76 E3
Yiling Hubei China 77 F2
Yilong Heilong. China 74 B3
Yilong Sichuan China 76 E2
Yilong Yunnan China see Shiping
Yilong Hu l. China 76 D4
Yimianpo China 74 C3
Yinbaing Myanmar 70 B3
Yincheng China see Dexing
Yinchuan China 72 J5
Yindarlgooda, Lake salt flat Australia 109 C7
Yingcheng China 77 G2
Yingde China 77 G3
Yinggehai China 77 F5
Yinggen China see Qiongzhong
Ying He r. China 77 H1
Yingjing China 76 D2
Yingkou China 73 M4
Yingshan China 77 G2
Yingtan China 77 H2
Yining Jiangxi China see Xiushui
Yining Xinjiang China 80 F3
Yinjiang China 77 F3
Yinkeng China see Yinkengxu
Yinkengxu China 77 G3
Yinmabin Myanmar 70 A2
Yinnyenin Myanmar 70 A3
Yin Shan mts China 73 J4
Yinxian China see Ningbo
Yipinglang China 76 D3
Yiquan China see Meitan
Yirga Alem Eth. 98 D3
Yirol Sudan 97 G4
Yisa China see Honghe
Yishan Guangxi China see Yizhou
Yishan Jiangsu China see Guanyun
Yishui China 73 L5
Yishun Sing. 71 [inset]

Yíthion Greece see Gytheio
Yitiaoshan China see Jingtai
Yi Tu, Nam r. Myanmar 70 B2
Yitulihe China 74 A2
Yiwu China 76 D4
Yixing China 77 H2
Yiyang China 77 G2
Yizheng China 77 H1
Yizhou China 77 F3
Yizra'el country Asia see Israel
Yläne Fin. 45 M6
Ylihärmä Fin. 44 M5
Yli-Ii Fin. 44 N4
Yli-Kärppä Fin. 44 N4
Ylikiiminki Fin. 44 O4
Yli-Kitka l. Fin. 44 P3
Ylistaro Fin. 44 M5
Ylitornio Fin. 44 M3
Ylivieska Fin. 44 N4
Ylöjärvi Fin. 45 M6
Ymer Ø i. Greenland 119 P2
Ynys Enlli i. U.K. see Bardsey Island
Ynys Môn i. U.K. see Anglesey
Yoakum U.S.A. 131 D6
Yoder U.S.A. 134 C3
Yogan, Cerro mt. Chile 144 B8
Yogyakarta Indon. 68 E8
Yoho National Park Canada 120 G5
Yokadouma Cameroon 97 E4
Yokkaichi Japan 75 E6
Yoko Cameroon 96 E4
Yokohama Japan 75 E6
Yokosuka Japan 75 E6
Yokote Japan 75 F5
Yola Nigeria 96 E4
Yolo U.S.A. 128 C2
Yolombo Dem. Rep. Congo 98 C4
Yŏlöten Turkm. 89 F2
Yoluk Mex. 133 C8
Yom, Mae Nam r. Thai. 70 C4
Yomou Guinea 96 C4
Yomuka Indon. 69 J8
Yonaguni-jima i. Japan 77 I3
Yōnan N. Korea 75 B5
Yonezawa Japan 75 F5
Yong'an Chongqing China see Fengjie
Yong'an Fujian China 77 H3
Yongbei China see Yongsheng
Yongcong China 77 F3
Yongding China 77 H3
Yongding Yunnan China see Yongren
Yongding Yunnan China see Fumin
Yongfeng China 77 G3
Yongfu China 77 F3
Yŏnghŭng N. Korea 75 B5
Yŏnghŭng-man b. N. Korea 75 B5
Yŏngil-man b. S. Korea 75 C6
Yongjing Guizhou China see Xifeng
Yongjing Liaoning China see Xifeng
Yŏngju S. Korea 75 C5
Yongkang Yunnan China 76 C3
Yongkang Zhejiang China 77 I2
Yongle China see Zhen'an
Yongning Guangxi China 77 F4
Yongning Jiangxi China see Tonggu
Yongning Sichuan China see Xuyong
Yongping China 76 C3
Yongqing China see Qingshui
Yongren China 76 D3
Yongsheng China 76 D3
Yongshou China 77 F1
Yongshun China 77 F2
Yongtai China 77 H3
Yongxi China see Nayong
Yongxing Hunan China 77 G3
Yongxing Jiangxi China 77 G3
Yongxiu China 77 G2
Yongyang China see Weng'an
Yongzhou China 77 F3
Yonkers U.S.A. 135 I3
Yopal Col. 142 D2
Yopurga China 80 E4
Yordu Jammu and Kashmir 82 C2
York Australia 109 B7
York Canada 134 F2
York U.K. 48 F5
York AL U.S.A. 131 F5
York NE U.S.A. 130 D3
York PA U.S.A. 135 G4
York, Cape Australia 110 C1
York, Kap c. Greenland see Innaanganeq
York, Vale of valley U.K. 48 F4
Yorke Peninsula Australia 111 B7
Yorketown Australia 111 B7
Yorkshire Dales National Park U.K. 48 E4
Yorkshire Wolds hills U.K. 48 G5
Yorkton Canada 121 K5
Yorktown U.S.A. 135 G5
Yorkville U.S.A. 130 F3
Yorosso Mali 96 C3
Yosemite U.S.A. 134 C5
Yosemite National Park U.S.A. 128 D3
Yoshkar-Ola Rus. Fed. 42 J4
Yos Sudarso i. Indon. see Dolok, Pulau
Yŏsu S. Korea 75 B6
Yotvata Israel 85 B5
Youbou Canada 120 E5
Youghal Ireland 51 E6
Young Australia 112 D5
Young U.S.A. 129 H4
Younghusband, Lake salt flat Australia 111 B6
Younghusband Peninsula Australia 111 B7
Youngstown Canada 121 I5
Youngstown U.S.A. 134 E3
You Shui r. China 77 F2
Youssoufia Morocco 54 C5
Youvarou Mali 96 C3
Youxi China 77 H3
Youxian China 77 G3
Youyang China 77 F2
Youyi China 74 C3
Youyi Feng mt. China/Rus. Fed. 80 G2
Yovon Tajik. 89 H2
Yowah watercourse Australia 112 B2
Yozgat Turkey 90 D3
Ypres Belgium see Ieper
Yr Wyddfa mt. U.K. see Snowdon



Ythan r. U.K. 50 G3
Ytre-Arna Norway see Arna
Ytyk-Kyuyel' Rus. Fed. 65 O3
Yu'alliq, Jabal mt. Egypt 85 A4
Yuan'an China 77 F2
Yuanbao Shan mt. China 77 F3
Yuanjiang Hunan China 77 G2
Yuanjiang Yunnan China 76 D4
Yuan Jiang r. Hunan China 77 F2
Yuan Jiang r. Yunnan China 76 D4
Yuanjiazhuang China see Foping
Yuanlin China 74 A2
Yuanling China 77 F2
Yuanma China see Yuanmou
Yuanmou China 76 D3
Yuanquan China see Anxi
Yuanshan China see Lianping
Yuanyang China see Xinjie
Yub'a i. Saudi Arabia 90 D6
Yuba City U.S.A. 128 C2
Yuben' Tajik. 89 I2
Yucatán pen. Mex. 136 F5
Yucatan Channel Cuba/Mex. 137 G4
Yucca U.S.A. 129 F4
Yucca Lake U.S.A. 128 E3
Yucca Valley U.S.A. 128 E4
Yucheng Henan China 77 G1
Yucheng Sichuan China see Ya'an
Yuci China see Jinzhong
Yudi Shan mt. China 74 A1
Yudu China 77 G3
Yuelai China see Huachuan
Yueliang Pao l. China 74 A3
Yuendumu Australia 108 E5
Yuen Long H.K. China 77 [inset]
Yueqing China 77 I2
Yuexi China 77 H2
Yueyang Hunan China 77 G2
Yueyang Hunan China 77 G2
Yueyang Sichuan China see Anyue
Yug r. Rus. Fed. 42 J3
Yugan China 77 H2
Yugorsk Rus. Fed. 41 S3
Yugoslavia country Europe see Serbia and Montenegro
Yuhang China 77 I2
Yuhu China see Eryuan
Yuhuan China 77 I2
Yuin Australia 109 B6
Yu Jiang r. China 77 F4
Yukagirskoye Ploskogor'ye plat. Rus. Fed. 65 Q3
Yukamenskoye Rus. Fed. 42 L4
Yukarı Sakarya Ovaları plain Turkey 59 N5
Yukarısarıkaya Turkey 90 D3

Yukon r. Canada/U.S.A. 120 B2
5th longest river in North America.

Yukon Crossing Canada 120 B2
Yukon Territory admin. div. Canada 120 C2
Yüksekova Turkey 91 G3
Yulara Australia 109 E6
Yule r. Australia 108 B5
Yuleba Australia 112 D1
Yulee U.S.A. 133 D6
Yulin Guangxi China 77 F4
Yulin Shaanxi China 73 J5
Yulong Xueshan mt. China 76 D3
Yuma AZ U.S.A. 129 F5
Yuma CO U.S.A. 130 C3
Yuma Desert U.S.A. 129 F5
Yumen China 80 I4
Yumenguan China 80 H3
Yumurtalık Turkey 85 B1
Yuna r. Australia 109 A7
Yunak Turkey 90 C3
Yunan China 77 F4
Yunaska Island U.S.A. 118 A4
Yuncheng China 77 F1
Yundamindera Australia 109 C7
Yunfu China 77 G4
Yungas reg. Bol. 142 E7
Yungui Gaoyuan plat. China 76 D3
Yunjinghong China see Jinghong
Yunkai Dashan mts China 77 F4
Yünlin Taiwan see Touliu
Yunling China see Yunxiao
Yun Ling mts China 76 C3
Yunlong China 76 C3
Yunmeng China 77 G2
Yunmenling China see Junmenling
Yunnan prov. China 76 D3
Yunt Dağı mt. Turkey 85 A1
Yunxi Hubei China 77 F1
Yunxian Hubei China 77 F1
Yunxian Yunnan China 76 D3
Yunxiao China 77 H4
Yunyang Chongqing China 77 F2
Yunyang Henan China 77 G1
Yuping Guizhou China see Libo
Yuping Guizhou China 77 F3
Yuping Yunnan China see Pingbian
Yuqing China 76 E3
Yurayegir National Park Australia 112 F2
Yurba Co l. China 83 F2
Yürekli Turkey 85 B1
Yurga Rus. Fed. 64 J4
Yuriria Mex. 136 D4
Yurungkax He r. China 82 E1
Yur'ya Rus. Fed. 42 K4
Yur'yev Estonia see Tartu
Yur'yevets Rus. Fed. 42 I4

Yur'yev-Pol'skiy Rus. Fed. 42 H4
Yushan China 77 H2
Yu Shan mt. Taiwan 77 I4
Yushino Rus. Fed. 42 L1
Yushkozero Rus. Fed. 44 R4
Yushu Jilin China 74 B3
Yushu Qinghai China 76 C1
Yushuwan China see Huaihua
Yusufeli Turkey 91 F2
Yus'va Rus. Fed. 41 Q4
Yuta West Bank see Yatta
Yutai China 77 H1
Yutan China see Ningxiang
Yuxi Guizhou China see Daozhen
Yuxi Hubei China 77 F2
Yuxi Yunnan China 76 D3
Yuyangguan China 77 F2
Yuyao China 77 I2
Yuza Japan 75 F5
Yuzha Rus. Fed. 42 I4
Yuzhno-Kamyshovyy Khrebet ridge Rus. Fed. 74 F3
Yuzhno-Kuril'sk Rus. Fed. 74 G3
Yuzhno-Muyskiy Khrebet mts Rus. Fed. 73 K1
Yuzhno-Sakhalinsk Rus. Fed. 74 F3
Yuzhno-Sukhokumsk Rus. Fed. 91 G1
Yuzhnoukrayinsk Ukr. 43 F7
Yuzhnyy Rus. Fed. see Adyk
Yuzhou Chongqing China see Chongqing
Yuzhou Henan China 77 G1
Yuzovka Ukr. see Donets'k
Yverdon Switz. 56 H3
Yvetot France 56 E2
Ywamun Myanmar 70 A2

Z

Zaamin Uzbek. see Zomin
Zaandam Neth. 52 E2
Zab, Monts du mts Alg. 57 I6
Zabănăbād Iran 88 C3
Zabaykal'sk Rus. Fed. 73 L3
Zabid Yemen 86 F7
Zābol Iran 89 F4
Zacapa Guat. 136 G5
Zacatecas Mex. 136 D4
Zacatecas state Mex. 131 C8
Zacharo Greece 59 I6
Zacoalco Mex. 136 D4
Zacynthus i. Greece see Zakynthos
Zadar Croatia 58 F2
Zadetkale Kyun i. Myanmar 71 B5
Zadetkyi Kyun i. Myanmar 71 B5
Zadi Myanmar 71 B4
Zadoi China 76 B1
Zadonsk Rus. Fed. 43 H5
Zadran reg. Afgh. 89 H3
Za'farâna Egypt see Za'farānah
Za'farānah Egypt 90 D5
Zafer Adaları is Cyprus see Kleides Islands
Zafer Burnu c. Cyprus see Apostolos Andreas, Cape
Zafora i. Greece see Sofrana
Zafra Spain 57 C4
Zagazig Egypt see Az Zaqāzīq
Zaghdeh well Iran 88 E3
Zaghouan Tunisia 58 D6
Zagorsk Rus. Fed. see Sergiyev Posad

Zagreb Croatia 58 F2
Capital of Croatia.

Zagros, Kühhā-ye mts Iran see Zagros Mountains
Zagros Mountains Iran 88 B3
Zagunao China see Lixian
Za'gya Zangbo r. China 83 G3
Zāhedān Iran 89 F4
Zahir Pir Pak. 89 H4
Zaḥlah Lebanon see Zahlé
Zahlé Lebanon 85 B3
Zähmet Turkm. 89 F2
Ẕaḥrān Saudi Arabia 86 F6
Zahrez Chergui salt pan Alg. 57 H6
Zahrez Rharbi salt pan Alg. 57 H6
Zainlha China see Xiaojin
Zainsk Rus. Fed. see Novyy Zay
Zaire country Africa see Congo, Democratic Republic of the
Zaïre r. Congo/Dem. Rep. Congo see Congo
Zaječar Serb. and Mont. 59 J3
Zaka Zimbabwe 99 D6
Zakamensk Rus. Fed. 80 J1
Zakataly Azer. see Zaqatala
Zakhidne Greece see Zacharo
Zakhmet Turkm. see Zähmet
Zākhō Iraq 91 F3
Zakhodnyaya Dzvina r. Europe see Zapadnaya Dvina
Zákinthos i. Greece see Zakynthos
Zakopane Poland 47 Q6
Zakouma, Parc National de nat. park Chad 97 E3
Zakwaski, Mount Canada 120 F5
Zakynthos Greece 59 I6
Zakynthos i. Greece 59 I6
Zala Croatia 76 B2
Zalaegerszeg Hungary 58 G1
Zalai-domsag hills Hungary 58 G1
Zalamea de la Serena Spain 57 D4
Zalantun China 74 A3
Zalari Rus. Fed. 72 I2
Zalău Romania 59 J1
Zaleski U.S.A. 134 D4
Ẕalim Saudi Arabia 86 F5
Zalingei Sudan 97 F3
Ẕalmā, Jabal az mt. Saudi Arabia 86 E4
Zama City Canada 120 G3
Zambeze r. Africa 99 C5 see Zambezi

Zambezi r. Africa 99 C5
4th longest river in the world. Also known as Zambeze.

Zambezi Zambia 99 C5
Zambia country Africa 99 C5
Africa 7, 94–95

THE SPLENDOUR OF
ISLAMIC CALLIGRAPHY

Abdelkebir Khatibi
Mohammed Sijelmassi

THE SPLENDOUR OF
ISLAMIC CALLIGRAPHY

with 232 illustrations, 98 in colour

THAMES AND HUDSON

Frontispiece
Detail of a page from a Qur'ān in Karmatian script,
an ornamented version of Eastern Kufic.

This is a revised and expanded edition of *The Splendour of Islamic
Calligraphy*, translated from the French *L'Art calligraphique arabe* by
James Hughes and first published in 1976; additional material included
in the revised French edition L'Art calligraphique de l'Islam (1994)
translated by E.J. Emory.

© 1994 Editions Gallimard, Paris
English translation © 1976 and 1995 Thames and Hudson Ltd, London

This edition first published in the United States of America in 1996 by
Thames and Hudson Inc., 500 Fifth Avenue, New York, New York 10110

British Library Cataloguing-in-Publication Data
A catalogue record for this book is available from the British Library

Library of Congress Catalog Card Number 95-78912

ISBN 0-500-01675-5

Printed and bound in Italy

CONTENTS

Symbol of Civilization

Ta'liq script. *The letter 'm' in its final form.*

Every text, whether sacred or secular, carries within it a desire to imagine the reader who approaches it. Therein lies its dream of eternity. What is the nature of the imagined reader within the ambit of Arab calligraphy? Recall the first words revealed to the Prophet Muhammad, 'Read, recite.' Does not the word Qur'ān also mean the act of reading and recitation? Read the world and the heavens as a table of signs. You are first and foremost a reader, then a believer.

Calligraphy is the art of the linear graphic; it restructures one's visualization of a language and its topography. In this sense, calligraphy in the Arabic language is constructed on a simple spatial principle: the Arabic alphabet is written in the interplay of a horizontal base line and the vertical lines of its consonants. It is read from right to left, with the addition of vowels, diacriticals and loops which are positioned variously above and below the base line. The originality of this written form, which in some respects has no equal, is created by the architecture and rhythm of the letters: here we recognize the force of the 'arabesque' as a plastic form.

Calligraphy can be seen as a reading and a writing in the second degree. It obeys a geometry of the spirit that is created in the opening of a space between the statement contained in a phrase and its realization as a work of art. This happens within the heart of every word, every phoneme, right down to the noiseless musical quality of the text as a whole, rendered by the calligrapher's art in the form of light and shade, the readable and the elusive, the impression of what one sees and the presence of the voice.

Calligraphy reveals the plastic scenography of a text: that of a letter turned into image, caught in the physical act of creating a line which is animated and led onwards by an inner rhythm. This art works by taking a text as a score consisting of strokes created by the graphic artist. For the language which practises it, and which thereby gains beauty, the calligraphic art constitutes a laboratory of signs. As in

the case of Chinese and Japanese writing, the Arabic script derives from a civilization of signs. By 'sign' we mean in this context a conventional mark, arbitrary in relation to the thing designated, which serves to convey the sound of the spoken language.

What calligraphy does is to take the written sign and alter its form and decorative style by changing the treatment of line. This plastic form simultaneously serves both the meaning of the actual statement and the composition of images, of letters that are recreated as image. The actual meaning of the statement here becomes secondary, so that the imagined reader is like a dreamer awakened, whose vision is woven within a context of art. Take a close look at any page of fine calligraphy and you find a delicate balance between matter (the ink and its supporting medium), colour and signs.

The characteristic aspect of this Islamic cultivation of signs and symbols is the pre-eminence of the art of orna-mentation, and in this the book has pride of place. We should remember that during the classical Arab era (the ninth and tenth centuries AD) the visual arts embraced the arts of the book (illumination, fine bindings and calligraphy itself), architecture (mosques, religious schools known as *madrasas*, mausoleums, palaces . . .) and the everyday applied arts such as ceramics, carpet-weaving, mosaics and leatherwork. Thus in Persia it would fall to the court calli-grapher to design the preliminary sketches for the finest carpets, giving us marvellous prayer mats where the artist, in collaboration with artisans, introduces us to an imagery of Paradise, literally woven into the words of Allah.

Graphic systems may be more or less beautiful in their conception. And, as in every art, calligraphy may be arrived at by skill or by serendipity and improvisation. As indicated above, the Arabic system of writing is created from a range of signs and their variants, combining elements of the verti-cal and the horizontal. it also features diacritical marks, the

loops which make up the bodies of letters, and the connect-ing links between them. Letters may be joined together or they may stand alone.

Given that this calligraphy derives from an ancient Semitic alphabet, it is no surprise to find that it still retains pictographic remnants such as ع ('*ayn*) representing the eye, and ج representing the camel. However, the alphabet has evolved greatly since the early manuscripts of the Qur'ān. It has embraced many forms of ornamentation and decoration, so that the letter recreated as image has become an essential paradigm of the arabesque. Initially an art con-fined to books, Arabic calligraphy has gone on to adapt it-self wonderfully to other media: stone, stucco, mosaics, ceramics . . . This iconic transformation has only been pos-sible thanks to the nature of this system of writing – as a highly flexible mutual adaptation between the sign and the image, between the sign and the act of writing it.

Calligraphy thus has its own sculptural autonomy as an art which is extremely abstract, and within which one can discern (as certain researchers have done) a geometry, even a mathematical quality, of the sign. For example, the simple dot (.), which signified nought among the Arabs of ancient times who invented it, came to serve as the means of indi-cating the diacriticals which distinguish various letters that have the same shape, such as ب (b) and ت (t), or س (s) and ش (sh). We shall see shortly how professional calligraphers adopted the dot as a module in developing different calligraphic styles.

The letter recreated as image follows three rules of composition: phonetic, semantic and plastic. Calligraphers create their compositions by joining letters together, and by adding vowels and diacriticals. Thus they give supple-mentary form to the meaning of the text which one is reading. Such is the ground that we shall be covering in our survey of the calligrapher's art.

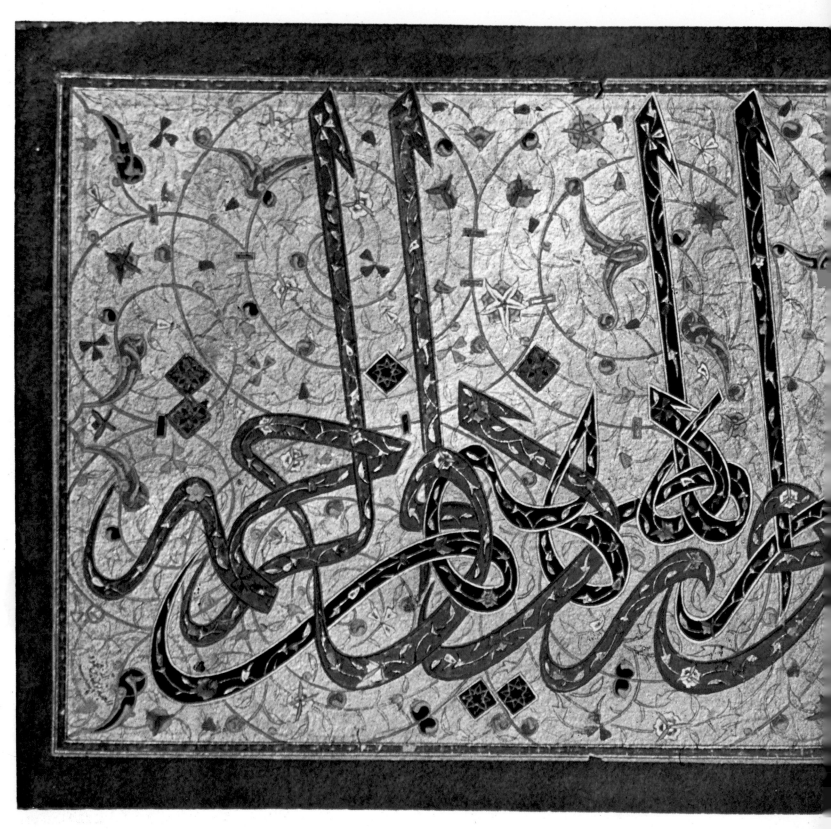

Interwoven floral kufic script.
*'Allah the Omniscient' (one of
the 99 names of God).*

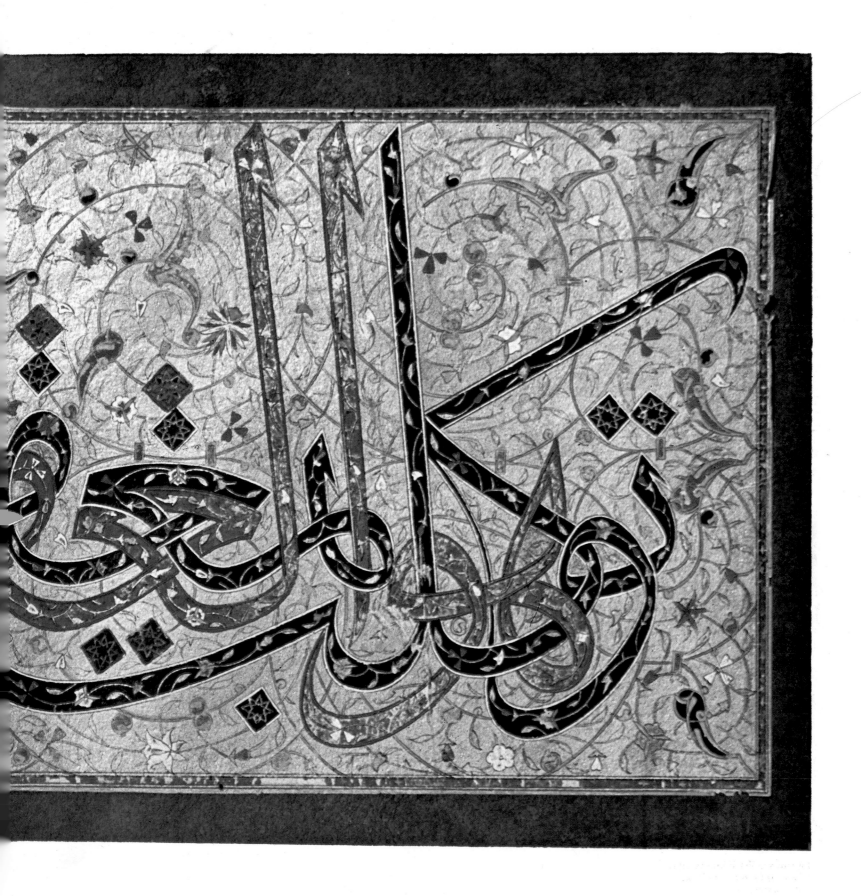

PRINCIPLES OF ARABIC WRITING

In its fully vocalized form, a text containing all the requisite signs (not all of which are still in use) would include the following:

1) A consonantal skeleton of twenty-eight letters. The form of the consonant varies according to its position at the beginning, middle or end of the word.

2) Three long vowels, *ā, ū, ī*, marked with a macron.

3) Three short vowels corresponding to the long vowels with *a* (*fatḥa*) and *u* (*ḍamma*) above the consonantal line, and *i* (*kasra*) below.

4) The special signs are:

ω (*shadda*), pairing to lengthen the consonant.

ς (*hamza*), a glottal stop.

ﺭ (*waṣla*), sign appearing above the *alif*, without phonetic value.

ﺥ (*madda*), extended vowel stress. Sign intensifying short vowels and representing a form of inflection.

Nunnation (the addition of a final *n*) 𝄞 ⁄ ⁄, un, an, in.

In a semi-vocalized form, only the consonants and long vowels have diacritical signs. This is the current usage, but it makes reading considerably more complicated.

A single letter in **sumbuli** *script.*

10

SYSTEM OF TRANSLITERATION

In the transliteration of Arabic characters we have used a much simplified system, but one which enables Arabic speakers and specialists to re-establish the precise equivalence of the signs.

ء ’(hamzah)	ج j	ز z	ظ ẓ	ل l
ا ā	ح ḥ	س s	ع ‘(ayn)	م m
ى a	خ kh	ش sh	غ gh	ن n
ب b	ذ d	ص ṣ	ف f	ه h
ت t	د dh	ض ḍ	ق q	و w, ū
ث th	ر r	ط ṭ	ك k	ى y, ī

11

TRACING
THE ORIGINS

Calligraphy means here – in the strict definition of the word – an art which is conscious, founded upon a code of geometric and decorative rules; an art which, in the patterns which it creates, implies a theory of language and of writing. This art starts off as part of the linguistic structure and institutes an alternative set of rules, derived from language but dramatizing and duplicating it by transposing it into visual terms.

The essence of calligraphy lies in its relation to language. Although the aims of the art of the calligrapher and that of the painter who incorporates words or letters into his work may sometimes be the same, the two part company in the way that the written character is given meaning and life.

Calligraphy is here under examination only insofar as calligraphy itself examines the nature of the language in which it resides. Our first concern is the calligrapher's attitude and his approach, which is both emotionally charged and yet rigorously precise. The calligrapher is an artist who copies and the text which he has to copy already exists. At the point where the meaning unfolds, an image appears which enchants language, in the original sense of incantation, that is, it transforms it into a divine (or magical) formula. Later, we shall determine the nature of this delicate image, whose potency and range had induced one calligrapher to declare – in the excitement of creation – that the tip of the pen is what marks the difference between cultures.

Calligraphy is of course the art of writing, but the practice is by no means universal. Many peoples have not developed it in detail, whereas for others it is regarded as a supreme art. The Japanese describe a person as 'having beautiful handwriting' when they mean he is graceful and handsome. The Arab calligraphers considered that their art was the geometry of the soul expressed through the body – a metaphor that can be taken literally and concretely with the literal design of its inspiring spirit. This metaphor refers back to an established language as, so to speak,

Floral kufic script. *The word* kalima, *meaning 'word'. Qur'ān, 14th–15th century.*

Pages 12–13
Thuluth *lettering against a background of floral spirals, by Abd al-Rahman al-Amidi al-Shafii, Yemen (1398).*

its reflection, its language of love. Among people without a calligraphic tradition beautiful handwriting can of course be found anywhere – in a private letter, for instance. But this comes from an expression of feeling not rooted in a general knowledge and technique of calligraphy. It remains an individual impulse within the totality of a culture. We use the word calligraphy here to denote an all-embracing cultural manifestation which structures the philosophical basis of regular language.

It should be noted here that a codified Arabic calligraphy presupposes the existence of an earlier graphic convention, including diacritical signs and vowels, which was developed gradually both before and after the appearance of Islam, and was applied to the painstaking and laborious task of transcribing the Qur'ān. But calligraphy was the work of a hieratic bureaucracy, who were keen to impose on society a political order inspired by the Qur'ān. The new discipline was established by Ibn Muqla, a man who, according to legend, was thrice Vezir, thrice went on a holy war, and whose

remains were thrice interred: first in the prison where he died, second in his house, and third in the cemetery. He will reappear in our story in a less legendary form, a pen in his right hand – the hand that the Caliph Rādi billāh ordered to be cut off.

As a historical phenomenon Arabic calligraphy dates, in its codified form, from Ibn Muqla (ninth century AD), and its decline coincides with the spread of printing. More than ten centuries of calligraphic tradition are represented in this growth and decline of Arabic culture.

It is to be understood that our concern here is not to compile a catalogue, large or small, of this art, but simply to honour it. Such a catalogue would be virtually impossible in any case, since it would have to cover ten centuries of history and a vast geographic area embracing the Muslim world. Indeed, Persian and Swahili, and Urdu too, are written in Arabic characters, as was Turkish before the drastic reforms of Kemal Atatürk after the fall of the Ottoman Empire.

وكاندوف

فولت

زوالسفو

فاستوا

وكذالله

وما الله
الكن
ن د ه
ك
د ح ق ن
و يلفا لا س

Karmatian kufic script.
Page from a Qur'ān.

Right. Ḳarmatian kufic script.

Pages 16–17
Archaic Kufic script *on parchment (9th century).*

LEGEND AND EPIGRAPHY

Present throughout Islam, calligraphy raises the question of writing at its original source in religious belief. The Prophet Muhammad said that the Qur'ān was revealed to him in 'pure Arabic'. What can we wager on knowing the 'agency' of this written sign?

First of all we must rid ourselves of the idea that calligraphy developed as compensation for the prohibition placed by Islam on the representation of the human or divine form. As the religion of an invisible god, early Islam had to compete with the pre-existing totemistic religions, which encouraged figural representation; it had to eradicate and blot out the memory of such established practices. But this prohibition, which has incidentally been little elaborated, conceals another approach, no less influential, which fits absolutely into a fundamental theory of the divine origin of writing: the human body is a progression in four stages: death (the inanimate), life, death again, and finally life in the beyond, be it in Paradise or Hell. The Qur'ān is the site of this migratory separation. And Allah speaks Arabic first: so the Qur'ān is not seen as a gospel to be revealed in any language. Hence the belief that the Arabic language, occurring in the Qur'ān, is to be considered as a miracle. How can a miraculous language be transcribed without giving the lie to its implicit perfection? And since all revelation enjoins silence and hushed voices, the scribe's sublime task is beset with grave problems. From the inception of Islam conflicts broke out over different recensions of the Qur'ān, which did not acquire its definitive form until after the death of the Prophet. The recensions themselves were transcribed in an orthographically incomplete form of writing: the system of vowel and diacritical signs – so important in calligraphy – was deficient. This is a major (but not the only) reason for the custom of chanting and reciting the text. It was not until the third Caliph, Uthmān (23/644–35/655) that an 'authorized' version was produced. Calligraphy, though not yet codified, was born at that moment, to establish the miraculous nature of the Qur'ān's origin.

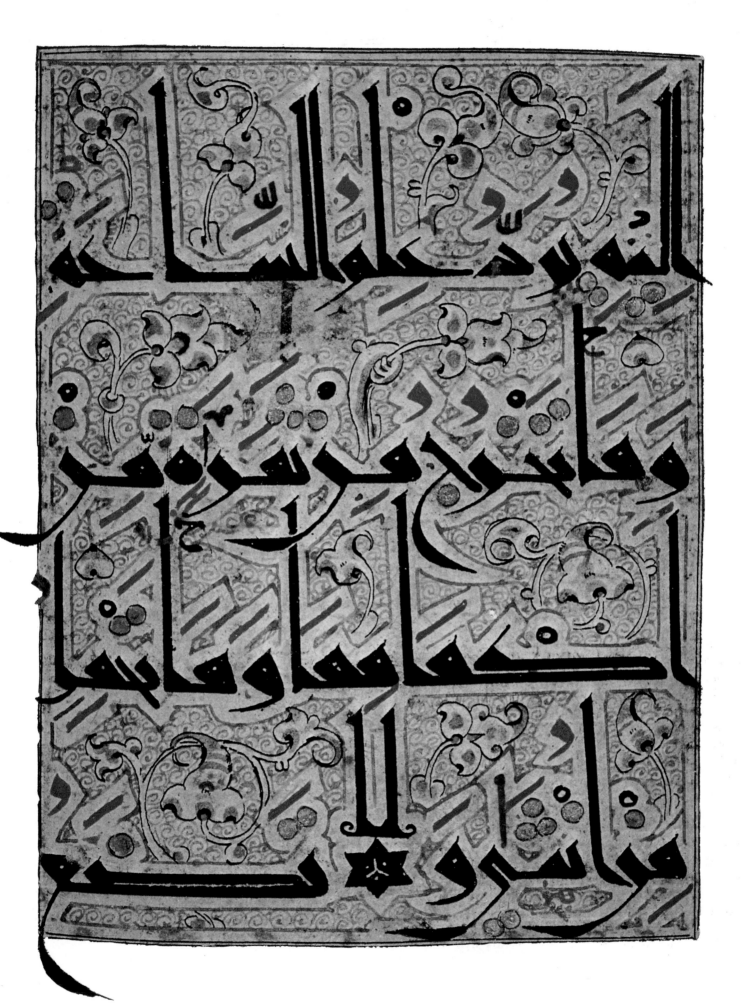

Interwoven floral kufic script.
'Allah the Omniscient' (one of
the 99 names of God)

MYTHS
OF ORIGIN

The origin of writing may be explained – or it may be a matter for reverie and meditation.

From the outset the Muslim finds himself mysteriously confused. For while Arabic script is definitely revealed in the Qur'ān as a miracle, we also know – from the other side of the looking-glass, so to speak – that it existed as the successor to Nabato-Aramaic, and therefore to Phoenician, beginning with the first letter *alif*. What can such a discrepancy mean? Is the truth of the Qur'ānic script above and beyond the evidence of its own past, with pre-Islam nothing but its crude semblance?

Further on we shall consider a factual, though perfunctory, explanation offered by some Muslim thinkers, written, as it were, in a clandestine script. Let us for the moment consider the origin of the Arabic language as it occurs in imagination and legend.

According to Abu al-Abbas Ahmed al-Bhūni, letters arose from the light on the pen that inscribed the Grand Destiny on the Sacred Table. Allah had ordained that therein should be recorded the deeds of all creatures, till the Last Judgment. After wandering through the universe, the light became transformed into the letter *alif*, from which developed all the others.

In another variation of the myth, Allah created the angels according to the name and number of the letters, so that they should glorify him with an infinite recitation of the Qur'ān. Allah said to them: 'Praise Me! I am Allah, and there is none other but I.' The letters prostrated themselves before him, and the first to do so was the *alif*, whereupon Allah said 'You have prostrated yourself to glorify My Majesty. I appoint you to be the first letter of My Name and of the alphabet.'

Another myth, which frequently appears in Arabic treatises, connects Adam with the origin of writing. Adam is said to have written a number of books three centuries

before his death. After the Flood, each people discovered the book that was destined for it. The legend describes a dialogue between the Prophet Muhammad and one of his followers, who asked: 'By what sign is a prophet distinguished?'

'By a revealed book,' replied the Prophet.

'O Prophet, what book was revealed to Adam?'

'A, b . . . ' And the Prophet recited the alphabet.

'How many letters?'

'Twenty-nine letters.'

'But, O Prophet, you have counted only twenty-eight.' Muhammad grew angry and his eyes became red.

'O Prophet, does this number include the letter *alif* and the letter *lām*?'

'*Lām-alif* is a single letter . . . he who does not believe in the number of twenty-nine letters shall be cast into Hell for all eternity.'

According to another tradition, the names of six kings of Madyan made up the letters of the Arabic alphabet. In fact, these imaginary names form the *abjād*, a mnemonic device to establish the order of the Arabic alphabet.

Like the Greeks, the Arabs gave a numerical value to each of their letters, classifying them in three series of nine: units from 1 to 9, tens from 10 to 90, hundreds from 100 to 900, and finally 1000. This system is still in use in popular treatises on divination.

Our purpose in providing a reminder of these myths is not to consider their emotive appeal: every culture records this interplay between myth and Logos. Our intention is to ensure that the myths should not be abruptly consigned to the limbo of 'pure illusion', in contrast to science, since the idea of myth, as well as that of science, is involved in the metaphysics of sign and symbol. This approach to the origin of writing is thus a way of setting it down in its metaphysical and theological origin. In Islam, writing is an absolute, *the* Absolute, the *Sanctum Sanctorum*. True, there may also be discerned in it the Greek theory of writing, formulated differently, that writing is the fine garment which clothes meaning, but the status of writing is nevertheless given a sacred character, and in a fundamental way. When writing is seen as an aspect of the Absolute, then scientific thought itself partakes of and prolongs the nature of revelation. Beyrūni wrote: 'As surprising for a science to be considered eternal as for a camel to be found in the channel of the Ka'ba.' Islam builds up science and philosophy from the basis of the Qur'ān and its miraculous rhetoric.

Interwoven floral kufic script. *Qur'ān, Afghanistan (18th century)*.

Aristotelianism was to come to Islam and then depart from it, but its descendants, the schools of scientific materialism, have never ceased to plague us since the nineteenth century. And now technology once again presents a challenge to the foundations of religion.

We are not directly concerned here with analyzing the interdependence (in Arabic script) between the different usages of religion, philosophy and science. But we must define, however briefly, the question of calligraphy in the field of a language which claims to be revealed by God. In such an investigation we cannot allow facts and images to fall into the province of punditry or aesthetics. Instead of analyzing Arab culture and its linguistic base, this type of image-making leads to ignorance. At best it is as lifeless as a photograph album – or a corpse embalmed in preparation for burial.

It has been well said that what will remain of the Arabs in the end is to be found, firstly, in the Qur'ān, secondly, in pre-Islamic poetry and, finally, in calligraphy and architecture. There remains the question of the Arabs themselves and their body of knowledge, past and present.

A consideration of calligraphy without further development of these philosophic issues limits our range. But at least there is no question of composing an obituary for the corpse of Arabic thought. Students of oriental sensualism, and Muslim exponents of nostalgia, have already done this better than we can.

Calligraphic art, operating at the edge of language, makes systematic use of the laws of rhetoric and in particular the *al-Adab*, a very subtle concept which acts upon the whole range of the Arabic language and its linguistic theory. *Al-Adab* combines the logical and the imaginative approach – two methods which should never have been separated – and rejects the primacy of any single system, summoning, instead, a whole range of disciplines (science, literature, education, legend, etc.). Thus the text becomes parenthetical, stylized by its calligraphy (as we shall try to show) in some well-known phrase or sentence, taken from the Qur'ān, with its forcefulness delicately veiled for our greater enjoyment.

To return to the beginning, the concept of the Qur'ān as a miracle has been marginally disputed by some Muslims, and perhaps even by the great al-Ma'arri (973–1057); but in its basic sense it has affected the whole process of writing. Rhetoric (al-Bayān) has emphasized the unique character of the Qur'ān and the nature of its composition, which ensures

that certain elements remain permanently obscure. Hence those isolated and mysterious letters which preface some of the Suras. Allah speaks through the Prophet. The Qur'ān has revealed its message in Arabic characters. If the Qur'ān has been revealed in 'pure Arabic', what are the presuppositions and the effects of this theory?

With or without a mystic formulation, the question of the origin of writing is that of the origin of language itself. Our synthesis of the subject has confined the Qur'ānic structure to a simplified theocentric discussion. There remains, in fact, a series of questions on the divinely created character – or otherwise – of the Qur'ān. Classical Arabic learning, especially in its grammar and philology, has been deeply influenced by it, particularly with the rationalistic Mu'tazila which, in the reign of the Caliph al-Mamūn (d. 218/833), accepted the thesis. Nazzām (d. 231/845) has even written, 'The structure of the Qur'ān and the beauty of its prose are not a miracle of the Prophet, nor proof of the truth of his mission. But what proves the truth of his mission is the fact that the Qur'ān contains the revelation of hidden things. As for the beauty of its language, men are capable of producing works of similar, and even superior, composition.'[1]

The word 'women' from a lithographed Arabic Qur'ān, with translation into Urdu. Probably mid-19th century.

24

This crucial point is decisive as regards the issue of writing. Let us consider, in outline, some questions arising from it: on the one hand, if God speaks Arabic in the absolute sense, what is the value of pre-Islamic Arabic? How can non-Arabs appreciate the inimitable beauty of the Qur'ān? What is to be said about the diffusion of all the other languages? We would suggest that Arabic may remain in a sense 'dormant' in all language, including that of other monotheistic cultures. But how can the 'dormant' or 'awakened' condition of a miraculously inspired grammar be evaluated? Ibn 'Askari has written: 'The language of Adam in the Garden of Eden was Arabic. After his disobedience he was deprived of it and spoke Syriac. Then, after Adam's repentance, God restored Arabic to him once more.'[2] Thus Arabic is seen as the prelapsarian language, which human sinfulness has caused to become latent in all other tongues – even here, in this text.

On the other hand, if the Qur'ān was transmitted to Muhammad by Allah, the terms of the process by which it came into existence need to be specified, and the importance of the human word in relation to the divine voice. How is the human origin of language and writing to be justified without departing from the theological framework?

Archaic kufic script. *Variants of letters (from a Qur'ān incorrectly attributed to the Caliph Uthmān).*

Andalusian maghribi script. *A typical example.*

بالحسنة السيئة

اولئك لهم عقبى

الدار جنات عدن

يدخلونها ومن

صلح من ابائهم

TAWQĪF
AND IṢṬILLĀḤ

Leaving aside the question of the divine utterance, the two sides of this debate straddle the twin concepts of *tawqīf* and *iṣṭilāḥ*, the theory of a language established by God and that of a language fixed by a convention among humans, and specifically in writing.

Tawqīf, from the verb *waqqafa*, (root, WQF) means to stop, to make a halt, to stand up, to put in restraint. H. Loucel has suggested 'a revealed confirmation' for *tawqīf*,[3] a translation which we accept with some reservations. The concept, which is both active, passive and between the two, of determining, being determined, standing up, and stopping, implies a delicate configuration of meanings in its written form. Some Arabic authors use, instead of *tawqīf*, the words *waḥy* and *ilhām*, which are usually translated as 'divine inspiration'. *Waḥa* (root, WH) means to insinuate, suggest, inspire, reveal, write. *Ilhām* comes from *alhama* (root, LHM), which means to inspire.

The word *iṣṭilāḥ* (from the verb *iṣṭalaḥa*) signifies agreement or accord between men, and, in this context, between the human institution of language and literature.

The contrast between these two concepts is not comparable to that between natural and conventional.[4] The concept of nature does not apply here, as it does in the Greek *physis*. No Muslim theologian would try to suggest, for example, that birds sing in Arabic. However, popular mythology in Islamic countries, unaware of this kind of debate, maintains that it is in Arabic that the dove coos its five daily prayers.

Arab thinkers reject the idea of a usage inspired by spontaneous naturalism. And if Ibn Jinni (d. 392/1001) seems to reconcile gods and men, this is not a reference to the Greek notion but a preparation for his theory that the Qur'ān was not divinely created. 'There are some', he writes, 'who claim that the origin of all languages is to be found in sounds heard, such as the whistle of the wind, the

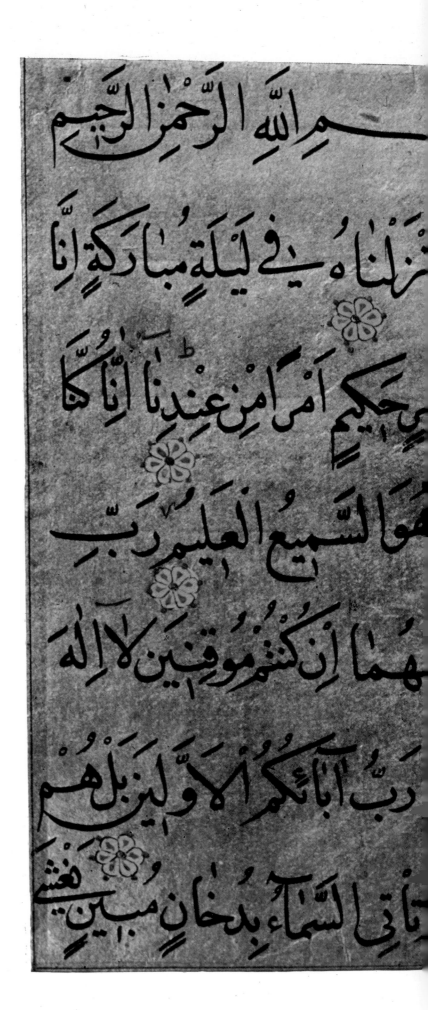

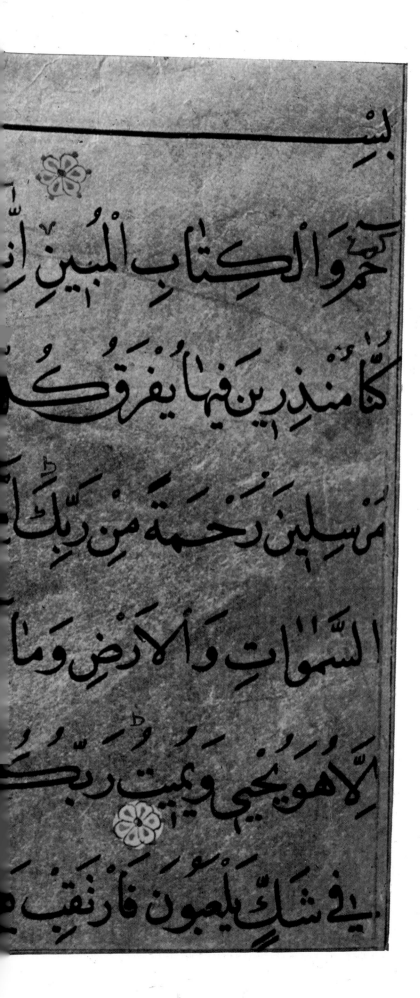

rumble of thunder, the trickling of water, the braying of donkeys, the cawing of crows, the neighing of horses, the belling of gazelles, etc . . . Languages are born from these sounds. In my opinion this view is interesting; it is an acceptable theory.'[5]

Does the origin of language and writing emerge from *tawqīf* or from *iṣṭilāḥ*? Let us synthesize, with A. Badawi, the varying responses of the Mu'tazila, leaving them open-ended and in suspense like an incompletely calligraphed letter: 'The word of Allah has form, that is, it is an articulated voice, and therefore it has been created.'[6]

'The word of Allah is an articulated voice, and human effort consists in reading (and transcribing) it.'

The word of Allah is uttered in several places. The adherents of Mu'ammer 'say that the Qur'ān is an act (an effect) of the place where it is heard. If it is heard from a tree, then it is the act of the tree. Thus, wherever it is heard it is the act of the place where it occurs.'[7] And according to al 'Allāf, the word of Allah is expressed in three places: in the written text of the Qur'ān (Muṣḥaf), in its recital in Arabic, and in the receptive ear, that which hears the voice. The notion of this transmigration of the divine voice, the omnipresent script that is written everywhere, becomes clearer in the doctrine of al 'Allāf: according to al-Ash'ari, 'Abū al-Huṭaīl (that is, al 'Allāf) taught that God created the Qur'ān from the Sacred Table. It exists in three places: the place where it is preserved (or memorized?), the place where it is written, and the place where it is read and heard. The word of God can exist in several places . . . The Qur'ān need not be transferred, or moved, or actually destroyed, yet it exists in a place even as it is written, or read, or preserved. If it is obliterated in one place, it will not for all that be destroyed there. If it is transcribed in one place, it shall not for all that be transferred from another place; likewise, even it it is memorized, read or heard, it may be destroyed. The word of

Naskhi script. *Qur'ān, 16th century.*

ابْيَضَّتْ وُجُوهُهُمْ فَفِي رَحْمَةِ اللَّهِ هُمْ فِيهَا خَالِدُونَ ۞ تِلْكَ آيَاتُ اللَّهِ نَتْلُوهَا عَلَيْكَ بِالْحَقِّ وَمَا اللَّهُ يُرِيدُ ظُلْمًا لِلْعَالَمِينَ ۞ وَلِلَّهِ مَا فِي السَّمَوَاتِ وَمَا فِي الْأَرْضِ وَإِلَى اللَّهِ تُرْجَعُ الْأُمُورُ ۞ كُنْتُمْ خَيْرَ أُمَّةٍ أُخْرِجَتْ لِلنَّاسِ تَأْمُرُونَ بِالْمَعْرُوفِ وَتَنْهَوْنَ عَنِ الْمُنْكَرِ وَتُؤْمِنُونَ بِاللَّهِ وَلَوْ آمَنَ أَهْلُ الْكِتَابِ لَكَانَ خَيْرًا لَهُمْ مِنْهُمُ الْمُؤْمِنُونَ وَأَكْثَرُهُمُ الْفَاسِقُونَ ۞ لَنْ يَضُرُّوكُمْ إِلَّا أَذًى وَإِنْ يُقَاتِلُوكُمْ يُوَلُّوكُمُ الْأَدْبَارَ ثُمَّ لَا يُنْصَرُونَ ۞ ضُرِبَتْ عَلَيْهِمُ الذِّلَّةُ أَيْنَمَا ثُقِفُوا إِلَّا بِحَبْلٍ مِنَ اللَّهِ وَحَبْلٍ مِنَ النَّاسِ وَبَاءُوا بِغَضَبٍ مِنَ اللَّهِ وَضُرِبَتْ عَلَيْهِمُ الْمَسْكَنَةُ ذَلِكَ بِأَنَّهُمْ كَانُوا يَكْفُرُونَ بِآيَاتِ اللَّهِ وَيَقْتُلُونَ الْأَنْبِيَاءَ بِغَيْرِ حَقٍّ ذَلِكَ بِمَا عَصَوْا وَكَانُوا يَعْتَدُونَ ۞ لَيْسُوا سَوَاءً مِنْ أَهْلِ الْكِتَابِ أُمَّةٌ قَائِمَةٌ يَتْلُونَ آيَاتِ اللَّهِ آنَاءَ اللَّيْلِ وَهُمْ يَسْجُدُونَ ۞ يُؤْمِنُونَ بِاللَّهِ وَالْيَوْمِ الْآخِرِ وَيَأْمُرُونَ بِالْمَعْرُوفِ وَيَنْهَوْنَ عَنِ الْمُنْكَرِ وَيُسَارِعُونَ فِي الْخَيْرَاتِ وَأُولَئِكَ مِنَ الصَّالِحِينَ ۞ وَمَا يَفْعَلُوا مِنْ خَيْرٍ فَلَنْ يُكْفَرُوهُ وَاللَّهُ عَلِيمٌ بِالْمُتَّقِينَ ۞ إِنَّ الَّذِينَ كَفَرُوا لَنْ تُغْنِيَ عَنْهُمْ أَمْوَالُهُمْ وَلَا أَوْلَادُهُمْ مِنَ اللَّهِ شَيْئًا وَأُولَئِكَ أَصْحَابُ النَّارِ هُمْ فِيهَا خَالِدُونَ ۞ مَثَلُ مَا يُنْفِقُونَ فِي هَذِهِ الْحَيَاةِ الدُّنْيَا كَمَثَلِ رِيحٍ فِيهَا صِرٌّ أَصَابَتْ حَرْثَ قَوْمٍ ظَلَمُوا أَنْفُسَهُمْ فَأَهْلَكَتْهُ وَمَا

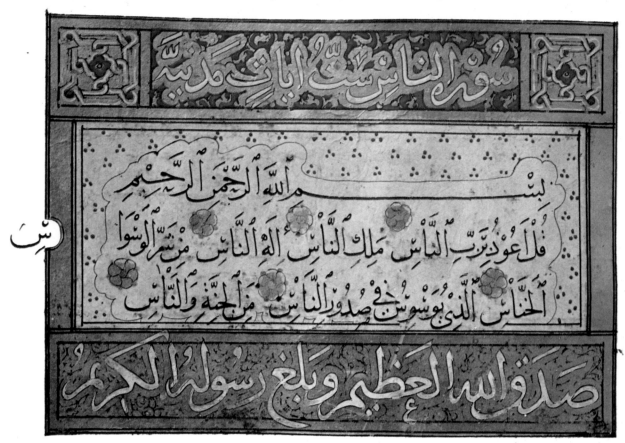

Naskhi script. *Page from a Qur'ān written by the leading calligrapher Yaqut al-Musta'simi (d. 1298).*

Left. **Oriental naskhi script.** *Qur'ān.*

man can also exist in several places according as it is memorized, or imitated (or reported?).'[8] Thus, human speech is regarded as imitation and repetition of the creating force in its movement, the articulation of the voice in memory, reading and transcription. Writing is to be found at this point. Its origin is in fact a form of imitation. But this theory of places is, as we shall see, a compromise between the tenets of the two theories.

Grammarians like Ibn Fāris (d. 390/999), Ibn Jinni (d. 392/1001) and Ibn Ḥazm (384/994–456/1064), are known to have rejected as absurd the very idea of a conventional language. Their grammar is based on the revealed, uncreated nature of the Qur'ān, thus discarding the thesis of Mu'tazila, for major metaphysical reasons.

First, for them, the Qur'ān is co-eternal with God. This explains, they say, the famous verse that has been the sub-

ject of passionate discussion throughout the centuries: 'God taught Adam all the names.' What was this language of Adam, the original and principal? If, as Ibn Ḥazm has called it, it is Paradise Lost, then man is to blame for dispersing, diversifying and corrupting such a language. 'We do not know what language Adam spoke at the beginning, but we can definitely state that this was the most perfect of all languages. . . .'[9]

Secondly, to create is to utter, to articulate. Man cannot articulate his bodily senses, for his sight, hearing and speech are delimited by Allah. Language descends upon him, as a revelation. A man's birth is ordained, and occurs in the context of a language already articulated and formed. The infant learns not conventional speech, but the ability to tune itself into the voice of the divine. The infant is potential, like a vibrating atom.

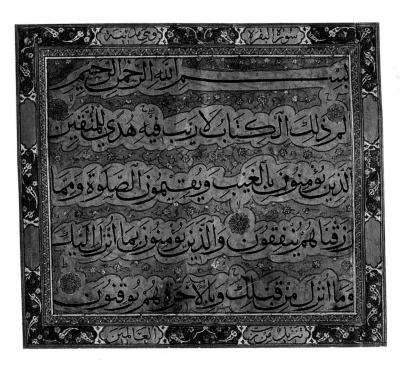

A page from a Qur'ān in **naskhi**: *the opening of the Sūra al-baqarah (the Cow). A stylized variant of naskhi script, with enlarged detail from line 4 above.*

Thirdly, language signifies and presupposes knowledge, and this is accorded by Allah. The concept of science has its origin in the divine voice, insofar as technology is, according to Heidegger, the offspring of metaphysics. The ultimate source (*aṣl*) of language is divine, whereas its later development may be the activity of humans. Every system of thought is thus pervaded by this absolute principle of the origin of language.

Fourthly, diversity of language results from a primary unity, the language of Adam. Ibn Ḥazm maintained that Arabic was spoken by Ismail, Syriac by Abraham, and Hebrew by Isaac. 'Some people', he wrote, 'have supposed their own language to be of superior value to others. But this means nothing because the criteria of superior value are known: they are based only on output and particular attribution. A language, however, does not have output, and we have no revealed text proclaiming the superior value of one language over another, since God has said: 'The Prophet has been sent only to bring enlightenment in the language of his people . . . And God has made it known that he sent down the Qur'ān in Arabic so that it should be understood by his people, and for no other reason.'[10]

Fifthly, the status of writing derives from the Qur'ān, which brings us back to our point of departure. Here we are to understand, with A. Badawi, that Ibn Ḥazm distinguished five elements in the Qur'ān's conceptual field: the word of Allah; the Qur'ān as uttered by the human

voice; the meaning of that which is uttered; the written record (Muṣḥaf); that which is memorized from the Qur'ān.[11]

The word of God is uncreated, whereas the other elements in the Qur'ānic concept are created, as also is writing, in its restricted meaning.

This is not the place to develop this discussion. By establishing the Qur'ān in such a setting we seek to free the art of Islam from certain prejudices and received ideas. These will occur later, too, in the context of the arabesque and the conflict between abstract and concrete, and they are allied to notions of the so-called superiority of Greek phonetics over consonantal language.

In their allusions to the myths of origin (in the form of *qīla* – 'It is said') some Arab thinkers and historians have given hints of their belief in a human origin of writing. These hints are too isolated and veiled, and their authors could not develop them without considerable fear of the consequences. Al-Ghazālī (d. 505/1111) himself left the question open in his sketchy formulation of a mystic theory of the written word:

'We ourselves think it possible that language could be conventional, in the sense that God acts upon the spirit of a man so that another may understand therein the design of the convention. But it is also possible that languages are fixed by revelation, in the sense that God has established their signs and characters: he who would see them clear might thus grasp their significance.'

This introduction provides food for thought, in view of the great intellectual rigour of this author, who attempted to bring philosophy and mysticism to order by means of a very subtle theology. For al-Ghazālī it was theology itself that was undeniable, not his interest in mysticism. This did not prevent him from writing, in his major work,[12] that language could not express the existence of God, and that language was made by men for men. This was clearly a heretical opinion, which appeared literally to contradict the content of certain verses of the Qur'ān. But it is known that his desire for theological truth made him end his days as a professor teaching – after his interest in mysticism – religious science.

Naskhi *on glass:*
a calligram in
the form of a tiger.
Artist unknown.

Inscription from Harrān (probably AD 518).

Inscription from Zabad in Greek and Arabic (AD 512).

*Funerary inscription from an-Namara (AD 328), speaking
of the famous pre-Islamic poet Imru l-Qays.*

Inscription from Umm al-Jimāl (between AD 250 and 271)

EPIGRAPHICAL CONFUSIONS

Let us now consider further evidence relating to a factual approach to the subject. Ibn Khaldūn (1332–1406), that disillusioned rationalist, exhausted by the futility of the chroniclers, has nothing to say on those theories of the origin of writing which relate to Adam, the Prophet, or the angels. He was a philosopher who lived at the time of historic Arab retreat, and he tried to explain the actual nature of the facts. 'The most plausible view', he wrote, 'is that the art of writing was transmitted by the Himayrites to the Tubbā; from them to the people of al Hira, and thence finally to the people of the Hijāz. . . . The Himayrites had a script known as *musnad* which could only be studied with their assent.'[13]

The assent of another party is common to all writing. But where does this hypothesis lead? In fact it supports the statements of most of the chroniclers, who make Hira and Anbār on the Euphrates pivots for the dissemination of Arabic script. The historical importance of these centres of commerce is well known. But our concern is with the theory of the Syriac origin of writing, which Balāduri summarizes as follows: 'There is the story of three people from T'ay who came together at Baqqa, and constituted the Arabic alphabet *according to the Syriac manner*. From there the language passed to Anbār and Hira, thence to Mecca, and so on.'

This thesis, though of course anecdotal, is partly confirmed by recent epigraphical research, and challenges other theories which will be discussed later. At first sight there is nothing surprising in this conjunction of Western epigraphy and Islamic lore as regards the origins of writing and the metaphysics of symbols. For, in spite of the refinement of its classifications, epigraphy attempts to trace different scripts back to a single source and a common origin. This is an extraordinarily difficult task, where certainty is impossible (and in a sense useless), when one

thinks of the languages and scripts that have been lost for ever, the chain of their connections broken and dispersed among many other languages. How are they to be reconstituted when their most subtle signs and remnants have been scattered beyond recall? To become such an epigrapher one has to be a solitary seeker after the nostalgia of metaphysical beginnings. How can surviving traces of a language found here and there be recomposed, and fragments of phrases inscribed on tombs be rearticulated? However, like the (theological) ant of the philosopher Nazzam, which was transported by spiritual power, epigraphy has from its birth learnt to jump. But in our situation the jump will be less dangerous, since the Arabic language is more recent and the earliest known document dates from *c.* AD 328. So, abandoning this laborious and confusing approach, let us analyze the origin of Arabic writing from an epigraphical viewpoint.

This discipline makes use of certain archaeological inscriptions and, on the theoretical level, of linguistics, the history of writing, and so forth. The first fact is that the Semitic script is linked with Phoenician (or possibly proto-Phoenician), and chiefly characterized by the use of consonants, by a systematic combination of roots, and by a graphic line running from right to left. This is of course the case with Arabic. The second fact is the existence of inscriptions at an-Namara, Zabad, Harrān, Umm al Jimāl, and the papyri of Engaddi. The four first inscriptions, which are familiar to specialists, derive from what is generally called the Syro-Palestinian domain.

An-Namara is the site of a funerary inscription referring to the celebrated pre-Islamic bard Imru l-Qays. Dated AD 328, it is written in monumental Nabataean script, but with some signs of Arabic tendency. At Zabad (near Aleppo) there is a bilingual inscription (Greek-Arabic) dating from AD 512. The inscription at Harrān (AD 518) is written in

three languages, Greek, Syriac and Arabic, and that at Umm al Jimāl probably dates from AD 250–271. It should be mentioned that these dates are provisional, and that scholarly opinions are not always in agreement.

Other documents concerned with Arabic script, which have been studied by J. Starkey and J.T. Milik, relate to the papyri of Engaddi from the end of the first century AD and to some inscriptions from the second, third and beginning of the fourth centuries.[14] There is also an incomplete redaction to be found in the important *Répertoire chronologique d'épigraphie arabe*.[15]

Semitic epigraphers have, since the nineteenth century, decided, on the evidence of the inscriptions, on a Nabataean origin for Arabic script, which is usually called Nabataean-Arabic. It is a script derived from cursive Aramaic, which is itself derived, 'in the last resort' (according to J. G. Février), from Phoenician. This transformation must have taken place in the second or third centuries AD, according to B. Moritz.[16]

Could this Nabataean-Arabic script perhaps have been what the Arabs call *musnad*? This was formed of characters usually made up of one or two perpendicular or very oblique strokes, accompanied by an arc, a point or a crochet. We shall return to this later, but will here note that the theory of the origin in *Estranghelo* (a variant of Aramaic) has been generally rejected.

To continue the discussion with a reconsideration of the texts, B. Moritz, a supporter of the Nabataean theory, has compared ancient Nabataean with ancient Arabic characters and has concluded that there was no horizontal base line. Yet horizontality defines the skeleton of Arabic script, above and below which fall the vowel and diacritical signs. Moritz thinks that the introduction of these marks (in the Syriac manner) very probably took place in pre-Islamic times.

This thesis is put forward in the majority of histories of writing. But J. Sourdel-Thomine has attacked its tenuous nature as exemplified in this statement by J.G. Février: 'Around the second century the Nabataean script, a variation of the Aramaic, appeared at El'Ula. A north Semitic script, itself derived from the Phoenician alphabet, is thus substituted for a south Semitic script. The Nabataeans, to judge from their proper names and some other elements, spoke an Arabic dialect, but for their written language employed Aramaic, the chief commercial language of the Ancient East at that time, using an alphabet, called Nabataean, which was merely a cursive variant of Aramaic. After the decline of the Nabataean kingdom in the first century AD, Arabic insertions occur with increasing frequency in the texts . . .'[17] Such 'insertions' would require that Arabic existed in its own ancestral language. However, the experts disagree over the direction of the 'insertions'. But Février, a supporter of nineteenth-century Semitic epigraphy, has raised the question of certain characteristics of archaic Arabic which need answering: since the Nabataean alphabet had twenty-two letters, and the Arabic twenty-eight, the latter must have developed by means of diacritical signs (insertion). The vowels triangle is used in an unsystematic way, and the use of *matrices lectionis* existed before Islam. The Arabic script adopted, from the Nabataean, its method of ligatures connecting the letters.

J. Sourdel-Thomine, in his restatement of the question, supports the hypothesis of J. Starkey,[18] which concurs with that of the Arabs themselves. Starkey writes, 'It will be easier for us if we abandon the theory of the Nabataean origin of the Zaban and Harrān script, and simply say that the archaic Arabic script, being relatively homogeneous, derives entirely from the Syriac as it was written in the Lahmid capital.' He also writes: '. . . the hypothesis of a Syriac origin accounts better for certain Arabic letters and

الْهٰىكُمُ التَّكَاثُرُ ۞ حَتّٰى زُرْتُمُ الْمَقَابِرَ ۞ كَلَّا سَوْفَ تَعْلَمُونَ ۞ ثُمَّ كَلَّا سَوْفَ

تَعْلَمُونَ ۞ كَلَّا لَوْ تَعْلَمُونَ عِلْمَ الْيَقِينِ ۞ لَتَرَوُنَّ الْجَحِيمَ ۞ ثُمَّ لَتَرَوُنَّهَا عَيْنَ الْيَقِينِ

ثُمَّ لَتُسْأَلُنَّ يَوْمَئِذٍ [سورة العصر] عَنِ النَّعِيمِ

بِسْمِ اللهِ الرَّحْمٰنِ الرَّحِيمِ

وَالْعَصْرِ ۞ إِنَّ الْإِنْسَانَ لَفِي خُسْرٍ ۞ إِلَّا الَّذِينَ آمَنُوا وَعَمِلُوا الصَّالِحَاتِ وَتَوَاصَوْا

بِالْحَقِّ ۞ وَتَوَاصَوْا بِالصَّبْرِ [الهمزة] بِسْمِ اللهِ الرَّحْمٰنِ الرَّحِيمِ

وَيْلٌ لِكُلِّ هُمَزَةٍ لُمَزَةٍ ۞ الَّذِي جَمَعَ مَالًا وَعَدَّدَهُ ۞ يَحْسَبُ أَنَّ مَالَهُ أَخْلَدَهُ

كَلَّا لَيُنْبَذَنَّ فِي الْحُطَمَةِ ۞ وَمَا أَدْرَاكَ مَا الْحُطَمَةُ ۞ نَارُ اللهِ الْمُوقَدَةُ ۞ الَّتِي

تَطَّلِعُ عَلَى الْأَفْئِدَةِ ۞ إِنَّهَا عَلَيْهِمْ مُؤْصَدَةٌ ۞ فِي عَمَدٍ مُمَدَّدَةٍ ۞

[سورة الفيل] بِسْمِ اللهِ الرَّحْمٰنِ الرَّحِيمِ

أَلَمْ تَرَ كَيْفَ فَعَلَ رَبُّكَ بِأَصْحَابِ الْفِيلِ ۞ أَلَمْ يَجْعَلْ كَيْدَهُمْ فِي تَضْلِيلٍ

وَأَرْسَلَ عَلَيْهِمْ طَيْرًا أَبَابِيلَ ۞ تَرْمِيهِمْ بِحِجَارَةٍ مِنْ سِجِّيلٍ ۞ فَجَعَلَهُمْ

كَعَصْفٍ [سورة قريش مكية وهي] مَأْكُولٍ

بِسْمِ اللهِ الرَّحْمٰنِ الرَّحِيمِ

لِإِيلَافِ قُرَيْشٍ ۞ إِيلَافِهِمْ رِحْلَةَ الشِّتَاءِ وَالصَّيْفِ ۞ فَلْيَعْبُدُوا رَبَّ

هٰذَا الْبَيْتِ ۞ الَّذِي أَطْعَمَهُمْ مِنْ جُوعٍ ۞ وَآمَنَهُمْ مِنْ خَوْفٍ

[سورة الماعون مكية وهي سبع آيات]

بِسْمِ اللهِ الرَّحْمٰنِ الرَّحِيمِ

أَرَأَيْتَ الَّذِي يُكَذِّبُ بِالدِّينِ ۞ فَذٰلِكَ الَّذِي يَدُعُّ الْيَتِيمَ ۞ وَلَا

Square kufic *with a maze-like quality, and a page of text in* interwoven floral kufic.

for the fact that, taken as a whole, Arabic script is *placed* along the length of the line, exactly as in Syriac script, while the succession of Nabataean letters is *suspended from this same line*.'

For his part, the Iraqi scholar Zayn al-Din Nāji[19] has tried to justify the theory of the *musnad* by means of Western epigraphy. In Arabic texts *musnad* and *jazm* are equally often suggested as the earliest Arabic scripts. This authority considers that *jazm* is merely a derivative of *musnad* and therefore there is no contradiction. In fact, what he calls *musnad* is called 'proto-Arabic script' in epigraphy. It is a script whose best known variants are *Safaitic, Tamoudian* and *Lihyanite*, and is characterized by the following: each pair of lines is separated by a stroke, in order to preserve the horizontality. And the line runs either from right to left, or left to right, or in *boustrophedon* (turning from one direction to the other, like the marks left when ploughing with oxen).

But all these theories are beset by fundamental contradictions. To attempt to recreate a prototype of Arabic by such methods is clearly to waver between a theory of resemblances on the one hand and a genealogical derivation on the other.

We have turned up some facts in the course of this critique. But we might do better, perhaps, when epigraphy and palaeography reconsider their ideas on the origin of Arabic script, and think of it as, in a sense, a dead body of symbol without name or feature.

Classical Arab philosophy turned to God to establish the inaccessible, indefinable origin, forever veiled from human understanding. It simultaneously made use of an insight into the past, the dawn's reflection, as it were, falling on consciousness in a shaft of metaphoric light, and, in the world of men, an inexorable call to start again. In his heart, of course, man had by no means lost awareness of those divine intimations lying, as it were, midway between the word of God and the human form, but the course of his development assumed a finality which sealed the signs of nature in their enigmatic opacity. The Qur'ān is presented as simultaneously revealed and concealed, absent and present, veiled – but by a celestial hand. And if man in his unsteady progress could express this transcendent order, where would he find a place if not in the ebb and flow of such a rhythmic transparency? Calligraphy was to be the flowing plainsong of the divine.

Epigraphy and palaeography no doubt progress at a diagonal to the metaphysical axis. Deriving from the eighteenth-century rationalism of the West, they too have kept to a limited concept of the origin. But both Islam and this rationalist discipline work towards an irreducible metaphysic, seeking the point of creation so as to assign to it the majesty of the beginning. And if, as modern thought repeats, the origin is nowhere, has no 'place', and never has had, except within something which far exceeds it, displacing it both at the level of the atom and in the lightning flash of cosmic movement, destroying its identity; if, then, the imagined dawn of writing can be realized only in sacred song, calligraphy too has its place in this voyage of discovery and, in the sense that script is sacramental, repeats its origin in the absolute line of the artist.

Shikesté script. *Triple overlapping of the letter 'kh'.*

Ta'liq script. *Text and marginal text.*

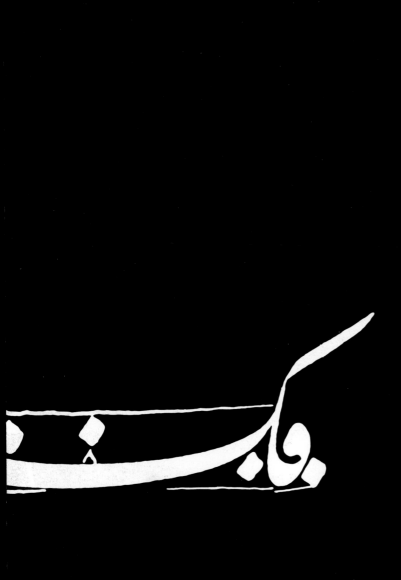

THE
PROPORTIONS
OF THE LINE

THE ALIF MODULE

The letter alif, *the first in the Arabic alphabet, is used as a module. Its length is determined by the dimensions of the nib of the reed pen. The rounded parts of the rest of the characters are made to fit within a circle, of which the alif serves as the diameter, its length being determined by the particular style adopted.*

We noted at the beginning that calligraphy constitutes a secondary code, related to language, and that it is based on geometric and decorative rules. Let us consider these rules in isolation, in order to understand better the composition of the character.

Clearly we do not want to reduce calligraphy to mere geometry. But we maintain that the proportioning of the characters, for example, plays a part in calligraphic designs in the same way that rhythm articulates music. The calligraphers had specified the elements of proportion, both in respect to the Arabic alphabet and to the interrelationship of the letters themselves. According to the most probable hypothesis, these geometric rules were invented by Ibn Muqla and afterwards perfected by numerous calligraphers. The principal points are described below.

The legibility of a text and the beauty of its line require rules of proportion. According to Arab calligraphers, the proportions of the characters always remain in a constant relationship: they all refer back to the size of *alif*, the first letter of the alphabet.

Alif is taken as the module of every Arabic calligraphic system; this choice and method are due to religious and mystical concepts, to which we will return. The length of the alif varies according to the writer, but all agree on using the dot as the universal unit of proportion. This is a square (rhombic) impression formed by pressing the tip of the pen onto the paper. The dimensions of each side of this square dot thus depend on the way in which the pen has been cut, and on the pressure exerted by the fingers. This pressure had to be sufficiently delicate and precise to separate the two sides of the nib.

What is meant by an Arabic dot and its measurement? The history of units of measurement is a very difficult subject, for these units change their names and designations from region to region, and thus make systematization impossible. In calligraphy, the dot is the craftsman's working unit. Al-Qalqashandi has shown that the standard pen was the official type used by the Abbasid Caliphs for signatures or initials. This pen, known as a *tomar*, consisted of twenty-four hairs of a donkey (or the equivalent), properly arranged and set.

Each calligrapher cut his pen in accordance with his own usage and that of his native land, and also in accordance with the kind of text he was to transcribe. In this sense, styles of script are definable by the pen and the width of the nib. In the thuluth style the width is equal to one-third of the *tomar*, and therefore the dot used for thuluth is also one-third.

The height of an *alif* varied from three to twelve dots depending on the author and the style of the script, its

Pages 44–5
Ta'liq script. *A stylistic exercise*

46

width then being equivalent to one dot. The important thing was to establish the height for each text. Once the calligrapher had chosen his alif module, he would draw it in the same way throughout the text. This was the general geometric principle, although in practice the calligrapher introduced variations. The arrangement of these variations is of great interest.

Alif was also used to measure the diameter of an imaginary circle within which all Arabic letters could be written. The calligrapher composed the characters, and therefore proportioned them according to the dot width, the size of the *alif*, and the diameter of the circle. These three elements were chosen by him.

For example, in naskhi script the *alif* is five dots high, and the letter *ba* (b) is seven dots wide and two dots for each of its serifs. In thuluth script the *alif* measures nine dots and the top of the character has a crochet of three dots. The length of the *ba* is either fifteen or eleven dots according to the two ways in which it can be written. When a letter is partly curved, it must be based on the arc of a circle of a given dimension, which is predetermined by the diameter of the *alif* standard. Thus, in thuluth the curve of the letters *'ayn, ra* (ع, ل) measures half a circle, which establishes the size.

It should be noted that the line of certain letters may determine one or two areas. This is the case, for example, with the letters *ṣad* (ص), *ḍād* (ض), *'ayn* (ع), etc. The area is established by the standard measure. In naskhi, for instance, the height of the curve of *sīn* (س) is four dots and its width five. The height of the curve of *ha* is six dots and its width five.

These examples reveal the general principle. The calligrapher establishes the dimensions of lines and areas for each letter and must ensure a consistency and a graphic symmetry throughout the text. In short, the size of the character must take account of a standard based on three measures: the dot, the *alif* module, whose size is equal to a fixed number of dots, and finally the circle, whose diameter is equal to the height of the *alif* module.

What is the interrelationship of letters themselves, as regards their reciprocal position, their direction, and their intervals? Let us place ourselves in the position of the reader, looking through the eyes of someone who neither speaks nor reads Arabic. What do we see? From this viewpoint, surveying a whole page of calligraphic script, we see within the margins an interplay of curves and uprights articulating the words, vowels and points; we also see floral or geometric designs and, finally, colours distributed sometimes over the whole or a part of the text.

Examination of the single character, the fundamental element in writing, reveals a head, a body, and finally a tail. With *'ayn*, for instance, the head is necessary for its recognition, providing the information by which it is determined. The secondary part of the character finally serves as a liaison, but its form and development require a style of ligatures.

The calligrapher wrote from right to left, along a horizontal line. On either side of the line, above or below, he inscribed the rectilinear or curvilinear elements of certain letters. Where the elements intersect the horizontal section of a letter they form an angle. We shall see later (pp. 230, 231) how the painter Boullata derives from this geometry the principles of Islamic art.

THE GEOMETRIC
INTERPLAY

Let us now consider a whole page of calligraphy. The angles made by the appendices and their intersections with the horizontal section of the letter are each equal to one another – whether acute, obtuse, or, naturally, right-angled. All the acute angles on a page lie at about 40°, and the obtuse angles at 100°. When the appendices are curved, these curves are of the same size, since they refer to the same standard circle.

The regularity of the line, based on the three co-ordinates (*alif*, dot, circle) chosen by the calligrapher, lead to a spatial distribution of the appendicular elements of the letter, forming parallel groups, perceived or imagined by the eye. By arbitrarily extending the ends of the appendices, a grid pattern is formed over the whole page. From this new surfaces emerge, overlapping those of the characters, and the planes thus formed are arranged like the facets of a crystal. This, then, becomes a script in three dimensions.

These lines, angles, planes and formal shapes, though subject to geometric rules, achieve life and movement through volutes, contrasted characters, interlocking and intertwined letters, and clear breaks.

A page of calligraphy at once invokes a feeling of movement and rhythm. In the present context, however, we cannot explore further the relationship between music and calligraphy – a relationship which, while not precisely homologous in kinetic terms, reveals something in common, for both arts share a dynamic which separates logic from its rationality and its rhetoric.

In calligraphy, the rhythmic intervals afford rest to the reader's eye as it runs over the text, providing a subtle pause between the forward movement of the line, a kinetic design emphasized by several elements: alteration of the characters' vertical sections; juxtaposition of unequal spaces; groupings of words in sequence or in insertion so as to create, outside the bounds of their assigned space, asymmetry and rhythmic breaks in the reading.

Other formative elements share in the process, including: elongation and cursive linkings of letters above and below their axes; serpentine lines between certain letters; cursives containing the next word within their decorative flourishes; stately and delicate positioning of letters so as to establish a subordinate relationship in form and meaning; and finally, the spiral.

Add to these a distribution of the major masses of text: down-strokes and up-strokes, open spaces, diacritical signs, vowel accents, floral and geometric motifs, and there results a cadence of arabesques which impresses itself upon the space/time continuum, by a process of artistic selection within the hand itself of the calligrapher and in the nerve endings of his fingers.

Let us make our way delicately through this field of symbols, changing our position according to the mood of the figure: first, the monumental characters, suggestive of the architecture of a mosque; then, a labyrinth in which the calligraphy itself seems entrapped; finally, slash marks which seem to have been traced with a warrior's sword.

Square kufic.
Above. 'Al hamdu lillah' ('*God be praised*'). *The interlaced design of the central medallion is formed by the long uprights of the letters* alif *(a) and* lam *(1).*
Left. The name Mahmūd Yazir rotating around a central letter mim *(m). (After M.B. Yazir; see bibliography).*

Facing page. Astrological treatise in the maghribi style.

Above. A calligraphic exercise by Muhammad Shāfiq (1874).

*Right. **Thuluth script.** A stylistic exercise in which the letters of the alphabet are accompanied by dots as proportional indicators. Hāj Hassan Rida (1900).*

COLOUR

Before trying to bring out the chromatic scale of the calligrapher's art, the origin of which cannot easily be determined, some introductory remarks are in order. The range of colours used by calligraphers is extremely rich and varied. Black was the basic ink, though not invariably so. In the Maghreb it was prepared from wool taken from the abdomen of a sheep. The tufts were shredded into an earthenware container which was placed over a fire to scorch the wool. Then it was pulverized with a stone and, after water had been added, the mixture was heated afresh. A paste was thus obtained which, after cooling, became hard and homogeneous. A piece could then be taken when needed and dissolved in water. A black or brown ink resulted, according to the degree of dilution.

The colours, which included gold, silver, blue, green, orange, violet, yellow, etc., were prepared from vegetable and mineral sources. Like certain painters, individual calligraphers would prepare their own inks, using secret formulas which were sometimes lost to posterity when their inventors died.

Colours are not automatically a feature of manuscripts. Their employment indicates the writer's special care and the exceptional value that he placed on the work. They may be varied and rich in every sense of the word, beginning with the complementary colours of the spectrum – red, blue and green; then yellow or gold with violet. The colours were applied separately, but their juxtaposition makes them appear even more vivid and warm, somehow like velvet.

Pastel colours, washes, and colour combinations giving a cool impression were used only rarely. It is the marriage of gold with other colours which gives both miniatures and scripts their elegant character. The skill of the calligrapher lay in his control of them, combining them with an exceptional sense of chromatic balance that may too easily be regarded as principally functional or decorative. But the meaning of such virtuosity, which gives life to miniature, arabesque and text, deserves closer scrutiny. By 'text' we mean a manuscript written in part or in its entirety using colours other than black or brown, these last two being widely used in calligraphy. Naturally, both arabesques and miniatures often serve to frame written passages.

Above. **Maghribi script.** *A marginal motif indicating the end of a Qur'ānic verse (1560).*

Right. **Polychrome maghribi script.** *Extract from the* Dakhira, *a text of the Sharqāwa religious sect (Morocco).*

اللّٰهُمَّ صَلِّ وَسَلِّمْ عَلَى سَيِّدِنَا وَمَوْلَانَا مُحَمَّدٍ
وَعَلَى السَّيِّدِ حَبِيبِكَ

الدُّعَاءِ إِذَا رَأَى إِبْرَاهِيمَ ثُمَّ يَعْشَمُ فِبْرَايِر وَشَأَ مَقَدَّمًا مُتَعَمِّدًا نَوَّالَ مِنْ إِجْمَاعٍ عَلَى أَسْرَارِ الْغُيُوبِ وَمَخْزُونِ السَّمَاءِ قَالَ مُحَمَّدٌ وَاللّٰهِ مَنَازِلُ السَّالِمِ وَالسَّلَامِ وَدَلِيلِ الْغَافِرِ وَالنَّآءِ وَمَلِيحُ مَآثِمِ أَهْلِ الْحِجَابِ وَالْكِبَآءِ

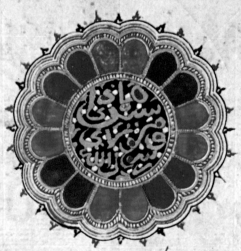

اللّٰهُمَّ صَلِّ وَسَلِّمْ عَلَى سَيِّدِنَا وَمَوْلَانَا مُحَمَّدٍ
وَعَلَى آلِ السَّيِّدِ حَبِيبِكَ

آذَار أَيْ إِبْرَاهِيمَ ثُمَّ يَشُمُّ مَارِس وَشَأَ مَقَدَّمًا مَالِكَ مِنْ أَحَادِيثِ الْمَنْثُورِ وَالْمَسَاجِدِ وَالْمَدَارِسِ قَالَ مُحَمَّدٌ وَالسَّبْجُ كَذَا الْأَرْبَعَ وَالْغَارِسِ فِي تَمِيمَةِ الْغَافِهِ وَالْحَارِسِ وَحِمَايَةِ إِبْنِ أَجْرَى وَالْغَارِسِ وَمُبَرِّدِ ثُمَّ أَنُوشِرْوَانَ وَكِسْرِيْ وَقَارِسِ

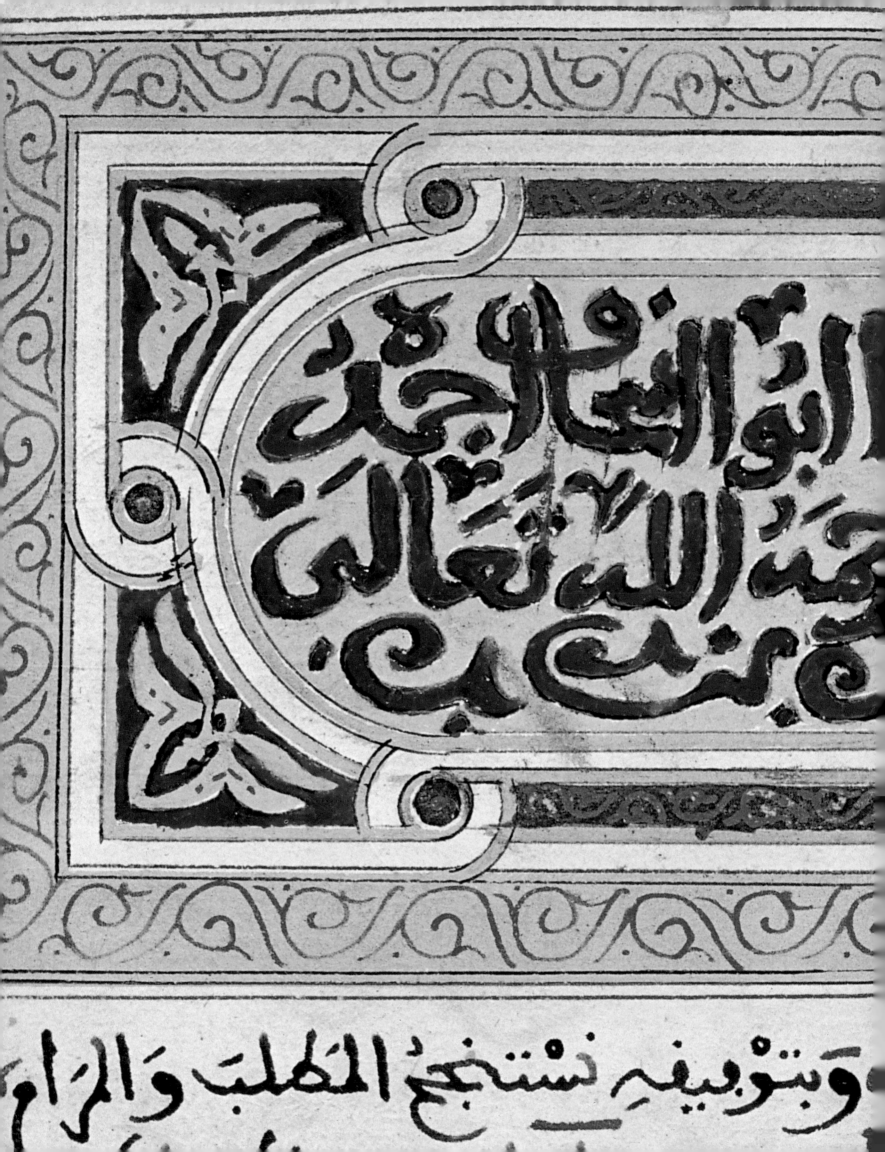

وبتوفيقه نستنجح المطلب والمرام

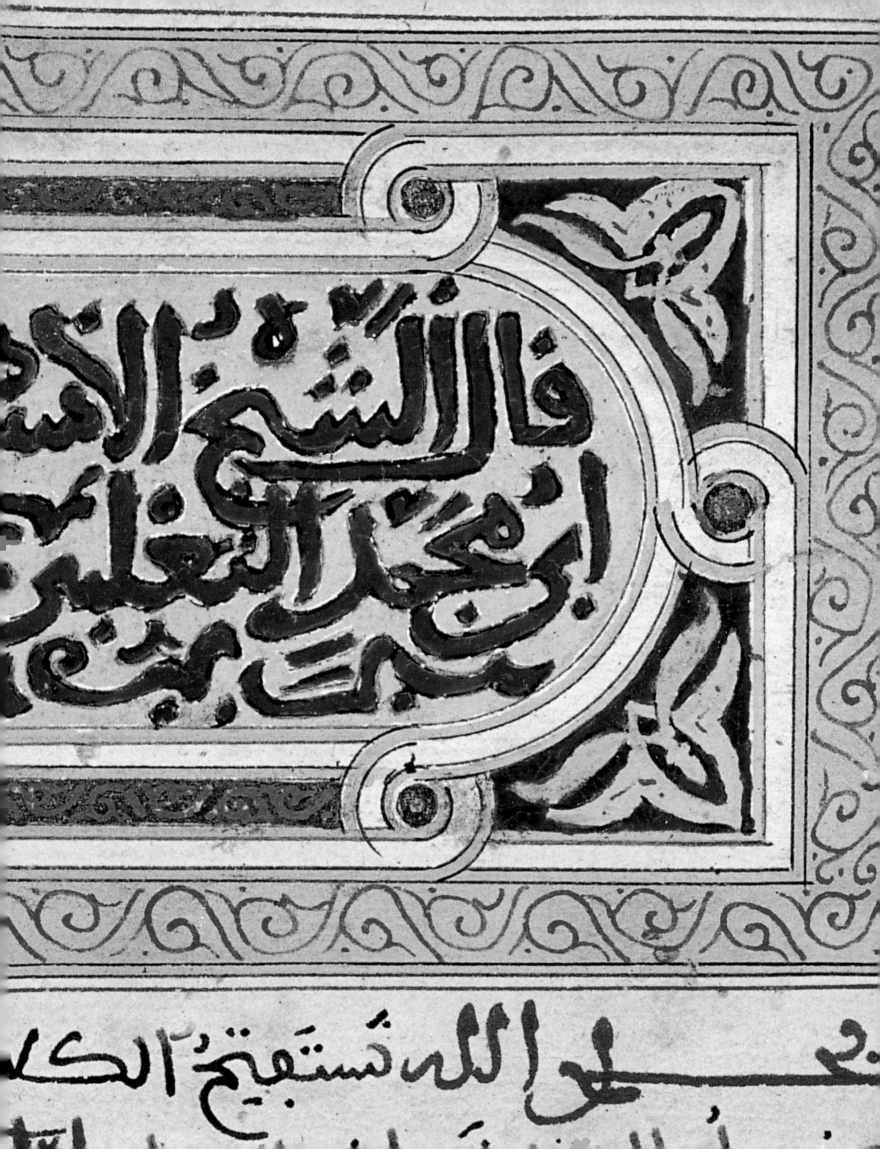

قال الشيخ الأ...
ابن محمد العلو...

...حا الله تستفتح الك...

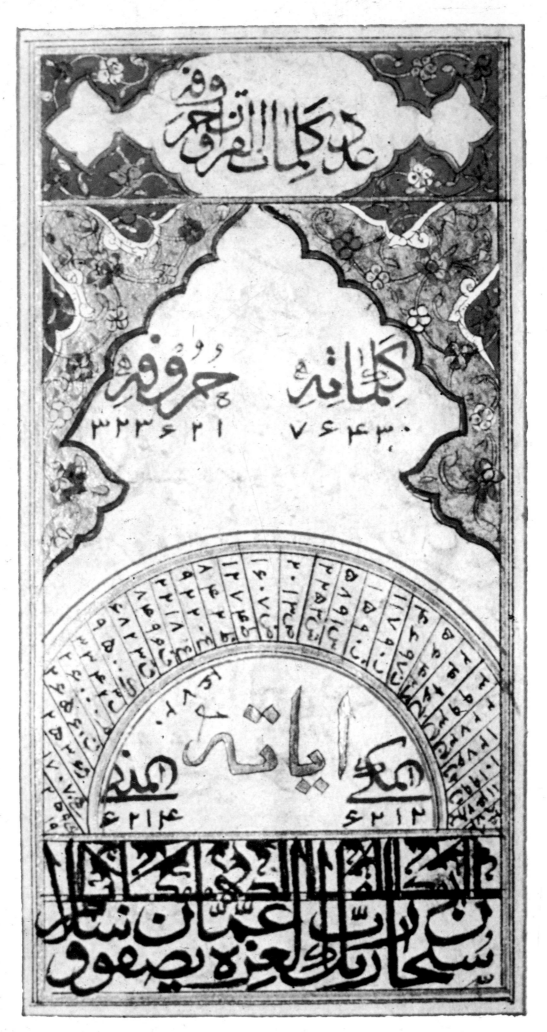

Left. Closing page of a Qur'ān, indicating the number of letters, words and verses contained therein.

Right. **Maghribi script.** *The verses are divided by motifs in gold, while diacriticals and vocalization are highlighted with the use of colour. Qur'ān (1560).*

Preceding pages. Homage to the lineage of the Prophet Muhammad. Al-Qandūsi (1828).

أولم يسيروا في الأرض فينظروا
كيف كان عاقبة الذين من قبلهم كانوا هم
أشد منهم قوة وأثاروا الأرض وعمروها أكثر
مما عمروها وجاءتهم رسلهم بالبينات فما
كان الله ليظلمهم ولكن كانوا أنفسهم
يظلمون ثم كان عاقبة الذين أساءوا السوأى
أن كذبوا بآيات الله وكانوا بها يستهزئون

ولقد أرسلنا موسى بآياتنا وسلطان مبين
الى فرعون وملإيه فقالوا إنه لساحر كذاب
فلما جاءهم بالحق من عندنا قالوا اقتلوا
أبناء الذين آمنوا معه واستحيوا نساءهم
وما كيد الكافرين إلا في ضلال وقال فرعون
ذروني أقتل موسى وليدع ربه إني أخاف أن
يبدل دينكم أو أن يظهر في الأرض الفساد
وقال موسى إني عذت بربي وربكم

Maghribi script.
A medallion.

Right. **Maghribi
script.** *A page
written by al-
Qandūsi. In the
central section the
colours used for
the consonants and
for the vowels and
diacriticals
respectively are
reversed.*

وضع يبلغ عني نزل

عن مشاهدتك محبتك

ودمشق على السنة

والجملك

والشوق الى

بقلب يا عا

لجلال والاكرام

Oriental **naskhi script.** *A Qur'ān copied by Abdul-Salam Hindi (18th century).*

Overleaf. Homage to the lineage of the Prophet Muhammad. Al-Qandūsi (1828).

الام التي سميت
المثبت منها
الأهم
عليه
العادة التي تعا
هو المتقدم

ان تصلي على سيدنا محمد وعلى آله وعج
خلفه ورضا نفسه

وهو بعض النطام
وقد بحث النطام ومثلك الحج طلب
اليه دعا الحجها الحج

ارامو
هو قوله اللهم والصلاة بالجحر الأخرى
المنشأ البهي اعلام

الحمد لله وجار وى عن السر فخر العباس
رقابه عنه م اراد بلاد ابي بوح خو لحط
بلغ اهل الوعاد واقو بارمن سلم
اعطنا بعض لا يسلم الصالحوري الكذ
بنود يما من خط ونفنعام خط
الشيخ نسبر محمربا لحرباء الفروبه
رض الله عنه وهم هذه
نجبرو لحيم رينا النشتور فني ايج بارهل
دستنور بارجال الله يلم اس بارهل
النوبة با عسالس فحضهاتك وجعار
عمار عليه راستجار بح قاطر قازدبه
السماع وابضيع علنام نقاع المطفى

Andalusian maghribi script.
Fragment of a page from the
Qur'ān, copied on coloured
silk.

Left. Detail of a page with
marginal annotations in
cursive maghribi script.

Preceding pages. A freely
flowing text written by al-
Qandūsi (1828) in a style
suggestive of modern
abstract art.

Andalusian maghribi script.
Detail from a Qur'ān copied on coloured silk.

MINIATURE
AND ARABESQUE

Maghribi script. *Title page of a work on culture and literature, with reference to the Hellenistic tradition (detail). Edited by the historian al-Baghdadi, 17th century. Bibliothèque Royale, Rabat.*

In this context the miniature owes its origin and impact to the art of Persia, where it first took form, derived from wall-paintings. It later migrated to countries such as Turkey, Iraq and Syria, but is rather seldom found in the remainder of the Arab world.

What, from our point of view, is the relation between calligraphic texts and page decoration? Those marvellous scenes filled with historical or legendary figures are widely known. The world of animals and of plants, generally covering the whole page, is drawn in minute detail, in contours that are clear, well defined and highly stylized. Sometimes flat washes of colour seem to flood into the compartments drawn by the artist, but usually the palette is dominated by intense colours, intensely sumptuous – gold and silver which emphasize a spiritual glory pervaded by sanctity. Qur'ānic verses, poems, or mystical and magical formulas rest in the depths of expanses of colour, or embellish them to accentuate the contrasts. Multicoloured floral

designs accompany blank spaces and give the work a feeling of completeness and order.

In contrast to the miniature, the arabesque has spread throughout the Muslim world. Originally an architectural feature, it found a privileged place in the written word. The miniaturization of floral and geometric designs, the skilful use of the pen in tracing them, the opportunity to apply colour and, above all, the superlatively creative style of the calligrapher, inspired a transfiguration in Arabic art comparable to the mystical tradition of self-transcendence.

The purely decorative designs of the arabesque are too familiar to require a detailed survey. Let us consider, however, besides the widely distributed geometric and floral decoration, certain areas of detail: the architectural motifs of famous mosques, and particularly the Ka'ba and the tomb of Muhammad in Mecca. These motifs reappear in manuscripts, sometimes traced with outstanding elegance. In these general views, which are usually to be found on the opening pages, the calligrapher provides information of a historic kind. In the body of the manuscript, ribbons of arabesques mark the openings of chapters, while other motifs, in the margin, mark the divisions of the verses of the Qur'ān.

In the arabesque, gold is constantly used. Its marriage – 'the golden ecstasy' – with other colours – silver, blue, green, yellow, white – is a subject for contemplation. The range is established with a richness and a harmonious contrast of tones which shine like the colours of a stained-glass window.

The artist took particular care with the design and colour of the medallions in the margins, which marked the chapters of a text or the subdivisions of the Qur'ān. The inscription set in its frame – *rubu'* = ¼, *thumun* = ⅛ of the *ḥizb* (plural *aḥzab*; the Qur'ān is divided into 60 *aḥzāb*) – are often written in kufic script while the actual text of the manuscript is written in, say, thuluth or maghribi. The colours are uniform, filling the areas marked out by the written line.

Maghribi script, *with improvised ornamentation.*

The chromatic profusion found in the arabesque is very powerful in certain manuscripts – power and delicacy sharing a sublime coexistence. Contrasting touches, the colours of diacritical signs and vowels, words or phrases given special emphasis by the calligrapher, all evoke the divine presence.

Thus the names of Allah or Muhammad, or words referring to them, recur like a leitmotif. They are drawn in green, blue or red ink, or in any other chromatic style likely to seize the attention, as if the calligrapher were inducing a mystical trance in the wink of an eye.

If the graphic composition follows an order imposed by the text, the colour will, as it were, challenge this order so as to draw from the text a fitful harmony. As a general rule, the colours are arranged in accordance with certain conventions – blue, green, red and so on – superimposed on each other and shaped according to the line of the words. This arrangement of black and coloured areas of script provides a dual colour level for the reader's eye to follow: the letters in black furnish the ground of the page, while the diacritical signs, vowels, and coloured words stand out. As the eye shifts from one plane to the other, a sensation of movement is created: the pictorial divide causes the page to move, with unexpected colour combinations and an effect of brilliance. One can sense in it the calligrapher's intention, concentrated in his fingertips, to catch on the point of his pen the unlooked-for moment of his rhythmic essence: unlooked-for, in the sense of its materialization through form on the mundane level.

Naskhi and ta'liq script, *with decoration of angels.*

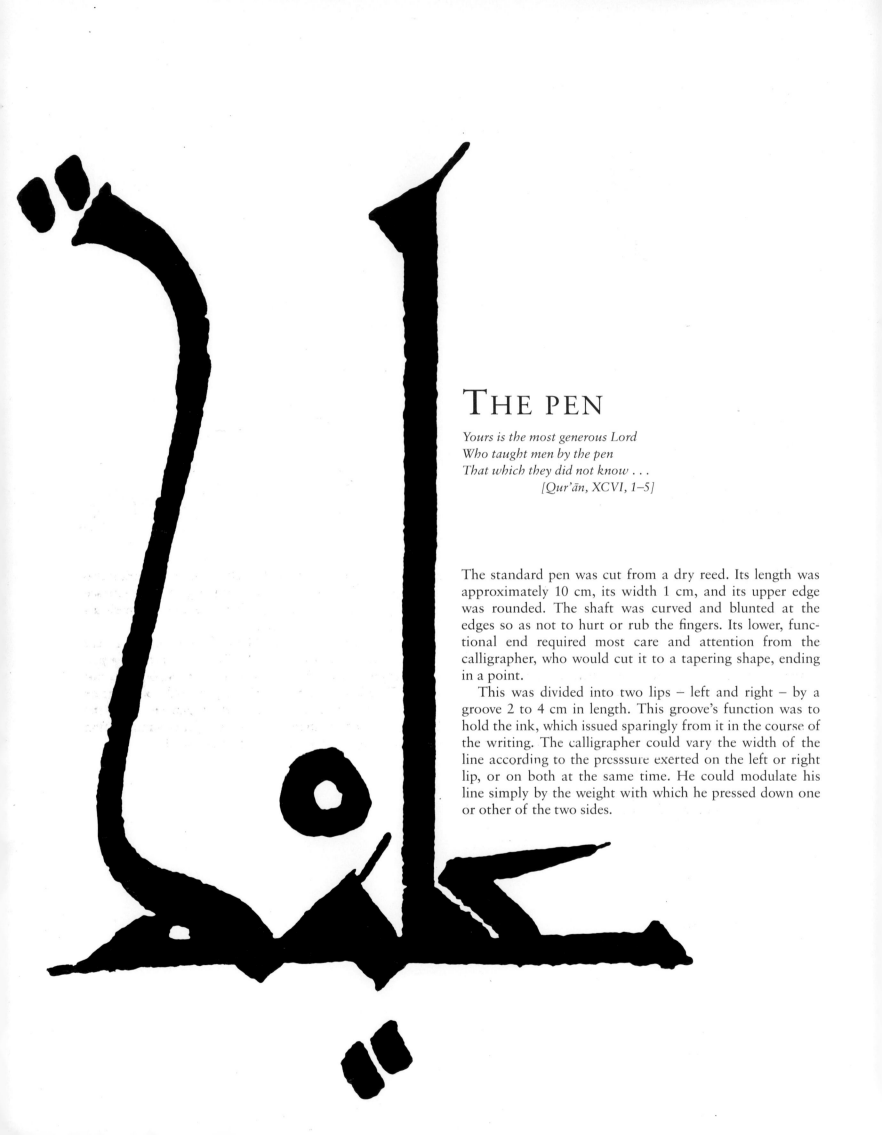

THE PEN

Yours is the most generous Lord
Who taught men by the pen
That which they did not know . . .
[Qur'ān, XCVI, 1–5]

The standard pen was cut from a dry reed. Its length was approximately 10 cm, its width 1 cm, and its upper edge was rounded. The shaft was curved and blunted at the edges so as not to hurt or rub the fingers. Its lower, functional end required most care and attention from the calligrapher, who would cut it to a tapering shape, ending in a point.

This was divided into two lips – left and right – by a groove 2 to 4 cm in length. This groove's function was to hold the ink, which issued sparingly from it in the course of the writing. The calligrapher could vary the width of the line according to the presssure exerted on the left or right lip, or on both at the same time. He could modulate his line simply by the weight with which he pressed down one or other of the two sides.

As already noted, the width of the nib was important in determining the *alif* module. In fact, the width of the dot decided the unit of proportion of the *alif* and, in consequence, that of all the other letters of the alphabet. It was therefore essential for the calligrapher to cut the point with precision and in accordance with the rules of the selected system of script. Thus there were pens suitable for the naskhi script, others for thuluth, and so on. In the application of colour, each required a particular pen. In order to write the *bismillah*, too, a specific pen was needed. This was also true of signatures (*ṭughras*) and of certain words in a text which were to be emphasized.

The point of the pen could be cut either straight or bevelled. The first gave regular lines of a well-proportioned thickness, the second was fine-pointed with up-strokes and down-strokes. The evenness and elegance of the script also depended on the way that the pen was angled to the surface of the paper. Thus the calligrapher, like an artist with his brushes, used a number of pens.

The materials required for the making of the pen were popularly endowed with symbols. To seal a marriage, a pen of red copper was to be used, with the writing on wax, not paper. To celebrate a friendship, a pen made of silver or from a stork's beak was employed. A pen cut from the branch of a pomegranate tree was used for communication with an enemy, as if to counteract an evil spell.

Above. Ḳarmatian kufic: *the letter 'k'.*

Left. Ḳarmatian kufic *(detail).*

SCHOOLS
AND STYLES

TYPOLOGY

KUFIC

Kufic script. *The double letter* lām *(l) and* alif *(a).*

Pages 76–7
Tughra *(signature) of the Ottoman Sultan Mahmūd Khan II (reigned 1808–39).*

How is one to determine the precise number of different calligraphic styles and definitive models? The compilations of historiography provide a mass of information, but little qualitative elaboration. Muslim historiography is basically genealogical in its approach to classification. These historians and chroniclers display in daunting detail the genealogy of the calligraphers for every style, providing a mass of information, though without any synthesis. No doubt there still exists innumerable treatises on calligraphy, but they constitute the backing for an orally transmitted teaching, and this reduces their actual scope. Some styles have changed their names or have merged with others no longer in existence. From one country to another, from one epoch to another, typologies and nomenclatures undergo transformations which baffle the contemporary researcher. So let us try to establish a major typology, based on seven styles, and reveal a noteworthy continuity. These are: kufic, thuluth, naskhi, Andalusian maghribi, riq'a, diwāni, ta'liq (or fārisi). There is no doubt that they possess cultural

coherence and have an extremely widespread geographical distribution.

We have several times pointed out that, from the beginning of Islam, *kufic* was the dominant priestly script, and was certainly reproduced according to a craftsman's procedure. The early texts do not record any code for its transcription, in spite of its importance and the variety of its regional forms.

Archaic kufic was particularly difficult to decipher since it lacked a vowel system, and tended not to give the various letters systematically differentiated forms.

Kufic and naskhi influenced each other. Thus, in the middle of the fourth/tenth century a slanting version of kufic appeared, but prior to that date all the manuscripts of the Qur'ān were written in old kufic.

It is an irrepressible style, lending itself to the most testing transformations. Its magnificent geometrical construction, based on angular elements, could be adapted to any space and to any material, from a simple silk square to

اب ت ج د ر ز ز س ش ص ط

ع ف ف ق ک ک ک ل

م ن و هه ی ے

ديوان الخط العربي

TA'LIQ *(with enlarged detail above)*

the Imperial Seal. First is the famous *diwāni* – a Persian term from which two very different words in modern use are derived: divan and douane (custom-house). The diwāni style made its appearance after 857/1453 and was codified at that period by Ibrahim Munīf. It was above all the style of the executive department and its official power. It is distinguished by a lively cursive flow accentuated by an oblique point of balance (from top to bottom and right to left), but slightly looser to the right at the ends of words and phrases. This style blends into an important ornamented variant, *jilli diwāni*, in use from the tenth/seventeenth century. This writing is smaller and more compact, and the intervals between letters is systematically filled by decorative details and strong flourishes.

Riq'a is the other great Turkish script, the use of which expanded as Ottoman dominance grew, with the earliest known examples dating from 886/1481. A stout, thick script, it is arranged, apart from the vertical lines, entirely along a lightly marked horizontal line from which the up-

strokes rise stiffly. It is also characterized by rounded hooks at the level of the tail and/or the head of the letter. The time required to read this script is therefore greater.

Sayaqit script has existed since the time of the Turkoman Seljuqs of Asia Minor. It has reference more to cryptography, and was designed to be read by officials of the same department, communicating top-secret political information; it therefore combined complexity of line with a secret code of meanings and ciphers.

The *tughra* script was of the same type, and was used in the signatures of political potentates. Theoretically, it was supposed to be impossible to imitate. It was probably of Tartar origin, and the name itself was kept a secret. This style made its official appearance after the capture of Constantinople by the Ottoman Sultan Muhammad al-Fātih (857/1453).

Persian script superimposed itself on the Arabic language with all the delicacy of choreography. *Pahlavi* is associated with a different linguistic system, and it was

ANDALUSIAN MAGHRIBI

SHEFIH

SHIKESTÉ

BEDR EL KEMAL

necesssary to adapt it by adding, for example, diacritical signs to certain letters in order to complete the Persian alphabet (such as پ for *p*). *Ta'liq* is the brilliant result of this adaptation, particularly powerful in the *shikesté* (broken) style, which is distinguished by an absence of diacritical signs and an interplay of conjoined ligatures.

There are two kinds of shikesté script: in one the characters are very close together, interlaced, while in the other they are widely spaced and individualized. In the *shefih* script, which is derived from ta'liq, the letters interlock in a kind of lovers' embrace.

Ta'liq is less demanding: it glides over the breaks with a winged grace. The same letter may display a thicker or a thinner line, and some terminal letters are greatly extended. It also tends to go up and down and from right to left without returning to the right.

Riḥani, a variant of naskhi, is characterizcd by a line in which the letters start with a thick stroke and taper to a thin point at the end. The script follows a horizontal course which may not be broken by strokes below the line, except for the letter *j*.

Finally, we should mention some particular scripts of either a highly eccentric nature or else used for secret and subtle communication: *ghobar*, for instance, is a very delicate script requiring the help of a magnifying glass for decipherment. It was used in messages sent by carrier pigeon. *Manashir* was used for sending letters of reprimand or satisfaction; in this case tails were added to the characters. *Ḥurūf tāj*, as its name implies (*tāj* = crown), was written in the form of a crown. *Ḥilali* used one or several crescent-shaped strokes. This name alone refers to the natural

TAŪS

RIHANI

HILALI

SHAKY SCRIPT

symbolism in Islamic scripts. But perhaps the most moving style is in some ways the *'shaky' script*, which was formed by tracing the characters of any script in saw-tooth fashion. Here, one can still discern the essence of the Arabic language retained within the ragged borders of its departed elegance.

A multitude of schools and styles developed in the course of the history of calligraphy. In each country there emerged and grew – or sometimes soon disappeared – a particular way of writing. The material upon which the calligraphy was inscribed also contributed to an original and fresh rendering of certain letters, so that a given style may be found on, say, wood rather than on ceramic, stone or parchment. It was also considered proper to use the style of calligraphy appropriate to the subject in hand – Qur'āns, poems, official documents, love letters, etc.

To make a definitive list of all the different styles would seem impossible. We have therefore restricted ourselves to a selection which is representative, though incomplete by reason of the obstacles in the way of achieving it. The object of this list is therefore to provide examples of the richness and variety of styles rather than an exhaustive inventory of them.

MOU INÉ

MANĀSHIR

MUHAQQAQ

TUGHRA

The word 'sura' (chapter) by al-Qandūsi (19th century).

اب ت ج ث ج ح خ د ر ز ر
س ش ض ط ظ ع ف ق
ك ك ل م ر ن و
هه ه لا ى ي

ديوان الخط العربي

ديوان الخط العربي

THULUTH

Sumbuli script. *Various monogram letters.*

MEANING
AND THE
WRITTEN WORD

The sovereignty of Divine Glory has shone forth.
Thus the pen survives, but the writer has
vanished.

[S.M.H. Gīsūdarāz
(15th-century Indian Sufi)]

What is the relation between language and calligraphy? The art of calligraphy is in no sense simple decoration; its germination is encoded and takes form in the singular structure of a language. it is this singularity, constantly under review here, which governs the force, rhythm and chromatic design of the script. Calligraphy relates to the total organization of language and writing in the form of *image*. In Islam, it glorifies the unseen face of Allah. We will consider later the consequences of this and the mirror games relating to the Name of God and, in general terms, the Sufic symbolism associated with the concepts of *ẓāhir* (manifest) and *bāṭin* (hidden).

The consonantal frame is set along a horizontal line, on each side of which come and go – in chromatic and musical interplay – the vowel triangle, the diacritical signs, and the other special signs. This establishes a mode at many different levels, departing from, but connected to, a firm rhythm. According to L. Massignon, who was much struck by this division, the consonantal line (the 'literal skeleton' and the 'corpse') contrasts with the vowels (the 'life-giving soul' or the 'spirit of life and voice'). Such a hypothesis takes us straight back to the ancient metaphysical ideas of form and substance, or matter and spirit. It is interesting to note that classical Arab philology, which is closely connected to theology, supports such an opposition, calling the consonants

ṣawāmit (mute letters) and the vowels *ḥarakāt* (symbols of movement). Moreover, Massignon puts his explanation in the form of a general principle: 'The triple vowel', he writes, 'is the basis of Arabic grammar, the *I'rāb*, and it is the basis of Semitic musical theory.'[1] In this sense orientalists interpret Islam according to Greek metaphysics, reconciled here with the monotheism of Abraham, in Massignon's enthusiastic synthesis.

Nonetheless, an examination of Arabic script must take into account the totality of verbal signs (vowels, consonants, diacritical signs, etc.) and the point which emerges – apart from this contrast – is the generative or creative movement of phonemes and script in their separate development, a development not reducible to the domination of the vowel. The point of it is the imagery of the written sign, any script being, within its limits, part of the province of poetry.[2]

Let us consider a simple example (see the illustration opposite). How is this square kufic calligraphy to be read? The reader will immediately note the sign ﻻ, on the right, which introduces the *shahada*, one of the key phrases in Muslim belief: 'There is no God but Allah, and Muhammad is His Prophet.'

Recognizing this statement, the reader will next try to discover the arrangement of the letters. This is a work of

recognition which, to be done properly, requires the deciphering of a number of rhetorical figures such as inversion, reversal of characters, and their rearrangement. Reading is thus not a matter of following a single line of text, for here it can in fact be recognized by any permutation of its letters.

Antecedent to the calligraphic line, the expression of a sentence from some other source (here the Qur'ān) requires to be *spelled*, to be re-articulated according to calligraphic requirements. This makes it irreconcilably different from the process of linear reading: the text is presented first, then gradually withdrawn, like musical variations on a theme. The effect of calligraphy is to disturb the course of the text. It emanates from language and returns to it, coming and going, as it were, at one remove from it. The mind takes pleasure in this paradoxical approach to the written line: in this calligraphic is rendering one reads only what one *already knows*. But perhaps this is the principle behind all imaginative language in its written form, such that the meaning is a sort of optical illusion, skimming across a celestial prism. Calligraphy alters the lighting effects, so to speak, removing preconceptions and reiterations from the linguistic base, and highlighting its tremulous symbolism. This is what the calligraphic line brings out for us, like an echo without an ultimate destiny.

Rectangular kufic script *(Samarqand): 'There is no God but God'.*

Left. Calligraphic exercises in various scripts (after M.B. Yazir; see bibliography).

DIACRITICAL SIGNS

We must now define the position of diacritical signs and vowel accents, a subject of particular fascination in Arabic writing and one which, in the wider sense, points up, marks and punctuates Arab thought. Here our purpose is simply to summarize the variations and the points of impact and of delight.

It is a strange fact that the Arabic language did not achieve its *scriptio plena* until the middle of the third/ninth century. The official reform began in the reign of the Caliph Abdelmalek (685/705), who made Arabic the official language. History has recorded the resistance of purists, who were averse to any interference with the language of Allah. The debate was stormy, but major political considerations carried the day. The establishment of a united empire required the formation of a class of scribes using a carefully executed and legible script. For how could an empire be administered without written documents in a generally understood script?

At first the Arabs used the vernacular languages of conquered nations, in view of the necessities of state, but this was only a temporary expedient. Ultimately they wanted to unite their empire through Islam and the universal use of Arabic. In the intellectual field this intention took form through philology and other linguistic disciplines. First of all, an authorized version of the Qur'ān was needed. The system of diacritical signs and vowel marks is usually attributed to the well-known lexicographer from Basra, al-Khalil ibn Ahmed (d. 170/786).

According to the most 'probable' hypothesis, the Arabs adopted their alphabet from the Syriac, adding diacritical signs to certain letters in order to differentiate them. This theory is supported by evidence from coins and papyri, dating from the first century of the Hegira. In Qur'āns written in kufic script, these marks took the form of oblique strokes.

One point of confusion, the accenting of ف (f) and ق (q), has never been resolved. The earliest punctuation consisted of a dot over the 'q', while the 'f' had no mark. This was the most economical form, but the diacritical system has its own development. Later the 'q' gained a second dot above it, and the 'f' a dot below, as is still used in the Mahgreb, but it tends to disappear or to co-exist with the last modification, which has remained constant: 'q' retains the two dots above and 'f' the one. The reform dates from the second century of the Hegira.

The gradualness of the reforms was due to political considerations (the need to compromise with local languages in conquered lands), and to a tendency in Arabic towards a *general diacritical system*. In the reign of Abdelmalek the vowel 'a' was shown by a dot above the letter, the vowel 'u' by a dot inside, and 'i' by a dot below the line. Nunnation was indicated by double dots. To avoid confusion between dots marking vowels and those marking consonants, a system of colours was used, especially in Qur'āns. The diacritical signs were written in black, and vowel accents were shown in red, yellow or sometimes, though rarely, in green.

The introduction of complementary signs and the transformation of vowel signs into the now established vowel triangle were the final stages. The remarkable fact about this reform is that it established from the outset a relationship between writing and phonetics. For example, the sign ء (hamza) is a ع ('ayn) without its tail; similarly, the sign ش (shadda) is a constituent of س, likewise without its tail. Alterations in the written form were made by taking the terminations from (phonetic) speech.

The system is not only a matter of vowels and diacritical signs; it is also a matter of phraseology: thus, the ends of verses were indicated by strokes, or by letters such as ه, or by small circles with or without a dot in the middle. Finally,

an entire decorative system of floral and vegetal motifs constituted the divisions, within the Qur'ānic text, between verses or chapters (Suras), together with the enumeration inscribed in the margin.

In addition to consonants (with or without diacritical signs) and the complicated interplay of arabesques, to which we will return, let us now consider, first, the vowel triangle; secondly, the complementary signs (inflection, lengthening, nunnation); thirdly, the decorative signs invented by calligraphers which, belonging as they did to an uncodified system, were originally displayed in the style of each artist. They included letters in miniature, either consonants or long vowels, which may or may not have been repeated in the letters of the text; and also, occasionally, whole words appeared in miniature, repeating or extending the text.

In fact, these techniques represent a whole, meticulous system of expression, employing the full range of written signs, and combining them according to the style of the artist. In some examples, the diacritical signs disappear completely or become lines indicating, as we have seen, short vowels. In another example (pp. 50, 51), the dot acting as module goes beyond its geometric function and itself becomes a massive partition.

Furthermore, the situation becomes highly complicated in the Persian script known as *shikesté*, which does without all vowel and diacritical signs by extending the consonantal line obliquely from top to bottom. The outline can be developed and folded in various directions, so that in practice it seems actually to encroach on the principles of painting and calligraphy. We will return to this subject in the final chapter.

وما كان الله ليعذبهم وأنت فيهم وما كان
الله معذبهم وهم يستغفرون وما
لهم ألا يعذبهم الله وهم يصدون
عن المسجد الحرام وما كانوا
أولياءه إن أولياؤه إلا المتقون
ولكن أكثرهم لا يعلمون وما
كان صلاتهم عند البيت إلا مكاء
وتصدية فذوقوا العذاب بما

النَّاسِ عَفْوًا وَالمَهْدِيُّ مُحَمَّدُ بْنُ عَبْدِ اللَّهِ

الَّذِي بَيَّنَ بَيْنَنَا لَمْ يَسْتَنَّهَا خَلِيفَةٌ قَبْلَهُ

وَعَجَبِي عَطَايَا لَمْ يُعْطِ بَعْضَهَا حَجَّ

وَرَدَّ المَظَالِمَ وَقَسَّمَ فِي أَهْلِ

الأَمْصَارِ فِي شِرَائِهِمْ وَصِلَابِهِمْ

وَعَجَبِي أَهْلَ الحَاجَةِ وَفَرَضَ لِلْمُجْرِمِينَ

وَالمَنْبُوذِينَ وَلَعَمْرِي فَرَضَ لَهُمْ حَجَّ

قَبْلَهُ وَالهَادِي وَالرَّشِيدُ

كَأَنْ أَذْخَرَ النَّاسَ فِي الإِجَاجِ وَالحَجِّ

وَعَجَبِي النَّاسِ نَفَقَةً فِيهِمَا جَامَعَ نَفْسِيَل

بِنَفْسِهِ وَأَنْفَقَ مَا لَمْ يُكْتَبْ بِهِ نَفْسٌ

أَجِجْ قَبْلَهُ وَلَمْ يَزَلْ خَلِيفَةٌ مُنْذُ كَأَنْ

الإِسْلَامِ مِثْلُ وَلَايَتِهِ وَلِي أَكْثَرُ

KUFIC AND NASKHI

As documents dating from the beginning of Islam have confirmed, the origin of calligraphy must have been two-fold: an angular, geometric script of a hieratic and monumental nature, used originally to transcribe the Qur'ān or texts of great religious or literary value; and a rounded cursive script employed by scribes for everyday documents.

It now became customary to designate the early script as 'kufic' the cursive type as 'naskhi'. However, the two classifications have led to contradictory results and explanations; by this we mean that they have not been thought out, or, if they have, then it is according to a principle, already discussed, which is based on the premise that the whole history of Arabic writing relates to an original, lost prototype. But we should keep in mind the hypothesis of a dual origin, for this is all-important in our thesis. Methodologically, the route is labyrinthine since, in order to define the scripts, the Arab chroniclers and scholars used varied and differing registers: a nomenclature referring to the inventors of calligraphic styles, as for example in the case of riḥāni, yāgūt; a geometric or arithmetical typology (e.g. thuluth); a regional toponymy (e.g. kufic, andalusi).

The chroniclers combined these registers together, so making an interpretation of their texts extremely difficult, particularly since these works frequently do not include any useful graphic indications. Orientalist epigraphy often goes astray here.

Arab historiography and orientalist epigraphy must be briefly examined in relation to each other in order to corroborate certain facts, but we should ignore the confused explanations which proliferate in the works of most of the chroniclers. It was this atomistic erudition that partly provided the Argentinian writer Borges with his metaphysical vision of the Secret Book – that which is absolutely undiscoverable. The Arabs usually distinguish four types of pre-Islamic script: *al-ḥiri* (from Hira), *al-anbāri* (from Anbār),

al-maqqi (from Mecca) and *al-madani* (from Medina). The famous author of *Fihrist*, Ibn Nadim (died *c.* 390/999) was the first to use the word 'kufic', deriving it from the *ḥiri* script. However, kufic script cannot have originated in Kufa, since that city was founded in 17/638, and the kufic script is known to have existed before that date, but this great intellectual centre did enable calligraphy to be developed and perfected aesthetically from the pre-Islamic scripts.

A later author, Ibn Khaldūn, agrees with this hypothesis, stressing the change of calligraphic styles: 'When . . . the Arabs founded their empire, they conquered towns and provinces. They settled at Basra and Kufa and their government had need of handwriting. Thus they began to learn it, and it came into current practice, developing rapidly till it reached, at Basra and Kufa, a high degree of accuracy, though it was not yet perfected. And today kufic script is well known. Afterwards, Arab conquests and expansion covered Ifriqiyya and Spain. The Abbasids founded Baghdad, where calligraphy was perfected as a result of the development of the civilization in that city, the capital of Islam and centre of the Arab dynasty. The script of Baghdad differs from kufic in the way that the letters are fully formed, and presented in an elegant and distinguished style. The difference increased under the Vezir (Abu) Ali ibn Muqla and his secretary, Ali ibn Hilāl, called Ibn al-Bawwāb. But the tradition of the calligraphy of Baghdad and Kufa disappeared with him after the tenth century. The principles and characters of the one differed to such an extent from the other that there was, as it were, an abyss between them.'[3]

Other Arab sources claim that the word 'naskhi' was invented by Ibn Muqla, but the point is that, following on this cursive style, the great calligrapher established a geometric codification which was to inspire subsequent schools (after the tenth century), and that he established it according to Euclidean theory, with which he was certainly famil-

iar – but at second hand, so to speak. We use the phrase by no means in its figurative sense alone, for his right hand was in truth cut off. In a celebration of Arabic calligraphy it is only proper to make reference to the tragic fate of that hand.

Orientalists have deduced some of their postulates from these sources, and allowed their own intuitions, together with epigraphical researches, based on the scientific rationalism of the eighteenth century, to be their guide. According to them, it has been confirmed that the two scripts (angular and cursive) co-existed both before and after the coming of Islam. So be it. How can this original duality be explained? B. Moritz[4] has provided a simple answer: it was due to the difference between the materials used, in the sense that kufic (angular) is a hieratical and monumental script suitable for inscriptions on masonry or coins, whereas naskhi (cursive) is better adapted for use on parchment. But this proposition will not bear close scrutiny, for the history of calligraphy has clearly demonstrated that it is the materials which are adapted to the driving impulse of calligraphy, and not the reverse. The solid mass of stone yields to the controlling action of man, by virtue of the power of his will that extracts from the rock its latent quality. Under the hand of man, nature reveals the completeness of its inner potential.

The written word inscribes the estranged, ephemeral symbolism of the separated being, whose double nature Arabic calligraphy expresses. It would be rash to say that materials used neither retain their form nor influence its expression, but they certainly cannot turn aside the extractive, expressive impulse.

In any event, Moritz's explanation is proved wrong in historic and epigraphic fact. Theoretically, it reduces the distinction between scripts to one of technique, a view that would justify a vision of cultural archaism. Such a distinction is certainly something to be considered, given the

complicated series of factors: phonetic, geometric, semantic, metaphysical, etc. Technique presumably operates in relation to all these aspects.

In short, this idea of technique is an element in the orientalist theory which again brings up the original duality of Arabic writing by the antithesis of sacred and profane: the contrast of religious morality secularized in the rationalism of epigraphy. J. Sourdel-Thomine[5] attempted to rephrase the issue of duality by suggesting that there was initially a fundamental unity in Arabic writing, and that duality in fact occurred only later. But this writer merely covers up the orientalist theory, which ultimately finds its metaphysical ground, as well it might, in the fall of the early empires.

It is the view of ourselves and others that writing, calligraphic or not, is dual, and always dual in all its instances. There is no point in reiterating the irretrievable nature of the split, evidence of which can be seen on the page, for all time. Naskhi and kufic scripts are used to express the same theme in the context of Islam.

According to this proposition, we can state that *the two scripts evolved in parallel*. And through the codification of the *khaṭ al-mansūb* (proportioned writing), Ibn Muqla reformed Arabic calligraphy from naskhi and not from kufic. The predominance of the former never led to the elimination of the latter. The remarkable continuity of their co-existence is rooted in the culture of Islam, in its different manifestations.

A Moroccan manuscript. Exegesis of the Qur'ān by al-Thalabi Abu Ishaq Ahmed b. Muhammad. In this detail of a chapter opening the lettering is framed in yellow to provide added contrast and improve the legibility of the text. 19th century.

Ibn Muqla

(272/886–328/940)

The haunting memory of the thrice-buried body of Ibn Muqla remains with us. What can one say about the fate of this calligrapher, whose severed hand still affects and influences the world of Muslim art?

Not one manuscript page written by him appears to have survived, though certain texts, which are in fact skilful forgeries, were formerly attributed to him in an attempt to cash in on his fame. It was the custom of the times; even the great Jāhiz confessed to having signed some of his books with famous names in order to get his own work read as it were by proxy. The marvellous image has disappeared, to be propagated today according to a genealogy carefully established and fiercely guarded, not least by devoted humanists of every breed.

Many poems and tributes bear witness to and celebrate the talent of Ibn Muqla. Abdullah ibn al-Zariji wrote in the tenth century: 'Ibn Muqla is a prophet in the art of calligraphy. His gift is comparable to the inspiration of bees as they build their cells.' According to the Arabs, Ibn Muqla was without any doubt the man who codified calligraphy, using the circle as the module for each of the characters, according to a measured proportion. This technique, already described in detail, makes use of the dot as the standard unit to establish the basic code, starting with the first letter of the alphabet.

In his *Epistle*,[6] Ibn Muqla defines the general principles of this discipline: round off the shape of the characters; observe the laws of proportion; clearly distinguish the geo-

There are no extant samples of the calligraphy of Ibn Muqla. This sample comes from the hand of Ibn al-Bawwāb, a pupil of Ibn Muqla. These two men are regarded as the 'fathers' of Arabic calligraphy. They laid down the rules which are still in use today.

Left. Extract from a Qur'ān dated 391 of the Hegira (AD 1000–1), with enlarged detail opposite.

metric forms according to their movement, horizontal, vertical, oblique and curved; observe carefully the thickness and thinness of the line; keep the hand steady but relaxed when handling the pen, so that the line shows no sign of wavering. These principles were to give harmonious form to the art of calligraphy.

Together with the theory, as it has come down to us, there is evidence of his very intense political life, the repercussions of which led to the severance of his hand. This hand secretly wrote, as it were, an invisible secular manuscript, perhaps the reason for Ibn Muqla's father describing him as 'son of the white of the eye', or 'of the pupil'. Once again we are met with silence, for not a single text of his is extant for us to admire. Mallarmé wrote – 'As there is no escape, once having entered the domain of art, under whichever sky it chooses to settle, from the ineluctable Myth; so may it be better to start with this knowledge and make use of the treasure-house, whether for document or pure divination', or dream, or fleeting fantasy. . . .

Ideologically a Sunni, the calligrapher-Vezir, like many Chinese or Arab princes, led a very unsettled life during the Abbasid era. His mortal battles with authority are renowned, in particular with the Caliph Rādi billāh and his rival the Vezir Rā'iq. Ibn Muqla plotted against the Caliph, to whom Rā'iq showed his confidential letters. As a result, Ibn Muqla's right hand was struck off. But, invincible, he took up his pen in his left hand and continued to write. With the Caliph's authority, Rā'iq had his tongue cut out.

The Arabs say, 'The pen is one of the two tongues'. In all senses of the word.

Finally, Ibn Muqla was sentenced to life imprisonment and died in jail, his corpse being moved twice thereafter. It is also said – according to legend – that his generosity was inexhaustible and his art was Paradisal. Let us imagine, then, a sumptuous garden, drawn by an infallible hand; plants so rare that they summon to the page every kind of arabesque; not forgetting the song birds and the miraculous fountains. Let us linger here and meditate on the calligraphy, recalling that the Vezir particularly loved the grace and delicacy of birds, hanging silken threads in his garden to serve as nests.

Imagine this entire scene and be a guest at the house of Emblematic Death. Ibn al-Bawwāb ('the janitor's son') will close the garden by another gate, taking up the work left by that severed hand.

From left to right.
Shikesté script. *A poem by Hāfiz copied by Mahmūd Khan Saba (1812–93), Iran.*

Shikesté script. *A poem transcribed by Muhammad Bāgher Ghertas, Iran (19th century).*

Shikesté script. *An example dating from the early 20th century.*

Below.
Diwāni script *by Iraq's best-known contemporary calligrapher, Hāqim Muhammad al-Khattāb (1919–70).*

Pages 102–3
Shikesté script. *A poem written in 1883 transcribed by Mahmūd Khan, Iran.*

Above. **Ta'liq script.**
A lion calligram by Shah Mahmūd Nisabūri (16th century).

Left. **Anthropomorphic script**
used as decoration on a copper object, attributed to a Persian workshop.

Far left. **Late Ta'liq script.**
A poem probably transcribed by the Iranian calligrapher Abdullah Farādi, late 19th-early 20th century.

Preceding pages.
A diagonal composition in **ta'liq script.**

بسم الله الرحمن الرحيم

Ta'liq. *A page by Shah Mahmūd Nisabūri (16th century).*

Left. **Ta'liq script.**
An Ottoman manuscript.

Jilli diwāni, *a larger version of* *diwāni. Composition by* *Muhammad 'izzat al-Karkūki.*

Right. A firman tughra of the *Ottoman Sultan Süleyman II* *(reigned 1687–91).*

Right. **Maghribi script.** *Title page of the Dalīl al-Khayrat (Prayer Book).*

Left. **Thuluth** *composition executed in boustrophedon style, changing direction in successive lines.*

IBN AL-BAWWĀB

(Abu l' Ḥasan ʿAli B. Hilāl, d. 413/1022)

Opposite. A bismillah by Ibn al-Bawwāb, with enlarged detail above.

The work of Ibn Muqla has passed beyond our reach following his death, the mysterious nature of which is discernible only in the traces of legend. Thus we must turn our attention to his disciples, in particular to Ibn al-Bawwāb, who made a definitive impact on Arab calligraphy and whose script is still in use today.

Ibn al-Bawwāb was by profession a calligrapher and illuminator in the Buwayid period. Known for his Qurʾān (399/1000–1), as well as for apocryphal texts, he is said – according to Arab sources – to have invented the riḥani and muḥaqqaq scripts. He made sixty-four manuscript copies of the Qurʾān in his own hand, and was also able to imitate to perfection the writing of Ibn Muqla.

In 1955, D.S. Rice published Ibn al-Bawwāb's single surviving manuscript, together with a well-documented and detailed analysis.[7] While paying due respect to this work, its limitations should also be noted. At the outset, Rice reduces

calligraphy to a geometric description and to a formalist value, even as he reviews its incomparable beauty – an approach consistent with the pictorial aesthetic of the nineteenth century; in reality, however, calligraphy is rooted in a sacred text, a celebration of the divine. This is not the place to survey in detail the relationship between calligraphy and its many points of reference in theology, politics, etc. What we should mention is the power of the sacred text in its chanted form, as recited in the incantation. By marking the vowels throughout the text, Ibn al-Bawwāb was enunciating this chant. The *bismillah* (*above*) is the principal formula introducing each Sura. The script builds up along a cursive line, accentuated by the use of oblique accents for diacritical signs and vowels. This asymmetry is pointed up by the slight inclination of the letters to the right and the elongation of the semicircles. The line is positive, necessary for instant legibility, delicately mod-

ulated by thin curves and flourishes flowing over the entire page; a disciplined excess and a golden serenity. The whole is written in gold with arabesques in the margin and in the midst of the text. There is surely an analogy with Arab music, but here it follows a literal inspiration, and not a simple correspondence between musical rhythm and graphic movement, so that the 'music' emerges through the interstices of the text.

These observations apart, Rice's study does make a useful contribution, and the annotated Qur'ān (M5.K16 in the Chester Beatty collection) constitutes a fundamental corpus for the study of calligraphy. Ibn al-Bawwāb uses a cursive naskhi script which is precise and regular, following the principles of the theory of proportion. But does such a regular script come from the bored impulse of a scribe obliged to earn his living, or from the extreme sobriety of repressed desire?

As Rice points out,[8] Ibn al-Bawwāb organizes his use of scripts according to the divisions of the Qur'ān: naskhi, in black (consonants, vowels and diacritical signs), serves as the principal script for the body of the text, while decorative scripts in colours emphasize the headings together with palmettes in the margin, and all kinds of chromatic variation punctuating the text.

The punctuation in its formal sense is marked by three dots in a triangle between every two verses. Every fifth verse is marked by a golden *khamisa* (a final *ha*, whose numerical value is five), every tenth verse by an *'achira*, a medallion in kufic script indicating the appropriate multiple of ten – *ya* for ten, *kaf* for twenty, and so on.

This division of the line has been modified. Nowadays, the verses are numbered one by one and not in groups of five and ten. In modern times, too, the Qur'ān has been divided into 60 *ahzab* which are themselves subdivided.

What is equally remarkable in the manuscript of Ibn al-Bawwāb is the absence of any recitation marks, which are a customary feature of contemporary Qur'āns, and indicate with a small *sah* (silence) the moment for the pause. And each school naturally expresses the pauses according to its particular style.

Among the later disciples of Ibn al-Bawwāb was the celebrated Yaqūt al-Musta'simi (d. 698/1298), who was the calligrapher of the last Abbasid Caliph. He gave the thuluth script its prominence and excelled in the other styles, but he could not match Ibn al-Bawwāb. He cut his reed obliquely, to introduce a line expressing finesse with slender upstrokes. In this book he is not accorded the importance which he generally commands, for Ibn al-Bawwāb is undeniably the source of his inspiration.

شِيمَ السَّماءُ ولاح وأعجاره مسه العِقر ومده المملوك

مثل المملوك بريحَبَ حتَّى إنَّه حوب المبطوط فمله النَّبرِ ما

يقول أنا راكِ ضَرَ والظَّمَأَ اكلعُنَى وأذوبه رَغبَةً وأكلَّ

ومِن كَأنَبُرا كَبِرُوا أَللّهِ بِالمُشَرِّح الراكِ وَلعلّ مُوسِها

علىُ الراكِ قالوا الخضَمَ من راعَ ضَرَ ما بن أنَّ بمعاياها وَنغلبه

معُّمَرَ عَنهَا والنعبُ موُصُّوه بِنثَّرَما الأكل ودوايم ومن اكل

من اكمنشرا ابرا كه اكلِ ميَر البرزدورَ وقِيل لا عَيلَيه لبدَ الزواب

اكلُ فَلا بُرزَدَوَه رَعُوبٌ فإذا كأنتَ المرّعَدونه اكلِ الدواب بعلَ

حسابُ نَّذ اف بنِيرا كلها إذا أرضعيّف وبعلا أنَّه بُوحَمِيج اكل المراه

مزمغُروه إنَّ النَّبلَ كَانَ أكثُر من عزا الرجلَ وكسَّايه هكزا

يغكونَهو أكثُر النِّساء ومن نَصِع من غزوه إنَّ النَّبلَ وكرَّادَ

لِحَّرو العرسِ

ومِن العزجانَ معلامُ بن بحل قالوا وكأنَ معاد امه وكأن بسمه

ابرميم حلمل الونَصرو لكرَوَ السَّلفَ أنَيسَ حرده ولا أنعم برَنا

مزمعَاذ وسيمَل برحبسف وأل النَّبصل الله عليه وسلّم أمركلَ

بِ من معاذ حتَّى خانه وكأنَ بعزرَ من الزِّمَاد السنّه وقُمشِه

المشا يدروون للنَّبِ الولايات وبنقُ الصّرف أنَّ وبعلمُ النّامرلاَ علام

ونزربسم العزانَ وموّطِ ابن أفل من نُشِر بن سنّه وكأنَ يعُّندَ

رسولَ اللّه وَحسيّهاً ودِ يغبُورُ المسلمز عطيماً وقال الأنبّيّ

أنّمَاً أنّ أقُالمنزلَ معّيم بن معنيه الطّابد داشئاب له قالبعنَ

CALLIGRAPHY AND HISTORY

Ibn Khaldūn pointed out that writing and calligraphy flourished when civilization was at its apogee, and decayed with its decline. This is no doubt true, but such a relation is always extremely subtle. Calligraphy has been influenced by many peoples and powers; it has accompanied, in its own way, the whole history of Islam. And wherever Islam triumphed, in war or religion, the indigenous culture would reinterpret calligraphy and re-establish it in the duality of its vision. The use of Arabic script in Afghanistan, in Persia, in Turkey, or even in China, bears witness to the power of this inspiration. The imagery of calligraphic art denies the integral nature of Islam and separates it from its total system. This imagery retains the movement of history within itself. Persian mysticism makes reference to the shattering instant when the written word is swallowed up in divine love; when ecstasy disrupts the continuity of history. This process accepts history, receives it, and moves within it. All calligraphy, all writing, advances when his-tory is idle.

The importance of Kufa and Basra since the first Arab empire is well known, and history has recorded the name of the first famous calligrapher, Khalid Abi Hayyẓ (seventh century). Goṭba (eighth century) is said to have invented in the Umayyad epoch (660–750) the four calligraphic styles, which were named after the places where they were supposedly developed: Mecca, Medina, Basra and Kufa.

This kind of theory is unverifiable. It arose primarily from an ideological conflict between sects within Islam, each seeking by whatever means to prove its legitimacy.

Some historians choose to mention the calligraphy of Ali, Muhammad's son-in-law, traces of whose writing have supposedly been found, but according to the evidence of palaeography there is nothing to support this contention.

Since the Umayyad era, naskhi and kufic developed side by side, with kufic reserved in particular for hieratic inscriptions; it is worth repeating that kufic did not originate in Kufa. Under the Abbasid dynasty (750–1258) Baghdad became the centre for calligraphy. Kufic script was ousted from its primacy during the second century of the Hegira (eighth and ninth centuries AD) in favour of naskhi and its variants.

This change is explained historically by the centralization of the power of the caliphates. There grew up a caste of scribes (*Kuttāb*): secretaries, administrators, functionaries and calligraphers. Naskhi was a script suitable for use by clerks in a centralized bureaucracy extending westward as far as Spain as a model and unified system. The military class and the caste of scribes shared power at the head of government.

This world achieved its cultural sovereignty in the tenth century AD, a fabled sovereignty in Arab folk memory, when one considers the historic retreat which has since relegated this period to the twilight of historical existence. Calligraphy has glorified this expansion and contraction, this back-and-forth between the crest and the trough. Thus one can discern in calligraphy a faint and subtly drawn sense of the futility of life; perhaps it was in this context

Various renderings of the letter kāf *(k):*
(top) **thuluth;** *(centre)* **stylized kufic;**
(below) **archaic kufic.**

that Ibn al-Bawwāb decorated the margins of the Qur'ān –
to keep it safe within pure imagination.

Historians proudly record this upsurge of learning and
ability which achieved a unique synthesis between Islam,
Hellenism and the Persian world. They speak of the growth
of schools and universities, of the insatiable accumulation
of manuscripts and the growth of libraries. Scribes and
calligraphers, paid by the state, directed and codified this
traffic of ideas.

This is where the three great schools of Ibn Muqla, Ibn
al-Bawwāb and Yaqūt really belong, historically. Not simply
because these calligraphers had elucidated the formal the-
ory of the written sign, but because, in an elegantly dis-
turbing form, they projected onto this profusion of images
the shadow of their ultimate futility. Classical Arab art is
aristocratic: its tendency is towards something outside his-
tory. And its concern with the sacramental maintains its im-
agery at the highest plane.

The centres of this profusion shift and multiply in the
Arab and Muslim world. They mark the different poles of
the hegemony, and calligraphy became, in institutional
terms, at the service of the imperial bureaucracy and its reli-
gious ideology.

Maghribi scripts.
Pages from manuscripts written in a variety of calligraphic styles: cursive maghribi, or mabsut; precious maghribi or muhawhar; administrative maghribi known as zemami or musnad; maghribi mustashrik or orientalized kufic which, unusually for kufic, features diacriticals.

Pages 125–5. Text written in Arabic (large letters) and Persian.

SYMBOLISM
OF THE PAGE

THE SPELL
OF THE FACE

It is a common mistake to suppose that Arab graphic art is characterized by a strongly abstract quality, in contrast to the representational and figurative nature of Western art.

First, the Qur'ān does not expressly forbid the representation of the human form. In fact, the subject is not mentioned anywhere. The *fuqaha* and the orthodox have twisted the allegorical meaning of the Qur'ān the better to impose rules and prohibitions. The task of theology lies in circumscribing the edges of symbolism and making an enclosure of it. We have seen how, in writing, the reform of diacritical signs and vowels was strongly contested. For theologians the text of the Qur'ān – the word of God – had to remain just as it was in its first and incorruptible revelation. Later, the introduction of floral and geometric decoration into the Qur'ānic text was to meet with the same hostility.

A *hadith* cited by al-Bukhari expresses the prohibition on figurative art straightforwardly: when he makes an image, man sins unless he can breathe life into it. Since the authenticity of the *hadith* (sayings of the Prophet) is unver-ifiable, one may discreetly recall that this alleged prohibition was directed against contemporary forms of totemism which were anathema to Islam, but could conceivably re-infiltrate it in the guise of art. The principle of the invisible face of God could be breached by such an image. In one sense, theology was right to be watchful; it had to keep an eye on its irrepressible enemy – art. The absolute aim of art is, specifically, to endow with soul – a wandering soul which reveals itself in the field of existence only to show the impossibility of a sojourn there.

Another Muslim tradition states that, on the contrary, Muhammad permitted one of his daughters to play with dolls, which are of course derived from totemic objects of worship. Moreover, there are numerous examples of figurative sculpture in Muslim art, as well as drawings of animals and humans. The Caliph al-Mansūr (eighth century) had a sculpture carved in his palace. There are a number of well-known manuscripts (narratives, medical treatises, etc.) illustrated with miniature figurative draw-ings. Coins were stamped with the heads of monarchs.

Repetition of the letter 'w' in the phrase Huwwa llah *('It is God himself').*

Preceding pages.
Nashki script. *A cosmogonic composition, 1819.*

Calligraphy itself imitates the forms of real objects and makes use of the shapes of men and animals.

On the other hand, the point to consider is not just the explicit prohibition itself, but the transfiguration of calligraphic script in terms of imagination and the erotic. In freeing art from theology, religion encroached on mysticism. *'Ichq, ḥbb, maḥabba*: the desire to merge oneself in the infinite presence of Allah. A giddiness took the soul – here conceived as ecstatic thought – and sent it on a double journey involving both body and mind. 'I journey towards Mecca and Mecca comes towards me,' cried the great *rabi'a*. A separate existence in the spark of the divine presence, as fire catches the breath of the mystic: chanting, echo of the void, abyss of the corporeal body. Sufism acquired an invocation beyond compare. Therein lies a consideration which must be cleared up to permit a better reading of calligraphy.

Understanding of the nature of this physical impulse may emerge as the result of an examination of classical Arab lore, as expressed by the mysterious *Ikhwān as-Safa* (the Honourable Brethren), a secret sect of the fourth/tenth century. This spiritual group sought to establish a relation between the mysticism of Ismail and the doctrine of Pythagoras as part of a universal language, in which script expressed the rhythm of the world's separate creation. Adam was created in the form of a being who spoke. Allah taught him letters and numbers, the alphabet then consisting of only nine characters. With the increase of mankind, and its dispersal, this number grew to twenty-eight – the precise number of characters in the Arabic alphabet. Other forms of writing were imperfect through having either too many or too few letters. Arabic writing symbolized cosmic harmony, the perfection of Allah. This number expressed both the rhythm of the stars and the form of man. At the same time, the movement of the universe followed a duality ordained by Allah – as in the duality of the straight line and the curve. The image of man was equivalent to the straight line, that of the animal to the curve. Similarly with writing, the *alif* constituted the first letter, and it was upright.

Can the human countenance be studied like a Qur'ān? According to the Ḥurūfi, a cabalistic sect, the invisible beauty of God vibrates in the body of each prophet and is extended to the human countenance. The divine aura surrounding the beauty of the loved one or the Cupbearer has been a theme which major Muslim poets have developed in terms of intoxicated abandon. Certain sects met together expressly to contemplate the countenance, and as part of the novice's initiation into the emotional meaning of the mystery he was required to submit to the ordeal of the intense gaze of the master, *his* master. Through the impact of this spell, the word of Allah resounded deep within before appearing exoterically in the written word.

As a microcosmic expression – a calligram – of the hidden beauty of Allah, the human face has a powerful quality of fascination. As in script, the face can bring out the spiritual vibration of the divine injunction, the *fiat*. To read thus is to arouse the erotic in the field of existence. It is a flight across the mirror of Allah dividing form into its two aspects: the hidden and the manifest. Or, more precise-

ly, the Ḥurūfi believe that there is a 'mute' Qur'ān and a manifested Qur'ān, which is revealed in the human face. They endow this face with the symbol of the number seven, which is that of the *Fātiḥa* or the first Sura of the Qur'ān: seven lines – two pairs of eyelashes (4), the eyebrows (2), and the hairline. A seemingly eccentric choice of number, but the number of the seven maternal (and therefore feminine) lines indicates, for the Ḥurūfi, the charm of the androgynous form, wherein is reflected the inaccessible being of Allah. And it is always divided into two.

Above. **Kufic script.** *The name of Allah. Detail of a mosaic inscription from a mosque in Samarqand.*

Facing page. **Maghribi script.** *'The Beloved' by al-Qandūsi.*

JAFR,
OR THE SCIENCE
OF LETTERS

Thus the compound organization of letters has a lively significance for spiritual or mystical speculation, which seeks to reveal, through the veil of appearances, the hidden reality in terms of intelligible form. In the field of classical Arab knowledge it is grammar, as well as Jafr (the science of letters) or alchemy, which symbolizes the desire for a 'geometry' of the soul, achieved by spiritual exercises based on a combining of numbers and letters. Everything unfolds, according to this view, in the indivisible unity of Allah. For example, the 'science of balance' of Jabir ibn Ḥayyān, known as Geber in the medieval West, relies on traces of the universal transformation of one form into another, matter into matter, symbol into symbol. Such development of the cosmic scripture is encoded in the structure of the Arabic language. From the root of a word, an extensive growth proliferates, a blossom of number and of rhetoric. These forms are, so to speak, poems dedicated to the glory of God.

This sort of theory (beyond the reach, perhaps, of archaeology) has pervaded the metaphysic of symbol from East to West, in every sense, and still survives in certain simplified stories used by the *fuqaḥa* in popular medicine (organic and psychosomatic).

Left. Marginal figure from a cosmogonic treatise: The Stars Explained so as to Harmonize the Namer and the Named *(1812).*

Right. A bird bringing a message to the mystic Abdelqadar Jilāli, known as the 'White Hawk'. Calligram in relief on an unidentifiable ground.

*Right. Liturgical formulas
framed in circles.*

*Left. A cosmogonic
representation.*

*Preceding pages.
A composition taken from the
Garden of Eternity by Abdallah
bnū Sayyid 'Ali al-Husayni
(completed 1819).*

FUTUḤAT, OR ISOLATED LETTERS

In the Qur'ān one finds, at the beginning of certain Suras, *futuḥāt* (isolated letters) which have defied every attempt at explanation. They belong to the Arabic script, yet they are totally arbitrary. These letters have provided material for much mystical speculation. According to legend, they are the initials of the first copyists to record the text of the Qur'ān, and it is also hinted that they mark a break in the recitation between one Sura and the next, but the *futuḥāt* are not systematically arranged. However, legend thrives on inconsistency – in the statement, for instance, that the arrangement of these letters is a cunning trick played by Allah to confound unbelievers. Tradition says that in every revealed book there lies a secret, and the secret of the Qur'ān is hidden in the *futuḥāt*.

The legend conceals a theory, namely that the combination of these signs somehow crystallizes the symbolism of the Name of Allah. This may be elaborated into an arrangement of anagrams but is easily disproved.

The mystical view sees in the *futuḥāt* a kind of sublime signal, a wink of the eye, a tip of divine intuition penetrating the cycle of existence, granting pause for meditation on these crystalline letters where meaning is dissolved. Then the letters may combine, according to the power of the mystic's insight, to reimpose meaning upon the random and arbitrary nature of their dispersal. But perhaps one should consider how Allah has sanctioned this random quality of chance. It is chance itself.

Archaic kufic script. *A letter* fa *('f').*

Stylized kufic. *Fragment of letter* fa *('f').*

Facing page.
Maghribi script. *The double letter* lām *and* alif.

Left. **Archaic kufic script** *on gazelle skin.*

Opposite (from top left to bottom right).
Shikesté script. *Repetition of the letter 'l'.*

Shikesté script. *Repetition and superposition of the letter fa ('f').*

A letter 's' in exaggerated **kufic script.**

THE BISMILLAH

As I think of rhymes and verses, my beloved says:
Think only of my form.
I answer: Will you not sit beside me and rejoice,
O Rhyme of my thought? . . .
Then what are these letters that they should absorb your mind,
 what are they?
Why, they are the thorns which surround the wine.
Yes, I shall annul the letter by means of voice and language.
And I shall hold with you a converse beyond all letters,
Beyond all voice and language.

[Jalal ad-Din Rūmī]

A bismillah in the form of a bird
appearing to drink.

'In the name of God, the Merciful, the Compassionate', is the traditional translation of this formula, which opens each Sura of the Qur'ān and punctuates the recitation. Like the right hand, which is for regulating physical movement, according to the *hadith* every important action undertaken by a Muslim should be preceded by a *bismillah*. This theme in a sense complements the spirituality of the believer, since it immerses him at the outset in the blessing of Allah. This formula is also the subject of extremely varied decoration and of a richness of calligraphic treatment which would alone be enough to 'transmute' the Arabic language.

Each script extols the form of the *bismillah* in its own way. The codified models are very precisely laid down. For example, with Ibn al-Bawwāb the character س (*s*) simultaneously contains the formula in its extension and projects it forward.

How are the attributes of Allah to be set out in terms of the graphic line? In this kind of formula, it is the whole entity of the godhead which is involved, the whole metaphysical range, in its symbolic aspect. For centuries Arab philosophy has been considering the question of its attribution: a strict monotheism must be maintained, while taking into account the many attributes of God mentioned in the Qur'ān. Can God be said to possess the attributes of created form? Can one behold him in Paradise? A series of questions relating to the nature of God and of his Name are repeated in the field of calligraphy, where the imagery is well equipped to express the modification of the hidden face of Allah by means of arabesques which sing out in their divine intoxication. This is in the margin, and it is the nature of the margin which now requires a brief consideration from another aspect of the Islamic text.

A bismillah *from a Qur'ān, Afghanistan, 18th century.*

Top. A bismillah *in the form of a hawk.*

143

A bismillah *by al-Qandūsi, from his remarkable 12-volume Qur'ān (completed 1849).*

Opposite. The opening of the sura Maryam (Mary), from al-Qandūsi's Qur'ān.

Following pages. **Maghribi script.** *'In the name of Allah', from a Qur'ān copied by Ahmed Malūsh al-Hadrami (1886).*

THE MARGIN

A margin may perhaps be defined as something totally outside the law and statutes of the text. Totally, because the margin breaks all the rules and all the limits of authority. In vain does the writer put a frame round his text, protecting it from harm with vigilant ceremonial: the margin breaks through the frame, goes through the looking-glass and creates a general scandal. Thus we can talk about a certain script's passionate and 'prideful' will.

First there is the conventional margin. Here the margin of the text is either left blank or contains a commentary. In calligraphy the margin can be decorated. Its conventional quality consists of the degree to which it is based on a central unity, a central principle around which revolves the margin, here regarded as an unnecessary accompaniment to the text.

But in the art of Arab calligraphy the margin may include alongside the actual text a parallel text; or marginal motifs may be transplanted into the text; or the reader's attention may be diverted by making the margin easy to read and the text very difficult. Or the margin may rob the text of its central position by framing it with script on all sides.

In the last case, so beautifully done in certain Turkish and Persian books, the marginal commentary may consist of a word or phrase belonging to the body of the text, put in so that this commentary breaks the line of the script and gives it an unsuspected drift. The book then has to be turned around in all directions so as to follow the line of the script. Thus, too, the body turns with the book, joining in a little dance.

But in its absolute sense (no longer controlled by official convention) the margin is active in the whole field of calligraphy. It is active there as the inexpressible which may yet be expressed. From the smallest diacritical sign to the clearly written heading, the mystery is always in the reflec-

tion of what is actually there. It is in the winding paths of this uncertainty that the genius or the talent of the calligrapher makes its uncertain way. For instance, the Moroccan al-Qandūsi gave his margins an insistent, powerful symmetry. The unity of the page is punctured by this unexpected element, and the resulting dislocation gradually breaks down the central principle until the margin becomes a text within the text.

Above. Pages written in **naskhi** *with marginal commentaries.*

Right. Text written in ta 'liq with marginal notes and interlinear commentary in **naskhi**.

باب صلوة المريض لا تعذر

القيام لمرض حدث قبل الصلوة او فيها صلى قاعدا يركع و
يسجد وان تعذرا اوم برأسه قاعدا وجعل سجوده اخفض
من ركوعه ولا يرفع اليه شيئا للسجود وان تعذر اومى مستلقيا

ورجلاه الى القبلة او مظطجعا ووجهه اليها والاول اولى

ان تعذر الايماء اخرت و لايومي بعينه وحاجبه وقلبه ان

تعذر الركوع والسجود للقيام قعد او وم او انقض الايماء

قايما ووم موق في الصلوة استأنف وقاعد يركع ويسجد صح

منها بني فان بنا صلى تاما في فلك جاز بلا عذر صح وفي المربوط لا الا

بعذر جرح اوامي عليه يوما وليلة قضى ما فات وان زاد على

باب سجود التلاوة وهي سجدة بين

يين تكبيرتين بشروط الصلوة بلا دفع يد وتشهد وسلم وفيها

٣٢٣

Left. Text with marginal and interlinear commentary.

Right. A text written by al-Qandūsi with marginal notes in maghribi script.

THE SIGNATURE

Some Moroccan *fuqaḥa* recite a religious invocation as they make their signature, speaking the first word as they write the first letter, and ending with the last movement of the hand. This is a mnemonic device which was called *bakhucha* (scarab) as a reference to the stick-like antennae of this little creature.

Signing the name was an art in itself, the act of putting down the proper name according to its divine and historic stock: thus the *ṭughra* is a royal signature signifying a transcendental order and meant to be impossible to imitate. Then official scribes became entitled to copy the image, with the result that the ritual value of the gesture was destroyed: a king without a signature, and a signature without a crown.

In the *ṭughra*, which is a sort of cipher, sometimes impenetrable, the first letters are particularly prominent and form a compact base from which certain appendices project forcefully upwards. The higher these letters reach, the harder they are to read; the vertical is caught in cursive loops on the right. The proper name resumes the rightward

momentum by overlapping it. In certain calligrams two signatures co-exist: the calligrapher inscribes his own name (which is not necessarily readable) to the left of the royal signature. Sometimes the calligrapher may displace the royal signature with a *bismillah* or a quotation from the Qur'ān.

To take another example, one can be surprised by the severe monotony of calligraphic phrases which are variations of Qur'ānic phrases, or the names of Allah, or those of Muhammad or the first Caliphs. But this limitation must be put in its historical context, when each Muslim sect introduced a hierarchy among the successors of the Prophet.

Ali is pre-eminent among the Shi'ite Sufis, who mourn his murder and that of his two children, a murder still commemorated at Karbela in Iraq. With prayer and lamentation the faithful strike their foreheads constantly and with increasing force against a small calligraphed stone placed on the ground. There, the calligraphy is a signature of the mystic blood.

Tughras, *or signatures of* Ottoman sultans, including a firman in **diwāni script,** *the monogram of Osman III* (reigned 1754–57).

A calligram in praise of a
Mamluk sultan, with his name –
'Husayn bnū Shaʻban' –
suspended in a grille formed by
the long uprights. The address is
accompanied by accounts of his
fame (1362).

Signature *in* sumbuli script *by*
ʿArif Hikmat
(After Zayn al-Din Nāji; see
bibliography).

A calligram written in the normal direction.

Below. The same calligram written in reverse. Composed by Yahya (19th century).

A complex arrangement of **thuluth script.** *The text can be read vertically as well as from right to left. Calligraphy by ʿUthmān al-Ḥāfiz.*

Extracts from a Turkish film, with calligraphy by Amentü Gemisi. A love story in which a male figure fires an arrow at wild animals. The animals avoid the arrow, which eventually wounds the man's beloved.

IN THE SIGHT
OF ALLAH

We have emphasized the sacred character of calligraphy, as well as its divine associations. We now need to outline the connecting links which, from several points of view, place the principle of calligraphy within 'the sight of Allah'. Later we will briefly discuss the way in which calligraphy was involved in other aspects of Islamic art, particularly architecture, and how, even today, it challenges the graphic arts throughout the Arab world. In order to escape the grasp of technology, Arab, Turkish and Persian painters are now seeking to establish new roots in their work. We shall attempt to discover the form which this reappraisal is taking.

Kufic script *written on gazelle skin (14th century).*

Preceding pages. The name of Allah as transcribed by al-Qandūsi. Extracts from 'A Miscellany of Quotations and Liturgies' (1828).

A DELICATE
VIBRATION

For the Muslim, the world bears witness to the divine omnipresence. How can such a thing-in-itself be translated? What emerges here, on the plane of transcendental existence, is not simply the effect of an image or symbol concealing the human countenance, but the whole body contained in its sacred envelope. Man is a symbol, a name stamped with the seal of Allah. This is the body, screened from itself, and as it were detached from motion in the sight of God. Inserted into this body, at the divine command, is a depiction of the soul released into the realm of heaven. In its way, calligraphy contains this depiction of the soul. It reveals the path of revelation.

Of course, the history of the written word is in a sense the whole history of Islam. Calligraphy must be given its due as a universal feature in the arts of Islam: architecture, mosaic, arabesque, etc.

Muslim art obviously did not arise, whole and entire, in some miraculous transmutation. A survey of its full extent reveals metaphysical and cultural influences which are necessarily diverse and numerous. The art of Islam is by no means centred on any one place, be it Mecca or Timbuktu; it presents a varied landscape, without any precise centre. Take the Arabic calligraphy written by Chinese Muslims.

Such a script is Arabic to excess, overflowing its own origins. A cursive ideogram twists the Arabic letter, turning it upon itself as if to test its plasticity. Each culture has its own particular joys, and artistic creativity flourishes when the seeds are scattered far and wide.

Two prejudices which are commonly held with respect to Islamic art are its aversion to empty space on the one hand and, on the other, the completely gratuitous nature of its use of geometry. We need to understand that these two prejudices, rooted as they are in Christian theology, presuppose that it is figural art which witnesses to the divine incarnation in human form. Religious art in the West – in its Byzantine form, for instance – has symbolized the equation of painting, in the depiction of Christ, with representation: the bodily form of God presupposes a transfigured concept of painting or sculpture. These arts may be likened to the rays of a sun resuscitating the spiritual bloodstream.

The Christian artist may be said to contemplate himself lovingly in the eye of God, the self-contemplation of a spirit troubled and tempted by the desire, the suffering and the sin of looking. Such an artist, one imagines, must re-create himself through the substance of the Holy Trinity to let his vision roam free in the sensual world. Resurrection

Left. The phrase 'The Omniscient', one of the names of Allah, written in **ta 'liq.**

Above. **Maghribi kufic** *with diacriticals in red, written on gazelle skin (14th century).*

Interwoven floral kufic script. *The name of Allah.*

Left. The word 'Allah' embroidered in silk thread on leather in a book of quotations and prayers composed by al-Qandūsi.

through art thus irradiates the perceptual order, where the fusion of God and man is reflected.

By contrast, a Muslim artist – constrained as he is by a general prohibition preventing any figural treatment of the divine or human countenance – must return to the fundamental theory which asserts that everything must pass through the sacred text, and return to it again: the sacred text and the central principle. The Muslim artist constructs the semblance of an object (for only God can *create*) relating to something already inscribed on the Sacred Table. By this action he expresses the essence of art: to bring out in infinite variety what is already there. By this action he initiates an esoteric spiritual art which fills the void and expresses itself in terms of outlines of gnomic import: calligraphy of the absolute, symbols in monogram, parabolic geometry of the divine. Hence the thrilling example of the arabesque. In the alternation of geometric and floral motifs, what the eyes sees through the clarification of form is marked out in the main outline of the script, surrounded by blank space, emptiness, and the decoration in the margins. Then, when this has been noted, one sees a mosaic of illumination setting off, with exquisite grace, a central line of calligraphy – central, though not

169

centred on the page. Between the calligraphic elements and the mosaic one sees (*right*) the emergent interaction of a delicate, elegant vibration.

This leads to the general conclusion that the significant factor in Islamic art is neither aversion to empty space nor a gratuitous use of geometric design, but a drive towards absolute sanctification. The superabundance of the sacred is such that it contains its own void. Muslim art moves onwards in a secret, veiled anguish which harbours in itself a mystical experience. Hence the arabesque, which expresses this anguish in decorative form. It holds the balance of line and colour to a point where they begin to waver and vibrate in an interlaced tracery, and epigraphy and natural or geometric decoration are combined. This tracery holds the superabundance in check, yet marks a secret desire to lose itself. Epigraphy tells the word of God. Geometry and nature bear witness to His omnipotent presence. And on this voyage of celebration, the world delivers the soul of the believer to the anguish of the Invisible.

Illuminations from the Dalīl al-Khayrat.

Following pages.
Illumination from the start of a chapter in a manuscript by al-Qandūsi, executed in a highly personal style (19th century).

The name of the Prophet
Muhammad in mirror image, by
Suhail Anwar, Istanbul.

Below. An example of the style
known as tomar (after al-
Qalqashandi; see bibliography).

Left. The word 'Paradise' by al-Qandūsi. Within the one word there is a contrast between the rectilinear and curvilinear styles (1850).

Below. The name of the Prophet Muhammad as composed by al-Qandūsi.

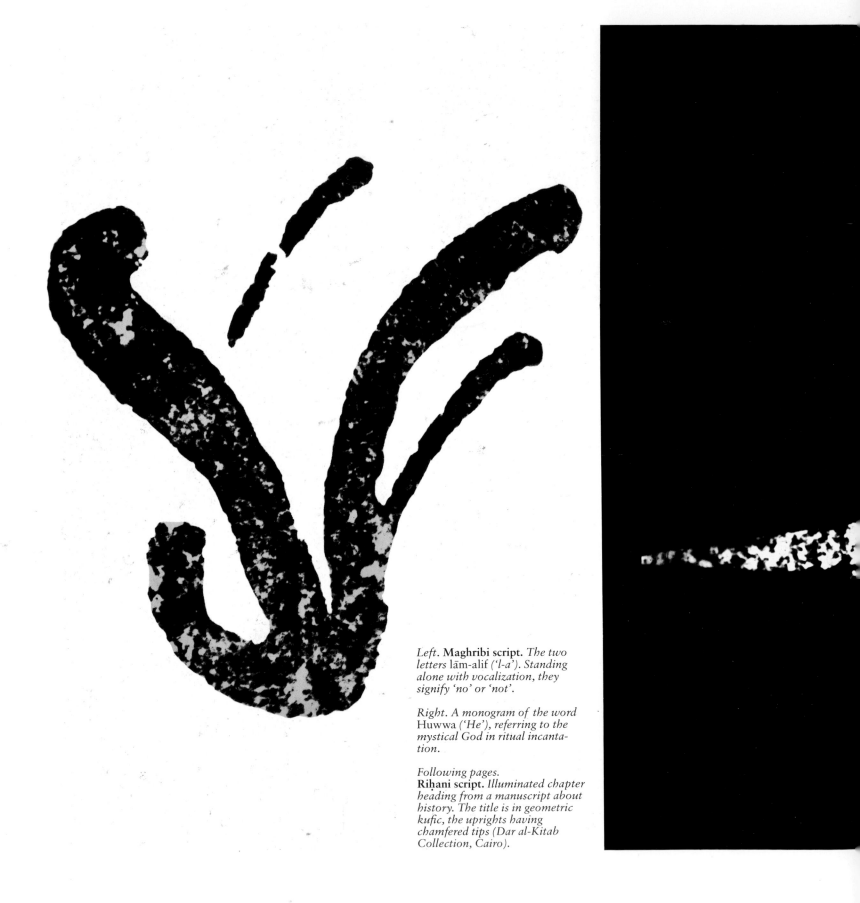

Left. **Maghribi script.** *The two letters lām-alif ('l-a'). Standing alone with vocalization, they signify 'no' or 'not'.*

Right. A monogram of the word Huwwa ('He'), referring to the mystical God in ritual incantation.

Following pages.
Rihani script. *Illuminated chapter heading from a manuscript about history. The title is in geometric kufic, the uprights having chamfered tips (Dar al-Kitab Collection, Cairo).*

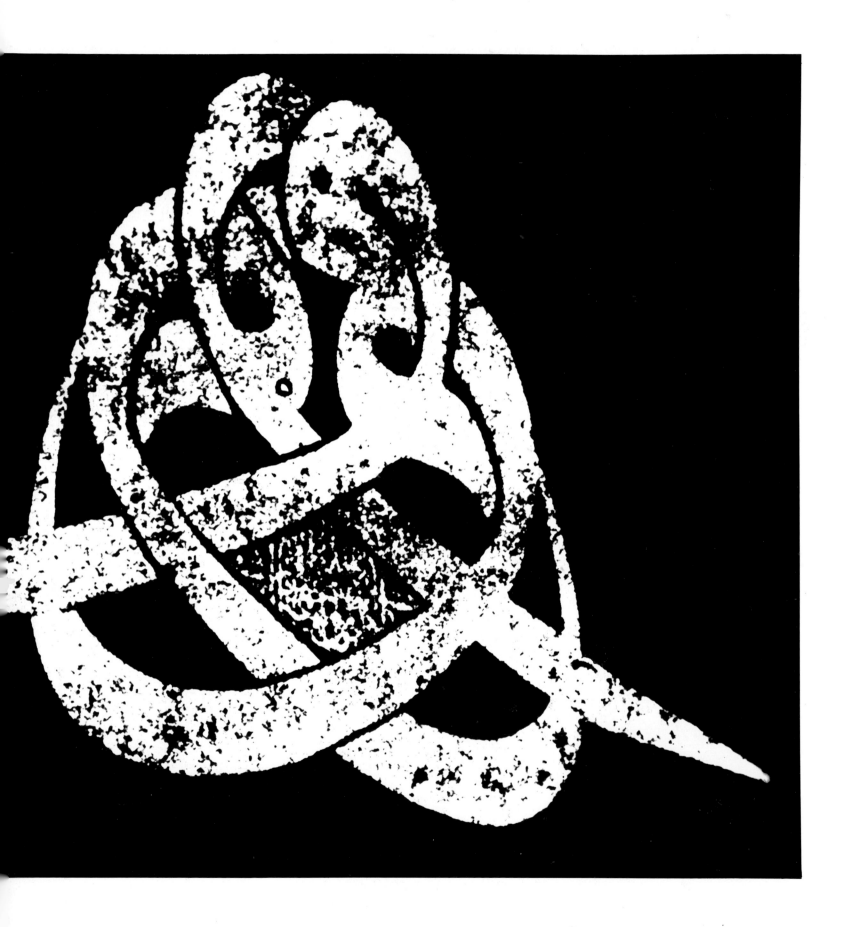

The Prophet Muhammad's footprint.

Right. The Prophet's footprint (from the Dakhira *of the* Sharqāwa, *a Moroccan brotherhood).*

ORNAMENTATION OF BUILDINGS

In the context of architecture, calligraphy plays an ambiguous role. On the one hand, it is projected from the manuscript page onto the monument, to decorate mosques, palaces, *madrasas*, tombs and any place with religious associations.

On the other hand, calligraphy becomes a veritable iconography of the written word. Qur'ānic manuscripts or liturgical texts may be ornamented with an assemblage of architectural themes: minarets, the holy sites of Mecca, the tombs of Muhammad and the four Orthodox Caliphs. No human features are depicted on these simply constructed shrine-pictures. Their purpose is simply to prompt the believer to meditate on the sacred, on an imagined pilgrimage to Mecca. The icon is there to symbolize the return to the source of Muslim belief.

But most often decoration takes the form of illumination and arabesque, which are inspired in equal measure by Byzantine, Greek or Persian art. The themes are well known: rosettes, flowers, palmettes, vines, garlands – a development of stylized forms following precise rules, and having as its function the revelation of God's omnipresence. Floral decoration, for example, is not in fact a pure abstrac-

Kufic *(in red) and* **thuluth** *– interplay between two scripts.*

tion. As a thing, and a thing in bloom, the floral subject contains, beneath its apparent emptiness, the fragrance of our being.

What is an arabesque? G. Marçais has written of this art form (in *L'art musulman*): 'The essential element, which may itself alone constitute the whole decoration, and which controls the design and the rhythm, is the band, the ribbon of constant width. To trace the design which the band is to follow, to compose it as a whole, simultaneously intricate and balanced, luxuriant and coherent, a design in which the eye can willingly lose itself and find itself again – that is the primary concern of the creator of the arabesque.'

What then is the essential meaning of this design? No doubt one can concentrate, as we have seen, on the geometric interweaving, and trace the combinations of letters and their stems in relation to geometric and natural ornamentation. Or, better still, one can try to work out the connections between decorative epigraphy and architecture as properly defined. But the real question remains unanswered, and it concerns the nature of the thing which graces Islamic art with its special quality. What is this quality to be called?

To be sure, historians have studied the development of Islamic art in relation to the triple influence of Greek, Byzantine and Persian art, a development which occurred from the tenth century onwards. Certainly, these historians have identified – insofar as it concerns our approach – the particular nature of decorative epigraphy. But these erudite and useful studies tend to give rise to a misleading over-simplification.

If Islamic art is to reveal itself to us, we must look into the philosophical heart in which it resides. In that heart, it lives unknown. Thus the simple example of the arabesque can still surprise us because of its refusal to be fitted into any of the accepted artistic categories.

Calligraphy, as we have said, is projected from the page onto the monument. It decorates the surfaces of mosques, palaces and tombs, emerging from a background of marble, stucco or wood, or indeed from any material imaginable. Mosaics, too, are included in this grand display of script. An impression of sumptuous magnificence is the immediate effect produced by these subtly fashioned garlands. But where does this genius of fantasy lead, this reordering of the stone between heaven and earth? One could even imagine

that the walls, columns, cupolas and domes might easily
uproot themselves and rise towards heaven!

Multifarious calligraphic designs envelop these build-
ings. Extended quotations from the Qur'ān are inscribed
on some surfaces, imitating the illuminated pages of manu-
scripts, often in kufic and/or thuluth script. As for the
friezes carved with arabesques, they release a universal
visual energy. But those familiar with Muslim art know
that these arabesques serve as a subtle and evanescent
initiation into Arab philosophy, and into the philosophy of
Islam.

Calligraphy and the arabesque cover a vast range of sites
and materials: monuments, miniatures, sculptures, carpets,
fabrics, jewels, coins, flags, mosaics, ceramics, enamelling –
a harmony of luxurious forms to mark the divine presence
or the power of aking. And because the use of calligraphy
serves as an illumination of the sacred, it manifests itself
everywhere, with scripts adapted to every material and
every form. It holds within it an essential measure of the
nature of being.

One should not assume, however, that all Muslim archi-
tecture is necessarily inspired by luxury. A mosque, for
example, need be nothing more than a walled enclosure, or,

in the desert, just two or three stones piled together and aligned towards Mecca. Islam should be seen in terms of its sacred hierarchy. Luxury marks the worldly power of a king, a governor, an empire. Each dynasty developed and fostered a particular artistic style which was intended to establish its legitimacy and its political power in the eyes of man and of God. In its essence, calligraphy is an aristocratic art. Its use elevated the governing class above the common run, between heaven and earth, in the eyes of God.

Now that the Arab world has embraced modern technology, the art of calligraphy is yielding to typography, but it has not yet disappeared from books or from journals, where it is generally displayed in headings. Nor has it disappeared from the streets, where one can buy posters cheaply. In these places of refuge, calligraphy survives in a marginal and subtly decadent form.

Now, exponents of Arab, Turkish and Persian painting and graphic arts are looking at calligraphy afresh. This is by no means surprising, for modern art may be a search for the pure symbol, the intrinsic truth, of script. Yet such a meeting may give rise to an ambiguous dialogue. The West arrived at abstract art after centuries of figural representa-tion, and the Arab painting did so by means of a doubtful short cut. This style of painting harks back to its origins in calligraphy and the popular arts, adopting a new way of combining signs which itself runs the risk of falling into the clutches of technology. But for as long as writing is able to exist over and above technology, so long will calligraphy remain a subject for poetry and meditation. Let us pay attention to messengers from the distant past.

Collage. Arches surrounding inscriptions in **thuluth** *script. Extract from the* Dakhira *of the* Sharqāwa.

186

THE
ARCHITECTURAL
CONTEXT

One of the more striking aspects of the architecture of Muslim countries is the way in which calligraphy serves as a key element of the decor in most of the monuments built in the period since the beginning of Islam up to the present day. Skilful arrangements of floral arabesque and geometric infills enable the artist to produce compositions which create a dialogue between light and shade, while at the same time highlighting subtleties of colour and form.

The malleable quality of the letters of the Arabic alphabet, the rhythmic movement of the way in which letters are joined and the harmonious nature of their forms combine to confer a sense of strength and elegance upon the buildings. Column capitals, arches, pillars, walls, doors and windows are enhanced by the presence of this lettered art form, which may be executed by painting, carving or incising, and which produces visual effects that are often arresting and act as an invitation to meditation.

Royal palaces, mausoleums, princely residences, town houses, public and private fountains, courtyards and garden kiosks, the tombs of caliphs, princes and dignitaries – wherever men have striven to build on a monumental scale, and wherever they have sought to glorify God and the Prophet Muhammad, the splendours of calligraphy were utilized to provide the final touch of grandeur and to impart the added lustre that would also serve to enhance the prestige of the building's patron.

Two friezes in Andalusian maghribi style, one (above) in carved plaster, the other in ceramic tiles with black-glazed lettering. Both are set against a background of spirals and double spirals. Madrasa al-Attarin, Fez (14th century).

Preceding pages. Sculpted stucco medallion: Al Mulk Lillah ('Allah is great'), c. 1480 (Hashem Khosrovani collection).

LANDMARKS

The use of calligraphy in Muslim architecture can be said to date from the end of the seventh century AD. The earliest known inscription is to be found in Jerusalem, in the Al-Aqsa Mosque – near the Dome of the Rock – completed in 691. It consists of a verse of the Qur'ān incorporated into decorative friezes running along the south wall of the building. The text, rendered in archaic kufic script, is still readable in parts.

The second important inscription of this period is to be found in the Mosque of the Prophet at Medina. This building was begun in the lifetime of Muhammad, and was enlarged and rebuilt several times, before it was finally completed in AD 709. Here the calligraphic text, in archaic kufic script, is a verse from the Qur'ān. We know from the tenth-century author al-Nadim that the calligrapher Khalid ibn abu al-Sayyaj had first produced a full-size sketch in gold lettering before having the design reproduced on the wall of the mosque.

Subsequently the Medina mosque would serve as a model for places of worship all over the Islamic world. It provided the inspiration both for the architectural use of calligraphy and for the art of organizing the mosque's internal space. It was this building which gave the orientation for the *mihrab*, the niche indicating the direction of Mecca (*qibla*) which Muslims face when praying in a mosque.

In regions such as the Maghreb and al-Andalus builders were more inclined to take as their model the Al-Aqsa Mosque at Jerusalem, particularly during the Almohad dynasty (eleventh century). It was under this dynasty that the orientation of the *qibla* wall was established in the Qarawiyyin mosque in Fez and the Great Mosques in Cordoba and Seville.

As Muslim civilization spread further from its Arabian heartland, and as major works of architecture proliferated, rules began to be laid down governing the structure of

Interwoven floral maghribi kufic, in which the uprights of the letters turn back at right angles, creating knots and fill-in ornamentation. Carved plaster frieze (detail), Madrasa ben Youssef, Marrakesh (16th century).

Cedar-wood partition separating the mosque courtyard from the prayer-hall of the al-Kabir Mosque, Fez. Text carved in relief and surrounded by a frame with geometric ornamentation (13th century).

Ta'liq inscription carved in relief. Façade of the Yeni Valide Mosque (1710), Üsküdar, a suburb of Istanbul on the Asian side of the Bosphorus.

Detail of wood partition with carved and openwork decoration. An alternation of bands of geometric and floral ornamentation which highlight the sobriety of the kufic lettering carved in relief, Qarawiyyin Mosque, Fez (10th century).

calligraphic texts, the manner of their arrangement, and their themes and contents.

Initially the subject matter consisted of short, unadorned phrases which were inscribed on friezes in particularly significant parts of the building. They later went on to become a regular feature of the decor, covering ceilings, columns, arches, doors, windows and whole stretches of walls.

The repertoire of calligraphic subject matter draws on quotations from the Qur'ān, phrases celebrating the glory of Islam, professions of faith, devotional invocation, exhortations, praise of sovereigns, philosophical maxims and mystical formulas.

To this body of subject matter can be added poetic texts, signature monograms (*tughras*), funerary inscriptions, information regarding the commissioning of the building in question, the names of caliphs, sultans, princes and high dignitaries, and details of the historical circumstances which a particular building was designed to commemorate. In addition, we find epitaphs and genealogies of famous public figures, and, in a later development, words which had no particular meaning and which were employed purely for decorative effect.

The names of the calligraphers and of the artisans who created and carried out the work are not generally given, any more than are the names of the architect or the builder, of whom one finds mention only later (and this only in some Ottoman and Persian buildings, but hardly ever in the monuments of the Maghreb).

The calligraphic texts as applied to architecture are, so to speak, a known quantity, given in advance, but they are nonetheless codified in the way they are presented, and there are rules governing their elaboration and execution.

However creative or competent the calligrapher who composes them, he has always been obliged to remain within the framework laid down by tradition, and was expected

to abide by the codes that govern each style. The specialist artisan working in any of the various different media – stone, marble, wood, stucco, ceramics, bronze etc. – was constantly subject to the control of his craft guild and its rules, even when his own individual inspiration was at its most creative and fanciful.

The text, which may be presented either raised in relief or incised, is always arranged within a framework defined by a line, 1 or 2 centimetres wide, which may likewise be either in relief or incised. This frame may take the form of a cartouche, a square, a rectangle, a circle or any of a variety of other regular geometric figures.

The dimensions of these frames vary according to a number of factors: the importance of the building; their position in relation to other elements of the decor; the degree of emphasis that the builder decides to give them; and the requirements of the artist's composition.

Mostly the framing devices are rectangular surfaces about 20 centimetres high and ranging between 1 metre and several metres in length. These friezes are used to frame large surfaces where a stylized vegetation and skilfully arranged geometric patterns create a dialogue that highlights the message conveyed in the text.

In other monuments these frames take the forms of squares and rectangles ranging from one to several metres long: the word Allah followed by one of his names, and the name of the Prophet or one of the first Caliphs are often created in a mirror calligraphy or by the use of interweaving lettering to give a labyrinthine effect. In some Ottoman buildings in particular, three or more rectangles may be superimposed, with each bearing calligraphic texts composed in a style different from the one immediately preceding it.

Building materials have played a determining role in deciding the form and arrangement of calligraphic lettering in architecture. They dictated the nature of the surface destined to receive the lettering and its accompanying arabesque – which may be flat, in relief or incised.

Colours tended to be reserved for wood, stucco and ceramics. They were generally of vegetable or mineral origin and the range was generally rather limited, in line with the technical possibilities available at the time. Gold and bright colours were applied to wood and stucco, while white, black, green and blue were generally reserved for tiles. Some of these colours have become famous – for example the turquoise blue associated with mosques at Samarqand and other sites in Central Asia.

The rules governing the use of calligraphy in architecture and the general principles that we have outlined are an integral part of the basic concepts and principles of Muslim aesthetics. While drawing on these principles, regional innovations and variants have provided new ideas, developing from one building to another while at the same time maintaining the overall image with which Islamic civilization has sought to endow its principal monuments.

Thus a large number of styles have been developed on the basis of scripts used in copying texts, and have been adapted to suit the monumental scale and the materials used in architecture. In the process the forms have been enhanced by various innovations regarding the body of the lettering, the tips and ends of letters and the manner in which they are linked. The original calligraphic styles have effectively been transformed by the nature of the materials used.

STYLES

Kufic *and* **naskhi** *panels from left (black excised ceramic tiles) to right (relief carved plaster). The* **naskhi** *letters are against a background of spirals. The* **geometric** *kufic letters have verticals ending in chamfered tips and other ornamental elements characteristic of the style.*

Kufic was the predominant – in fact virtually the only – calligraphic style used in architecture until the eleventh century. It has two kinds of characters: long letters extending upwards, and squatter letters extending downwards or outwards. The former represent the vertical elements of tall letters, and the latter the curving lines of rounded letters and the shorter risers of the other vertical letters. Rigid horizontal lines provide the base line and link the letters in order to create words.

Thus a calligraphic phrase in kufic script consists of a succession of vertical letters with long or short uprights, and lower, squat, rounded letters, together with horizontal link lines. This all evolves within a space which is traversed by rectilinear outlines creating a geometric arrangement of empty spaces which are treated in various ways by calligraphers in order to bring the composition to life.

The tall and short letters, the linear link lines and the empty spaces provide the basic parameters within which the calligrapher organizes his work. The words themselves are arranged around a rigorously observed horizontal base line which is *de rigueur* for all calligraphic compositions executed in the kufic style.

The space within which the phrase is expressed consists of two zones, one above and one below the line, and a perfect equilibrium is maintained between these two parts. The upper area has an airy quality, and contains the verticals and the empty spaces, while the lower area is more densely packed. These are the two areas within which the calligrapher's imagination can work with the interplay of letters, the balance of their proportions and the organization of the empty spaces between the verticals. The resulting rhythm and harmony of a piece are derived from the subtle interplay of these parameters.

Subsequent calligraphic styles were created by transforming the structures of the letters, the proportions of

their verticals, the design of their tips and the treatment of the areas above and below the base line.

There were several types of kufic script to be found in Islamic architecture, each deriving from a given epoch or geographical region. Later they would be taken up by builders in other countries, who adapted and modified them with varying degrees of felicity.

The main stylistic variations are archaic kufic, which is the archetype of Arabic script, floral kufic, geometric kufic, interwoven kufic, Andalusian-maghribi kufic, braided kufic and bordered kufic.

In the era of the Umayyads (until the mid-eighth century) the only style in use was archaic kufic. This style, which was generally engraved, fast arrived at a degree of aesthetic perfection. It was characterized by lines of equal thickness and rigid appearance. There are few buildings extant from this period of the Arabs' early conquests and settlement, given that in that period they had not had the opportunity to build important monuments.

In al-Andalus and the Maghreb, the oldest surviving specimens of archaic kufic are to be found in the Great Mosque of Qayrawan and the former Great Mosque in Cordoba. The Qarawiyyin Mosque in Fez once had a number of inscriptions, but the only one extant is to be found carved in relief on a cedarwood beam dating from the ninth century and bearing the name of Daud ibn Idris, son of Idris II, the town's founder. It is preserved in the Dar Batha Museum in Fez.

The geometric structure of the lettering in archaic kufic is characterized by a regularity of layout and the rigidity of the base line. The empty spaces between verticals are not ornamented, and contain neither floral decoration nor geometric infills. There is also no letter-pointing using diacritical dots. The rhythmic effect of this style derives from the interplay between tall letters and short letters and

the balance between their proportions. The interplay of light and shade created by the alternation between incised and flat-surface lettering accentuates this effect.

Under the Abbasids (ninth century) the development of science and knowledge went hand in hand with developments in manuscripts and architecture. This period saw the building of many mosques, *madrasas* and palaces. Now artists were brought in from all over the region to which Islam had spread, and they brought with them new ideas and new sensibilities which then influenced the evolution of calligraphic style.

There were important changes in various aspects of individual letters and the spaces created between them. Appendages in the form of flowers and flowery ornaments were added to the tips of certain letters, giving rise to floral kufic, which became the principal style in all provinces up to the eleventh century.

The kufic lettering of this era tends to be long and slender; the joining lines tend to be shorter, but are still straight. The tips of the letters take the form of an angular chamfer, where they had been somewhat thicker and concave in the earlier period. The bodies of the letters become thicker, as if better to support the enlargement of some of their parts. The spaces created by the uprights are filled by adding decorative elements such as stylized floral arabesques and complex geometric compositions.

These innovations went from strength to strength, sometimes ending by overstating the decorative aspect to the detriment of sensitivity and creativity, as can be seen in a number of monuments built in later periods.

The floral kufic style also introduced other transformations: the upright letters sometimes turn at right angles and join in knots or intricate patterns; the chamfered tips of the letters may take on ornamental elements typical of given regions, as for example the fine specimens of geometric

floral kufic to be found in the Alhambra, Granada, or in the mausoleum of Timur in Samarqand.

In some monuments the stylistic variants are so complex that it becomes hard to read the calligraphic text. On the other hand, in buildings such as the Qarawiyyin mosque in Fez or the Great Mosque in Tlemcen, the lettering itself remains sober, while the background is filled with flowers, rosettes, palm leaves and other stylized elements which serve to highlight the script.

The bordered kufic style developed principally in Iran. It consists of sober lettering with an independent decorative border, and in some monuments it includes geometric forms. The two elements stand out against a stylized floral composition which facilitates the readability of the inscription itself.

The so-called braided kufic style owes its name to the braided effect of the uprights of the letters. This style made its first appearance in Iran, and was then taken up in other countries, most notably al-Andalus and the Maghreb.

Persia, which saw the creation of several varieties of the kufic style, had a particularly inventive calligraphy because of its longstanding tradition of writing in other languages, of which the best known is *pahlavi*. The Arabic language, with its new characters, quickly took over, and became the preferred alphabet for all calligraphic texts on monuments, even when their original language was Persian or Turkish. The same thing occurred in Muslim India, where Urdu was written in Arabic lettering.

Other variations of the kufic style were applied to a wide range of building materials: carved or incised stone, stucco worked on several levels, brickwork arranged in relief in order to form words, engraved and painted wood, coloured tiles, and engraved or cast metals . . . These variants complemented by linear decoration of arabesques and infills are seen in numerous monumental graphic compositions which

*The interiors of many mosques in Iran and
Turkey are ornamented with inscriptions. In
the examples illustrated three circular
compositions feature letters pointing towards
the centre and arabesques providing framing
elements. The main example (centre) shows a
detail of the tile panels incorporating
calligraphic inscriptions surrounding the
mihrab of the Sokollu Mehmet Paşa Mosque,
Istanbul (1571).*

Preceding pages.
Archaic kufic script *in a geometric decorative
scheme. A rare specimen of calligraphy in
this style, characterized by horizontal and
vertical elements of equal thickness and
displaying a certain rigidity, highlighted by
the spaces between the letters. Mausoleum of
Jalal ad-Din Rūmī (interior), Konya, Turkey
(1295).*

can be counted among the finest examples of Muslim archi-
tecture.

Naskhi script first appeared in the East in the tenth
century, and by the eleventh century had been adopted
in the majority of Muslim countries. Its cursive structure
offered builders new decorative possibilities through the use
of new combinations of calligraphic styles.

In Morocco and al-Andalus naskhi script was introduced
under the Almoravids (eleventh century) and became wide-
spread under the Almohads (eleventh and twelfth centuries)
after the unification of the Maghreb under that dynasty. In
Iran naskhi script first appeared in the eleventh century,
whereas in Turkey it features in architecture only after the
twelfth century, in the Seljuq era.

The naskhi script, codified by Ibn al-Muqla and his pupil
Ibn al-Bawwāb, as noted earlier, developed in the East in the
ninth century, in manuscripts and court correspondence,
before arriving in the Maghreb and al-Andalus, where it was
to be greatly transformed. It took a while before naskhi was
adopted in the context of architecture, and it only became
predominant in the first half of the twelfth century.

Given that the naskhi style has a supple, cursive script, it
is easier to handle, inasmuch as its layout corresponds to
the natural movements of the writer's hand. The creative
options which it offers distinguish it from kufic, which is
angular, rigid and difficult both to execute and to read.

Its lettering is sometimes continuous and sometimes
detached, with supple rounded ligatures which often break
the continuity. Here the base line loses its rigidity, and so we
lose the rectangular aspect of the kufic style, which defines
an upper area with an exuberant floral decor and a freer,
more relaxed sublinear area. In naskhi inscriptions the
calligraphy of both areas is animated by the suppleness of
the bodies of the letters, and the varying directions taken by
their terminal parts.

The supple way in which naskhi is written, with the continuous movement of the linking lines between letters, provides a direct contrast with the earlier rectilinear spatial organization of calligraphic lettering, as well as a means of setting off the essentially rectilinear aspect of most buildings. It thus acts as a visual counterpoint to the mass of the built structure.

Naskhi's harmonious curves fit easily with the single and double spirals with which it is classically associated, with their wealth of foliage, flowers and assorted floral ornamentation. Over the centuries, and across the regions, calligraphers have introduced many stylistic variations into the naskhi script, creating local styles, some of which have been used exclusively in their own architectural contexts without ever being adopted elsewhere in the Muslim world.

The best-known variants of naskhi include, first and foremost, thuluth. Then, depending on the region, there are taliq, nastāliq, muhaqqaq, riq'a, rihani and, particularly worthy of note, the Andalusian-maghribi style, which can be located midway between kufic and naskhi

These different styles have led to some remarkable creations, which have enriched the architectural heritage of the Muslim world with new ways of combining lettering with floral and geometric arabesques.

Thus, in buildings in Iran one finds Persian and Arabic inscriptions where the monumental lettering of the naskhi script stands out prominently, producing a result that is a world away from some of the more floral compositions found elsewhere. These inscriptions provide the principal aesthetic element for the architectural decor within which they are featured.

In Turkey, on the other hand, decorative inscriptions tend to be enclosed within a large frame or cartouche which itself is likely to be subdivided by thin lines separating calligraphic texts executed in different styles.

In many Ottoman and Persian monuments the royal signatures (*tughras*) display their characteristic lettering in the shape of elongated, closely packed uprights that join at their tops to form an elegant mass with its own distinctive characteristics dictated by the style of the period in which it was created.

There are many variants of naskhi used in other forms of Islamic art which have not been adopted for architectural use, due to difficulties of execution when working with traditional building materials. However, the thuluth style has been the most popular variant throughout the Muslim world since the twelfth century, to such a point that kufic is now only used in certain parts of buildings where the inscriptions are short, repetitive and easy to read.

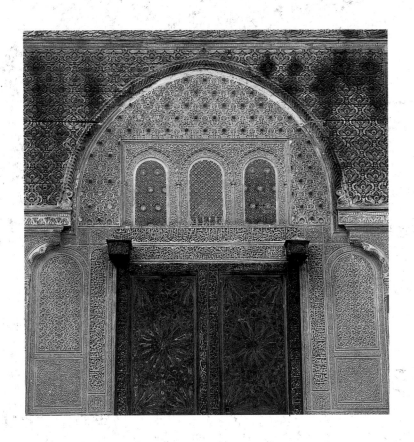

Various calligraphic styles employed in a single space, to stimulate the viewer and to facilitate a reading of the message.

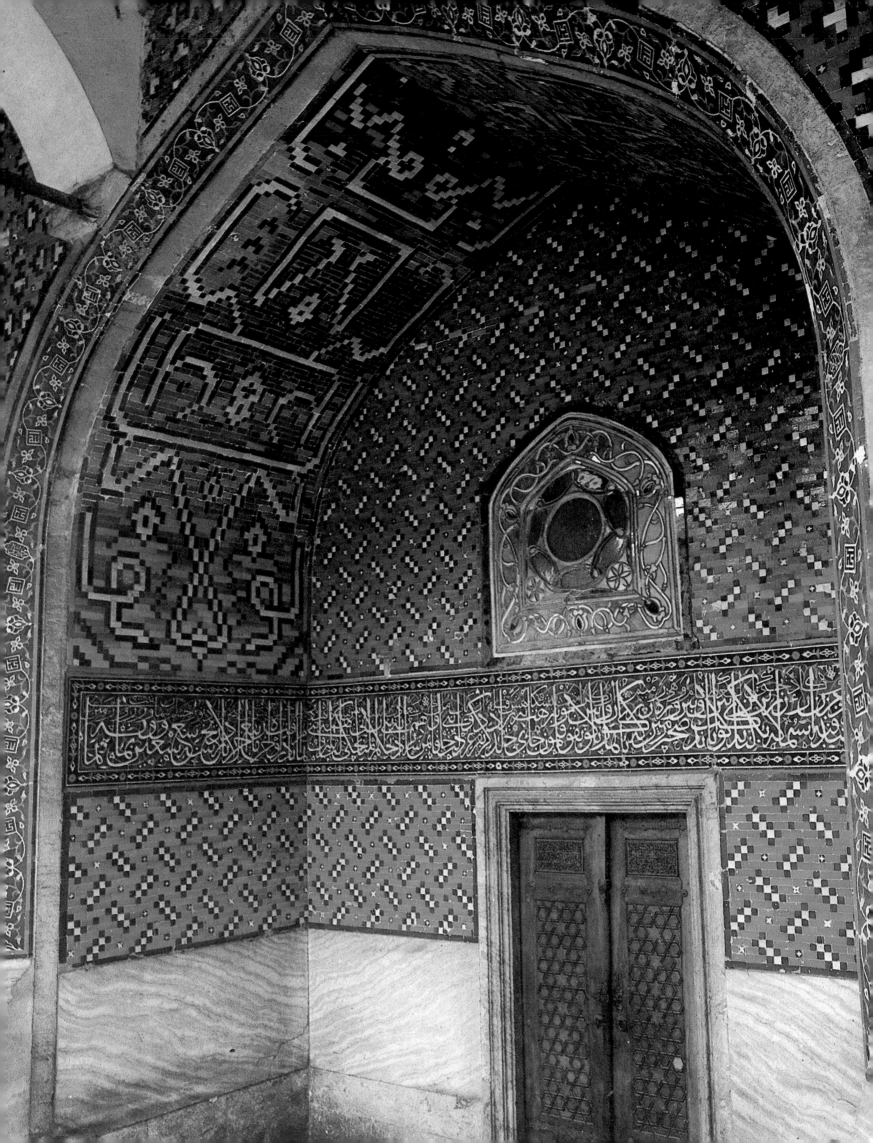

*Alternation and juxtaposition of a supple, cursive style with rigid, angular **kufic** lettering. The combination of stylized floral ornamentation, geometric interlacing and the richness of the polychrome treatment highlight the individual words and invocations. Mosque of Hassan II, Casablanca (1993).*

Overleaf. Rhythm, judicious positioning and movement are the criteria for beauty of execution in calligraphy. A good example of these qualities occurs in the dome of the Şehzade Camii, Istanbul (1548).

The repertoire of calligraphic
themes on monuments includes
quotations from the Qur'ān, pro-
fessions of faith, glorifications of
a sovereign and mystic sentences
or reflections. Çinili Camii,
Istanbul (1571), and the
Mausoleum of Jalal ad-Din
Rūmī, Konya (1295).

Preceding pages.
Enamelled ceramic tiles (detail)
featuring cursive calligraphy with
a background of single and
double spirals. Madrasa al-
Attarin, Fez (14th century).

Right. Materials play a key role
in deciding the form and arrange-
ment of calligraphic lettering in
an architectural context,
particularly whether the orna-
mentation will be flat, recessed or
in relief. Çinili Kösk, Istanbul
(1473).

CONTEMPORARY
PAINTING

One can compare painting to calligraphy. We refer to them both as 'imprints of the heart'. Initially it is from the well-springs of the spirit that the activity of imagination draws the forms of shapes. Since these forms are in accord with the spirit, one is right in calling them 'imprints'. In calligraphy and painting, if the things that spring from the imagination to appear on paper or bare silk are not 'imprints', then what are they?

Kuo-Jo-Hiu (11th century)

At the beginning of this book we observed that one of the characteristics of Islamic civilization is the strength of the ornamental arts, in which the Book has pride of place. The initial reference point of this abstract art remains the use of written characters. In the opinion of the painter Kamal Boullata, the arabesque itself, with its geometric and floral motifs, embodies a systematic relationship to the forms of Arabic letters.

Since writing is part and parcel of the graphic arts, it is inextricably linked to other arts such as drawing, painting and architecture. It meets them on a common ground: the construction of shapes and their development in graphic form. One has only to study a fine mosque – in an appropriate spirit of meditation – to convince oneself of the coherence of this art. We prefer to say 'coherence' rather than 'unity', because unity is a concept, an ideal of perfection, whereas the artist stands always on the brink of failure to achieve what he has set out to do.

Although painting has developed along its own singularly independent track, one finds that it constantly returns to the written form and to the creative discoveries it embodies. Further more, whether realist or abstract, painting always remains somehow within the ambit of ornamental art, inasmuch as it depends on an integral interrelationship between matter, colour and symbols. The enigma of the arabesque, which inspired Western artists such as Paul Klee and Henri Matisse, resides not so much in its decorative qualities as in its variations of kinetic rhythm. Calligraphy derives its strength from the act of reading, and that of looking without reading. There is at all times an imbalance between the two, a displacement, a scansion and a loss of meaning. That is why a piece of calligraphy may be considered a picture in

process of developing from its original conception. It opens the way to another stage of reading, that of the writer, who searches continually for an emotional and perceptional rhythm for the written structure that he strives to create. It is within the very syntax of a style that one senses this desire for rhythm and for ways of varying it: the variations of appearance, as Paul Valéry would say – the province of ornamental art. And that belongs us to modern art.

According to François Cheng (who has made important contributions to the study of calligraphy), the graphic arts provide a foundation not only for calligraphy as drawing, but also for the distribution of colours within the space occupied by any creative exercise. It was perhaps this quality which so captivated certain painters in North America (Kline, Tobey and Pollock) and Europe (Degottex and Michaux, to name but two) and encouraged them to turn for inspiration to the Far East and its civilizations, with particular reference to the calligraphy of China and Japan. In the words of Francine C. Legrand: 'If one simplifies things and overlooks the detail, one might conclude that the invasion of painting by writing takes place in successive waves, and that it becomes predominant in some of its phases: Cubism and its followers, Surrealism and its derivatives, abstract art and its later developments, and action painting.[1] Whenever painters direct their attention to abstract art, they come up against the centuries-old tradition of lettering as an art form, one which obviously is not merely the skill of knowing how to draw, but also involves the putting together of colours and the transformation of the matter of the composition by physical movement, as well as the use signs and symbols in an overall rhythm.

Among examples of painting inspired by Arabic scripts,

one finds calligraphy as such (or rather a false calligraphy, which is far more common), given that this is a form which continues to be practised in the Arab world, side by side with the use of functional lettering used to convey information. One also finds a number of distinctive strands within it:[2]

- A geometric treatment of letters in which the painter starts from a creative fragmentation and recomposition of the alphabet, and seems driven by a desire to melt into the talismanic magic of the language, as if seeking to translate into visual images passages from the Qur'ān. In a sense a chant (a litany) is visible in the treatment of line, the physical movement and the rhythm of the piece. The written text is inseparable from voice. This is the most common use of calligraphy, of which we could cite many examples: letters in the form of fountains, ruins, as well as a host of imaginative renderings.
- A process of abstraction of the painted letter: a letter which, in superimposing itself on a background of colours, somehow relates to the picture, by giving it a cultural identity, the stamp of a civilization and that civilization's invention of characteristic symbols (as seen, for example, in the work of the Iraqi Shakir Hassan, or that of Monir, a Bangladeshi painter and engraver living in Madrid).
- An emblematic use of lettering, in which the painting is saturated with signs that assume a mystical quality as talismans: Arabic letters, cabalistic ciphers, and, in the work of Rashid Koraishi, an intriguing interest in the distinctive qualities of Chinese and Japanese calligraphy.
- A decorative treatment of lettering, in which a word, a fragment of a word, a phrase or sometimes an entire text are presented in a calligraphic style which is clearly readable and representative of real letters, in a continuity deriving from the arabesque and kufic calligraphy in particular.

What we have here is often a form of decorative writing which mimics one or other of the styles of traditional calligraphy. Traditional calligraphy has its own aesthetic canon, its models and its proportions. It is learned by an arduous process of transmission from master to disciple, like a guild secret which is jealousy guarded, and which eventually enables the artist to earn his own place, and perhaps find his paradise, among the people of the Book (the *ahl al-kitab*).

We shall feature the work of four outstanding artists as we attempt to illustrate our ideas, while at the same time recognizing the contributions of others. The artists in question are: Hossein Zenderoudi, born in Tehran in 1937 and now living and working in Europe; Kamal Boullata, born in Jerusalem in 1942 and living and working in Washington, D.C.; Rashid Koraishi, born at Ain Beida in Algeria in 1947 and living and working in Tunis; and Al-Said Hassan Shakir, born at Samawa in Iraq in 1925, and now living and working in Baghdad.

Pages 212–13
Shakir Hassan al-Saïd.
Al hassud la yassud, *1979.*
Acrylic on wood,
84.5 × 123 cm.

The highly personal writing of the Iranian Muhammad Saber Fiuzi (1909–73)

ZENDEROUDI

Hossein Zenderoudi is a versatile artist with a solid grounding in traditional calligraphy. After all, he comes from Iran, a country which, as well as producing superlative carpets, has also produced some of the most refined calligraphy to be found anywhere in the Islamic world. Following in this tradition, he has shown himself to be capable of building an entire composition – or a series of compositions – out of variations of a single letter.

Sometimes he will produce multiple series of labyrinths based on letters in a meaningful phrase which is more or less readable, building them up to the point of saturating – almost to bursting point – the entire space of his painting or drawing. However, he is also capable, in moments of meditation, of somehow emptying the letter of its original written form, retaining only its movement and essence. He knows that there exists a living force, a rhythm behind every successful example of calligraphy. In his work the calligrapher seeks to transmit this essence, this material life.

Sometimes the letter is presented in a variety of different ways (horizontal, vertical, slanting, reversed, or superimposed to give a palimpsest effect), so that the writing appears to walk and run and skip across the space. On another occasion, with a sustained energy that can sometimes be ferocious, the artist projects the viewer into a maze where one is liable to trip on the reading of a word and be thrown off balance.

In this work there is no longer any real difference between the painted picture and the page of a book, between painting and writing; what we have is a plastic treatment of letters which serves to unify all the movements within the graphic line.

One can almost sense the moment of something being about to happen at the tip of the artist's brush. If the eventual desire of the writer is to imagine the reader, in other words to set free a part of his own life that would otherwise remain inhibited, one can say that the desire of the painter-calligrapher is to invent a sort of image-maker reader, an artistically conscious viewer, capable of reading the letters both as signs and as images, with an equal intensity. Zenderoudi is heir to a great and magnificent graphic tradition in which the various arts of the book (calligraphy, miniature-painting and illumination) each contributed to the other's beauty. Here we have a feast of signs and symbols which the Persian carpet has, from time immemorial, raised to the highest levels of art. Thus, when one examines one of Zenderoudi's paintings closely, for example his *Rows of Numbers Replacing the 24* (1976), one is struck by the illusion of reversibility: this picture presents simultaneously the appearance of a manuscript and that of a talisman, a carpet or an arabesque.

The silkscreens which accompany the French translation of the Qur'ān[3] by the poet Jean Grosjean are the first works of this kind. They stand confidently opposite this sacred text which traditionally has always been accompanied by gilded illumination, in itself representing the yearning for Paradise. Now, Zenderoudi is a modern painter, an action painter and an artist of the letter, handling colour with great dexterity. Right at the start of Grosjean's translation

Page 218
Hossein Zenderoudi, The Prophet on the Flying White Horse. *Study for an illustration of the Qur'ān. Silkscreen, 24 × 18 cm. Editions Philippe Lebaud, Paris, 1972.*

Left. **Hossein Zenderoudi**, Homage to Nur Ali Elahi, Master, *1980. Acrylic on paper, 28 × 21 cm.*

Right. **Hossein Zenderoudi**, Rows of Numbers Replacing the 24, *1976. Acrylic on canvas, 162 × 130 cm.*

of the Qur'ān one comes upon a double page conceived as a mirror effect. Thus, the artist immediately distances himself from the traditional style of illumination, which is designed to frame headings, sub-headings and other sets of words which are readable and explicit. No mistaken reading here. In the traditional approach the letter was ornamented, whereas in these silkscreens the letter is treated as pure sign; it may be recognizable in its shapes, but it is devoid of real meaning. It is this absence of meaning which gives rise to the distinctive form of this calligraphy, transforming it into the realm of the mystical.

We might perhaps consider these silkscreens as the beginnings of the 'new arabesque', which in his time, Matisse attempted to create within a purity of creative space; in this process the relations between materials, colours and symbols are ordered within the rules of ornamental art. Perhaps we might also rethink Islamic art (as we shall see below in the case of Boullata) in its deeply rooted abstract coherence between the forms of Arabic letters and the variations of the arabesque, which thus becomes a paradigm of the imaginal. The French art critic and poet Jean-Clarence Lambert has observed:

> . . . the product of that faculty of imagination which is the creator of images and which, as Corbin says, 'should never be mistaken for the kind of imagination that modern man understands, which is "fantasy" and which secretes only the "imaginary". In the thinking of Ibn Arabi and the Iranians, the faculty of imagination is "accorded

as much importance as the intellect and the senses, as . . . an organ of perception which is matched to the world which it inhabits, and which enables one to understand it." And, later: 'The power of imagination has full entitlement to lay claim to real being.'[4]

Zenderoudi has drawn attention to the fact that, for him, Nur Ali Elahi (who died in Tehran in 1974) is an essential reference point for these concepts.

What is being done in these silkscreens by Zenderoudi? Since he is dealing with the Qur'ān, he geometricizes the name of Allah, but this geometricization no longer accords with the vision of Islamic theology. It brings in other figures with sacred associations: *mandalas*, in the form of wheels, circles, sundials, medallions and bands within which lettering runs off in all different directions.

In some of the silkscreens one has a calculated effect of palimpsest, of superimposition and jostling in which the writing – a writing that is deliberately designed to be unreadable – is superimposed on the serenity of a *mandala*, which gives a hint of the supernatural. He makes use of several kinds of unreadability, sometimes by cutting up a phrase and fragmenting it, or by piling letters together so that the writing is transformed into something else: it becomes a cipher, or map-making, or emblem, or talisman, as if the writing had – by a projection into a past that is in the process of developing – to traverse all the different strata of memory, in which the artist's first name (Hossein) provides a reminder of Husain, the son of Ali and a founding father of

Islam in Iran. The sign then takes on aspects of original myth.

Other artists working in a similar vein include M. Omar, M. Benbella, N. Mahdoui, E. Adnan and Mehdi Qotbi, who was born in Rabat in 1951 and now lives and works in Paris.

At first sight Qotbi's work is calligraphic painting. However, a phrase like that demands explanation. It suggests a continuous space within which each of the two arts (calligraphy and painting) enhances and accentuates the qualities of the other. Which is drawing which? Is the overall quality of the work created by the letters? Or by form? Or by colour? What is the particular putting together of imaginary structures that enables the letter to transform itself into painting?

Qotbi often works on the basis of a single phoneme (generally Arabic) in a deconstruction of the alphabet (or rather of the solitary nature of the letter) as if the whole meaning of the pictorial process is to enable the letter to become disengaged from meaningful language and its process of signification.

We do not see this painting as embodying a mystic experience, inasmuch as the mystic experience demands a sacred text as an initiation into the secrets of the invisible and the world beyond. However, the pulsations of the solitary letter in Qotbi's work, and its never-ending repetitions remind us of precisely that: there is a tradition in which, in the chanting of the Qur'ān, the mystics deconstruct the name of God (Allah). By the end the only sound which they make – and which then fades away to nothing – is a fragment of the phoneme 'h' that ends the name of Allah. This is the essence of mystic chant, to end with the sacred letter.

Qotbi works essentially as a painter of the letter. And he treats this letter (in every sense of the word) in the spirit of modern art. What preoccupies him – as we see in the restlessness of his paintings – is the idea of transforming his paintings into an image, an image which may be apparent to all. This explains why his paintings are open to two different readings: one by Arabic-speakers, another by non-Arabic-speakers. However, each of these readings exists symbiotically with the other. When you look at the artist's signature, you find that it appears in both Roman and Arabic letters. A signature in which the painter presents two aspects of his own identity.

This style of calligraphic painting has to be viewed in the context of the encounter between two civilizations, that of the sign (Arabic) and that of the (Western) image, both figurative and otherwise.

Qotbi. Star on the Threshold, *1984, with enlarged detail above. Gouache on paper, 55 × 50 cm. Private collection, Paris.*

KORAISHI

Koraishi's curious fascination[5] with Chinese calligraphy has led him to attempt a dialogue between distinctive forms of writing coming from different origins, and taking in pictography on the way. However, his is not true Chinese calligraphy; it is more a semblance, an imitation of the ideographic act. For example, in the twenty engravings that he produced on the theme of Palestine, the most striking feature is the central monogram.

In order to appreciate the spatial directions in these engravings, one needs to be aware that Koraishi is left-handed, and that, in part, he works with the Arabic alphabet (which of course reads from right to left) and that he also works with made-up Chinese ideograms. Now, in the process of engraving the engraver must work on the plate in reverse, so that the printed image is seen the right way round. In Koraishi's work one also finds a number of architectural motifs, reminiscent of mosques, cupolas and religious locations, but this evocation soon evaporates in the face of this mobile topography of signs. The strength of these engravings lies in the fact that we do not know where the reading begins and where it ends, in other words where it is the writing that gives rise to the engraving, and where it is the other way round. It is as if, in the initial act of Koraishi's art there was no distinction between form and formlessness, structure and chaos – just an indeterminate quality. It is precisely this quality which is the delight of graphic art: it is from here that it draws its desire to re-invent and rebuild everything.

Earlier we referred to the encounter between Islamic art and the culture of other civilizations. In Koraishi's work it is represented in a dialogue between Arabic writing and painting (both Western and Far Eastern), particularly painting that is concerned with the search for pure signs. Each of Koraishi's engravings has this quality of a bridge between civilizations. But beyond this dialogue, what this artist has discovered is that each word is already inwardly written before actually being pronounced, before being written in any particular style. Every word represents the trace of a physical action. It is to this that the calligrapher's hand aspires. Even if a calligrapher's work were totally readable, it would still destabilize the habitual order of reading and its duration. Reading is not linear, even though it follows the rule of the line; it suspends duration, separating language from its immediate signification. Calligraphy realizes poetics in its most radical act; it is rooted precisely at the point where the word is a painting, a graphic form full of desire and energy. It is also rooted at the point where writing sculpts the meaning of language. As Mallarmé – an expert in the alchemy of

Rashid Koraishi, Untitled.
Engraving on paper, 105 × 85 cm.

Combattant No. 18, *1984, with enlarged detail (right). Engraving on Arche vellum, 77 × 57 cm.*

words – put it: 'My whole dream! A rarefaction of images into individual signs, rather in the same way that (you will smile at this) is done in divinatory Japanese art.' [Letter to E. de Roberty, November 1893].

How does Koraishi set about translating Mahmud Darwish's Palestine poems into engravings? He never writes them out in their entirety; he takes fragments, which he repeats, or reverses, or turns around. The words are there, but they are not totally readable. There is a tension, a violence, between the readable and the unreadable. We can read, but equally we cannot read: the itinerary of our reading is continually being broken off, continually setting off on voyages, journeys, going back through time. We might encounter *tifinagh* script (in the Berber alphabet) next to a cipher, which in turn is transformed by the presence of a densely-packed mass of phonemes. Viewed in detail, the reading has infinite possibilities.

The central monogram embodies the vibrations of this violence between the readable and the unreadable. Koraishi does not create calligraphy as such: he writes by drawing the pictorial movement of language. Try to read what he produces: one's attention is soon derailed by the pictorial strength of the piece. To a certain extent it does not even matter if you are not an Arabic-speaker! One begins to real-

ize that these writings are not there to be read, but to be viewed with a pictorial eye. They represent an encounter between different ways of seeing, between civilizations, between different ways of writing, between desires (of the letter desiring to be drawn; the act of drawing it).

Every work of art embodies its own theory to the extent that it is a creation of the mind in various aspects. In the case of painting one might argue that the theory is in fact produced by the act of painting, by the construction and rigour of the piece. In all instances where human imagination explores the unknown, it relies on a set of laws and internal conventions. Wherever it finishes up, it has to justify to the viewer's gaze the movement of a thought. One might well veer towards the notion of a graphic art made up of forces of the imagination that are productive of thought. Just as the dance step gives rhythm to a living thought (the body), the act of making a pictorial work of art fixes thought in a construction.

We have here a putting together of imaginary forms that is capable of having a wide appeal. We do not necessarily need to know the Chinese language in order to love Chinese painting, and, while loving it, to analyze it. We rely on our ability to span the world – in both the real and the imaginary sense. Nor do we need to know the Arabic language to

derive pleasure from its calligraphy. What we are invited to do is to explore the different places of language. Language is not the domain of a fixed set of meanings, but is like a laboratory of tongues. The artistic realities described here could be defined as intercultural. It is the experimental aspect that motivates the restless spirit of Rashid Koraishi.

SHAKIR HASSAN

An artist of the painted letter, of the letter as a drawn object, Hassan has developed a mystical and symbolic microtheory which presents painting – and his own in particular – as a workshop, a seat of civilization, an *aide-mémoire* in which signs construct the artistic identity of the Arab intellectual. In his search for what he calls the 'uni-dimensional' Hassan sees language as an 'open field in which all known aspects of contemporary Arab civilization are in operation.'[6] In his opinion, 'in a picture one can only achieve a logical complement if the letter loses all links with language.' But how does this happen? By decomposition and the destruction of meaning? By dislocation of the consonantal line? The shattering and violent juxtaposition of letters? Nothing is ruled out here; everything is possible. What the artist proposes is a transformation of calligraphy, writing and language into pure sign, into graphic line, in the midst of many other symbols – street graffiti, ideas borrowed here and there from Islamic imagery or from unknown sources. He liberates letters in order to cast them into the great adventure of abstract art, as elements of a new abstraction; or, more exactly, he integrates the violence of the act of doing within abstraction. Here we are no longer dealing with calligraphy, but with an extended spatial world in which the painted letter, whether recognizable or not, refers back to itself. The artist remembers himself, and his action bespeaks that remembering, that torn and lacerated nostalgia. One finds a similarly melancholic quest in Tapiés – a search for roots. In the case of Shakir Hassan, there is no sense of sacrifice: where calligraphy ends, painting begins.

Shakir Hassan al-Saïd,
Muhammad, *1975. Oil on wood,*
152 × 152 cm

BOULLATA

Boullata has followed a quite different path. In his work he goes to the linguistic and symbolic roots of calligraphy. Rather than chipping away at calligraphy and attempting to turn it into something else, he takes it as the central paradigm and foundation of Islamic art. In his view the arabesque is a geometric development of Arabic letter forms; the structures of letters provide the basis for its vegetal and floral motifs. Within classical Arab science, geometry, mathematics and the form of letters share an identical basic structure. The theory is difficult to demonstrate in all its dimensions, but it is rich in intuition. After all, one should not expect an artist to teach us the grammar of signs of science and history; the artist's job is to enable us to see ourselves. And furthermore, if one accepts the view of the poet Francis Ponge that the figures of rhetoric (ellipses, parables, hyperbole . . .) are related to Euclidean geometry, then one could justifiably join Boullata in asking oneself what is the topography and spatial logic to which the Arabic language relates.

Boullata provides a double answer to this question, as both painter and researcher. His work has been the most geometrical among the creations of modern Arab calligraphers, as exemplified in a fine group of silkscreens. His work is based on the kufic style, with a purity of line and a certain angular rigour, avoiding fanciful effect, as if by this transparent linearity he is attempting to uncover the secrets and the enigma of Arabic lettering.

The fact that all his work is inspired by classical calligraphy gives him an important status within contemporary art. His concern is to examine the kind of abstraction that characterizes the art of Islam, whether in its script, or the various arts of the book, or the arabesque, or mosaics. It is possible that his theory is merely intended to project his work (this is what we tend to think), but nonetheless it deserves our attention.

There is, in his opinion, a perfect correspondence between calligraphy and the arabesque.[7] The early origins of some of the letters in drawn forms is now accepted, and this applies to other Hamitic-Semitic languages. One can recognize this in the following pictographic remnants:

- ج (j): the camel
- ك (k): the hand, including the wrist
- ى (ya): the hand (*yad*)
- س (s): teeth
- ن (n): fish.

In the first Arabic dictionary, compiled by Al-Khalil Bnu Ahmed in the eighth century, the character ع (meaning eye, spring) 'was the letter which, in the author's opinion, enabled letters to enter the throat'. Now, Boullata says that the appearance of diacritical dots led Arab mathematicians to transcribe their zero as a point or full stop, which then served to indicate vowels, as can be clearly seen in the older manuscripts of the Qur'ān written in kufic script. Learned people used a common code of transcription before each branch of the knowledge which concerns us, namely arithmetic and geometry, developed separately.

The ancient rhetoricians classified words according to whether they were two or three-letter roots. This typology of twos and threes, which one also finds in the allocation of diacriticals, represents the two principles of the arabesque and its geometric compositions. The very fact that letters vary according to whether they are at the start, the middle or the end of a word, gives each letter a particular form, in relation to the base line of the writing, which offers as many as seventy-three variants of the letter 'm'.

This phenomenon of variation has its counterpart in the arabesque. The grammarians' classification of words into biliterals and triliterals, and the way in which words are transformed by inversion, changes of letters and removal and addition of letters . . . this whole process involved in the structuring of language and the very body of Arabic linguistics, represents, in Boullata's opinion, the foundation of the arabesque. Its secret lies in the union between line and circle, which constitutes the correspondence between arabesque and calligraphy. The nature of this correspondence can be summarized as shown below and overleaf:

I CALLIGRAPHY

A The principal dualist oppositions

- Verticality/horizontality
- Letters extending above the base line/letters extending below the base line
- Words with no inner break/words with breaks
- Words with prefixes and suffixes/words without
- The principal visual counterposition: the circle/the dot

B The principal graphic contrasts of triliterality

- Three forms of the letter, depending on whether it is at the start, middle or end of a word
- Three forms of diacritical: one dot; two dots; three dots
- The writing of vowels in three forms, above and below the base line
- Words are recognized by whether they have diacriticals inserted above or below the base line, or whether they have none

II THE ARABESQUE

A The principal dual contrasts

- Contrast between circle and line
- Division of the line or the circle into equal surfaces
- The division of this contrast into a counterposing duplication, or lateral duplication, or both together

B The principal divisions into three

The arabesque is created in three stages:

- The drawing of the circle
- The division of the surface into equidistant parts
- The drawing of straight lines between the points thus arrived at.

Kamal Boullata,
Silkscreen, 1985.

Page 230.
Kamal Boullata,
Silkscreen, 1985.

Maghribi mujawhar script.
*Calligraphic laudatory formula
(19th century).*

EPILOGUE

As the reader will have discovered in the course of this book, the letter has already been transformed, into an imagery, into a kind of fantasy world. We love calligraphy for its beauty, and its beauty – ornamented as it is with every kind of adornment – poses major questions for an understanding of art. We love this beauty, but at the same time it is a matter of concern, because how can one write about this art (which is by definition a writing in the second degree) without hesitating? What style would one have to bring into play to transcribe the discipline of the angular script, the subtle movement of the cursive, and all the other inventions of those oft-forgotten calligraphers, and those who are only known to us as names in history? It is as if, for history to be written, we were leaving our written heritage in the care of a child who is only just beginning to spell out words and given them meaning. This is the dawning moment from which the great adventure that is language begins.

NOTES ON THE TEXT

TRACING THE ORIGINS

1 A. Badawi, *Histoire de la philosophie en Islam*, vol. I, Paris, 1972.
2 Henri Loucel, 'L'origine du langage selon les grammairiens arabes', in *Arabica*, 1963 (pp. 188–208 and 281), 1964 (pp. 57–72 and 151–87).
3 H. Loucel, op. cit.
4 Roger Arnaldez, 'L'origine du langage', in *Grammaire et théologie chez Ibn Ḥazm*, Paris, 1956.
5 H. Loucel, op. cit.
6 A. Badawi, op. cit., p. 80
7 Ibid. pp. 80–1.
8 Ibid. p. 82.
9 R. Arnaldez, op. cit., p. 45.
10 Ibid. pp. 81–82.
11 A. Badawi, op. cit., pp. 81–2.
12 *Iḥya"ulum ad-din*, IV, p. 316.
13 Ibn Khaldūn, *al-Muqaddima*, cf. section on 'Script and calligraphy', UNESCO, Beirut, 1968, vol. 2
14 J. Sourdal-Thomine, 'Les origines de l'écriture arabe . . . ', in *Revue des études islamiques*, Paris, 1967.
15 Vol. I, ed. by E. Combe, J. Sauvaget and G. Wiet, Cairo, 1931.
16 Article on Arabic script, in *Encyclopedia of Islam*, 1st ed., 1913.
17 J. G. Février, *Histoire de l'écriture*, Paris, 1959, p. 263.
18 J. Starkey, 'Petra et Nabataea', in *Dictionnaire de la Bible* (supplement), Paris, 1964.
19 Zayn al-Din Nāji, Atlas of Arabic Calligraphy (in Arabic), Baghdad, 1968.

SCHOOLS AND STYLES

1 L. Massignon, 'Voyelles sémitiques et sémantique musicale', in *Parole donnée,* coll. 10 18, Paris, 1962, p. 381.
2 See the important contribution by J. Derrida, *De la grammatologie*, Ed. de Minuit, 1967.
3 Ibn Khaldūn, *Al Muqaddima*, op. cit., pp. 852–3.
4 B. Moritz, 'Arabic Script', in *Encyclopedia of Islam*, 1st edition, 1913.
5 J. Sourdel-Thomine, loc. cit.
6 Letter preserved in the Dar al kutub al Misriyya, Cairo.

7 D. S. Rice, *The Unique Ibn al-Bawwab Manuscript in the Chester Beatty Library*, Dublin, 1955.
8 Rice, op. cit.

CONTEMPORARY PAINTING

1 *Quadrum*, no. 13, Brussels, 1962.
2 A Khatibi, 'Interférences' in *Croisement de signes* (exhibition catalogue), Institut du Monde Arabe, Paris, 1989.
3 French translation of the Qur'ān, Paris, 1972.
4 J.-C. Lambert, 'Le Règne imaginal', in *En Islam iranien*, III, 16, Paris, 1991.
5 Engravings accompanying a text by A. Khatibi (unpublished).
6 See article by Buland al-Haidan, 'La Lettre arabe dans l'art pictoral contemporain', in catalogue of the Institut du Monde Arabe, Paris, 1987.
7 See study (in Arabic) in *L'Islam et la modernité*, London, 1990.

BIBLIOGRAPHY

This bibliography is necessarily selective. We have therefore chosen those works on Islamic calligraphy which are basic and essential to the subject. Also included are several important books relating to the theory and analysis of writing, which have been mentioned in the text and footnotes. Major Arabic texts, such as the *Fihrist*, are too well known to require precise bibliographical documentation.

ARABIC

Epistles of *The Brothers in Integrity*, Cairo, 1928
Friḥa, A., *The Arabic Script*, Beirut, 1961
Ghazlan, L., *The Diwāni Script*, Cairo, 1934
'Ibada, A., *The Spread of Arabic Writing*, Cairo, 1915
Jahiz, *On Script and Writing*
Khaldūn (Ibn), *Al Muqaddima*
Muqla (Ibn), *On Calligraphy*, MS at Dar al Kitab, Cairo;
——, *On the Proportions of Calligraphy*, MS at the Bibliothèque 'Attarine, Tunis
Nadīm (Ibn), *Fihrist*
Nāji, Zayn al-Din, *Atlas of Arabic Calligraphy*, Baghdad, 1968
Qalqashandi (al), *Subḥ al'a 'sha*, vol. 3, Cairo, 1913
Tawhīdī (A), *On Calligraphy*, Damascus, 1951
Yāsin, S., *Arabic Script and its Development under the Abbasids*, Baghdad, 1962
Yussuf, A., *Kufic Script*, Cairo, 1933
Zaki, M. H., *Atlas of Islamic Ornamentation and Decoration*, Cairo, 1956

OTHER

Abbott, N., 'Arabic paleography', in *Ars Islamica*, VIII, 1941;
——, *The Rise of the North Arabic Script*, Chicago, 1939
Alazard, J., *L'Orient et le peinture française au XIX siècle, d'Eugène Delacroix à Auguste Renoir*, Paris, 1940
Arnold, T., *Painting in Islam*, Oxford, 1928
Arnold, T. and Grohmann, A., *The Islamic Book*, London, 1929
Ars Islamica, quarterly review, Ann Arbor, Mich., 1934–51; followed by *Ars Orientalis*, Ann Arbor, Mich., 1951–
Berque, J., *Langages arabes du Présent*, Paris, 1974
Blachère, R., *Introduction au Coran*, Paris, 1947

Burckhardt, Titus, *Art of Islam: Language and Meaning*, London, 1976
Claudel, P., 'La philosophie du livre', iin *Œuvres de la prose*, Paris, 1965
Creswell, K. A. C., article on Architecture in *Encyclopedia of Islam*, 2nd ed.;
——, *Early Muslim Architecture* (2 vols.), Oxford, 1932/40 (revised ed., vol. I, Oxford, 1969); reprinted New York, 1978/9
Derrida, J., *De la grammatologie*, Paris, 1967
Diez, E., *Die Kunst der Islamischen Völker*, Berlin, 1915
Dodd, Erica Cruickshank, and Khairallah, Shereen, *The Image of the Word. A Study of Quranic Verses in Islamic Architecture* (2 vols.), Beirut, 1981
Ettinghausen, R., *Arab Painting*, London, 1962
Ettinghausen, R. and Grabar, O., *The Art and Architecture of Islam 650–1250*, New York and Harmondsworth, 1987; paperback ed., New Haven, Conn., and London, 1992
Farès, B., *Essai sur l'esprit de décoration*, Cairo, 1952
Février, J.G., *Histoire de l'écriture*, Paris, 1959
Gayot, H., *Le décor floral dans l'art de l'Islam occidental*, Rabat, 1955
Gelb, L.-J., *Pour une théorie de l'écriture*, Paris, 1973
Gluck, H. and Diez E., *Arte del Islam*, Madrid/Barcelona/Buenos Aires, 1932
Golvin, L., *Essai sur l'architecture religieuse musulmane*, Paris, 1970
Grabar, O., *The Formation of Islamic Art*, New Haven, 1973
Grabar, O. and Ettinghausen, R., 'Art and architecture', in *The Legacy of Islam*, Oxford, 1974;
——, *Islamic Architecture and its Decoration, A.D. 800–1500*, Chicago, 1964
Grohmann, A., *Arabische Paläographie*, Vienna, 1967
Houdas, P., 'L'écriture maghrébine', in *Nouveaux mélanges orientaux*, Paris, 1886
Huart, C., *Les calligraphes et les miniaturistes de l'Orient-musulman*, Paris, 1908
Kühnel, E., 'The Arabesque', in *Encyclopedia of Islam*, 2nd ed.;
——, *Die Arabeske: Sinn und Wandlung eines Ornaments*, Wiesbaden, 1949
Lings, Martin, *The Quranic art of calligraphy and illumination*, London, 1976
Lings, Martin and Safadi, Yasin Hamid, *The Qur'ān* (exhibition catalogue), London, 1976

Longperier, A., 'De l'emploi des caractères arabes dans l'ornementation chez les peuples chrétiens de l'Occident', in *Revue archéologique*, Paris, 1845

Marçais, G., *L'art musulman*, Paris, 1962;

——, *L'architecture musulmane d'Occident*, Paris, 1952

Massignon, L., *Parole donnée*, Paris, 1962

Mignon, G., *Manuel d'art musulman* (II), Paris, 1907

Moritz, B., article 'Arabic script' in *Encyclopedia of Islam*, 1st ed.;

——, *Arabic Palaeography*, Cairo, 1905

Otto-Dorn, K., *L'art de l'Islam*, Paris, 1967

Panofsky, E., *Studies in Iconology*, New York, 1939

Peignot, J., *De l'écriture à la typographie*, Paris, 1967

Répertoire chronologique d'épigraphie arabe, edited by E. Combe, J. Sauvaget and G. Wiet, vols. 1 and 4, Cairo, 1931

Rice, David Talbot, *Islamic Art*, London, 1965; paperback ed. 1975

Robertson, E., 'Muhammad ibn 'Abd ar-Raḥmān on calligraphy', in *Studia semitica et orientalia*, Glasgow, 1920

Safadi, Yasin Hamid, *Islamic Calligraphy*, London and New York, 1978

Schimmel, Annemarie, 'The Art of Calligraphy', in R. W. Ferrier (ed.), *The Arts of Persia*, New Haven, Conn., and London, 1989, pp. 306–14;

——, *Islamic Calligraphy*, Leiden, 1970

Soucek, P. P. (ed), *Content and Context of Visual Arts in the Islamic World*, University Park, Pa, 1988

Sourdel-Thomine, J., 'Les Origiines de l'écriture arabe à propos d'une hypothèse récente', in *Revue des études islamiques*, Paris, 1967

Vadja, G., *Album de paléographie arabe*, Paris, 1958

Yazan, Midhat Sertoğlu, *Tughra Osmanli Türklerinde*, Istanbul, 1975

Yazir, M. B., Calligraphy (in Turkish), Ankara, vol. I (1972) and vol. II (1974).

ACKNOWLEDGMENTS

The authors are grateful for having been allowed access to archives and libraries in Morocco, kindly arranged by the late Hadj M'hamed Bahrini, sometime Minister of Culture.

We wish to thank all those who permitted us to consult and to photograph manuscripts which are not generally accessible. They include: Farukh Hosni, the Egyptian Minister of Culture; the curators of the Topkapi Saray, the Süleymaniye, and Koprolü Libraries, all in Istanbul; the Bibliothèque Royale, Rabat, the University of Qarawiyyin, Fez, the General Library and Archives, Rabat, the National Library (Dar al-Kitab), Cairo, the National and Guilali Libraries, Baghdad, and the Razza Library, Rampur, India.

We are also indebted to Ahmed-Shawki Rafif, Yahia Fiüzi, Ferit Edgü, Dr Ekmeleddin Ihsanoglu, Qahtan al Madfaï, Abderrahman Tazi, Abdellatif Laraki, Brahim Alaoui of the Institut du Monde Arabe, Paris, the calligraphers Abdeslam Guenoun and Ghani Alani, and Kamal Boullata.

PHOTOGRAPHIC SOURCES

With the exception of the items noted below, all photographs were taken by Mohammed Sijelmassi:
Nuri Arlassez (IRCICA archives, Turkey) pp. 194 above, 198–202, 206–7, 210–11;
Yahia Fiüzi pp. 216–17;
Amentü Gemsi pp. 160–1;
Ara Güler pp. 8–9, 19, 28–9, 31, 34–5, 61, 108–9, 110–12, 153;
Musée d'Art et d'Histoire, Geneva, pp. 188–9.

Works by Hossein Zenderoudi reproduced on pp. 218, 220, 221
© 1994 SPADEM.